A Dictionary of
Twentieth-Century Art

Ian Chilvers is a freelance writer and editor. He is co-editor of the *Oxford Dictionary of Art* (which has been translated into four languages) and of the *Concise Oxford Companion to Classical Literature*. He has also contributed to many other reference books, including the *Macmillan Encyclopedia of Architects* and the Macmillan (Grove) *Dictionary of Art*, and he is one of the principal consultants for the *Oxford Children's Encyclopedia*.

A Dictionary of

Twentieth-
Century Art

IAN CHILVERS

OXFORD
UNIVERSITY PRESS

OXFORD

UNIVERSITY PRESS

Great Clarendon Street, Oxford OX2 6DP

Oxford University Press is a department of the University of Oxford
It furthers the University's objective of excellence in research, scholarship,
and education by publishing worldwide in

Oxford New York

Athens Auckland Bangkok Bogotá Buenos Aires Calcutta
Cape Town Chennai Dar es Salaam Delhi Florence Hong Kong Istanbul
Karachi Kuala Lumpur Madrid Melbourne Mexico City Mumbai
Nairobi Paris São Paulo Singapore Taipei Tokyo Toronto Warsaw

with associated companies in Berlin Ibadan

Oxford is a registered trade mark of Oxford University Press
in the UK and in certain other countries

Published in the United States
by Oxford University Press Inc., New York

British Library Cataloguing in Publication Data

Data available

Library of Congress Cataloging in Publication Data

Data available

ISBN 0-19-211645-2

10 9 8 7 6 5 4 3 2

Typeset by Invisible Ink
Printed in Great Britain
on acid-free paper by
Biddles Ltd.,
Guildford & King's Lynn

To David Samuel Allsop (born 1992)

in the hope that he inherits the artistic skills as well as the many other admirable qualities of his father

David John Allsop (born 1956, died 1992)

Introduction

In 1992 I was commissioned by the Oxford University Press to produce a revised and abridged edition of Harold Osborne's *Oxford Companion to Twentieth-Century Art* (1981). Once I began work, however, I soon realized that I was changing the material in the *Companion* to such an extent that I was creating a book which bore little resemblance to its notional starting point. I also found that in rewriting I was tending to expand entries rather than shorten them. The OUP therefore allowed me to scrap the original idea and generously gave me the time to produce a book that is twice the length we had originally envisaged (half a million words rather than a quarter of a million words). Although Harold Osborne's *Companion* provided my initial framework, probably less than two per cent of its text has survived into the present book, which is very different in spirit—less austere and I hope more geared to the interests of the general reader (there are many more anecdotes, for example, and in the biographical entries I have tried wherever possible to give some glimpse of the subject's personality as well as an account of his or her career). I have also incorporated material from the *Oxford Dictionary of Art* (1988, new edition 1997), but this, too, accounts for a fairly small proportion of the text. Moreover, of the 1700 entries in the present book, about a quarter are on personalities or topics that are not included in either the *Oxford Companion to Twentieth-Century Art* or the *Oxford Dictionary of Art*. Thus, although it is related to other titles in the Oxford family of reference books, this dictionary is essentially a new work.

The scope of the book is difficult to define with precision. Primarily it deals with painting, sculpture, and the graphic arts (including some material on cartoonists and illustrators), but it also embraces various other fields of activity that are now usually grouped with the more traditional visual arts—Conceptual art, Performance art, Video art, and so on. Architecture, design, photography, and the applied arts are outside the book's territory, although they are often mentioned in passing, and there are entries on various individuals who were active mainly in these fields but who also worked as painters, sculptors, or graphic artists; Brassaï and Le Corbusier are examples. Most of the entries are biographical; in addition to artists, they cover collectors, dealers, museum administrators, patrons, and writers. There are also a few figures who fall into a miscellaneous category: the forger Elmyr de Hory, the model Kiki of Montparnasse, the publisher Albert Skira, the bookseller Anton Zwemmer, and so on. The non-biographical entries are devoted mainly to groups of artists, movements, and styles; they also cover artistic techniques that have been invented— or most fully exploited—in the 20th century, such as acrylic and linocut, as well as important exhibitions, major art journals, and institutions of various kinds, notably galleries and museums that are devoted solely or primarily to 20th-century art.

In deciding which artists are chronologically eligible for inclusion, I have adopted a rule of thumb employed by Philip Larkin in his *Oxford Book of*

Twentieth-Century English Verse (1973), which deals with poets 'who were alive during the twentieth century and during it made or added to their reputations'. Thus I have included entries on several artists who lived only a few years into the 20th century but who had a major influence on later generations: Cézanne (d. 1906), Gauguin (d. 1903), and Whistler (d. 1903) are among the most obvious examples. In such entries I have concentrated on the impact these artists had on 20th-century art rather than on the details of their own careers. Certain influential artists who died before 1900, and who are therefore excluded from having their own entries, are discussed within other entries, to which the reader is directed by cross-references of the type 'Gogh, Vincent van. See EXPRESSIONISM and POST-IMPRESSIONISM'. In the case of artists whose careers were divided more or less equally between the 19th and the 20th centuries, I have been flexible in how much attention I have devoted to the earlier part of the life. Sometimes this has been briefly summarized, but with Munch, for example, it seemed essential to discuss his early years in some detail to provide a coherent account of his work. Many eminent artists who lived well into the 20th century are not included, as their achievement seems to belong so clearly to the 19th century; J. W. Waterhouse (1849–1917) is an example. However, I have included Sir Edward Poynter (1836–1919); as an artist he too belongs to the Victorian era, but he was president of the Royal Academy for almost a fifth of the 20th century, so he deserves a place here as an administrator.

At the other end of the time span covered by the book, the problem arises that the nearer we approach the present day, the more difficult it is to be even-handed in the selection and treatment of material, not least because of the sheer volume and diversity of work produced in recent years. Some kind of self-imposed restriction is therefore necessary, and I have adopted an arbitrary rule that no artist born after 1965 has an entry of his or her own; the youngest artists with an individual entry are Damien Hirst and Alison Watt, both of whom were born in the cut-off year. Artists born later than this are sometimes mentioned within other entries, such as that on avant-garde, but this is not the book for readers who are primarily interested in the contemporary art scene, in which reputations are so often ephemeral.

Within these limits at the beginning and end of the century, I have tried to be broad-ranging and balanced in the choice of entries. In any selective reference work, the compiler's personal preferences will obviously play some part, but I have aimed to produce a book that is useful to a wide readership and which therefore includes—to the best of my ability to judge—the people and topics that are most likely to be looked up. A few entries have been included not so much because of their intrinsic importance as for the sake of internal coherence. Certain writers, for example, were not on my original headword list but were added along the way because I happened to quote them several times and it seemed more helpful to give them their own short entries than to tag them 'the art historian X' or 'the critic Y' every time the names occurred. I could easily have added many more entries, but I had to draw the line somewhere, as I wanted the book to appear whilst we were still in the 20th century. As it will be used mainly in English-speaking countries, there is a bias towards art and artists in those countries, especially Britain and the USA, that I hope readers will welcome or at least accept as reasonable.

Although most of the entries are on people and subjects that are part of what might be called the mainstream of art history, I have also included numerous artists who do not usually find their way into general reference books. Here I have been guided largely by instinct; if I thought that an artist was likely to be the subject of enquiry by a substantial number of readers, I have considered the artist for inclusion, whether or not he or she is academically 'respectable'. Some of my choices will seem unusual, but I hope none of them will appear eccentric or frivolous. A prime example is Vladimir Tretchikoff. Within fairly recent memory he was one of the most famous artists in the world, so it surprises me that I have not been able to find him in any art reference book (including standard dictionaries of artists from Russia, his country of birth, and South Africa, his adopted home). He seems to me well worth a place here, as a phenomenon in the history of taste if nothing else.

In trying to be representative in the choice of entries, I have perforce included a number of controversial artists, some of whom produce work that I personally find meaningless, trivial, or distasteful. In such instances, I have tried to be fair by suggesting why these artists (mainly contemporary figures) are considered significant, and to this end I have often quoted critical opinions for and against. With the established masters of 20th-century art, we are on safer ground, and although I have again attempted to take a balanced view, I have not tried to hide my own enthusiasms. The length of an entry can usually be taken as an indication of the historical significance of the subject, but it is impossible to be rigidly systematic about this, as there are so many complicating factors. For example, certain artists are discussed at length in related stylistic entries (Braque under Cubism; Wyndham Lewis under Vorticism), so their own biographical entries are shorter than they might otherwise have been, and—more generally—some lives are simply easier to summarize than others. Those artists who travelled a great deal, or had fingers in many pies, or who for one reason or another led especially interesting lives are likely to have longer entries than equally accomplished artists who stayed at home and devoted themselves to one speciality. By the same token, the span of an artist's career is likely to affect the amount there is to say about him or her (Gaudier-Brzeska died aged 23, Duncan Grant aged 93, working almost to the end). Nevertheless, in spite of these complicating factors, it will come as no surprise that Picasso has the longest biographical entry in the book or that the chasing group includes such big guns as Bacon, Duchamp, Kandinsky, Klee, Matisse, Mondrian, Moore, Munch, Pollock, and Warhol. Similarly, the longest non-biographical entries are on two complex and centrally important topics— abstract art and Cubism.

Although the book contains a few pieces of information that to the best of my knowledge have not previously been published, it can make no claim to original research, being based almost entirely on secondary sources. I have tried to make sure that these sources are sound and up to date, but it is sometimes surprisingly difficult to be sure that even the most basic information is correct. The Surrealist painter Léonor Fini, for example, is described as Argentinian in *Contemporary Artists*, French in the Macmillan *Dictionary of Art*, and Italian in the *International Who's Who*—reference works that can each lay claim to a substantial degree of authority. I could quote similar examples in which equally

responsible sources cite three different spellings of an artist's name or give three different dates of birth. This last issue is complicated by the fact that some artists seem to have deliberately falsified their ages, Milton Avery being an example.

Just as I have tried to keep abreast of current scholarship in the matter of birth dates such as Avery's, so I have made serious (but by no means exhaustive) efforts to ensure that the book is up to date in recording deaths. I had high hopes that the huge and prestigious Macmillan *Dictionary of Art* (34 volumes, 1996), would be thorough in this respect and therefore save me a lot of effort, but in fact it is often disappointingly out of date; for example, it does not give death dates for John Canaday (1907–85), Cecil Collins (1908–89), Jan Matulka (1890–1972), Edward Middleditch (1923–87), or Orovida Pissarro (1893–1968), even though these are recorded in fairly obvious sources such as *Who's Who in American Art* (each edition of which contains a cumulative necrology) and *Who Was Who*. I have trawled through many such sources, as well as through hundreds of newspaper clippings files in the Tate Gallery Archive, in search of obituaries and death notices. I have also had help from overseas branches of the OUP and from various embassies and other institutions, but I am certain that some deaths must have escaped me, and I would be grateful to any reader who can supply such missing information. (I'd also welcome factual corrections of any kind; all polite letters will be answered.) When it can be reasonably assumed that an individual is dead but I have not been able to find the date of death, I have used the form 'Vauxcelles, Louis (1870–?)'.

There are sometimes problems with questions of nationality as well as with questions of dates. Occasionally, as with Léonor Fini, who has already been mentioned in this respect, the problems stem from mixed parentage and/or a peripatetic career, but usually they are a consequence of the many changes in names and boundaries of countries during the 20th century. With some artists it is therefore difficult to give an accurate statement of nationality without being cumbersome. Ivan Meštrović is an example. He was born in 1883 in what was then Croatia-Slovenia, for much of his career he was a citizen of Yugoslavia (which was formed in 1918 but did not adopt the name until 1929), and he took American nationality late in life in 1954. In such instances I have been undogmatic, tending to adopt the form that I think will cause the reader the least inconvenience, and in this case referring—for the sake of simplicity—to 'Yugoslavia' when it did not strictly exist. Similarly, I have usually described artists from the former Soviet Union as 'Russian', even if they came from one of the other republics that made up the USSR; I trust that this convenient shorthand will not mislead anyone. (Cities as well as countries sometimes change names, most obviously St Petersburg, which was called Petrograd from 1914 to 1924, then became Leningrad, and reverted to St Petersburg in 1991. I have usually employed the name that was in use at the time I mention the city, but I have sometimes used forms such as 'Petrograd (now St Petersburg)' if there is likely to be any confusion.)

Artists from the British Isles are usually designated 'British' unless they are particularly associated with one of the constituent countries, when they are referred to as English, Irish, Scottish, or Welsh. These more precise descriptions are used fairly frequently with Irish and Scottish artists, but much less often

with English and Welsh artists (I have called Augustus and Gwen John 'British' rather than 'Welsh', for example, for although both were born in Wales, Augustus spent most of his career in England and Gwen spent most of hers in France). Sometimes I have qualified the designation of nationality if it seems helpful or relevant to do so; for example, I have said that Sir Robin Philipson was English by birth but considered himself Scottish 'by adoption'. In the majority of cases, however, the nationalities that I have given for British artists are meant merely as a rough guide for the reader, rather than as indications of patriotic sentiment, and I apologize to any artist who feels that he or she has been misrepresented.

In the alphabetical ordering of artists' names, prefixes are usually ignored. Thus Niki de Saint Phalle and Henry van de Velde are found under 'Saint Phalle' and 'Velde' respectively, rather than under 'de' or 'van'. There are certain artists, however, where usage goes against this principle. Thus Sir Roger de Grey and Mark di Suvero are found under 'de Grey' and 'di Suvero'. Cross-references are provided where the reader is likely to have any doubt as to where to look: 'Grey, Sir Roger de. See DE GREY' and so on. The order of entries is strictly alphabetical up to the first comma or other punctuation mark, ignoring any spaces in the wording. Thus a representative sequence goes: New English Art Club; New Image Painting; Newlyn School; Newman, Barnett; New Realism; Newton, Algernon; New York School. The few headings that begin with a numeral are treated as if the numeral were spelled out; thus the periodical *391* comes between Thornycroft and Throbbing Gristle. Names beginning with Mc or St are ordered as though they were spelled Mac and Saint respectively. In the spelling of Russian names (and others originating in a non-Roman alphabet) I have used forms that look familiar in English rather than trying to adopt a standard system of transliteration. Thus I have referred to Alexander Deineka rather than Aleksandr Deyneka.

Cross-references from one article to another are indicated by an asterisk (*) within the main text or by the use of small capitals when the formula 'see so-and-so' is used. Names of all people who have their own entries are automatically asterisked on their first mention in another entry, and this is also the policy with groups and movements. However, cross-references are used selectively when referring to certain types of non-biographical entries and given mainly when further elucidation under that heading might be helpful to the reader. Thus in the entry on Alfred H. Barr, the first reference to the Museum of Modern Art, New York, is asterisked, because there is further discussion of Barr in the museum's entry, but when in the entry on Henry Moore I say that there is a good collection of his work in the Tate Gallery, I have not asterisked the Tate, because there is nothing in the gallery's entry that is specifically about Moore. I have been very sparing with cross-references to terms such as 'abstract art', 'avant-garde', and 'modernism', as these occur so frequently (often used fairly loosely) that it would be purposeless to direct the reader to the entries on them every time they happened to appear. I have also been flexible when measurements are given. Usually these are in metric ('a statue 15 metres high'), but occasionally they are given in imperial in quoted matter or in instances where it would be unidiomatic or give a misleading sense of precision to convert them (see the entry on Franz Kline, for example).

Many people have helped bring this dictionary to fruition, and it is a pleasure to thank them. At the Oxford University Press, Angus Phillips commissioned the book and—as it grew and grew—waited patiently and supportively for me to finish it. He also provided the computer on which the text was typed. When the text was about three-quarters finished, it was scrutinized by two expert readers chosen by the OUP (their identities unknown to me), one in Britain and one in the USA. They made many pertinent suggestions for additions and modifications, almost all of which I have incorporated. Nicola Bion, who saw the book through the press, helped a good deal in its final stages, notably by resourcefully tracking down various pieces of information that had eluded me. More generally, it has been a comfort to be able to draw on the OUP's incomparable resources in the field of reference books. I have taken a good deal of information from the *Dictionary of National Biography* and the *Oxford English Dictionary*, the two brightest jewels in the OUP's crown, and I have also benefited from many of the Oxford *Companions* and *Dictionaries* when their fields happened to overlap with mine (for example, in my Marcel Duchamp entry the story about his wife's revenge for neglecting her comes from the *Oxford Companion to Chess*, and my entry on Postmodernism is greatly indebted to the lucid characterization of this controversial word in the *Concise Oxford Dictionary of Literary Terms*).

The copy-editing and typesetting were done in the USA by Angela Blackburn, formerly of the OUP, and I count myself very fortunate to have had the advantage of her experience, energy, knowledge, and skill. Although she worked with formidable speed and had her hands full ironing out my inconsistencies and adding hundreds of cross-references, she spotted many points needing attention that I had overlooked. In addition she coped dextrously with my seemingly endless stream of additions and alterations. All this she did with such good humour that our lengthy transatlantic communications by fax and phone, which could have been an expensive chore for me, instead became an expensive pleasure.

Among the friends who have given me help, pride of place goes to John Glaves-Smith, senior lecturer in art history at the University of Staffordshire. He wrote some two dozen entries for me, mainly on art critics and sculptors, and I'm particularly grateful for his lengthy piece on direct carving, which I think is probably the best entry in the book (it is certainly the most erudite). Apart from contributing in this way, he has been unfailingly generous in giving me the benefit of his great knowledge of 20th-century art, answering questions and making constructive suggestions throughout the entire course of my work on the book. His wife, Pauline de Souza, kindly contributed the entry on Aaron Douglas, a subject of which she has special knowledge, as she was involved with organizing the 'Harlem Renaissance' exhibition at the Hayward Gallery, London, in 1997.

Other friends who have been particularly generous with their time include Celestine Dars (who found information in France for me that I would never have managed to trace myself) and Claudia Stumpf (who similarly was always on hand to answer queries relating to German art). Maggie Ramsay and Iain Zaczek were among those who provided accommodation during my trips to London, and both of them kindly checked information for me in libraries there when I was unable to visit them myself. Valerie Levitt, of Newcastle Bookshop, has

supplied me with many books that I could not otherwise have obtained and has been a constant source of stimulation and support.

Among the other friends and colleagues who have provided advice, information, or encouragement are: Jonathan Alden, Dr Tim Ayers, Caroline Bugler, Emma Clifton, Alison Cole, Tom Deas, Lavinia Down, Dr Tom Faulkner, Suzie Green, Julia Hanson, Juliet Hardwicke, Dr Michael Jacobs, Caroline Juler, Blaise Keogh, Mandy Little, Cathy Lowne, Calista Lucy, Lorrie Mack, Bridget Martyn, Brian Mills, Albert Moore, Sir Felix Moore, Anna Morter, Jenny Mulherin, George Otigbah, Alice Peebles, David Pinder, Anna Rosenthal, Penelope Ruddock, Pauline Stride, Lucilla Watson, Jude Welton, and Dr Peter Willis.

I'd also like to thank Dr Dennis Farr, formerly director of the Courtauld Institute Galleries, with whom I had a happy collaboration on the *Oxford Dictionary of Art* a decade ago, for taking an interest in this book from the beginning and for putting me on the right route to find an elusive date of birth. Similarly, David Elliott, formerly director of the Museum of Modern Art, Oxford, and now director of the Moderna Museet, Stockholm, made some useful suggestions in the early stages of the book and came to my rescue late in the day by providing some information that I had despaired of finding.

Several people whom I have never met have also kindly responded to my requests for help, notably Professor Bernard Cohen, Elizabeth Fisher of the Lisson Gallery, London, Harriet McNamee of the National Museum of Women in the Arts, Washington, DC, Dr Frank Whitford, and Kazuyo Yamashita (who was generous enough to phone from Japan with the information I required). Librarians at several institutions, including the Museum of Modern Art and the Whitney Museum of American Art in New York, have provided other elusive facts and figures, and I am particularly grateful to the staff of the Tate Gallery Archive, who—over a period of several days—cheerfully carried hundreds of press cuttings files for me to examine and drew my attention to various things that I would otherwise have missed.

On a more personal note, I owe a great deal to various members of my family, particularly my sister, Doreen Chilvers, who has helped me in ways too numerous to mention. Both she and my brother, George Chilvers, gave me generous financial support in the final stages of the book so that I could give up other commitments to bring it to completion. My niece, Kendra Hall, has given me expert advice on government publications; my nephew, Gavin Chilvers, has helped me to overcome my resistance to new technology in searching newspaper CD-ROMs for information; my cousins Andrea, Chris, and Jamie Barker have often been bounteous hosts in London; and another cousin, Harry Allsop, has helped me with computer problems and other practical matters. Finally, for inspiration from afar, thanks to Deborah Lambert and Victoria Kirkham.

Jesmond, Newcastle upon Tyne IAN CHILVERS
December 1997

Abbreviations

ARA	Associate of the Royal Academy
ASL	Art Students League
DNB	*Dictionary of National Biography*
ICA	Institute of Contemporary Art
MOMA	Museum of Modern Art
NG	National Gallery
NPG	National Portrait Gallery
OED	*Oxford English Dictionary*
PRA	President of the Royal Academy
RA	Royal Academy or Royal Academician
RCA	Royal College of Art
TLS	*Times Literary Supplement*
V&A	Victoria and Albert Museum

AAA. See ALLIED ARTISTS' ASSOCIATION and AMERICAN ABSTRACT ARTISTS.

Aalto, Alvar (1898–1976). Finnish architect, designer, sculptor, and painter. Aalto is principally renowned as one of the greatest architects of the 20th century, but he was also an important furniture designer and a talented abstract sculptor and painter. His early buildings were predominantly in the sleek International Modern style (see MODERN MOVEMENT), but he developed a much freer and more expressive manner. He had an international reputation by the late 1930s (an exhibition of his work was held in the Museum of Modern Art, New York, in 1938) and after the Second World War several of his most important commissions came from abroad, particularly the USA (he was professor of architecture at Massachusetts Institute of Technology from 1945 to 1949). Appropriately for an artist who came from a land of forests, Aalto made extensive use of timber in his work, and in 1933 he patented a method of bending plywood for furniture. He not only furnished his own buildings, but also produced his designs commercially, founding a firm called Artek in 1935 to manufacture and distribute them. Completely free of ornament, his designs were well suited to mass production, and their flowing lines became internationally popular. As well as furniture, Artek manufactured fabrics and light fittings and in the 1930s Aalto also designed some excellent glassware. In the same period he engaged in what have been described as artistic laboratory experiments, using laminated wood to make abstract reliefs and free-standing sculptures, characterized by irregularly curved forms. These sculptural experiments served the dual purpose of solving technical problems concerning the pliancy of wood relevant to the manufacture of furniture and of developing spatial ideas for Aalto's architec-tural work (ideas that received their fullest expression after the Second World War, as in the Edgar J. Kaufmann Conference Rooms at the Institute of International Education in New York (1965), where the wooden interior walls are conceived as abstract sculptural reliefs). In the 1950s Aalto took up sculpture on a large scale, working in bronze, marble, and mixed media. His outstanding work in this field is his memorial (1960) for the Battle of Suomussalmi, a leaning bronze pillar on a stone pedestal set up in the arctic wastes of the battlefield (a Finnish victory against the Soviet Union in 1939–40). Aalto was note-worthy also for helping to introduce modern art to the Finnish public, particularly the works of his close friends *Calder and *Léger.

Aalto, Ilmari. See NOVEMBER GROUP.

Aaltonen, Wäinö (1894–1966). Finnish sculptor, born at Marttila, near Turku, the son of a village tailor. He became deaf in childhood and took up art as a way of overcoming his disability, studying painting at the School of Drawing of the Turku Art Association, 1910–15, and then turning to sculpture. Following the period in which Finland declared itself independent from Russia, endured civil war, and established itself as a republic (1917–19), Aaltonen made a name for himself as a sculptor of war memorials, and by 1927, when he had a large exhibition in Stockholm, he was regarded as an embodiment of the Finnish national character and way of life. His most typical works are tributes to national heroes such as the monument to the runner Paavo Nurmi (1925, the best-known cast is outside the athletics stadium in Helsinki) and the bust of the composer Sibelius (1928, various casts exist). In addition to bronze he worked in stone (particularly granite) and various other materials, including glass. His

style was heroic and basically naturalistic, although sometimes touched with *Cubist stylizations.

Abakanowicz, Magdalena (1930–). Polish abstract sculptor, the pioneer and leading exponent of sculpture made from woven fabrics. She was born in Felenty into an aristocratic family and studied at the Academy in Warsaw, 1950–5. Initially she worked in conventional media in painting and sculpture, but from 1960 (the year of her first one-woman show at the Galerie Kordegarda, Warsaw) she concentrated on textiles, using hessian and rope (in some works she has also incorporated wood). Sometimes she obtained her raw materials by visiting Poland's Baltic harbours and collecting old ropes, which she then unravelled and dyed. At first she made reliefs, but soon moved on to large three-dimensional works. In 1962 she first exhibited in the West (at the International Tapestry Biennial in Lausanne) and thereafter her work appeared regularly outside Poland in both solo and group shows, winning her an international reputation, accompanied by numerous awards, including a gold medal at the São Paulo *Bienal in 1965. In the same year she began teaching at the School of Art in Poznań, and in 1974 she was appointed a professor there. She writes of her work: 'My intention was to extend the possibilities of man's contact with a work of art through touch and by being surrounded by it. I have looked to those slowly growing irregular forms for an antidote against the brilliance and speed of contemporary technology. I wanted to impose a slower rhythm on the environment as a contrast to the immediacy and speed of our urban surroundings.' Examples of her work are in several Polish collections, notably the Museum of Textiles at Łódź, and in the Museum of Modern Art, New York. See also FIBRE ART.

Abate, Alberto. See PITTURA COLTA.

Abbal, André. See DIRECT CARVING.

Abbey, Edwin Austin (1852–1911). American painter, etcher, and illustrator, active and highly successful in England (where he settled in 1878) as well as in his native country. He specialized in historical scenes and had several large and prestigious commissions,

most notably a set of murals representing *The Quest of the Holy Grail* (completed 1902) in Boston Public Library (his friend *Sargent also painted murals there) and the official painting commemorating Edward VII's coronation in 1902 (Buckingham Palace, London). Such works now seem rather overblown and ponderous, and his reputation rests mainly on his lively book and magazine illustrations. He was particularly prolific for the American political and literary journal *Harper's Weekly*, his association with it lasting from 1870 until his death. Although he always remained an American citizen, Abbey was devoted to cricket and had a private ground at his house at Fairford in Gloucestershire.

ABC art. An alternative term for *Minimal art. It was coined by the American art historian Barbara Rose, who used it as the title of an article in the October 1965 issue of *Art in America*.

abstract art. Art that does not depict recognizable scenes or objects, but instead is made up of forms and colours that exist for their own expressive sake. Much decorative art can thus be described as abstract, but in normal usage the term refers to 20th-century painting and sculpture that abandon the traditional European conception of art as the imitation of nature. Herbert *Read (*Art Now*, revised edn., 1948) gave the following definition: 'in practice we call "abstract" all works of art which, though they may start from the artist's awareness of an object in the external world, proceed to make a self-consistent and independent aesthetic unity in no sense relying on an objective equivalence.' Abstract art in this sense was born and achieved its distinctive identity in the decade 1910–20 and is now regarded as the most characteristic form of 20th-century art. It has developed into many different movements and 'isms', but two or three basic tendencies are recognizable. In *Cubism and Abstract Art* (1936), Alfred H. *Barr, 'at the risk of grave oversimplification', divided abstraction into two main currents: the first (represented by *Malevich) he described as 'intellectual, structural, architectonic, geometrical, rectilinear and classical in its austerity and dependence upon logic and calculation'; the second (exemplified by *Kandinsky) he described as 'intuitional and emotional rather than intellectual; organic and *biomorphic rather than

geometrical in its forms; curvilinear rather than rectilinear, decorative rather than structural, and romantic rather than classical in its exaltation of the mystical, the spontaneous and the irrational'. Looking at the subject in a slightly different way (and from a later viewpoint than Barr's), it is possible to see three main strands in abstract art: (i) the reduction of natural appearances to radically simplified forms, exemplified in the sculpture of *Brancusi (one meaning of the verb 'abstract' is to summarize or concentrate); (ii) the construction of works of art from non-representational basic forms (often simple geometric shapes), as in Ben *Nicholson's reliefs; (iii) spontaneous, 'free' expression, as in the *Action Painting of Jackson *Pollock. Many exponents of such art dislike the term 'abstract' (*Arp, for example, hated it, insisting on the word '*Concrete'), but the alternatives they prefer, although perhaps more precise, are often cumbersome, notably non-figurative, non-representational, and *Non-Objective.

The basic aesthetic premiss of abstract art—that formal qualities can be thought of as existing independently of subject-matter—existed long before the 20th century. Ultimately the idea can be traced back to Plato, who in his dialogue *Philebus* (c. 350 BC) puts the following words into Socrates' mouth: 'I do not mean by beauty of form such beauty as that of animals and pictures . . . but understand me to mean straight lines and circles, and the plane or solid figures which are formed out of them by turning-lathes and rulers and measures of angles; for these I affirm to be not only relatively beautiful, like other things, but eternally and absolutely beautiful.' More explicitly, in his 10th *Discourse* to the students of the Royal Academy (1780), Sir Joshua Reynolds advised that 'we are sure from experience that the beauty of form alone, without the assistance of any other quality, makes of itself a great work, and justly claims our esteem and admiration'; and in discussing the *Belvedere Torso* (a famous antique sculpture) he referred to 'the perfection of this science of abstract form'. Many eminent critics of the 19th century followed this line. In 1846, for example, Charles Baudelaire wrote that 'painting is interesting only in virtue of line and colour'; in 1890—in a much quoted remark—Maurice *Denis said 'Remember that a picture—before being a war horse or a nude woman or an anecdote—is

essentially a flat surface covered with colours assembled in a certain order'; and in 1896 George *Santayana, after noting that colour may produce unpleasant as well as pleasant effects, 'almost like a musical discord', proposed that 'a more general development of this sensibility would make possible a new abstract art, an art that should deal with colours as music does with sound' (the analogy with music was often pursued; *Whistler, for example, sometimes gave his paintings pseudo-musical titles, as later did Kandinsky, *Kupka, and other artists, including the Lithuanian composer-painter M. K. *Čiurlionis).

Many of the leading painters of the 1890s—notably the *Symbolists—stressed the expressive properties of colour, line, and shape rather than their representative function, and the major avant-garde movements of the first decade of the 20th century—notably *Cubism, *Expressionism, and *Fauvism—took this process further. At the same time, the flat linear plant forms typical of *Art Nouveau were sometimes only a short step away from abstraction, as in a painting such as *Composition* (c. 1902, Stadtmuseum, Munich) by Hans *Schmithals.

By 1910, then, the time was ripe for abstract art, and it developed more or less simultaneously in various countries. Kandinsky is often cited as the first person to paint an abstract picture, but no artist can in fact be singled out for the distinction; as George Heard *Hamilton writes, 'it is probable that there was never a particular moment when a particular individual for the first time self-consciously set out upon the new path. Rather, a number of artists in several different places and at various times, although on the whole within a year or so of 1910, came gradually to understand the limitless potentials of design divorced from representation.' (A work by Kandinsky known as 'First Abstract Watercolour' (Pompidou Centre, Paris) is signed and dated 1910, but some scholars believe that it is later and was inscribed by Kandinsky some years after its execution. This kind of problem arises not only with Kandinsky: several early abstract artists were keen to stress the primacy of their ideas and were not above backdating works—see, for example, RAYONISM.) Among the other pioneers who produced abstract paintings at about the same early date as Kandinsky were the American Arthur *Dove and the Swiss

Augusto Giacometti (1877–1947), cousin of Alberto *Giacometti.

The individual pioneers were soon followed by abstract groups and movements—among the first were *Orphism and *Synchromism in France. There was a particularly rich crop in Russia, with *Constructivism, Rayonism, and *Suprematism all launched by 1915. With some artists, abstraction represented merely a brief phase in their careers (among them the British artists Vanessa *Bell, Duncan *Grant, and Wyndham *Lewis), but with others it was a vocation or even a mission. The almost religious fervour with which some of the Russian artists pursued their ideals was matched by the members of the De *Stijl group in Holland, founded in 1917 (Herbert Read thought that the most serious pioneers of abstract art tended to belong to 'the metaphysically anguished races—Russian, German, and Dutch'). To such artists, abstraction was not simply a matter of style, but a question of finding a visual idiom capable of expressing their most deeply felt ideas.

Kandinsky and *Mondrian, probably the most famous and influential pioneers of abstraction, shared an almost mystical attitude towards art. Although their paintings are at virtually opposite poles of abstraction—Kandinsky's free-flowing and emotional, Mondrian's rigorously geometrical—both artists were influenced by theosophy, an ancient philosophical system that became a modern cult with the foundation of the Theosophical Society in New York 1875. Theosophists believe that the universe is essentially spiritual in nature, and their idea that a deep harmony underlies the apparent chaos of the world had strong appeal to artists such as Kandinsky and Mondrian who thought their paintings could help bring about a spiritual revival in the materialistic West. Kandinsky formulated his philosophical justification for abstract art shortly before he began painting purely abstract pictures, in his famous book *Concerning the Spiritual in Art* (written in the summer of 1910 and published late in 1911). He thought that if the artist could go beyond the outer shell of appearances he could 'touch the beholder's soul'; colour was a prime means of achieving this goal, for he believed that colours have 'a spiritual vibration' that could be linked with 'a corresponding vibration in the human soul'. His attempt to visualize the spiritual

had precedents in the colour illustrations accompanying accounts of higher worlds in certain Theosophical texts. One of these was *Thought Forms* (1905) by Annie Besant and C. W. Leadbetter, illustrated with cloud-like configurations. A German translation appeared in 1908 and Kandinsky owned a copy. (There is an earlier precedent in the 'spirit drawings' made in the 1860s by the British artist Georgiana Houghton; see AUTOMATISM.) Mondrian joined the Theosophical Society in 1909 and remained a member all his life. Like Kandinsky, he thought that abstract art could penetrate external appearances to reveal a greater truth beneath, and he believed that his art of clarity and balance would lead to a society in which life would be governed by a universal visual harmony.

Among the other pioneers of abstract art who were influenced by theosophy were Kasimir Malevich, who tried to paint the 'supreme reality', and Theo van *Doesburg, Mondrian's principal colleague in De Stijl. Van Doesburg was extremely active in promoting the group's ideas, and in the period between the two world wars its severely geometrical style was one of the most influential currents in abstraction, together with the technologically-orientated Constructivism (they came together in the *Bauhaus). Paris was the main centre of abstract art at this time, partly because it attracted so many refugee artists from Germany and Russia, where abstract art was banned in the 1930s under Hitler and Stalin. There was also a strong abstract element in *Surrealism, which was born in Paris. The first exhibition devoted solely to abstract art was held there by the *Cercle et Carré group in 1930, and its successor, the *Abstraction-Création association, founded in 1931, brought together a large number of abstract artists of various types and provided a focus for their activities. In general, however, figurative art was dominant in the interwar period and abstract art won little public acceptance. It was very much a minority taste in Britain and the USA, for example, in spite of such outstanding individual contributions as the sculptures of *Calder and *Hepworth and the efforts of groups such as *American Abstract Artists (founded in 1936) and *Unit One (founded in 1933). Indeed, as late as 1953 the British artist Adrian *Heath opened his book *Abstract Painting* by saying: 'There seems to be little understanding of the values of abstract painting

and consequently no general appreciation of its qualities. Other aspects of modern art are invariably found more stimulating. When, therefore, the pretensions of abstract painting as an art form are seriously stressed, or when public money has been spent on its acquisition, a violent reaction is provoked.' (For an example of such a reaction in England see FESTIVAL OF BRITAIN.)

However, by the time that Heath wrote these words, abstract art was already entering its second heroic period with the burgeoning of *Abstract Expressionism in the USA and its European equivalent *Art Informel. By about 1960 abstract art was not only widely accepted but on the verge of becoming the dominant orthodoxy in Western art. It no longer seemed to need philosophical justification of the kind given by Kandinsky and Mondrian (although several of the Abstract Expressionists were equally high-minded in approach); however, abstraction was sometimes invested with a moral dimension as an embodiment of Western freedom of thought, as opposed to the totalitarianism that had banned avant-garde art in Nazi Germany and Soviet Russia (see DEGENERATE ART and SOCIALIST REALISM). In this respect it is significant that many of the Abstract Expressionists were influenced by European Surrealists who had fled to New York during the Second World War to escape the fear of such repression. Thus, in the USA particularly, support for abstract art could be regarded almost as a form of patriotism—Clement *Greenberg used the term *'American-Type Painting' as an alternative to Abstract Expressionism, and one of the standard books on the movement (Irving Sandler's *Abstract Expressionism*, 1970) is subtitled *The Triumph of American Painting*. Indeed, Eva Cockcroft writes that 'Links between cold war politics and the success of Abstract Expressionism are by no means coincidental . . . They were consciously forged at the time by some of the most influential figures controlling museum politics' ('Abstract Expressionism: Weapon of the Cold War', *Artforum*, June 1974). Abstract Expressionism represented a great watershed in art and many later developments were either evolutions from it or reactions against it. These included a revival of figuration, in the form particularly of *Pop art, but also new styles of abstraction, including *Post-Painterly abstraction, *Op art, and

*Minimal art, all of which flourished in the 1960s.

Some exponents and supporters of abstract art have argued that it can reach the same heights as the greatest art of the past. Kandinsky, for example, wrote that 'The impact of the acute angle of a triangle on a circle produces an effect no less powerful than the finger of God touching the finger of Adam in Michelangelo's *Creation*'. Keith *Vaughan's succinct reply to this comment was 'Not to me, boy', and many critics have sympathized with him rather than Kandinsky. Among them have been Kenneth *Clark, who found abstract art 'somewhat monotonous', and E. H. Gombrich, who in 1958 wrote: 'To me it seems that there are works of colour music, canvasses by Kandinsky which are really pleasing, just as there are figures or shapes by Mondrian or Nicholson which command respect and interest . . . But when I seriously compare my reaction to the best "abstract" canvas with some work of great music that has meant something to me, it fades into the sphere of the merely decorative.' Later Gombrich added: 'I do not think abstract art can ever be as good as the art of a religious age. It stands on a different level of human aspiration.'

Abstract Classicism. See HARD-EDGE PAINTING.

Abstract Expressionism. The dominant movement in American painting in the late 1940s and the 1950s, characterized by a desire to convey powerful emotions through the sensuous qualities of paint, often on canvases of huge size. It was the first major development in American art to achieve international status and influence, and it is often reckoned the most significant art movement anywhere since the Second World War. The tremendous vitality it brought to the American art scene helped New York to replace Paris as the world capital of contemporary art, and to many Americans the heyday of the movement has already acquired a kind of legendary status as a golden age.

The phrase 'Abstract Expressionism' had originally been used in 1919 to describe certain paintings by *Kandinsky, and it was used in the same way by Alfred H. *Barr in 1929. In the context of modern American painting it was first used by the *New Yorker* art critic Robert Coates (1897–1973) in 1946 and it had

become part of the standard critical vocabulary by the early 1950s. The painters embraced by the term worked mainly in New York and there were various ties of friendship and loose groupings among them, but they shared a similarity of outlook rather than of style—an outlook characterized by a spirit of revolt against tradition and a belief in spontaneous freedom of expression. The stylistic roots of Abstract Expressionism are complex, but despite its name it owed more to *Surrealism—with its stress on *automatism and intuition—than to *Expressionism. A direct source of inspiration came from the European Surrealists who took refuge in the USA during the Second World War. The most important in this context was *Matta, who promoted what Meyer *Schapiro called the 'idea of the canvas as a field of prodigious excitement, unloosed energies'. The war also brought Peggy *Guggenheim back to America, and during its brief lifetime (1942–7) her Art of This Century gallery was the main showcase for Abstract Expressionism during its formative period.

David Anfam (*Abstract Expressionism*, 1990) writes that '*Pollock, *de Kooning, *Still, *Rothko, *Newman, *Kline, Philip *Guston, Arshile *Gorky, Robert *Motherwell and Adolph *Gottlieb are by consensus prime members of the Abstract Expressionist canon.' Among the secondary figures were William *Baziotes, James *Brooks, Lee *Krasner, Richard *Pousette-Dart, Theodorus *Stamos, and Bradley Walker *Tomlin. Hans *Hofmann and Ad *Reinhardt were major figures, but not central to the movement. The work of these artists varied greatly and was sometimes neither abstract (de Kooning) nor Expressionist (Rothko). Attempts have been made to arrange them into stylistic groupings (see ABSTRACT IMAGISTS), but these are of doubtful use as they require so many qualifications. Their work varied from the explosive energy of Pollock's *Action Painting to the serene contemplativeness of Rothko's *Colour Field Painting. Even within these two polarities, however, there are certain qualities that are basic to most Abstract Expressionist painting: the preference for working on a huge scale; the emphasis placed on surface qualities so that the flatness of the canvas is stressed; the adoption of an *all-over type of treatment, in which the whole area of the picture is regarded as equally important; the glorification of the act of painting itself;

the conviction that abstract painting could convey significant meaning and should not be viewed in *formalist terms alone; and a belief in the absolute individuality of the artist (for which reason most of the Abstract Expressionists disliked being labelled with an 'ism', preferring *New York School as a group designation).

Almost without exception, the artists who created Abstract Expressionism were born between 1900 and 1915 and most of them struggled during their early careers, which coincided with the Depression. Apart from Motherwell, the major figures began as representational painters, but generally moved towards abstraction in the late 1930s or early 1940s. The idea that these artists were beginning to create a new movement took shape in about 1943, and in 1945 Peggy Guggenheim mounted an exhibition called 'A Problem for Critics', almost as a challenge for someone to come up with a name for this movement. By 1948, when de Kooning had his first one-man show and Pollock first exhibited his drip paintings, it was approaching maturity. Initially the new way of painting was found perplexing or outlandish by many people, but during the 1950s the movement became an enormous critical and financial success, helped by the support of the influential writers Clement *Greenberg and Harold *Rosenberg. It had passed its peak by 1960, but several of the major figures continued productively after this and a younger generation of artists carried on the Abstract Expressionist torch. By 1960, also, reaction against the movement was under way, in the shape principally of *Pop art and *Post-Painterly Abstraction. Sculptors as well as painters were influenced by Abstract Expressionism, the leading figures including Ibram *Lassaw, Seymour *Lipton, and Theodore *Roszak. The immense significance of the movement in American culture was summed up by Maurice Tuchman when he wrote in 1971: 'Virtually every important American artist to have emerged in the last fifteen years looks to . . . abstract expressionism as the point of departure, in the same way that most European artists of the 1920s and 1930s referred in their work to the inventions of *cubism' (*The New York School*, 1971, revised edn. of the catalogue of an exhibition held at the Los Angeles County Museum of Art in 1965). Since then Abstract Expressionism has continued to be influential, notably as one of the

sources of *Neo-Expressionism, and Robert *Hughes considers that the success of the movement has 'encouraged a phoney grandiloquence, a confusion of pretentious size with scale, that had plagued American painting ever since'.

Abstract Imagists. A term that has been applied to certain *Abstract Expressionist painters—notably *Newman, *Rothko, and *Still—whose work uses predominantly flat areas of colour and relatively impersonal brushwork, as opposed to the more impulsive, *gestural painters of the movement—notably *Kline and *Pollock—whose work is characterized by extremely vigorous handling of paint. The term was used in the title of an exhibition, 'American Abstract Expressionists and Imagists', held at the Guggenheim Museum, New York, in 1961. However, the distinction is a rather artificial one, as the work of the painters involved is too varied to fit neatly into such a scheme; for example, Still's handling of paint is often highly gestural.

Abstract Impressionism. A term coined by Elaine *de Kooning to describe paintings that resemble certain late *Impressionist pictures (notably those of *Monet) in their brushwork but have no representative content: 'Retaining the quiet uniform pattern of strokes that spread over the canvas without climax or emphasis, these followers keep the Impressionist manner of looking at a scene but leave out the scene.' In 1956 the critic Louis Finkelstein applied the term to Philip *Guston's paintings to distinguish them from the more exuberant type of *Abstract Expressionism known as *Action Painting, and in 1958 Lawrence *Alloway used the term as the title of an exhibition he organized in London; the artists represented included Bernard and Harold *Cohen, Sam *Francis, Patrick *Heron, and Nicolas de *Staël. The term has also been applied to various French abstract painters of the same period, for example *Bazaine and *Manessier.

abstraction. 'In the fine arts, the practice or state of freedom from representational qualities; a work of art with these characteristics' (*OED*). Some critics prefer to restrict the term to those types of *abstract art that have their starting-point in the external world—in other words, those in which the image is 'abstracted' or distilled from the appearance of some real object or scene. Usually, however, the term is used as a convenient synonym for abstract art as a whole.

Abstraction-Création. An association of abstract painters and sculptors formed in Paris in February 1931 in succession to the short-lived *Cercle et Carré group, whose mailing list the new association took over. The prime movers behind Abstraction-Création were Jean *Hélion, Auguste *Herbin, and Georges *Vantongerloo, who all practised the type of abstract art in which works are constructed from completely non-representational, usually geometrical, elements, rather than derived from natural appearances. Although geometrical abstraction was especially well-represented in the association, it was open to abstract artists of all persuasions and the membership at one time rose to as many as 400. Artists of numerous nationalities joined, among them *Arp, *Gabo, *Kandinsky, *Lissitzky, *Mondrian, and *Pevsner. Many members had left the totalitarian regimes in Nazi Germany and Stalinist Russia, where avant-garde art was outlawed, and their presence in Paris helped to make it the most important centre for abstract art in the 1930s. Also included in the membership were artists who were never permanently resident in Paris, such as Barbara *Hepworth and Ben *Nicholson. The association operated by arranging group exhibitions and by publishing an illustrated annual entitled *Abstraction-Création: Art non-figuratif*, which appeared from 1932 to 1936 with different editors for each issue. The first issue explained the choice of name of the association and the annual: 'abstraction, because certain artists have come to the concept of non-figuration by the progressive abstraction of forms from nature'; 'creation, because other artists have attained non-figuration direct, purely via geometry, or by the exclusive use of elements commonly called abstract, such as circles, planes, bars, lines, etc.'; and 'non-figuration, that is to say a purely plastic culture which excludes every element of explication, anecdote, literature, naturalism, etc.' In the later 1930s the association dwindled, but after the Second World War its ideals were carried on by the *Salon des Réalités Nouvelles.

Abstraction Lyrique. See LYRICAL ABSTRACTION.

Abstract Sublime. A term coined *c.* 1960 by the American art historian Robert Rosenblum (1927–) to characterize the feelings of vastness and solitude suggested by certain *Abstract Expressionist paintings, for example those of *Newman, *Rothko, and *Still. Newman had earlier used the word 'sublime' in connection with his own work ('The Sublime is Now', *Tiger's Eye*, December 1948). Rosenblum first used the term 'Abstract Sublime' in print as the title of an article in the February 1961 issue of *Art News*, and two years later Lawrence *Alloway coined the term 'American Sublime' to describe the same quality ('The American Sublime', *Living Arts*, June 1963). In 1994 David *Sylvester referred to the 'cosmic grandeur' of Newman, the 'cosmic energy' of *Pollock, and the 'cosmic pathos' of Rothko.

académie. A French term for a private art school, several of which flourished in Paris in the late 19th and early 20th centuries. Entry to the official École des *Beaux-Arts was difficult (almost impossible for foreigners, who from 1884 had to take a vicious examination in French) and teaching there was conservative, so private art schools, with their more liberal regimes, were often frequented by progressive young artists. Three académies are particularly important in this context.

The **Académie Carrière** was opened in 1890 by Eugène Carrière (1849–1906), a painter of portraits, religious pictures, and—his speciality—scenes of motherhood. His characteristic style was misty, monochromatic, and vaguely *Symbolist. *Rodin was a great admirer of his work. There was no regular teaching at the school, though Carrière visited it once a week. It was here that *Matisse met *Derain and *Puy, thus expanding the nucleus of the future *Fauves.

The **Académie Julian** was founded in 1873 by Rodolphe Julian (1839–1907), whose work as a painter is now forgotten. The school had no entrance requirements, it was open from 8 a.m. to nightfall, and it was soon the most popular establishment of its type. Julian opened several branches throughout Paris, one of them for women artists, and by the 1880s the student population was about 600. Although the Académie Julian became famous for the unruly behaviour of its students, it was regarded as a stepping-stone to the École des Beaux-Arts (Julian had astutely engaged teachers from the École as visiting

professors). Among the French artists who studied there were *Bonnard, *Denis, *Matisse, *Vallotton, and *Vuillard. The list of distinguished foreign artists who studied there is very long.

The **Académie Ranson** was founded in 1908 by Paul Ranson (1864–1909), who had studied at the Académie Julian. After Ranson's early death, his wife France took over as director, and his friends Denis and *Sérusier were among the teachers. Among later teachers at the school the most important was Roger *Bissière, who in the 1930s influenced many young painters in the direction of expressive abstraction; his pupils included *Le Moal, *Manessier, and *Vieira da Silva. The Académie Ranson remained a popular training centre for foreign artists up to and after the Second World War.

Académie de la Grande Chaumière. See BOURDELLE.

Académie de l'Art Moderne (later **Académie de l'Art Contemporain**). See LÉGER.

Académie Montparnasse. See LHOTE.

Accardi, Carla (1924–). Italian painter, a founder member of the *Forma group in Rome in 1947. Her early painting resembled automatic script on a monochrome ground in the manner of *Tobey's 'white writing', but she later moved away from this kind of *Art Informel to more deliberately planned compositions. This was in line with the tenets of the *Continuità group, which she joined in 1960.

Acconci, Vito. See BODY ART.

Ackermann, Max (1887–1975). German painter, born in Berlin. Between 1907 and 1912 he studied first in Weimar under Henry van de *Velde, then at the Academies of Dresden and Munich, and finally in Stuttgart under Adolf *Hölzel. From 1936 he lived in Switzerland, at Horn on Lake Constance. Ackermann made an intensive study of colour theories and developed a form of abstraction he called 'absolute painting', in which colours were supposedly combined according to musical laws.

acrylic. A modern synthetic paint, made with a resin derived from acrylic acid, that com-

bines some of the properties of oils and water-colour. It was the first new painting medium in centuries and has become a serious rival to oil paint. Acrylics are a refined version of paints developed for industrial use and can be applied to almost any surface with a variety of tools (brush, *airbrush, knife, sponge, and so on) to create effects ranging from thin washes to rich impasto and with a matt or gloss finish. Most acrylic paints are water-based, although some are oil compatible, using turpentine as a thinner. Thinly applied paint dries in a matter of minutes, thickly applied paint in hours—much quicker than oils. Colours, which include fluorescent and metallic tints, are characteristically clear and intense. Acrylic paint first became available to artists in the 1940s in the USA and certain American painters discovered that it offered them advantages over oils. Colour stain painters (see COLOUR FIELD PAINTING) such as Helen *Frankenthaler and Morris *Louis, for example, found that they could thin the paint so that it flowed over the canvas yet still retained its full brilliance of colour. David *Hockney took up acrylic during his first visit to Los Angeles in 1963; he had earlier tried and rejected the medium, but American-manufactured acrylic was at this time far superior to that available in Britain, and he felt that the flat, bold colours helped him to capture the strong Californian light. Hockney used acrylic almost exclusively for his paintings until 1972, when he returned to oils because he had come to regard their slowness in drying as an advantage: 'you can work for days and keep altering it as well; you can scrape it off if you don't like it. Once acrylic is down you can't get it off.' In spite of these differences in properties, the finished appearance of an acrylic painting is sometimes more or less indistinguishable from an oil, and some artists (for example Richard *Estes) have often combined the two techniques in the same painting. In addition to being versatile, acrylics are less susceptible to heat and damp than traditional media, but in the 1990s some doubts began to be expressed about their permanence.

Action. See AKTION.

Action Painting. A type of dynamic, impulsive painting, practised by certain *Abstract Expressionists, in which the artist applies paint with energetic *gestural movements—sometimes by dribbling or splashing—and with no preconceived idea of what the picture will look like. Sometimes the term has been used loosely as a synonym for Abstract Expressionism, but this usage is misleading, as Action Painting represents only one aspect of the movement. The term was coined by the critic Harold *Rosenberg in an article entitled 'The American Action Painters' in *Art News in December 1952. Rosenberg saw Action Painting as a means of giving free expression to the artist's instinctive creative forces and he regarded the act of painting itself as more significant than the finished work: 'At a certain moment the canvas began to appear to one American painter after another as an arena in which to act—rather than as a space in which to reproduce, re-design, analyze or "express" an object, actual or imagined. What was to go on the canvas was not a picture but an event. The painter no longer approached his easel with an image in his mind; he went up to it with material in his hand to do something to that other piece of material in front of him. The image would be the result of this encounter.' Although the term 'Action Painting' soon became established, many critics were unconvinced by Rosenberg's idea of the canvas being 'not a picture but an event': Mary McCarthy, for example, wrote that 'you cannot hang an event on a wall, only a picture'.

Rosenberg's article did not mention individual painters and was unillustrated, but the artist who is associated above all with Action Painting is Jackson *Pollock, who vividly described how he felt when working on a canvas laid on the floor: 'I feel nearer, more a part of the painting, since this way I can walk around it, work from the four sides and literally be *in* the painting . . . When I am *in* my painting, I am not aware of what I'm doing. It is only after a sort of "get acquainted" period that I see what I have been about. I have no fears about making changes, destroying the image, etc., because the painting has a life of its own. I try to let it come through.' To many conservative critics it seemed that such pictures were mindless and lacking in craft, but Pollock (somewhat at variance with his words above) played down the role of chance: 'When I am painting I have a general notion as to what I am about. I *can* control the flow of paint; there is no accident.' The photographer Hans Namuth (1915–90), who documented

Pollock's method in a famous series of pictures, wrote of seeing him at work: 'It was a great drama—the flame of explosion when the paint hit thecanvas; the dance-like movement; the eyes tormented before knowing where to strike . . . my hands were trembling.'

There have been numerous accounts of how Pollock came to develop his drip technique, including an unlikely story that the idea came to him when he accidentally kicked over a can of paint. A theory that has been much discussed is that he was influenced by sand paintings of the Navajo Indians of New Mexico, who in certain rituals pour coloured earth onto the ground to form elaborate patterns. Irving Sandler (*Abstract Expressionism*, 1970) writes: 'It must be stressed that Pollock's "drip" painting evolved primarily from the slow internal development of his own style, and from suggestions by *Graham and the *surrealist *automatists, which fostered this development . . . Perhaps the Navajo Indians did influence Pollock . . . not because they taught him the "drip" technique, but rather because they obliterated their pictures at the close of their ritualistic ceremony. To them, the act of painting was more important as magic than as picture-making. Their attitude may have given Pollock the confidence to take liberties with conventional approaches to painting.' Whatever his sources, Pollock used Action Painting to produce what are generally regarded as some of the greatest abstract pictures ever created. In the work of lesser artists, however, the technique could easily degenerate into messy self-indulgence, and it gave rise to a good deal of outrage and mockery, especially after the British painter William Green (1934–) took to riding a bicycle over the canvas. This feat, which was imitated by the comedian Tony Hancock in the film *The Rebel* (1961), inspired a poem in the journal *Studio*:

> Where Pollock spilled, now others ride,
> Anxious to show they've nothing to hide.
> Not even talent need get in the way,
> When you're hep on a bike with nothing
> to say.

In a similar vein, in 1955–6, various members of the *Gutai Group in Japan produced Action Paintings through highly unorthodox means: one of them painted with his feet whilst hanging from a rope, for example, and another used a remote-controlled model car

rigged with a can of paint. These burlesque aspects of Action Painting have an interesting precedent in Japanese art in the work of the great Katsushika Hokusai (1760–1849), who in his early years used to create huge pictures in front of festival crowds, using a broom and a bucket of ink, and on one occasion dipped the feet of a chicken in paint and let it run over his paper.

Activists. A Hungarian artistic, literary, and political group, active from about 1914 to about 1926. It was the most important of the associations that emerged after the break-up of The *Eight, Hungary's pioneering avant-garde group. The Eight and the Activists had one member in common, Lajos Tihanyi (1885–1938), but the Activists were more radical in outlook; the group agitated for the creation of a socialist society and had 'at the centre of its ideas the almost aggressive, violent transformation of life . . . Their actions were most closely rooted in topicality, more closely related to the protests against war and the cause of the workers' movement and revolution, than any earlier group of artists in Hungary' (catalogue of the exhibition 'The Hungarian Avant-Garde: The Eight and the Activists', Hayward Gallery, London, 1980). Stylistically, the Activists were influenced by several recent movements, including *Cubism, *Expressionism, and *Futurism, and later *Dada and *Constructivism. An important stimulus to the group was provided by an exhibition of Expressionist and Futurist art at the National Salon in Budapest in 1913 (previously shown at the *Sturm Gallery in Berlin). The Activists formed only a loose grouping, but a focus for their activities was provided by the journal *MA* (Hungarian for 'today'), founded in 1916 by the writer and artist (painter, sculptor, printmaker, collagist) Lajos Kassák (1887–1967). Kassák had previously published (1915–16) an anti-war periodical *A Tett* ('The Deed'), which had been banned by the authorities as 'propaganda hostile to the nation'. The first issue of *MA* included an essay by Kassák entitled 'The Poster and the New Painting', in which he argued that painting should aspire to the same kind of vivid communication as the political poster. Several Activists did in fact produce posters during the brief Communist regime in Hungary in 1919. This regime banned *MA*, but Kassák began publication again in Vienna after he moved there in 1920.

It ran until 1926, when Kassák returned to Hungary.

Actual art. See ARTE POVERA.

Adam, Henri-Georges (1904–67). French sculptor, graphic artist, and designer, born in Paris, the son of a jeweller and goldsmith. He studied metalwork with his father and initially made his reputation with etchings, winning the Blumenthal Prize for them in 1938. In 1943 he had his first major success as a designer with scenery and costumes for Jean-Paul Sartre's play *Les Mouches*. Adam also became a noted tapestry designer, but increasingly he was known for sculpture, which he took up in 1939. In this field he was encouraged by *Picasso, who met him in 1943 and lent him both his studio in Paris and his chateau at Boisgeloup, where the coach-house had been converted into a studio particularly suitable for large-scale work. Adam's early sculpture was figurative and conceived in large expressive planes, somewhat in the manner of *Brancusi; later he did geometrical abstracts, influenced by *Arp, which he sometimes decorated with engraved patterns. His work included several large public monuments, notably the *Beacon of the Dead* (1957–8) at Auschwitz and *Swan* (1964) at the Porte de Vincennes, Paris.

Adami, Valerio (1935–). Italian painter and graphic artist, his country's leading exponent of *Pop art and one of the few non-American or non-British artists to achieve international success in the field. He was born in Bologna and from 1953 to 1957 studied at the Brera in Milan, the city that has been the main centre of his activities (in 1961–2 he worked in London and in 1962–4 in Paris). Initially he painted abstracts, but in the 1960s he turned to figuration. Characteristically his pictures resemble frames from comic strips, with firm outlines and flat colours. His subject-matter has been drawn largely from advertising, but he has also used literary, philosophical, and political themes. The images are often fragmented and his work sometimes has an air of fantasy recalling *Surrealism.

Adams, Robert (1917–84). British sculptor, born in Northampton. He studied (mainly part-time) at Northampton School of Art, 1933–44, whilst working at various jobs including engineering and printing. After the Second World War he moved to London, where he taught at the Central School of Arts and Crafts, 1949–60. His mature work was completely abstract and he was regarded as one of the leading British exponents of *Constructivism, alongside Anthony *Hill, Kenneth and Mary *Martin, and Victor *Pasmore. Adams worked in stone and wood and from about 1955 also in metal and concrete. His most characteristic works were reliefs, but he also made free-standing pieces featuring metal blocks interspersed with rods. Among his major commissions were a large concrete relief for the Municipal Theatre, Gelsenkirchen, Germany (1959), and reliefs for the liners *Canberra* and *Transvaal Castle* (1961). From about 1970 he worked mainly in bronze.

Adeney, Bernard. See GILL.

Adler, Jankel (1895–1949). Polish painter. He was born at Tuszyn, near Łódź, and studied in Germany at the School of Arts and Crafts in Barmen (now part of Wuppertal), 1913–14. In about 1922 he settled in Düsseldorf, where he became a friend of Paul *Klee and painted several murals, including frescos for the Planetarium. He left Germany in 1933 because of the rise of the Nazism and travelled widely in the next few years, living mainly in Paris, where he worked with *Hayter at Atelier 17. On the outbreak of war he joined the Polish army in France and in 1940 was evacuated to Britain, where he lived for the rest of his life, first in Scotland and then from 1943 in London. Adler was primarily a figure painter, best known for his portrayals of Jewish life in Poland (as a youth he had considered becoming a rabbi). His style in his mature work was eclectic and expressionistic, influenced by Klee and *Picasso. In turn his cosmopolitanism was a stimulus against wartime isolation for several young British artists, notably *Colquhoun and *MacBryde (in the mid-1940s Adler shared a house with them in Bedford Gardens, London).

Adrian-Nilsson, Gösta (1884–1965). Swedish painter (sometimes known—from his initials—as GAN), a pioneer of modernism in Scandinavia. From 1912 he made visits to Berlin, where he came into contact with *Cubism and *Futurism and developed a semi-abstract style (typically expressed in

dynamic cityscapes) influenced by *Kandinsky and *Marc. By 1919 he was painting completely non-figurative works—these are often said to be the first pure abstracts by a Swedish artist, although *Eggeling probably contests the distinction with him. In the 1930s Adrian-Nilsson turned to *Surrealism and became the focus of a group of Surrealists at Halmstad, a city on the south-western coast of Sweden. Examples of his work are in the Moderna Museet, Stockholm.

aerograph. See AIRBRUSH.

Aeropittura. Movement in Italian art, a development of *Futurism, in which artists attempted to depict the sensation of flight (the term is Italian for 'air painting'). *Marinetti published a manifesto of Aeropittura in 1929 and there were exhibitions in Italy in 1931, Paris in 1932, and Berlin in 1944, but no important works emerged from the movement, which virtually came to an end with Marinetti's death in 1944. The artists associated with Aeropittura included the painter Gerardo Dottori (1884–1977) and the sculptor Bruno Munari (1907–).

affichiste. Name (literally 'poster designer') taken by the French artists and photographers Raymond Hains (1926–) and Jacques de la Villeglé (1926–), who met in 1949 and during the early 1950s devised a technique of making *collages from fragments of torn-down posters. They called these works, which they first exhibited in 1957, *affiches lacérées* (torn posters). Villeglé manipulated the posters to create particular images and effects, but Hains left them more or less as he found them in an attempt to demonstrate the aesthetic bankruptcy of the advertising world. Other artists adopted a similar technique in the 1950s, notably the Italian Mimmo *Rotella and the German Wolf *Vostell.

Afro (Afro Basaldella) (1912–76). Italian painter and stage designer, brother of the sculptors Dino *Basaldella and Mirko Basaldella (who like Afro preferred to be known simply by his first name; see MIRKO). Afro was born in Udine, the son of a decorative painter, and he studied in Florence and Venice. He had his first one-man exhibition at the Galleria del Milione, Milan, in 1932, and in 1938 moved to Rome, where he lived for most of the rest of his life. During the Second World War he served in the Italian army and fought with the Resistance. After the war he joined the *Fronte Nuovo delle Arti in 1947 and the *Gruppo degli Otto Pittori Italiani in 1952. From 1950 he often visited the USA; he had regular exhibitions at the Catherine Viviano Gallery in New York and he taught at Mills College in Oakland, California. Afro's early work, which included landscapes, portraits, and still-lifes, was influenced by *Cubism, but after the war he developed a loose improvisatory abstract style influenced by *Abstract Expressionism and he came to be regarded as one of the leading Italian artists working in this *Art Informel idiom. He was awarded the City of Venice painting prize at the 1956 Venice *Biennale and had several public commissions, notably a mural entitled *The Garden of Hope* for the restaurant of the Unesco Building in Paris (1958).

Agam, Yaacov (Jacob Gipstein) (1928–). Israeli sculptor and experimental artist, active mainly in Paris, where he settled in 1951. He was born in Rishon-le-Zion and studied at the Bezalel School, Jerusalem, 1947–8, the Giedion Art School, Zurich, 1949, and the Atelier d'Art Abstrait, Paris, 1951. In 1953 he had his first one-man show at the Craven Gallery, Paris, and in 1955 he took part—with *Bury, *Calder, *Soto, *Tinguely, and others—in the exhibition 'Le Mouvement' at the Denise *René Gallery, considered the key event in the birth of the *Kinetic art movement. From this time he established a reputation as one of the most inventive figures in the kinds of abstract art that lay stress on movement and spectator participation. Agam often uses light and sound effects in conjunction with his sculptures, and sometimes the components of the works can be rearranged by the spectator. He has had several major public commissions in France, among them the design of a square in the Défense quarter of Paris (1973).

Agar, Eileen (1899–1991). British painter, born in Buenos Aires, the daughter of a British businessman who made a fortune there. She moved to England as a child and studied with Leon *Underwood, 1924, at the *Slade School, 1925–6, and in Paris, 1928–30. During the 1930s she became one of the leading British exponents of *Surrealism, taking part in several of the major international

exhibitions of the movement (although she was never much concerned with its polemical side). As well as paintings she made mixed-media *objects such as *Angel of Anarchy* (Tate Gallery, London, 1940). In the 1940s and 1950s she changed direction, painting cool *Tachiste abstracts, although her work still retained Surrealist elements. She published an autobiography, *A Look at My Life*, in 1988; the book is full of famous names, for she knew many eminent artists and writers. It concludes with the words: 'I hope to die in a sparkling moment.'

agitprop art (or **agitational art**). Art used to manipulate ideological beliefs, specifically to spread the ideals of Communism in Russia in the period immediately following the 1917 Revolution. The term 'agitprop' (an abbreviation for *agitatsionnaya propaganda*: 'agitational propaganda') was first used soon after the Revolution, and a Department of Agitation and Propaganda was established by the Communist Party in 1920. Agitprop art took numerous forms, ranging from spectacular theatrical performances (such as a re-enactment of the storming of the Winter Palace, performed in Petrograd in 1920 with a cast of 10,000) to the design of sweet wrappers. In the visual arts, one of the most remarkable expressions of agitprop came in the decoration of 'agit-boats' and 'agit-trains', in which Alexandra *Exter played a leading part. 'These trains were conceived as educational and publicity vehicles with the purpose of taking the Revolution to the furthest corners of Russia. The trains usually had a cinema carriage which showed films of Lenin or Trotsky, and in addition they were well-stocked with Revolutionary manifestos, pamphlets and leaflets. Initially they spread the knowledge of the Revolution into far-flung towns and villages, but later they were used as propaganda vehicles and were sent out to cheer the cause of the Red Army on the Civil War front. Some of the trains painted by Exter and her pupils bore the striking images of the Revolution and the resounding mottos of its leaders, while others were covered in *Suprematist compositions which gave the carriages a festive and somewhat fantastic appearance' (M. N. Yablonskaya, *Women Artists of Russia's New Age*, 1990).

AIA. See ARTISTS' INTERNATIONAL ASSOCIATION.

Air art. A term describing various types of work using inflatable objects such as balloons. This kind of art had a vogue in the late 1960s, when exhibitions were devoted to it in France ('Structures gonflables' at the Musée d'Art Moderne, Paris, 1968) and the USA ('Air Art', Philadelphia Arts Council, 1968, and 'Inflatable Sculpture', Jewish Museum, New York, 1969). The term *Sky art is sometimes used synonymously, but is really a broader category.

airbrush. An instrument for spraying paint or varnish by means of compressed air. It looks rather like an outsize fountain pen and is held in a similar fashion, the pressure of the forefinger on a lever regulating the air supply. It can be controlled so as to give large areas of flat colour, delicate gradations, or a fine mist. Originally the air compressors used to power the brushes were cumbersome, noisy, and expensive, but modern versions are quiet and portable; small cans of compressed air can also be used, but these are not suitable for prolonged use. The airbrush was invented by Charles Burdick, an American watercolour painter, who patented it in England in 1893 and in the same year set up a manufacturing firm called The Fountain Brush Company. In 1900 he founded the Aerograph Company, and the tradename Aerograph was for many years used as a general term for airbrushes (like Biro for ballpoints); *Man Ray called paintings he did with an airbrush 'aerographs'. In the early 20th century airbrushes were used mainly for photographic retouching, and their principal use is now in commercial art. Artists who have made distinctive use of them in this field include the British designer Abram Games (1914–96), who created many memorable posters for the War Office during the Second World War, and the Peruvian-born Alberto Vargas (1896–1982), whose pictures of pin-up girls appeared in almost every issue of *Playboy* magazine from 1960 to 1978. Airbrushes are also used by painters such as *Hard-Edge abstractionists and *Superrealists who require a very smooth, impersonal finish.

Aitchison, Craigie (1926–). British painter, born in Edinburgh. He studied at the *Slade School, 1952–4, and has spent most of his life in London, but he has not forgotten his Scottish roots and the Isle of Arran has inspired

some of his best landscape paintings. As well as landscapes, he paints portraits, still-lifes, animals, and religious subjects. His style is flat (sometimes with an almost heraldic simplicity of image) and whimsical; admirers find it luminous and poetic, detractors find it twee and poorly drawn. Aitchison himself writes: 'My pictures are always of something; they're not just "planes of colour" or anything posh like that. When I do a still-life or a portrait, I place the object or the person in front of the colour that is to appear in the picture. It may take hours of fiddling about with different backdrops of paper or cloth to get the colour right. You can't get the composition right if the colour's wrong. I suppose what most irritates me is if someone says I'm a "naive" painter.' Aitchison is a colourful character, a well-known figure in Soho.

Aitken, Charles (1869–1936). British administrator. He was born in York and studied at New College, Oxford University. From 1900 to 1911 he was the first director of the *Whitechapel Art Gallery, London, and from 1911 to 1930 he was director of the *Tate Gallery, succeeding D. S. *MacColl. Sir John *Rothenstein writes that Aitken was 'an ordinary man: his intelligence was relatively pedestrian, his powers of self-expression scarcely adequate'. However, Rothenstein considers that the job 'brought out qualities that made him a great director: clarity and firmness of purpose, and a burning devotion to the Tate . . . It was as a selfless co-ordinator of the gifts of others—one of the most precious gifts the director of a museum can possess—that Aitken was at his best.' Muirhead *Bone also had a high opinion of Aitken, referring to him as 'a genius of a gallery-director, with great originality of vision'. Aitken's taste, however, was old-fashioned, and Kenneth *Clark criticizes him and his successor J. B. *Manson because they 'set their faces against all *post-impressionist painting, and did their best to prevent such pictures entering the Gallery, even as gifts'.

Aizenberg, Roberto (1928–). Argentinian painter and draughtsman. He was a pupil of Juan *Batlle-Planas, 1950–3, and has followed him as one of South America's leading painters in the *Surrealist tradition. His most characteristic works (including highly finished drawings as well as paintings) depict headless figures or mysterious towers. In 1977 he moved to Paris and in 1981 to Tarquinia in Italy. Some of his later work shows the influence of *Delvaux and *Magritte.

Akasegawa, Genpei. See NEO-DADA ORGANIZERS and HI-RED CENTER.

AKhRR. A Russian artists' association founded in Moscow in 1922. Its first group show, held in that year, was entitled 'Exhibition of Pictures by Artists of the Realist Direction in Aid of the Starving', but it then adopted the name Assotsiatsiya Khudozhnikov Revolyutsionnoi Rossii (Association of Artists of Revolutionary Russia), which was abbreviated to AKhRR. The primary aim of its members was to present revolutionary Russia in a realistic, documentary manner by depicting the everyday life of the proletariat, the peasantry, the Red Army, and so on; in their desire for authenticity many members visited such places as factories, railway depots, and shipyards. They were fervently opposed to *Futurism and other modernist trends, and stylistically were much indebted to the academic realism that had characterized much 19th-century Russian painting (see SOCIALIST REALISM). Many of the older members had indeed been brought up in this tradition, notably Abram Arkhipov (1862–1930), Nikolai Kasatkin (1859–1930), and Konstantin Yuon (1875–1958). Artists of a younger generation included Isaak Brodsky (1884–1939), Alexander *Gerasimov, and Boris Ioganson (1893–1973). By the mid-1920s AKhRR was the most influential body of artists in Russia, having affiliations throughout the country, its own publishing house, and direct government support. In 1928 its name was changed to Assotsiatsiya Khudozhnikov Revolyutsii (Association of Artists of the Revolution), abbreviated to AKhR, and in 1929 it established its own journal, *Iskusstvo v massy* (Art for the Masses). In 1932, together with all other art and literary groups, AKhR was dissolved by Stalin.

Aktion. A word, meaning 'activity' or 'process', used in German-speaking countries in the context of modern art to refer to works that in Britain and the USA would generally be described as *Happenings or *Performance art (the plural is 'Aktionen', but the word is sometimes anglicized as 'Action', with the plural 'Actions'). Some German-speaking artists prefer it to the English

alternatives not only because it is native to their language, but also because it has a feeling of greater seriousness, without the suggestion of art as entertainment conveyed by the English terms. The artists to whose work the word has particularly been applied include Joseph *Beuys and the *Vienna Actionists.

Aktionismus. See VIENNA ACTIONISTS.

Albers, Josef (1888–1976). German-born painter, designer, writer, and teacher, who became an American citizen in 1939. He was born at Bottrop, Westphalia. From 1908 to 1918 he worked intermittently as a schoolteacher, and he studied art at the Royal Art School, Berlin (1913–15), the School of Arts and Crafts, Essen (1916–19), the Munich Academy (1919–20), and the *Bauhaus at Weimar (1920–3). From 1923 to 1933 he was a teacher at the Bauhaus (in Weimar, Dessau, and Berlin), his wide-ranging activities including stained glass, typography, and furniture design. When the Bauhaus was closed by the Nazis in 1933, Albers emigrated to the USA—he was one of the first of the Bauhaus teachers to move there and one of the most active in propagating its ideas. From 1933 to 1949 he taught at *Black Mountain College, and from 1950 to 1959 he was head of the department of design at Yale University (the art gallery there has an outstanding collection of his work); he lectured at many other places and received numerous academic awards.

Although Albers had made lithographs and woodcuts in his student days, it was not until he settled in the USA that he took up oil painting. Some of his student prints had been *Expressionist, but as a painter he worked in an entirely different vein, developing an art of intellectual calculation. From 1949 until his death he worked on a long series of paintings called *Homage to the Square* and it is for these uncompromisingly abstract pictures that he is best known; they consist of three or four squares of carefully planned size set inside one another, painted in flat, usually fairly subdued colours. He favoured the square so much because he believed that of all geometrically regular shapes it best distanced a work of art from nature, emphasizing its man-made quality. The colours in which they were painted often demonstrated the tendency of colours placed in proximity to expand or contract, advance or recede, in relation to each other. Albers's research in this area appeared in *Interaction of Color* (1963), the most important of his numerouspublications (which also included a book of poems, 1958). His rational approach and disciplined technique were influential on geometrical abstract painters such as *Op artists. America's leading Op artist, Richard *Anuszkiewicz, studied under him at Yale.

Albers's wife, **Anni Albers** (1899–1994), whom he met when she was a student at the Bauhaus, was a weaver; her rectilinear designs have something of the severe economy of her husband's paintings. From 1963 she also made prints in various techniques.

Albright, Ivan Le Lorraine (1897–1983). American painter (and occasional sculptor), born in Chicago, the son of **Adam Emory Albright** (1862–1957), a painter, mainly of portraits, who had studied under *Eakins. From 1915 to 1917 he studied architecture at Northwestern University and the University of Illinois, whilst painting in his spare time. After the USA entered the First World War in 1917, he served in France as a medical illustrator in an army hospital, making drawings and watercolours of wounds. The meticulous detail and clinical precision of this work anticipated his later paintings, which show a morbid obsession with death and corruption: sagging, almost putrescent flesh (which he described as 'corrugated mush'), decrepit, decaying objects, and lurid lighting are typical of his work. Often it evokes a feeling of melancholy for a beauty that is past. Albright came from a wealthy family and his financial independence allowed him to work slowly, producing a fairly small number of elaborate, highly-finished pictures. He was an individual figure who stood apart from mainstream movements (although he has sometimes been called a *Magic Realist). For most of his life he lived in or near Chicago, and the city's Art Institute has the best collection of his works. It includes the painting Albright did for the Hollywood film (1943) of Oscar Wilde's *The Picture of Dorian Gray*, showing the loathsomely corrupted title figure; Albright's identical twin brother, **Malvin Marr Albright** (1897–), did the portrait of the young and beautiful Dorian for this film. Ivan also wrote poetry, which the art historian Richard Calvocoressi says 'makes excruciating reading'.

Alechinsky, Pierre (1927–). Belgian painter and graphic artist. He was born in Brussels, where he studied book illustration and typography at the École Supérieure d'Architecture et des Arts Décoratifs, 1944–8. In 1947 he became a member of the *Jeune Peinture Belge association and in 1949 he joined the *Cobra group. He organized a Cobra exhibition in Liège in 1951, but soon after this the group disbanded and in the same year Alechinsky moved to Paris to study printmaking under a French government grant. In 1952 he studied with *Hayter at Atelier 17 and at about this time he became fascinated by Japanese calligraphy—in 1955 he visited the Far East and produced a prizewinning film entitled *Calligraphie japonaise*. From 1960 he travelled widely in Europe, the USA, and Mexico, but he continued to live and work mainly in France. His paintings are in a style of vigorous, even violent, expressive abstraction. They retain residual figurative motifs and their vein of turbulent fantasy shows a strong debt to his countryman *Ensor. Alechinsky is regarded as one of the leading Belgian artists of the 20th century and has an international reputation; in 1976 he was the first recipient of the Andrew W. Mellon Prize and this award was accompanied by a major retrospective exhibition of the Museum of Art, Carnegie Institute, Pittsburgh, in 1977.

Alfelt, Else. See PEDERSEN.

Alison, David. See EDINBURGH GROUP.

Allais, Alphonse. See MINIMAL ART.

Alliance of Youth. See UNION OF YOUTH.

Allied Artists' Association (AAA). A society of British artists formed in 1908 by the critic Frank *Rutter and artists in *Sickert's circle for the purpose of organizing annual exhibitions in the jury-free manner of the French *Salon des Indépendants. The association, which represented a reaction to the relatively conservative values of the *New English Art Club, held its first exhibition in the Albert Hall, London, in 1908. More than 3,000 works were displayed, each artist being allowed to show up to five (subsequently reduced to three) on payment of a subscription. Six more annual exhibitions followed at the Albert Hall, then five smaller shows at the Grafton Galleries between 1916 and 1920. The *Cam-

den Town Group, founded in 1911, was made up largely of members of the Allied Artists' Association. The exhibitions also included the work of foreign artists: *Brancusi (1913), *Kandinsky (1909), and *Zadkine (1913) received their first British showings at these events.

all-over painting. A term used for a type of painting in which the whole surface of the work is treated in a relatively uniform manner and traditional ideas of composition—of the picture having a top, bottom, or centre—are abandoned. The term was first used in the 1950s of the 'drip' paintings of Jackson *Pollock, and it has subsequently been applied to other works that avoid any obvious composition or grouping of forms, whether they rely on colour, as with *Colour Field painters, or on texture, as with the 'scribbled' pictures of Cy *Twombly. The German term is *Streu-Kompositien*.

Alloway, Lawrence (1926–90). British art critic and curator, active for much of his career in the USA. He suffered from tuberculosis in his childhood and had little formal education, but he attended classes in art history at London University. After working as a lecturer at the National Gallery and the Tate Gallery, he moved to the *Institute of Contemporary Arts, where he became assistant director, and was one of the leading figures in the *Independent Group, founded there in 1952. It was from this group that British *Pop art grew; Alloway himself coined the term and argued that 'acceptance of the mass media entails a shift in our perception of what culture is. Instead of reserving the word for the highest artefacts and noblest thoughts of history's top ten, it needs to be used more widely as a description of what a culture does.' He was opposed to the anti-Americanism dominant in British intellectual and artistic circles during the early years of the Cold War, and in particular was a strong supporter of *Abstract Expressionism. In his book *Nine Abstract Artists* (1954) he argued against the association between abstraction and an idealist social philosophy that been a feature of much pre-war writing on the subject; for him, a taste for geometric form was a taste like any other, not to be buttressed by reference to a Platonic world view. He was equally critical of the tendency in Britain to domesticate abstract art by associ-

ating it with the natural world: 'Landscape is the tender trap of British art', he wrote in 1959. In the light of such views, his emigration to the USA in 1961 seemed an obvious step. He was appointed a curator at the *Guggenheim Museum in New York in 1964 but resigned two years later over a disagreement about the artists chosen for the US Pavilion at the 1966 Venice *Biennale. Subsequently he became professor of art history at the State University of New York at Stony Brook, Long Island, 1968–81. He organized several major exhibitions and his books include *The Venice Biennale: 1895–1968* (1968), *American Pop Art* (1974), and *Topics in American Art since 1945* (1975). From 1963 to 1971 he was art critic to the *Nation*.

Alloway was married to the British-born painter Sylvia Sleigh (*c.* 1935–), who settled with him in the USA. There she became involved in the feminist movement, and she is best known for paintings of the male nude in which the figures parody Old Master depictions of the female nude.

Altman, Natan (1889–1970). Russian painter, stage-designer, and graphic artist, born at Vinnitsa. He studied at the Odessa Art School, 1901–7, and the Académie Russe in Paris, 1910–12. From 1912 to 1921 he lived in St Petersburg; he was in Moscow 1921–8, in France 1928–35, and then again in St Petersburg (or Leningrad as it had now been renamed) for the rest of his life. In the 1910s he was active in the *Union of Youth and took part in many avant-garde exhibitions, including those of the *Knave of Diamonds. He painted portraits, landscapes, and still-lifes, his most famous work being the dazzling portrait of the poet Anna Akhmatova (Russian Museum, St Petersburg, 1914), one of the masterpieces of Russian *Futurism.

Aman-Jean, Edmond (1860–1936). French painter, printmaker, and writer. Early in his career he was a leading exponent of *Symbolism, his favourite subject being mysterious women, but from about 1910 he painted in an *Intimiste style similar to that of *Bonnard. In a different vein he carried out two commissions of decorative painting in Paris—at the Musée des Arts Décoratifs (1900) and the Sorbonne (*The Four Elements* in the chemistry amphitheatre, 1912). Aman-Jean also made etchings and lithographs. He wrote a good deal of art criticism and published a book on Velázquez (1913).

Amaral, Tarsila do (1886–1973). Brazilian painter, sculptor, and art critic, born in São Paulo, the daughter of a wealthy rancher. She is regarded as one of the major figures in 20th-century Brazilian art, the creator of a style that combined nationalism with modernism. Initially she studied sculpture, but in 1917 she turned to painting. In 1920–2 she studied at the *Académie Julian, Paris, but it was not until she returned to Brazil that she became thoroughly converted to modern art, after becoming friendly with *Malfatti and the avant-garde writer and social agitator Osvald de Andrade, whom she later married. She spent most of 1924 in Europe, this time studying with *Gleizes, *Léger, and *Lhote, and she returned to Brazil with the Swiss poet Blaise Cendrars. With Cendrars and Andrade she began exploring historic towns and started to paint pictures that combined the exotic colour of folk art with the distortions of *Cubism, to which she later added elements of *Surrealism. This *Pau-Brasil* (Brazilwood) approach developed into the movement called *Antropofagismo* (Anthropophagy or Cannibalism), named after a manifesto entitled *Antropófago* that Andrade published in 1928. 'The central tenet of Anthropophagy was that the Brazilian artist must devour outside influences, digest them thoroughly and turn them into something new' (Edward *Lucie-Smith, *Latin American Art of the 20th Century*, 1993). This phase of Tarsila's career was brief, but it is generally thought to be her most creative period. In 1930 Gutúlio Vargas assumed power in Brazil after a revolution and his dictatorship (1930–45) was unsympathetic towards modern art. During this period, influenced partly by a visit to Russia in 1931, Tarsila took up *Social Realist themes. After the Second World War she returned to the vivacious colours of her work of the 1920s. Large retrospective exhibitions of her work were held in 1950 (in São Paulo) and 1969 (in Rio de Janeiro and São Paulo). In addition to painting and sculpting, she wrote art criticism for many Brazilian newspapers and journals.

American Abstract Artists (AAA). An association of abstract painters and sculptors formed in New York in 1936 with the aim of promoting members' work and fostering

public understanding of it. The group held annual exhibitions (the first in 1937) and disseminated information by lectures and publications. Balcomb *Greene was the first president, and among the other early members were Josef *Albers, Ilya *Bolotowsky, Willem *de Kooning, Jackson *Pollock, and David *Smith. In 1940 members picketed the *Museum of Modern Art, demanding that it should show American art, but after the Second World War abstract art received the recognition they had sought and the activities of the association dwindled. It continued to stage exhibitions, however, and in the 1950s it revived other activities and built up a membership of more than 200.

American Artists' Congress. An association of American artists formed in 1936 'to demand increased public aid to artists, to protest censorship and other attacks on civil liberties, and to condemn Fascism in Italy and Germany' (Irving Sandler, *Abstract Expressionism*, 1970). More than 300 painters, sculptors, designers, and photographers assembled in New York in 1936 for the first meeting, which was entitled American Artists' Congress Against War and Fascism. They were addressed by the sociologist Lewis Mumford, who said that 'The time has come for the people who love life and culture to form a united front . . . to be ready to protect and guard—if necessary fight for—the human heritage which we, as artists, embody.' Stuart *Davis was one of the founder members and became national secretary and chairman, but he resigned in 1940 because the Congress was increasingly insisting on using art as a propagandist tool. Communist members 'pressured artists not only to devote full time and energy to politics but also to adopt a *Social Realist position . . . even though the Congress was supposed to be nonpartisan in aesthetic matters and was joined by artists who worked in every existing style' (Sandler). The Congress broke up soon after Davis left.

American Place, An. See STIEGLITZ.

American Scene Painting. A very broad term applied to the work of various painters who in the 1920s and 1930s depicted aspects of American life and landscape in a naturalistic, descriptive style. The term probably derives from a book entitled *The American Scene* (1907), a collection of essays and impressions by the novelist Henry James, who in 1904 made a tour of his native country after an absence of 'nearly a quarter of a century'; it was first used in the context of the visual arts in the early 1920s. It does not signify an organized movement, but rather an aspect of a general tendency for American artists to move away from abstraction and the avant-garde in the period between the two world wars. Part of this tendency was a patriotic repudiation of European, specifically French, influence; in 1933 Edward *Hopper declared that 'we are not French and never can be and any attempt to do so is to deny our inheritance and to try to impose upon ourselves a character that can be nothing but a veneer upon the surface'. Apart from Hopper, the best-known exponent of American Scene Painting is Charles *Burchfield; in an essay on Burchfield published in 1928, Hopper wrote that he captured 'all the sweltering, tawdry life of the American small town, and . . . the sad desolation of our suburban landscapes'. The term also embraces the *Regionalists, who were more self-conscious in their nationalism.

American Sublime. See ABSTRACT SUBLIME.

American-Type Painting. A term that has sometimes been used as an alternative to *Abstract Expressionism. It comes from the title of an essay by Clement *Greenberg first published in the Spring 1955 issue of the intellectual journal *Partisan Review*. It was reprinted in Greenberg's book *Art and Culture* (1961).

Amiet, Cuno (1868–1961). Swiss painter (and occasional sculptor), a leading exponent of *Symbolism and *Post-Impressionism in his country. He was born in Solothurn and studied locally, then at the Munich Academy, 1886–8, and the *Académie Julian, Paris, 1888–91. After a year at Pont-Aven working with members of *Gauguin's circle, he returned to Switzerland, living at Basle and then Solothurn before settling at Oschwand in 1898. Thereafter he drew much of his inspiration from the surounding countryside. He was a friend of *Hodler and like him had a high reputation in German-speaking countries in the period leading up to the First World War. In 1906 he was invited to join Die *Brücke and thereafter contributed regularly to the group's exhibitions, although he did not meet the other members until 1912,

when he was in Cologne for the *Sonderbund exhibition. In 1918 he took up sculpture (mainly portrait heads) and he also did a few murals. Up to the outbreak of the Second World War he made regular visits to Paris.

Amour de l'art, L'. See VAUXCELLES.

Amshewitz, J. H. (John Henry) (1882–1942). British painter, etcher, and cartoonist, born in Ramsgate, the son of a scholarly rabbi. His mother, Sarah Epstein, was related to Jacob *Epstein. He studied at the *Royal Academy, 1902–7, winning a prize for mural decoration in 1905. Whilst still a student he attracted the support of M. H. Spielmann (1858–1949), who was editor of the *Magazine of Art* and a noted connoisseur and scholar (he was the leading authority on portraits of Shakespeare and his book *British Sculpture and Sculptors of Today* (1901) is still considered a standard work). Amshewitz's output included portraits, still-lifes, Jewish subjects, and scenes of the theatre (he was briefly a professional actor), as well as book illustrations and cartoons, but he is best known as a muralist. He specialized in colourful historical 'costume pieces' such as *The Granting of the Charter by King John* (one of a series of four lunettes he painted in Liverpool Town Hall, 1907–9). From 1916 to 1922 he lived in South Africa, and he settled there permanently in 1936. In spite of delicate health, he painted numerous murals representing scenes from South African history in his adopted country, for example at the New General Post Office, Cape Town (1941).

Amsterdam, Stedelijk Museum. See STEDELIJK MUSEUM.

Anacranismo. See PITTURA COLTA.

Analytical art. See CONCEPTUAL ART.

Analytical Cubism. See CUBISM.

Anderson, Laurie (1947–). American *Performance artist, poet, and musician, born in Chicago, the daughter of a wealthy paint manufacturer. In 1967 she moved to New York, where she gained a BA in art history from Barnard College in 1969 and an MFA from Columbia University (where she trained in painting and sculpture) in 1972. She also studied privately with Sol *LeWitt. In 1972 she gave her first Performance piece, *Automo-*

tive, an outdoor concert for car horns, and by 1976 was well known in the USA and Europe. Her performances include numerous audio and visual effects (including slide projection and films) combined with spoken and sung elements (she is a singer and violinist, and since 1974 has been making her own instruments, notably a modified violin with an internal loudspeaker). Her sense of humour and endearing stage presence have been much admired. Anderson's major work is *United States*, 'an eight-hour opus of song, narrative and sleights of hand and eye' (RoseLee Goldberg, *Performance Art*, 1988). It is in four parts, and was first performed complete in 1983 at the Brooklyn Academy of Music over two nights. A song from the show, 'O Superman', was released on record in 1981 and got to number 2 in the British singles' chart. Her first album, *Big Science*, was released in 1982. The entry on Anderson in the *New Grove Dictionary of Women Composers* (1994) says that 'By the early 1980s she had become the best-known American performance artist, and her popularity reached its peak in 1986, the year she directed *Home of the Brave*, a feature film of one of her performances, toured internationally with a large pop band and even appeared in an American Express television commercial. Finding herself overwhelmed by . . . such undertakings, Anderson returned to a more intimate style.' She began to concentrate more on music, and in her later works 'her whimsical futuristic bemusement has turned into darker, less romantic visions of the future'. In 1997 she was director of the Meltdown Festival in London, an annual concert series that specializes in unusual musical events and collaborations.

Andre, Carl (1935–). American sculptor and poet, one of the best-known exponents of *Minimal art. He was born in Quincy, Massachusetts, and from 1951 to 1953 attended Phillips Academy at Andover, in the same state, where he became a close friend of his fellow pupil Frank *Stella. For the next decade he was variously employed (in the US Army and as railroad brakeman and conductor, for example), before beginning to exhibit sculpture in New York in the mid-1960s, notably at the '*Primary Structures' show in 1966. Typically he produces his sculptures by placing identical ready-made commercial units (bricks, cement blocks, metal plates, etc.) in simple geometrical arrangements

Andrews, Michael

without adhesives or joints; the works are dismantled when not on exhibition. His most characteristic pieces abjure height and are arranged as horizontal configurations on the floor ('more like roads than buildings', in his own words); some of them are even intended to be walked upon. However, Andre has also used three-dimensional 'natural' products such as logs or bales of hay as his units, and in addition has made 'scatter pieces' consisting of randomly spilled bits of plastic. Sometimes his sculptures are so visually unremarkable that they fail to be recognized as human artefacts; in 1971, at an exhibition at Arnhem in the Netherlands, a work by him was mistaken for rubbish and cleared away by a park attendant. The term 'Lost Sculptures' (on the analogy of 'found objects'—see OBJET TROUVÉ) has been applied to such works that may be read as nondescript parts of the everyday world.

In Britain Andre is best known for the sensational publicity accompanying 'the Tate bricks' episode in 1976. His *Equivalent VIII* (1966), consisting of 120 firebricks arranged two deep in a rectangle, was vandalized and there was an outcry about the alleged waste of public money on its purchase by the *Tate Gallery (which had occurred some four years earlier). Andre made headlines again in 1985, when he was charged with murdering his wife (who died after falling from a window); he was acquitted of the charge.

Andrews, Michael (1928–95). British painter. He studied art part-time in his native Norwich and then at the *Slade School under *Coldstream, 1949–53. A slow, fastidious worker, he concentrated on ambitious figure compositions, subtly handled and often with an underlying emotional tension. He shunned publicity and was little known to the public until an *Arts Council exhibition of his work in 1980, after which he achieved a considerable reputation, although some critics found his work rather plodding. In the mid-1980s he had a change of direction with a series of huge, brilliantly coloured landscapes featuring Ayers Rock in Australia.

Angry Penguins. An Australian avant-garde quarterly journal (1940–6) devoted to art and literature, published first in Adelaide and then from 1943 in Melbourne. It was founded by the poet and critic Max Harris (1921–96), the title coming from a line in one of his poems. Harris was joined in Melbourne by

John Reed (1901–81), a solicitor and art patron, and his wife Sunday Reed (1905–81). The magazine encouraged and provided a focus for a group of young painters who worked in an *Expressionist vein and were attempting at this time to create an authentic Australian art free from European dominance; among them were Arthur *Boyd, Sidney *Nolan, John *Perceval, and Albert *Tucker. They were opposed by a group of *Social Realists, including Noel *Counihan, Victor O'Connor (1918–), and Yosl Bergner (1920–), an Austrian-born painter who moved to Australia in 1937 and settled in Israel in 1950. The debate waged between the two factions helped to make Melbourne a lively artistic centre in the early 1940s. Nolan later recalled that 'For the preceding seven years, I'd been building up a stock of knowledge and impressions about modern art and modern writing, and *Angry Penguins* was the chance to put all this into practice, to have poems published and articles written. We felt we were a kind of Paris in Melbourne; we were like James Joyce or Rimbaud or Lorca.'

In 1944 *Angry Penguins* was the victim of a celebrated hoax when it devoted its autumn issue to the poems of the non-existent 'Ern Malley', whose works were 'consciously contrived nonsense' put together by two fairly traditional poets who thought the journal was pretentious and wanted to test the critical judgement of the editors; the sources from which they drew quotations included an army report on mosquito control. In their defence, the editors contended that the hoaxers had created better poetry by this *Surrealistic method of relinquishing conscious contol (see AUTOMATISM) than they had ever done before; certainly, some of their efforts would easily pass muster in any anthology of modernist verse. However, the magazine never really recovered from the bad publicity caused by the hoax.

John Reed is described in the *Oxford Companion to Australian Literature* (1985) as 'one of the most influential proponents of modernism in Australian art'. He was president of the *Contemporary Art Society, Melbourne, 1940–3 and 1953–8, and he founded and directed the Museum of Modern Art and Design of Australia, Melbourne, which existed from 1958 to 1966. Its collections formed the nucleus of the Museum of Modern Art at Heide, Bulleen, Victoria, established in 1981.

Angus, Rita (1908–70). New Zealand painter, mainly of portraits and landscapes. Angus was born at Hastings, near Napier, and studied at Canterbury School of Art, Christchurch, 1927–31. She was considered one of the leading figures in New Zealand art, particularly in the 1940s, and with Colin *McCahon and Toss *Woollaston she was a pioneer of modernism in her country. Working in both oils and watercolours, she painted in a forthright, brightly coloured style. She also painted under her married name, Rita Cook. The National Art Gallery, Wellington, has the best collection of her work.

Anker, Albert (1831–1910). Swiss painter. He specialized in rather sentimental scenes of peasant village life that were once very popular. His chief claim to fame is that he was one of Adolf Hitler's favourite artists.

Annesley, David. See NEW GENERATION.

Annigoni, Pietro (1910–88). Italian painter (and occasional sculptor), the only artist of his time to become internationally famous as a society and state portraitist. He was born in Milan and spent most of his life in Florence, where he studied at the Academy. In 1949 he became well-known in Britain when a self-portrait was voted 'Picture of the Year' at the *Royal Academy's summer exhibition, and in 1954 an exhibition of his work at the dealers Wildenstein's in London was a huge success with the public. This led to a commission from the Worshipful Company of Fishmongers to paint a portrait of Queen Elizabeth II (1954–5), the work that secured his fame (it was reproduced endlessly, notably on the postage stamps and banknotes of various countries; the jacket blurb of Annigoni's autobiography—*An Artist's Life*, 1977—claims that it made him 'the most famous artist in the world—not excluding even *Picasso'). Subsequently he painted many other celebrity sitters, including several other members of the British royal family, Presidents Kennedy and Johnson, and Pope John XXIII. In style and technique he based himself on the masters of the Italian Renaissance, placing great stress on draughtsmanship and often working in tempera. Characteristically his work was very smoothly finished and detailed, melodramatic in lighting, and melancholy in mood. Annigoni also painted religious works (including frescos in Italian churches) and ambitious allegorical scenes, and he regarded these as more important than his portraits. Critics often dismissed his work as portentously inflated and tasteless, but his royal portraits particularly were highly popular with the general public: in 1969 he painted a second portrait of the Queen, now in the National Portrait Gallery, London, and more than 200,000 people went to see it during the two weeks it was first exhibited at the gallery in 1970.

Anquetin, Louis (1861–1932). French painter, designer, and writer. He was born and brought up in Normandy and moved to Paris in 1882. Early in his career he moved in circles that included some of the outstanding avant-garde painters of the day, most notably his close friend Toulouse-Lautrec, and he was a pioneer of *Cloisonnism. After about 1895, however, Anquetin's work became much more traditional, and he devoted much of his time to research into the techniques of the Old Masters, especially Rubens (he wrote a book entitled *Rubens: Sa technique*, published in 1924). He was a prolific draughtsman and made tapestry cartoons for the Beauvais and Gobelins factories. A collection of Anquetin's writings on art, *De l'Art*, was published in 1970.

Anrep, Boris (1883–1969). Russian-born mosaicist and painter, active mainly in England. He studied law in his native St Petersburg, but developed a passion for Byzantine art and travelled widely to see it—in Russia, the Near East, and Italy. He studied at the *Académie Julian, Paris, in 1908, and at the Edinburgh College of Art, 1910–11, and in 1912 he organized the Russian section of Roger *Fry's second *Post-Impressionist exhibition. After the First World War, in which he served in the Russian army, he settled in London, although he lived for a time in Paris after his wife left him for Fry in 1926. He came to specialize in mosaic pavements, the best-known examples being in the Tate Gallery, representing William Blake's *Proverbs* (1923), and the National Gallery—four floors on and around the main staircase, executed between 1926 and 1952. The subjects are *The Awakening of the Muses*, *The Modern Virtues*, *The Labours of Life*, and *The Pleasures of Life*; portraits of many well-known contemporaries are incorporated in them, for example the philosopher Bertrand Russell representing 'Lucidity' and

the film actress Greta Garbo as Melpomene, the Muse of Tragedy (see also SITWELL). They were paid for by Samuel *Courtauld and other benefactors. Anrep wrote of his work: 'It is more natural for us to look down than to look up to a decorated ceiling ... As a matter of fact, the sight of pavement artists outside the National Gallery gave me the idea of decorating the vestibule. I approached the Director, Sir Charles Holmes. I had luck and the Director and Trustees agreed. I got in on the ground floor, while the other pavement artists, poor beggars, are still outside the Gallery.' Among his private commissions were an entrance floor for Ethel *Sands's home at 15 The Vale, Chelsea (1917), and a mosaic representing *Various Moments in the Life of a Lady of Fashion* (1922) for Sir William and Lady Jowitt at 35 Upper Brook Street, Mayfair (now in the City Museum and Art Gallery, Birmingham).

Anshutz, Thomas Pollock (1851–1912). American painter and teacher, assistant to Thomas *Eakins at the Pennsylvania Academy of the Fine Arts from 1876 to 1886, and his successor as professor when Eakins resigned in 1886. Anshutz was very different in character from Eakins (modest rather than awe-inspiring), but he upheld his great predecessor's tradition nobly, maintaining his emphasis on the study of anatomy and close observation of the subject; like Eakins, too, he was disdainful of students competing for medals and prizes. Robert *Henri was one of the students who found Anshutz a particularly sympathetic teacher; there are many references to him in Henri's diary, where he says Anshutz urged him to 'Get the big things first, then the little ones', and in 1919 he recalled him as 'a great influence, for he was a man of the finest quality, a great friend, gave excellent advice, and never stood against a student's development'. His other pupils included Charles *Demuth, William *Glackens, George *Luks, John *Marin, and Everett *Shinn. Anshutz's own paintings—mainly portraits and female nudes—are firmly constructed, like Eakins's, but more glossy.

Antes, Horst (1936–). German painter, sculptor, and printmaker. He was born in Heppenheim and studied at the Academy in Karlsruhe, 1957–9. His early paintings were influenced by *Abstract Expressionism, especially *de Kooning, but from about 1960 his style became more firmly structured. He is best known for his 'Gnome' paintings, featuring clumsy, heavily stylized torsoless figures, their huge heads—characteristically seen in profile—attached to the top of their legs. With their almond-shaped staring eyes, the figures are reminiscent of Egyptian sculpture. He has taken part in many international exhibitions, and in 1966 was awarded the Unesco prize at the Venice *Biennale.

anti-art. A loosely used term that has been applied to works or attitudes that debunk traditional concepts of art. The term is said to have been coined by Marcel *Duchamp in about 1914, and his *ready-mades can be cited as early examples of the genre. *Dada was the first anti-art movement, and subsequently the denunciation of art became commonplace—almost *de rigueur*—among the avant-garde.

anti-form. An imprecise term, originating in the late 1960s, applied to certain types of works that react against traditional forms, materials, and methods of artistic creation—*Arte Povera, *Land art, some kinds of *Conceptual art, and the early 'provisional, non-fixed, elastic' sculptures of Richard *Serra, for example. Robert *Morris, who wrote an article entitled 'Anti-Form' in the April 1968 issue of *Artforum*, defined the term—somewhat opaquely—as an 'attempt to contradict one's taste'.

Anti-Minimalism. See POST-MINIMALISM.

Anti-Object art. See CONCEPTUAL ART.

Antipodeans (or **Antipodean Group**). The name adopted by a group of Australian painters (Arthur *Boyd and John *Perceval were the best known) who held an exhibition in Melbourne in 1959; the catalogue contained a manifesto of their aims, attacking abstraction and championing figurative art. The manifesto, written by the art historian Bernard Smith (1916–), has been described by Robert *Hughes (*The Art of Australia*, 1970) as 'the most controversial document in recent Australian painting'. Hughes points out that much Australian abstract painting of the time was indeed vacuous and derivative, but says the error of the manifesto 'was to suppose that the paintings were weak because they were abstract'.

Antropofagismo. See AMARAL.

Antúnez, Nemesio (1918–93). Chilean painter, printmaker, diplomat, and art administrator, active in the USA and Europe as well as his native country. He trained as a graphic artist with *Hayter in Paris and served successively as director of the Contemporary Art Museum of the University of Chile, cultural attaché at the Chilean embassy in Washington, and director of the Museum of Fine Arts in Santiago. After the military coup in Chile in 1973 he moved to Europe, living in Barcelona, London, and Rome, before returning to his country in 1984. Edward *Lucie-Smith writes that 'Antunez's work reflects this peripatetic, cosmopolitan lifestyle—his paintings have a kind of detatched elegance. The most typical are representations of vast landscapes, simplified and geometricized, populated by swarming crowds of tiny figures' (*Latin American Art of the 20th Century*, 1993). His best-known work, however, is probably the mural *The Heart of the Andes* (1966) in the United Nations Building, New York.

An Túr Gloine (The Tower of Glass). Stained-glass workshop founded in Dublin in 1903 by Sarah *Purser and the playwright Edward Martyn (1859–1923), an ardent nationalist in the arts who had written articles attacking cheap commercial furnishings in Irish churches. The workshop was in purpose-built premises at 24 Upper Pembroke Street. Purser was the main shareholder and her role was chiefly administrative, although she also did some designing. With the exception of Harry *Clarke, most of the leading Irish stained-glass artists of the day worked there at one time or another, among them Wilhelmina Geddes (1887–1955), Michael Healy (1873–1941), and Evie *Hone. The first major commission was for Loughrea Cathedral, County Galway, and many others followed throughout Ireland. Purser ran the company until she died at the age of 94 in 1943; it was dissolved the following year.

Anuszkiewicz, Richard (1930–). American painter, his country's leading exponent of *Op art. He was born in Erie, Pennsylvania, and studied at the Cleveland Institute of Art, 1948–53, and then at Yale University under Josef *Albers, 1953–5. Albers stimulated his interest in the effects of colour on perception, but it was not until about 1960 that he started

to address this in his painting. 'My work', he says, 'is of an experimental nature and has centered on an investigation into the effects of complementary colors of full intensity when juxtaposed and the optical changes that occur as a result.' His painting is distinct from that of the two most famous exponents of Op art; whereas Bridget *Riley's pictures are often aggressively dazzling and Victor *Vasarely's often contain suggestions of a third dimension, Anuszkiewicz's are concerned with radiating expanses of lines.

Apollinaire, Guillaume (Wilhelm Apollinaris de Kostrowitzky) (1880–1918). French poet and art critic, a major figure in the avant-garde world of Paris in the early 20th century. He was born in Rome, the illegitimate son of a high-class Polish courtesan, Olga Kostrowitzky, whose surname he used until 1902, when he adopted his pseudonym; his father was probably an Italian nobleman, although Apollinaire liked to hint he was the offspring of a high-ranking clergyman. He was brought up in Monte Carlo and received his education in French. From about 1900 he lived in Paris, where he earned his living mainly with journalism, especially art criticism—he was, indeed, one of the prototypes of the modern journalistic critic, his writing containing much that is superficial and gossipy. His importance stems not so much from the quality of his writing as from his brilliance as a propagandist on behalf of those artists he most admired: John *Golding writes that 'no other critic has ever helped and encouraged such an impressive number of gifted and, for the most part, unknown young painters.' In particular he championed *Picasso (his first substantial articles, in 1905, were on him) and later the *Cubists in general (including the *Orphists, whose name he coined). Among the other artists whose reputations he either established or consolidated were *Chagall, de *Chirico, *Derain, *Matisse, and *Rousseau. He was also influential on *Dada (his friend Marcel *Duchamp's interest in visual punning was partly inspired by Apollinaire's love of jest and linguistic acrobatics) and on *Surrealism (he coined the term in 1917 and his suggestion that artists should explore 'interior universes' stimulated André *Breton, who dedicated the first Surrealist manifesto to his memory). The less impressive aspects of his career include his failure to understand *Brancusi and his over-

rating of Marie *Laurencin (his lover), whom he placed on the same level as Picasso.

Apollinaire enlisted in the French army in 1914 and was discharged in 1916 after receiving a head wound; weakened by this, he died of influenza two years later. The only book on art he published in his lifetime was *Méditations esthétiques: Les peintres cubistes* (1913), but a collected edition of his criticism appeared in 1960 under the title *Guillaume Apollinaire: Chroniques d'Art 1902–18* (an English translation was published in 1972 as *Apollinaire on Art: Essays and Reviews 1902–18*). John Golding sums up his position in the history of art as follows: 'no other man reflected so completely every facet of the artistic temper of his age. He was a weather-vane which responded to the slightest intellectual vubration; he was a net which caught and gathered up every new aesthetic trend. Artists loved his company, and he made them aware of themselves and of each other. Above all he was a cardinal figure in creating the artistic climate of Paris early this century—a climate in which anything and everything was thought possible. It was this belief that made the early twentieth century one of the most exciting periods in the entire history of the visual arts, and Apollinaire, for all his failings, remains its spokesman and its most representative critic' ('Guillaume Apollinaire: The Painters' Friend' in *Visions of the Modern*, 1994).

Appel, Karel (1921–). Dutch abstract painter, sculptor, graphic artist, designer, ceramicist, and poet, regarded as the most powerful of the post-war generation of Netherlandish artists. He was born in Amsterdam, where he studied at the Academy, 1940–3, and he had his first one-man exhibition at Het Beerenhuis in Groningen in 1946. At this time he was influenced by *Dubuffet and was attempting to work in the spirit of children's drawings. In 1948 he helped to found Reflex, the experimental group of Dutch and Belgian artists from which the *Cobra group sprang, and in 1949 he painted a fresco in the cafeteria of Amsterdam City Hall which caused such controversy that it was covered for ten years. The following year he settled in Paris, where he found an influential supporter in the critic Michel Tapié, who organized exhibitions of his work. By the end of the decade he had an international reputation, having travelled widely and won the Unesco Prize at the Venice *Biennale in 1954, the International Painting Prize at the São Paulo Bienal in 1959, the Guggenheim International Award in 1960, and several other honours. He first visited New York in 1957 and subsequently divided his time mainly between there, Paris, and Monaco.

His most characteristic paintings are in an extremely uninhibited and agitated *Expressionist vein, with strident colours and violent brushwork applied with very thick impasto. The images usually look purely abstract at first glance, but they often retain suggestions of human masks or of animal or fantasy figures, sometimes fraught with terror as well as a childlike naivety: Herbert *Read wrote that in looking at his pictures one has the impression of 'a spiritual tornado that has left these images of its passage'. Such works were influential on *Neo-Expressionism. In 1968 Appel began to make relief paintings, followed by painted sculptures in wood and then aluminium. He has also made ceramics and done a varied range of design work, including carpets, stained glass, and the scenery for a ballet, *Can we Dance a Landscape?*, for which he also wrote the plot; it was performed at the Paris Opéra in 1987.

appropriation. See PHOTO-WORK.

a.r. (revolutionary artists). See BLOK and STRZEMIŃSKY.

Arakawa, Shusaku. See NEO-DADA ORGANIZERS.

Arbeitsrat für Kunst (Workers' Council for Art). See NOVERBERGRUPPE.

Arcevia, Bruno d'. See PITTURA COLTA.

Archipenko, Alexander (1887–1964). Russian-born sculptor who became an American citizen in 1928. He studied at the art school in his native Kiev from 1902 to 1905, when he was expelled for criticizing the academic attitudes of his teachers. In 1906 he moved to Moscow and in 1908 to Paris, where he left the École des *Beaux-Arts after two weeks' study, again showing his impatience of discipline. Instead, he studied ancient and medieval sculpture in the Louvre, and some of the work of his early years in Paris (mainly female figures) is in a primitivistic manner recalling Egyptian art. In about 1910, however, he was introduced to *Cubism by *Léger

(whose studio was near his own) and he became one of the outstanding sculptors of the movement. In works such as the bronze *Walking Woman* (Denver Art Museum, 1912) he analysed the human figure into geometrical forms and opened it up with concavities and a central hole to create a contrast of solid and void, thus ushering in a new sculptural idiom: George Heard *Hamilton writes that 'This is the first instance in modern sculpture of the use of a hole to signify more than a void, in fact the opposite of a void, because by recalling the original volume the hole acquires a shape and structure of its own'. In the same year, with *Médrano I* (destroyed), Archipenko began making sculptures that were assembled from pieces of commonplace materials, paralleling the work of *Picasso; *Médrano II* (Guggenheim Museum, New York, 1913) is made of painted tin, wood, glass, and painted oilcloth. (Médrano was the name of a circus in Paris much frequented by artists; these two figures represented performers there.)

Archipenko quickly built up a reputation in France and elsewhere, particularly in Germany. In 1912 he had a one-man exhibition at the Folkwang Museum in Hagen and in 1913 one at the *Sturm Gallery in Berlin; also in 1913 his work was included in the *Armory Show in New York. His rise to international prominence was interrupted by the First World War, during which he lived in Cimiez, a suburb of Nice; his work of this period included a number of sculpto-paintings, a type of work he created in which forms project from and develop a painted background. After the war he soon relaunched his career, organizing an exhibition of his work that toured widely in Europe in 1919–21 (Athens, Brussels, Geneva, London, Munich, among several other cities). He also exhibited at the Venice *Biennale in 1920, on which occasion his work was condemned by a Venetian cardinal. His first one-man show in the USA was given by the *Société Anonyme in New York in 1921. At this period he was undoubtedly the best known and most influential of all Cubist sculptors.

From 1921 to 1923 Archipenko lived in Berlin, where he ran an art school, then emigrated to the USA. He lived, worked, and taught in various places, but chiefly in New York, where he directed his own school of sculpture from 1939 until his death. The work he did in America did not compare in quality or historical importance with that of his European period, but he continued to be highly inventive. In 1924, for example, he invented the *Archipentura* (a kind of *Kinetic painting), and after the Second World War he experimented with 'light' sculptures, making structures of plastic lit from within. His work was influential in both Europe and America, notably in the revival of polychromy, in the use of new materials, and in pointing the way from the sculpture of solid form towards one of space and light.

Ardizzone, Edward (1900–79). British illustrator, painter, printmaker, and writer, born in Haiphong, Indo-China (now Vietnam), the son of a Scottish mother and a French father of Italian parentage who worked for the Eastern Telegraph Company. His family moved to London in 1905 and he became a British citizen (by birth he was French) in 1922. From 1919 to 1926 he attended evening classes at Westminster School of Art (*Meninsky was one of his teachers) whilst working as a statistical clerk. In 1926 he gave up that job and from then on worked as a full-time artist, mainly as an illustrator, although he also did oil paintings and lithographs. From 1940 to 1945 he was an *Official War Artist in France; almost 3,000 of his watercolours are in the Imperial War Museum and his work is recorded in his books *Baggage to the Enemy* (1941) and *Diary of a War Artist* (1974). However, it is as an illustrator of children's literature that Ardizzone is best known. His output in this field was prolific and he won several distinctions, including in 1956 the first Kate Greenaway Medal (awarded annually by the Library Association for the best work in the illustration of a children's book). Ardizzone also wrote such books himself, beginning with *Little Tim and the Brave Sea Captain* (1936). In the *Oxford Companion to Children's Literature* (1984) he is described as 'the most eminent British children's illustrator between 1945 and 1970, with a reputation as high in America as in his own country. His characteristic style, which makes great use of cross-hatching, appears casual, but was worked out over many years, and only became fully developed after the Second World War. It is particularly suited to nostalgic scenes of Edwardian city life, with fog-bound streets and the cosy interiors of sitting-rooms.'

His son **Philip Ardizzone** (1931–78) was a painter and etcher.

Ardon, Mordecai (originally Max Bronstein) (1896–1992). Polish-born Israeli painter. He was born in the village of Tuchów, the son of a Jewish watchmaker. From 1920 to 1925 he studied at the *Bauhaus, where he became a friend of his teacher *Klee. In 1926 he moved to Munich, then taught at *Itten's art school in Berlin from 1929 to 1933, when he fled to Jerusalem because of Nazi persecution. He taught at the Belazel School of Arts and Crafts in Jersualem, 1935–52 (he was the school's director, 1940–52), and he was artistic adviser to the Israeli Ministry of Education and Culture, 1952–62. From 1965 he spent much of his time in Paris. Ardon's obituary in the *Independent* described him as 'Israel's best-known artist internationally' and said that he brought the country into contact with 'the leading European art movements of the early Thirties—at a time when Palestine was a far outpost of the Ottoman empire'. His work of this time was strongly influenced by *Expressionism and often concerned with Jewish religion and mysticism. From the 1950s his style became more abstract. His major works include a stained-glass window representing *Isaiah's Vision of Eternal Peace* (1982–4) at the Jewish National University and Library, Jerusalem. There are examples of his paintings in the Tate Gallery, London, the Museum of Modern Art, New York, and many other collections of modern art.

Arenal, Luis. See TALLER DE GRÁFICA POPULAR.

Arensberg, Walter (1878–1954) and **Louise** (1879–1953). American collectors and patrons, husband and wife. Both came from wealthy families and were thus able to devote themselves to artistic pursuits. They married in 1907 and from 1914 to 1921 they lived in New York, where their home formed a kind of salon for the *Dada movement in America; *Picabia's wife recalled that 'at any hour of the day or night one was sure of finding sandwiches, first-class chess players, and an atmosphere entirely free from conventional and social prejudices'. In particular, the Arensbergs were the main patrons of Marcel *Duchamp, who acted as their art adviser as well as selling them his own work. They collected non-Western art as well as avant-garde work. In 1921 they settled in Los Angeles; at this point they graciously sold Duchamp's unfinished *Large Glass* to Katherine *Dreier so

that he could continue to work on it. In Los Angeles their collection expanded greatly, reaching a total of about 1,500 works. They initially concentrated on a brief period from about 1910 to 1914, and especially on *Cubist works, but later they expanded their interests to include *Surrealism, for example. Originally they intended that their collection should be bequeathed to an institution near their California home, but negotiations with potential recipients repeatedly foundered, mainly because of the unusual stipulation that the bequest should include a research centre dedicated to promoting the idea that the Elizabethan statesman Francis Bacon was the true author of Shakespeare's plays. This was a pet theory of Walter Arensberg's, and he wrote several books and pamphlets in support of it; commenting on these, Samuel Schoenbaum (*Shakespeare's Lives*, 1970) writes that 'Those who knew him recall Arensberg as a rational man, but on this subject he was mad, and mad from the outset'. Eventually his Francis Bacon Foundation was created at Pomona College in Claremont, California, and the art collection was bequeathed to the Philadelphia Museum of Art, where it went on display in 1954, soon after the death of both donors. Up to this time the collection had been little known, but its public availability now contributed greatly to a revival of interest in Duchamp's work.

Argan, Giulio Carlo. See CONTINUITÀ.

Arikha, Avigdor (1929–). Romanian-born Israeli painter, draughtsman, printmaker, designer, and writer on art who has worked mainly in France. He moved to Israel in 1944, and from 1949 to 1951 studied at the École des *Beaux-Arts in Paris, where he settled in 1954. Initially he made his name as a book illustrator, then from 1957 to 1965 he was primarily an abstract painter, working in an *Art Informel vein. Between 1965 and 1973 he abandoned painting for drawing and etching, his work of this period including a series of portraits of the writer Samuel Beckett, who was a close friend. When he resumed painting in 1973, he concentrated on working from the life, his subjects including landscapes, interiors, still-lifes, and portraits, among which are a few commissioned portraits (*Queen Elizabeth, the Queen Mother*, NPG, Edinburgh, 1983). He has won a reputation as one of the leading figurative painters of his

day and has been described as 'An artist positively steeped in knowledge of the Old Masters ... whose work nonetheless remains contemporary in the immediacy of the technique used, as well as in the evident conviction that behind appearances lies an all-too-real world of irrationality and danger' (H. H. *Arnason, *A History of Modern Art*, 3rd edn., 1988). Arikha has also written on art and has organized exhibitions at the Houston Museum of Fine Arts on the work of Poussin (1982) and Ingres (1986).

Arkhipov, Abram. See AKHRR.

Arman (Armand Fernandez) (1928–). French-born sculptor who settled in New York in 1963 and became an American citizen in 1972. He was born in Nice and studied briefly in Paris at the École des Arts Décoratifs and the École du Louvre. In 1957, with his friend Yves *Klein, he decided to be known by his first name only, and the form 'Arman' was adopted in 1958 as the result of a printer's error on the cover of a catalogue. Like Klein he was interested in Japanese culture, particularly Zen Buddhism, and (again like Klein) he worked for a time as a judo instructor. In the early 1960s Arman gained a reputation as one of the leading exponents of *Nouveau Réalisme and he is best known for his *assemblages of junk material. These range from modest collections of household debris (*Accumulation of Sliced Teapots*, Walker Art Center, Minneapolis, 1964) to a huge tower (about 20 metres high) of 60 automobiles embedded in cement (*Long-Term Parking*, Cartier Museum, Jouy-en-Josas, 1982).

Armando. See NUL.

Armfield, Maxwell (1881–1972). British painter, illustrator, and writer. He was born in Ringwood, Hampshire, and studied at Birmingham School of Art, 1899–1902, then in Paris at the Académie de la Grande Chaumière. In 1905 he moved to London and from 1915 to 1922 lived in the USA. He worked in a traditional style, often using tempera paint, on which he wrote two books—*A Manual of Tempera Painting* (1930) and *Tempera Painting Today* (1946). His subjects included portraits and figure compositions, often on literary themes. Armfield was also a book illustrator, wrote poetry, composed music, and took an active interest in the theatre (in 1909 he mar-

ried the playwright Constance Smedley, with whom he worked closely until her death in 1941; their best-known collaborative project is *The Flower Book*, published in 1910). He had been born into a Quaker family, but he became a Christian Scientist under his wife's influence, and after her death he became interested in mysticism and eastern religions, writing on these subjects under pseudonyms. He was virtually forgotten for many years after the Second World War, but he lived long enough to see a revival of interest in his work, expressed particularly in an exhibition 'Homage to Maxwell Armfield' at the Fine Art Society, London, in 1970.

Armitage, Kenneth (1916–). British sculptor and graphic artist, born in Leeds. He studied at Leeds College of Art, 1934–7, and at the *Slade School, 1937–9. After serving in the army throughout the Second World War, he was head of the sculpture department at the newly-founded *Bath Academy of Art, Corsham, 1946–56 (during this period he was also *Gregory Fellow at Leeds University, 1953–5). His first one-man exhibition was at Gimpel Fils, London, in 1952 and in the same year his work was well received at the Venice *Biennale (see GEOMETRY OF FEAR), marking the beginning of an international reputation. At the 1958 Biennale he won the David E. Bright Foundation award for the best sculptor under 45, and the following year he had a retrospective exhibition at the Whitechapel Art Gallery, London, by now firmly established as one of the leading British sculptors of his generation—a position he has maintained ever since, with numerous exhibitions in Europe and the USA.

Armitage's pre-war work consisted mainly of carvings (most of which he later destroyed), but soon after the war he began to work in bronze, which has remained a favourite material for what he describes as 'the fluid, unifying and sensual quality it can give'. Bronze was also much more suitable than carving for the spindly-legged, slab-bodied shapes that were characteristic of his figures at this time; he depicted them singly or in groups, in everyday attitudes, with a sense of affection and often humour: 'I find most satisfying work which derives from careful study and preparation but which is fashioned in an attitude of pleasure and playfulness.' *People in a Wind* (Tate Gallery, London, 1951) is a well-known example from this phase of his

career and one of the first works in which he achieved a distinctively individual style. From the mid-1950s his figures became more impersonal in character and often larger in scale, and from the late 1960s he became more experimental in technique, combining sculpture and drawing in figures of wood, plaster, and paper. In the 1970s he returned to bronze and began to explore non-human subject-matter. He has also worked in fibreglass.

Armory Show. An exhibition (officially entitled the International Exhibition of Modern Art) held in New York, 17 February–15 March 1913, at the Armory of the National Guard's Sixty-Ninth Regiment, Lexington Avenue, Manhattan. It was a daring presentation of new and still controversial art on a mammoth scale (about 1,300 works by about 300 artists) and is regarded as the most important exhibition ever held in the country and one of the milestones in 20th-century American culture. The initiative for it came from a group of artists, several of them from the circle of Robert *Henri, who in 1911 formed an organization called the Association of American Painters and Sculptors to find exhibition space for young artists. The breadth of vision with which the show was conceived was primarily due to the Association's president, Arthur B. *Davies, whose enthusiasm for presenting a comprehensive picture of current European movements largely overshadowed the original idea of an exhibition of American art. Davies was influenced in this direction by the great international *Sonderbund exhibition in Cologne in 1912. Walt *Kuhn saw this exhibition and he was later joined in Europe by Davies; together they were mainly responsible for borrowing works from artists and dealers—'Davies quiet, reflective, decisive, and Kuhn enthusiastic, adventurous and eager' (Ian Dunlop, *The Shock of the New*, 1972). John *Quinn was their legal adviser.

The Armory Show was in effect two exhibitions in one. The American portion presented a cross-section of contemporary art from the USA, heavily weighted in favour of younger and more radical artists. The foreign section, which was the core of the exhibition and became the main centre of controversy, traced the evolution of modern art, showing work by Goya, Delacroix, Courbet, and the *Impressionists and *Post-Impressionists, as well as leading contemporary artists including *Kandinsky, *Matisse, and *Picasso.

French artists were best represented, and there was comparatively little German art. From New York a reduced version of the exhibition went to Chicago (Art Institute, 24 March–16 April) and Boston (Copley Hall, 28 April–19 May). More than a quarter of a million visitors paid to see it, and its impact was enormous on a public that generally knew little of Post-Impressionism, let alone *Fauvism, *Cubism, or abstract art (the Metropolitan Museum, New York, bought a *Cézanne at the Show and this was the first picture by the artist to enter an American public collection). Though there was a good deal of ridicule and indignation (directed particularly at Marcel *Duchamp's *Nude Descending a Staircase*), there were also many favourable reviews and the show stirred up public interest in art and created a climate more favourable to experimentation. It had a profound effect on many American artists, for example Stuart *Davis, who regarded it as the turning-point of his career. Several important patrons and collectors made their first tentative purchases of modern art at the show, notably Lillie P. *Bliss and Katherine *Dreier, and some artists could count the exhibition a notable financial success (Jacques *Villon, for example, sold all nine of his pictures that were included). It has therefore become commonplace to speak of the Armory Show as the real beginning of an interest in progressive art in the USA, and it is an indication of the significance attached to the event that the Royal Academy's major survey exhibition entitled 'American Art in the 20th Century' (1993) took 1913, rather than 1900, as its starting-point.

Armstrong, Elizabeth. See FORBES.

Armstrong, John. See UNIT ONE.

Armstrong-Jones, Antony (Lord Snowdon). See MESSEL.

Arnason, H. Harvard (1909–86). American art historian and administrator. He was born in Winnipeg, Canada, and studied there at the University of Manitoba, and subsequently at Northwestern and Princeton Universities. From 1936 to 1938 he taught at Northwestern University, and from 1938 to 1942 he was a lecturer at the Frick Collection, New York. During the Second World War he worked in Europe for the Office of War Information,

1942–5, and he subsequently served with other government bodies. From 1947 to 1960 he was professor of art history at the University of Minnesota, from 1951 concurrently holding the post of director of the Walker Art Centre, Minneapolis. He was vice-president, art administration, of the Solomon R. *Guggenheim Foundation, 1960–9, and was a member of various boards and committees in the art world. His major publication is *A History of Modern Art* (1969, 2nd edn., 1977, 3rd edn., revised by Daniel Wheeler, published posthumously in 1987). This deals with painting, sculpture, and architecture (the third edition also includes photography) from the mid-19th century to contemporary art, and it is the most comprehensive book of its type available in English, with well over a thousand illustrations. Arnason's other publications include monographs on *Calder (1966), *Lipchitz (1969), and *Motherwell (1976), and he collaborated on Lipchitz's autobiography, *My Life in Sculpture* (1972).

Arneson, Robert. See FUNK ART.

Arnold, Ann and **Graham**. See BROTHERHOOD OF RURALISTS.

Arosenius, Ivar (1878–1909). Swedish painter and draughtsman, born and mainly active in Gothenburg. He studied there and in Stockholm, and in 1904 and 1905 he visited Paris, where he was influenced by the bold colour of the *Fauves. Arosenius suffered from haemophilia—the cause of his early death—and the knowledge that his life could end suddenly at any time no doubt contributed to the sense of melancholy and wistful humour (as well as the sensuous appetite) that characterize his work. Generally he worked on a small scale (often in tempera), painting subjects such as medieval and oriental fantasies (in a *Symbolist vein), portraits (a memorable self-portrait watercolour of 1906 is in the Nationalmuseum, Stockholm), and scenes of family life (particularly after his marriage in 1906). Arosenius was also an outstanding book illustrator, notably of his own book *The Cat's Journey* (posthumously published in 1909), which is regarded as one of the classics of Swedish children's literature. He left incomplete one of his most ambitious paintings, *Noah's Ark* (Nationalmuseum, Stockholm)—'an expression of his hope that a divine miracle might occur to save him from

early death' (Neil Kent, *The Triumph of Light and Nature: Nordic Art 1740–1940*, 1987).

Arp, Jean (or **Hans**) (1886–1966). French sculptor, painter, and poet who was prominently involved with several major avant-garde groups and movements in the first half of the 20th century. He was born in Strasbourg, then under German rule, and he spoke French and German with equal fluency (he wrote poetry in both languages). His initial training was at the School of Arts and Crafts in Strasbourg, after which he studied at the Weimar Academy and briefly at the *Académie Julian in Paris (1908). He spent the next few years mainly in Switzerland, working in isolation, but in 1912 he met Robert and Sonia *Delaunay in Paris and *Kandinsky in Munich, where he participated in the second *Blaue Reiter exhibition. In 1915 he moved to Zurich, where he was one of the founders of the *Dada movement and met his future wife Sophie *Taeuber (they married in 1922), with whom he collaborated in experiments with cut-out paper compositions and *collages (see AUTOMATISM). During the war years in Zurich he also made his first abstract polychrome relief carvings in wood (*Dada Relief*, Kunsthaus, Basle, 1916). In 1919–20 he lived in Cologne, where he continued his Dada activities in collaboration with his friend Max *Ernst.

From 1920 Arp worked mainly in Paris and in 1928 he settled at nearby Meudon. From 1925 he participated in the *Surrealist movement, his work including experiments with chance arrangements. He joined *Cercle et Carré in 1930 and he was a founder member of *Abstraction-Création in 1931. Also in 1931 he took up sculpture in the round (previously he had made only reliefs) and began to produce what are now his most familiar and distinctive works—sensuous abstract pieces (usually in bronze or marble) that convey a suggestion of organic forms without reproducing actual plant or animal shapes (*Growth*, Guggenheim Museum, New York, 1938). 'I tried to make forms grow', he wrote, 'I put my trust in the example of seeds, stars, clouds, plants, animals, men, and finally in my innermost being.'

During the Second World War Arp fled to Grasse on the French Riviera, where he and his wife lived with Sonia Delaunay and Alberto *Magnelli, 1941–2: 'For two years we lived in that wonderful place . . . Despite the

horror of those years, I look back on this period of work with my friends as one of the finest experiences of my life. Never was there a trace of vanity, arrogance, rivalry.' By 1942, however, the south of France was becoming unsafe, so Arp fled to Switzerland, where his wife died in an accident in 1943. He returned to Meudon in 1946 and in 1959 bought a house near Locarno in Switzerland (coinciding with his happy second marriage to Marguerite Hagenbach, a Swiss collector of his work). In his post-war work he did not seriously add to his earlier achievements, but he won many honours and prestigious public commissions; in 1954, for example he was awarded the International Sculpture Prize at the Venice *Biennale, and in 1958 he made a relief for the Unesco building in Paris. Large retrospective exhibitions of his work were held at the Museum of Modern Art, New York, in 1958 and the Musée National d'Art Moderne, Paris, in 1962.

Herbert *Read writes of him: 'Arp was a man distinguished by simplicity, gentleness, integrity and wisdom. He found his own direction early in life; he chose a narrow path and never deviated from it; he remained completely uncorrupted by success and by the intrigues of the art-world. He had the qualities of one of those Japanese Zen artists . . . with the same love of nature and the same tolerance of human beings in all their variety. Humour was an essential part of his outlook on life, and his fantasy, even in his early Dada days, was never violent or deranged. His wisdom was instinctive . . . His work, both as a poet and a sculptor always faithfully reflects his personality' (*Arp*, 1968).

Arroyo, Eduardo (1937–). Spanish painter, sculptor, printmaker, stage designer, potter, and filmmaker, active mainly in France. He was born in Madrid and was mainly self-taught as an artist. In 1958 he left Spain to avoid military service, living in Paris until 1968, then spending four years in Milan before returning to Paris in 1973. He was among the artists who took a studio in La *Ruche after it reopened in 1978. Arroyo's work has been varied, but typically he uses imagery in a *Pop art vein to satirize targets in the world of art or politics or aspects of Spanish life. His attacks on his wide range of dislikes have made him a controversial figure.

Art abstrait. See JEUNE PEINTURE BELGE.

Art & Language. A loose organization of mainly British artists and art theorists operating since the late 1960s who have attempted to make a type of *Conceptual art out of discussion about art, primarily through their journal *Art-Language*, the first issue of which was published in Coventry in May 1969. The original members were Terry Atkinson (1939–), David Bainbridge (1941–), Michael Baldwin (1945–), and Harold Hurrell (1940–). Joseph *Kosuth soon joined as American editor of the journal, and in the early 1970s membership rose to about 30; it then fell rapidly, however, with only Baldwin remaining of the original members by 1977. Since then, the main figures involved, along with Baldwin, have been Mel Ramsden (1944–) and the art historian and critic Charles Harrison (1942–). Although some of the members have had strong Marxist convictions, they reject the idea that their work should make immediately accessible political statements—indeed their work is more or less impenetrable to outsiders. Since about 1979 members of Art & Language have produced paintings, but largely with ironic intent. An example is the triptych *Gustave Courbet's 'Burial at Ornans'; Expressing a Sensuous Affection . . . /Expressing a Vibrant Erotic Vision . . . /Expressing States of Mind that are Vivid and Compelling 1981* (Tate Gallery, London, 1981). In 1991 Harrison published *Essays on Art & Language*.

Art and Letters. See RUTTER.

Artaud, Antonin. See RÉVOLUTION SURRÉALISTE.

Art Autre. A term coined by the French critic Michel Tapié (1909–87) in his book *Un Art autre* (1952) to describe a type of art that he regarded as appropriate to the turbulent mood in France in the post-war period—an art than worked through 'paroxysm, magic, total ecstasy'. The term is a vague one and is sometimes used synonymously with *Art Informel (also coined by Tapié). However, Art Autre can be seen as a broader term, for it embraces figurative art (for example that of *Dubuffet) as well as abstract art. In using the phrase 'art autre' (other art) Tapié claimed that post-war art showed a complete break with the past. In addition to Dubuffet, Tapié

cited *Mathieu, *Matta, and *Wols as leading representatives of Art Autre.

Art Brut (French: 'Raw Art'). Term coined by Jean *Dubuffet for the art produced by people outside the established art world—people such as solitaries, the maladjusted, patients in psychiatric hospitals, prisoners, and fringe-dwellers of all kinds. In English the term 'Outsider art' (the title of a book by Roger Cardinal, 1972) is generally used to cover this type of work. Dubuffet claimed that such art—'springing from pure invention and in no way based, as cultural art constantly is, on chameleon- or parrot-like processes'—is evidence of a power of originality that all people possess but which in most has been stifled by educational training and social constraints. He may have become interested in the subject as early as 1923, but he did not begin collecting Art Brut until 1945, following a visit to Switzerland, where there were already collections of works by the mentally ill in psychiatric hospitals. Thereafter he devoted a good deal of his energies to promoting Art Brut, through writing, lecturing, and organizing exhibitions. From 1948 to 1951 he ran an association called the Compagnie de l'Art Brut, the aims of which he specified as 'To seek out the artistic productions of humble people that have a special quality of personal creation, spontaneity, and liberty with regard to convention and received ideas; to draw the public's attention towards this sort of work, to create a taste for it and encourage it to flourish'. The best-known of the exhibitions he organized was probably 'L'Art Brut Préféré aux Arts Culturels' at the Galerie René Drouin, Paris, in 1949; it featured more than 200 works by 63 artists.

In 1972 Dubuffet presented his own collection (by then numbering more than 5,000 items) to the city of Lausanne, where it was opened to the public at the Château de Beaulieu in 1976. Among the artists represented were the French painter, draughtsman, sculptor, and writer Gaston Chaissac (1904–64), who used rough and ready materials and was influenced by child art, Madge Gill (see AUTOMATISM), the Swiss draughtsman and painter Louis Soutter (1871–1942), who after contracting typhoid was plagued by years of ill health and eccentric behaviour, Scottie *Wilson, and the Swiss draughtsman, collage maker, writer, and musician Adolf Wölfli (1864–1930), who was institutional-

ized in 1895 after committing a series of sex offences. Nearly half the collection was produced by patients in psychiatric hospitals, usually schizophrenics, but Dubuffet repudiated the concept of psychiatric art, claiming that 'there is no art of the insane any more than there is an art of the dyspeptics or an art of people with knee complaints'. He also distinguished Art Brut from *naive art on the more dubious ground that naive painters remain within the cultural mainstream, hoping for public recognition, whereas Art Brut artists create their works for their own use as a kind of private theatre.

Art d'aujourd'hui. See BLOC.

Art Concret (Konkrete Kunst). See CONCRETE ART.

Art Contemporain, L' (Kunst van Heden). An association of Belgian artists founded in Antwerp in 1905 by the dealer François Franck (1872–1932) to promote interest in avant-garde work. It organized an exhibition almost every year until 1955. Among its members were van den *Berghe, *Brusselmans, *Ensor, *Permeke, de *Smet, *Spilliaert, *Tytgat, and *Wouters.

Art Deco. The most fashionable style of design and decoration in the 1920s and 1930s in Europe and the USA, characterized by sleek geometrical or stylized forms and bright, sometimes garish colours. The name comes from the 'Exposition Internationale des Arts Décoratifs et Industriels Modernes' held in Paris in 1925—the first major international exhibition of decorative art since the end of the First World War (it was originally planned for 1915). The emphasis of the exhibition was on individuality and fine craftsmanship (at the opposite extreme from the contemporary doctrines of the *Bauhaus), and Art Deco was originally a luxury style, with costly materials such as ivory, jade, and lacquer much in evidence. However, when the exhibition 'Machine Art'—another great showcase of the style—was held at the Museum of Modern Art, New York, in 1934, the emphasis was on the general style and impression of an interior rather than upon the individual craft object. Perhaps partly because of the effects of the Depression, materials that could be easily mass-produced—such as plastics—were adapted to the style.

Art Deco may have owed something to several of the major art movements of the early 20th century—the geometry of *Cubism (it has been described as 'Cubism tamed'), the bold colours of *Fauvism, and the machine forms of *Constructivism and *Futurism. Similarly, although the term is not often applied to painting or sculpture, the Art Deco style is clearly reflected in the streamlined forms of certain artists of the period, for example the painter Tamara de *Lempicka and the sculptor Paul *Manship. There was a revival of interest in Art Deco during the 1960s (it was then that the name was coined) and its bold, bright forms have a kinship with *Pop art.

Arte Povera (or **Art Povera**). Term (Italian for 'poor' or 'impoverished art') coined in 1967 by the Italian critic Germano *Celant to describe a type of work, related to *Conceptual and *Minimal art, in which the materials used—such as soil, twigs, and newspaper—are deliberately chosen for their 'worthlessness' as a reaction against the commercialization of the art world. Celant organized several exhibitions on the theme, and in 1969 edited a book entitled *Arte Povera* (it was translated into English the same year as *Art Povera: Conceptual, Actual or Impossible Art?*). In this volume he offered various alternative names for the trend or movement, including Actual Art, Impossible Art, Micro-emotive Art, Raw Materialist Art, and *Anti-Form. According to Celant, 'Arte Povera expresses an approach to art which is basically anti-commercial, precarious, banal and anti-formal, concerned primarily with the physical qualities of the medium and the mutability of the materials. Its importance lies in the artists' engagement with actual materials and with total reality and their attempt to interpret that reality in a way which, although hard to understand, is subtle, cerebral, elusive, private, intense.' Although this does not get one very far, it is lucid compared with most writing on Arte Povera, and the term has been used in a bewilderingly diffuse way. It has been applied to *Happenings, *installations, and *Land art, for example, and to the work of many non-Italian artists, including Carl *Andre, Joseph *Beuys, Walter *De Maria, Jan *Dibbets, Richard *Long, and Robert *Morris. Among the Italian (or Italian-based) artists who are regarded as leading figures in the movement are Jannis *Kounnelis and Mario Merz

(1925–). Merz's most characteristic works include 'igloos' constructed of metal armatures covered in nets, mud, twigs, and so on, often incorporating neon lighting and sometimes enclosed within an outer structure of metal and glass—a double igloo (*Double Igloo*, Staatsgalerie, Stuttgart, 1968–81). Far from the anti-commercial ethos envisaged by Celant, such works patently take a good deal of time, trouble, and money to produce, and dealers have shown that even much more casual examples of Arte Povera can be commercially exploited.

Edward *Lucie-Smith (*Art Today*, 1995) writes that 'The appearance of Arte Povera had a liberating effect on artists ... It made it clear that it was now possible to use any kind of material, in any way the artist liked, to create something which could be convincingly described as art.' Elsewhere Arte Povera has been described as 'poor art, of poor materials, in exultation of a poor life'.

Arte Programmata. Term (Italian for 'programmed art') originally used in Italy in the 1960s for *Kinetic art in which works are motor-driven in a set sequence of movements, although random elements may be built into the movement programme. From this fairly precise meaning, the term was later extended to cover other types of art involving real or apparent movent, including *environments (especially when they involved spectator participation) and *Op art. In 1963 an exhibition in Frankfurt called 'European Avant-Garde' was subtitled 'Arte Programmata, Neue Tendenzen, Anti-Peinture, Zero' (see NOUVELLE TENDANCE). In 1964 the Royal College of Art in London staged an 'Arte Programmata' exhibition that was later circulated in the USA by the Smithsonian Institution.

Art for the Masses (*Iskusstvo v massy*). See AKHRR.

Artforum. Periodical (ten issues a year) devoted to contemporary art, founded in San Francisco in 1962. The place of publication moved to Los Angeles in 1965 and to New York in 1967, and the title changed to *Artforum International* in 1982. It is the leading American journal in its field, well produced and illustrated, attracting contributions from many well-known avant-garde artists, and often serving as an arena for controversy. The

critics particularly associated with *Artforum* include Michael Fried (1939–), who is regarded as one of the main disciples of Clement *Greenberg. Fried's essay 'Art and Objecthood', originally published in its pages in 1967, is one of the most frequently reprinted theoretical texts of its time. It was a riposte to the *Minimal artists Donald *Judd and Robert *Morris, whom Fried designated 'literalists'. They had questioned the continued viability of painting, believing that 'the tendency of modern art was progressively to expunge relational composition in the quest for a more unitary, less illusionistic form of work' and proposing instead 'the substitution of "real" relations in "real" space for the illusionism in which painting, by its very nature, was forced to trade' (Charles Harrison and Paul Wood, *Art in Theory 1900–1990*, 1992). Fried, on the other hand, believed that 'there is a conflict between our readings of physical works of art as art, and as objects; he claims that when we view a painting as an object we are regarding it as a non-art entity. He believes that *Modernist Painting, to be valid, must find a way to defeat or suspend its own objecthood but without resorting to illusionistic pictorial devices of the past' (John A. Walker, *Glossary of Art, Architecture and Design Since 1945*, 1973, 3rd edn. 1992). A collection of pieces from the journal was published as *Artforum Anthology* in 1984.

Art Front. See DAVIS, STUART.

Artigas, Josep Llorens. See MIRÓ.

Art Informel. Term coined by the French critic Michel Tapié to describe a type of spontaneous abstract painting popular among European artists in the 1940s and 1950s, roughly equivalent to *Abstract Expressionism in the USA. Tapié popularized the term in his book *Un Art autre* (1952), and these two terms—*Art Autre and Art Informel—are sometimes used more or less synonymously. They are rarely used with any precision, but some critics regard Art Informel as a narrower term, representing only one aspect of the broader trend of Art Autre (which includes figurative as well as abstract work). In English the term 'Informalism' is sometimes used as an equivalent to Art Informel, but the word 'informel' (which Tapié himself devised) might be translated as 'without form' rather than 'informal'. Following sug-

gestions made by *Kandinsky, Tapié argued that expressive, non-geometrical abstract art is a method of discovery and of communicating intuitive awareness of the fundamental nature of reality. See also TACHISME.

'Art is Life'. See MAKOVETS.

Artists' Congress. See AMERICAN ARTISTS' CONGRESS.

Artists International Association (AIA). An association of left-wing British artists founded in London in 1932 with the aim of achieving 'the unity of artists against Fascism and war and the suppression of culture'. Originally it was called Artists International, but it added the word 'Association' to its name when it was reconstituted in 1935. It continued until 1971, but abandoned its political objectives in 1953, thereafter existing as an exhibiting society. Initially there were 32 members, mainly commercial artists and designers, although they also included the German-born Marxist art historian Francis Klingender (1907–55), who described his work as 'theoretical and historical studies designed to elucidate the role of art as one of the great value-forming agencies in the social structure and social change'. The first chairman was the industrial designer Misha Black (1910–77), who later played an important role in the *Festival of Britain. At the outset the position of the group was avowedly Marxist and its activities included producing pamphlets, posters, and other propaganda material (making use of facilities at the Central School of Art, where one of the founder members, James Fitton (1899–1982), taught lithography). Modern art, with its 'negation of content', was viewed with some suspicion as a sign of bourgeois decadence, but after the Association was reconstituted in 1935 it became much less doctrinaire and attracted support from artists working in a wide range of styles. Its exhibition, 'Artists against Fascism and War' (1935), for example, included work by Robert *Medley, Henry *Moore, and Paul *Nash, and by the end of the Second World War the Association had more than a thousand members. In addition to holding exhibitions, the AIA published a journal (sporadically and under different titles and formats, beginning as *Artists International Bulletin*, 1934–5) and also a book of essays entitled *5 on Revolutionary Art* (1935). This was

edited by the sculptor Betty Rea (1904–64) and the five contributors were Eric *Gill, the ethnomusicologist A. L. Lloyd, Klingender, Herbert *Read, and the writer Alick West.

Most of the Association's early exhibitions were held in its premises in Charlotte Street, although numerous other venues were used, including the basement canteen of the John Lewis department store for the 1943 show 'For Liberty'. Among its other exhibitions was 'The Engineer in British Life', arranged for the Amalgamated Engineering Union to celebrate its Silver Jubilee in 1945. Klingender wrote that this was 'the first art exhibition sponsored by a British trade union' and that it gave him the idea for his most famous book, *Art and the Industrial Revolution* (1947); his other books included *Marxism and Modern Art* (1942). In 1947 Claude *Rogers found new premises in Lisle Street and the AIA Gallery was opened there that year; the Association dissolved when the lease expired in 1971. Distinguished foreign artists sometimes showed work at the later exhibitions, notably *Léger and *Picasso.

The Artists International Association is not to be confused with the International Artists' Association (founded 1952), an affiliated organization of Unesco; Richard *Carline was chairman of both associations.

Art-Language. See ART & LANGUAGE.

Art moderne. See LIBRE ESTHÉTIQUE.

Art News *(ARTnews)*. American journal, first published in 1902 as *Hyde's Weekly Art News*. In 1904 the title changed to *American Art News*, in 1923 to *The Art News*, in 1941 to *ART News*, and in 1969 to *ARTnews*. On the way the journal changed from a newspaper to a magazine and from a weekly to a monthly (there are now ten issues a year). It has by no means been devoted entirely to modern art, but as the oldest and most widely read art magazine in the USA it has played an important role in recording and sometimes shaping events; from the first it campaigned for the recognition and popularization of American art. The contributors have included a large number of distinguished artists and critics, among them Alfred H. *Barr, Kenneth *Clark, Clement *Greenberg, Henry *Moore, Louise *Nevelson, Barnett *Newman, and Jean-Paul *Sartre. It was in the magazine's pages that Harold *Rosenberg first used the term *Action

Painting in print (December 1952), and it was prominent in promoting the work of the *Abstract Expressionists. Particularly noteworthy in this respect is the article 'Pollock Paints a Picture' (May 1951), accompanied by some now celebrated photographs by Hans Namuth that helped to define Jackson *Pollock's public image (similar articles on other artists in the movement followed). It was not only in the USA that the magazine was influential; in *The Art of Australia* (1970), commenting on the situation that most abstract painting in that country was 'only a remote gloss on what had been painted before in Europe or America', Robert *Hughes writes that 'One detail of a *de Kooning, seen in black and white in *Art News*, could (and did) supply enough forms for three exhibitions in Sydney.' An anthology of pieces from the magazine, including many of the most famous articles, was published in 1977 to mark its 75th anniversary; it is entitled *The Art World* and is edited by Barbaralee Diamonstein.

Art News was also the title of a British periodical, the journal of the *Allied Artists' Association, edited by Frank *Rutter and launched in 1909. It soon merged with *Art Chronicle*.

Art Nouveau. Decorative style flourishing in most of Western Europe and in the USA from about 1890 to the First World War. As the name suggests, it was a deliberate attempt to create a new style in reaction against the imitation of historical forms that had been such a prominent feature of 19th-century architecture and design. Its most characteristic theme was the use of sinuous asymmetrical lines based on plant forms; flower, leaf, and tendril motifs are common features, as are female figures with abundant flowing hair. At their most typical these motifs are found in the decorative and applied arts, such as interior design, metalwork, glassware, and jewellery, but Art Nouveau also had a major vogue in illustration and poster design and its influence can be seen to varying degrees in much of the painting and sculpture of the period—in a fairly pure form in the work of Alfred *Gilbert and Jan *Toorop, for example, and in certain aspects of such diverse artists as *Munch (his penchant for undulating lines) and *Matisse (the flat arabesque forms of the trees in some of the landscapes of his *Fauve period).

The style takes its name from a shop called La Maison de l'Art Nouveau opened in Paris in 1895 by the German-born art dealer Siegfried Bing (1838–1905), a leading propagandist for modern design. Paris was one of its most important centres, but its origins were diverse (Celtic and Japanese art have been cited as influences) and its roots were less on the Continent than in England, where the Arts and Crafts movement had established a tradition of vitality in the applied arts. In France, indeed, Art Nouveau is sometimes known by the name 'Modern Style', reflecting these English origins. In Germany the style was called Jugendstil (from the Munich journal *Die Jugend*, founded in 1896); in Austria, Sezessionstil (after the Vienna *Sezession); in Spain, Modernista; and in Italy, Stile Liberty (after the Regent Street store that played so large a part in disseminating its designs). The style was truly international, its archetypal exponents ranging from *Mucha, a Czech whose most characteristic work was done in Paris, to *Tiffany in New York, and to the Spanish architect Antoni Gaudí (1852–1926) in Barcelona, the centre of a distinctive regional version of the style charcterized by exaggerated bulbous forms. This cosmopolitanism was encouraged by the great international exhibitions that flourished during this period, and the style perhaps reached its apogee at the Paris 'Exposition Universelle' of 1900. It nowhere survived the outbreak of the First World War to any extent, but it played a significant part in shaping modern aesthetic attitudes: George Heard *Hamilton writes that 'its fundamental concept of the expressive properties of form, line, and colour was an important contribution to the discovery and formulation of abstract and non-objective art.'

Art of the Real. A term applied to a broad trend in American art in the 1950s and 1960s in which works of art were presented as irrefutable physical objects making no attempt at representation and no allusion to the perceived world by symbol, metaphor, or suggestion. The trend represents a reaction against the subjectivity of *Abstract Expressionism and embraces several more precisely defined styles or movements such as *Hard-Edge Painting, *Minimal art, and *Op art. The term was given wide currency by an exhibition at the Tate Gallery, London, in 1969: 'The Art of the Real: An Aspect of American Painting and Sculpture 1948–1968.' Among the artists represented in the exhibition were Donald *Judd, Ellsworth *Kelly, Sol *LeWitt, Robert *Morris, Kenneth *Noland, Larry *Poons, and Frank *Stella.

Art of This Century gallery. See GUGGEN-HEIM, PEGGY.

Arts and Crafts movement. See CRANE.

Artschwager, Richard (1923–). American sculptor and painter, born in Washington, DC, the son of a German immigrant botanist. After taking a degree in chemistry and mathematics at Cornell University, he moved to New York in 1949 and studied for a year under *Ozenfant, whose preference for stark, geometrical forms greatly influenced Artschwager. In the 1950s he took various jobs to support himself and in 1953 he began designing and manufacturing furniture, but he returned to painting after a fire destroyed his workshop in 1958. However, he continued to make furniture, and a commission from the Catholic Church in 1960 to produce altars for ships led him to the kind of work for which he is best known—sculptures that mimic the appearance of mundane objects such as tables in a simplified, almost comic-book manner. Typically they are block-like in form but bright in colour, combining elements of *Minimal art and *Pop art (*Table and Chair*, Tate Gallery, London, 1963–4). Artschwager says of such works: 'I'm making objects for non-use ... By killing off the use part, non-use aspects are allowed living space, breathing space.' Examples were shown in his first one-man exhibition, at Leo *Castelli's gallery, New York, in 1964. Artschwager has also continued to produce paintings, typically monochromatic depictions of buildings.

Arts Council. An organization established in 1945 and incorporated by Royal Charter in 1946 'to preserve and improve standards of performance in the various arts'. It was a successor to the Council for the Encouragement of Music and the Arts (CEMA), a wartime organization that had operated from 1940 to 1945. Originally it was called the Arts Council of Great Britain, with separate committees for Scotland and Wales, but in 1994 the Scottish and Welsh Arts Councils became autonomous bodies, and the main organization was renamed the Arts Council of England.

There is also an Arts Council of Northern Ireland (likewise a successor to CEMA), and the Republic of Ireland has an Arts Council, founded in 1951. Funding for the Arts Council of England comes from the Department of National Heritage, but it operates independently of the government, and the other Arts Councils function in similar ways. Their main activities in connection with the visual arts consist of the organization of exhibitions, many of which are accompanied by scholarly catalogues. The Arts Council of England has two galleries in London for such exhibitions: the Hayward Gallery—a large, rather grim concrete building opened in 1968 as part of the South Bank arts complex alongside the Thames; and the much smaller and prettier Serpentine Gallery in Kensington Gardens, which was originally an Edwardian tea-house and was opened as a gallery in 1970. Before this the major Arts Council exhibitions were usually held at the Tate Gallery. Many exhibitions travel to other venues in Britain. The Arts Council inherited from CEMA the policy of purchasing works by living artists and it has built up a large collection of 20th-century British art; this, however, does not have a permanent home. It also makes grants directly to artists and galleries. It is the most important source of art patronage in Britain, but it is frequently attacked for alleged shortcomings, including too much bureaucracy and too little vision.

Artscribe. Bi-monthly magazine of contemporary art, founded in London in 1977. Originally it was very basic (sometimes erratic) in production and had a reputation for being more radical than the established art glossies, but it became much more polished in presentation. In 1986 the title changed to *Artscribe International*. It ceased publication in 1991.

Arts Monthly. See GROUP OF PLASTIC ARTISTS.

Art Students League of New York. An art school established in 1875 when that of the National Academy of Design temporarily closed. Unlike the Academy School (which reopened in 1877), the Art Students League had no entrance requirements and no set course. Its more progressive teaching methods soon attracted many students—at the turn of the century the enrolment stood at nearly a thousand. By this time it was the most important

art school in the country, and its teachers and students have included some of the most illustrious names in 20th-century American art. The first two important teachers were Walter Shirlaw (1838–1919), who was there from the beginning, and William Merritt *Chase, who arrived in 1878. Those who followed included Thomas *Eakins, Robert *Henri, Augustus *Saint-Gaudens, and John *Sloan.

Art Workers' Coalition (AWC). A short-lived association of art-activists founded in New York in 1969 to demand artists' rights and museum reform. One of the founders, Carl *Andre, explained that the term 'art worker' was chosen in preference to 'artist' because it included all those who made 'a productive contribution to art'; other leading figures of the association included Lucy *Lippard, Robert *Morris, and Robert *Smithson. In February 1969 the AWC presented a list of '13 Demands' to the *Museum of Modern Art, New York, one of which (in revised form) read 'Museum staffs should take positions publicly and use their political influence in matters concerning the welfare of artists, such as rent control for artists' housing, legislation for artists' rights and whatever else may apply specifically to artists in their area. In particular, museums, as central institutions, should be aroused by the crisis threatening man's survival and should make their own demands to the government that ecological problems be put on a par with war and space efforts.' The AWC also demanded that museums should show 'the accomplishments of Black and Puerto Rican artists' and 'encourage female artists to overcome centuries of of damage done to the image of the female as an artist by establishing equal representation of the sexes in exhibitions, museum purchases and on selection committees'. The association soon broadened its scope to include protests against the Vietnam War. It organized demonstrations and picketings of various kinds, including the New York Art Strike Against War, Rascism, Fascism, Sexism and Repression, which closed the city's museums for a day in May 1970. Such activities encouraged two smaller but more militant American groups, Art Workers United and Guerrilla Art Action, as well as a related group in Britain, the International Coalition for the Abolition of Art, which disrupted the opening of the *Young Contemporaries exhibition

in 1970. Opponents of the AWC included Donald *Judd, who thought that 'citizens are equal', but not artists. Several of the association's members became disenchanted with its militancy and it broke up in the early 1970s.

Art Workers' Guild. See ROYAL COLLEGE OF ART.

Art Workers United. See ART WORKERS' COALITION.

Ashcan School. A term retrospectively applied to a number of American painters (not a formal group) active in New York in the decade before the First World War in reference to their shared interest in subject-matter from everyday urban life; the term was first used in print in 1934 in a book entitled *Art in America in Modern Times*, edited by Holger Cahill and Alfred H. *Barr. The painters embraced by the term were inspired largely by Robert *Henri (one of whose dictums was that 'Art cannot be separated from life') and the four central figures—*Glackens, *Luks, *Shinn, and *Sloan—were all members of The *Eight, a short-lived group founded by Henri in 1908. (The two terms are often confused, but 'The Eight' has a precise meaning, whereas 'Ashcan School' is a broader and vaguer notion; there is overlap between them, but some of the members of The Eight did not paint Ashcan-type subjects.) Before settling in New York (between 1896 and 1904) the four central Ashcan artists had all been artist-reporters on the *Philadelphia Press*. At a time when the camera was little used in newspaper work, the job of making rapid sketches on the spot for subsequent publication demanded a quick eye and and a rapid hand, and encouraged an interest in scenes of everyday life. However, in style and technique the artists of the Ashcan School are now seen to have differed less from contemporary academic painting than they themselves believed. Although they often painted slum life and outcasts and were referred to as the 'revolutionary black gang', they were interested more in the picturesque aspects of their subjects than in the social issues they raised; it was not until the 1930s that *Social Realism became a major force in American art. Among the other painters who have been described as members of the Ashcan School are George *Bellows, Glenn Coleman (1887–1932), Eugene Higgins (1874–1958), Edward *Hopper, and Jerome *Myers

Ashington Group. A group of British amateur painters, active in Ashington, Northumberland, from 1934 to 1984. The group originated when Robert Lyon (1894–1978), master of painting at King's College, Newcastle upon Tyne (then part of Durham University), was asked to run an extra-mural class in the nearby mining town of Ashington under the auspices of the Workers' Educational Association (founded 1903): 'I was invited to join in with a number of men in Ashington who had met to discuss the possibility of forming an art appreciation group . . . they were all associated with the pits [although not all miners] and had direct connection with the life of Ashington.' About 20 people generally attended the classes, which were held in a YMCA hut. The art appreciation lessons were quickly dropped in favour of practical instruction, and the group held its first exhibition at the Hatton Gallery, Newcastle, in 1936. Lyon, who was regarded as an inspiring teacher, encouraged the members of the Ashington Group to 'paint what you know', and their pictures mainly featured scenes of their working, domestic, and social lives. Their work soon became known outside their immediate locality, partly because it attracted the attention of 'Mass Observation' (founded 1937), 'an early endeavour to apply a form of casual social anthropology to the contemporary culture of Britain' (Charles Harrison, *English Art and Modernism*, 1981). In 1938 the Ashington painters featured prominently in the 'Unprofessional Painting' exhibition organized by Mass Observation in Gateshead (Alfred *Wallis was among the other artists shown), and in the same year an article on them by Lyon appeared in the Penguin book *Art in England*, edited by R. S. Lambert (the article had previously been published in *The Listener*).

Lyon left Newcastle in 1942 to become principal of Edinburgh College of Art (a post he held until he retired in 1960), but the Ashington Group continued to flourish through changing times and fluctuating membership, holding several substantial exhibitions outside the region, including one at the Whitechapel Art Gallery, London, in 1973. Reviewing this in the *Guardian*, Caroline Tisdall wrote that 'One of the most exciting achievements to emerge from the plethora of

workers' education projects in the depressed thirties was the intense activity of the Ashington Group'. There were even exhibitions of the Group's work outside Britain, including one in Peking in 1980, but by this time it was known for its past achievements rather than for its current production. It disbanded in 1984, but in 1991 a permanent collection of its work was established at the Woodhorn Colliery Museum, Ashington.

Ashton, Julian. See LAMBERT, GEORGE WASHINGTON.

Asmus, Dieter. See ZEBRA.

assemblage. Term describing works of art made from fragments of natural or preformed materials, such as household debris. It was coined in 1953 by Jean *Dubuffet, who originally applied it to some of his own two-dimensional works ('assemblages d'empreintes') made by cutting and pasting together sheets of paper; these have been seen as extensions of the *Cubist *collage. However, Dubuffet soon extended the meaning of the word 'assemblage' to cover small sculptures he made from such materials as sponge and scraps of wood. Subsequently some critics have maintained that the term should apply only to three-dimensional found material and not to collage, but it is not usually employed with any precision and has been used to embrace *photomontage at one extreme and room *environments at the other. Allan *Kaprow's book *Assemblage, Environments & Happenings* (1966) attempted to clarify the terminology, but the vague usage continues.

In its broadest sense, assemblage has its roots in the sculptural experiments of *Picasso, in *Dada (particularly the work of *Schwitters), and in *Surrealism (many of whose exponents made *objects from diverse materials), but it was not until the 1950s that a vogue for this kind of work began. The term itself gained wide currency with an exhibition called 'The Art of Assemblage' at the Museum of Modern Art, New York, in 1961. The exhibits included *ready-mades by Marcel *Duchamp, boxed constructions by Joseph *Cornell, 'sacking' pictures by *Burri, compressed automobile bodies by *César, tableaux by *Kienholz, collages by a wide range of artists, sculptures by *Nevelson and *Tinguely, and much else besides. In the

introduction to the catalogue, the exhibition organizer, William C. Seitz, said that 'The current wave of assemblage . . . marks a change from a subjective, fluidly abstract art towards a revised association with the environment. The method of juxtaposition is an appropriate vehicle for feelings of disenchantment with the slick international idiom that loosely articulated abstraction has tended to become, and the social values that this situation reflects.' During the 1960s assemblage was much used by *Pop artists and it has continued to be a favoured technique with many sculptors.

Association of American Painters and Sculptors. See ARMORY SHOW.

Association of Artists of Revolutionary Russia. See AKHRR.

Atelier. See STUDIO.

Atelier 17. See HAYTER.

Atkinson, Terry. See ART & LANGUAGE.

Atl, Dr (Gerardo Murillo) (1875–1946). Mexican painter and art administrator. He was an ardent nationalist and a pioneer of the 20th-century renaissance of his county's art—chapter 1 of MacKinley Helm's book *Modern Mexican Painters* (1941) is entitled 'Dr Atl, the Saint John Baptist of Mexican Art'. He travelled and studied in Europe, 1897–1903, obtained a doctoral degree in philosophy and law at Rome in 1898, and adopted the name Atl—an Aztec word for 'water'—in 1902. After his return to Mexico he became a teacher at the Academy of San Carlos in Mexico City, where his pupils included *Orozco, *Rivera, and *Siqueiros. In 1910 he organized an exhibition of Mexican art as a counterblast to the European art promoted by the country's president, Porfirio Díaz. After the outbreak of revolution, Atl went to Europe in 1911, but he returned to Mexico in 1913 and rallied artists to the cause of Venustiano Carranza, who became president in 1917. In 1920 Carranza was murdered and was succeeded by Alvaro Obregón, under whose relatively peaceful and liberal regime there was a cultural efflorescence; in the government post of director of the department of fine arts, Atl promoted the mural decoration of public buildings that was Mexico's greatest contribution to 20th-

century art. He painted murals himself, but his talent in this field was modest, and as an artist he is better known for his landscapes, particularly those featuring volcanoes, a subject in which he was passionately interested. He often worked in 'Atl-colour' (a kind of wax crayon). Late in life—already a semi-legendary figure—he became a recluse. Adolfo López Mateos, president of Mexico 1958–64, declared Atl 'the nation's beloved son'.

Atlan, Jean-Michel (1913–60). French painter, lithographer, and poet, born in Algeria of Jewish-Berber stock and active mainly in Paris, where he settled in 1930. Atlan took a degree in philosophy at the Sorbonne and was self-taught as an artist. He began painting in 1941 but was arrested by the German occupying forces in 1942 because of his activities in the Resistance; he saved his life by feigning madness and was confined to an asylum (where he was allowed to paint) until the Liberation of Paris in 1944. In that year he had his first one-man exhibition at the Galerie de l'Arc-en-Ciel. His early work was violently expressionistic and semi-figurative, but after the war he developed an abstract style featuring rhythmical forms in deep, rich colours, often enhanced by thick black outlines. Initially he was successful with this work, but from 1948 he went through a period of neglect and poverty. His fortunes were reestablished with a one-man show at the Galerie Bing, Paris, in 1956, and thereafter his work was widely exhibited in France and elsewhere.

Attwell, Mabel Lucie (1879–1964). British illustrator, born in the East End of London, the daughter of a butcher. She studied briefly at the Regent Street Art School and Heatherley's Art School, leaving each in turn because she disliked the dry, formal methods of teaching. Initially she made her living with magazine work, but she soon found a niche in illustrating children's books, working mainly in pen-and-ink and watercolour. In 1908 she married another illustrator, Harold Earnshaw (d. 1937), who was badly wounded during the First World War, losing his right arm. Although he taught himself to draw with his left hand, Lucie was now the main breadwinner for them and their three children: 'It was a responsibility which accorded well with her temperament, for this handsome woman was strong-willed and dedicated to her work . . .

she remained active as an artist to the end of her life' (*DNB*). From the 1920s she became a household name for her depictions of cute, chubby infants, who appeared not only in books, but also on greetings cards, calendars, and all sorts of nursery and household equipment (including plaques with such mottoes as 'Please remember, don't forget, never leave the bathroom wet'). Overproduction affected the quality of her work, and she 'became synonymous in Britain with the sentimentalization of childhood' (*Oxford Companion to Children's Literature*, 1984), but the *Lucie Attwell Annual* (1922–74) continued to be published for a decade after her death, and she still has many admirers. Her children have a cheeky innocence, but the situations in which they are placed sometimes have adult overtones, with suggestions of *doubles entendres*, a factor that may appeal to some of the present-day collectors of her work. This sexual element is usually considered unconscious, but Attwell herself said near the end of her life: 'The message is between adults—me and any other. Children would not understand it.'

Atwood, Clare. See CAMDEN TOWN GROUP.

Auberjonois, René (1872–1957). Swiss painter and graphic artist, born at Lausanne. He studied briefly in Dresden, Vienna, and the Kensington School of Art, London, before spending three years (1897–1900) in Paris, at the École des *Beaux-Arts and in *Whistler's studio. After visiting Florence in 1900 he returned to Paris in 1901 and lived there until 1914. He spent the rest of his life living in seclusion at Lausanne, ignoring contemporary developments and evolving a distinctive figurative style from the influences he had absorbed during his years in Paris. His paintings are characterized by warm colours and a poetic mood (sometimes with a feeling of melancholy akin to that of *Modigliani). After about 1940 he produced a good deal of graphic work.

Auerbach, Frank (1931–). German-born painter and printmaker who was sent to England by his Jewish parents as a refugee in 1939 (he never saw them again) and became a British citizen in 1947. He studied in London at *St Martin's School of Art, 1948–52, the *Royal College of Art, 1952–5, and at evening classes under David *Bomberg, whom he found an inspiring teacher. Auerbach's paint-

ings are in the *Expressionist vein of Bomberg's late work and they are notable for their use of extremely heavy impasto, so that the paint at times seems modelled rather than brushed. His favourite subjects include portraits (particularly of people he knows well), nudes, townscapes, and the building site. The poet Stephen Spender has characterized the figures in his paintings as 'people who seem burdened with perhaps terrible experience . . . like refugees conscious of concentration camps' and he has suggested that Auerbach's fascination with building sites reflects the destruction he saw around him in his childhood. From the mid-1950s Auerbach has also made prints (drypoints, etchings, and screenprints), his subjects including nudes and portraits. There was a major *Arts Council exhibition of Auerbach's work in 1978, and in 1986 he represented Britain at the Venice *Biennale—indications of the high reputation he enjoys. As early in his career as 1961, David *Sylvester wrote of him: 'It is because of the subtle and profound way in which Auerbach's work gives expression and coherence to the complexity of our perceptions of simple things that he is for me the most interesting painter in this country.' Some critics, however, find his paintings muddy and overworked.

Aujame, Jean. See NÉO-RÉALISME.

Ault, George (1891–1948). American painter, born in Cleveland, Ohio. His family moved to England in 1899 and he lived there until 1911. He studied in London at the *Slade School and St John's Wood School of Art and made several trips to Paris. In 1911 he settled in New York. Ault is something of a shadowy figure, who appropriately specialized in nocturnal scenes. Initially these were influenced by *Ryder and *Whistler, but in 1920 he began painting in a *Precisionist style; his views of New York at night evoke a sense of bleak melancholy, and he is regarded as one of the most poetic American painters of his time. He suffered ill health for much of his life and in 1937 moved to Woodstock, New York State, because of the more wholesome climate. In his final years his work included moonlit desert landscapes that have a suggestion of *Surrealist mystery. He committed suicide.

Auto-destructive art. A term applied to works deliberately intended to self-destruct.

Works of art that are inherently short-lived are not unique to the 20th century—witness the butter sculptures of Tibet, the sand paintings of some North American Indian tribes (see ACTION PAINTING), and the snowman made by the young Michelangelo for Piero de' Medici. However, the idea of using self-destruction as the point of a work did not emerge until the late 1950s. The most committed exponent of the genre has been Gustav *Metzger, who originated the term and wrote several manifestos on the subject, the first in 1959. From 1960 he gave public demonstrations in which he 'painted' with acid, spraying it on nylon cloth, creating rapidly changing patterns until the nylon was destroyed (one such demonstration was on London's South Bank on 3 July 1961). Such displays have been interpreted as expressions of fatalism at the impermanence of all things and as protests against consumerism. Metzger himself maintained that he was protesting against arms expenditure. He also believed that Auto-destructive art could provide an acceptable channel for human aggression. Among those said to have been influenced by his ideas is the rock musician Pete Townshend, whose stage act with his group The Who used to include smashing guitars.

Apart from Metzger, the artist most associated with Auto-destructive art is Jean *Tinguely, whose approach was very different, stressing fancifulness and humour. He created the most famous of all auto-destructive works—*Homage to New York*, a giant motorized junk assemblage that had its moment of glory in the sculpture garden of the Museum of Modern Art, New York, on 17 March 1960. The contraption, which included a piano, bicycle wheels, a klaxon horn, numerous motors, and smoke-emitting chemicals, failed to perform as programmed and instead took on a life (or death) of its own. Calvin *Tomkins, one of the members of the distinguished audience, wrote that a 'small carriage suddenly shot out from under the piano, its klaxon shrieking, and smoke and flames pouring from its rear end. It headed straight for the audience, caromed off a photographer's bag, and rammed into a ladder on which a correspondent for *Paris-Match* was standing; he courageously descended, turned it around, and sent it scuttling into the NBC sound equipment.' Worried museum officials called in firemen, at whose

hands the contraption perished. Tinguely was delighted at the outcome, believing that the unplanned performance was far more entertaining than anything he had foreseen. Tomkins wrote that to Tinguely 'the machine was anything that anyone said it was—social protest, joke, abomination, satire—but, in addition, it was a machine that had rejected itself in order to become humor and poetry'.

automatism. Method of producing paintings or drawings (or writing or other work) in which the artist suppresses conscious control over the movements of the hand, allowing the unconscious mind to take over. There are various precedents for this kind of work, most notably the 'blot drawings' of the 18th-century English watercolourist Alexander Cozens, who stimulated his imagination by using accidental blots on the paper to suggest landscape forms. Cozens himself remarked that 'something of the same kind had been mentioned by Leonardo da Vinci', and slightly before Leonardo, Leon Battista Alberti (in his treatise *De Statua, c.* 1460) gives an imaginative account of the origins of sculpture, describing ancient peoples observing 'in tree trunks, clumps of earth, or other objects of this sort, certain outlines which through some slight changes could be made to resemble a natural shape'. Alberti's version of events may be not far from the truth, for scholars of prehistoric art have found examples of such spontaneous discovery of representational images in chance natural formations of cave walls. However, automatism in its fully developed form is a 20th-century phenomenon. The *Dadaists made some use of the idea, although they were more interested in chance effects than in automatism as such. In 1916–17, for example, *Arp made a series of *Collages with Squares Arranged According to the Laws of Chance*, in which he said he arranged the pieces of paper 'automatically, without will', and in 1920 *Picabia published an ink blot labelled 'La Sainte Vierge' in his magazine *391*. However, it was the *Surrealists who first made automatism an important part of their creative outlook; whereas the Dadaists used the idea dispassionately, to the Surrealists exploration of the unconscious through such methods was deeply personal.

In the first Surrealist manifesto (1924) André *Breton discussed automatism in a passage that refers to literary composition but could equally well apply to drawing or painting: 'Secrets of Surrealist magical art . . . have someone bring you writing materials, once you have got into a position as favourable as possible to your mind's concentration on itself. Put yourself in the most passive, or receptive, state you can. Detach yourself from your genius, your talent, and everyone else's talent and genius.' Later, in *Le Surréalisme et la peinture* (1928), he wrote: 'The fundamental discovery of Surrealism' is that 'without any preconceived intention, the pen which hastens to write, or the pencil which hastens to draw, produces an infinitely precious substance all of which is not perhaps immediate currency but which at least seems to bear with it everything emotional that the poet harbours within him.' According to René Passeron (*Concise Encyclopedia of Surrealism*, 1984), 'the true inventor of "automatic" Surrealist drawing' was André *Masson: 'in about 1923 or 1924 his drawings developed into "wandering lines" which here and there suggested perhaps the outlines of a beast or a bird.' Masson soon developed a more elaborate automatic technique in which he drew on the canvas with an adhesive substance, then added colour by sprinkling coloured sands.

Other Surrealists devised different methods, and some of them regarded the use of dream imagery (as in the work of *Dalí) as a kind of psychological—as opposed to mechanical—automatism. Sometimes they used chance—rather than strictly automatic—methods to provide the initial image (see DECALCOMANIA, FROTTAGE, and FUMAGE). The Surrealist interest in automatism had a strong influence on the *Abstract Expressionists, some of whom took their ideas further. With Surrealists, once an image had been formed by automatic or chance means, it was often exploited deliberately with fully conscious purpose, but with *Action Painters such as Jackson *Pollock, automatism in principle permeated the whole creative process.

Other types of automatism are those in which the artist works under the influence of drugs (see MICHAUX, for example) or by alleged occult means. Austin *Spare claimed to be able to conjure up horrific survivals of man's pre-human ancestry from deep within his mind, but more usually the artist claims to work under the inspiration of a beneficent spirit guide (a notion not necessarily to be taken lightly, as no less an artist than William

Blake claimed to have direct inspiration from his dead brother). The British painter Georgiana Houghton (1814–84) gave up conventional art because of grief at the death of her sister in 1851, but in 1861 she began to produce 'spirit drawings', using coloured pencils and later watercolour and ink. She held an exhibition of them at the New British Gallery, London, in 1871, and examples are preserved in the Victorian Spiritualists' Union, Melbourne. They feature 'all-over dynamic linear meshes of coloured spirals, vortices, and arabesques in which figure and ground are indistinguishable' and have been claimed as the earliest abstract pictures (see Tom Gibbons, 'British Abstract Painting of the 1860s: The Spirit Drawings of Georgiana Houghton', *Modern Painters*, Summer 1988).

Unlike Blake and Houghton, most psychic artists of this kind have no particular artistic gifts or inclinations in their 'normal' life. An example is Madge Gill (1882–1961), an uneducated British housewife who became interested in spiritualism after a series of traumatic events (two of her children died tragically and she lost an eye through illness). From 1919 she produced hundreds of ink drawings whilst in a trance-like state, allegedly directed by her spirit guide 'Myrninerest' (one acquaintance said unkindly that the spirit which really guided her was gin). From 1932 she exhibited regularly at shows for amateur artists at the *Whitechapel Art Gallery, London. Her drawings ranged from postcard-sized sketches to works more than 20 feet wide. In 1926 her son Laurie issued a broadsheet entitled *Myrninerest, the Spheres*, in which he described the range of his mother's automatic activities: 'Spiritual or Inspirational drawings, Writings, Singing, Inspired Piano-Playing, making knitted woollen clothes and weaving silk mats in beautifully blended colours'.

Automatistes, Les. A radical group of Canadian abstract painters active in Montreal from 1946 to about 1954; the name was taken from their interest in *automatism deriving from *Surrealism. The dominant figure was Paul-Émile *Borduas, who was appreciably older than the other six original members: Marcel Barbeau (1925–), Roger Fauteux (1920–), Pierre Gauvreau (1922–), Fernand Leduc (1916–), Jean-Paul Mousseau (1927–), and Jean-Paul *Riopelle. Five of these (Borduas, Gauvreau, Leduc, Mousseau, and

Riopelle) had exhibited together in New York in January 1946, and all seven first showed their work as a group in an office lent by Gauvreau's mother on Amherst Street, Montreal, in April of that year. This was the first exhibition by a group of abstract artists to be held in Canada. In 1948 the group published *Refus global* ('Total Refusal'), an anarchic manifesto attacking various aspects of Canadian life and culture, including the Church. Borduas was largely responsible for this document, which expressed his commitment to a free and creative life. It caused outrage and has been described as 'the single most important social document in Quebec history and the most important aesthetic statement a Canadian has ever made' (Dennis Reid, *A Concise History of Canadian Painting*, 1973). Two group exhibitions were held after this, in 1951 and 1954, but by the time of the first, Leduc and Riopelle were living in Europe and the group identity was breaking up.

Automne, Salon d'. See SALON D'AUTOMNE.

Auty, Giles. See PERFORMANCE ART.

avant-garde. A term originally used to describe the foremost part of an army advancing into battle (also called the vanguard) and now applied to any group, particularly of artists, that considers itself innovative and ahead of the majority; as an adjective, the word is applied to work characteristic of such groups. In its original sense the term is first recorded in English in the late 15th century (in Malory's *Morte d'Arthur*). It was probably first applied to art by the French political theorist Henri de Saint-Simon. Regarded as the founder of French socialism, he thought that science and technology could solve most problems and that artists could help lead the way to a more just and humane society. In his *Opinions littéraires, philosophiques et industrielles* (1825), he has the artist say to the scientist: 'It is we, the artists, who will serve as your avant-garde [i.e., as the prophets of future events].' During the 19th century, the term continued to be associated particularly with radical political thought, but from the early 20th century it was used more neutrally to denote cultural innovators of any persuasion; the earliest quotation in the *Oxford English Dictionary* to illustrate this sense ('The pioneers or innovators in any art in a particular period') dates from 1910. Many 20th-century writers,

however, have used the term in more loaded ways, often suggesting that the avant-garde has an exalted role beyond the mass of humanity. In his book *Concerning the Spiritual in Art* (1912), *Kandinsky argued that the artist was at the very apex of a triangle that led mankind upwards to greater spirituality. Clement *Greenberg saw avant-garde art as necessarily elitist in its distance from mass culture, and some writers have argued that the term should be applied only to modern art that actively challenges not just the traditional forms of art but also its existing institutional status.

In 1967 the American art historians Barbara Rose (1937–) and Irving Sandler (1925–) published (in the periodical *Art in America*) the results of a large survey they had conducted among New York artists asking the question 'Is there an avant-garde today?'; the majority answered 'No'. Eight years later, another American art historian, H. W. Janson (1913–82), published an essay in which he addressed the same issue ('The Myth of the Avant-Garde' in *Art Studies for an Editor: 25 Essays in Memory of Milton S. Fox*, 1975). Summarizing recent writings on 'the death of the avant-garde', he wrote: 'the avant-garde demands as a condition of its existence a social environment sufficiently set in its traditions and taste to be disturbed and offended by works of art that abandon accepted standards in the search for new form and meaning. From the Romantic era (i.e., the early nineteenth century) to the 1950s, significant innovation in art enjoyed just such a social environment . . . Before 1800, in contrast, there was no sense of alienation among artists, because the public was more sympathetic . . . The official rejection that came to be the artist's fate from the early nineteenth century on produced suffering as well as freedom, and the avant-garde artist depended on it in articulating his attitude toward his work. What, then, broke the pattern? It was the acceptance by the public of the *New York School of painters in the years 1955–60 . . . suddenly and surprisingly . . . these artists were eagerly bought by museums and private collectors . . . the new attitude of acceptance is just as indiscriminate as the older attitude of rejection . . . Change, titillation, had become a positive value in itself.' Janson then goes on question whether 'there ever was . . . such a thing as an artistic avant-garde'. He concludes that 'There never seems to be only

one avant-garde but several, striking out in as many directions at once' and that 'Once we acknowledge this state of affairs, we can continue to employ the term avant-garde only in rather watered-down fashion for artists whose work is in some sense exploratory, regardless of the direction it takes.'

In *The Avant-Garde in Exhibition: New Art in the 20th Century* (1994), Bruce Altshuler writes that 'considered as part of the history of *modernism, the avant-garde seems to have disappeared with the arrival of the cultural, social, and economic changes that together have been designated "*postmodern" . Judging by verbal practice, today young artists do not even use the term, burdened as it is with such notions as complete originality and faith in artistic progress.' In spite of such theoretical objections, if avant-garde art is judged merely by its ability to shock, alienate, disgust, or dismay members of the public (and certain critics), then it still seems to be alive and the term is certainly still used a good deal. The annual award of the *Turner Prize, for example, regularly attracts a good deal of unfavourable press comment, and in 1997 the London *Sunday Times* published an article on 'the shock artist' in which it discussed some of the recent works and events in 'the avant-garde world of "shock art"' that had 'caused predictable apoplexy among the Disgusteds of Tunbridge Wells'. These included, in the world of British art, Damien *Hirst's 'pickled cows' that won the 1995 Turner Prize; a work by the Palestinian-born *Video artist Mona Hatoum (1952–), short-listed for the same prize, in which she explored the inside of her own body with a miniature camera; *Piss Flowers* (1994) by the sculptor and *Performance artist Helen Chadwick (1952–96), consisting of a 'series of 12 bronzes cast from cavities made in the snow where she and her male partner had urinated'; and—the event that prompted the article—'the arrest of the sculptor Anthony-Noel Kelly [1955–] on suspicion of possessing human remains for use in his work'. From the world of American art, the article singled out the photographs of Andres Serrano (1950–), which include *Piss Christ* (1987) a picture of 'a crucifix suspended in a tank of his own urine' (which 'caused a huge row in Congress') and 'blurred photographs of his own semen in a series called Ejaculate in Trajectory'.

In 1997 an exhibition of such deliberately shocking art (loaned by the *Saatchi

Collection) was held at the *Royal Academy, London; it was provocatively entitled 'Sensation' and generated a great deal of controversy even before it opened. The work that aroused the fiercest debate was a giant portrait (1995) by Marcus Harvey (1963–) of the infamous 1960s child murderer Myra Hindley, based on a much reproduced police mugshot. There were calls for the picture to be withdrawn on the grounds that it would cause 'unnecessary suffering to the victims' relatives', and protesters defaced it with ink and eggs on the first day of public viewing. Michael *Sandle resigned from the RA in protest against the exhibition, and Brian *Sewell described the show as a 'pathetic attempt at sensationalism' by an institution that was desperate to 'bring in the hordes to alleviate its financial problems . . . They should be ashamed.' Some critics, however, were impressed by the show or at least by some of the works on view. The word 'avant-garde' was used in many of the reviews or discussions of the exhibition. For example, an article in *The Times* on 15 September (three days before the exhibition opened) was entitled 'Avant-garde kicks itself out of view', and in it Rachel Campbell-Johnston described the avant-garde as being 'rather like the family lunatic brought down from the attic—ranting, unpredictable and a bit threatening'.

Avery, Milton (1885–1965). American painter. He was born in Altmar, New York, spent most of his early life in Connecticut, and settled in New York City in 1925. Although he studied briefly at the Connecticut League of Art Students, he was essentially self-taught as an artist, and in his early years he supported himself with a variety of night jobs so he could paint during the day. It was only after his marriage in 1926 that his wife's earnings (she was an illustrator) allowed him to concentrate full-time on painting. (Avery's wife, Sally Michel, was considerably younger than him and it was perhaps to improve his chances in courting her that he took eight years off his age; his date of birth is usually given as 1893, but there is good evidence to indicate that he was born in 1885.)

Avery was an independent figure, described by Robert *Hughes as 'a mild, unassuming man who disliked publicity and at best made a bare living from his work . . . a man of absolute dedication and conviction, a painter who did almost nothing but paint'; if he was asked to discuss his work his usual reply was 'Why talk when you can paint?' At a time when most of his leading contemporaries were working in fairly sober, naturalistic styles (see AMERICAN SCENE PAINTING), he followed the example of *Matisse in using flat areas of colour within flowing outlines. He was the main and practically only channel through whom this subtle colouristic tradition was sustained in America until a new interest was taken in it in the 1940s by younger artists such as *Rothko (his close friend) and *Gottlieb. Rothko in particular acknowledged the debt that he and other abstract painters owed to the 'sheer loveliness' of Avery's work, in which he had 'invented sonorities never seen nor heard before'. Although Avery himself never abandoned representation (his favourite subjects included landscapes and beach scenes), some of his later works are so broadly conceived and ethereally painted that they can at first glance be mistaken for abstracts (*Spring Orchard*, National Museum of American Art, Washington, 1959).

Axis. A magazine devoted to contemporary art, published in London 1935–7, edited by the writer Myfanwy Evans assisted by her husband John *Piper. In the first issue (January 1935) *Axis* was described as 'a quarterly review of contemporary abstract painting and sculpture', but the quarterly intervals became almost half-yearly; the last issue (the 8th) appeared in winter 1937. Evans was encouraged by the French abstract painter Jean *Hélion and it was originally intended that *Axis* should parallel the concerns of the Paris-based *Abstraction-Création group. In later issues, however, the commitment to abstraction was abandoned in favour of a *Neo-Romantic nostalgia for the English landscape tradition. The impressive list of contributors included Paul *Nash and Herbert *Read. Although short-lived, the magazine was influential in introducing knowledge of contemporary European trends to Britain.

Ayres, Gillian (1930–). British abstract painter, born in London, where she studied at Camberwell School of Art, 1946–50. She was one of the first British painters to be influenced by American *Abstract Expressionism and *Colour Field Painting, and was among the artists who first achieved prominence at

the *Situation exhibition in 1960. Some of her work of the late 1950s made use of *Pollock's drip techniques and in the 1960s she did some lusciously coloured stain paintings. In the 1970s her handling became more painterly and she introduced suggestions of floral motifs, creating some of the most richly sensuous images in recent British art. Ayres taught at *Bath Academy of Art, Corsham, 1959–66, *St Martin's School of Art, 1966–78, and Winchester School of Art (as head of painting), 1978–81. She then moved to Wales and devoted herself full-time to painting. In the catalogue of the exhibition 'British Art in the 20th Century' (Royal Academy, London, 1987), Susan Compton writes of Ayres that 'During the entire period of her maturity as an artist she has produced abstract paintings of strong individual character'.

Aycock, Alice. See LAND ART.

Ayrton, Michael (1921–75). British painter, sculptor, theatre designer, graphic artist, film-maker, writer, and broadcaster, born in London, son of the poet Gerald Gould and the Labour politician Barbara Ayrton; he adopted his mother's surname so that he could appear near the beginning in alphabetically arranged mixed exhibitions. After leaving school at the age of 14, he studied at Heatherley's and St John's Wood Schools of Art and travelled extensively in Europe, sharing a studio with John *Minton in Paris in 1939. In 1942 he was invalided out of the RAF and for the next two years taught theatre design at Camberwell School of Art (with Minton he designed sets and costumes for John Gielgud's production of *Macbeth* at the Piccadilly Theatre in 1942). From 1944 to 1946 he was art critic of the *Spectator* (succeeding John *Piper), in which position he was a leading (and provocative) spokesman for *Neo-Romanticism. His own painting at this time was often turbulent and melodramatic, featuring anguished figures in strange landscapes (*The Temptation of St Anthony*, Tate Gallery, London, 1942–3), but it later grew more restrained. After the Second World War he became a regular radio broadcaster, giving talks on art and appearing on *The Brains Trust* (he was the youngest member of the panel) and *Round Britain Quiz*; later he also made tele-

vision documentaries. In 1951 he settled in a country house in Essex, and—encouraged by Henry *Moore—he took up sculpture, virtually abandoning painting for it in the late 1950s. He is generally considered more significant as a sculptor than as a painter. His career was often marred by ill-health, but he travelled widely and had a long list of works to his credit.

Ayrton was an erudite, inventive, and highly versatile artist (some detractors thought that he was too much of a jack of all trades and this attitude has been blamed for his lack of official honours). Apart from portraits, his work tended to revolve around certain recurring ideas and themes. In particular he was obsessed with the myth of Daedalus and Icarus, which he treated as analogous to his own artistic endeavours: 'I find myself involved in this legend and strangely aware of the relationship between the creative Daedalus and his son, who, lacking his father's talent, compensated for this lack in one superb and pathetic moment of suicidal action.' The most extreme expression of his obsession is the enormous maze of brick and stone (1968) he built for Armand Erpf, an eccentric American millionaire, at Arkville in New York State, imitating the labyrinth Daedalus built for king Minos of Crete at Knossos. A bronze version of the Minotaur that he created for the maze was erected in 1975 in Postman's Park (near the General Post Office), London.

Like his work in the visual arts, Ayrton's literary output was extensive and varied. His books include *The Testament of Daedalus* (1962), which is a mixture of prose and verse, and two novels, *The Maze Maker* (1967) and *The Midas Consequence* (1974). The latter deals with a celebrated modern artist named Capisco who is based partly on *Picasso and partly on Ayrton himself. His non-fiction books include *British Drawings* (1946), *Giovanni Pisano, Sculptor* (1969), which has an introduction by Henry Moore, and several collections of essays. Ayrton also illustrated many books—classics of English literature as well as modern works.

Ayshford, Paul (Lord Methuen). See BATH ACADEMY OF ART.

Azbe, Anton. See KANDINSKY.

Bacon, Francis (1909–92). British painter, a descendant of the Elizabethan writer and statesman of the same name, born in Dublin of English parents. As a child he suffered from severe asthma and he had little conventional schooling. His father, a race-horse trainer, was a puritanical figure and sent his son away from home when he was 16 after he was discovered trying on some of his mother's underwear. He spent about two months in Berlin and then about 18 months in Paris (where he was powerfully impressed by an exhibition of *Picasso's work at the Paul *Rosenberg Gallery in 1928) before settling in London in 1929. Initially he made a living there designing furniture and rugs. He had no formal training as an artist, but he began making drawings and watercolours in 1926 and painting oils two or three years later. In 1933 he began exhibiting in London commercial galleries, and in the same year one of his paintings was reproduced in Herbert *Read's book *Art Now*. However, he destroyed much of his early work and in the later 1930s virtually gave up painting for several years, supporting himself with various odd jobs, including running an illegal casino (he had inherited a love of gambling from his father). He returned to painting seriously in the Second World War (during which he worked in Civil Defence, excused military service because of his asthma), and he burst into prominence in April 1945 when his *Three Studies for Figures at the Base of a Crucifixion* (Tate Gallery, London, 1944) was exhibited in a mixed show at the Lefevre Gallery and made him overnight the most controversial painter in the country. John *Russell (*Francis Bacon*, 1971) writes that visitors to the exhibition were shocked by these 'images so unrelievedly awful that the mind shut snap at the sight of them. Their anatomy was half-human, half-animal, and they were confined in a low-ceilinged, window-less and oddly proportioned space. They could bite, probe, and suck, and they had very long eel-like necks, but their functioning in other respects was mysterious. Ears and mouths they had, but two at least of them were sightless. One was unpleasantly bandaged.'

Bacon's imagery later became more naturalistic, but at same time the emotional impact of his work was increased by a change in technique, as he moved away from fairly impersonal brushwork to develop a highly distinctive handling of paint, by means of which he smudged and twisted faces and bodies into ill-defined jumbled protruberances suggestive of slug-like creatures of nightmare fantasy: 'Art is a method of opening up areas of feeling rather than merely an illustration of an object ... I would like my pictures to look as if a human being had passed between them, like a snail, leaving a trail of the human presence and memory trace of past events as the snail leaves its slime.' Characteristically his paintings show single figures in isolation or despair, set in a bleak, sometimes cage-like space, and at times accompanied by hunks of raw meat: 'we are all meat, we are potential carcasses', he said in 1966. Often his work was based on his own everyday world (he did numerous self-portraits), but he also used imagery from photographs and film-stills as a starting point. In particular he based a series of paintings (begun in 1951) on Velázquez's celebrated portrait of Pope Innocent X (1650), but in place of the implacable expression of the original, he sometimes gave the pope a screaming face derived from a still from Sergei Eisenstein's film *The Battleship Potemkin*, as in *Study after Velázquez's Portrait of Innocent X* (Des Moines Art Center, 1953). Bacon regarded Velázquez as a 'miraculous' and 'amazingly mysterious' painter who could 'unlock the greatest and deepest things that man can feel', and he tried 'to paint like Velázquez but with the texture of a hippopotamus skin'.

From 1946 to 1950 Bacon lived mainly in Monte Carlo and thereafter in London. From 1949 he had fairly regular one-man exhibitions (first in London, then in New York, Paris, and elsewhere). His work was so novel and unsettling that for many years 'Critics and public vacillated uneasily between the opinions that he was a flashy sensationalist and that he was the most significant painter whom Britain had produced for several generations' (John *Rothenstein, *Francis Bacon*, 1967). In 1962, however, a retrospective exhibition of ninety of his paintings was held at the Tate Gallery, London, subsequently touring to several venues on the Continent, and this event firmly established him as a major figure. Thereafter his international reputation grew rapidly, and in the catalogue of a second major retrospective exhibition at the Tate, in 1985, the director of the Gallery, Alan *Bowness, wrote that Bacon was 'surely the greatest living painter; no artist in our century has presented the human predicament with such insight and feeling'. Many critics at the time concurred in this judgement, although others found his despairing vision—his view of life as a 'game without reason'—hard to take. He thought that 'man now realizes he is an accident, that he is a completely futile being' and that 'art has now become completely a game by which man distracts himself'. Peter *Fuller was among those who resisted this outlook: 'Bacon is an artist of persuasive power and undeniable ability; but he has used his expressive skills to denigrate and degrade. He presents one aspect of the human condition as necessary and universal truth . . . Bacon's skills may justly command our admiration; but his tendentious vision demands a moral response and, I believe, a refusal' (*The Cambridge Guide to the Arts in Britain*, vol. 9, 1988).

Alongside his reputation as one of the giants of contemporary art, Bacon built up a sulphurous personal legend on account of his promiscuous homosexuality, hard drinking, and heavy gambling. In 1985 he said: 'I hope I shall go on painting—in between drinking and gambling—until I drop dead, and I hope I shall drop dead working.' In spite of the huge amount of attention he has attracted, his work has had comparatively little stylistic effect on his contemporaries; it is so personal that it has been difficult for other artists to absorb it without producing a mere pastiche. However, his obituary in *The Times* commented that 'His influence on younger artists during the 1950s and 1960s was very considerable—not stylistically, for he had few imitators—but through his attitude to his work and the sense he gave of the ultimate seriousness of art.'

'Bad Painting'. See NEO-EXPRESSIONISM.

Baertling, Olle (1911–81). Swedish painter and sculptor, born at Halmstad and active mainly in Stockholm, where he settled in 1928. For many years he painted part-time whilst earning his living working in a bank. His early paintings were *Expressionist, but his style moved towards abstraction in the mid-1940s. In 1948 he visited Paris, working there with *Léger and *Lhote, and the following year he began painting completely abstract pictures. At first he was influenced by the rectangular formats of *Mondrian, but he developed a distinctive style featuring *Hard-Edged sharply pointed wedges of strong metallic colour (*Ardek*, Tate Gallery, London, 1963); he described his pictures as 'spaces and dynamics in high velocity'. In 1954 Baertling took up sculpture, using welded and painted iron (*Kero*, Tate, 1957).

Bainbridge, David. See ART & LANGUAGE.

Baj, Enrico (1924–). Italian painter, sculptor, graphic artist, and writer on art, born in Milan, where he studied art part-time at the Brera Academy whilst reading for a law degree. He has worked in a wide variety of materials and styles and has been a vigorous propagandist for avant-garde art, but he is best known for his collages. They combine elements of *Surrealism and *Pop art, expressing contempt for traditional values of art.

Bakst, Léon (originally Lev Rosenberg) (1866–1924). Russian painter, graphic artist, and stage designer, active for much of his career in Paris. He was born at Grodno and studied at the St Petersburg Academy, 1883–7, and then in Paris, at the *Académie Julian and elsewhere. In 1898 he was a founder member of the *World of Art group in St Petersburg. Originally he made his name as a portraitist, but from about 1902 he turned increasingly to stage design and is now remembered above all for his costumes and sets for *Diaghilev's Ballets Russes, his work playing a major part in the tremendous impact the company made

in the West. The Diaghilev ballets for which he made designs include some of the most celebrated works in the history of dance, notably *The Firebird* (1910, music by Stravinsky), *L'Après-midi d'un faune* (1912, music by Debussy), and *Daphnis and Chloe* (1912, music by Ravel). In 1909 he had been exiled from St Petersburg as a Jew without a residence permit and from then he lived mainly in Paris, where he worked for Ida Rubinstein's ballet company as well as Diaghilev, designing for her *The Martyrdom of St Sebastian* (1911, music by Debussy). Bakst's work revolutionized stage design. His costumes and sets are remarkable for their sheer uninhibited splendour, combining Oriental fairy-tale magnificence with the gaudy colours of Russian peasant art (he believed that colour could have a significant emotional effect on spectators). There are examples of his designs in the Victoria and Albert Museum, London.

Baldwin, Michael. See ART & LANGUAGE.

Ball, Hugo. See CABARET VOLTAIRE.

Balla, Giacomo (1871–1958). Italian painter and designer, one of the leading *Futurist artists. He was born in Turin and was mainly self-taught as an artist. In 1895 he moved to Rome, where he spent most of the rest of his life. He visited Paris in 1900–1 and brought back to Italy a feeling for colour and light that he passed on to *Boccioni and *Severini. His early works included landscapes and portraits, and after the turn of the century he became more interested in painting aspects of modern industrialized life. In 1910 he signed the two Futurist manifestos of painting, but he was initially cautious over his involvement with the movement and did not show his work in a Futurist group exhibition until 1913. By this time, however, he was becoming one of the most original and inventive of Futurist artists. His paintings showed a preoccupation with the characteristic Futurist aim of portraying motion, but unlike other members of the movement, Balla was not interested in machines and violence, his paintings tending rather towards the lyrical and the witty. The most famous is the delightful *Dynamism of a Dog on a Leash* (Albright-Knox Art Gallery, Buffalo, 1912), in which the blurred multiple impressions of the dog's legs and tail convey movement in a manner that later became a cartoon convention. In

1913–16 Balla went beyond the principles of the Futurist manifesto, painting pictures that approach pure abstraction, having only the most residual resemblance to the observations in reality that inspired them (*Abstract Speed—The Car Has Passed*, Tate Gallery, London, 1913). After the First World War, most of the other leading Futurists abandoned the movement, but Balla stayed true to its ideals and became its leading figure. In 1929 he signed the manifesto of its offshoot movement *Aeropittura, but from 1931 he reverted to a more traditional figurative style, 'in the conviction that pure art is to be found in absolute realism, without which we fall into decorative, ornamental forms'. By the end of his long life he was revered as the last survivor of a brilliant phase of modern Italian art.

Ballets Russes. See DIAGHILEV.

Balthus (Count Balthasar Klossowski de Rola) (1908–). French painter and stage designer, born in Paris of aristocratic Polish parents, both of whom painted. He had no formal artistic training, but taught himself mainly by copying Renaissance paintings in the Louvre and in Italy (the monumental dignity of Piero della Francesca particularly impressed him and left its mark on the solidity and formal balance of his work). He was also encouraged by *Bonnard, *Derain (of whom Balthus painted a memorable portrait, MOMA, New York, 1936), and the Austrian poet Rainer Maria Rilke, all family friends. The first painting in which he showed a strong personal vision was *The Street* (MOMA, New York, 1933), a carefully structured urban view with figures, two of which—a man caressing a girl—looked forward to the erotic imagery that was soon to dominate his work. His favourite theme has been the adolescent girl awakening to sexual consciousness; characteristically these girls are shown languidly sprawled or kneeling awkwardly over books in claustrophobic interiors that have a suggestion of *Surrealist oddness (*The Living Room*, Minneapolis Institute of Arts, 1941–3). *The Street* was one of the works shown at his first one-man exhibition, at the Galerie Pierre, Paris, in 1934, which caused a scandal because of the sexual content of the pictures (one of them was placed in a back room and shown only to selected visitors). None of the works sold, but Balthus made a living with portraits and stage designs.

At the beginning of the Second World War Balthus joined the French army, but he was soon discharged on medical grounds and spent the years 1943–6 in Switzerland. He then returned to Paris and built up a reputation with one-man shows in Paris (Wildenstein Galerie, 1946), New York (Pierre Matisse Gallery, 1949), London (Lefevre Gallery, 1952), and elsewhere. In 1954 he moved to the Château de Chassy near Autun, and from 1961 to 1977 he was Director of the French Academy in Rome. Since then he has lived mainly in seclusion in Switzerland. His output is small (he works slowly) and he shuns publicity, but his highly distinctive, poignantly erotic images have made him internationally famous, indeed something of a cult figure. His work has generally been warmly received by critics as well as the public (although some have accused him of having a Lolita complex) and he is widely regarded as one of the 20th century's leading upholders of the great tradition of figure painting. George Heard *Hamilton, for example, writes that 'No other painter has so shockingly depicted the stresses of adolescence, just as few others have had the courage to adapt traditional realism to contemporary purposes on such a monumental scale'.

Banham, Reyner. See INDEPENDENT GROUP.

Bänninger, Otto. See RICHIER.

Baranoff-Rossiné, Vladimir (1888–1944). Russian painter, sculptor, musician, and experimental artist, born at Kherson in the Ukraine. After studying painting in St Petersburg he spent the years 1910 to 1916 in Paris, where he moved from *Post-Impressionism to *Cubism. An example of his sculpture of this period is Symphony No. 1 (MOMA, New York, 1913), a witty figure of a musician made of polychrome wood, cardboard, and crushed eggshells; it looks rather like a junk *Archipenko. After the Russian Revolution Baranoff-Rossiné taught at various art institutions in Petrograd (St Petersburg) and (from 1919) Moscow. His work of this time included abstract paintings and constructions, some of them made from manufactured bits and pieces such as old gutter pipes, bedsprings, etc. He also constructed a 'colour piano' or 'opto-phonic piano' (Pompidou Centre, Paris, 1923) on which he gave 'visual' concerts intended to demonstrate a synthesis of music

and the visual arts. After leaving Russia in 1925 he settled in Paris; he was arrested there by the Gestapo in 1943 and died in a prison camp the following year.

Barbeau, Marcel. See AUTOMATISTES.

Barclay, John R. See EDINBURGH GROUP.

Barker, Clive. See POP ART

Barlach, Ernst (1870–1938). German sculptor, printmaker, and writer, a leading figure of *Expressionism. He was born at Wedel, near Hamburg, the son of a doctor, and studied at the School of Arts and Crafts in Hamburg, 1888–91, the Dresden Academy, 1891–5, and the *Académie Julian, Paris, 1895–6. After his return to Germany he spent the next decade working variously in and around Hamburg and in Berlin. During this period he worked as much on ceramics as on sculpture in a fairly derivative *Art Nouveau style, but a turning-point in his career came in 1906 when he went to Russia to visit a brother who was working for an industrial company in the Ukraine. The vast empty landscape and the sturdy Russian peasants made a great impact on Barlach, as his sketchbooks show. These hardworking people, with their simple faith, symbolized for him 'the human condition in its nakedness between Heaven and Earth' and helped inspire him to create a massively powerful figure style through which he expressed a wide range of emotion. He was influenced also by medieval German carving, with which he recognized both a spiritual and a technical affinity—he preferred to carve in heavy, close-grained woods, but even when his figures were modelled in clay and cast in bronze they retain the broad planes and sharp edges typical of woodcarving.

In 1907 Barlach became financially secure when he signed a contract with the Berlin dealer Paul *Cassirer, agreeing to sell him his entire output for a fixed salary. In 1910 he moved to Güstrow, a small town near Rostock, where he was to spend the rest of his life, and by this time he had created his mature style, which changed little thereafter. His most characteristic works are massive, blocklike, heavily robed single figures or pairs of figures symbolizing some aspect of the human condition (The Solitary One, Kunsthalle, Hamburg, 1911). George Heard *Hamilton writes that 'Whether in wood or plaster the forms are

sometimes so tightly compact that their emotional charge seems about to explode'. Barlach also produced several monuments commemorating the First World War and he was a prolific maker of lithographs and wood-cuts, particularly of illustrations to his own plays. The first of these to appear was *Der tote Tag* (The dead day), published by Cassirer's Pan-Presse in Berlin in 1912; the text was accompanied by a separate portfolio of 27 lithographs. He published six more plays, the last in 1929; they are sombre works, typically showing the individual wrestling with the ties of the material world in search of God, but they sometimes have a grotesque humour not seen in his sculpture.

After the First World War (in which he served briefly in the army) Barlach was much honoured. He was made a member of the Berlin Academy in 1919, for example, and of the Munich Academy in 1925, and in 1924 was awarded the Kleist Prize (for literature). His autobiography, *Ein selbsterzähltes Leben*, was published in 1928 and his 60th birthday in 1930 was marked by a large exhibition of his work at the Berlin Academy. After the Nazis came to power in 1933, however, he was declared a *degenerate artist; 381 of his works were confiscated from museums and his war memorials at Güstrow, Kiel, and Magdeburg were dismantled. In 1937 he wrote: 'A pimp or a murderer is better off. He at least gets a legal hearing and can defend himself. But we are simply repudiated, and whenever possible purged.' He died the following year. After the war, his memorial in Güstrow Cathedral was restored and a copy made for the Antoniter-kirche in Cologne; it takes the form of a hovering bronze angel and is considered by many to be his most deeply spiritual work. His studio in Güstrow is now a museum of his work and there is another museum dedicated to him in Hamburg. His collected writings were published in three volumes (1956–9) and his letters in two volumes (1968–9).

Barnard, George Grey (1863–1938). American sculptor, an independent, original, and controversial figure. He was born in Belle-fonte, Pennsylvania, and after studying briefly at the Art Institute of Chicago he moved to Paris in 1883. After years of hardship there he had a sensational success with his over-life-size marble group *Struggle of the Two Natures in Man* (Metropolitan Museum, New York), when it was exhibited at the Salon de la

Nationale in 1894. In the same year he returned to the USA (against the advice of *Rodin, to whom his vigorous style was much indebted) and settled in New York. Initially he made little impact there, but in 1902 he received the largest commission given to an American sculptor up to that date—a vast scheme of allegorical decorations for the Pennsylvania State Capitol at Harrisburg. He returned to France to work on this. In 1906 there was a scandal in Harrisburg over misuse of public funds, bringing payment to Barnard to an end, but he continued the project at his own expense and it was unveiled—on a much smaller scale than originally envisaged—in 1911. His final major work was a bronze statue of Abraham Lincoln, set up in Lytle Park, Cincinnati, in 1917. It caused a furore; Barnard had attempted to show the national hero as an ordinary man in deep thought, but some thought it made him look like a 'dis-shevelled dolt' and Lincoln's son described the statue as 'grotesque and defamatory'. However, it also had strong supporters, including the former President Theodore Roosevelt, who said 'The greatest statue of our age has revealed the greatest soul of our age'. Controversy continued when it was proposed to erect a copy of the statue in Parliament Square, London; *Epstein defended it against attack in a letter to the *Daily Telegraph*, describing Barnard (his former teacher) as 'a very great sculptor'. Eventually it was a replica of *Saint-Gaudens's statue of Lincoln that went to London, whilst a replica of the Barnard went to Manchester (it was unveiled in 1919 and is now in Lincoln Square). During his many years in France Barnard made a superb collection of medieval art; this was bought for the Metropolitan Museum, New York, in 1925 and forms the basis of its outstation, The Cloisters, opened in 1938. Barnard devoted his final years to a visionary project for a colossal *Rainbow Arch* (to be dedicated to the mothers of war dead), which he hoped to erect near The Cloisters.

Barnes, Dr Albert C. (1872–1951). American drug manufacturer, art collector, and patron, born in Philadelphia. He made a fortune with the antiseptic Argyrol, which he invented in 1901 (its success is said to have depended largely on its being adopted as the standard anti-venereal treatment of the French army), and by about 1912 he was devoting his life to collecting. Around this time, William

*Glackens, an old school friend, encouraged him to turn his attention from the Barbizon School to *Impressionism and *Post-Impressionism; thereafter modern French painting remained his chief field of interest, although he also collected Old Masters and primitive art. In 1922 he established the Barnes Foundation at Merion, Pennsylvania, to house his collection and to provide education in art appreciation. He wrote and lectured on art (his books include *Art in Painting*, 1926), but the museum he created was not open to the public during his lifetime, partly because he had a grudge against critics and the art establishment in general after his collection received a hostile reception when it was shown at the Pennsylvania Academy of the Fine Arts in 1923. In addition to collecting works, Barnes commissioned *Matisse to paint a mural decoration for the Foundation in 1931, and when it turned out to be unusable because of an error in the measurements he had been given, Matisse did a new version. The abortive scheme, *The Dance I* (1931–2), is in the Musée d'Art Moderne de la Ville de Paris, and the second scheme, *The Dance II* (1932–3), is *in situ* in the Barnes Foundation. The collection of Matisse's work is one of the best in the world, and *Cézanne, *Picasso, and *Renoir are among the other artists who are particularly well represented.

In *The Rare Art Traditions: The History of Art Collecting and its Linked Phenomena* (1982), Joseph Alsop describes Barnes as 'perhaps the greatest single American art collector of the twentieth century'. Alsop writes that he used 'shameless flattery' to gain admission to the Foundation in 1929, when he was a 19-year-old student, and several of the other visitors who managed to gain access commented on the shortcomings in Barnes's personality. According to Kenneth *Clark, for example, he was 'not at all an attractive character. His stories of how he had extracted Cézannes and Renoirs from penniless widows made one's blood run cold.' Jacob *Epstein wrote that he had 'a reputation for boorishness of which, on my visit to see him, I found no trace', but added that 'I was told that dictaphones were installed in the walls, so that critics who were facetious or too frank could be instantly reported and told to go'. Among the distinguished artists and art historians who were refused admission to the Foundation were *Le Corbusier, Meyer *Schapiro, and John Rewald (1912–94), author of celebrated histories of

Impressionism (1946, 4th edn., 1973) and Post-Impressionism (1956, 3rd edn., 1978). Rewald refers to the 'unpleasant and sometimes even revolting traits' of Barnes's character, to his 'dreadful, crude, and unspeakably stupid manners', and to 'his cunning, his ruthlessness, and his lack of scruples' (*Cézanne and America*, 1989). Others who fell foul of Barnes included the philosopher Bertrand Russell, who was engaged to give courses of lectures at the Foundation in the early 1940s. Barnes reneged on their contract and Russell successfully sued him.

After Barnes's death (in a car accident), a lengthy campaign was carried out—led by the publisher of the *Philadelphia Inquirer*, Walter Annenberg—to try to force the trustees of the Foundation to open the collection to the public or lose its tax-exempt status. An agreement was reached in 1960 allowing restricted public access, but the collection retained its almost legendary aura as a virtually inaccessible treasure trove. In his will Barnes had stipulated that his paintings should remain exactly as he left them, but in 1993–4, following court action, a selection of pictures went on tour to Washington, Paris, and Japan. The catalogue of the exhibition reproduced many of the paintings in colour for the first time, for the Foundation had previously forbidden this.

Barr, Alfred H. (1902–81). American art historian and administrator who played an enormously important role in establishing an intellectual framework for the study and appreciation of modern art; his obituary in the *International Herald Tribune* described him as 'possibly the most innovative and influential museum man of the 20th century'. He was born in Detroit, the son of a Presbyterian minister, and studied art and archaeology at Princeton University, graduating in 1922 and taking an MA degree the following year (his thesis was on Piero di Cosimo). After several months travelling in Europe, he returned to the USA and taught art history successively at Vassar College (1923–4), Harvard University (1924–5), Princeton University (1925–6), and Wellesley College (1926–7); the rapid changes of job were part of a career plan to gain wide experience. At Vassar he mounted an exhibition of *Kandinsky's work, and at Wellesley he taught the first course at an American college devoted solely to 20th-century art, which by this time had become his greatest interest. In

1929 he was appointed director of the newly-founded *Museum of Modern Art, New York, and over the next four decades he was largely responsible for building the museum's collections and reputation (he resigned as director in 1943 so he could devote more time to writing, but he continued as director of research, and retired in 1967 with the title of director of museum collections). After his retirement he compiled a massive catalogue of all the paintings and sculptures that were in the permanent collection at the end of his 38 years of service; this was published in 1977 as *Painting and Sculpture in the Museum of Modern Art 1929–1967*, containing entries for 2,622 works by 999 artists, of which about two-thirds are illustrated. In the foreword to this volume, Richard E. Oldenburg, the director of the Museum at that time, wrote of Barr: 'He believed that a museum collection should not be built up on the same principle as a private one, subject only to personal taste, but should rather be catholic—and systematically seek to be so. If this no longer seems a novel idea, then it is to Mr Barr's credit that his concept of a modern museum is now so widely accepted.' An important aspect of his catholic and systematic approach was that he widened the traditional concept of the art museum to embrace visual arts as a whole, including architecture, industrial design, and motion pictures.

Barr organized more than 100 exhibitions at the Museum of Modern Art, including such famous shows as 'Cubism and Abstract Art' and 'Fantastic Art, Dada, Surrealism' (both 1936), and he did much to create the modern idea of an art exhibition, through such means as special lighting, expository wall captions, and scholarly, fully illustrated catalogues. He wrote numerous books and catalogues himself, setting impressive standards of scholarship but presenting his findings in an accessible style. His two most famous books are probably *Picasso: Fifty Years of his Art* (1946) and *Matisse: His Art and his Public* (1951). These have stood the test of time extremely well and are still considered standard works; indeed, in 1985 John *Golding described the Matisse book as 'in many respects still the most satisfactory monograph on any major twentieth-century artist'. In spite of the praise he received for his work, Barr was a controversial figure. He was attacked by sectarians within the world of modern art as well as by conservatives, and some critics thought that the

museum he created had too powerful an influence in shaping—rather than reflecting—the course of modern art; in 1960, for example, John *Canaday described Barr in the *New York Times* as 'the most powerful tastemaker in American art today and probably in the world'. Richard E. Oldenburg writes that Barr 'replied that he was a "reluctant" tastemaker, for he did not believe that it was a museum's primary task to discover the new, but to move at a discreet distance behind developing art, not trying to create movements or reputations but putting things together as their contours begin to clarify'.

In addition to his work at the Museum of Modern Art, Barr served on the advisory boards of other museums and the juries of art competitions. After the Second World War he won a stream of awards from the USA and elsewhere, including being made a member of the Legion of Honour by France. In a profile in *Current Biography* (1961) he was described as 'slender, bespectacled, and scholarly . . . fragile in appearance but boundless in energy'.

Barrett, Oswald (1892–1945). British illustrator who worked under the name 'Batt'. He was born in London, where he studied at Camden School of Art, then—after service in the army in the First World War—at Heatherley's School of Art and Goldsmiths' School of Art. From 1930 until his death he worked regularly for the *Radio Times*, and he is best known for the imaginative portraits of famous composers he produced for it and for the *Oxford Companion to Music* (1938). These were usually in black-and-white, but he produced an oil painting of Beethoven specially for the frontispiece of the *Companion*. Batt was an ardent music-lover, and the editor of the *Companion*, Percy Scholes, wrote that his illustrations represented 'years of research, study, and profound thought'. They were not retained for the *New Oxford Companion to Music* (1983), in the preface to which Denis Arnold wrote: 'The proposed editorial policy towards Batt's illustrations has been the chief matter raised with me by those who discovered I was the editor of the *New Companion*, and I can only say that the number of admirers is balanced by those who disliked them intensely.'

Barry, Robert. See CONCEPTUAL ART.

Bartholomé, Albert (1848–1928). French sculptor, born at Thivernal, Seine-et-Oise. He

was originally a painter, turning to sculpture (in which he was self-taught) in about 1886; his young wife died in that year, and his first noteworthy work was her tomb monument (1887) at Bouillant, Crépy-en-Valois. Funerary sculpture remained his forte, the *Monument to the Dead* (1889–99) at Père Lachaise Cemetery, Paris, being his most famous creation. Appropriately, there is often a strong element of melancholy in his work. His successful career was at its peak around the turn of the century, and in 1900 he won the grand prix for sculpture at the Paris Universal Exhibition. Bartholomé is often described as an academic or traditional artist, but his work was included in the 'Pioneers of Modern Sculpture' exhibition at the Hayward Gallery, London, in 1973, and Fred Licht (*Sculpture: 19th and 20th Centuries*, 1967) wrote of him: 'Rebelling against *Rodin's looseness of treatment, as well as the detail burdened Academic style, Bartholomé introduced a new Classic compactness and economy, which paralleled the work of *Hildebrand, and was decisive for the development of such later sculptors as *Maillol.' Much of his later career was devoted to making monuments commemorating the First World War.

Bartlett, Jennifer. See NEW IMAGE PAINTING.

Barye, Antoine. See POMPON.

Basaldella, Dino (1909–77). Italian sculptor, born in Udine. His work is abstract, characteristically in iron and composed of rugged forms. He was the brother of two artists more famous than himself who prefer to be known simply by their Christian names—the painter *Afro and the sculptor *Mirko.

Baselitz, Georg (1938–). German painter, printmaker, draughtsman, and sculptor, born at Deutschbaselitz, Saxony. He began his training in East Berlin, but moved to West Berlin in 1956 and studied at the Academy. It was at this time that he gave up his original surname, Kern, and adopted a name derived from his place of birth. In the 1960s he became controversial for producing deliberately crude paintings that give him a place as one of the pioneers of *Neo-Expressionism. The most notorious of these pictures is *The Great Piss-Up* (also called *Big Night Down the Drain*, Museum Ludwig, Cologne, 1962–3); it shows a man with an enormous penis

(Edward *Lucie-Smith says it was 'perhaps intended as a self-portrait') and it was seized by the police when it was first shown in Berlin in 1963. Baselitz attracted more controversy in 1969 when he began painting the images in his pictures upside down. In the catalogue of the exhibition 'A New Spirit in Painting' (Royal Academy, London, 1981), Christos M. Joachimides, one of the show's organizers, wrote that in doing this Baselitz 'not only liberated himself from the bonds of a traditional conception of painting but took up, by this affront, a position of resistance within the context of art'. Jonathan Fineberg (*Art Since 1940*, 1995) describes 'the idea of turning whole paintings upside down' as 'a signature device to take the focus off the subject matter and redirect it toward the expressive surface'. Since 1979 Baselitz has also made sculptures; in these the figures are the normal way up. He has become one of the best-known European artists of his generation, but critical opinion on him is divided. Daniel Wheeler (*Art Since Mid-Century*, 1991) praises his 'exceptionally full, ripe color' and considers that his work exudes 'a Renaissance dignity and presence suggesting a culture determined to become whole again through inventive reintegration with its rich but problematic past'. Robert *Hughes, on the other hand, describes Baselitz as a 'fountain of overwrought mediocrity'.

Baskin, Leonard (1922–). American sculptor, printmaker, draughtsman, and book designer, born in New Brunswick, New Jersey, the son of a rabbi. He had a long and varied training, studying first with the sculptor Maurice Glickman, 1937–9, then at the universities of New York, 1939–41, and Yale, 1941–3. After serving in the US Navy during the Second World War, he continued his studies at the New School for Social Research in New York, graduating in 1949, then at the Académie de la Grande Chaumière in Paris, 1950, and the Academy in Florence, 1951. On his return to the USA he began teaching at Smith College, Northampton, Massachusetts, in 1953. Baskin has said that 'man and his condition have been the totality of my concern', and his belief that art should express moral and social concerns was at odds with the prevailing abstraction of the 1950s. His most characteristic sculptures are brooding, full-length, standing figures (in bronze, stone, or wood) portraying 'anxiety-ridden man imprisoned in his ungainly self' (*Man with a Dead*

Bird, MOMA, New York, 1951–6). They have a kinship with the graphic art of *Barlach and *Kollwitz—the two modern artists Baskin admires most. Baskin himself has been a prolific printmaker, especially of woodcuts, many of which are used as book illustrations. His interest in books encompasses the whole of their design, including typography and binding, and in 1952 he founded the Gehenna Press to produce limited editions. He has won numerous awards for his work, including the printmaking prize at the 1961 São Paulo *Bienal.

Basquiat, Jean-Michel. See GRAFFITI ART.

Bataille, Georges. See *MINOTAURE*.

Bateau-Lavoir (Washerwomen's Boat). A cluster of tumbledown studios in the rue Ravignan, Montmartre, Paris, where several artists who later became famous lived and worked in the early years of the 20th century, most notably *Picasso. He lived there from 1904 to 1909 and held on to his studio until 1912. Others who lived there at the same time included van *Dongen, *Gris, and briefly *Modigliani. The building had begun life as a piano factory and was converted into studios in 1889. Rents were cheap, reflecting the primitive conditions (there was no gas or electricity), and it became a place of seedy allure, associated for a time with anarchist activity. Largely under the influence of Picasso's personality it became a literary and artistic centre and it is usually regarded as the birthplace of *Cubism (it was here that Picasso painted *Les Demoiselles d'Avignon*). Among the writers who lived there were the poets Max *Jacob and André *Salmon, both of whom have been credited with coining its name—a reference to the fact that in windy weather parts of the rickety building would sway like laundry boats moored in the Seine. In 1969 André *Malraux declared the Bateau-Lavoir a historical monument, but it burned down the following year. A new complex of artists' studios was erected on the site, now 13 Place Émile-Goudeau.

Bateman, H. M. (Henry Mayo) (1887–1970). British cartoonist, designer, and painter, born in Australia of English parents. His family returned to England when he was a baby and he studied in London at Westminster School of Art—on the advice of Phil May (1864–1903), one of the most popular cartoonists of his day—and at Goldsmiths' College. He first had his work published in 1903, in *Scraps*, and the following year he began his long association with the *Tatler* magazine, one of the many periodicals for which he worked. In 1911 he had his first one-man exhibition at the Brook Street Gallery, London. His style was greatly influenced by the Russian-born French cartoonist Emmanuel Poiré (1858–1909), who worked under the name 'Caran d'Ache' (from the Russian for pencil: *karandash*). Bateman thought that 'Caran d'Ache was the greatest master of the art of telling a story in pictures without words ... He combined the perfection of the droll story with superb draughtsmanship, and an astounding observation and knowledge of humanity.' Although he followed Caran d'Ache in that his humour rarely depended on a caption, Bateman differed in his pictorial territory; he seldom dealt with politics, concentrating instead on the types of clubland and suburbia. In particular he became famous for his 'The Man Who ...' cartoons, a long-running series illustrating social gaffes based on middle-class aspirations and snobbery. (The idea is said to have originally come from another cartoonist, Cyril Bird (1887–1965), who worked as 'Fougass' and during the Second World War designed a famous series of 'Careless Talk Costs Lives' posters for the Ministry of Information.)

Bateman enlisted in the army during the First World War, but he was discharged in 1915 because of ill-health. In the interwar years he was said to be the highest-paid cartoonist in Britain and he was also in demand as a designer of advertising posters (notably for Guinness beer and Kensitas cigarettes). He was popular, too, in the USA, which he toured for *Life* magazine in 1923. About a dozen books of his drawings were published (beginning with *Burlesques* in 1916) and he illustrated books by many other people. Shortly after the outbreak of the Second World War in 1939 he decided upon semi-retirement and moved to Devon, now finding more time for painting, which he had always pursued for his own enjoyment. In his later years he spent the winters in Malta, where he died.

Bath Academy of Art. Art school established in 1946 at his home Corsham Court, Wiltshire (about eight miles from Bath), by Paul

Ayshford, Lord Methuen (1886–1974), a painter of landscapes and architectural and figure subjects (examples of his work are in the Tate Gallery, London). It incorporated an earlier school that had been in existence since 1832. The Academy attracted distinguished teachers and quickly achieved a high reputation. Kenneth *Armitage was the first head of sculpture and the teachers of painting have included Gillian *Ayres and Howard *Hodgkin

Batlle Planas, Juan (1911–66). Argentine painter, printmaker, designer, and writer, considered the father of *Surrealist painting in his country. He was born in Spain and moved to Buenos Aires with his family in 1913. Although he had lessons from his painter uncle José Planas-Casa (1900–60), he was essentially self-taught. He was an energetic publicist for modern art and trained and influenced numerous Argentinian artists. His work included murals in public and private buildings, stage designs, and book illustrations, and he also wrote poetry and numerous articles about the psychological response to colour and form.

Batsford, Sir Brian (1910–91). British painter, designer, publisher, and politician, born in Gerrards Cross, Buckinghamshire. He was originally called Brian Cook, but in 1946 he adopted his mother's maiden name. In 1928 he began working for the production department of the publishing firm of B. T. Batsford, of which his uncle, Harry Batsford, was chairman. At the same time he studied part-time at the Central School of Arts and Crafts, London. During the 1930s he was a prolific designer of covers for Batsford's books, notably in the 'British Heritage', 'English Life', and 'Face of Britain' series. His designs typically featured a continuous 'wrap-around' image (a novelty at the time) in flat, bright colours, creating a distinctive look that became a Batsford trademark. He also designed posters in a similar style for the British Tourist Board, the Thomas Cook (no relation) travel agency, and the London and North Eastern Railway, and his obituary in *The Times* commented that 'his distinctive *Art Deco style became an important influence on how people viewed their rural heritage in an era before colour photography'. During the Second World War he served in the RAF, and in 1952, following his uncle's death, he became chairman of Bats-

ford, a position he held until 1974. From 1958 to 1974 he was also Conservative MP for Ealing South. During this period he had continued to paint, but his role as an artist was submerged under his other activities. In the 1980s, however, there was a revival of interest in his work, and he once again found himself in demand as a designer, notably for the National Trust. Two of his paintings were included in the exhibition 'Landscape in Britain 1850–1950' at the Hayward Gallery, London, in 1983, and he published *The Britain of Brian Cook* in 1987. In his later years he lived in Rye, Sussex.

Batt. See BARRETT.

Bauchant, André (1873–1958) French *naive painter. He was a market gardener until 1914 and did not begin painting until 1919, when he was demobilized after war service (in the army he had shown a talent for drawing and had been trained as a map-maker). In 1921 his work was shown at the *Salon d'Automne, and he soon became one of the best-known painters of his type. He was promoted by Wilhelm *Uhde, the leading impresario in the cult for the naive, and his admirers and patrons included *Diaghilev (who in 1928 commissioned him to design costumes and sets for the ballet *Apollo Musagète*, to music by Stravinsky), *Le Corbusier, *Lipchitz, and *Ozenfant. Bauchant's favourite subjects were history and mythology, for which he found inspiration in old illustrated books; two examples are in the Tate Gallery, London (*Greek Dance in a Landscape*, 1937; and *Funeral Procession of Alexander the Great*, 1940). From 1929 he also painted landscapes, flower pieces, and biblical scenes. His style was meticulously detailed.

Baudelaire, Charles. See MODERNISM.

Bauhaus. A school of art and design founded by Walter *Gropius in Weimar in 1919 and closed by the Nazis in 1933 after moving successively to Dessau (1925) and Berlin (1932); in spite of its short life, it was the most famous art school of the 20th century, playing key roles in establishing the relationship between design and industrial techniques and in breaking down the hierarchy that had previously divided 'fine' from 'applied' arts.

The Bauhaus was created when Gropius was appointed head of two art schools in

Weimar in 1919 and united them in one; they were the Kunstgewerbeschule (Arts and Crafts School) and the Hochschule für Bildende Kunst (Institute of Fine Arts). He gave his new school the name Staatliches Bauhaus in Weimar (Weimar State 'Building House'), coining himself the word 'Bauhaus' (an inversion of 'Hausbau'—house construction). His manifesto formulated three main aims for the school: first, to unite the arts so that painters, sculptors, and craftsmen could in future embark on co-operative projects, combining all their skills harmoniously; secondly, to raise the status of the crafts to that enjoyed by the fine arts; and thirdly, to establish 'constant contact with the leaders of the crafts and industries of the country' (an important factor if the school were to survive in a country that was in economic chaos after the war).

All students had to take a six-month preliminary course (Vorkurs) in which they studied the principles of form and colour, were acquainted with various materials, and were encouraged to develop their creativity. After that they moved on to workshop training in the field of their choice. Each workshop—in carpentry, metalwork, stained glass, weaving, typography, and so on—was run by two people—a Werkmeister (Workshop Master—a craftsman) and a Formmeister (Master of Design—an artist): 'The former would teach method and technique while the latter, working in close co-operation with the craftsmen, would introduce students to the mystery of creativity and help them achieve a formal language of their own' (Frank *Whitford, Bauhaus, 1984). In theory the Werkmeister and Formmeister had equal status, but in practice the Formmeister were regarded as more important. Students were known as 'journeymen' and then (after moving to the workshop stage) as 'apprentices', emphasizing the craft-based nature of the school.

Gropius brought together a remarkable collection of teachers at the Bauhaus. The first head of the preliminary course was Johannes *Itten, and when he left in 1923 he was succeeded by László *Moholy-Nagy, who replaced Itten's rather metaphysical approach with an austerely rational one. The Formmeister included some illustrious painters, most notably *Kandinsky and *Klee. Lyonel *Feininger was the only teacher to be on the Bauhaus staff for its entire history (although he did little actual teaching for much of that

time). Among the few women teachers the most important was the weaver Gunta Stölzl (1897–1983) (see FIBRE ART). Admission was difficult for students and many who did get in were rejected after the preliminary course. On average there were about a hundred students at the Bauhaus at any one time, the total enlistment in its 14-year history being about 1,250. Several students went on to become teachers at the school, notably Josef *Albers and Herbert *Bayer.

In 1924 right-wingers gained power in the provincial elections and cut funding to the Bauhaus, which consequently moved to Dessau the following year; it was housed in a group of new buildings designed by Gropius (built 1925-6). The school now styled itself a Hochschule für Gestaltung (Institute for Design), teachers were called professors (a term Gropius had previously avoided because it smacked of academicism), and the dual Werkmeister–Formmeister system was abandoned; Gropius had envisaged this last change from the start, for now former students were available to teach both theory and practice: 'a new previously unavailable type of collaborator for industry, craft, and building, who is the master equally of technique *and* form'.

The Bauhaus had been involved in architectural commissions from the outset (Gropius's manifesto had begun by saying 'the ultimate aim of all creative activity is the building'), but it was only in 1927 that an architectural department was established. Students who chose to specialize in this subject after their preliminary course were not obliged to acquire any craft skill. The Swiss architect Hannes Meyer (1889–1954) was appointed first professor in this department, and when Gropius resigned suddenly a year later to devote himself to private practice he named Meyer as his successor as director. It was an unpopular choice with the staff, as Meyer was a Marxist and instituted a sociological approach that changed the whole tone of the school, with politics occupying an important place in the curriculum. Moholy-Nagy resigned immediately and Bayer soon afterwards. Meyer wanted the Bauhaus to supply 'the needs of the people instead of the needs of luxury' and encouraged the workshops to make mass-produced goods. His approach earned considerable funds for the school but disaffected most of the staff, who hated the idea of advertising dominating aesthetics. In

1930 Meyer was forced to resign and was replaced by Ludwig Mies van der Rohe (1886–1969), one of the greatest architects of the 20th century.

Mies's main task was to rid the school of its political associations and thereby make it a less easy target for its right-wing opponents (the Nazi party was gaining strength throughout Germany). However, there were now a good many committed left-wing students at the school and one of their noisy meetings almost degenerated into a riot. Mies banned all political activity on threat of expulsion, but in 1932 the Dessau parliament closed the school. In an attempt to keep it alive Mies rented a disused factory in Berlin and reopened the Bauhaus there as a private enterprise, but it was closed by the Nazis in April 1933, soon after Hitler assumed power.

In its last few years the Bauhaus was dominated by architecture, but it produced a great range of goods, with many of them (furniture, textiles, and electric light fittings in particular) being adopted for large-scale manufacture. They were highly varied in appearance, but the style that is generally thought typical of the Bauhaus was severe, geometric, and undecorated. The school published a journal (*Bauhaus*, 1926–31) and a series of books, and its ideas were spread also by the emigration of many of its teachers before and during the Second World War (an exhibition was devoted to the Bauhaus at the Museum of Modern Art, New York, in 1938, and the fact that the school had fallen victim to the Nazis enhanced its status in the democratic world). It has had an enormous influence on art education in the Western world and on visual creativity in general: 'The look of the modern environment is unthinkable without it. It left an indelible mark on activities as varied as photography and newspaper design . . . [and] achieved a language of design liberated from the historicism of the previous hundred years' (Frank Whitford, *Bauhaus*).

After the Second World War Dessau became part of East Germany and the Bauhaus buildings were left derelict. In 1976 the school was faithfully restored for the 50th anniversary of its opening in Dessau, and after the reunification of Germany in 1990 it was reopened as a design institution.

Baumeister, Willi (1889–1955). German abstract painter. Unlike most significant German painters of his time, he stood outside the ambit of *Expressionism and is regarded as the most 'European' in spirit of his contemporaries. He was born in Stuttgart, where he trained as an interior decorator and then studied at the Academy under *Hölzel. Between 1911 and 1914 he had several stays in Paris (sometimes in company with his close friend Oskar *Schlemmer) and his early work was influenced by *Cubism. After military service in the First World War, he began to develop a personal style in a series (1919–23) of *Mauerbilder* ('wall paintings'), so called because he added sand, putty, etc., to his pigments to give a textured effect. In the mid-1920s his work became more figurative in a manner recalling *Léger and the *Purists (he met Léger, *Le Corbusier and *Ozenfant when he revisited Paris in 1924), and his work met with considerable acclaim in France. In 1928 he was appointed professor of typography at the Städel School in Frankfurt, but in 1933 was dismissed by the Nazis, who declared his work *degenerate. From then until the end of the Second World War he worked in obscurity in Stuttgart. During this time his work became freer, with suggestions of primitive imagery, creating a kind of abstract *Surrealism. His interest in imagery from the subconscious was described in his book *Das Unbekannte in der Kunst* (The Unknown in Art), written in 1943–4 and published in 1947. After the war Baumeister became a hero to a younger generation of German abstract artists. From 1946 until his death he was a professor at the Stuttgart Academy. See also ZEN 49.

Bawden, Edward (1903–89). British watercolour painter, illustrator, and designer of posters, wallpaper, tapestries, and theatre decor, born at Braintree, Essex. From 1919 to 1922 Bawden studied at Cambridge School of Art, and from 1922 to 1925 at the *Royal College of Art, where his teachers included Paul *Nash and he was a close friend of Eric *Ravilious. He was on *Official War Artist in the Second World War (in France and the Middle East) and painted numerous murals (for example, at Queen's University, Belfast, 1965), but he is best known for his book illustrations. Most of them were done in pen and ink in an incisive economical style, but he also worked with linocut, lithography, and stencil.

Bay Area Figuration (or **West Coast Figuration**). A term applied to the work of a number of American painters active in the San Fran-

cisco Bay area in the 1950s whose paintings were figurative but strongly influenced by the broad and vigorous brushwork of *Abstract Expressionism. The main artists involved were Elmer Bischoff (1916–91), Richard *Diebenkorn, and David Park (1911–60), all of whom had either studied or taught at the California School of Fine Arts (where *Rothko and *Still had been teachers in the late 1940s). Among the other painters covered by the term are William Theo Brown (1919–), Nathan Oliviera (1928–), and Paul Wonner (1920–).

Bayer, Herbert (1900–85). Austrian-born designer, architect, typographer, painter, photographer, and sculptor who became an American citizen in 1944. He was born at Haag and studied architecture in Linz and mural painting under *Kandinsky at the *Bauhaus in Weimar. His work of this time included designing one-billion-mark notes (1923) during Germany's period of hyperinflation. From 1925 to 1928 he taught typography at the Bauhaus (which had now moved to Dessau) and from 1928 to 1937 he ran an advertising business in Berlin, his work including typography and exhibition planning. During this period he continued to paint and also took up *photomontage in a *Surrealist vein. In 1938 he emigrated to New York, where he did a very wide range of work, including designing the Museum of Modern Art's Bauhaus exhibition in 1938. (He continued to be an important figure in spreading Bauhaus ideas and in 1968 he designed the largest ever exhibition devoted to the school; it showed in several cities, beginning in Stuttgart, and including London (Royal Academy), where it was entitled '50 Years Bauhaus'.) In 1946 he moved to Aspen, Colorado, to work on the development of the ski resort and cultural centre. He was consultant to the Aspen Institute of Humanistic Studies, designing its Seminar Building (1953) and Walter Paepcke Memorial Building (1961). In the same period he was chairman of the design department of Container Corporation of America and throughout his life he continued to interest himself in a very broad range of cultural and environmental issues, including the conservation of historical buildings. Reginald R. Isaacs writes that 'The impact of this modest Bauhausler has been quietly and anonymously influential on architecture and design—on all design—everywhere' (*Macmillan Encyclopedia of Architects*, 1982). Although his main impact was in these fields, Bayer always considered himself as primarily a painter.

Bayes, Gilbert (1872–1953). British sculptor, born in London, the son of **Alfred Walter Bayes** (1832–1909), a painter and etcher. A leading exponent of the *New Sculpture, he concentrated on romantic themes taken from such sources as medieval chivalry and Wagner, and his work was much admired by conservative critics. One such critic, Herbert Maryon, wrote that Bayes's small bronze *Sigurd* (Tate Gallery, London, c. 1910), judged as a 'decorative composition', was 'unsurpassed by any other equestrian group in existence' (*Modern Sculpture*, 1933). Bayes's other works include the stone relief of sporting figures (1934) outside Lord's cricket ground, London, and the design of the Great Seal of King George V. He wrote *Modelling for Sculpture: A Book for the Beginner* (1930).

His brother, **Walter Bayes** (1869–1956), was a painter and writer on art. He was art critic of the *Athenaeum* from 1906 to 1916 (succeeding Roger *Fry), a founder member of the *Camden Town Group (1911) and of the *London Group (1913), and a highly regarded teacher as principal of Westminster Art School, 1919–34, and director of painting at the Lancaster School of Arts and Crafts, 1944–9. His work as a painter consisted mainly of figure subjects, landscapes, and decorations. He wrote several books, including *The Art of Decorative Painting* (1927) and *A Painter's Baggage* (1932).

Bazaine, Jean (1904–). French painter and designer, born in Paris. His early love was sculpture, which he studied at the École des *Beaux-Arts, but in 1924 he abandoned it for painting, which he studied at the *Académie Julian. From 1931 he exhibited at the *Salon d'Automne, and in 1932 he had his first one-man show. This was seen by *Bonnard, who encouraged Bazaine. His work of this time was figurative and mildly *Expressionist, but after the Second World War he gained an international reputation as one of the leading exponents of *Tachisme. However, he continued to base his compositions on natural appearances and denied that his work was abstract; his principle, in his own words, was that 'an essential quality of the object devours the complete object'. He set out his ideas on art in his book *Notes sur la peinture d'aujourd'hui*, published in 1948. Apart from

painting, his work included stained windows for the church at Assy (1944–6), a ceramic mural for the church at Audincourt (1948–51), and a mosaic for the Unesco building in Paris.

Baziotes, William (1912–63). American painter, one of the minor masters of *Abstract Expressionism. He was born in Pittsburgh and studied at the National Academy of Design, New York, 1933–6. From 1936 to 1941 he worked for the *Federal Art Project, and during the Second World War he became interested in *Surrealism and experimented with various types of *automatism. He had his first one-man exhibition at Peggy *Guggenheim's Art of This Century gallery in New York in 1944. In 1948–9 he collaborated with *Hare, *Motherwell, *Newman, and *Rothko in running the *Subjects of the Artist School in New York and from this grew a meeting centre of avant-garde artists known as The Club. In the early 1950s Baziotes developed his characteristic style, which was not fully abstract but used strange *biomorphic shapes, akin to those of *Miró, suggesting animal or plant forms in an underwater setting (*Mammoth*, Tate Gallery, London, 1957). He said: 'It is the mysterious that I love in painting. It is the stillness and the silence. I want my pictures to take effect very slowly, to obsess and to haunt.'

Beal, Jack (1931–). American *Superrealist painter, born in Richmond, Virginia, and active mainly in New York. Like Alfred *Leslie, he is unusual among Superrealists in that he concentrates on narrative or allegorical subjects, rather than scenes from the banal everyday world. He believes that art should have a didactic message and in 1979 said: 'I think that what we have to try to do . . . is to make beautiful paintings about life as we live it.' His works are often ambitious in scale and composition, notably four panels on *The History of Labour in America* (1976–7) for the United States General Services Administration.

Bearden, Romare (1912–88). American painter, collagist, writer, and lecturer. Bearden is regarded as a leading figure in black American culture, but it was only fairly late in life that he achieved widespread recognition, especially following a retrospective exhibition at the Museum of Modern Art, New York, in 1971. He was born in Charlotte, North Carolina, grew up there, in Pittsburgh, and in

Harlem, and read mathematics at New York University, 1932–5, before studying under George *Grosz at the *Art Students League, 1936–7. During the Second World War he served in the US Army, and from 1950 to 1954 he lived abroad, travelling in Europe and north Africa (in 1951 he studied art history and philosophy at the Sorbonne, Paris). His work up to this time had been varied in style (sometimes approaching abstraction) and had often used African imagery, but Jonathan Fineberg writes that 'It was the Civil Rights movement in the early sixties, together with his discovery of black Caribbean culture on the island of St Martin in 1960, that seems to have galvanized him into focusing his artistic gifts on the complexity of the black experience, with all its heritage and adaptations, in late twentieth-century America' (*Art Since 1940*, 1995). From 1964 his most characteristic works were collages combining fragmented photographic images with vivid flat areas of colour; their busy collisions and contrasts of pattern have evoked comparisons with jazz music (in which Bearden—like Stuart *Davis, who influenced him—had a great interest). Bearden was visiting lecturer in African and Afro-American art at Williams College, Massachusetts, in 1969; he also lectured elsewhere, wrote several articles, and co-authored two books: *The Painter's Mind* (1969, with Carl Holty) and *Six Black Masters of American Art* (1972, with Harry Henderson).

Beaton, Sir Cecil. See SITWELL.

Beaudin, André (1895–1980). French painter, sculptor, graphic artist, and designer. He was born at Mennecy, Seine-et-Oise, and studied at the École des Arts Décoratifs, Paris, 1911–14. The most important event in his artistic development was his meeting in 1922 with Juan *Gris, who introduced him to *Cubism. Combining this with something of *Matisse's decorative use of colour, he evolved a poetic style characterized by limpid colours and clearly patterned structures. He often painted in series, returning again and again to the same theme (*Horses*, *Rivers*, *Villas*, *The Bicycle*) until he felt he had exhausted it. In 1930 Beaudin took up sculpture, employing block-like Cubistic forms, and he also made designs for tapestry. Although he was virtually uninfluenced by *Surrealism, he had a number of Surrealist literary friends and illustrated books by several of them.

Beaux, Cecilia (1855–1942). American painter, active mainly in her native Philadelphia and in New York. Her training included a period in Paris, where she studied at the *Académie Julian and the Académie Colarossi, 1888–9. She was a highly successful and much honoured society portraitist, working in a dashing and fluid style similar to that of *Sargent. Her sitters included celebrities such as Henry James and Theodore Roosevelt, as well as leading personalities of the First World War (her last major commission came from the US War Portraits Commission in 1919). In 1930 she published her autobiography, *Background with Figures*. Examples of her work are in many American museums.

Beaux-Arts, École Nationale Supérieure des, Paris. The chief of the official art schools of France. The origins of the École des Beaux-Arts go back to 1648, the date of the foundation of the Académie Royale de Peinture et de Sculpture, but it was not established as a separate institution until 1795, during the administrative reforms of the French Revolution. It controlled the path to traditional success with its awards and state commissions, and teaching remained conservative until after the Second World War. Entry was difficult—among the artists who failed the examinations were *Rodin and *Vuillard—and students often preferred the private *académies. However, even some of the most progressive artists obtained a sound technical grounding there. The École, which is housed in a complex of early 19th-century buildings in Paris, has a large and varied collection of works of art. Many of them are primarily of historical interest (including a vast number of copies and portraits of teachers), but the collection of drawings is of high quality. The École also often hosts temporary exhibitions.

Beaux Arts Gallery, London. See LESSORE.

Beckett, Sister Wendy. See *MODERN PAINTERS*.

Beckmann, Max (1884–1950). German painter and graphic artist, one of the most powerful and individual of *Expressionist artists. He was born in Leipzig, the son of a flour merchant, and studied at the Weimar Academy, 1900–3. After spending five months in Paris, he settled in Berlin in 1904. At the beginning of his career Beckmann painted figure subjects in a conservative, more or less *Impressionist style, with which he built up a successful career, but his experiences as a medical orderly in the First World War completely changed his outlook and style. The horrors he witnessed affected him so badly that he was discharged in 1915 after a nervous breakdown. He settled in Frankfurt, where he initially worked mainly on drawings and drypoints; it was only after the war that painting became predominant again. Although he rarely depicted scenes from the war itself, his works became full of horrifying imagery, and his forms were expressively distorted in a manner that reflected the influence of German Gothic sculpture. The brutal intensity and element of social criticism in his work led him for a time to be classified with the artists of the *Neue Sachlichkeit, with whom he exhibited at the Kunsthalle, Mannheim, in 1925, but Beckmann differed from such artists as *Dix and *Grosz in his concern for allegory and symbolism and in his highly personal blend of the real and the visionary. His paintings were intended as depictions of lust, sadism, cruelty, etc., rather than illustrations of specific instances of those qualities at work; he ceased to regard painting as a purely aesthetic matter, and thought of it as a moral necessity.

Beckmann was appointed a professor at the Städelsches Kunstinstitut, Frankfurt, in 1929, and from this time began to spend each winter in Paris. In 1933 he was dismissed from his post by the Nazis, and in that year he began *Departure* (MOMA, New York), the first of a series of nine great triptychs that occupied him for much of the rest of his life and in which he expressed his horror at man's cruelty. He moved to the Netherlands in 1937 (leaving Germany the day after he witnessed Hitler opening the House of German Art in Munich—see NATIONAL SOCIALIST ART). Originally he had intended moving to Paris, but he lived in Amsterdam until 1947. In 1938 he visited London for the exhibition of 'Twentieth-Century German Art' put on at the New Burlington Galleries as a reply to the Nazi *Degenerate Art exhibition. At the London exhibition Beckmann delivered a lecture *My Theory of Painting* (*Meine Theorie der Malerie*), which was published in 1941. In 1947 he emigrated to the USA, where he spent the remaining three years of his life; he taught at various art schools, mainly in St Louis and New York. Beckmann's philosophical outlook, as

expressed in *My Theory of Painting*, is somewhat incoherent, but his work forms one of the most potent commentaries on the disorientation of the modern world. Apart from his allegorical figure compositions, he is best known for his portraits, particularly his numerous self-portraits, in which he charted his spiritual experiences.

Beerbohm, Sir Max (1872–1956). British writer, caricaturist, and broadcaster, born in London, the son of a German-born grain merchant. He studied at Oxford University, where he won a reputation as a dandy and wit that lasted throughout his life (although Kenneth *Clark remarked that 'I never heard him say anything amusing'). In 1892, when he was still an undergraduate, some of his drawings appeared in print for the first time (in the *Strand* magazine); he had drawn from childhood but had no formal training in art. William *Rothenstein, whom he met in 1893, helped to introduce him to artistic and literary circles in London, and his ironic wit was usually directed at the absurd or pretentious in fashionable society. The first of his many books, *Caricatures of Twenty-Five Gentlemen*, was published in 1896. He usually worked in pen and ink, rapidly and from memory; he thought that 'to sit down to write is a business requiring thought and conscience. Caricaturing, on the other hand, is pure instinct without any trouble at all. However, in spite of the spontaneity of the drawings themselves, he often thought about them in advance, taking notes on his subjects for future use—of Oscar Wilde, for example, he wrote: 'Wax statue, huge rings, fat white hand, feather bed, pointed fingers, cat-like tread, heavy shoulders, enormous dowager'. In 1910 he married an American actress (who seldom understood his English humour) and settled at Rapallo in Italy, where he spent the rest of his life apart from the war years. His work remained Edwardian in spirit and 'his life was passed mainly in humorous and leisurely contemplation, only interrupted by an occasional visit to England to supervise an exhibition of his drawings' (*DNB*). One of these exhibitions, in 1923, caused a rare note of controversy in his career, for he withdrew some caricatures of the royal family after a number of critics had taken offence at them. He was knighted in 1939 and late in life he won a new audience with talks on BBC radio. His books include various collections of essays, but his best-

known literary work is his only completed novel, *Zuleika Dobson* (1911), a satire on Oxford student life. In 1952 Osbert *Lancaster painted a series of pictures showing scenes from the novel for the Randolph Hotel, Oxford.

'Beggarstaff, J. & W.' (the 'Beggarstaff Brothers'). Pseudonym used by the brothers-in-law William *Nicholson and James *Pryde for their poster designs. 'They joined forces in 1894, and for the next five years they produced a series of posters which by their bold simplicity and clarity of design revolutionized certain aspects of poster art througout Europe . . . they presented the image in its starkest form; the background is stripped bare of unnecessary detail and the fullest use is made of the silhouette . . . Despite the brilliant originality of their work, or perhaps because of it, they received relatively few commissions and several of their designs never reached the hoardings' (Dennis Farr, *English Art 1870–1940*, 1978). Nicholson explained their choice of the name 'Beggarstaff' thus: 'Pryde and I came across it one day in an old stable, on a sack of fodder. It is a good, hearty, old English name, and it appealed to us, so we adopted it immediately.' They signed their work 'J. & W. Beggarstaff'; in due course some people started referring to the 'Beggarstaff Brothers', but the artists themselves did not care for this version.

Behan, John. See KELLY, OISÍN.

Bell, Clive (1881–1964). British writer on art, born at East Shefford, Berkshire, the son of a civil engineer. He studied history at Trinity College, Cambridge, then spent a year in Paris, 1903–4, looking at art and enjoying the company of painters. In 1910 he met Roger *Fry (by chance, on a train) and—immediately discovering they were kindred spirits—he became Fry's chief apostle in helping to spread an appreciation of the *Post-Impressionist painters in Britain. Bell helped with the organization of Fry's first Post-Impressionist exhibition (1910), and he chose the British section of the second one (1912), including work by his wife Vanessa *Bell, Fry himself, and Duncan *Grant among *Bloomsbury Group artists, with Spencer *Gore and Wyndham *Lewis representing the more radical wing. His aesthetic ideas, expressed most fully in his book *Art* (1914), were much con-

cerned with the theory of 'significant form'. He invented this term to denote 'the quality that distinguishes works of art from all other classes of objects'—a quality never found in nature but common to all works of art and existing independently of representational or symbolic content. The book is not now taken seriously as philosophy, and it contains some absurd statements ('The bulk of those who flourished between the high Renaissance and the contemporary movement may be divided into two classes, virtuosi and dunces'); however, it is written with fervour, and his ideas were undoubtedly influential in spreading an attitude that placed emphasis on the formal qualities of a work of art (see FORMALISM). Bell was a great Francophile; his other books include *An Account of French Painting* (1931) and a study of the writer Marcel Proust (1928). He was made a chevalier of the Legion of Honour but received no comparable distinction from his own country.

Quentin Bell (1910–96), the son of Clive and Vanessa Bell, was a painter, sculptor, potter, and author, probably best known for his writings on art, mainly on the Victorian period and the Bloomsbury Group. Between 1962 and 1975 he was a professor successively at the universities of Leeds, Hull, and Sussex. Quentin's daughter, **Cressida Bell**, is a textile designer, and his son, **Julian Bell** (1952–), is a painter and writer on art, author of a monograph on *Bonnard (1994).

Bell, George (1878–1966). Australian painter, draughtsman, teacher, and critic. In 1903–20 he lived in Europe (he was an *Official War Artist in the First World War), then returned to his native Melbourne. He started teaching privately in 1922 and in 1925 founded the Bell–Shore School with Arnold Shore (1897–1963). By this time Bell was a well-established painter working in an uncontroversial *Impressionist style, but he was plagued by doubts about the validity of his work, thinking that he should be trying to extract the 'underlying truth' from visual appearances rather than merely recording them. His style began to move more towards *Post-Impressionism, and in 1934–5 he made another visit to Europe, this time specifically to study modern painting (he was the first Australian artist to do so): *Braque, *Cézanne (above all), *Matisse, and *Picasso were among the artists to whom he paid the most attention. He was less distinguished as a painter than as a

teacher—a seminal figure in the development of modernism in Australia: Robert *Hughes calls him 'arguably the most influential single teacher who ever worked in Australia' (*The Art of Australia*, 1970). Russell *Drysdale was his most famous pupil. Bell was art critic for the *Melbourne Sun News-Pictorial*, 1923–48.

Bell, Graham (1910–43). British painter and art critic, born in South Africa. After studying at Durban Art School he moved to London in 1931 and became a pupil of Duncan *Grant. In the early 1930s he painted abstracts (he exhibited with the *Objective Abstractionists in 1934), but from 1934 to 1937 he abandoned painting for journalism, writing art criticism in a socialist vein for the *Left Review*, the *Listener*, and the *New Statesman* (he also wrote a pamphlet called *The Artist and his Public*, 1939). When he returned to painting it was in the soberly naturalistic style associated with the *Euston Road School. His work included portraits, landscapes, interiors, and still-lifes; his best-known picture is probably *The Café* (City Art Gallery, Manchester, 1937–8). Bell volunteered for war service in 1939 and was killed in a crash during an RAF training flight. In the introduction to *Paintings of Graham Bell*, published in 1947, Kenneth *Clark wrote: 'his critical intelligence was extremely acute . . . I think he would have become a very good painter. There is an air of largeness and essential truth in his best work which only needs filling out and enriching in order to become great.'

Bell, Julian. See BELL, CLIVE.

Bell, Larry (1939–). American abstract sculptor. He was born in Chicago and studied at the Chouinard Art Institute, Los Angeles, 1957–9. In the early 1960s he turned from painting to making glass sculptures of refined simplicity, his work representing an extreme development of the tendency among certain young Californian artists of the time to dematerialize the art object and work with pure qualities of light. His virtually invisible glass panels (subtly coated to create varying degrees of opacity and reflection) were the most novel works shown at the exhibition 'Spaces' at the Museum of Modern Art, New York, in 1970. In 1972 he began to make outdoor sculptures of coated glass.

Bell, Quentin. See BELL, CLIVE.

Bell, Robert Anning (1863–1933), British painter, sculptor, designer, illustrator, and teacher, born in London. His highly varied artistic training began with two years in an architect's office, continued at the *Royal Academy and the Westminster School of Art, and was rounded off with stays in Paris and Italy. He gained some of his sculptural expertise by sharing a studio for a while with Sir George *Frampton. Bell's interest in the architectural setting of art helped him to win numerous decorative commissions for mosaics, stained glass, and relief sculpture. His clear, linear style, influenced by Italian Renaissance art, was well suited to this type of work. Examples of his mosaics are in Westminster Cathedral and the Houses of Parliament, and his stained glass includes the Shakespeare window in Manchester Reference Library—his last major work, completed shortly before his death. His versatility stood him in good stead as a teacher at University College in Liverpool, where he was appointed to teach painting and drawing in 1895, *Glasgow School of Art, where he became head of design in 1911, and the *Royal College of Art, where he was professor of design from 1918 to 1924. As a painter he worked mainly in watercolour; his subjects were often in a romantic *Pre-Raphaelite vein. As an illustrator he was noted particularly for his work for children's books. He had a considerable reputation on the Continent as well as in Britain. His second wife, **Laura Anning Bell** (1867–1950), was a portraitist, mainly in pastel.

Bell, Vanessa (1879–1961). British painter and designer, born in London into a distinguished literary family; her father was Sir Leslie Stephen, the first editor of the *Dictionary of National Biography*, and her younger sister became famous as the novelist Virginia Woolf. She studied at the *Royal Academy Schools, 1901–4, and in 1905 founded the *Friday Club as a discussion group for artists. In 1907 she married Clive *Bell, and their house at 46 Gordon Square became one of the focal points of the *Bloomsbury Group. Her early work, up to about 1910, and her paintings produced after the First World War are tasteful and fairly conventional, in the tradition of the *New English Art Club, but in the intervening period she was briefly in the vanguard of progressive ideas in British art. At this time, stimulated by the *Post-Impressionist exhibitions organized by Roger *Fry (with whom she

had an affair), she worked with bright colours and bold forms, and by 1914 she was painting completely abstract pictures. Her designs for Fry's *Omega Workshops include a folding screen (V&A, London, 1913–14) clearly showing the influence of *Matisse (Gertrude *Stein had introduced her to Matisse and *Picasso in Paris in January 1914).

From 1916 Bell lived with Duncan *Grant, by whom she had a daughter in 1918. However, she remained on good terms with her husband, who was lavish in his praise of both her and Grant's work. Bell and Grant spent a good deal of time in London and travelling abroad, but they lived mainly at Charleston Farmhouse, at Firle, Sussex, and did much painted decoration in the house; it has been restored as a Bloomsbury memorial and is open to the public (the couple are buried together nearby in Firle churchyard). In addition to the work at Charleston, they collaborated on other decorative schemes, including a series of murals at Berwick church, Sussex, a few miles away. Bell's independent work included portraits, landscapes, interiors, and figure compositions. She also did a good deal of design work, including covers for books published by the Hogarth Press, founded by Virginia Woolf and her husband Leonard Woolf in 1917. After the Second World War, her work—like that of Grant—went out of fashion, but she continued painting vigorously into her old age, even though the death of her son, the poet Julian Bell (1908–37), in the Spanish Civil War was 'the end of all real happiness' (Richard Shone, *Bloomsbury Portraits*, 1976). Throughout her life Bell was a voluminous correspondent. About 3,000 of her letters survive, providing a rich source of information on the Bloomsbury circle; some 600 of them appear in *Selected Letters of Vanessa Bell*, edited by Regina Marler (1993).

Bellany, John (1942–). Scottish painter, working in a vigorous—at times rather tormented—*Expressionist style. He was born and brought up in the fishing village of Port Seton, near Edinburgh, and the imagery of his work is often derived from the sea, although it is transformed into a kind of personal mythology. From 1960 to 1965 he studied at Edinburgh College of Art, and from 1965 to 1968 at the *Royal College of Art, London. His most characteristic works are large compositions involving hybrid human and animal forms, painted with explosive brushwork and

suggesting some vague menace. An example is *Mizpah* (NG of Modern Art, Edinburgh, 1978), of which Christopher Johnstone writes: 'Mizpah has the form of a crucifixion. The boat's mast and furled sail are the cross; a fish (an ancient symbol for Christ) hangs from the man's neck. As the sea washes over the deck a creature plays an accordion and a bird with breasts looks on. The effect is of a modern Ship of Fools. Biblical names for fishing boats are still quite common since religion plays an important role in fishing communities. The Hebrew word Mizpah appears in Genesis . . . The word appears in several of Bellany's paintings where it takes on the characteristics of a highly personal talisman' (*Fifty 20th Century Artists in the Scottish National Gallery of Modern Art*, n.d.). Bellany himself says of his work: 'I'm trying to say something deep about the human condition . . . My heroes are not bores like Andy *Warhol . . . I prefer meat on the bone to facile statements by graphic designers.' In addition to his allegorical compositions, Bellany has painted many portraits, including a well-known one of the cricketer Ian Botham (NPG, London, 1985). In the late 1980s Bellany became seriously ill and he had a liver transplant in 1988; after his recovery his work became more optimistic in spirit. This is expressed in the coloured etchings he began to produce in the early 1990s as well as his paintings. His work has been widely exhibited in Britain, Europe, and the USA.

Belling, Rudolf (1886–1972). German sculptor, born in Berlin, where he studied at the Academy, 1911–12. In 1918 he joined the *Novembergruppe and during the 1920s he was influential in introducing *Cubist and *Futurist ideas to Berlin. His own work was strongly influenced by *Archipenko, notably in its alternation of solids and voids. However, his style became more self-consciously formalized than Archipenko's, as in *Sculpture* (MOMA, New York, 1923), a robot-like head in polished metal. From 1937 to 1966 Belling taught in Istanbul, then settled at Krailling, near Munich.

Bellingham Smith, Elinor. See MOYNIHAN.

Bellmer, Hans (1902–75). German-French graphic artist, painter, sculptor, photographer, and writer, all of whose work is explicitly erotic. He was born in Kattowitz, Germany (now Katowice, Poland). In 1922–4 he studied engineering in Berlin (compelled by his tyrannical father), but he gave up the course after becoming friendly with *Dix and *Grosz and began working as a typographer and bookbinder, then as a draughtsman in an advertising agency. In 1933 he constructed an articulated plaster figure of a young girl, inspired partly by an infatuation with his 15–year-old cousin Ursula and partly by memories of secret sexual encounters of his adolescence. He photographed his creation in various attitudes and states of dismemberment (sometimes partly clothed) and published a collection of the photographs as *Die Puppe* ('The Doll') in Karlsruhe in 1934; a French edition, *La Poupée,* was published in Paris in 1936. Bellmer sent samples of the photographs to André *Breton in Paris, and the *Surrealists were highly excited by these striking images of 'vice and enchantment'. In 1938, in danger of arrest by the Nazis, Bellmer fled to Paris to join the Surrealists. He was interred at the beginning of the war (with Max *Ernst), then lived in the South of France, 1942–6, before returning to Paris. He then 'began a long series of drawings and etchings which further developed the violent eroticism of his dolls . . . these are often ambiguous superimposed images conjuring up visions of far-from-innocent little girls taking part in advanced sexual exercises, or strange anatomical inventions made up of of sexual apertures and throbbing organs. These exciting, honest, and totally unprurient creations are always executed in a marvellously refined and elegant technique, culminating in the large and highly complex two-colour etchings entitled *Petit Traité de la Morale* (1968), which illustrate the sexual dreams of young girls and at the same time the sexual fantasies of their author. These ten prints constitute one of the finest expressions of erotocism in twentieth-century art, and they show the uniqueness of Bellmer's erotic art in that they are *non-naturalistic*, graphic transcriptions of mental images relating to erotic desire' (Peter Webb, *The Erotic Arts*, 1975). Bellmer also produced paintings and sculpture in a similar vein. His work was not well known until a large retrospective in 1971–2 at the Centre National d'Art Contemporain, Paris.

Bellows, George Wesley (1882–1925). American painter and lithographer, born in Columbus, Ohio. He studied at Ohio State University

before moving in 1904 to New York, where he was a pupil of Robert *Henri and became associated with the *Ashcan School. An outstanding athlete in his youth and noted for his hearty, outgoing character, Bellows is best known for his boxing scenes. The most famous of them is *A Stag at Sharkey's* (Cleveland Museum of Art, 1907), remarkable for its vivid sense of movement and energetic, sketchy brushwork: he said 'I don't know anything about boxing [a 'stag' was a boxing match held in a private club]; I'm just painting two men trying to kill each other'. Such works rapidly won him a reputation, and in 1909—aged 27—he became the youngest person ever elected an associate member of the National Academy of Design. He took a highly active part in the art life of his day and was one of the organizers of the *Armory Show in 1913. After this, his work tended to become less concerned with movement, placing more emphasis on formal balance. He was a man of strong social conscience, and his work included scenes of the urban poor—of which the most famous is the crowded tenement scene *Cliff Dwellers* (Los Angeles County Museum of Art, 1913)—and a series of paintings and lithographs about First World War atrocities. He did not take up lithography until 1916, but in the nine remaining years of his life he produced almost 200 prints, and he is accorded a high place among modern American printmakers; his *A Stag at Sharkey's* (1917), in which he reworked the composition of his celebrated painting, has been described as 'the most famous American print of this century' (Frances Carey and Antony Griffiths, *American Prints 1879–1979*, 1980). In the last five years of his life Bellows turned to landscapes and portraits and was considered one of the finest American portraitists of his day. His early death was caused by a ruptured appendix.

Belsky, Margaret (née Owen) (1918–89). British cartoonist. Under the name 'Belsky' she worked for the *Daily Herald* and the *Sun*. Her obituary in the *Daily Telegraph* described her as 'the first woman to break into what had been the exclusively male world of cartoon drawing'. She was married to the Czech-born sculptor **Franta Belsky** (1921–), whose work includes the statue of Lord Mountbatten (1983) on Foreign Office Green, London.

Belzile, Louis. See PLASTICIENS.

Ben (Benjamin Vautier). See BODY ART.

Beneš, Vincenc. See GROUP OF PLASTIC ARTISTS.

Benjamin, Karl. See HARD-EDGE PAINTING.

Benjamin, Walter (1892–1940). German writer, regarded as one of the leading cultural critics of the 20th century. He was born in Berlin into an intellectual Jewish family and studied successively at the universities of Freiburg, Berlin, Munich, and Berne, where he obtained a PhD in 1919. For most of his career he made a precarious living as a journalist in Berlin. In 1933 he left Germany because of the rise of Nazism and settled in Paris. After the German invasion of France he fled to Spain and committed suicide at the border in a moment of despair when he was denied entry for trivial bureaucratic reasons. Benjamin's writings are 'a curious mixture of esoteric, sometimes mystical Jewish thought, artistic modernism and unorthodox Marxism' (Terry Eagleton in *The Fontana Dictionary of Modern Thinkers*, 1983). In the context of the visual arts, his most important essay is 'Das Kunstwerk im Zeitalter seiner technischen Reproduzierbarkeit' (The work of art in the age of mechanical reproduction), originally published in 1936 in *Zeitschrift fur Socialforschung*, which was operating in exile in New York. In this he 'argues that the "aura" of the original unique work of art is lost to reproducibility; but that this, far from being something to mourn, opens up progressive possibilities' (Charles Harrison and Paul Wood, *Art in Theory 1900–1990*, 1992). He believed that technical change could encourage a progressive popular art: 'Mechanical reproduction of art changes the reaction of the masses toward art.'

Benois, Alexandre (1870–1960). Russian painter, stage designer, art historian, and critic, a leader and spokesman of the *World of Art group. Born in St Petersburg of Franco-Italian descent (his father, Nikolai Benois, was an architect in imperial service), he studied law at university, 1890–4, and was largely self-taught as an artist. He was a close friend and collaborater of *Diaghilev, both in Russia and later in Paris, and he is best known for his stage designs for the Ballets Russes, in which he harmonized the tradition of Russian folk art with French Rococo elements, one of the

most notable examples being Stravinsky's *Petrushka* (1911). Following a difference of opinion with Diaghilev he worked at Stanislavsky's Moscow Arts Theatre, 1912–14. After the Revolution he was appointed curator of paintings at the Hermitage in Leningrad, Russia's greatest museum. He held this post from 1918 to 1925, then settled permanently in Paris, where he continued to work as a stage designer. His writings include several volumes of memoirs and books on art, including works translated into English as *The Russian School of Painting* (1916), *Reminiscences of the Russian Ballet* (1941), and *Memoirs* (1960).

Benois's son, **Nikolai** (1901–88), was a stage designer at La Scala, Milan; his niece, **Nadia Benois** (1896–1975), settled in London in 1920 and worked as a stage designer, notably for the Ballet Rambert and the Sadler's Wells Ballet. The actor and writer Peter Ustinov is her son.

Benoit, Rigaud. See HYPPOLITE.

Benson, F. W. See TEN.

Benton, Thomas Hart (1889–1975). American painter, the great-nephew of a famous American statesman of the same name. He was born in Neosha, Missouri, and studied at the Art Institute of Chicago, 1907–8, and at the *Académie Julian, Paris, 1908–11. In Paris he became a friend of the *Synchromist Stanton *Macdonald-Wright, and after his return to the USA (he settled in New York in 1912) he continued painting in the Synchromist manner for some years. He exhibited in the *Forum Exhibition of Modern American Painters in 1916, but having failed to win success working in an avant-garde style, he abandoned modernism around 1920 and gained fame as one of the leading exponents of *Regionalism and the chief spokesman for the movement. He claimed that the success enjoyed by himself, Steuart *Curry, and Grant *Wood came from the fact that they 'symbolized esthetically what the majority of Americans had in mind—America itself'. Benton's style in his Regionalist work was richly coloured and vigorous, with restlessly energetic rhythms and rather flat, sometimes almost cartoonish figures. His work included several murals, notably scenes of American life (1930–1) at the New School for Social Research in New York. Their popularity encouraged government support for such wall paintings, although Benton himself never did any work for the *Federal Art Project. In 1935 he left New York to become director of the City Art Institute and School of Design in Kansas City, Missouri, and he lived in that city for the rest of his life. He continued to paint murals as well as a variety of easel pictures, including landscapes, portraits, and a novel kind of work in which he introduced American types into representations of Greek myths or biblical stories (*Susanna and the Elders*, California Palace of the Legion of Honor, 1938).

Benton wrote numerous articles on art, many published in the University of Kansas's *University Review*, and he was the author of two autobiographies, *An Artist in America* (1937) and *An American in Art* (1969). A passage from the second shows how completely he turned his back on the modernism he had espoused in his youth: 'Modern art became, especially in its American derivations, a simple smearing and pouring of material, good for nothing but to release neurotic tensions. Here finally it became like a bowel movement or a vomiting spell.' In view of these words, it is ironic that Benton was influential on Jackson *Pollock, whom he taught at the *Art Students League of New York in the early 1930s.

Bérard, Christian (1902–49). French designer, painter, and draughtsman. He was born in Paris and studied at the *Académie Ranson (under *Vuillard) and the *Académie Julian. With *Berman and *Tchelitchew he was the leading representative of *Neo-Romanticism in French painting, but his career was devoted mainly to design, particularly for the theatre and also for the cinema and the fashion world. His first notable success was the design of the ballet *Les Elves* (1924) for Michel Fokine, and subsequently he worked for many other leading choreographers. He also had a fruitful relation with Jean *Cocteau, whom he met in 1926 and whose portrait he painted in 1928 (MOMA, New York). Bérard made designs for several of his plays and three of his films, most famously *Beauty and the Beast* (1946), which was perfectly suited to his gift for fantasy and 'may be considered in some respects almost as much the achievement of Bérard as of Cocteau' (*Oxford Companion to Film*, 1976). His other work included fashion drawings in such magazines as *Harper's Bazaar* and *Vogue*. 'Bérard, a ubiquitous personality in the theatre world, was a short dishevelled man with an unruly beard whose appearance belied the stunning beauty of his stage designs' (Tom

Mikotowicz in *The Cambridge Guide to World Theatre*, 1988).

Bergen, Edgar. See HAMNETT.

Berger, John (1926–). British writer and broadcaster, well known both as a left-wing art critic and as a novelist. He was born in London, where he studied at the Central School of Art and Chelsea School of Art, and began his career as a painter and teacher of drawing. From 1952 to 1961 he wrote regularly for the *New Statesman*, and this was the period of his greatest influence as a critic. His support for realist painters, notably *Bratby and the other members of the *Kitchen Sink School, was combined with political sympathies for the Communist Party. Although he never slavishly followed the party line in uncritical praise for *Socialist Realism, he attacked contemporary art in the West as being over-concerned with *formalism. In 1958 he published his first novel, *A Painter of Our Time*, in which he explored the dilemma of the Communist artist in the West, particularly after the Soviet invasion of Hungary in 1956; the book was loosely inspired by László (or Peter) Peri (1899–1967), a Hungarian-born sculptor and painter who emigrated from Germany to England in 1933. A collection of Berger's criticism appeared in book form in 1960 as *Permanent Red: Essays in Seeing* (in the USA it was given the significantly less politicized title *Toward Reality*), but he stopped writing regular criticism the following year. By this time, many of those he had supported had turned away from realism and the success of *Abstract Expressionism represented a defeat for his values.

Subsequently Berger achieved fame as a novelist (he won the Booker Prize for *G* in 1972), but he continued to write on art, producing several controversial books, including *Success and Failure of *Picasso* (1965), which emphasized the artist's anarchist roots and examined the failure of the Communists to make real use of one of their most celebrated adherents. His most famous book is *Ways of Seeing* (1972, originating in a television series of the same name, 1969), in which he challenged the whole tradition of Western art, linking it to political, economic, and sexual exploitation, particularly through advertising. The views he expressed were initially strongly contested (Lawrence *Gowing said that Berger was managing to 'interpose himself ... between us and the visible meaning of

a good picture'), but the book's arguments have tended to become a complacently accepted orthodoxy. It is often one of the first texts art students are recommended to read, possibly to persuade young idealists that they might as well work for the advertising industry. Berger's other books include monographs on *Guttuso (1957) and *Léger (1966) and *Art and Revolution: Ernst *Neizvestny and the Role of the Artist in the USSR* (1969). In the 1970s Berger moved to France, living in a peasant farming community in the Jura. Introducing a 1979 reprint of *Permanent Red*, he concluded that 'I now believe that there is an absolute incompatibility between art and private property, or between art and state property—unless the state is a plebeian democracy'. See also FULLER.

Bergh, Richard (1858–1919). Swedish painter, writer, and art administrator, born in Stockholm, son of a landscape painter, Edvard Bergh (1828–80). From 1878 to 1881 he studied at the Academy in Stockholm, where his father was a professor, then spent the next three years in Paris. His work was strongly influenced by French open-air painting and *Symbolism, but he made them the basis of a distinctive Swedish national romanticism, as in his most famous work, *Nordic Summer Evening* (Konstmuseum, Gothenburg, 1899–1900). It shows a man and a woman on a veranda looking out over a lake in an atmosphere heavy with psychological tension. Bergh was also a fine portraitist, notably of his artist and intellectual friends. He took a keen interest in political and social issues and was a founding member (1885) of the Artists' Union, which revolted against the conservatism of the Stockholm Academy. In 1915 he was appointed Director of the Nationalmuseum in Stockholm, which he reorganized into a modern, dynamic institution. Collections of his articles on art were published in 1908 (revised 1919) and (posthumously) in 1921.

Berghe, Frits van den (1883–1939). Belgian painter, born in Ghent, where he studied (1897–1904) and later taught (1907–11) at the Academy. While teaching in Ghent he lived at nearby *Laethem-Saint-Martin, where he was a member of a colony of artists including *Permeke and de *Smet. He also worked with de Smet in Holland when they fled there during the First World War. It was at this time that his work turned decisively from *Impres-

sionism to *Expressionism, and he is regarded as one of Belgium's leading exponents of the style. He returned to Belgium in 1922 and settled permanently in Ghent in 1925. Initially his Expressionist work was vaguely derived from *Cubism, with block-like forms and matt surfaces, but from the mid-1920s his paintings took on a more fantastic quality in the tradition of *Ensor and Hieronymus Bosch. These works have been seen by some as an anticipation of *Surrealism. His subjects included landscapes, portraits, nudes, and allegories of the human condition.

Bergman, Anna-Eva. See HARTUNG.

Bergner, Yosl. See *ANGRY PENGUINS*.

Berman, Eugene (1899–1972). Russian-born painter and stage designer who became an American citizen in 1937. He was born in St Petersburg, the son of a prosperous banker, and fled with his family during the Revolution, settling in Paris in 1918 and studying at the *Académie Ranson. During the 1920s, with *Tchelitchew (another Russian emigré) and *Bérard, he was a leading exponent of *Neo-Romanticism, painting dreamlike scenes with mournful drooping figures. In 1935 he emigrated to New York, where he worked mainly as a designer for ballet and opera, in which field he was considered one of the outstanding artists of his day. In particular he often collaborated with the Russian-born choreographer George Balanchine, from *Concerto Grosso* (for American Ballet Caracan) in 1941 to *Pulcinella* (for New York City Ballet) in 1972. He continued painting, however, his style showing the influence of *Surrealism. In both his paintings and his stage designs he often featured architectural ruins. In his later life Berman spent much of his time in Italy and he died in Rome.

Bernard, Émile (1868–1941). French painter and writer, born in Lille. As a young man he studied in Paris alongside van Gogh and Toulouse-Lautrec, and between 1888 and 1891 he worked closely with *Gauguin. Bernard seems to have had a stimulating effect on his great colleague, but thereafter his work as a painter declined in importance and he became of interest chiefly for his activities as a writer, playing a significant role as a sponsor of *Post-Impressionism. In 1890 he helped to organize the first retrospective exhibition of van Gogh's work (soon after his death), he published much journalism and criticism on *Cézanne, *Redon, and other artists, and his correspondence with some of the leading painters of the time has been a rich quarry for art historians (much of it published in *Lettres de Vincent van Gogh, Paul Gauguin, Paul Cézanne . . . a É. Bernard*, 1926; new edn., 1942). Bernard travelled in the Near East and Egypt, 1893–1904, then settled in Paris, where he founded and edited the journal *La Rénovation esthétique*, 1905–10; it expressed what by this time had become his reactionary views on art and politics.

Bernard, Joseph. See DIRECT CARVING.

Bernheim-Jeune. French family of art dealers and publishers. **Alexandre Bernheim-Jeune** (1839–1915), the son of an artists' supplier, opened a gallery in Paris in 1865 and was succeeded by his sons **Joseph** (known as Josse) (1870–1941) and **Gaston** (1870–1953), who was himself an artist, painting under the name Gaston de Villers. (Although they have the same year of birth, the brothers were not twins; Joseph was born in January, and Gaston in December.) By the 1890s the gallery was dealing in the work of leading *Impressionists, including *Monet, *Pissarro, and especially *Renoir, who painted five portraits of the family (the other artists who painted the family included *Bonnard and *Vuillard; there are examples by all three artists in the Musée d'Orsay, Paris). From about the turn of the century the gallery began showing an interest in more avant-garde work, and in 1901 it held a major retrospective exhibition of van Gogh's work (see EXPRESSIONISM). Its links with a younger generation of artists were reinforced when Félix *Vallotton married Alexandre's daughter in 1899 and when Félix *Fénéon became a director in 1906. He remained with the Galerie Bernheim-Jeune until 1925, in charge of its modern section; in this role he dealt particularly in the work of *Neo-Impressionists such as Henri-Edmond *Cross and the *Fauves (including *Matisse), but he also, for example, arranged the first group exhibition of the *Futurists in France (1912) and showed the work of the *Synchromists in 1913. The firm published monographs on several of the artists in which it dealt and also issued a periodical, *Bulletin de la vie artistique*.

Bertini, Gianni. See MEC ART.

Bertoia, Harry (1915–78). Italian-born sculptor and designer who settled in the USA in 1930 and became an American citizen in 1946. He studied at the Detroit Society of Arts and Crafts, then at the Cranbrook Academy of Art, Michigan; in 1939 he began teaching metalwork at Cranbrook. His colleagues there included the architect and designer Charles Eames (1907–78), and in 1943 Bertoia moved to California to join him in designing a series of chairs. In 1950 he moved to Bally, Pennsylvania, where in 1952 he designed the Bertoia chair, which features an elegant moulded mesh of chromium-plated steel wire. It was well suited to the open planning becoming popular in American homes and offices and was marketed with great success by Knoll Associates Inc. By this time, however, Bertoia was turning increasingly to sculpture, and in 1953 he received his first large sculptural commission—a screen for the General Motors Technical Center in Detroit. Many other major commissions followed, including a fountain (1967) at the Civic Center, Philadelphia. Typically his sculptures are sensitively related to their architectural setting and combine strong abstract forms with intricately worked detail (sometimes deriving from plant tendrils and other organic forms) in which he demonstrated his skill as a metalworker (the materials he used included brass, bronze, and steel). From 1960 until the end of his life, Bertoia also experimented with incorporating sound effects in his sculpture, generally by using metal rods that strike against one another.

Beskin, Osip. See FORMALISM.

Besnard, Albert (1849–1934). French painter, graphic artist, designer, and administrator, born in Paris, where he studied at the École des *Beaux-Arts. He combined academic skill in draughtsmanship with the light colours of *Impressionism in a way that brought him great success (particularly as a decorative artist) and many official honours. The public buildings he decorated in Paris included the Musée des Arts Décoratifs (1900), the Hôtel de Ville (1905–13), and the Petit Palais (1907–10). His other work included portraits and designs for stained glass. In 1913 he was appointed director of the French Academy in Rome, and in 1922 director of the École des Beaux-Arts in Paris. There is a large collection of his etchings in the Musée Baron Martin at Gray,

Haute-Saône; they provide a fascinating commentary on French art and society at the turn of the century.

Beuys, Joseph (1921–86). German sculptor, draughtsman, *Performance artist, and teacher, one of the leading figures in avant-garde art in Europe in the 1970s and 1980s. Like Yves *Klein, he was highly influential in shifting emphasis from what an artist makes to his personality, actions, and opinions, and he succeeded in creating a kind of personal mythology. (As a Luftwaffe pilot he was shot down in the Crimea in 1943 and according to his own account, which has been doubted, he was looked after by nomadic Tartars who kept him warm with fat and felt—materials that came to figure prominently in his work. The hat that he habitually wore hid the head injuries he received in the crash.)

Beuys was born in Krefeld and spent most of his early life in or near Kleve. He had intended being a paediatrician, but because of the outbreak of the Second World War he went virtually straight from school into the German air force. During his service he was wounded five times and he ended the war as a prisoner. In 1946–51 he studied at the Düsseldorf Academy, and in 1961 he was appointed professor of sculpture there. Characteristically his sculpture is made of junk material or rough, unworked wood. However, he probably became better known for performances, of which a famous example was *How to Explain Pictures to a Dead Hare* (1965). In this he walked around an exhibition in the Schmela Gallery in Düsseldorf, his face covered in honey and gold leaf, carrying in his arms a dead hare, to which he gave an explanation of various pictures. He described the performance as 'A complex tableau about the problems of language, and about the problems of thought, of human consciousness and of the consciousness of animals'.

In 1962 Beuys became a member of *Fluxus, an international group of artists opposed to tradition and professionalism in the arts, and he was also active in politics, aligning himself with the Greens, the West German ecological party. His 'presumptuous political dilettantism' was condemned by several of his colleagues at the Academy and in 1972 he was dismissed from his professorship. The protests that followed included a strike by his students, and a settlement was eventually reached whereby he kept his title and his

studio but his teaching contract was ended. From this point he devoted more and more of his time to public speaking and debate, the well-known personalities with whom he conferred including Andy *Warhol and the Dalai Lama. Although he continued to make sculpture, he dismissed the art object as 'a useless piece of merchandise whose only purpose is to provide the artist with an income'. This was in line with the ideas of *Arte Povera, seeking to undermine the commercialization of the art world, but even the blackboards that he used in his lectures and demonstrations have been sold for hefty sums. By the end of his life he was an international celebrity and was regarded by his admirers as a kind of art guru. Edward *Lucie-Smith writes that 'Beuys's mission, as he saw it, was to offer society a form of moral, social, and psychological therapy, but not necessarily any form of visual stimulus' (*Visual Arts in the Twentieth Century*, 1996). Writing a few years before the artist's death (in *The Fontana Dictionary of Modern Thinkers*, 1983), Peter *Fuller took a less charitable view: 'Beuys's many vociferous proponents maintain that he is demonstrating that the whole process of living itself can be regarded as a creative act. In reality, however, Beuys may be little more than an adroit poseur who has successfully exploited the decadence of late modernist vanguardism to his own advantage.'

Bevan, Robert (1865–1925). British painter and lithographer, born in Hove, Sussex. He studied briefly at Westminster School of Art under Fred *Brown (1888), then at the *Académie Julian in Paris. During the 1890s he travelled a good deal (including visits to Spain and Tangier) and he had two lengthy stays in Pont-Aven, where he met *Gauguin in 1894. In 1900 he settled in London, where he became a member of *Sickert's circle in 1908 and was a founder member of the *Camden Town Group (1911), the *London Group (1914), and the *Cumberland Market Group (1914). His work was much influenced by Gauguin's strong colour and flat patterning, and in his last years his style became increasingly simplified and schematic. He is best known for paintings featuring horses (*The Cab Horse*, Tate Gallery, London, c. 1910), and he also painted landscapes and market scenes. Frank *Rutter wrote of him: 'During his lifetime his work received less recognition than was its due outside of a sympathetic circle of fellow-artists and art-lovers. It was sober, sincere and unspectacular and these are not the qualities which the general public expects to discover or feels called on to appreciate in modern art. Of recent years, however, Bevan's true worth as an original artist and sturdily individual painter . . . has begun to be widely acknowledged' (*Modern Masterpieces*, 1940).

Bevan's wife, the Polish-born Stanislawa de Karlowska (1876–1952), whom he married in 1897, was also a painter. He made several visits to Poland with her.

Biddle, George (1885–1973). American painter and lithographer. Originally he trained as a lawyer, but in 1908 he turned to painting, studying at the Pennsylvania Academy of Fine Arts in his native Philadelphia, then between 1911 and 1914 in Munich and Paris (at the *Académie Julian). He served in the US Army in the First World War, then travelled widely (he spent two years in Polynesia) before settling permanently in the USA in 1932. Biddle was a man of strong social conscience and he was inspired by the idea of art for the masses expressed by the Mexican mural painters. In 1933 he helped to persuade President Franklin D. Roosevelt of the need for government sponsorship of the arts—a need that was met two years later with the *Federal Art Project. Biddle himself was employed by the Project, painting a mural for the Department of Justice Building in Washington (1935). He wrote an autobiography, *An American Artist's Story*, published in 1939.

Biederman, Charles (1906–). American abstract artist and art theorist, born in Cleveland, Ohio, of Czech immigrant parents. He trained in Cleveland as a commercial artist, 1922–6, then studied at the Art Institute of Chicago School, 1926–9. In 1936–7 he lived in Paris, where he met *Léger, *Mondrian, and *Pevsner, amongst other leading artists. After returning to the USA he lived in New York until 1940, then after two years in Chicago settled in Red Wing, Minnesota, in 1942. From 1937 he abandoned painting and concentrated on coloured geometric reliefs, to which for some years he applied the word 'Structurist' (*Structurist Relief, Red Wing No. 20*, Tate Gallery, London, 1954–65): 'a Structurist work is neither painting nor sculpture, but a structural extension of the two.' His promotion of such works in his book *Art as the Evolution of Visual Knowledge* (1948) had an important influence on British *Constructivists, notably

Anthony *Hill, Kenneth and Mary *Martin, and Victor *Pasmore, each of whom corresponded with Biederman. He has written other books and many articles on art theory. In his writings, particularly *Art as the Evolution of Visual Knowledge*, Biederman argued that from the beginning art had been dominated by two conflicting aims—the imitation of natural appearances and the exercise of the 'inventive' or 'creative' faculty. This faculty had led artists to depict the typical or generic or to search for the 'ideal', rather than literally recording 'the uniquely particular or individual characteristics of the objective world'. Because the camera can perform the recording function more efficiently, artists were now free to give themselves up wholly to 'invention'. He then went on to argue that since illusion is no longer necessary, the illusion of three-dimensional space must also be abandoned. This line of reasoning can hardly be described as watertight, but it had a strong appeal for many abstract artists of the time, especially those who held it a virtue to present their works as real things in the real world.

Biennale (or **Bienal** or **Biennial**). An art exhibition held every two years, particularly a large and prestigious exhibition of international scope. The first to be founded and still the most famous is the Venice Biennale, instituted in 1895 as the 'International Exhibition of Art of the City of Venice', and claiming to represent 'the most noble activities of the modern spirit without distinction of country'. It was organized to celebrate the 25th wedding anniversary of King Umberto I and Queen Margherita of Savoy, but in fact took place two years after the event. At this first Biennale, artists from sixteen different nations were represented, 516 works were exhibited, and there were more than 200,000 visitors. The committee included some of the most famous artists of the time, including Sir Edward Burne-Jones (see PRE-RAPHAELITISM), the Dutch painter Jozef Israëls (1824–1911), Max *Liebermann, and the French *Symbolist painters Gustave Moreau (1826–98) and Pierre Puvis de Chavannes (1824–98). The exhibition soon acquired world-wide prestige, and after it resumed in 1948 following the Second World War it became the leading showplace for the established international avant-garde. Henry *Moore, for example, set the seal on his reputation when he won the International Sculpture Prize in 1948.

The Biennale is centred in the Giardini Pubblici (Public Gardens), where a number of pavilions have been built by the countries that exhibit at the exhibition. These structures are permanent (although there has been much rebuilding over the years) and their styles provide an interesting array of national self-images. There is often controversy over the selection of artists to represent each country (entrusted to or sponsored by bodies such as the British Council in Britain and the Smithsonian Institution in the USA) and the press frequently carries rumours of intrigue or corruption surrounding the awarding of prizes (the jurors are usually distinguished figures in the art world, more likely to be susceptible to flattery than bribery). Lawrence *Alloway (who resigned from the Guggenheim Museum, New York, because of a disagreement over the choosing of American artists for the 1966 Biennale) published a history of the exhibition in 1968 (*The Venice Biennale: 1895–1968*). He writes that 'here are more artists, dealers, collectors, and writers in one place at one time than can be found anywhere else in the world ... The 1966 Biennale showed 2,785 works by artists from thirty-seven countries, with eight hundred art critics, journalists, and free-wheelers in addition.' Since then the Biennale has grown still further in size and now spills over from the Giardini Pubblici into numerous other sites in the city. From 1895 to 1909 the Biennale was held in odd-numbered years, but the 9th Biennale was advanced a year and held in 1910. Thereafter it was held in even years (with gaps in 1916, 1918, 1944, and 1946 because of the two world wars) until 1990. The Biennale was not held in 1992 and from 1993 has been in odd years (this change was made so that the exhibition could be held in the centenary year of the original event).

Several other biennales have been instituted on the Venice model, some of them general and others devoted to a specific category of art, such as *naive painting or printmaking. The one with the highest prestige next to Venice is the São Paulo Bienal, founded in 1951. Also well known is the Paris Biennale, inaugurated in 1959 on the initiative of the critic Raymond Cogniat. It is confined to artists under 30 years of age and has become a major forum for experimental art. There are also triennial exhibitions, held every three years.

Bigaud, Wilson (1931–). Haitian *naive painter, born into a poor family in Port-au-Prince. He was encouraged by Hector *Hyppolyte, who was a neighbour, and in 1946 he began studying at the Centre d'Art in Port-au-Prince; this had been established two years earlier by the American teacher DeWitt Peters (1902–66) as a place where artists could attend classes and exhibit their work. Bigaud rapidly established a reputation as an artist of outstanding talent, hailed as the 'Raphael' of Haitian painting because of the limpid beauty of his work, in which he combined lush detail with clarity of design. His output included portraits and everyday life scenes, as well as religious subjects (both Christian and Voodoo). When he was only 21 he became the first Haitian to have a picture accepted for the *Carnegie International Exhibition—*Earthly Paradise* (Musée d'Art Haitien, Port-au-Prince, 1952). This success was almost immediately followed by a commission to paint a large *Marriage Feast at Cana* for Holy Trinity Cathedral, Port-au-Prince, which is often cited as his masterpiece. In 1957, however, he suffered a series of mental breakdowns, said to have been caused by Voodoo powers because he had devoted too much of his efforts to glorifying Christianity (it has been remarked that in Haiti, ninety per cent of the population is Catholic, but one hundred per cent is Voodoo). According to the *World Encyclopedia of Naive Art* (ed. O. Bihalji-Merin and N.-B. Tomašević, 1984), Bigaud 'eventually became the puppet of a Mambo (Voodoo priestess). She kept him in the backwoods churning out worse and worse paintings, which she would subsequently sell for a few dollars on her trips to Port-au-Prince.'

Bigge, John. See UNIT ONE.

Bill, Max (1908–94). Swiss painter, sculptor, architect, designer, teacher, and writer, born in Winterthur. He trained as a silversmith at the Zurich School of Arts and Crafts, 1924–7, but after hearing a lecture by *Le Corbusier he decided to turn to architecture. From 1927 to 1929 he studied at the *Bauhaus, then returned to Switzerland, where he lived mainly in Zurich. He regarded himself primarily as an architect, but he was active in a variety of fields, his ultimate aim being to establish a unity among the individual branches of the visual arts—he once defined art as the 'sum of all functions in harmonious

unity'. However, he has probably become best known for his sculptures, which characteristically employ smooth, elegant, spiralling abstract forms in stone or polished metal. He took the term '*Concrete art' from van *Doesburg to describe his work in this vein and popularized the term in Switzerland in place of 'abstract'. In 1941 he visited Argentina and Brazil, introducing the concept of Concrete art there, and he was a vigorous publicist of his ideas (he wrote several books and numerous articles, in English as well as German, and he organized exhibitions of abstract art). His sculptures have been considered precursors of *Minimal art, but in fact they represent a subtle blending of mathematics and intuition, and some Minimalists, including Donald *Judd and Robert *Morris, have repudiated his influence. Outside Switzerland his work and ideas have had most impact in Argentina and Italy, where he was the inspiration for a number of associations of Concrete art. As an architect Bill's work included his own house in Zurich (1932–3) and the much-praised Hochschule für Gestaltung (College of Design) in Ulm (1951–5), where, working on a limited budget, he created an austerely elegant complex of buildings delicately placed in a romantic setting. He was co-founder of the school and head of the departments of architecture and produce design from 1951 to 1957.

Bing, Siegfried. See ART NOUVEAU.

biomorphic. A term applied to forms in abstract art that derive from or suggest organic (rather than geometric) shapes, as for example in the sculpture of Henry *Moore.

Birch, Lamorna. See NEWLYN SCHOOL.

Bird, Cyril. See BATEMAN.

Birley, Sir Oswald (1880–1952). British painter, mainly of portraits, born in Auckland, New Zealand, the son of wealthy parents who were making a world tour. He was educated at Harrow and Trinity College, Cambridge, and had his main artistic training at the *Académie Julian, Paris, 1901–4. From 1906 he worked mainly in London, although he travelled extensively. In 1928 he did a portrait of King George V (National Museum of Wales, Cardiff) and thereafter painted many other members of the royal family, as well as

leading statesmen and military leaders. His style was blandly accomplished. In 1943 he lost the sight in one eye after an accident when he was serving in the Home Guard, but he continued to paint. There are examples of his work in the National Portrait Gallery, London. He also painted landscapes and occasional figure subjects.

Birolli, Renato (1906–59). Italian painter whose outspoken political views and advanced and energetic artistic outlook gave him a prominent place in his country's avant-garde. He was born in Verona, where he studied at the Academy before settling in Milan in 1928. His early work was *Expressionist, influenced by *Ensor and van Gogh, and a visit to Paris in 1936 introduced him to the work of the *Fauves. In 1938 he took a prominent part in founding the anti-Fascist *Corrente organization; he published articles in many journals and was persecuted and imprisoned for his political activities. After the Second World War he was strongly influenced by *Picasso and gradually moved towards abstraction, his work eventually coming within the orbit of *Art Informel. In 1947 he joined the *Fronte Nuovo delle Arti. From 1948 his work was shown at the Venice *Biennale on several occasions and was much exhibited elsewhere in Italy. A large memorial exhibition was held in Milan in 1960.

Bischoff, Elmer. See BAY AREA FIGURATION.

Bishop, Isabel (1902–88). American painter and etcher. She was born in Cincinnati, Ohio, and raised in Detroit. In 1918 she moved to New York to study at the School of Applied Design for Women, originally intending to be an illustrator. From 1922 to 1924 and again in 1926 she studied at the *Art Students League, where her teacher Kenneth Hayes *Miller helped to form her preference for urban themes. Most of her subject-matter is drawn from New York street life, particularly working-class women going about their everyday business. They are depicted in a sensitive and unsentimental way, in an unusual technique—using thin washes of paint—that recalls the oil sketches of Rubens. Bishop—a quiet but distinctive voice in *American Scene Painting—also did female nudes. She worked slowly, averaging about three paintings a year, and her total output amounts to fewer than 200 pictures. In 1937 she became the

first full-time woman teacher at the Art Students League, and she won numerous awards for her work.

Bissier, Julius (1893–1965). German painter and designer, born at Freiburg. After studying briefly at the Academy in Karlsruhe he served in the First World War and afterwards resumed painting without further formal training. His early style was representational and had affinities with *Neue Sachlichkeit, but in the 1930s he turned to abstraction. This was partly because of the influence of *Baumeister (with whom he was friendly from 1929) and of *Brancusi (whom he met in Paris in 1930) and partly because of the influence of Chinese calligraphy and hieroglyphics (he had been introduced to Chinese culture by the Orientalist Ernest Grosse). He used abstract shapes that he called 'signs of bipolar life', which were intended to induce meditation. Most of his early work was destroyed in 1934 by a fire at the University of Freiburg, where Bissier taught, 1929–34. After the Second World War he became a member of the *Zen Group and developed a more painterly style, exploring unusual colour combinations in small, precisely executed watercolours or egg tempera paintings (sometimes irregularly shaped). It was these works that first brought him widespread recognition. He won the Museum of São Paulo Prize at the 1960 Venice *Biennale. Apart from painting, he also designed carpets and fabrics, which were woven by his wife.

Bissière, Roger (1886–1964). French painter, sculptor, teacher, and writer on art. He was born in Villeréal in the province of Lot-et-Garonne and studied at the École des Beaux-Arts in Bordeaux, the nearest large city. His early works consisted mainly of landscapes of the local countryside. In 1910 he moved to Paris, where he earned his living as a journalist for some time whilst continuing to paint. He was slow to mature as an artist and did not exhibit his work until 1920, first at the *Salon d'Automne, then at the *Salon des Indépendants. At this time he was influenced by *Cubism, which he attempted to 'humanize' (in 1920–1 he wrote articles for L'*Esprit nouveau, in which he espoused the classical rigour of great French painters of the past— Corot, Ingres, and Seurat; he also wrote the first monograph to be published on *Braque, 1921). From 1925 to 1938 he taught at the

*Académie Ranson, where he was a popular and influential figure among his students, who included *Le Moal, *Manessier, and *Vieira da Silva. His success as a teacher came partly from the fact that regarded himself as still learning about art, so in this sense he put himself on the same plane as his students: 'I prefer those artists who make a blunder from time to time, especially those who don't always do the same thing, who try a new turn every day, unknown, dangerous, risking their neck every time, those who can't catch sight of a door without wanting to see what's behind it, even if behind it there's a booby trap.' He was one of the first French artists to recognize the importance of Paul *Klee, whose ideas he introduced to his classes.

Although Bissière played an important part in shaping the careers of his students, he had still not found a distinctive artistic voice of his own and remained little known as a painter. In 1938 he retired to Lot and the following year he contracted an eye ailment that left him unable to paint. During the Second World War he worked as a farmer, but he also made totemistic sculptures (sometimes carved, sometimes put together from old agricultural machinery) and collaborated with his wife in producing primitivistic compositions made from patchwork materials. He started painting again in 1945 and an operation in 1948 partially restored his sight. Therafter he worked with renewed vigour and from the early 1950s he belatedly achieved an international reputation. His mature paintings were rich and glowing tapestry-like compositions. Representational elements were gradually submerged in scintillating patterns of colour, but Bissière said that they were always based on natural appearances and refused to accept the term 'abstract' for his work. In addition to paintings, from 1957 he made designs for stained glass, notably for Metz Cathedral (1960–1). Despite his success, he continued living quietly in Lot for the rest of his life.

Bisson, Henri. See RIOPELLE.

Black, Dorrit. See LINOCUT.

Black, Sir Misha. See ARTISTS INTERNATIONAL ASSOCIATION and FESTIVAL OF BRITAIN.

Blackadder, Elizabeth (1931–). British painter and printmaker. She was born at Falkirk and studied at Edinburgh College of Art and Edinburgh University, 1949–55. She works in oil and watercolour 'with no particular preference' (in her own words). 'The work falls into two main areas, landscape and still life—occasionally figures . . . I like to work on several paintings at the same time, but work slowly, and each painting, watercolours included, may take months to complete.' Duncan Macmillan (*Scottish Art 1460–1990*, 1990) describes her paintings of flowers and plants as 'based on a description that is so fastidious it becomes poetic'. Blackadder is also a prolific printmaker and has occasionally executed portrait commissions.

Black Mountain College. American art educational establishment at Black Mountain, North Carolina, founded in 1933 by a group of progressive academics led by John Andrew Rice (1888–1968) and closed in 1957 after long-standing financial problems. It was owned and administered by the teaching staff, with no outside control, and was kept deliberately small (with an average of about 50 students a year) to reduce administration; a variety of arts were taught and interaction between them was encouraged. Mary Emma Harris, a leading historian of the college, has written of it: 'At Black Mountain learning and experience were to be closely bound, and emotional maturity and the ability to think were to be as much the goal of education as the assimilation of information and ideas . . . As it took shape, the college became a unique combination of liberal arts school, summer camp, farm school, pioneer village, refugee centre and religious retreat . . . Crucial to the founders' vision was that the college remain open to new ideas in a truly experimental spirit: the community changed from year to year, driven by the ideas and personalities of its faculty and students . . . For the twenty-four years of its existence, the college played a significant role in the reinterpretation and assimilation of European modernist thought into American culture, and it was . . . a catalyst for the emergence of the American avant-garde after the Second World War' (chapter on Black Mountain College in the catalogue of the exhibition 'American Art in the 20th Century', Royal Academy, London, 1993).

In the visual arts, the teacher most associated with Black Mountain College was Josef *Albers, who arrived there with his wife Anni (who taught weaving) soon after it opened

and stayed until 1949. Mary Emma Harris writes that 'At Black Mountain he adapted the curriculum of the *Bauhaus to general education, emphasizing the education of the students' visual perception and basic skills in drawing, colour theory and design concepts. He challenged the American idealization of, and subservience to, the cultures of Europe and Classical Greece, and instead turned the attention of his students to their own culture—to advertisements, to architecture and engineering, to the natural world and to New World cultures.' Other illustrious figures who taught at Black Mountain include Robert *Motherwell and the composer John *Cage, whose ideas on chance and indeterminacy in the arts were widely influential. In 1952 he organized there a partly programmed performance (involving paintings and readings) that has subsequently been designated as the first *Happening. Famous former students of the college include John *Chamberlain, Kenneth *Noland, and Robert *Rauschenberg.

Blake, Peter (1932–). British painter, sculptor, and designer, a leading exponent of *Pop art. He was born in Dartford, Kent, and studied at Gravesend School of Art, 1949–51, then after two years in the RAF at the *Royal College of Art, 1953–6. In 1956–7 a Leverhulme scholarship enabled him to travel extensively on the Continent studying folk and popular art (this had been an interest since his teenage years, stimulated by visits to fairgrounds). His early work was meticulously painted and often featured items of popular ephemera, particularly magazine covers (*On the Balcony*, Tate Gallery, London, 1955–7). From 1959 he moved more into the mainstream of Pop with pictures of pop singers and film stars, painted in a much broader manner and often featuring collage elements, and within a few years had become established as one of the leading figures of the movement in England (in 1961 he won first prize in the Junior Section of the *John Moores Liverpool Exhibition and in the same year he was featured in Ken Russell's television film *Pop Goes the Easel*, which did as much as anything to arouse public interest in Pop art). During the 1960s the pop music world continued to be a major source of inspiration (his most famous work is the cover design for the Beatles LP *Sergeant Pepper's Lonely Hearts Club Band*, 1967), and his other favourite images of the time included fairground wrestlers and striptease dancers.

In 1969 Blake moved to Wellow, near Bath, and in 1975 he was one of the founders of the *Brotherhood of Ruralists, a seven-strong group of painters who took as their inspiration 'the spirit of the countryside'. A series of winsome fairy paintings are characteristic of his Ruralist phase. They show something of the combination of sophistication and naivety that often occurs in his work as well as his penchant for imagery drawn from childhood (his two daughters have often featured in his work). He returned to London in 1979 and since then he has continued to paint both contemporary and fantasy subjects. In 1983 he had a major retrospective exhibition at the Tate Gallery, London; it proved a great popular success, showing how fondly his early work is regarded by many people for its colourful evocation of the 'swinging sixties'. In 1994–6 he was Associate Artist at the National Gallery, London.

Blanchard, Maria (1881–1932). Spanish-French painter, born at Santander, Spain, of a Spanish father and a Franco-Polish mother. After studying in Madrid she moved to Paris in 1906 and was introduced by van *Dongen into the *Cubist circle. From 1913 to 1916 she lived in Spain, then settled permanently in Paris. Although she became closely linked with the Cubists, she took from them structural mannerisms rather than a commitment to the intellectual principles of the movement. Indeed, her approach was emotional rather than cerebral; she was best known for her scenes of everyday life, and her depictions of sad or solitary children are particularly memorable—a reflection perhaps of the fact that she was herself crippled from childhood.

Blanche, Jacques-Émile (1861–1942). French painter, born in Paris, the son of Émile Blanche, a noted pathologist. He grew up in a cultured atmosphere and became a well-known figure in artistic and society circles—he was a friend of *Degas, *Renoir, *Whistler, the writers Henry James and Marcel Proust, and many other celebrities. His best-known works are stylish portraits of people from this milieu; the finest collection is in the Musée des Beaux-Arts at Rouen, and there are several examples in the Tate Gallery, London. Blanche lived mainly at Offranville, near the Channel port of Dieppe (the local church has decorative painting by him), and he was a frequent visitor to Britain, painting numerous

views of London (the Tate has an example). He wrote several books of criticism and reminiscence, including *Mes Modèles* (1928), *Portraits of a Lifetime ... 1870–1914* (1937) and *More Portraits of a Lifetime ... 1918–38* (1939).

Blast. See VORTICISM.

Blaue Reiter, Der (The Blue Rider). A loosely organized association of artists founded in Munich in December 1911 as a splinter group from the *Neue Künstlervereinigung (NKV). It held only two exhibitions (poorly received by press and public) and was broken up by the First World War, but its brief life is considered to mark the high point of German *Expressionism. The founders of the Blaue Reiter were Wassily *Kandinsky (the driving force), Franz *Marc, and Gabriele *Münter, who together resigned from the NKV early in December 1911 in protest against its growing conservatism and organized a rival exhibition that opened on the same day as the NKV's last show (18 December) in the same venue (the Moderne Galerie Tannhauser, Munich). The new group's exhibition was entitled 'First Exhibition by the Editorial Board of the Blue Rider', a reference to an *Almanac* (a collection of essays and illustrations) that Kandinsky and Marc had been planning for some time and which appeared in May 1912 (it was originally intended to be an annual, but this was the only issue that ever appeared); the cover featured a drawing by Kandinsky of a blue horseman (blue was the favourite colour of Marc, who regarded it as particularly spiritual, and the horse was his most cherished subject; Kandinsky, too, often painted horses with riders, evoking ideas of medieval knights or warrior saints).

The first Blaue Reiter exhibition, which obviously had to be arranged at very short notice, featured only 43 works by fourteen artists; apart from the three founders they were: the American painter Albert Bloch (1881–1961), David and Vladimir *Burliuk, Heinrich *Campendonk, Robert *Delaunay, Elizabeth Epstein (1879–1956), Eugen Kahler (1882–1911), August *Macke, Jean Bloé Niestlé (1884–1942), the recently deceased Henri *Rousseau, and the composer Arnold Schoenberg (1874–1951), who was a friend of Kandinsky and Marc and a talented amateur painter. In March 1912 the exhibition travelled to Berlin to inaugurate the *Sturm Gallery, and it was also shown (with some additions) in Cologne, Frankfurt, and Hagen. The second Blaue Reiter exhibition was held at the dealer Hans Goltz's gallery in Munich in February–April 1912. It included only watercolours, drawings, and prints, but was larger and broader in scope than the first show, featuring 315 works by thirty-one artists, among them (in addition to many of those who took part in the first exhibition) *Braque, *Derain, *Goncharova, *Klee, *Larionov, *Picasso, *Vlaminck, and the artists of the *Brücke group. This was was the last exhibition to bear the Blaue Reiter name, but four of the 'core' artists—Kandinsky, Klee, Macke, and Marc— were also represented at two of the greatest exhibitions of the era—the *Sonderbund exhibition in Cologne in 1912 and the 'First German *Salon d'Automne' at the Sturm Gallery in Berlin in 1913. Although *Jawlensky's work was not included in either of the two official group shows, he did exhibit alongside Kandinsky, Klee, Macke, and Marc at the Sturm Gallery in 1913 and he is generally considered part of the Blaue Reiter circle; indeed, it is to these five that the idea of a Blaue Reiter 'group' chiefly applies. *Feininger, also, showed his work with this group at the Sturm exhibition.

Unlike the members of Die Brücke, the main artists associated with the Blaue Reiter were not stylistically unified, although their work tended towards the spiritual (rather than the more earthy concerns of the Brücke) and also towards abstraction. They had no artistic or social programme and no plans for communal activities apart from exhibitions. According to a statement in the catalogue of the first exhibition, their aim was 'simply to juxtapose the most varied manifestations of the new painting on an international basis ... and to show, by the variety of forms represented, the manifold ways in which the artist manifests his inner desire'. Their urge for freedom of expression, unrestricted by the normal conventions of European art, comes out clearly in the *Almanac*, which was dominated by Kandinsky's interest in the relationship between painting and music (Schoenberg contributed an article) and by Marc's enthusiasm for various types of '*primitive' art. In this last respect, it reproduced a remarkable variety of works, including folk art from Germany and Russia, Japanese prints, African and Oceanic art, medieval sculpture, *naive paintings by Rousseau, and children's drawings. (This was one of the first instances of the

reproduction of children's art; see CIŽEK.) The essential idea behind this outlook was Nietzsche's dictum that 'Who wishes to be creative . . . must first blast and destroy accepted values'.

Blaue Vier, Die (The Blue Four). A group of four painters—*Feininger, *Jawlensky, *Kandinsky, and *Klee—formed in 1924 at the instigation of the German art dealer Galka Scheyer (1889–1945) with the aim of promoting their work abroad (where there was a better market for art than in economically depressed Germany). The four had all been associated with the *Blaue Reiter, and Scheyer chose the name 'Blaue Vier' because 'a group of four would be significant though not arrogant . . . the colour blue was added because of the association with the early group of artists in Munich that founded the "Blue Horseman" . . . and also because blue is a spiritual colour'. In addition, Kandinsky wanted a name that did not suggest an 'ism'. The artists signed an agreement on 31 March 1924 and Scheyer embarked for the USA in May, taking with her a selection of their works. She staged several Blaue Vier exhibitions at various venues over the next decade, together with lectures; the venture was a moderate financial success and an important factor in spreading the reputation of the four artists. Scheyer settled in the USA and became an American citizen. Her own collection of paintings by the Blaue Vier is now in the Norton Simon Museum, Pasadena, California.

Bleyl, Fritz. See BRÜCKE.

Bliss, Lillie P. (1864–1931). American collector and patron, born into a wealthy Boston family. She was a friend of Arthur B. *Davies, who stimulated her interest in modern art. At the *Armory Show (1913), masterminded by Davies, she bought pictures by *Degas, *Redon, and *Renoir, and later developed a taste for more avant-garde work. In 1929 she was one of the founders of the *Museum of Modern Art, New York, and when she died two years later she left the bulk of her collection to the Museum. Her bequest included eleven oils and eleven watercolours by *Cézanne (her favourite artist) and works by *Derain, *Gauguin, *Modigliani, *Picasso, *Rousseau, and other major figures. The gift formed the foundation of the permanent collection, and its importance was immediately recognized,

as is clear from an editorial in *The Arts* in April 1931, a month after her death: 'The bequest is a nucleus round which to build; a magnet for other collections; a continuing living reply to the doubters; a passing on of the torch; a goodly heritage. It begins the transition of the Museum from a temporary place of exhibitions to a permanent place of lasting activities and of acquisitions.' The generous spirit of Miss Bliss's will meant that certain paintings she bequeathed could be sold or exchanged to enhance the Museum's collection, and several major works were obtained in this way, notably Picasso's *Les Demoiselles d'Avignon* (which was acquired in 1938 and paid for partly by the sale of a Degas from the Bliss Bequest).

Bloc, André (1896–1966). French sculptor, designer, writer, editor, and exhibition organizer, born in Algiers. After studying architecture and engineering in Paris he became a friend of *Le Corbusier and founded the periodical *Architecture d'aujourd'hui*. He took up sculpture in 1940, initially being influenced by *Laurens. In 1949 he turned to abstract sculpture, and launched the periodical *Art d'aujourd'hui*, which ran until 1954. It was the first periodical to be devoted solely to abstract art, and Michel *Seuphor wrote that 'The complete collection of thirty-six parts, notwithstanding occasional errors, provides a unique documentation of abstract art in France and indeed all over the world'. Bloc used a wide variety of materials and techniques in his work, but he is more important as an editor and exhibition organizer than as a creative artist. See also GROUPE ESPACE.

Bloch, Albert. See BLAUE REITER.

Bloch, Martin. See MAISTRE.

Blok. A group of Polish avant-garde artists, active in Warsaw from 1924 to 1926; Blok was also the name of the group's quarterly magazine, which ran to eleven issues. The most important members of the group were Vladislav *Strzemiński, his wife Katarzyna Kobro, and the painter Henryk Stażewski (1894–1988). Although Blok's outlook was essentially *Constructivist, there were doctrinal splits among some of the members, and the group ceased its activities in 1926. Many of the members, including the three named above, joined its successor, Praesens, which

ran from 1926 to 1939; it, too, published a magazine with the same name as the group. In 1929 Strzemiński, Kobro, and Stażewski left to found another group, a.r. (revolutionary artists), which continued until 1936.

Blomfield, Sir Reginald. See MODERNISMUS.

Bloom, Barbara. See INSTALLATION.

Bloomsbury Group. A loose association of writers, artists, and intellectuals that was a distinctive force in British cultural life during the early decades of the 20th century. Leading members of the group included the writers E.M. Forster, Lytton Strachey, and Virginia Woolf, and the economist John Maynard *Keynes (who was also a notable patron); among the artists and critics were Clive *Bell, Vanessa *Bell, Dora *Carrington, Roger *Fry, Duncan *Grant, and Henry *Lamb. They frequently met at the houses of Clive and Vanessa Bell, or of Vanessa's sister, Virginia Woolf, in the Bloomsbury district of London, which had long been a favourite area for artists, musicians, and writers (the British Museum, the University of London, various learned institutions, and numerous publishers' offices are all in the locality). The original meeting place, from about 1905, was 46 Gordon Square, at that time the home of Vanessa and Virginia Stephen (as they were before their marriages).

The association stemmed from student friendships formed at Cambridge University; most of the 'Bloomsberries' had been at either King's College or Trinity College and many had been 'Apostles'—members of an exclusive, semi-secret intellectual club. However, the Bloomsbury Group had no formal membership and no common social or aesthetic ideology. The members were united mainly by their belief in the importance of the arts and— in revolt against the restrictions of Victorian society—by their frankness and tolerance in sexual matters (several of them were homosexual or bisexual and their love lives were often complexly intertwined). A key book for them was *Principia Ethica* (1903) by the Cambridge philosopher G. E. Moore, in which it is argued that 'By far the most valuable things ... are ... the pleasures of human intercourse and the enjoyment of beautiful objects ... it is they that form the rational ultimate end of social progress'.

In the visual arts, the Bloomsbury Group made its most significant impact in the 1910s, after it had been joined by Roger Fry (he had lived in New York from 1906 to 1910). Fry was highly influential in promoting an awareness of modern art—through his writing and lecturing, through his two *Post-Impressionist exhibitions (1910 and 1912), and through his founding of the *Omega Workshops (1913). It was at this time, too, that Vanessa Bell and Duncan Grant were at their most adventurous, both of them producing pure abstracts by 1914. From the 1920s the members of the group were no longer in the forefront of ideas, but Duncan Grant was at this time at the peak of his popularity. The richly coloured figurative style in which he and Vanessa Bell worked in the period between the two world wars is considered the 'typical' Bloomsbury style. By the early 1930s the Bloomsbury Group had ceased to exist in its original form; the death of Lytton Strachey in 1932 is sometimes taken as a convenient terminus, although it was perhaps the suicide of Virginia Woolf in 1941 that really marked the end of an era. After the Second World War, Bloomsbury ideas fell out of fashion and the members of the group were attacked as dilettantist and elitist. However, from the late 1960s there has been a great revival of interest in all aspects of the group, marked by the publication of numerous biographical and critical studies.

Blow, Sandra (1925–). British abstract painter, born in London. She studied at *St Martin's School of Art under Ruskin *Spear, 1942–6, and the Academy in Rome, 1947–8. In 1961 she won second prize for painting at the *John Moores Liverpool Exhibition and in the same year began teaching at the *Royal College of Art. She has worked in a number of abstract styles, including *gestural abstraction and *Colour Field Painting, and she has experimented with adding various substances or objects to the canvas. She considers herself an 'academic abstract painter', primarily concerned with such problems as balance and proportion—'issues that have been important since art began'.

Blue Four. See BLAUE VIER.

Blue Rider. See BLAUE REITER.

Blue Rose (Golubaya Roza). Group of Russian painters active in the first decade of the 20th

century, named after an exhibition held in Moscow in 1907. Their acknowledged inspiration was *Borisov-Musatov and their style was essentially *Symbolist, although there was also influence from *Fauvism and an interest in *primitivism. (The origin of the name is uncertain, but the colour blue was particularly significant for Symbolists, associated with the sky and spirituality, and the rose has many symbolic associations: in 1904 an exhibition called the Crimson Rose or Scarlet Rose (Alaya Roza) had been held in Saratov, Borisov-Musatov's home town, and the Blue Rose was a successor to this.) Borisov-Musatov's most talented follower was Pavel Kuznetsov (1878–1968); other members of the group included the Armenian Martiros Saryan (1880–1972) and the Greek-born Milioti brothers, Nikolai (1874–1955) and Vasily (1875–1943). Georgy Yakulov (1882–1928), best known as a stage designer, was not a formal member, but he shared the group's concerns and was invited to contribute to their retrospective exhibition in 1920. The group was promoted by the journal *Golden Fleece and exhibited under its auspices.

Blume, Peter (1906–92). American painter. Born in Russia, he was brought to the USA as a child in 1911 and trained at various art colleges in New York, including the *Art Students League. He used the meticulous technique of the *Precisionists, but combined this with bizarre imagery in a way that won him a reputation as one of the first American *Surrealists. In 1934 he came to prominence when his *South of Scranton* (MOMA, New York, 1931) won first prize at the *Carnegie International Exhibition, and in 1939 he caused controversy when his most famous painting, *The Eternal City* (MOMA, New York, 1934–7), was rejected for exhibition at the Corcoran Gallery Biennial in Washington because it was considered too inflammatory. Blume had visited Italy in 1932–3 and the painting is a satirical attack on Fascism, showing Mussolini as a gruesome, green-headed jack-in-the-box. Although Blume used the imagery of Surrealism, the appeal for him was intellectual and not, as with most European Surrealists, to associations of the subconscious mind: he said that 'Since I am concerned with the communication of ideas I am not at all ashamed of "telling stories" in my paintings, because I consider this to be one of the primary functions of the plastic arts'. His work-

ing method was slow and painstaking, so his output is small. In 1970 he began making sculptures.

Blumenschein, Ernest. See TAOS COLONY.

Blunt, Anthony (1907–83). British art historian and spy. He was born in Bournemouth and grew up mainly in Paris, where his father was chaplain at the British embassy. From 1926 to 1930 he studied at Trinity College, Cambridge, initially reading mathematics, then switching to modern languages, and in 1932 he became a fellow of the college. In 1936 he joined the staff at the Warburg Institute, London, and at about the same time he started lecturing at the recently founded *Courtauld Institute of Art. During the 1930s Blunt wrote a good deal on modern art, mainly in the form of articles and reviews in the *Spectator*, for which he was the regular art critic for several years: 'At first he championed the modern movement . . . but later, influenced by the Marxism which he had first espoused in 1934, he just as fiercely, if temporarily, attacked modernism as irrelevant to the contemporary political struggle' (DNB), arguing—as he later recalled—'against esoteric art and in favour of a realistic, widely appealing style'. One of his attacks was on *Picasso's *Guernica*, which he thought was 'not the right way to commemorate a great human and revolutionary tragedy', being 'merely an expression of his [Picasso's] private sensation of horror'. These views (which he later repudiated) brought Blunt into dispute with Herbert *Read, 'though in a friendly manner because we happened to be members of the same club'.

In 1939 Blunt became deputy director of the Courtauld Institute and from 1947 to 1974 he was director. In this position he played a major role in establishing art history as a serious academic discipline in Britain: 'in almost every sense he was a superb director' (DNB). From 1945 to 1972 he was also Surveyor of the King's (later Queen's) Pictures, and he received numerous honours. After the war, his publications were mainly on 17th-century French and Italian art, but he kept an interest in Picasso, on whom he wrote two short books: *Picasso: The Formative Years* (1962) (in collaboration with Phoebe Pool); and *Picasso's 'Guernica'* (1967). The only other 20th-century artist on whom he published a book was *Rouault—*Rouault's 'Miserere'* (1951). In 1979, it

was sensationally announced in Parliament that Blunt had been a spy for the Soviet Union during the Second World War (when he worked for MI5). He had confessed in 1964, being offered immunity from prosecution in return for the information he provided. The revelation caused a huge scandal, for Blunt was not only a highly distinguished academic, but also a former senior royal servant. He coped calmly with the disgrace (which included being stripped of his knighthood) and continued his scholarly work until the end of his life. See also SEWELL.

Boccioni, Umberto (1882–1916). Italian *Futurist painter, sculptor (the only one in the movement), and art theorist. He was born in Reggio Calabria and in 1899 moved to Rome, where he worked as a commercial artist. In 1901 he met *Balla, who introduced him to *Divisionism. Balla's studio was a forum for Rome's artistic and literary avant-garde and it was there that Boccioni met *Severini, who became a close friend. In 1906 he visited Paris and Russia, then after brief stays in Padua and Venice he settled in Milan in 1907. Over the next two years he experimented with various styles, but it was only after he joined the Futurists in 1909 that his career took off, and all his important work was done in the seven years between then and his premature death. He signed the two Futurist manifestos of painting (both 1910), wrote the one on sculpture (1912), and became the most energetic member of the group. Advocating a complete break with the art of the past, Boccioni was centrally concerned with the two main preoccupations of the Futurists—the production of emotionally expressive works and the representation of time and movement. In his early Futurist works he often showed an interest in social themes, particularly big city life, but later (especially after a visit to Paris in 1912, when he was influenced by *Cubism) he tended to use his paintings more as vehicles for his theories than as comments on life around him. Eventually this tendency led him close to abstraction, in pictures such as *Dynamism of a Human Body* (Galleria d'Arte Moderna, Milan, 1913).

Boccioni's ideas were set out most fully in his book *Pittura scultura futuriste: Dinamismo plastico* (1914). In this he proposed that whereas the *Impressionists painted to perpetuate a single moment of vision, Futurism synthesizes in a picture all possible moments; and in contrast to the objective outlook of Cubism, he claimed that Futurist painting aspires also to express 'states of the soul'. In common with the other Futurists (following the ideas of the contemporary French philosopher Henri Bergson), he believed that physical objects have a kind of personality and emotional life of their own, revealed by 'lines of force' with which the object reacts to its environment. This notion is perhaps best shown in Boccioni's most famous piece of sculpture, *Unique Forms of Continuity in Space* (casts in the Tate Gallery, London, MOMA, New York, and elsewhere, 1913), which vividly expresses bodily movement. His ideas about sculpture were extremely forward-looking. He advocated the use of materials such as glass and electric lights and the introduction of electric motors to create movement. However, he died in an accident whilst serving in the Italian army before most of his ideas could be put into practice. In some of the paintings done near the end of his life he in any case seemed to be turning away from Futurism to a more sober figurative style recalling the work of *Cézanne (*Portrait of Ferruccio Busoni*, Galleria Nazionale d'Arte Moderna, Rome, 1916).

Boch, Anna. See LUMINISM.

Böcklin, Arnold. See HODLER.

Bode, Arnold. See DOCUMENTA.

Bodmer, Walter (1903–73). Swiss sculptor and painter, born in Basle. He studied at the School of Arts and Crafts there, and also in France and Spain. After working in a *Post-Impressionist style he turned to abstraction in the early 1930s and in 1936 he began making the abstract wire sculptures and open-space constructions for which he is best known. He was one of the main representatives of *Constructivist art in Switzerland and one of the pioneers of wire sculpture, his work in this field having something of the elegance and wit of *Klee.

Body art. A type of art in which the artist uses his or her own body as the medium; it is closely related to *Conceptual art and *Performance art, and flourished mainly at the same time that these forms of expression were at their peak—the late 1960s and 1970s. Sometimes the work is executed in private and communicated by means of photographs or

video recordings; sometimes the execution of the 'piece' is public. The performance may be pre-choreographed or extemporaneous. Spectator participation is not usually invited.

The leading exponents of Body art have often been concerned with self-inflicted pain or ritualistic acts of endurance. Probably the best-known specialists in this vein have been the American Vito Acconci (1940–) and the Italian Gina Pane (1939–90), who worked mainly in Paris. Acconci's best-known performances include 'Rubbing Piece' (1970), in which he sat at a restaurant table and rubbed his left forearm with his right hand until a distinct weal appeared, 'Trappings' (1971), in which 'he spent three hours dressing his penis in doll's clothing and talking to it "as a playmate"' (Michael Archer, *Art Since 1960*, 1997), and 'Seedbed' (1972), in which he spent hours every day masturbating under a gallery-wide ramp while the sounds of his activity were relayed via loudspeakers to visitors overhead. Pane's performances include 'Nourishment' (1971), in which she forced herself to regurgitate meat, and 'Action Sentimentale' (1973), in which she pushed a row of tacks into her forearm. She believed that her work had a purifying effect necessary 'to reach an anaesthetized society', and wrote that 'My corporeal experiments show that the body is invested and fashioned by Society; they have the aim of demystifying the common image of the body experienced as a bastion of our individuality to project into it into its essential reality, with the function of social mediation'. Other explanations of the philosophy behind such works seem equally obscure.

In *Art of the Seventies* (1980) Edward *Lucie-Smith writes that 'Perhaps the most drastic of these sado-masochistic body artists is the Californian Chris Burden [1946–]. In 1974 his roster of activities included one in which the spectators were invited to push pins into his body, one in which he had himself crucified to the roof of a Volkswagen, and one in which he was kicked down two flights of concrete stairs. In the name of art, Burden has also had himself shot, and has had his body splashed with burning alcohol.' Other artists who have put themselves through unpleasant and potentially harmful experiences include Stuart *Brisley, Rudolf *Schwarzkogler, and the *Vienna Actionists.

Exponents of Body art in a more playful vein include the American Bruce *Nauman and the Scottish-born, London-based Bruce McLean (1944–). One of Nauman's best-known works is *Self-Portrait as a Fountain* (1970), a photograph in which he is shown spouting water out of his mouth. McLean, who has worked with *Gilbert & George, has had himself photographed in poses parodying the works of famous modern sculptors. In 1972 he founded 'Nice Style', 'the World's First Pose Band', with which he performed until 1975: 'After a year of preparation and preview performances . . . the Pose Band presented a lecture on "Contemporary Pose" (1973) at the Royal College of Art Gallery in London . . . it was illustrated by members of the group variously dressed in silver spacesuits (inflated with a hair-dryer), exotic drag and a distinctive double-breasted raincoat [a tribute to the group's hero, the Hollywood star and "self-confessed bad actor" Victor Mature]. The "perfect poses" that the lecturer discussed at length were demonstrated with the aid of specially constructed "stance moulds" or "physical modifiers" (articles of clothing with built-in poses) and giant measuring instruments that ensured the accuracy of an elbow angle or a tilted head' (RoseLee Goldberg, *Performance Art*, 1988).

Although the 1970s marked the heyday of Body art, there has been something of a revival in the 1990s, one of the best-known exponents being the French artist Orlan (1947–), whose means of expression consists of having her face and body reshaped by plastic surgery to produce features based on Renaissance masterpieces, such as the chin from a Botticelli Venus. Edward Lucie-Smith writes that 'The operations are choreographed by the artist as public performances, with musical accompaniment, poetry, and dance. The artist herself directs them, since the surgery is performed under local anaesthetic only, using an epidural block. The sado-masochistic undertone of much of the avant-garde art of the 1990s is here married to a form of "appropriation"' (*Visual Arts in the Twentieth Century*, 1996). Orlan herself writes: 'My work is not against cosmetic surgery, but against the dictates of beauty standards which are imposed more and more on feminine flesh . . . I have given up my body for art. After my death it will be given to a museum for mummification . . . As my friend the French artist Ben Vautier says, "art is a dirty job but somebody's got to do it."' (Benjamin Vautier (1935–), who works under the name

Ben, is a painter and Performance artist whose work has included *Vomit Pictures*, consisting of black canvasses onto which he vomited, and performances in which he banged his head against a wall.)

Bogart, Bram. See MATTERISM.

Boguslavskaya, Kseniya. See POUGNY.

Boldini, Giovanni (1842–1931). Italian painter, one of the most renowned society portraitists of his day. His dashing brushwork and gift for making his sitters look poised and graceful recalled the work of his even more successful contemporary, John Singer *Sargent, and like Sargent he had an international career. Together with another flamboyant portraitist, Antonio Mancini (1852–1930), he was probably the best-known Italian artist at the turn of the century. Apart from portraits, Boldini's work includes some excellent street scenes of Paris, where he spent most of his career. There is a Boldini museum in his native Ferrara; the collection includes a self-portrait (1911) that is considered one of his finest works. As with Sargent, his work went out of favour after his death, being considered merely glossy and superficial (*Sickert referred to his 'wriggle-and-chiffon' style).

Bolotowsky, Ilya (1907–81). Russian-born painter who became an American citizen in 1929. His family fled revolutionary Russia in 1920 and in 1923 settled in New York, where he studied at the National Academy of Design, 1924–30. In the early 1930s his work was *Expressionist (he was a member of The *Ten), but in 1933 he was deeply impressed by paintings by *Mondrian and thereafter became one of America's most committed exponents of geometrical abstraction. He wrote: 'After I went through a lot of violent upheavals in my early life, I came to prefer a search for an ideal harmony and order which is still a free order, not militaristic, not symmetrical, not goose-stepping, not academic', and 'In my paintings I avoid all associations. I try for perfect harmony, using neutral elements. I want things absolutely pure and simple.' Bolotowsky was a founding member of *American Abstract Artists in 1936 and his mural for the Williamsburg Housing Project, New York, of that year was one of the first abstract murals to be commissioned. After the Second World War he taught at various art schools, notably *Black

Mountain College, 1946–8. In spite of his reverence for Mondrian, his approach was far from cerebral and he had a love of intense, sensuous colour (*Vibrant Reds*, National Museum of American Art, Washington, 1971). In 1971 he began to make painted geometrical constructions that represented extensions of his paintings into three dimensions, and he was also a playwright and experimental filmmaker.

Bolus, Michael. See NEW GENERATION.

Bomberg, David (1890–1957). British painter and teacher. He was born in Birmingham of Polish-Jewish immigrant parents and grew up in the Whitechapel area of London, where his father was a leather-worker. In 1908 he gave up an apprenticeship as a lithographer to devote himself to painting, encouraged by *Sargent, who had noticed him drawing in the Victoria and Albert Museum. He studied under *Sickert at Westminster School of Art (1908–10) and—with support from the Jewish Education Aid Society—at the *Slade School (1911–13), where he won a prize for a drawing of his fellow-student Isaac *Rosenberg. Whilst still a student Bomberg showed an advanced understanding of avant-garde Continental painting, particularly *Cubism and *Futurism (he visited Paris with *Epstein in 1913), and his work has much in common with that of the *Vorticists, although he turned down Wyndham *Lewis's invitation to join the group. His best-known work of this time is probably *In the Hold* (Tate Gallery, London, 1913–14), a large, dazzlingly coloured abstraction of fragmented geometric forms, based on the subject of men working in the hold of a ship in the docks. It was one of the most discussed works at the first exhibition of the *London Group in 1914, and in the same year Bomberg's first one-man show, at the Chenil Gallery, London, was well received critically (although sales were poor). In 1915 he enlisted in the Royal Engineers, then transferred to the King's Royal Rifles as a sapper, and in 1918 he was commissioned by the Canadian War Memorials Fund to make a large painting of *Sappers at Work: A Canadian Tunnelling Company*. His first version (Tate Gallery, London, 1918–19) was turned down as being too avant-garde, so he replaced it with a more conventionally naturalistic picture (NG, Ottawa, 1919).

In the years immediately after the First World War Bomberg continued to receive

respectful press notices but to have difficulty selling his work. Dismaying of achieving success in Britain, he moved to Palestine in 1923 (at the suggestion of Muirhead *Bone, whose advice he had sought) and for the next four years he lived mainly in Jerusalem, where he worked for the Zionist Organization, producing illustrations for newspapers and pamphlets. He returned to Britain in 1927 but continued to travel widely. In his illustrations for the Zionist Organization he had of necessity worked in a fairly naturalistic style and in his paintings he began moving away from abstraction to a heavily-worked, somewhat *Expressionist figurative style, painting mainly portraits and landscapes. Much of his later career was devoted to teaching at various London colleges, most notably Borough Polytechnic, 1945–53. Many of his pupils, among them Frank *Auerbach and Leon *Kossoff, found him an inspiring teacher. Auerbach recalls that in his classes 'there was an atmosphere of research and radicalism that was extremely stimulating'. Bomberg's pupils exhibited together under the name Borough Group, 1947–50, and then as the Borough Bottega, 1953–6. In spite of the admiration he received from those who knew him well, Bomberg was by this time becoming increasingly embittered at the lack of general recognition for his work (John *Rothenstein writes that during his lifetime he was 'the most neglected major British artist of his time'), and in 1954 he moved to Spain. He returned to England shortly before his death. Since then his reputation has soared; a major exhibition was devoted to him at the Tate Gallery in 1988.

Bombois, Camille (1883–1970). French *naive painter, born at Vénarey-les-Laumes, the son of a boatman. He spent his childhood on canal barges until he became a farmhand at the age of 12. Later he was a road labourer and a wrestler in travelling circuses. From 1907 he lived in Paris, where after working as a porter on the Métro, a navvy, and a docker, he took a night job in a printing establishment so that he could paint during the day. He served in the French army during the First World War and was awarded a Military Medal. In 1922, when he was painting outdoors in Montmartre, a journalist noticed his work and he came to the attention of Wilhelm *Uhde and other critics. With their encouragement he was able to devote all his time to painting and

he became one of the best-known naive painters of his day, exhibiting his work widely. His paintings include landscapes, townscapes, portraits, hefty female nudes (inspired by his wife), and scenes of circus life. It is for his circus pictures that he is now best known; they have great strength and vigour and sometimes an unconscious *Surrealist air. For example, in *Carnival Athlete* (Pompidou Centre, Paris, c. 1930) some of the bowler-hatted figures are similar to those seen in *Magritte's paintings.

Bone, Sir Muirhead (1876–1953). British draughtsman, printmaker, and occasional painter, mainly of architectural subjects, born in Glasgow, the son of an architect. From 1890 to 1894 he trained to be an architect, whilst taking evening classes at *Glasgow School of Art. He moved to London in 1901 and in the same year first had his illustrations published in *Glasgow in 1901* by James Hamilton Muir (a pseudonym for his brother James Bone, a journalist). In 1903 he married Gertrude Dodd, a writer and sister of Francis Dodd (1874–1949), a painter and etcher, mainly of portraits; Bone later illustrated several of his wife's books. In the years before the First World War he built up a considerable reputation as a printmaker (drypoint was his favourite medium), and his success enabled him to live abroad for several years. He was not interested in traditional picturesque views, however, finding nothing in Florence to inspire him: 'Every cat in the world had been there and the plate had been licked clean.' Instead, his 'special province was the rendering of great masses of buildings under construction or demolition, with all the attendant paraphernalia, in such a manner that out of superficial chaos there emerged a beautiful and ordered design' (Robert Cumming in *Country Life*, 23 February 1978). This ability to combine an overall sense of structure with a wealth of detail has been attributed to a peculiarity of Bone's eyesight: he was short-sighted in one eye and long-sighted in the other. Although his own work was traditional in style, he was sympathetic to modern art and was forthright in defending his friend *Epstein from attacks by conservative critics. Among the other avant-garde artists he admired was David *Bomberg, who moved to Palestine on Bone's advice.

In 1916 Bone was the first person to be appointed an *Official War Artist. A collection

of his lithographs was published in 1917 in two volumes as *The Western Front*, with a text by the journalist C. E. Montague. Bone's enthusiasm played an important part in the founding of the Imperial War Museum, and he served as an Official War Artist again in the Second World War and was a member of the War Artists' Advisory Committee. Kenneth *Clark, the chairman of the Committee, described him as 'one of the most honest, warm-hearted and unselfish men I have ever known'. Bone was a trustee of the National Gallery and the Tate Gallery, was knighted in 1937, and received various other honours.

His son **Stephen Bone** (1904–58) was a painter (mainly of landscapes), art critic (notably for the *Manchester Guardian*), and broadcaster. Like his father, he was an Official War Artist in the Second World War.

Bonn, Kunst- und Ausstellungshalle der Bundesrepublik Deutschland. See HULTEN.

Bonnard, Pierre (1867–1947). French painter, lithographer, and designer, born at Fontenay-aux-Roses, near Paris. His father, an official in the War Ministry, insisted that he study law, but from 1888 he also attended classes at the École des *Beaux-Arts and at the *Académie Julian, where he met several young artists (including his lifelong friend *Vuillard), who formed a group of *Symbolist painters called the *Nabis. After doing military service, 1889–90, he abandoned law and became a full-time artist, initially sharing a studio in Paris with *Denis and Vuillard. His first one-man exhibition was at *Durand-Ruel's gallery in 1896. At this time, as well as painting, he was producing posters and coloured lithographs, and designing for the stage; he worked on the original production of Alfred Jarry's *Ubu-Roi* (1896), considered the first work of the Theatre of the Absurd. He prospered steadily in his career and by 1912 was sufficiently distinguished to be offered the Legion of Honour (he declined, as did *Roussel, *Vallotton, and Vuillard at the same time). In the same year he bought a house at Vernonnet in the Seine Valley and from then until the Second World War he divided his time mainly between this house and the South of France. In 1925 he bought a house called 'Le Bosquet' at Le Cannet, near Cannes, and spent his final years there. His life was quiet and uneventful, although he travelled a good deal before the First World War.

Like Vuillard, Bonnard is best known for intimate domestic scenes to which the term *Intimiste is applied. He generally painted on a larger scale than Vuillard, however, and with greater richness and splendour of colour. His favourite model was his wife, and some of his most characteristic pictures are those in which he depicted her in the bath (she had an obsession with personal cleanliness and spent much of her time in the bathroom). His other subjects included flowers and landscapes. He also did numerous self-portraits. The late ones show his desolation after the death of his wife in 1940, but in general his work radiates a sense of warmth and well-being. This quality and his lively broken brushwork make him one of the most distinguished upholders of the *Impressionist tradition. In the catalogue of a large exhibition of his work at the Royal Academy, London, in 1966, Denys Sutton referred to Bonnard as 'the most important "pure" painter of his generation' and wrote that 'His paint has something almost edible about it, and it was hardly fortuitous that he so often painted meals and food on the table'.

After the death of his wife, Bonnard faked a will in her name to avoid certain legal complications. This went undetected during his lifetime, but after his own death it caused lengthy lawsuits, as a result of which his substantial collection of his own work was sequestered from public view for many years.

Bontecou, Lee (1931–). American sculptor and printmaker, born at Providence, Rhode Island. She studied under William *Zorach at the *Art Students League, 1952–5, and then worked in Rome on a Fulbright Fellowship, 1957–8. In 1959 she had her first one-woman show (of bronzes), at the 'G' Gallery, New York, and in the same year she began making *assemblages. Typically they were constructed from grey canvas or tarpaulin, cut into irregular shapes and affixed to a support in faceted planes by means of wire with protruding hooks and barbs, creating a deliberately brutal air; often they also incorporated welded steel and miscellaneous scrap. She continued to be inventive in her use of materials; some of her work in painted plaster relief and free-standing or hanging plastic, for example, explored a fairyland of imaginary flora and fauna. From the late 1960s she concentrated on printmaking.

Book art. A term applied to books produced as a kind of *Conceptual art, valued for the ideas they embody rather than for their appearance or literary content. This type of work originated in the 1950s (Dieter *Rot began issuing such books in 1954), although there are precedents for the making of one-off 'book-objects' or 'object-books' (see OBJECT) in the work of the *Surrealists, and in 1920 Suzanne *Duchamp received instructions for a proto-Conceptual work involving a book as a wedding present from her brother Marcel. The first exhibition devoted to books of the type defined above was probably 'Book as Art-work' at the Nigel Greenwood gallery, London, in 1972, and the term 'book art' began to be used soon afterwards. John A. Walker (*Glossary of Art, Architecture and Design Since 1945*, 1973, 3rd edn., 1992) writes that it 'refers to publications by individuals or small groups of artists whose background and training is in the visual arts rather than literature. These publications are usually small in size, slim, white, often effete pamphlets, journals, or booklets issued in small editions and marketed via art galleries rather than via bookshops . . . Frequently the text and illustrations are minimal and the majority are not splendid examples of printing or binding.' Other terms that have been used in the same way are 'Bookworks' and 'artists' books', although Walker writes that 'the latter has more recently been used to describe publications which document a work executed in a medium which has an independent status (i.e. using the book format as a way of presenting a work, e.g. a set of photographs, which could be displayed separately), whereas "Book Art" has been used to denote artists' books in which the form is intrinsic to the work from its inception'. None of these terms is to be confused with *livre d'artiste, a very luxurious type of illustrated book. Among the artists who have made something of a speciality of Book art is Ed *Ruscha.

Borduas, Paul-Émile (1905–60). Canadian painter, active mainly in Montreal but also in Paris and New York. He trained as a church decorator under Ozias *Leduc, then studied at the École des Beaux-Arts, Montreal. In 1928 he went to Paris, where he studied briefly with Maurice *Denis, and in 1930 returned to Montreal, where he opened a studio for mural decoration. This met with little success, so he supported himself by working as an art teacher. In the early 1940s, under *Surrealist influence, he started to produce 'automatic' paintings (see AUTOMATISM) and he was the driving force behind the radical abstract group Les *Automatistes. The group's anarchistic manifesto, *Refus global*, published in 1948, led to his dismissal from his teaching post. Serious ill-health and in 1951 the breakup of his marriage increased his problems. In 1953 he moved to New York, where he met several leading *Abstract Expressionists (although communication was difficult as Borduas spoke little English), and in 1955 he settled in Paris. In his final years he achieved an international reputation, and at the time of his death (of a heart attack) the Stedelijk Museum in Amsterdam was planning a 'mid-career' retrospective that turned into a memorial tribute. His mature work has an *all-over surface animation recalling the work of Jackson *Pollock, although the only American influence Borduas acknowledged was that of Franz *Kline. He ranks with *Riopelle as one of the most important Canadian abstract painters of the post-war years, and like Riopelle he was widely influential in his country.

Borès, Francisco (1898–1972). Spanish painter, active mainly in France. He was born in Madrid, where he studied at a private academy, and moved to Paris in 1925. Under the influence of *Gris he flirted for a while with *Cubism, then experimented with *Surrealism before developing a distinctive style of his own. Characteristically he used a flat pastel-coloured background against which he arranged groups of familiar objects in black outline; there is influence from Cubism in the fragmentation of forms, but the treatment is emphatically two-dimensional. In the 1930s such paintings won Borès a position as one of the leading figures of the *École de Paris, but his reputation faded somewhat after the Second World War.

Borglum, Gutzon (1867–1941). American sculptor of Danish descent, born at Bear Lake, Idaho. In the 1890s he worked in Paris (where he studied at the *Académie Julian) and London, then settled in New York in 1902. He made his name with large-scale public works, notably the statues of the twelve Apostles for the Cathedral of St John the Divine, New York (1905), and a six-ton marble head of Abraham Lincoln (1908) for the US Capitol in Washington. Following their successful reception, he

took still further the American cult for the colossal (what his wife called 'the emotional value of volume') when he was commissioned to carve a portrait of the Confederate general Robert E. Lee into the rock of Stone Mountain, near Atlanta, Georgia. Work began in 1917, but the project was aborted in 1925 after a dispute between Borglum and the commissioners. However, the project led to his most famous work (begun 1927), the 'carving' (he used dynamite and pneumatic drills) of a huge cliff at Mount Rushmore in the Black Hills of South Dakota with colossal portrait busts of Presidents Washington, Jefferson, Lincoln, and Theodore Roosevelt. Washington's head was completed in 1930, Jefferson's in 1936, Lincoln's in 1937, and Roosevelt's in 1939; the final details were added in 1941, after Borglum's death, by his son Lincoln. The project was sponsored by the US Government and cost more than $1,000,000.

Solon Hannibal Borglum (1868–1922), Gutzon's brother, was also a sculptor, mainly of Wild West subjects.

Borisov-Musatov, Victor (1870–1905). Russian painter and graphic artist. He studied in Paris, 1895–8, and acquired a taste for *Impressionism and *Symbolism, the latter appealing to the dreamy temperament that had been noted in him since his boyhood (which was marred by ill health). He painted landscapes and portraits, but he is best known for figure compositions featuring languid young women in 18th-century costume—often these were decorative panels intended for specific interiors. His work has an exquisite feeling for colour and pattern, and Alan Bird (*A History of Russian Painting*, 1987) has written that 'he brought into Russian painting an elegant and restrained beauty tinged with mystical nuances which it was never to experience again'. Although he worked mainly in provincial Saratov (his birthplace), he was well known by the time of his early death—not only in Russia, but also in France and Germany (his work was successfully exhibited in these countries in 1904–5). He was particularly influential on the *Blue Rose group.

Borofsky, Jonathan. See NEW IMAGE PAINTING.

Borough Group and **Borough Bottega**. See BOMBERG.

Boshier, Derek (1937–). British painter, sculptor, designer, and experimental artist, born in Portsmouth. He studied at Yeovil School of Art, 1953–7, Guildford College of Art, 1957–9, and the *Royal College of Art, London, 1959–62. His contemporaries at the RCA included David *Hockney, Allen *Jones, R. B. *Kitaj, and Peter *Phillips, and like them Boshier is regarded as one of the leading British exponents of *Pop art. His work of the early 1960s was much concerned with the manipulative forces of advertising, treating the human figure in the same way as mass-produced goods and blending them together. However, although Boshier's interest in advertising later resurfaced in his work, his involvement in Pop art was short-lived. In 1962 he spent a year in India, and this introduced Hindu symbolism into his work; soon afterwards he began producing *Hard-Edge geometrical abstracts. In 1966 he abandoned painting for sculpture in perspex and neon, then turned to photography, film, and *Conceptual art. He took up painting again in 1979 and in the following year moved to Houston, Texas, as assistant professor of painting at the university. He returned to Britain in 1993. Although his career has been fairly low-key compared with those of some of his Pop art colleagues from the early 1960s, many critics think that Boshier's work has stood the test of time at least as well as theirs; several reviewers of the 'Pop Art' exhibition at the Royal Academy in 1991 and the 'Sixties' exhibition at the Barbican Art Gallery in 1993 singled out his work for special praise.

Botero, Fernando (1932–). Colombian painter and sculptor, born in Medellin. He studied in Madrid and Florence, has travelled extensively, and since the early 1970s has lived mainly in New York and Paris. His early work was influenced by various styles, including *Abstract Expressionism, but in the late 1950s he evolved a highly distinctive style in which figures look like grossly inflated dolls; sometimes his paintings are sardonic comments on modern life, but he he has also made something of a speciality of parodies on the work of Old Masters. Botero has acquired an international reputation for such works, accompanied by huge prices in the saleroom. In the early 1970s he began making sculpture in a similar vein to his paintings, and he has made several public monuments in bronze, notably *Broadgate Venus* (Exchange Square,

London, 1990). His work is well represented in the Museo de Arte Moderno in Bogotá.

Boucher, Alfred. See RUCHE.

Bourdelle, Émile-Antoine (1861–1929). French sculptor, born in Montauban, the son of a cabinet-maker. His family was very poor, but in 1876 he was given a grant by the town of Montauban to study at the École des Beaux-Arts in Toulouse. From there he went on to the École des *Beaux-Arts in Paris, 1884–6, and he worked as an assistant to *Rodin, 1893–1908. His first major independent commission (1897–1902) was a monument commemorating the Franco-Prussian War for Montauban (now in the Place Bourdelle). It conveyed the brutality of war without the conventional heroic trappings expected of such monuments and attracted more abuse than praise; Rodin, however, described it as 'an epic work, one of the great achievements of sculpture today'. Bourdelle's first unqualified public success was the bronze *Heracles the Archer* (1909, various casts exist; the Bourdelle Museum in Paris has an example, as it does of virtually all his work). After it was exhibited to great acclaim in 1910, he was generally regarded as the outstanding sculptor in France apart from Rodin himself.

Bourdelle's work has been somewhat over-shadowed by his association with Rodin, but he was already an accomplished artist when he began working for him and he developed an independent style; he revered his master, but said 'all my tendencies and my experiences as well run counter to the laws that rule his art'. His energetic, rippling surfaces owe much to Rodin, but his flat rhythmic simplifications of form, recalling Romanesque art, are highly personal. He was particularly interested in the relationship of sculpture to architecture, and his reliefs for the Théâtre des Champs-Élysées (1910–13), inspired by the dancing of Isadora Duncan, are among his finest works. Bourdelle had many other prestigious public commissions and he made numerous portraits of distinguished contemporaries. He also achieved great distinction as a teacher at the Académie de la Grande Chaumière from 1909 until his death. One of his students there, Vera *Mukhina, described him as 'A little Nibelung, shorter than myself, with an enormous shining high forehead, thick, bushy brows and a black wedge-shaped beard'. He was a talented painter

and draughtsman as well as a sculptor. His house and studio in Paris have been converted into a museum of his work; the first part opened in 1961 to mark the centenary of his birth.

Bourgeois, Louise (1911–). French-American abstract sculptor, born in Paris. She began her artistic training in the family craft of tapestry restoration, then studied at various art academies and in *Léger's studio. In 1938 she married the American art historian Robert *Goldwater and settled in New York. She first made a name as an abstract painter, but turned increasingly to sculpture in the 1940s. Her first one-woman show, at the Bertha Schaefer Gallery, New York, in 1945, included drawings, prints, and wood sculpture; her first exhibition devoted solely to sculpture—consisting mainly of painted vertical wooden forms arranged in groups—was held at the Peridot Gallery, New York, in 1949. In the 1950s she produced wood constructions, painted uniformly black or white, that slightly preceded the similar works of Louise *Nevelson. Subsequently Bourgeois has worked in various materials, including stone, metal, and latex, and she has built up a reputation as one of the leading contemporary American sculptors. She continued to be active in her 80s and in 1993 she represented the USA at the Venice *Biennale.

Although Bourgeois's work is abstract, it is often suggestive of the human figure, sometimes with sexual overtones. Edward *Lucie-Smith writes that her 'essential subject matter is entirely personal . . . She explores and re-explores the consequences of wounds inflicted on her in childhood—by her philandering father and by the hated English governess who was her father's mistress. "My mind, as an artist, was conditioned by that affair, by my jealousy of that hated intruder"' (*Visual Arts in the Twentieth Century*, 1996).

Boussingault, Jean-Louis (1883–1943). French painter, designer, and graphic artist, born in Paris into academic circles, his grandfather, Jean-Baptiste Boussingault, being an eminent chemist. His training included periods at the École des Arts Décoratifs and at the *Académie Julian, where he met his lifelong friend *Dunoyer de Segonzac. Among his early works were poster designs (he was a skilled lithographer) and illustrations for popular journals, and from 1911 he designed

costumes for the fashionable dressmaker Paul Poiret. Like Dunoyer de Segonzac he stood somewhat apart from the mainstream of art in Paris, cultivating a poetic and elegant style, with subtle and sumptuous colour. He is best known for his still-lifes, but he also painted nudes and portraits. Late in his career he also did several large murals (for example at the Théâtre du Palais de Chaillot, Paris, 1937) and designed cartoons for tapestries.

Bowery, Leigh. See FREUD.

Bowie, David. See MODERN PAINTERS.

Bowness, Sir Alan (1928–). British art historian and administrator, son-in-law of Barbara *Hepworth and Ben *Nicholson. He studied modern languages at Cambridge University and history of art at the Courtauld Institute, London. After working for the *Arts Council, he taught at the Courtauld Institute, 1957–79, then was director of the *Tate Gallery, 1980–8. In addition he served on numerous committees, including that of the *Contemporary Art Society. His writings, all on late 19th-century or 20th-century art, include two highly regarded introductory surveys—*Modern Sculpture* (1965) and *Modern European Art* (1972)—as well as numerous more specialist studies, notably on Hepworth and *Moore. He has also organized and catalogued several major exhibitions.

Boyce, Sonia (1962–). British painter, born in London to West Indian immigrant parents. She studied at East Ham College of Art and Technology, 1979–80, then at Stourbridge College of Art, near Birmingham, graduating in 1983. Penny Dunford writes that 'This was the first time she had lived outside London, in a predominantly white area, and she was conscious of having to struggle to assert her identity, because of being female and black' (*A Biographical Dictionary of Woman Artists in Europe and America Since 1850*, 1990). In 1982 she attended the first national conference of black artists, where she met the Tanzanian-born painter Lubaina Himid (1954–), who has been a leading figure in encouraging and promoting the work of black women artists—in 'making ourselves more visible by making positive images of black women'. Boyce's paintings and mixed media images of contemporary black life have been widely exhib-

ited and have won her a considerable reputation. In 1989 she was included in a large exhibition of Afro-Asian art entitled 'The Other Story' at the Hayward, Gallery, London, and was one of only two artists whom Brian *Sewell thought worthy of praise (the other was the Guyanan Donald Locke (1930–), 'a sculptor of exquisite craftsmanship and wicked wit'). Sewell wrote that 'Sonia Boyce matches perfectly the subtle delicacy of pastel to strident colour, sculptural form and robust imagery, so that her work is decorative and profound, sophisticated and primitive, beautiful and urgently political'.

Boyd, Arthur (1920–). Australian painter, printmaker, sculptor, designer, and ceramicist, born in Murrumbeena, near Melbourne. He is the most famous member of a dynasty of artists founded by his grandfather, **Arthur Merric Boyd** (1862–1940), and his wife **Emma Minnie Boyd** (1858–1936), both of whom were landscape painters. His father, **William Merric Boyd** (1888–1959), was a sculptor and potter, and his mother, **Doris Boyd** (*c*. 1883–1960), was a painter and potter, but he was largely self-taught as an artist. In 1937, when he was only 17, he had his first one-man show, at the Westminster Gallery, Melbourne, but his career was interrupted by the Second World War, during which he served in the Australian army as a cartographer. During the 1950s he became one of the best-known artists in his country, scoring notable successes with his large ceramic 'totem pole' at the Olympic Pool, Melbourne (for the Olympic Games of 1956), and his series (twenty pictures) *Love, Marriage and Death of a Half-Caste* (1957–9), concerned with the life and death of an aboriginal stockman and his half-caste bride. These paintings, done in a style combining elements of *Expressionism and *Surrealism, were made the subject of a film, *The Black Man and his Bride*, which won an award in the experimental section of the 1960 Australian Film Festival. Bernard Smith (*Australian Painting 1788–1990*, 1991) writes that 'In these paintings Boyd succeeded better, perhaps, than any other member of the original *Angry Penguin circle in elevating an Australian theme to a universal level, endowing it with a breadth of reference and feeling beyond the limits of nation or region'.

In 1959 Boyd moved to London, where he made his name with a one-man show at the *Zwemmer Gallery in 1960 and a retrospec-

tive show at the Whitechapel Art Gallery in 1962. Since then he has consolidated his reputation, and Sidney *Nolan is probably the only Australian artist who has exceeded him in international fame. Boyd returned to Australia in 1971, but he has continued to spend a good deal of time in England and also in Italy. In 1971 he bought a house at Shoalhaven on the south coast of New South Wales, followed soon afterwards by another property nearby. He presented these to the nation in 1993 and has also given many of his works to the National Gallery of Australia, Canberra. Apart from paintings, Boyd's large output has included sculpture, ceramics, designs for the stage, and prints (mainly etchings and lithographs).

His sister, **Mary Boyd** (1926–), a painter and potter, was married successively to John *Perceval and Sydney *Nolan. Among the other artist members of the family, the best known is probably Arthur's and Mary's cousin **Robin Boyd** (1919–71), an architect and writer on architecture.

Boyle, Mark (1934–). British sculptor, painter, and *Performance artist, born in Glasgow. He served in the army, 1950–3, and studied law at Glasgow University, 1955–6, then worked at a variety of jobs (clerk, labourer, waiter), before turning to art—untrained—when he met the painter Joan Hills (1936–) in 1958. Thereafter they lived and worked together, based in London, and in the 1980s they were joined in their artistic endeavours by their children Georgia (1962–) and Sebastian (1964–), collaborating as the Boyle Family. In the early 1960s Boyle and Hills were involved in performances or *Happenings, one of which was 'Theatre' (1964); in this they 'led a group of people down London's Pottery Lane to a dilapidated rear entrance marked "Theatre". Once inside, Boyle and Hills invited their company to be seated on kitchen chairs ranged before a set of blue plush curtains, which opened upon a performance composed of nothing more, nor less, than the ongoing, everyday activity of the street outside' (Daniel Wheeler, *Art Since Mid-Century*, 1991). In 1967–8 they worked on light-shows for rock musicians, including Jimi Hendrix, and since 1969 they have devoted much of their energies to a long-running project called 'Journey to the Surface of the Earth'. This has involved making minutely detailed replicas in fibreglass of

small areas (usually about 2×2 metres) of the earth's surface at sites chosen at random by having blindfolded friends or members of the public throw darts at a map of the world: 'The aim is to produce as objective a work as possible.' Exhibitions of these works, which are hung on the wall like pictures, have been held at the Hayward Gallery, London (1986), and elsewhere.

Bramley, Frank. See NEWLYN SCHOOL.

Brancusi, Constantin (1876–1957). Romanian sculptor, active for almost all his career in Paris (he became a French citizen the year before his death), one of the most revered and influential of 20th-century artists. He was born in the village of Hobitza into a peasant family and learnt woodcarving whilst working as a shepherd in the Carpathian Mountains. In 1896 he won a scholarship to the Bucharest School of Fine Arts, and in 1903 he moved to Munich, then in 1904 to Paris, where he endured several years of poverty. (According to his own romanticized account, Brancusi made his way to Paris entirely on foot, but this has been doubted.) The first works he exhibited in Paris (at the *Salon d'Automne in 1906) were influenced by *Rodin, but when Rodin offered to take him on as an assistant, Brancusi refused with the famous comment, 'No other trees can grow in the shadow of an oak.' Soon he rejected Rodin's surface animation, and in 1907 he began creating a distinctive style, based on his feeling that 'what is real is not the external form but the essence of things. Starting from this truth it is impossible for anyone to express anything essentially real by imitating its exterior surface.' From this time his work (in both stone and bronze) consisted largely of variations on a small number of themes (heads, birds, a couple embracing—*The Kiss*) in which he simplified shapes and smoothed surfaces into immaculately pure forms that sometimes approach complete abstraction. He was particularly fond of ovoid shapes—their egg-like character suggesting generation and birth and symbolizing his own creative gifts. (His woodcarvings, on the other hand, are rougher—closer to the Romanian folk-art tradition and to African sculpture.)

In 1913 five of Brancusi's sculptures were shown at the *Armory Show in New York. This helped to establish his name (John *Quinn, legal representative of the exhib-

ition, became an important patron of his work), and the following year *Stieglitz gave him a one-man show. During the 1920s he became known to a wider public when he was involved in two celebrated art scandals. In 1920 his *Princess X* was removed by police from the *Salon des Indépendants because it had been denounced as indecent (there is a clear resemblance to a phallus); and in 1926 he became involved in a dispute with the US Customs authorities. They attempted to tax his *Bird in Space* (one of his most abstract works) as raw metal, rather than treat it as sculpture, which was duty-free. Brancusi was forced to pay up to get the work released for exhibition at the Brumner Gallery, New York, but he successfully sued the Customs Office, winning the court decision in 1928. By this time he had a growing international reputation and he travelled widely in the 1930s, including making a visit to India from December 1937 to January 1938 to discuss plans for a Temple of Meditation for the Maharajah of Indore. This was never built, but in the same period Brancusi did carry out his largest work, a complex of sculpture for the public park at Tirgu Jiu near his birthplace. The main elements of the scheme (which was inaugurated in October 1938) are the enormous *Endless Column* (about 30 metres high), which is a funerary monument to soldiers who died in the First World War (he made four other versions of this work), the *Table of Silence*, and the *Gate of the Kiss*. By his final years he was widely regarded as the greatest sculptor of the 20th century. He was rather vain and enjoyed the attention his status as a living legend gave him; he even took to talking about himself in the third person. Although he had many friends in the art world (Marcel *Duchamp and the composer Erik Satie were among the closest), he was secretive about his private life, and this increased his legendary aura.

Brancusi's originality in reducing natural forms to their ultimate—almost abstract—simplicity had profound effects on the course of modern sculpture, as did his masterly skill as a stonecarver, which helped to bring about a revival of *direct carving. He introduced *Modigliani to sculpture, *Archipenko and *Epstein owed much to him, and *Gaudier-Brzeska was his professed admirer. Later, Carl *Andre claimed to have been inspired by *Endless Column*, converting its repeated modules into his horizontal arrangements of identical units. More generally, Henry *Moore wrote of

Brancusi: 'Since the Gothic, European sculpture had become overgrown with moss, weeds—all sorts of surface excrescences which completely concealed shape. It has been Brancusi's special mission to get rid of this undergrowth and to make us once more shape-conscious.' However, although his work is so central to the history of modern art, John *Golding writes that 'as an artist he always managed to stand somewhat apart. When he was presented with a chart of "isms" drawn up by Alfred *Barr and published in Michel *Seuphor's *Art abstrait* in 1949 and saw that he didn't fit into any of them, he was delighted.'

Brancusi was a perfectionist and became increasingly reluctant to part with his work. He spent a good deal of his time arranging it in his studio and photographing it, sometimes documenting works in progress. His friend *Man Ray helped him to improve his camera technique. On his death he bequeathed the studio and its contents to the French Government; it included versions of most of his best works (they often exist in multiple replicas in different materials) and more than a thousand photographs. The studio has now been reconstructed at the *Pompidou Centre in Paris. There is another outstanding Brancusi collection in the Philadelphia Museum of Art.

Brandt, Bill. See NEO-ROMANTICISM.

Brangwyn, Sir Frank (1867–1956). British painter, graphic artist, and designer, born in Bruges, the son of a Welsh architect who specialized in church furnishings. The family returned to Britain in 1875 and from 1882 to 1884 Brangywn was apprenticed to the great designer-craftsman William Morris, after which he travelled the world for several years before settling in London. He considered himself self-taught as a painter, but he was influenced by Morris's romantic medievalism and like his master was active in a wide variety of fields. He was an *Official War Artist in the First World War, for example, he was a skilful etcher and lithographer, and he made designs for a great range of objects (furniture, textiles, ceramics, glassware, jewellery, and so on), but he became best known as a mural painter. This was his main field of activity from 1902 (when he began his first such commission, for Skinners' Hall, London: scenes relating to the fur trade) to 1937 (when he completed further

work in the same building). During the First World War he took up temporary residence in Ditchling, Sussex, and in 1924 he settled there permanently, his large studio providing space for even his biggest works. His most important commission was a series of 18 panels on the theme of the British Empire for the House of Lords. They were begun in 1924 and rejected as too flamboyant for their setting in 1930, a decision that caused great controversy. Offers for the panels came from all over the world, and in 1934 they were installed in the Guildhall in Swansea in a specially constructed room named after the artist. His other mural commissions included several from the USA, for example at the Rockefeller Center, New York (1930–5), where he replaced a work by *Rivera that was found politically unacceptable. His work at its most characteristic was floridly coloured, crowded with detail and incident, and rather Rubensian, although it became somewhat flatter, lighter, and more stylized later in his career. From middle age he suffered a good deal of ill-health, but he lived to be 89 and remained highly prolific. In old age he became something of a recluse.

During his lifetime Brangwyn was one of the most famous of British artists (probably *the* most famous worldwide). In 1952 he was given a retrospective exhibition at the *Royal Academy, the first time a living Academician had been so honoured, and it was commonplace to hear him compared with the great masters of the past. His reputation on the Continent stood extremely high; he received many awards from foreign academies and in 1936 was made an honorary citizen of Bruges to mark his gift of a large collection of his work to found the Brangwyn Museum there. He made a similar gift to the Musée de la Ville at Orange in France in 1947, and he is also well represented in the William Morris Gallery, Walthamstow, to which he donated his art collection as well as many of his own works. Since his death his huge reputation has crumbled. He was a prodigiously hard worker and one of the finest draughtsmen of his time, but his paintings now tend to be dismissed as facile and sentimental.

Braque, Georges (1882–1963). French painter, graphic artist, and designer, celebrated as the joint creator (with *Picasso) of *Cubism. His father and grandfather were skilled painter-decorators, and Braque was brought up to follow their profession (although he was anti-academic, he had a reverence for good craftsmanship and even ground his own pigments). In 1900 he moved from his family home in Le Havre to Paris to complete his professional training, and in 1902–4 he took lessons in painting and drawing at various art schools, including briefly the École des *Beaux-Arts. Through friendship with his fellow students *Dufy and *Friesz (see LE HAVRE GROUP) he was drawn into the circle of the *Fauves, and in 1905–7 he painted in their brightly-coloured impulsive manner. In 1907, however, two key events completely changed the direction of his work: first, he was immensely impressed by the *Cézanne memorial exhibition at the *Salon d'Automne; secondly, the dealer *Kahnweiler (with whom he signed a contract in that year) introduced him to *Apollinaire, who in turn introduced him to Picasso. In Picasso's studio he saw *Les Demoiselles d'Avignon*, and although he was initially disconcerted by it, he soon began experimenting with the kind of dislocation and fragmentation of form it had introduced. He and Picasso worked closely together over the next few years—most closely in the period 1910–12—as they created the revolutionary new style of Cubism. At times it is difficult to tell their work apart, but John *Golding senses some fundamental differences of outlook: 'Picasso's approach was predominantly linear and sculptural; it was he who formulated the concept of "simultaneous vision"—that is to say, the concept of combining different viewpoints of a subject into a single, coherent image. Braque's approach was more painterly, more poetic; significantly, of all the major Cubist painters, only he retained an interest in the evocative properties of light. And he was the technician who through patient research was able to solve so many of the pictorial problems which arose in the creation of this supremely complex and sophisticated style' (*Georges Braque*, 1966).

In 1914 Braque enlisted in the French Army. He served with distinction, twice being decorated for bravery, before being seriously wounded in the head in 1915 and demobilized in 1916. His first important work after recovery was *The Musician* (Kunstmuseum, Basle, 1917–18), showing the influence of *Gris in its use of broad planes of colour. From now on Braque's work diverged sharply from that of Picasso. Whereas Picasso went on experimenting restlessly, Braque's painting

became a series of sophisticated variations on the heritage of his pre-war years. His style became less angular, tending towards graceful curves, and he used subtle muted colours, sometimes mixing sand with his paint to produce a textured effect. In 1922 an exhibition of his work at the Salon d'Automne celebrated his 40th birthday, and by this time he was well-established and prosperous. In the 1930s his reputation became international, and thereafter he accumulated an impressive list of prizes and honours, including the main prize for painting at the 1948 Venice *Biennale. Still-life and interiors remained his favourite subjects, and many critics regard his *Studio* series, begun in 1947, as the summit of his achievement. In his final years he also painted numerous landscapes.

In addition to the type of painting for which he is best known, Braque also did much book illustration, designed stained glass and stage sets and costumes, and did some decorative work, notably the ceiling of the Etruscan Gallery in the Louvre, 1952–3. He was made a Commander of the Legion of Honour in 1951, and ten years later had the honour of being the first living artist to have his work exhibited in the Louvre. After this came the final accolade of a state funeral—an occasion that seemed at odds with his life of unassuming dedication to his art.

Brassaï (pseudonym of Gyula Halász) (1899–1984). Hungarian-born photographer, draughtsman, sculptor, and writer who became a French citizen in 1948. He was born in Brasso, Transylvania (now Brasov, Romania), the son of a professor of French literature, studied art in Budapest and Berlin, settled in Paris in 1924, and adopted his pseudonym (from the name of his native town) in 1925. At this time he was a sculptor and draughtsman, but in 1926 he was introduced to photography by his countryman (later an American citizen) André Kertész (1894–1985), and although Brassaï continued to draw and make sculpture intermittently, it was as a photographer that he achieved international fame. In 1933 he published his first book, *Paris de nuit*, a haunting portrait of the city at night that made his reputation. The people and places of his adopted home continued to be his favourite subjects, and the American writer Henry Miller called him 'the eye of Paris'. For the journal *Minotaure* (1933–9) he produced numerous photographs

of artists in their studios, and this began a life-long friendship with *Picasso (who admired his drawings and encouraged him to continue making them). In 1948 Brassaï published *Sculptures de Picasso*, with a text by *Kahnweiler (English translation 1949), and in 1964 he published *Conversations avec Picasso* (translated as *Picasso and Company*, 1966). Picasso in turn wrote an introduction to a book of photographs of graffiti that had attracted Brassaï as he roamed around Paris—*Graffiti de Brassaï* (1961). Brassaï illustrated many other books, including John *Russell's *Paris* (1960).

Bratby, John (1928–92). British painter (of portraits, landscapes, figure compositions, and still-life), designer, and writer. He was born in London and studied at Kingston School of Art, 1949–50, and the *Royal College of Art, 1951–4. In 1954 he had his first one-man show at the Beaux Arts Gallery, London, and with a number of other painters who exhibited there he formed the *Kitchen Sink School, named after their scenes of drab domestic life (although in Bratby's case they were often painted with rather bright colours). In the same vigorously impasted style he painted the pictures used in the film *The Horse's Mouth* (1959), in which the main character is an artist, Gulley Jimson, played by Alec Guinness. Later Bratby's style became lighter and more exuberant, his work including some colourful flower pieces. In the 1960s he painted several murals, including *Golgotha* in St Martin's Chapel, Lancaster (1965), and in 1984 he did paintings for another film, *Mistral's Daughter*. Among his publications are the novel *Breakdown* (1960) and a book on Stanley *Spencer (1970). Bratby had a talent for self-promotion (he appeared on radio and television and circulated celebrities to see if they might want their portraits painted) and he became one of the best-known British artists of his generation. From 1953 to 1977 he was married to the painter Jean Cooke (1927–). They often depicted each other in their work.

Brauer, Erich. See FANTASTIC REALISM.

Brauner, Victor (1903–66). Romanian painter, sculptor, and draughtsman, active mainly in France, where he was a member of the *Surrealist movement. His father dabbled in spiritualism, and from an early age Brauner was interested in the occult and the weird. He studied briefly at the School of Fine Arts in

Bucharest and had his first one-man exhibition at the Galerie Mozart there in 1924. In 1930 he moved to Paris, where he became friendly with his countryman *Brancusi. Through Brancusi he met *Tanguy, and through Tanguy he joined the Surrealist movement in 1933; the following year he had an exhibition at the Galerie Pierre, for which André *Breton wrote the preface to the catalogue. From 1935 to 1938 he lived in Romania, then returned to Paris. Soon afterwards, on 27 August 1938, he lost an eye when he was struck by a bottle during a brawl at a party in Óscar *Domínguez's studio. This caused amazement and gave him a reputation for clairvoyance, because for several years his paintings had shown a preoccupation with the theme of mutilated eyes; he had even painted a self-portrait in 1931 depicting himself with one eye bleeding. During the Second World War he fled Paris and lived for a time in the Pyrenees and then the Hautes-Alpes. Unable to find painting materials, he experimented with other techniques, including *collage and *fumage. In 1945 he returned to Paris. Three years later Breton expelled him from the Surrealists, but his work continued to be Surrealist in style. From 1961 he lived mainly at Varengeville, near Dieppe. In 1966, the year of his death, he represented France at the Venice *Biennale.

Brauner was an eclectic artist whose work shows influences from many of the leading Surrealists with whom he came into contact, as well as from other contemporaries, including *Klee and *Picasso. Typically he painted figure compositions, often with magical themes. His best-known work, however, is probably not one of his paintings, but the sculpture or *object *Wolftable* (private collection, 1947), in which a stuffed wolf's head and tail are mounted on a table that forms the animal's body and legs.

Brecheret, Victor. See SEMANA DE ARTE MODERNA.

Breitner, George Hendrik. See SLUYTERS.

Breker, Arno (1900–91). German sculptor, printmaker, and architect, born in Elberfeld, the son of a stonemason. He trained locally, then at the Academy in Düsseldorf, 1920–5. From 1927 to 1933 he lived in Paris, where he became a friend of *Despiau and *Maillol, then spent a year in Rome. In 1934 he settled in Berlin, where he became a professor at the Hochschule für Bildende Kunste in 1937. Breker's early work had included abstracts, but he turned to heroic figure sculpture, influenced by the antique and Renaissance art he had seen in Rome, and the gigantic musclebound warriors in which he specialized brought him enormous success in Nazi Germany (see NATIONAL SOCIALIST ART). Hitler's favourite sculptor, he was provided with a castle, vast studio, and prisoner-of-war labourers, and was known as the 'German Michelangelo'. His work included many state commissions, most of which were destroyed after the Second World War as they were considered such potent symbols of Nazism. Breker himself was reckoned fortunate to escape with no more than a caution for his involvement with Hitler, and for some time after the war he kept a low profile and was virtually forgotten to the art world. He settled in Düsseldorf in 1950 and returned to full-time work as a scultor in 1960. Although he made some figures in his earlier idiom, his later sculptures were mainly portrait busts. To many critics, these had little more than curiosity value, but Peter *Ludwig, who was one of his patrons, described Breker as 'a great portraitist whose achievement has been buried beneath a mountain of tendentious slogans'.

Bremmer, H. P. See KRÖLLER-MÜLLER.

Breton, André (1896–1966). French poet, essayist, critic, and editor, the founder of the *Surrealist movement and its chief theorist and promoter. He was born at Tinchebray, Orne, and studied medicine in Nantes, intending to specialize in mental disorders; his work with the insane was one of the sources of his interest in irrational imagery. During the First World War he served as an orderly in a military hospital; the suffering he saw appalled him and encouraged him to turn to writing, for he believed that emotional and imaginative forces could be used to offset the bankruptcy of science and rationalism. After his military service, Breton settled in Paris, where he became one of the editors of the review *Littérature* (1919–24), which encouraged new talent and in particular supported the *Dada movement (Marcel *Duchamp became one of his heroes at this time). In 1920 he published *Les Champs magnétiques* (Magnetic Fields), containing texts he

had produced with a writer friend, Philippe Soupault, by the method of free association—the first published examples of the techniques of *automatism that were to become so important to Surrealism. This was followed in 1924 by Breton's *Manifeste du surréalisme* (dedicated to the memory of his friend *Apollinaire), which marked the official launch of the movement. The manifesto was concerned mainly with the literary aspects of Surrealism, but Breton was deeply interested in painting; in 1925 he helped organize the first Surrealist exhibition ('La Peinture surréaliste', Galerie Pierre, Paris) and when he took over as editor of *La *Révolution surréaliste* in the same year he greatly increased its visual material. The first issue edited by Breton (no. 4) contained the first instalment of his most important statement on painting, *Le Surréalisme et la peinture*, which appeared in slightly expanded form as a book in 1928 (partly translated in *What is Surrealism?*, 1936, and fully translated as *Surrealism and Painting*, 1972). There had previously been some disagreement as to whether painting had a valid place in Surrealism, for automatism—so central to the movement—depended on a rapid flow of ideas, whereas painting is inherently static. Breton, however, argued that 'vision is the most powerful of the senses, and so the ability to fix visual images means that Surrealism does have an interest in painting ... overall, as in other areas of Surrealist work, the aim was to produce a crisis in bourgeois consciousness, to use painting, in Breton's words, as an "expedient" in the service of revolution' (Charles Harrison and Paul Wood, *Art in Theory 1900–1990*, 1992). He always thought of painting (as well as poetry) as a way of understanding and releasing our true natures, rather than as an aesthetic end in itself, and it dismayed him that the success of some Surrealist painters (especially *Dalí) led the public to think of Surrealism as primarily a matter of style (Dalí was one of several leading figures whom he expelled from the movement at various times for doctrinal reasons).

In the final issue of *La Révolution surréaliste* (no. 12, 1929) Breton published his *Second Manifeste du surréalisme*, and the following year he launched another magazine, *Le Surréalisme au service de la révolution* (1930–3). He was interested in revolutionary ideas in politics as well as art and in 1927 he had joined the French Communist Party. Communism had attracted him as a bold endeavour to change humanity,

but he became disenchanted with Stalin and transferred his Marxist political sympathies to Trotsky, whom he met when he made a lecture tour of Mexico in 1938. They jointly wrote a manifesto entitled *Pour un art révolutionnaire indépendant*, which appeared under the names of Breton and Diego *Rivera (Trotsky thought it expedient to substitute the Mexican painter's name for his own); it appeared in translation as 'Towards a Free Revolutionary Art' in the left-wing American journal *Partisan Review* (autumn 1938) and soon afterwards in the *London Bulletin* (see MESENS). In 1939 Breton was drafted into the medical corps of the French army, but he was released the following year and in 1941 he emigrated to the USA, where he spent the remainder of the Second World War. In New York he formed part of a group of expatriate Surrealists who had an important influence on the genesis of *Abstract Expressionism, and he helped David *Hare to produce the magazine *VVV*; its first issue (June 1942) contained (in French and English) Breton's 'Prolégomène à un troisième manifeste du Surréalisme ou non' ('Prolegomena to a third manifesto of Surrealism or else').

In 1946 Breton returned to Paris, where he continued to be regarded as the 'Pope of Surrealism'. By this time, however, the movement was no longer a central force in intellectual life, and his death in 1966 was regarded by many as marking its end. Sarane Alexandrian (*Surrealist Art*, 1970) writes that 'The number of tributes from his oldest companions which appeared in Parisian daily papers showed the degree to which he had been able to be not so much the leader of a school as a director of conscience . . . Even those who had long been divided from him by differences of every kind ... made public statements of the sad nostalgia they felt.' Among these people was Max *Ernst, one of the major painters whose reputation Breton had helped to establish. Breton himself did not paint, but he made *objects and collaborated in *cadavre exquis drawings. He was interested in many aspects of art that lay outside the Western mainstream, including *naive painting (notably the work of Hector *Hyppolite) and psychotic art, owned a good collection of Polynesian artefacts, and had numerous enthusiasms ranging from Gothic novels to butterflies. These interests are suggestive of his complex and sometimes contradictory personality. John *Golding writes that

although he was 'intellectually fearless and a genuine radical', he was also 'oddly enough, a man who disliked excess . . . Like a lot of imaginative people . . . he was attracted to recklessness in others . . . but understandably enough he often felt more comfortable in their company if they happened to be dead or distant' ('The Blind Mirror: André Breton and Painting' in *Visions of the Modern*, 1994).

Brianchon, Maurice. See NÉO-RÉALISME.

Brik, Osip and **Lili**. See MAYAKOVSKY.

Brisley, Stuart (1933–). British avant-garde artist, active in various fields, including photography, video, and sculpture, but best known as a *Body or *Performance artist. He was born in Haslemere and studied at Guildford School of Art, 1949–54, the *Royal College of Art, 1956–9, the Munich Academy (on a Bavarian State Scholarship), 1959–60, and Florida State University, Tallahassee (on a Fulbright Travel Award), 1960–2. Subsequently he taught part-time at several art schools, including the *Slade School. He has won much publicity for his performances concerned with self-inflicted pain and humiliation. The best known is probably *And for today . . . nothing*, performed at Gallery House, German Institute, London, in 1972 as part of the show 'A Survey of the Avant-Garde in Britain'. In this he lay in a bath of water for several days in a room in which the floor was scattered with pieces of rotting meat. Eventually the other artists participating in the show asked him to stop. According to Frances Spalding (*British Art Since 1900*, 1986), 'his discomfort obliges an anaesthetized, depoliticized society forcibly to consider the isolation and alienation of the individual'.

Brock, Sir Thomas (1847–1922). British sculptor, one of the most successful specialists in monuments and public statues at the turn of the century. His most famous work is the huge Queen Victoria Memorial (unveiled 1911) outside Buckingham Palace, London; also well known is his equestrian statue of the Black Prince (1903) in Leeds. He was founder president of the Royal Society of British Sculptors (1905).

Brockhurst, Gerald Leslie (1890–1978). British-born painter and etcher who became an American citizen in 1949. He was born in

Birmingham and studied—at a precocious age—at the School of Art there, 1901–7, and then at the *Royal Academy Schools, 1907–13. An excellent draughtsman and a fine craftsman, Brockhurst won several prizes at the Academy Schools and went on to have a highly successful career as a society portraitist, first in Britain and then in the USA, where he settled in 1939, working in New York and New Jersey. He is best known for his portraits of glamorous women, painted in an eye-catching, dramatically-lit, formally posed style similar to that later associated with *Annigoni. As an etcher Brockhurst is remembered particularly for *Adolescence* (1932), a powerful study of a naked girl on the verge of womanhood staring broodingly into a mirror. The model for this work—one of the masterpieces of 20th-century printmaking—was Kathleen ('Dorette') Woodward, whom Brockhurst met in 1928, when she was 16 and he was 38; their relationship led to the break-up of Brockhurst's marriage and a protracted divorce case, much sensationalized in the press. Brockhurst and Kathleen eventually married in 1947.

Brodsky, Isaak. See AKHRR.

Brodzky, Horace (1885–1969). British painter, graphic artist, designer, writer, and editor. He was born in Australia and spent four years in the USA before moving to London in 1908. His early paintings were influenced by the *Vorticists and he was particularly friendly with *Gaudier-Brzeska, who made a plaster portrait bust of him in 1913 (casts are in the Tate Gallery, London, and elsewhere). Brodzky later wrote a biography of Gaudier-Brzeska (1933) and a book on his drawings (1946). From 1915 to 1923 he lived in New York, where he became a friend of Jules *Pascin, on whom he wrote a monograph (1946). Brodzky's paintings were mainly figure compositions and portraits. He also made pen drawings of the nude (a collection of his drawings was published in book form in 1935) and he was one of the first serious artists to take an interest in *linocut (1912). In 1948 he became art editor of the *Antique Dealer and Collector's Guide*.

Broglio, Mario. See *VALORI PLASTICI*.

Broodthaers, Marcel (1924–76). Belgian artist, writer, photographer, and film-maker.

He worked mainly in the literary world (as a poet and bookseller) until 1963, when he turned to the visual arts (in which he thought he had a better chance of making money) and began producing objects in the *Surrealist tradition (he knew *Magritte). The best-known example is *Casserole and Closed Mussels* (Tate Gallery, London, 1965), an arrangement of mussel shells bursting in a neat column from a pot. The postcard of this work is one of the Tate Gallery's bestsellers, but much of his subsequent work was much less accessible, in a *Conceptual vein. From 1968 Broodthaers carried out his activities in the name of a fictitious museum, the Musée d'Art Moderne; he mounted exhibitions of his work under the auspices of its imaginary departments (for example the Department of Eagles) and he addressed the public in a series of 'open letters' in the service of its supposed section chiefs. These activities 'provided an extended critique of the museum system' (Michael Archer, *Art Since 1960*, 1997). In the catalogue of a large retrospective exhibition of his work held at the Tate in 1980, the gallery's director, Alan *Bowness, claimed that 'Broodthaers created an amazing variety and quantity of works and rapidly established himself as one of the most original artists of his day', but the exhibition was not well received by public or critics. Nevertheless, Broodthaers is a figure to be reckoned with in the art world. He sold most of his work directly to private collectors, and since his death little has appeared on the market; when nine of his works came up for sale at a Christie's auction in London in July 1992, all of them fetched far above their estimates, with one bringing ten times the expected price. A Christie's press officer was quoted as saying 'I've never seen such excitement at a modern sale'.

Brooks, James (1906–92). American painter, born in St Louis, Missouri. He studied at Dallas Art Institute, 1925–6, and at the *Art Students League, New York, 1927–31. During the 1930s and early 1940s he worked with the *Federal Art Project in a *Social Realist vein, creating some impressive murals; unfortunately the largest one, the 70-metres-long *Flight* (1942) at La Guardia Airport, New York, has been destroyed. Brooks served in the US Army, 1942–5, and when he resumed painting in 1954 he took up *Cubism. In 1946 he became a friend of Jackson *Pollock and in the 1950s he was one of the minor masters of the *Abstract Expressionist movement. A typical work of this period is *Boon* (Tate Gallery, London, 1957), which Brooks described as 'completely abstract—having been developed from a purely improvised start and held into a non-figurative channel'. In 1963 he was artist in residence at the American Academy in Rome.

Brooks, Romaine (1874–1970). American painter, active mainly in Paris. She was born Romaine Goddard in Rome to wealthy American parents, and in her early life she lived variously in England, France, Italy, and Switzerland, her main training as a painter being in Rome, 1899–1900. In 1903 she made a marriage of convenience to John Ellingham Brooks, an English homosexual, believing that she would have greater freedom as a married woman. She separated from her husband the following year and thereafter was part of a close circle of lesbian friends; they included Radclyffe Hall, whose novel *The Well of Loneliness* (1928) was banned because of its frank treatment of love between women. Brooks's main work was done in Paris between 1905 and 1936, after which she virtually abandoned painting. She was a successful society portraitist, her work being glamorous in an unconventionally strong and sombre way; she said she was in love with 'the mystery of greys', and her friend the Italian writer Gabriele d'Annunzio described her as 'the most profound and wise orchestrator of greys in modern painting'. There is often a decadent, slightly morbid quality in her portraits, and this is seen more fully in her eerily erotic, almost necrophiliac portrayal of the dancer Ida Rubinstein in *The Voyage* (National Museum of American Art, Washington, *c.* 1911): Rubinstein (with whom Brooks had an affair) is shown lying naked on a mysterious white shape seemingly floating in a dark void (the Russian painter Valentin *Serov also did a remarkable nude portrait of her). Brooks lived in Florence, 1940–67, then moved to Nice, where she died. For many years her work was generally forgotten or dismissed as corrupt, but in the year of her death she came back into the limelight with an exhibition at the Smithsonian Institution, Washington, entitled 'Romaine Brooks: Thief of Souls'. The sub-title comes from a remark of the poet Robert de Montesquiou—a reference to the probing nature of her portraits, which sometimes perhaps disclosed more than the subjects wished.

Brotherhood of Ruralists. A group of seven British painters formed in 1975 when all the members were living in the predominantly rural west of England (their definition of 'ruralist' being 'someone who is from the city who moves to the country'). They were Ann Arnold (1936–) and her husband Graham Arnold (1932–), Peter *Blake, the American-born Jann Haworth (1942–), who was married to Blake, 1963–81, David Inshaw (1943–), Annie Ovenden (1945–), and her husband Graham Ovenden (1943–). In the catalogue of a touring exhibition (Birmingham, Bristol, Glasgow, London) of the group held in 1981, Nicholas Usherwood points out that there were 'only the loosest of geographical ties' between the members and writes that the Brotherhood was 'quite simply an association of friends who shared strongly held views on the nature of art, and who felt the need at a certain point to make a commitment to those values they held to be important . . . The Ruralists believe that sentiment and poetry have, for no valid reason, become taboo subjects for progressive contemporary art and they see in this a serious deprivation of its powers of expression. Closely interwoven with this belief is their intuition that in the country there lies a potent source of inspiration and imagery that they as artists should not ignore. It is for the Ruralists not simply a question of observing nature closely with an objective eye but of bringing to it the full range of their experience and subjective perception of poetry, literature, music, history and myth.'

The Ruralists first exhibited as a group at the Royal Academy summer exhibition in 1976 and last showed together (minus Haworth) at Blake's retrospective at the Tate Gallery in 1983. In between they had several other group exhibitions, took working holidays together, and divided among themselves a commission to design the covers for the 37–volume New Arden edition of Shakespeare's plays. However, they shared ideals rather than a common style. They attracted a good deal of attention (a BBC film 'Summer with the Brotherhood' was broadcast in 1977), including what Nicholas Usherwood calls some 'quite surprisingly vehement attacks'. Many critics, indeed, found their paintings insufferably twee and self-conscious, especially those involving fairies— one review of the 1981 touring exhibition was headed 'Tinkerbell lives'.

Apart from Blake, the best known of the members of the Brotherhood are probably David Inshaw and Graham Ovenden. Inshaw specializes in tightly handled enigmatic landscapes with figures, such as *Our Days were a Joy and our Paths through Flowers* (City Art Gallery, Bristol); Michael Jacobs describes this as 'a typically silly Ruralist title' (*The Mitchell Beazley Traveller's Guide to Art: Britain & Ireland*, 1984). Ovenden is best known for pictures of pre-pubescent girls, which have sometimes been attacked as pornographic. In 1977 he published a book called *Nymphets and Fairies*, and in 1979 he wrote: 'My work is the celebration of youth and spring—the fecundity of nature and our relationship to it. This is why the subject-matter of my work tends towards the girl child (more often than not at the point of budding forth) and the English landscape in all its richness and mystery.' Ovenden is also an authority on Victorian photography, on which he has published several books, and in the late 1970s he was involved in a scandal involving faked or pastiched photographs in 19th-century style. In 1981 he stood trial at the Old Bailey for conspiracy to defraud, but he and his co-defendant were acquitted: 'John Mortimer, Ovenden's QC, argued that Ovenden had wanted to demonstrate that collectors and dealers in Victorian photography equate age with beauty' (Mark Haworth-Booth in Mark Jones, ed., *Fake? The Art of Deception*, catalogue of an exhibition at the British Museum, London, 1990). Ovenden had another clash with the law in 1993 when officers from the obscene publications squad of the Metropolitan Police seized a large quantity of his photographs. They were eventually returned following a petition on Ovenden's behalf by fellow artists.

Brown, Frederick (1851–1941). British painter and teacher, born at Chelmsford, the son of a painter. A founder member of the *New English Art Club in 1886, he was responsible for drawing up the rules of the club and was amongst the most energetic in its campaign against the conservatism of the *Royal Academy. After teaching at Westminster School of Art for 15 years, he was made professor at the *Slade School in 1892 and presided over its golden period, retiring in 1917. Brown had hated the mechanical teaching methods of his own student days (at the National Art Training School, which later

became the *Royal College of Art) and he aimed to develop the individuality of his pupils. Soon after becoming professor, he appointed *Tonks (another outstanding teacher) as his assistant, and he also recruited *Steer to the staff. He made a fine collection of his contemporaries' and pupils' work. Examples of his own work, including a late self-portrait (1932), are in the Tate Gallery, London.

Brown, Oliver. See LEICESTER GALLERIES.

Brown, William. See BAY AREA FIGURATION.

Browse, Lillian (1906–). British art historian, dealer, collector, and exhibition organizer, born in South Africa. She trained as a ballet dancer, but gave up this career in 1931 and from then until 1939 worked for the Leger Galleries, one of the leading London dealers in Old Masters and British watercolours. During the Second World War she organized exhibitions for several institutions, most notably the National Gallery, where they complemented the famous wartime recitals given by the pianist Dame Myra Hess (the first exhibition was 'British Painting Since Whistler', which opened in March 1940). In 1945 she went into partnership with two German-born dealers, Henry Roland (1907–93) and Gustav Delbanco (1903–97), to found the firm of Roland, Browse & Delbanco, which ran a gallery in Cork Street, London. dealing mainly in British figurative painters. Among the artists it helped to establish were Prunella Clough (1919–), Bernard *Dunstan, Joan *Eardley, Josef *Herman, and Anthony Whishaw (1930–). The firm was renamed Browse & Darby in 1977 and its gallery still operates in Cork Street under this name. Browse wrote several books, including *Augustus *John Drawings (1941), *Degas Dancers (1949), *Forain, the Painter (1978), and two monographs on *Sickert (1943 and 1960; she also organized the Sickert exhibition commemorating the centenary of his birth at the Tate Gallery, London, in 1960). She made a fine art collection of her own, consisting mainly of British and French painting and sculpture of the late 19th and 20th centuries. In 1983 she presented most of it to the *Courtauld Institute of Art.

Bruce, Edward. See FEDERAL ART PROJECT.

Bruce, Patrick Henry (1881–1936) American painter, born at Long Island, Virginia. After studying with Robert *Henri in New York, 1902–3, he went to Paris, where he remained for almost the whole of the rest of his life. He studied under *Matisse and became a friend and follower of *Delaunay, working closely with him from about 1912 to 1915. Thus he was moving towards abstraction at the same time as two other Americans in Paris—the *Synchromists Stanton *Macdonald-Wright and Morgan *Russell. For a time, in a series of pictures entitled Compositions (1916–17), Bruce was fairly close to them in style, but then in a series of Formes (1917–36) he developed a more geometric style featuring thickly pigmented blocks of bright colour based on still-life forms (there is a kinship with the hard-edged forms of *Purism, but Bruce was more subtle and inventive than *Le Corbusier and *Ozenfant, its chief exponents). In both series Bruce showed outstanding gifts as a colourist. His work was exhibited at the *Armory Show in 1913, but he remained almost unknown in the USA. Disillusioned by his lack of success, he destroyed most of his paintings in 1932. He returned to the USA in 1936 and committed suicide a few months later.

Brücke, Die (The Bridge). Group of German *Expressionist artists founded in Dresden in 1905 and disbanded in Berlin in 1913 (its full name was 'Die Künstlergruppe Brücke'—'The Artists' Group of the Bridge'). The founders were four architecture students at the Dresden Technical School: Fritz Bleyl (1880–1966), Erich *Heckel, Ernst Ludwig *Kirchner, and Karl *Schmidt-Rottluff. The name was suggested by Schmidt-Rottluff, because of their admiration for the philosopher Nietzsche, who in Also sprach Zarathustra wrote that 'What is great about man is that he is a bridge and not a goal'; it indicated their faith in a happier, more creative future, to which their own work would act as a bridge. Kirchner—at 25 the oldest of the group and the only one to have had any professional training as a painter—was the dominant figure; it was he who wrote the group's short manifesto (1906) and cut it in wood so it could be issued as a broadside. It reads: 'With a belief in progress and in a new generation of creators and supporters, we summon all youth together. As youth we carry the future and want to create for ourselves freedom of life and movement in opposition to the well-established older forces.

Everybody belongs to our cause who reproduces directly and passionately whatever urges him to create.' This document typifies the vagueness of their aims, for no clear programme emerged from any of their publications; however, in essence they were in revolt against passionless middle-class conventions and wished to create a radically new style of painting that would be in tune with modern life.

The Brücke artists often worked in close collaboration, although they never lived together as a community. Initially they rarely signed their work, and one member would sometimes use a print by one of the others as a basis for a painting. This group solidarity and interchange of ideas meant that critics sometimes had difficulty telling one member's work from another's. Their subjects were mainly landscapes and figure compositions (a favourite theme being nudes in the open air); they were treated in an emotional style characterized by strong (and often unnaturalistic) colour and simplified, energetic, angular forms. Although there is some kinship of spirit with *Fauvism (founded in the same year), notably in the bold colour and sense of spontaneity, the work of the Brücke artists was markedly different in feeling and technique: in place of exuberance there was restlessness and anxiety, and in place of French sophistication there was the crude vigour of artists who had had almost no formal tuition as painters. They were influenced not only by late medieval German art, which is often extremely intense emotionally, but also by *primitive art, of which the Museum of Ethnology in Dresden had a substantial collection, acquired from German colonies in Africa and Oceania.

The Brücke artists promoted their work by more than twenty exhibitions; the first was held in the Seifert Lamp Factory in Dresden in October 1906, but later ones were usually in more traditional gallery spaces. Exhibitions that consisted only of graphic art generally travelled to several venues. They attached great importance to printmaking and played a major role in the revival of the woodcut that was such a feature of early 20th-century graphic art. Like their paintings, their prints often had a harsh, untutored intensity, with the forms sometimes almost hacked into the block. The prints were sold not only at exhibitions, but also by means of annual portfolios, issued to subscribers (or 'honorary members'), of whom there 68 in 1910 (they all came from German-speaking countries, apart from a Miss Edith Buckley of Crawley, Sussex, about whom unfortunately nothing is known). By this time the original membership of Die Brücke had changed. Bleyl had dropped out in 1909 and several other artists had joined, although some of them were really 'corresponding members' whose contributions were marginal. The most committed recruits were Max *Pechstein, who joined in 1906, and Otto *Müller, who joined in 1911. Emil *Nolde also took up an invitation to join in 1906 (surprisingly, given the fact that he was a loner by instinct), but he left the following year. Four foreign artists whose work was admired by the founders also became members, but they had nothing in common with the Germans stylistically: they were the Swiss Cuno *Amiet, the Dutch-born, French-resident Kees van *Dongen, the Finn Akseli *Gallen-Kallela, and the Czech Bohumil *Kubišta.

By 1911 all the German members of Die Brücke had moved to Berlin, where there was a more vigorous cultural scene (the group had made an impact at the first exhibition of the Neue *Sezession there in 1910). Pictures showing the stress of urban life now became increasingly important in their work, often conveying a nightmarish sense of claustrophobia and depravity. They were now beginning to achieve national recognition, but they were also losing their group identity as their individual styles emerged more clearly. In 1912 Pechstein was dismissed for exhibiting outside the group, and other personal differences emerged. To try to reaffirm their cohesion, the remaining members decided to publish a Chronicle of their activities, written by Kirchner. It had the opposite effect from the one intended, for the other members objected to certain of Kirchner's statements and the association was dissolved by mutual agreement in 1913. A museum of the group's work opened in Berlin in 1967, funded by Schmidt-Rottluff.

George Heard *Hamilton writes of the Brücke artists: 'Their association did not last long, but it was remarkable for the intensity of their convictions, for their intellectual and technical cooperation, and for the insight with which, as critics of society, they exposed its moral decline . . . They had created Germany's first modern movement with works, morbid and displeasing as at times they may be, that are often of authentic and indisputable force.'

Brus, Günter. See VIENNA ACTIONISTS.

Brusselmans, Jean (1884–1953). Belgian painter, born in Brussels. After training as a commercial lithographer-engraver, he studied painting at the Brussels Academy. His early works were naturalistic, in the tradition of late 19th-century French painting, but he developed a heavy, austere *Expressionist style, which he displayed in peasant scenes, landscapes, still-lifes, and interiors. He was little appreciated in his lifetime, but he is now regarded as one of the leading Belgian painters of his time: 'Brusselmans is the dourest, most unyielding of expressionists. it has taken a long time—until after his death, sad to say—before the world discovered that the intentional sparseness of form, the coarse bread Brusselmans offers us has a rare and pure taste . . . His work is poor and monotonous in appearance only. It shines with life, jubilantly soaring up from its own limitations' (W. Vanbeselaere, *Moderne Vlaamse Schilderkunst*, 1966, translated in the catalogue of the exhibition 'Ensor to Permeke: Nine Flemish Painters, 1880–1950', Royal Academy, London, 1971).

Brymner, William. See CANADIAN ART CLUB.

Buchheister, Carl (1890–1964). German painter, active mainly in his native Hanover. He began to paint in 1919 without formal training. His early work belonged to the *Neue Sachlichkeit movement, but in the later 1920s—influenced by *Constructivism—he turned to abstraction and from 1933 to 1936 he was a member of *Abstraction-Création. From 1945 he taught at the Hanover Academy. His post-war work includes abstract collages, sometimes in a style akin to *Art Brut.

Buffet, Bernard (1928–). French painter, etcher, lithographer, designer, and occasional sculptor, born in Paris, where he studied at the École des *Beaux-Arts, 1944–5. Highly precocious, he had his first one-man exhibition in 1947, at the Galerie des Impressions d'Art in Paris, and the following year, aged only 20, he was awarded the Prix de la Critique jointly with the much older Bernard Lorjou (see HOMME-TÉMOIN). By this time Buffet had already established his distinctive style, characterized by elongated, spiky forms with dark outlines, sombre colours, and an overall mood of loneliness and despair. He used it for a wide range of subjects, including religious scenes, landscapes, still-lifes, and portraits (*Self-portrait*, Tate Gallery, London, 1956). His work seemed to express the existential alienation and spiritual solitude of the post-war generation, and he enjoyed enormous success in the 1950s. Later, as he found himself overwhelmed with commissions, his work became more stylized and decorative, losing much of its original impact. A museum devoted to him opened in Shizuoka Prefecture, Japan, in 1973, and there are examples of his prolific output in many collections of modern art.

Bugatti, Rembrandt (1885–1916). Italian sculptor and draughtsman, son of Carlo Bugatti (1856–1940), who is best known as a furniture designer but also painted, and brother of the famous automobile designer Ettore Bugatti (1881–1947). He was born in Milan and worked mainly in Paris (where his family settled in 1904) and Antwerp (where he lived from 1907 until the outbreak of the First World War). Precociously gifted, he was stimulated by making visits to *Trubetskoy's studio when he was a boy, but he had no formal training in art. His speciality was bronze animal sculptures, in which he moved from an impressionistic style to a more abstracted idiom. He was one of the most acclaimed artists of the day in his field (he was made a Chevalier of the Legion of Honour when he was only 26), but he committed suicide because of a combination of illness, depression (partly caused by a failed love affair), and financial problems (the war had ruined his market). After his death his reputation faded, except perhaps in Antwerp, where the zoo encouraged animal artists (this had been his main reason for moving there). In 1947 the Royal Zoological Society of Antwerp founded the Bugatti Prize for Sculpture in his memory, and in 1955 it published a monograph on him. By the 1970s his reputation had greatly revived. In 1979 an exhibition entitled 'The Amazing Bugattis' (featuring the work of Carlo, Ettore, and Rembrandt) was held at the *Royal College of Art, London.

Buhler, Robert. See SPEAR.

Bulatov, Eric. See SOTS ART.

'Bulldozer Show'. See UNOFFICIAL ART.

Bulletin de l'Effort Moderne. See ROSEN-
BERG, LÉONCE.

Bunny, Rupert (1864–1947). Australian
painter, active in Paris for most of his career.
He was born in Melbourne, the son of a judge,
and moved to Europe in 1884, studying first in
London, then in Paris, where he settled in
1886. His work became deeply French in spirit
and was well received in his adopted country;
he also exhibited with success at the *Royal
Academy during his frequent visits to Lon-
don. Bunny's paintings included landscapes,
portraits, and mythological subjects, but he is
best known for leisurely scenes involving ele-
gant, beautifully dressed women (*Returning
from the Garden*, Art Gallery of New South
Wales, Sydney, 1906). In 1911 he visited Aus-
tralia, and in the same year his work was
shown in Pittsburgh and Rome. At this time
he was at the height of his career, but the First
World War ended the carefree world of para-
sols and lace he loved to depict. He remained
in France until 1933, when he returned to
Australia following the death of his French
wife, and settled near Melbourne. Although
he continued to work, he was little appreci-
ated in Australia until very near the end of his
life. Bernard Smith (*Australian Painting
1788–1990*, 1991) writes that 'Bunny was a tal-
ented and sensitive exponent of the more con-
servative side of French painting at the turn
of the century . . . No Australian artist ever
painted women more perceptively . . . There
was something in his gentle nature that led
him to idealize feminine charm and grace
with a becalming innocence of mind . . . A few
months before his death Sir Daryl *Lindsay
arranged a retrospective exhibition of his
work, at the National Gallery of Victoria,
which revealed for the first time to Aus-
tralians the range and variety of his work . . .
Since his death his work has been held in the
highest regard . . . some critics . . . considering
him the finest of all Australian painters.'

Burchfield, Charles (1893–1967). American
painter, mainly in watercolour. He was born
in Ashtabula Harbor, Ohio, and studied at the
Cleveland School (now Institute) of Art,
1912–16. In 1921 he settled permanently in
Buffalo, where he worked as head designer in
a wallpaper factory until he was able to devote
himself full-time to art in 1929. Burchfield's
work divides into three clear phases. Up to
about 1918 he painted scenes of nature that
have an obsessive, macabre quality, often
based on childhood memories and fantasies.
In his second phase—during the 1920s and
1930s—he was one of the leading *American
Scene Painters, portraying the bleakness of
small-town life and the grandeur and power
of nature. In the early 1940s he became disen-
chanted with realism, however, and changed
his style again, reviving the subjective spirit
of his youthful work but in a more monu-
mental vein, as he turned to a highly personal
interpretation of the beauty and mystery of
nature (*The Sphinx and the Milky Way*, Munson-
Williams-Proctor Institute, Utica, 1946).
'His last paintings are filled with chimerical
creatures—butterflies and dragonflies from
another world. Few American artists have
ever responded with such passion to the land-
scape or have made it such a compelling
repository as well as a mirror of their intimate
feelings' (Matthew Baigell, *Dictionary of Ameri-
can Art*, 1979). In the 1950s Burchfield taught
at several institutions including the Buffalo
Fine Arts Academy and the University of Buf-
falo. The Charles E. Burchfield Foundation,
Buffalo, possesses his papers and a good col-
lection of his paintings.

Burden, Chris. See BODY ART.

Burdick, Charles. See AIRBRUSH.

Buren, Daniel (1938–). French painter and
*Conceptual artist. He was born in Boulogne-
Billancourt and studied in Paris at the École
Nationale Supérieure des Métiers d'Art,
1956–60. Since 1965 his work has invariably
featured deckchair-like vertical stripes,
alternating white with a single colour. These
stripes, always 8.7 cms wide, have been used
in various contexts—applied to billboards, for
example, or in gallery installations. Often
they are ephemeral, but in 1986 he created
Deux Plateaux ('Two Levels'), an arrangement
of striped marble columns of varied heights
in the courtyard of the Palais Royale, Paris.
According to Charles Harrison and Paul Wood
(*Art in Theory 1900–1990*, 1992), 'His declared
aim is to reduce painting to an essential state,
by this means to effect a rupture with tradi-
tional concepts of development in art, and to
reinstate painting as a practice of theory as
distinct from decoration or craft'—an analysis
that at least has the virtue of brevity com-
pared with Buren's own tortuous explica-
tions.

Burgin, Victor (1941–). British *Conceptual artist. He studied at the *Royal College of Art, 1962–5, and Yale University, 1965–7, and became dissatisfied with 'the sort of formal stylistic games that were prevalent then'. Since the early 1970s he has worked with photo-essays: 'Images culled from advertising photography are juxtaposed with written quotations obviously at variance with them, creating a thought-provoking multiplicity of texts' (catalogue of the exhibition 'British Art in the 20th Century', Royal Academy, London, 1987).

Burle Marx, Roberto (1909–). Brazilian artist, best-known as one of the outstanding landscape architects and garden designers of the 20th century, but also active as a painter, sculptor, and designer of fabrics, jewellery, and stage sets. He was born in São Paulo to a Brazilian mother of French descent and a German-born father. In 1928–9 his family lived in Berlin, where he attended art classes at the Academy and developed an interest in Brazilian plants through visits to the city's Botanic Gardens. Back in Brazil he enrolled at the School of Fine Arts in Rio de Janeiro in 1930, studying painting under *Portinari, whom he later assisted with tiled murals at the Ministry of Education in Rio (1937). In 1933 Burle Marx completed the first of the many garden projects that have made him one of the most celebrated and best-loved artists in his country. He uses colourful tropical plants arranged as sculptural groups within free-flowing patterns and has succeeded in creating 'a style of landscape design that is at once essentially Brazilian and wholly of the 20th century' (*Oxford Companion to Gardens*, 1986). Many of his designs are skilfully harmonized with examples of Brazil's striking modern architecture, for example his garden and roof terraces (1938) for the Ministry of Education in Rio (the architect was Lucio Costa, later famous for his work at the new capital Brasilia). Burle Marx has designed gardens in other counties in Latin America and also in the USA.

Burliuk, David (1882–1967) and **Vladimir** (1886–1917). Russian painters, brothers, leading members of the avant-garde in the period leading up to the First World War. They were born in the Ukraine and both of them had varied artistic educations, including a period in Munich. Some of their early work was in *Neo-primitive vein close to that of *Goncharova and *Larionov. In 1909 they were among the founders of the *Knave of Diamonds group, and they were among the first exponents of *Futurism in Russia, c. 1911. In Munich they had become friendly with *Kandinsky, and through him they participated in the second *Neue Künstlervereinigung exhibition in 1910 and in the first *Blaue Reiter exhibition in 1911. David wrote an article on the state of Russian painting for the Blaue Reiter *Almanac*, translated into German by Kandinsky as 'Die Wilden Russlands' (The Russian Savages). Vladimir, who was considered by Kandinsky to be the more talented of the two, was killed in action in the First World War. David settled in New York in 1922 and became an American citizen in 1930. He edited an art magazine, *Color Rhyme*, and ran an art gallery. There was another painter brother, **Nikolai** (1890–1920), and two painter sisters, **Lyudmila** and **Nadezhda**.

Burne-Jones, Sir Edward. See PRE-RAPHAELITISM.

Burra, Edward (1905–76). English painter, draughtsman, and occasional stage designer, one of the most delightfully eccentric figures in the history of British art. From childhood he was ravaged continuously by ill-health (he had arthritis and anaemia) and he lived almost all his life in the genteel Sussex seaside town of Rye (he called it an 'overblown gifte shoppe'), but he travelled indomitably and had a tremendous zest for life that comes out in his chaotically misspelt letters as well as his paintings. His life and work, in fact, represent a revolt against his repectable middle-class background (his father was a barrister), for he was fascinated by low-life and seedy subjects, which he experienced at first hand in places such as the streets of Harlem in New York and the dockside cafés of Marseilles. From 1921 to 1925 Burra trained in London at Chelsea Polytechnic and the *Royal College of Art, and he had his first one-man exhibition at the *Leicester Galleries, London, in 1929. By this time he had already formed a distinctive style, depicting squalid subjects with a keen sense of the grotesque and a delight in colourful detail. Usually he worked in watercolour, but on a larger scale than is generally associated with this medium and using layer upon layer of pigment so that—in reproduction at any rate—his pictures appear to have the physical substance of oil paintings.

Burra's work has been compared with that of George *Grosz, whom he admired, but whereas Grosz bitterly castigated evil and ugliness, Burra concentrated on the picturesque aspects of his subjects, depicting them with warmth and humour. Particularly well known are his Harlem scenes of 1933–4, with their flamboyant streetwise dudes and other shady characters (examples are in the Tate Gallery, London, and the Cecil Higgins Art Gallery, Bedford). Burra's style changed little, but about the mid-1930s his imagery underwent a radical change as he became fascinated with the bizarre and fantastic (*Dancing Skeletons*, Tate, London, 1934). Many of his recurrent images—such as the bird-man—and his manner of juxtaposing incongruous objects have a *Surrealist air, and although he generally kept aloof from groups he exhibited with the English Surrealists (he was also a member of *Unit One, organized by his friend Paul *Nash in 1933). The Spanish Civil War and the Second World War evoked a sense of tragedy in Burra that found expression in occasional religious pictures, and during the 1950s and 1960s his interest turned from people to landscape. By this time he had achieved critical and financial success, but he reacted with sardonic humour towards his growing fame.

Burri, Alberto (1915–95). Italian painter, collagist, and designer, born at Città di Castello in Umbria. In 1940 he took a degree in medicine at Perugia University, and in 1943 he was captured while serving as a doctor with the Italian army in north Africa. He was held as a prisoner of war in Hereford, Texas, and it was there that he began to paint in 1944, using whatever materials were to hand, including sacking. After his repatriation he settled in Rome in 1946 and abandoned medicine for art; he had his first one-man exhibition (of *Expressionist landscapes and still-lifes) at the Galleria La Margherita, Rome, in 1947. In 1948 his work became abstract, and in 1949 he began incorporating sacking in his pictures as collage elements; often he splashed red paint on the cloth in a way that suggested blood-soaked bandages (*Sacking with Red*, Tate Gallery, London, 1954). From the late 1950s he also began to use more substantial materials in his pictures, such as pieces of wood or rusted metal, and he sometimes burnt parts of the work, suggesting his experience of the carnage of war. Burri was among the first to exploit the evocative force of waste materials in this way, and his work looked forward to *Arte Povera in Italy and *Junk art in the USA. His pictures were first shown in America at a one-man exhibition at the Frumkin Gallery, Chicago, in 1953, and he subsequently spent a good deal of time in the country, particularly in Los Angeles, the birthplace of his wife, a dancer with Martha Graham's company. Among his American admirers is Robert *Rauschenberg, who visited his studio in 1953 (Rauschenberg's *combine paintings, begun in 1955, were perhaps influenced by Burri's work).

Burri was a fairly reclusive character, but from the 1960s he was among the most internationally famous of Italian artists and he won numerous prestigious awards, including the Grand Prix (jointly with *Vasarely) at the São Paulo *Bienal in 1965. Apart from paintings and collages his work included stage decor for La Scala in Milan and other theatres and the design of the poster for 'Italia 90' (the 1990 football World Cup, which was held in Italy). In 1991 he settled on the French Riviera. According to his obituary in *The Times*, 'the art of Alberto Burri expressed a sensibility lacerated by the experience of total war with a pungency that perhaps none of his contemporaries [matched] . . . In an age which has seen far too much junk dubiously enlisted in the ranks of art, it was universally acknowledged as possessing an arresting dignity and elegance.' Some critics, however, thought that its elegance deprived it of its emotional force, and 'Burri has even been accused of translating the horrors of war into fashionable wall decorations' (Lavinia Learmont in Colin Naylor and Genesis *P-Orridge, eds., *Contemporary Artists*, 1977). Burri himself said 'I've always been interested in making something beautiful from poor materials.'

Burrough, Betty. See MARSH, REGINALD.

Bury, Pol (1922–). Belgian sculptor, painter, and designer, best known as one of the leading exponents of *Kinetic art. He was born in Haine-St-Pierre and studied at the Academy in Mons. During the Second World War he was a member of the Belgian Resistance. He was a founder member of the *Jeune Peinture Belge group in 1947 and of the *Cobra group in 1949. In 1953, however, he abandoned painting for Kinetic sculpture and took part in the 'Mouvement' exhibition at the Galerie Denise

*René, Paris, in 1955, regarded as a key event in the birth of a Kinetic movement. His early works could be rotated at will, inviting spectator participation, but from about 1957 he began to incorporate electric motors. The movement was usually very slow and the impression made was humorous and poetic, in contrast to the violent effects of *Tinguely. Bury has also made films and stage designs. Since 1961 he has lived mainly in Paris.

Bush, Jack Hamilton (1909–77). Canadian painter, one of his country's leading exponents of abstract art. He was born in Toronto and spent most of his life there. Initially he worked in the tradition of the *Group of Seven (*Village Procession*, Art Gallery of Ontario, Toronto, 1946), but in the early 1950s, inspired by Jock *Macdonald and *Borduas's work, he began to experiment with *automatism. In 1952 he made the first of what became regular visits to New York. The influence of these, together with that of his fellow members of *Painters Eleven, brought him by the mid-1950s to a type of *Abstract Expressionism. Later, however, he developed a more individual style, exploring the unaffectedly emotional use of colour, as in his most famous picture, *Dazzle Red* (Art Gallery of Ontario, 1965), which Dennis Reid (*A Concise History of Canadian Painting*, 1973) describes as 'one of the most monumentally beautiful paintings of the decade—there is a boldness that is in no way brash. It is a huge great living banner of colour in which Bush has even managed to infuse naturally cool blue and green with vital human warmth. It reflects the open joy of personal fulfilment.' Bush worked as a commercial designer for most of his career and did not paint full-time until 1968. By this time, however, he was acquiring an international reputation (he had a one-man exhibition in New York in 1962, quickly followed by two more there, and another in London in 1964, and in 1967 he represented Canada at the São Paulo *Bienal).

Bussy, Simon (1870–1954). French painter. He studied at the École des *Beaux-Arts, Paris, and became a lifelong friend of his fellow-pupils *Matisse and *Rouault. In 1903 he married Dorothea Strachey, sister of the *Bloomsbury Group writer Lytton Strachey, and thereafter spent the summers in England and Scotland. He did several portraits of members of the Bloomsbury Group—that of Lady Ottoline Morrell (Tate Gallery, London, *c.* 1920) is particularly well known—but increasingly he turned to landscape and studies of animals (he often made sketches in London Zoo). His favourite medium was pastel.

Butler, Horacio (1897–1983). Argentine painter and designer, born in Buenos Aires, where he studied at the National School of Fine Arts. In 1922 he went to Europe and after spending ten months at the artists' colony at *Worpswede he studied in Paris under *Friesz and *Lhote. He returned to Argentina in 1933 and began to exhibit there and to participate in international group shows. His paintings include landscapes, still-lifes, and figure compositions in a flat, decorative manner that combines various features of the styles he had encountered in Europe. His work as a designer includes stage sets and costumes and a huge tapestry (1965) for the Basilica of St Francis in Buenos Aires.

Butler, Reg (1913–81). British sculptor, draughtsman, and printmaker, born at Buntingford, Hertfordshire. He was an architect by training (his work included the clock-tower of Slough Town Hall, 1936), but he began making sculpture in 1944, without formal training. Architecture remained his main activity until 1950, when he gave up his practice and became the first *Gregory Fellow in sculpture at Leeds University, 1950–3. In 1953 he suddenly came to prominence on being awarded the first prize (£4,500) in the international competition for a 'Monument to the Unknown Political Prisoner' (defeating *Calder, *Gabo, and *Hepworth among other established artists). The competition, financed by an anonymous American sponsor and organized by the *Institute of Contemporary Arts, was intended to promote interest in contemporary sculpture and 'to commemorate all those unknown men and women who in our time have been deprived of their lives or their liberty in the cause of human freedom'. Butler's design was characterized by harsh, spindly forms, suggesting in his own words 'an iron cage, a transmuted gallows or guillotine on an outcrop of rock'. The monument was never built (one of the models is in the Tate Gallery, London), but the competition established Butler's name and he won a high reputation among the British sculptors of his generation.

Butler had learned iron-forging when he

worked as a blacksmith during the Second World War (he was a conscientious objector) and iron was his favourite material. His early sculpture is remarkable for the way in which he used his feeling for the material to create sensuous textures. His later work, which was more traditional (and to many critics much less memorable), included some bronze figures of nude women, realistically painted and with real hair, in contorted poses looking as if they had strayed from the pages of 'girlie' magazines. Butler was a sensitive draughtsman and made drawings as independent works. He also produced a few lithographs and wood engravings. An articulate writer and radio broadcaster, he vigorously argued the case for modern sculpture; five lectures he delivered to students at the *Slade School in 1961 were published in book form the following year as *Creative Development* (he taught at the Slade from 1951 to 1980). He was a widely read man, who numbered leading intellectuals among his friends, and his liberal sympathies were shown by his donation of works to such causes as the campaign against capital punishment.

Byam Shaw, John. See SHAW.

Cabaret Voltaire. A club founded in Zurich in February 1916 by the German poet, musician, and theatrical producer Hugo Ball (1886–1927); it was one of the chief breeding grounds of the *Dada movement. A press announcement on 2 February read: 'Cabaret Voltaire. Under this name a group of young artists and writers has been formed with the object of becoming a centre for artistic entertainment. The Cabaret Voltaire will be run on the principle of daily meetings where visiting artists will perform their music and poetry. The young artists of Zurich are invited to bring along their ideas and contributions.' It opened on 5 March. Among the leading figures were the singer Emmy Hennings (later Ball's wife), the poets Tristan Tzara and Richard Hülsenbeck, and the artists Jean *Arp, Marcel *Janco, and Hans *Richter. The Cabaret Voltaire was, in Richter's words, 'an overnight sensation', but it was forced to close early in 1917 because of 'the complaints of respectable citizens outraged by the nightly excesses'. An account of a typical night was given by Georges Hugnet, a Surrealist poet: 'On the stage someone thumped keys and bottles to make music until the audience, nearly crazy, protested . . . A voice from beneath an enormous hat shaped like a sugarloaf declaimed Arp's poems. Hülsenbeck bellowed his poems, while Tzara emphasized the rhythms and crescendos by banging on a bass drum.' After the closure Ball and Tzara rented a gallery, opened in March 1917 as the Galerie Dada, to which they transferred their activities.

Cabaret Voltaire was the name of the first Dada publication—a pamphlet edited by Ball issued on 15 June 1916.

cachetage. A technique in which casual odds and ends such as nails, screws, bottle caps, studs, buttons, coins, etc. are sealed onto a picture ground made of a resinous substance in order to create an abstract pattern. The technique was principally practised by the German painter and printmaker Werner Schreib (1925–).

cadavre exquis. A game in which a small group of people contribute in turn to make up a sentence or a drawing, no member of the group being aware of what the others have contributed (in the case of a drawing, the paper is usually folded in such a way that the edge of the previous participant's work—meaningless in itself—is visible, providing a starting-point for the next person). This old party game, usually called 'consequences', was given a new seriousness and significance by the *Surrealists as a device for tapping the collective unconscious or exploiting the element of chance that they believed to be a path to creativity. In *Breton's *Dictionnaire abrégé du surrealisme* (1938) it is described as follows: 'A game with folded paper. Every participant makes a drawing without knowing what his predecessor has drawn, because the predecessor's contribution is concealed by the folded part of the paper. The example which has become a classic, and to which the game owes its name, was the first sentence produced by this method [in 1925]: "Le cadavre exquis boira le vin nouveau" [The exquisite corpse will drink the new wine].' An example of a cadavre exquis drawing from 1926 is in the Museum of Modern Art, New York, the participants having been Breton, *Tanguy, and four others.

Cadell, F. C. B. (Francis Campbell Boileau) (1883–1937). Scottish painter. He studied at the *Académie Julian, Paris, 1899–1902, and lived in Munich, 1906–8, before settling in his native Edinburgh. Unlike the other *Scottish Colourists, he was initially less influenced by *Post-Impressionism and *Fauvism than by the tradition of virtuoso brushwork stemming from Manet. Cadell's *The Black Bottle* (NG,

Edinburgh, 1903), for example, could in reproduction easily be mistaken for a late Manet, and in *The Model* (NG of Modern Art, Edinburgh, *c.* 1910) his luscious handling of paint is at least as close to that of certain northern European painters, such as *Liebermann or *Zorn, as it is to anything in contemporary French painting. From about 1920, however, Cadell's work became brighter and bolder (and less subtle)—closer to that of his friend *Peploe. Like Peploe, Cadell is now particularly well known for landscapes painted on the island of Iona, which he visited regularly from 1919, after he returned from active service in the First World War. The island's inhabitants regarded him as a delightful eccentric. He was a much-liked man, but it was not until after his death that he achieved wide recognition as an artist.

Cadmus, Paul (1904–). American painter and draughtsman. Both his father and mother were commercial artists. He studied in his native New York at the National Academy of Design, 1919–25, and the *Art Students League, 1928–30, then worked for an advertising agency before travelling in Europe, 1931–3. On his return to New York in 1933 he started work for the Public Works of Art Project (see FEDERAL ART PROJECT) and in the following year was involved in the first of a series of scandals that characterized his career and established him in the public eye. It was caused by his painting *The Fleets's In!* (Naval Historical Center, Washington, 1934), portraying sailors on shore leave; it was described by the secretary of the navy as 'a most disgraceful, sordid, disreputable, drunken brawl, wherein apparently a number of enlisted men are consorting with a series of streetwalkers and denizens of the red-light district', and was withdrawn from the first Public Works of Art exhibition at the Corcoran Gallery, Washington. In its brutal satire and frankness in portraying carnal desires (he is particularly good at showing sexual hunger and loneliness), the picture is typical of Cadmus's work. The other salient features of his style are his sheer gusto and his complete rejection of modernism—he often uses the poses and compositional devices of the Old Masters and he paints with an extremely meticulous technique, usually in egg tempera. Because of his high polish and precision he is sometimes described as a *Magic Realist. He works slowly and his output as a painter has been small.

However, he has been a comparatively prolific draughtsman, because—as he says—'drawings are more saleable than paintings—they're less expensive'.

Caffin, Charles H. See WRIGHT.

Cage, John (1912–92). American composer, philosopher, writer, teacher, printmaker, and draughtsman. Cage is principally famous as a composer, in which role 'he has had a greater impact on world music than any other American composer of the 20th century' (*New Grove Dictionary of Music and Musicians*, 1980), but he had a deep interest in the visual arts, collaborated with and influenced many of his artist friends, and late in life acquired a reputation as a printmaker. He was born in Los Angeles into a cultured family (his father was an engineer and inventor and his mother a journalist). After being a star pupil at high school, he went to Pomona College, California, in 1928, but he dropped out of his course in 1930 and spent a year and a half travelling around Europe, studying art and architecture as well as music. He tried his hand at abstract painting, but after his return to the USA he concentrated on music; his training included a period of study (1935–7) with Arnold Schoenberg, who himself was interested in painting (see BLAUE REITER). After a period of varied activity (including a spell as a dance-class accompanist), Cage settled in New York in 1942 and became a prominent figure in avant-garde circles, his artist friends eventually including Marcel *Duchamp, Max *Ernst, Jasper *Johns, and Robert *Motherwell.

In 1943 Cage directed a concert at the Museum of Modern Art, including three of his own pieces, and this established his reputation. His compositions are extremely unorthodox, cultivating random and chance effects and experimenting with unusual sound sources, including electronic devices and the 'prepared piano' (Cage's invention), in which a piano is transformed into a percussion instrument by the insertion of various objects between the strings. He toured widely performing his works and often received abuse, but David Mason Greene writes that 'through all his ups and downs' he 'remained unbothered, cheerful, and eager for the next step forward . . . whether in most instances the results qualify as music, save by a kind of Alice-in-Wonderland logic, is questionable, and it remains to be seen whether Cage has

liberated the art or, in the desperate way of the twentieth century, painted it into yet one more corner' (*Greene's Biographical Encyclopedia of Composers*, 1985). In 1948–9 Cage lectured at the *Subjects of the Artist School on 'Indian Sand Painting or the Picture that is Valid for One Day', and from 1948 to 1952 he spent the summers teaching at *Black Mountain College, where in 1952 he organized an event that has been described as the first *Happening. Among the students he met at Black Mountain College was Robert *Rauschenberg, who was one of the artists most directly influenced by Cage's example in using unconventional materials and procedures (for another example of his influence see VIDEO ART). Cage often treated his scores as visual compositions (they have been exhibited in galleries), and from 1978 he began experimenting with printmaking (mainly etching). In the 1980s he also took up drawing seriously. David *Sylvester is of the opinion that his best graphic works 'are among the most beautiful prints and drawings made anywhere in the Eighties'.

Cahiers d'art. Art journal published in Paris from 1926 to 1960. Several issues appeared every year, but the frequency varied; publication was suspended in 1941–3. It was produced by the Greek-born writer Christian Zervos (1889–1970) in collaboration with his wife Marion (1905–70). The journal covered a wide range of subjects, including poetry, music, film, architecture, and Mediterranean archaeology, but it concentrated on modern art, and in particular published many articles on Zervos's friend *Picasso. In 1937, for example, a special number was devoted to his painting *Guernica*, with photographs showing it in various stages of progress. The colour illustrations in the journal were of high quality and sometimes consisted of original lithographs. Zervos also edited and published the standard catalogue of Picasso's works (33 volumes, 1932–78). For an example of the influence of *Cahiers d'art* see SMITH, DAVID.

Cahill, Holger. See FEDERAL ART PROJECT.

Caillebotte, Gustave. See IMPRESSIONISM.

Calder, Alexander (1898–1976). American sculptor and painter, born in Lawnton, Pennsylvania (now part of the city of Philadelphia); he is famous as the inventor of the *mobile and thereby as one of the pioneers of *Kinetic art. His grandfather, **Alexander Milne Calder** (1846–1923), and his father, **Alexander Stirling Calder** (1870–1945), were sculptors, and his mother was a painter, but he began to take an interest in art only in 1922, after graduating in mechanical engineering in 1919 and working at various jobs. From 1923 to 1926 he studied painting at the *Art Students League, New York, where his teachers included George *Luks and John *Sloan. Calder and his fellow students made a game of rapidly sketching people on the streets and in the subway, and Calder was noted for his skill in conveying a sense of movement by a single unbroken line. From this he went on to produce wire sculptures that were essentially line drawings in space; the earliest, made on a visit to Paris in 1926, were amusing, toylike figures of animals, and from these he developed a miniature circus, with which he began giving performances in 1927 (again in Paris). He also made much larger works in this manner, including the well-known group *Romulus and Remus* (Guggenheim Museum, New York, 1928), which features a wolf about 3 metres long. His first exhibition of such works was at the Weyhe Gallery, New York, in 1928.

From now on Calder divided his time between the USA and France, and he knew several leading avant-garde artists in Paris, most notably *Miró, who became his lifelong friend. In 1931 Calder joined the *Abstraction-Création group, and in the same year he produced his first abstract moving construction. In 1932 Marcel *Duchamp baptized these constructions 'mobiles' and *Arp suggested 'stabiles' as a name for the non-moving constructions. Calder's first mobiles were moved by hand or by motor-power, but in 1934 he began to make the unpowered mobiles for which he is most widely known. Constructed usually from pieces of shaped and painted tin suspended on thin wires or cords, these were light enough to respond to the faintest air currents. They were described by Calder as 'four-dimensional drawings', and in a letter to Duchamp in 1932 he spoke of his desire to make 'moving *Mondrians'. Calder was in fact greatly impressed by a visit to Mondrian's studio in 1930, and no doubt envisaged himself as bringing movement to Mondrian-type geometrical abstracts. However, the personalities of the two men were very different: Calder's delight in the comic and fantastic, which can often be seen even in his largest works, was at

the opposite pole to the messianic seriousness of Mondrian.

In 1952 Calder won first prize for sculpture at the Venice *Biennale and after this carried out numerous public commissions—both mobiles and stabiles—in the USA, France, and elsewhere. Some of his later works are very large: the motorized hanging mobile *Red, Black, and Blue* (1967) at Dallas Airport is 14 metres wide. Calder also worked in a variety of other fields, painting gouaches and designing, for example, rugs and tapestries, but his mobiles are far and away his most important and influential works: 'They reached beyond *Futurism and *Constructivism because of their displacement of space by means of random as well as planned movement. Calder was the first sculptor, European or American, to explore so intently the implications of motion, and although his mobiles move through circumscribed spaces, he was also the first to allow process and chance to alter the forms of his pieces. No other American had yet contributed so fundamentally to the progress of modern art' (Matthew Baigell, *A Concise History of American Painting and Sculpture*, 1984).

Calderon, Frank. See NEWTON, ALGERNON.

Camberwell College of Arts. See ST MARTIN'S SCHOOL OF ART.

Cambridge, Kettle's Yard. See EDE.

Camden Town Group. Group of British painters formed in 1911 who took their name from the drab working-class area of London (as it was then) made popular as a subject by *Sickert. In addition to being the prime inspiration of the group, Sickert suggested the name, saying that the district had been so watered by his tears that something important must come from its soil. The group lasted only two years and held only three exhibitions, but the name is also used in a broader sense to characterize a distinctive strain in British painting from about 1905 to 1920, and as Wendy Baron, the group's leading historian, has written, 'If we define Camden Town painting as the objective record of aspects of urban life in a basically Impressionist-derived handling, and recognize it as a distinct movement in British art, then we must accept that the heyday of Camden Town painting was

over by the time the Camden Town Group was born.'

When Sickert settled in England in 1905 after spending most of the previous two decades in France, he said he wanted to 'create a *Salon d'Automne milieu in London', where progressive artists could discuss, exhibit, and sell their work. To this end he kept open house every Saturday afternoon at his studio at 8 Fitzroy Street (this is in Bloomsbury, but he lived at Mornington Crescent, in the borough of Camden, less than a mile away). In 1906 several of his disciples rented premises at 19 Fitzroy Street that were used as a showroom for their work, and the name 'Fitzroy Street Group' has been applied to the artists who met there. Many of these artists also showed their work at the exhibitions of the *Allied Artists' Association, founded in 1908, and several of them also did so at the *New English Art Club, but for some of them these institutions were not progressive enough, which led to the decision to form the Camden Town Group in 1911. Women were excluded and it was decided to limit the membership to 16, who were originally Walter *Bayes, Robert *Bevan, Malcolm *Drummond, Harold *Gilman, Charles *Ginner, Spencer *Gore (president), J. D. *Inness, Augustus *John, Henry *Lamb, Wyndham *Lewis, Maxwell Gordon Lightfoot (1886–1911), J. B. *Manson (secretary), Lucien *Pissarro, William Ratcliffe (1870–1955), Sickert himself, and John Doman Turner (c. 1873–1938), an amateur painter who had been a pupil of Gore. Lightfoot resigned after the first exhibition and committed suicide a few months later; he was replaced by Duncan *Grant.

These artists varied considerably in their aims and styles, but their paintings are generally small, unpretentious, and based on everyday life. Their subjects included not only street scenes in Camden Town, but also landscapes, informal portraits, still-lifes, and nudes in shabby bed-sitters (Sickert wrote in 1908: 'Taste is the death of a painter . . . His poetry is the interpretation of everyday life'). Several of the Camden Town artists painted with a technique that can loosely be described as *Impressionist, with broad, broken touches, but particularly after Roger *Fry's *Post-Impressionist exhibitions of 1910 and 1912, the use of bold, flat areas of colour became characteristic of others, notably Bevan, Gilman, Ginner, and Gore. These four best represent a distinctive Camden Town

'style', one that was much imitated by painters of the urban scene up to the Second World War and beyond.

The Camden Town Group held two exhibitions at the Carfax Gallery, London, in 1911 and a third in 1912. They were financially disastrous, and as the gallery then declined to put on more exhibitions, they merged with a number of smaller groups to form the *London Group in November 1913. The new body organized a collective exhibition in Brighton at the end of 1913, and although it was advertised under the name of the Camden Town Group, it may be regarded rather as the first exhibition of the London Group (see also CUMBERLAND MARKET GROUP).

Among the artists associated with Camden Town painting in the broader sense are: Clare Atwood (1866–1962); Sylvia *Gosse; Nina *Hamnett; Anna Hope (Nan) Hudson (1869–1967); Bevan's wife, Stanislawa de Karlowska (1876–1952); Therese *Lessore; William *Rothenstein and his brother Albert (1881–1953), who changed his surname to Rutherson in 1914; Sir Walter Westley Russell (1867–1949); Ethel *Sands; and Marjorie Sherlock (1897–1973).

Cameron, Sir David Young (1865–1945). Scottish painter, etcher, and draughtsman, born in Glasgow, the son of a clergyman. He abandoned brief unhappy careers in commerce and law to study at *Glasgow School of Art and the Royal Scottish Academy in Edinburgh. Most of his work consisted of landscapes (especially scenes of mountains) and architectural views, and he is best known for his etchings of buildings, including Gothic churches on the Continent—rich and sombre works with which he established a reputation as one of the outstanding printmakers of the day. As a painter his work included First World War scenes done in 1917–18 as an *Official War Artist for the Canadian government. He was knighted in 1924, appointed King's Limner in Scotland in 1933, and received numerous awards and distinctions, including honorary doctorates from several universities. A kindly man who was generous with his time, he served on numerous committees and helped with the administration of the British School at Rome, which he visited several times. He had a deep religious faith and made 'unwearied appeals for a greater recognition of the arts by the Church . . . it was after an impassioned appeal to give the arts their place in worship that he collapsed and died at Perth' (*DNB*).

His sister, **Katherine Cameron** (Mrs Arthur Kay) (1874–1965), was a painter (mainly of landscapes and flowers) and etcher.

Cameron, H. A. See EDINBURGH GROUP.

Camoin, Charles (1879–1965). French painter, born in Marseilles. In 1896 he moved to Paris, where he studied at the École des *Beaux-Arts alongside *Manguin, *Marquet, and *Matisse. With them he became a member of the *Fauves, but although he shared their liking for pure and bright colour, his work was less extreme. In 1916 he met *Renoir, whose paintings greatly impressed him, and from this time Camoin's work belongs more to the *Impressionist tradition than to any of the revolutionary movements of the 20th century. *Bonnard was another major influence on him. His work was varied in subject, his prolific output including portraits, still-lifes, interiors, landscapes, and nudes, all painted with an air of freshness and spontaneity.

camouflage. See THAYER.

Campbell, Steven (1953–). Scottish painter, born and mainly active in Glasgow. After leaving school he worked for seven years as a maintenance engineer and steel fitter, and it was not until 1978, when he was 25, that he enrolled as a student at *Glasgow School of Art. Initially he was interested in *Performance art, but he turned to painting and soon made up for his late start, winning a Fulbright Scholarship that took him to New York in 1982, within months of graduating. He remained in New York until 1986 and as early as 1983 had two one-man shows, at Barbara Toll Fine Arts and the John Weber Gallery. These were well received, and Duncan Macmillan writes that his success 'served as an inspiration and an encouragement to younger artists back in Scotland, for not since *Gear, *Paolozzi, *Davie and *Turnbull forty years before had a Scottish artist moved so effortlessly into the mainstream' (*Scottish Art in the 20th Century*, 1994). After his return to Scotland in 1986, Campbell became the focal point of a flourishing group of figurative painters in Glasgow (see GLASGOW SCHOOL), and 'his achievement has done much to shape the evolution of Scottish painting in recent

years' (Macmillan). Campbell's paintings—often very large in size—typically show bulky figures of offbeat or outlandish appearance placed in strange settings, and he has a taste for unconventional titles (*The Building Accuses the Architect of Bad Design*, Laing Art Gallery, Newcastle upon Tyne, 1984). 'His tweed-clad, mainly male cast of characters roam the countryside and become embroiled in bizarre, nonsensical occurrences. Birds, beasts and men compete in a hostile garden environment, performing strange rituals which defy nature's logic . . . This cultivation of the absurd . . . has parallels in the stories of P. G. Wodehouse (a writer Campbell greatly admires). The settings in Campbell's paintings resemble a theatre set with its claustrophic sense of space and tipped-up perspective. The characters, too, wide-eyed and earnest, recall actors from a second-rate play. Campbell works quickly, painting directly onto the canvas, inventing and changing elements as he progresses' (catalogue of the exhibition 'Scottish Art Since 1900', NG, Edinburgh, 1989).

Campendonk, Heinrich (1889–1957). German painter and designer, born at Krefeld, where he studied under *Thorn Prikker at the Arts and Crafts School. In 1911 he moved to Bavaria and in that year exhibited with the *Blaue Reiter in Munich. His paintings at this time showed the influence of *Macke's interpretation of *Orphism combined with a taste for Bavarian folk art. In 1914 he met *Chagall, and Campendonk's later work, which included numerous stained-glass windows, often has something of Chagall's sense of dreamlike fantasy. Campendonk taught at various art schools in the 1920s, and in 1933 he was dismissed from his post at the Düsseldorf Academy by the Nazis, his work being declared *degenerate. He then moved to Amsterdam, where he taught at the Academy for most of the rest of his life.

Campigli, Massimo (1895–1971). Italian painter, born in Florence. He trained as a journalist in Milan (where he associated with the *Futurists) and was self-taught as a painter. In the First World War he fought in the Italian army and was taken a prisoner of war; after his release he settled in Paris, where he lived from 1919 to 1933. As Campigli himself said, *Léger and *Picasso were major influences on his early work, but after seeing an exhibition of Etruscan art on a visit to Rome in 1928 his style was completely transformed: he abandoned perspective and his figures became two-dimensional and hieratic (although they have an air of dolls rather than of ancient presences). In the 1930s he began to establish an international reputation and received several commissions for large murals, to which his flat figures with their exaggerated gestures were well suited; examples are in the Palace of the League of Nations in Geneva (1937), the Palazzo di Giustizia, Milan (1938), and the Palazzo del Liviano, Padua (1939–40). In 1933 Campigli had returned to Milan; he spent the Second World War there and in Venice, and afterwards lived variously in Milan, Paris, Rome, and St-Tropez (where he died). By the middle of the century he was perhaps the best known internationally among contemporary Italian painters, and his work is represented in many public collections of Europe and America. His reputation has faded somewhat since his death.

Canaday, John (1907–85). American writer, born in Fort Scott, Kansas. He studied at the University of Texas at Austin (BA, 1929), then at Yale (MA in the history of art, 1933), and after private study in Paris for several years taught at various colleges in the USA. During the Second World War he served in the marines. From 1953 to 1959 he was director of educational activities at the Philadelphia Museum of Art, and from 1959 to 1977 he was art news editor for the *New York Times*. In this position he often attacked contemporary art, particularly *Abstract Expressionism (for an example of his opinions, see NEWMAN), and he became a controversial figure; in March 1961 a group of 49 artists, critics, dealers, and so on sent a joint letter to the *Times* deploring his writings, particularly his use of words such as 'charlatan' and 'fraud'. However, like Brian *Sewell in a similar situation 33 years later, Canaday had strong public support (after two weeks' correspondence, the *Times* reported 311 letters defending him and 56 in favour of his critics). Although he disliked much of the art of his own time, Canaday wrote sensitively about earlier 20th-century art, notably in his book *Mainstreams of Modern Art* (1959). In the preface to the second edition (1981), Canaday describes this as 'a history of painting and sculpture in the nineteenth century with their immediate genesis in the late eighteenth and immediate continuations in the

first decades of the twentieth' (the first edition was rather broader in scope, taking the account further into the 20th century and also including a section on architecture). It is one of the best introductory books of its type—serious and well-informed, but written in an attractive, accessible style. His other books include *Embattled Critic: Views on Modern Art* (1962); *The Lives of the Painters* (4 vols., 1969), a series of short biographies of artists from the Middle Ages to *Post-Impressionism; and *Metropolitan Seminars in Art*, issued by the Metropolitan Museum of Art, New York, in 24 monthly portfolios in 1958–60 and described as 'assisted self-education'. Canaday also wrote mystery novels under the pseudonym Matthew Head (seven were published between 1943 and 1955, three of them featuring a female medical missionary in Africa as the detective). He was a noted gourmet and from 1974 worked as restaurant critic for the *New York Times*.

Canadian Art Club. A private exhibiting society of Canadian artists active in Toronto from 1907 to 1915. The main instigators of the Club were the painters Edmund Morris (1871–1913) and Curtis Williamson (1867–1944), who were 'deeply disturbed by the tired, old-fashioned look of Canadian art as seen in the various annual exhibitions' (Dennis Reid, *A Concise History of Canadian Painting*, 1973) and attempted to establish higher standards through small, carefully hung shows. Membership of the Club was by invitation only. Homer *Watson was the first president, and other members included the Scottish-born William Brymner (1855–1925), who had been the first Canadian painter to study in Paris (at the *Académie Julian), Maurice *Cullen, J. W. *Morrice, and Horatio *Walker. The work of these artists was varied in style and subject, but generally showed influence from *Impressionism and *Whistler. Their eight exhibitions were well received, but the Club disbanded in 1915, having lost some of its momentum because of the death (by drowning) of Morris in 1913 and because of the distractions of the First World War (there were also personality clashes among some of the members). However, the Club helped to prepare the way for the *Group of Seven.

Canadian Group of Painters (CGP). A group of Canadian painters formed in Toronto in 1933 as a successor to the *Group of Seven,

whose last exhibition had been in 1931. Two former members of the Group of Seven—A. Y. *Jackson and Arthur Lismer—were among the leading figures of the new organization. The CGP regarded itself as 'a direct outgrowth of the Group of Seven' and aimed 'to encourage and foster the growth of art in Canada which has a national character'; although landscape continued to be the dominant subject among the members of the group, it recognized 'the right of Canadian artists to find beauty and character in all things' and encouraged 'more modern ideas of technique and subject'. Its first exhibition was held in Atlantic City, New Jersey, in summer 1933 and its second at the Art Gallery of Toronto the following November; thereafter an annual November exhibition became the norm. The Group soon expanded (Montreal and Vancouver were the other two main centres of its activities) and many of the best-known Canadian artists exhibited with it up to the time it disbanded in 1969.

Canogar, Rafael (1935–). Spanish painter. He was born in Toledo and studied in Madrid, where in 1957 he was a founder member of the group *El Paso, which was hostile to the Franco regime. His work at this time had developed from *Social Realism to aggressively expressive abstraction, but in the 1960s he reintroduced representational elements, with overtones of humour and satire, through which he expressed human alienation in the modern world: 'The protagonist of my work, man, is a clear denunciation of industrial society, which enslaves our urban existence and reduces the human being to pure functionalism, incapable of the most elementary co-existence and brotherhood.' Canogar has travelled and exhibited widely and is regarded as one of the leading Spanish painters of his generation. In 1971 he was awarded the Grand Prix at the São Paulo *Bienal.

Čapek, Josef (1887–1945). Czech painter, graphic artist, stage designer, and writer, born at Hronov in Bohemia, the son of a doctor. His career was many-sided, but he regarded himself primarily as a painter. Like *Filla and *Gutfreund, he was one of the earliest artists outside France to work in a *Cubist idiom, and with them he was one of the founders of the *Group of Plastic Artists, established in Prague in 1911 with the object

of combining Cubism and German *Expressionism into a new national style. Later the Expressionist current in his work prevailed, revealing his deep concern with fundamental moral and social questions (*Bad Conscience*, Moravian Gallery, Brno, 1926). His humanist outlook was shared by his more famous younger brother, the writer Karel Čapek, several of whose books he illustrated. Both of them fervently opposed the threat from Nazi Germany in the 1930s; Karel died the year before the outbreak of the Second World War, but Josef lived to see its full horrors and died in Belsen concentration camp. His work as a writer included poetry, a novel, and plays written in collaboration with Karel, most notably *The Insect Play* (1920), a comic fantasy satirizing greed and selfishness.

Cappuccio, Antonella. See PITTURA COLTA.

Caran d'Ache. See BATEMAN.

Carline, George F. (1855–1920). British painter and illustrator, the head of a family of artists. He studied in London, Antwerp, and Paris (at the *Académie Julian) and his work consisted mainly of landscapes, portraits, and genre scenes in an accomplished but unexceptional style. His wife **Anne** (1862–1945) took up painting when she was in her sixties; Sir John *Rothenstein writes that 'Certain of her paintings are reminiscent of *Lowry's (which she is unlikely to have seen); others show the influence of *Cubism, originally interpreted.' They had three painter children: **Sydney** (1888–1929), **Hilda** (1889–1950), and **Richard** (1896–1980), all of whom studied at the *Slade School. One of Sydney's fellow-students there was Stanley *Spencer, who met Richard in 1915 and Hilda in 1919, when he went to dinner with the Carline family. He was immediately smitten with her: 'As she came towards me . . . with the soup, I though how extraordinary she looked . . . I could feel my true self in that extraordinary person.' They married in 1925 after a stormy courtship. Their relationship was often argumentative and they divorced in 1937, but even after this and his bizarre marriage to Patricia *Preece, Spencer remained devoted to Hilda. During their engagement, they often painted together, and Spencer thought highly of her work, which consisted mainly of landscapes. Her early work was influenced by *Post-Impressionism, her later work by Spencer. She

exhibited at the *New English Art Club from 1920 to 1944 and at the *Royal Academy from 1920 to 1944.

Sydney's paintings were mainly landscapes and portraits; he also made etchings and designed medals. During the First World War he served with the army and RAF and was an *Official War Artist in 1918. In 1921 he became Master of Drawing at the Ruskin School, Oxford, a post he held until his death. Richard also fought during the First World War and was the youngest of all Official War Artists, working for the RAF in 1918–19. In spite of his youth, he 'could be said to have initiated RAF art' (Meirion and Susie Harries, *The War Artists*, 1983). He was ordered 'to draw up an overall scheme of subjects and artists as a methodical basis for the building of an RAF art collection. At this time Carline had two main concerns—to explore the possibilities of landscapes painted from the air and, more urgently, to save his elder brother Sydney . . . from further active service as a fighter pilot' (he had been shot down over the Somme). After his war service, Carline—still very young—became a student at the Slade, then taught at the Ruskin School under his brother's mastership. Much of his later career was motivated by his desire to achieve international peace and friendship, and he was an active member of various organizations that promoted such ideals, including the *Artists International Association. As an adviser on art education to Cambridge University, he helped to establish more liberal criteria for conducting examinations and judging excellence in children's art. He wrote *Draw They Must* (1968), a history of art education, and *Stanley Spencer at War* (1978). Richard's wife, **Nancy Carline** (1909–), is also a painter.

Carlstedt, Birger (1907–75). Finnish painter and designer, a pioneer of abstract art in his country. He was born in Helsinki and studied there at the Central School of Applied Art. Very early in his career he scored a success with his interior decoration for the Chat Doré restaurant in Helsinki (1928), but it was not until after the Second World War that he achieved general recognition in Finland. By this time he was painting in a completely abstract style—similar to that of *Herbin—featuring intertwining curvilinear forms. He had numerous public commissions for murals, notably for the Television Building, Helsinki (1961).

Carmichael, Frank. See GROUP OF SEVEN.

Carnegie International (also known as Pitts-
burgh International). A large exhibition of
contemporary art held at the Museum of Art,
Carnegie Institute, Pittsburgh, at regular
intervals since 1896. The Institute was
founded in that year by the Scottish-born
industrialist and philanthropist Andrew
Carnegie (1835–1919), who intended that its
permanent collection should grow out of
wide-ranging exhibitions of contemporary
art: 'The field for which the gallery is
designed begins this year.' The Carnegie Inter-
nationals were originally held annually and
later triennially. The prizes awarded at the
exhibition carry great prestige. Among the
artists who have won them are *Matisse
(1927), *Braque (1937), *Calder (1958),
*Giacometti (1961), and Miró (1967).

Caro, Sir Anthony (1924–). British sculptor,
one of the most influential figures in post-
war British art. He was born in London and
studied engineering at Christ's College, Cam-
bridge, 1942–4. After war service in the Fleet
Air Arm, he studied sculpture at Regent Street
Polytechnic, 1946, and the *Royal Academy,
1947–52. From 1951 to 1953 he worked as part-
time assistant to Henry *Moore, who was 'very
generous with his help; when I had no studio
he encouraged me in my own time to make
my own art in his studio'. Caro's early works
were figures modelled in clay, but a radical
change of direction came after he visited the
USA and met David *Smith in 1959. In the fol-
lowing year he began making abstract metal
sculpture, using standard industrial parts
such as steel plates and lengths of aluminium
tubing, as well as pieces of scrap, which he
welded and bolted together and then gener-
ally painted a single rich colour. The colour
helped to unify the various shapes and tex-
tures and often set the mood for the piece, as
with the bright and optimistic red of *Early One
Morning* (Tate Gallery, London, 1962). This,
like many of Caro's sculptures, is large in
scale and open and extended in composition;
it rests directly on the ground, and Caro has
been one of the leading figures in challenging
the 'pedestal' tradition: 'I think my big break
in 1960 was in challenging the pedestal,
killing statuary, bringing sculpture into our
own lived-in space. And doing that involved a
different kind of looking. These sculptures of
mine incorporated space and interval so that

you could not grasp them from a single view;
you had to walk along to take them in.' The
novelty of his work was quickly realized; his
first one-man show after setting off on his
new path (at the Whitechapel Art Gallery,
London, in 1963) was greeted by *The Times* with
the headline 'Out-and-out originality in our
contemporary sculpture'.

Caro taught part-time at *St Martin's
School of Art, 1953–79, and he had a major
influence on several of the young sculptors
who trained under him, initiating a new
school of British abstract sculpture (see NEW
GENERATION). In the 1970s his work became
much more massive and rougher in texture,
sometimes incorporating huge chunks of
metal. In the 1980s he returned to more tradi-
tional materials and techniques and began
making figurative (or semi-abstract) works in
bronze, including (in the early 1990s) a series
inspired by the Trojan War. His reputation is
high in the USA as well as Britain (the Ameri-
can critic Clement *Greenberg wrote of him
in 1965: 'He is the only new sculptor whose
sustained quality can bear comparison with
Smith's . . . the first sculptor to digest Smith's
ideas instead of merely borrowing from
them'). Caro has also had his detractors, how-
ever, among them Peter *Fuller, who
described the work with which he became
famous as 'nothing if not of its time: it
reflected the superficial, synthetic, urban,
commercial American values which domin-
ated the 1960s'.

Carolus-Duran. See SARGENT.

Carr, Emily (1871–1945). Canadian painter of
*Expressionist landscapes, born in Victoria,
British Columbia. She felt the urge to paint
from an early age, but her artistic develop-
ment was slow and halting, interrupted by ill-
health and the need to undertake other work
to earn a living. Her training was principally
in San Francisco, 1889–95, England (mainly at
Westminster School of Art), 1899–1904, and
Paris, 1910–11. During her stay in France she
probably studied briefly with the New
Zealand painter Frances *Hodgkins, but the
main influence on her at this time was the
work of the *Fauves. After her return to
Canada she painted the landscape of British
Columbia with passionate feeling for the
power of nature, executing much of her work
out of doors. She had little success, however,
and discouraged by years of neglect, she had

almost ceased to paint when in 1927 she first saw the work of the *Group of Seven in Toronto. The effect was overwhelming: 'Oh, God, what have I seen? Where have I been? Something has spoken to the very soul of me, wonderful, mighty, not of this world. Chords way down in my being have been touched. Dumb notes have struck chords of wonderful tone. Something has called out of somewhere. Something in me is trying to answer ... Jackson, Johnson, Varley, Lismer, Harris—up-up-up-up-up!' Thereafter she worked with renewed energy and deepened spirituality, overcoming her earlier neglect to attain the status of a national heroine. She wrote several autobiographical books, including *The House of All Sorts* (1944), describing her experiences as the owner of a boarding house, and *Growing Pains* (1946). Her work is well represented in the National Gallery of Canada in Ottawa.

Carr, Thomas. See OBJECTIVE ABSTRACTIONISTS.

Carrà, Carlo (1881–1966). Italian painter and writer on art, a prominent figure in both *Futurism and *Metaphysical Painting. He was born in Quarguento in Piedmont and began his training at the age of 12 with a local decorative painter and stucco-worker. In 1895 he settled in Milan, where he continued to work as a decorative artist and from 1904 attended classes at the School of Applied Arts and then at the Brera Academy. He later destroyed his early paintings, so little is known of his work at this time. In 1908 he met *Boccioni and *Russolo and in 1910 he signed the two Futurist manifestos of painting. On a visit to Paris in 1911 he met *Braque and *Picasso and this introduced a *Cubist element into his work. The previous year he had begun his best-known painting, *The Funeral of the Anarchist Galla* (MOMA, New York), and after his return from Paris he reworked it to assimilate Cubist fragmentation of form into the dynamic Futurist vision. In 1917 Carrà met de *Chirico whilst both were in the military hospital in Ferrara and he was converted to Metaphysical Painting, producing about twenty works with de Chirico's paraphernalia of posturing mannequins, half-open doors, mysterious interiors, etc., though generally without his typically sinister feeling. In 1919 Carrà published a book entitled *Pittura metafisica*, but in the same year he broke with de Chirico and abandoned the style. In the

1920s and 1930s he adhered to the classical principles of the *Novecento Italiano, championing the return to traditional values in the journal *Valori plastici* and also in the Milan newspaper *L'Ambrosiano*, of which he was art critic from 1921 to 1938. From 1941 to 1952 he was professor of painting at the Brera Academy. In his work after the Second World War his style became somewhat looser, with freer brushwork. A collected edition of his writings, *Tutti gli scritti*, was published in Milan in 1978.

Carrick, Alexander. See LORIMER.

Carrick, Edward. See CRAIG.

Carrière, Eugène. See ACADÉMIE.

Carrington, Dora (1893–1932). British painter and designer, born in Hereford into a comfortable middle-class family. She studied at the *Slade School, 1910–14, and from 1917 lived with the writer Lytton Strachey, one of the leading figures of the *Bloomsbury Group. Her emotional life was complex and often distressing, for Strachey was a homosexual and Carrington married another man (Ralph Partridge) and had numerous affairs. Nevertheless, she was utterly devoted to Strachey and she committed suicide a few weeks after his death. Carrington painted portraits, landscapes, and figure compositions, did designs for the *Omega Workshops and for the Hogarth Press (owned by Leonard and Virginia Woolf), and in her later life put a good deal of time into decorative work at her house Ham Spray in Wiltshire, where she lived with her husband and Strachey from 1924. She also devoted much of her energy to a voluminous correspondence, which she illustrated with delightful drawings. Her work was seldom exhibited during her lifetime and she was virtually forgotten for years afterwards. A collection of her letters and extracts from her diaries was published in 1970, marking the beginning of a revival of interest in her. Since then there have been several books and exhibitions devoted to her work, and a film about her life, *Carrington*, was released in 1995. Her brother **Noel Carrington** (1895–1989) was a publisher and book designer.

Carrington, Leonora (1917–). British-born painter and writer (in French) who took Mexican nationality in 1942. She was born in

Lancashire, the daughter of a wealthy textile manufacturer, and from an early age was used to moving in sophisticated society. After being expelled from two convent schools, she went to finishing schools in Florence and Paris, then in 1936 became the first student to enrol at *Ozenfant's art academy in London. In 1937 she met Max *Ernst and settled in France with him; in the following year she began exhibiting with the *Surrealists in Paris. After the outbreak of war in 1939 and Ernst's internment, she fled to Spain, where she suffered a nervous breakdown, recounted in her book *En Bas* (1943, translated as *Down Under*, 1944). From Spain she went via Portugal to New York and then settled in Mexico in 1942, following a marriage of convenience to the Mexican poet Renato Leduc. After divorcing him, she married Imre Weisz, a Hungarian photographer. She became a close friend of Remedios *Varo, another woman Surrealist who had settled in Mexico, and remained there until she moved to the USA in 1985.

As a painter and writer Carrington has remained a dedicated Surrealist. Her pictures typically feature insect-like humanoids, and her stories deal with an imaginary world where hyenas go to the ball and white rabbits feed on human flesh. A retrospective exhibition of her work was held at the Serpentine Gallery, London, in 1992.

Cartier-Bresson, Henri. See TÉRIADE.

CAS. See CONTEMPORARY ART SOCIETY.

Cascella, Pietro (1921–). Italian sculptor, painter, ceramicist, and designer. He was born at Pescara and studied at the Academy in Rome. The son of a traditional sculptor, he has shown a preference for carving in stone (including marble) that is unusual in artists of his generation. Initially, however, he worked mainly as a painter and he did not start to concentrate on sculpture until the late 1950s. His work is abstract and has an archaic simplicity and grandeur well suited to the public monuments with which he has established a reputation as one of the leading sculptors of the post-war era.

His brother **Andrea** (1920–) is also a sculptor and has often assisted Pietro on his major commissions, notably the Martyrs Monument at Auschwitz in Poland (1958–67). His independent works are smaller in scale than Pietro's and often elegant in form.

Casorati, Felice (1883–1963). Italian painter, born at Novara. He was a talented musician and took a law degree in 1906, but he decided to become a painter and studied at the Academies of Padua, Naples, and Verona. After serving in the Italian army during the First World War he began to teach at the Turin Academy in 1918 and soon became a leading figure in the city's intellectual and artistic circles. His early work, influenced by *Art Nouveau, was dominated by hard outlines and strong colours. In the 1920s he was influenced by *Metaphysical Painting, producing pictures emphasizing the volume and substance of the figures and often using strange perspective effects to heighten the air of unreality (*Midday*, Galleria d'Arte Moderna, Trieste, 1922). As well as figure paintings he did numerous commissioned portraits. In the 1930s he adopted a lighter and less harsh palette and a more rhythmic type of composition. By the 1940s he was regarded internationally as 'one of the outstanding artists of the older generation in Italy' (catalogue of the exhibition 'Twentieth-Century Italian Art', MOMA, New York, 1949). He won a prize at the Venice *Biennale in 1938 and again in 1952. In addition to painting, Casorati did much set and costume design, notably for La Scala, Milan, and also made prints and sculpture.

Cassatt, Mary (1844–1926). American painter and printmaker who worked mainly in Paris in the circle of the *Impressionists (she was a friend particularly of *Degas). She specialized in everyday life scenes, her favourite theme being a mother with her child or children. Her early paintings were thoroughly Impressionist in style, but from about 1890 her forms became more solid and firmly outlined. She was an outstanding pastellist and printmaker, her finest prints being in colour and in a combination of techniques (aquatint, drypoint, etching). Their bold flattened forms and unconventional viewpoints were influenced by an exhibition of Japanese prints she saw in Paris in 1890. Cassatt's eyesight began to fail when she was in her fifties and she had virtually stopped working by 1914. She came from a wealthy family and had an important influence on American taste by urging her rich friends to buy Impressionist works.

Cassinari, Bruno. See FRONTE NUOVO DELLE ARTI.

Cassirer, Paul (1871–1926). German art dealer and publisher. He studied art history at Munich University, then moved to Berlin, where he played an important role in promoting contemporary art, both as a dealer and a publisher. In 1908 he founded the Verlag Paul Cassirer, which published belles-lettres, including *Expressionist drama, and in 1910 he established the Pan-Presse, through which he encouraged artists to take up printmaking. These included *Barlach, who illustrated his own plays with lithographs, and *Chagall, who made his first etchings in 1922 as illustrations to his autobiography. Because of difficulties in trying to translate his quirky literary style into German, the text was not published, but the illustrations were issued in 1923 as a portfolio entitled *Mein Leben*. Chagall worked under the tutelage of Hermann Struck (1876–1944), the author of a standard book on etching technique: *Die Kunst des Radierens* (1908). Cassirer was a friend of Paul *Durand-Ruel and also promoted the work of the French Impressionists. His gallery and publishing firm continued after his death (he committed suicide) until they were closed by the Nazis in 1933. His cousin **Bruno Cassirer** (1872–1941) was also a dealer and publisher.

Casson, A. J. See GROUP OF SEVEN.

Casson, Sir Hugh. See FESTIVAL OF BRITAIN and ROYAL ACADEMY OF ARTS.

Castelli, Leo (1907–). Italian-born American art dealer. He was born in Trieste, studied law at Milan University, and initially worked in banking and insurance. In 1939 he opened a gallery in Paris specializing in *Surrealist art, and in 1941 he emigrated to New York. Finding the market for European works dominated by more established dealers, he turned to American art, and in 1958 he first showed work by Jasper *Johns and Robert *Rauschenberg, the two artists with whom he is most closely identified. In the catalogue of the exhibition 'American Art in the 20th Century' (Royal Academy, London, 1993), Castelli is described as 'perhaps the most influential art dealer of the twentieth century . . . The reputations of most of the major artists of the 1960s were made under his guidance. He established the careers of Cy *Twombly, Frank *Stella and Roy *Lichtenstein, before enhancing the standing of Andy *Warhol . . . With his first exhibition of Claes *Oldenburg in 1974, Castelli completed his group of *Pop celebrities . . . In the early years he helped to change the American gallery system by introducing a European-type retainer (monthly wages advanced against royalties from future sales), enabling his artists to concentrate exclusively on their art . . . He has been extremely shrewd in his development of a network of contemporary dealers, increasing the status of his artists by providing accessibility to collectors outside the New York area.'

Caulfield, Patrick (1936–). British painter and printmaker, born in London, where he studied at Chelsea School of Art, 1956–9, and the *Royal College of Art, 1959–63. In 1963 he began teaching at Chelsea School of Art and in 1965 he had his first one-man exhibition at the Robert Fraser Gallery, London. He is often described as a *Pop artist, but he dislikes the label and his work has a distinct individuality. His deadpan handling, with flat colours contained by uniform black outlines, is very much in the Pop vein, but he has generally avoided imagery from popular culture, concentrating instead on more traditional subjects such as landscape, still-life, and domestic interiors; 'In his search for anonymity through the use of familiar, even trite, images, he has created, paradoxically, a very personal style, capable of conveying with extreme subtlety a variety of moods and atmospheres' (catalogue of the exhibition 'Pop Art: An International Perspective', Royal Academy, London, 1991). He took up *screenprinting in 1964 and the following year won a prize for graphics at the Paris *Biennale. Subsequently much of his output has consisted of prints. An exhibition was devoted to his work at the Tate Gallery, London, in 1981.

Cavalcanti, Emiliano di (1897–1976). Brazilian painter, draughtsman, and writer, born in Rio de Janeiro, a pioneer of modern art in his country. He trained for a career in law, but he turned seriously to art after a successful exhibition of his caricatures in São Paulo in 1917. In 1922 he helped to organize the *Semana de Arte Moderna in São Paulo, which is regarded as a turning-point in Brazilian culture; it included dance spectacles, poetry readings, and an art exhibition. From 1923 to 1925 he was based in Paris as a correspondent for the newspaper *Correio de Manha*; during this time he got to know many leading avant-garde artists, including *Braque, *Cocteau,

*Léger, *Matisse, and *Picasso, and he travelled widely in Europe. He returned to Europe in 1938–40. His work draws on a wide range of influences, including *Cubism, *Fauvism and Picasso's *Neoclassicism of the 1920s, which he blended into an extravagantly colourful style, well suited to the high-keyed Brazilian subjects he favoured: sensuous mulatto women, carnival and festival scenes, poor fishermen, and prostitutes were among his favourite themes. His cheerful, conservative brand of modernism and his preference for local subjects won him great popularity in Brazil. He published two volumes of memoirs (1955 and 1964).

Cawén, Alvar. See NOVEMBER GROUP.

Celant, Germano (1940–). Italian art critic. He studied at Genoa University, where he gained a doctorate in art history. In 1967 he coined the term *Arte Povera and he is best known as the chief propagandist for this kind of art, although he has also written on other subjects, including the American photographer (also sculptor and collagist) Robert Mapplethorpe (1946–89), whose homoerotic photographs have often aroused controversy. In 1988 Celant was appointed to the new post of curator of contemporary art at the Guggenheim Museum, New York.

CEMA. See ARTS COUNCIL.

Central St Martin's College of Art and Design, London. See ST MARTIN'S SCHOOL OF ART.

Central School of Arts and Crafts (later **Central School of Art and Design**), London. See ST MARTIN'S SCHOOL OF ART.

Cercle et Carré (Circle and Square). A discussion and exhibition society for abstract artists formed in Paris in 1929 by the critic Michel *Seuphor and the painter Joaquín *Torres-García. They published a journal of the same name (3 numbers, 1929–30): 'The choice of the circle and square as both title and cover illustration reflected, Seuphor later felt, a certain order in the world and evoked the ancient Chinese symbols for heaven and earth, yin and yang; the world of the senses and the world of the mind' (Anna Moszynska, *Abstract Art*, 1990). Although Seuphor and Torres-García aimed to promote geometrical abstrac-

tion, the association was in fact open to abstract artists of various persuasions. It held only one exhibition, at Galerie 23 in April 1930. This was the first exhibition ever devoted solely to abstract art; 46 artists showed work, including *Mondrian and *Vantongerloo but also such non-geometricians as *Kandinsky and *Schwitters. This broadness of approach was attacked by the singleminded van *Doesburg, who in 1930 launched his own review *Art Concret* (see CONCRETE ART) as a counterblast. In 1931 Cercle et Carré was superseded by the larger and longer-lived *Abstraction-Création association, but it had a sequel in Uruguay: in 1935 Torres-García formed an Asociación de Arte Constructivo in Montevideo and he edited a journal *Círculo y Cuadrado* (7 numbers, 1936–8).

César (César Baldaccini) (1921–). French sculptor and experimental artist, born in Marseilles of Italian parents. He studied at the École des Beaux-Arts, Marseilles, 1935–9, and the École des *Beaux-Arts, Paris, 1943–8. His work has been highly varied, but he has become best known for his ingenious use of scrap material. In the mid 1950s he began to make sculptures from objects that he found in refuse dumps—scrap iron, springs, tin cans, and so on—building these up with wire into strange winged or insect-like creatures. In spite of the materials from which they were made, these had closer affinities with the work of Germaine *Richier than with the California school of *Junk sculpture. His use of ready-made commercial objects was shared by several other French artists of the time, and the term *Nouveau Réalisme was coined for their work in 1960. In the same year César began making works consisting of car bodies crushed with a hydraulic press into dense packages (he calls sculptures in this genre *Compressions*) and it is on these that his international reputation is mainly based (*The Yellow Buick*, MOMA, New York, 1961). In 1965 he began working with plastics, creating, for example, giant shiny images of parts of the human body that bring him within the orbit of *Pop art (*Thumb*, Tate Gallery, London, 1965; this is in red plastic—there are also casts in bronze and other materials). In 1967, as a counterpart to his *Compressions*, he began making *Expansions*, using plastics that expand rapidly and quickly solidify; sometimes he made such works in public as a kind of

*Happening. He explored this technique further in the 1970s, using materials such as glass.

Cézanne, Paul (1839–1906). French painter, with *Gauguin and van Gogh the greatest of the *Post-Impressionists and a figure of central importance in the development of 20th-century art. He was born in Aix-en-Provence, the son of a hat dealer who became a prosperous banker, and his financial security enabled him to survive the indifference to his work that lasted until the final decade of his life. Much of his early career was spent in Paris in the circle of the *Impressionists (he participated in the first and third of their eight group exhibitions), but after the death of his father in 1886 and his inheritance of the family estate (the Jas de Bouffan, which figures in many of his paintings), Cézanne lived mainly in Aix. His goal was to create an art combining the best of the French classical tradition of formal structure with the best in contemporary naturalism, and he summed up this objective in two much-quoted remarks: that it was his ambition 'to do Poussin again after nature' and that he wanted to make of Impressionism 'something solid and enduring like the art of the museums'. He devoted himself mainly to certain favourite themes—portraits of his wife Hortense, still-lifes, and above all the landscape of Provence, particularly the Monte Ste-Victoire (in 1896 he remarked 'When one was born down there . . . nothing else seems to mean anything'). His painstaking analysis of nature differed fundamentally from *Monet's exercises in painting repeated views of objects such as *Haystacks* or *Poplars*. Cézanne was interested in underlying structure, and his paintings rarely give any obvious indication of the time of day or even the season represented. His later paintings are generally more sparsely composed and open than his earlier works, permeated with a sense of air and light. The third dimension is created not through perspective or foreshortening but by extraordinarily subtle variations of tonality. In his final decade his work included three large pictures of *Bathers* (female nudes in a landscape setting) that are among his greatest and most radical achievements. The first two (Barnes Foundation, Merion, Pennsylvania, and NG, London) were probably begun in about 1895 and 1900 respectively and worked on intermittently up to his death; the third (Philadelphia Museum of Art) was perhaps entirely painted in 1906. In these majestic works he sacrificed anatomical accuracy for pictorial structure, the simplified forms of the figures echoing the broad sweeps of the tree trunks. Henry *Moore first saw the National Gallery picture in 1922 (when it was in a private collection) and later recalled, 'If you asked me to name the ten most intense moments of visual emotion in my life, that would be one of them.'

Cézanne worked in comparative obscurity until he was given a one-man show in Paris by Ambroise *Vollard in 1895. It made little impact on the public but excited many younger artists, and because Cézanne was rarely seen he began to acquire a legendary reputation. By the end of the century he was revered as the 'Sage' by many of the avant-garde and in 1904 the *Salon d'Automne gave him a special exhibition. A memorial exhibition of his work at the same venue in 1907, the year after his death, was a major factor in the genesis of *Cubism, and his subsequent influence has been profound, varied, and enduring. Richard Verdi (*Cézanne*, 1992) sums up his impact on his immediate followers: 'so protean were the implications of Cézanne's art that few of the most advanced painters of the next generation could afford to ignore it. His "pupils" thus became virtually everyone of consequence connected with the birth of early modern art. For *Picasso he was "like our father . . . who protected us"; for *Matisse, "a god of painting". *Klee regarded him as "the teacher *par excellence*"; and even *Kandinsky—who derived little stylistic influence from Cézanne's art—acclaimed him as an artist who had laid the foundations of abstract art by relegating the objects he painted to the status of pictorial things. "A whole generation of otherwise dissimilar artists have drawn inspiration from his work", claimed the English critic Clive *Bell in 1914. "That is why it implies no disparagement of any living artist when I say that the prime characteristic of the new movement is its derivation from Cézanne."' Forty years after Bell's remarks, Lawrence *Gowing summed up the awesome status Cézanne continued to enjoy among artists and critics: 'He is like a patron saint. Whoever does not feel the force of his art and the heroic virtue of his example . . . is not on the threshold of valuing what it is that is precious to this century' (introduction to the catalogue of the Arts Council Cézanne exhibition, Tate Gallery, London, 1954). Cézanne is now also immensely popular with the public.

The official attendance figure for his exhibition at the Tate in 1996 was 408,688—a record for any show at the gallery.

Cézanne was a laboriously slow painter—he is said to have had over a hundred sittings for a portrait of Ambroise Vollard (Petit Palais, Paris, 1899) before abandoning it with the comment that he was not displeased with the shirt front—but he left a substantial body of work (drawings and watercolours as well as oils). There are examples in many major collections, with particularly fine representations in, for example, the Courtauld Gallery, London, the Barnes Foundation, Merion, Pennsylvania, the Pushkin Museum, Moscow, the Musée d'Orsay, Paris, and the Hermitage, St Petersburg. His studio in Aix is now a Cézanne museum, reconstructed as it was at the time of his death and displaying personal mementoes such as his hat and clay pipe.

Chabot, Hendrik (1894–1949). Dutch painter, sculptor, and graphic artist. He was born at Sprang and spent most of his life in Rotterdam, where he studied at the Academy. In his early work he experimented with *Cubism, but he turned to *Expressionism and became one of his country's leading exponents of the style. He is best known for his paintings depicting the Netherlands during the German Occupation in the Second World War. His subjects included refugees, prisoners of war, and Resistance fighters, depicted with great pathos. The bombardment of Rotterdam in May 1940 destroyed his studio and many of his works. After the war his paintings became lighter in colour and spirit. There is a museum of his work in Rotterdam.

Chadwick, Helen. See AVANT-GARDE.

Chadwick, Lynn (1914–). British sculptor, born in London. He began his career as an architectural draughtsman, but after the Second World War (during which he served as a pilot), he took up sculpture without any formal training. In 1950 he had his first one-man exhibition at *Gimpel Fils, London, and after that he rapidly made a name for himself. Initially he concentrated on *mobiles, often derived from insect forms (*Dragonfly*, Tate Gallery, London, 1951), and these were followed by ponderous, bristling, rough-finished metal structures supported on thin legs. It was with this kind of work that he attracted attention at the 1952 Venice *Biennale (see GEOMETRY OF FEAR). In 1953 he won an Honourable Mention in the competition for the Monument to the Unknown Political Prisoner (see BUTLER, REG) and in 1956 he won the International Sculpture Prize at the Venice Biennale. Since then he has consolidated his reputation as one of the leading British sculptors of his generation. His work is generally based on the human figure (often in couples), but is sometimes so strongly schematized that it comes close to abstraction. In the 1960s his work, influenced by *Minimal art, became more block-like—suitable for the numerous commissions he received for outdoor monuments. However, in the later 1960s he returned to figuration, typically contrasting highly polished faceted surfaces with rougher areas. In the 1970s his sculpture became less aggressive in feeling, and in the 1980s he began experimenting with sheet steel as a material.

Chadwick, Whitney. See GUERRILLA GIRLS.

Chagall, Marc (1887–1985). Russian-born painter and designer, active mainly in France. He was born in Vitebsk of a deeply religious Jewish family, and trained in St Petersburg, 1906–9 (this included a short period under *Bakst). In 1910–14 he lived in Paris, where he was a member of an avant-garde circle including *Apollinaire, *Delaunay, *Léger, *Modigliani, and *Soutine. After going to Berlin in 1914 for his first one-man show (at the *Sturm Gallery) he visited Russia and had to remain because of the outbreak of war. After the Revolution in 1917 he was appointed Fine Arts Commissar for the province of Vitebsk, where he founded and directed an art academy. *Malevich was among the other teachers there, and after disagreements with him Chagall moved to Moscow in 1920 and there designed for the newly founded Jewish Theatre. He returned to Paris in 1923 at the invitation of the dealer Ambroise *Vollard, who commissioned much work from him, including illustrations for Gogol's *Dead Souls* (1923), La Fontaine's *Fables* (1925), and the Bible (1930–1). In 1941 he moved from occupied France to the USA, where he lived for the next seven years. This period of exile was often painful personally (his first wife died in 1944), but he was honoured as an artist and in 1946 had a retrospective exhibition at the Museum of Modern Art, New York, and the Art Institute, Chicago. He returned to Paris in

1948 and from 1950 lived at St-Paul-de-Vence near Nice, working to the end of his very long life—the last survivor of the generation of artists who had revolutionized painting in the years leading up to the First World War.

Chagall was prolific as a painter and also as a book illustrator and designer of stained glass (in which he did some of his most impressive late work) and of sets and costumes for the theatre and ballet. His work was dominated by two rich sources of imagery: memories of the Jewish life and folklore of his early years in Russia; and the Bible. He derived some of his spatial dislocations and prismatic colour effects from *Cubism and *Orphism, but he created a highly distinctive style, remarkable for its sense of fairy-tale fantasy, his figures sometimes floating or hovering in the air. This caused André *Breton to claim him as one of the precursors of *Surrealism, but Chagall himself stated in his autobiography *Ma Vie* (1931) that however fanciful and imaginative his pictures appeared, they were based on reality and direct reminiscences of his early years. Often they are specifically autobiographical, as for example *The Birthday* (MOMA, New York, 1915), showing Chagall's fiancée surprising him with a gift of flowers. There is a museum devoted to Chagall's religious art in Nice. The work there does not always show him at his best, for he could be sentimental and overblown, but his finest paintings have won him an enduring reputation as one of the greatest masters of the *École de Paris. At the time of his death, aged 97, a major exhibition of his work was showing at the Royal Academy, London. In the catalogue, Susan Compton writes that 'There have been few artists this century who have enjoyed such a sensuous enjoyment of the act of painting with such wide-ranging and thought-provoking subject-matter. It is his genius at responding to the age-old comedies and tragedies woven by man into legends and myths which gives Chagall's work in every medium such depth and meaning in addition to its appeal to the eye . . . he has made reference to very many well-known (and obscure) myths, plays, and even poems—always recreating them for his own ends, just as the great story-tellers have always done.'

Chaissac, Gaston. See ART BRUT.

Chamberlain, John (1927–). American sculptor, born at Rochester, Indiana. He studied at the Chicago Art Institute School, 1950–2, and at *Black Mountain College, 1955–6, then moved to New York in 1957. His early sculpture, made largely from metal pipes, was influenced by that of David *Smith, but in 1957 he began introducing scrap metal parts from cars in his work and from 1959 he concentrated on sculpture made entirely from crushed automobile parts welded together. Usually he retains the original colours, and the expressive energy of his work, with its twisted planes and crumpled surfaces, has been compared to that of *Action Painting. Many of his compositions are intended for wall hanging rather than to stand on the ground. An example is *Dolores James* (Guggenheim Museum, New York, 1962); Chamberlain has described how this work never felt quite right until one night he threw a sledgehammer at it, 'all the pieces went chink, chink, chink', and it shifted into shape.

Although he has continued with work of this type, which has been widely acclaimed since the early 1960s, Chamberlain has also experimented with other types of sculpture and other media. In 1966, for example, he started using urethane foam, as in *Koko-Nor II* (Tate Gallery, London, 1967): 'the foam is very interesting to me. I thought it was very funny. And you can see the humor. I mean it's really instinctive and sexual. I tried working it several ways and I returned to the first way, which was tying and squeezing it.' He has also done abstract paintings and made experimental films.

Chapman, Dinos and **Jake**. See YOUNG BRITISH ARTISTS.

Chase, William Merritt (1849–1916). American painter, born in Williamsburg, Indiana. He was a versatile and prolific painter, but is remembered chiefly as the most important art teacher of his generation in the USA. His principal posts were in New York—at the *Art Students League, 1878–94, and at his own Chase School, 1896–1908—but he also taught in Chicago, Philadelphia, and elsewhere. From 1891 to 1902 he ran the Shinnecock Summer School on Long Island, the first important school of open-air painting in America, and he also pioneered study trips abroad (he visited Europe regularly throughout his career). A flamboyant and popular man who said 'I like to keep good company',

he was active in virtually every art organization in New York, including the American Watercolor Society, the Society of Painters in Pastel, the New York Etching Club, and The *Ten. He did a great deal to promote the art of his colleagues and countrymen, one of his obituaries praising his 'American shrewdness and unfailingly American sympathies'. Apart from teaching, he made his living mainly through portraiture, but he was often in financial difficulties. His other subjects included still-lifes, interiors, and landscapes. He took great joy in the process of painting, and the vigorous brushwork and fresh colour that characterizes much of the best American painting of the early 20th century owes much to his example. His students included Charles *Demuth, Marsden *Hartley, Edward *Hopper, Rockwell *Kent, Georgia *O'Keeffe, and Charles *Sheeler.

Chekrygin, Vasily. See MAKOVETS.

Chelsea Art School. A school of painting and drawing run by Augustus *John and William *Orpen in London, 1903–7. It was located at Nos. 4 and 5 Rossetti Studios, Flood Street, Chelsea. Orpen's brother-in-law Jack Knewstub was secretary and general manager (he also ran the Chenil Gallery, an art supplies shop and exhibition space), and various ex-*Slade friends helped with lectures and demonstrations (Gwen Salmond, who later married Matthew *Smith, was 'Lady Superintendent'—men and women students were segregated). The school opened in autumn 1903 and by January 1904 it had 35 students. Both principals enjoyed teaching, but John's initial enthusiasm soon faded and Orpen was too busy elsewhere to carry it on his own, so the school died of neglect. It is not to be confused with Chelsea School of Art, which was founded in 1882 and is still in existence as Chelsea College of Art and Design. It is one of the colleges that make up the London Institute (see ST MARTIN'S SCHOOL OF ART).

Chia, Sandro (1946–). Italian painter, born in Florence, where he studied at the Academy. In the early 1970s he experimented with *Conceptual and *Performance art, but he returned to painting in 1975 and by the end of the decade he had adopted the style with which he has become one of the best-known Italian painters of his generation, characteristically featuring muscle-bound figures in

pseudo-heroic situations parodying the Old Masters (*Courageous Boys at Work*, NG of Modern Art, Edinburgh, 1981). Robert *Hughes describes his figures as 'ladylike coal-heavers expelling wind while floating in postures vaguely derived from classical statuary'. Chia has also made sculpture in a similar vein.

Chicago, Judy (1939–). American painter, sculptor, and experimental artist, born Judy Cohen in Chicago, from which she takes her adopted name. She studied at the University of California, Los Angeles, 1960–4, and has worked mainly in California. Probably the most famous of *Feminist artists, she was co-founder (1971) with Miriam *Schapiro of the Feminist Art Program at the California Institute of the Arts, Valencia. She is best known for her sculpture or installation *The Dinner Party* (Through the Flower Corporation, 1974–9), which has been seen by large audiences at several venues in the USA and elsewhere (its first showing was in San Francisco in 1979, when it attracted 100,000 visitors in three months). In a publicity leaflet for its appearance at the 1984 Edinburgh Festival it was described as: 'an open triangular banquet table, 48 feet on each side, with 39 place settings, each representing a woman of achievement in Western civilization. Plates of delicate china-painted porcelain rest on elaborate cloth runners of needlework typical of each woman's era. The table rests on the Heritage Floor of porcelain tiles inscribed with the names of 999 other women who have made significant contributions to our cultural development.' Many women worked on the project, one of Chicago's aims being to elevate crafts such as needlework that were traditionally associated with women to the mainstream of art. Her subsequent work has included other collaborative projects. She has written books on *The Dinner Party* (1979), *The Birth Project* (1985), and *The Holocaust Project* (1993), and also *Through the Flower: My Struggle as a Woman Artist* (1975).

Chicago Museum of Contemporary Art. See MUSEUM OF CONTEMPORARY ART, CHICAGO.

children's art. See CIŽEK.

Chillida, Eduardo (1924–). Spanish sculptor in iron, born in the Basque city of San Sebastian. He studied architecture at Madrid University, 1943–7, but soon afterwards turned to

drawing and sculpture. In 1948–51 he lived in France, then returned to Hernari, near his birthplace, and carried on the tradition of sculpture in wrought iron initiated by his older compatriots *Gargallo and *González. Chillida's sculptures, however, are abstract rather than figurative, developing from jagged skeletal or ribbon-like forms (*From Within*, Guggenheim Museum, New York, 1953) to much more solid pieces, often characterized by twisting, interlocking shapes (*Modulation of Space I*, Tate Gallery, London, 1963). There is usually no suggestion of figuration, however remote, and no trace of modelling or carving. The impact of the works depends partly on the obscure emotional appeal of the contorted shapes in a stubborn material. Chillida has won many awards and is widely regarded as Spain's greatest living sculptor. He has also had a distinguished career as a printmaker, his work including etchings, lithographs, and woodcuts.

Chirico, Giorgio de (1888–1978). Italian painter, sculptor, designer, and writer, the originator of *Metaphysical Painting. He was born at Volo in Greece, the son of a railway engineer who was working there, and had an old-fashioned training at the Athens Polytechnic, 1903–5, followed by a year at the Academy in Florence, 1905–6. When his father died in 1906 his mother moved the family to Munich for the sake of her sons' education; Giorgio studied at the Academy and his brother, who later adopted the name Alberto *Savinio, continued his musical training under the composer Max Reger. De Chirico found the instruction at the Academy boring, but he was influenced by the *Symbolist work of Max *Klinger and the Swiss painter Arnold Böcklin (1827–1901), with their juxtaposition of the commonplace and the fantastic. In 1909 he moved to Italy (dividing his time between Florence, Milan, and Turin) and there painted his first 'enigmatic' pictures, which convey an atmosphere of strangeness and uneasiness through their empty spaces, illogical shadows, and unexpected perspectives. In 1911 he joined his brother in Paris, where he lived until 1915, becoming friendly with many members of the avant-garde, including *Apollinaire (who championed his work) and *Picasso. During this period he developed a more deliberate theory of 'metaphysical insight' into a reality behind ordinary things by neutralizing the

things themselves of all their usual associations and setting them in new and mysterious relationships. In order to empty the objects of his paintings of their natural emotional significance he painted tailors' dummies as human beings (from 1914)—an innovation in which he was influenced by his brother.

In 1915 de Chirico (with his brother) was conscripted into the Italian army and sent to Ferrara. There he suffered a nervous breakdown, and in 1917 met *Carrà in the military hospital and converted him to his views, launching Metaphysical Painting as a movement. It was short-lived, virtually ending when de Chirico and Carrà quarrelled in 1919, but it was highly influential on *Surrealism, and it was during the later 1920s, when Surrealism was becoming the most talked-about artistic phenomenon of the day, that de Chirico's international reputation was established. However, it was his early work that the Surrealists admired and they attacked him for adopting a more traditional style in the 1920s, when his output included some distinctive pictures featuring horses on unreal sea-shores with broken classical columns. In the 1920s and 1930s he spent much of his time in Paris (and in 1935–7 he lived in the USA) before settling permanently in Rome in 1944. By this time his work had become repetitive and obsessed with technical refinement. He produced numerous replicas and variants of his early work, sometimes unscrupulously passing them off as earlier originals (which led to considerable controversy and more than one lawsuit). His other work included a number of small sculptures (mainly from the last decade of his life) and set and costume designs for opera and ballet; his writings include a Surrealistic novel, *Hebdomeros* (1929), and two volumes of autobiography (1945 and 1960) translated into English as *The Memoirs of Giorgio de Chirico* (1971).

Edward *Lucie-Smith writes (*Lives of the Great Twentieth Century Artists*, 1986): 'For many years de Chirico was treated as if he had died somewhere around 1922. Just before his death in 1978, however, the attitude of part of the avant-garde began to change, and there was a tendency to celebrate him as a premature *Post-Modernist and to discover hidden ironies in work that had previously been discussed as vulgar and shameless. If he intended his late paintings to be ironic, de Chirico never admitted it. The claims he made for himself in his second volume of mem-

oirs . . . were more self-applauding than ever.' In the catalogue of the exhibition 'Italian Art in the 20th Century' (Royal Academy, London, 1989) Wieland Schmied underlines this sense of ambivalence: 'Giorgio de Chirico remains among the most controversial of all twentieth-century artists. There is no other figure of such seminal importance on whom the experts' opinions are so divided or their interpretations so widely divergent.'

Chirino, Martín. See EL PASO.

Christie, James Elder. See GLASGOW BOYS.

Christo (Christo Javacheff) (1935–). Bulgarian-born sculptor and experimental artist who settled in New York in 1964 and became an American citizen in 1973. He was born in Gabrovno, the son of an engineer-chemist who ran a textile factory, and studied at the Academy in Sofia, 1952–6. After brief periods in Prague, Vienna (where he studied sculpture with *Wotruba), and Geneva, he moved to Paris, where he lived from 1958 to 1964. Initially he earned his living there as a portrait painter, but soon after his arrival he invented 'empaquetage' (packaging), a form of expression he has made his own and for which he has become world-famous. It consists of wrapping objects in materials such as canvas or semi-transparent plastic and dubbing the result art. He began with small objects such as paint tins from his studio (in this he had been anticipated by *Man Ray), but they increased in size and ambitiousness through trees and motor cars to buildings and sections of landscape. His first one-man exhibition was at the Galerie Haro Lauhus, Cologne, in 1961 and in the same year he made his first project for a wrapped public building. He spends a great deal of time and effort negotiating permission to carry out such work and then (if negotiations are successful) in planning the operations, which can involve teams of professional rock-climbers as well as construction workers. He finances such massive enterprises through the sale of his smaller works. The buildings that he has succeeded in wrapping include the Kunsthalle, Berne (1968), the Museum of Contemporary Art, Chicago (1969), the Pont-Neuf in Paris (1985, after nine years of negotiations), and the Reichstag in Berlin (1995). Among the landscape projects he has carried out are the packaging of a mile of coastline near Sydney,

Australia (1969), Valley Curtain across Rifle Gap, Colorado (1972), and Running Fence, something like a fabric equivalent of the Great Wall of China, undulating through 24 miles of Somona and Martin Counties, California (1976). Christo says of his work: 'You can say it's about displacement. Basically even today I am a displaced person, and that is why I make art that does not last . . . I make very stimulating things. Unlike steel, or stone, or wood, the fabric catches the physicality of the wind, the sun. They are refreshing. And then they are quickly gone.' Christo's wife, Jeanne-Claude (née de Guillebon) (1935–), collaborates with him in his work. See also ENVIRONMENTAL ART.

Chromatic Abstraction. See COLOUR FIELD PAINTING.

Chryssa (Chryssa Vardea Mavromichaeli) (1933–). Greek-born American sculptor, a leading exponent of *Light art. She was born in Athens, studied at the Académie de la Grande Chaumière, Paris (1953–4), and the California School of Fine Arts, San Francisco (1954–5), then settled in New York. There she experimented with various kinds of avant-garde work, and she was one of the first to explore the kind of banal subject-matter associated with Jasper *Johns and Andy *Warhol, sometimes using words or letters as the entire content of a piece. In her early years in New York she was 'utterly alone, broke and very happy', and she became fascinated with the bright lights of Times Square: 'America is very stimulating, intoxicating for me. Believe me when I say that there is wisdom, indeed, in the flashing of the lights of Times Square. The vulgarity of America as seen in the lights of Times Square is poetic, extremely poetic. A foreigner can observe this, describe this. Americans feel it.' In 1962 she began incorporating neon tubing in her work (she is said to have been the first American do to this) and she soon moved on to pieces that consisted entirely of neon tubing apart from the necessary wiring and casing. In 1964–6 she produced *The Gates to Times Square* (Albright-Knox Art Gallery, Buffalo), a huge, brilliantly coloured work, that is generally regarded as one of the most impressive light sculptures ever made; it is in the shape of a giant letter 'A', symbolizing America. Her work is sometimes categorized as *Minimal art, and it is also placed within the orbit of *Pop art

because it takes its inspiration from advertising signs. Sam Hunter describes Chryssa as 'perhaps the only "light" artist in America who has managed to transcend both the limitations of Pop imagery and the technical seductions of her chosen medium', and he considers *The Gates to Times Square* 'one of the truly impressive sculptures of the American post-war period' ('Chryssa' in *Art Studies for an Editor: 25 Essays in Memory of Milton S. Fox*, 1975).

Chuikov, Semyon. See SOCIALIST REALISM.

Circle. A collective manifesto of *Constructivism published in London in 1937, edited by the architect Sir Leslie Martin (1908–), the painter Ben *Nicholson, and the sculptor Naum *Gabo. Sub-titled 'International Survey of Constructive Art', it is nearly 300 pages long with numerous illustrations and was originally intended as an annual. The volume contains an editorial by Gabo entitled 'The Constructive Idea in Art', Piet *Mondrian's essay 'Plastic Art and Pure Plastic Art', and a short statement by *Moholy-Nagy on 'Light Painting'. There are also essays or statements by, amongst others, *Hepworth (who took much of the responsibility for the layout and production), *Le Corbusier, *Moore, and *Read. The artists illustrated included (in addition to those already mentioned) *Malevich, *Lissitzky, *Pevsner, together with many others whose work did not conform with the theoretical concept of Constructivism—among them *Brancusi, *Braque, *Giacometti, and *Picasso. Dennis Farr (*English Art 1870–1940*, 1978) writes of *Circle*: 'In the context of British art of the 1930s it not only provided the key to much that was most vital and exciting on the international front, but showed, too, there were Englishmen able to make a significant contribution to the modern movement in art and architecture.' *Circle* was reprinted in 1971.

Čiurlionis, M. K. (Mikolajus Konstantinas) (1875–1911). Lithuanian composer and painter, a strange personality whose highly idiosyncratic paintings have sometimes been claimed as the first examples of *abstract art. He was born in Varena, the son of an organist, and had a varied musical training, notably at the Warsaw Music Institute and the Leipzig Conservatory. His compositions include numerous piano pieces ('his greatest achieve-

ment' according to the *New Grove Dictionary of Music and Musicians*, 1980), chamber music, and orchestral poems. These works are romantic and nationalist in spirit, sometimes inspired by Lithuanian folklore. For many years, they were virtually unknown outside his own country, but several recordings appeared in the West in the 1990s; reviewing one of these in February 1995, *Gramophone* magazine commented that 'Had he lived beyond 35, he would surely have developed into a figure of international stature (a Lithuanian Szymanowski perhaps).' He began making pastels in 1902, influenced by *Redon's work, and took up painting seriously in 1905. Although he briefly attended the Warsaw Academy, he was essentially self-taught. He showed his paintings with some success in Warsaw in 1905 and in the first exhibition of Lithuanian art in Vilnius in 1907. He moved to Vilnius in that year and visited St Petersburg in 1909. After his return to Lithuania he suffered a mental collapse, and he died in an asylum near Warsaw. In 1912 the *World of Art group devoted a section of its exhibition to his paintings, one of several tributes that helped to establish his fame.

About 300 paintings by Čiurlionis survive, all dating from a short period (*c*. 1905–9) and mainly preserved in the museum named after him in Kaunas. Through visual art, he tried to express a transcendental mysticism that he felt he could not fully communicate through music. He gave his pictures musical titles, such as *Fugues* and *Sonatas*, and composed them in accordance with musical principles. Melody was expressed by line, tempi by flowing curves or short zigzags, and pitch by nuances of colour. These paintings clearly have precedence in date to the first abstracts of such acknowledged pioneers as *Dove, *Kandinsky, and *Kupka, but it is doubtful to what extent Čiurlionis's pictures can be regarded as abstracts rather than stylizations of natural motifs. George Heard *Hamilton writes that 'Čiurlionis's *Composition* of 1906 [M. K. Čiurlionis State Art Museum, Kaunas] is in one sense an abstract design, but in another it is an arrangement of sailing-boats and architectural elements (perhaps columns?) seen against the sun. The most abstract forms are the irregularly disposed and intersecting bands, one of which is compulsively filled with the small circles which sometimes occur in the work of the mentally deranged (the artist did, indeed, die insane).'

Čižek, Franz (1865–1946). Austrian painter and teacher, a key figure in the history of children's art education. He was born in Leitmeritz (now Litoměřice in the Czech Republic) and studied at the Academy in Vienna, the city where he spent most of his career (he was a member of the Vienna *Sezession and of the *Wiener Werkstätte). Initially he worked as a painter of portraits and genre scenes, but from 1897 he was primarily a teacher. In that year he founded a school called the Jugendkunstklasse ('Children's art class') for children from the age of three upwards, and in 1904 it was incorporated into the Vienna School of Arts and Crafts (Kunstgewerbeschule), where he taught until 1934 (*Kokoschka was among his adult pupils). Čižek was the originator of the idea that children's art is a special branch of art (extending up to the age of about 14, after which he thought the freshness and spontaneity was lost): 'People make a great mistake in thinking of child art merely as a step to adult art. It is a thing in itself, quite shut off and following its own laws, and not the laws of grownups.' He regarded education as 'growth and self-fulfilment' and urged teachers to 'Make your schools into gardens where flowers may grow as they grow in the garden of God'. His ideas became well known through lectures (he spoke at educational conferences in London in 1908 and Dresden in 1912) and through exhibitions of the work of his pupils, which he toured in England and the USA (these helped to popularize *linocut as a technique specially suited to children). His work also helped to bring child art to the attention of avant-garde artists, among whom it had something of a vogue in the years immediately before the First World War. The first occasion on which children's art was shown alongside professional adult art was the Mostra d'Arte Libera in Milan in 1911 (the exhibition in which *Futurist painting made its public debut); in 1912 *Stieglitz held an exhibition of children's work in New York, and in the same year *Kandinsky and *Marc reproduced children's drawings in their *Blaue Reiter *Almanac*.

Clarà, José (Josep Clarà i Ayats) (1878–1958). Spanish sculptor who enjoyed a successful international career with an ample classical style close to that of his friend *Maillol. He was born in Olot in Catalonia and trained locally, in Bordeaux, and in Paris (at the École des *Beaux-Arts and in *Rodin's studio). He was based in Paris from 1900 to 1932, but he exhibited widely in Europe and America and maintained close links with Spain. His early work was influenced by Rodin, but he gave up emotional expressiveness for a supple, serene grandeur, and he came to be widely regarded as the acceptable face of modern sculpture. Like Maillol, he favoured female nudes. In 1932 he settled in Barcelona, where—unlike many artists—he accepted the Franco regime, and he remained an honoured figure until his death. His studio in Barcelona is now a museum dedicated to his work.

Clark, Kenneth (Lord Clark of Saltwood) (1903–83). British art historian, administrator, patron, and collector, born in London into a wealthy family whose fortune had been made in thread-manufacturing: 'My parents belonged to a section of society known as "the idle rich", and, although, in that golden age, many people were richer, there can have been few who were idler.' He was educated at Winchester and Trinity College, Oxford (where he studied history), then spent two years working in Florence with Bernard Berenson, the famous connoisseur of Italian art. From 1931 to 1934 he was keeper of fine art at the Ashmolean Museum, Oxford, then was director of the National Gallery, London (1934–45), at the same time holding the position of Surveyor of the King's Pictures (1934–44). During the Second World War he was chairman of the War Artists' Advisory Committee (see OFFICIAL WAR ART), and after the war he was chairman of the *Arts Council (1953–60) and the first chairman of the Independent Television Authority (1954–7). In addition, he served on numerous boards and committees, and in particular was a key figure in the *Contemporary Art Society, of which he was a committee member from 1937 to 1953. The part he played as a patron and collector is less well known, but was of considerable importance. He inherited substantial wealth from his parents and his purchases of the work of *Moore, *Pasmore, *Piper, and *Sutherland in the 1920s and 1930s helped to establish their reputations (he also made a regular allowance—in strict secrecy—to several artists).

Clark was a polished television performer as well as an elegant and stimulating writer, and he did a great deal to popularize art history, most notably with his television series

Civilisation (1969, also published then as a book), which was broadcast in over 60 countries. Although his major books were on Renaissance art or on general topics (notably *Landscape into Art*, 1949, and *The Nude*, 1956), he also wrote on 20th-century art (for example *Henry Moore Drawings*, 1974) and he was editor of the 'Penguin Modern Painters' series, founded in 1943. He did not care much for abstract art, however, summing it up as 'somewhat monotonous, somewhat prone to charlatanism, but genuinely expressive of our time'. His two volumes of autobiography—*Another Part of the Wood* (1974) and *The Other Half* (1977)—are highly entertaining (see MANSON), if not always accurate in detail, but some of the pot-boilers that appeared in his old age would have been better left unpublished.

Clark, Lygia (1920–88). Brazilian sculptor, painter, and experimental artist, born at Belo Horizonte. She studied in Rio de Janeiro under Roberto *Burle Marx and then in Paris, 1950–2, under *Léger. After her return to Brazil she became a leading figure in the country's vogue for *Concrete art (or Neo-Concrete art as it tended to be called there). In 1959 she turned from painting to sculpture, making first reliefs and hinged pieces that could be manipulated by the spectator. Her most characteristic works include 'three inter-related series of sculpture, generally fairly small—the *Bichos* (*Machine Animals*), the *Repantes* (*Climbing Grubs*) and the *Borrachas* (*Rubber Grubs*). The essential idea in all of these is more or less the same. The sculpture, though completely abstract, is conceived of as a small beast, a quasi-independent being' (Edward *Lucie-Smith, *Latin American Art of the 20th Century*, 1993). An example is *Rubber Grub* (Museu de Arte Moderna do Rio de Janeiro, 1964, remade by the artist 1986), a hanging arrangement of corrugated rubber. She often worked with non-rigid materials such as this, and in 1964 she initiated 'vestiary' sculpture, designed to be worn by the spectator. In the 1970s her work became more experimental as she became concerned with *environments and 'situations'; she was a practising psychologist and particularly interested in stimulating spectator participation. Clark was one of the most internationally known of Brazilian artists; she received many awards and represented her country at the Venice *Biennale in 1960, 1962, and 1968.

Clarke, Geoffrey (1924–). British abstract sculptor, designer, and printmaker, born at Darley Dale, Derbyshire. He studied at Preston School of Art and Manchester School of Art before serving in the RAF, 1943–7, then had his main training at the *Royal College of Art, 1948–52. His sculpture is mainly in forged, welded, and cast metal, initially iron and lead and then aluminium (in 1958 he installed an aluminium foundry at his studio in Suffolk). Unusually for an artist working in such a modern idiom, he has devoted a good deal of his career to religious commissions, including a number of works for Coventry Cathedral (1953–62) and a pulpit (1966) in Chichester Cathedral, made of stone-faced reinforced concrete and cast aluminium. Such works have been praised for showing the potentialities of modern art in a religious setting: in *Church Furnishing and Decoration in England and Wales* (1980) Gerald Randall describes his high altar cross in Coventry Cathedral as 'abstract, but vividly conveying the agony and contortion of crucifixion'. Clarke's secular work includes commissions for numerous public buildings, notably for several universities, and reliefs for the liners *Canberra* and *Oriana*. He has worked in various media other than sculpture, including enamel, mosaic, stained glass, and etching.

Clarke, Harry (1889–1931). Irish artist, chiefly famous as one of the 20th century's greatest designers of stained glass, but also a mural painter, textile designer, and book illustrator. He was born in Dublin, the son of a church decorator, and had his main training at the Dublin Metropolitan School of Art, 1910–13. Scholarships then enabled him to study medieval glass in France. He took over the family business on his father's death in 1921 and had a large output in spite of his short life (he died from tuberculosis). The Harry Clarke Stained Glass Studios Ltd. continued in business until 1973. Clarke's glass was sumptuous and often rather bizarre in style—in the spirit of French *Symbolist painters. As an illustrator he had a taste for the macabre and is particularly remembered for his black-and-white drawings for an edition of Edgar Allan Poe's *Tales of Mystery and Imagination* (1923). His wife **Margaret Clarke** (née Crilley) (1888–1961), whom he married in 1914, was a painter. She studied under *Orpen and was strongly influenced by him, although her posthumous portrait of her husband (NG, Dublin, *c.* 1932) is in

a more decorative, highly coloured style. After Harry's death she became director of the stained-glass studios.

Classical Revival. See NEOCLASSICISM.

Claus, Emil. See LUMINISM.

Clausen, Sir George (1852–1944). British painter (mainly of landscapes and scenes of rural life), born in London, the son of an interior decorator of Danish descent. His training included a few months at the *Académie Julian, Paris, in 1883 and his work was influenced by French plein-air painting. He was preoccupied with effects of light, often showing figures set against the sun, but he always retained a sense of solidity of form. With other like-minded painters he was a founder of the *New English Art Club in 1886. From 1904 to 1906 he was professor of painting at the *Royal Academy. His lectures were published as *Six Lectures on Painting* (1904) and *Aims and Ideals in Art* (1906); a collected edition appeared as *Royal Academy Lectures on Painting* in 1913. In them he urged the traditional study of the Old Masters. From 1881 (after his marriage) he lived mainly in Berkshire and then Essex, using his surroundings as material for many of his paintings. He also occasionally painted portraits (a self-portrait, 1918, is in the Fitzwilliam Museum, Cambridge), nudes, and interiors, and he did some large decorative commissions, including a mural on *The Reading of Wycliffe's Bible in English* for St Stephen's Hall, Westminster, in 1927. 'In personal character he was quiet, modest, kindly, and of courtly manners' (*DNB*). An exhibition of his work was shown in Bradford, Bristol, London, and Newcastle upon Tyne in 1980.

Clavé, Antoni (1913–). Spanish painter, graphic artist, theatrical designer, and sculptor, born in Barcelona, where he studied at the School of Fine Arts in the evenings whilst apprenticed to a sign-writer and poster artist. In 1939 he moved to Paris, where he was initially influenced by the *Intimisme of *Bonnard and *Vuillard. From the mid-1940s, however, his painting became more expressive, with affinities to the the rich and vibrant manner of *Rouault. In the late 1950s he began to do the works for which he is best known—*Lyrical Abstractions featuring paint over damask tapestry collages. In addition to

painting, Clavé has had much success as a graphic artist, particularly with coloured lithographs, and as a designer of theatrical sets and costumes, notably for Roland Petit's ballet company. In the 1960s he took up metal sculpture, making both plaques and free-standing abstract compositions.

Clemente, Francesco. See NEO-EXPRESSIONISM.

Clemente, Rodriguez. See POPULAR PRINTS.

Clert, Iris. See CONCEPTUAL ART.

Cloisonnism. Style of painting associated with some of the painters who worked at the artists' colony at Pont-Aven at Brittany in the 1880s and 1890s, characterized by dark outlines enclosing areas of bright, flat colour, in the manner of stained glass or cloisonné enamel (*cloison* is French for 'partition'). *Anquetin and *Bernard first developed the style, and *Gauguin also worked in it. The term was coined by the critic Édouard Dujardin (1861–1949) in an article on Anquetin published in 1888 and has remained in use for work in a similar style done in the 20th century.

Close, Chuck (1940–). American painter. He was born in Monroe, Washington, and studied at Yale University, graduating in 1964. His early work was *Abstract Expressionist, but he soon turned to *Superrealism, becoming well known for huge portrait heads, seen frontally like gigantic passport photographs—his self-portrait (1968) in the Walker Art Center, Minneapolis, is almost 3 metres high. Originally he worked in black-and-white, but in about 1970 he turned to colour. He works from photographs, dividing them into a grid and then transferring the grid to the canvas. In some of his later work he has deliberately emphasized the grid, creating 'low resolution' images resembling a computer scan or a face seen through frosted glass. Most of Close's portraits depict friends, but he says he regards the human figure as a 'source of information', rather than a vehicle for 'outworn humanist notions'.

Clough, Prunella. See BROWSE.

Club, The. See SUBJECTS OF THE ARTIST SCHOOL.

Cnac (Centre National d'Art et de Culture). See POMPIDOU CENTRE.

Coates, Robert. See ABSTRACT EXPRESSIONISM.

Coates, Wells. See UNIT ONE.

Cobra. A group of *Expressionist painters formed in Paris in 1948 by a number of Netherlandish and Scandinavian artists. The name derived from the first letters of the capital cities of the three countries of the artists involved—Copenhagen, Brussels, Amsterdam. The Dutchman Karel *Appel, the Belgian *Corneille, and the Dane Asger *Jorn were the leading figures among the founders, and the artists who subsequently joined included Pierre *Alechinsky, Jean *Atlan, and William *Gear. Christian *Dotremont, who suggested the group's name, was the main spokesman. The aim of the Cobra artists was to give free expression to the unconscious, unimpeded and undirected by the intellect. In their emphasis on spontaneous gesture, they had affinities with the American *Action Painters, but they differed in their strange and fantastic imagery, related in some instances to Nordic mythology and folklore, in others to various magical or mystical symbols of the unconscious. Their approach was similar to that of the *Art Informel painters *Fautrier and *Wols, but more savage and vigorous. The group published a journal and various pamphlets and short monographs. It arranged Cobra exhibitions in Copenhagen (1948), Amsterdam (1949), and Liège (1951), but the members soon went their own ways and the group disbanded in 1951.

Coburn, Alvin Langdon. SEE VORTICISM.

Cocteau, Jean (1889–1963). French writer, film director, designer, painter, and draughtsman. One of the most dazzling figures of his time in the intellectual avant-garde, he was the friend of leading painters such as *Modigliani and *Picasso, and in his work for the theatre he collaborated with, for example, *Diaghilev and the composers Erik Satie and Igor Stravinsky. His work included poetry, novels, plays, films, and a large number of paintings, drawings, theatrical designs, and pottery articles. He was self-taught as an artist. In his painting and drawing he was much influenced by Picasso, and his favourite themes included the figures of Harlequin, embodying the theatre, and Orpheus, the personification of the poet. His most lasting achievement was in the cinema, his reputation resting mainly on his beautiful adaptation of the famous story of Beauty and the Beast (*La Belle et la Bête*, 1946, with design by Christian *Bérard), and on three films dealing with the role of the artist and the nature of his inspiration—Cocteau's recurrent preoccupation—*Le Sang d'un poète* (1930), *Orphée* (1950), and *Testament d'Orphée* (1960).

There is a Cocteau museum at Menton on the Côte d'Azur; in discussing it Michael Jacobs and Paul Stirton comment that 'It is unlikely that Cocteau would have achieved any reputation at all as an artist had he not been so talented in other fields; his strongly linear works seem merely to reflect all that was sentimental and slapdash in the art of his friend Picasso' (*The Mitchell Beazley Traveller's Guides to Art: France*, 1984). At Menton Cocteau also decorated the room reserved for civil marriages in the town hall; Jacobs and Stirton consider that 'The place would make an excellent setting for a high-class confectioners'. Other examples of Cocteau's decorative work include paintings (1960) of the Crucifixion, Annunciation, and Assumption in the church of Notre Dame de France, Leicester Place, London—'The draughtsmanship precise and elegant, as one would expect, the style, as one would also expect, similar to Picasso's in his most classicist mood, the mood however of a somewhat mannered sentimentality' (Nikolaus Pevsner and Bridget Hcerry, *The Buildings of England: London*, vol. i, 1973).

Cohen, Bernard (1933–). British abstract painter, born in London of Polish-Russian parents. He studied at *St Martin's School of Art, 1950–1, and the *Slade School, 1951–4, then in 1954–6 lived in France, Italy, and Spain on a travelling scholarship. Cohen is regarded as one of the leading British abstract artists of his time and his work has been individual and varied. In the 1960s some of his paintings looked like arrangements of what has been called 'highly coloured spaghetti' (*In That Moment*, Tate Gallery, London, 1965); later his work has generally been less densely packed, with galaxies of coloured patches and spots floating against a light background. He has taught at several art schools and in 1988 he became professor at the Slade School. His brother, **Harold Cohen** (1928–), is also an

abstract painter and a noted exponent of *computer art. See also SITUATION.

Cold art (Kalte Kunst). A term sometimes used as a synonym for *Cool art and sometimes applied more specifically to works that rely on mathematical systems and formulae for either the conception or the development of a work. It was in the latter sense that the term was used by the Swiss painter Karl Gerstner (1930–) in his book *Kalte Kunst* (1954). A follower of Max *Bill, Gerstner helped (like Richard *Lohse) to extend Bill's idea of mathematical programming into the realm of colour.

Coldstream, Sir William (1908–87). British painter, mainly of portraits, but also of landscapes, nudes, and still-lifes. He was born at Belford, Northumberland, the son of a doctor, and studied at the *Slade School, 1926–9. After working in documentary films for the GPO, 1934–7, he returned to full-time painting and in 1937 was one of the founders of the *Euston Road School, which helped to establish a tradition of sober figurative painting of which he was one of the main representatives. In 1939 he joined the Royal Artillery and in 1943–5 he was an *Official War Artist, working in the Near East and then Italy. After the war he taught at Camberwell School of Art, 1945–9, then was professor at the Slade School from 1949 to 1975. He exerted an important influence not only through his teaching there but also through his appointment as chairman of the National Advisory Council on Art Education in 1959. The 'Coldstream Report' of 1960 helped to change the structure of art school teaching in Britain, introducing the compulsory study of art history for art students and eventually leading to degree status being awarded to recognized art school courses. His virtues as a teacher and administrator were praised by Keith *Vaughan, one of his staff at the Slade: 'With all his over-talkativeness and sometimes tiresome long-windedness, everyone is the better off for having known him. To me, personally, he has given a consistent supportive encouragement, almost flattery . . . He never knocks anyone, or makes them feel foolish, or tries to outsmart them. He makes people feel better than in fact they are.'

Coldstream's work as an artist was austere and always based on direct observation. In an article 'How I Paint' in the *Listener*, 15 September 1937, he wrote: 'I find I lose interest unless I let myself be ruled by what I see.' Kenneth *Clark had been an early supporter (he gave him financial assistance in the 1930s), but he came to see Coldstream's attitude to art as one of 'dismal rectitude'. His work is well represented in the Tate Gallery, London.

Cole, Rex Vicat. See SHAW.

Coleman, Glenn. See ASHCAN SCHOOL.

Colla, Ettore (1896–1968). Italian sculptor, painter, printmaker, art dealer, editor, and critic. Born in Parma, he studied at the Academy there, then in 1921 moved to Paris, where he met several leading sculptors, notably *Bourdelle, in whose studio he worked. In 1924 he was assistant to *Lehmbruck in Munich, and after a year of odd jobs, including being an elephant trainer's assistant in Vienna, he settled in Rome in 1926. Initially he worked on the gigantic monument to Vittorio Emanuele II, which had been begun in 1885 but with its hundreds of marble figures took decades to finish. In the 1930s he made a name with portrait busts and nude figures showing the influence of Bourdelle and Arturo *Martini. During the Second World War Colla temporarily abandoned sculpture, working as an art dealer, editor, and critic. In about 1948 he started painting in a geometrical abstract style, and in 1950 he opened a gallery called Origine, where exhibitions were devoted to *Balla and *Vantongerloo amongst others. From 1952 to 1958 he edited the review *Arti Visive*, which sometimes included examples of his screenprints, either as the cover or bound-in with the text. In 1952 he returned to sculpture, but in an abstract rather than figurative style. Initially he made reliefs in wood and iron, and in 1955 he began using welded iron, usually assembled from scrap material such as old machine parts. Typically his work evokes a feeling of new life rising from rubble and ruin and sometimes it has a fetishistic suggestion. He gained an international reputation and had several large commissions, including the 10-metre-high *Gran Spirale*, made for the 1962 Spoleto Festival and now outside the Galleria Nazionale d'Arte Moderna, Rome.

collage. A term applied to a type of picture (and also to the technique used in creating such pictures) in which objects such as

photographs, news cuttings, and pieces of printed paper are pasted on to a flat surface, often in combination with painted passages (the word comes from the French *coller*, 'to gum'). Long popular as a leisure-time occupation for children and amateurs (in scrapbooks, for example), it first became an acknowledged artistic technique in the early 20th century, when it drew much of its material from the proliferation of mass-produced images in newspapers, advertisements, cheap popular illustrations, etc. The *Cubists were the first to make collage a systematic and important part of their work. *Picasso began using the technique in 1912, one of the earliest examples being *Still Life with Chair Caning* (Musée Picasso, Paris, 1912), in which the caning is represented by a piece of oilcloth printed with a lattice pattern. *Braque soon followed with his own distinctive type of collage, the *papier collé, in which he applied strips or fragments of paper to a painting or drawing. Picasso also extended the principle of collage to three dimensions, making sculptures from scrap materials that influenced *Tatlin's creation of *Constructivism and stand at the beginning of the tradition of *assemblage.

Subsequently collage has been used in many major art movements, for example *Dada, *Surrealism, and *Pop art. For some artists—notably Kurt *Schwitters—it has been the central concern of their work, and others have created personal versions of it. Examples are Max *Ernst, with his 'collage novels', *Matisse with his late *gouaches decoupées* (paper cut-outs), Alberto *Burri with his 'sacking' pictures, and Lee *Krasner, who created collages by cutting up and re-using her own drawings and paintings. See also MONTAGE and PHOTOMONTAGE.

Collin, Marcus. See NOVEMBER GROUP.

Collin, Raphaël. See FOUJITA.

Collins, Cecil (1908–89). British painter of visionary subjects, born in Plymouth. He studied at Plymouth School of Art, 1923–7, and at the *Royal College of Art, 1927–31. In 1936 he took part in the International *Surrealist Exhibition in London, but he quickly repudiated Surrealism. He had a mystical outlook and was influenced by the prophetic writings of William Blake and by the American artist Mark *Tobey, who introduced him to the Baha'i religion and to the art and philosophy of the Far East (Tobey was artist-in-residence at Dartington Hall, a progressive school in Devon, 1931–8, and Collins taught there, 1939–43). In 1947 Collins settled in Cambridge and in that year published his book *The Vision of the Fool*, in which he explains his philosophy of art and life. He attacks the 'great spiritual betrayal' of the modern world, 'the betrayal of the love and worship of life by the dominance of the scientific technical view of life in practically all the fields of human experience'. The artist, together with the poet and the saint, 'is the vehicle of the continuity of that life, and its guardian, and his instrument is the myth, and the archetypal image'. His own archetypal image was the Fool, who represented purity and spontaneity in contrast to modern commercialism and materialism. In 1940 he began a long series of paintings and drawings, originally entitled 'The Holy Fool' but later renamed 'The Vision of the Fool' in accordance with the title of his book; *The Sleeping Fool* (Tate Gallery, London, 1943) is an example. His work also included the design of a large Shakespearean tapestry (1949) for the British embassy in Washington and an altarpiece (1973) for Chichester Cathedral. A retrospective exhibition of his work opened at the Tate Gallery a month before his death. Some recent writing on Collins has come close to hagiography, but he also has detractors who find his reputation overblown.

Cologne, Ludgwig Museum. See LUDWIG.

Colour Field Painting. A type of abstract painting in which the whole picture consists of large expanses of more or less unmodulated colour, with no strong contrasts of tone or obvious focus of attention. Sometimes Colour Field Paintings use only one colour; others use several that are similar in tone and intensity. This type of painting developed in the USA in the late 1940s and early 1950s, leading pioneers including Barnett *Newman and Mark *Rothko. It is thus an aspect of *Abstract Expressionism (developing the *Field Painting of Jackson *Pollock), and it has also been seen as a type—or precursor—of *Minimal art. Many of the leading American abstract painters of the 1950s and 1960s were exponents of Colour Field Painting, among them Ellsworth *Kelly and Jules *Olitski. From 1952 Helen *Frankenthaler developed Colour Field Painting by soaking or staining

diluted paint into unprimed canvas, so that the paint is integral with the surface rather than superimposed on it. The term **Colour Stain Painting** is applied to works of this type. Frankenthaler's work was influential on many artists, including the *Washington Color Painters.

Colour Painting. An alternative name for Colour Stain Painting (see COLOUR FIELD PAINTING). The term implies that when the canvas is stained with poured paint, purely visual colour results, without any of the tactile associations of brushwork. 'Chromatic Abstraction' is another synonym.

Colquhoun, Robert (1914–62). British painter, graphic artist, and designer. He was born in Kilmarnock and in 1933–8 studied at *Glasgow School of Art, where he became the inseparable companion of his fellow student Robert *MacBryde (their personal and artistic relationship was thereafter so close that they are—very unusually—given a joint entry in the *Dictionary of National Biography*). After Colquhoun was invalided out of the army they settled in London in 1941 (MacBryde was exempt from military service because of tuberculosis); Colquhoun was an ambulance driver in the Civil Defence Corps by day and painted by night. Within a few years the studio of the Roberts (as they were generally known) at 77 Bedford Gardens, Campden Hill, had become a centre for a group of young artists and writers, including Rodrigo *Moynihan and Keith *Vaughan. The Polish immigrant Jankel *Adler took a studio in the same building in 1942 and was an important influence on Colquhoun's work. Colquhoun's first one-man exhibition was at the Lefevre Gallery, London, in 1943, and after that he soon developed a reputation as one of the outstanding British painters of his generation; his characteristic angular figure compositions owed something to *Cubism, but had an expressive life of their own. After he and MacBryde were evicted from their studio in 1947, however, his fortunes began to decline and he died (of a heart attack) in relative obscurity, even though there had been a major retrospective exhibition of his work at the Whitechapel Art Gallery four years earlier. The Roberts had always been fond of the bottle, and after Colquhoun's death MacBryde drank more than ever and led an aimless existence; he was knocked over and

killed by a car in Dublin. Apart from painting, both Colquhoun and MacBryde produced many lithographs and worked together on stage designs (Colquhoun, alone, made designs for a production of *King Lear* at Stratford in 1953).

Colville, Alexander (1920–). Canadian painter, born in Toronto. He trained in the Fine Art Department at Mount Allison University, Sackville, 1938–42, then joined the army, being commissioned as an *Official War Artist in 1944. After his discharge in 1946 he began teaching at Mount Allison, remaining until 1963, when he was able to devote himself full-time to painting. He is regarded as a leading exponent of *Magic Realism, his work showing a remarkable ability to infuse a sense of haunting mystery into mundane situations (*Couple on a Beach*, NG, Ottawa, 1957). Dennis Reid (*A Concise History of Canadian Painting*, 1973) writes: 'It is the unfulfilled desire to touch and become involved in the painting, half realized in anticipation but discouraged by the "distant" quality of his pictures, that gives his work its poignant ambiguity. This is unusual in painting; one more often senses it in films. Colville's images are in fact much closer to those of the best film-makers of the British-American popular tradition—particularly Alfred Hitchcock—than to those of other painters. There is the same concern for precise composition and the arrested moment.' Less typical work by Colville has included a mural, *History of Mount Allison* (1948), for Mount Allison University, and the designs for the special issues of Canadian coinage commemorating the centenary of Confederation (1967). In 1973 Colville settled in Wolfville, Nova Scotia.

combine painting. A term coined by Robert *Rauschenberg for a type of work he created—a very radical form of *collage—in which a painted surface is 'combined' with various real objects, or sometimes photographic images, attached to it. Rauschenberg first showed such works at a one-man exhibition at the Charles Egan Gallery, New York, in 1955. Most of them used fairly modest collage elements, but there was one notable exception, *Bed* (MOMA, New York), which featured a real pillow, sheet, and quilt splashed with paint in an *Abstract Expressionist manner. He is said to have spontaneously decided to use the bedding when he ran out of canvas. *Bed* was hung

on the wall like a picture, but Rauschenberg later created 'freestanding combines', in which the painted surface rests on the floor with objects superimposed on it. The most famous example is *Monogram* (Moderna Museet, Stockholm, 1955–9), featuring a stuffed goat with a tyre around its middle.

Comfort, Charles (1900–94). Scottish-born Canadian painter and art administrator. He was born in Edinburgh, emigrated to Canada with his parents in 1912, and in 1914 began working for a commercial art firm. In 1920, in Toronto, he saw the first exhibition of the *Group of Seven and was inspired by it to become a painter. He studied at Winnipeg School of Art under Frank Johnston (one of the original members of the Group of Seven) and at the *Art Students League in New York. His best work—landscapes and portraits—was done in the 1930s in a bold style, often employing dramatic light effects. He was an *Official War Artist, 1942–6 (he published a book on his experiences, *Artist at War*, 1956), and held various teaching and administrative posts. Most notably, from 1959 to 1965 he was director of the National Gallery of Canada.

composite media. See MIXED MEDIA.

computer art. Art produced with the aid of a computer or more specifically art in which the role of the computer is emphasized. Artists first began to experiment with computers in the 1950s and a Computer Arts Society was founded in Britain in 1969. At this time the art produced with computers was usually graphic material, in which, for example, specified geometric shapes were printed in random combinations. However, the development of the 'light pen' or stylus in the 1970s allowed the artist to work interactively with a display on a screen. Among the well-known artists who have experimented with such technology are Richard *Hamilton and David *Hockney. As well as enabling artists to use relatively direct 'painting' techniques, computers have been programmed to produce extremely complex images. Harold *Cohen is highly skilled in this field, developing his own program to generate abstract drawings that he then enlarges and colours by hand (*Socrates' Garden*, Buhl Science Center, Pittsburgh, 1984). Computers have also been used, for example, to control the movements of *Kinetic sculpture.

Conceptual art. A type of art in which the idea or ideas that a work represents are considered its essential component and the finished 'product', if it exists at all, is regarded primarily as a form of documentation rather than as an artefact. Conceptual art flourished particularly in the late 1960s and early 1970s, but its origins go back to Marcel *Duchamp, who 'reduced the creative act to a stunningly rudimentary level: to the single, intellectual, largely random decision to name this or that object or activity "art" . . . He used language and all manner of verbal and visual punning, randomness as well as deliberately plotted chance, trivial and ephemeral substances, his own person, provocative gestures directed at his own or other art, as the means and subjects of his work' (Roberta Smith, 'Conceptual Art' in Nikos Stangos, ed., *Concepts of Modern Art*, 1974, revised edn. 1981). His *Fountain* (1917), a urinal bowl with minimal alteration (see SOCIETY OF INDEPENDENT ARTISTS), can be considered the classic proto-Conceptual work. The artists who followed Duchamp in producing this kind of iconoclastic gesture include several figures who were prominent in the 1950s and early 1960s; among them were Piero *Manzoni, whose contributions to art include cans of his own excrement, Yves *Klein, who in 1958 held an exhibition consisting of an empty room at the Paris gallery of the Greek-born dealer Iris Clert (1925?–), and Robert *Rauschenberg, who in 1960—when invited to participate in an exhibition of portraits at the same gallery—sent a telegram saying 'This is a portrait of Iris Clert if I say so'. However, it was not until the later 1960s that Conceptual art became a recognizable movement and acquired its name. The expression 'Concept art' was used by the American 'anti-artist' Henry Flynt (1940–) in 1961, but the term 'Conceptual art' did not gain currency until Sol *LeWitt's article 'Paragraphs on Conceptual Art' appeared in *Artforum* in 1967. LeWitt wrote that 'In Conceptual art the idea or concept is the most important aspect of the work . . . all planning and decisions are made beforehand and the execution is a perfunctory affair. The idea becomes the machine that makes the art.'

The first major exhibitions of Conceptual art were held in 1969–70 in London, New York, and elsewhere, and the movement flourished most vigorously in the early 1970s, often overlapping with other art forms and movements that were fashionable at this

time, notably *Arte Povera, *Body art, *Land art, and *Performance art. These have all been seen as aspects of *Post-Minimalism—the reaction against the *formalism and commercialism of *Minimal art—and in the introduction to her anthology *Conceptual Art* (1972) the sculptor and critic Ursula Meyer stresses the unmaterialistic qualities of Conceptual art: 'The shift from object to concept denotes disdain for the notion of commodities—the sacred cow of this culture. Conceptual artists propose a professional commitment that restores art to artists, rather than to the "money vendors".' However, Conceptual art has proved just as susceptible to commercial exploitation as other forms of avant-garde expression, with dealers selling the documentation of Conceptual works to collectors and museums. Such documentation takes varied forms, including photographs, sound and video cassettes, texts, maps, diagrams, and sets of instructions, but some Conceptual works do not have any physicality at all, an example being *Telepathic Piece* (1969) by the American artist Robert Barry (1936–), consisting of a statement that 'during the exhibition I will try to communicate telepathically a work of art, the nature of which is a series of thoughts that are not applicable to language or image'. He writes that 'The world is full of objects, more or less interesting; I do not wish to add any more. I prefer, simply, to state the existence of things in terms of time and/or space.' Barry's other activities have included releasing small quantities of inert gases into the atmosphere and taking photographs of their dispersal (which is completely invisible).

Although some Conceptual art purports to deal with serious political issues (see HAACKE, for example), much of it is concerned with deliberately abstruse analysis of language (see ART & LANGUAGE) or with the kind of eccentric private concerns shown by Robert Barry. Exponents and admirers of Conceptual art see such activities as posing questions about the nature of art and provocatively expanding its boundaries. Robert *Morris, for example, wrote in 1970 that 'The detatchment of art's energy from the craft of tedious object production ... refocuses art as an energy driving to change perception'. To many, however, Conceptual art is as pointless as it is pretentious; in 1972 Keith *Vaughan wrote that 'the term is a contradiction in itself, art being the realization of concepts, not just having them'.

According to Roberta Smith's article cited above, 'Conceptual Art probably was the largest, quickest-growing and most genuinely international of all twentieth-century art movements ... due to its reliance on language, the reproducible image and the media, it was easily and quickly communicated ... Almost every country in Europe, North and South America boasted some sort of serious Conceptual activity' (opponents of Conceptual art would say that its proliferation owed much to the fact that it involved no perceptible skill and therefore could be done by anyone). However, the wave of enthusiasm for this kind of expression was fairly short-lived, and by the mid-1970s the term 'Post-Conceptual' was being used, suggesting that the movement had passed its peak (Roberta Smith writes that 'Looking back from the beginning of the 1980s, the Conceptual "moment" seems to have ended somewhere around 1974 or 1975'). Conceptual art continued more sporadically for the next decade until there was a substantial revival of interest in it in the mid-1980s (for example in the work of some of the exponents of *Neo-Geo). The term 'Neo-Conceptual' is sometimes applied to this revival.

Alternative names that have been used for Conceptual art include Anti-Object art, Dematerialized art, Documentary art, Head art, Idea art, and Post-Object art. The terms Analytical art and Ultra-Conceptualism are sometimes applied to Conceptual art that is concerned with philosophical enquiry into the concept of art. A journal called *Analytical Art* was published in Britain in 1971–2 (2 issues).

Concrete art. Term applied to abstract art that is intended to be totally autonomous, repudiating all figurative reference and symbolic associations. The name was coined by Theo van *Doesburg, who in Paris in 1930 issued a manifesto called *Art Concret* (it took the form of the first number of a periodical with this title, but no other numbers were issued). In this he declared: 'The work of art ... should receive nothing from nature's formal properties or from sensuality or sentimentality ... A pictorial element has no other significance than "itself" and therefore the picture has no other significance than "itself". The construction of the picture, as well as its elements, should be simple and controllable visually. Technique should be

mechanical, that is to say exact, anti-impressionistic.' Van Doesburg died the following year, but his ideas were developed by the *Abstraction-Création group. One of its members, Max *Bill, was a major force in helping Concrete art survive beyond the Second World War (he lived in neutral Switzerland). After the war, several new associations of Concrete art were formed, notably in Italy and in South America (which Bill visited in the 1950s), and it was later influential on *Minimal art and *Op art. Bill, who organized international exhibitions of Concrete art in Basle in 1944 and in Zurich in 1960, gave the following definition: 'Concrete painting eliminates all naturalistic representation; it avails itself exclusively of the fundamental elements of painting, the colour and form of the surface. Its essence is, then, the complete emancipation of every natural model: pure creation.' Although Concrete art is typically austerely geometrical, it is not necessarily so; Bill's sculpture, for example, often uses graceful spiral or helix shapes.

Concrete poetry. A type of poetry in which the physical appearance of the words embodies or extends their meaning and which is therefore considered a visual as well as a literary art (although some would say that most examples scarcely rate as either). The term was devised in about 1955, and it was soon after this that a Concrete poetry movement began, but the idea of a coincidence or interaction between meaning and appearance goes back much further. For example, the collection of ancient epigrams known as the *Greek Anthology* includes a poem in the shape of an axe and another in the shape of an egg, and this type of writing had something of a vogue during the English Renaissance; George Puttenham devotes a chapter to such verses in *The Arte of English Poesie* (1589), and there are well-known examples shaped like an altar and a pair of angel's wings by the devout 17th-century poet George Herbert (the term 'altar poem' is sometimes used as an alternative to 'shaped poem', and the phrase 'pattern poetry' is also encountered). In 1897 the French *Symbolist poet Stéphane Mallarmé used different type sizes in *Un Coup des dés* (A Throw of Dice), in 1918 *Apollinaire wrote 'Il pleut' (It Rains), in which the arrangement of the lines suggests drops of rain falling down the page, and the *Dadaists and *Futurists experimented freely with typography. Con-

crete poetry, as the term is now understood, goes beyond the silhouetting of Herbert's 'Easter Wings' and Apollinaire's 'Il pleut', often dispensing with conventional syntax and arrangement of lines.

There is some uncertainty about who coined the term Concrete poetry, and it seems to have come into use in several places more or less simultaneously around 1955. Among the first to use it were the Swiss Eugen Gomringer and the Brazilian Decio Pignatari. Gomringer was at this time working as secretary to Max *Bill, whose *Concrete art provided a model of self-sufficient abstract forms. An exhibition of Concrete art in São Paulo in 1956 was the launching-pad for Concrete poetry as a movement, and in a manifesto published in 1958 the Noigandres group of poets (to which Pignatari belonged) characterized a concrete poem as an object 'in and by itself'. The movement quickly became international and flourished throughout the 1960s, with many anthologies, magazines, and exhibitions devoted to it (the exhibitions included 'Between Poetry and Painting' at the Institute of Contemporary Arts, London, in 1965). In the 1970s much of the group activity petered out, but individual poets continued working in the vein. The best-known British exponent of Concrete poetry is Ian Hamilton *Finlay. Another was the poet and painter Kenelm Cox (1927–68), whose life was cut short by a car crash. He experimented with combining poetry and movement in *Kinetic sculpture. In America those who have experimented with Concrete poetry include John *Cage.

Conder, Charles (1868–1909). British painter and occasional printmaker, born in London, a direct descendant of the great 18th-century sculptor Roubiliac. In 1884 he emigrated to Australia to work for his uncle, a surveyor, but he gave this up for art. He mainly painted landscapes at this time and was influenced by Tom *Roberts, whom he met in Melbourne, where Conder lived from 1888 to 1890 (see HEIDELBERG SCHOOL). In that year he returned to Europe, briefly visiting England before moving to Paris, where he studied at the *Académie Julian and became part of a circle of artists, including *Anquetin, *Bonnard, and Henri de Toulouse-Lautrec (1864–1901). He appears in two of Lautrec's paintings of the Moulin Rouge, and like Lautrec was notoriously dissipated; his friend

William *Rothenstein said he was 'often without a sou, but . . . never without a lady'. In 1897 Conder settled in London, but he made frequent visits to Dieppe and Paris. His work was included in numerous exhibitions, including one-man shows, and he became a well-known figure in the art world, but he fell seriously ill in 1906—a result of his debauched life—and stopped painting. He is best known for landscapes, arcadian fantasies, and painted fans; Frank *Rutter wrote that 'As a water-colour painter on silk, as the creator of the most exquisite fans, Conder not only had no rival in his life-time, but no superior in the past or the present'. He also painted portraits and made a few lithographs and etchings. His work, which is well represented in the Tate Gallery, London, is often tinged with a feeling of *fin de siècle* decadence. He was influenced by *Whistler, but Rothenstein commented that 'Whistler never liked Conder and didn't care for his work . . . He probably thought him too involved with his ladies of Montmartre, too fond of his absinthe.'

Connor, Bruce. See FUNK ART.

Conroy, Stephen (1964–). Scottish painter. He was born at Helensburgh, near Dumbarton, and studied at Glasgow School of Art, 1982–7. Even before starting his postgraduate year (1986–7), he had achieved considerable success, and he was soon being hailed as the boy wonder of Scottish painting. In 1986 he won first prize for painting at the Royal Academy's British Institute Fund Awards and his degree show sold out. In 1987 he was the youngest artist included in 'The Vigorous Imagination', the main exhibition at the Edinburgh Festival, in 1988 he was interviewed in *Vogue* magazine, and in 1989 he had a one-man exhibition at *Marlborough Fine Art, one of the most prestigious London dealers. This meteoric rise was not without its problems, for he became embroiled in a legal dispute (eventually settled out of court) over a contract he regretted signing with a management firm, evoking comparisons with the tribulations of certain pop singers: 'I tried so hard to avoid "hype" and commercialization', he said. Conroy had begun his studies at Glasgow School of Art just as Steven *Campbell was leaving it for America in a blaze of glory, and he was influenced by him in his choice of enigmatic figurative subjects. Conroy, however, differs from Campbell in various ways;

he works more slowly and deliberately, making detailed preparatory drawings, typically uses softer handling and warmer lighting, and employs more formal poses (his figures sometimes wear evening dress, recalling the theatre pictures of *Degas or *Sickert). Duncan Macmillan writes that he 'uses this kind of anachronism to create a strange detachment. It hovers on the brink of the surreal without ever actually explicitly taking us into a wholly different reality, and so creates an atmosphere of mystery. In fact, his young men with their uniform appearance and dead-pan faces and the vague echo that they carry of belonging to another time suggest that it is *Gilbert and George in their suits and ties and with their neat haircuts who have stepped into the picture' (*Scottish Art in the 20th Century*, 1994).

Consagra, Pietro (1920–). Italian sculptor and occasional painter. He was born at Mazara del Vallo, Sicily, and studied at the Academy of Fine Arts, Palermo, 1938–44. In 1944 he settled in Rome, where he started to make abstract sculpture soon afterwards and joined the groups *Forma in 1947 and *Continuità in 1961. In the 1950s he began making what he called *ferri trasparenti* ('transparent irons')—double-sided low reliefs pierced with jagged holes—and it is for these that he is best known. Although he usually works in metal, he has also used marble and wood. Consagra is regarded as one of the leading figures in post-war Italian sculpture and has won several awards, notably the International Sculpture Prize at the 1960 Venice *Biennale; his public commissions include a large fountain for the Piazzale della Farnesina in Rome (1966). He has written numerous articles on art and in 1952 published the book *Necessità della scultura*, a response to Arturo *Martini, who had declared that sculpture was dead.

Constant (Constant A. Nieuwenhuys) (1920–). Dutch painter, sculptor, draughtsman, and printmaker, born in Amsterdam, where he studied at the Academy, 1939–42. He was a member of the *Cobra group of *Expressionist painters, but from the early 1950s he turned more to *Constructivist sculpture. From 1956 to 1969 he devoted much of his time to work on an ideal urban project, *Nieuw Babylon* (New Babylon), for which he made many designs and models. In the 1970s he returned to painting.

Constructivism. A movement or trend in abstract art that originated in Russia in about 1914, became dominant there for a few years after the 1917 Revolution, and in the 1920s spread to the West, where it has subsequently been influential on a wide spectrum of artists. Constructivism is typically characterized by the use of industrial materials—such as glass, plastic, and standardized metal parts—arranged in clear formal relationships, but the meaning to be attached to the word varies according to context, and some writers prefer to use the terms 'Soviet Constructivism' (or 'Russian Constructivism') and 'European Constructivism' (or 'International Constructivism') to make a distinction between the original movement and its much more diffuse aftermath. Even in the context of Revolutionary Russia, however, the meaning of the word is far from clear-cut.

The father of Constructivism was Vladimir *Tatlin, who visited Paris in 1914 and on his return to Russia began making abstract *Relief Constructions* using materials such as sheet metal, wood, and wire. He was influenced by the sculptural experiments of *Picasso, who had used a variety of ingeniously assembled odds and ends, and perhaps also by the *Futurist sculptural manifesto (1913), in which *Boccioni similarly advocated a move away from the traditional techniques of modelling and carving in favour of sculpture that was constructed from various new materials—this was the essential idea behind Constructivism. From his reliefs Tatlin went on to develop small openwork structures (sometimes hanging), and several other artists, including Alexander *Rodchenko, created similar works in the years immediately after the 1917 Revolution. The Revolution created a ferment of enthusiasm in Russia for the building of a better society, with machinery seen as a liberating force, and in this climate Tatlin's idea of investigating and exploiting industrial materials came into its own. Initially, indeed, Soviet Constructivism was inseparable from politics, and was meant to be neither 'an abstract style in art nor even an art, per se. At its core, it was first and foremost the expression of a deeply motivated conviction that the artist could contribute to enhance the physical and intellectual needs of the whole of society by entering directly into a rapport with machine production, with architectural engineering and with the graphic and photographic means of communication. To meet the material needs, to express the aspirations, to organize and systematize the feelings of the revolutionary proletariat—that was their aim: not political art, but the socialization of art' (Aaron Scharf, 'Constructivism', in Nikos Stangos, ed., *Concepts of Modern Art*, 1974).

The most heroic celebration of this faith in a Communist society was intended to be Tatlin's gigantic Monument to the Third International; it never progressed beyond a wooden model, exhibited in 1920, but it has become the great symbol of Soviet Constructivist ideals. Several other major projects remained unrealized because of lack of funds and materials, but the new spirit was fervently expressed in a whole range of objects and activities, including the decoration of propaganda boats and trains (see AGITPROP ART). This revolutionary zeal for socially useful art led many Soviet artists to conclude that traditional 'fine art' was dead. In 1921, for example, Rodchenko and several associates signed a joint declaration in which they acknowledged 'self-sufficient easel painting as extinct and our activities as mere painters useless', and the following year Rodchenko and his wife Varvara Stepanova published the 'Programme of the First Working Group of Constructivists', in which they declared 'uncompromising war on art'. In this way, a term that had originated in Tatlin's modest reliefs expanded to embrace the whole of applied art, and 'by 1925 Constructivism had become a blanket term for any angular designs applied to furniture, fabrics, porcelain or theatre sets' (Robert Auty and Dimitry Obolensky, eds., *An Introduction to Russian Art and Architecture*, 1980).

Many artists who were not prepared to abandon traditional art for industrial design left Russia at this time. Among them were the brothers Naum *Gabo and Antoine *Pevsner, who left in 1922 and 1923 respectively. Although they wanted to reflect modern technology in their work, they rejected the idea that art must serve an obvious social purpose; they thought that 'fine art' could make an important contribution to society by being spiritually uplifting, and they conceived a purely abstract type of sculpture that used industrial materials such as plastic and glass. Their ideas were expressed in the *Realistic Manifesto*, which they published in Moscow in 1920; in this they appealed for 'the construction of the new Great Style' and wrote that

'Space and time are the only forms on which life is built and hence art must be constructed.' It is from their work that European or International Constructivism derives, and each of them played an important part in spreading their ideals. Pevsner spent the rest of his life in Paris, which was the main centre of abstract art in the interwar years (see ABSTRACTION-CRÉATION), and Gabo lived successively in Germany, France, England, and the USA. In England he was co-editor of *Circle (1937), in which he published his essay 'The Constructive Idea'. The subtitle of Circle is International Survey of Constructive Art, an indication of the 'international constructive tendency' that was recognized at this time. Among the other contributors to the volume, *Moholy-Nagy was one of the outstanding representatives of this tendency, and was particularly influential in the spread of Constructivism through his teaching at the *Bauhaus and elsewhere. (Meanwhile, Constructivism in the Soviet Union was dead by this time, killed—like all other modern forms of expression—by *Socialist Realism. In the second edition of the Great Soviet Encyclopedia, 1949–60, the article 'Konstruktivizm' begins: 'A *formalistic tendency in bourgeois art, which developed after the First World War, 1914–18. Anti-humanistic by nature, hostile to realism, Constructivism appeared as the expression of the deepest decline of bourgeois culture in the period of the general crisis of capitalism.')

Gabo's concept of Constructivism, as expressed in his essay in Circle, was vague, being equated with 'creative human genius' in art, science, or any other sphere, and since the Second World War the term has been applied to a very broad range of work; in 1974 a critic remarked that 'Constructivism must be just about the most abused term in current art usage' (Ronald Hunt, 'Constructivism Mistaken', Studio International, Nov. 1974). Sometimes it is used as a rough equivalent of 'geometrical abstraction'—George *Rickey's book Constructivism: Origins and Evolution (1968), for example, encompasses *Hard-Edge Painting, *Minimal art, and much else besides. In Britain, however, the word is often used to refer specifically to a type of work— reliefs and free-standing constructs in metal or perspex—that became popular with a group of abstract artists in the 1950s and 1960s. These artists were influenced by Charles *Biedermann's book Art as the Evolu-

tion of Visual Knowledge (1948), and one of them—Anthony *Hill—wrote that Biedermann had helped them to 'accept the construction as the successor to the old domain of painting and sculpture'. Apart from Hill, the other British Constructivists of this time included Robert *Adams, Adrian *Heath, Kenneth and Mary *Martin, and Victor *Pasmore, who showed their work as a group at the 'British Abstract Art' exhibition at the AIA Gallery, London, in 1951. Three years later John Ernest (1922–) and Stephen Gilbert (1910–) joined the group, which maintained its identity until about 1960. In addition to making their characteristic small constructions, these artists sometimes had the opportunity to put their ideas into practice on an architectural scale—for example Mary Martin at Musgrave Park Hospital, Belfast, and Pasmore at Peterlee New Town. Their work and teaching influenced many artists of the next generation, including Peter Lowe (1938–) and Gillian Wise-Ciobotaru (1936–), who were among the members of a Constructivist association called Systems Group, founded in 1969.

contemporary art. An imprecise term applied to art that has been made fairly recently and which is considered modern in spirit. The term is necessarily somewhat elastic, as—apart from other problems of definition—our viewpoint constantly moves forward in time; thus what was regarded as contemporary in 1900 is now several generations old. Various writers or bodies have explicitly or implicitly suggested guidelines as to how they think the term should be understood. The *Contemporary Art Society, founded in 1910, is concerned with work 'not more than twenty years old', but the *Institute of Contemporary Arts, founded in 1947, takes a broader and somewhat vaguer view; when it moved to a new home in 1968, one of its founders, Sir Herbert *Read, wrote that it would 'remain what we have been from the beginning, an experimental workshop inspired by those revolutionary ideals that in the past fifty years have transformed the world of art'. Earlier, in his book Contemporary British Art (1951, revised edn. 1964), Read confined himself to 'the work of artists still living', but a more inclusive policy was adopted in the huge biographical dictionary Contemporary Artists (1977), which includes entries on numerous artists who were deceased at the

time of publication. The editors of the book, Colin Naylor and Genesis *P-Orridge, wrote in their introduction that 'The inclusion of deceased artists is dependent upon the continuing influence of their work on current art activity—though, for general purposes, no artist deceased prior to 1930 was to be included.' The companion volumes, *Contemporary Architects*, *Contemporary Designers*, and *Contemporary Photographers*, have adopted similar flexible views. More recently, Robert Atkins, in *Art Speak: A Guide to Contemporary Ideas, Movements, and Buzzwords* (1990), proposes that the term 'contemporary' should be used to cover the period since the Second World War. Jonathan Law, editor of *European Culture: A Contemporary Companion* (1993), is broadly in agreement, his book containing 'entries only for those figures who have emerged, or added significantly to their achievement, since 1945'. The *Museum of Contemporary Art, Los Angeles, covers a similar time range, 1940 being its notional starting point, but the *New Museum of Contemporary Art, New York, is restricted to the art made within the past ten years. This last notion of 'contemporary' means that such a museum can never have a permanent collection in the normal sense, as works will so quickly lose their contemporary status.

Contemporary Art Society (CAS). A society formed in London in 1910 to promote contemporary art and to acquire works by living artists for gift or loan to public museums in Britain (and later in the Commonwealth and occasionally elsewhere). It was envisaged as the counterpart, in the modern field, of the National Art Collections Fund, which had been founded in 1903 to assist public collections in purchasing works of art. Originally it was planned to call the society the Modern Art Association, but the present name had been adopted by the time the CAS was formerly inaugurated on 18 May 1910 at 44 Bedford Square, the home of Philip Morrell, a Liberal MP, and his wife Lady Ottoline Morrell (1873–1938), a celebrated hostess and patron of the arts. They were members of the original committee, which also included Charles *Aitken (then director of the *Whitechapel Art Gallery, later director of the *Tate Gallery), Clive *Bell, Roger *Fry, and D. S. *MacColl. Later members of the committee have included many distinguished figures in the art world, notably Kenneth *Clark, whose

energy and financial generosity were important in helping the society to survive the Second World War.

In 1991 a book was published to mark the 80th anniversary of the CAS: *British Contemporary Art 1910–1990: Eighty Years of Collecting by the Contemporary Art Society*. In the introduction Sir Alan *Bowness wrote that 'The intentions and procedures of the Contemporary Art Society have changed little since its formation in 1910 ... Paintings and sculptures, not more than twenty years old, were to be acquired, exhibited as widely as possible, and then presented to national and municipal collections. Funds were to come from these municipal galleries, in expectation of receiving gifts of modern works of art, and from individual subscribers' (corporate patronage began in the 1970s). By the time Bowness wrote these words, the CAS had presented more than 4,000 such works, mainly but not exclusively by British artists. In the final essay of the 80th anniversary volume Edward *Lucie-Smith wrote: 'For purely financial reasons, works by major artists—*Hockney and *Bacon for instance—have nearly always been bought early in their careers. Late Hockney and late Bacon have always been well beyond the Society's reach . . . On the whole the buyers have got matters right far more often than they have got them wrong. From the standpoint of 1991 they have bought many more good works of art than bad ones. Where British art is concerned, while they have bought some good artists rather late, there have been very few whom they have neglected altogether.'

Other countries have established Contemporary Art Societies, although not invariably with the same type of purpose as the British CAS. In Australia, a CAS was formed in Melbourne in 1938 in opposition to the Australian Academy of Art, founded the previous year, which was considered by its opponents to be a bastion of conservatism. Opposition to the Academy was led by George *Bell, who issued a leaflet entitled *To Art Lovers* in which he proposed forming 'a society which will unite all artists and laymen who are in favour of encouraging the growth of a living art, who are determined both to prevent any dictatorship in art and to nullify the effect of any official recognition acquired by a self-constituted Academy'. In its early years the CAS was split by disputes among members, but it established branches in Sydney and Adelaide and

then in other states and through its exhibitions became the main channel for transmitting knowledge of avant-garde art. In 1961 the Contemporary Art Society of Australia was formed

In Canada, a Contemporary Art Society was founded in Montreal in 1939 by the painter John Lyman (1886–1967) and ran until 1948. It held annual exhibitions and aimed to promote an international outlook in contrast to the nationalistic concerns of the *Group of Seven and the *Canadian Group of Painters. The artists who exhibited with the Canadian Contemporary Art Society included *Borduas and *Riopelle.

Contemporary Group. The name of two associations of Australian artists—one in Sydney, the other in Melbourne—founded to encourage an appreciation of modern art in their country; they were separate but existed at the same time. The first was founded in Sydney in 1925; its two prime movers were George *Lambert, the most successful Australian portraitist of his day, and his former pupil Thea Proctor (1879–1966), a watercolourist; a splendid portrait of Proctor by Lambert (1903) is in the Art Gallery of New South Wales, Sydney. Participants in its exhibitions included several artists influenced by *Post-Impressionism, among them Margaret *Preston and Grace Cossington *Smith. The Melbourne Contemporary Group was founded by George *Bell in 1932 and was short lived because in 1938 he turned his energies to the *Contemporary Art Society.

Contemporary Style. A term describing a trend in British art, architecture, and particularly design in the late 1940s and early 1950s characterized by a light, spiky, spindly look, often combined with bright or cheerful colours. The style was popularized by the *Festival of Britain in 1951 and is sometimes known as 'Festival Style' or 'South Bank Style' (another term that has been used for it is 'New English Style'). Although it is not generally associated with painting or sculpture, there are clear analogies in the stringed sculptures of Barbara *Hepworth and the spiky figures of the *Geometry of Fear sculptors, as well as in some of the abstract painting of the time. The style, indeed, was so popular for a time that it was found 'even in the three-dimensional models of molecular structures used in plastics technology and science laboratories' (Guy

Julier, *The Thames and Hudson Encyclopaedia of 20th Century Design and Designers*, 1993). John A. Walker writes that 'In the context of an exhibition, experimental design was appropriate but the mannerisms of 1951 quickly became cliches disfiguring the interior decor of coffee bars, public houses and exterior features such as street furniture. Many Contemporary Style products were eccentric in design and poorly constructed' (*Glossary of Art, Architecture and Design since 1945*, 3rd edn., 1992).

Contimpuranul. See JANCO.

Continuità. A group of Italian artists formed in Rome in 1961 with the critic Giulio Carlo Argan (1909–92) as its spokesman. Several members had previously belonged to the group *Forma, notably Carlo *Accardi, Pietro *Consagra, Piero *Dorazio, Gastone Novelli (1925–68), Achille *Perilli, and Giulio *Turcato. Other members included Lucio *Fontana and Arnaldo and Giò *Pomodoro. In the exposition of their aims the name 'Continuità' was given a twofold meaning. On the one hand, they called for an overhauling of current Italian painting and sculpture in order to re-establish continuity with the great Italian art of the past. On the other hand, they stood for continuity or greater structural rigour within the work of art as opposed to the looseness of *Art Informel. Some members also held that there should be continuity of the work of art with its spatial environment, in accordance with Fontana's doctrines.

Cook, Beryl (1926–). British *naive painter, born in Reading. She took up painting seriously in early middle age: 'I was happily settled at home, and with my son away at college I had plenty of spare time. There was also the incentive of all the bare walls in our cottage [at Looe in Cornwall], and the driftwood from the beach provided an ideal material to paint on.' Soon she was 'painting compulsively'. In 1975 she had her first exhibition, at the Plymouth Arts Centre, and it was a great success. Within a few years she was well known through other exhibitions, television appearances, and the publication of the first of several collections of her work in book form (*The Works*, 1978), with the paintings accompanied by her own amusing captions. Her chubby, usually jovial characters have also been much used on greetings cards. Cook's subjects are taken from everyday life and

often involve the kind of saucy humour associated with seaside holidays (she used to run a boarding house in Plymouth) and with tabloid Sunday newspapers (sometimes she incorporates real pieces of newsprint as a collage element). Edward *Lucie-Smith described her as 'the nicest thing to happen to British painting for years'.

Cook, Brian. See BATSFORD.

Cook, Rita. See ANGUS.

Cooke, Jean. See BRATBY.

Cool art. A term that has been applied to various types of abstract art characterized by such qualities as calculation, detachment, and impersonality. Usually the art referred to is geometrical, and often it is made up of repetitive structures or units. The term was evidently first used in print by the critic Irving Sandler in 1965 (in an article in *Art in America*), but the term 'Cool School' had been used a year earlier (in an article in *Artforum* by P. Leider). The art historian Barbara Rose has referred to the term as a synonym for *Minimal art, which she describes as 'an art whose blank, neutral, mechanical impersonality contrasts so violently with the romantic, biographical *Abstract Expressionist style which preceded it that spectators are chilled by its apparent lack of feeling or content'. See also COLD ART.

Cooper, Douglas (1911–84). British art historian and collector. He lived in France for much of his life and was severely critical of the British for what he regarded as their failure to appreciate or patronize modern art. Born in London, the son of wealthy parents, he read modern languages at Trinity College, Cambridge, then briefly attended the Sorbonne in Paris and the University of Freiburg, studying art history. His main interest was *Cubism, and in 1932 he decided to devote part of his inheritance to forming a collection of its four main protagonists—*Picasso, *Braque, *Gris, and *Léger—in its greatest period, 1907–14. He later added works by other artists, but the Cubists remained the core. In the Second World War he worked in intelligence and helped to identify, protect, and repatriate works of art. In 1949 he discovered the dilapidated Château de Castille in Argilliers, near Avignon, in southern France, and this became

his main home. Picasso was a neighbour and visitor, but their friendship turned to hostility. Cooper, indeed, had a notoriously difficult temperament and enjoyed controversy; in the 1950s he became particularly well known for his attacks on the *Tate Gallery and its director Sir John *Rothenstein. He was a formidable scholar and published substantial books on all four major Cubists. He also organized exhibitions, among them two major Cubist shows: 'The Cubist Epoch' at Los Angeles County Museum and the Metropolitan Museum, New York, in 1970, and 'The Essential Cubism' at the Tate Gallery, London, in 1983. See also RICHARDSON.

Corinth, Lovis (1858–1925). German painter, printmaker, and writer, born in Tapiau, East Prussia. He studied at the Academies of Königsberg and Munich, then in 1884–7 at the *Académie Julian, Paris, and he was strongly influenced by the painterly brushwork of recent French artists such as Courbet and Manet as well as by Old Masters such as Frans Hals, Rembrandt, and Rubens. After his return to Germany he lived first in Königsberg, then from 1891 in Munich, and from 1901 in Berlin. With *Liebermann and *Slevogt (both of whom also lived in Berlin) he was recognized as one of the leading German exponents of *Impressionism and in the first decade of the century he was a great fashionable success. However, in 1911 he was partially paralysed by a stroke and when he began to paint again (with great difficulty) it was in a much looser and more powerful *Expressionist manner, to which he had previously been strongly opposed (he has been described as 'an eleventh-hour convert to modernism'). He was varied and prolific as a painter and printmaker. His paintings included landscapes, portraits, and still-lifes, and he had a fondness for voluptuous allegorical and religious subjects (*The Temptation of St Anthony*, Tate Gallery, London, 1908). His prints were mainly drypoints and in his later years lithographs (which he used for the numerous commissions he had for book illustrations). He also made a few etchings and woodcuts. An edition of his writings, *Gesammelte Schriften*, was published in 1920, and a collection of autobiographical notes was published posthumously in 1926 as *Selbstbiographie mit Bildnissen*. After the Nazis came to power in 1933 his later works were declared *degenerate. *Kirchner said of Corinth, 'In the

beginning, he was only of average stature; at the end he was truly great.'

Corneille (Corneille Beverloo) (1922–). Belgian painter, active mainly in Paris. Born in Liège, he studied drawing at the Amsterdam Academy, 1940–3, but he was self-taught as a painter. In 1948 he was one of the founders of the *Cobra group and in 1950 he moved to Paris with his fellow member Karel *Appel. His work of this time was typical of the Cobra style—brilliant in colour and vigorous in brushwork, with child-like imagery suggesting mythical beings. During the 1950s he gradually abandoned figurative references for a swirling abstract style, but in the 1960s he reintroduced the imagery of his Cobra period.

Cornell, Joseph (1903–72). American sculptor, one of the pioneers and most celebrated exponents of *assemblage. He was born in Nyack, New York, and after leaving Phillips Academy in Andover, Massachusetts, in 1921, he worked for a while as a salesman in his father's textile firm. In 1929 he settled at Flushing, New York, where he lived quietly for the rest of his life, becoming rather reclusive in his later years. He had no artistic training, but he had a strong interest in the arts in general and he began frequenting the Julien Levy Gallery—which became a major venue for *Surrealism—soon after it opened in New York in 1931. He was also a keen collector of old books, engravings, and other articles of historical interest, and influenced by Surrealism—especially Max *Ernst—he began to make collages, using his own hoard as source material. In 1932 his work was included in a show at the Levy Gallery, and by 1936 he was well enough known to be included in a major exhibition at the Museum of Modern Art—'Fantastic Art, Dada and Surrealism'. By this time Cornell had developed his distinctive form of expression—small boxes, usually glass-fronted, in which he arranged collections of photographs, magazine illustrations, trinkets, and all manner of bric-a-brac. His work is sometimes compared with that of *Schwitters, but whereas Schwitters was fascinated by refuse, Cornell concentrated on fragments of once beautiful and treasured possessions, using the Surrealist technique of irrational juxtaposition to evoke a feeling of nostalgic reverie. From the late 1940s—perhaps influenced by *Mondrian, whom he

much admired—his work began to become more abstract. Cornell also painted, and from the late 1930s he made several Surrealist films, sometimes using discarded Hollywood movie footage. Towards the end of his life several major exhibitions were devoted to his work, notably one at the Guggenheim Museum, New York, in 1967.

Corpora, Antonio (1909–). Italian painter, born in Tunis of Sicilian parents. He trained at the Tunis Academy under Armand Vergeaud (1876–1949), who had been a fellow-student of *Dufy and *Matisse, then lived in Paris from 1930 to 1937. In 1939 he settled in Rome, where he became a member of the *Fronte Nuovo delle Arti in 1946 and one of the *Gruppo degli Otto Pittori Italiani in 1952. From *Cubist and *Fauvist influences in his early work Corpora developed to expressive abstraction and by the end of the 1940s he was painting in a *Tachiste manner akin to that of Jean *Bazaine and other followers of Roger *Bissière who based their abstractions on nature. During the 1950s, however, he began to paint abstract colour compositions that had no basis in natural appearances. He had a one-man show at the Venice *Biennale in 1960.

Corrente. An anti-Fascist association of young Italian artists formed by Renato *Birolli in Milan in 1938. *Guttuso was one of the founder members; *Afro and *Mirko were among those who joined later. The association had no fixed programme, but was opposed to the provincialism of the *Novecento. The members stood for the defence of 'modern' art at a time when the Nazi campaign against *degenerate art was spreading to Italy. Corrente arranged exhibitions in Milan in March and December 1939; older Milanese artists were included in the first, but only the younger generation participated in the second. It also published a fortnightly review of literature, politics, and the arts. This grew out of a Fascist youth journal called *Vita giovanile*, founded in Milan in January 1938; in October 1938 it was retitled *Corrente di vita giovanile* (Stream of youthful life) and by this time had become anti-Fascist in stance. From February 1939 the title became simply *Corrente*. The journal ceased publication in 1943 and the activities of the group were dissipated by the Second World War.

'Cor-Ten' steel. See IRON AND STEEL.

Cortissoz, Royal. See WRIGHT.

Cosey Fanni Tutti. See P-ORRIDGE.

Cossington Smith, Grace. See SMITH, GRACE COSSINGTON.

Costa, Joachim. See DIRECT CARVING.

Costakis, George (1912–90). Russo-Greek diplomat and collector. He was born in Moscow, the son of a Greek merchant who had emigrated to Russia in 1907, and he had Greek nationality throughout his life. From 1931 to 1976 he worked in various diplomatic legations in Moscow. He started collecting in the 1930s, at a time when the Soviet government was selling huge amounts of art to gain foreign currency. Originally he bought antiques and Old Master paintings, then moved on to icons, and from the late 1940s began building up a superb collection of modern Russian works, beginning with the established masters such as *Chagall and *Kandinsky and moving on to his own younger contemporaries. He researched his collection carefully, so it formed a highly important historical resource. The type of art he owned was considered dangerously subversive at a time when only *Socialist Realism was officially sanctioned, and Costakis once said that he felt as if he were 'sitting on a barrel of dynamite'. In 1978, when he retired to Greece, he was allowed to take part of his collection with him in return for presenting the bulk of it to the Tretyakov Gallery in Moscow. The works he brought out of Russia were exhibited at various venues in Europe and the USA. In Greece, Costakis continued collecting up to his death and presented numerous works to museums. His obituarist in *The Times* wrote that 'A vital aspect of the development of 20th-century abstract painting was saved by the passion and doggedness of this one man'. See also UNOFFICIAL ART.

Cottingham, Robert. See SUPERREALISM.

Council for the Encouragement of Music and the Arts. See ARTS COUNCIL.

Counihan, Noel (1913–86). Australian painter and graphic artist, one of his country's leading exponents of *Social Realism. In 1930 he began attending evening classes in drawing at the National Art Gallery School in his native Melbourne and worked for a time as a caricaturist, but he did not begin painting until 1940. Counihan had an unhappy childhood (partly because of his father's heavy drinking) and was a man of strongly held humanistic beliefs; during the 1930s he was involved in left-wing political activities, and many of his early works were either direct political statements or personal recollections of the Depression years in Melbourne. In 1945 he won first prize in the 'Australia at War' exhibition held at the National Gallery of Victoria, and in 1949 he attended the First World Peace Conference in Paris as a member of the Australian delegation. After living for two years in England he returned to Australia in 1951, but he continued to be a great traveller, visiting Russia in 1956 and 1960, for example. During the 1960s he painted many pictures based on the life of the Australian Aborigines, as well as a series of mother and child paintings related to the Vietnam War. In 1969 he visited Mexico, France, and Eastern Europe, where he found new inspiration in the folk carving of Poland. He returned to France in 1982 and lived there for a year. See also *ANGRY PENGUINS*.

Courbet, Gustave. See MODERN ART.

Courtauld, Samuel (1876–1947). British industrialist, collector, and philanthropist. He came from a family of prosperous silk merchants and was chairman of the textile firm Courtaulds Ltd. from 1921 to 1946. Although he enjoyed looking at paintings from a fairly early age, it was not until the turn of the century that art became a serious interest, and it was not until 1922 that he began collecting. He was greatly stimulated by the exhibition of Sir Hugh *Lane's collection at the *Tate Gallery in 1917, and Courtauld—like Lane—mainly bought 19th-century French paintings, chiefly works by the great masters of *Impressionism and *Post-Impressionism. His collection included, for example, choice works by *Cézanne, *Gauguin, *Monet, and *Renoir (among them a portrait of the dealer *Vollard, painted by Renoir in 1908 and bought from Vollard himself in 1927). In 1923 Courtauld gave the Tate Gallery £50,000 for the purchase of French paintings in his own area of interest (which was poorly represented), and this fund was used to buy 23 paintings over the next few

years, transforming the Tate's collection. His interests also extended to living artists, and in 1925 he joined his friend Maynard *Keynes in founding the *London Artists' Association to provide financial assistance to young painters and sculptors. In 1931 came his most famous benefaction when he endowed the Courtauld Institute of Art, London, Britain's first specialist centre for the study of the history of art. The Institute opened in 1932 in Courtauld's former home, a splendid Robert Adam building in Portman Square, and in the same year Courtauld presented most of his collection to the University of London, together with funds for a building to house them. The Courtauld Institute Galleries opened in Woburn Square in 1958, and in 1989–90 all the Institute's activities and collections were brought together under one roof at Somerset House, fulfilling Courtauld's intention that students should work in intimate contact with original works of art. Kenneth *Clark described Courtauld as a 'quiet, modest man . . . a man of principle, if ever there was one', and Dennis Farr writes that 'He brought to his collecting that combination of flair, energy, and sense of public duty that had marked his successful career as a leading industrialist. He did not seek to acquire social status by virtue of his collecting. Indeed, he refused a peerage in the 1937 Coronation Honours List, preferring to keep his independence and integrity' (*Impressionist & Post-Impressionist Masterpieces: The Courtauld Collection*, 1987). Courtauld himself said that art was 'religion's next-of-kin'.

Courteline, Georges. See NAIVE ART.

Couturier, Robert (1905–). French sculptor, born in Angoulême. He moved to Paris with his parents in 1910 and originally trained as a commercial lithographer. In 1930 he met *Maillol and became his friend and disciple. Although Couturier always spoke of Maillol with respect and gratitude, he eventually threw off his influence, preferring plaster to stone, and working towards a very different ideal of sculptural form—more attenuated, more open, and more expressive. His figures grew longer and thinner, developing into the 'weightless' style with which he is chiefly associated. In 1945 he became professor of sculpture at the École des Arts Décoratifs in Paris and from the 1950s he built up an international reputation. His major commissions

included stone reliefs of *The Arts* (1960) for the French Embassy in Tokyo.

Cowie, James (1886–1956). Scottish painter of portraits, figure compositions, landscapes, and still-lifes. He was born on a farm in Aberdeenshire, and after abandoning a degree course in English literature at Aberdeen University and qualifying as a teacher he studied at *Glasgow School of Art, 1912–14. During the First World War he was a conscientious objector and worked on roaddigging and similar tasks. From 1918 he taught at Bellshill Academy, near Glasgow, then, after a year as head of painting at Gray's School of Art, Aberdeen, he was warden of Hospitalfield House, Arbroath (a summer school) from 1937 to 1948. His pupils there included Robert *Colquhoun, James *MacBryde, and Joan *Eardley. In 1948 he moved to Edinburgh and became secretary of the Royal Scottish Academy.

Cowie was one of the most individual Scottish painters of the 20th century. Whereas the central tradition of modern Scottish painting has been one of rich colouring and lush, free brushwork (see, for example, SCOTTISH COLOURISTS), Cowie worked in a strong, hard, predominantly linear style—highly disciplined rather than intuitive (he made many preparatory drawings and often worked on a picture for several years). He took his subjects from what he saw around him, but he was also inspired by the Old Masters, often using their compositions as a starting-point, without actually imitating them. Among his contemporaries he was perhaps closest in spirit to John *Nash, an artist he greatly admired. They shared an ability to infuse the ordinary with a sense of the mysterious. Cowie has continued to be a much admired artist in Scotland, and in the 1980s his work was an influence on Alison *Watt.

Cowper, Frank Cadogan (1877–1958). British painter, born at Wicken, Northamptonshire, son of Frank Cowper, a writer of historical novels, some of which he illustrated himself. He studied at St John's Wood School of Art, 1896–7, and the *Royal Academy Schools, 1897–1902, then spent six months working with E. A. *Abbey. An arch-conservative, Cowper inherited his father's love of historical romance and was perhaps the last notable exponent of the type of mystical, medieval (and often rather mawkish) subject

favoured in the 19th century by the *Pre-Raphaelites, exhibiting pictures in this vein at the Royal Academy until almost the time of his death. In 1952 he caused controversy when his painting *The Jealous Husband*, showing a man disguised as a priest hearing his wife's confession, was thought by some people to be too unseemly for the walls of the Academy. By this time, however, he was devoting himself mainly to portraiture, as the taste for historical and literary pictures declined. He lived in London for most of his career, but moved to the Cotswolds after the Second World War and died in Cirencester.

Cox, Kenelm. See CONCRETE POETRY.

Cox, Kenyon. See WRIGHT.

Cragg, Tony (1949–). British sculptor. He was born in Liverpool, and after studying at the *Royal College of Art he settled in Germany in 1977. In his early work he grouped fragments of junk (such as discarded household plastic) to form simple shapes or images arranged on the floor or wall (*Union Jack*, City Art Gallery, Leeds, 1981). According to Lynne Cook (in the *Thames and Hudson Encyclopaedia of British Art*, 1985), 'The unassuming appearance of these works belies the philosophical issues at stake, which arise from the interaction of image, material and title.' Since 1984 Cragg has made free-standing sculptures, some using geometric wooden frames stacked together, others combining ready-made utilitarian objects with plastic or stone. One of his most conspicuous works is *Raleigh* (1986), outside the Tate Gallery, Liverpool. The gallery's publication *Sculpture on Merseyside* (1988) writes of it: 'Cragg returned to his hometown to make a sculpture for this site . . . He used different materials from those he normally worked with to respond to the dock site and Liverpool's tradition of heavy industry. He selected two granite and a number of cast iron bollards from an artefact store, and the casts for the sculpture were made from Cragg's drawings in the Bootle iron foundry, Bruce & Hyslop. The horns symbolize a fanfare of greeting or farewell, and also suggest messages carried across the water.' In 1988 Cragg represented Britain at the Venice *Biennale, and also won the *Turner Prize.

Craig, Gordon (1872–1966). British theatrical designer and graphic artist, born at Steven-age, the illegitimate son of the actress Ellen Terry and the architect and theatre critic E. W. Godwin ('Craig' was a stage name he adopted in his early days as an actor, later formalized by deed poll). Tall and good-looking, with the theatre in his veins, Craig became a successful leading man (his roles included Hamlet and Romeo), but in 1897 he gave up acting to concentrate on design and directing. His approach was highly unconventional, aiming for simplicity and unity in place of Victorian elaboration, and his productions tended to be admired by the avant-garde but fail at the box-office. In 1904 he visited Berlin (where he began an affair—one of his many romances—with the dancer Isadora Duncan), and from 1907 he lived on the Continent, first in Italy and then from 1931 in France. In 1913 he founded a theatre school in Florence at which he made experiments with moving lights and scenery that give him a claim to be regarded as a pioneer of *Kinetic and *Light art (he conceived of a theatre without actors or words in which the elements of spectacle alone would engender the emotional response). The only production in which he managed to use moving screens was Konstantin Stanislavsky's *Hamlet* at the Moscow Art Theatre in 1912, and after Craig's theatre school closed in 1915 because of the First World War he concentrated more on writing, notably in his quarterly periodical *The Mask* (1908–29), which he produced virtually single-handedly, using dozens of pseudonyms for his articles. He also developed his talent as a printmaker (he had learnt wood engraving from his friends William *Nicholson and James *Pryde). In this field, Craig is best known for his strikingly bold illustrations to the Cranach Press edition of *Hamlet* (1927). By the time of his death at the age of 94 he had 'seen the best of his former revolutionary ideas pass into general theatre practice' (*DNB*).

Craig had many children, legitimate and illegitimate; one of them, **Edward Anthony Craig** (1905–), was a painter, book illustrator, and designer for the stage and cinema. He sometimes worked under the name Edward Carrick. His son **John Craig** (1931–) and daughter **Helen Craig** (1934–) continue the family tradition as illustrators.

Craig-Martin, Michael (1941–). British painter, sculptor, *Conceptual artist, writer, and teacher. He was born in Dublin, moved to the USA as a child, and studied at Yale Univer-

sity. In 1966 he settled in England, where he taught at Bath Academy of Art and then from 1973 at Goldsmiths' College in London (he became Millard professor of fine art there in 1994). He is probably best known for Conceptual work, of which an example is *Oak Tree* (NG, Canberra, 1973), consisting of a glass of water on a shelf. When this was exhibited at the Rowan Gallery, London, Nigel Gosling described it in the *Observer* as 'a condensation of thoughts about identity and time . . . Not for the first time (we are reminded of *Magritte's painting of a pipe labelled 'This is not a pipe') art puts out an elegant feeler into the subtle and obscure waters of identity'. Commenting on this passage, Giles Auty writes (*The Art of Self Deception*, 1977): 'How would the self-same critic react if, on ordering oak planks for an outhouse, he were sent instead a bucketful of water? Would he gently muse on "the subtle and obscure waters of identity"—or make immediate reflections on the mental wellbeing of his timber suppliers?' Craig-Martin himself writes of his work: 'I have tried to strip away everything inessential, to touch the line between art and the world, meaning and no meaning, feeling and no feeling. Using objects and imagery as neutral as possible, I have tried to make an art as charged as possible. Through extreme clarity and explicitness, I have tried to confirm mystery and depth. The closer a work of art brings me to the crisis of experience, the more inclusive its significance.'

Crane, Walter (1845–1915). British illustrator, designer, painter, writer, and administrator. He was the son of a miniaturist and trained as a wood engraver. His career was very varied, but he is best remembered today as an illustrator of children's books, a field in which he was prolific throughout his life. He took this work very seriously, believing that 'We all remember the little cuts that coloured the books of our childhood. The ineffaceable quality of these early pictorial and literary impressions affords the strongest plea for good art in the nursery and the schoolroom.' Originally he worked in black-and-white, but he adapted well to the photomechanical colour processes that came in at the end of the 19th century and was one of the pioneers of the full-colour picture book for children. He was also one of the first illustrators to treat a double-page spread as a visual unity. His work for adults included designing wall-

paper, and he was a leading figure in the Arts and Crafts movement that tried to rehabilitate good design and craftsmanship. Like William Morris (1834–96), the leading figure of this movement, Crane was a Socialist, and he illustrated A. A. Watts's *The Child's Socialist Reader* (1907). He was greatly interested in art education, serving on various examination boards; in the 1890s he taught in Manchester and Reading, and in 1898–9 he was principal of the *Royal College of Art. His writings included three primers that were much used by students: *The Basis of Design* (1898), *Line and Form* (1900), and *Of the Decorative Illustration of Books* (1901). Crane said that he enjoyed illustrating children's books because 'in a sober and matter-of-fact age' they afforded an 'outlet for unrestrained flights of fancy'. He evidently carried the fairy-tale world he depicted into his own domestic life, for his wife once received astonished guests 'dressed as a sort of sunflower'.

Cravan, Arthur. See DADA.

Craven, Thomas. See REGIONALISM.

Crawford, Ralston. See PRECISIONISM.

Crawhall, Joseph. See GLASGOW BOYS.

Craxton, John (1922–). British painter, graphic artist, and theatre designer, born in London, son of the pianist Harold Craxton and brother of the oboist Janet Craxton. In 1939 he studied briefly in Paris and then for the next three years in London, at Westminster School of Art, the Central School of Art, and Goldsmiths' College. He was a friend of Graham *Sutherland and in his early work was one of the leading exponents of *Neo-Romanticism, depicting visionary landscapes peopled with solitary poets and shepherds. Craxton said that these pictures (often heavily-worked drawings) 'were my means of escape and a sort of self-protection . . . I wanted to safeguard a world of private mystery, and was drawn to the idea of bucolic calm as a kind of refuge.' In 1946 he visited Greece and since then has spent much of his time in the Aegean (he has also travelled extensively in other parts of the world). He is now perhaps best known for his portraits. Typically they are marked by clear drawing (with mild *Cubist stylization), subtle low-key colouring, and nervous sensitivity of characterization;

there is a kinship of feeling with the early work of Lucian *Freud (Craxton shared a studio with him in 1942–4). As a theatre designer Craxton is best known for his costumes and sets for the 1951 Sadler's Wells Ballet production of Ravel's *Daphnis and Chloe*, choreographed by Frederick Ashton.

Crimson Rose. See BLUE ROSE.

Crippa, Roberto (1921–72). Italian painter and sculptor. He was born in Monza and studied at the Brera Academy in nearby Milan, *Carrà being one of his teachers. His work was very varied. Early in his career he painted geometrical abstractions, then in the late 1940s and early 1950s he was involved in the *Spatialism movement of his friend *Fontana, whilst at the same time producing the first *Action Paintings by an Italian artist (in his series of calligraphic spiral paintings of 1949–52). In the mid-1950s he turned to various types of three-dimensional work, including cast-iron sculpture and relief collages incorporating materials such as wood and newspaper. Their expressive quality is far removed from the cool objectivity of Spatialism, but he continued to see himself as a colleague of Fontana. Crippa was a qualified pilot and died when an aeroplane he was flying crashed.

Cross, Henri-Edmond (1856–1910). French painter, mainly of landscapes. He worked in an *Impressionist and then a *Neo-Impressionist style, and his use of large dots of bright colour had a brief but important influence on the early work of the *Fauves, notably *Matisse, who in 1904 visited him at his home at Le Lavandou on the Mediterranean coast when he was spending the summer at St-Tropez, near *Signac. Alfred H. *Barr wrote of their relationship: 'Cross was a gentler personality than Signac and a better colorist. Matisse has often spoken of him with respect and it seems probable that Cross, at least as much as Signac, now helped change the course of Matisse's art' (*Matisse: His Art and his Public*, 1951).

Crotti, Jean. See DUCHAMP, SUZANNE.

Crown Point Press. See PRINT RENAISSANCE.

Cruz-Diez, Carlos (1923–). Venezuelan painter and *Kinetic artist, resident in Paris since 1960. He was born in Caracas, where he studied at the School of Fine Arts, 1940–5, and from 1946 to 1951 he was director of the Venezuelan branch of the McCann Erickson Advertising Agency. In 1953–5 he was an illustrator for the newspaper *El Nacional* and taught typography, and in 1955–6 he lived in Spain; he made two visits to Paris during his stay in Europe and it was at this time that he became interested in optical phenomena. He returned to Venezuela in 1957 and became assistant director of the School of Fine Arts in Caracas and professor of typographical design at the Central University of Venuezuela. In 1960 he settled in Paris, where he became friendly with other Latin American artists, notably his fellow Kineticist *Soto, and continued the experiments with arrangements of primary colours he had started during his earlier visits. Using arrangements of thin intersecting bands he found he could create the illusion of a third or fourth colour. This led to a series of works entitled *Chromatic Induction*, *Chromointerference*, *Additive*, and *Physichromie*. In the last—low reliefs which he started making in 1959—he created shifting geometric images that emerge, intensify, change, and dematerialize as the viewer moves in front of them. He achieved this effect by using narrow strips of painted metal or plastic arranged in parallel lines or at right angles to each other (*Physichromie 113*, Tate Gallery, London, 1963, reconstructed by the artist 1976). His work has been featured in many international exhibitions and he has won several awards, including the International Painting Prize at the São Paulo *Bienal in 1967. He represented Venezuela at the 1970 Venice Biennale. His later work has included architectural installations, or 'chromatic environments' as he calls them, in public buildings.

Crypt Group. See ST IVES SCHOOL.

Cubism. A term describing a revolutionary style of painting created jointly by *Braque and *Picasso in the period 1907–14 and subsequently applied to a broad movement, centred in Paris but international in scope, in which their ideas were adopted and adapted by many other artists. These artists were mainly painters, but Cubist ideas and motifs were also used in sculpture, and to a more limited and superficial degree in the applied arts and occasionally in architecture. Cubism

was a complex phenomenon, but in essence it involved what Juan *Gris (its leading exponent apart from the two founders) called 'a new way of representing the world'. Abandoning the idea of a single fixed viewpoint that had dominated European painting for centuries, Cubist pictures used a multiplicity of viewpoints, so that many different aspects of an object could be simultaneously depicted in the same image, presenting the artist's accumulated idea of a subject rather than an imitation of its appearance at any one moment. Such fragmentation and rearrangement of form meant that a picture could now be regarded less as a kind of window through which an image of the world is seen, and more as an artificial structure on which a subjective response to the world is created; painting became a matter of two-dimensional composition rather than three-dimensional illusionism. This new approach proved extraordinarily influential, and John *Golding, one of the leading writers on the subject, has described Cubism as 'the pivotal movement in the art of the first half of this century' and as 'perhaps the most important and certainly the most complete and radical artistic revolution since the Renaissance'.

Braque and Picasso met in October 1907. Their friendship was to some extent an attraction of opposites, for as Wilhelm *Uhde wrote, 'Braque's temperament was limpid, precise and bourgeois; Picasso's sombre, excessive and revolutionary'. Nevertheless, at times they worked in such close harmony—'like mountaineers roped together' in Braque's memorable phrase—that it can be difficult to differentiate their hands. At the time they met, Braque had recently been overwhelmed by the memorial exhibition of *Cézanne's work at the *Salon d'Automne, and Picasso had spent much of the year working on Les Demoiselles d'Avignon (MOMA, New York, 1907), in which the angular and aggressive forms owed much to the influence of African sculpture. These two sources—Cézanne and *primitive art—were of great importance in the genesis of Cubism. Cézanne's late work, with its subtle overlapping patches of colour, had shown how a sense of solidity and pictorial structure could be created without traditional perspective or modelling; and primitive art offered an example of expressively distorted forms and freedom from inhibition. In Les Demoiselles d'Avignon, two of the figures are not only given faces resembling African masks, but also are twisted so that more of them is visible than could be seen from a single viewpoint. Like others who saw the picture at this time, 'Braque was shocked and troubled by its violence', but he was also 'profoundly excited and moved. What is so remarkable is that he seems to have realised instantly what it took so many other painters several years to perceive and digest: that Picasso, leaning heavily on Cézanne and exhilarated by his contact with African art, had for the first time intuitively but consciously broken with traditional Western single viewpoint perspective' (John Golding, Georges Braque, 1966). The impact of Picasso on Braque's work was immediate; in the winter of 1907–8 he painted a Large Nude (private collection) that is virtually a variant of one of the figures in Les Demoiselles d'Avignon.

Because Cubism made such a radical break with established traditions, initiating a new concept of pictorial space, attempts have been made to link it with new views about the nature of reality that were coming to the fore at the same time (Einstein's Special Theory of Relativity, for example, was published in 1905). However, although Braque and Picasso were intellectual in approach, they were intuitive rather than scientific in their methods, and Picasso himself stressed that Cubism was fundamentally about painting: 'Mathematics, trigonometry, chemistry, psychoanalysis, music and whatnot have all been related to cubism to give it an easier interpretation. All this has been pure literature, not to say nonsense, which brought bad results, blinding people with theories. Cubism has kept itself within the limits and limitations of painting, never pretending to go beyond it.' In this respect it is noteworthy that Braque's and Picasso's Cubist paintings are unconcerned with depicting things that evoke the modern world (indeed, they were necessarily limited to portraying a repertoire of familiar, fairly 'timeless' forms, in order that the spectator could appreciate how these forms had been manipulated); their favourite subjects were still-lifes (often involving fruit bowls or musical instruments), landscapes, portraits, and figure studies (Braque being more inclined to landscapes and Picasso to figures). The support of their dealer *Kahnweiler allowed them the freedom to experiment, repeating favourite themes again and again as they developed their ideas.

The pictures to which the term 'Cubism'

was first applied were a group of landscapes painted by Braque in the summer of 1908, when he was staying at L'Estaque, near Marseilles. They were rejected by the *Salon d' Automne later that year, and a member of the selecting jury (*Matisse according to some sources) is said to have remarked slightingly that they were composed of 'petits cubes'. (According to Frank *Rutter, citing Léonce *Rosenberg as his authority, the word 'cubisme' itself was uttered on this occasion.) Soon afterwards these pictures were shown at Kahnweiler's gallery, and in reviewing this exhibition in *Gil Blas* (14 Nov. 1908), Louis *Vauxcelles made reference to Braque's way of reducing 'everything—sites, figures, and houses—to geometric outlines, to cubes'. The following March, describing some Braques shown at the *Salon des Indépendants, Vauxcelles used the expression 'bizarreries cubiques' (cubic eccentricities), and by 1911 the term 'Cubism' had entered the English language. The word is undoubtedly apposite for the block-like forms in some of the Braque landscapes that occasioned Vauxcelles's jibes, such as *Houses at L'Estaque* (Kunstmuseum, Berne, 1908), and in a few similar works by Picasso, but it is not really appropriate to their mature Cubist pictures, in which the forms tend to be broken into facets rather than fashioned into cubes (and it is completely inappropriate to later Cubism). However, they soon accepted the term, as did their followers.

Braque and Picasso's working relationship was at its closest in what John Golding calls 'the "look-alike" years between the autumn of 1910 and the autumn of 1912', when the similarities between their work were 'so great that even the trained and experienced eye has occasionally to pause and blink'. During this period they worked in nearby studios in Montmartre, but Picasso moved to Montparnasse in 1912, and the outbreak of the First World War two years later ended their collaboration. Their work of 1910–12 is sometimes characterized as 'High Cubism', in reference to the brief peak of poise and equilibrium it is thought to have attained; and another term that has been applied to it is 'Hermetic Cubism', conveying the idea that at this time Cubism reached its most esoteric, near-abstract state. More commonly, however, Braque and Picasso's mature Cubism is divided into two phases—Analytical Cubism (1909–11) and Synthetic Cubism (1912–14).

The 'Analytical' phase is so called 'because one can find evidence of the artists' having taken objects apart, of having analyzed them into their compound elements, only to rearrange them on the canvas in a new and exclusively pictorial order' (George Heard *Hamilton). The relatively solid massing of the earliest Cubist paintings gave way to a process of composition in which the forms of the object depicted are fragmented into a large number of small, intricately hinged planes that fuse with one another and with the surrounding space. There is no sense of recession, the image seeming to be compressed into a shallow, subtly modelled continuum that stretches across the entire picture surface (Braque referred to 'tactile space' and 'manual space', and later wrote 'That is what early Cubist painting was—a research into space'). This fascination with pictorial structure led to colour being downplayed ('colour disturbed the space in our paintings' said Braque), and the archetypal Analytical Cubist paintings are virtually monochromatic, painted in muted browns or warm greys. Examples—showing how close the two artists were in style at this date—are Braque's *The Portuguese* (Kunstmuseum, Basel, 1911) and Picasso's *The Accordionist* (Guggenheim Museum, New York, 1911).

In *The Portuguese*, Braque introduced the use of stencilled lettering, a practice that Picasso adopted soon afterwards. By the following year, Braque was experimenting with mixing materials such as sand and sawdust with his paint to create interesting textures and emphasize further the idea that the picture was a physical object with its own integrity rather than an illusionistic representation of something else. He refined this notion again by imitating the effect of wood graining (using techniques that he had learnt in his early days as a painter-decorator). Later in the same year, 1912, Picasso took this a stage further when he produced his first *collages, and Braque quickly followed with his own type of collage (the *papier collé), consisting of compositions of pieces of decorative paper. These developments—marking a move away from the very cerebral near-abstraction of Analytical Cubism to a more relaxed and decorative art incorporating everyday ephemera—ushered in Synthetic Cubism. This reversed the compositional principle of Analytical Cubism, the image being built up ('synthesized') from pre-existing elements or

shapes rather than being created through a process of fragmentation. A consequence of this concern with greater surface richness was that Braque and Picasso reintroduced colour to their paintings. Examples are Braque's *Still-life with a Violin, Glass and Pipe on a Table* (also known as *Music*, Phillips Collection, Washington, 1914) and Picasso's *Still-life with a Fruit Dish on a Table* (Columbus Museum of Art, Ohio, 1914–15).

In the Synthetic phase of Cubism, Juan Gris played as important a role as Braque or Picasso, and by this time many other artists had been won over to the movement (including Fernard *Léger, who is often considered the fourth major Cubist). Indeed, Cubism had become the dominant avant-garde idiom in Paris as early as 1911. In that year the movement had its first organized showing when a number of Cubists exhibited together at the Salon des Indépendants, among them *Delaunay, *Gleizes, *La Fresnaye, *Metzinger, and *Picabia (they had the support of advanced critics such as *Apollinaire, but their work was met with scorn or bewilderment by many people). The following year, two of these artists—Gleizes and Metzinger—published the first book on the subject, *Du Cubisme*. It was translated into English in 1913, and the first book written in English on the subject, A. J. *Eddy's *Cubists and Post-Impressionism*, was published in Chicago in 1914 and in London in 1915. British and American audiences had already been introduced to Braque's and Picasso's work through Roger *Fry's second *Post-Impressionist exhibition in 1912 and the *Armory Show in 1913. However, the two founders of the movement did not take part when their followers exhibited collectively; Braque's and Picasso's Cubist work was generally sold by Kahnweiler to a select group of well-informed clients rather than displayed in the open marketplace in the various salons. For this reason, the public image of Cubism in its early days was provided mainly by the lesser figures rather than the chief masters. Some art historians therefore use the terms 'true' or 'essential' Cubism (coined by Douglas *Cooper) to distinguish the work of Braque and Picasso (and later Gris and to a lesser extent Léger) from the the work of the 'Salon Cubists', whom Cooper described as 'derivative'.

The First World War interrupted the course of Cubism, but it re-emerged as a powerful force at the end of the war, with Léonce Rosenberg beginning a series of Cubist exhibitions at his Galerie de l'Effort Moderne in 1918. By this time Cubism had already been highly influential on avant-garde art throughout Europe and had made a significant impact in the USA. It proved immensely adaptable and was the starting-point or an essential component of several other movements, including *Constructivism, *Futurism, *Orphism, *Purism, and *Vorticism, as well as a spur to the imagination of countless individual artists. These included not only painters, but also sculptors, who adapted Cubist ideas in various ways, notably by the opening up of forms so that voids as well as solids form distinct shapes. Picasso himself made Cubist sculpture, and other leading artists who worked in the idiom include *Archipenko (whose international success played a great part in spreading Cubist ideas), *Duchamp-Villon, *Laurens, *Lipchitz, and *Zadkine. Another noted Cubist sculptor was the Czech Otto *Gutfreund, who was part of a remarkable flowering of Cubist art and design in Prague in the years immediately before the First World War. This was the only place where there was a significant adaptation of Cubism to architecture (although the *Puteaux Group exhibited a model of a 'Maison Cubiste' at the 1912 Salon d'Automne). Several Czech architects, mainly members of the *Group of Plastic Artists, broke up the façades of their buildings with abstract, prismatic forms in a way that clearly recalls the fragmentation of Analytical Cubism. The best-known of these architects was probably Josef Gočár (1880–1945), who also designed Cubist furniture; several pieces by him are in the Museum of Decorative Arts, Prague. More generally, Cubism was one of the sources of *Art Deco.

It was not only in terms of style that Cubism had an immense impact on 20th-century art, but also in terms of ideas. Simon Wilson (*What is Cubism?*, 1983) describes it as 'the most important and influential single innovation in the early history of modern art. Cubist painting gave to artists complete freedom to deal with reality in art in any way they chose. Cubist collage gave them in addition the equally radical freedom to *make* art out of anything they chose. These developments have been enormously fruitful—they have been and they continue to be the basis of much of the best of modern art.'

Cubist Centre. See REBEL ART CENTRE.

Cubist-Realism. See PRECISIONISM.

Cubo-Expressionism. A term coined in the early 1970s to describe a trend in Czech avant-garde art in the second decade of the 20th century in which elements of *Cubism and *Expressionism were combined. The fusion of Cubist fragmentation of form and Expressionist emotionalism is seen particularly in the work of the members of the *Group of Plastic Artists. In a broader and vaguer sense, the term 'Cubo-Expressionism' has been used to describe other aspects of Czech avant-garde art and literature in this period.

Cubo-Futurism. A term applied by *Malevich to works he showed at the *Donkey's Tail (1912) and *Target (1913) exhibitions in which he combined aspects of *Cubism and *Futurism, notably the fragmentation of form of Cubism and the sense of mechanistic movement of Futurism. The term fits some of his works of this time better than others, and it has often been used rather vaguely to refer to other aspects of Russian art of this time, literature as well as painting. For example, Dmitri V. Sarabianov (*Russian Art*, 1990) writes: 'The avantgarde movement of the early 1910s is known by the name "Cubo-Futurism" ... the term was very convenient, since it embraced Futurist poets as well as Cubist painters. The Cubo-Futurist group also included painters who did not practice Cubism and were closer to *Expressionism.'

Cucci, Enzo. See NEO-EXPRESSIONISM.

Cuevas, José Luis (1934–). Mexican graphic artist and painter. He was virtually self-taught as an artist and is a highly individual figure. His most characteristic works are incisive satirical drawings of grotesque creatures and degraded humanity; prostitutes, poor children, and people in institutions for the insane have been among his subjects, and he has often included self-portraits in his compositions. Although these drawings are in the tradition of Goya, they are strongly flavoured by contemporary life, including horror and detective films. Cuevas had his first exhibition in 1953 in Mexico City, when he was only 19, followed by one the next year at the Pan American Union in Washington, which launched his career abroad. In connection with this exhibition he gave an interview for *Time* magazine in which he criticized the 'Mexican nationalism' of *Rivera and *Siqueiros (on the other hand, he admired the satirical sense of *Orozco, the third member of the great triumvirate of Mexican muralists). After thus establishing himself as an *enfant terrible*, he continued to court controversy but also gained official recognition for his work, notably with the first international prize for drawing at the São Paulo *Bienal in 1959 for his series *Funeral of a Dictator* (1958). Apart from drawings and paintings, Cuevas's work has included stage design and prints in a variety of techniques, and he has written several autobiographical books. He is considered a leading figure in offering Mexican art an alternative to the muralist tradition that had so dominated it in the first half of the 20th century.

Cuixart, Modesto (1925–). Spanish painter, born in Barcelona, where he began studying medicine at the university in 1944. In 1946 he abandoned his course to devote himself to painting, having already exhibited his work with some success, and in 1948 he became a founder member of *Dau al Set. He painted in the *Surrealist manner favoured by the group, though with anticipations of expressive abstraction, and by the mid-1950s he was working in an *Art Informel style. In the mid-1960s his paintings began to assume a more mystical character, with bizarre suggestions of faces, limbs, or figures, and in the late 1960s his work became more representative, sometimes incorporating real objects attached to the surface of the canvas. Cuixart is one of the best-known Spanish artists of his generation and has won numerous awards.

Cullen, Maurice (1866–1934). Canadian painter, whose work was influential in introducing *Impressionism to his country. He was born in St John's, Newfoundland, brought up in Montreal, and originally trained as a sculptor. From 1889 to 1895 he lived in Paris and elsewhere in France, with trips to Venice and North Africa, and it was in this period that he switched from sculpture to painting. He made two shorter trips to Europe before settling for good in Canada in 1902. His subjects included city scenes (*Old Houses, Montreal*, Montreal Museum of Fine Arts, *c*. 1900) and landscapes on the St Lawrence River, in the Laurentian hills, at St John's, and in the Rocky Mountains. After about 1920 he lived in virtual retirement in a cabin he built at Lac

Tremblant in the Laurentians. His friend J. W. *Morrice said of his work: 'he gets at the guts of things'. See also CANADIAN ART CLUB.

Cultured Painting. See PITTURA COLTA.

Cumberland Market Group. A small group of painters formed in London towards the end of 1914, with Robert *Bevan, Harold *Gilman, and Charles *Ginner as the core members; all three had belonged to the recently defunct *Camden Town Group and were at this time members also of its successor, the *London Group. The Cumberland Market Group was named after 49 Cumberland Market in Camden, London, the address of Bevan's studio where the members used to meet. They held only one exhibition, at the Goupil Gallery in April 1915, by which time John *Nash had joined the group. Other members included McKnight *Kauffer and C. R. W. *Nevinson. The group never officially disbanded, but it lapsed in about 1918.

Cuneo, Terence (1907–96). British painter and illustrator, born in London. His father and his mother were illustrators: the American-born Cyrus Cuneo (1879–1916) and Nell Tenison (1867–1953), whom he married in 1903. They gave Cuneo his initial instruction in art, but his main training was at Chelsea School of Art and the *Slade School. In the 1930s he worked primarily as an illustrator, but after the Second World War (in which he served in the Royal Engineers and was an *Official War Artist) he turned more to painting. His work included official portraits, ceremonial, military, and engineering subjects (particularly railways), and fantasy scenes (typically featuring anthropomorphized mice). He travelled widely and the places he visited are sometimes reflected in his work. His autobiography, *The Mouse and his Master*, was published 1977 and *The Railway Painting of Terence Cuneo* in 1984.

Cuningham, Vera. See SMITH, SIR MATTHEW.

Cunningham, Merce. See RAUSCHENBERG.

Currie, Ken. See GLASGOW SCHOOL.

Curry, John Steuart (1897–1946). American painter. He was born on a farm near Dunavant, Kansas, and never forgot his Midwestern roots. After studying at the Kansas City Art Institute, 1916, and the Art Institute of Chicago, 1916–18, he worked as an illustrator for pulp magazines from 1919 to 1926, then spent a year in Europe before settling in New York, where he was encouraged and supported by Gertrude Vanderbilt *Whitney. He believed that art should grow out of everyday life and be motivated by affection, and his subjects were taken from the Midwest he loved. Two of his most famous works are *Baptism in Kansas* (Whitney Museum, New York, 1928) and *Hogs Killing a Rattlesnake* (Art Institute of Chicago, 1930); they show his anecdotal, rather melodramatic style (he often depicted the violence of nature)—sometimes weak in draughtsmanship, but always vigorous and sincere. In the 1930s Curry was recognized—along with Thomas Hart *Benton and Grant *Wood—as one of the leading exponents of *Regionalism, and he was given commissions for several large murals; the best known—generally regarded as his masterpieces, even though the scheme was never finished—are in the state capitol in Topeka, Kansas (1938–40), where the subjects include the activities of John Brown, the famous campaigner against slavery. In 1936 Curry was appointed artist-in-residence by the College of Agriculture at the University of Wisconsin, one of the first such posts to be created in the country. He held the position for the rest of his life.

Cursiter, Stanley (1887–1976). Scottish painter (mainly of landscapes, portraits, and figure subjects), printmaker, administrator, and writer. He was born at Kirkwall, Orkney, and after serving an apprenticeship as a lithographer he studied at Edinburgh College of Art and the *Royal College of Art, London. His best-known paintings are a series of works he did in 1913 inspired by the *Futurists—he was one of the few British artists to try to adopt their methods for representing movement. During the First World War he served in the army in France and afterwards travelled there before settling in Edinburgh in 1920. From 1924 to 1948 he worked at the National Gallery of Scotland, first as keeper and then from 1930 as director. During his directorship he proposed the foundation of a *Scottish National Gallery of Modern Art, but this did not come into being until 1960. On his retirement from the National Gallery in 1948 he was appointed King's Painter and Limner in Scotland. From this time he lived on Orkney,

painting the local landscape and writing articles on various aspects of the island's life. He also wrote three books: a monograph on *Peploe (1947), *Scottish Art at the Close of the* *Nineteenth Century* (1949), and *Looking Back: A Book of Reminiscences* (1974).

Curzon Committee. See TATE GALLERY.

Dacre, Winifred. See NICHOLSON, BEN.

Dada. A movement in European art (with manifestations also in New York), *c.* 1915–*c.* 1922, characterized by a spirit of anarchic revolt against traditional values. It arose from a mood of disillusionment engendered by the First World War, to which some artists reacted with irony, cynicism, and nihilism. Originally Dada appeared in two neutral countries (Switzerland and the USA), but near the end of the war it spread to Germany and subsequently to a few other countries. The unprecedented carnage of the war led the Dadaists to question the values of the society that had created it and to find them morally bankrupt: Marcel *Janco, for example, wrote, 'We had lost the hope that art would one day achieve its just place in our society. We were beside ourselves with rage and grief at the sufferings and humiliation of mankind.' Their response was to go to extremes of buffoonery and provocative behaviour to shock people out of corrupt complacency. One of their prime targets was the institutionalized art world, with its bourgeois ideas of taste and concern with market values. The Dadaists deliberately flouted accepted standards of beauty and they exaggerated the role of chance in artistic creation. Group activity was regarded as more important than individual works, and traditional media such as painting and sculpture were largely abandoned in favour of techniques and devices such as *collage, *photomontage, *objects, and *ready-mades, in which there was no concern for fine materials or craftsmanship. Although the Dadaists scorned the art of the past, their methods and manifestos—particularly the techniques of outrage and provocation—owed much to *Futurism; however Dada's nihilism was very different from Futurism's militant optimism.

European Dada was founded in Zurich in 1915 by a group of artists and writers including Jean *Arp, Hans *Richter, and the Romanian poet Tristan Tzara (1896–1963). According to the most frequently cited of several accounts of how the name (French for 'hobby-horse') originated, it was chosen by inserting a penknife at random in the pages of a dictionary, thus symbolizing the anti-rational stance of the movement. The name was first used in 1916, and Arp later wrote: 'I hereby declare that Tzara invented the word Dada on 6 February 1916, at 6 p.m. . . . it happened in the Café de la Terrasse in Zurich, and I was wearing a brioche in my left nostril.' The main centre of Dada activities in Zurich was the *Cabaret Voltaire and it was primarily a literary movement, typical manifestations including the recitation of nonsense poems (sometimes several simultaneously and to a background of cacophanous noise). Tzara edited the movement's first periodical *Dada*, the first issue of which appeared in July 1917; the last issue (number eight) was published in September 1921 at Tarrenz in Austria, entitled *Dada Intirol*. This was an unusually long life, for the many other Dada periodicals that appeared were usually very ephemeral. The spirit of the movement often comes out not only in the contents of these journals, but also in the eccentric typography that was typical of them, different typefaces being freely mixed together in defiance of traditional notions of design.

By the end of the war Dada was spreading to Germany, and there were significant Dada activities in three German cities: Berlin, Cologne, and Hanover. In Berlin the movement had a strong political dimension, expressed particularly through the brilliant photomontages of *Hausmann, Höch, and *Heartfield and through the biting social satire of *Dix and *Grosz; eventually it gave way to *Neue Sachlichkeit. In Cologne a brief Dada movement (1919–20) was centred on

two figures: Arp, who moved there from Zurich when the war ended; and Max *Ernst, who made witty and provocative use of collage and organized one of Dada's most notorious exhibitions, at which axes were provided for visitors to smash the works on show. In Hanover Kurt *Schwitters was the only important Dada exponent but one of the most dedicated of all.

Dada in New York arose independently of the European movement and virtually simultaneously. It was mainly confined to the activities of Marcel *Duchamp, *Man Ray, and Francis *Picabia, although other artists (for example Morton *Schamberg) were occasionally affected by the Dada spirit. Their work tends to be more whimsical and less violent than that of their European counterparts, although they too liked to shock. In 1917, for example, Duchamp and Picabia arranged for Arthur Cravan (1887–1919?), who combined the careers of poet and professional heavyweight boxer, to give a lecture on modern art to a large audience including many society ladies; Cravan arrived late and drunk, and after mounting the platform unsteadily, he proceeded to undress and shout obscenities at the audience. Eventually he was subdued by the police.

Picabia was the most important link between European and American Dada. He founded his Dada periodical *391 in Barcelona in 1917 and he introduced the movement to Paris in 1919. In Paris the movement was mainly literary in its emphasis, and its tendency towards absurdity and whimsicality formed the basis for *Surrealism, which was officially launched there in 1924. Other Dada groups appeared in Austria, Belgium, the Netherlands, and elsewhere. There was a Dada festival in Prague in 1921, in which Hausmann and Schwitters participated, and an international Dada exhibition was held in Paris in 1922. However, by this time the impetus was flagging, and at a meeting in Weimar in 1922, attended by Arp, Schwitters, and others, Tzara delivered a funeral oration on the movement.

Although it was fairly short-lived and confined to a few main centres, Dada–'the most violent, disruptive, and controversial movement in twentieth-century art' (George Heard *Hamilton)–was highly influential, establishing the 'anti-art' vein in modern culture and the tendency–almost obligation–for avant-garde movements to question or debunk traditional methods or concepts. Its creative techniques involving accident and chance were of great importance to the Surrealists (see AUTOMATISM) and were also later exploited by the *Abstract Expressionists. *Conceptual art, too, has its roots in Dada. The spirit of the Dadaists, in fact, has never completely disappeared, and its tradition has been sustained in, for example, *Junk sculpture and *Pop art, which in the USA was sometimes known as *Neo-Dada.

Dadswell, Lyndon. See SOCIETY OF SCULPTORS AND ASSOCIATES.

Dalí, Salvador (1904–89). Spanish painter, sculptor, graphic artist, designer, film-maker, and writer, born in Figueras, Catalonia. An elder brother, also called Salvador, had died a few months before Dalí's birth, and in childhood he came to identify morbidly with his namesake and had a constant craving for attention. He studied at the Academy of Fine Arts, Madrid, 1921–4 and 1925–6, being suspended for a year for insubordination and eventually expelled for indiscipline. By this time he had already had a successful one-man show in Barcelona (1925), which *Picasso had admired (Dalí visited Picasso the following year when he made his first trip to Paris). After working in a variety of styles, influenced by *Cubism, *Futurism, and *Metaphysical Painting, he had turned to *Surrealism by 1929. In that year he had a sell-out exhibition at the Galerie Camille Goemans in Paris; André *Breton wrote the catalogue preface, and this marked Dalí's official membership of the Surrealist movement. His talent for self-publicity rapidly made him its most famous representative—its symbol in the mind of the general public. Throughout his life he cultivated eccentricity and exhibitionism, claiming that this was the source of his creative energy (one of his most outrageous stunts was delivering a lecture at the London International Surrealist Exhibition in 1936 dressed in a diving suit; he almost suffocated). He adopted the Surrealist idea of *automatism but transformed it into a more positive method that he named 'critical paranoia'. According to this theory, one should cultivate genuine delusion as in clinical paranoia while remaining residually aware at the back of one's mind that the control of the reason and will has been deliberately suspended. He claimed that this method should be used not

only in artistic and poetical creation but also in the affairs of daily life.

During the heyday of Surrealism in the 1930s Dalí produced several of the established 'icons' of the movement, using a meticulous academic technique that was contradicted by the unreal 'dream' space he depicted and by the strangely hallucinatory character of his imagery. He described his pictures as 'hand-painted dream photographs' and had certain favourite and recurring images, such as the human figure with half-open drawers protruding from it, burning giraffes, and watches bent and flowing as if made of melting wax (*The Persistence of Memory*, MOMA, New York, 1931). Dalí himself said that the melting watches—one of the most parodied images in 20th-century art—were inspired by eating a ripe camembert cheese, but some commentators have sought deeper meanings, seeing them, for example, as expressing a fear of impotence.

In the late 1930s Dalí made several visits to Italy and adopted a more traditional style; this together with his political views (he was a supporter of General Franco) led *Breton to expel him from the Surrealist ranks in 1939 (he had been accused of 'counter-revolutionary activities' as early as 1934). He moved to the USA in 1940 and remained there until 1948. During this time he devoted himself largely to self-publicity and making money (Breton coined the anagram 'Avida Dollars' for his name). From 1948 he lived mainly at Port Lligat in Spain, but also spent much time in Paris and New York. Among his later paintings the best-known are probably those on religious themes, although sexual subjects and pictures centring on his wife Gala were also continuing preoccupations. The religious paintings in particular are sometimes dismissed by critics as *kitsch, but they are highly popular with the general public: in a London *Sunday Times* poll published in 1995, *Christ of St John of the Cross* (St Mungo Museum, Glasgow, 1951) was voted readers' 8th favourite painting (*Monet and *Munch were the only other painters active in the 20th century to make it into the top ten).

In old age Dalí became one of the world's most famous recluses, generating rumours and occasional scandals to the end (as for example when there were newspaper stories about the appearance of series of prints signed by him but evidently not made by him). Apart from paintings and prints, his output included sculpture, book illustration, jewellery design, and work for the theatre. In collaboration with the director Luis Buñuel he also made the first Surrealist films—*Un Chien andalou* (1929) and *L'Age d'or* (1930)—and he contributed a dream sequence to Alfred Hitchcock's *Spellbound* (1944). He wrote a novel, *Hidden Faces* (1944), and several volumes of flamboyant autobiography—the first of these, *The Secret Life of Salvador Dalí* (1942), was described by George Orwell as 'a striptease act conducted in pink limelight'. Although he is undoubtedly one of the most famous artists of the 20th century, his status is controversial; many critics consider that he did little if anything of consequence after his classic Surrealist works of the 1930s. There is a museum devoted to Dalí's work in Figueras and two in the USA; at Cleveland, Ohio, and St Petersburg, Florida.

Dalwood, Hubert (1924–76). British abstract sculptor, born in Bristol. He trained as an engineer, 1940–4, and served in the Royal Navy, 1944–6, before studying under Kenneth *Armitage and William *Scott at the Bath Academy, 1946–9. From 1951 to 1955 he taught at Newport School of Art, then was the third sculptor to be awarded the *Gregory Fellowship at Leeds University, 1955–8, following in the distinguished steps of Reg *Butler and Armitage. Thereafter he taught at various art schools, notably as head of sculpture at Hornsey College of Art, 1966–73, and head of sculpture at the Central School of Art, London, 1974–6. He won the first prize for sculpture at the 1959 *John Moores Liverpool Exhibition and the David Bright Prize (for a sculptor under 45) at the 1962 Venice *Biennale, and he had numerous public commissions, including several from universities (for example a fountain at Nuffield College, Oxford, 1962). Dalwood was one of the leading figures of the generation that broke away from the raw, expressive manner in wrought and welded metal that was so prominent in British sculpture in the 1950s (his own earliest work was in this vein). His favourite medium was aluminium, which he sometimes painted. With this he created volumetric objects that contrast ribbed and edged forms with smoother and more fluid areas (*Large Object*, Tate Gallery, London, 1959). He also made sensitively modelled reliefs in aluminium. In the late 1960s, following a stay in the USA as visiting professor at the Univer-

sity of Illinois (1964), he turned to bigger, shiny, columnar forms. (He returned to the USA in 1967 as visiting professor at the University of Wisconsin.) In the 1970s he began making large room installations in wood.

Dardé, Paul. See DIRECT CARVING.

Dardel, Nils von (1888–1943). Swedish painter and designer, active mainly in Paris. He was born at Bettna, near Stockholm, into an aristocratic and artistic family—his grandfather, **Fritz von Dardel** (1817–1901), was a history painter—and he became something of an eccentric dandy, with a reputation for sarcastic wit. After studying at the Stockholm Academy, he settled in Paris in 1910, although he travelled very widely, visiting Japan in 1917, for example. He was fascinated with the morbid and the decadent, and fairly early in his career he painted some remarkable pictures that anticipate *Surrealism—weird dreamlike scenes of death and depravity in a fiercely coloured, semi-*naive style (*Visit to an Eccentric Lady*, Nationalmuseum, Stockholm, 1921). The stage designs he did for the Ballets Suédois during its short life (1920–5) are sometimes in a similar vein. In the 1920s and 1930s, however, he concentrated on portraits, in a more conventional style. After the outbreak of the Second World War he moved to the USA, and his last works include some watercolours made on a visit to Mexico and Guatemala. He died in New York.

Darwin, Sir Robert (known as Robin) (1910–74). British painter, teacher, and administrator, born in London, great-grandson of Charles Darwin, author of *The Origin of Species*, and great-great-grandson of the celebrated potter Josiah Wedgwood; his father was a 'gentleman-journalist' and his mother was a painter and sculptor. After schooling at Eton, he studied briefly at Cambridge University and at the *Slade School, where he had what he described as 'a great bust-up with old *Tonks', then had a spell as a journalist before becoming an art teacher at Watford Grammar School and Eton. During the Second World War he worked on camouflage and at the Ministry of Town and Country Planning, and from 1946 to 1948 he was professor of fine art at Durham University. In 1948 he succeeded Percy *Jowett as principal of the *Royal College of Art, the role for which he is best remembered. Darwin remained as head of the RCA until 1971 (his title changed to rector in 1967 when it acquired university status) and transformed its character. When he arrived it was in a fairly moribund state (on his first day he found 'every wall of the College was painted with the deadliest and most institutional grey paint that the Ministry of Works could devise'), but under his direction it became 'by general consent the foremost institution of its kind in the world and its influence spread through the whole edifice of art education in Britain . . . he widened the range of disciplines taught to match the industries the college ought to serve, developed academic and administrative systems that would win respect for the place and its products among those most sceptical of the art student's value in an industrial society, and attracted many of the leading practitioners of the day to organize and staff the various schools' (*DNB*). Darwin was knighted in 1964. He had numerous one-man exhibitions of his paintings (mainly landscapes and portraits), but they are considered of minor account compared with his administrative work.

Dasburg, Andrew (1887–1979). American painter, born in Paris. He studied in New York at the *Art Students League and with Robert *Henri, then in 1909–10 lived in Paris, where he discovered modern French painting. At the *Armory Show in 1913 he was represented by two *Cubist paintings and a sculpture (the only one he ever made). His work was also included in the *Forum Exhibition of Modern American Painters in 1916, but after this his style became less avant-garde, with *Cézanne as a major influence. In 1930 he settled at *Taos in New Mexico, where there was an artists' colony. Dasburg is now perhaps best remembered for the part he played in bringing the *naive painter John *Kane to public attention.

Dau al Set (The Seven-Spotted Dice). An association of Spanish artists founded in Barcelona in 1948 and active until 1953; it published a periodical of the same name (since six is the usual maximum number of spots on the side of a die, the name implied going beyond normal limits). The most significant members were the critic Eduardo Cirlot, the Existentialist philosopher and poet Arnoldo Puig, and four painters—Modesto *Cuixart, Joan *Ponç, Antoni *Tàpies, and Joan José *Tharrats. In the catalogue of the

exhibition 'New Spanish Painting and Sculpture' at the Museum of Modern Art, New York, in 1960, Frank O'Hara gave the following assessment of the importance of the group and the publication: 'At that time the frontiers of esthetic communication were all but closed to innovation and experimentation. The artists involved in this publication ... set out to rectify this situation and, what is more, to give the emerging Spanish avant-garde, few in number at that time, a mouthpiece and a showplace. While the overall tone was *Surrealist, other movements were not neglected ... Not until the founding of the group *El Paso ... in Madrid in 1957 was there another such historic moment in the development of contemporary Spanish art.'

Davey, Grenville. See NEW BRITISH SCULPTURE and TURNER PRIZE.

David, Jacques-Louis. See MODERN ART.

Davie, Alan (1920–). British painter, graphic artist, poet, musician, silversmith, and jeweller, born at Grangemouth, Stirlingshire, son of a painter and etcher. Davie studied at Edinburgh College of Art, 1937–40, and after serving in the Royal Artillery, 1941–6, had his first one-man show at Grant's Bookshop, Edinburgh, in 1946. He then briefly worked as a professional jazz musician (he plays several instruments) before spending almost a year (1948–9) travelling in Europe. This gave him the chance to see works by Jackson *Pollock and other American painters in Peggy *Guggenheim's gallery in Venice, and he was of the first British painters to be affected by *Abstract Expressionism. Other influences on his eclectic but extremely personal style are African sculpture and Zen Buddhism. His work is full of images suggestive of magic or mythology (some based on ancient forms, some of his own invention) and he uses these as themes around which—like a jazz musician—he spontaneously develops variations in exuberant colour and brushwork: 'Although every work of mine must inevitably bear the stamp of my own personality, I feel that each one must, to be satisfactory, be a new revelation of something hitherto unknown to me, and I consider this evocation of the unknown to be the true function of any art.'

After his return to Britain in 1949, Davie settled in London, where he worked until 1953 as a jeweller. By the mid-1950s, however, he was gaining a considerable reputation as a painter (he had regular one-man exhibitions at *Gimpel Fils Gallery from 1950), and in the 1960s this became international. His many awards have included the prize for the best foreign painter at the São Paulo *Bienal of 1963 and first prize at the International Graphics Exhibition, Cracow, in 1966. Since 1971 he has spent much of his time on the island of St Lucia and this has introduced Caribbean influences into his imagery.

Davies, Arthur Bowen (1862–1928). American painter, printmaker, and tapestry designer, born in Utica, New York. During his lifetime he had a high reputation as an artist, but he is now remembered mainly for his role in promoting avant-garde art (even though his own work was fairly conservative). He studied art in Chicago and worked in Mexico as an engineering draughtsman before settling in New York in 1886. Initially he supported himself as a magazine illustrator, whilst studying at the *Art Students League and elsewhere, 1886–8. In 1893 he visited Europe, and his enthusiasm for the *Pre-Raphaelites, *Whistler, and the French *Symbolist Pierre Puvis de Chavannes was part of the remarkably diverse artistic background from which he created his style and outlook. He painted various subjects, but before the First World War he specialized in idyllic, fantasy landscapes inhabited by dreamlike, visionary figures of nude women or mythical animals, often arranged in flat, frieze-like compositions (*Unicorns*, Metropolitan Museum, New York, 1906). In spite of his preference for such subject-matter, he was part of the circle of Robert *Henri, the chief apostle of the idea that art should be in touch with everyday life. This contradiction was typical of Davies: 'his nature was paradoxical: His art was both intuitive and intellectual; it was rooted in past styles but he was keenly interested in the avant-garde. His personality seemed in harmony with his mild decorous manner but it hid totally unsuspected depths. His sympathy with the more adventurous younger men led to his exhibiting with The *Eight in 1908 [indeed, Davies organized the show], though his art was at the opposite pole from New York realism' (David W. Scott in *Britannica Encyclopedia of American Art*, 1973).

In 1911 Davies became president of the Association of American Painters and Sculp-

tors, formed to create the exhibition that became known as the *Armory Show (1913). His wide and liberal culture and his enthusiasm for the project were largely responsible for the scope of the show and the force of its impact. After the Armory Show his work showed superficial *Cubist influence for a while, but in the 1920s he returned to a more traditional style, devoting much of his time to lithography and designing tapestries for the Gobelins factory in Paris. In 1924 a book was published by Phillips Memorial Art Gallery, Cambridge, Massachusetts, celebrating Davies's work (*Arthur B. Davies: Essays on the Man and his Art*). It shows the remarkably high opinion in which he was held, one contributor (Edward Root) describing him as 'the most comprehensive intelligence that has yet, in America, attempted to express itself in paint'.

Davies, John (1946–). British sculptor, born in Cheshire. He studied painting at Hull and Manchester Colleges of Art, 1963–7, then sculpture at the *Slade School, 1967–9. His work typically consists of clothed male figures, the heads cast from the life in plaster; they wear real clothes and shoes and have glass eyes, but their flesh is painted an ashen grey and their vacant inexpressiveness of face and posture is reminiscent of shop-window display dummies. Timothy Hyman writes that 'The effect is as though we've been made to *dream* them, figures seen through rain or tears, and to take on their burden of grief' (catalogue of the exhibition 'British Sculpture in the Twentieth Century', Whitechapel Art Gallery, London, 1981). Davies's sculpture has sometimes been described as *Superrealist, but many critics think that it is too personal for such classification. During the 1970s he attracted a good deal of attention (in *Super Realism* (1979) Edward *Lucie-Smith described him as 'perhaps the most exciting young artist to have emerged in England during the 1970s'), but his reputation has perhaps declined somewhat since (Lucie-Smith does not mention him in *Art Today* (1995)).

Davis, Gene. See WASHINGTON COLOR PAINTERS.

Davis, Ron (1937–). American painter, born in Santa Monica and active mainly in Los Angeles. His early work was influenced by the *Abstract Expressionist Clyfford *Still, but in the mid-1960s he emerged as a leading expon-

ent of *Post-Painterly Abstraction, painting *Hard-Edged compositions on *shaped canvases (*Vector*, Tate Gallery, London, 1968). Often his pictures employ motifs such as stripes, zigzags, and chequerboard patterns to create ambiguous or self-contradictory spatial effects, so his work has sometimes been classified as *Op art.

Davis, Stuart (1894–1964). American painter, born in Philadelphia. He grew up in an artistic environment, for his father was art director of the *Philadelphia Press*, a newspaper that had employed *Glackens, *Luks, *Shinn, and *Sloan—the four artists who were to form the nucleus of The *Eight—and his mother, Helen Stuart Foulke, was a sculptor. After leaving High School, he moved to New York at the age of sixteen and studied with Robert *Henri, 1910–13; his early works included street and bar-room scenes in the spirit of the *Ashcan School. In 1913 Davis was one of the youngest exhibitors at the *Armory Show, which made an overwhelming impact on him: 'All my immediately subsequent efforts went toward incorporating Armory Show ideas into my work.' He began experimenting with a variety of modern idioms, but for the next few years, 1913–16, he earned his living mainly as an illustrator for the left-wing journal *The Masses*. In 1915 he spent the first of many summers in the port of Gloucester, Massachusetts, where the bright light helped to introduce stronger colour into his work. He had his first one-man exhibition (of watercolours and drawings) at the Sheridan Square Gallery, New York, in 1917.

During the 1920s Davis achieved a sophisticated grasp of *Cubism, but it was only after spending a year in Paris in 1928–9 (funded by selling two of his pictures to Gertrude Vanderbilt *Whitney) that he forged his distinctive style. Using motifs from the characteristic environment of American life, he rearranged them into flat, poster-like patterns with precise outlines and sharply contrasting colours (*House and Street*, Whitney Museum, New York, 1931). In this way he became the only major artist to treat the subject-matter of the *American Scene painters—extremely popular at this time—in avant-garde terms; he was both distinctly American and distinctively modern—a rare combination that won him wide admiration. During the 1930s he worked for the *Federal Art Project and became involved in the art

politics of the Depression years: in 1934 he was elected president of the Artists' Union, an organization set up that year to combat alleged discrimination in the distribution of public funds to artists (he edited its journal, *Art Front*, in 1935–6); and in 1936 he was a founder member of the *American Artists' Congress, subsequently serving as its national secretary and chairman. In 1940, however, he resigned disillusioned from the Congress, and from 1940 to 1950 he taught at the New School for Social Research, New York. His work at this time became more purely abstract, although he often introduced lettering or suggestions of advertisements, etc. into his bold patterns (*Owh! in San Pao*, Whitney Museum, 1951). The zest and dynamism of such works reflect his interest in jazz; in the early 1940s he went to concerts with *Mondrian and in 1960 he said: 'For a number of years jazz had a tremendous influence on my thoughts about art and life. For me at that time jazz was the only thing that corresponded to an authentic art in America . . . I think all my paintings, at least in part, come from this influence, though of course I never tried to paint a jazz scene.' In his later years he became a much honoured figure, and received numerous prizes and awards.

Davis is generally regarded as the most important American painter to come to maturity between the two world wars and the outstanding American artist to work in a Cubist idiom. He made witty and original use of it and created a distinctive American style, for however abstract his work became he always claimed that every image he used had its source in observed reality: 'I paint what I see in America, in other words I paint the American scene.' He was an articulate defender of abstract art, an important influence on many younger artists, including his friends *Gorky and *de Kooning, and a precursor of *Pop art. Edward *Lucie-Smith describes him as 'the link between the American art world of the 1930s, in many respects still isolated and provincial, and the triumphant internationalism of the post-war epoch' (*Lives of the Great Twentieth Century Artists*, 1986).

Davringhausen, Heinrich. See NEUE SACH-LICHKEIT.

Dawson, Montague (1895–1973). British marine painter, born in Chiswick, London (not at sea, as is stated in some books). He had no formal artistic training, but he inherited a love of ships and of painting from his father (an engineer-cum-inventor who was an enthusiastic yachtsman) and his grandfather (who was a successful landscape painter). In 1910 he began work in a commercial art studio in London, and on the outbreak of war in 1914 he joined the Royal Navy. While on duty in Falmouth he met the painter Charles Napier Hemy (1841–1917), who was renowned for his seascapes, and Dawson was greatly influenced by him. After the war he became a full-time painter and illustrator and from the 1920s he worked under contract to the art dealers Frost & Reed. Through them his work became very well known in reproduction (see POPULAR PRINTS) and he was acknowledged as king of the 'clipper ship school', his most characteristic subject being a graceful vessel under full sail ploughing majestically through blue seas under a serene sky. Such paintings have many admirers, although his detractors find Dawson's work chocolate-boxey and repetitive. There are examples in the National Maritime Museum, London, and the Royal Naval Museum, Portsmouth.

Deacon, Richard (1949–). British sculptor, born in Bangor, Wales. He studied at *St Martin's School of Art, 1969–72, and the *Royal College of Art, 1974–7. In 1978–9 he lived in New York, and after returning to London he held various teaching posts. Deacon makes large abstract pieces, often with open, cage-like forms. He is regarded as a leading figure among the *New British Sculptors and in 1987 he won the *Turner Prize. Daniel Wheeler, in his revision of H. H. *Arnason's *A History of Modern Art* (1986), writes of his work: 'Mystery and poetry inform this art from beginning to end, for although calling himself a "fabricator", Deacon employs simple methods, like riveting, and unaesthetic materials, such as steel and linoleum, prepares no preliminary drawings or models, and permits initial idea, material, and process to interact to produce sculptures that insist on their presence even as they imply absence.' Brian *Sewell, however, describes his work as 'the fagged out tag end of *Surrealism and the *objet trouvé wearily exploiting familiar materials in unfamiliar contexts and alien relationships'.

Dean, Catherine. See HOUTHUESEN.

Dean, Graham. See SUPERREALISM.

De Andrea, John (1941–). American *Super-realist sculptor, born in Denver, Colorado, where he has continued to live and work. He studied at the University of Colorado, Boulder, 1961–5, and had his first one-man exhibition at the O. K. Harris Gallery, New York, in 1970. Since then he has established a reputation second only to Duane *Hanson in his field. Like Hanson's, his figures are cast from the life and are realistic to the last detail, but De Andrea's characteristic subject-matter is very different. He specializes in nude figures and his models are usually young and attractive, if rather vapid (*Model in Repose*, NG of Modern Art, Edinburgh, 1981). He says: 'I always work towards some idea of beauty and I thought that if nothing else comes of this at least I'm going to make a beautiful figure . . . I set up my own world, and it's a very peaceful world—at least my sculptures are.'

Debord, Guy. See SITUATIONISM.

Debschitz, Wilhelm von. See SCHMITHALS.

decalcomania. A technique for producing pictures by transferring an image from one surface to another. It is thought to have been invented by the Spanish *Surrealist Óscar *Domínguez in Paris in about 1935, although the term had been applied in the 19th century to a similar idea used in ceramic design (the word comes from the French *décalquer*, 'to transfer', + *manie*, 'mania', and in the 1860s there was indeed a craze for transferring pictures to glass, porcelain, etc.). In Domínguez's method, splashes of colour were laid with a broad brush on a sheet of paper. This was then covered with another sheet and rubbed gently so that the wet pigment flowed haphazardly from one surface to the other, typically producing effects resembling fantastic grottoes or jungles or underwater growths. The point of the process, which had the blessing of *Breton, was that the picture was made without any preconceived idea of its subject or form (*sans objet préconçu*). Several other Surrealists adopted it, most notably Max *Ernst, who sometimes began a picture by decalcomania and finished it by conventional means. See also AUTOMATISM.

De Camp, Joseph R. See TEN.

de Francia, Peter (1921–). British painter, teacher, and writer on art, born at Beaulieu,

France. He studied at the Brussels Academy, 1938–40, and then, after army service in the Second World War, at the *Slade School. After working in Canada and the USA, 1948–51, he was in charge of planning and production of art programmes at BBC Television, 1951–3. Subsequently he taught at several art schools, notably the *Royal College of Art, where he was professor of painting, 1973–86. He writes: 'I have always worked as a figurative artist and I draw more than I paint. I frequently work in series.' His work is often concerned with social comment, and his vigorous style has been compared to those of *Grosz and *Guttuso. He has written two books on *Léger: a short study (1969) on *The Great Parade* (Guggenheim Museum, New York) in the series 'Painters on Painting' edited by Carel *Weight; and a substantial monograph (1983).

Degas, Edgar (1834–1917). French painter, graphic artist, and sculptor, one of the outstanding figures of *Impressionism. He exhibited at seven out of the eight Impressionist exhibitions, but he stood somewhat aloof from the other members of the group and his work was Impressionist only in certain limited aspects. Like the other Impressionists, Degas aimed to give the suggestion of spontaneous and unplanned scenes and a feeling of movement, and like them, he was influenced by photography (he often cut off figures in the manner of a snapshot) and by Japanese colour prints (he imitated their use of unfamiliar viewpoints). However, he had little interest in landscape (he did not paint out of doors) and therefore did not share the Impressionist concern for rendering the effects of changing light and atmosphere. The appearance of spontaneity and accidental effects in his work was an appearance only; in reality his pictures were carefully composed. He said that 'Even when working from nature, one has to compose' and that 'No art was ever less spontaneous than mine'.

Degas always worked much in pastel and when his sight began to fail in the 1880s his preference for this medium increased. He also began modelling in wax at this time, and during the 1890s—as his sight worsened—he devoted himself increasingly to sculpture, his favourite subjects being horses in action, women at their toilet, and nude dancers. These figures were cast in bronze after his death. For the last 20 years of his life Degas was virtually blind and led a reclusive life. He

was a formidable personality and his complete devotion to his art made him seem cold and aloof (as far as is known, he never had any kind of romantic involvement). His genius compelled universal respect among other artists, however: *Renoir ranked him above *Rodin as a sculptor, and in 1883 Camille *Pissarro wrote that he was 'certainly the greatest artist of our epoch'. He was the first of the Impressionist group to achieve recognition and his reputation as one of the giants of 19th-century art has endured undiminished. His influence on 20th-century art has been rich and varied—on artists whom he knew personally, such as *Sickert, and on later admirers. He was a superlative draughtsman and his work has appealed greatly to other outstanding draughtsmen, such as *Hockney and *Picasso. His mastery of pastel has been an inspiration to *Kitaj.

degenerate art (*entarte Kunst*). Term applied by the Nazis to all contemporary art that did not correspond to their ideology (see NATIONAL SOCIALIST ART). Such art, which included most avant-garde work, was systematically defamed and suppressed in Germany throughout the period when the Nazi Party ruled the country, 1933–45. The first of a number of exhibitions designed to ridicule modern art was held at Karlsruhe in 1933, soon after Hitler took power, and Hitler made his first speech against 'degenerate art' at Nuremberg in 1934. The ruthless campaign against modern ideas in art included the closing of the *Bauhaus ('a breeding-ground of cultural Bolshevism') in 1933 and culminated in 1937 with the infamous exhibition entitled 'Entarte Kunst' in the old gallery of the Hofgartenarkaden in Munich. It opened on 19 July, a day after the first annual 'Great German Art Exhibition' of officially approved art had opened in the House of German Art nearby. The works displayed as 'degenerate' were confiscated from German museums and were mocked by being shown alongside pictures done by inmates of lunatic asylums. They were grouped into sections under such headings as 'Mockery of German Womanhood', 'Destruction of the Last Vestige of Race Consciousness', and 'Vilification of the German Heroes of the World War'. The artists represented were mainly German (by birth or residence), but a few foreigners were included. Among the total of over 100 were many distinguished figures and several of the

giants of 20th-century art: *Beckmann, *Ernst, *Grosz, *Kirchner, *Klee, *Kokoschka, *Marc, *Mondrian, *Picasso (the inclusion of Marc caused some embarrassment, for he had been killed in action fighting for Germany— as a volunteer—in the First World War).

As a propaganda exercise the exhibition was a huge success: more than two million people went to see it in Munich and similar huge crowds turned out when it toured other major German cities. Georg Bussmann writes that 'Never before or since has an exhibition of modern art reached a greater number of people, or found a greater resonance, than this anti-exhibition' ('German Art in the 20th Century', Royal Academy, London, 1985). The guards on duty were instructed to be on the look-out for visitors who did appear to be suitably enraged or amused by the exhibits. One visitor is recorded as saying: 'The artists ought to be tied up next to their pictures, so that every German can spit in their faces—but not only the artists, also the museum directors who, at a time of mass unemployment, poured vast sums into the ever-open jaws of the perpetrators of these atrocities' (Richard Grunberger, *A Social History of the Third Reich*, 1971). More than 700 works were shown out of a total of about 16,000 confiscated from museums throughout the country (the worst sufferers were the National Gallery, Berlin, the Folkwang Museum, Essen, and the Kusthalle, Hamburg, with over 1,000 works each). They were chosen by a committee led by the painter Adolf Ziegler: 'From the field of degenerate art those works are to be viewed which offend against German sentiment, destroy or distort natural form, or display obvious evidence of inadequate craftsmanship or artistry on the part of the producer.' Some of these works were sold by auction in Lucerne in 1939, Nazi officials helped themselves to others, and the 'unsaleable stock' is said to have been burnt in Berlin (although it has been doubted whether this really happened).

The attack on *entarte Kunst* was directed not only against innovative art but also against anyone who was in sympathy with it. Such people were dismissed from their posts in museums and teaching institutions and deprived of their honours. In 1935 a decree brought all exhibitions, public and private, under the control of the Reich Chamber of Culture (Reichskulturkammer). Artists who refused to conform were faced with

formidable sanctions. These 'ranged from *Lehrverbot* (deprivation of the right to teach) through *Ausstellungsverbot* (deprivation of the right to exhibit) to the most crippling of all, *Malverbot* (deprivation of the right to paint). Lest the *Malverbot* should be circumvented in the privacy of an artist's home, the Gestapo would carry out lightning raids of inspection, checking up—as in Carl *Hofer's case—on whether the paint brushes were still wet. They also placed lists of proscribed artists in the paint shops, so as to cut off their supply of materials at source' (Grunberger).

The speeches and writings of Hitler and Alfred Rosenberg (the chief theoretical spokesman of Nazism) linked artistic production with political and racial doctrines (in *Mein Kampf* Hitler wrote: 'Was there ever any filth, any form of indecency, especially in cultural life, in which at least one Jew was not involved?'), but it is significant that the artist who had the 'distinction' of having the most works confiscated as degenerate (more than 1,000, mainly graphics) was Emil *Nolde, who was racially 'pure' and had even been a member of the Nazi party. He protested in vain to Joseph Goebbels, the propaganda minister: 'My art is German, strong, austere and sincere.' The suppression of 'degenerate art' was not, therefore, simply a matter of political expediency, but also a symptom of the general antipathy to new forms of artistic expression that has been such a feature of the history of 20th-century art. In the normal course of events such hostility rarely goes beyond verbal abuse and occasional acts of vandalism, but in Nazi Germany aesthetic revulsion was armed with political power.

Degouve de Nunques, William. See LUMIN-ISM.

de Grey, Sir Roger (1918–95). British painter, a nephew of Spencer *Gore. He was educated at Eton and had two periods at Chelsea School of Art, 1937–9 and 1946–7, in between serving in the West Kent Yeomanry and the Royal Armoured Corps in the Second World War. From 1947 to 1953 he taught (under Lawrence *Gowing) in the department of fine art at King's College, Newcastle upon Tyne (later Newcastle University), and from 1953 to 1973 he was senior tutor (later reader) in painting at the *Royal College of Art. From 1984 to 1993 he was president of the *Royal Academy. His favourite subject was landscape and he said that an 'obsession for working out of doors has been the motivation and limitation of my painting'. Some of his early work was sombre and solid, in the tradition of the *Euston Road School, but his style became much more light and airy, sometimes conveying an exhilarating sense of space. An exhibition of his work was held at the Royal Academy in 1996, subsequently touring to other venues.

de Hory, Elmyr. See HORY.

Deineka, Alexander (1899–1969). Russian painter, sculptor, graphic artist, and designer of mosaics, born at Kursk. He studied at Kharkov Art Institute, 1914–17, and—after serving in the Red Army—at *Vkhutemas in Moscow. Deineka is described by Alan Bird (*A History of Russian Painting*, 1987) as 'the artist who most successfully created a style which was entirely at one with the spirit of the proletarian revolution and the rebuilding of socialist Russia', his work concentrating on 'the heroic effort to defend the homeland and rebuild its economic strength, and on the life of the anonymous citizen caught up in great historical events'. His most famous work is *The Defence of Petrograd* (Tretyakov Gallery, Moscow, 1927), which Bird describes as 'one of the great humanitarian (and proletarian) creations of the 1920s'. The flat, frieze-like arrangement of the figures—grimly determined workers-turned-soldiers—recalls *Symbolist painting, but in the 1930s Deineka's work became less innovative formally, moving within the mainstream of *Socialist Realism demanded by Stalin's oppressive regime. In spite of the restraints this imposed, his work kept its sense of honesty and humanity. The great reputation he enjoyed in Soviet Russia is indicated by the fact that—most unusually—he was allowed to exhibit his work abroad and even travel abroad himself (he won a prize at the *Carnegie International in 1932 and visited France, Italy, and the USA in 1935). Among the most notable of his later works is the mosaic ceiling decoration of Novokuznetskaya Station (1943–4) on the Moscow metro.

Deira, Ernesto. See OTRA FIGURACIÓN.

Dekkers, Ad (Adrian) (1938–74). Dutch sculptor and experimental artist. He was born in Nieuwpoort and studied at the Rotterdam Academy, 1954–8. His work was strongly

influenced by the austere abstract art of
*Mondrian and from 1961 he specialized in
severe geometrical reliefs. He soon aban-
doned colour, working entirely in white, and
from 1965 his work became more linear,
sometimes consisting of lines cut in a flat sur-
face (Engraving in Wood No. 26 and Engraving in
Wood No. 27, Tate Gallery, London, both 1973).

de Kooning, Willem (1904–97). Dutch-born
painter (and latterly sculptor) who became an
American citizen in 1961, one of the major fig-
ures of *Abstract Expressionism. He was born
in Rotterdam, where he was apprenticed to a
commercial art and decorating firm in 1916,
at the age of 12; from 1916 to 1924 he also
studied at night at the Rotterdam Academy. In
1926 he went to America as a stowaway and in
1927 settled in New York. For the next few
years he supported himself mainly as a house-
painter, signwriter, and carpenter. In 1935–6
he worked on the *Federal Art Project and
thereafter he was a full-time painter.

De Kooning's early work had been conserv-
ative, but in 1929 he met Arshile *Gorky, who
became one of his closest friends and intro-
duced him to avant-garde circles. Other
friends in his early days in the USA included
Stuart *Davis and John *Graham; de Kooning
referred to these two and Gorky as 'the three
smartest guys on the scene'. During the 1930s
and 1940s de Kooning experimented vigor-
ously and was especially strongly influenced
by Gorky; he said 'I am an eclectic artist by
choice; I can open almost any book of reprod-
uctions and find a painting I could be influ-
enced by'. By the time of his first one-man
show in 1948 (at the Egan Gallery, New York)
he was painting in an extremely energetic
abstract style (often in black-and-white) close
to that of Jackson *Pollock. The exhibition
established his reputation (although prosper-
ity was still some years away) and after it
he was generally regarded as sharing with
Pollock the unofficial leadership of the
Abstract Expressionist group.

Unlike Pollock, de Kooning usually
retained some suggestion of figuration in his
work, and in 1953 he caused a sensation when
his Women series (Women Nos. I–VI) was exhib-
ited at his third one-man show, at the Sidney
*Janis Gallery. Woman I (MOMA, New York,
1950–2), with its grotesque leer and frenzied
brushwork, shocked the public and dismayed
those critics who believed in a rigorously
abstract art. One of these was Clement

*Greenberg, but New York's other most influ-
ential critic of avant-garde art—Harold
*Rosenberg—supported de Kooning. Woman I
became one of the most reproduced paintings
in the USA and de Kooning was enormously
influential on young painters at this time.
Irving Sandler (Abstract Expressionism, 1970)
writes that his 'works of the late 1940's and
1950's gave rise to hundreds of imitations.
Indeed, of the older Abstract Expressionists,
he was the most influential on the generation
that matured in the 1950's. Accountable for
his leading role was the freshness of his paint-
ings and their masterliness, his availability to
younger artists, his charismatic personality,
and his verbal brilliance.' By the end of the
1950s, however, he was beginning to be
regarded as an elder statesman whose best
days as a creative force were past. From the
1960s he had honours heaped on him and in
1968 he returned triumphantly to Holland
(he had not been back since emigrating) for a
large retrospective exhibition of his work at
the Stedelijk Museum in Amsterdam. His
paintings continued to mix abstract and
semi-figurative work and in 1969 he began
making sculpture—figures modelled in clay
and later cast in bronze. He continued work-
ing well into his eighties, until he was incap-
acitated by Alzheimer's disease. In 1994–5 a
large retrospective was shown in Washington,
DC (NG), New York (Metropolitan Museum),
and London (Tate Gallery). In the catalogue
David *Sylvester suggested that de Kooning
was 'the supreme painterly painter of the sec-
ond half of the century and the greatest
painter of the human figure since *Picasso',
but Brian *Sewell wrote: 'Wandering round
the Tate . . . I wonder at the awe and adulation
expended on this man, most of whose paint-
ings reveal not the slightest merit.'

His wife, **Elaine de Kooning** (1920–89), was
also a painter, notably of *Expressionist por-
traits, and a writer on art. The couple married
in 1943, separated amicably in 1957, and
reunited in 1975. A collection of her writings,
The Spirit of Abstract Expressionism, was pub-
lished in 1994. Many of her articles and
reviews had originally appeared in *Art News,
of which she became editorial associate in
1948. Sewell maintains that Willem's reputa-
tion was founded by 'her busy bedding of crit-
ics in exchange for favourable reviews'.

Delaunay, Robert (1885–1941). French
painter, born in Paris into an aristocratic

family. In 1902–4 he was apprenticed to a firm that produced theatre sets, then took up painting (in which he was essentially self-taught), first exhibiting his work in public (at the *Salon des Indépendants and the *Salon d'Automne) in 1904. Initially he painted in an *Impressionist style, but in 1906 he began the experiments with the abstract qualities of colour that were to provide the central theme of his career. His starting-point was the *Neo-Impressionism of Georges Seurat, but instead of using Seurat's pointillist technique he investigated the interaction of large areas of contrasting colours. He was particularly interested in the interconnections between colour and movement. By 1910 he was making an individual contribution to *Cubism, combining its fragmented forms with a personal use of vibrant colour and applying them to the dynamism of city life rather than to the standard Cubist repertoire of still-life and so on. In particular he did a memorable series of paintings of the Eiffel Tower, in which the huge monument seems to be unleashing powerful bursts of energy (*The Eiffel Tower*, Guggenheim Museum, New York, 1910). He had his first one-man show in February 1912 at the Galerie Barbazanges, Paris, and by the end of the year he was painting completely abstract pictures (the first French artist to do so). *Apollinaire gave the name *Orphism to Delaunay's work of this period because of its analogies with the abstract art of music.

In 1911 *Kandinsky had invited Delaunay to take part in the first *Blaue Reiter exhibition, and in 1913 he had a one-man show at the *Sturm Gallery in Berlin. His work was a major influence on German *Expressionists such as *Klee, *Macke, and *Marc, and it also powerfully affected the *Futurists in Italy and the American *Synchromists. Delaunay was notoriously competitive and fully aware of the importance of his work; at about this time he drew up a list of all the artists, however minor, he thought he had influenced. However, the period when he was a key figure in modern art was fairly brief; he lived in Spain and Portugal during the First World War and after his return to Paris in 1920 his work lost its inspirational quality and became rather repetitive. His home became a meeting-place for *Dada artists, but Delaunay's own paintings continued to be related to colour theories. His last major works (done in collaboration with his wife Sonia *Delaunay-Terk) were large murals for pavilions in the Paris

World Fair of 1937 (his training as a scene painter gave him a lifelong taste for working on a big scale). He died following an operation for cancer.

Delaunay-Terk, Sonia (1885–1979). Russian painter, graphic artist, and designer, active in Paris, the wife of Robert *Delaunay. Her original surname was Stern, but she adopted the name Terk from a wealthy uncle who brought her up in St Petersburg. Max *Liebermann was a friend of the family and encouraged her to paint. She settled in Paris in 1905, married Delaunay in 1910 (after a short-lived marriage of convenience to Wilhelm *Uhde), and became associated with him in the development of *Orphism. During the 1920s she worked mainly as a designer of hand-printed fabrics and tapestries; she made a strong impact on the world of international fashion, designing creations for such famous women as Nancy Cunard and Gloria Swanson. The Depression affected her business, however, and in the 1930s she returned primarily to painting and became a member of the *Abstraction-Création association. After the death of her husband in 1941 she continued to work as a painter and designer. In 1963 she gave 58 of her own works and 40 of her husband's to the Musée National d'Art Moderne, Paris; they were exhibited at the Louvre the following year and she thus became the first woman to be exhibited at the Louvre during her lifetime.

Delbanco, Gustav. See BROWSE.

Delvaux, Paul (1897–1994). Belgian painter and printmaker. He was born at Antheit, near Huy, the son of a lawyer, and studied architecture, then painting at the Académie des Beaux-Arts in Brussels, 1920–4. After working in *Neo-Impressionist and *Expressionist manners, he discovered *Surrealism in 1934 and became an instant convert, destroying much of his earlier work. He was never formally a member of the movement, and was not in sympathy with its political aims, but he became regarded as one of the foremost upholders of the Surrealist tradition. Most of his paintings show nude or semi-nude women in incongruous settings. The women are always of the same type—beautiful, statuesque, unattainable dream figures, lost in thought or reverie or even in a state of suspended animation: André *Breton said that

'Delvaux has turned the whole universe into a single realm in which one woman, always the same woman, reigns over the great thorough-fares of the heart.' These dream beauties are often placed in elaborate architectural set-tings, reflecting both de *Chirico's strange perspectives and Delvaux's interest in the buildings of ancient Rome (he visited Italy in 1938 and 1939). Sometimes the settings are timeless, but in many paintings the build-ings, costumes, and accessories are part of a mysterious turn-of-the-century city that the artist referred to as 'La Ville inquiète' (The Uneasy City). Delvaux often included skele-tons in his pictures (influenced by *Ensor), as in *Sleeping Venus* (Tate Gallery, London, 1944), and trains were another recurrent motif. A large retrospective of his work was held at the Palais des Beaux-Arts, Brussels, in 1944, and this marked the beginning of his inter-national reputation. From 1950 to 1962 he taught at the École Superieure d'Art et d'Architecture in Brussels. In his later work he could be rather repetitive, but George Heard *Hamilton writes that in his best years, 1936–42, 'Delvaux added to the Surrealist iconography an unforgettable and Freudian *danse macabre* of love caught between time and death'. There is a museum devoted to Del-vaux's work at Saint-Idesbald, Belgium.

De Maria, Walter (1935–). American sculp-tor and graphic artist. He was born in Albany, California, and studied at the University of California, Berkeley, 1953–9. In 1960 he moved to New York, where he took part in early *Happenings, worked in various media, and composed music (in 1965 he worked for a short time as drummer in the Velvet Under-ground rock group). He was one of the earliest exponents of *Minimal art, producing examples of the type in about 1960, before the term was current, and he was also a pioneer of earthworks (see LAND ART); he says 'I feel proud to have started minimal and land art'. Some of his work belongs to the category of *Conceptual art, for example *Mile Long Draw-ing* (1968), consisting of two parallel chalk lines 12 feet apart in the Mojave Desert. In 1968 he had a one-man show at the Heiner Friedrich Gallery, Munich, at which he exhib-ited a room filled wall to wall with earth—1,600 cubic feet (45 cubic metres) in all.

Demarco, Richard (1930–). Scottish painter, printmaker, dealer, entrepreneur, writer, lec-turer, and broadcaster, a many-sided and out-spoken character who has done much to pro-mote modern art in Scotland. He was born in Edinburgh and studied there at the College of Art, 1949–54. His work as an artist—mainly in the form of watercolours and prints—is fairly conventional, and he is considered of much greater significance for his other activities. From 1966 to 1992 he ran the Richard Demarco Gallery in Edinburgh, which 'in the sixties and early seventies especially...played an important role, giving their first one-per-son show to a large number of artists who have gone on to distinguished careers' (Dun-can Macmillan, *Scottish Art 1460–1990*, 1990). He has also organized many exhibitions at the Edinburgh Festival, introducing the work of numerous avant-garde artists to British audi-ences. In addition, he has acted in feature films (including Bill Forsyth's comedy *That Sinking Feeling*, 1979), made radio and tele-vision broadcasts, and—according to his entry in *Who's Who*—'lectured in over 150 univer-sities, art colleges, schools, and art galleries'. In 1993 he became professor of European cul-tural studies at Kingston University, Surrey.

De Morgan, Evelyn (1855–1919). British painter, born Evelyn Pickering; in 1887 she married **William De Morgan** (1839–1917), famous as a designer of pottery, tiles, and ceramics, but also a painter himself (late in life he also became a successful writer, his first novel, *Joseph Vance*, being published in 1906). Evelyn specialized in literary subjects, done in a style owing much to the *Pre-Raphaelites and to such Renaissance artists as Botticelli (she and her husband spent each winter in Italy for the sake of his health). At the end of her career she painted several alle-gories relating to the First World War, exhibit-ing them to raise money for the Red Cross.

Demuth, Charles (1883–1935). American painter and illustrator. He was born in Lan-caster, Pennsylvania, and had his main train-ing at the Pennsylvania Academy of the Fine Arts, Philadelphia, under *Anshutz, 1904–11. He made visits to Europe in 1907–8, 1912–14, and 1921, staying mainly in Paris, and during the second of these visits he became seriously interested in avant-garde art, particularly *Cubism. Its influence was felt in his paint-ings of architectural subjects from about 1916 and he became one of the leading exponents of *Precisionism. His distinctive output also

included sinister and sexually morbid illustrations to books such as Zola's *Nana* and Henry James's *The Turn of the Screw* (these were done not on commission, but for his own enjoyment—he came from a wealthy family and could afford to indulge himself). His most personal paintings are what he called 'poster portraits' (pictures composed of words and objects associated with the person 'represented') The most famous example is *I Saw the Figure Five in Gold* (Metropolitan Museum, New York, 1928), a tribute to the poet William Carlos Williams and named after one of his poems.

Demuth was lame from childhood and in the last decade of his life was debilitated by diabetes. Often he worked on a small scale in watercolour, rather than in more physically demanding media. The fastidious taste and concentrated energy of his work is suggested by his comment: 'John *Marin [another great American watercolourist] and I drew our inspiration from the same source, French modernism. He brought his up in buckets and spilt much along the way. I dipped mine out with a teaspoon, but I never spilled a drop.' Echoing this, Sam Hunter writes of Demuth: 'He was an artist of restricted sensibility . . . but for continuous creative impulse and for his distinction as a stylist he must stand in the first rank of the pioneers of twentieth-century American art' (Milton W. Brown, Sam Hunter et al., *American Art*, 1979).

Denis, Maurice (1870–1943). French painter, designer, lithographer, illustrator, and writer on art theory. He was born at Granville and spent most of his life at St Germain-en-Laye, a suburb of Paris. In 1888 he became a student at the *Académie Julian and in the same year, with a number of fellow students including *Bonnard and *Sérusier, he founded a group of *Symbolist painters called the *Nabis. Together with Sérusier, Denis was the chief theorist of the group; he published articles in several reviews, most notably 'Défense du Néo-traditionnisme' (Definition of Neo-Traditionalism), which appeared in *Art et critique* in August 1890. This 'Manifesto of Symbolism', as Denis later called the article, contains a pronouncement that has become famous as an anticipation of the underlying principle of much modern—especially abstract—art: 'Remember that a picture—before being a war horse or a nude woman or an anecdote—is essentially a flat surface covered with colours

assembled in a certain order.' Denis's early work, strongly influenced by *Gauguin, did indeed place great emphasis on flat patterning, but he did not intend to encourage non-representational art, for he was also very much concerned with subject-matter; he was a devout Catholic and wanted to bring about a revival of religious painting. Many of his easel paintings have religious subjects, and in 1899 he carried out his first large-scale religious commission—a mural in the Chapelle de la Sainte-Croix at Vésinet. Numerous others followed, and in 1919 he founded the Ateliers d'Art Sacré with Georges *Desvallières to provide church decorations of various kinds, including mosaics and stained glass.

Typically Denis's style in his religious work was tender and mild, with pale colours and relaxed lines. He also did a good deal of secular decorative work, for example murals at the Théâtre des Champs-Elysees, Paris (1912), and a series of eleven large canvases on *The Story of Psyche* (1908–9) for the Moscow home of Ivan *Morozov (Denis visited Moscow in 1909 in the course of this work). Throughout his career he continued to paint small-scale works, many depicting his own family life. His most famous single picture is probably *Homage to Cézanne* (Musée d'Orsay, Paris, 1900) showing Denis himself and a number of Cézanne's other admirers, including Bonnard, *Redon, Sérusier, and Vuillard, gathered round a still-life by the master. His best paintings were done early in his career; after about 1900 they became more classical in style (influenced by visits to Italy) and increasingly bland. Denis's prolific output also included lithographs, book illustrations, and designs for the stage. He also found time to teach at the Académie Ranson, 1909–19. His critical writings are for the most part collected in *Théories* (1912) and *Nouvelles Théories* (1922). In 1939 he published *Histoire d'art religieux*, and his *Journal* was posthumously published in three volumes in 1957–9. Denis died after being hit by a lorry. The 17th-century building that was his home in St Germain-en-Laye from 1914 has been converted into the highly attractive Musée du Prieuré, housing a fine collection of works by himself and his associates.

Denny, Robyn (1930–). British abstract painter, printmaker, and designer. He was born at Abinger, Surrey, and studied at *St Martin's School of Art and the *Royal College

of Art, 1951–7. In 1960 he helped organize the first *Situation exhibition, an important landmark in British abstract art. One of the pictures he showed there is *Baby is Three* (Tate Gallery, London, 1960), which is typical of the calm, meditational character of his work. Characteristically he paints on a large scale, and in his early work he used very soft, muted colours within a subtle geometrical framework: 'The colour is applied to an absolutely immaculate smooth matt finish so that the surface of the painting is impossible to perceive and the spectator, his attention fixed by the central motif, looks into what appears to be an infinite coloured misty space' (Simon Wilson, *British Art from Holbein to the Present Day*, 1979). Later his brushwork became more painterly. Denny has taught at various art schools and won several awards. He has received many public commissions, including a series of vitreous enamel panels at Embankment Underground Station in London.

Depero, Fortunato (1892–1960). Italian painter, poet, designer, and experimental artist, born at Fondo in the South Tyrol, which was Austrian territory until 1918. In 1913 he moved to Rome, where he was befriended by *Balla and *Marinetti and became a member of the *Futurist movement. He was co-signatory with Balla of a *Manifesto for a Futurist Reconstruction of the Universe* in 1915 and continued with his Futurist activities after the First World War, even though all the life had by that time gone out of the movement. In 1928–30 he lived in New York, where he designed magazine covers and restaurant decor (including murals). He was also involved in stage design and advertising work, notably a campaign for Campari. For most of his later life he lived in Rovereto, near his birthplace, where a museum devoted to him was opened in 1959, a year before his death.

Derain, André (1880–1954). French painter, printmaker, theatrical designer, and sculptor, born at Chatou on the outskirts of Paris, the son of a prosperous pastrycook. In 1898–9 he studied at the *Académie Carrière, where he became a friend of *Matisse, and in 1900 he met *Vlaminck, with whom he shared a studio for a while. From 1901 to 1904 he did his military service and had little time for painting, but after leaving the army he was soon at the heart of avant-garde developments and

made a major impact in the art world. In 1905 Ambroise *Vollard bought the entire contents of his studio and later that year he was one of the painters who gave birth to *Fauvism at the *Salon d'Automne. A good example of his Fauve period is his portrait of Matisse (1905) in the Tate Gallery, London; the Tate also has Matisse's portrait of Derain, executed at the same time, when they were painting together at Collioure, near the Mediterranean border with Spain. In 1907 he signed a contract with *Kahnweiler (*Braque's and *Picasso's dealer) and by the following year had moved away from the brilliant colours of Fauvism to a style influenced by *Cubism. His friends in the Cubist circle included *Apollinaire, whose first book, *L'Enchanteur pourrissant* (1909), he illustrated with woodcuts. However, his links with Cubism were fairly short-lived, and by 1911 he was painting pictures whose archaic stylization reflect the influence of Byzantine art. Another aspect of his involvement in the avant-garde during this period of vigorous experimentation was his interest in African sculpture—like his friend Vlaminck he was a pioneer collector of such *primitive art (his own main contribution to sculpture is that he was one of the pioneers of *direct carving in stone).

Throughout the First World War Derain served in the French army. He was able to do very little artistic work in this period, but his first one-man show was held in 1916, at the Galerie Paul Guillaume, Paris. After he was discharged from the army in 1919 he rapidly picked up his successful career again, beginning with the design of *La Boutique fantastique* (1919) for *Diaghilev's Ballet Russes. In the 1920s he moved away from his pre-war experimentation to a much more conservative style reflecting his admiration for the Old Masters. The works he painted in this manner (including landscapes, portraits, still-lifes, and nudes) made him wealthy and famous (he exhibited widely abroad), but they dismayed many supporters of avant-garde art. He polarized opinion so much that in January 1931 the periodical *Les Chroniques du jour* published a feature entitled 'André Derain: Pour ou Contre'. Among the people quoted in this was Jacques-Émile *Blanche, who—even though he was a fairly conservative painter himself—wrote: 'Youth has departed: what remains is a highly cerebral and rather mechanical art.' Those quoted in favour of Derain included André *Salmon.

In 1935 Derain bought a large country house at Chambourcy, near St Germain-en-Laye. He kept a flat in Paris (partly as a place to entertain his mistresses), but by this time he had lost touch with many of his friends from his avant-garde days. During the German occupation of France in the Second World War, his country house was requisitioned and he lived mainly in Paris. Because he was now seen as a great upholder of the classical tradition, his art was viewed sympathetically by the Nazis, who courted him for propaganda purposes. In 1941, with Vlaminck and other artists, he visited Germany, where his 'only function was to smile for the newsreel cameras under the eye of the ever-present Gestapo officers' (Jane Lee, *Derain*, 1990). Because of this visit, he was ostracized by many French people after the war, even though 'Braque publicly upbraided the scandalmongers' and 'to Derain's Jewish friends of many years, any suggestion of sympathy with the Germans was ridiculous' (Lee). He continued to have a versatile and prosperous career, his work including a good deal of stage design, but in his final years he became reclusive and his relationship with his wife deteriorated. They separated soon before his death, which followed a stroke and a road accident.

The differences of opinion he had provoked in his life continued after his death. Many critics think that his work after the First World War was essentially a long anti-climax, but some admirers have thought extraordinarily highly of him, notably *Giacometti, who wrote in 1957: 'Derain excites me more, has given me more and taught me more than any painter since *Cézanne; to me he is the most audacious of them all.' Two years later John *Canaday summed up the situation in his book *Mainstreams of Modern Art*: 'His detractors think of him as a parasite on both the past and the present, but . . . some critics award Derain unique status as the only twentieth-century painter to achieve an individual compound of the great tradition of French culture as a whole with the spirit of his own time . . . This opinion is particularly held in France—where, of course, it is most legitimate.'

Despiau, Charles (1874–1946). French sculptor and illustrator, born at Mont-de-Marsan, the son of a master-plasterer. In 1891 he moved to Paris, where he studied at the École des Arts Décoratifs, 1891–3, and the École des *Beaux-Arts, 1893–6. For several years he endured poverty, earning his living for a time by colouring postcards, and from 1907 to 1914 he worked as one of *Rodin's assistants. After this he turned from his master's intense, vigorous style to a more static, generalized manner in the vein associated with *Maillol. His best-known works are his portrait busts, with their intimate delineation of character (*Head of Madame Derain*, Philips Collection, Washington, 1922). He also produced full-length nude figures, standing or seated, and made several monuments, including a war memorial at Mont-de-Marsan, 1920–2. The books he illustrated included an edition of Baudelaire's *Les Fleurs du mal* (1933). In the 1920s and 1930s his reputation stood very high in France, but at the end of his life he was ostracized because of his friendship with the Nazi sculptor Arno *Breker (they had known each other since before the war and in 1942 Despiau attended an exhibition of the German's work in occupied Paris).

Despierre, Jacques. See FORCES NOUVELLES.

De Stijl. See STIJL.

Desvallières, Georges (1861–1950). French painter, born in Paris, where he studied at the École des *Beaux-Arts and became one of the founders of the *Salon d'Automne in 1903. He was a high-minded man and around this time his work included mythological subjects and morally edifying scenes from everyday life. When his son was killed in the First World War he took a vow to devote himself exclusively to religious art and in 1919 he founded the Ateliers d'Art Sacré with Maurice *Denis. He painted murals and designed stained glass for numerous churches in France and other countries (including the USA). His style was somewhat tortuous, with much harsh realistic detail that he hoped would help to convince the irreligious of the ugliness of society.

Dewhurst, Wynford. See IMPRESSIONISM.

Dewing, Thomas. See TEN and TONALISM.

Dezeuze, Daniel. See SUPPORTS-SURFACES.

Diaghilev, Sergei (1872–1929). Russian impresario, famous above all as the founder of the Ballets Russes, through which he exerted great influence on the visual arts as well as on dancing and music. He was born in

Novgorod province, the son of an army officer, and became an accomplished pianist as a boy. From 1890 to 1896 he studied law in St Petersburg, where he became part of a circle of musicians, painters, and writers including Léon *Bakst and Alexandre *Benois. In 1899 he founded the magazine *World of Art*, with the object of interchanging artistic ideas with Western Europe. When it ceased publication in 1904 he concentrated for a while on organizing exhibitions, including one of Russian painting at the 1905 *Salon d'Automne in Paris—the most comprehensive to have been seen in the West up to that time. It occupied twelve rooms in the Grand Palais, with decor designed by Bakst. In 1907 Diaghilev organized a series of concerts of Russian music in Paris, and in 1909 he brought a ballet company for the first time (this is usually described as the Ballets Russes, but the name was first used in 1911). The company was a sensational success, as much for the exotic designs of Bakst and Benois as for the music and choreography (the dancers included Nijinsky and Pavlova). Diaghilev, indeed, envisaged the visual spectacle as being just as important as the music and movement, and his designers were given great freedom to express themselves. In place of the tasteful backdrops, conventional costumes, and subdued lighting of traditional theatrical performances, they produced flamboyant and colourful designs that were an essential part of the experience of the work rather than mere embellishments.

Among the company's many triumphant performances there were also a few scandals, including perhaps the most celebrated fiasco in theatrical history—the opening night of *The Rite of Spring* (music by Stravinsky, choreography by Nijinsky, decor by *Roerich) at the Théâtre des Champs Elysées, Paris, on 29 May 1913, when a riot broke out in the audience between shocked conservatives and supporters of the avant-garde. For two decades, until his death in 1929, Diaghilev toured Europe and America with his ballet (he never returned to Russia after the 1917 Revolution and Paris remained the principal centre of his operations). He was often on the verge of bankruptcy, but he had a remarkable flair for spotting young talent and for integrating various interests and people, enabling him to bring together as his collaborators some of the foremost artistic personalities of his time; the painters who worked for him included *Braque, de *Chirico, *Derain, *Matisse, and *Picasso. He preferred using painters rather than artists who had trained as stage designers, as he thought specialists were likely to be too tied to old ideas.

Dial, The. See MCBRIDE.

Dibbets, Jan (1941–). Dutch *Conceptual artist, best known for his work with photographs of landscape, particularly his 'perspective correction' photographs. In these—utilizing the well-known phenomenon that parallel lines appear to converge as they recede from the spectator—he makes lines on the ground or floor that in reality diverge away from the camera but appear exactly parallel on the flat surface of the photographic image. He writes: 'I really believe in having projects which in fact can't be carried out, or which are so simple that anyone could work them out. I once made four spots on the map of Holland, without knowing where they were. Then I found out how to get there and went to the place and took a snapshot. Quite stupid. Anybody can do that.'

Dick, Sir William Reid (1878–1961). British sculptor, born in Glasgow, where he studied at the School of Art, 1906–7, following a five-year apprenticeship to a stonemason. In 1907 he moved to London, where he lived for the rest of his life, although he maintained links with his native country and was appointed King's Sculptor in Ordinary for Scotland in 1938. In the years between the two World Wars (and for some years afterwards) Reid Dick was probably the leading sculptor of public monuments in Britain—dependable, a fine craftsman, and rather dull. Two well-known examples of his work in London are the Portland stone statue of George V (unveiled 1947) in Old Palace Yard, Westminster, and the bronze statue of President F. D. Roosevelt (1946) in Grosvenor Square. He also did numerous portrait busts.

Dickinson, Edwin (1891–1978). American painter and draughtsman, born in Seneca Falls, New York. His training included periods at the *Art Students League, New York, and the Académie de la Grande Chaumière, Paris. From 1920 to 1944 he lived at Cape Cod, then moved to New York, where he taught at various art schools. He often treated enigmatic or disquieting subject-matter and he has been

described as 'perhaps the first American artist about whom some knowledge of dream theory is essential for decoding his works' (Matthew Baigell, *A Concise History of American Painting and Sculpture*, 1984). His personal symbolism is seen at its most disturbing and provocative in his self-portraits, in which he sometimes painted himself as dead. He is best known, however, for large compositions such as *The Fossil Hunters* (Whitney Museum, New york, 1926–8). Dickinson often worked on his big pictures for a number of years and said that they were never 'really finished'. From 1959 he visited Greece several times, producing delicate pencil drawings of classical ruins. He has been called a *Surrealist and has also been seen as a sophisticated culmination of the 19th-century Romantic tradition.

Dickinson, Preston (1891–1930). American painter. He was born in New York and studied at the *Art Students League there, but he regarded the five years he spent in Europe, 1910–15, as his real artistic education. In Paris he was particularly influenced by the structural features of *Cézanne's work and by the high-keyed colour of the *Fauves, but in the 1920s his work became less experimental as he became associated with the *Precisionists. Like others of the group, he favoured subjects that were adapted to representation in terms of semi-geometrical design, in particular the machine (*Industry*, Whitney Museum, New York, *c*. 1924). He died very suddenly in Spain.

Dicksee, Sir Frank (1853–1928). British painter, the best-known member of a family of artists. He specialized in romantic historical scenes (often from his own imagination rather than based on a particular event or literary source) and—in the later part of his career—portraits; he also occasionally produced scenes of modern social drama. At his best, he painted with a sumptuous technique and a feeling for bold and unusual lighting effects, but he could be rather twee. He was at the height of his esteem at the turn of the century; in 1900 he was awarded a medal at the Paris Universal Exhibition, and in the same year his pious medieval pageant scene *The Two Crowns* (Tate Gallery, London) was voted the most popular picture at the *Royal Academy summer exhibition. By the end of his career, however, he was regarded as distinctly old-fashioned, and when he was elected president of the Royal Academy in 1924, this was seen as

a concession to his seniority rather than as an indication of his standing in the art world. He was strongly opposed to modernism in art and his speeches as president fit the stereotype of the old attacking the new.

Other painter members of his family included his brother **Herbert** (1862–1942) and his sister **Margaret** (1858–1903).

Diebenkorn, Richard (1922–93). American painter, born in Portland, Oregon. His family moved to San Francisco in 1924 and he spent almost all his career in California, mainly in the San Francisco Bay area; from 1963 he lived in Santa Monica. He studied and taught at various colleges and universities, including the California School of Fine Arts, San Francisco, where he studied briefly and then taught from 1947 to 1950. His fellow teachers included Mark *Rothko and Clyfford *Still, and under their influence he abandoned the still-lifes and interiors he had been painting and adopted an *Abstract Expressionist style. In the mid-1950s, however, he moved away from the subjective emotionalism of this way of painting and developed a style in which he tried to apply the vigorous brushwork of Abstract Expressionism to studies of figures in an environment (see BAY AREA FIGURATION). Subsequently he moved between abstraction and figuration, his work in both modes making use of large areas of colour that owed much to the example of *Matisse (whose work he admired in an exhibition in Los Angeles in 1952). Diebenkorn's best-known works are a series of large pictures entitled *Ocean Park*, begun in 1967 (*Ocean Park No. 96*, Guggenheim Museum, New York, 1977). They are abstract, but the light-filled colours suggest sky, sea, and sand; Diebenkorn said that temperamentally he had always been an abstract painter.

Dietrich, Adolf (1877–1957). The best-known Swiss *naive painter—the first from his country to achieve an international reputation. He was born of a peasant family in Berlingen on Lake Constance and worked as at a variety of jobs—woodsman, railwayman, ropemaker, labourer, factory hand—until he was able to devote himself full-time to painting from about 1926. His subjects included animals, country scenes, portraits, and still-lifes.

Diller, Burgoyne (1906–65). American abstract painter and sculptor, born in New

York. He grew up in Michigan but returned to New York to study at the *Art Students League, 1928–33, and privately with Hans *Hofmann. From 1935 to 1940 he was supervisor of the New York Mural Division of the *Federal Art Project, and during the Second World War he worked for the US Navy. After the war he taught at Brooklyn College and the Pratt Institute until 1964. Diller's early work was influenced by *Impressionism and *Cubism, but by 1934 he had become probably the earliest American exponent of *Mondrian's type of geometrical abstraction. He remained committed to this style for the rest of his career, in his sculpture (which is restricted to rectangular elements and primary colours) as well as his painting. He had several one-man exhibitions before and after the war, but his work attracted little public attention and it was not until the last few years of his life that he was generally acknowledged as one of the best American abstract artists of his generation.

Dine, Jim (1935–). American painter, printmaker, experimental artist, and poet, born in Cincinnati, Ohio. Both his father and his grandfather were storekeepers whose stock included painting materials. He studied at the University of Cincinnati, the School of the Museum of Fine Arts, Boston, and Ohio University, Athens, where he graduated in 1957. In 1959 he moved to New York and quickly became one of the pioneers of *Happenings and then—in the early 1960s—one of the most prominent figures in American *Pop art (he also made an impact in England, where he lived 1967–71). His Pop canvases were vigorously handled in a manner recalling *Abstract Expressionism, but he often attached real objects to them—generally everyday items such as clothes and household appliances (including a kitchen sink). Characteristically the objects were Dine's personal possessions and his work often has a strong autobiographical flavour. In addition to such *assemblages, he also made free-standing works and *environments, but since his return to the USA in 1971 he has concentrated more on conventional two-dimensional work, especially drawings (he has written and illustrated several books of poetry) and prints. His style, too, has become more traditionally figurative, under the influence of *Kitaj. He has made lithographs and *screenprints, but his favourite printmaking medium is etching: 'Dine prefers not to draw directly on the plate,

making instead meticulous preparatory drawings which are transferred photographically or by tracing. The image is often considerably reworked, surface tone is elaborately built up, and finally, in some cases, the plate is reworked altogether and used for a different composition' (Frances Carey and Antony Griffiths, *American Prints 1879–1979*, 1980).

direct carving. The practice of producing sculpture (particularly stone sculpture) by cutting directly into the material, as opposed to having it reproduced from a plaster model using mechanical aids and assistants. Although this might seem a purely technical matter, in the 20th century it became associated with aesthetic, ethical, and even political issues, particularly in Britain (where it was related to the idea of *truth to materials) and in France.

During the 19th century it was customary for sculpture to be exhibited in plaster; it was much more expensive and time-consuming to produce bronze casts or marble carvings, so these were usually made only when firmly commissioned. A device called a pointing machine enabled the sculptor to make an exact replica or enlargement of the plaster model by taking a series of measured points on it and transferring them to the copy. It was common for both bronzes and marbles to be produced from the same model and for smaller versions to be made for the domestic market (for an example see JOHN, SIR WILLIAM GOSCOMBE). This situation reflected economic realities (a sculptor would want to maximize earnings from a work in which much time and effort had been invested), but it also indicated a priority of idea and subject over material—the sculptor's artistry being located in the concept and form, rather than in the handicraft. A successful sculptor could thus become the administrator of a large studio producing numerous, almost identical versions of popular works (*Rodin employed many assistants, including artists of the calibre of *Bourdelle, *Despiau, and *Pompon, and he rarely touched hammer and chisel himself, only occasionally adding final touches to his works in marble). This kind of procedure had been attacked by John Ruskin (1819–1900), the most influential British art critic of the 19th century, in his *Aratra Pentelici: Six Lectures on the Elements of Sculpture* (1872), where he denounced the 'modern system of modelling the work in clay, getting it

into form by machinery, and by the hands of subordinates'. Ruskin argued that the sculptor of such works thinks in clay and not in marble and that 'neither he nor the public recognize the touch of the chisel as expressive of personal feeling and that nothing is looked for except mechanical polish'. In embryonic form he was stating two fundamental tenets of the philosophy of direct carving as it later developed: that stone, as opposed to plaster, has particular qualities of its own; and that there is a special relationship between the hand of the artist and the material he uses.

In spite of Ruskin's influence and the force of his arguments, it was not until the early years of the 20th century—when his authority as a critic and prophet was waning—that his ideas on direct carving were put into practice by sculptors in Britain. Among the most important pioneers were Jacob *Epstein, Eric *Gill, and Henri *Gaudier-Brzeska, who collectively illustrate some of the range of issues involved in the practice. For Epstein, the activity of carving was linked to his interest in sculpture from outside the Graeco-Roman tradition, such as that of Assyria and Africa, and it reflected his contact in Paris with *Brancusi and *Modigliani, who had similar interests. For Gill, a return to carving was a return to a medieval practice, through which he hoped to overcome the iniquitous effect of industrialism in dividing the work of the thinker and maker. For Gaudier-Brzeska, carving was equated with a struggle that was both manual and creative, an aspect of a 'virile' art that contrasted with the 'feminine' modelling which had dominated the previous generation of *New Sculptors; he wrote that in the sculpture he admired 'every inch of the surface is won at the point of a chisel'. The difficult economic conditions in which Gaudier-Brzeska lived also had an influence on his working methods, for he was dependent on found or even stolen fragments of stone in odd shapes that would suggest forms and subjects.

After the First World War a number of British sculptors, including Barbara *Hepworth, Henry *Moore, and John *Skeaping, practised direct carving as a dogma, while others, such as Frank *Dobson and Leon *Underwood, worked as both carvers and modellers. Whereas academic sculptors favoured white marble because of the smooth and detailed finish it made possible, these direct carvers used a wider variety of stone,

which they exploited for its range of texture and colour (see HOPTON WOOD STONE and HORNTON STONE). However, direct carving was not associated exclusively with avant-garde artists; it was advocated, for example, by the conservative critic Kineton Parkes (1865–1938) in articles in *Architectural Review* and in his book *The Art of Carved Sculpture* (2 vols., 1931).

In France there was a similar development, whereby direct carving (*taille directe* in French) moved from being chiefly an avant-garde concern before 1914 to wider acceptance in the 1920s. *Brancusi and *Derain made direct carvings as early as 1907, and they were almost certainly preceded by the more traditional Joseph Bernard (1866–1931). The issue of precedence is complicated by the existence of an artisanal tradition of stone carving in provincial France; one of the major exponents of *taille directe*, André Abbal (1876–1953), came from a family of stonecarvers working near Moissac in the south of the country.

The death of Rodin in 1917 had important consequences for public awareness of the issues involved in direct carving, for until then it had not been widely appreciated how much the most famous sculptor of the day had relied on assistants (*praticiens*) in the physical production of his work. In 1919 there was a scandal when a number of fakes of his work were revealed, leading to legal action, and the press coverage included accounts by some of Rodin's *praticiens* of the extent of their involvement. The critic Louis *Vauxcelles took advantage of the situation to attack the 'lie of modelling'—the mechanical transcription of one material into another. The scandal encouraged the acceptance of direct carving, which became such a vogue that by 1922 even the *praticien* Charles Jonchery (1873–?), who had been implicated in the Rodin scandal, was exhibiting work described as *taille directe*.

Another factor in the growth of direct carving in France was the way in which it was stimulated by nationalist rhetoric in the wake of the First World War. For example, in his book *Modelleurs et tailleurs de pierre, nos traditions* (1921), the sculptor Joachim Costa (1888–1971) linked direct carving with medieval French cathedrals; these had suffered so much damage in the war that some patriots accused the Germans of a deliberate campaign against them. Another consequence of the war was the demand for

memorials, and several of the leading exponents of this type of sculpture were direct carvers, among them Abbal, Paul Dardé (1890–1963), and Raoul Lamourdedieu (1877–1953).

Patriotic support for direct carving also came from the journal *La Douce France* (originally called *La Belle France*), published from 1919 to 1924. Its ideology went beyond conventional nationalism to propose a pure Celtic French identity associated with the north of France, in opposition to the south, in which the heritage had been corrupted by compromise with Latin invasion. (This is especially bizarre in view of the actual geographical origins of some of the carvers.) 'La Douce France' was also the name of a group of sculptors, founded in 1913, which held six exhibitions between 1922 and 1931. These featured carving alongside the equally medieval arts of fresco and tapestry, but the group's most permanent monument is a pergola made for the Paris Exposition des Arts Décoratifs (see ART DECO) in 1925. It was originally intended that the pergola should be placed in a prime site in the garden behind Notre Dame Cathedral in Paris, but it has ended up in a park in Étampes, about 50 kilometres south of the capital. In this work the idea of Celtic identity is expressed in the choice of subjects from Arthurian legend, and patriotism is underlined by the use of stone from the battlefield at Verdun. However, the fact that the Russian-born *Zadkine was among the ten sculptors who worked on the pergola (others were Costa, Lamourdedieu, and Pompon) suggests that La Douce France may have been more dogmatically nationalist in theory than in practice.

In the period between the two world wars, direct carving was taken up in other countries; Fritz *Wotruba was an influential exponent in Austria, for example, and leading American adherents included John B. *Flannagan and William *Zorach. Since the Second World War the carving versus modelling debate has been rendered largely obsolete by the prevalence of newer techniques that make both procedures seem conservative. However, for many older sculptors in the postwar period the sense of personal engagement with the material through carving still remained of central importance (in her later years Barbara Hepworth was concerned to conceal the extent to which assistants participated in her work). Isamu *Noguchi vividly expressed the sheer love of stone—the sense of communion with the material—that means so much to certain carvers: 'Sometimes out of despair, when we have given up, the stone itself sends a message—should one say bit by bit—so that we may receive it. Finally everything falls into place and emerges with a precision so remarkable that it cannot be chance.'

Direction 1. A group exhibition of five Australian abstract artists (four painters and a sculptor) held at the Macquarie Galleries, Sydney, in 1956. The painters were John *Olsen, John Passmore (1904–84), William Rose (1930–), and Eric Smith (1919–); the sculptor was Robert Klippel (1920–), who, according to Robert *Hughes, 'has since become the only first-rate sculptor to work in Australia' (*The Art of Australia*, 1970). Hughes writes that the exhibition 'revealed that abstract painting had become a distinct force, a serious challenge to figurative modes in Sydney' and that 'it has some claim to be called the most important group show by local painters between 1945 and the *Antipodean Exhibition in 1959'.

Dismoor, Jessica (1885–1939). British painter, born at Gravesend. She studied at the *Slade School, 1902–3, and the Atelier La Palette, Paris, where her teachers included *Blanche, *Dunoyer de Segonzac, and *Metzinger, 1910–13. In 1913 she met Wyndham *Lewis and she joined the *Vorticists the following year, signing the manifesto in the first issue of *Blast* and later taking part in all the group's key activities. After the First World War she exhibited with other ex-Vorticists as *Group X (1920) and from 1926 she was a member of the *London Group and of the *Seven & Five Society. During the 1930s her work became completely abstract. She also wrote poetry.

di Suvero, Mark (1933–). American sculptor, born in Shanghai, the son of an Italian naval officer who was stationed there. He migrated with his family to to California in 1941 and he majored in philosophy at the University of California at Berkeley, also studying at the California School of Fine Arts. In 1957 he moved to New York and had his first one-man show at the Green Gallery there in 1960. His work consists of assemblages of beams, tyres, pieces of furniture, chains, and other scrap from demolished buildings or junk-

yards and has tended to become increasingly large in scale. His constructions sometimes contain makeshift seats inviting the spectator to participate in the space and tension of the work. In 1964–5, following his gradual recovery from a near-fatal accident that hindered his movements, he began making large outdoor sculptures. As a protest against the USA's involvement in the Vietnam War he built a huge Peace Tower in Los Angeles in 1966, and in 1971 his political views led him to move into self-imposed exile in Europe, where he exhibited in several countries. He returned to the USA in 1975 and in the same year he created a series of outdoor, environmental sculptures for five New York boroughs. His later work has tended to become more linear, with greater structural clarity, using industrially manufactured units such as I-beams. In the second edition of his *A History of Modern Art* (1977), H. H. *Arnason wrote of di Suvero that his 'unlimited imagination and originality, as well as the increasing scale and power of his works, have resulted in his emergence in the 1970s as one of the foremost monumental sculptors . . . More than any other American sculptor di Suvero, in his imaginative use of gigantic scale, is the heir of and successor to the late David *Smith.' Curiously, in the third edition of the book (1986) this passage is deleted and di Suvero gets only a passing mention.

divisionism. A method and technique of painting in which colour effects are obtained by applying small areas or dots of pure, unmixed colours on the canvas in such a way that to a spectator standing at an appropriate distance they appear to react together, producing greater luminosity and brilliance than would have resulted if the same colours had been physically mixed together. The method was used empirically by the *Impressionists, but it was not developed systematically and scientifically until the 1880s in the work of the *Neo-Impressionists.

'Divisionism' (usually with a capital 'D') was also the name of an Italian movement, a version of Neo-Impressionism, that flourished in the last decade of the 19th century and the first decade of the 20th, initially in Lombardy (especially Milan) and Piedmont, and then in Rome. 'The moral climate of Italian Divisionism was different . . . [to that elsewhere in Europe; artists] . . . were motivated by a basic dissatisfaction with modern civiliza-

tion and felt the dual need to endow art with a scientific approach and to make it an instrument of "social illumination" (*espansività sociale*)' (Anna Maria Damigella in the catalogue of the exhibition 'Italian Art in the 20th Century', Royal Academy, London, 1989). The most remarkable work embodying these ideals is *The Fourth Estate* (Galleria d'Arte Moderna, Milan, 1901) by Giuseppe Pellizza da Volpedo (1868–1907), a huge canvas (5 metres wide) showing the working classes advancing towards social justice. Divisionism was one of the sources of *Futurism: 'The Futurists, however, adopted the Divisionist method in an instinctive rather than a scientific manner, freely applying the laws of divided and complementary colours to obtain strident and dissonant tones' (Damigella).

Dix, Otto (1891–1969). German painter and printmaker, born at Untermhaus in Thuringia. He was apprenticed to a local painter-decorator, 1905–9, then studied at the Dresden School of Arts and Crafts, 1910–14. At this time he was influenced by the *Expressionist group Die *Brücke, which had been founded in Dresden in 1905, and by an exhibition of van Gogh's work held there in 1913. During the First World War he served in the German army, witnessing the full horror of trench warfare, then took up his studies again at the Academy in Düsseldorf, 1919–22. In the 1920s he was, with George *Grosz, the outstanding artist of the *Neue Sachlichkeit movement, employing a detailed technique that showed his admiration for the masters of the German Renaissance. His work of this time conveyed disgust at the horrors of war and the depravities of a decadent society with unerring psychological insight and devastating emotional effect. *The Match Seller* (Staatsgalerie, Stuttgart, 1920), for example, is a pitiless depiction of indifference to suffering, showing passers-by ignoring a blind and limbless ex-soldier begging in the street, and Dix's fifty etchings entitled *The War* (1924) have been described by George Heard *Hamilton as 'perhaps the most powerful as well as the most unpleasant anti-war statements in modern art'. Another favourite theme was prostitution, and he also painted brilliantly incisive portraits, such as that of the journalist Sylvia von Harden (Pompidou Centre, Paris, 1926), in which 'he condemned the social and spiritual values of an era, as well as of a way of life, by a

merciless analysis of a particular person' (Hamilton).

In 1925 Dix moved to Berlin, then in 1927 he was appointed a professor at the Dresden Academy. Although he had no strong political views, his anti-military stance drew the wrath of the Nazis and he was dismissed from his academic post in 1933. The following year he was forbidden to exhibit, and eight of his paintings were shown in the infamous *Degenerate Art exhibition in 1937. They included *The Trench* (1923), a large triptych that had been his most controversial painting on account of its horrific depiction of war; it was destroyed by the Nazis in 1939. By this time Dix was living quietly in the country, at Hemmenhofen near Lake Constance (he moved there in 1936), painting traditional landscapes, but he still aroused suspicion; in 1939 he was arrested on a charge of complicity in a plot on Hitler's life, but he was soon released. He was conscripted into the *Volkssturm* (Home Guard) in 1945 and was a prisoner of war in France, 1945–6, after which he returned to Hemmenhofen. From 1949 he regularly visited Dresden. His post-war work—which was much more loosely handled and often inspired by religious mysticism—did not compare in originality or strength with his great achievements of the 1920s.

Dix made prints in a variety of techniques—woodcut, etching, drypoint, lithography—and has been described as 'together with *Beckmann . . . the dominant figure in the field of original printmaking in Germany after the First World War' (Frances Carey and Antony Griffiths, *The Print in Germany 1880–1933*, 1984). After the Second World War he worked mainly in lithography, and as with his late paintings, there was a sharp decline from the standard of his pre-war work.

Dobell, Sir William (1899–1970). One of the best-known Australian painters of the 20th century. He was born in Newcastle, New South Wales, the son of a building contractor, and originally trained as an architect. In 1923 he settled in Sydney, where he attended evening classes in art, and in 1929 he won a travelling scholarship that enabled him to study at the *Slade School in London (he also had some private tuition from *Orpen). Dobell remained in London for a decade. During this time he won prizes for drawing and figure painting at the Slade and exhibited at the Royal Academy and with the *New English Art Club and the *London Group. By the time he returned to Sydney in 1939 his style had changed from the carefully studied, solidly constructed naturalism of his early works to a much looser and more *Expressionist manner, sometimes with a satirical air. The rich colours and textures were influenced by art he saw on his travels in Europe, particularly the paintings of *Soutine.

Dobell immediately acquired a circle of admiring patrons in Sydney, some of whom commissioned portraits from him, and in 1944 he became a household name in Australia when he was involved in a *cause célèbre* for modernism. In January of that year he was awarded the 1943 Archibald Prize for portraiture, given annually by the Art Gallery of New South Wales, Sydney. His winning picture was *Portrait of an Artist* (since damaged beyond repair by fire), representing his friend and fellow-painter Joshua Smith (1905–95). 'Smith was a thin, bony man with prominent features and Dobell produced a portrait which, though not unsympathetic, adopted a manneristic attenuation of form and an expressionistic intensity of colour more vigorous and thoroughgoing than anything he had attempted previously' (Bernard Smith, *Australian Painting 1788–1990*, 1991). Two of the unsuccessful competitors contested the award in the Supreme Court of New South Wales, on the grounds that the winning work was not a portrait but a caricature—a 'pictorial defamation of character'. Their suit was dismissed and the case was regarded as a significant victory for the cause of modern art in Australia: 'The irony of the case was that Dobell was not a self-conscious modernist . . . He considered himself a 'traditionalist', but in his hands the tradition proved too malleable for his Archibald rivals. What they seemed to find intolerable was that the expression of the inner being of the sitter should be allowed to distort the external form of his body beyond the bounds of "objective" likeness . . . One witness in the trial said the picture reminded him of something he had seen in a psychiatric textbook' (Christopher Allen, *Art in Australia*, 1997). Some critics think that the Smith portrait marks the peak of Dobell's career and that much of his later work shows a decline in confidence. He continued to be much in demand as a portraitist (*Dame Mary Gilmore*, Art Gallery of New South Wales, Sydney, 1957), however, and also painted landscapes, some of them inspired by

visits to the highlands of New Guinea in 1949 and 1950. In 1954 (with *Drysdale and *Nolan) he represented Australia at the Venice *Biennale. He was knighted in 1966

Dobson, Frank (1886–1963). British sculptor, born in London, the son of an illustrator of the same name. From 1902 to 1904 he worked as an assistant to William Reynolds-Stephens (see NEW SCULPTURE). He then spent two years in Cornwall, earning his living with landscape watercolours, before winning a scholarship to Hospitalfield Art Institute, Arbroath, where he studied 1906–10. After returning to London, he continued his studies at the City and Guilds School, Kennington, then again lived in Cornwall, where he shared a studio with Cedric *Morris in *Newlyn. His early work consisted mainly of paintings, the few surviving examples showing how impressed he was by Roger *Fry's *Post-Impressionist exhibitions (Stanhope *Forbes, whom he met in Newlyn, had been shocked by his modernism). He made his first carving in 1913, but his first one-man exhibition—at the Chenil Gallery, London, in 1914—consisted of paintings and drawings. After the First World War (when he served in France with the Artists' Rifles), he turned increasingly to sculpture, and had his first one-man exhibition as a sculptor in 1920, at the *Leicester Galleries, London.

During the 1920s and 1930s Dobson gained an outstanding reputation: in 1925 Roger Fry described his work as 'true sculpture and pure sculpture . . . almost the first time that such a thing has been even attempted in England'. The monumental dignity of his work was in the tradition of *Maillol, and like him Dobson found the female nude the most satisfactory subject for three-dimensional composition, as in *Cornucopia* (University of Hull, 1925–7), described by Clive *Bell as 'the finest piece of sculpture by an Englishman since—I don't know when'. His work was more stylized than Maillol's however, and his sophisticated simplifications of form made him one of the pioneers of modern sculpture in Britain. Dobson was also outstanding as a portrait sculptor, his best-known work in this field being the head of Sir Osbert *Sitwell in polished brass (Tate Gallery, London, 1923). He worked in various other materials including bronze, terracotta, and stone, and he was prominent in the revival of *direct carving. His craftsmanship in all these materials was superb and he played an important role as a liberal-minded and kind-hearted teacher at the *Royal College of Art, where he was professor of sculpture from 1946 to 1953. With the rise of a younger generation led by Henry *Moore, however, Dobson's prestige as an artist dropped; his work was regarded as dated, and the memorial exhibition organized by the *Arts Council in 1966 was poorly received. Since then his reputation has greatly revived and he has again been recognized as one of the outstanding figures in 20th-century British sculpture.

Documenta. A large international exhibition of contemporary art held every four or five years since 1955 at Kassel, Germany. The first Documenta exhibition, the brainchild of Arnold Bode (1900–77), a teacher at the Kassel Academy, signified Germany's reacceptance of avant-garde art, which had been banned by the Nazis as *degenerate. The second Documenta, in 1959, contained an American section that demonstrated the achievements of the *New York School, and the fourth, in 1968, was dominated by American *Colour Field Painting, *Minimal art, and *Pop art. Out of some 150 artists invited, 57 were from the USA and many of the works they exhibited were of huge size. Subsequent Documenta exhibitions have often been organized around a theme—for example 'questioning reality' in 1972 and 'art and media' in 1977. Edward *Lucie-Smith writes that the exhibitions were begun 'as a platform for the statement of the superiority of Western values over those of Communism. The location was significant, since Kassel had been somewhat isolated geographically by the division of Germany. The exhibitions, lavishly funded and extremely ambitious in scale, began as relatively conservative and conventional Modernist surveys. The first Documenta exhibition contained art from the entire twentieth century, starting with Aristide *Maillol (born in 1861) and Paula *Modersohn-Becker (who died in 1907). Gradually, however, the exhibitions came to focus on strictly contemporary art, and thus they increasingly set the agenda for the international avant-garde of the day. Their influence was probably at its height in the 1970s, when they were able to draw vast audiences' (*Visual Arts in the Twentieth Century*, 1996).

Documents of Modern Art. A series of key texts and anthologies of writings on aspects of 20th-century art, edited by Robert *Motherwell and published in New York from 1944 to 1961. There are 14 volumes in the series, although the numbering goes up to 15, as volume 13 was never published. They include *Apollinaire's *The Cubist Painters* (1944), *Mondrian's *Plastic Art and Pure Plastic Art* (1945), and *Kandinsky's *Concerning the Spiritual in Art* (1947).

Documents of 20th-Century Art. A series of texts and anthologies of writings by leading 20th-century artists and critics, begun in 1971 with Robert *Motherwell as general editor and published in London and New York. Volumes include *Picasso on Art: A Selection of Views*, edited by D. Ashton (1972), *My Life in Sculpture* by Jacques *Lipchitz (1972), and *The Writings of Robert Motherwell*, edited by A. A. Cohen (1978).

Dodd, Francis. See BONE.

Doesburg, Theo van (1883–1931). Dutch painter, designer, writer, and propagandist, born in Utrecht. His original name was Christiaan Kuppers, after his biological father, a German photographer, but he called himself after his Dutch stepfather. Initially he planned to have a career in the theatre, but he had begun painting by 1899 and he had his first exhibition in The Hague in 1908. He had no formal artistic training. In 1913 he published a collection of his poems, and he was also writing art criticism at this time. His early paintings were influenced variously by *Impressionism, *Fauvism, and *Expressionism, but in 1915 he met *Mondrian and rapidly underwent a conversion to complete abstraction. In 1917 he founded De *Stijl and he devoted the rest of his life to propagating the association's ideas and the austerely geometrical style it stood for. He saw himself as a crusader fighting to cleanse the world of cultural impurities, and George Heard *Hamilton writes that 'His tireless energy, inexhaustible intellectual curiosity, and powers of persuasion made him an irresistible proselytizer. It was he who first had the vision of an inclusive modern style, one which would embrace all the arts and all the productions whereby the man-made environment is created as specifically human.'

Up to about 1920 van Doesburg's paintings were very close in style to those of Mondrian, both of them predominantly using small, irregularly disposed rectangles of primary colour on a light background, but thereafter their paths diverged. Mondrian had returned to Paris in 1919 and van Doesburg spent much of the 1920s travelling to promote De Stijl ideas, particularly in Germany. From 1922 to 1924 he taught intermittently at the *Bauhaus, which in 1925 published a German translation—*Grundbegriffe der neuen gestaltenden Kunst*—of his most important book, *Grondbegrippen der nieuwe beeldende Kunst* (1919). (An English translation, *Principles of Neo-Plastic Art*, appeared in 1968). While he was in Germany van Doesburg became friendly with *Schwitters and briefly practised *Dada (this marked a great departure from his normal work, but he was always interested in radical new ideas). By the mid-1920s he had abandoned the rigid horizontal-vertical axes insisted upon by Mondrian and introduced diagonals into his paintings in a series of works entitled *Counter-compositions* (*Counter-composition in Dissonance XVI*, Gemeentemuseum, The Hague, 1925). He called this new departure *Elementarism, publishing a manifesto describing it in *De Stijl* in 1926; Mondrian dissociated himself from De Stijl because of this heresy.

In addition to painting, writing, and lecturing, van Doesburg collaborated on several architectural projects, the most important of which was the remodelling of the Café d'Aubette in Strasbourg (1926–8), in which he worked with Jean *Arp and Sophie *Taeuber-Arp. Contrary to what the name might suggest, the Café is a large building, part of a prominent architectural complex (in the city's main square) that dates in part back to the 13th century and has served a variety of uses. Van Doesburg was in overall charge of the project and 'also designed virtually every piece of equipment, from the electrical fuseboards to the ash-trays and crockery' (Paul Overy, *De Stijl*, 1991). The principal room he worked on was the Cinema Dance Hall, which featured a series of very bold diagonal elements that obscured the definition of wall and ceiling. With its bright colours, it was like a huge walk-in version of one of his paintings. When the Café reopened the public hated the decoration so much that the management had it altered or covered (it was restored in the 1990s), but it anticipated the kind of 'total design' seen in major corporate buildings

after the Second World War. In 1929 van Does-
burg moved to Paris and designed a house and
studio for himself at Meudon in a stark and
stripped style (1929–31); he thought that an
artist's studio should resemble a medical lab-
oratory. In 1930 he published a manifesto of
*Concrete art and in February 1931 a meeting
of artists in his new studio led to the forma-
tion of the *Abstraction-Création association.
The following month he died of a heart attack
in Switzerland, where he had gone for treat-
ment for his chronic asthma.

He died a disappointed man because of the
fate of his Café Aubette designs and a general
sense of rejection of his ideas, but only five
years later Alfred H. *Barr gave De Stijl a cent-
ral place in his *Cubism and Abstract Art* (origin-
ally published to accompany an exhibition at
the Museum of Modern Art, New York) and
described van Doesburg as 'painter, sculptor,
architect, typographer, poet, novelist, critic,
lecturer and theorist—a man as versatile as
any figure of the Renaissance'. Although he
has a secure place in the history of modern
art, he has provoked conflicting opinions:
'Some historians and critics have visualized
and described van Doesburg as a scorned
prophet, shouting the truth in a wilderness of
conventional deceit, while others now view
him as just one of the many self-proclaimed
messiahs who shouted their ways through
the 1920s' (Theodore M. Brown in *Macmillan
Encyclopedia of Architects*, 1982).

Domínguez, Óscar (1906–58). Spanish
painter and sculptor, active mainly in France.
He was born at Tenerife in the Canary Islands,
the son of a banana exporter, and was self-
taught as an artist. In 1927 he first visited
Paris, where he came under the spell of the
*Surrealists, and in 1933 he helped organize a
Surrealist exhibition on Tenerife. His early
paintings were in the 'veristic' manner of
*Dalí, but soon after settling permanently in
Paris in 1934 he began experimenting with
techniques of *automatism and he is credited
with inventing *decalcomania. It is for this
that he is best remembered, for the rest of his
work did little more than plagiarize his more
famous contemporaries. In addition to paint-
ings, he produced Surrealist sculptures incor-
porating *ready-made elements.

Donagh, Rita. See HAMILTON, RICHARD.

Donati, Enrico. See SPATIALISM.

Dongen, Kees van (1877–1968). Dutch-born
painter and printmaker who became a French
citizen in 1929. He was born in Delfshaven,
the son of a brewer, and studied at the Acad-
emy in nearby Rotterdam, 1894–5. In 1897 he
first visited Paris, and he settled there in 1899,
living in poverty for a while in the *Bateau-
Lavoir (where he was a friend of *Picasso) and
eking out a living with various jobs, including
bill-sticker and circus wrestler. He had his
first one-man show at *Vollard's gallery in
1904. His early work was *Impressionist in
style, but in 1906 he became a member of the
*Fauves. From this time he rapidly made a
name for himself in France and elsewhere; he
was given contracts by *Kahnweiler in 1907
and *Bernheim-Jeune in 1908, and had
numerous one-man shows in Paris and else-
where in the period leading up to the First
World War. The foreign exhibitions at which
his work appeared included a Die Brücke
show in Dresden in 1908 and the second
*Golden Fleece exhibition in Moscow in 1909.
He had a reputation as a ladies' man, and his
work (mainly nudes and female portraits) was
often erotic in spirit; in 1913 one of his
pictures was removed from the *Salon
d'Automne by the police on the grounds of
alleged indecency. After the First World War
he became internationally famous for his
paintings of fashionable life, particularly por-
traits of insolently glamorous women, in
which he created a feminine type described
by the art historian Frank Elgar as 'half draw-
ing-room prostitute, half sidewalk princess'.
His great facility led to repetition and banal-
ity, and it is generally agreed that most of his
best work was done before 1920. From 1959 he
lived in Monaco, and his work is represented
in several galleries on the French Riviera,
notably the Musée des Beaux-Arts in Nice.
Among his works here are not only portraits
but also several large imaginative composi-
tions, including 'a triptych entitled *Tango of
the Archangel*, which features a girl, naked save
for black fishnet stockings, dancing with a
dinner-jacketed man with wings; all the
decadence of high society between the wars
seems captured in this work' (Michael Jacobs
and Paul Stirton, *The Mitchell Beazley Traveller's
Guides to Art: France*, 1984). In 1967–8 a large
retrospective exhibition in honour of his 90th
birthday was held at the Musée National d'Art
Moderne, Paris, and the Boymans Museum,
Rotterdam.

Donkey's Tail (in Russian: Oslinyi Khvost). Title of an exhibition organized in Moscow in 1912 by *Goncharova and *Larionov after they had dissociated themselves from the *Knave of Diamonds group in 1911. They accused the Knave of Diamonds of being too much under foreign influence, and advocated a nationalist Russian art; at this time Goncharova and Larionov themselves were painting in a *Neoprimitivist manner based partly on icon painting and peasant art. *Malevich and *Tatlin were the only other major artists who were well represented at the exhibition; *Chagall sent one picture, but otherwise the artists involved were minor figures. The title of the exhibition was an aspect of Larionov's primitivism, referring to an incident in 1910 when three pictures painted with a brush tied to a donkey's tail were shown at the jury-free *Salon des Indépendents in Paris (this stunt was devised by a journalist called Roland Dorgelès, who wanted to poke fun at modern art; the pictures were hung as works of the fictitious 'Boronali', an anagram of *aliboron*, 'jackass'). At the Moscow exhibition there was an outcry because some of the paintings on view had religious subjects—for example Goncharova's *The Four Evangelists* (Russian Museum, St Petersburg, 1910–11)—and it was thought to be irreverent to show religious works under such a title (the police ordered several to be removed). Goncharova and Larionov followed it up with the *Target Exhibition in 1913.

Dorazio, Piero (1927–). Italian painter, born in Rome. He started a course studying architecture at Rome University, but in 1946 gave this up for painting, initially producing *Social Realist subjects. In 1947, however, he turned to abstraction and joined the *Forma group (like many of its members he later joined the *Continuità group). He experimented with various types of abstract work before creating a distinctive style in the 1960s with brightly luminous bands of colour—'like an heraldic flag', as he puts it (*Very Sharp*, Tate Gallery, London, 1965). Dorazio has travelled a good deal and has spent several years in the USA; from 1963 to 1967 he taught at the University of Pennsylvania.

Dotremont, Christian (1922–1979). Belgian writer (mainly a poet, but also a novelist) and painter. In 1947 he founded a movement called Le Surréalisme Revolutionaire in Brussels, but when it became evident that it would be impossible to co-operate with the French *Surrealists (he was opposed by their leader *Breton), he became one of the founders of *Cobra in 1948. Dotremont was the group's chief spokesman and the main editor of its periodical. He also collaborated with other Cobra artists in creating pictures in which words and images are combined. In his later paintings he used quasi-Oriental calligraphic forms that he called logograms.

He was no relation to **Philippe Dotremont** (1898–1969), a Belgian industrialist who made an impressive collection of contemporary art, especially rich in American work.

Dottori, Gerardo. See AEROPITTURA.

Douce France, La. See DIRECT CARVING.

Douglas, Aaron (1899–1979). American painter and illustrator, probably the best known among the visual artists who were involved in the (primarily literary) *Harlem Renaissance. He was born into a working-class family in Topeka, Kansas, and studied fine art at Nebraska University, completing his degree in 1922 after service in the army in the First World War. In 1925 he moved to New York, where he met Charles Johnson, editor of *Opportunity*, the journal of the National Urban League, an association that fought racial discrimination, and also William E. B. Du Bois, a leading sociologist and editor of *Crisis*, the journal of the National Association for the Advancement of Colored People. From 1926 Douglas made illustrations for both journals, creating positive images of black history and culture that challenged the stereotype of the 'negro' familiar to white American society. His dramatic use of black-and-white was influenced by the German-born painter and graphic artist Winold Reiss (1886–1953), who taught him privately, 1925–7. In 1926 Douglas met Albert C. *Barnes, and in 1927–8 he spent a year at the Barnes Foundation, where the work he studied included *Cubist paintings and West African masks. Their influence, together with imagery from ancient Egyptian art, can be seen in Douglas's best-known work, the mural series *Aspects of Negro Life* (1934), painted for the Schomberg Library in Harlem and now in New York Public Library. The murals feature both secular and religious imagery and allude to issues such as slavery

and notions of utopia. Douglas's other work included landscapes and portraits. From 1940 to 1966 he taught at Fisk University, Nashville, Tennessee, and he lived in Nashville for the rest of his life.

Dova, Gianni. See SPATIALISM.

Dove, Arthur (1880–1946). American painter, a pioneer of abstract art. He was born in Canandaigua, New York State, studied law and art at Cornell University, graduating in 1903, then settled in New York City. For most of his career he earned his living as a commercial illustrator and he was often in great financial difficulty, even though he was championed by *Stieglitz and later supported by Duncan *Phillips, who from 1930 paid him a regular monthly stipend. He visited Europe in 1907–9, coming into contact with *Fauvism and other avant-garde movements, and in 1910 he painted the first abstract pictures in American art (*Abstraction No. 1–Abstraction No. 6*, private collection), which are somewhat similar to *Kandinsky's work of about the same date. Dove never exhibited these pictures in his lifetime, but he displayed similar works in his first one-man exhibition at Stieglitz's 291 Gallery in 1912. These abstracts are based on natural forms, suggesting the rhythms of nature through pulsating shapes (*Sand Barge*, Phillips Collection, Washington, 1930); Dove wrote 'I should like to take wind and water and sand as a motif and work with them, but it has to be simplified in most cases to color and force lines and substances just as music has done with sound'. From the mid-1930s the vestiges of representation in his work began to disappear and in the the 1940s he experimented with a more geometric, hard-edged type of abstraction (*That Red One*, William H. Lane Foundation, Leominster, Massachusetts, 1944). Throughout his career Dove also made collages, among them *Portrait of Alfred Stieglitz* (MOMA, New York, 1925), which features a camera lens and a photographic plate amongst other objects. In his later years he took a leading part in a campaign to win artists royalty rights for the reproduction of their work. From 1924 Dove was married to the painter Helen Torr (1886–1967).

Dow, Arthur Wesley (1857–1922). American painter (mainly of landscapes), printmaker, teacher, and writer. His work as an artist is unexceptional, but he was an important educator. He taught at various colleges, including the *Art Students League, New York, and his book *Composition* (1899) was widely read. In it he puts forward the idea that an artist need not imitate nature and should be concerned essentially with 'filling a space in a beautiful way'. This justification of abstract art helped to shape the ideas of some pioneer modernists in American art. Georgia *O'Keeffe and Max *Weber were among the artists who acknowledged Dow's influence.

Dow, Thomas Millie. See GLASGOW BOYS.

Downing, Thomas. See WASHINGTON COLOR PAINTERS.

Dowson, Sir Philip. See ROYAL ACADEMY.

Dreier, Katherine S. (1877–1952). American painter, patron, and collector, a wealthy heiress remembered chiefly for her missionary zeal in promoting modern art in the USA. She was born in New York, the daughter of immigrant German parents, and studied at the Brooklyn Art Students League and elsewhere. Her early paintings consisted of traditional portraits and still-lifes, but in 1913 the *Armory Show converted her into an ardent supporter of avant-garde art and she devoted much of the rest of her life to championing it. She did this mainly through the *Société Anonyme, which she founded in 1920 with Marcel *Duchamp and *Man Ray. 'A domineering woman of tireless energy and Wagnerian proportions, she was the antithesis of Duchamp in every possible way, and they got along famously' (Calvin *Tomkins, *The World of Marcel Duchamp*, 1966). In addition to organizing exhibitions (the main business of the Société Anonyme), she did a good deal of lecturing, and she also promoted avant-garde music and dance. Her best-known painting is her portrait of Duchamp (MOMA, New York, 1918). Soon after this her work became abstract, influenced by *Kandinsky. She bequeathed 99 works from her personal art collection to the Museum of Modern Art, New York, including examples by *Brancusi, Duchamp, Kandinsky, *Klee, and *Mondrian.

Drummond, Malcolm (1880–1945). British painter, born at Boyne Hill, Berkshire. He read history at Oxford University, 1899–1903, then studied at the *Slade School, 1903–7, and

under *Sickert at Westminster School of Art. Like others in Sickert's circle he was a founder member of the *Camden Town Group in 1911 and of its successor the *London Group in 1913, and he is best known for paintings of this period. They are done in simplified forms and broad, flat areas of colour in a style similar to that of *Gilman or *Gore, but generally rather quieter; *19 Fitzroy Street* (Laing Art Gallery, Newcastle upon Tyne, *c*. 1913–14), representing *Ginner, Gore, and *Manson looking at a group of paintings in their showroom near Sickert's studio, is probably his most reproduced work, partly because it is such a valuable historical record. Drummond virtually gave up painting during the First World War (he worked on munitions and as a translator at the War Office); after the war his work included several religious commissions (he was a convert to Catholicism in childhood). In 1925 he began teaching at Westminster School of Art, but following the death of his first wife (the painter Zina Lilias Ogilvie) in 1931 he left London and settled in Moulsford, Berkshire. He lost the sight of one eye in 1937 and became completely blind in 1943. He was almost forgotten at the time of his death, but the London Group held a memorial exhibition in 1945, and several others followed in the next few years.

Drury, Alfred (1856–1944). British sculptor, mainly of portraits and monuments, but also of the kind of literary or symbolic figures typical of the *New Sculpture. His work includes a good deal of public sculpture in London, including decorative figures in stone on the facade of the Victoria and Albert Museum (1905–7), four colossal bronze figures for Vauxhall Bridge (1909), and the bronze statue of Sir Joshua Reynolds in the courtyard in front of the Royal Academy (1931). His son **Paul Drury** was an engraver.

Drysdale, Sir Russell (1912–81). British-born Australian painter. In spite of his British roots and the fact that he trained partly in Europe, he was one of the most Australian in spirit of his country's major 20th-century artists. He was born in Bognor Regis, Sussex, into a family that had owned land in Australia since the 1820s, and he spent several years of his childhood there. The family settled in Melbourne in 1923 and in the mid-1930s Drysdale gave up farming to study art (first in Melbourne under George *Bell, 1935–8, then in Paris and Lon-

don, and finally for another year with Bell, 1939–40). After moving to Sydney in 1940 he devoted himself full-time to painting. His early work had been bright and decorative, but in the 1940s it became sombre and serious. This change reflected the onset of the Second World War and also Drysdale's experience of the effects of a devastating drought in the Riverina district of New South Wales in 1940 (in 1944 he was commissioned by the *Sydney Morning Herald* to paint pictures of another drought in the state). His work revived the tradition of hardship and melancholy associated with the Australian bush that had been obscured by the much more optimistic tradition developed by the city-based painters of the *Heidelberg School. In place of the basically *Impressionist style of the Heidelberg painters, Drysdale blended *Expressionist and *Surrealist features founded on his knowledge of contemporary European painting—'the expressionistic quality in his colour and figuration; the surrealist in his use of such devices as deep perspective, vacancy and disjunctive images to create absurd, whimsical or disquieting effects' (Bernard Smith, *Australian Painting 1788–1990*, 1991). His work in this vein became well known throughout Australia in the 1940s, and in 1949 Kenneth *Clark, on a visit to Sydney, encouraged Drysdale to exhibit in London. In 1950 he had a one-man show at the *Leicester Galleries, London, and this marked the beginning of a new interest in Australian art in Britain and in Europe—a trend that peaked in the early 1960s. *Dobell and *Nolan were two other artists whose work became well known in the northern hemisphere in this period and together with Drysdale they represented Australia at the 1954 Venice *Biennale.

Of these three artists, Drysdale remained closest to the Australian soil. In the 1950s he travelled widely in the vast tract of Northern Australia, which he described as 'magnificent in dimension, old as time, curious, strange, and compelling'. As well as the landscape, he painted the life of the aborigines and was indeed 'the first to make the Australian aborigine a major theme of his art, while neither elevating him into a romantic stalking horse nor degrading him into a figure of fun. He approached aboriginal myth and legend sympathetically, as a mysterious complex of religious and poetic forces . . . in his northern paintings . . . aborigines share the landscape

on equal terms with white settlers ... they are pervaded by a moving dignity as human beings' (Robert *Hughes, *The Art of Australia*, 1970). In 1957–8 Drysdale lived in London, and in 1960 he had a major retrospective exhibition at the National Gallery of Victoria, Melbourne. During the early 1960s he experienced periods of depression accentuated by the death of his son and his wife. He was knighted in 1969.

Dublin, Hugh Lane Municipal Gallery of Modern Art. See LANE.

Dublin, Irish Museum of Modern Art. See IRISH MUSEUM OF MODERN ART.

du Bois, Guy Pène. See PÈNE DU BOIS.

Dubuffet, Jean (1901–85). French painter, sculptor, lithographer, and writer, born in Le Havre, the son of a wealthy wine merchant. In 1918 he moved to Paris, where he studied at the *Académie Julian for six months. He began to doubt the value of art and culture, however, and in 1924 he stopped painting and entered the wine trade. In 1933 he made another abortive attempt at painting, then in 1942 took up art seriously again, his first one-man exhibition coming in 1945. He was fascinated by graffiti and by *Art Brut ('raw art'), the products of psychotics or wholly untrained persons, preferring untrained spontaneity to professional skill. His own work was aggressively reminiscent of such 'popular' art, often featuring subjects drawn from the street life of Paris (*Man with a Hod*, Tate Gallery, London, 1956). Frequently he incorporated materials such as sand and plaster into his paintings, and he also produced large sculptural works made from junk materials. His work initially provoked outrage, but then found acceptance and eventually reverence, and he is one of the key figures in the tendency in modern art to depreciate traditional materials and methods and, as he himself said in 1957, to 'bring all disparaged values to the limelight'. He produced a huge amount of work, constantly experimenting with new materials and styles, and although he was a champion of artistic discovery and disorder, he documented his output thoroughly; the complete catalogue of his work runs to 37 volumes (1964–84). His critical writings were published in a collected edi-

tion in 1967 under the title *Écrits de Jean Dubuffet*.

Opinions about his work have differed widely, but he has undoubtedly been a highly influential figure, foreshadowing many of the 'far out' trends of the 1960s and beyond. George Heard *Hamilton writes of him: 'By discrediting even more thoroughly than *Schwitters ... all conventional artistic and aesthetic standards ... Dubuffet made all aspects of our environment, without exception, available to the artist. By denying any possibility of distinguishing between beautiful and ugly objects he, as much as anyone else, created the aesthetic conditions for the "junk culture" and "Pop art" of the 1960s' (*Painting and Sculpture in Europe 1880–1940*, 1967: this passage is in the postscript, which was deleted in later editions of the book). Edward *Lucie-Smith has echoed these words: 'Dubuffet probably exercised a greater influence over both his European and his American contemporaries than any other artist of the immediately post-war epoch' (*Lives of the Great Twentieth Century Artists*, 1986).

Duchamp, Marcel (1887–1968). French-born avant-garde artist and art theorist who became an American citizen in 1955. His output was small (most of his key works are in the Philadelphia Museum of Art) and for long periods he was more or less inactive, but he is regarded as one of the most potent figures in modern art because of the originality and fertility of his ideas; in *Lives of the Great Twentieth Century Artists* (1986), Edward *Lucie-Smith writes that he has 'probably exercised an influence over Modernism second only to that of *Cézanne' and he describes him as 'perhaps the most important art-theorist and avant-garde *provocateur* of the twentieth century. He directed attention away from the work of art as a material object, and instead presented it as something which was essentially an idea: he shifted the emphasis from making to thinking.' To many people, however, this achievement is something to lament rather than to applaud.

Duchamp was born at Blainville, Normandy, one of six children (three sons and three daughters) of a successful notary. Their grandfather was an amateur engraver, and Marcel's two brothers and one of his sisters also became artists—Suzanne *Duchamp, Raymond *Duchamp-Villon, and Jacques *Villon. In 1904 Duchamp followed his broth-

ers to Paris, where he studied for a year at the *Académie Julian. His early paintings were influenced by *Post-Impressionism and then *Fauvism, and he also did humorous drawings for various journals to help earn his living. From the outset he was interested in art primarily as a vehicle for ideas and had little concern for skilled craftsmanship or beauty of technique. In 1909 he began exhibiting his work in public, at the *Salon des Indépendants and the *Salon d'Automne, but he had no interest in achieving conventional career success.

By 1911 Duchamp was part of the *Cubist circle, and in that year he produced his first work to show real originality—Nude Descending a Staircase, No. 1 (Philadelphia); it depicts a stylized, semi-abstract figure walking down a spiral staircase, movement being suggested by the use of overlapping images, in the manner of rapid-fire multiple-exposure photography. The following year, 1912, he painted a more sophisticated version, Nude Descending a Staircase, No. 2 (Philadelphia), in which the figure is more machine-like and the movement more dynamic. This was shown in Barcelona and Paris in 1912, but it was in New York the following year that it first made a great impact, becoming the most discussed work in the *Armory Show. The attention it received was mainly negative (probably the most quoted comment about it was that it looked like 'an explosion in a shingles factory'), but there were also more appreciative remarks, and the publicity made Duchamp suddenly much better known in the USA than he had ever been in France. This first conspicuous success as a painter was also Duchamp's last, for in 1913 he made his first *ready-made and from this point virtually abandoned conventional media.

In 1915, after spending two leisurely years as a library assistant at the Bibliothèque Sainte-Geneviève in Paris, Duchamp moved to New York and spent the rest of the First World War there (he was excused military service on account of a minor heart complaint). His fame (or notoriety) from the Armory Show had not been forgotten, and he was greeted by reporters as he disembarked and made welcome in intellectual circles. The art collectors Walter and Louise *Arensberg provided him with a studio, but he refused all offers from dealers to handle his work (he had a disdain for making money as an end in itself) and instead supported himself by giving French

lessons. With *Man Ray and Francis *Picabia he formed the nucleus of New York's *Dada movement. Duchamp's main contribution to this was the ready-made, the best-known of which was Fountain (1917), consisting of a urinal bowl signed 'R. Mutt', which was rejected by the *Society of Independent Artists. In 1918–19 Duchamp spent nine months in Buenos Aires playing chess, then returned briefly to Paris, where he produced one of his most famous creations debunking the art world—a reproduction of the Mona Lisa to which he added a moustache, beard, and rude inscription.

From 1920 to 1923 Duchamp again lived in New York, and during this period he was engaged mainly on his most complex and ambitious work—an enigmatic construction entitled The Bride Stripped Bare by Her Bachelors, Even, also known as The Large Glass (Philadelphia; replica by Richard *Hamilton, 1965–6, in the Tate Gallery, London). (The French title is 'La Mariée mise à nu par ses célibataires, même', which contains a characteristic Duchampian pun, for 'même' sounds the same as 'm'aime', which would give the translation 'The bride stripped bare by her bachelors loves me'.) Duchamp's plans for this work go back as far as 1912 and he began constructing it in 1915. He abandoned it as 'definitively unfinished' in 1923, but it was damaged whilst being transported in 1926 (following its first public showing at the 'International Exhibition of Modern Art' at the Brooklyn Museum) and ten years later he made repairs, incorporating cracks in the shattered glass as part of the image and declaring it completed 'by chance'. This unruffled pace was typical of Duchamp, for he once said 'I've never been able to work more than two hours a day'.

The Large Glass is a window-like structure about nine feet high, featuring an upper and lower glass panel in an aluminium framework; each panel is embellished by oil paint, lead wire and foil, dust, and varnish. The upper panel features 'the bride's domain' and the lower panel 'the bachelor apparatus'. Duchamp wrote detailed commentaries explaining his elaborate machine imagery, which expresses his vision of the frustrations and futility of sex; essentially the work 'consitutes a diagram of an ironic love-making machine of extraordinary complexity in which the male and female machines communicate only by means of two circulatory systems, and without any point of contact'

(Ronald Alley, *Catalogue of the Tate Gallery's Collection of Modern Art*, 1981). Scholars have produced voluminous interpretations of the work, which John *Golding considers has 'a substantial claim to be the most complex and elaborately pondered art object that the twentieth century has yet produced'. To many people, however, it is an incomprehensible joke.

In 1923 Duchamp returned to Paris and lived there until 1942 (although he made several visits to New York). Both his parents died in 1925, leaving him a legacy that made him less inclined than ever to work. Instead he devoted much of his time to his passion for chess. He was one of the best players in France (he represented the country at four Olympiads and was champion of Paris in 1932), and the International Master Edward Lasker described him as 'a marvelous opponent. He would always take risks in order to play a beautiful game, rather than be cautious and brutal to win.' His obsessive devotion to the game ruined his first—rather frivolous—marriage in 1927, of which Man Ray wrote: 'Duchamp spent the one week they lived together studying chess problems, and his bride, in desperate retaliation, got up one night when he was asleep and glued the chess pieces to the board. They were divorced three months later.' (With his aristocratic looks and enormous charm, Duchamp was highly attractive to women, and a friend wrote that he 'could have had his choice of heiresses'; in 1954 he made a happy second marriage to Alexina Sattler, who had previously been the wife of the art dealer Pierre Matisse, son of Henri *Matisse.)

In 1942 Duchamp settled permanently in New York, although he regularly visited France. By this time he seemed to have long abandoned art, but he had in fact continued to experiment quietly, for example with rotating coloured discs that anticipate *Kinetic art. He also did a good deal to promote avant-garde art, particularly *Surrealism, in France and the USA, notably through the activities of the *Société Anonyme, but in the exciting post-war New York art world he was for many years a marginal figure. From the late 1950s, however, avant-garde artists began to rediscover his work and ideas (it was not until 1954, when the Arensberg collection went on show at the Philadelphia Museum of Art, that his work was easily accessible), and in his final years he was revered as a kind of patron

saint of modern art, giving numerous interviews in which he showed his characteristic graciousness and wit. In 1959, exhibitions of his work were held in London, New York, and Paris, and many others followed, including 'The Almost Complete Works of Marcel Duchamp' at the Tate Gallery, London, in 1966.

Near the end of his life Duchamp revealed that he had been working in secret for 20 years (1946–66) on a large mixed-media construction called *Etant donnés: 1° La Chute d'eau, 2° Le Gaz d'éclairage* (Given: 1. The Waterfall, 2. The Illuminating Gas). It features a naturalistic painted sculpture of a nude reclining woman holding a lantern, with behind her a simulated landscape, including a trickle of water representing a waterfall; this elaborate tableau is viewed through peepholes in a heavy wooden door. He presented it to the Philadelphia Museum of Art, where it joined the majority of his other works. Duchamp died on a visit to France and was buried with other members of his family in Rouen. He composed the inscription for his gravestone, jesting to the last: 'D'ailleurs c'est toujours les autres qui meurent' (All the same, it's always other people who die).

Duchamp's iconoclasm and experimental attitude have been enormously influential, most obviously on *Conceptual art, but also for example on *Minimal art and on *Pop art, in which the ready-made has played such a big part. His wit and irony have been sadly lacking in most of his followers, however, and it could be argued that his influence has been mainly baleful, encouraging people of no discernible talent to believe that anything they do, say, or think is worthy of attention as art.

Duchamp, Suzanne (1889–1963). French painter, the sister of Marcel *Duchamp, Raymond *Duchamp-Villon, and Jacques *Villon. She exhibited with the *Section d'Or group in 1912, and after the First World War became involved with the *Dada movement in Paris. In 1920 she married the Dada painter Jean Crotti (1878–1958), and as a wedding present her brother Marcel sent instructions for an 'unhappy *ready-made', consisting of a geometry text book suspended by strings from her balcony; 'the wind had to go through the book', he said, 'choose its own problems, turn and tear the pages'. Suzanne made a painting of it—*Marcel's Unhappy Ready-Made* (private col-

lection, 1920). Her paintings were typically in a delicately mechanistic abstract vein.

Duchamp-Villon, Raymond (1876–1918). French sculptor, born in Damville, near Rouen, the brother of Marcel and Suzanne *Duchamp and of Jacques *Villon (he adopted the name Duchamp-Villon in about 1900). After illness forced him to give up his medical studies at the University of Paris in 1898 he took up sculpture, at which he was self-taught. For the next dozen years or so he experimented with various styles until in about 1910 he became involved with *Cubism. Several other Cubists used to meet in the studios of Duchamp-Villon and Villon (see PUTEAUX GROUP) and from these meetings the *Section d'Or group emerged. In 1914 Duchamp-Villon enlisted in the army as an auxiliary doctor, and he contracted typhoid fever in 1916; he spent his last two years as an invalid before he died in a military hospital in Cannes. His death cut short a career of great promise, for his major work, *The Horse* (1914), has been described by George Heard *Hamilton as 'the most powerful piece of sculpture produced by any strictly Cubist artist' (there are casts in the Tate Gallery, London, MOMA, New York, and elsewhere). This 'abstract diagram of the muscular tensions developed by a leaping horse' (Hamilton) has been compared with the work of the *Futurists, particularly that of *Boccioni, who met Duchamp-Villon in 1913. In the success with which it suggests taut energy it certainly achieves at least one of the things the Futurists were aiming at in their attempts to represent 'the dynamics of movement'.

Dufresne, Charles (1876–1938). French painter, designer, and engraver, born at Millemont, Seine-et-Oise. He trained as a commercial engraver, then studied medal engraving at the École des *Beaux-Arts, Paris, but he turned increasingly to painting, exhibiting his pictures regularly from 1899. In 1910 he was awarded the Prix de l'Afrique du Nord and spent the next two years in Algeria. This contact with an exotic civilization stimulated his sense of colour and stirred his interest in the kind of romantic African subjects painted by Delacroix in the 19th century. During the First World War he served in the French army, and after being gassed he worked in *Dunoyer de Segonzac's camouflage unit. Like Segonzac, Dufresne became recognized in the inter-

war period as an upholder of traditional skills and values (see NÉO-RÉALISME), but he also adopted a mild degree of *Cubist stylization. His output included religious paintings and portraits, but his most characteristic works are imaginative scenes recalling his exotic travels (*Spahi Attacked by a Lion*, Tate Gallery, London, 1919). Dufresne also produced many engravings, made designs for tapestries and for the ballet, and painted murals, notably a huge composition at the École de Pharmacie in Paris, completed in the year of his death.

Dufy, Raoul (1877–1953). French painter, graphic artist, and designer. He was born in Le Havre and from 1892 studied at evening classes at the École Municipale des Beaux-Arts there (see LE HAVRE GROUP) whilst working for a firm of coffee importers. In 1900 he won a scholarship that took him to the École des *Beaux-Arts in Paris for four years. His early work was *Impressionist in style, but he became a convert to *Fauvism in 1905 after seeing *Matisse's *Luxe, calme et volupté* ('this miracle of creative imagination in colour and line') at the *Salon des Indépendants. He exhibited with the Fauves in 1906 and 1907, but in 1908 he worked with *Braque at L'Estaque and abandoned Fauvism for a more sober style influenced by *Cézanne. However, he soon returned to a lighter style and in the next few years developed the highly distinctive personal manner for which he has become famous. It is characterized, in both oils and watercolours, by rapid calligraphic drawing on backgrounds of bright, thinly washed colour and was well suited to the scenes of luxury and pleasure Dufy favoured. He had achieved considerable success by the mid-1920s and the accessibility and *joie de vivre* of his work helped to popularize modern art. George Heard *Hamilton writes that 'Like many minor masters he found a formula which, once established, he never fundamentally changed, but it is so amusing, and its variations so clever, that it rarely grows tiresome'.

In 1910 Dufy made friends with the fashion designer Paul Poiret (1879–1944), and he did design work for both Poiret and Bianchini-Férier, a silk manufacturer of Lyons. His other work included stage designs, numerous book illustrations, notably for *Apollinaire's *Bestiare* (1910), and several murals, the largest of which was *The Spirit of Electricity*, commissioned for the Pavilion of Light at the 1937

Paris World Fair and now in the Musée d'Art Moderne de la Ville de Paris. With Othon *Friesz (a friend since boyhood) he did another large mural (1937–40) on the subject of the River Seine for the bar of the Théâtre du Palais de Chaillot, Paris (now in the Pompidou Centre, Paris); Friesz painted the section covering the river from its source to Paris, and Dufy the section from Paris to the sea at Le Havre. In 1952 he was awarded the main painting prize at the Venice *Biennale. His popularity has continued undiminished since his death, not least in Japan, where he is a favourite with collectors.

Dujardin, Édouard. see CLOISONNISM.

Dulac, Edmund (1882–1953). French-born illustrator, designer, painter, and sculptor who settled in England in 1904 and became a British citizen in 1912. Dulac is best known as a book illustrator, particularly for fairy-tale and legendary subjects, in which his sense of fantasy and gifts as a colourist were put to brilliant effect (he was much influenced by Middle and Far Eastern art). In the period before the First World War, when there was a vogue for lavish and expensive children's books, he was Arthur *Rackham's only serious rival in the field. He was also a portrait painter and caricaturist, and a highly versatile designer; his output included much work for the stage (notably for plays by his friend W. B. Yeats), and one of his last commissions was a stamp commemorating the coronation of Queen Elizabeth II in 1953.

Dumitresco, Natalia (1915–). Romanian-born painter who became a French citizen in 1965. She was born in Bucharest, where she studied at the Academy, 1934–9. In 1947 she settled in Paris, where she shared a studio with her countryman *Brancusi. She is an exponent of *Lyrical Abstraction, using fresh colours and calligraphic-like forms. Her husband, Alexandre Istrati (1915–91), whom she married in 1939, was also a Romanian-born abstract painter.

Dunn, Anne. See MOYNIHAN.

Dunoyer de Segonzac, André (1884–1974). French painter, printmaker, and designer. He was born at Boussy-St-Antoine, Seine-et-Oise, and studied at various academies in Paris, 1900–7 (interrupted by military service in 1902–3). Early in his career he went through a period of *Cubist influence, but after the First World War he became recognized as one of the leading upholders of the naturalistic tradition in a period dominated by anti-naturalistic tendencies (see NÉO-RÉALISME). (During the war he was in charge of a camouflage unit, in which Charles *Dufresne, an artist of similar outlook, worked). Segonzac's oil paintings (mainly landscapes, still-lifes, and figure compositions) are often sombre in tone and usually executed in thick paint, emphasizing the weight and earthiness of the forms. His watercolours and etchings, however, are more elegant and spontaneous, with a wider range of subject-matter, including dancers and boxers. He also did designs for the theatre and ballet.

Segonzac's reputation was at its height in the 1930s; he won first prize at the *Carnegie International in 1933 and the main painting prize at the Venice *Biennale in 1934. He is now considered a secondary figure, 'but notable for his serious, impeccable craftsmanship, an example of that famous *belle facture* which has been one of the constituent elements in French painting for centuries and which enables many minor artists to hold a worthy position beside the more imaginative masters' (George Heard *Hamilton). His work is well represented in the Musée de l'Île de France at Sceaux.

Dunstan, Bernard (1920–). British painter, born in Teddington, Middlesex. He studied at the Byam *Shaw School of Art, 1939, and the *Slade School, 1939–41. His work is 'mostly to do with figures in interiors: nudes particularly, but also musical subjects, scenes in galleries and so on; a few portraits; also townscapes, mostly Italian, and the odd landscape. I have always liked the French-English tradition of the 19th/20th century (pre-Cubist) . . . and have never felt a need to do anything different. The combination of everyday charm and solid painting—finding the colour and the pattern by observation—seems to me inexhaustible.' He has had numerous one-man shows, notably a series at Roland, Browse & Delbanco (see BROWSE) between 1952 and 1972, and he has exhibited regularly at the *Royal Academy since 1945; in 1993 a small retrospective of his work was held there to coincide with the publication of his autobiographical book *The Paintings of Bernard Dunstan*. He has also written instructional

manuals, such as *Learning to Paint* (1970). In Jeffrey Archer's novel *Not a Penny More, Not a Penny Less* (1976), the villain, Harvey Metcalfe, is an admirer of Dunstan's work: 'Harvey made a special point of looking at the Bernard Dunstans in the [Royal Academy Summer] Exhibition. Of course, they were all sold. Dunstan was one of the artists whose pictures always sold in the first minutes of the opening day.'

Durand-Ruel, Paul (1831–1922). The best-known member of a family of French picture-dealers. He took over the family firm in Paris in 1865 and is celebrated chiefly as the first dealer to give consistent support to the *Impressionists—his belief in them often brought him close to bankruptcy. The firm was one of the main channels through which the American collector *Barnes and the Russian collectors *Morozov and *Shchukin built up their superb representations of modern French painting. In 1911 Durand-Ruel handed over the business to his sons **Joseph** (1862–1928) and **Georges** (1866–1933). The New York branch of the business (established in 1886) closed in 1950 and the Paris gallery continued until 1974, run by Joseph's son, **Charles** (1905–85).

Eakins, Thomas (1844–1916). American painter, mainly of portraits, active for most of his life in his native Philadelphia. He began teaching at the Pennsylvania Academy of Fine Arts there in 1876 and was attacked for his radical ideas, particularly his insistence on working from nude models. In 1886 he was forced to resign after allowing a mixed class to draw from a completely nude male model, but his ideals were carried on by his successor *Anshutz. Eakins also caused controversy more than once because of the unsparing realism of his work. Financial support from his father enabled him to continue on his chosen course despite public abuse, but much of his later career was spent working in bitter isolation. In 1894 he wrote: 'My honours are misunderstanding, persecution, and neglect, enhanced because unsought.' It was only near the end of his life that he achieved recognition as a great master, and in the first two decades of the 20th century his desire to 'peer deeper into the heart of American life' was reflected in the work of the *Ashcan School and other realist painters. In 1917 a memorial exhibition of his work was held at the Metropolitan Museum, New York, and Robert *Henri—one of Eakins's greatest admirers—wrote an open letter to his students at the *Art Students League, urging them to study the work of the great man: 'His quality was honesty. "Integrity" is the word which seems best to fit him. Personally I consider him the greatest portrait painter America has produced.' This verdict is now shared by most critics; indeed, many consider him the greatest of all American painters. Eakins also made a few sculptures. Little of his work can be seen outside the USA; the best collection is in the Philadelphia Museum.

His wife, **Susan Hannah Macdowell Eakins** (1851–1938), whom he married in 1884, was also a painter and photographer, as well as an accomplished pianist.

Eames, Charles. See BERTOIA.

Eardley, Joan (1921–63). British painter, born in Sussex but considered Scottish (her mother was Scottish and she lived in Scotland from 1940). She studied at Goldsmiths' School of Art, London, 1938–9 (leaving because of the outbreak of war), *Glasgow School of Art, 1940–3, and after working for three years as a joiner's labourer, at the summer school at Hospitalfield House, Arbroath, 1947. Her teacher there was James *Cowie; he perhaps helped to shape her preference for subjects drawn from everyday experience, but her approach was more earthy and sensuous than his. In 1948–9 she travelled abroad, mainly in Italy, on a scholarship awarded by the Royal Scottish Academy. After her return she divided her time between Glasgow (where she painted *Kitchen Sink type subjects) and the fishing village of Catterline, about 20 miles south of Aberdeen on the north-east coast. She discovered this fairly remote spot in 1950 and became increasingly devoted to it, acquiring a house and studio there. Her favourite subjects in her later years were the village and the sea, especially in stormy weather (she is said to have set off from her Glasgow home as soon as she heard reports of gales). The freely painted, often bleak and desolate works that resulted are among the most powerful and individual landscapes in 20th-century British art. After her early death from breast cancer her ashes were scattered on the beach at Catterline. Her work is well represented in the Scottish National Gallery of Modern Art, Edinburgh.

Earnshaw, Harold. See ATTWELL.

earthwork. See LAND ART.

East Anglian School of Painting and Drawing. See MORRIS, SIR CEDRIC.

École de Paris (School of Paris). A term that was originally applied to a number of artists of non-French origin, predominantly Jewish in background, who in the years immediately after the First World War lived in Paris and painted in figurative styles that might loosely be called poetic *Expressionism, forming the most distinctive strand in French painting between *Cubism and *Surrealism. *Chagall (a Russian), *Foujita (a Japanese), *Kisling (a Pole), *Modigliani (an Italian), *Pascin (a Bulgarian), and *Soutine (a Lithuanian) are among the most famous artists embraced by the term. However, the meaning of the term was soon broadened (particularly outside France) to include all foreign artists who had settled in Paris since the beginning of the century (the Dutchman van *Dongen and the Spaniard *Picasso, for example), and then it expanded still further to cover virtually all progressive art in the 20th century that had its focus in Paris. In this broadest sense, the term reflects the intense concentration of artistic activity, supported by critics and dealers, that made the city the world centre of innovative art up to the Second World War.

In 1951 an exhibition devoted to the École de Paris, covering the period 1900 to 1950, was held at the New Burlington Galleries, London. In his introduction to the catalogue Frank McEwen wrote that Paris then had 130 galleries (as opposed to a maximum of 30 in any other capital city), in which were shown the work of some 60,000 artists, one-third of them foreigners; there were 20 large Salons exhibiting annually an average of 1,000 painters each, mostly semi-professionals. George Heard *Hamilton writes of 'the presence in Paris after 1900 of painters and sculptors from every civilised country of the globe. They had come because Paris offered the freest of conditions in which to live and work, as well as unparalleled opportunities for the discussion and exhibition of their work.' Before the First World War the centre of artistic activity was Montmartre. After the war Montmartre was left to the tourists and artistic activity passed to Montparnasse on the Left Bank.

École des Beaux-Arts, Paris. See BEAUX-ARTS.

Eddy, Arthur Jerome (1859–1920). American collector and writer on art. He was a lawyer by profession and spent most of his career in Chicago. The World's Fair held there in 1893 led him to become interested in art, particularly the work of *Rodin (who made a bust of Eddy in 1898) and *Whistler, and he began lecturing on the subject. In 1904 he published *Delight, the Soul of Art*. His interest in contemporary art was galvanized by the *Armory Show (1913), at which he bought more than twenty works. It encouraged him to visit Europe, where he met *Kandinsky, whose work he eagerly collected. In 1914 Eddy published *Cubists and Post-Impressionism*, which is notable as one of the first attempts to explain modern art to an American readership. It includes information from the artists themselves and features the first discussion in English of Kandinsky's ideas. Eddy's collection was dispersed after his death, but several works were acquired by the Art Institute of Chicago.

Eddy, Don (1944–). American *Superrealist painter. He was born in Long Beach, California, and studied at the University of Hawaii, 1965–9, and the University of California, Santa Barbara, 1969–70. In 1972 he began teaching at New York University. Early in his career he concentrated on automobiles or glossy details of them, but since 1971 he has specialized in depictions of shop windows, in which the reflections of the street are treated just as meticulously as the goods for sale (*New Shoes for H*, Cleveland Museum of Art, 1973).

Ede, H. S. (1895–1990). British collector, curator, lecturer, and writer, born in Penarth, Glamorgan, the son of a solicitor; the 'H. S.' stands for Harold Stanley, but from about 1920 he adopted the name 'Jim'. After leaving school he began training as a painter at *Newlyn and then Edinburgh College of Art, but the First World War interrupted his studies. He joined the South Wales Borderers in 1914 and served in France and India. From 1919 to 1921 he studied at the *Slade School, then became the photographer's assistant at the National Gallery. In 1922 he moved to the *Tate Gallery, where he worked until 1936. During this period of 14 years, 'Ede established close contacts with avant-garde artists in Paris but served under a director, J. B. *Manson, who was unable to recognize his talents. Had his friendships with *Picasso, *Braque, *Chagall, *Brancusi, *Mirw, and others been exploited, the Tate could have had an unrivalled collection of early twentieth-century art' (*DNB*). The British artists with whom he

was friendly included Ben and Winifred *Nicholson (whom he met in 1923 and who played an important part in stimulating his interest in contemporary art), Barbara *Hepworth, David *Jones, Henry *Moore, and Christopher *Wood. In 1926 he discovered the work of *Gaudier-Brzeska when his estate was offered to—and declined by—the Tate. Ede acquired much of it and from that point championed the artist's work, by making gifts to museums in Britain and France and by writing *A Life of Gaudier-Brezska* (1930), which was reprinted in 1931 with the title *Savage Messiah*. He was regarded as a leading contender to be next director of the Tate, but he resigned in 1936, being unable to work any longer with Manson (who ironically resigned himself in 1938).

After leaving the Tate, Ede moved to Tangier and supported himself partly with lecture tours in America. In 1952 he moved to France, then in 1956 returned to England. The following year he bought four derelict 17th-century cottages in Cambridge and converted them into a single house that he called Kettle's Yard. 'Here he arranged his by then considerable collection of works of art . . . in a manner which would make modern art not merely approachable but alive, combining his twentieth-century enthusiasms with his love of artefacts and materials from the past. Works of art by Ben Nicholson and Brancusi would sit alongside antique country furniture, ancient stones, flints, and amphora . . . in a building which harmonized the modernist spirit of the 1930s with the experience of living in north Africa. A respect for light and space were the hub of Ede's vision' (*DNB*). The house was open to the public every afternoon, and in 1966 Ede presented it and its contents to the University of Cambridge. An extension and exhibition gallery, designed by Sir Leslie Martin (see *CIRCLE*), were added in 1970, but Kettle's Yard still retains the character of a private home. Apart from Gaudier-Brzeska (the collection of whose work is surpassed only by that of the Pompidou Centre in Paris), the artists who are best represented include David Jones, Ben Nicholson, Alfred *Wallis, and Christopher Wood. Ede moved to Edinburgh in 1973 and lived there for the rest of his life, but he kept close links with Kettle's Yard and published a book on it in 1984: *A Way of Life: Kettle's Yard*.

Edelson, Mary Beth. See FEMINIST ART.

Edinburgh, Scottish National Gallery of Modern Art. See SCOTTISH NATIONAL GALLERY OF MODERN ART.

Edinburgh Group. A group of Scottish painters who exhibited together in 1912, 1913, 1919, 1920, and 1921, adopting the name formally for the last three (post-war) exhibitions. The members of the formal group were: John R. Barclay (1884–1963), William Oliphant Hutchison (1889–1970), Dorothy Johnstone (1892–1980), Mary Newbery (1892–1985), Eric Robertson (1887–1941), J. G. Spence Smith (1880–1951), A. R. Sturrock (1885–1953), who was married to Newbery, D. M. Sutherland (1883–1973), and Cecile Walton (1891–1956). Others who exhibited in the pre-war exhibitions were David Alison (1882–1955), H. A. Cameron (fl. 1901–23), W. M. Glass (1885–1965), and J. W. Somerville (d. 1916). They painted in a variety of figurative styles and attracted a good deal of public and critical attention. In 1920 a reviewer in *The National Outlook* wrote: 'Usually people look to the Edinburgh Group . . . for something unique rather than universal; for something of pagan brazenness rather than parlour propriety. Half Edinburgh goes to [the New Gallery in] Shandwick Place secretly desiring to be righteously shocked, and the other half goes feeling deliciously uncertain it may be disappointed by not finding anything sufficiently shocking.' Interest in the group was fanned by the notoriously involved love lives of several of the members, most notably Eric Robertson. William Hutchison had the most distinguished career of any of the Edinburgh Group artists; he was director of *Glasgow School of Art, 1933–43, and was knighted in 1953.

Eggeling, Viking (1880–1925). Swedish painter, draughtsman, and film maker, born at Lund. After studying painting in Milan and teaching drawing in Switzerland, he moved to Paris in 1911. He met *Arp in 1915 and soon afterwards moved to Switzerland, where he became a member of the *Dada group in Zurich in 1916. In 1918 he met Hans *Richter, who later said that they found themselves in 'complete agreement on aesthetic as well as philosophical matters', and they began collaborating on 'scroll' paintings consisting of sequences of images on long rolls of paper investigating transformations of a given geometrical form. By multiplying, transforming,

and shifting the geometrical elements and combining them with curving lines it was intended to produce in the spectator the impression of continuous movement as he passed from one image to the other. After quarrelling in 1921, Eggeling and Richter went on to work separately on film animation. Eggeling moved to Berlin in 1922 and his *Diagonalsymphonie*, first shown there publicly in 1925, was one of the first purely abstract films. It was in essence an animated version of the drawings in the scroll paintings.

Eight, The. A name of three groups of artists, respectively (1) American, (2) Czech, and (3) Hungarian; they were not connected in any way, but they all originally consisted of eight members, and they were all active in the first decade of the 20th century.

(1) A group of eight American painters who exhibited together in 1908, united by opposition to the conservative National Academy of Design and a determination to bring painting into direct touch with life. The eight members were: Arthur B *Davies, William J. *Glackens, Robert *Henri, Ernest *Lawson, George *Luks, Maurice *Prendergast, Everett *Shinn, and John *Sloan. They banded together when the National Academy of Design rejected work by Glackens, Luks, and Sloan for its 1907 exhibition. Henri, who was the dominant personality of the group and a member of the Academy's jury, withdrew his own work in protest, and Davies was then asked to organize an independent exhibition at the Macbeth Gallery, New York. This took place in February 1908; it was the only exhibition in which The Eight showed together as a group, but it was subsequently circulated to nine other venues over a period of a year and gained a good deal of publicity for their work and ideals. The members of the group were not unified stylistically (one hostile reviewer referred to the 'clashing dissonances of eight differently tuned orchestras'), but their predominant theme was contemporary urban life (several of them were part of the broader trend known as the *Ashcan School). Their exhibition is regarded as an important landmark in American art; its principle of non-juried selection was taken up in the Exhibition of Independent Artists in 1910 (see HENRI), which in turn led the way to the *Armory Show of 1913.

(2) A group of progressive Czech artists formed in Prague in 1906 (the name in Czech is Osma). The members, who were essentially *Expressionist in outlook, held two exhibitions, in 1907 and 1908. These were poorly received and the group ceased to function, although it never officially disbanded. *Filla and *Kubišta were the best-known members.

(3) A group of Hungarian painters founded in Budapest in 1909, the first avant-garde group in Hungarian art (the name in Hungarian is Nyolcak). The members were opposed to *Impressionism, desiring an art that had a greater sense of order and structure, *Cézanne being a major influence. Originally the group was called 'The Seekers'; the name 'The Eight' was adopted in 1911. Károly Kernstok (1873–1940) was the leading figure of the group. It held three exhibitions (1909, 1911, 1912), the first of which prompted an essay by the philosopher Georg Lukács (1885–1971) entitled 'The Ways Have Parted', in which he wrote that The Eight had made 'a declaration of war on Impressionism'. John Willett writes that 'His views are important . . . first and foremost as showing how the Hungarian middle-class radicals interpreted the new art . . . to Lukács, who was philosophically and temperamentally against anything so vague as the essences, atmospheres and impressions which he felt had invaded painting, Kernstok and his group were striking a gratifyingly sharp blow on behalf of Order' (catalogue of the exhibition 'The Hungarian Avant Garde: The Eight and the Activists', Hayward Gallery, London, 1980). The Eight disintegrated after its third exhibition, but it made an important impact on Hungarian art and prepared the way for other groups, particularly the *Activists.

Eight Italian Painters. See GRUPPO DEGLI OTTO PITTORI ITALIANI.

Eilshemius, Louis Michel (1864–1941). American painter, one of the great eccentrics of 20th-century art. Born in New Jersey, the son of a Dutch merchant, he studied at the *Art Students League, New York, 1884–6, and the *Académie Julian, Paris, 1886–7, then travelled widely—in Europe, Africa, and the South Seas—before settling in New York in 1903. His early work, influenced by the *Impressionists, was fairly conventional, but by the turn of the century he had adopted a visionary manner, depicting scenes from a private dream world in which figures often float in the air (*Afternoon Wind*, MOMA, New York,

1899). There is a kinship of feeling with the poetic introverted work of another eccentric, Albert Pinkham *Ryder, but Eilshemius's style was rougher and sometimes had a *naive quality. He adopted the pseudonym 'Mahatma' and grew embittered at the lack of recognition he thought was due to him as 'the world's mightiest mind'. Although he was championed by Marcel *Duchamp (who arranged for him to have a one-man show at the *Société Anonyme in 1920) and by Duncan *Phillips, he abandoned painting in 1921 and failed to profit when his work gained belated recognition in the 1930s.

Ekelund, Ragnar. See NOVEMBER GROUP.

Élan, L'. A periodical published by *Ozenfant in Paris from April 1915 to December 1916 (ten issues). It was intended to form a channel of communication between avant-garde artists serving in the armed forces and those remaining in Paris, and it arranged monthly meetings, attended by *Apollinaire, *Matisse, *Picasso, and other leading figures in the art world. Among the articles that appeared in its pages was Ozenfant's 'Notes sur le cubisme', published in the final issue, in which he aired his objections to the decorative tendencies of Synthetic *Cubism and propounded some of the ideas that later contributed to *Purism.

Elementarism. A modified form of *Neo-Plasticism propounded by van *Doesburg in a manifesto published in De *Stijl in 1926. Whilst maintaining *Mondrian's restriction to the right angle, Elementarism abandoned his insistence on the use of strict horizontals and verticals. By introducing inclined lines and forms van Doesburg sought to achieve a quality of dynamic tension in place of the classical repose of Mondrian: 'Through his diagonal *Counter-Compositions* Van Doesburg believed he could construct a non-reductivist abstract painting capable of a convincing representation of the variety and vitality of life. This embodied a schematic rendering of the dynamics of human experience of movement and changing relationships instead of the static balancing of "universals" found in earlier De Stijl theory and practice' (Paul Overy, *De Stijl*, 1991). Mondrian was so offended by this rejection of his principles that he left De Stijl.

Elkan, Benno. See KEYNES.

Elliott, David. See MUSEUM OF MODERN ART, OXFORD.

El Paso. An association of Spanish artists formed in Madrid in 1957. The name, meaning 'crossing' or 'passage', was meant to suggest movement or renewal. Its founding members were the painters *Canogar, *Feito, *Millares, and *Saura, together with the writers José Ayllón and Manuel Condé. They were soon joined by the painters Manuel Rivera (1927–) and Manuel Viola (1919–87) and the sculptor Martín Chirino (1925–). The group, inspired by *Dau al Set, was important in establishing expressive abstraction or *Art Informel as a major idiom in Spanish art and its work inspired a series of public demonstrations against it. It held exhibitions until 1960.

Éluard, Paul (pseudonym of Eugène Grindel) (1895–1952). French writer, patron, collector, entrepreneur, draughtsman, and collagist, a leading figure of *Surrealism from the beginning of the movement. Éluard is best known as one of the outstanding French poets of the 20th century, but he was deeply interested in the visual arts and was a friend of many distinguished painters, several of whom he commissioned to illustrate his books (notably Max *Ernst, *Man Ray, and *Picasso). He helped to organize various events, including the International Surrealist Exhibition in London in 1936, and he was on the editorial committee of *Minotaure*. His first wife, Gala, later married another leading Surrealist, Salvador *Dalí. Éluard made a varied and constantly changing art collection, including work by many of his contemporaries as well as examples of African and other non-Western art. In the late 1930s he abandoned Surrealism. He joined the Communist Party in 1942 and remained a committed member for the rest of his life. During the Second World War he was the best known of the Resistance writers, his works circulating clandestinely in occupied France.

Emin, Tracy. See YOUNG BRITISH ARTISTS.

empaquetage (packaging). See CHRISTO.

Enckell, Knut Magnus. See SEPTEM.

Energism. See NEO-EXPRESSIONISM.

English, Michael. See SUPERREALISM.

Ensor, James (1860–1949). Belgian painter and etcher (his father was English and he had British nationality until 1929). One of the most original artists of his time, Ensor had links with *Symbolism, was a major influence on *Expressionism, and was claimed by the *Surrealists as a forerunner, but his work defies classification within any school or group. He was born in Ostend, where his parents kept a souvenir shop, and apart from a period studying at the Academy in Brussels, 1877–80, and a few brief trips abroad, he rarely left his home town. His early works were mainly bourgeois interiors painted in a thick and vigorous technique. When several were rejected by the Salon in Brussels in 1883, Ensor joined the progressive group Les Vingt (see LIBRE ESTHÉTIQUE). From about this time his subject-matter changed and he began to introduce the fantastic and macabre elements that are chiefly associated with his name: 'Reason is the enemy of art', he said. 'Artists dominated by reason lose all feeling, powerful instinct is enfeebled, inspiration becomes impoverished and the heart lacks its rapture.' He made much use of carnival masks, grotesque figures, and skeletons, his bizarre and monstrous imaginings recalling the work of his Netherlandish forebears Bosch and Bruegel. The interest in masks probably originated in his parents' shop, but he was also one of the first European artists who appreciated African art, in which they play such a great part. Through his 'suffering, scandalized, insolent, cruel, and malicious masks', as he called them, he portrayed life as a kind of hideous carnival. Often his work had a didactic or satirical flavour involving social and religious criticism; his most famous work, the huge *Entry of Christ into Brussels* (Getty Museum, Malibu, 1888), shows how he imagined Christ might be greeted on a new Palm Sunday. It provoked such an outburst of criticism among his associates in Les Vingt (who refused it for exhibition) that he was almost expelled from the group.

Although Ensor continued to exhibit with the Les Vingt and later with La Libre Esthétique, from this time he became something of a recluse and his work become even more misanthropic. Nevertheless, from about the turn of the century his reputation grew rapidly. In 1899, for example, the Paris journal *La Plume* devoted a special issue to him and organized an exhibition of his work; in 1903 he was made a Knight of the Order of Leopold; in 1905 he was given a large one-man exhibition at L'*Art Contemporain in Antwerp; and in 1908 there appeared the first major monograph on him (by the poet Émile Verhaeren). The culmination of his career came in 1929, when the inaugural exhibition of the Palais des Beaux-Arts in Brussels was devoted to his work (*The Entry of Christ into Brussels* was shown in public for the first time) and he was created a baron by King Albert. His work changed little after about 1900, however, and he was content to repeat his favourite themes. From 1904 he also gave up printmaking (he was one of the greatest etchers of his time and also made some lithographs). There is a museum of his work in Ostend.

entarte Kunst. See DEGENERATE ART.

Environment (or **Environmental**) **art**. An art form in which the artist creates a three-dimensional space in which the spectator can be completely enclosed and involved in a multiplicity of sensory stimulations—visual, auditory, kinetic, tactile, and sometimes olfactory. This type of art was prefigured in the *Proun Rooms for *Lissitzky and the Merzbau of Kurt *Schwitters begun during the 1920s, and in the elaborate decor of some of the *Surrealist exhibitions of the 1930s, as well as in certain types of entertainments at funfairs, but as a movement it originated in the late 1950s and flourished chiefly in the 1960s, when it was closely connected with *Happenings. Allan *Kaprow, who wrote a book called *Assemblage, Environments & Happenings* (1966), gave the following definitions: 'The term "environment" refers to an art form that fills an entire room (or outdoor space) surrounding the visitor and consisting of any materials whatsoever, including lights, sounds and colour . . . The term "happening" refers to an art form related to theatre, in that it is performed in a given time and space. Its structure and content are a logical extension of environments.' Apart from Kaprow, the other leading figures who have worked in Environment art include *Kienholz and *Oldenburg, and one of the most celebrated works in the genre was created by Niki de *Saint Phalle.

The term has been loosely used, and confusingly it has sometimes been applied to *Land art or its analogues—that is, to a category of art that consists in manipulating the natural environment, rather than to an art

that *creates* an environment to enfold and absorb the spectator. *Christo's work, for example, is sometimes described as Environmental art.

Enwonwu, Ben (1921–94). Nigerian sculptor and painter, an Ibo born at Onitsha in Eastern Nigeria. His father was a carver of masks and traditional images for ceremonies and shrines. In 1944 he was awarded a scholarship to study in Britain and in 1947 he took a degree at the *Slade School. Subsequently his work was widely exhibited in Britain, Africa, and the USA, and he won numerous distinctions, including the MBE in 1955. In 1947 he was appointed Art Supervisor by the Nigerian Government and in 1959 Art Adviser to the Federal Government. His public commissions include the bronze statue of Elizabeth II in front of the Federal Parliament, Lagos. Enwonwu's work unites the magical quality of traditional African art with an awareness of contemporary developments in Western art. In his more expressive work there are frequent reminiscences of traditional African tribal styles and in particular his own Ibo art. In his obituary in the *Independent* he was described as 'the leading light in Nigeria's rich aggregation of contemporary artists'.

Epstein, Elizabeth. See BLAUE REITER.

Epstein, Sir Jacob (1880–1959). American-born sculptor (and occasional painter and illustrator) who settled in England in 1905 and became a British citizen in 1911. He was born in New York into a family of Polish-Russian Orthodox Jews. After prospering as a tailor, his father had gone into property. From 1894 to 1902 Epstein studied sporadically at the *Art Students League whilst working at various jobs; he discovered a 'love of the purely physical side of sculpture' when he spent several weeks cutting ice on Greenwood Lake, New Jersey, and this encouraged him to find work in a bronze foundry, 1900–1. At the same time he attended evening classes in sculpture at which he was taught by George Grey *Barnard, whom he admired greatly, referring to him as 'my old master'. In 1902, on the proceeds of his illustrations for *The Spirit of the Ghetto* by the journalist Hutchins Hapgood, Epstein moved to Paris. There he studied at the École des *Beaux-Arts and the *Académie Julian, and visits to the Louvre aroused an interest in ancient and *primitive

sculpture that lasted all his life and powerfully affected his work. In 1905 he moved to London, where he executed his first important commission in 1907–8: eighteen Portland stone figures, over lifesize, for the façade of the British Medical Association's headquarters in the Strand. They aroused a furore of abuse on the grounds of alleged obscenity and were mutilated in 1937 after the building was bought by the government of Southern Rhodesia. Such verbal attacks and acts of vandalism were to become a feature of Epstein's career.

The next outcry came with his tomb of Oscar Wilde (Père Lachaise Cemetery, Paris, 1912), a magnificently bold and original piece featuring a hovering angel inspired by Assyrian sculpture; it was banned as indecent until a bronze plaque had been placed over the angel's sexual organs, and after the plaque was removed in a night raid by a group of artists and poets, a tarpaulin was placed over the tomb and remained in place for two years. Epstein carved the tomb in London (it is in *Hopton Wood stone), but he spent a good deal of time in Paris during the initial period of controversy; he met *Brancusi, *Modigliani, and *Picasso there and was influenced by their formal simplifications. Back in England, he associated with the *Vorticists (although he was never officially a member of the movement), and at this time he created his most radical work—*The Rock Drill* (1913–15), a robot-like figure that was originally shown mounted on an enormous drill; he said it symbolized 'the terrible Frankenstein's monster we have made ourselves into' (casts of the torso are in the Tate Gallery, London, and elsewhere).

Epstein's later work was generally much less audacious than this, but his public sculptures were still attacked with monotonous regularity, their expressive use of distortion being offensive to conservative eyes even when they were immune to charges of indecency (David *Sylvester cites a story of an old lady saying about a figure of Christ: 'I can never forgive Mr Epstein for his representation of Our Lord—so un-*English*'). Often Epstein was mocked as well as censured, and in the 1930s some of his works were even acquired by showmen to be displayed in a kind of seaside freakshow. *Rima*, a stone relief memorial to the naturalist W. H. Hudson in Hyde Park, London (1922), roused perhaps the greatest storm of any of Epstein's works. It was daubed

with green paint and a number of well-known figures petitioned for its removal; they included *Dicksee and *Munnings (present and future presidents of the Royal Academy) and Sir Arthur Conan Doyle. Muirhead *Bone came to its defence with a letter in *The Times*, signed by an equally impressive line-up, including *Dobson, *Kennington, and George Bernard Shaw. In the face of such controversy Epstein concentrated increasingly on bronze portrait busts, which found a more apprecia-tive audience than his monumental works. Many notable men and women sat for him and he portrayed them with psychological intensity and great mastery of expressive sur-faces, carrying on the tradition of *Rodin (Frank *Rutter, indeed, called him 'the great-est modeller since Rodin').

It was only after the Second World War that Epstein's work began to achieve public accept-ance, and in the 1950s he belatedly received a stream of honours (including a knighthood in 1954) and of major commissions. In 1956 he wrote: 'I am inundated with requests for work on buildings, large works which I don't know I will ever be able to accomplish. I was for so long without any commissions, I don't feel like turning down anything that comes my way: but it is all coming too late I'm afraid.' Almost all these commissions were in bronze, including the huge *St Michael and the Devil* (1956–8) at Coventry Cathedral, but Epstein was also a formidable carver and two of his finest late works are in stone: *Lazarus* (New College Chapel, Oxford, 1947–8) and the Trades Union Congress War Memorial (Congress House, Great Russell Street, London, 1956–7).

Epstein published an autobiography, *Let There Be Sculpture*, in 1940 (a revised edition, entitled *An Autobiography*, came out in 1955). *The Sculptor Speaks* (a series of his conversa-tions on art) appeared in 1931. A few days after Epstein's death, Henry *Moore paid tribute to his central role in the development of modern sculpture in Britain: he 'took the brickbats . . . the insults . . . the howls of derision with which artists since Rembrandt have learned to become familiar. And as far as sculpture in this century is concerned, he took them first.'

Eragny Press. See PISSARRO.

Erbslöh, Adolf. See NEUE KÜNSTLERVEREINI-GUNG MÜNCHEN.

Ernest, John. See CONSTRUCTIVISM.

Ernst, Jimmy (1920–84). German-born Ameri-can painter, originally called Ulrich Ernst. He was born at Brühl, the son of Max *Ernst and his first wife, the art critic Louise Strauss. After leaving school he studied typography and became a printer's apprentice, but he had no formal training in painting. In 1939 he emigrated to the USA and in 1941 he had his first one-man exhibition at the Norlyst Gallery, New York. He was a friend of *Matta and his painting was in a vein of *Surrealist abstraction influenced by him.

Ernst, Max (1891–1976). German-born painter, printmaker, collagist, and sculptor who became an American citizen in 1948 and a French citizen in 1958, one of the major fig-ures of *Dada and even more so of *Surreal-ism. He was born at Brühl, near Cologne; his father, who taught at a school for deaf and dumb children, was a keen amateur painter. A nervous and imaginative child, he was strangely affected at the age of 14 by the death of a favourite cockatoo on the same day as the birth of a sister. Later (referring to himself in the third person) he wrote that 'In his imagi-nation Max coupled these two events and charged the baby with the extinction of the bird's life. There followed a series of mystical crises, fits of hysteria, exaltations and depres-sions. A dangerous confusion between birds and humans became fixed in his mind and asserted itself in his drawings and paintings' (he came to identify himself with Loplop, a birdlike creature that features in many of his works). In 1909 Ernst began to study philo-sophy and psychology at Bonn University, but he became fascinated by the art of psychotics (he visited the insane as part of his studies) and in 1911 he abandoned academic study for painting. He had no professional training as an artist, but he was influenced by August *Macke, whom he met in 1911. Throughout the First World War he served as an artillery engineer, but thanks to an art-loving com-manding officer he was sometimes able to paint, and he exhibited at the *Sturm Gallery in 1916. After the war he settled in Cologne, where with his lifelong friend *Arp (whom he had met in 1914) he became the leader of the city's Dada group. In 1920 he organized one of Dada's most famous exhibitions in the con-servatory of a restaurant: 'In order to enter the gallery one had to pass through a public lavatory. Inside the public was provided with hatchets with which, if they wanted to, they

could attack the objects and paintings exhibited. At the end of the gallery a young girl, dressed in white for her first communion, stood reciting obscene poems' (David Gascoyne, *A Short History of Surrealism*, 1935).

In 1922 Ernst settled in Paris, where he joined the Surrealist movement on its formation in 1924. Even before then, however, he had painted works that are regarded as Surrealist masterpieces, such as *Celebes* (Tate Gallery, London, 1921) in which an elephant is transposed into a strange mechanistic monster. The irrational and whimsical imagery seen here, in part inspired by childhood memories, occurs also in his highly original collages. In them he rearranged parts of banal engravings from sources such as trade catalogues and technical journals to create strange and startling scenes, showing, for example, a child with a severed head in her lap where a doll might be expected. He also arranged series of such illustrations with accompanying captions to form 'collage novels'; the best-known and most ambitious is *Une Semaine de bonté* ('A Week of Kindness'), published in Paris in 1934. Other imaginative techniques of which he was a leading exponent were *frottage (which he invented in 1925) and *decalcomania. In 1930 he appeared in the Surrealist film *L'Age d'or*, created by Luis Bunuel and Salvador *Dalí, and in 1935 he made his first sculpture (he worked seriously but intermittently in this field, characteristically creating totemic-like figures in bronze).

Ernst left the Surrealist group in 1938, as he refused to comply with André *Breton's demand that members should 'sabotage in every possible way the poetry of Paul *Éluard' (a close friend of Ernst), but the break did not affect his work stylistically. At this time he was living with the British Surrealist painter Leonora *Carrington, whom he had met in 1936. They set up home at St-Martin-d'Ardèche, near Avignon, but in 1939, after the outbreak of the Second World War, he was interned as an enemy alien. Éluard helped to secure his release, but he was twice more interned, escaping each time. In 1941 he managed to flee to the USA, where he stayed until 1953 (apart from a visit to France in 1948), living first in or near New York and then in Arizona. While in the USA he collaborated with Breton and *Duchamp in the periodical *VVV*. He was briefly married (his third of four wives) to the American art dealer Peggy

*Guggenheim, then in 1946 married the American Surrealist painter Dorothea *Tanning. In 1953 they settled in France, living first in Paris and then from 1955 in Huismes, Loire. Ernst had often struggled financially early in his career, but in 1954 he won the main painting prize at the Venice *Biennale and this marked the beginning of a much honoured old age, when he received many awards and was the subject of several major retrospective exhibitions. His work of this time became more lyrical and abstract.

Erró (Gudmundur Gudmundsson) (1932–). Icelandic painter, active mainly in Paris, which has been the principal centre of his activity since 1958. He is a leading exponent of *Pop art, his most characteristic works being large canvases of densely packed arrays of consumer goods or foodstuffs. He has also made films and taken part in *Happenings.

'Erster Deutscher Herbstsalon'. See STURM.

Erté (Romain de Tertoff) (1892–1990). Russian-born French designer, painter, and sculptor. He was born in St Petersburg into an aristocratic family and in 1912 moved to Paris, where he studied at the *Académie Julian. Erté was best known for his fashion illustrations (particularly for the American magazine *Harper's Bazaar*) and for his costume and set designs for theatre, cabaret, opera, ballet, and cinema (he designed costumes for Mata Hari among other celebrities). However, he also painted, and in the 1960s he made lithographs and sculptures of sheet metal.

Escher, M. C. (Maurits Cornelis) (1898–1972). Dutch printmaker. He was born in Leeuwarden and studied at the School of Ornamental Design in Haarlem, 1919–22, becoming a virtuoso craftsman in woodcut; later he took up lithography and wood engraving. He lived in Italy from 1922 to 1934, then successively in Switzerland and Belgium, before returning to the Netherlands and settling in Baarn in 1941. His early prints were mainly landscapes and townscapes in a bold but fairly naturalistic style; however, after he left Italy he turned increasingly to what he described as 'inner visions'. Many of these were expressed as sophisticated designs in which repeated figures of stylized animals, birds, or fish are arranged in dense, interlocking patterns. From about 1940 the bizarre element in his

work became more overtly *Surrealist, particularly in the kind of print for which he is now most famous—views of strange imaginary buildings in which he made brilliant play with optical illusion to represent, for example, staircases that lead both up and down in the same direction (*Ascending and Descending*, 1960). He said of his work: 'By keenly confronting the enigmas that surround us, and by considering and analyzing the observations that I had made, I ended up in the domain of mathematics. Although I am absolutely innocent of training or knowledge in the exact sciences, I often seem to have more in common with mathematicians than with my fellow artists.' His prints have indeed been of considerable interest to mathematicians as well as psychologists involved with visual perception; an exhibition of them was given at the International Mathematical Congress in Amsterdam in 1964. At the same period Escher's work found a large popular audience, especially among young people, some of whom felt that his images complemented the 'mind-expanding' experiences gained through hallucinogenic drugs.

Espace. See GROUPE ESPACE.

Esprit nouveau, L'. A periodical edited by *Le Corbusier and *Ozenfant, published in Paris from October 1920 to January 1925 (it was theoretically a monthly but appeared irregularly—28 issues in all). It was the main channel for promoting the ideas of *Purism, but it also provided a platform for other views on contemporary art (its subtitle was *Revue internationale illustrée de l'activité contemporaine*). The contributors included Roger *Bissière, André *Breton, Jean *Cocteau, Max *Jacob, Fernand *Léger, Jean *Lurçat, the poet Blaise Cendrars, and the composer Erik Satie.

Estes, Richard (1936–). American painter and printmaker, one of the best-knownesponents of *Superrealism. Born in Kewanee, Illinois, he studied at the Art Institute of Chicago, 1952–6, and settled in New York in 1959. He worked as a graphic artist for several years and did not devote himself full-time to painting until 1966. His first one-man show was at the Allen Stone Gallery, New York, in 1968, and by the end of the decade he was a leading figure in his field. Estes's work is devoted to the urban landscape; early paintings focused on people, but since about 1967

buildings have been the main point of interest. He usually depicts fairly anonymous or typical pieces of streetscape, however, his only 'portrait' of a well-known building being his commissioned painting of the Solomon R. Guggenheim Museum (Guggenheim Museum, New York, 1979). His method of work is to take several photographs of a scene and then combine parts of them until the 'feel' is right. Unlike many Superrealists, he works with traditional brushes rather than airbrushes, often using acrylic paint and then switching to oils for the finishing touches to obtain extra clarity of focus. He presents the city as a visual spectacle, usually in bright light, so that even the garbage looks glossy. Estes has also made very elaborate *screenprints.

Estève, Maurice (1904–). French painter, printmaker, and designer, born in Culan, Cher. He worked at a variety of jobs, notably as a designer for a textile factory in Barcelona, before studying at the Académie Colarossi in Paris in 1924. In 1930 he had his first one-man exhibition (at the Galerie Yvangot) and in 1937 he assisted Robert *Delaunay on his mural decorations for the Paris World Fair. His main subjects at this time were figure compositions, interiors, and still-lifes, and these formed the basis for the abstract style that he gradually developed in the 1940s, featuring tightly-knit interlocking shapes. In the 1950s he acquired an international reputation as one of the leading abstract painters of the *École de Paris. He also made collages and designed stained glass.

Estorick, Eric and Salome. See FUTURISM.

Etchells, Frederick (1886–1973). British painter (of figure compositions, portraits, and still-lifes), architect, designer, and writer. He was born in Newcastle upon Tyne, the son of an engineer, and studied at the *Royal College of Art, 1908–11. In the second decade of the century he was active in some of the most avant-garde developments in British art: he showed six paintings at Roger *Fry's second *Post-Impressionist exhibition in 1912, for example, he worked briefly for the *Omega Workshops in 1913 before siding with Wyndham *Lewis in his quarrel with Fry (Etchells's textile designs are regarded as some of the best work produced by Omega), and he participated in the *Vorticist exhibitions in London

in 1915 and New York in 1917. From about 1920, however, he concentrated on architecture. He translated *Le Corbusier's *Towards a New Architecture* (1927) and *The City of Tomorrow* (1929), and his most important building—the office block for W. S. Crawford Ltd. in High Holborn, London (1930)—has been described by Sir Nikolaus Pevsner as 'a pioneer work in the history of modern architecture in Britain'. Later Etchells specialized in church architecture and restoration, and with G. W. O. Addleshaw wrote *The Architectural Setting of Anglican Worship* (1948). In 1912 Vanessa *Bell had described Etchells as a 'somewhat uncouth north-country youth'; in 1931 she met him by chance in London and wrote to Roger Fry: 'He is now a flourishing architect and has a house in Davies St. where he lives and has offices and employs several young men and a youngish woman who also lives there. He owned a car and also a house and a wife near Uckfield! Altogether I have never seen anyone so changed except that he is still a bore.'

Etching Revival. A term applied in Britain to a renewal of interest in etching as a creative printmaking technique, lasting from about 1860 to the First World War, following a period when etching had been used mainly for commercial work such as book illustration. The leading light of the revival was *Whistler, one of the greatest etchers of all time, who settled in England in 1859. He particularly encouraged three other important figures in the movement: his brother-in-law Sir Seymour Haden (1818–1910), an amateur artist (he was a surgeon by profession) who in 1880 became first president of the Royal Society of Painter-Etchers and Engravers, an organization that did much to enhance the status of printmaking as an independent art form; his friend Alphonse *Legros, who became an influential teacher of etching at the *Slade School; and *Sickert, who was Whistler's most illustrious pupil and one of the greatest etchers as well as painters of his period. Other outstanding British etchers at the turn of the century included Muirhead *Bone, D. Y. *Cameron, Frank *Short, and William *Strang. The Revival also attracted many uninspired followers, however, including amateurs, and in 1912 Sickert published an essay entitled 'The Old Ladies of Etching-Needle Street' in which he wittily attacked his less gifted brethren. The First World War dealt a severe blow to the Revival, and the market in prints declined sharply in the early 1930s during a period of worldwide economic slump.

Euston Road School. A name coined in 1938 by Clive *Bell for a group of British painters centred round the 'School of Drawing and Painting' that opened in a studio at 12 Fitzroy Street, London, in 1937, and soon transferred to nearby 316 Euston Road. Its founding teachers were William *Coldstream, Victor *Pasmore, and Claude *Rogers, and the organizing secretary was Thelma Hulbert (1913–95), whose work included landscapes and pictures of birds and flowers; Lawrence *Gowing was also an important member of the circle. These artists advocated a move away from modernist styles to a more straightforward naturalism. The School's prospectus said that 'In teaching, particular emphasis will be laid on training the observation, since this is the faculty most open to training'. By encouraging sound skills in representational painting, the teachers hoped to end the isolation of artist from public that avant-garde movements had created. The outbreak of the Second World War in 1939 caused the School to close, but although it was so short-lived, it was influential; the term 'Euston Road' was used for a decade or so afterwards as a generic description for painting done in a style similar to that practised by the founders. Coldstream, through his position as professor at the *Slade School, was the chief upholder of the tradition.

Evans, Garth (1934–). British sculptor and printmaker, born in Cheadle, Cheshire. He studied at Manchester Regional College of Art, 1955–7, and the *Slade School, 1957–60. His work is *Minimalist, mainly in strip steel and painted wood. He has taught at Camberwell School of Art, *St Martin's School of Art, and the Slade School, and in 1973 he was visiting professor at the Minneapolis College of Art and Design.

Evans, Merlyn (1910–73). British painter, printmaker, and sculptor. He was born in Cardiff and grew up in Glasgow, where he studied at the School of Art from 1927 to 1930. During this period he was already experimenting with abstract art. A travelling scholarship then took him to France, Germany, Denmark, and Sweden, after which he continued his studies at the *Royal College of Art in

London and from 1934 to 1936 in Paris, where he worked in *Hayter's printmaking studio and met many leading artists, including *Kandinsky and *Mondrian. His work at this time was influenced by both *Cubism and *Surrealism, and he took part in the International Surrealist Exhibition in London in 1936. From 1938 to 1942 he lived in South Africa, teaching at the Natal Technical College in Durban. In the early 1940s his work included some anti-war paintings in a style owing something to *Vorticism, but from 1942 to 1945 he served with the army in North Africa and Italy. After the war he settled in London, where he had his first substantial one-man exhibition at the *Leicester Galleries in 1949. From the 1950s his paintings tended to grow larger and more abstract. He occasionally made sculpture and was regarded as one of the leading British printmakers of his day; some of his prints were in mezzotint, a technique he helped to revive. From 1965 until his death he taught painting at the Royal College of Art.

Evans, Myfanwy. See *AXIS* and PIPER.

Eve, Jean. See NAIVE ART.

Evergood, Philip (1901–73). American painter, born in New York, the son of Myer Blashki, a landscape painter of Australian-Polish descent (Blashki changed his surname in 1914, anglicizing it to a version of his mother's maiden name, Immergut). Philip's mother came from a cultured British family and in 1909 he was sent to England to receive the best possible education. After schooling at Eton, he went to Trinity Hall, Cambridge, where he studied English literature, but he left without taking a degree to go to the *Slade School, 1921–3. Subsequently he studied at the *Art Students League in New York, 1923–4, and the *Académie Julian in Paris, 1924–6. He returned to Paris in 1929–31 and during this time briefly studied engraving under *Hayter. His early works were mainly of biblical and imaginative subjects, but after settling in New York in 1931 he became a leading figure among the *Social Realists who used their art as an instrument of protest and propaganda during the Depression years. He described how 'one of the things I saw that probably drove me faster into this way of thinking' was coming across a group of 'outcasts of New York' huddled around a fire on a

cold winter's night: 'I went over to the fire and talked to them . . . their tragedy hit me between the eyes because I had never been as close to anything like that before. Then I got a brain wave. It seemed to me that I should be involved in my work with this kind of thing. So I . . . got some drawing materials and came back and sat with them and drew all night.' He became involved in several organizations concerned with the civil rights of artists, and under the banner of the *Federal Art Project he produced militant paintings of social criticism, his best-known work in this vein being *American Tragedy* (Whitney Museum, New York, 1937), which commemorates a police attack on striking steel workers in Chicago.

After the 1930s Evergood was less concerned with topical or political themes and returned to allegorical and religious paintings, but these too sometimes had sociological overtones, as in *The New Lazarus* (Whitney Museum, 1954), with its figures of starving children. He experimented technically (sometimes, for example, mixing marble dust with his paint to obtain a textured surface) and his work was varied stylistically; at times his inclination for the bizarre and the grotesque brought his work close to *Surrealism, as is seen particularly in his most famous work, *Lily and the Sparrows* (Whitney Museum, 1939). Evergood taught at various universities and won numerous awards.

experimental art. An imprecise term applied to art that is concerned with exploring new ideas and/or technology. It is sometimes used virtually synonymously with '*avant-garde', but 'experimental' usually suggests a more explicit desire to extend the boundaries of the art in terms of materials or techniques, whereas 'avant-garde' can include novel ideas expressed through traditional means. John A. Walker (*Glossary of Art, Architecture and Design Since 1945*, 1973, 3rd edn., 1992) writes that 'it is a word with both positive and negative connotations: it is used to praise and condemn. Those writers for whom it is a term of praise often mean by it an empirical practice in which the artist plays with his materials and adopts chance procedures in the expectation that something of value will result . . . Those writers for whom "experimental" is a pejorative description mean by it "a trial run", "not the finished work", "something transitional".' Walker points out that in E. H. Gombrich's celebrated book *The Story of Art*,

first published in 1950, the whole of 20th-century art was originally embraced in a chapter called 'Experimental Art'.

Expressionism. A term employed in the history and criticism of the arts to denote the use of distortion and exaggeration for emotional effect. The term is used in several different ways and can be applied to various art forms. In the pictorial arts, it can be used in its broadest sense to describe art of any period or place that raises acute subjective feeling above objective observation, reflecting the state of mind of the artist rather than images that conform to what we see in the external world. The paintings of the 16th-century artists Grünewald and El Greco, which convey intense religious emotion through distorted forms, are outstanding examples of expressionism in this sense (when used in this way the word is usually spelled with a small 'e'). More commonly, the term is applied to a trend in modern European art in which strong, non-naturalistic colours and distorted or abbreviated forms were used to project inner feelings. More specifically, the term is used for one aspect of that trend—a movement that was the dominant force in German art from about 1905 until about 1930. (In the German-speaking countries Expressionism also had a powerful effect on other arts in this period, notably drama, poetry, and the cinema, which often show a common concern with the eruption of irrational forces from beneath the surface of the modern world. Some music, too, is described as Expressionist because of its emotional turbulence and lack of conventional logic, and there are also a few remarkable Expressionist buildings, although the most startling architectural designs remained on paper.)

In the second (broad European) sense described above, Expressionism traces its beginnings to the 1880s, but it did not crystallize into a distinct programme until about 1905, and as a description of a movement the term itself is thought to have been first used in print in 1911—in an article in Der *Sturm (it was used more loosely long before this, in English and in German). The most important forerunner of Expressionism was the Dutch painter Vincent van Gogh (1853–90), who consciously exaggerated natural appearances 'to express . . . man's terrible passions'. He was virtually unknown at the time of his death, but his reputation grew rapidly after that and

his work made a major impact at a number of exhibitions in the early years of the 20th century. His first retrospective after the turn of the century was at the Galerie *Bernheim-Jeune in Paris in 1901; this and his exhibition at the *Salon des Indépendants in 1905 were important in the development of *Fauvism (for an example of the overwhelming effect the Bernheim-Jeune show had on one of the future Fauves, see VLAMINCK). In 1905 a huge exhibition of van Gogh's work was held at the Stedelijk Museum, Amsterdam, and his influence reached England with Roger *Fry's first *Post-Impressionist exhibition of 1910. He was the dominant artist at the great *Sonderbund exhibition in Cologne in 1912 and was well represented at the *Armory Show in New York in 1913.

Van Gogh's friend *Gauguin was also important for the development of Expressionism. His own work cannot be described as Expressionist, but he was the first to accept explicitly the principles of *Symbolism, which in turn influenced Expressionism. He simplified and flattened forms, and sometimes used colour in a way that abandoned all semblance of realism. As a counterpart to his stylistic innovations, Gauguin sought for simplicity of subject-matter and found it first in the peasant communities of Brittany and later in the islands of the South Pacific. In turning away from European urban civilization, he discovered folk art and *primitive art, both of which later became of absorbing interests for the Expressionists.

A third fundamental influence on Expressionism (especially in Germany, where he spent much of his career) was the Norwegian Edvard *Munch, who knew the work of van Gogh and Gauguin well. From the mid-1880s he began to use violent colour and linear distortions to express the most elemental emotions of fear, love, and hatred. In his search to give pictorial form to the innermost thoughts that haunted him he came to appreciate the abrasive expressive potential of the woodcut—its revival as an independent art form (in which Gauguin also played a prominent role) was a distinctive feature of Expressionism; many of the leading German artists of the movement did outstanding work in the medium. Another artist whose formative influence on Expressionism was spread partly through the medium of prints (in this case etchings) was the Belgian James *Ensor, who depicted the baseness of human nature

by the use of grotesque and horrifying carnival masks.

The first Expressionist groups appeared almost simultaneously in 1905 in France (the Fauves) and Germany (Die *Brücke). Matisse, the leader of the Fauves, summed up their aims when he wrote in 1908: 'What I am after above all is expression . . . The chief aim of colour should be to serve expression as well as possible . . . The expressive aspect of colours imposes itself on me in a purely instinctive way. To paint an autumn landscape I will not try to remember what colours suit this season; I will be inspired only by the sensation that the season arouses in me.' Even at their most violent, however, the Fauves always retained harmony of design and a certain decorativeness of colour, but in Germany restraint was thrown to the winds. Forms and colours were tortured to give vent to a sense of revolt against the established order. *Kirchner, the dominant figure of Die Brücke, wrote in 1913: 'We accept all the colours that, directly or indirectly, reproduce the pure creative impulse.'

The high point of German Expressionism came with the *Blaue Reiter group, formed in Munich in 1911 with *Kandinsky and *Marc as leaders. These two and other members tried to express spiritual feelings in art and their work was generally more mystical in outlook than of the Brücke painters. The Blaue Reiter was dispersed by the First World War (during which Marc and another key member, August *Macke, were killed), but after the war Expressionism became widespread in Germany. Even artists such as Otto *Dix and George *Grosz, who sought a new and hard realism (see NEUE SACHLICHKEIT), kept a good deal of Expressionist distortion and exaggeration in their work. However, Expressionism was suppressed by the Nazis when they came to power in 1933, along with all other art they considered *degenerate. It revived after the Second World War, and Germany has been one of the main homes of its descendant *Neo-Expressionism.

In its broadest sense, the influence of Expressionism can be seen in the work of artists of many different persuasions—*Chagall and *Soutine for example—and in movements such as *Abstract Expressionism.

Exter, Alexandra (née Grigorovich) (1882–1949). Russian painter and theatrical designer. She was born at Belestok, in the Kiev region of the Ukraine, and studied at the Kiev School of Art, graduating in 1906. In 1908 she visited Paris for the first time and from then until the outbreak of the First World War she made regular visits there, forming a link between the Western avant-garde and that in Russia (she knew *Apollinaire, *Braque, and *Picasso, among other luminaries). Her work was shown at numerous avant-garde exhibitions in Russia in this period, in Moscow, St Petersburg, and elsewhere; she was a member of the *Knave of Diamonds and the *Union of Youth, for example, and M. N. Yablonskaya writes that 'Because of her Western contacts Exter was always treated with respect by the Russian avant-garde and was ofen consulted as an authority on Western developments' (*Women Artists of Russia's New Age*, 1990).

Exter's early paintings were influenced by various modernist styles, including *Futurism and *Cubism, and by 1917 she had arrived at complete abstraction, using interpenetrating, semi-geometrical slabs of colour in a manner that is something like a cross between *Delaunay's *Orphism and *Malevich's *Suprematism. From 1917 to 1921 she taught at her own studios first in Odessa (1917–18) and then in Kiev (1918–21). Her pupils, who included Pavel *Tchelitchew, helped her to create huge abstract designs for agit-steamers (propaganda boats) and agit-trains, which the new Soviet government used to celebrate the Russian Revolution and spread knowledge of it (see AGITPROP ART). Her most impressive and original work, however, was as a stage designer, particularly for Alexander Tairov's Kamerny (Chamber) Theatre in Moscow between 1916 and 1921. In powerful *Constructivist sets she explored the architectural potential of the stage through what she called 'the dynamic use of immobile form', avoiding traditional decorative illusionism on the one hand and flat stylization on the other. Perhaps her most famous set design is for *Romeo and Juliet* (1921), in which she pioneered multi-level staging; the set was 'conceived as a dynamic three-dimensional construction comprising ladders, platforms, rails, and inclined planes which were brought to life by their bold intersection and the bright colours of the beams of light which played on them. The various vertical levels of the set were transformed into different locations by the rapid furling and unfurling of curtains' (Yablonskaya). Exter

also designed Constructivist costumes (made from 'industrial materials') for the science fiction film *Aelita* (1923). Her friend the poet Benedikt Livshits called her an 'Amazon of the avant-garde'.

In 1924 Exter settled in Paris, and she lived in France for the rest of her life. She earned part of her living from teaching (at her friend *Léger's school and in her own studio), but in her later career she was mainly active as a theatre, ballet, and fashion designer. She also made witty marionettes (for an unrealized film), using a variety of materials and motifs drawn from Cubism and Suprematism. A good collection of her drawings for stage designs is in the Victoria and Albert Museum, London.

Eyck, Charles (1897–1962). Dutch painter, sculptor, and designer. He often worked on a large scale, particularly as a church decorator. His best-known work is probably his bronze sculpture group in Maastricht commemorating the liberation of the city from the Germans in 1944; it was the first Dutch city to be freed.

fabricated photography. See PHOTO-WORK.

Fairweather, Ian (1891–1974). Scottish-born Australian painter. Fairweather was an off-beat character who led a pictureque life; he was also, according to Robert *Hughes, '[arguably] the most gifted painter who has so far appeared in Australia'. After serving in the British army in the First World War, he studied intermittently at the *Slade School, 1919–24, then travelled the world. In 1934 he visited Melbourne, where he obtained a commission to paint a mural for the Menzies Hotel. Because it was compared unfavourably with the work of *Brangwyn he destroyed it and boarded a ship bound for the Philippines the following morning. From 1940 to 1943 he served as a captain in the British army in India. On being invalided out he lived in Melbourne and then near Cairns before moving to Darwin. In April 1952 he attempted to sail from Darwin to Dili in Timor on a raft made of softwood and petrol drums. He was presumed lost at sea and an obituary appeared in the *Melbourne Herald* on 13 May 1952, but thirteen days later he landed on a Timor beach. The Indonesian authorities refused him permission to stay and eventually deported him to Singapore, where he was placed in a home for the destitute. He was eventually returned to England as a result of the intervention of British government authorities, but after some disagreeable experiences, such as digging ditches in the winter to repay his fare, he returned to Sydney in 1953. He constructed a hut for himself on Bribie Island, off the Queensland Coast near Brisbane, and lived and worked there until his death.

Fairweather painted mainly in earth colours used by the artists of South-East Asia and the Pacific and he was one of the first artists to assimilate aboriginal art into his own work. He also had a great admiration for Chinese art and civilization, which was expressed in his fluent, calligraphic style. He began as a painter of figure subjects, but his work 'moved gradually towards an abstraction that allowed him to transcend personal anxieties and construct a cosmological or religious vision in which, most perfectly in *Monastery* [NG, Canberra, 1961], the movement of becoming and the stillness of being could be held in a tenuous equilibrium. Fairweather took no part in the artistic movements of his time, but his work was so exemplary in its integrity that it has formed a local reference-point for Australian abstract painting ever since' (Christopher Allen, *Art in Australia*, 1997).

Falk, Robert (1886–1958). Russian painter (mainly of landscapes, portraits, and still-life), graphic artist, and stage designer, born in Moscow. His early work was influenced by *Cézanne and he was a founder member of the avant-garde *Knave of Diamonds group in 1909. He was also a member of the *World of Art group and of *AKhRR. From 1918 to 1928 he taught at *Vkhutemas, and from 1928 to 1938 he lived in France. After his return to Russia he taught at the Samarkand Regional Art Institute, then in 1944 settled again in Moscow, where he lived for the rest of his life and taught at the Moscow Institute of Aplied and Decorative Art. His later works tended towards mild *Expressionism. In 1962, four years after his death, they were attacked by Khrushchev, and the press branded him a 'cultural deviationist'. In 1966, however (two years after Khrushchev's downfall), a comprehensive retrospective exhibition of Falk's work in Moscow rehabilitated him from official censure.

Fantastic Realism (Phantastischer Realismus). A style of painting that developed in Vienna in the late 1940s. Its exponents, mainly pupils of *Gütersloh, depicted a fairy-

tale world of fantasy and imagination with minute detail. They shared an interest in the art of the past, notably that of Pieter Bruegel (supremely well represented in the Kunsthistorisches Museum in Vienna) and their paintings were often literary and anecdotal in character. Ernst *Fuchs is the best-known representative of Fantastic Realism; others include Erich Brauer (1929–), Rudolf Hausner (1914–), Wolfgang Hutter (1928–), Gütersloh's illegitimate son, and Anton Lehmden (1929–).

Fascist art. See TOTALITARIAN ART.

Fattah, Ismail (1934–). Iraqi sculptor and painter, born in Basra. He graduated from the Institute of Fine Arts in Baghdad in 1958, then continued his studies in Rome. In the 1970s he produced various murals and sculptures for public buildings in Baghdad, and in 1981–3 carried out his most famous work, the enormous Martyrs' Monument commemorating the dead in the Iran–Iraq War. Situated in the middle of an artificial lake in Baghdad, it consists of an onion dome about 40 metres high, split in half to reveal the Iraqi flag rendered in twisted metal.

Fauteux, Roger. See AUTOMATISTES.

Fautrier, Jean (1898–1964). French painter, sculptor, and printmaker, born in Paris. He was illegitimate and was brought up by his grandmother. In 1908 both she and his father died and Fautrier moved to London to live with his mother. He began studying at the *Royal Academy in 1912, when he was fourteen, and also studied briefly at the *Slade School. In 1917 he was called up into the French army and was gassed. After the war he returned to Paris, where he exhibited regularly at the *Salon d'Automne and in commercial galleries; his work included still-lifes, portraits, and nudes in a style similar to that of *Derain. He achieved considerable success in the 1920s (André *Malraux was one of his admirers), but the economic decline of the 1930s damaged his market and from 1935 to 1939 he worked as a ski instructor in the Alps. He returned to Paris in 1939, but after being briefly imprisoned by the Germans in 1943 he fled to Châtenay-Malabry on the outskirts of the city, living there for the rest of his life. His new home was within earshot of woods where the Nazis carried out massacres, and it was here that Fautrier began the series for which he is particularly famous—*Hostages*, inspired by his horror at brutality and suffering in wartime. These strange paintings feature layer upon layer of heavy paint creating a central image that is abstract but suggests a decaying human head. The pale powdery colours evoke death, but the delicacy of the handling gives them a mysterious ambivalence. They were exhibited at the Galerie René Drouin in Paris in 1945 and were much acclaimed. Fautrier also created sculptural versions of the *Hostages* (examples of both types are in the Musée de l'Île de France, Sceaux).

The painted *Hostages* have been seen as forerunners of *Art Informel, and with the postwar vogue for this kind of expressive abstraction Fautrier gained a reputation as one of the leading painters of the *École de Paris. Many exhibitions of his work were held in the 1950s, including one at the Institute of Contemporary Arts in London in 1958 that led Herbert *Read to comment—somewhat excessively—that 'Fautrier, no less than *Kandinsky, or *Klee, or *Pollock, is a pioneer of a movement which has transformed the whole basis and intention of the plastic arts'. In 1960 he won the Grand Prix at the Venice *Biennale. Fautrier's other works included prints (notably lithographs illustrating Dante's *Inferno*, 1928), and he developed a novel type of work called 'multiple originals', printing a basic drawing on anything up to 300 canvases and then completing each work by hand. He first exhibited such works in 1950. See also MULTIPLES.

Fauvism. Movement in painting based on the use of intensely vivid, non-naturalistic colours; centred on a group of French artists who worked together from about 1905 to 1907, it was the first of the major avant-garde movements in European art in the period of unprecedented experimentation between the turn of the century and the First World War. The dominant figure of the Fauvist group was Henri *Matisse, who used vividly contrasting colours as early as 1899, but first realized the potential of colour freed from its traditional descriptive role when he painted with *Cross and *Signac in the bright light of St-Tropez in the summer of 1904 and with *Derain at Collioure in the summer of 1905. The Fauves first exhibited together at the *Salon d'Automne of 1905 and their name was given

to them by the critic Louis *Vauxcelles, who pointed to a Renaissance-like sculpture in the middle of the same gallery and exclaimed: 'Donatello au milieu des fauves!' (Donatello among the wild beasts). The remark was printed in the 17 October issue of *Gil Blas* and the name immediately caught on. Predictably, the Fauvist pictures came in for a good deal of mockery and abuse; Camille *Mauclair, for example, wrote that 'A pot of paint has been flung in the face of the public'. However, there were also some sympathetic reviews, and Gertrude and Leo *Stein bought Matisse's *Woman with a Hat* (private collection), the picture that was attracting the worst abuse. This greatly helped to restore Matisse's battered morale and marked the beginning of a dramatic rise in his fortunes.

Among the artists who exhibited with Matisse at the 1905 Salon d'Automne were Derain, *Friesz, *Marquet, *Rouault, *Vlaminck, and the Dutch-born van *Dongen. Later they were joined by *Dufy (1906) and *Braque (1907). All of these were a few years younger than Matisse (mainly in their 20s, whereas he was 36 in 1905). Lesser figures associated with the group included Jean *Puy and Louis *Valtat. These artists were influenced in varying degrees by *Cézanne, van Gogh, *Gauguin, and the *Neo-Impressionists. Their most characteristic subject was landscape and the outstanding feature of their work was extreme intensity of colour—colour used arbitrarily for emotional and decorative effect, but sometimes also (as it had been by Cézanne) to mould space. Apart from this, they had no programme in common.

As a concerted movement Fauvism reached its peak in the Salon d'Automne of 1905 and the *Salon des Indépendants of 1906, and by 1907 the members of the group were drifting apart. For most of them Fauvism was a temporary phase through which they passed in the development of widely different styles (Valtat was an exception), and their work never again displayed such similarity. Although short-lived, however, Fauvism was highly influential, for example on German *Expressionism and the work of the *Scottish Colourists.

Federal Art Project (FAP). A project run by the US Government from 1935 to 1943 with the dual purpose of helping artists through the Depression years and of deploying the artistic potential of the country in the decoration of public buildings and places. There were also a Federal Writers' Project, a Federal Theater Project, and a Federal Music Project, and collectively they are known as the Federal Arts Projects. They were part of the Works Progress Administration (later called Work Projects Administration, both abbreviated to WPA), a work programme for the unemployed executed as part of President F. D. Roosevelt's New Deal. The Federal Art Project grew out of a previous scheme of a similar nature—the Public Works of Art Project; this was set up to assist artists over the winter of 1933–4 by employing them on public works for a weekly wage. As a sequel, in October 1934 the Section of Painting and Sculpture in the Treasury Department was established to commission murals and sculpture for new public buildings. This was not a relief project, artists being paid only if their designs were accepted, but the following year the Federal Art Project was set up with the primary aim of helping the unemployed. There was also a smaller Treasury Relief Art Project (TRAP), set up in in 1935 to commission art for existing public buildings; this was essentially a relief project, although it also employed some established artists. These schemes are sometimes known collectively as the Federal Art Projects. Thus it is possible to distinguish between the Federal Art Project (the main scheme), the Federal Art Projects (the main scheme plus the various other ones), and the Federal Arts Projects (the WPA schemes for the visual arts, music, theatre, and writing collectively). Not surprisingly, the terms are very often confused.

The Federal Art Project was directed by Holger Cahill (1887–1960), a museum administrator and expert on American folk art. It employed people on a monthly salary and at its peak there were more than 5,000 on the payroll. They not only decorated public buildings, but also produced prints, posters, and various works of craft, and they set up community art centres and galleries in parts of the country where art was virtually unknown. The Project also involved an Index of American Design, a gigantic documentation of the decorative arts in America. Virtually all the major American artists of the period were involved in the Project, either as teachers or practitioners (Barnett *Newman is one of the rare exceptions). A huge amount of work was produced, the *Encyclopaedia Britannica* giving the following figures: '2,566 murals [few of these survive], more than 100,000 easel paintings, about 17,700 sculp-

tures, nearly 300,000 fine prints, and about 22,000 Index of American Design plates, along with innumerable posters and objects of craft'. Most of the work was unremarkable in quality, but this was in line with Cahill's philosophy: 'The organization of the Project has proceeded on the principle that it is not the solitary genius but a sound general movement which maintains art as a vital, functioning part of any cultural scheme. Art is not a matter of rare, occasional masterpieces.'

Feeley, Paul (1910–66). American painter, designer, and teacher, born at Des Moines, Iowa. He moved to New York in 1931 and studied at the *Art Students League under *Benton and privately with Cecilia *Beaux. In 1935 he opened a commercial art studio, designing such things as stage sets and window displays, and in the same year he began teaching at the Cooper Union Art School. From 1939 until his death (with the exception of the years 1943–6, when he served with the US Marines), Feeley taught at Bennington College, Vermont. Helen *Frankenthaler was among his pupils there, and he organized exhibitions of the work of Hans *Hofmann, Jackson *Pollock, and David *Smith.

Feeley's early works moved through various *Expressionist modes, but in the 1950s he began to reject what he called the 'jungles of movement and action' in search of an art of 'sanity, joy, peace, and pleasure'. His most characteristic works employ fairly simple geometrical shapes—such as the quatrefoil or 'jack' shape—arranged in formal patterns. However, the effect is not stark or *Minimalist; there is a rhythmic interplay of convex and concave contours and a striking feeling for colour. They can be classified as *Post-Painterly Abstraction and as *Systemic art. Feeley often worked in series to test the effect of different colours on a particular motif or arrangement. He also made experiments with *shaped canvases, and in 1935 he began to make painted wooden sculptures, in which in effect he projected his paintings into three dimensions.

Feibusch, Hans (1898–). German-born painter, sculptor, and lithographer who settled in England in 1933 to escape the Nazi regime. He has been Britain's most prolific specialist in mural painting in churches, working in a rather mannered swirling figure style. Examples are in Chichester Cathedral

and many parish churches in the south of England, and some are illustrated in his book *Mural Painting*, published in 1946. In the 1970s he concentrated on landscapes and in 1975 he took up sculpture; he has done many portraits and also figures such as the fibreglass statue of John the Baptist (1979) outside St John's Wood Church, London.

Feininger, Lyonel (1871–1956). American painter, printmaker, and caricaturist who spent most of his career in Europe. He was born in New York into a German-American musical family, and in 1887 he went to Germany with the intention of studying music (he played the violin and also composed); although he later maintained that 'Music has always been the first influence in my life', he turned instead to art, studying in Hamburg, Berlin, and Paris between 1887 and 1893. After returning from Berlin to Paris, he became a full-time caricaturist and by the turn of the century he was Germany's leading exponent of political cartoons. In 1906 he received a lucrative contract for comic strips from the *Chicago Sunday Tribune* and this allowed him to live in Paris for the next two years. During this time he turned to painting, and on a subsequent visit to Paris in 1911 he first saw *Cubist pictures. Under their influence he quickly evolved a highly distinctive style in which natural forms were treated in terms of a rhythmic pattern of prismatically coloured interpenetrating planes bounded by straight lines—a manner that he applied particularly to architectural and marine subjects. Although—as an American citizen—he was an alien, he remained in Germany throughout the First World War and afterwards taught at the *Bauhaus from its foundation in 1919 (one of his woodcuts appeared on the cover of its manifesto) until its closure by the Nazis in 1933; he was the only person to be on the staff from start to finish (although he did little teaching in its later years). From 1919 to 1925 he was in charge of the school's printing workshop, where he was influential in introducing colleagues and students to the technique of woodcut. In 1935 he visited the USA and in 1937 the Nazi exhibition of *Degenerate Art (in which his own work was included) made him decide to return there permanently. He settled in New York and adopted the architecture of Manhattan as one of his favourite subjects. At first he found it hard to adjust to his new life, after

half a century in Europe, but he became an honoured and respected figure and worked with vigour into his 80s, his later work becoming more colourful and spontaneous. His son Andreas Feininger (1906–) is a distinguished photographer and writer on photography. Another son, T. Lux Feininger (1910–), is a photographer and painter.

Feito, Luis (1929–). Spanish painter. He was born in Madrid, where he studied at the San Fernando School of Fine Arts, graduating in 1954. After a figurative and sometimes near-*Surrealist period, he turned to expressive abstraction and in 1957 was one of the founder members of *El Paso, the group principally responsible for promoting *Art Informel in Spain. His later paintings display isolated abstract or semi-abstract images upon a monochromatic background, creating a world of mysterious suggestion. Feito's work has been shown in many international exhibitions and he has won several awards. He has spent much of his career in Paris and in 1983 moved to New York.

Felixmüller, Conrad (1897–1977). German painter and graphic artist, born in Dresden, where he studied at various schools. Felixmüller's early work was in a politically-orientated vein combining elements of *Expressionism and *Neue Sachlichkeit—it was eclectic (he toyed with *Cubist and *Futurist mannerisms), wild, and uneven. In 1923 the poet Carl Sternheim wrote, rather exaggeratedly, that 'He tore the aesthetic mask . . . from the face of his contemporaries: in his pictures the proletarian who, until now, had been overlooked by the bourgeoisie, appeared for the first time'. From about 1930 Felixmüller's work began to lose its bite and he settled into a much more conventional naturalistic style. He spent most of his career in Berlin (where he exhibited at the *Sturm Gallery and with the *Novembergruppe), but in 1949–61 he taught at the University of Halle.

Fell, Sheila (1931–79). British painter. She was born in Aspatria, Cumberland, and studied at Carlisle School of Art, 1947–9, and *St Martin's School of Art, London, 1949–51. Although she lived in London for most of her later life (she taught at Chelsea School of Art from 1958), she often visited her family in Cumberland, and in 1977 she wrote: 'My main

concern is landscape (although I have painted several portraits) and I have mostly drawn and painted in Cumbria, Yorkshire and Wales. The chief influence has therefore been that of the country and the different activities which take place on the land, the presence of the mountains, moors, sea, and the effect of the changing light in relation to the earth.' Her early death was caused by an accident.

Feminist art. A term applied to art that deals with issues specifically relating to women's identity and experience. As a movement it originated in the late 1960s, in parallel with the militant Women's Liberation movement. Previously the most concerted feminist activity in the arts had been the vigorous support given by numerous British women artists to the campaign for voting rights for women at the beginning of the 20th century. In the intervening period, gender ceased to be a burning issue in art, and some women artists (for example Grace *Hartigan) even exhibited under male names, seeing themselves as artists, not women artists, and wanting to be judged on exactly the same terms as men (Léonor *Fini said 'I am a painter, not a woman painter'). Many women artists, even when they are feminist in outlook in other ways, continue to think this way, and some critics have suggested that the attempt to define an 'art of women' runs the risk of placing female creativity in a ghetto. This feeling can be underlined when feminist art is linked with other 'minority' art, as with black feminist artists such as Sonia *Boyce and Faith *Ringgold. Nevertheless, feminist art, particularly in the USA, 'has been one of the most powerful forces for change within the contemporary art world since the early 1970s' (Edward *Lucie-Smith, *Art Today*, 1995).

Feminist art is not associated with any particular style or medium, but rather is concerned with a range of endeavour aimed at giving women a just place in the world and specifically in the art world, which feminist artists regard as heavily biased in favour of men. Much of this endeavour has been collective—for example in the organization of exhibitions (devoted to reviving the reputations of women artists of the past as well as promoting the work of women artists of the present), in the setting up of courses dealing with women's art (such as the Feminist Art Program at the California Institute of Arts, established in 1971), and in the publishing of

periodicals, several of which have appeared since the early 1970s, the best-known including the *Feminist Art Journal* (founded in New York in 1972), *Women's Art Journal* (Knoxville, Tennessee, 1980), and *Women's Art Magazine* (London, 1986).

Some feminist art has been fairly traditional in presentation—for example the paintings of Sylvia Sleigh (see ALLOWAY), in which long-standing stereotypes of the nude are reversed by presenting males as a subject for female erotic delectation. Much feminist, art, however, uses more avant-garde types of expression; indeed, Lucie-Smith comments that 'Since many of the artists affected by feminism felt that traditional forms, such as painting and sculpture, were tainted by patriarchy, they tended to be interested in newer forms of expression, such as *environmental work, *performance, and *video'. The spectrum has ranged from aggressive public demonstrations to intimate personal explorations. Examples at these extremes are the activities of the *Guerrilla Girls (responsible for some of the most conspicuous protests against male domination of the art world) and the works of the American Conceptual artist Mary Kelly (1941–), best known for her long-term project *Post-Partum Document* (1973–7), in which she recorded her relationship with her young son, using such means as drawings, diagrams, objects, and sound recordings. When part of this work was exhibited at the Institute of Contemporary Arts, London, in 1976, it caused outrage and disgust because it included imprints of soiled nappies; Kelly said that she was 'trying to show the reciprocity of the process of socialization in the first few years of life'.

The imagery of feminist art often focuses on sexuality, both in celebrating female eroticism and in attacking male sexual violence, and another common theme is matriarchy, as in the work of the American *installation and Performance artist Mary Beth Edelson (1933–) or the paintings of the Swedish-born, British-domiciled Monica Sjoo (1938–). Edelson draws on ancient traditions of goddess worship and aims at 'exorcizing the patriarchal creation myth through a repossession of the female visionary faculties'. Sjoo is best known for her painting *God Giving Birth* (1969), similarly inspired by goddess-worship, which aroused great controversy when it was shown at the 'Womanpower' exhibition at the Swiss Cottage Library, London, in 1973, leading to threats of legal action on the grounds of blasphemy and obscenity. Some feminist art, however, is more concerned with technique than imagery. Indeed, an important aspect of the movement has been the desire to revive interest in art forms such as quiltmaking that employ skills traditionally regarded as female and which have generally been given a low status compared with 'fine art'. This helped to create the interest in *Fibre art and in the kind of rich decorative effects that characterize Miriam *Schapiro's 'femmages' and the *Pattern and Decoration movement in painting. Judy *Chicago's huge sculpture *The Dinner Party*, probably the most famous 'icon' of feminist art, similarly emphasized a return to craft skills; more than a hundred women (and also some men) worked on the elaborate china-painting and needlework it involved.

Fénéon, Félix (1861–1944). French art and literary critic, dealer, and collector. He was most active as an art critic in the 1880s and 1890s, when he wrote for various magazines and became particularly known as a champion of Georges Seurat (in 1886 Fénéon coined the term *Neo-Impressionism to characterize his work). From 1896 to 1903 he was editor of the literary journal *La Revue blanche*, and from 1906 to 1925 he was a director of the Galerie *Bernheim-Jeune, where he promoted the work of various avant-garde artists. His own collection included work by leading contemporaries such as *Braque and *Derain and also African art. He devoted much of his retirement to assisting César de Hauke with a catalogue raisonné of Seurat's work, eventually published in two volumes in 1961. *Oeuvres*, a collection of Fénéon's articles and other works, was published in 1948.

Ferber, Herbert (1906–91). American sculptor (and in his later career, painter), born in New York. He attended evening classes at the Beaux-Arts Institute of Design, New York, 1927–30, while studying dentistry at Columbia University, and subsequently continued both professions (in this respect his career is remarkably similar to that of *Lipton). His sculpture has passed through many phases. He first carved massive nudes in the manner of *Maillol. Then, after being influenced by Romanesque sculpture and German *Expressionism on a visit to Europe in the late 1920s, his work displayed increasingly violent distortion and by 1940 he had practically reached

abstraction. In 1945 he abandoned representation altogether and developed an open-work abstract style using welded rods and strips of lead, copper, or brass. By the end of the decade he was prominent among the group of sculptors, including *Lassaw, Lipton, and *Roszak, whose metal sculpture paralleled the work of the *Abstract Expressionist painters. His constructions were cage-like but suggestive of organic forms and he was one of the first to obtain an expressively textured surface by the manipulation of molten metal. In the 1950s he received several commissions for sculptures on or in religious buildings, and it was partly through these that he began to eliminate the base, experimenting, for example, with forms suspended from the ceiling. These in turn led to room-sized *environmental sculptures, the first of which he created for the Whitney Museum, New York, in 1961. In the 1970s Ferber began to devote much of his time to painting.

Fergusson, J. D. (John Duncan) (1874–1961). Scottish painter (mainly of landscapes and figure subjects) and occasional sculptor, one of the *Scottish Colourists who introduced *Post-Impressionism to their country. He was born at Leith and began to study medicine in Edinburgh, but he gave this up for art. Apart from a brief period of study at the Académie Colarossi (and possibly at the *Académie Julian) in Paris he had no formal training. From about 1895 he made regular visits to Paris and he lived there 1907–14. His early work was *Whistlerian and he then came under the influence of Manet, but by 1907 he had adopted the bold palette of *Fauvism and became the most uncompromising adherent to the style among British artists (*Blue Beads*, Tate Gallery, London, 1910). From 1911 to 1913 he was art editor of *Rhythm*, a short-lived avant-garde journal (originally a quarterly, then a monthly), founded by the writers John Middleton Murry and Michael Sadleir. The cover design featured a boldly stylized nude adapted by Fergusson from his painting *Rhythm* (University of Stirling, 1911), and the Anglo-American artists in Fergusson's circle in Paris are sometimes called the *Rhythm Group. In 1914 the war brought him back to Britain; he lived in London, 1914–29, in Paris, 1929–40, and finally in Glasgow, 1940–61. Soon after his arrival in Glasgow he founded the New Art Club to provide better exhibiting facilities for the city's progressive artists, and

out of it grew the New Scottish Group (1942), of which Fergusson was first president. At this time he was also editor of the periodical *Scottish Art and Letters*, and he wrote a book entitled *Modern Scottish Painting* (1943). At his death he left instructions for the founding of a permanent collection of his work, which led to a group of his paintings being presented to the University of Stirling. He was married to the dancer Margaret Morris (1891–1980) who wrote *The Art of J. D. Fergusson: A Biased Biography* (1974).

Festival of Britain. A large-scale celebration of British culture mounted in 1951; ostensibly it was meant to commemorate the centenary of the Great Exhibition (held in the Crystal Palace in Hyde Park, London), but in fact it was intended as 'a tonic to the nation' (the words of Sir Gerald Barry, director general of the Festival) following a period of post-war austerity. The heart of the Festival was a huge exhibition, the South Bank Exhibition, held from 3 May to 30 September on a large area of formerly derelict land in central London, on the south bank of the River Thames between Westminster Bridge and Waterloo Bridge. There were also major exhibitions in Belfast and Glasgow, and a large travelling exhibition was seen in Birmingham, Leeds, Manchester, and Nottingham; a Festival ship, the *Campania*, visited various ports, and many places staged local events—indeed, virtually every town and village joined in the celebrations in some way. Hugh Casson (later president of the *Royal Academy) was director of architecture for the South Bank Exhibition, which featured an impressive array of specially designed buildings; all of these were intended to be temporary apart from the Royal Festival Hall, which remains as one of London's leading concert halls, forming part of the South Bank arts complex that has grown around it, including the Hayward Gallery (see ARTS COUNCIL) and the National Theatre. The exhibition attracted more than eight million visitors and acted as a massive showcase for British design; it displayed an enormous range of manufactured goods and helped create a fashion for zany patterning and bright colours.

The industrial designer Misha Black (1910–77), who was a leading figure in organizing the Festival, wrote that he and his colleagues had two main objectives: 'The first was to demonstrate the quality of modern

architecture and town planning; the second to show that painters and sculptors could work with architects, landscape architects and exhibition designers to produce an aesthetic unity. On these two counts our success was complete.' He thought that 'there was little real innovation, almost nothing on the South Bank which had not previously been illustrated in the architectural magazines . . . but what had previously been the private pleasure of the cognoscenti suddenly, virtually overnight, achieved enthusiastic public acclaim'. The roster of painters and sculptors involved was highly impressive: Black writes that 'We sought the collaboration both of the famous and of those who were not yet renowned and this collaboration was enthusiastically provided. Henry *Moore, Jacob *Epstein, Barbara *Hepworth, Keith *Vaughan, Victor *Pasmore, Ben *Nicholson, John *Minton, Feliks *Topolski, Frank *Dobson, Graham *Sutherland, John *Piper, Reg *Butler and some twenty other artists carved, modelled and painted in complete unison with the architects who ensured that walls were available for murals and plinths for sculpture. Practically every concourse was designed to contain a major work.' In spite of this array of talent, Black thought that painting and sculpture made relatively little impact on public or press, probably because they had to compete with the sheer size of the Festival and the diversity of other attractions. There was, however, a mild rumpus when an abstract painting by William *Gear was one of five pictures awarded a purchase prize (£500) by the Arts Council at an exhibition it organized. The other four prizes went to figurative works by Lucian *Freud, Patrick *Heron, Rodrigo *Moynihan, and Claude *Rogers

Festival Style. See CONTEMPORARY STYLE.

Fetting, Rainer. See NEO-EXPRESSIONISM.

Few, Elsie. See ROGERS.

Fibre art. A broad term that covers various types of modern work that are made with fibre but which are distinct from traditional categories such as tapestry. Experimental work with fibre goes back at least as far as the 1920s, when Gunta Stölzl (see BAUHAUS) created abstract tapestries in which variations of texture are an important part of the design; slightly later, Anni *Albers, too, created tex-

tiles that do not merely reproduce a design made in another medium, but depend for their effect on the distinct physical properties of the fibre. However, it was not until the 1960s that there was anything like a movement in fibre art (Magdalena *Abakanowicz was the best-known pioneer) and the term itself was coined in the 1970s, when the breaking down of distinctions between 'fine art' and 'craft' was a significant strand in *Feminist art. Whitney Chadwick (*Women, Art, and Society*, 1990) writes that 'The use and development of non-traditional materials in art, combined with feminist consciousness about the relationship between certain materials and processes and women's cultural and historical traditions, led to an intense questioning of art traditions . . . The idea of using fabric as an art material both summed up the iconoclasm of the 1970s and established a context within which to mount a feminist challenge to the way art history honored certain materials and certain processes instead of others.' Most of the leading exponents of Fibre art are women, including the Americans Sheila Hicks (1934–), whose work includes floor pieces, Faith *Ringgold, well known for her 'story-quilts', and Claire Zeisler (1903–91), whose work included cascading pieces.

Field Painting. A type of painting developed in the USA from about 1950 in which the picture is no longer regarded as a structure of interrelated elements but as a single indivisible expanse. Field Painting has affinities with *Systemic art and with the *All-over style associated with Jackson *Pollock. The term *Colour Field Painting has been used when emphasis is placed on brilliance and saturation of colour. Rather than being a specific style, it may be regarded as an aspect of a very general tendency during the 1950s and 1960s to eschew traditional composition in favour of a single 'total' theme.

Figari, Pedro (1861–1938). Uraguayan painter, born and mainly active in Montevideo. He had a versatile and distinguished career as a lawyer, politician, writer, and editor (he founded the Montevideo newspaper *El Diario*) and although he had studied painting in his youth he did not devote himself full-time to art until 1921, when he moved to Buenos Aires. Although he was already 60, he rapidly made a name for himself as an artist

and his work was widely exhibited in Uraguay, the USA, and Europe. From 1925 to 1933 he lived in Paris, then returned to Montevideo. Edward *Lucie-Smith (*Latin American Art of the 20th Century*, 1993) writes: 'Figari's work shows the direct influence of the French *intimistes, that of *Vuillard perhaps even more clearly than that of *Bonnard, spiced with a certain deliberate naïveté. His thematic range, however, is wider than that of either of the French artists. It is also specifically Latin-American, since it includes not only bourgeois interiors but historical and literary scenes, and also Creole and Afro-American subjects.' His work is well represented in the National Museum at Montevideo.

Figuration Libre. See NEO-EXPRESSIONISM.

Filipović, Franjo. See NAIVE ART.

Filla, Emil (1882–1953). Czech painter, sculptor, graphic artist, and writer on art, born at Chropyně in Moravia. He studied at the Prague Academy, 1903–6, and in 1906 was one of the founders of The *Eight (2). Between 1907 and 1914 he spent much of his time in France, Germany, and Italy, and during this period he turned from his early *Expressionist manner to *Cubism, becoming the pioneer and one of the most distinguished exponents of the style in Czechoslovakia in both painting and sculpture. He spent the First World War in the Netherlands and returned to Prague in 1920. His most characteristic paintings of this time were still-lifes, but in the late 1930s he turned to themes of violence, presaging the horrors of the Second World War (during which he was imprisoned in the concentration camp at Buchenwald). After the war he taught at the School of Industrial Art in Prague. His post-war work was more naturalistic in style and included some large landscapes. He wrote numerous articles on art and several books of which the best known is *Kunst und Wirklichkeit: Erwägungen eines Malers* (Art and Reality: Considerations of a Painter), published in Prague in 1936.

Filliou, Robert. See FLUXUS.

Filonov, Pavel (1883–1941). Russian painter, illustrator, designer, teacher, and poet, born in Moscow and active mainly in St Petersburg/Leningrad. He was one of the most individual Russian artists of his time, developing a style that has been described as proto-*Surrealist and remaining untouched by the general trend towards *Constructivism. In 1925 he founded a school named 'The Collective of Masters of Analytical Art' in Leningrad and ran it until 1932, when the state—intent on imposing *Socialist Realism—disbanded all existing art groups. His paintings (often in watercolour or gouache) are elaborately finished and highly eclectic stylistically: Alan Bird (*A History of Russian Painting*, 1987) writes that they owe 'a little to child art, a little to icon painting, mosaic, primitivism and analytical *Cubism, and much more to his own researches into Oriental and African art as well as that of the Middle Ages . . . they are deeply pessimistic about the human condition'. Filonov died in the siege of Leningrad during the Second World War.

Finch, Willy (Alfred William) (1854–1930). Belgian painter, graphic artist, ceramicist, and designer, of British extraction, active mainly in Finland. He was a friend of Georges Seurat and Paul *Signac and helped to introduce their *Neo-Impressionist style to Belgium. In 1897, having temporarily abandoned painting for ceramics, he moved to Finland to direct the Iris pottery factory at Porvoo, near Helsinki, and had a notable influence on the modernization of Finnish design. The Iris factory closed in 1902, and although Finch continued to work in ceramics he also resumed painting in 1905 and became a leader of the *Septem group. He taught at the Drawing School of the Finnish Arts' Association, 1902–5, and at the Finnish Central School of Applied Art, 1905–30, and in these roles he was an important force in bringing the fine and applied arts of Finland into contact with contemporary European trends.

Fini, Léonor (1908–96). Italian painter, stage designer, and illustrator, active mainly in Paris. She was born in Buenos Aires to an Argentinian father and an Italian mother and was brought up in Trieste, her mother's home town. She painted from an early age but had no formal training; her artistic education was instead gained from visiting galleries and from her uncle's extensive library. In 1935 she had her first one-woman exhibition in Paris and at this time she became friendly with some of the leading *Surrealists, including Victor *Brauner and Max *Ernst. She showed her work in several Surrealist exhibitions but

never formally joined the movement, as she disliked its authoritarian attitudes. After the Second World War she had numerous one-woman shows in Europe and the USA, and in 1972 a retrospective exhibition toured Japan. Fini also made a reputation as a stage designer, particularly for the ballet; she created one ballet herself, *Le Rêve de Léonor* (1949), with choreography by Frederick Ashton and music by Benjamin Britten (his *Variations on a Theme of Frank Bridge*). Her work also included book illustrations. In her obituary in *The Times* she was described as 'perhaps the last link with the Surrealist era' and 'a woman of such arresting beauty that many beholders found her presence even more disconcerting than the nightmarish visions of her canvases [her paintings are characteristically concerned with themes of morbid eroticism] . . . her entrance to private views and parties was such that critics were left with their pencils poised inertly over their notebooks'. She never married but 'her lovers were legion. Their names read like a roll of the literary and artistic talents of that brilliant age.'

Finlay, Ian Hamilton (1925–). Scottish artist-poet, born in Nassau, Bahamas, of Scottish parents. He studied briefly at *Glasgow School of Art, but originally attracted attention as a poet. In 1963 he began making *Concrete poetry, in which the physical appearance of the poem—its shape and typography—is regarded as part of its meaning. From this he developed the idea of using artists and craftspeople—stone carvers, potters, calligraphers, even specialists in neon lighting—to translate his poems into other media. In 1967, with his wife Sue, he moved to Stonypath, a remote farmhouse in the Pentland Hills of 'Strathclyde, the Infernal Region' (Finlay's words), and they created a garden in which many of his poem objects are displayed: 'it is a garden full of surprises and contrasts, and manages to entertain as well as to stimulate thought. Visual puns and other jokes abound: for instance, a headstone next to a birch tree has the slogan "Bring back the birch"; a real clump of grass resembling an Albrecht Dürer watercolour has Dürer's monogram placed next to it; a tortoise carries the words "Panzer Division" engraved in gothic lettering on its shell; and birds land on a bird tray in the form of an aircraft carrier' (Michael Jacobs and Paul Stirton, *The Mitchell Beazley Traveller's Guides to Art: Britain & Ireland*,

1984). The garden has attracted considerable publicity, not only because of its artistic interest, but also because of Finlay's long-term fight against Strathclyde Council, which has attempted to tax a garden 'temple' as a commercial art gallery. Finlay has many admirers, but Brian *Sewell dismisses his work as 'adolescent word-play' and writes that 'I find the puffed portent of his enigmatic statements as irksome as his whimsy.'

Fischer, Harry. See MARLBOROUGH FINE ART.

Fischer, Lothar. See SPUR.

Fischl, Eric (1948–). American painter and printmaker, born in New York. He studied at the California Institute of Arts, Valencia, and taught at the Nova Scotia College of Art and Design, Halifax, before returning to New York in 1978. Characteristically he paints large figure compositions showing scenes of middle-class American life, often with a strong sexual element. Edward *Lucie-Smith writes that these works are 'a sour commentary, with roots in the work of Edward *Hopper, on the lives of the American bourgeoisie . . . What has fascinated critics about Fischl's work is the uncertainty of his technique. Both his drawing and his handling of paint seem tentative and even fumbling—characteristics which have been read as a deliberate mimesis, the visually impoverished reflection of a spiritually impoverished society' (*Visual Arts in the Twentieth Century*, 1996). Some critics categorize his work as 'Bad Painting' (see NEO-EXPRESSIONISM).

Fisher, Sandra. See KITAJ.

Fitton, James. See ARTISTS INTERNATIONAL ASSOCIATION.

Fitzgerald, LeMoine. See GROUP OF SEVEN.

Fitzroy Street Group. See CAMDEN TOWN GROUP.

Flack, Audrey. See SUPERREALISM.

Flanagan, Barry (1941–). British sculptor. He studied at various art schools, principally *St Martin's School of Art, London, 1964–6, his main teacher there being Phillip *King. In the late 1960s he began to make a name for himself with sculptures in unusual, non-rigid

materials, such as *June 2 '69* (Tate Gallery, London, 1969), consisting of a sheet of flax propped against a wall by three branches; Peter *Fuller refers disparagingly to this kind of work as 'the mere placement of virtually unworked materials in stacks, heaps, piles or bundles'. Since 1973, however, Flanagan has concentrated on more traditional materials, notably stone and bronze. In particular he has become well known for bronze figures of hares, typically shown leaping or prancing. Frances Spalding (*British Art Since 1900*, 1986) writes: 'These works had a joyous élan and instant appeal, the hares perhaps symbolizing the imaginative agility of the artist's mind.' In 1982 Flanagan represented Britain at the Venice *Biennale.

Flannagan, John B. (1895–1942). American sculptor, an isolated figure whose career was blighted by illness and poverty and ended in suicide. He was born at Fargo, North Dakota, and studied painting at the Minneapolis Institute of Arts, 1914–17. In 1922 he was rescued from near destitution by Arthur B. *Davies, at whose suggestion he took up woodcarving. About five years later he was attracted to the natural beauty of stone and he became a highly original exponent of *direct carving in this medium. He preferred natural to quarried material, and for him part of the creative process lay in 'seeing' the image within the raw stone (in 1930–1 and 1932 he visited Ireland and drew special inspiration from some of the stones he found in remote areas there). He made a few portraits, but most of his subjects were taken from the animal world. His early work was rather tortured in style, fusing elements from Germanic *Expressionism and medieval art. During the 1930s, however, his style broadened and became increasingly abstract, as he pared his work down to an intense, primordial simplicity (*Triumph of the Egg*, 1, MOMA, New York, 1937).

Flash Art. Italy's leading periodical in the field of contemporary art. It was founded in Milan as a monthly journal in 1967, since when there have been various changes of identity. In Italy it is now published as *Flash Art Italia* (8 issues a year) and elsewhere as *Flash Art International* (6 issues a year). A Chinese edition has also appeared. Germano *Celant was among the early contributors to the journal; an article by him in the 5th issue

(November–December 1967) launched the term *Arte Povera.

Flavin, Dan (1933–96). American sculptor and experimental artist, born in New York. Apart from some lessons at the Hans *Hofmann School in 1956 he had no formal training in art and he did not take it ip seriously until 1959. In 1961 he had his first one-man exhibition (of watercolours and constructions) at the Judson Gallery, New York, and in the same year he began to make 'icons', in which plainly painted, square-fronted constructions were combined with lights. In 1963 he began using coloured fluorescent tubes, and it is for this type of work that he became well known. In general he eschewed complicated effects of pulsating or flashing lights, preferring a bare and simple presentation that brought him within the orbit of *Minimal art. By 1968 his work had developed into room *environments. He had many commissions, including the lighting of several tracks at New York's Grand Central Station in 1976.

Flight, Claude. See LINOCUT.

Flint, Sir William Russell (1880–1969). British painter, printmaker, and illustrator, born in Edinburgh, the son of a commercial artist. After a six-year apprenticeship with a firm of lithographic printers he moved to London in 1900. In 1903–7 he was a staff artist on the *Illustrated London News*, and then he went freelance. He was a prolific and highly successful book illustrator, but is now best remembered for his watercolours (particularly his mildly erotic nudes and Spanish gypsy scenes), painted in a distinctive, rather flashy style. From 1936 to 1956 he was president of the Royal Society of Painters in Water-Colour. 'He was a modest and unassuming man, a fine and versatile craftsman, entirely detached from everything that was controversial or experimental in the art of his time' (*DNB*). His son **Francis Russell Flint** (1915–77) was also a painter.

Flouquet, Pierre-Louis. See SERVRANCKX.

Fluxus. A loosely organized international group of avant-garde artists set up in Germany in 1962 and flourishing until the early 1970s. There was no common stylistic identity among the members; one of their manifestos stated that its aim was to 'purge the world of

bourgeois sickness . . . of dead art . . . to promote a revolutionary flood and tide in art, to promote living art, anti-art'. Reviving the spirit of *Dada, Fluxus was fervently opposed to artistic tradition and to everything that savoured of professionalism in the arts. Its activities were mainly concerned with *Happenings (usually called 'Aktions' in Germany), street art, and so on. Fluxus festivals were held in various European cities (including Amsterdam, Copenhagen, Düsseldorf, London, and Paris), and also in New York, which became the centre of the movement's activities. The most famous artist involved with Fluxus was Joseph *Beuys. Other participants included leading avant-garde artists from various countries, among them the Frenchman Robert Filliou (1926–87), the American Dick Higgins (1938–), the Japanese-born American Yoko Ono (1933–), and the German Wolf *Vostell. The movement's chief co-ordinator and editor of its many publications was the Lithuanian-born American George Maciunas (1931–78), who coined its name—Latin for 'flowing', suggesting a state of continuous change.

Flynt, Henry. See CONCEPTUAL ART.

Folkwang Museum, Hagen. See SONDERBUND.

Fondation Maeght. See MAEGHT.

Fontana, Lucio (1899–1968). Italian painter, sculptor, and ceramicist, born in Argentina, the son of an Italian sculptor, Luigi Fontana, and an Argentinian mother. In 1905 his family moved to Milan, where he studied sculpture, first with his father and then (after spending several years in Argentina) at the Brera Academy, 1928–30. He had his first one-man show at the Galleria del Milione, Milan, in 1930; this was the first exhibition in which abstract sculpture was seen in Italy and Fontana became a leading figure in promoting abstract art in his country. In 1935 he moved to Paris, where he became a member of the *Abstraction-Création association, then in 1940 returned to Argentina, where in 1946 he issued his *White Manifesto*. This introduced a new concept of art called *Spatialism (Spazialismo), which aimed for co-operation with scientists in synthesizing new ideas and materials. In 1947 he returned to Milan, and in the same year officially launched the Spa-

tialist movement and issued the *Technical Manifesto of Spatialism* (four more Spatialist manifestos followed, the last in 1952). He lived in Milan for most of the rest of his life, but usually spent the summers at Albisola Marina, where he made ceramics. His most characteristic works, which he began producing in 1958, are paintings in which completely plain surfaces are penetrated by gashes in the canvas, but he also made *environments (for example using neon lights in blackened rooms) and carried out various decorative projects. In 1966 he was awarded the International Grand Prize for Painting at the Venice *Biennale.

Forain, Jean-Louis (1852–1931). French painter, lithographer, and caricaturist, born in Reims, the son of a house-painter. In the first half of his career he worked mainly on satirical illustrations for various Paris journals, but he exhibited at four of the *Impressionist exhibitions and after the turn of the century he concentrated more on painting. His most distinctive work included some court scenes, two examples of which are in the Tate Gallery, London: *The Court of Justice* (c. 1902) and *Counsel and Accused* (1908). Forain was a friend of *Degas and was much influenced by him; Degas said of him 'he paints with his hand in my pocket'.

Forbes, Stanhope (1857–1947). British painter, born in Dublin. His mother was French, and after studying at the *Royal Academy Schools (1874–8) he completed his training in Paris (1880–2). He was impressed by contemporary French *plein-air* painting, and in the summer of 1881 he painted out of doors in Brittany with H. H. *La Thangue, who had been a fellow student at the RA. In 1889 Forbes married the Canadian-born painter Elizabeth Armstrong (1859–1912) and later that year they settled in Newlyn, a Cornish fishing village that he 'discovered' in 1884. Forbes was not the first painter to work there, but he encouraged others to do so and was 'the centre and rallying point' (*Art Journal*, 1896) of the colony of artists that became known as the *Newlyn School. In 1899 he and his wife founded the Newlyn School of Art, which continued until 1938, and Forbes lived in the village until the end of his long life. His devotion to outdoor painting introduced, in his own words, 'a breath of fresh air in the tired atmosphere of the studios', and he often exhibited

with like-minded artists at the *New English Art Club (of which he had been a founder member in 1886). He painted landscapes, genre scenes, and historical subjects. From about 1910 his palette lightened somewhat, and figures gradually became of lesser importance in his work, but otherwise his style altered little, and his later paintings often have a nostalgic air, reflecting the realization that the world he depicted was fast disappearing.

Forbes, Vivian. See PHILPOT.

Forces Nouvelles. An association of painters formed in Paris in 1934 with the aim of bringing new life to French art by reviving strict principles of draughtsmanship and craftsmanship and combining them with an expressive vigour relevant to the values of contemporary life. The leading figures included Jacques Despierre (1912–95), Robert Humblot (1907–62), and Georges Rohner (1913–), who were united in condemning current avant-garde movements as too precious. The group held exhibitions from 1935 to 1943, but its impetus had been lost by the beginning of the Second World War.

Ford, Edward Onslow. See NEW SCULPTURE.

Form. See SPARE.

Forma. Group of Italian artists, founded in Rome in 1947, who declared themselves both 'formalists and Marxists' in opposition to the members of the *Fronte Nuovo delle Arti, who advocated an art with a more human content. Forma represented an early foray into abstraction for Italian artists; two of the members, Pietro *Consagra and Giulio *Turcato, founded a monthly journal entitled *Forma 1*, which in April 1947 published a manifesto of abstract art. Consagra, Turcato, and several other members of the group went on to join *Continuità.

formalism. A term used in the discussion of the arts to describe an approach (on behalf of creator or critic) in which the formal qualities of a work—such as line, shape, and colour—are regarded as self-sufficient for its appreciation, and all other considerations—such as representational, ethical, or social aspects—are treated as secondary or redundant. The idea that formal qualities can have meaning

or resonance independently of representative function was essential to the development of *abstract art, and many notable writers on art in the 20th century have been essentially formalist in outlook. Among them were Clive *Bell and Roger *Fry, who were among the leading British critics in the first half of the century, and Clement *Greenberg, the most influential American critic of the 1950s and 1960s. By directing attention away from *what* was represented in a work to *how* it was represented, such writers played an important role in increasing appreciation of various types of non-naturalistic art, but their views were sometimes narrow-minded. Bell coined the vague term 'significant form' to try to isolate what he considered was the factor that stirred our aesthetic emotions—the common denominator in all visual art. He did not deny that there were other qualities to be enjoyed in art, but these were subsidiary. Fry was less explicitly theoretical in approach, but his outlook was broadly similar, as is indicated by the following passage, in which he discusses Indian sculpture with a sweeping lack of concern for its cultural context: 'A great deal of their art, even their religious art, is definitely pornographic, and although I have no moral prejudices against that form of expression, it generally interferes with aesthetic considerations by interposing a strong irrelevant interest which tends to distract both the artist and spectator from the essential purpose of a work of art.'

Greenberg's ideas on formalism were more sophisticated but no less dubious. He thought that art should be 'pure', eliminating any effect 'that might conceivably be borrowed from . . . any other art'; in painting, this involved 'stressing the ineluctable flatness of the support (i.e. the stretched canvas or panel) . . . Flatness alone was unique and exclusive to that art . . . and so, *Modernist painting oriented itself to flatness as it did to nothing else.' He did not dismiss representative paintings wholesale (which might be thought the logical outcome of his beliefs), but he judged them with the same kind of blinkered self-assurance that Fry displayed towards Indian sculpture, as in the following passage, where he takes *Picasso to task for the 'will to illustrative expressiveness' that he shows in *The Three Dancers* (Tate Gallery, London, 1925): it 'goes wrong, not just because it is literary . . . but because the theatrical placing and rendering of the head and arms of the

center figure cause the upper third of the picture to wobble'.

Many other writers have been strongly opposed to the ideas of critics such as Bell, Fry, and Greenberg, believing that form and 'content' are to a large extent interdependent. Formalism has been particularly opposed in Communist countries, especially Stalinist Russia, where art was supposed to serve a moral purpose in the education and inspiration of the masses and anything that suggested cultural elitism was condemned. The Soviet authorities regarded formalism as a sign of Western decadence—so much so that the word was used virtually as an all-purpose term of abuse for Western art or its influence. In 1933, Osip Beskin (1892–1969), head of the critics' section of MOSSKh (Moscow Section of the Union of Soviet Artists) published a book entitled *Formalism in Painting*. It begins by remarking that 'Formalism in any area of art, in particular in painting, is now the chief form of bourgeois influence' and goes on to censure painters who have not adhered closely enough to the ideals of *Socialist Realism. Artists guilty or suspected of formalism were persecuted and encouraged to make public recantations for their offences. This applied to writers and composers as well as painters and sculptors. In 1936, for example, Dmitri Shostakovich was attacked in *Pravda* for producing 'leftist confusion instead of music for the people' in his opera *Lady Macbeth of the Mtsensk District*, which 'tickles the perverted tastes of bourgeois audiences abroad'. In literature, 'The charge of formalism will commonly mean that a novelist has devoted too much attention to plot, characterization and description, and that his work lacks the requisite inspirational quality' (C. Hunt, *Guide to Communist Jargon*, 1957).

Formes. See JEUNE PEINTURE BELGE.

Fortescue-Brickdale, Eleanor. See SHAW.

Forum Exhibition (in full, Forum Exhibition of Modern American Painters). An exhibition arranged in New York in 1916 by the critic Willard Huntingdon *Wright with the support of the magazine *The Forum*, to which he was a regular contributor. The purpose of the exhibition was to pinpoint the best of progressive American painting in order to convince the public that it could stand up to the work of the European avant-garde, which had made a great impact at the *Armory Show three years earlier. Robert *Henri and Alfred *Stieglitz were on the selection committee. The exhibition consisted of about 200 pictures by seventeen artists, including *Benton (ironically, later a bitter enemy of modernism), *Dove, *Macdonald-Wright (Wright's brother), *Marin, *Sheeler, and *Zorach. Anticipating that some of the work on show might be too advanced for public taste, Wright wrote in the catalogue: 'Not one man represented in this exhibition is either a charlatan or a maniac', and he vigorously defended abstraction: 'It is neither the subject-matter nor the painter's approximation to nature which makes his work great: it is the inherent aesthetic qualities of order, rhythm, composition and form.'

Fougass. See BATEMAN.

Foujita, Tsugouharu (Tsuguharu Fujita) (1886–1968). Japanese-French painter and graphic artist, born in Tokyo, the son of an army doctor. From 1906 to 1910 he studied at the Tokyo Academy, which had made Western-style oil painting part of the curriculum in 1896, then with Kuroda Seiki (1866–1924), who was an important figure in introducing French influence to Japanese art; he had trained in Paris with Raphaël Collin (1850–1916) and had adopted something of his mentor's light palette and penchant for female nudes. In 1913 Foujita himself moved to Paris. At this time he said 'I didn't even know of the existence of *Cézanne', but he soon became a member of bohemian circles in Montparnasse, and by 1918 he was regularly selling his work, helped greatly by his first wife, the art dealer Fernande Vallé. In the 1920s he developed a distinctive style of delicately mannered *Expressionism, combining Western and Japanese traits, and he became recognized as a leading figure of the group of emigrés who made up the *École de Paris—the only Japanese artist of his time to earn a considerable reputation in Europe. Characteristic works in his prolific output include landscapes, nudes, pictures of cats (which were once very popular in reproduction), and compositions in which still-life and figures are combined. He also painted portraits, a good example being his self-portrait (1928) in the Pompidou Centre, Paris. Typically his work is elegantly drawn, with a melancholic air.

In 1933 Foujita returned to Japan, where he remained (apart from a visit to France in 1939–40) until 1950. He then settled once again in Paris and became a French citizen in 1955. In 1959 he converted to Roman Catholicism and adopted the first name Léonard in recognition of his admiration for Leonardo da Vinci. From this time he began painting religious subjects, including a series of frescos in the Chapel of Our Lady of Peace, Reims (1966). These sugary works do not show him at his best, for in his later career he tended to lapse into sentimentality. 'Despite Fujita's popularity in France and elsewhere, his reputation in Japan has remained ambiguous. Some Japanese critics find him ... a kind of artistic opportunist who, in abandoning his own culture, lost his personal integrity ... Yet at his best, Fujita exhibits an assurance and a charm that can appeal to both Eastern and Western tastes' (catalogue of the exhibition 'Paris in Japan: The Japanese Encounter with European Painting', The Japan Foundation, Tokyo/Washington University in St Louis, 1987).

found object. See OBJET TROUVÉ.

Four, The. See GLASGOW FOUR.

Fourteenth Street School. See MILLER, KENNETH HAYES.

Frampton, Sir George (1860–1928). British sculptor, born in London. Early in his career he was one of the leading exponents of the *New Sculpture, experimenting with unusual materials and polychrome and working in a style imbued with elements of *Art Nouveau and *Symbolism (*Mysteriarch*, Walker Art Gallery, Liverpool, 1892). Later his work became more traditional and he had a successful career with accomplished but uninspired monuments, including two well-known sights of London—the bronze Peter Pan statue (1911) in Kensington Gardens and the Edith Cavell memorial (1920) in St Martin's Place; the figure of the First World War heroine is in marble and the rest of the structure in granite. Above the statue the monument terminates in a cross surmounted by a sorrowing woman protecting a child—symbolizing humanity protecting the smaller nations of the world, including Belgium, where Nurse Cavell was executed by the occupying Germans for helping British and French

soldiers escape to the Netherlands. While the Peter Pan statue is Frampton's most popular work, the Cavell memorial has been much criticized from its unveiling onwards. At the time, some of the details in the symbolic group were considered too modernistic and it is now generally dismissed as heavy-handed; in the *London Encyclopaedia* (ed. Ben Weinreb and Christopher Hibbert, 1983) it is described as 'a very ugly monument'. Frampton's wife, née Christabel Annie Cockerell (1863–1951), was a painter of landscapes and children.

Their son, **Meredith Frampton** (1894–1984), was a painter, primarily of portraits. Like his father, he studied at the *Royal Academy, and he exhibited there from 1920, his work winning increasing critical recognition. However, he gave up painting in 1945 because his sight was failing and was almost entirely forgotten until an exhibition of his work was held at the Tate Gallery, London, in 1982, revealing him as an artist of great distinction. His work is beautifully finished, with a sense of hypnotic clarity (the images seem almost palpable yet at the same time strangely remote), and he excelled at conveying the intellectual qualities of his sitters. He was a slow worker and his output was small; the Tate Gallery and the National Portrait Gallery each has one picture by him. He wrote of his own work: 'I think my principal aim has always been to paint the sort of picture that I would like to own and live with had it been painted by someone else.'

The painter **Edward Reginald Frampton** (1870–1923) was not related, but he was a friend of Sir George and Lady Frampton. He specialized in murals (including several in churches as war memorials) in a flat stately style influenced by French *Symbolism and by stained glass (his father was a stained-glass artist). His work also included symbolic subjects and landscapes, and early in his career he made sculpture.

Francis, Sam (1923–94). American painter, one of the leading second-generation *Abstract Expressionists. He was born in San Mateo, California, and studied psychology and medicine at the University of California, Berkeley, 1941–3. While serving in the US Army Air Corps he injured his spine in a plane crash and he took up painting in 1944 while he was recovering in hospital. He studied with David *Park in San Francisco, then returned

to the University of California and took an MA in fine arts in 1950. In the same year he settled in Paris, where he studied under *Léger and was friendly with *Riopelle and other *Art Informel painters; his style was influenced by these artists as well as by Americans such as Jackson *Pollock. In 1957–8 Francis twice travelled round the world, making a long stay in Japan. He often returned there, and the thin texture of his paint, his drip and splash technique, and his asymmetrical balance of colour against powerful voids (he often left areas of canvas blank) led critics to speak of influences from Japanese traditions of contemplative art. In 1961 Francis returned to California, settling first at Santa Barbara and then in Santa Monica. From the mid-1960s the feeling of oriental simplicity in his painting increased, bringing his work into closer affinity with *Minimal art. Francis carried out several mural commissions, but he often worked on a small scale in watercolour. He also made lithographs (from 1960) and sculpture (from 1965).

Frank, François. See ART CONTEMPORAIN.

Frankenthaler, Helen (1928–). American painter, printmaker, and sculptor, born in New York, where she has spent most of her life. She studied at various art schools, her teachers including *Hofmann and *Tamayo, and by 1950 she had met many of the leading *Abstract Expressionists. The work of Jackson *Pollock particularly impressed her, and she developed his drip technique by pouring and running very thin paint—like washes of watercolour—onto canvases laid on the floor. She first used this method in *Mountains and Sea* (artist's collection, on loan to NG, Washington, 1952), which is regarded as the seminal work of Colour Stain Painting (see COLOUR FIELD PAINTING); it particularly impressed Morris *Louis and Kenneth *Noland when they saw it in her studio in 1953. In 1962 Frankenthaler changed from oil to *acrylic paint, which allowed her to achieve more richly saturated colour. The limpid veils of colour float on the surface of the canvas, but they often evoke suggestions of landscape: she believes that 'Pictures *are* flat and part of the nuance and often the beauty or the drama that makes a work, or gives it life . . . is that it presents such an ambiguous situation of an undeniably flat surface, but on it and within it an intense play and drama of space, move-

ments, light, illusion, different perspectives, elements in space'.

Frankenthaler has continued to exploit her stain techniques in her later paintings, often working on a large scale. She had her first major success in 1959, when she won first prize at the Paris *Biennale, and since then has received numerous awards and distinctions, including representing the USA at the Venice Biennale in 1966 and at Expo 67 in Montreal the following year. In the 1980s her paintings generally became calmer in mood and more sombre in colour. Since 1960 she has also made aquatints, lithographs, and woodcuts; in 1964 she began to work in ceramics, and in 1972 she made her first sculpture. From 1958 to 1971 she was married to Robert *Motherwell.

Frayling, Christopher. See ROYAL COLLEGE OF ART.

Freddie, Wilhelm (1909–). Danish *Surrealist painter, sculptor, collagist, printmaker, draughtsman, designer, and film-maker, well known for the explicit erotic quality of his work, which often caused controversy. He was born in Copenhagen and studied briefly at the Academy there, but he was essentially self-taught. In 1929 he was introduced to Surrealism by the magazine *La *Révolution surréaliste*, and he became a pioneer of the movement in Denmark. His early work was influenced by the highly detailed style of *Dalí, but it later moved towards abstraction. He first made a major public impact in 1937, when, as Sarane Alexandrian writes (*Surrealist Art*, 1970), 'there were angry scenes at his Copenhagen exhibition "Sex-Surreal", which included "sado-masochistic interiors" and "sensual objects". One protestor was so infuriated that he hurled himself on Freddie on the day of the opening and tried to strangle him. The gallery was closed by the police, who confiscated the works on show, some of which . . . went to their "black museum", from which Freddie was not able to retrieve them until much later.' (In 1961, he provoked a reopening of the case and succeeded in having the country's obscenity laws revised.) During the Second World War, Denmark was occupied by the Germans and his work was declared *degenerate, prompting him to flee to Sweden, where he lived from 1944 to 1950. After his return to Denmark, his work was gradually found more acceptable by the public. He

received several decorative commissions and from 1973 to 1979 he was a professor at the Copenhagen Academy.

Freedman, Barnett (1901–58). British painter, lithographer, book illustrator, and designer, born in the East End of London into a poor Russian-Jewish immigrant family (his father was a journeyman tailor). For much of his life he suffered ill-health and from the age of 9 to 14 he was in hospital, where he taught himself to draw and paint and to play the violin. His artistic talents enabled him to find employment in a monumental mason's workshop and then in an architect's office, and after studying for five years at evening classes at *St Martin's School of Art he won a scholarship to the *Royal College of Art in 1922. After leaving the RCA in 1925, he suffered poverty for several years before his career began to flourish. He regarded himself as a painter and hoped to make his living as such, but in fact he was chiefly successful in various types of commercial work, in which he made use of his expert skills as a lithographer. His output included many book jackets and posters, and—less typically but indicative of his all-round professionalism—the George V Jubilee postage stamp in 1935. From 1941 to 1946 he was an *Official War Artist, first with the army in France, then with the navy—on Arctic convoys and on submarines. Examples of his war paintings—in which he said he 'tried hard to depict men doing their jobs'—are in the Imperial War Museum and the Tate Gallery, London. After the war he became well known for appearances on radio and television, revealing a character that Sir John *Rothenstein describes as 'wise, witty and of conspicuous yet humane candour (he was known as "Soc", short for Socrates)'. The *Dictionary of National Biography* comments that 'His personality was that of a true original, showing marked independence of mind, coupled with a keen enjoyment of dialectic, eccentric humour . . . It was one of the chief satisfactions of his life that he, a cockney from the east end, should have been elected in 1945 to membership of the Athenaeum Club.'

French, Daniel Chester (1850–1931). The most famous American sculptor of public monuments during his day. His best-known work is the seated marble figure of Abraham Lincoln (dedicated 1922) on the Lincoln Memorial in Washington. He also made a standing figure of Lincoln for the town of Lincoln, Nebraska (1912). More typical of his work, however, are allegorical figures of women (*Alma Mater*, Columbia University, New York, 1903). 'Chesterwood', French's home and studio near Stockbridge, Massachussetts, has been preserved as a memorial to him.

French, Leonard (1928–). Australian painter, active mainly in his native Melbourne. He was apprenticed to a signwriter, which encouraged him to think as a muralist, and studied at night at the Melbourne Technical College, 1944–7. His first commission was for two frescos in the Congregational Church, Brunswick (the district of Melbourne in which he was born)—*To the War Dead* and *One World* (1948), executed in the manner of *Orozco. In 1949 he worked his passage to England and met Alan *Davie in London. He visited Ireland and studied the heavy, intertwined shapes of Celtic art, but the work of *Gromaire and *Permeke, and later that of *Delaunay and *Léger, exercised a more direct influence on the paintings he produced after his return to Melbourne in 1952. His work at this time was geometrical and flat, taut in line and strident in colour, and he began to show a preference for epic themes from literature (notably the *Iliad* and the *Odyssey*). Although his pictures often involved literary or religious imagery, his style became semi-abstract and intuitively evolved: 'I don't really know what I am going to paint; it has to grow up in the process of one colour on top of another.' His mature style emerged in the early 1960s in a series of paintings inspired by reading Evelyn Waugh's biography of the 16th-century Jesuit martyr Edmund Campion, which had been lent to him by the Catholic poet Vincent Buckley, a close friend. These paintings best express French's ideal of the heroic, in which the spiritual will battles with and yet is in a sense contained by the mechanical, the seasonal, and the cyclical. In 1962–3 French lived for a time in Greece. On returning to Melbourne he was commissioned to design a stained-glass ceiling for the Great Hall of the new National Art Gallery of Victoria. French has also produced etchings and lithographs related to the themes of his paintings.

Freud, Lucian (1922–). German-born British painter and draughtsman. He was born in

Berlin, son of an architect, Ernst Freud, and grandson of Sigmund Freud. In 1932 he settled in England with his parents, and he acquired British nationality in 1939. His earliest love was drawing and he began to work full-time as an artist after being invalided out of the Merchant Navy in 1942 (his formal training was brief but included an important period in 1939 studying with Cedric *Morris, who encouraged his pupils to let feelings prevail over objective observation). From 1948 to 1958 he taught at the *Slade School. He first exhibited his work in 1944 and first made a major public impression in 1951 when his *Interior at Paddington* (Walker Art Gallery, Liverpool) won a prize at the *Festival of Britain; it shows the sharply focused detail, pallid colouring, and obsessive, slightly bizarre atmosphere characteristic of his work at this time. Because of the meticulous finish of such paintings, Freud has sometimes been described as a 'Realist' (or rather absurdly as a *Superrealist), but the subjectivity and intensity of his work has always set him apart from the sober tradition characteristic of most British figurative art since the Second World War. From the late 1950s he painted with much broader handling and richer colouring, without losing any of his intensity of vision. His work includes still-lifes, interiors, and urban scenes, but his specialities are portraits and nudes, often observed in arresting close-up, with the flesh painting given an extraordinary quality of palpability (*The Painter's Mother*, Tate Gallery, London, 1982). He prefers to paint people he knows well, one of his favourite recent subjects being the Australian *Performance artist Leigh Bowery (1961–94), who was a friend from the mid-1980s: 'If you don't know them, it can only be like a travel book.'

Freud's work has been shown in numerous one-man and group shows and he has steadily built up a formidable reputation as one of the most powerful contemporary figure painters. In 1993 Peter *Blake wrote that since the death of Francis *Bacon the previous year, Freud was 'certainly the best living British painter', and by this time he was also well-known abroad (a major retrospective exhibition of his work in 1987–8 was seen in Paris and Washington as well as London). His fame has been won in spite of an aversion to self-publicity. Sir John *Rothenstein writes of him: 'Freud holds himself aloof not only from official life but also from conventional social life

as well. This is due largely to his determination to preserve the utmost possible independence, but even more because he needs an exceptional measure of freedom from distraction in order to work . . . Freud is, in fact, an anomalous figure, a socially sought-after solitary with a seemingly facile mind to whom the pursuit of his vocation is a sombre ordeal daily renewed, a seemingly material temperament, who, like Francis Bacon [a close friend], beyond needing ready cash in his pocket, is without the acquisitive urge, and whose successive studios would be rejected as unfit to live in by the student of today' (*Modern British Painters*, vol. 3, 1984).

Freundlich, Otto (1878–1943). German painter, sculptor, and designer (of mosaics, tapestries, and stained glass), active mainly in France. He was born at Stolp in Pomerania, studied history of art in Munich (under Heinrich Wölfflin) and Florence, and began painting in 1905. From 1909 to 1914 he spent much of his time in Paris, where he was a member of *Picasso's circle (he had a studio in the *Bateau-Lavoir) and flirted briefly with *Cubism. In 1918 he was a member of the *Novembergruppe in Berlin and soon afterwards he began producing purely abstract paintings, composing with interlocking swathes of colour. From 1924 to 1939 he lived in Paris, where he was a member of *Cercle et Carré and *Abstraction-Création. In his own country his work was condemned as *degenerate (his sculpture *The New Man* was reproduced on the cover of the catalogue of the infamous exhibition of 'Degenerate Art' held in Munich in 1937 and was later destroyed by the Nazis). He did not take up large-scale sculpture until 1928, but his few surviving works in this field are generally considered his finest achievements, notable for their feeling of sombre mystery. Much of Freundlich's work perished during the Second World War. His studio in Paris was confiscated by the occupying Germans and he died at Maidanek concentration camp, near Lublin, in Poland.

Friday Club. An informal association founded in 1905 by Vanessa *Bell as a meeting-place for progressive artists to discuss their work and theories, listen to lectures, and hold exhibitions. After five or six years the Club ceased to function as a meeting-place (Bell's home at 46 Gordon Square, London, had been

the usual venue), but exhibitions were continued up to 1922 (mainly at the Alpine Club Gallery). The exhibitions brought together a wide range of artists. Originally there was a strong *Bloomsbury Group presence, but in 1913 Roger *Fry, Duncan *Grant, and Bell herself left to found a splinter society, the Grafton Group, and new blood at the Friday Club exhibition in 1914 included David *Bomberg, the *Nash brothers, and Edward *Wadsworth. By the time of the final show, other exhibitors had included Robert *Bevan, Frank *Dobson, Eric *Gill, Charles *Ginner, Eric *Kennington, Charles Rennie *Mackintosh, and Lucien *Pissarro.

Fried, Michael. See ARTFORUM.

Friesz, Othon (1879–1949). French painter (of landscapes, portraits, figure compositions, and still-lifes), graphic artist, and designer, born in Le Havre. He studied there at the École des Beaux-Arts, 1896–9, then in 1899–1904 at the École des *Beaux-Arts in Paris, where he met *Matisse. His early work was *Impressionist in style, then from 1905 to 1907 he was one of the *Fauves—his best work dates from this brief period. In 1907 he abandoned Fauvism and reverted to a more traditional and solidly constructed style, under the influence of *Cézanne; from 1911, following a visit to Portugal, he adopted looser, freer handling. After serving in the army during the First World War, he returned to Paris, but up to 1930 he worked a good deal in Toulon and Provence. From 1929 he taught at the Académie Scandinave in Paris (and later at the Académie de la Grande Chaumière, 1941–4), and in his final years he often painted on the Normandy coast. In 1937–40, with *Dufy (his friend since student days in Le Havre), he painted a large mural in the Palais de Chaillot, Paris, on the theme of the River Seine. As well as paintings, he made book illustrations and tapestry designs. By the end of his life he was a much honoured figure, but his later career is generally seen as marking a steep decline from his Fauve days: 'Friesz went on producing rather than creating, resorting to the cheap devices, easy effects, and outworn rules of his craft . . . The son of a sea captain had cast anchor in the pool of stale ideas . . . he left a body of work in which the most brilliant promise was followed by skilful evasions' (Carlton Lake and Robert Maillard, eds., A Dictionary of Modern Painting, 1956).

Frink, Dame Elisabeth (1930–93). British sculptor and graphic artist, born at Thurlow, Suffolk. She studied at Guildford School of Art, 1947–9, and Chelsea School of Art, 1949–53, then taught at Chelsea, 1953–61, and *St Martin's School of Art, 1954–62. In 1964 she became a visiting instructor at the *Royal College of Art. Her main teacher at Chelsea was Bernard *Meadows, through whom she underwent some influence from Henry *Moore; she was also influenced for a while by *Giacometti, some of her early work being angular and menacing. During the 1960s her figures—typically bronze horses and riders or male nudes—became smoother, but she retained a feeling of the bizarre in the polished goggles that feature particularly in her over-life-size heads: 'I think my sculptures are about what a human being or an animal feels like, not necessarily what they look like. I use anatomy to create the essence of human and animal forms.' Frink achieved success early (whilst still a student she won a prize in the competition for the Monument to the Unknown Political Prisoner (see BUTLER, REG) against competition from a huge international field) and she became one of the best-known British sculptors of her generation. Her work included numerous public commissions, beginning with the concrete Wild Boar (1957) for Harlow New Town; a characteristic work is the bronze Horse and Rider (1975) in Piccadilly, London (at the corner of Dover Street), commissioned by Trafalgar House Investments Ltd. Later in her career she also did numerous portrait busts of distinguished sitters. In addition to sculpture she also made prints and drawings. She was created a Dame in 1982.

Fronte Nuovo delle Arti (New Art Front). An association of Italian artists founded in 1946 (it was originally called the Nuova Secessione Artistica Italiana but was renamed in 1947). It aimed to combat the pessimism of the postwar world and revitalize Italian art, which had not been a leading force in Europe since the heyday of *Futurism. *Birolli and *Guttuso were the best-known figures in the group, which embraced artists of very different styles and ideologies. Among the others were the painters Bruno Cassinari (1912–92) and Ennio Morlotti (1910–) and the sculptors Leonardo Leoncillo (1915–68) and Alberto Viani (1906–89). The split between abstractionists and realists led to the disintegration

of the association by 1952, when several of the members joined the *Gruppo degli Otto Pittori Italiani.

Frost, Terry (1915–). British painter, born in Leamington Spa, Warwickshire, one of the leading artists of the *St Ives School. He attended evening classes in art when he was sixteen, but then worked at various jobs, mainly concerned with electricity and radio, and did not take up painting until 1943, when he was a prisoner of war in Germany. His fellow prisoner Adrian *Heath encouraged him. After the war Frost studied at St Ives School of Art (1946) under its founder Leonard Fuller (1891–1973), then at Camberwell School of Art (1947–50) under *Coldstream and *Pasmore (whom he described as 'my god'). In 1951 he worked as assistant to Barbara *Hepworth, but his main period of residence at St Ives was 1959–63. His early work had been in the sober realistic tradition of the *Euston Road School, but he soon turned to abstraction. His work remained based on observations of nature, however, often the harbour at St Ives. Of *Blue Movement* (Vancouver Art Gallery, 1953) he wrote: 'On one particular blue twilit evening, I was watching what I can only describe as a synthesis of movement and counter-movement . . . the rise and fall of the boats . . . the opposing movements of the incoming sea and the outblowing off-shore wind . . . I was trying to give expression to my total experience of that particular evening. I was not portraying the boats, the sand, the horizon or any other subject matter but concentrating on the emotion engendered by what I saw. The subject matter is in fact the sensation evoked by the movement and the colour in the harbour. What I have painted is an arrangement of form and colour that evokes for me a particular feeling.' Characteristically he uses patterns of interlinked shapes—strongly outlined but avoiding geometrical regularity. Frost taught at Bath Academy of Art, 1952–4, Leeds College of Art, 1956–9, and Reading University, 1965–81. He was appointed professor at Reading in 1977 and became emeritus professor on his retirement. His son **Anthony Frost** (1951–) is also an abstract painter of the St Ives School.

frottage (French: 'rubbing'). A technique of creating an image by placing a piece of paper over some rough surface such as grained wood or sacking and rubbing the paper with a crayon or pencil until it acquires an impression of the surface quality of the substance beneath. The resulting image is usually taken as a stimulus to the imagination, forming the point of departure for a picture expressing subconscious imagery. The technique was invented in 1925 by Max *Ernst, who described how he was inspired by some floorboards, 'the grain of which had been accentuated by a thousand scrubbings . . . I made from the boards a series of drawings by placing on them, at random, sheets of paper which I began to rub with black-lead. In gazing attentively at the drawings thus obtained . . . I was surprised by the sudden intensification of my visionary powers and by the hallucinatory succession of contradictory images superimposed, one upon the other, with the persistence and rapidity peculiar to amorous memories. My curiosity awakened and astonished, I began to examine indiscriminately, using the same means, all sorts of materials found in my visual field: leaves and their veins, the frayed edges of a bit of sackcloth, the brush strokes of a "modern" painting, a thread unwound from a spool, etc.' Many other *Surrealists adopted the technique. See also AUTOMATISM.

Fry, Roger (1866–1934). British critic, painter, and designer, born in London into a distinguished Quaker family. Although he gave up Christian beliefs in adulthood, his Quaker upbringing influenced his character in many ways, notably in his respect for truth, his industriousness, and his sense of social responsibility. In 1885–8 he studied natural sciences (botany was his speciality) at King's College, Cambridge, graduating with a first-class degree. By this time, however, art was already replacing science as his main interest (to his parents' dismay), and over the next few years he travelled to France and Italy to study art (briefly at the *Académie Julian in 1892) and began to build up a reputation as a writer and lecturer (and a more modest one as a painter). Kenneth *Clark writes that he was 'by common consent, the most enthralling lecturer of his time'. His success in this field depended partly on his mellifluous voice; George Bernard Shaw said it was one of only two he knew that was worth listening to for its own sake—the other was that of the actor Sir Johnston Forbes-Robertson. From 1901 to 1906 Fry was the regular art critic of the *Athenaeum*, a prestigious literary review. This

helped to make his name known in the USA and in 1906 he was appointed curator of paintings at the Metropolitan Museum, New York, where he worked until 1910 (immediately after accepting this post he was offered the directorship of the National Gallery, London, but he turned it down as he felt bound to honour his agreement with New York). He had won his scholarly reputation writing on Italian Old Masters (his first book was on Giovanni Bellini, 1899, but in the year he took up his New York appointment he began to be strongly drawn to *Cézanne and he developed into his period's most eloquent champion of modern French painting. In this role he waged 'a long and often thankless crusade . . . to lift English art out of its besetting provincialism' (Dennis Farr, *English Art 1870–1940*, 1978).

After his return to London in 1910 Fry organized two exhibitions of *Post-Impressionist painting at the Grafton Galleries (1910 and 1912) that are regarded as milestones in the history of British taste. They attracted an enormous amount of publicity and comment, much of it unfavourable; the establishment view was expressed by the eminent painter Sir William Blake Richmond (1842-1921), who wrote that 'Mr Fry must not be surprised if he is boycotted by decent society'. Many people thought that Fry was a charlatan or possibly even insane (his wife unfortunately was insane—she had been committed to an asylum in 1910—which prompted the unkind idea that her condition had somehow infected him). Certain young artists were immensely impressed by the exhibitions, however, and Fry became an influential figure among them. They included Vanessa *Bell and Duncan *Grant, both of whom worked for the *Omega Workshops, which Fry founded in 1913.

Fry kept up a steady output of writing and lecturing for the rest of his life and also continued to work seriously as a painter (he always regarded this activity as a central part of his career); at the time of his death he was Slade professor of fine art at Cambridge University. His books include monographs on Cézanne (1927) and *Matisse (1932) as well as several collections of lectures and essays, including *Vision and Design* (1920) and *Transformations* (1926). The Cézanne book is described by John Rewald in his *History of Impressionism* as 'the first good study of Cézanne's artistic evolution'. In his writing

Fry—like his friend Clive *Bell—stressed the formal qualities of works of art (see FORMALISM), and this outlook made him responsive to African and other non-European art. However, his range of sympathy towards avant-garde was limited. He did not care for *Expressionism or for German art in general (it was too emotional for his intellectual temperament) and he said of the *Futurists: 'All they do is to paint the confusion of the brain in a railway journey.' In spite of these limitations and the initial opposition to his ideas, he probably did more than anyone else to awaken public interest in modern art in England. Kenneth Clark called him 'incomparably the greatest influence on taste since Ruskin' and said: 'In so far as taste can be changed by one man, it was changed by Roger Fry.' Clark was unimpressed with Fry's work as a painter, however: 'his hand was heavy and lifeless . . . the chief merit of his paintings is a naive earnestness which is sometimes rather touching.' Fry's painting was sometimes experimental (his work included a few abstracts), but his best pictures are fairly straightforward naturalistic portraits; his sitters included several of his *Bloomsbury Group friends (examples, including a self-portrait, are in the National Portrait Gallery, London), and towards the end of his life he occasionally did commissioned portraits. In 1976 an exhibition of his portraits was held at the Courtauld Institute Galleries, London, and the Mappin Art Gallery, Sheffield. In her introduction to the catalogue, Frances Spalding is more generous than Kenneth Clark in her evaluation of Fry as a painter: 'If the portraits painted during the last fourteen years of his life are stylistically less adventurous than those of the previous decade, they are often richer in human value. They reveal an intelligence and lack of rhetoric that gives them a freshness and immediacy of effect.'

Fuchs, Ernst (1930–). Austrian painter and graphic artist, born in Vienna. He studied at the Vienna Academy under *Gütersloh, 1946–50, and is the best-known member of the school of *Fantastic Realism made up mainly of Gütersloh's pupils. His subjects are drawn from religion and magic, treated in a outlandish and vividly detailed manner—often his imagery is close to that of horror comics. He is a prolific etcher as well as a painter, and Riva Castelman (*Prints of the 20th Century*, 1976) writes of this aspect of his work:

'Technically, Fuchs has no peer in the compulsively precise execution of his plates. While his subjects are nearly always without contemporary motifs, they have a symbolic relevance to contemporary conditions.' Fuchs has an international reputation and in 1993 had a major exhibition at the Russian Museum, St Petersburg.

Fujita. See FOUJITA.

Fullard, George. See SMITH, JACK.

Fuller, Leonard. See FROST.

Fuller, Peter (1947–90). British art critic, born in Damascus, the son of a doctor. After graduating in English from Cambridge University in 1968, he began working for *City Press*, *New Society*, and other journals in London, and for the rest of his life he earned his living as a writer. At Cambridge he had been influenced by Marxist ideas, and in art criticism he was initially a follower of John *Berger. However, he gradually abandoned Marxism, and in 1980 he published *Seeing Berger* (reissued in 1988 with the title *Seeing Through Berger*), a riposte to his former mentor's highly influential book and television series *Ways of Seeing*: 'He argued that Berger's book tended to reduce art works to little more than documents of unequal power relations, or commodities to be sold and resold at ever higher prices. For Fuller this now seemed a violently reductive way of treating art and aesthetics. Surely, a great work of art had an intrinsic *aesthetic* value over and above its commercial or ideological value' (John McDonald, introduction to *Peter Fuller's Modern Painters: Reflections on British Art*, 1993). His views became increasingly conservative, and in 1988 he founded the journal *Modern Painters* to champion traditional values. The following year he was appointed art critic of the *Sunday Telegraph*, one of the most right-wing of British newspapers. Although his outlook had changed greatly over the years, his bellicose personality had not, and he became the most controversial British critic of his time; to his admirers he was a bold, plain-speaking champion of time-honoured values and common sense, and to his detractors he was a short-sighted philistine. He died in a car crash. 'Modern Painters: A Memorial Exhibition for Peter Fuller' was shown at the City Art Gallery, Manchester, in 1991. Apart from works on art, Fuller wrote an autobiography, *Marches Past* (1986), and he was co-author with John Halliday of *The Psychology of Gambling* (1974) (early in his life he had been a compulsive gambler).

fumage. A technique of *automatism devised in the late 1930s by Wolfgang *Paalen; by moving a candle flame underneath a sheet of paper he deposited strange, dreamlike formations of soot-blackening on it, exemplifying *Surrealist ideas of chance as a means of releasing imagery from the subconscious mind. These effects were imitated in oil painting.

Funk art. Term applied to a type of art that originated in California (specifically the San Francisco area) around 1960 in which tatty or sick subjects—often pornographic or scatological—are treated in a deliberately distasteful way (the word 'funky' has various meanings, including 'smelly'; when applied to music it can mean 'earthy' or 'authentic'). By the mid-1960s there was something approaching a Funk movement, and an exhibition called 'Funk' was held at the University Art Museum, Berkeley, California, in 1967. Although the first works of Funk art were paintings, its most characteristic products are three-dimensional—either sculpture or *assemblage. Influenced by *Dada and *Pop art, Funk art was 'dedicated to rude subversion of everything the New York scene stood for, especially its purist formalism, temple-like galleries, and priestly caste of critics . . . Funk artists . . . cultivated ephemeral as well as cheap materials, sloppy execution, weird eccentricity, and outrageously vulgar fun poked at everything sacred, from religion, patriotism, and pets, to art, sex, and politics' (Daniel Wheeler, *Art Since Mid-Century*, 1991). Edward *Kienholz was the best-known practitioner of the genre and one of its most distinctive exponents was Robert Arneson (1930–92), who worked mainly in ceramics, creating, for example, painted sculptures of toilets (*John with Art*, Seattle Art Museum, 1964). Other exponents include Bruce Conner (1933–) and Paul Thek (1933–).

Futurism. Italian avant-garde art movement, launched in 1909, that exalted the dynamism of the modern world; it was literary in origin, but most of its major exponents were painters, and it also embraced sculpture,

architecture, music, the cinema, and photography. The First World War brought the movement to an end as a vital force, but it lingered in Italy until the 1930s, and it had a strong influence in other countries, particularly Russia.

The founder of Futurism was Filippo Tommaso *Marinetti, who launched the movement with a manifesto published in French in the Parisian newspaper Le Figaro on 20 February 1909. In bombastic, inflammatory language, he attacked established values ('set fire to the library shelves . . . flood the museums') and called for the cultural rejuvenation of Italy by means of a new art that would celebrate technology, speed, and all things modern. Many Italians shared Marinetti's dismay that—following the stirring days of unification in the mid-19th century—their country had failed to become a truly modern nation, and few, if any, of the ideas expressed in the manifesto are original: they emerge from 'a tangled web of turn-of-the-century political, cultural and philosophical currents' (Caroline Tisdall and Angelo Bozzolla, Futurism, 1977). What was new was the exaggerated violence of the language and the skill with which the document was publicized. Marinetti was a brilliant manipulator of the media, and it is typical of his panache that he had his manifesto published not in some obscure journal, but on the front page of one of the most prestigious newspapers in the world (he was very wealthy and simply hired the space). Futurism was also novel as a movement in that it chose its own name and that it started with an idea and only gradually found a way of expressing it in artistic form.

In spite of Marinetti's repeated use of 'we' in the manifesto, there was no Futurist group when it was published. However, he soon attracted adherents among other Italians, notably a group of painters based in Milan, whom he helped to produce the Manifesto of Futurist Painters, published as a leaflet by his magazine Poesia in February 1910. It was drawn up by *Boccioni, *Carrà, and *Russolo, and also signed by *Balla (who lived in Rome) and *Severini (who was in Paris at this time). The same five signed the Technical Manifesto of Futurist Painting, published in April 1910. Whereas the first painters' manifesto is little more than a repetition of Marinetti's bombast, the Technical Manifesto does suggest—although in vague terms—the course that Futurist painting would take, with the emphasis on conveying movement (or the experience of movement): 'The gesture which we would reproduce on canvas shall no longer be a fixed moment in universal dynamism. It shall simply be the dynamic sensation itself.'

In trying to work out a visual idiom to express such concerns, the Futurist painters at first were strongly influenced by *Divisionism, in which forms are broken down into small patches of colour—suitable for suggesting sparkling effects of light or the blurring caused by high-speed movement, as in Boccioni's The City Rises (MOMA, New York, 1910–11). In 1911, however, Boccioni and Carrà visited Marinetti and Severini in Paris, where they were influenced by *Cubism. Thereafter they began using fragmented forms and multiple viewpoints, with the sense of movement often accentuated by vigorous diagonals. Balla developed a different approach to suggesting motion, imitating the effects of multiple-exposure photography in which successive images taken a fraction of a second apart overlap and blur (such photographs had first been taken by Étienne-Jules Marey in the 1880s). The subjects of the Futurist painters were typically drawn from urban life, and they were often political in intent.

Futurist paintings were first publicly shown at a mixed exhibition in Milan in 1911, but the first proper group exhibition was held in February 1912 at the Galerie *Bernheim-Jeune in Paris. Subsequently it travelled to London (the Sackville Gallery), Berlin (the *Sturm Gallery, where many of the exhibits were bought by a private collector), Amsterdam, Zurich, Vienna, and Budapest. Marinetti's skilful promotion techniques (backed by his personal fortune) ensured that the exhibition gained a great deal of publicity; reactions to it were very mixed, but the Futurists were never ignored. The preface to the catalogue, signed by Balla (who did not exhibit), Boccioni, Carrà, Russolo, and Severini, was in effect an updated manifesto, in which they discussed a vague principle of 'force-lines', through which objects fuse with their surroundings. Their ideas are summarized by George Heard *Hamilton as follows: 'According to this document they wanted to portray the sum of visual and psychological sensations as a "synthesis of what one remembers and of what one sees". In addition to the visible surface of objects, there are the dynamic sensations conveyed by the invisible extensions of their "force-lines", which reveal how the object "would resolve

itself were it to follow the tendencies of its forces". Since the work of art, through this process of "physical transcendentalism", can be considered the representation of a state of mind, and the force-lines, as perspective elements, tend towards infinity, the spectator is placed "in the centre of the picture".'

Boccioni (the only major sculptor in the group) expressed similar ideas about the relationship of form, motion, and environment in his *Manifesto of Futurist Sculpture*, published in April 1912. There was also a *Manifesto of Futurist Architecture*—by Antonio Sant' Elia (1888–1916), whose powerful and audacious designs remained on paper—as well as musical manifestos (see RUSSOLO), and several on other topics, including a *Manifesto of Futurist Lust* (1913) by the French writer, dancer and painter Valentine de Saint-Point (1875–1953). She thought that lust was an essential part of life's dynamism: 'It is the sensory and sensual synthesis that leads to the greatest liberation of the spirit. It is a communion of a particle of humanity with all the sensuality of the earth.' The Futurists spread their ideas also through meetings—in various public venues—that were sometimes like a cross between political rally and variety theatre, anticipating *Performance art.

In keeping with this talent for self-promotion, the Futurists had widespread influence in the period immediately before and during the First World War. Stylistically, the influence is clear in the work of the *Vorticists in England, for example, and that of Marcel *Duchamp in France and Joseph *Stella in the USA, whilst the use of provocative manifestos and other shock tactics was most eagerly adopted by the *Dadaists. Outside Italy, however, it was in Russia that Futurism made the greatest impact, although there were significant differences between the movements in the two countries: Russian Futurism was expressed as much in literature and the theatre as in the visual arts, and it combined modern ideas with an interest in *primitivism. The *Union of Youth, founded in 1910, was an important nurturing ground for

Futurism, but its starting-point as a movement in Russia is often reckoned to be the manifesto *A Slap in the Face for Public Taste* (1912), the signatories of which included David *Burliuk and Vladimir *Mayakovsky. The Russian Futurists rejected Symbolism, which had been such a powerful force in the country's art, demanding a new and experimental attitude, and they welcomed the Revolution. In terms of Russian painting, Futurism was particularly influential on *Rayonism (see also CUBO-FUTURISM).

Russian Futurism flourished into the 1920s, but Italian Futurism—as an organized movement—was virtually ended by the First World War (during which Boccioni, its outstanding artist, and also Sant' Elia died; ironically, Marinetti had welcomed the war as a means of cleansing the world). Of the leading painters of the pre-war phase, only Balla remained true to Futurism, and its centre of activity moved from Milan to Rome, where he lived. Carrà changed course completely during the war, joining de *Chirico in *Metaphysical Painting. After the war, Marinetti continued with his literary and political activities, supporting Fascism (he was a friend of Mussolini). Fascism and Futurism shared an aggressive nationalism and the names are often linked; Futurism has even been described as 'the official art of Fascism'. This, however, is untrue. Although Fascism was ideologically close to Nazism, it was much more tolerant and open in artistic matters; there was no official art of the regime, but in the 1930s the pompous style favoured by some *Novecento artists came much closer to this than Futurism ever did (see TOTALITARIAN ART). By this time all the life had gone out of Futurism, and Marinetti's attempt to revive it as *Aeropittura was a mere footnote to the movement.

One of the best collections of Futurist art outside Italy is the Eric and Salome Estorick Foundation, London, which opened to the public in 1998. The collection was made by the American-born art dealer Eric Estorick (1913–93) and his wife Salome (d. 1989).

G. The title of a magazine founded by Hans *Richter in Berlin in 1923 with the intention of making it 'the organ of the *Constructivists in Europe'. There were six issues before it folded in 1926. *Lissitsky, who had himself published a short-lived Constructivist journal called *Vesch, suggested the single-letter title: 'G' stands for 'Gestaltung' (Formation). The first number contained an article by van *Doesburg entitled 'Elemental Formation', in which he discussed two opposing modes of expression. The art of the past, which he called 'decorative', depended on individual taste and intuition. In contrast to this, the art of the present (by which he meant Constructivism) he called 'monumental' or 'formative'. He claimed that Constructivist art is no longer impulsive or intuitive but done in accordance with objective aesthetic principles and that the Constructivist has 'conscious control of his elemental means of expression'. Other contributors to the magazine included *Arp, *Hausmann, *Man Ray, and *Schwitters.

Gabo, Naum (Naum Neemia Pevsner) (1890–1977). Russian-born sculptor who became an American citizen in 1952, the most influential exponent of *Constructivism. He was born in Klimovichi, Belarus, and brought up in Briansk, where his father ran a prosperous metallurgy business. His surname was originally Pevsner, but he adopted another family name, Gabo, in 1915 to avoid confusion with his younger brother, Antoine *Pevsner. In 1910 he began studying medicine at Munich University, but he soon switched to natural sciences, then engineering. He was introduced to avant-garde art when he visited his brother in Paris in 1913–14, and in 1915 he began to make geometrical constructions in Oslo, where they had taken refuge during the First World War. In 1917 the brothers returned to Russia and in 1920 they published

their *Realistic Manifesto*, which set forth the basic principles of Constructivism (originally the manifesto was issued as a poster to accompany an open-air exhibition of their work in Moscow). They advocated a pure abstract sculpture, but official policy in the new Soviet Russia increasingly insisted on art being channelled into industrial design and other socially useful work (as exemplified by *Tatlin). Gabo therefore left Russia in 1922 and spent the next ten years in Berlin, where he knew many of the leading artists of the day, particularly those connected with the *Bauhaus. In 1932 he moved to Paris, where he was a leading member of the *Abstraction-Création group, and in 1935 he settled in England, living first in London (where in 1937 he was co-editor of the Constructivist review *Circle) and then from 1939 in Cornwall (see ST IVES SCHOOL).

In 1946 Gabo moved to the USA, settling at Middlebury, Connecticut, in 1953. He had a joint exhibition with Pevsner at the Museum of Modern Art, New York, in 1948, and in the remaining three decades of his life he became a much honoured figure, receiving various awards and carrying out numerous public commissions in America and Europe. He often worked on themes over a long period; his *Torsion Fountain* outside St Thomas's Hospital in London, for example, was erected in 1975, but it is a development from models he was making in the 1920s. (Small models are a feature of his work; there are numerous examples in the Tate Gallery, London, which has an outstanding collection of Gabo material, presented by the artist himself.)

Gabo never trained as an artist, but came to art by way of his studies of engineering and science. He was one of the earliest to experiment with *Kinetic sculpture (in 1919) and to make extensive and serious use of semi-transparent materials for a type of abstract sculpture that incorporates space as a positive

element rather than displacing or enclosing it. Throughout his career he was an advocate of Constructivism not merely as an artistic movement but as the ideology of a way of life. In the catalogue of the exhibition 'Naum Gabo: The Constructive Process' (Tate Gallery, London, 1976) Teresa Newman writes: 'Constructivism was and is "real" in the sense that it consists of three-dimensional, palpable images set in space . . . But constructive reality also has a philosophical dimension insofar as these sensuous images express a modern, life-affirming consciousness with materials and methods appropriate to our time. The constructive principle, in Gabo's words, "embraces the whole complex of human relationships to life: it is a mode of thinking, acting, perceiving and living." Creation, for Gabo, is another word for life.'

Galerie de l'Effort Moderne, Paris. See ROSENBERG, LÉONCE.

Galerie l'Actuelle, Montreal. See MOLINARI.

Galí, Francisco. See MIRÓ.

Gallatin, A. E. (Albert Eugene) (1881–1952). American collector, writer on art, and painter. He was born into a wealthy family, the great-grandson of the Swiss-born financier Albert Gallatin, who had been Secretary of the US Treasury, 1801–14. His earliest collecting interests were in Aubrey Beardsley and *Whistler, but in the 1920s he began buying more recent works, stimulated by his frequent visits to Europe, especially Paris. He was dismayed by the dispersal of John *Quinn's collection in 1926, and in 1927 he installed his own collection as a small, informal museum at New York University, where it remained until 1943 (when it was closed because of the war). It was entitled the Gallery of Living Art (renamed the Museum of Living Art in 1936) and was America's first museum devoted exclusively to contemporary art. Artists represented included *Arp, *Delaunay, *Hélion (who acted as Gallatin's adviser), *Léger, *Miró, *Mondrian, and *Picasso. Gallatin himself was an abstract painter, and his museum was an important stimulus for his fellow members of *American Abstract Artists. After its closure in New York, he presented most of his collection to the Philadelphia Museum of Art, and he encouraged the *Arensbergs to do likewise. Gallatin wrote a good deal on art,

including books, articles, or exhibition catalogues on Max *Beerbohm, *Braque, *Demuth, *Ricketts (he collected books he had designed), and Whistler.

Gallen-Kallela, Akseli (1865–1931). Finnish painter, graphic artist, designer, and architect, his country's most famous artist and a major figure in the *Art Nouveau and *Symbolist movements. He was born in Pori and studied in Helsinki and then in Paris (1884–9, notably at the *Académie Julian). In 1894 he settled at Ruovesi in central Finland, where he designed his own home and studio (1894–5) in a romantic vernacular style, together with its furnishings. He travelled widely, however, and was well-known outside his own country, particularly in Germany (he had a joint exhibition with *Munch in Berlin in 1895 and exhibited with Die *Brücke in Dresden in 1910). In 1911–13 he built a new home and studio for himself at Tarvaspää near Helsinki (now a museum dedicated to him). Gallen-Kallela was deeply patriotic (he volunteered to fight in the War of Independence against Russia in 1918, even though he was in his 50s) and he was inspired mainly by the landscape and folklore of his country, above all by the Finnish national epic *Kalevala* ('Land of Heroes'). His early work was in the 19th-century naturalistic tradition, but in the 1890s he developed a flatter, more stylized manner, well suited to the depiction of heroic myth, with bold simplifications of form, strong outlines, and vivid—sometimes rather garish—colours. Apart from easel paintings, Gallen-Kallela did a number of murals for public buildings (including the Finnish National Museum, Helsinki, 1928). His work also included book illustrations (notably for an edition of *Kalevala*, 1922) and designs for stained glass, fabrics, and jewellery. He is regarded not only as his country's greatest painter, but also as the chief figure in the creation of a distinctive Finnish art, and he was given a funeral befitting a national hero. His son **Jorma Gallen-Kallela** (1898–1939) was also a painter.

Galleria Nazionale d'Arte Moderna, Rome. Italy's major collection of late 19th-century and 20th-century art. It was founded in 1883 as one of the expressions of national pride that followed the unification of the country, and its original purpose was the documentation and promotion of living Italian artists.

In 1911 the collection moved into a new building, the Palazzo delle Belle Arti, in the grounds of the Villa Borghese near the British School in Rome. The façade has low-relief carvings of artistic scenes by the sculptor Giovanni Prini (1877–1958). In 1933 the building was enlarged and in 1988 a new wing was added to house the large collection of international contemporary art acquired since the Second World War. The Galleria Nazionale is not to be confused with Rome's municipal collection of 'modern art'—the Galleria Comunale d'Arte Moderna, which is much smaller and devoted mainly to 19th-century art.

Gallery of Living Art, New York. See GAL-LATIN.

Gallery of Modern Art, Glasgow. Museum of modern art (initially devoted to the work of living artists), opened in 1996 following a decision by Glasgow District Council in 1991 to provide a fund of £3 million for buying contemporary works. It is housed in the former Royal Exchange, a handsome 18th-century building in Queen Street in the centre of the city. The collection is particularly strong in works by Scottish artists, but it is international in scope, including work by Niki de *Saint Phalle, for example. It covers graphic art and photography as well as painting and sculpture.

Games, Abram. See AIRBRUSH.

GAN. See ADRIAN-NILSSON.

Gargallo, Pablo (1881–1934). Spanish sculptor. He was born at Maella, near Catalonia, and trained at the Barcelona Academy. In 1903 he won a scholarship to Paris, but because of the death of his father he soon had to return home to support his family. However, he went back to Paris in 1914, remaining there until 1911, and during this period he started experimenting with *Cubism. Building on the Spanish tradition of fine metalcraft, he began to compose masks from thin sheets of iron and copper, hammered, twisted, cut, and fitted together. He was one of the first sculptors to transpose convex and concave surfaces, and also, in his later work (which included full-length figures), one of the first to give positive significance to enclosed space. In 1914–24 he lived in

Barcelona, then returned to Paris, and during the last decade of his life achieved recognition as one of the most inventive of modern sculptors in metal. His style in this period became freer and more expressive.

Garstin, Norman. See NEWLYN SCHOOL.

Garwood, Tirzah (Tirzah Ravilious). See RAVILIOUS.

Gatch, Lee (1902–68). American painter. He was born in Baltimore, where he studied at the Maryland Institute of Fine Arts, 1920–4 (John *Sloan was one of his teachers). After this he spent a year in Paris, studying under *Lhote and *Kisling, then moved to new York in 1925. From 1935 he lived a secluded life at Lambertville, New Jersey, although he exhibited in several individual and collective shows over the next 30 years. His main subject was landscape, which he painted in a semi-abstract style—lyrical and contemplative. He was a perfectionist who worked slowly, so his output is fairly small. In 1957 he began to experiment with collage and in the 1960s he started making 'stone pictures', in which the collage elements include thin pieces of flagstone.

Gaudí, Antoni. See ART NOUVEAU.

Gaudier-Brzeska, Henri (Henri Gaudier) (1891–1915). French sculptor and draughtsman, active in England for most of his very short career and usually considered part of the history of British rather than French art. He was born at St Jean-de-Braye, near Orleans, the son of a carpenter, and was destined for a career in commerce. In 1910 he took up sculpture in Paris without formal training, and in the same year he met Sophie Brzeska, a Polish woman 20 years his senior, with whom he lived from that time, both of them adopting the hyphenated name. In 1911 they moved to London, which Gaudier had visited briefly in 1906 and 1908, and lived for a while in extreme poverty. He became a friend of Wyndham *Lewis, Ezra *Pound, and other leading literary and artistic figures, and his work was shown in avant-garde exhibitions, such as the *Vorticist exhibition of 1915. In 1914 he enlisted in the French army and he was killed in action the following year, aged 23.

Gaudier developed with astonishing rapidity from a modelling style based on *Rodin to

a highly personal manner of carving in which shapes are radically simplified in a way recalling the work of *Brancusi (*Red Stone Dancer*, Tate Gallery, London, c. 1913). In Britain, only *Epstein was producing sculpture as stylistically advanced at this time. Gaudier's work was appreciated by only a small circle during his lifetime, but since his death he has become recognized as one of the outstanding sculptors of his generation and has acquired something of a legendary status as an unfulfilled genius. Sophie Breszka's devotion to his memory bore fruit in a memorial exhibition of his work at the *Leicester Galleries, London, in 1918, and biographies of him were written by H. S. *Ede (1930) and Horace *Brodzky (1933). Ede's biography was originally entitled *A Life of Gaudier-Breszka*, but when it was reprinted in 1931 it was retitled *Savage Messiah* in allusion to the demonic intensity and energy of his life; this was also the title of Ken Russell's film on the artist (1972). See also DIRECT CARVING.

Gauguin, Paul (1848–1903). French *Post-Impressionist painter, sculptor, and printmaker, born in Paris, the son of a journalist from Orleans and a Peruvian Creole mother. He was one of the giants of 19th-century art and a profound and enduring influence on 20th-century art. In 1883 he gave up a successful career as a stockbroker to devote himself to painting (previously a spare-time occupation for him) and in 1886 he abandoned his family, spending much of the next five years at Pont-Aven in Brittany, where he became the pivot of a group of artists who were attracted by his powerful personality and stimulating ideas about art. In 1887–8 he visited Panama and Martinique, and in 1891 he left France for Tahiti. Apart from two years in 1893–5 when ill-health and poverty forced him back to France, he spent the rest of his life in the South Seas, where he said 'I have escaped everything that is artificial and conventional. Here I enter into Truth, become one with nature. After the disease of civilization, life in this new world is a return to health.' His theory and practice of art reflected these attitudes. He was one of the first to find visual inspiration in the arts of ancient or primitive peoples (see PRIMITIVISM), and he reacted vigorously against the naturalism of the *Impressionists and the scientific preoccupations of the *Neo-Impressionists. As well as using colour unnaturalistically for its decor-

ative or emotional effect, he employed emphatic outlines forming rhythmic patterns suggestive of Japanese colour prints or stained glass. Gauguin also did woodcuts in which the black-and-white areas formed almost abstract patterns and the tool marks were incorporated as parts of the design. Along with those of Edvard *Munch, these prints played an important part in stimulating the major revival of the art of woodcut in the 20th century. Gauguin's other work included woodcarving and pottery.

In spite of ill-health (he had syphilis) and lack of money, Gauguin painted his finest pictures in Tahiti. His colours became more resonant, his drawing more grandly simplified, and his expression of the mysteries of life more profound. He was often unable to obtain proper materials and was forced to spread his paint thinly on coarse sacking, but from these limitations he forged a style of rough vigour wholly appropriate to the boldness of his vision. In 1897 he painted his largest and most famous picture, an allegory of life entitled *Where Do We Come From? What Are We? Where Are We Going To?* (Museum of Fine Arts, Boston), before attempting suicide (although he had deserted his family he had been devastated that year by the news of the death of his favourite daughter). In September 1901 he settled at Dominica in the Marquesas Islands, where he died two years later. 'Having fallen out with the local bishop, he was denied a Christian burial, and because some of his works were deemed indecent they were burned. The inventory of his remaining effects which were sold at auction reveals his colonial life to have been by no means as impoverished or primitive as he liked to maintain' (Belinda Thomson, *Gauguin*, 1987).

Gauguin was not forgotten in France during his years in the South Seas, but at the time of his death few would have agreed with his self-assessment: 'I am a great artist and I know it. It is because I am that I have endured such suffering.' His reputation was firmly established, however, when 227 of his works were shown at the *Salon d'Automne in Paris in 1906: 'For a whole new generation of young artists in Paris, such as Henri *Matisse, André *Derain and Raoul *Dufy, this comprehensive survey of Gauguin's achievements could not have been better timed. Their enthusiasm for his bold, unnaturalistic use of colour and decorative simplicity fully justified Gauguin's confident prediction that his work in itself

was less important than its consequences would be: the liberation of the next generation from the trammels of naturalism . . . [His] introduction of exotic, "primitive" elements into the stylistic and iconographic repertoire . . . has proved an equally enduring aspect of his legacy to the artists of the twentieth century' (Thomson). Because of the romantic appeal of his personality, particularly his willingness to sacrifice everything for his art, Gauguin (like his friend van Gogh) has also been an inspiration for popular and fictional biography, including the novel *The Moon and Sixpence* (1919) by Somerset Maugham, and the opera of the same title (1957) by John L. Gardner.

Gauld, David. See GLASGOW SCHOOL.

Gauvreau, Pierre. See AUTOMATISTES.

Gear, William (1915–97). British painter, teacher, and administrator, born at Methil, Fife. He spent several years of his career on the Continent and was one of the most international in spirit among British artists of his generation and one of the relatively few to make a reputation outside Britain. After studying painting at Edinburgh College of Art, 1932–6, and history of art at Edinburgh University, 1936–7, he spent a year in Europe on a travelling scholarship, working under *Léger in Paris for several months. During the Second World War he served in the Royal Signal Corps in Europe and the Middle East, but he found time to paint and in 1944 he had one-man shows in Florence and Siena. In 1946–7 he worked in Germany for the commission dealing with the country's monuments and art in the wake of the war, and from 1947 to 1950 he lived in Paris, where he became a member of the *Cobra group in 1948. His work at this time was in the mainstream of the *École de Paris—abstract but based on nature (he once described his paintings as 'statements of kinship with the natural world'); typically he used rich colours within a framework of strong black lines, in a manner suggesting stained glass. Like his friend and fellow Scot Alan *Davie, he was also aware of the work of the American *Abstract Expressionists; he met *Rothko in Paris, for example. In 1950 Gear settled in England (initially living in Buckinghamshire), and the following year he was one of five painters who was awarded an Arts Council

Purchase Prize at the *Festival of Britain; the decision caused protest from the press and public, for Gear's picture (*Autumn Landscape*, NG of Modern Art, Edinburgh, 1950) was the only abstract work among the five chosen and abstract art was at this time still generally regarded with deep suspicion in Britain. From 1958 to 1964 he was curator of the Towner Art Gallery, Eastbourne, and from 1964 to 1975 he was head of the department of fine art at Birmingham College of Art (later Polytechnic). In England, Gear's style became more delicate, as his characteristic grid dissolved and colours flowed into one another. Although he continued to exhibit with success, his later career was relatively low-key. From the 1980s, however, several retrospective exhibitions of his work have highlighted his significant contribution to European and British abstract painting.

Geddes, Wilhelmina. See AN TÚR GLOINE.

Geflecht. See SPUR.

Gehenna Press. See BASKIN.

Gehry, Frank. See GUGGENHEIM.

Geldzahler, Henry (1935–94). American administrator and writer, born in Antwerp, the son of a diamond broker. His mother held American citizenship and the family settled in New York in 1940 after fleeing Belgium because of the Second World War. Geldzahler studied art history at Yale, graduating in 1957, then moved to Harvard to do a PhD on *Matisse's sculpture. In 1960 he left Harvard, leaving his thesis unfinished, to become curatorial assistant in contemporary art in the department of American painting and sculpture at the Metropolitan Museum, New York. To the dismay of some of the museum's trustees, he was more of an active participant in the contemporary art scene than a scholarly observer. He took part in *Happenings, was portrayed by David *Hockney, Alice *Neel, Larry *Rivers, and other artists, and was the subject of an Andy *Warhol film, *Henry Geldzahler* (1964), showing him smoking a cigar for 90 minutes. In 1967 he was appointed curator of the Metropolitan's new department of contemporary art (later department of 20th-century art), and in 1969 he organized a huge exhibition 'New York Painting and Sculpture 1940–70' as part of

the museum's centenary celebrations. The exhibition caused a great deal of controversy, John *Canaday calling it 'a boo-hoo on the grand scale' and Hilton *Kramer 'modish, arbitrary, and confused'. Other controversies followed, and in 1977 Geldzahler resigned to become commissioner of cultural affairs for New York City, a post he held until 1983. His writings include a book on Warhol's portraits (1993, co-author with Robert Rosenblum) and *Making it New: Essays, Interviews and Talks*, posthumously published in 1994.

Gemeentemuseum (Municipal Museum), The Hague. Museum consisting primarily of an outstanding collection of modern art. It had its origins in a collection founded in 1862 to illustrate the history of The Hague, but it was enriched to the extent that the artistic aspect of the collection took over from the historical. In 1935 it moved into a new building designed by the Dutch architect H. P. Berlage in a style in which the severe geometry of De *Stijl is modified with vernacular touches. The art department has a fine representation of 19th- and 20th-century art from the Netherlands and elsewhere, including the largest *Mondrian collection in the world. There are also departments devoted to decorative arts and music.

Gemini Graphics Editions Ltd. See PRINT RENAISSANCE.

Generalić, Ivan (1914–92). Yugoslav (Croatian) *naive painter, the most famous figure of the school of peasant painters associated with his native village of Hlebine (see HLEBINE SCHOOL). He began drawing when working as a shepherd boy, and at the age of sixteen he was taught to paint by Krsto *Hegedušić. The following year—1931—he exhibited with Hegedušić's group *Zemlja. His first one-man show was at the Salon Ulrich, Zagreb, in 1938, and after the Second World War he became internationally recognized as one of the finest of all naive artists, his work featuring in numerous group and solo exhibitions and winning him various awards. In spite of his success, he continued to live the life of a peasant and to paint only in his spare time. Nor was his work in any way affected by his occasional contacts with orthodox and historic art. Unlike most naive painters, Generalić had a wide repertory. Most of his pictures depict scenes from village life—weddings,

funerals, farm work, fairs, and so on—but he also painted landscapes, portraits, still-lifes, and imaginative subjects. Some of his pictures are idyllic in mood, but in others there is an element of grotesque fantasy or of *Surrealist strangeness. Usually he painted on glass and his pictures often have a kind of inner glow. His son **Josip** (1936–) is also a naive painter, and his brother **Mato** (1920–85) was a naive sculptor.

Genovés, Juan (1930–). Spanish painter and graphic artist, born in Valencia. He studied at the School of Fine Arts there, and afterwards settled in Madrid. His most characteristic paintings feature crowds or groups of anonymous figures, seen from a very high viewpoint, threatened by some unseen but alarming force. They suggest the brutal use of power and the terror of the oppressed fleeing before it, but their character is quasi-metaphysical rather than crudely political. The main influence on Genovés is the Russian film-maker Sergei Eisenstein, whose work features some memorable crowd scenes.

Geometry of Fear. A term coined by Herbert *Read to characterize the angst-ridden look of the work of a group of eight British sculptors who exhibited together at the 1952 Venice *Biennale: Robert *Adams, Kenneth *Armitage, Reg *Butler, Lynn *Chadwick, Geoffrey *Clarke, Bernard *Meadows, Eduardo *Paolozzi, and William *Turnbull. Several were strongly influenced by the 'Existentialist' sculptures of *Giacometti and *Richier, with their spindly forms and tortured surfaces, which seemed to encapsulate the anguish and bewilderment of the post-war generation. This was the first major international showing for these British sculptors, but their work made a strong impact; Alfred H. *Barr wrote that 'it seemed to many foreigners the most distinguished national showing of the Biennale.'

George, Patrick (1923–). British painter and teacher, born in Manchester. He studied at Edinburgh College of Art, 1941–2, and Camberwell School of Art, London, 1946–9. From 1974 he taught at the *Slade School, and he was Slade professor from 1985 to 1987. His paintings are mainly landscapes, interiors, and portraits. He writes of his work: 'I try to paint a likeness of what I see . . . In London I paint pictures of people, of things lying

around my room and the view out of the window. In the country I go outside and paint the landscape . . . The pictures take a long time to paint, sometimes several years.'

Gerasimov, Alexander (1881–1963). Russian painter, stage designer, architect, and administrator, a dominant figure in Soviet art. He was born in Kozlov (later renamed Michurinsk), the son of a cattle dealer, and studied at the Moscow School of Painting, Sculpture, and Architecture, 1903–15. After army service he returned to Kozlov and worked as a stage designer at the town theatre, which had been erected to his design in 1913 (this was his only executed architectural design, apart from a house he built for himself in the 1930s). In 1925 he settled in Moscow, where his friendship with Kliment Voroshilov, the Red Army chief, helped his career to prosper. However, even with friends in such high places, he sometimes had to tread warily; one of his large military pictures, shown at the Soviet Pavilion at the 1937 Paris International Exhibition, included portraits of army personnel who were imprisoned or executed in one of Stalin's purges soon after it was completed, so when the picture came back from Paris, he removed it from its stretcher and kept it under a carpet on his studio floor for twenty years.

Gerasimov painted various types of picture, and his most admired works are now perhaps those in which he recalled his peasant upbringing, notably *The Slaughter* (Gerasimov Museum, Michurinsk, 1929), a powerful scene of a bull being killed. In *Russian Art* (1949) Tamara Talbot Rice wrote: 'Gerasimov is one of those Soviet artists whose work will sooner or later come into its own in the West. There is nothing startling about it, nothing striking beyond its quiet excellence. He works with equal success in water-colours and in oils. He is an admirable portraitist, and the creator of some lovely still-lifes and flower pictures; his gifts are, however, perhaps more to the fore in his landscapes. Their gentle quality and crystalline colours have captured the spirit of Russia with amazing success.' However, he has in fact become best known for his hagiographical pictures of Stalin (*Stalin and Voroshilov in the Kremlin Grounds*, Tretyakov Gallery, Moscow, 1938), indeed as the archetypal artist of the repressive Stalinist era (see SOCIALIST REALISM): 'Gerasimov was president of the Academy of Arts of the USSR from 1947 to 1957; and also dominated the USSR Union of Artists, showing an implacable hostility towards the slightest signs of advanced art and meriting the epithets of "sinister" and "evil" which were showered upon him by Western critics and the more courageous of his countrymen' (Alan Bird, *A History of Russian Painting*, 1987). After Stalin had been denounced by his successor Khruschev in 1956, Gerasimov was out of official favour. He had a heart attack the same year and never recovered his health. See also AKHRR.

Gerasimov, Sergei. See MAKOVETS.

Gérome, Jean-Léon. See IMPRESSIONISM.

Gerstl, Richard (1883–1908). Austrian painter, born in Vienna, where he studied at the Academy. His early painting was in the style of the Vienna *Sezession, but by 1905 he had developed a highly personal style of *Expressionism. His finest works are portraits, including two groups of the family of the composer Arnold Schoenberg (Österreichische Galerie, Vienna), remarkable for their psychological intensity. Gerstl was a tormented character, and after running off with Schoenberg's wife he committed suicide. His work, 'savage in character, with a tinge of mania and an amazing impasto technique . . . [was] largely independent of any influence of his teachers, and, apart from a certain colouristic connection with the work of *Klimt and, more especially, Edvard *Munch, appears wholly original in conception and development, characterized by even more violent abbreviations of form than *Kokoshka . . . ever permitted himself' (Peter Vergo, *Art in Vienna 1898–1918*, 1975). Gerstl came from a wealthy family and had no need to try to earn a living from painting. It was not until the 1930s that his work became widely known and he was hailed as an 'Austrian van Gogh'.

Gertler, Mark (1891–1939). British painter. He was born in the East End of London to poor Polish-Jewish immigrant parents and he spoke only Yiddish up to the age of eight. In 1907 he started work in a stained-glass factory, but in 1908 he was enabled by the Jewish Educational Aid Society to go to the *Slade School. He was a student there until 1912 and during that time won several prizes and scholarships. His fellow students included Dora *Carrington, with whom he later had an

affair until she left him for the writer Lytton Strachey in 1917. Gertler worked mainly in London, but between 1917 and 1927 he also stayed regularly at Garsington Manor in Oxfordshire, the home of the patron and hostess Lady Ottoline Morrell (see CONTEMPORARY ART SOCIETY). After the First World War he spent a good deal of time in the South of France for the sake of his delicate health (he had tuberculosis). Gertler was influenced by *Post-Impressionism, but his style was highly individual, with strong elements of Eastern European folk art. His favourite subjects included female portraits, still-lifes, and nudes, such as the earthy and voluptuous *The Queen of Sheba* (1922) in the Tate Gallery, London, painted in his characteristic feverishly hot colours. The Tate also has his only piece of sculpture, *Acrobats* (1917), and the painting that is probably his best-known work, *Merry-Go-Round* (1916); in this powerful and original image—probably a satire on militarism—figures spin on fairground horses in a mad, futile whirl.

Gertler had many admirers, including distinguished figures in the literary world; Gilbert Cannan based his novel *Mendel* (1916) on his life and D. H. Lawrence made him the model for the sculptor Loerke in *Women in Love* (1920). Everyone who knew him seems to have been impressed by his capacity for hard work and his devotion to his art as well as by his talent. The word 'genius' was frequently applied to him, and he was seen by many as the acceptable face of modernism. However, he began to lose popularity in the early 1930s when he adopted a more avant-garde style characterized by a flatter sense of space and a greater emphasis on surface pattern. He had always been subject to fits of depression, and after the failure of an exhibition at the Lefevre Gallery, London, in 1939 he committed suicide. *Mark Gertler: Selected Letters*, edited by Noel Carrington, was published in 1965.

Gerstner, Karl. See COLD ART.

Gestel, Leo (1881–1941). Dutch painter. He was born in Woerden and studied at the Academy in Amsterdam. Although he was a painter of modest talent, he was significant as one of the first Dutch artists to experiment with *Expressionism and *Cubism, and he helped to introduce these trends to his country. His knowledge of avant-garde art came partly from two visits to Paris—in 1904 (with

Jan *Sluyters) and 1910–11. During the First World War he lived in Bergen and he eventually settled at Blaricum, where there is a museum dedicated to him. His work included landscapes, nudes, and still-lifes. He also made lithographs.

gestural painting. The application of paint with expansive gestures so that the sweep of the artist's arm is deliberately emphasized. The term carries an implication not only that a picture is the record of the artist's action in the process of painting it, but that the recorded actions express the artist's emotions and personality, just as in other walks of life gestures express a person's feelings. It has been applied particularly to *Abstract Expressionism and is sometimes used more or less as a synonym for *Action Painting. However, it can also apply to figurative painting, notably *Neo-Expressionism.

Ghika, Nicolas (1906–94). Greek painter and graphic artist, born in Athens. In 1922 he enrolled at the Sorbonne in Paris to study French and Greek literature, but he devoted himself mainly to painting and engraving at the *Académie Ranson under *Bissière. He had his first one-man show at the Galerie Percier in 1927 and lived in Paris until 1934. At this time his work was strongly influenced by *Braque and *Picasso, but after his return to Athens he became interested also in Mediterranean landscape and Greek popular art. From the late 1930s he was recognized at home and abroad as Greece's leading painter, admired for his success in achieving a synthesis between his country's ancient traditions and contemporary artistic movements. In 1942 he was appointed a professor at the University of Athens and he continued to teach there until his retirement in 1960. Besides painting, Ghika made numerous book illustrations, notably for a collected edition of the work of Constantine Cavafy, Greece's most famous modern poet (1966).

Giacometti, Alberto (1901–66). Swiss sculptor, painter, and draughtsman, active mainly in Paris. He was born in the village of Borgonovo, near the Italian border, the son of the painter **Giovanni Giacometti** (1868–1933), whose work was influenced by *Impressionism and *Post-Impressionism. Although he was to spend almost all his career in France, he retained great affection for Switzerland

and returned regularly to visit his family. After short periods at the École des Arts et Métiers, Geneva (1919–20), and in Italy (1920–1), he moved to Paris, where he studied under *Bourdelle at the Académie de la Grande Chaumière from 1922 to 1925. At this time he tried to get 'as close as I could to my vision of reality', but in 1925 he abandoned naturalism and began a period of restless experimentation. From 1930 to 1935 he took part in the *Surrealist movement, developing a highly individual attenuated manner, exemplified in the open-cage construction of *The Palace at 4 a.m.* (MOMA, New York, 1933), made of wood, glass, wire, and string. Some of his work of this period dealt with themes of sex and violence, notably *Woman with her Throat Cut*, a semi-abstract bronze piece whose jagged forms brutally suggest the body of a woman who has been raped and murdered (there are casts in MOMA, New York, the NG of Modern Art, Edinburgh, and elsewhere). He abandoned Surrealism in 1935 and began to work again from the model. In 1941–4 he lived in Geneva to escape the German occupation of France, but he then returned permanently to Paris. Since 1935 most of his sculpture had been very small, but in 1946 he started working on a bigger scale and in 1947 he began evolving the style for which he became famous, characterized by human figures of extremely elongated proportions and emaciated, nervous character (*Man Pointing*, Tate Gallery, London, 1947).

Giacometti's gaunt figures, which were sometimes disposed in groups, were interpreted by many contemporaries as reflecting the horrors of the Second World War, specifically concentration camps. More generally, they were seen as encapsulating the fragile, essentially lonely nature of human existence. Giacometti himself refrained from making pronouncements about the meaning of his sculpture, but he was a friend of the existentialist philosopher Jean-Paul *Sartre, who wrote on his work, notably the introduction to the catalogue of his exhibition at the Pierre *Matisse Gallery, New York, in 1948. It was this exhibition that established Giacometti's post-war reputation, and his work soon had widespread influence, seen, for example, the '*Geometry of Fear' sculptors who exhibited at the Venice *Biennale in 1952 and in several of the entries for the competition for a Monument to the Unknown Political Prisoner in 1953 (see BUTLER, REG).

By this time Giacometti was becoming regarded as one of the outstandingly original sculptors of the 20th century, and from the late 1950s his reputation as a painter also began to increase. Most of his paintings and drawings are portraits of his family and friends; his brother **Diego** (1902–85), who was a skilled technician and a lifelong assistant, was a favourite model and the subject of dozens of sculptures, paintings, and drawings. Characteristically the paintings are grey in tonality, which together with their dusty-looking surfaces and the skeletal proportions of the figures often conveys a ghostly feeling. Some of them are obsessively overpainted, an expression of the doubts and anxieties Giacometti felt about his creations. He was admired not only for the quality of his work, but also for the force of his personality, his integrity, and his devotion to his art. Throughout his career in Paris he worked in the same tiny, shabby studio, and Simone de Beauvoir, Sartre's companion, wrote of him: 'Success, fame, money—Giacometti was indifferent to them all.' Giacometti himself said: 'Establishing yourself, furnishing a house, building up a comfortable existence, and having that menace hanging over your head all the time—no, I prefer to live in hotels, cafés, just passing through.' There are examples of his work in many major collections, notably in the Giacometti Foundation at the Zurich Kunsthaus.

Giacometti, Augusto. See ABSTRACT ART.

Gibbings, Robert (1889–1958). British wood engraver, book designer, and travel writer, born in Cork, Ireland, the son of a clergyman. After abandoning medical studies at University College, Cork, he moved to London in 1911 and studied at the *Slade School and then from 1912 at the Central School of Arts and Crafts, where he was taught wood engraving by Noel Rooke (1881–1953), a leading specialist in the medium. Gibbings served in the army during the First World War and was wounded at Gallipoli in 1915. He was invalided out with the rank of captain in 1918. In 1919 he helped to found the Society of Wood Engravers, and from 1924 to 1933 he ran the *Golden Cockerell Press (founded 1920), one of the most distinguished private presses of the day. Gibbings illustrated many of its books himself and also employed engravers such as Eric *Gill and Eric *Ravilious. He went through a nudist phase at about

this time and sometimes typeset in the nude. From 1939 to 1942 he was lecturer in wood engraving and typography at Reading University. Gibbings's books typically combine topographical impressions, personal anecdote, and observations of nature, illustrated with his own engravings; they include two works on the River Thames—*Sweet Thames Run Softly* (1940) and *Till I End My Song* (1957). 'His experience in publishing and printing made Gibbings exceptionally sensitive to the relationship between illustration and the printed page . . . His own engravings were characterised by exceptional economy and precision' (Brigid Peppin and Lucy Micklethwait, *Dictionary of British Book Illustrators: The Twentieth Century*, 1983).

Gibson, Charles Dana (1867–1944). American illustrator and painter, born in Roxbury, Massachusetts. He studied at the *Art Students League of New York, 1884–5, and in the 1890s became a great success with pen-and-ink drawings contributed to such magazines as *Collier's Weekly*, *Harpers*, and *Life*. He specialized in scenes of fashionable social life and achieved immortality with his creation of the 'Gibson Girl', a type (modelled on his wife) representing an ideal of American womanhood—feminine and gracefully attired, but a lover of sports and the outdoor life. His work was immensely popular until about 1914, influencing fashions in women's clothes and hairstyles, and he earned a fortune. He also tried to gain recognition as a portrait painter, but he was much less successful in this field.

Giersing, Harald (1881–1927). Danish painter and critic, the most energetic advocate of modern art in Denmark at the beginning of the 20th century. He was born in Copenhagen, where he trained at the Academy, 1900–4, and then under Kristian Zahrtmann (1843–1917), 1904–6. In 1906–7 he visited Paris, where he was influenced by *Bonnard, *Cézanne, *Matisse, and *Vuillard. From these artists he took a feeling for vigorous simplified shapes, which he combined with deep, saturated colours. From about 1917 he was influenced by *Cubism. His work included landscapes, still-lifes, and figure compositions. He exercised an important influence on young Danish artists, not only through his work, but also through his teaching (he ran his own art school for ten years)

and writing (he was one of his country's leading art critics).

Gilbert, Sir Alfred (1854–1934). British sculptor and metalworker, born in London. He originally intended becoming a surgeon, but after failing the entrance examination at the Middlesex Hospital in 1872 he turned to art, training in London at Heatherley's School and the *Royal Academy, and then from 1875 to 1878 at the École des *Beaux-Arts in Paris. After spending six years in Italy, he returned to England in 1884 and worked on several major projects, the best known of which is his Shaftesbury Memorial Fountain in Piccadilly Circus, London (1887–93). The celebrated figure of *Eros* that surmounts the fountain is cast in aluminium, one of the earliest examples of the use of this metal in sculpture. Its light weight allowed Gilbert to achieve a more delicately poised pose than if he had been restricted to the traditional material of bronze. Although Gilbert was hard-working, respected, and sought-after, he was unworldly and a hopeless businessman; his refusal to delegate or to compromise his high standards in any way meant that he took on more work than he could handle and he sometimes lost money on commissions. In 1901 he became bankrupt and moved into self-imposed exile in Bruges, where he lived for the next quarter of a century. Initially he kept up contact with the Royal Academy, but after 1907 he did not exhibit there again until 1932. His failure to complete new commissions led to unpleasant publicity (including an exposé in the sensationalist newspaper *Truth*) and he resigned from the Academy in 1908.

For many years thereafter Gilbert did little work, but he was not forgotten in England and in 1926 he returned to London, helped by Lady Helena *Gleichen, who provided him with a studio, and by the journalist Isabel McAllister (1870–1945), who acted as his secretary (she also published a book on him in 1929). In 1926–8 he completed his masterpiece, the tomb of the Duke of Clarence in St George's Chapel, Windsor Castle, which he had begun in 1892. The sinuous and labyrinthine detailing, crafted with consummate skill, reveals Gilbert as one of the major practitioners of *Art Nouveau, although he was disparaging about the style. His final major work was the memorial to Queen Alexandra at Marlborough Gate, London (1926–32). On its completion he was knighted

and restored to membership of the Royal Academy. His reputation sank after his death because he was so clearly outside the mainstream of 20th-century art (stylistically the Alexandra memorial looks more like a work of the 1890s than the 1930s), but he is now regarded as the greatest English sculptor of his generation. See also NEW SCULPTURE.

Gilbert, Stephen. See CONSTRUCTIVISM.

Gilbert & George (Gilbert Proesch, 1943– , and George Passmore, 1942–). British artists (Gilbert is Italian-born) who met whilst studying at *St Martin's School of Art in London in 1967 and since 1968 have lived and worked together as self-styled 'living sculptures': 'Being living sculptures is our life blood, our destiny, our romance, our disaster, our light and life.' They initially attracted attention as *Performance artists, their most famous work in this vein being *Underneath the Arches* (1969), in which—dressed in their characteristic neat suits and with their hands and faces painted gold—they mimed mechanically to the 1930s music-hall song of the title. Although they gave up such 'living sculpture performances' in 1977, they still see themselves as living sculptures, considering their whole lifestyle a work of art. Since the early 1970s their work has consisted mainly of photo-pieces (see PHOTO-WORK)—large and garish arrangements of photographs, usually in black-and-white and fiery red, and often violent or homoerotic in content, with scatological titles. The images are often drawn from the street life of the East End of London in which they live.

Gilbert & George have become the most famous British avant-garde artists of their generation. Their work has been shown worldwide and has attracted an enormous amount of commentary: Wolf Jahn's *The Art of Gilbert & George* (1989) lists more than 100 exhibitions of their work and the book's bibliography has more than 400 items. In 1986 they won the *Turner Prize. Critical opinion on them is sharply divided, however: to some they are geniuses, to others tedious poseurs. For example, in the first issue of *Modern Painters* in 1988, a letter from the Anthony d'Offay Gallery, London, which has shown several exhibitions of their work, stated: 'One of the things we most admire about Gilbert and George is their positive attitude and their understanding of present time. They are great contemporary artists because they see the present for what it is.' In the same issue of the journal, however, the philosopher and critic Roger Scruton wrote: 'they are masters of hype, and can find for any painting, however boring, some suitable paragraphs of art-school lingo with which to market it . . . With brazen effrontery they lay claim to every possible moral and artistic virtue . . . Their sole skill is in having made self-advertisement profitable, in having sold as creative masterpieces works which have no aesthetic quality at all.'

Gili, Phillida. See STONE.

Gill, Eric (1882–1940). British sculptor, engraver, typographer, and writer, born in Brighton, the son of a clergyman. After studying at Chichester Art School, he was apprenticed to an architect in London from 1900 to 1903. During this period he also took evening classes in masonry at the Westminster Technical Institute and in lettering at the Central School of Art and Design, where he was taught by the celebrated calligrapher Edward Johnston (see ROYAL COLLEGE OF ART), who 'profoundly altered the whole course of my life and all my ways of thinking'. He began to earn his living as a letter cutter in 1903 and carved his first figure piece in 1910. In 1913 he became a convert to Roman Catholicism and was commissioned to make fourteen relief carvings of the *Stations of the Cross* for Westminster Cathedral (1914–18). These and the *Prospero and Ariel* group (1929–31) on Broadcasting House, London, are his best-known sculptures. Early in his career as a sculptor, Gill sometimes collaborated with Jacob *Epstein (Gill carved the lettering for Epstein's Oscar Wilde tomb), but they later quarrelled. Like Epstein, Gill was one of the leading figures in the revival of *direct carving, and his work usually has an impressive simplicity of conception; he wrote that his 'inability to draw naturalistically was, instead of a drawback, no less than my salvation. It compelled me . . . to concentrate upon something other than the superficial delights of fleshly appearance . . . to consider the significance of things.' In life, as in his work and writing, he was an advocate of a romanticized medievalism, and he tried to revive a religious attitude towards art and craftsmanship. His unconventionality was well known in his own time (he disliked trousers, for example, pre-

ferring to wear smocks), but the most bizarre and unpleasant aspects of his personality were not revealed until Fiona MacCarthy's biography was published in 1989: he had incestuous relationships with two of his sisters and two of his daughters and sexual congress with a dog. Apart from religion, sex is the main subject of his work.

Gill was an important figure in book design and typography as well as sculpture. He illustrated many books, notably for the Golden Cockerell Press (see GIBBINGS), and his 'Gill Sans-Serif' (1928) and 'Perpetua' (1930) typefaces are among the classics of 20th-century typography; they were commissioned for the Monotype Corporation by its consultant Stanley Morison (1889–1967), 'Britain's greatest authority on letter-design' (*DNB*). Gill's main literary works are *Christianity and Art* (1927), *Art* (1934), and *Autobiography* (1940), and he also wrote numerous pamphlets on art, religion, and sociology. He designed one building, the Roman Catholic church of St Peter the Apostle at Gorleston, Norfolk (1938–9), built of brick in a stripped-down Gothic style. From 1907 to 1924 he lived at Ditchling, Sussex, running the St Dominic's Press amongst other activities, and also setting up an artistic community (David *Jones was one of the members). In 1924 he moved to Capel y Ffin, Wales, and in 1928 settled at Pigotts, near High Wycombe, in Buckinghamshire.

His brother **Macdonald Gill** (1884–1947) was an architect, mural painter, and designer (mainly of posters and maps). The mural commissions on which he worked included a series of seven large canvases representing the pleasures of London (1911) for the students' dining room at Borough Polytechnic, London. Six painters were involved, the other five being Bernard Adeney (1878–1966), Frederick *Etchells, Roger *Fry (who directed the scheme), Duncan *Grant (who painted two pictures), and Albert *Rothenstein (who later became Albert Rutherston). Dennis Farr writes that 'Fry regarded the project as a practical vindication of his view of the social function of art in a modern state' (*English Art 1870–1940*, 1978). The dining room was demolished in 1929 and the paintings were bought by the Tate Gallery, London, in 1931. Gill's contribution is *Punch and Judy*. His cousin **Colin Gill** (1892–1940) was a painter, mainly of murals, although he also did portraits and genre subjects and was an *Official War Artist

in the First World War. His murals include *King Alfred's Attack on Danish Invaders at Swanage, 877*, part of a series painted at St Stephen's Hall in the Palace of Westminster (Houses of Parliament) in 1927 (the other artists who worked on this commission included *Clausen, *Monnington, and *Philpot). In 1939 Gill went to South Africa to paint murals in the Magistrates' Court, Johannesburg, and he died there the following year before completing the work. With his wife Una Long, he wrote the novel *Five Came to London* (1938), under the pseudonym Richard Saxby.

Gill, Madge. See AUTOMATISM.

Gilliam, Sam (1933–). American painter. He was born in Tupelo, Missouri, studied at the University of Louisville, Kentucky, 1952–6 and 1958–61, and in 1962 settled in Washington, DC, where he turned to abstraction and worked in the vein of the *Washington Color Painters. In 1968 he began producing stretcherless pictures, which were sometimes suspended from the ceiling to create pleated forms, and he has subsequently experimented with other techniques to create works that are part painting and part sculpture. Some of his works are huge, creating a kind of *environmental experience (*Autumn Surf*, MOMA, San Francisco, 1973). Gilliam has become the best-known black American abstract painter; Edward *Lucie-Smith writes that he 'has caused considerable irritation amongst African-American militants and has sometimes been accused of "Uncle Tom-ism" because of his insistence on being judged purely as an artist, not as a generic representative of minority culture' (*Art Today*, 1995).

Gillies, Sir William (1898–1973). Scottish painter and art teacher. For most of his life he was associated with Edinburgh College of Art. He graduated there in 1924, and after two years studying with *Lhote in Paris, he returned as a teacher; he stayed until his retirement in 1966, serving as head of painting, 1946–60, and principal, 1960–6. His favourite subject was landscape, especially views in and around his home at Temple, a village about ten miles south of Edinburgh, where he settled in 1939: 'On coming to Temple I began to cope with my new material by relying on simple planning and tonal relationships as subtle and evocative as I could make them.' His work, which also includes

still-lifes influenced by *Matisse, is indeed intimate, poetic, and completely unpretentious, and it has won him a position of affection as one of the most popular Scottish painters of recent times. Gillies was knighted in 1970 and in that year the Scottish Arts Council mounted a large retrospective of his work. A good collection of his oils, watercolours, and drawings is in the Scottish National Gallery of Modern art, Edinburgh.

Gilman, Harold (1876–1919). British painter of interiors, portraits, and landscapes, born at Rode, Somerset, the son of a country parson. He became interested in art during a long convalescence after an accident and he had his main training at the *Slade School, 1897–1901; his fellow student Spencer *Gore became a close friend. In 1907 Gilman met *Sickert and became one of the leading figures in his circle; he was a founder member of the *Camden Town Group in 1911 and of the *London Group (of which he was first president) in 1913. However, with his friend *Ginner he fell out with Sickert in 1914 (see NEO-REALISM). Gilman travelled fairly extensively (Odessa, 1895; Spain, 1902–3; America, 1905; Paris, 1911; Sweden, 1912; Norway, 1913), but he spent most of his career in or near London. After Gore's death in 1914 he took over his teaching at Westminster Art School, and in 1915–17 he ran his own art school with Ginner. His early work was rather sombre, but under the influence of Sickert he adopted a higher colour register and a technique of using a mosaic of opaque touches. From Sickert also he derived his taste for working-class subjects. After Roger *Fry's first *Post-Impressionist exhibition (1910) and a visit to Paris (1911) he used very thick paint and bright (sometimes garish) colour. He was one of the most gifted British painters of his generation and one of the most distinctive in his reaction to Post-Impressionism, but his career was cut short by the influenza epidemic of 1919.

Gilmour, Maeve. See PEAKE.

Gimpel, René (1881–1944). French art dealer. He inherited successful galleries in Paris and New York from his father and became one of the best-known international dealers of his day (his wife, Florence, was the sister of the British dealer Joseph Duveen—see TATE GALLERY). Gimpel was mainly interested in

French art of the 18th century, but he also bought and sold modern pictures and he was friendly with numerous artists, notably Marie *Laurencin, who painted several portraits of members of his family. During the Second World War he worked for the Resistance and after being arrested by the Germans he died in a concentration camp. One of his fellow prisoners described his remarkable fortitude: 'Knowing that he was soon to die, he continued, as if nothing was happening, to speak of life and to give to his companions, overwhelmed by exhaustion, despair and disgust, the example of the serenity of a man who, having nothing more to lose and having done what he can, is left with one duty, which is not to flinch and help others.' Between the wars he kept a diary that gives a lively account of the art world in Europe and the USA. It was published as *Journal d'un collectionneur* in 1963 (English translation, *Diary of an Art Dealer*, with an introduction by Herbert *Read, 1966). After the Second World War his sons Charles and Peter continued the family tradition with the firm of Gimpel Fils in London and New York.

Ginner, Charles (1878–1952). British painter, born in Cannes, the son of an English doctor who was practising there. He grew up in France and because of parental oposition to his ambition to be a painter he initially trained in architecture. However, from 1904 to 1908 he studied painting in Paris, at the École des *Beaux-Arts and elsewhere. After a visit to Buenos Aires (where he had his first one-man exhibition) in 1909, he settled in London in 1910. He was already a friend of *Gilman and *Gore (having met them at the *Allied Artists' Association exhibition in 1908) and through them he was drawn into *Sickert's circle, becoming a founder member of the *Camden Town Group in 1911 and the *London Group in 1913. His Continental background made him a respected figure among his associates, who were united by an admiration for French painting. Ginner was primarily a townscape and landscape painter and he is known above all for his views of London (often drab areas, although he also depicted the hustle and bustle of places such as Leicester Square and Victoria Station). He painted with thick, regular brushstrokes and firm outlines, creating a heavily textured surface and a feeling of great solidity. Once he had established his distinctive style (by about

1911) it changed little and he became one of the main upholders of the Camden Town tradition after the First World War (ironically, unlike other members of the group, he never actually lived in Camden Town). He worked for the Canadian War Records Commission in the First World War and was an *Official War Artist in the Second. See also NEO-REALISM.

Glackens, William James (1870–1938). American painter and draughtsman, born in Philadelphia, where he studied at the Pennsylvania Academy of the Fine Arts. His early career was spent mainly as a newspaper illustrator, but he was encouraged to take up painting by Robert *Henri, whom he met in 1891. In 1895 he visited Paris and in 1896 he settled in New York. There he initially continued to work for newspapers and magazines, but he devoted more time to painting and did little illustration after about 1905. In 1908 he was one of the group of painters who exhibited together as The *Eight. His work as a newspaperman led him to depict scenes of contemporary life, and he is considered one of the central figures of the *Ashcan School. However, he was less concerned with *Social Realism than with representing the life of the people as a colourful spectacle, and he was heavily influenced by the *Impressionists. *Chez Mouquin* (Art Institute of Chicago, 1905), a high-keyed depiction of a restaurant that was a favourite resort of artists in his circle, was inspired by Manet's famous *A Bar at the Folies-Bergère*. By the time of the *Armory Show (1913), which he helped to organize, Glackens was painting in a style reminiscent of the early *Renoir. From 1912 he was employed as art consultant by Dr Albert C. *Barnes and toured Europe buying paintings that formed the nucleus of the celebrated Barnes Foundation at Merion, Pennsylvania. In 1917 he was elected first president of the *Society of Independent Artists.

Glarner, Fritz (1899–1972). Swiss-born abstract painter who became an American citizen in 1944. He was born in Zurich and studied at the Academy in Naples, 1916–21. From 1923 to 1935 he lived in Paris, where his work developed from *Impressionism to *Constructivism; in 1933 he became a member of the *Abstraction-Création association. After a year in Zurich, Glarner emigrated to the USA in 1936, settling in New York, where he was an early member of *American Abstract Artists. He was a friend of *Mondrian and painted in a style similar to his but less severe, with the forms often departing from strict horizontal and vertical alignment, creating a shifting, dynamic feeling (he gave the name 'Relational Painting' to this modification of Mondrian's *Neo-Plasticism). Unlike Mondrian, Glarner often worked on a large scale, as with his murals for the lobby of the Time-Life Building, New York (1959–60).

Glasgow Boys. A loose association of Scottish artists active from about 1880 to the turn of the century; there was no formal membership or programme, but the artists involved were linked by a desire to move away from the conservative and parochial values they thought were represented by the Royal Scottish Academy in Edinburgh. Several of them had worked in France and were proponents of open-air painting. David and Francina Irwin write that they 'sought their inspiration in the freshness and tranquillity of pastoral scenes or remained indoors to paint studio portraits. Only occasionally . . . is there an indication that they are associated with Glasgow at all' (*Scottish Painters at Home and Abroad 1700–1900*, 1975). The *Scottish Arts Review*, founded in 1888, acted as their mouthpiece. William York Macgregor is sometimes referred to as the 'father' of the group; he was a few years older than most of the others and ran a life class in his Glasgow studio in which many of them used to meet. The heyday of the group was over by 1900 and it did not survive the First World War, but it rejuvenated Scottish art, breaking ground where the *Scottish Colourists were soon to follow.

The membership of the group is not clearcut, but according to its last survivor, Robert Macaulay Stevenson, the following twenty-three artists (all painters, although Macgillivray was mainly a sculptor) should be considered Glasgow Boys: Sir D. Y. *Cameron; James Elder Christie (1847–1914); Joseph Crawhall (1861–1913); Thomas Millie Dow (1848–1919); David Gauld (1865–1936); Sir James *Guthrie; James Whitelaw Hamilton (1860–1932); George Henry (1858–1943); Edward Atkinson Hornel (1864–1943); William Kennedy (1859–1918); Sir John *Lavery; James Pittendrigh Macgillivray (1856–1938); William York Macgregor (1855–1923); Harrington Mann (1864–1937); Arthur Melville (1855–1904); Thomas Corsan Morton (1859–1928); Stuart Park (1862–1933); James Paterson

(1854–1932); Sir George Pirie (1864–1946); Alexander Roche (1861–1921); Robert Macaulay Stevenson (1856–1952); Grosvenor Thomas (1856–1923); and Edward Arthur Walton (1860–1922). See also GLASGOW SCHOOL.

Glasgow Four. A name sometimes given to four artists, interrelated by blood and marriage, who often worked together in Glasgow in the period from about 1890 to 1910, developing a common *Art Nouveau style in such fields as posters, metalwork, and interior decoration. The four were Charles Rennie *Mackintosh, Herbert MacNair (1868–1955), and the English-born sisters Frances Macdonald (1874–1921) and Margaret Macdonald (1864–1933), who were married to MacNair and Mackintosh respectively. Their work, which was influenced by Celtic art and *Symbolism, was more appreciated on the Continent than in Britain; an issue of the Viennese periodical *Ver Sacrum* was devoted to them in 1901. All four worked as painters as well as designers.

Glasgow School. A term that has been applied to several groups of artists whose activities have centred on Glasgow. The largest of these groups, which was at its peak in the last years of the 19th century, consisted mainly of painters who challenged the conservatism of the Royal Scottish Academy; they preferred to be known as the *Glasgow Boys. A slightly later group, of which Charles Rennie *Mackintosh was the leading member, created a distinctive Scottish version of *Art Nouveau; the four principal members of this group are also known as the *Glasgow Four. These two groups are distinct, but there is a slight overlap between them, as George Walton (1867–1933), a painter and designer who sometimes worked with Mackintosh, was the brother of the Glasgow Boy E. A. Walton. (Cecile Walton, the daughter of E. A. Walton, was a member of the *Edinburgh Group.)

More recently, the term 'Glasgow School' (or facetiously 'Glasgow pups') has been applied to a group of figurative painters working in the city from the 1980s. They include Steven *Campbell, Ken Currie (1960–), Peter Howson (1958–), and Adrian Wiszniewski (1958–), all of whom were students at *Glasgow School of Art at much the same time. (Among their teachers there was Sandy Moffat (1943–), who encouraged a return to figurative art after the 'anything goes' 1970s.)

Duncan Macmillan (*Scottish Art in the 20th Century*, 1994) writes: 'In this group, Campbell, who was considerably older than the others, was the undoubted driving force . . . The success of this group as a whole was an important factor in Glasgow's cultural renaissance.'

Glasgow School of Art. Art school founded in 1840 as the School of Design in Ingram Street, Glasgow. In 1869 it moved to Sauchiehall Street, and in 1885 Francis *Newbery was appointed Director, ushering in the School's golden period, when under his guidance it 'developed rapidly from a provincial art school providing mainly evening classes into a significant centre of art training with a style and reputation of its own' (Julian Halsby and Paul Harris, *The Dictionary of Scottish Painters: 1600–1960*, 1990). In 1896 Charles Rennie *Mackintosh won a competition to design a new building for the School in Renfrew Street and this was erected in 1897–9, with a library block and other extensions added in 1907–9. Together they form one of the most original and dramatic works of architecture of the period anywhere in Europe. Mackintosh himself had attended evening classes at the School, and Newbery had introduced him to another student, Frances Macdonald, who became his wife. Newbery's own wife, Jessie Newbery, née Rowat (1864–1948), joined the staff of the School in 1894 and taught embroidery. 'Together they created a formidable team. Fra Newbery was excellent at recognizing talent, often appointing very young ex-students to the staff and employing more women than was usual at the time. He also treated all areas of design as equal to the fine arts . . . He had wide connections abroad and encouraged the staff and students to take part in exhibitions in Europe' (Halsby and Harris). The First World War followed by Newbery's retirement in 1918 brought the School's most distinguished period to an end, but it retained a high reputation and produced another outstanding crop of graduates in the 1980s, including Steven *Campbell, Stephen *Conroy, and Alison *Watt.

Glasgow Gallery of Modern Art. See GALLERY OF MODERN ART, GLASGOW.

Glass, W. M. See EDINBURGH GROUP.

Gleichen, Lady Feodora (1861–1922). British sculptor, born in London, daughter of Count

Victor Gleichen (also known as Admiral Prince Victor of Hohenlohe-Langenburg), who was related by marriage to Queen Victoria and was himself a sculptor as well as a naval officer. She studied at the *Slade School and in Rome and exhibited regularly at the *Royal Academy from 1892. Her work included several public monuments, including the Diana Fountain (1899) in Hyde Park, London, the Edward VII Memorial (1912) in Windsor, and the statue of Florence Nightingale (1914) in Derby. She also made numerous portrait busts. Her style was solidly traditional. In 1922 she was posthumously made the first woman member of the Royal Society of British Sculptors. Her sister, **Lady Helena Gleichen** (1873–1947), was a painter of landscapes, flowers, and animals, particularly horses. Their brother, **Lord Edward Gleichen** (1863–1937), a soldier by profession, wrote several books; they are mainly on military matters but also include *London's Open-Air Statuary* (1928), which is still a useful work. See also GILBERT.

Gleeson, James (1915–). Australian painter and writer. He was born in Sydney and studied at East Sydney Technical College, 1934–6. Gleeson has been Australia's most committed exponent of *Surrealism, both as a painter and a propagandist: 'Possessed of poetical and critical interests he lectured and wrote a good deal during the early 1940s to make surrealism better understood' (Bernard Smith, *Australian Painting 1778–1990*, 1991). An example of his work at this time is *We Inhabit the Corrosive Littoral of Habit* (NG of Victoria, Melbourne, 1940), which shows a human face disintegrating and is close to *Dalí in style. Gleeson's paintings have been shown in many solo and group exhibitions. His writings include art criticism for various journals and several books, notably a standard monograph on William *Dobell (1964) and *Masterpieces of Autralian Painting* (1969).

Gleizes, Albert (1881–1953). French painter, graphic artist, and writer, born in Paris. After leaving school he worked in his father's design studio and he began to paint seriously whilst serving in the army, 1901–5. In 1906, with several friends, he founded the Abbaye de Créteil, near Paris, a utopian community of artists and writers, but in 1908 it closed because of financial difficulties. Gleizes's early work had been *Impressionist in style,

but in 1909 he took up *Cubism, and in 1912 he wrote with *Metzinger the book *Du Cubisme* (an English translation, *Cubism*, appeared in 1913 and in 1947 the authors produced a revised deluxe edition of the French text, illustrated with original prints). This was the first book on the movement and it remains Gleizes's main claim to fame. In 1912 he was among the founders of the *Section d'Or group and in 1913 he exhibited at the *Armory Show, New York. After serving again in the French army, 1914–15, Gleizes lived from 1915 to 1917 in New York, where he underwent a religious conversion. Much of his later career was devoted to trying to achieve a synthesis of medieval and modern art, expressing Christian ideas through pseudo-Cubist forms. In this he is generally reckoned to have been conspicuously unsuccessful and his modest reputation as a painter rests on his pre-war work. In 1927 he founded another utopian community—Moly-Sabata at Sablons—and in the 1930s he painted several murals, taking as his ideal the close relationship between architecture, sculpture, and painting in the Middle Ages. He expounded his views in several books and pamphlets, including *La Peinture et ses lois* (1924).

Glickman, Maurice. See BASKIN.

Gluck (Hannah Gluckstein) (1895–1976). British painter, a rebellious figure who dressed like a man (enjoying the embarrassment this caused) and adopted her monosyllabic name—'no prefix, suffix, or quotes'—because she thought the sex of the painter was irrelevant. She was born into the family that founded the J. Lyon & Co. catering empire and had the wealth to indulge her eccentricities. She studied at St John's Wood School of Art, 1913–16, and was encouraged by *Munnings. In the 1920s and 1930s she become well known for portraits and formal flowerpieces (she was a friend of the flower arranger Constance Spry), exhibiting with great success at the Fine Art Society, London. Her pictures were painted with fashionable panache in an *Art Deco style and in 1932 she designed and patented a frame in keeping with them; it consisted of three white bands stepped back from the picture so that, in her own words, 'the usual essence of all frames was reversed and instead of the outer edge dominating, it was made to die away into the wall and cease to be a separate feature'. After

the Second World War she faded from prominence and in the 1950s and 1960s she devoted much of her time to an obsessive campaign to improve the quality of artists' materials. Near the end of her life she returned to the limelight with a retrospective exhibition at the Fine Art Society in 1973.

Gober, Robert (1954–). American sculptor and installation artist. He was born in Wallingford, Connecticut, and studied at Middlebury College, Vermont, from 1972 to 1976, also spending a year during this period at the Tyler School of Art in Rome, 1974–5. In 1976 he settled in New York, where he had his first one-man exhibition at the Paula Cooper Gallery in 1984. This brought him considerable attention, and in *Art Today* (1995) Edward *Lucie-Smith wrote that Gober was 'at the moment when this is being written, undoubtedly the most fashionable, most discussed younger artist in New York'. In *Visual Arts in the Twentieth Century* (1996) Lucie-Smith writes that 'Gober's art is notoriously elusive. Some of its typical ingredients are as follows: realistic models of human legs, sticking out of the wall . . . a dressmaker's dummy wearing a wedding dress; a paper bag filled with doughnuts, placed on a pedestal; a baby's cot with slanting sides; wallpaper showing a pattern of male and female sexual organs; a repetitive design in which a sleeping man is paired with a lynch-mob victim hanging from a schematic tree. Since Gober is openly gay, this imagery has been connected with the impact of AIDS on the New York art world. Examined objectively, however, it seems much less specific. To say flatly that Gober's work is "art about AIDS" requires energetic reading between the lines. What it does undoubtedly convey is a general feeling of disturbance, of restless unease.' Reviewing an exhibition of Gober's work at the Serpentine Gallery, London, in 1993, Brian *Sewell commented that his work gave 'evidence, not of artistry but of a disturbed mind, either troubled to the edge of lunacy or still cunning enough to exploit the current New York vogue for violence and filth'.

Gočár, Josef. See CUBISM.

Goeritz, Mathias (1915–90). German painter, sculptor, architect, designer, teacher, writer, and controversialist, active in Mexico for most of his career. He was born in Danzig and studied philosophy and history of art in Berlin. From 1936 to 1938 he lived in Paris, where he studied painting, then returned to Berlin and gained a PhD in history of art in 1939. The following year he fled Germany and settled in Spanish Morocco. At the end of the Second World War he moved to Spain, living successively in Granada, Madrid, and finally Santillana, where in 1948 he helped to found an avant-garde group called the School of Altamira, which was devoted to creative freedom. In 1949 he moved to Mexico, where he had been invited to become professor of visual education and design in the School of Architecture at the University of Guadalajara. He remained in this post until 1954, when he settled permanently in Mexico City to teach at the National School of Architecture.

Goeritz played an important role in introducing modern ideas to Mexican art and he was attacked by some nationalists for infecting the country with 'European decadence': in response to his foundation of a short-lived museum of experimental art ('El Eco') in Mexico City (1951–3), *Rivera and *Siqueiros wrote an open letter in which they described him as 'a faker without the slightest talent or preparation for being an artist, which he professes to be'. His work was varied in range and style, but he is probably best known for his collaboration with architects in large-scale projects, particularly for his *Five Towers* (1957–8) at Satellite City, near Mexico City, carried out in partnership with the architect Luis Barragan. This group of five immense painted concrete towers, rising to heights of between 120 and 190 feet (35 and 58 metres), has been hailed as an early example of *Minimal art, but Goeritz was very different in his intentions from the Minimalists. He championed human values in art and denounced what he considered the frivolity or vacuity of much contemporary painting and sculpture. For example, when Jean *Tinguely demonstrated his *autodestructive *Homage to New York* at the Museum of Modern Art, New York, in 1960, Goeritz distributed pamphlets outside the museum calling for a stop to 'aesthetic so-called "profound" jokes' and a return to timeless 'static' values.

Gogh, Vincent van. See EXPRESSIONISM and POST-IMPRESSIONISM.

Goguen, Jean. See NOUVEAUX PLASTICIENS.

Goings, Ralph (1928–). American *Superrealist painter, active in his native California, where he studied at the California College of Arts and Crafts, Oakland, 1950–3, and has taught at various schools and universities. His main subject is the automobile, often shown at a garage or service station. He works by projecting a slide or transparency onto the canvas and although he uses traditional brushes rather than airbrushes, his finish is seamlessly impersonal: 'Emphasis should be placed not on essences, generalizations or formal structures but specific, objective things and places. Looking supersedes formal contrivance, depiction becomes an extension of seeing.'

Golden Cockerell Press. See GIBBINGS.

Golden Fleece (*Zolotoye Runo*). Russian art journal edited by the banker and collector Nikolai Riabushinsky (1876–1951) and published in Moscow between 1906 and 1909 (the last two issues for 1909 in fact appeared early in 1910). It carried on the tradition of the *World of Art* journal (which ceased publication in 1904) and was particularly associated with *Symbolist artists and writers, especially the *Blue Rose group. The *Golden Fleece* organized three exhibitions in Moscow—in 1908, 1909, and 1909–10. The first two included French sections, and that in 1908 has been described by Alfred H. *Barr as 'the most discriminating exhibition of French *Post-Impressionist painting held anywhere— including France—up to that time'. Only Russian works were shown at the third exhibition, which was dominated by *Goncharova and *Larionov.

Golden Hind. See SPARE.

Golding, John (1929–). British painter and art historian. He is probably best known as an eminent scholar of 20th-century art, particularly of *Cubism, but he has also made a reputation as an abstract painter. His early education was in Mexico and Canada, and in 1951–7 he did postgraduate work at the Courtauld Institute of Art, London, his PhD thesis forming the basis of his book *Cubism: A History and an Analysis, 1907–1914*, published in 1959. This appeared in revised editions in 1968 and 1988 and remains the standard work on the subject. His other publications include a short monograph on *Braque (1966) in 'The

Masters' series and *Marcel *Duchamp: The Bride Stripped Bare by her Bachelors, Even* (1973) in the Penguin 'Art in Context' series; with Sir Roland *Penrose he edited a volume entitled *Picasso: 1881–1973* (1973), contributing to it himself an essay on Picasso and *Surrealism. A collection of his essays, *Visions of the Modern*, appeared in 1994. Unlike many specialists in modern art, he writes with admirable clarity. Golding taught history of art at the Courtauld Institute from 1962 to 1981, and in 1976–7 he was Slade professor of fine art at Cambridge University. He painted seriously throughout his academic career (his first one-man exhibition was in 1962) and eventually devoted his full time to it. In 1971 he started to teach at the *Royal College of Art and in 1981–6 (having given up his post at the Courtauld Institute) was senior tutor there. His abstracts are typically large in scale, with broad expanses of glowing colour; he sees them as 'basically reflective or contemplative'.

Goldwater, Robert (1907–73). American art historian. He was born in New York and studied at Columbia College (BA 1929), Harvard University (MA 1931), and New York University (PhD 1937). From 1934 he held various teaching positions, and in 1957 he became professor of art history at New York University. He wrote mainly on late 19th- and 20th-century art, his books including *Primitivism in Modern Painting* (1938; revised edn., as *Primitivism in Modern Art*, 1967), which was a pioneering work on the subject, *Gauguin* (1957), *What is Modern Sculpture?* (1969), and the posthumously published *Symbolism* (1979). He was also the compiler (with Marco Treves) of an excellent anthology of artists' writings, *Artists on Art: From the XIV to the XX Century* (1947, 3rd edn., 1974). Goldwater was married to the sculptor Louise *Bourgeois.

Golovin, Alexander (1863–1930). Russian stage designer and painter. He was born in Moscow, where he studied architecture and painting. From 1889 he made several visits to Europe, during which he studied under various painters in Paris, including *Blanche. Golovin began making theatrical designs in 1898, and in 1902 he moved from Moscow to St Petersburg to work for the imperial theatres. He was a member of the *World of Art group and worked with *Benois on designs for *Diaghilev's production of Mussorgsky's

opera *Boris Gudunov* at the Paris Opera in 1908. The success of this production encouraged Diaghilev to take his ballet company (which became famous as the Ballets Russes) to Paris the following year. Golovin also worked for many other eminent figures in the history of the stage, including Konstantin Stanislavsky in Moscow and Ida Rubinstein in Paris. His style was rich and architectural. As a painter his work included landscapes, still-lifes, and portraits, among them several of notable stage personalities (*Chaliapin in the Role of Boris Godunov*, Russian Museum, St Petersburg, 1912).

Golub, Leon (1922–). American painter. He was born in Chicago, where he studied art history at the University, graduating in 1942. After serving in the army during the Second World War, he studied painting at the Art Institute of Chicago, 1946–50, and he had his first one-man exhibition at the Contemporary Gallery, Chicago, in 1950. Subsequently he taught at various colleges in the USA (in Chicago, New York, and elsewhere) and spent two periods in Europe, living in Italy, 1956–7, and Paris, 1959–64. His work has been widely exhibited in Europe as well as the USA and he has won numerous awards.

At the beginning of his career Golub experimented with abstraction, but he soon turned to figurative painting and became an outspoken opponent of the *Abstract Expressionism that dominated American art in the 1950s. One of the earliest and strongest influences on him was *Picasso's *Guernica*, which was exhibited in Chicago in 1939. His work has mainly been concerned with themes of stress and violence; often it is very large in scale, and his handling of paint is expressively raw, increasing the emotional impact of his images. In the 1950s many of his paintings depicted monster-like creatures, but thereafter his work became more naturalistic and more politically orientated, dealing with themes such as the Vietnam War, the activities of mercenary soldiers, and interrogation and torture by brutal guards (*Interrogation II*, Art Institute of Chicago, 1981). Matthew Baigell writes that 'Golub has explored the condition of man in an ongoing sequence of burnt, flailed, flawed, and brutalized figures . . . Refusing to paint specific events or to place his figures in specific locations, Golub is not a belated *Social Realist, but a realist whose subject matter is human savagery' (*A Concise History of American Painting and Sculpture*, 1984).

In 1951 Golub married the painter Nancy Spero (1926–), who had been a fellow-student at the Art Institute of Chicago. Her work, much concerned with political and feminist issues, has included long scroll compositions incorporating texts and collage elements.

Golubkina, Anna (1864–1927). Russian sculptor, one of her country's outstanding artists in the early 20th century. She was born in Zaraysk, the daughter of a market gardener, and studied in Moscow and St Petersburg before making two visits to Paris (1895–6 and 1897). During the first of these she studied at the Académie Colarossi and during the second she met *Rodin, whose vigorous surfaces and *Symbolist leanings strongly influenced her work (she later wrote to him: 'While I live I shall always venerate you as a great artist and the person who gave me the possibility of life'). After her return to Russia she settled in Moscow. Golubkina was principally renowned as a portraitist, and one of her most famous works is the first sculptural portrait of Karl Marx (Tretyakov Gallery, Moscow, 1905). Typically, she donated her fee for this to a fund for homeless workers, for she had passionate humanistic convictions and took an active part in the Russian Revolution of 1905; two years later she was imprisoned for distributing literature urging peasants to 'overthrow the Tsar and the government', but she was soon released because of ill-health. In 1914–15 she organized an exhibition of her work at the Museum of Fine Arts in Moscow 'in aid of the war-wounded'. From 1918 to 1921 she taught at *Svomas and then *Vkhutemas. She worked mainly in bronze, but also in marble and wood. Following serious illness in 1924, she concentrated on smaller works, including cameos. M. N. Yablonskaya (*Women Artists of Russia's New Age*, 1990) writes that 'Golubkina was one of the new generation of artists who searched for fresh expressive possibilities with which to convey contemporary life' and that she 'almost single-handedly introduced a renaissance into the medium of sculpture'.

Gombrich, E. H. See ABSTRACT ART and EXPERIMENTAL ART.

Gomringer, Eugen. See CONCRETE POETRY.

Goncharova, Natalia (1881–1962). Russian-French painter, graphic artist, and designer, born in Negayevo, Tula province, near Moscow, into an impoverished noble family (she was related to the poet Pushkin). From 1898 to 1902 she studied at the Moscow School of Painting, Sculpture, and Architecture. Initially she trained as a sculptor (she was taught by *Trubetskoy), but in 1900 she met her fellow student Mikhail *Larionov, who encouraged her to turn to painting. They became lifelong companions and in the years leading up to the First World War were among the most prominent figures in Russian avant-garde art, taking part in and often helping to organize a series of major exhibitions in Moscow. Her early paintings were *Impressionist, but after the first *Golden Fleece* exhibition in 1908 she was strongly influenced by modern French painting (including the work of *Cézanne, *Gauguin, and *Matisse), combining this with her interest in peasant art and icon painting to create a *Neo-primitive style. To the influences of *Fauvism, she later added *Cubism and *Futurism, and by the time of the *Target exhibition of 1913 she was painting in a near-abstract *Rayonist style (*Cats*, Guggenheim Museum, New York, 1913). This was Goncharova's most prolific period as a painter; in 1913 she held a one-woman exhibition in Moscow in which she showed more than 700 works. The preface to the catalogue takes the form of a manifesto in which she says that Western art has 'dried up' and that consequently she was looking to the East for inspiration. She was interested not only in ancient Russian art, but also in Chinese and Indian painting.

In 1915 Goncharova left Russia with Larionov and after settling in Paris in 1919 she devoted herself mainly to designing settings and costumes for the theatre, particularly *Diaghilev's Ballets Russes; this aspect of her work is well represented in the Victoria and Albert Museum, London. She also did a good deal of book illustration and continued to paint intermittently to the end of her life, but after the death of Diaghilev in 1929, her main period of achievement was over. Goncharova and Larionov became French citizens in 1938 and were married in 1955. By this time they had been virtually forgotten, but there was a great revival of interest in them in the early 1960s.

González, Julio (1876–1942). Spanish sculptor, metalworker, painter, and draughtsman,

the leading pioneer in the use of welded iron (see IRON AND STEEL) as a sculptural medium. He learnt to work metal under his father, a goldsmith and sculptor, but his early career was spent mainly as a painter. In about 1900 he moved to Paris and formed a lifelong friendship with *Picasso, whom he had earlier met in his native Barcelona. In his early years in Paris he supported himself mainly by making metalwork and jewellery, but he also exhibited paintings and made sculpture. It was not until the late 1920s, when he was already in his 50s, that he devoted himself wholeheartedly to sculpture and turned to welded metal as a material (Picasso sought his technical advice about metal sculpture, and in helping him González liberated his own imagination). His best-known work, *Montserrat* (Stedelijk Museum, Amsterdam, 1937), is a fairly naturalistic piece, showing a woman with a child in her arms, and commemorates the suffering of the Spanish people in the civil war (Montserrat is a holy mountain in Spain). More usually, however, his sculptures are semi-abstract skeletal figures, as in his series of *Cactus People*—formidable pieces with some of Picasso's savage humour. His work had great influence, notably on Picasso, who made use of the welding facilities in González's studio, and on a generation of British and American sculptors exemplified by Reg *Butler and David *Smith. George Heard *Hamilton writes that 'since 1945 it has proved so rich a source of inspiration for younger artists working in brazed and welded metals . . . that it is difficult to recall how truly original it was in its time.'

His brother **Joan González** (1868–1908) was a draughtsman and painter, active in Barcelona and Paris. He died young of tuberculosis and his work was virtually unknown until the late 1950s, when his niece Roberta González discovered a collection of his drawings (and a few paintings) in the attic of the family home. She presented numerous works by both Julio (her father) and Joan to the Tate Gallery, London, in 1972.

Goodrich, Lloyd (1897–1987). American art historian and museum administrator, born in Nutley, New Jersey. He studied in New York at the *Art Students League and the National Academy of Design, then worked in publishing for several years before joining the staff of the *Whitney Museum of American Art as a writer and researcher in 1935. This was the

start of a lifelong association with the museum; he was Director from 1958 until his retirement in 1968, then held the title of Director Emeritus until his death. Goodrich played a leading role in helping to build the Whitney Museum from a moderately-sized private collection to a large public institution. His writings include several standard monographs on American painters, notably two on Thomas *Eakins (1933 and 1982).

Goodyear, A. Conger. See MUSEUM OF MODERN ART, NEW YORK.

Gordon, Douglas. See TURNER PRIZE.

Gore, Spencer (1878–1914). British painter of landscapes, music-hall scenes, interiors, and occasional still-lifes. He was born in Epsom, Surrey, into a distinguished family: his father, Spencer Walter Gore, a surveyor by profession, was a famous sportsman (he won the first Wimbledon tennis championship in 1877); and his uncle, Charles Gore, was Bishop of Oxford. In 1896–9 he studied at the *Slade School, where he was a particular friend of Harold *Gilman. Another Slade contemporary was Wyndham *Lewis, with whom he visited Spain in 1902. In 1902, together with Albert *Rothenstein (who later changed his name to Rutherston) Gore visited *Sickert in Dieppe; this marked the beginning of his close acquaintance with recent French painting (he returned to France in 1905 and 1906), and the enthusiasm of the two young painters helped to decide Sickert to return to London later that year. For the rest of his short career Gore was part of Sickert's circle, becoming a founder member successively of the *Allied Artists' Association in 1908, the *Camden Town Group (of which he was first president) in 1911, and the *London Group in 1913. He and Sickert often visited music halls together, and both of them painted memorable scenes of this world. His early paintings were *Impressionist in style, but he was strongly influenced by Roger *Fry's *Post-Impressionist exhibitions (Gore's own work was included in the second in 1912) and his later pictures show vivid use of flat, bright colour and boldly simplified forms. He died of pneumonia aged 35 and was much lamented by his many friends in the art world. Sickert said Gore was 'probably the man I love and admire most of any I have known', and Frank *Rutter described him as 'the most lovable man I ever

knew'; his obituary in the *Morning Post* remarked that 'his personal character was so exceptional as to give him a unique influence in the artistic affairs of London in the last dozen years.' His son **Frederick Gore** (1913–) is also a painter and Roger *de Grey was his nephew.

Gorin, Jean. See GROUPE ESPACE.

Gorky, Arshile (Vosdanig Manoog Adoian) (1904–48). Armenian-born American painter, one of the leading figures of *Abstract Expressionism. During the First World War his father emigrated to the USA to avoid conscription into the Turkish army and his mother died a victim of Turkish persecution of the Armenians. Gorky managed to escape with his sister, and they found their way to America, settling first at Providence, Rhode Island. In his new country he adopted the pseudonym Arshile Gorky, the first name being derived from the Greek hero Achilles, the second (Russian for 'the bitter one') from the Russian writer Maxim Gorky, to whom he sometimes liked to claim he was related (evidently not realizing that the writer's name also was a pseudonym). In 1925 he moved to New York, where he first studied and then taught (1926–31) at the Grand Central School of Art. Gorky took a romantic view of his vocation and is said to have hired a Hungarian violinist to play during his classes to encourage his students to put emotion in their work. His early paintings were strongly influenced by *Cézanne (whom he considered 'the greatest artist that has lived') and he also fell under the spell of *Picasso, as can be seen both in the haunting *The Artist and his Mother* (Whitney Museum, New York, c. 1926–9), based on a photograph taken when he was a child, and in his experimentation with *Cubism at this period. Much of his work of the 1930s represents an attempt to synthesize the flatness of Cubist structure (in which he was influenced also by Stuart *Davis) with the improvisatory fluidity and energy of *Surrealist *automatism.

From 1935 to 1939 Gorky worked for the *Federal Art Project, his paintings under its auspices including an abstract mural for Newark Airport, New Jersey. In the early 1940s he came into contact with the circle of European Surrealists who had emigrated to New York to escape the Second World War and under their influence (particularly that of

*Matta and *Miró) he created the distinctive style of his last phase, featuring 'a mass of delicately drawn, visceral shapes floating in a tangible world of brilliant transparent color. The shapes are suggestive of internal organs, brutally mutilated, or microscopic views of plants and flowers transformed into strange menacing beasts or enbracing in an ecstasy of sexual fulfilment. They are at the same time living organisms, still-lifes, or landscapes, all filled with an ecstatic and disturbing sense of physical vitality and psychological conflict' (H. H. *Arnason in *Britannica Encyclopedia of American Art*, 1973). However, just as Gorky began to emerge as a powerful original voice in American art, he suffered a tragic series of misfortunes. In 1946 a fire in his Connecticut studio destroyed a large proportion of his recent work, and in the same year he was operated on for cancer. In 1948 he broke his neck in an automobile accident, and when his wife left him soon afterwards he hanged himself, leaving a message chalked nearby reading 'Goodbye My Loveds'.

Gorky has been called both the last of the great Surrealists and the first of the Abstract Expressionists, and his work in the 1940s was a potent factor in the emergence of a specifically American school of abstract art: Adolph *Gottlieb wrote that he recognized 'the vital task was a wedding of abstraction and surrealism. Out of these opposites something new could emerge, and Gorky's work is part of the evidence that this is true.' Willem *de Kooning in particular was a close friend and was greatly influenced by him.

Gormley, Antony. See TURNER PRIZE.

Goscombe John, Sir William. See JOHN, SIR WILLIAM GOSCOMBE.

Gosse, Sir Edmund (1849–1928). British writer. A major figure in the cultural life of his time (H. G. Wells called him the 'official British man of letters'), Gosse is now best known for his literary criticism and for his autobiography *Father and Son* (1907). However, early in his career he wrote a good deal of art criticism and played a significant role in promoting interest in contemporary British sculpture (he was a friend of Hamo *Thornycroft and coined the term *New Sculpture). His daughter **Sylvia Gosse** (1881–1968) was a painter and etcher of landscapes, still-lifes, street scenes, portraits, and interiors with fig-

ures. One of *Sickert's most devoted followers, she virtually ran his art school for several years and she helped to care for him in his old age. She often followed the master's practice of working from photographs, as with her portrait of Sickert (1923–5) in the Tate Gallery, London.

Gotch, Thomas Cooper. See NEWLYN SCHOOL.

Gottlieb, Adolph (1903–74). American painter, one of the leading *Abstract Expressionists. He was born in New York, where he studied at various art schools in the early 1920s, on either side of a visit to Europe in 1921–3. His early work was *Expressionist and from 1935 to 1940 he exhibited with the Expressionist group The *Ten. In 1936 he worked for the *Federal Art Project, then in 1937–9 lived in the Arizona desert. Some of his landscapes of this time have a *Surrealist air, and after his return to New York in 1939 this tendency was enhanced by contact with expatriate European Surrealists, who helped him to develop an interest in Freudian psychology and the idea of the subconscious as a source of artistic inspiration. His work began to take on a distinctive identity in the early 1940s, and from then until the end of his life he worked in three main series: *Pictographs* (1941–51), *Imaginary Landscapes* (1951–7, and again in the mid-1960s), and *Bursts* (1957–74). The *Pictographs* use a loose grid- or compartment-like arrangement with schematic shapes or symbols suggesting some mythic force. (Of this series Gottlieb wrote: '*Rothko and I came to an agreement on the question of subject matter; if we were to do something which could develop in some direction other than the accepted directions of that time, it would be necessary to use different subjects to begin with and, around 1942, we embarked on a series of paintings that attempted to use mythological subject matter, preferably from Greek mythology . . . it seemed that if one wanted to get away from such things as the *American scene or *social realism and perhaps *cubism, this offered a possibility of a way out, and the hope that given a subject matter that was different, perhaps some new approach to painting . . . might also develop.') The *Imaginary Landscapes* feature a zone of astral shapes against a foreground of heavy *gestural strokes ; and the *Bursts*, becoming still freer, suggest solar orbs hovering above violently coloured terrestial explosions (*Orb*,

Dallas Museum of Fine Arts, 1964). Gottlieb also designed stained glass and other works for churches and synagogues, suggesting a religious mood without any specific representation.

Götz, Karl Otto. See QUADRIGA.

Gowing, Sir Lawrence (1918–91). British painter, teacher, administrator, and writer on art, born in London. From 1936 to 1938 he studied under *Coldstream, first privately and then at the *Euston Road School, and much of his subsequent work (mainly landscapes, portraits, and still-lifes) was in the sombre Euston Road vein. However, he also painted abstracts, and in 1976 he began producing large pictures in which he traced the outline of his own naked body stretched out on the canvas, the paint being applied by an assistant. He had a prominent career as a teacher, notably as professor of fine art at King's College, Newcastle upon Tyne (later Newcastle University), 1948–58, at Leeds University, 1967–75, and at the *Slade School, 1975–85. From 1965 to 1967 he was deputy director of the Tate Gallery, and he had a long association with the *Arts Council, for which he helped to organize and catalogue several exhibitions, notably the major *Matisse exhibition that inaugurated the Hayward Gallery, London, in 1968 (he also published a monograph on Matisse in 1979). Other major 20th-century artists on whom he wrote in book or catalogue form include *Cézanne (Arts Council exhibition, Edinburgh and London, 1954; 'Cézanne: The Late Works', MOMA, New York, 1977) and Lucian *Freud (monograph, 1982). He was knighted in 1982 and in 1983 an Arts Council retrospective of his work was shown in London, Newcastle upon Tyne, Hull, and Plymouth. The catalogue of this exhibition describes Gowing as 'singularly distinguished as a writer, a professor of painting and an adviser to the nation on the arts'; Brian *Sewell, however, called him 'a feeble landscape painter of no substance but much self-importance'.

Grabar, Igor (1871–1960). Hungarian-born Russian painter, art historian, and administrator. He was born in Budapest and studied in St Petersburg (first law at the university, then art at the Academy). From 1896 to 1901 he lived in Munich, and he travelled extensively in Europe and Russia up to the time of the

1917 Revolution. Early in his career as an artist he worked mainly as a landscapist, and Alan Bird (*A History of Russian Painting*, 1987) comments that he 'was one of the first Russian painters to take over the manner and the palette of *Impressionism, producing some extremely sensitive scenes of the landscape under snow' (*September Snow*, Tretyakov Gallery, Moscow, 1903). Grabar continued to paint throughout his life, his work including portraits of some of his distinguished contemporaries, but after the Revolution he became better known as a scholar and administrator (even before this, in 1913, he had been appointed director of the Tretyakov Gallery in 1913, a post he held until 1925). He was a professor of art history at Moscow University until 1946 and also held important posts in the state establishments for art restoration and scientific research in art history. In these varied roles he did much to preserve his country's artistic heritage. His writings included numerous books and articles on Russian art, including a two-volume monograph on *Repin (1937, 2nd edn., 1963–4), for which he was awarded a Stalin Prize in 1941, and he was editor of the standard work *Istoriya russkogo iskusstva* ('History of Russian Art', 6 vols., 1906–16) and co-editor of the revised and expanded version (13 vols., 1953–68). His autobiography appeared in 1937. Alan Bird writes that 'Grabar's career is an interesting example of survival in the face of official hostility without any ostensible sacrifice of personal principles. He opposed the *Futurists who wanted to destroy the art of the past, as did many of the *Constructivists; he defied the Soviets by returning confiscated pictures to their aristocratic or bourgeois owners . . . and he defied the Communist Party whose ideologists found his work lacking in *partiinost* [Party spirit]; and yet always acted without malice or self-interest.'

Graevenitz, Gerhard von (1934–83). German sculptor and experimental artist, born at Schilde, Mark Brandenburg. After reading economics at Frankfurt University he studied art at the Munich Academy from 1957 to 1961. In the early 1960s he began to make *Kinetic pictures in which geometrical shapes were given random movement by electric motors. Later in the decade he developed 'light objects' in which movable aluminium parts were made to reflect light in constantly changing patterns. He conceived such work as

an attempt to go beyond *Constructivism in the creation of a new art form and wrote in the catalogue of the exhibition 'Kinetics' at the Hayward Gallery, London, in 1970: 'My kinetic objects are visual objects. The elements are simple and geometric. Kinetic objects are not traditional sculptures set in motion. Motion means the changing of the network of relationships which defines the structure in space and time. Kinetic art is not a new style but a new art in the sense that it establishes a new object-spectator relationship.' Graevenitz died in an aeroplane crash.

Graffiti art (also called Spraycan art and Subway art). A type of painting based on the kind of spraycan vandalism familiar in cities all over the world and specifically in the New York subway system; the term can apply to any work in this vein, but refers particularly to a vogue in New York in the 1980s (several commercial galleries specialized in it at this time and a Museum of American Graffiti opened there in 1989). The best-known figures of Graffiti art are Jean-Michel Basquiat (1960–88) and Keith Haring (1958–90), both of whom enjoyed huge reputations (and prices) during their brief careers, which were ended for Basquiat by a drugs overdose and for Haring by AIDS. Basquiat was a genuine street artist who 'crossed over' into the gallery world (although he came from an upper-middle-class family and was not the 'urban noble savage' that some of his publicity maintained); Haring had an art school training but adopted a cartoon-like style based on graffiti. Basquiat in particular continues to have a large following; in 1996 a film about his life was released (directed by Julian *Schnabel) and in the same year Edward *Lucie-Smith wrote that his work 'possesses immense energy and a vast range of cultural reference . . . It is perhaps the most fascinating product of the New York art scene during this period' (*Visual Arts in the Twentieth Century*). Many critics, however, consider his reputation grossly inflated; Robert *Hughes referred to him and Haring as 'Keith Boring and Jean-Michel Basketcase'.

Graffiti art had less of a vogue in Britain. In 1996 a young man called Simon Sunderland was given a five-year jail sentence for a campaign of graffiti vandalism in the Sheffield area. However, he was released later that year to take up a place at art college, having found 'a sense of purpose and direction in his art'.

Graham, John (1881–1961). Russian-American painter and writer on art, born Ivan Dambrowsky in Kiev. His early life is obscure and it is not certain where or even whether he received formal training in art. However, it is evident from his writings that he knew certain members of the Russian avant-garde—David *Burliuk, *Gabo, *Lissitsky, and *Mayakovsky—and his early paintings show the influence of *Rayonism. Like *Kandinsky and *Malevich, he later became interested in Theosophy. He emigrated to the USA in the early 1920s and studied under John *Sloan at the *Art Students League. His paintings are eclectic, drawing variously on *Cubism, *Fauvism, and *Surrealism; they sometimes have an engaging eccentricity, but he is more important for his other activities. He introduced Jackson *Pollock to his future wife Lee *Krasner in 1941, knew many other young artists who later became celebrated figures (Stuart *Davis, Willem *de Kooning, Arshile *Gorky, David *Smith), and gained a reputation as the mouthpiece of modernism and a link with the European avant-garde. His emphasis on the importance of the unconscious as a spring of artistic inspiration has been cited as a source for the young *Abstract Expressionists, and David Anfam writes: 'On the evidence of his book *System and Dialectics of Art*, read by the cognoscenti at its appearance in 1937, Graham embodied a fascinating storehouse of ideas and pursuits for anyone eager to escape provincialism' (*Abstract Expressionism*, 1990). He collected African sculpture and received European magazines such as *Cahiers d'art* that were a stimulus to the artists in his circle. In the 1940s, however, Graham repudiated modernism and became immersed in the study of the occult. He spent his final years in London and Paris.

Graham, Martha. See NOGUCHI.

Grant, Duncan (1885–1978). British painter, decorator, and designer, born into an ancient Scottish family at Rothiemurchus, Inverness (although both his grandmothers were English). His father was an army officer stationed in Burma, and Grant spent most of his early childhood there. He studied at Westminster School of Art, 1902–5, at the Académie de la Palette, Paris, under *Blanche, 1906–7, and for six months at the *Slade School, 1907. Through the writer Lytton Strachey (his cousin) he became a member of the *Blooms-

bury Group, and he was also familiar with avant-garde circles in Paris (he met *Matisse in 1909 and *Picasso soon afterwards). Up to about 1910 his work—which included landscapes, portraits, and still-lifes—was fairly sober in form and restrained in colour, but he then underwent a rapid development to become one of the most advanced of British artists in his response to modern French painting (he exhibited at Roger *Fry's second *Post-Impressionist exhibition in 1912). From about 1913 he was also influenced by African sculpture, and he was one of the first British artists to produce completely abstract art; in 1914 he made an *Abstract Kinetic Collage Painting*, which was meant to be unrolled to the accompaniment of music by J. S. Bach (this is now in the Tate Gallery, London, which has had a film made demonstrating the painting being unrolled in the desired fashion). However, this extreme avant-garde phase was fairly-short-lived and he soon reverted to a figurative style. In 1913 he began working for the *Omega Workshops, and having discovered a taste and talent for interior decoration, he sought similar commissions when the Workshops closed in 1919. In this field he worked much in collaboration with Vanessa *Bell, with whom he lived from 1916 (although Grant was basically homosexual, he enjoyed a long and happy relationship with Bell, who bore him a daughter in 1918).

Grant was at the height of his popularity and esteem in the 1920s and 1930s. He had several decorative commissions for private houses, and he was also active as a designer of stage decor, textiles, and pottery. Gradually he became something of an establishment figure, but his work still retained the power to shock conservative eyes, as when his murals for the new Cunard liner *Queen Mary* (1935) were rejected by the company. His largest commission (executed with Vanessa Bell and her son Quentin) was a series of wall paintings in Berwick church, Sussex, 1942–3, commissioned by George Bell, Bishop of Chichester (Kenneth *Clark and Frederick *Etchells helped to make the work possible). In *The Buildings of England*, Nikolaus Pevsner writes of this work: 'It was a noble effort on the part of the bishop—art in wartime and modern art in a church, yet if one remembers Duncan Grant and Vanessa Bell in their prime, how sad does it seem now, so conventional, so sentimental.' After the war, Grant's work went totally out of fashion and he had

difficulty selling his pictures. However, he lived long enough to see a great revival of interest in the Bloomsbury Group, which brought a renewed appreciation of his own work. He continued painting until a few days before his death at the age of 93. Sir John *Rothenstein considers that as an artist he had 'a tasteful intelligence' but 'an insufficiency of passion'.

Graves, Morris (1910–). American painter, born at Fox Valley, Oregon. Between 1928 and 1930 he worked as a seaman on mail ships to the Far East, bringing him into touch with Oriental art, which had a deep and lasting effect on his work and outlook. As a painter he was mainly self-taught, although he had some instruction from Mark *Tobey (another artist inspired by Eastern culture), whom he met in about 1935. From 1932 to 1964 Graves lived in or near Seattle, then moved to Loleta in north-west California. His work has affinities with *Surrealism as well as Oriental traditions, but it speaks a highly individual symbolic and formal language that has little in common with the work of his contemporaries. He paints mainly birds and small animals, with a keen eye for characteristic attitudes and poses, and a highly personal sense of fantasy reflecting an inner mystical world. In his *American Art of the 20th Century* (1973) Sam Hunter has written of him: 'A deeply religious man . . . Graves has made a tender, lyrical poetry from such images as a pine tree tremulously holding a full moon in its branches, or tiny birds and snakes, images which seem to be secreted rather than painted on canvas or paper. His art is rapt, visionary, hypnotic.' He works for preference on Chinese or Japanese paper, finding 'a delight in the fragility, the transiency of the material'. In the 1960s he turned also to abstraction in the form of three-dimensional constructions. Graves has travelled widely, had numerous one-man exhibitions, and won several awards. His work is in many public collections, the largest representation being at the Morris Graves Archival Collection at the Museum of Art of the University of Oregon in Eugene.

Graves, Nancy (1940–95). American sculptor and painter, born at Pittsfield, Massachusetts. She studied at Vassar College and Yale University and won a scholarship for painting that took her to Paris, 1964–5. Later in 1965 she vis-

ited North Africa and the Middle East, and in 1965–6 she lived in Florence, then settled in New York. In Florence she began making the lifesize, realistically painted sculptures of Bactrian camels for which she is best known; *Camels VI, VII,* and *VIII,* 1968–9, are in the National Gallery of Canada, Ottawa). Graves also produced abstract sculpture in painted bronze, abstract paintings, and films. She was married to Richard *Serra.

Greaves, Derrick (1927–). British painter and graphic artist, born in Sheffield. After an apprenticeship with a signwriter, he studied at the *Royal College of Art, 1948–52. In the 1950s he was a leading figure of the *Kitchen Sink School, depicting dour subjects including views of his home town (*Sheffield,* City Art Gallery, Sheffield, 1953). In the 1960s he moved away from a descriptively realistic style to one bordering on abstraction. He has taught at several art schools and in 1983 he became head of printmaking at Norwich College of Art.

Greaves, Walter (1846–1930). British painter and etcher, mainly of river scenes, landscapes, and portraits. He was the son of a London boatbuilder and waterman who used to ferry J. M. W. Turner across the Thames. In the early 1860s Walter and his brother Henry met *Whistler (a neighbour in Chelsea) and began to row him about the river, which was one of his favourite subjects. In about 1863 they became his unpaid pupils and studio assistants; they hero-worshipped him, and their unsophisticated attempts to imitate his stylish dress and manner caused much amusement. Walter continued to be associated with Whistler until the 1890s. He had painted even before he met Whistler, and his early work is in a detailed, almost *naive style; he soon came completely under the master's style, however, and in his *Self-portrait* (Tate Gallery, London, *c.*1890) he is clearly trying to paint just like Whistler as well as to look just like him (on occasion he was in fact mistaken for him). However, he recognized a difference in outlook when it came to river scenes: 'To Mr Whistler a boat is always a tone, to us it was always a boat.' Greaves was poor and unrecognized for most of his life, but he became well known after a group of paintings (discovered in bad condition in a London bookshop in 1910) were exhibited as his work at the Goupil Gallery, London, in 1911 and the Cottier

Gallery, New York, in 1912. Many critics hailed him as an unsung genius, but Joseph and Elizabeth *Pennell thought that at least some of the pictures were Whistlers that Greaves had retouched and signed. A great controversy followed (*Sickert was one of those who defended Greaves) and the matter was never entirely resolved, the authorship of some of the pictures still being disputed. In 1922 Greaves was admitted to the Charterhouse, a hostel for poor men, where he lived for the rest of his life.

Greco, Emilio (1913–). Italian sculptor, born at Catania, Sicily. After an apprenticeship with a funerary stonemason he studied briefly at the Palermo Academy of Art, 1934. In 1943 he settled in Rome, where he was professor of sculpture at the Liceo Artistico, 1948–52. He then taught at the Carrara Academy, 1952–5, and the Naples Academy, 1955–67, before returning to Rome as professor at the Academy. His most characteristic works are in bronze, chiefly portrait busts and lifesize (or slightly over lifesize) female nudes. The latter are tall and posturing, with a Mannerist elegance embodying witty parody of classical statues (*Large Bather I,* Tate Gallery, London, 1956). He has done many other kinds of work, however, including the Pinocchio monument at Collodi (1956), three bronze doors for Orvieto Cathedral (1959–64), and the monument to Pope John XXIII in St Peter's, Rome (1965–6).

Green, Anthony (1939–). British painter, born in London, where he studied at the *Slade School, 1956–60. He specializes in scenes from his own middle-class domestic life portrayed on a large scale with loving attention to detail and an engaging sense of whimsy. Often he uses irregular *shaped canvases that accentuate his strange perspective effects, and his subjects are frequently erotic as well as humorous (*Our Tent, 14th Wedding Anniversary,* Rochdale Art Gallery, 1975). His work is instantly recognizable and is generally highly popular with visitors to the *Royal Academy summer exhibition, for he communicates with rare intensity the loving feeling that he puts into his painting: 'I do not remember people, rooms, tents, incidents from a fixed view point—I just remember. I remember joy, sadness, colours, patterns, scale. I remember the personality of objects; radiators are hard and shiny, my wife's lips

are red and soft and lip-like, my mother's hair is up and French and never down . . . all this I want in one image. It is who I am *now*.' In 1984 he published a book about his life and work, *A Green Part of the World*.

Greenberg, Clement (1909–94). American art critic, born in New York. He was his country's most influential writer on contemporary art in the period after the Second World War when American painting and sculpture first achieved a dominant position in world art, his only serious rival being Harold *Rosenberg; in particular he was a major champion of *Abstract Expressionism. Greenberg studied at the *Art Students League and Syracuse University; before he became a full-time writer he worked as a clerk for the US Customs. He was regular art critic for the *Nation* from 1942 to 1949 and wrote for several other journals, including *Arts Digest* and *New Leader*. Some of his early writing in the left-wing *Partisan Review*, notably the article 'Avant-Garde and *Kitsch' (1939), was concerned with the social and political role of art, but he later became strongly associated with a *formalist approach to criticism. He argued that in each of the arts there was an urge towards 'purity'—dissociation from other arts—and that in painting this resulted in a progressive emphasis on the flatness of the picture surface and the rejection of any form of illusionism: 'The history of avant-garde painting is that of a progressive surrender to the resistance of its medium; which resistance consists chiefly in the flat picture plane's denial of efforts to "hole through it" for realistic perspectival space' ('Towards a Newer Laocoon', *Partisan Review*, July-August 1940). Although he claimed he made 'disinterested aesthetic' appraisals of art, Greenberg's early contacts with Marxism gave him a strong sense of history having an order and purpose, and this enabled him to endow his verdicts with a claim for historical certainty: 'in a period in which illusions of every kind are being destroyed the illusionist methods of art must also be renounced . . . Let painting confine itself to the disposition pure and simple of color and line, and not intrigue us by associations with things we can experience more authentically elsewhere' ('Abstract Art', *The Nation*, 15 April 1944).

Greenberg wrote on many of the leading Abstract Expressionists, but he is particularly associated with Jackson *Pollock. He praised

his first one-man show in 1943, and in 1945 he wrote: 'Jackson Pollock's second one-man show . . . establishes him, in my opinion, as the strongest painter of his generation.' The artists he later championed included the sculptors David *Smith and Anthony *Caro and *Post-Painterly Abstractionist painters such as Morris *Louis and Kenneth *Noland, whose emphasis on pure flat colour was perfectly in line with his theoretical outlook. In contrast, he rejected the work of artists such as *Rauschenberg as mere 'novelty'. Greenberg's influence was at its peak in the 1950s and 1960s, and he was unusual among critics in that artists valued his advice (in such matters as the cropping or hanging of paintings). A collection of his essays, *Art and Culture* (1961), was one of the best-known aesthetic texts of the time, as is shown by John *Latham's ceremonial destruction of a copy in 1966 as a protest against the dominance of its ideas. In the 1970s, however, Greenberg's influence waned in the face of developments such as *Conceptual art and *New Figuration. The way in which he divorced art from social and ethical considerations was suspect to many younger writers, but his essays are still frequently reprinted as exemplifying a certain type of modernist criticism. In his later years he devoted himself to lecturing rather than writing. His *Collected Essays and Criticism* were published in four volumes in 1986–93. Greenberg also wrote monographs on *Miró (1948), *Matisse (1953), and *Hofmann (1961). See also MODERNIST PAINTING.

Greene, Balcomb (1904–90). American painter, born at Niagara Falls. He began to paint seriously in 1931 without formal training, having previously studied psychology (he did postgraduate work under Freud in Vienna) and taught English literature. In 1931–3 he lived in Paris, and on his return to the USA settled in New York. By 1935 his style had become completely abstract and in 1936 he was the first chairman of the *American Abstract Artists association. From 1936 to 1939 he worked for the *Federal Art Project, painting several abstract murals in a severe geometrical style. In the 1940s representational elements entered his work (he sometimes showed figures fragmented against an abstract background), and from the late 1950s a new note of humanism, almost of existentialism, became apparent in many of his pictures.

Greffe, Léon. See NAIVE ART.

Gregory, Eric (1887–1959). British collector, patron, and philanthropist. He had a successful career in printing and publishing, becoming chairman of the firm of Lund Humphries in his native Bradford, and he began collecting in the 1920s, favouring work by contemporary British artists, especially sculptors. Among them was his fellow Yorkshireman Henry *Moore, whom he met in 1923 and who later became a close friend. Gregory was also an early patron of Barbara *Hepworth, Ben *Nicholson, and Graham *Sutherland. In 1943 he established Gregory Fellowships at Leeds University to be held by painters, sculptors, composers, or poets for two years (sometimes extended to three). In view of the particular support he gave to sculpture, it was appropriate that the first holders of the sculpture fellowship went on to have distinguished careers: Reg *Butler was the first in 1950–3, followed by Kenneth *Armitage in 1953–5, and Hubert *Dalwood in 1955–8. One of the aims of the fellowships was to reduce the over-centralization of the arts in London, but Gregory was also active there; most notably he helped to found the *Institute of Contemporary Arts in 1947 and held the post of treasurer for the rest of his life.

Greis, Otto. See QUADRIGA.

Grey, Sir Roger de. See DE GREY.

Gris, Juan (1887–1927). Spanish painter, sculptor, graphic artist, and designer, active mainly in Paris, where he was one of the major figures of *Cubism. He was born in Madrid, the son of a wealthy merchant, and his real name was José Victoriano González (he had adopted his pseudonym by about 1905). From 1902 to 1904 he studied mathematics, physics, and engineering in Madrid, then took up painting, training with a local academic artist. In 1906 he moved to Paris and found accomodation in the *Bateau-Lavoir, where *Picasso was already living. For the next few years he earned his living mainly with humorous drawings for various periodicals and he did not begin painting seriously until 1910. However, he made such rapid strides that by 1912 he was becoming recognized as the leading Cubist painter apart from the founders of the movement, Picasso and *Braque. His work stood out at the *Sec-

tion d'Or exhibition in that year, attracting the attention of collectors and dealers (Gertrude *Stein was among those who bought his paintings and *Kahnweiler gave him a contract). In 1913–14 he developed a personal version of Synthetic Cubism, in which *papier collé played an important part. He said that he conceived of his paintings as 'flat, coloured architecture' and his methods of visual analysis were more systematic than those of Picasso and Braque. His subjects were almost all taken from his immediate surroundings (mainly still-lifes, with occasional landscapes and portraits), but he began with the image he had in mind rather than with an object in the external world: 'I try to make concrete that which is abstract . . . *Cézanne turns a bottle into a cylinder, but I make a bottle—a particular bottle—out of a cylinder.'

Gris was able to continue working in Paris throughout the First World War, and in 1919 he had his first major one-man exhibition there, at Léonce *Rosenberg's Galerie l'Effort Moderne. In 1920, however, he was seriously ill, possibly with tuberculosis, and from then on his health was often poor; for this reason he spent much of his time in the South of France. He was only 40 when he died of kidney failure. In this last period of his life his style became more painterly (*Violin and Fruit Dish*, Tate Gallery, London, 1924). Apart from paintings, his work included polychrome sculpture, book illustrations, and set and costume designs for *Diaghilev. Gris was of a logical turn of mind, but Douglas *Cooper writes that he 'always tempered his science with the workings of his personal sensibility, and the many *pentimenti* and freely invented passages in his paintings are evidence of his constant concern that the reality of natural forms should not be subjected to "monstrous" distortions dictated by some pre-determined design'. He wrote a few essays on his aesthetic ideas and a collection of his letters, edited and translated by Cooper, was published in 1956.

Grohmann, Will (1887–1968). German art historian, born at Bautzen, Saxony. He studied literature at university, but he became interested in art through exhibitions of Die *Brücke in Dresden, then formed friendships with several leading painters of the day. In the 1920s he published books on *Kandinsky (1924), *Kirchner (1925 and 1926), and *Klee (1929), but when the Nazis came to power in 1933 he was prevented from working (see

DEGENERATE ART). He resumed his career after the Second World War and became professor of art history at the Hochschule für Bildende Künste in Berlin in 1948. From then until his death he published a succession of monographs on German art, including further studies of Kandinsky, Kirchner, and Klee. Several of his books were translated into English, and he also helped to introduce German art to a British audience through collaborating on catalogues of exhibitions held by *Marlborough Fine Art in London, for example 'Painters of the Bauhaus' in 1962.

Gromaire, Marcel (1892–1971). French painter, graphic artist, and designer, born at Noyelles-sur-Sambre of a French father and Belgian mother. He had no formal training, but from 1910 he frequented artists' studios in Paris, meeting pupils of *Matisse and getting advice from *Le Fauconnier. Before the outbreak of the First World War he visited the Netherlands, Belgium, Germany, and England; he was impressed by contemporary *Expressionism and also by the naturalism of the Old Masters of the Low Countries. He fought in the war and was wounded in 1916. His early work was influenced by *Cézanne and the *Fauves, but after the war he looked more to *Léger, reducing his figures to bulky, simplified, rounded shapes. Later his style became looser and more expressionistic. He painted a variety of subjects (although his main interest was in depicting the life of the people) and he did some of his best work as a decorative artist; with Jean *Lurçat he was primarily responsible for the renaissance of French tapestry design in the 1930s. Gromaire also did a good deal of graphic work.

Grooms, Red (Charles Rogers Grooms (1937–). American sculptor, painter, filmmaker, and creator of *Happenings, born in Nashville, Tennessee. He studied in Nashville at the Peabody College, then at the Art Institute of Chicago, the New School for Social Research in New York, and Hans *Hofmann's summer school at Provincetown. In the late 1950s he was one of the pioneers of Happenings in New York, and in the 1960s he developed the type of work for which he is best known—mixed-media constructions or *environments 'in which he peoples entire rooms with cut-out figures and objects painted in brilliant and clashing colors . . . characterized by wild fantasy and broad slap-

stick humor . . . rather like three-dimensional comic strips that are rooted in a precise observation of contemporary popular culture' (H. H. Arnason in *Britannica Encyclopedia of American Art*, 1981). These are often on a very large scale, built with the aid of collaborators he calls the Ruckus Construction Co. Grooms has also often collaborated with his wife, the painter Mimi Gross, and with the film-maker Rudolph Burckhardt.

Gropius, Walter (1883–1969). German-born architect, designer, and teacher who became an American citizen in 1944. In 1919 he founded the *Bauhaus, of which he was director until 1928, when he resigned to resume his architectural practice in Berlin. In 1934, after the Nazis had come to power, he moved to England, and in 1937 he settled in the USA, where he had been offered the Chair of Architecture at the Graduate School of Design at Harvard University. He occupied this post until 1951 and remained active until the end of his life, with a long list of notable buildings to his credit. His architecture is characterized by an uncompromising use of modern materials (he was one of the pioneers in the use of a glass screen to form the entire outer wall of a building), but also by lucidity and gracefulness. Although Gropius's practical work was mainly in the fields of architecture and interior design, his influence on modernist trends in all the visual arts was enormous. At the Bauhaus he brought together an unprecedented collection of outstanding artists, and through their teaching his ideas gained international currency; left-wing in his political views, he believed that design should be a response to the needs and problems of society, utilizing to the full the resources of modern technology and expressing the ideal of a humane, integrated community.

Gropper, William (1897–1977). American graphic artist and painter. He was born in New York into a poor family (his father was a sweatshop garment worker), but he saved enough money from various menial jobs to study under George *Bellows and Robert *Henri at the Ferrer School, New York, 1912–13, and then at the National Academy of Design, 1913–14, and the New York School of Fine and Applied Art, 1915–18. In 1920 he joined the staff of the *New York Herald-Tribune* as a cartoonist, but he was soon dismissed because of his left-wing political sympathies

and then worked as a freelance cartoonist, contributing to fashionable periodicals such as *Vanity Fair* as well as radical publications such as *The New Masses*. His Communist sympathies led him to make a lengthy visit to the USSR in 1927, during which he worked for the Party newspaper *Pravda* in Moscow; the following year he published a book entitled *Fifty-Six Drawings of the USSR*. He had begun painting in 1921 and in 1936 had his first one-man show at the ACA Gallery in New York. In the late 1930s he also painted several murals under the auspices of the *Federal Art Project. His paintings were closely related to his caricatures in subject and style; he was concerned with exposing social injustice, sympathizing with the downtrodden and attacking businessmen and politicians in a formally simplified, satirical manner bordering on *Expressionism (he has been called 'the Expressionist Daumier'). His best-known painting is probably *The Senate* (MOMA, New York, 1935). In his later years he moved from satire to themes of broader social concern, his work taking on a more spiritual feeling. He was the recipient of many awards.

Grosman, Tatyana. See PRINT RENAISSANCE.

Gross, Mimi. See GROOMS.

Grosvenor School of Modern Art, London. See MACNAB.

Grosz, George (1893–1959). German-born painter and draughtsman who became an American citizen in 1938. He was born in Berlin and studied drawing at the Dresden Academy, 1909–11, and the School of Arts and Crafts, Berlin, 1912–14. In 1914 he enlisted in the army, but he was discharged on medical grounds the following year (he was called up again in 1917, but again discharged as unfit). The war instilled in him a hatred of the Prussian military caste, which he attacked mercilessly in his work—the most famous of the satirical anti-war illustrations he made at this time is the drawing *Fit for Active Service* (MOMA, New York, 1918), in which a fat, complacent doctor pronounces a skeleton fit for duty. In 1917, with *Heartfield, he anglicized his name (adding an 'e' to Georg) as a protest against the hatred being whipped up against the enemy, and he became overwhelmed with loathing for his countrymen: 'To be German means invariably to be crude, stupid, ugly, fat

and inflexible—it means being unable to climb a ladder at forty, to be badly dressed—to be a German means to be a reactionary of the worst kind; it means only one amongst a hundred will, occasionally, wash all over.'

From 1917 to 1920 Grosz was a prominent figure in the *Dada movement in Berlin, and in the 1920s, with *Dix, he became the leading exponent of the *Neue Sachlichkeit. In 1917 he published the first of several collections of drawings, through which he established an international reputation. The most famous are *Das Geschicht der herrschenden Klasse* ('The Face of the Ruling Class', 1921) and *Ecce Homo* (1927). In these and in his paintings he ruthlessly denounced a decaying society in which gluttony and depraved sensuality are placed beside poverty and disease; prostitutes and profiteers were frequently among his cast of characters. Grosz often used watercolour, and in spite of the nastiness of the subject-matter and the bluntness of his satire, his works in this medium are remarkable for the sheer beauty and delicacy of their technique. His more conventional works of this time include a number of portraits, of which the best known is probably that of the poet Max Hermann-Neisse (Kunsthalle, Mannheim, 1925), which rivals Dix's portraits in incisiveness.

Grosz was prosecuted several times for obscenity and blasphemy, and in 1933, despairing of the political situation in Germany, he moved to the USA to take up the offer of a teaching post at the *Art Students League of New York. (He had joined the Communist Party in 1918 and after he left Germany he was described as 'Cultural Bolshevist Number One'.) In America Grosz largely abandoned his satirical manner for more romantic landscapes and still-lifes, with from time to time apocalyptic visions of a nightmare future. Although he won several honours in the last decade of his life, he regarded himself as a failure because he was unable to win recognition as a serious painter rather than a brilliant satirist, and he painted several self-portraits showing how isolated and depressed he was in his adopted country (*The Wanderer*, Memorial Art Gallery, University of Rochester, New York, 1943). His autobiography, *A Little Yes and a Big No*, was published in New York in 1946. He returned to Berlin in 1959, saying 'my American dream turned out to be a soap bubble', and died there shortly after his arrival following a fall down a flight of stairs.

Groupe de Recherche d'Art Visuel (GRAV). A group of *Kinetic artists formed in Paris in 1960. The members, who included *Le Parc and *Yvaral, adopted a scientific approach and investigated the use of modern industrial materials for artistic purposes. As well as creating individual works, they often worked together on anonymous collective projects, and it was one of their aims to produce art that called for involvement from the spectator (they were much concerned with the idea idea of 'ludic' art, or the art of the game). The group had its base at the Galerie Denise *René, but on various occasions it attempted to bring art into the life of the streets. It disbanded in 1968.

Groupe Espace. An association founded in Paris in 1951 by André *Bloc and artists associated with his periodical *Art d'aujourd'hui*. The members of the group included Jean Gorin (1899–1981), Edgard Pillet (1912–), and Nicolas *Schöffer. Their object was to promote the part of *Constructivist doctrine that formed the subject of the last paragraph of *Mondrian's essay 'Plastic Art and Pure Plastic Art', namely that Constructivist art, united with architecture, should create a new environment appropriate to the new society that was to emerge in the modern age. They envisaged a 'public art', art as a social and collective—not an individual—phenomenon.

Group of Plastic Artists (Skupina Výtvarných Umělců). A splinter group of progressive Czech artists that broke away from the *Mánes Union in Prague in 1911 and flourished up to the First World War. The leading members of the group were Vincenc Beneš (1893–1979), Josef *Čapek, Emil *Filla, Otto *Gutfreund, and Antonín Procházka (1882–1945). Stylistically they combined *Cubism with *Expressionism, along with some *Futurist influence after 1913. The group published a journal *Umělecký měsíčník* (Art Monthly) from 1911 to 1914 and held six exhibitions in Prague between 1912 and 1914; at two of these, works by leading contemporary painters from other countries were shown (among them *Braque, *Gris, *Munch, *Pechstein, and *Picasso). The members were in touch with the artists of Die *Brücke in Germany and in 1913 they showed as a group in the *Sturm Gallery in Berlin. Closely associated with the group was the art historian Vincenc Kramář (1877–1960), who formed a superb collection of Cubist art. He became director of the National Gallery in Prague and bequeathed his collection to the nation.

Group of Seven. Group of Canadian painters, based in Toronto, who found their main inspiration in the landscape of northern Ontario and created the first major national movement in Canadian art. The group was officially established in 1920, when it held its first exhibition, in the Art Gallery of Toronto, the seven painters involved being Frank Carmichael (1890–1945), Lawren *Harris, A. Y. *Jackson, Frank Johnston (1888–1949), Arthur Lismer (1885–1969), J. E. H. *MacDonald, and Fred Varley (1881–1969). Some members of the group had, however, been working together since 1913, and Tom *Thomson, who was one of the early leaders, had died in 1917. Johnston resigned in 1926 and was replaced by A. J. Casson (1898–1992), and two other artists later joined, bringing the numbers up to nine: in 1930 Edwin Holgate (1892–1977), best known for his female nudes in landscape settings, and in 1932 LeMoine FitzGerald (1890–1956). The members made group sketching exhibitions and worked in a forceful *Expressionist style characterized by brilliant colour and bold brushwork. After initial critical abuse, they won public favour, and Emily *Carr was inspired by their example. The group held its last exhibition in 1931 and two years later it was disbanded and superseded by the *Canadian Group of Painters; thereafter the members worked more as individuals and developed separately, Harris eventually becoming an abstract artist. In 1966 a gallery dedicated to the Group of Seven—the McMichael Canadian Collection—was opened in Kleinburg, Ontario.

Group X. A short-lived association of British artists, including some former members of the *Vorticist movement, formed in 1919 with the aim of providing a focus for London's avant-garde and an alternative exhibiting venue to that of the *London Group. The association, whose name seems to have had no particular significance, held only one exhibition, in 1920, at the Mansard Gallery. Wyndham *Lewis, who wrote the introduction to the catalogue, was the leading figure of the group. The other members were Jessica *Dismoor, Frank *Dobson, Frederick *Etchells, Charles *Ginner, Cuthbert Hamilton (1884–1959), McKnight *Kauffer,

William *Roberts, John Turnbull, and Edward *Wadsworth.

Gruber, Francis (1912–48). French painter, born in Nancy, the son of a stained-glass designer. In 1916 the family moved to Paris. Gruber suffered from asthma as a child and was unable to have a normal education, but the artistic talent he showed from an early age was encouraged by his father and by his neighbours *Bissière and *Braque, who gave him private instruction. In 1929–32 he studied at the Académie Scandinave under *Dufresne and *Friesz, and in 1930 he had his first public success at the *Salon d'Automne; after this he rapidly made a name for himself, in spite of his youth. His early work was often of visionary subjects, but from about 1933 he began to paint mainly from the model in the studio; he also did still-lifes, views through windows, and from 1937 landscapes painted out of doors. Gruber's characteristic style was grave and melancholy, featuring long, drooping figures, and he is regarded as the founder of the 'Misérabiliste' strain in French painting, later associated chiefly with Bernard *Buffet. A typical work is *Job* (Tate Gallery, London, 1944), painted for the 1944 Salon d'Automne, which was known as the Salon of the Liberation because it was held soon after Paris was freed from the German occupation; the picture symbolizes oppressed peoples, who like Job in the Bible had endured a great deal of suffering. In spite of the tuberculosis that caused his early death, Gruber worked with great energy and had a substantial output.

Grünewald, Isaac (1889–1946). Swedish painter, designer, and teacher, born in Stockholm. He studied under Richard *Bergh and then in Paris under *Matisse, 1908–11, evolving a basically *Fauvist style that aroused considerable hostility among the establishment in Sweden (in 1913 he won a competition to decorate the Wedding Registry of Stockholm Town Hall, but official opposition prevented him from carrying out his design). From the 1920s he developed a more solid manner of painting, in which objects were defined in heavy impasto, and had a successful career with this less controversial style. His work included landscapes, portraits, still-lifes, nudes, and mural painting, including the decoration of an auditorium in Stockholm Concert Hall (1926). He also did a good deal of stage design, beginning in 1921 with sets for a production of Saint-Saëns' opera *Samson et Dalila* at the Theatre Royal, Stockholm. These are regarded as marking the beginning of an anti-naturalistic, modernist phase in Swedish stage design. Through his teaching in Stockholm (first at the College of Art, 1932–42, then at his own school, 1942–6) he exerted a strong influence on younger Swedish artists.

His wife **Sigrid Hjertén Grünewald** (1885–1948), whom he married in 1911, was also a painter. She too was a pupil of Matisse and is regarded as one of the finest colourists among Swedish artists of her generation.

Gruppo degli Otto Pittori Italiani. A group of eight Italian abstract painters organized in 1952 by the art historian and critic Lionello Venturi (1885–1961). Six of the eight had previously been members of the *Fronte Nuovo delle Arti: Renato *Birolli, Antonio *Corpora, Ennio Morlotti (1910–), Giuseppe Santomaso (1907–90), Giulio *Turcato, and Emilio *Vedova; the other two were *Afro and Mattia Moreni (1920–). They exhibited together at the 1952 Venice *Biennale, and the works shown there also travelled to several venues in Germany. Venturi stressed the idea of autonomy and liberty in their work: 'These painters are not, and do not wish to be considered, "abstract" painters; nor are they, or do they wish to be considered "realistic". Instead, they propose to break away from the contradictions inherent in these two terms, contradictions which tend, on the one hand, to reduce abstraction to a new mannerism and, on the other, to give priority to political considerations, which can only lead to the disintegration of artistic freedom and spontaneity' (*Otto Pittori Italiani*, 1952). He described their style as 'abstract-concrete . . . born of a tradition that began around 1910 and that includes *Cubism, *Expressionism and *Abstraction'. At this time, several of the artists used geometrical forms, but later in the 1950s some of them moved on to a looser style, Afro in particular becoming a noted exponent of *Art Informel.

Grützke, Johannes. See UGLY REALISM.

Guerrilla Art Action. See ART WORKERS' COALITION.

Guerrilla Girls. A group of women artists founded in New York in 1984 to combat what

they considered sexism and racism in the art world. Jonathan Fineberg writes that 'After the Museum of Modern Art held its vast "International Survey of Contemporary Art" in 1984, in which almost no women or minorities were included, a number of professional women in the New York art world founded this collective organization. The Guerrilla Girls appeared on television (wearing gorilla masks to maintain their anonymity), they advertised, and distributed leaflets and posters to bring attention to the widespread race and gender discrimination that exists in the art world' (*Art Since 1940*, 1995). One of their posters shows a reclining female nude by Ingres, with the woman's head replaced by a gorilla's and accompanied by the words: 'Do women have to be naked to get into the Met. Museum? Less than 5% of the artists in the Modern Art Sections are women, but 85% of the nudes are female.' The group's activities were documented in a book published in 1995, *Confessions of the Guerrilla Girls (Whoever They Really Are)*. It includes an essay by the American art historian Whitney Chadwick (1943–), who has written a good deal on feminist issues in art, notably in her book *Women, Art, and Society* (1990).

Guevara, Alvaro. See SITWELL.

Guggenheim, Solomon R. (1861–1949). American industrialist, collector, and philanthropist, a member of a famous family of financiers whose fortunes were based on the mining and smelting of metals. Like other members of the family, he devoted much of his vast wealth to philanthropy and in 1937 he founded the Solomon R. Guggenheim Foundation 'for the promotion and encouragement of art and education in art'. He started to collect art seriously soon after the turn of the century, and began to focus his attention on abstract painting in the later 1920s, influenced by his friend Baroness Hilla Rebay von Ehrenweisen (1890–1967), herself an avant-garde artist. In 1939 the collection was first opened to the public in a gallery at 24 East 54th Street, New York, with the Baroness as Director. It was called the Museum of Non-Objective Painting. In 1943 Guggenheim commissioned Frank Lloyd Wright to design a museum to house the collection and it was opened in 1959, a decade after the founder's death. The name had been changed to the Solomon R. Guggenheim

Museum in 1952, this more neutral title reflecting the broadening scope of the collection, which had grown to include sculpture as well as painting and many types of avant-garde art other than abstraction. It ranges from late 19th century to contemporary art and includes examples by virtually all the major avant-garde artists of the time. Its chief glories include the world's largest collection of *Kandinsky's work. The museum is famous for its architecture as well as for its contents. The building—the last great work of America's most illustrious architect—marks a complete departure from traditional museum design, the exhibition space being a continuous spiral ramp, six 'storeys' high, encircling an open central space. It is architecturally exhilarating, but its suitability for displaying paintings and sculpture has been much questioned; some people think that the building upstages the exhibits.

Guggenheim's niece, **Peggy Guggenheim** (1898–1979), was a patron, collector, and dealer who played an important role in promoting avant-garde art, in particular by helping to introduce *Surrealism to the USA and by furthering the careers of many leading *Abstract Expressionists. Her father, Benjamin Guggenheim, died when the *Titanic* sank in 1912, leaving her a substantial inheritance (although she was not as rich as some people assumed). She moved to London in her early 20s, living mainly in Paris, and in 1938 opened a gallery in London, Guggenheim Jeune, at which she organized exhibitions of abstract and Surrealist art. In 1941 she left war-torn Europe for the USA and in 1942 opened a gallery entitled Art of This Century in New York. She attended the opening 'wearing a tiny pink landscape by Yves *Tanguy on one ear-lobe and a metal and wire mobile by Alexander *Calder on the other in an attempt to demonstrate equal respect for Surrealist and abstract art. The gallery was both an exhibition space for young artists and a place to display Guggenheim's growing private collection . . . Guggenheim's frenzied whirl of parties and openings set the New York art world spinning, offering young American artists the chance to associate with the European avant-garde. Her support of *Pollock and encouragement of Robert *Motherwell, Hans *Hofmann, Clyfford *Still, Mark *Rothko and Adolph *Gottlieb made her the chief patron of the *New York School in its infancy' (catalogue of the exhibition 'American Art in the

20th Century', Royal Academy, London, 1993). Guggenheim had affairs with several artists and was briefly married to Max *Ernst. In 1946 she closed Art of This Century and returned to Europe, settling in Venice, where she founded another gallery. Her own superb collection is open to the public in Venice under the administration of the Solomon R. Guggenheim Foundation.

In 1997 a new Guggenheim Museum opened in Bilbao, Spain, financed by the Basque regional government. Designed by the American architect Frank Gehry (1929–), it is one of the most spectacular museum buildings in the world—huge, eccentric in shape, and clad largely in titanium; writing in the *Observer*, Robert McCrum described it as 'half Martian space-craft, half Californian Bacofoil fantasy'. It is intended particularly for the display of contemporary works that are too large to be shown in the Guggenheim Museum in New York, and one of its rooms is the biggest single gallery space in the world—more than 100 metres long. Several artists have been commissioned to produce work for this space, including Richard *Serra (a friend of the architect's), who created *The Snake*, a massive piece in rolled steel, with sinuous curves echoing the forms of the building. Gehry had previously done other notable museum work, for example at the *Museum of Contemporary Art, Los Angeles.

Guiette, René. See MATTERISM.

Guillaumin, Armand (1841–1927). French landscape painter, one of the minor figures of the *Impressionist group. Lack of success made him take a post with the department of bridges and causeways until he won a prize in a lottery in 1891 and was able to devote all his time to painting. Often his paintings are of industrial subjects, but he also painted seascapes. His style was bold and often brilliantly coloured. He was the last survivor of those who exhibited in the first Impressionist exhibition in 1874, dying the year after *Monet.

Guino, Richard. See RENOIR.

Gunn, Sir James (1893–1964). British portrait painter, born in Glasgow. He studied at *Glasgow School of Art, Edinburgh College of Art, and the *Académie Julian, Paris, then after serving in the Artists' Rifles in the First World War, he settled in London. There he enjoyed a successful career with portraits of eminent soldiers, academics, judges, and so on, painted in a solid, forthright style. He was a more interesting painter in less traditional work, notably his portrait of the blind composer Delius (City Art Gallery, Bradford), which was the public's choice as 'picture of the year' at the *Royal Academy in 1933. Also well known is Gunn's *Conversation Piece at the Royal Lodge, Windsor, 1950* (NPG, London), showing George VI, Queen Elizabeth (the Queen Mother), and Princesses Elizabeth (later Elizabeth II) and Margaret. In 1953 Gunn succeeded Augustus *John as president of the Royal Society of Portrait Painters. He also painted landscapes, but rarely exhibited them.

Guston, Philip (1913–80). American painter. He was born in Montreal and grew up in Los Angeles, where he was a schoolfriend of Jackson *Pollock. In 1930 he spent a few months at the Otis Art Institute, Los Angeles, but otherwise he was self-taught as an artist. After travelling in Mexico in 1934, studying the work of *Orozco and *Rivera in particular, he settled in New York and from 1934 to 1941 worked as a muralist on the *Federal Art Project. In 1941 he moved to Iowa City to teach at the State University there, and from 1945 to 1947 he was artist-in-residence at Washington University, St Louis. After leaving New York he switched from mural to easel painting, and during the 1940s his work changed in another fundamental way, moving from social and political subjects to abstraction; by 1950 (when, after travels in Europe, he settled in New York again) he had eliminated all figurative elements from his work. His most characteristic paintings feature luminous patches of overlapping colours delicately brushed in the central area of a canvas of light background (*Dial*, Whitney Museum, New York, 1956). This manner of his has been described as '*Abstract Impressionism' and he was associated with the more lyrical wing of *Abstract Expressionism—he was the only member of the group who had already had a successful career as a figurative painter. During the 1960s shades of grey encroached on the earlier brilliance of colour and vague naturalistic associations crept in, until in the 1970s he returned to figurative painting in a satirical, garishly coloured, cartoon-like style that has been seen as the source of *New Image Painting. His subjects in this manner included

scenes of fantastic social comment, involving, for example, the Ku Klux Klan.

Gutai Group (or Gutai Art Association). A group of Japanese avant-garde artists founded at Osaka in 1954; the name means 'embodiment'. Jiro *Yoshihara was the group's leader; he was appreciably older than the other members of the group, and his personal wealth was largely responsible for financing their activities. These were varied, but the group was best known for *Performance art. In 1960, for example, it produced a Sky Festival: 'Large balloons bearing banners by the artists, and some invited foreigners like Lucio *Fontana and Alfred *Leslie, were released from the roof of a department store in Osaka, recalling a similar piece by Yves *Klein done in 1957' (Adrian Henri, *Environments and Happenings*, 1974). The Gutai artists also produced *Action Paintings using extremely unconventional techniques. The group held numerous exhibitions and published 14 numbers of its magazine before breaking up following Yoshihara's death in 1972.

Gütersloh, Albert Paris von (1887–1973). Austrian painter, graphic artist, and writer, remembered mainly as a teacher. He was originally called Albert Conrad Kiehtreiber, but he adopted a pseudonym for his writings (he published several novels) and took Gütersloh as his official name in 1921. Early in his career he was an actor and stage designer (using the name Albert Matthäus) and later he worked as a journalist. He was self-taught as a painter. From 1919 to 1938 he taught at the Vienna School of Arts and Crafts, bringing new life to the department of tapestry design, and from 1945 until his retirement in 1962 he was a professor at the Vienna Academy, where his teaching was influential on the group of artists who created the *Fantastic Realism movement. His other pupils included *Kitaj.

Gutfreund, Otto (1889–1927). Czech sculptor. After training in Prague, he spent several months in Paris, 1909–10. He worked under *Bourdelle at the Académie de la Grande Chaumière, but he was inspired more by paintings he saw by *Braque and *Picasso and he became one of the first artists to try to apply the principles of *Cubism to sculpture. On his return to Prague in 1911 he became a member of the *Group of Plastic Artists who attempted to fuse Cubism with *Expression-

ism. An example of his work from this time is *Cubist Bust* (Tate Gallery, London, 1912–13). In the First World War he fought with the French Foreign Legion and was taken prisoner. He returned to Prague in 1920 and in his later work developed a more naturalistic style based on folk art. He committed suicide by drowning.

Guthrie, Sir James (1859–1930). Scottish painter, mainly of portraits. In the 1880s and 1890s he was one of the *Glasgow Boys, and for a few years he also kept a studio in London, but in 1902 he was elected president of the Royal Scottish Academy (the youngest person ever to hold this office) and moved to Edinburgh. He retired from the post in 1919, having held it 'with conspicuous success' (*DNB*), and intended devoting himself quietly to his own work, but later that year he received a commission from the National Portrait Gallery in London that occupied him for most of the rest of his life. This was for the huge group portrait *Statesmen of World War I*, completed in 1930, shortly before his death. Numerous studies for it are in the Scottish National Portrait Gallery, Edinburgh. Frank *Rutter considered Guthrie to be 'probably the greatest portrait painter Scotland has had since Raeburn' (*Modern Masterpieces*, 1940).

Guttuso, Renato (1912–87). Italian painter, born at Bagheria, near Palermo, in Sicily. He was a forceful personality and Italy's leading exponent of *Social Realism in the 20th century; although he never subordinated artistic quality to political propaganda, his art was often the direct expression of his hatred of injustice and the abuse of power. In 1931 he abandoned legal studies for painting, in which he was mainly self-taught. He settled in Rome in 1937 and in the following year became a founder member of the anti-Fascist association *Corrente. Fascism was not his only target, however, for he also pilloried the Mafia and in 1943 published a series of drawings protesting against the massacres that took place under the German occupation of Italy. His most famous painting of this time is probably the *Crucifixion* (Galleria Nazionale d'Arte Moderna, Rome, 1941), which caused a public outcry when it won an award at a competition in Bergamo in 1942. It was attacked by the Catholic Church because of its modernity and use of female nudity. After the war (in which he worked with the Resistance)

Guttuso became a member of the *Fronte Nuovo delle Arti in 1946. His post-war works were often inspired by the struggles of the Sicilian peasantry, and his other subjects included the 1968 student riots in Paris, a city he often visited (he was widely travelled and his work was admired and influential in Eastern Europe). Many of his paintings were large, with allegorical overtones, typically painted in a vigorous *Expressionist style. His interest in the history of art provided him with a major theme in his work, separate from his political and social concerns, and he introduced visual 'quotations' from *Picasso and other artists into his own paintings. However, there was a completely different side to his work, for he also painted simple and direct still-lifes. Bernard Berenson, the famous connoisseur of Renaissance art, called Guttuso 'the last painter in the great tradition of Italian art'.

Gwathmey, Robert (1903–88). American painter, born in Richmond, Virginia. He studied at North Carolina State College, 1924–5, the Maryland Institute of Design, Baltimore, 1925–6, and the Pennsylvania Academy of the Fine Arts, Philadelphia, 1926–30. Up to his retirement in 1968 he taught at various colleges, notably the Cooper Union School, New York, 1942–68. In 1939 he was a prizewinner in the government-sponsored Forty-Eight States Mural Competition, but he is better known for his easel paintings. His favourite subject was rural black workers in the Southern states, and his paintings often had strong social implications, castigating poverty and oppression, with occasional use of satire. However, he did not paint naturalistically, simplifying his subjects into strongly patterned designs featuring flat colours and bold outlines. He worked slowly and exhibited rarely.

Haacke, Hans (1936–). German *Conceptual and experimental artist, active mainly in the USA. He was born in Cologne, studied in Kassel, and first went to the USA on a Fulbright travelling scholarship in 1961, since when he has taught and exhibited widely there, living mainly in New York. His early work was much concerned with movement, light, and the reaction of objects with their environment. In the early 1960s, for example, he began making constructions in which fluids are enclosed in plastic containers in such a way that they can be seen responding to changes in temperature, etc. Wind and water have played a large role in his work and he participated in the '*Air Art' exhibition that toured the USA in 1968. From about the mid-1960s, however, he became more interested in spectator participation, the social function of art, and ecological issues. Haacke's work has often caused controversy because of his preoccupation with 'exposing systems of power and influence. His *Real Time Social System* of 1971 featured photographs of a large group of New York slum buildings, all owned by one firm, while captions revealed an array of holding companies, mortgage data, assessed values and property taxes. When the *Guggenheim Museum cancelled his exhibition there rather than show this work, Haacke did one which traced the various family and business ties between the Guggenheim trustees' (Roberta Smith, 'Conceptual Art' in Nikos Stangos, ed., *Concepts of Modern Art*, revised edn., 1981).

Hacker, Arthur. See NEW ENGLISH ART CLUB.

Haden, Sir Seymour. See ETCHING REVIVAL.

Haftmann, Werner (1912–). German art historian and administrator. He was born in Glowno (now in Poland) and studied at the universities of Berlin and Göttingen. From 1935 he worked at the Kunsthistorisches Institut in Florence. After the Second World War he settled in Hamburg, where he taught history of art and worked as a freelance writer. From 1967 to 1974 he was director of the Nationalgalerie, Berlin. His major work is *Malerie im 20 Jahrhundert* (2 vols, 1954; 2nd edn., 1957), translated as *Painting in the Twentieth Century* (2 vols., 1961; 2nd edn., 1965). This is the most detailed survey of its type, and the second English edition contains more than a thousand illustrations. His other writings are mainly monographs on 20th-century artists, including *Nolde (1958), *Nay (1960), *Wols (1963), *Chagall (1972 and 1975), and *Uhlmann (1975). He was also one of the organizers of the exhibition 'German Art of the Twentieth Century' at the Museum of Modern Art, New York, in 1957.

Hague, Gemeente Museum. See GEMEENTE MUSEUM.

Haines, Lett (Arthur Lett-Haines). See MORRIS, SIR CEDRIC.

Hains, Raymond. See AFFICHISTE.

Halicka, Alicia. See MARCOUSSIS.

Hall, Fred. See NEWLYN SCHOOL.

Halley, Peter. See NEO-GEO.

Hambling, Maggi (1945–). British painter. She was born in Hadleigh, Suffolk, and studied at the East Anglian School of Art (with Cedric *Morris and Arthur Lett-Haines), 1960, Ipswich School of Art, 1962–4, Camberwell School of Art, 1964–7, and the *Slade School, 1967–9. In 1979 she wrote: 'I returned to painting in 1972 following a period of experiment with more "avant-garde" means of expression. I committed myself then to trying to

paint people and I believe that this work will continue for the rest of my life.' Her style is colourful and energetic and she is perhaps best known for her vigorous portraits, such as that of the eminent chemist Dorothy Hodgkin (NPG, London, 1985). She has also painted series on the comedian Max Wall, on the mythological figure of the Minotaur, and on the sun. In 1980-1 she was the first artist-in-residence at the National Gallery, London, and in the mid-1980s she became well known for her trenchant views on art as a panellist on the television quiz show *Gallery*. See also MELLY.

Hamilton, Cuthbert. See GROUP X.

Hamilton, George Heard (1910-). American art historian. For most of his career he was associated with Yale University, where he studied (BA, 1932; MA, 1934; PhD, 1942) and then taught from 1936 to 1966 (he was appointed a professor in 1956). During this time he was also a curator of modern art at Yale University Art Gallery. From 1966 to 1977 he was director of the Sterling and Francine Art Institute in Williamstown, Massachusetts, and from 1966 to 1975 professor of art at its sister institution, Williams College, Williamstown. He has also held distinguished temporary posts, such as the Slade professorship of fine art at Cambridge, 1971-2, and has won numerous academic awards. Hamilton's literary output is fairly small but of exceptional quality. His best-known book is *Painting and Sculpture in Europe 1880-1940* (1967) in the Pelican History of Art series. This is the most authoritative and readable introduction to its subject and has been revised and reprinted several times. His other books include *19th and 20th Century Art: Painting, Sculpture, Architecture* (1970), a shorter but more lavishly illustrated survey than his Pelican volume. Hamilton also wrote another volume in the Pelican History of Art series (a unique double for an author), *The Art and Architecture of Russia* (1954, and several times revised and reprinted), which covers Russian art up to about 1900. He was a friend of Marcel *Duchamp and translated works by and about him.

Hamilton, James Whitelaw. See GLASGOW BOYS.

Hamilton, Richard (1922-) British painter, printmaker, teacher, exhibition organizer, and writer, one of the leading pioneers of *Pop art. He was born in London and after leaving school at 14 worked in advertising and commercial art whilst attending evening classes in painting. He then studied at the *Royal Academy in 1938-40 and 1946 (interrupted by war service as an engineering draughtsman) and at the *Slade School, 1948-51. In 1952 he became a member of the *Independent Group and in 1956, with other members, he helped to organize the exhibition 'This is Tomorrow' at the Whitechapel Art Gallery. Hamilton's photomontage *Just What Is It that Makes Today's Homes So Different, So Appealing?* (Kunsthalle, Tübingen. 1956) was displayed blown up to life-size at the entrance to the exhibition; a satire on consumerism and suburbia, it is made up of advertising images (including a lollipop bearing the word 'Pop') and is sometimes considered to be the first Pop art work. 'Ever since then, his paintings and prints have engaged with countless aspects of popular culture and styling, as well as investigating the borderline between hand-made and mechanically made imagery' (catalogue of the exhibition 'British Art in the 20th Century', Royal Academy, London, 1987). Hamilton's work has influenced *Blake and *Hockney amongst others, and he has played a significant role as an organizer of exhibitions (notably 'The Almost Complete Works of Marcel *Duchamp' at the Tate Gallery, London, in 1966, for which he made a reconstruction of Duchamp's *The Bride Stripped Bare by her Bachelors, Even*, now in the Tate's collection). He has also had a distinguished career as a teacher, notably at King's College, Newcastle upon Tyne (later Newcastle University), 1953-66. The admiration and affection in which he is held by many former students was shown by the tributes paid to him on his 70th birthday in 1992. An anthology of his writings, *Collected Words*, appeared in 1982. His second wife (whom he married in 1991) is the painter Rita Donagh (1939-).

Hammershøi, Vilhelm (1864-1916). Danish painter, active mainly in his native Copenhagen. He painted portraits, architectural subjects (including two murals for Copenhagen Town Hall), and landscapes, but he is best known for his quiet interior scenes. Often featuring a single standing or seated figure, they have a certain affinity with the work of the 17th-century Dutch painter Vermeer,

although Hammershøi's colours are more muted. Two examples are in the Tate Gallery, London: *Interior* (1899) and *Interior: Sunlight on the Floor* (1906). Neil Kent writes that 'in both his landscapes and his domestic interiors, he achieved images embodying spiritual states of strength, patience, quietude and endurance which are virtually unequalled by any other European artist of the period' (*The Triumph of Light and Nature: Nordic Art 1740–1940*, 1987). His brother **Svend Hammershøi** (1873–1948) was also a painter.

Hammersley, Frederick. See HARD-EDGE PAINTING.

Hamnett, Nina (1890–1956). British painter, designer, and illustrator, famous more for her flamboyant bohemian life than for her work. She was born in Tenby, Wales, the daughter of an army officer, and studied at various art schools in Dublin, London, and finally Paris, where she met several leading avant-garde artists, including *Brancusi, *Modigliani, and *Zadkine. Another artist she met there was the Norwegian Roald Kristian (also known as Edgar de Bergen), whom she married in 1914. They are depicted in *Sickert's *The Little Tea Party* (Tate Gallery, London, 1915–16): 'Edgar and I sat for him together, on an iron bedstead, with a teapot and a white basin and a table in front of us. We looked the picture of gloom.' They were an ill-matched couple and she seems to have been relieved when he was deported as an unregistered alien during the First World War; they never saw one another again. From 1913 to 1919 Hamnett worked for Roger *Fry's *Omega Workshops; Fry (with whom she had a love affair) painted several portraits of her, of which that in the Courtauld Gallery, London (1917) is generally considered the best. In the 1920s, she spent much of her time in Paris, where she knew many leading figures of the avant-garde, including Jean *Cocteau and the composers Satie and Stravinsky. However, she often returned to London for exhibitions of her work, which included portraits, landscapes, interiors, and figure compositions (notably café scenes) in a robust style drawing on various modern influences. Her work sometimes sold well, but she was virtually permanently in financial trouble. In addition to paintings, she made book illustrations (spontaneous pen-and-ink drawings), notably for Osbert *Sitwell's *The People's Album of London Statues*

(1928). From the 1930s the quality of her work declined, partly because of the influence of alcohol; she died following a fall from the window of her flat in London. Her colourful, uninhibited life is recounted in two volumes of autobiography—*Laughing Torso* (1932) and *Is She a Lady?* (1955).

Hanak, Anton. See WOTRUBA.

Hanly, Patrick (1932–). New Zealand painter and printmaker, born at Palmerston North. After studying at the University of Canterbury School of Art, he spent five years in Europe, 1957–62. He is one of New Zealand's best-known contemporary artists and his work has included several murals in major public buildings, among them Christchurch Town Hall (1972) and Auckland International Airport (1977). His style is colourful and expressionistic, the influences on him including *Chagall and *Pop art.

Hanson, Duane (1925–96). American sculptor, the best-known exponent of *Superrealism in sculpture. He was born in Alexandria, Minnesota, and had his main training at Cranbrook Academy of Art, Michigan, where he graduated in 1951. From 1953 to 1960 he lived in Germany. In 1965, after teaching at various art schools, he moved to Miami, and in the late 1960s he began to attract attention with large tableaux of figures cast from the life in fibreglass, minutely detailed, dressed in real clothes, and accompanied by real props. The subjects were usually emotive or violent, dealing with issues such as the Vietnam War or race riots. However, in 1970 Hanson abandoned these 'expressionist' groups, as he called them, to concentrate on figures representing mundane types. In these he commented pungently on depressing or tasteless aspects of everyday American life—down-and-outs, exhausted shoppers, or in one of his most famous works, a pair of fat, ageing, and garishly dressed sightseers (*Tourists*, NG of Modern Art, Edinburgh, 1970). 'The subject matter that I like best', he wrote, 'deals with the familiar lower and middle class American types of today. To me, the resignation, emptiness and loneliness of their existence captures the true reality of life for these people. Consequently, as a realist I'm not interested in the human form ... but rather a face or body which has suffered like some weather-worn landscape the erosion of time. In

portraying this aspect of life I want to achieve a certain tough realism which speaks of the fascinating idiosyncracies of our time.'

Happening. A form of entertainment, often carefully planned but usually including some degree of spontaneity, in which an artist performs or directs an event combining elements of theatre and the visual arts. The term was coined in 1959 by Allan *Kaprow, to whom the concept of the Happening was closely bound up with his rejection of traditional principles of craftsmanship and permanence in the arts. He thought of the Happening as a development mainly from the *assemblage and the *environment. While both the assemblage and the environment were relatively fixed and static—the assemblage something constructed to be contemplated from outside, to be 'handled or walked around', and the environment something to be 'walked into', something by which the observer was enveloped and manipulated—the Happening was conceived of as a genuine 'event'. It had close affinities with *Performance art (the two terms have sometimes been used more or less synonymously) and it was not restricted like the environment to the confines of a gallery or some other specific site. In line with the theories of the composer John *Cage about the importance of chance in artistic creation, Happenings were described as 'spontaneous, plotless theatrical events'.

Cage (one of Kaprow's teachers) organized a performance at *Black Mountain College in 1952 that has sometimes been described as the first Happening. Kaprow's own first Happening was *Intermission Piece*, staged at the Reuben Gallery, New York, in 1959; in October of the same year he performed *18 Happenings in 6 Parts* at the same venue, and this was the first event to be actually titled a Happening. It took part in three 'rooms' (created by plastic walls dividing a loft space), with chairs arranged in circles and rectangles, so that spectators faced in different directions. The programme note with which they were provided explained that 'The performance is divided into six parts. Each part contains three happenings which occur at once. The beginning and end of each will be signalled by a bell. At the end of the performance two strokes of the bell will be heard.' RoseLee Goldberg (*Performance Art*, 1988) writes: 'The visitors (whom the programme notes designated as members of the cast) took their seats

at the ring of a bell. Loud amplified sounds announced the beginning of the performance: figures marched stiffly in single file down the narrow corridors between the makeshift rooms and in one room a woman stood still for ten seconds, left arm raised, forearm pointing at the floor. Then two performers read from hand-held placards . . . Flute, ukelele and violin were played, painters painted on unprimed canvas set into the walls, gramophones were rolled in on trolleys, and finally, after ninety minutes of simultaneous happenings, four nine-foot scrolls toppled off a horizontal bar between the male and female performers reciting monosyllabic words . . . As promised, a bell rang twice signalling the end.' Although Kaprow announced that the term 'happening' was meant to indicate 'something spontaneous, something that just happens to happen', the entire piece was carefully rehearsed for two weeks before it opened and daily during the week's run of performances.

Apart from Cage and Kaprow, the artists chiefly responsible for the development of the form in the USA include Jim *Dine, Roy *Lichtenstein, Claes *Oldenburg, and Robert *Rauschenberg. Outside America, the Happening was widely exploited in the 1960s and 1970s—by the *Gutai Group in Japan, for example, and by many artists in Europe. The term has often been used to cover staged demonstrations for political or social propaganda, as for example in the work of *Fluxus group (whose Happenings in Germany were usually called '*Aktions'). At the other pole, some practitioners thought that the Happening should bring into being situations or events in which everyday life and everyday technology are invested with the strangeness of the poetic and the fantastic. The theory of the Happening is as diverse as the practice.

Hard-Edge Painting. A type of abstract painting in which forms, although not necessarily geometrical, have sharp contours and are executed in flat colours. It was one of the types of painting that developed as a reaction against the spontaneity and painterly handling of *Abstract Expressionism (see POST-PAINTERLY ABSTRACTION). The term was coined by the American critic Jules Langsner in 1958 and was popularized by Lawrence *Alloway, who in 1966 wrote that it was meant 'to refer to the new development that combined economy of form and neatness of

surface with fullness of colour, without continually raising memories of earlier geometric art'. Major exponents of Hard-Edge Painting have included Ellsworth *Kelly and Kenneth *Noland. The four West Coast painters to whom Langsner originally applied the term were Karl Benjamin (1925–), Lorser Feitelson (1898–1978), Frederick Hammersley (1919–), and John McLaughlin (1898–1976); they preferred the term 'Abstract Classicism'.

Hare, David (1917–91). American sculptor, painter, and photographer, born in New York. He initially studied chemistry and had no formal training in art, which he approached as a form of experimentation. In the late 1930s he worked as a commercial photographer and in about 1940 he began to experiment with the technique of 'heatage' (gently heating the emulsion of a photographic plate so that it melted and the image flowed). His interest in this technique (pioneered by Raoul *Ubac) brought him into contact with the European *Surrealists who had moved to New York to escape the Second World War, and Hare founded and edited the Surrealist magazine *VVV, which ran from June 1942 to February 1944. In 1942 he began to make sculpture, using a variety of materials and showing a typically Surrealist interest in visual puns. From 1944 he had many one-man shows, the first at Peggy *Guggenheim's Art of This Century gallery. In 1948 he was one of the founders of the *Subjects of the Artist School; the other four founders were leading *Abstract Expressionist painters and Hare's sculptures have been seen as three-dimensional analogues of their work. From 1948 to 1953 he lived in France. By the time he returned to New York he was working mainly in metal—welded or cast. In the 1960s he took up painting, but he returned to sculpture as his main medium in the 1970s.

Haring, Keith. See GRAFFITI ART.

Harkness, Edward. See 'RECORDING BRITAIN'.

Harlem Renaissance. A term describing a flowering of activity among black American artists in the 1920s, centred on the Harlem district of New York. It was primarily a literary movement, one of the leading figures being Alain Locke (1886–1954), an editor, literary critic, art historian, and philosopher (from 1907 to 1910 he had been the first black

Rhodes Scholar at Oxford University, and in 1918 he became professor of philosophy at Howard University, Washington, DC). In 1925 he edited a special issue of the Survey Graphic magazine entitled 'Harlem, Mecca of the New Negro', and he expanded this into The New Negro, an anthology of fiction, poetry, and essays, published in the same year. His introduction to the volume expressed the idea that there was a new spirit of opportunity among among black writers. Locke encouraged black American artists to explore their ancestral heritage, and he wrote several books dealing with black American culture and the influence of African art on modern painting and sculpture, among them Negro Art: Past and Present (1936) and The Negro in Art (1941). Among the visual artists who were involved in the Harlem Renaissance, the outstanding figure was the painter and illustrator Aaron *Douglas, who is regarded as the first black American painter consciously to incorporate African imagery in his pictures. Palmer Hayden (1890–1964) and Malvin Gray Johnson (1896–1934) were among the other artists associated with the movement, which was ended by the Great Depression of the 1930s. An exhibition entitled 'Rhapsodies in Black: Art of the Harlem Renaissance' was held at the Hayward Gallery, London, in 1997; a reduced version was subsequently shown in Bristol and Coventry.

Harris, Lawren Stewart (1885–1970). Canadian painter, born at Brantford, Ontario, into a wealthy family. From 1904 to 1908 he studied in Berlin, where his work was influenced by *Expressionism. After a period of travel in the Middle East and a stint as a magazine illustrator in Minnesota, he returned to Canada in 1909 and settled in Toronto. Early in his career his favourite subjects were cityscapes and views of houses, but after meeting J. E. H. *MacDonald in 1911 he also took up landscape and from 1920 (when he was one of the founder members of the *Group of Seven) this became his main interest. In 1918 he had discovered Algoma in northern Ontario, and the dramatic and colourful style he had developed was well suited to depicting the lushness of its countryside (Autumn, Algoma, Victoria University, Toronto, 1920). Harris was a follower of Theosophy (see ABSTRACT ART) and he used spectacular scenery as a way of expressing spiritual values. To this end he sought out the most

overpowering landscapes he could find—in the Rockies and even the Arctic. The transcendental quality in his work was maintained when he turned to abstraction in the 1930s.

In 1934 Harris moved to Dartmouth College, Hanover, New Hampshire, as artist-in-residence, then in 1938 to Santa Fé, New Mexico, where he was one of the founders of the Transcendental Group of Painters; its members—influenced by the writings of *Kandinsky—sought 'to carry painting beyond the appearance of the physical world, through new concepts of space, colour, light, and design, to imaginative realms that are idealistic and spiritual'. He returned to Canada in 1940 and settled in Vancouver, where his presence did much to stimulate the artistic scene—a number of younger artists, including Jock *Macdonald, were encouraged by him. Harris, indeed, became a kind of patriarch of Canadian painting, and in 1948 he was given a large retrospective at the Art Gallery of Toronto; the exhibition then toured the country. Another major retrospective was held at the National Gallery of Canada, Ottawa, in 1963.

Harris, Max. See ANGRY PENGUINS.

Harrison, Charles. See ART & LANGUAGE.

Hart, George Overbury 'Pop'. See ROCKEFELLER.

Hartigan, Grace (1922–). American painter, born at Newark, New Jersey. During the Second World War she worked as an industrial draughtswoman whilst studying art at night. Later in the 1940s she travelled in Europe and lived for a while in Mexico before settling in New York. In the 1950s she became recognized as one of the leading figures among the second wave of *Abstract Expressionists, and in 1960 she was described as the most famous woman artist in America (earlier she had exhibited her work under the name 'George Hartigan' to try to combat bias against women artists). Her work—strongly influenced by that of *de Kooning—often retains figurative elements and is characterized by brilliant colour, with thick black outlines surrounding the forms. She writes: 'I want an art that is not "abstract" and not "realistic" ... my "subject" concerns that which is vulgar and vital in modern American life, and the possibilities of its transcendence into the beauti-

ful. I do not wish to *describe* my subject ... I want to distill it until I have its essence. Then the rawness must be resolved into form and unity.'

Hartley, Marsden (1877–1943). American painter, whose work represents a diverse yet also highly personal response to European modernism. He was born in Lewiston, Maine, and studied in Cleveland, at the School (now Institute) of Art, and then from 1898 in New York, first at the *Art Students League and then at the National Academy of Design. In 1900 he returned to Maine and for the next decade his pattern was to spend the summer there and the winter in New York. His chief works of this time were views of the Maine mountains, painted with nervous strokes and broken colours. They show the influence of *Cézanne and also of Albert Pinkham *Ryder, who was his favourite American artist. In 1909 Hartley was given a one-man exhibition by *Stieglitz, and in 1912 help from Stieglitz and Arthur B. *Davies enabled him to travel to Europe—the beginning of the almost compulsive travels that lasted throughout his life. He went first to Paris, where he frequented the *Stein household, and then Germany, where he met *Kandinsky and *Marc in Berlin. In 1913 he returned to New York and exhibited at the *Armory Show. From 1914 to 1916 he was again in Europe, visiting London, Paris, Berlin, and Munich. During these years he created a distinctive semi-abstract manner that combines 'a fascination with Germany's pre-war military pageantry with American Indian motifs' (catalogue of the exhibition 'American Art in the 20th Century', Royal Academy, London, 1993). The most famous instance is *Painting No. 5* (Whitney Museum, New York, 1914–15); it represents a remarkably personal synthesis of modernist trends, being more closely structured and objective than German *Expressionism and more freely patterned and highly coloured than French *Cubism. *A German Officer* (Whitney Museum, 1914) is in a similar vein. These 'portraits' of German soldiers were inspired by Hartley's friendship with Karl von Freyburg, a young officer killed early in the First World War (they were condemned as pro-German when they were exhibited at Stieglitz's 291 Gallery).

In 1916 Hartley returned to America, and in 1918 said that he had grown weary of 'emotional excitement in art'—not surprisingly since 'Within an eight-year period, he had

reviewed roughly three decades of modern art, careering from Cézannesque and Cubist landscapes to Expressionist and symbolic statements and back to Cubist manipulations of abstract form, all charged with an emotional aura uniquely his own' (Matthew Baigell, *A Concise History of American Painting and Sculpture*, 1984). He turned once again to landscape as his principal subject, working in a more representational but still highly formalized style. In 1921 he returned to Europe, stayed there for a decade, then continued his wandering life in the early 1930s, visiting Mexico in 1932, for example, when he painted a series of pictures of the volcano Popacatepetl. In 1934 he returned to Maine, where he lived for the rest of his life apart from a visit to Nova Scotia in 1936. The work of his final years (usually rugged mountain and coastal scenes) was characterized by blunt block-like forms, showing a powerful feeling for the beauty and grandeur of nature. Hartley was a lonely, reclusive, rather haunted character who never achieved much worldly success (in 1935 he destroyed a hundred of his paintings because he was unable to pay for their storage). He was a writer as well as a painter; a volume of his criticism, *Adventures in the Arts*, appeared in 1921, and he published three booklets of verse, from which *Selected Poems* was posthumously assembled in 1945.

Hartung, Hans (1904–89). German-born abstract painter and printmaker who became a French citizen in 1946. He was born in Leipzig, where he studied philosophy at the University and art at the Academy, continuing his studies at the Academies of Dresden and Munich. In Munich he met *Kandinsky and became interested in the work of *Marc. From 1926 to 1931 he lived mainly in Paris, then from 1932 to 1934 on the island of Minorca, where he is said to have angered peasants who thought his abstracts were blueprints for a fortress. In 1934 he returned briefly to Germany, but left because of the Nazis and settled in Paris in 1935. During the Second World War he fought in the French Foreign Legion; he was badly wounded in 1944 and had a leg amputated without anaesthetic. After the war he returned to Paris, where he remained based for the rest of his life.

Hartung was an individualist who pursued his own path, unconcerned with fashion and sustained by what he called 'stubborn staying power'. He had begun painting abstracts in 1922, when he was only 17, and developed a sensuous, freely improvised style that anticipated post-war developments. It was only after the war that he made a reputation and was hailed as one of the pioneers of *Art Informel. His fame was at its peak around 1960, in which year he was joint winner of the main painting prize at the Venice *Biennale. In some of his paintings the vibrant thick black lines and blotches have a kinship with the work of Franz *Kline, but Kline is more brusquely energetic and less subtle. Reviewing an exhibition of Hartung's work at the Tate Gallery, London, in 1996, Frank *Whitford wrote: 'Hartung spent most of his life in France because he believed his art was more French than German. Yet it is its strikingly German character that makes it more interesting than the abstraction of almost all his French contemporaries. The abrasive, febrile quality of his marks and the brooding, sultry colours beneath and between them produce precarious harmonies that convey a sense of unease and urgency. His images are, in short, intensely expressive.'

Hartung gave his paintings 'T' numbers (for *toile*—French for canvas) instead of titles (*T1963—R6*, Tate Gallery, London, 1963). He was a prolific draughtsman, often basing his paintings on his drawings, and he also made etchings, lithographs, and (through friendship with Julio *González) a few sculptures. In 1929 Hartung married the Norwegian painter Anna-Eva Bergman (1909–87). He divorced her in 1939 and married Roberta González (daughter of the sculptor), but subsequently he divorced her also and remarried Bergman in 1957.

Harvey, Marcus. See AVANT-GARDE.

Hassam, Childe (1859–1935). American painter and printmaker, one of his country's foremost exponents of *Impressionism. Hassam trained as a wood engraver in Boston and early in his career he was a successful illustrator, particularly of children's stories. He discovered Impressionism on his second visit to Europe in 1886–9, when he studied briefly at the *Académie Julian, and he was one of the first artists to import the style to the USA. On his return to America he settled in New York, and the life of the city became one of his main sources of subject-matter; scenes of rainy streets were something of a speciality.

Another favourite theme was a woman in an interior. His early paintings are fresh and clear but sometimes rather slick and saccharine. After the turn of the century, his style tended towards greater simplification and flatness in composition and his colour became lusher—somewhat in the manner of *Bonnard. Hassam was immensely prolific in oils, watercolour, pastel, and a variety of drawing media; in his 50s he also took up printmaking seriously, producing a large number of etchings and lithographs (notably harbour scenes in a style reminiscent of *Whistler). His work was much exhibited and won a great deal of critical acclaim (although, not surprisingly, he was sometimes accused of overproduction). In addition to being a prominent figure at the annual shows of The *Ten, he had numerous one-man exhibitions, including one at the Paris galleries of *Durand-Ruel in 1901—a remarkable distinction for a non-Frenchman. He received many honours and died a wealthy man, although by this time he was seen in artistic circles as a very conservative figure. He left all his own paintings still in his possession to the American Academy of Arts and Letters, which profited greatly from their sale.

Hausmann, Raoul (1886–1971). Austrian painter, photographer, and writer, born in Vienna, the son of an academic painter who gave him his first instruction in art. In 1901 he moved to Berlin and in 1918 became one of the founders of the *Dada movement there, together with *Grosz, *Heartfield, and others. Hausmann and Heartfield are particularly well known for the *photomontages they produced in their Dada period—they were among the earliest and most brilliant exponents of the technique. Hannah *Höch, with whom Hausmann lived for several years, was another pioneer of this art form. An example of Hausmann's work of this time is *The Art Critic* (Tate Gallery, London, 1919–20), an 'ironic photomontage depicting the critic as exclusively preoccupied with fashion and women and whose analyses are no more than successions of words without meaning ... His portrait is stuck onto the background of a poem-poster whose huge letters speak the new language, which is beyond the understanding of the blinded critic' (Michel Giroud, *Raoul Hausmann*, 1975). In 1923 Hausmann abandoned painting and in 1927 he invented an apparatus called the optophone, which

turned kaleidoscopic forms into music. Around this time he also experimented with various photographic techniques. In 1933 he left Germany and after much travelling settled in France in 1938. A few years later he took up painting again. From 1944 until his death he lived in Limoges.

Hausner, Rudolf. See FANTASTIC REALISM.

Haworth, Jan. See BROTHERHOOD OF RURALISTS.

Hayden, Palmer. See HARLEM RENAISSANCE.

Hayter, S. W. (Stanley William) (1901–88). British printmaker, draughtsman, and painter, born in London, a member of a dynasty of artists that included Queen Victoria's official portraitist Sir George Hayter. He studied chemistry and geology at London University, 1917–21, then worked in the oil industry in the Persian Gulf for several years. In 1926 he settled in Paris, where he studied briefly at the *Académie Julian, and in 1927 he founded an experimental workshop for the graphic arts—Atelier 17—that played a central role in the 20th-century revival of the print as in independent art form. (The name was adopted in 1933 when Hayter moved his establishment from its original home to no. 17 rue Campagne-Première.) In 1940–50 Hayter lived in New York (his second wife was the American sculptor Helen Phillips (1913–95)), taking Atelier 17 with him. After returning to Paris in 1950 he re-established Atelier 17 there and closed the American branch in 1955. The list of artists who worked with him includes some of the most distinguished names in 20th-century art, among them *Chagall, *Ernst, *Giacometti, and *Lipchitz. Hayter's training as a chemist gave him an unrivalled knowledge of the technicalities of printmaking, on which he wrote two major books, *New Ways of Gravure* (1949) and *About Prints* (1962). Although his historical importance has long been acknowledged (probably no modern British artist has been so influential internationally), he was uninterested in self-promotion and his work was little exhibited in his lifetime. However, his obituary in the *Guardian* described him as 'by far the finest British printmaker of this century'. His prints are varied in technique and style, but most characteristically are influenced by the abstract vein of *Surrealism and are notable

for their experiments with texture and colour.

Hayward Gallery, London. See ARTS COUNCIL.

Healy, Michael. See AN TÚR GLOINE.

Heartfield, John (Helmut Herzfelde) (1891–1968). German designer, painter, and journalist, born in Berlin, the son of a political radical who had been imprisoned for writing and publishing a revolutionary socialist poem. He studied at the School of Arts and Crafts in Berlin, 1912–14, then did military service. In 1918 he was one of the founders of the Berlin *Dada group. His brother Wieland Herzfelde owned a publishing firm and printed most of the group's literature. Heartfield is best known as one of the pioneers and perhaps the greatest of all exponents of *photomontage (rivalled in his time only by *Hausmann, also a leading light of Dada in Berlin). With *Grosz he anglicized his name during the First World War as a protest against German nationalistic fervour and his finest works are brilliantly satirical attacks—often in the form of book covers and posters—against militarism and Nazism. One of the most famous is *Hurrah, die Butter ist alle!* (Hurrah, the butter is finished!, 1935), showing a Nazi family, including the baby and dog, eating bicycle chains, hatchets, and other metal implements—a literal interpretation of Hermann Goering's dictum that 'Iron makes a country strong; butter and lard only make people fat'. Harassed by the Nazis, Heartfield left Germany in 1938 and moved to London, where he lived until 1950. His work there included designs for Penguin Books. In 1950 he returned to Germany and settled in Leipzig, where his work included stage design. He died in Berlin.

Heath, Adrian (1920–92). British abstract painter, born in Burma. He studied at Newlyn School of Art under Stanhope *Forbes in 1938 and in the following year went to the *Slade School. In 1940 he joined the RAF and he was a prisoner of war in Germany, 1942–5; one of his fellow prisoners was Terry *Frost, whom he encouraged to paint. After the war Heath returned to the Slade School, 1945–7. In 1949 and 1951 he visited St Ives, where he met Ben *Nicholson, and he formed a link between the *St Ives School and the London-based *Constructivists—Anthony *Hill, Kenneth and Mary *Martin, and Victor *Pasmore—with whom he was also associated. During the early 1950s Heath was a significant figure in promoting *abstract art—by organizing collective exhibitions at his London studio (at 22 Fitzroy Street) in 1951, 1952, and 1953, and by writing a short popular book on the subject, *Abstract Painting: Its Origin and Meaning* (1953). The exhibitions helped to inspire Lawrence *Alloway's book *Nine Abstract Artists* (1954). Heath's paintings of this time featured large, block-like slabs of colour, heavily brushed. He also made a few constructions. Later his paintings became freer and more dynamic. From 1955 to 1976 he taught at the *Bath Academy of Art, and from 1980 to 1985 at the University of Reading.

Heath Robinson, William. See ROBINSON.

Heckel, Erich (1883–1970). German painter and printmaker, born in Döbeln, Saxony. In 1904 he began studying architecture in Dresden, and in 1905, with three of his fellow students, he founded Die *Brücke. He gave up his architectural course soon afterwards, but supported himself by working in an architect's office until 1907, when he became a full-time artist. His work was somewhat more lyrical than that of other members of Die Brücke and he showed a special concern for depicting sickness and inner anguish (*Convalescent Woman*, Busch-Reisinger Museum, Harvard, 1913). His landscapes, too, sometimes have a decorative quality foreign to most German *Expressionism. In 1911 he moved to Berlin, where he had his first one-man exhibition in 1913 (Die Brücke now having broken up), at Fritz Gurlitt's gallery. Heckel was classified unfit for active service in the First World War, but he volunteered to work as a medical orderly in Flanders. His unit was commanded by an art historian, Walter Kaesbach (1879–1961), and through him Heckel met *Beckmann and *Ensor, who influenced his work; it became more melancholic and tragic, his landscapes expressing the agony of war throught conflict of the elements. After the war his painting lost much of its intensity, with pastel tones replacing the bold, sometimes harsh colours he had earlier used. In 1937 his work was declared *degenerate by the Nazis and in 1944 his Berlin studio was destroyed in an air raid. Heckel then moved to Hemmenhofen on Lake Constance. From 1949 until his retirement in 1955 he taught at the Karlsruhe Academy.

Apart from *Kirchner, Heckel was the most prolific printmaker among the Brücke artists, producing more than 400 woodcuts, about 400 lithographs, and nearly 200 etchings, mainly in the period 1903–23. George Heard *Hamilton regards his prints as 'a better measure of his talents than his paintings, in which his technique is often hesitant'.

Hegedušić, Krsto (1901–75). Yugoslav painter, theatrical designer, and graphic artist, born in Petrinja in Croatia. He studied at the Academy in Zagreb, 1920–6, and then in Paris, 1926–8. On his return to Yugoslavia he became the artistic and ideological leader of the group *Zemlja (Earth), founded in 1929, which promoted an art of revolutionary social protest. He believed that the worn-out academicism of the day could be revitalized by direct contact with peasant life and with the genuine folk art of the people. In pursuit of this aim he was chiefly responsible for founding a school for peasant painters in the village of *Hlebine (where he had grown up) and for fostering the talent of Ivan *Generalić, the greatest of the Yugoslav *naive painters. His own painting had affinities with the *Neue Sachlichkeit of *Dix and *Grosz, with *Surrealism, and with the famous peasant scenes of the 16th-century Netherlandish painter Pieter Bruegel, but essentially his work is an expression of his deeply committed social conscience. A typical example is *A Fair at Koprivnica* (Tate Gallery, London, 1930). Between 1931 and 1941 Hegedušić was arrested a number of times for left-wing political activities and he was interred during the German occupation in the Second World War. From 1936 he taught at the Zagreb Academy and was appointed a professor there in 1945.

Heidelberg School. Group of Australian painters who worked together at Heidelberg, Victoria (at the time a village, now a suburb of Melbourne), from 1886 to about 1900. At first they met in painting camps, and in 1888 three of the best-known artists of the group—Charles *Conder, Tom *Roberts (the dominant figure), and Arthur *Streeton—moved into a disused farmhouse at nearby Eaglemont. This became a rendezvous for many young artists. The work of the group, based on the *Impressionist ideal of painting in the open air, featured local subject-matter and was associated with the emergence of a distinctive

Australian literature. By 1900 the group had broken up, many of the leading members having gone to Europe, but its vision of Australian life and landscape came to dominate the country's painting in the early 20th century and inspired many other artists in later decades.

Heizer, Michael. See LAND ART.

Held, Al (1928–). American painter, born in New York, where he studied at the *Art Students League, 1948–9. He then spent two years in Paris, and on his return to New York worked in the prevailing *Abstract Expressionist idiom, being particularly influenced by Jackson *Pollock. From about 1960, however, he began to develop a more individual style characterized by clean-edged, bold, brightly coloured geometrical forms. It had affinities with *Hard-Edge Painting, but Held's work was distinguished by his use of very heavily textured paint. He often worked on a huge scale, giving his paintings an extremely forceful physical impact. In 1967 he began making black-and-white paintings, using white linear structures on a black ground or black lines on a white ground to create overlapping and interlocking box-like forms that demonstrate his interest in Renaissance perspective. In the 1980s he re-introduced colour with a vengeance, as in his 17-metre-long mural *Mantegna's Edge* (Southland Center, Dallas, 1983), a work of tremendous high-keyed vigour.

Heldt, Werner (1904–54). German painter, born in Berlin, where he studied at the School of Arts and Crafts, 1923–4, and the Academy, 1924–30. In 1933–6 he lived on the island of Majorca, but had to leave because of the outbreak of the Spanish Civil War. After serving in the German army in the Second World War, he settled in West Berlin but made frequent visits to Ischia. Heldt is best known as a painter of street scenes and for this reason has been called 'the *Utrillo of Berlin'. He visited Utrillo in Paris in 1930 and like him was a heavy drinker, but the resemblance between their work was slight. Heldt's streets are often depicted at night and are usually empty, sometimes with suggestions of mysterious or '*Metaphysical' perspectives. In some of his pictures he embodied his war experiences in views of dream cities that border on the *Surrealistic. Towards the end of his career his work became increasingly abstract.

Hélion, Jean (1904–87). French painter, born at Couterne, Orne. In 1921 he moved to Paris, where he was apprenticed to an architectural firm. He began painting full-time—self-taught—in 1925. His early work—landscapes, portraits, still-lifes—was naturalistic, but he was soon influenced by avant-garde art. An enterprising and energetic man, he quickly gained many friends in the art world, including *Torres-García, who introduced him to *Cubism. Hélion was also influenced by *Mondrian and by 1929 he was painting in an uncompromisingly abstract style. In 1930 he signed van *Doesburg's manifesto *Art Concret* (see CONCRETE ART), and in 1931 he was a founder member of the *Abstraction-Création group. Hélion's most characteristic works were done during the next few years—broadly patterned geometrical abstractions with strangely curving tube-like forms recalling the mechanistic paintings of *Léger (*Île de France*, Tate Gallery, London, 1935). Following visits to New York in 1932 and 1934, Hélion moved to the USA in 1936 (dividing his time between New York and Virginia), becoming an important link between the European and American avant-gardes. In 1940 he returned to Europe to join the French army. He was taken prisoner but escaped and made his way back to America, where he published an account of his experiences, *They Shall Not Have Me*, in 1943. After the war he returned to France and radically changed his style, reverting to figurative painting and producing bold, colourful, almost caricature-like everyday life scenes. This move 'was the result of an aesthetic and moral crisis: an interrogation of the relationship between the visible world and its significations in the context of the social and political crisis which preceded the war' (catalogue of the exhibition 'Aftermath: France 1945–54, New Images of Man', Barbican Art Gallery, London, 1982).

Hemy, Charles Napier. See DAWSON.

Henri, Robert (1865–1929). American painter, teacher, and writer, a major figure in combating conservative attitudes in American art in the early 20th century. He was born Robert Henry Cozad in Cincinnati but changed his name after his father killed a man in self-defence in 1882 and spent several years as a fugitive before being cleared of murder. From 1886 to 1888 he trained at the Pennsylvania Academy of the Fine Arts, Philadelphia, under

Thomas *Anshutz, who passed on the tradition of Thomas *Eakins, an artist Henri came to admire deeply. In 1888–91 he lived in Paris, studying mainly at the *Académie Julian. After returning to Philadelphia he became the leader of a circle of young artists—*Glackens, *Luks, *Shinn, *Sloan—that later became the nucleus of The *Eight and the *Ashcan School. In 1895–7 and 1898–1900 he again lived in Paris, then in 1900 settled in New York. There he became an outstanding teacher, first at the New York School of Art, 1902–9, then at his own school, 1909–12, at the Modern School of the Ferrer Center (a radical educational establishment), 1911–18, and finally at the *Art Students League, 1915–28.

The essence of Henri's teaching was that art should grow from life, not from theories. He said that he wanted his own paintings to be 'as clear and as simple and sincere as is humanly possible', and he was a powerful force in turning young American painters away from academism to look at the rich subject-matter provided by modern urban life. In 1910 he was the prime mover behind the Exhibition of Independent Artists, the first large, unrestricted, no-jury exhibition in American art, and he was 'regarded by many of his contemporaries as the most influential single force affecting the development of American art in the generation preceding the *Armory Show of 1913' (William Innes Homer, *Robert Henri and his Circle*, 1969). Henri was open-minded about the new developments seen at the Armory Show (he often commented on *Braque, *Matisse, and *Picasso in his classes), but he was not interested in experiment for experiment's sake and his own work was little affected by it. His early work had been *Impressionist, but in the 1890s he adopted a darker palette, with rapid slashing brushwork geared to creating a sense of vitality and immediacy. From 1909 his work became more colourful again. Apart from scenes of urban life, he painted many portraits, and also landscapes and seascapes (which have been rather neglected). He made frequent visits to Europe and found inspiration there for figure studies of picturesque characters—Irish peasants, gypsies, and so on.

Henri's paintings are now generally found dashing but rather superficial and they are regarded as much less important than his teaching and crusading. He wrote numerous articles on art and in 1923 published *The Art Spirit*, a collection of his letters, lectures, and

aphorisms, in which art is seen as an expression of love for life. It was highly successful and continues to be read. William Innes Homer comments that 'It has had universal appeal because it addresses an audience on so many levels: as a painter's manual, a guide to aesthetic appreciation, a philosophy of art and life, and a spur to creative activity'.

Henry, George. See GLASGOW BOYS.

Hepher, David. See SUPERREALISM.

Hepple, Norman (1908–94). British painter, born in London. Several members of his family were amateur or professional artists, notably his uncle **Wilson Hepple** (1853–1937), an animal painter active in Northumberland. Norman studied at Goldsmiths' College and the *Royal Academy. He painted various subjects (including landscapes in Spain, where he often spent the winter), but he was best known for his formal portraits, particularly of members of the royal family (he painted the Queen Mother four times). His style was thoroughly traditional. From 1979 to 1983 he was president of the Royal Society of Portrait Painters. Early in his career Hepple also made book illustrations.

Hepworth, Dame Barbara (1903–75). British sculptor, one of the most important figures in the development of abstract art in Britain. She was born in Wakefield, Yorkshire, the daughter of a civil engineer, and won scholarships to Leeds School of Art, 1919–21, and the *Royal College of Art, 1921–24. Henry *Moore was among her fellow students at both places and became a lifelong friend. In 1924 she came second to John *Skeaping in the competition for the Prix de Rome, but she obtained a travelling scholarship and spent the years 1924–5 in Italy, marrying Skeaping in Rome in 1925 (they were divorced in 1933). Her early sculptures were quasi-naturalistic and had much in common with Moore's work (*Doves*, Manchester City Art Gallery, 1927), but she already showed a tendency to submerge detail in simple forms, and by the early 1930s her work had become entirely abstract. At this time she worked in both stone and wood, and she described an important aspect of her early career as being 'the excitement of discovering the nature of carving' (she had learnt carving in Italy). In this she was united with Moore (see DIRECT CARVING), but whereas his abstractions always remained based on natural forms, hers were often entirely unrepresentational in origin. Yet Hepworth consistently professed a Romantic attitude of emotional affinity with nature, speaking of carving both as a 'biological necessity' and as an 'extension of the telluric forces which mould the landscape'.

In 1931 Hepworth met Ben *Nicholson and began living with him soon afterwards (they were married in 1938 and divorced in 1951). Through him she became more aware of contemporary European developments and more committed to abstraction. They joined *Abstraction-Création in 1933 and *Unit One in the same year. During the 1930s Hepworth, Nicholson, and Moore (who lived near them in Hampstead) worked in close harmony and became recognized as the nucleus of the abstract movement in Britain. Hepworth's outlook was already clearly formed in the short introduction she wrote for the book *Unit One* published in 1934: 'I do not want to make a stone horse that is trying to and cannot smell the air. How lovely is the horse's sensitive nose, the dog's moving ears and deep eyes; but to me these are not stone forms and the love of them and the emotion can only be expressed in more abstract terms. I do not want to make a machine which cannot fulfil its essential purpose; but to make exactly the right relation of masses, a living thing in stone, to express my awareness and thought of these things . . . In the contemplation of Nature we are perpetually renewed, our sense of mystery and our imagination is kept alive, and rightly understood, it gives us the power to project into a plastic medium some universal or abstract vision of beauty.'

In 1939 Hepworth moved to St Ives in Cornwall with Nicholson (see ST IVES SCHOOL) and she lived there for the rest of her life. The Cornish landscape helped to reintroduce a suggestion of natural forms to her sculpture and the ancient standing stones of the region encouraged her to use upright forms, sometimes pierced, although ovoid shapes also remained characteristic of her work. She had introduced the use of the 'hole' to British sculpture in 1931 with *Pierced Form* (destroyed during the Second World War) and she now developed this with great subtlety, making play with the relationship between the outside and inside of a figure, the two surfaces sometimes being linked with threaded string, as in *Pelagos* (Tate Gallery, London, 1946). *Pela-*

gos also shows her sensitive use of painted surface to contrast with the natural grain of the wood. In all her work she showed a deep understanding of the quality of her materials and superb standards of craftsmanship.

By the 1950s Hepworth had an international reputation and in her later career she received many honours, including the main prize at the 1959 São Paulo *Bienal, and numerous prestigious public commissions, among them the memorial to Dag Hammerskjöld—*Single Form*—at the United Nations in New York (1963). She now worked more in bronze, especially for large pieces, but she always retained a special feeling for direct carving. Occasionally she diversified into other areas, notably with her sets and costumes for the first production of Michael Tippett's opera *The Midsummer Marriage* in 1955. Hepworth died tragically in a fire at her studio in St Ives, which is now a museum dedicated to her work. At the time of her death she was generally regarded as the world's greatest woman sculptor, and her obituary in the *Guardian* described her as 'probably the most significant woman artist in the history of art to this day'. She was 'small and intense in appearance, deeply reserved in character, and totally dedicated to her art. It was always a measure of surprise that such a frail woman could undertake such demanding physical work, but she had great toughness and integrity' (*DNB*).

Hepworth, Dorothy. See PREECE.

Herbin, Auguste (1882–1960). French painter, born at Quiévy, near Cambrai. He studied at the École des Beaux-Arts, Lille, 1900–2, then in 1903 moved to Paris, where he initially painted in a style influenced by the *Impressionists and *Post-Impressionists. However, after taking a studio in the *Bateau-Lavoir in 1909, his work was influenced by *Cubism and by about 1917 he was painting purely abstract compositions. In the early 1920s he reverted to a more figurative (though still Cubist-influenced) style, in which he did landscapes and portraits, but from about 1926 he turned to pure abstraction again and in 1931 he was a founder member of the *Abstraction-Création association. After the Second World War he painted completely flat compositions featuring simple geometrical shapes (circles, triangles, crescents, and so on) in pure, vivid, unmodulated colours. They were painted according to a highly personal theory of abstract art that he set out in his book *L'Art non-figuratif, non-objectif* (1949); it was based on correspondences between colours, shapes, forms, and letters of the alphabet. Herbin had an international reputation. He was one of the few French painters who consistently devoted himself to geometrical abstraction over a lengthy period and he had considerable influence on younger abstract artists. Apart from paintings his work included geometric reliefs of cement, concrete, and wood, and—in the 1950s—tapestry designs.

'Herbstsalon'. See STURM.

Herkomer, Sir Hubert von (1849–1914). German-born painter, printmaker, designer, teacher, and writer who settled in England in 1857 with his father (a woodcarver) and became a British citizen. He is now chiefly remembered for his scenes of social concern, which were at the time something of a novelty in British art (*On Strike*, Royal Academy, London, 1891). However, he was a versatile artist and a man of many parts. He composed operas, which were performed at his private theatre at Bushey, Hertfordshire, and as well as performing in them and designing the sets, he experimented with new forms of stage lighting (Gordon *Craig acknowledged their influence on him). Herkomer also experimented with printmaking techniques and designed sets for the cinema. From 1883 to 1904 he ran his own art school at Bushey (William *Nicholson was one of his pupils) and he lectured widely. His books include *Etching and Mezzotint Engraving: Lectures Delivered at Oxford* (1892) and the autobiographical *My School and My Gospel* (1908).

Herman, Josef (1911–). Polish-born painter who became a British citizen in 1948. He was born in Warsaw, the son of a Jewish cobbler, and studied at the Warsaw School of Art, 1930–1. In 1938 he moved to Brussels, then in 1940 to Glasgow, where he became a friend of another Polish refugee, Jankel *Adler. He moved to London in 1943, then from 1944 to 1953 lived in the Welsh mining village of Ystradgynlais. Ill health forced him to seek a drier climate and subsequently he lived in London and Suffolk. Herman is best known for his sombre pictures of Welsh miners, with whom he felt a strong affinity. He often

showed their black figures silhouetted against the sun: 'This image of the miners on the bridge against a glowing sky mystified me for years with its mixture of sadness and grandeur.' Michael Jacobs and Malcolm Warner write that 'The harsh realities of life here provided a subject perfectly attuned to his expressionist style of painting. He feels that he has achieved a special empathy with the local inhabitants, and knew that he was accepted by them as soon as they referred to him by the affectionate nickname "Joe bach" (little Joe). Much of his time at Ystradgynlais was spent underground observing the life of the miners' (*The Phaidon Companion to Art and Artists in the British Isles*, 1980). Herman made a considerable reputation with his mining scenes and was commissioned to paint a mural for the Festival of Britain in 1951 (*Miners*, Vivian Art Gallery and Museum, Swansea). In subsequent paintings he has depicted the life of other working people he has seen on his extensive travels, which are documented in his book *Related Twilights: Notes from an Artist's Diary* (1975). He has made an impressive collection of African sculpture and his figure style is to some extent based on it.

Hermes, Gertrude. See UNDERWOOD.

Hermetic Cubism. See CUBISM.

Hermitage, St Petersburg. See MOROZOV and SHCHUKIN.

Heroic Realism. See SOCIALIST REALISM.

Heron, Patrick (1920–). British painter, writer, and designer, born in Leeds. He studied at the *Slade School, 1937–9, and during the Second World War, when he was a conscientious objector, he worked on a farm, then as an assistant to the potter Bernard Leach in St Ives (Heron had lived there as a child). After the war he worked as art critic for *New English Weekly*, 1945–7, and the *New Statesman and Nation*, 1947–50, and he was London correspondent of the New York journal *Arts* from 1955 to 1958. In the 1930s and 1940s he also made designs for Cresta Silks, a firm founded by his father T. M. Heron, who also commissioned work from *Kauffer, Cedric *Morris, and Paul *Nash. Heron's early paintings were influenced by *Braque and *Matisse, but in 1956 he turned to abstraction; in the same

year he settled at Zennor (see ST IVES SCHOOL). His abstracts have been varied, including stripe paintings—vertical and horizontal—as well as looser formats with soft-edged shapes, but all his work is notable for its vibrancy of colour. His writings include a collection of essays entitled *The Changing Forms of Art* (1955), and books on *Vlaminck (1947), *Hitchens (1955), and *Braque (1958).

Hesse, Eva (1936–70). German-born American sculptor. Her family fled the Nazis, settling in New York in 1939, and she became a US citizen in 1945. She studied at various art schools in New York, then at Yale University under Josef *Albers, graduating in 1959. She did not take up sculpture until 1964, so her career lasted only six years, before her early death from a brain tumour. However, in that time she gained a high reputation as an exponent of 'Eccentric Abstraction' (the title of an exhibition in which her work was included, organized by her friend Lucy *Lippard, at the Fischbach Gallery, New York, in 1966). Hesse is sometimes described as a *Minimalist, but her work was too restlessly experimental to fit neatly into any category. It often shared with Minimal art the use of repeated units and severely limited colour, but she made inventive use of materials (including fibreglass, wood, wire, various fabrics, and rubber tubing), and her work is far from the emotional reserve associated with Minimalism; her forms are often organic and sexually suggestive. She was described in her obituary in the *Guardian* as 'certainly one of the most outstanding sculptors to emerge during the sixties'.

Hessing, Leonard (1931–). Australian painter, born at Chernovtsy (Czernowitz), which at the time was part of Romania (it is now in the Ukraine). He studied painting under *Léger in Paris, 1950–1, then moved to Australia to join his parents, who had recently emigrated there. He took a degree in architecture at Sydney University in 1958. In the 1960s he established a reputation as one of Australia's leading abstract painters, working in a vigorous but sophisticated *Abstract Expressionist vein.

His mother, **Perle Hessing** (1908–), took up art in the 1960s, encouraged by Leonard, and became a well-known *naive painter. Later both settled in Britain.

Heymans, Adrien. See LUMINISM.

Heysen, Sir Hans (1877–1968). German-born Australian landscape painter, mainly in watercolour. He was born in Hamburg and emigrated to Australia with his parents when he was six. For most of his career he lived in or near Adelaide, but he returned to Europe to study, notably at the *Académie Julian, Paris. Robert *Hughes (*The Art of Australia*, 1970) writes: 'Heysen's large body of work was immensely popular; it has most of the textbook virtues and, for many years, no Australian business firm was considered quite solid unless it had a Heysen in its boardroom . . . The only deficiency of his art is that it has no imagination . . . He was, in fact, the Alfred *Munnings of the gum-tree.' Heysen was knighted in 1959. His work (which included occasional etchings) is represented in all Australian state galleries and many provincial galleries. The best collection is in the Art Gallery of South Australia, Adelaide.

Hicks, Edward. See NAIVE ART.

Hicks, Sheila. See FIBRE ART.

Higgins, Dick. See FLUXUS.

Higgins, Eugene. See ASHCAN SCHOOL.

High Cubism. See CUBISM.

Hildebrand, Adolf von (1847–1921). German sculptor and writer on art. He spent much of his career in Italy and is regarded as one of his period's main upholders of the classical tradition in sculpture. His most characteristic works were nude figures—timeless and rather austere, in the high-minded spirit of Greek art—although he also made several large monuments, including a statue of Johannes Brahms in Meiningen (1898) and an equestrian statue of Bismarck in Bremen (1907–10). These are both in bronze, but he also worked a good deal in stone. He is now, however, better known for his treatise *Das Problem der Form in der bildenden Kunst* (1893) than for his highly accomplished but rather bland sculpture. The book went through many editions (an English translation, *The Problem of Form in Painting and Sculpture*, was published in 1907) and it was influential in promoting a move against surface naturalism in sculpture in favour of clarity of form. Later his work was adopted as one of the models for the pseudo-classical sculpture typical of *National Socialist art.

Hilder, Rowland (1905–93). British painter, printmaker, illustrator, and designer. He was born in Long Island, New York, to British parents, and in 1915 moved to London, where he studied etching and drawing at Goldsmiths' College, his teachers including E. J. Sullivan (1869–1933), one of the most prolific and successful book illustrators of his time. Hilder taught at Goldsmiths' from 1929 to 1941 and also lectured at other colleges. At this time he experimented a good deal with printmaking techniques, and he is said to have produced the first *screenprint ever made in Britain (1924). During the Second World War he worked on camouflage for the Royal Engineers, and after the war he was employed mainly in publishing and advertising, illustrating many books, including Geoffrey Grigson's *The Shell Guide to Flowers of the Countryside* (1955), and also designing posters. Hilder's most characteristic works are pleasant views of the English countryside (often winter scenes), which have been much reproduced on greetings cards, calendars, and so on. His obituary in the *Independent* states that 'It is hard to think of any landscape painter of his generation whose work is as widely known, and whose images . . . have taken such a hold of the public affection'. These images have received little serious attention, but one of his paintings was included in the exhibition 'Landscape in Britain 1850–1950' held at the Hayward Gallery, London, in 1983. Hilder wrote two books on watercolour technique: *Starting with Watercolours* (1966) and *Painting Landscapes in Watercolour* (1983; entitled *Expressing Land, Sea and Sky in Watercolour* in the USA). A collection of his work was published in 1986 as *Rowland Hilder's England*.

Hill, Anthony (1930–). British abstract painter and maker of reliefs, born in London. He studied at *St Martin's School of Art, 1947–9, and at the Central School of Art and Design, 1949–51. After a period of experimentation with various styles and modes of expression in the early 1950s, he adopted a highly disciplined form of abstract painting. In 1954 he made his first relief and he abandoned painting two years later. With Kenneth and Mary *Martin he became recognized as one of the leaders of the *Constructivist movement in Britain. His reliefs often use industrial materials such as plastic and mass-produced aluminium sections arranged in accordance with mathematical dictates (he

was honorary research fellow in the mathematics department at University College London in 1971–3). He has published several articles on art and mathematics, and in 1968 he edited an anthology *DATA: Directions in Art, Theory and Aesthetics*, which was described by the critic Stephen Bann as 'by far the most illuminating and comprehensive recent survey of attitudes towards the constructive tradition'.

Hillier, Tristram (1905–83). British painter of landscape, still-life, and occasional religious subjects, born in Peking, where his father was manager of the Hong Kong and Shanghai Bank. After two years studying at Cambridge University (which he described as 'a waste of time'), he was apprenticed to a London firm of chartered accountants, but he quickly abandoned this career to study at the *Slade School under *Tonks, 1926–7, whilst also attending evening classes at the Westminster School of Art under *Meninsky and *Schwabe. He then went to Paris, where he studied at the Académie Colarossi under *Lhote, and until 1940 he lived mainly in the south of France, with visits to Spain, which he 'came to love above all other countries'. (Hillier also kept contacts with the London art world, however, and in 1933 was a member of *Unit One.) During the Second World War he served in the Royal Naval Volunteer Reserve, 1940–4, and then settled in Somerset, where he often painted agricultural subjects. He continued to travel regularly, spending much time in Spain and Portugal. Early in his career Hillier was influenced by a variety of modern idioms, and his work (which included abstracts) showed little individuality. In the mid-1930s, however, he evolved a distinctive style to which he remained faithful for most of his life; he painted with great sharpness of definition and smoothness of finish, creating scenes of stillness and calm that evoke an air of *Surrealist strangeness and otherworldliness through the juxtaposition of incongruous objects and the use of unreal perspectives. One of the earliest examples in which he showed this personal voice is *La Route des Alpes* (Tate Gallery, London, 1937), which like many of his paintings is executed in tempera. He came to regard himself as 'the slave of my own style', but in some of his later work he used freer brushwork or applied paint with a palette knife. In 1954 he published an autobiography, *Leda and the Goose*.

Hills, Joan. See BOYLE.

Hilton, Roger (1911–75). British painter of German extraction, born in Northwood, Middlesex. His father (a cousin of the great scholar Aby Warburg, founder of the Warburg Institute) was a doctor who changed his surname (Hildesheim) because of anti-German feeling during the First World War. His mother, Louisa Holdsworth Sampson, had trained as a painter at the *Slade School. Hilton also studied at the Slade, 1929–31 and 1935–6, and during the 1930s he lived in Paris for a total of about two and a half years, spending part of this time at the *Académie Ranson, where he was taught by *Bissière. In 1939 he joined the army, and he was prisoner of war from 1942 to 1945 after being captured in a commando raid on Dieppe. After the war he taught for several years, at Bryanston School and then from 1954 to 1956 at the Central School of Arts and Crafts. In 1950 he began painting abstracts; intitially he was influenced by developments in Paris (which he revisited regularly), but after meeting the Dutch painter *Constant in 1953 and visiting Amsterdam with him, he was inspired more by *Mondrian: 'Hilton simplified his painting, limiting his palette to the primaries, black and white, and a few earth colours; some works suggest landscape or the human female figure but some are among the most uncompromisingly abstract paintings of their time executed in Britain' (*DNB*). From 1955 he reintroduced a sense of a shallow pictorial space, and from 1956, when he began making visits to St Ives (see ST IVES SCHOOL), there are suggestions of beaches, boats, rocks, and water in his work. In 1961 he returned to overt figuration with a series of exuberant, jokey female nudes. These dismayed some of his admirers, who regarded him as a standard-bearer for abstraction, but they are now among his most popular works (*Oi yoi yoi*, Tate Gallery, London, 1963). In 1965 he moved from London to St Just in Cornwall and lived there for the rest of his life. For the last few years of his life he was bedridden with a muscular disease, but his ill-health was belied in the series of colourful, good-humoured gouaches he did in this period.

Hilton won numerous awards, including first prize at the 1963 *John Moores Liverpool Exhibition and the Unesco prize at the 1964 Venice *Biennale. He 'thought deeply about painting; acutely perceptive about art and

people, he was often discomfiting company, particularly when inflamed by alcohol, when he often became verbally aggressive, though he had a deep streak of tenderness. Like his art, he could be both abrasive and life-enhancing' (*DNB*).

Hiltunen, Eila (1922–). Finnish sculptor. She was born at Sordavala, Karelia, and studied at the Academy in Helsinki, 1942–6. She began her career working in a naturalistic style and made her name as a sculptor of war memorials, of which the one at Simpele is considered the best. In the 1940s and 1950s she also did portrait busts of distinguished Finns. She worked in bronze, marble, and granite, but in the late 1950s she discovered the technique of welding and concentrated on this after meeting *Archipenko during a visit to the USA in 1958. Initially her welded pieces were figurative, but she then turned to abstraction, as in her most famous work, the Sibelius Monument (1967) in Sibelius Park, Helsinki. This consists of a nest of polished steel tubes that have been likened both to organ pipes and to the pine trunks of the Finnish forests.

Himid, Lubaina. See BOYCE.

Hippolite, Hector. See HYPPOLITE.

Hi-Red Center. A group of Japanese *installation and *Performance artists active in 1963–4. The main figures were Genpei Akasegawa (1937–), Natsuyuki Nakanishi (1935–), and Jiro Takamatsu (1936–), and the group's title is a translation of parts of their names. They worked in the spirit of *Dada (Akasegawa had previously been a member of *Neo-Dada Organizers).

Hirschfeld-Mack, Ludwig (1893–1965). German-Australian abstract painter, experimental artist, and teacher, born in Frankfurt. While a student at the *Bauhaus (1919–25) he created 'Colour Light Plays' (1922 onwards) that give him a place as one of the pioneers of *Kinetic art and *Light art. He taught at various art schools from 1925 to 1936, when he left Germany because of pressure from the Nazis and moved to Britain. When war broke out he was interred and in 1940 he was sent to Australia. On being released from internment in 1942 he became art master at Geelong Grammar School in Victoria, where he remained until his retirement in 1957. During these years he introduced Bauhaus teaching methods and he wrote *The Bauhaus: An Introductory Survey* (1963). The paintings he produced in Australia continued the colour researches of his Bauhaus days; an example is *Composition* (1946) in the Art Gallery of New South Wales, Sydney. A retrospective exhibition of Hirschfeld-Mack's work was held in this gallery in 1974.

Hirshfield, Morris (1872–1946). Polish-born American *naive painter. He emigrated to the USA in 1890 and settled in New York, where he worked in the garment industry and then as a manufacturer of slippers. When illness forced him to retire in 1937, he at last had time to satisfy the artistic impulse he had felt since childhood (he had done some carving as a boy, but nothing since). He worked slowly and his output was consequently small (77 pictures in his nine-year career). Most of his pictures fall into two main groups: animal subjects, taken from illustrations in children's books, but transformed from the banal originals into fabulous creatures from a fairy-tale world; and erotic female nudes with vacant faces (they have been compared to the work of Tom *Wesselmann, though Hirshfield's nudes were done without irony or conscious exhibitionism). He painted with meticulous attention to detail and with a strong sense of pattern, characteristics that perhaps stem from his experience with linear design and needlework in his business days. In 1939, only two years after he started painting, Hirshfield was 'discovered' by the art dealer Sidney *Janis, and in 1943 he was given an exhibition at the Museum of Modern Art, New York—a rare honour for a naive painter and an indication of the esteem in which he was held. His reputation remains high.

Hirshhorn Museum and Sculpture Garden, Washington, DC. Collection of modern painting and sculpture founded by Joseph H. Hirshhorn (1899–1981), a Latvian immigrant to the USA, and presented to his adopted country in 1966. It is administered by the Smithsonian Institution. Hirshhorn left Latvia at the age of 6 and fulfilled the rags-to-riches American dream, his enormous fortune being made mainly from uranium mining. He began collecting in the early 1930s, relying entirely on his own instincts—if he liked an artist's work he tried to buy as much of it as possible. The collection extends from about 1880 to con-

temporary art and is particularly strong in sculpture, in American painting, and in European painting since the Second World War. Highlights include about 40 *de Koonings and about 50 Henry *Moores. The museum building was designed by one of the USA's leading architects, Gordon Bunshaft (of the firm of Skidmore, Owings & Merrill), and was opened to the public in 1974. It consists of a huge concrete drum raised above a plaza on four massive piers. The museum is linked by an underground passage to the sculpture garden on the opposite side of Jefferson Drive. Hirshhorn gave the trustees of the museum the freedom to add or dispose of the works as they saw fit, and the collection continues to expand.

Hirst, Damien (1965–). British sculptor, painter, and designer, a flamboyant personality whose flair for self-publicity has helped him become the most famous British artist of his generation. He was born in Bristol and after an undistinguished school career (he often played truant and merely scraped an A Level in art) he worked on building sites in London while trying to get into art school. He failed to win a place at *St Martin's School of Art (his mother said this was 'Because you stick rubbish to bits of board'), but he was accepted by Goldsmiths' School of Art, where he studied 1986–9. Whilst still at Goldsmiths' he made a name for himself by organizing an exhibition of student work ('Freeze', 1988) in a large disused building in the Docklands area of London and persuading leading dealers and critics to come and see it. From his youth he had a fascination with death (he bought and stole pathology books 'for morbid curiosity about burns'), and his best-known works use dead animals or fish as the raw materials (he became such a good customer at Billingsgate market in London that his regular fishmonger there was invited to his private views). His most famous work is *The Physical Impossibility of Death in the Mind of Someone Living* (Saatchi Collection, London, 1991), consisting of a dead tiger-shark 'floating' in preserving fluid in a large tank made of glass and steel. The shark came from Australia rather than Billingsgate (he had also tried Harrods in vain), and Hirst has to put a good deal of planning into creating such large and potentially dangerous works (there have been scares over noxious fluid leaking from the tanks of his 'pickled animal' sculptures). He

employs several assistants, who sometimes wear protective rubber clothing and use breathing apparatus when handling the preserving fluid, and he says 'If I was to learn every skill that was involved in making my work I wouldn't have the time left to make it. I feel more like an architect.'

In 1995 Hirst was awarded the *Turner Prize. The work he showed at the exhibition of shortlisted candidates' work at the Tate Gallery included *Mother and Child Divided*, consisting of four tanks containing the severed halves of a cow and calf. According to the accompanying catalogue, 'Hirst strips the closest of bonds between living creatures to its starkest reality', but many people hated the work, and a letter to *The Times* suggested that the Tate authorities must be suffering from mad cow disease. Hirst himself said 'It's amazing what you can do with an E in A Level art, a twisted imagination and a chainsaw.' Hirst's other works include paintings consisting of rows of coloured spots and the interior design of the Quo Vadis restaurant in London (1997). In 1997 he published a book entitled *I Want to Spend the Rest of my Life Everywhere, with Everyone, One to One, Always, Forever*, which Cosmo Landesman, writing in the London *Sunday Times*, described as an 'obscene love letter from the artist to himself . . . It is very shocking and very disgusting and very pointless . . . a fat, colourful pop-up book with very big pretensions'. Edward *Lucie-Smith writes that 'The only thing which binds Hirst's creations together is his own assertive personality, which has a great fascination for the media. It is symptomatic that when an article about him appeared in the *Sunday Times* colour supplement, it had six photographic portraits of the artist himself, most of them full-page, but contained no illustration of his sculpture or painting' (*Visual Arts in the Twentieth Century*, 1996). See also YOUNG BRITISH ARTISTS.

Hitchens, Ivon (1893–1979). British painter, mainly of landscapes. He was born in London, son of the painter Alfred Hitchens, and studied at St John's Wood School of Art, 1911–12, and the *Royal Academy Schools (several years on and off between 1912 and 1919). In 1920 he became a founder member of the progressive *Seven & Five Society and was the only artist to belong to it throughout its entire lifetime until its demise in 1935. During this time he experimented with pure abstraction (he

exhibited as one of the *Objective Abstractionists in 1934), but by the late 1930s he had created a highly distinctive style on the borderline between abstraction and figuration in which broad, fluid areas of lush colour, typically on a canvas of wide format, evoke but do not represent the forms of the English countryside that were his inspiration. In 1940, following the bombing of his London studio, he settled permanently at Lavington Common, near Petworth, in Sussex. His work altered little from then, apart from the fact that his palette changed from naturalistic browns and greens to much more vivid colours such as bright yellows and purples. Contrary to what often happens when an artist remains constant in one style over several decades, Hitchens's work did not become stereotyped or banal. In addition to landscapes, Hitchens painted flowers and figure subjects (usually nudes) and he did several large murals, for example at Nuffield College, Oxford (1959), and the University of Sussex (1963). His work is represented in the Tate Gallery, London, and many public collections. His son **John Hitchens** (1940–) is also a painter, mainly of landscapes and flower pieces.

Hjorth, Bror (1894–1968). Swedish sculptor, painter, and draughtsman. He studied in Copenhagen and then in Paris under *Bourdelle, 1921–3, but his earthy, vigorous style is in the tradition of Swedish folk art. Among his most characteristic works are roughly hewn, gaily painted wooden reliefs, usually representing erotic subjects or cult-symbols. He ran a school for sculptors in Stockholm in 1931–4 and in 1949–59 taught at the Academy there. There is a museum dedicated to him in Uppsala.

Hlebine School. A term applied to Yugoslav (Croatian) *naive painters working in or around the village of Hlebine, near the Hungarian border, from about 1930. At this time, according to the *World Encyclopedia of Naive Art* (1984), the village amounted to little more than 'a few muddy winding streets and one-storey houses', but it produced such a remarkable crop of artists that it became virtually synonymous with Yugoslav naive painting. The school developed from the encouragement given by Krsto *Hegedušić to the young Ivan *Generalić, whom he met in 1930. Generalić in turn encouraged his friends Franjo *Mraz (likewise a native of Hlebine) and Mirko

*Virius (who came from the nearby village of Djelekovac) and these three, sometimes known as the 'Hlebine Trio', formed the nucleus of the group. Hegedušić encouraged them to paint scenes of social protest in line with his own left-wing political views, but after the Second World War, Hlebine painters concentrated more on idyllic depictions of country life (the post-war phase is sometimes characterized as 'second Hlebine School'). Generalić continued to be the dominant figure, and the younger artists included his son Josip. In the 1950s the school became well known internationally, shown at leading exhibitions such as the São Paulo *Bienal in 1955.

Höch, Hannah (1889–1978). German artist, now best remembered as one of the pioneers of *photomontage. She was born in Gotha and studied in Berlin, where she worked as a designer for a publishing firm from 1916 to 1926. For much of this time she lived with Raoul *Hausmann, and like him belonged to the Berlin *Dada scene. In 1916 she began making *collages and soon afterwards photomontages, the best of which are worthy of comparison with Hausmann's. At this time she also made 'abstract paintings, not unlike the work of Sophie *Taeuber-Arp, [that] were among the earliest examples of purely non-objective painting in northern Germany' (George Heard *Hamilton). From 1926 to 1929 she lived in The Hague, then returned to Berlin. A one-woman exhibition of her work was planned to be shown at the *Bauhaus in 1932, but it never took place because the school was closed by the Dessau parliament that year. After the Nazis came to power, she lived in seclusion.

Hockney, David (1937–). British painter, draughtsman, printmaker, photographer, and designer, active mainly in the USA. After a brilliant career as a student, Hockney had achieved international success by the time he was in his mid-20s, and he has since consolidated his position as by far the best-known and most critically acclaimed British artist of his generation. His phenomenal success has been based not only on the flair and versatility of his work, but also on his colourful personality, which has made him a recognizable figure even to people not particularly interested in art—so much so that a film about him, *A Bigger Splash* (1974), enjoyed some popularity in the commercial cinema.

Hockney was born in Bradford, Yorkshire, into a working-class family, and studied at Bradford School of Art, 1953–7. His early work—including portraits and views of his surroundings—was in the tradition of the *Euston Road School. After two years working in hospitals in lieu of National Service (he was a conscientious objector), he went to the *Royal College of Art in 1959 and graduated with the gold medal for his year in 1962. His fellow students included Derek *Boshier, Allen *Jones, R. B. *Kitaj, and Peter *Phillips, and with them Hockney was regarded as one of the leaders of British *Pop art after the *Young Contemporaries exhibition in 1961. Hockney himself disliked the label 'Pop', but his work of this time makes many references to popular culture (notably in the use of graffiti-like lettering) and is often jokey in mood.

In 1963 he had his first one-man show at the gallery of the London dealer John Kasmin (1934–), and his first retrospective came as early as 1970, at the *Whitechapel Art Gallery, London (it subsequently toured to Hanover, Rotterdam, and Belgrade). By this time he was painting in a weightier, more traditionally representational manner, in which he did a series of large double-portraits of friends, including the well-known *Mr and Mrs Clark and Percy* (Tate Gallery, London, 1970–1). These portraits are notable for their airy feeling of space and light and the subtle flattening and simplification of forms, as well as for the sense of stylish living they capture. Hockney often paints the people and places he knows best (his art is frequently autobiographical) and he has memorably celebrated his romance with Los Angeles (he first visited the city in 1963 and settled there permanently in 1976), particularly in his many paintings featuring swimming pools (*A Bigger Splash*, Tate Gallery, London, 1967). R. B. Kitaj has written of these works: 'It is a rare event in our modern art when a sense of place is achieved at the level of very fine painting. *Sickert's Camden Town comes to mind, and above all *Hopper's America, in which I grew up. Hockney's California is one of the only recent exemplars.'

Another contemporary of Hockney's, Tom *Phillips, has written that 'his seemingly effortless draughtsmanship is the envy of fellow artists', and he has indeed been as outstanding as a graphic artist as he has as a painter. His work in this field includes etched illustrations to Cavafy's *Poems* (1967) and *Six Fairy Tales of the Brothers Grimm* (1969), as well as many individual prints, often on homoerotic themes. In the 1970s he came to the fore also as a stage designer, notably with his set and costume designs for Stravinsky's *The Rake's Progress* and Mozart's *The Magic Flute*, produced at Glyndebourne in 1975 and 1978 respectively. In the 1980s he experimented a good deal with photography, producing, for example, photographic collages and—since 1986—prints created on a photocopier. Painting has continued to be his central activity, however. His works of the 1990s include a series entitled *Very New Paintings*, begun in 1992, in which he depicted Californian scenery in almost abstract terms. The loose handling of such works has disappointed some critics who admired the clarity of his earlier paintings. Hockney is a perceptive commentator on art and has published two substantial books on his own work: *David Hockney by David Hockney* (1976) and *That's the Way I See It* (1993). See also ACRYLIC and PHOTOWORK.

Hodgkin, Sir Howard (1932–). British painter and printmaker. He was born in London and studied at Camberwell School of Art, 1949–50, and *Bath Academy of Art, 1950–4; he later taught at Bath, 1956–66. His paintings sometimes look completely abstract, but he bases his work on specific events, usually an encounter between people—'one moment of time involving particular people in relation to each other and also to me'. He has travelled widely, making several visits to India, and his preference for flat colours and decorative borders reflects his admiration for Indian miniatures, of which he has made a collection. His work has won him a reputation as one of the outstanding colourists in contemporary art, although Brian *Sewell has referred to him disparagingly as 'a painter of pretty post-*Omega tea trays' (Hodgkin is in fact distantly related to Roger *Fry and was familiar with Omega products from childhood). Sewell's comment reflects the small scale characteristic of Hodgkin's work, although in the 1980s he began producing much bigger pictures. A well-known figure in the art world, he has been a Trustee of the National Gallery and the Tate Gallery, and in 1985 he was awarded the *Turner Prize. He was knighted in 1992, and in 1997 there was a major exhibition of his work at the Hayward Gallery, London. His work is well represented in the Tate Gallery.

Hodgkins, Frances (1869–1947). New Zealand painter, active mainly in England, where she settled in 1913 after some time spent alternating between the two hemispheres (her first visit to Europe had been in 1901). She was taught watercolour painting by her father—a barrister and amateur artist who had emigrated from England in 1859—and she studied at Dunedin Art School, 1895–8, but she did not begin to paint in oils until 1915. Until that time her work had been conventional, but she gradually developed a more modern style, echoing *Matisse and *Dufy in its use of vibrant colour (she spent a good deal of time in France). In 1929–34 she was a member of the progressive *Seven & Five Society and her late paintings, based on fluid colour, approach abstraction in a manner akin to the work of her fellow member Ivon *Hitchens. From the early 1930s she lived mainly at Corfe Castle in Dorset. Her chief subjects were landscape and still-life.

Hodler, Ferdinand (1853–1918). Swiss painter, born in Berne and active mainly in Geneva. He ranks alongside Arnold Böcklin (1827–1901) as the outstanding Swiss artist of his time, but his early work was rather unimaginatively naturalistic, his landscapes amounting to ambitious colour postcards for tourists. However, in 1890, with his brooding *Night* (Kunstmuseum, Berne), Hodler began a sudden change of style. This picture, depicting a black-shrouded, phantom-like presence amid a number of semi-naked sleeping figures, set the pattern for his most characteristic works—allegories featuring stately groups of flat, stylized figures composed into a rhythmic and repetitive pattern of lines, forms, and colours. Often the same basic figure is repeated throughout the picture with only slight variations. Hodler called his method 'Parallelism'; he used the same principles in scenes from Swiss history and landscapes. By the turn of the century he had become immensely popular throughout the German-speaking world and in 1904 a group of 31 of his paintings was the main attraction at the Vienna *Sezession's international exhibition. George Heard *Hamilton writes that 'This occasion, when Hodler was one of a group that included *Munch, *Gallen-Kallela, Cuno *Amiet, and Jan *Thorn Prikker, may be considered the climax of *Symbolist painting. In the year that followed *Gauguin's death and preceded the first *Fauve manifestation these

men were the acknowledged leaders of modern art in Norway, Finland, Switzerland, and Germany.' In the last decade of his life Hodler returned more to landscape painting: 'In spare lines and a few vivid colours, comparable to the best Fauve work, he set forth his mystique of the Alpine landscape' (Hamilton). As well as being a major figure of Symbolism and *Art Nouveau, Hodler has been seen as one of the harbingers of *Expressionism.

Hofer, Karl (1878–1955). German painter, born in Karlsruhe, where he studied at the Academy under *Thoma, 1896–1901. Early in his career he found support from a rich Swiss patron, Dr Theodor Reinhardt, and this enabled him to live from 1903 to 1908 in Rome, where he painted in an idealized classical style. From 1908 to 1913 he lived in Paris, where he was influenced by the structural solidity of *Cézanne, and in 1909 and 1911 he visited India (at Reinhardt's expense), which for a time introduced an iconography of swooning, lyrical figures into his work. In 1913 he settled in Berlin, but he was trapped in Paris at the outbreak of the First World and spent three years in an internment camp; George Heard *Hamilton writes that 'His memories of that time must have been ineradicable, because even years later the constraint of his figures and their hesitant gestures seem affected by physical or psychical confinement'. On his return to Berlin in 1918 he became a teacher at the Hochschule für Bildende Künste. He achieved considerable success, highlighted by a large exhibition in Berlin in 1928 to mark his 50th birthday, and his reputation spread outside Germany. However, in 1933 his work was declared *degenerate by the Nazis and he was removed from his teaching post. His studio and much of his work were destroyed by bombing in 1943. At the end of the Second World War he was reinstated at the Hochschule and was appointed its director. He wrote several critical and autobiographical books, including *Aus Leben und Kunst* (Life and Art), published in 1952.

In *Aus Leben und Kunst* Hofer said 'One must have the courage to be unmodern', and although his subjects in his work after the First World War were taken from modern life, he rejected the *Expressionism that was the dominant force in German art of his time. Except for a brief experiment with abstract painting in 1930–1, he concentrated on a small range of obsessively recurrent images,

through which he expressed a dark and disillusioned vision of the world. His most typical works portray brooding figures, singly or in couples, but he also did portraits, landscapes, and large figure compositions. The simplicity and strength of design of his compositions reflect his lasting admiration for Cézanne, but their cool, chalky colours are distinctive. In the catalogue of the exhibition 'Modern German Painting and Sculpture' (MOMA, New York, 1931), Alfred H. *Barr wrote that Hofer had created 'a highly individual style, severe, thoughtful and decidedly more classical in feeling than that of any other important contemporary German painter . . . he has succeeded in doing well what few other Germans are really interested in: composition in the tradition of Cézanne'.

Hoffmann, Josef. See KLIMT.

Hofmann, Hans (1880–1966). German-born painter and teacher who became an American citizen in 1941. He was born in Weissenburg, Bavaria, and brought up in Munich, where he studied at various art schools. From 1904 to 1914 he lived in Paris, where he knew many of the leading figures of *Fauvism, *Cubism, and *Orphism. In 1915 he founded his own art school in Munich and taught there successfully until 1932, when he emigrated to the USA (following visits in 1930 and 1931 during which he taught at the University of California, Berkeley). He founded the Hans Hofmann School of Fine Arts in New York in 1934 (followed the next year by a summer school at Provincetown, Massachusetts) and became a teacher of great influence on the relatively small number of American artists who practised abstract painting during the 1930s. Hofmann continued teaching until 1958, when he closed his schools so that he could concentrate on his own painting. This was to counter opinions that he was merely an academic figure and a symbol of the avant-garde rather than a significant creative artist himself. In the course of his career he experimented with many styles, and was a pioneer of the technique of dribbling and pouring paint that was later particularly associated with Jackson *Pollock. His later works, in contrast, feature rectangular blocks of fairly solid colour against a more broken background. He gave a large collection of his pictures to the University of California, Berkeley.

As a painter and teacher Hofmann was an important influence on the development of *Abstract Expressionism. The essence of his approach was that the picture surface had an intense life of its own: 'Depth in a pictorial plastic sense is not created by the arrangement of objects one after another toward a vanishing point, in the sense of Renaissance perspective, but on the contrary by the creation of forces in the sense of push and pull.' In 1945 Clement *Greenberg described him as 'in all probability the most important art teacher of our time . . . He has, at least in my opinion, grasped the issues at stake better than did Roger *Fry and better than *Mondrian, *Kandinsky, *Lhote, *Ozenfant, and all the others who have tried to "explicate" the recent revolution in painting . . . this writer . . . owes more to the initial illumination received from Hofmann's lectures than to any other source . . . I find the same quality in Hofmann's painting that I find in his words—both are completely relevant. His painting is all painting . . . asserting that painting exists first of all in its medium and must there resolve itself before going on to do anything else.'

Hogarth Press. See BELL, VANESSA.

Holgate, Edwin. See GROUP OF SEVEN.

holography. See LIGHT ART.

Holroyd, Sir Charles. See TATE GALLERY.

Holt, Nancy. See SMITHSON.

Holty, Carl. See REINHARDT.

Hölzel, Adolf (1853–1934). German painter, designer, writer, and teacher, born in Olmütz, Moravia. After working in lithography and typography Hölzel studied at the Vienna and Munich Academies. In 1888 he settled in Dachau, where he opened a private school of painting in 1891; *Nolde was among his pupils. In 1906 he became head of the department of composition at the Stuttgart Academy, where his students included *Baumeister, *Itten, and *Schlemmer. From 1916 until his retirement he was director of the Academy.

Hölzel made an intensive study of colour theory and from about 1895 developed his own ideas about colour harmonies that eventually led him to produce paintings that come

close to complete abstraction. In 1916 he wrote 'there exist certain qualities that are justified in their own right and do not require representational supplementation, in fact atrophy under it'. His theoretical views were widely read, for they were published mainly in the popular journal *Die Kunst für Alle* ('Art for All'), which had been founded in 1899 and to which he contributed from 1904. After his retirement from the Stuttgart Academy, Hölzel worked mainly in pastel and as a stained-glass designer (notably for windows in Stuttgart Town Hall). Shortly before his death his work was declared *degenerate by the Nazis.

Holzer, Jenny (1950–). American *Conceptual artist, whose work consists of verbal statements (typically aphorisms or exhortations) expressed in such forms as posters, electronic signs, or *installations. She was born in Gallipolis, Ohio, and studied successively at Duke University, Durham, North Carolina, the University of Chicago, Ohio University, Athens, and the Rhode Island School of Design. In 1977 she settled in New York and in the same year began producing *Truisms*—broadsheets, printed with statements such as 'There is a fine line between information and propaganda', which were pasted on buildings and walls. These were followed by other series in various media—T-shirts, stickers, metal plaques, and especially electronic signs (displayed in public places such as Times Square), the form for which she has become best known: 'The topics range from the scientific to the personal and include "thoughts on aging, pain, death, anger, fear, violence, gender, religion, and politics"' (Whitney Chadwick, *Women, Art, and Society*, 1990). In 1989–90 she had an exhibition at the Guggenheim Museum, New York, that featured a vast installation of signs running around the spiral space of the interior, and in 1990 she was the first woman to represent the USA at the Venice *Biennale. Daniel Wheeler (*Art Since Mid-Century*, 1991) describes her as 'an installation artist of great power and invention' and writes that 'With her child-like diction, activist alarm, and sense of spectacle, Holzer, perhaps more than any other Conceptual artist, has succeeded in releasing the surreal in language, as well as in making words take command of space with something like the emotional, physical drama of a *Serra sculpture.' Peter *Fuller, on the other hand,

described her as 'an unspeakably awful artist', whose work illustrates 'the infantile involvement with the trivia of the mass media which preoccupies the American art world'.

Homme-Témoin, L' (Man as Witness). A group of predominantly young French painters formed in Paris in 1948 to promote a style of expressive *Social Realism in opposition to the prevailing taste for abstraction. A manifesto drawn up for them by the critic Jean Bouret affirmed that 'Painting exists to bear witness, and nothing human can remain foreign to it.' The original group had five members, including Bernard Lorjou (1908–86) and Paul *Rebeyrolle, and first exhibited at the Galerie du Bac, Paris, in 1948. In 1949 they exhibited at the Galerie Claude, augmented by other artists including Bernard *Buffet and André Minaux (1923–). Their paintings depicted everyday life in a gloomy, pessimistic manner. Werner Haftmann (*Painting in the Twentieth Century*, 1965) describes their work as 'the pictorial equivalent of existentialism' and says 'what these painters bore witness to was the emptiness of the world, the desolation of things deserted in the ghost-like barrenness of space, man's vulnerability'. This despairing outlook was for a time very fashionable, and the work of the group—particularly that of Buffet—proved highly popular with collectors. The success of the group led to imitators and the creation of the Salon des Peintres Témoins de leur Temps in 1951.

Hone, Evie (1894–1955). Irish painter and stained-glass designer, born in Dublin, a member of a dynasty of artists (her most famous ancestor was the 18th-century portraitist Nathaniel Hone). She was partly crippled by polio at the age of eleven and was often ill thereafter, but she worked indomitably, sustained by a strong religious faith. After studying at various art schools in London (her teachers included *Sickert and *Meninsky), she spent much of the period 1920–31 in Paris, where she studied with *Lhote and *Gleizes. Her painting at this time became abstract, like that of her friend Mainie *Jellett, and these two have been described as 'the great innovators in modern Irish painting' (Bruce Arnold, *A Concise History of Irish Art*, 1969). However, after being overwhelmed by the deep spirituality of *Rouault's work, Hone began designing

stained glass in 1933; this was to be her main preoccupation for the rest of her life and she is ranked among the 20th century's greatest artists in the field. Her most famous work is the huge east window of Eton College Chapel, commissioned in 1949 to replace glass destroyed by bombing in the Second World War and completed in 1952. The subjects are *The Crucifixion* and *The Last Supper*. Sir Nikolaus Pevsner (*The Buildings of England: Buckinghamshire*, 1960) describes the window as 'a triumph for the authorities of Eton, which refused to be satisfied with the anaemic glass put into so many churches of England before and after the Second World War. Here is bold, vigorous design and strong, glowing colour.'

Hopper, Edward (1882–1967). American painter and etcher. He was born in Nyack in New York State and spent almost all his career in New York City, but he travelled extensively in the USA, making long journeys by car. After a year at a commercial art school he studied from 1900 to 1906 at the New York School of Art; his teachers included *Chase and *Henri and his fellow students included George *Bellows and Rockwell *Kent. Between 1906 and 1910 he made three trips to Europe (mainly Paris), but these had little influence on his style (he admired the *Impressionists but took no interest in avant-garde art). In 1913 he exhibited (and sold) a picture at the *Armory Show, but from then until 1923 he earned his living entirely by commercial illustration. After turning to painting full-time in 1924, however, he enjoyed a fairly rapid rise to recognition as the outstanding exponent of *American Scene Painting (he was given a retrospective exhibition by the *Museum of Modern Art in 1933 and this set the seal on his reputation).

Hopper's distinctive style was formed by the mid-1920s and thereafter changed little. The central theme of his work is the loneliness of city life, generally expressed through one or two figures in a spare setting—his best-known work, *Nighthawks* (Art Institute of Chicago, 1942), showing an all-night diner, has an unusually large 'cast' with four. Typical settings are motel rooms, filling stations, cafeterias, and almost deserted offices at night. He was the first artist to seize on this specifically American visual world and make it definitively his own. However, although his work is rooted in a particular period and place, it also has a peculiarly timeless feel and deals in unchanging realities about the human condition. He never makes feelings explicit or tries to tell a story; rather he suggests weariness, frustration, and troubled isolation with a poignancy that rises above the specific. Hopper himself enjoyed solitude (although he was happily married to another ex-student of Henri's) and he disliked talking about his work. When he did, he discussed it mainly in terms of technical problems; one of his best-known pronouncements is that he wanted only to 'paint sunlight on the side of a house'. Of *Nighthawks* he said: 'I didn't see it as particularly lonely . . . Unconsciously, probably, I was painting the loneliness of a big city.' Deliberately so or not, in his still, reserved, and blandly handled paintings he exerts a powerful psychological impact that makes him one of the great painters of modern life.

Hopper worked in watercolour as well as oil and also made etchings, beginning in 1915. In fact his individual vision emerged in printmaking before it did in painting—he later commented that 'After I took up etching, my painting seemed to crystalise'. His best-known print is *Evening Wind* (1921), establishing a theme that would later often recur in his paintings—the female nude in a city interior. He virtually abandoned printmaking in 1923, but in spite of his short career in the medium he has been described as 'undoubtedly the greatest American etcher of this century' (Frances Carey and Antony Griffiths, *American Prints 1879–1979*, 1980).

Hopper was dismayed by the rise of *Abstract Expressionism and in 1953 was one of a group of representational painters who launched the journal *Reality* as a mouthpiece for their views; in 1963 they protested to the Museum of Modern Art and the *Whitney Museum of American Art about the 'gobbledegook influences' of abstract art in their collections. Nevertheless, Hopper's widow, who survived him by only a year, left his entire artistic estate—over 2,000 works—to the Whitney.

Hopton Wood stone. A very hard limestone from the Hopton Wood Quarries, near Middleton, Derbyshire, varying in colour from light grey to light tan, flecked with dark-grey glistening crystalline speckles. It can be cut to a smooth face and sharp ridge and takes a good polish. Jacob *Epstein used a twenty-ton block of it for his tomb of Oscar Wilde (1912)

in Père Lachaise Cemetery Paris, and other modern British sculptors who have used it include Barbara *Hepworth and Henry *Moore.

Horn, Rebecca (1944–). German sculptor, *Performance artist, and film-maker, active in New York for much of her career. She was born in Michelstadt and studied at the Hochschule für Bildende Künste, Hamburg, 1964–70. Her work has been varied in media, sometimes fairly traditional (within the context of avant-garde art), but often experimental; she thinks that it is 'very important to go under the skin, to journey beneath the surface, to scratch about in search of something, to liberate a certain energy, to simply shake people, and wake them up. Especially in our time, you have to have a jolting attitude and then afterwards caress. It's very important to commit oneself, even to destroy certain existing values and through this destructive process discover something more meaningful and build something new.' Much of her early work featured costumes or artificial extensions of the body, 'devised for performances (and increasingly films), as in the fabric and wood horn and straps for her *Unicorn* of 1970 to 1972, which she performed nude in natural surroundings, and recorded on film' (Jonathan Fineberg, *Art Since 1940*, 1995). The suggestion of fetishism and sexual fantasy in this work is often apparent also in the large installations she began making in the 1980s. These typically feature eccentric machines, which Brian *Sewell sees as descendants of the wacky inventions of William Heath *Robinson. Reviewing an exhibition of her work in 1994 (Tate Gallery and Serpentine Gallery, London), Sewell said he found her contraptions 'very funny', but concluded that 'Aesthetically Miss Horn's machines are no more significant than Hornby trains and cuckoo clocks . . . less art than automata, they ought perhaps to be installed in public places to amuse the witless tourist who waits for Fortnum's clock to strike the midday hour'.

Hornel, Edward Atkinson. See GLASGOW BOYS.

Hornton stone. A limestone named after quarries at Hornton in north-west Oxford-shire. It is typically a rich rusty brown in colour, but green and greyish-blue tints also occur. It was a favourite stone of Henry *Moore, the celebrated *Madonna and Child* (1943–4) in St Matthew's, Northampton, being one of his best-known works in this material. The quarries at Hornton are now closed, but similar stone is obtained at nearby Edge Hill in Warwickshire.

Hory, Elmyr de (1911–76). Hungarian painter, draughtsman, and printmaker, notorious as a forger of the work of leading 20th-century artists. He came from a wealthy family and studied art in Budapest, Munich, and Paris (where *Léger was one of his teachers), and according to his own account he spent part of the Second World War in a German concentration camp. After the war he returned to Paris, and his career as a forger is said to have begun in 1946 when a visitor to his studio assumed a drawing on his wall was by *Picasso rather than by de Hory himself and offered to buy it; being very poor at the time he sold it without confessing it was his own work. (The story is typical of his romantic presentation of himself as an essentially decent person who was the victim of circumstances—and later of unscrupulous dealers.) In 1947 he moved to the USA, living mainly in New York and Los Angeles, where he liked to cultivate the company of Hollywood celebrities, including his fellow Hungarian Zsa Zsa Gabor. He sometimes posed as 'Baron de Hory' and made his living selling his fakes to dealers and private collectors (few went to museums; one of his '*Matisse' drawings was bought by the Fogg Art Museum, Harvard, in 1955, but there were soon doubts about it and it was never put on display). The artists he imitated were mainly stars of the pre-war art world he had known in Paris—including Picasso, Matisse, *Modigliani, van *Dongen, and *Vlaminck; his first-hand knowledge of this world helped him to produce plausible histories for his fakes. They included copies of genuine drawings and prints, as well as pastiches in the style of his chosen artists. His best drawings are skilful imitations, but his paintings are generally of much lower quality. In 1959 he returned to Europe, thereafter living mainly in Ibiza. He was arrested in 1968, following criminal charges against one of his associates, and he served a short sentence for a variety of offences, including homosexual practices and consorting with known criminals. Following his exposure he became something of a celebrity. He was the subject of a biography, *Fake! The Story of Elmyr de Hory, the Greatest Art*

Forger of our Time (1969) by Clifford Irving, and of a television documentary, and he featured in Orson Welles's film *F for Fake* (1973). However, he never made much money and led a precarious existence until he committed suicide with an overdose of sleeping pills (although according to an article in the *Independent* in 1991 'some suspect he may have faked his own death').

Houthuesen, Albert (1903–79). Dutch-born painter and printmaker who became a British citizen in 1922. He was born in Amsterdam, the son of **Pierre Houthuesen** (1878–1911), who was originally a pianist but took up painting. Following Pierre's death from a head injury (officially an accident but evidently caused in a violent quarrel with his wife), his widow moved to London with her four children in 1912. Albert studied at evening classes at *St Martin's School of Art, 1917–23, whilst working at various jobs, then won a scholarship to the *Royal College of Art, where he studied 1923–7. One of his fellow students at the RCA was the painter Catherine Dean (1905–83), whom he married in 1931. His work was often interrupted by ill-health and he and Catherine often endured poverty, making a living mainly from teaching at various art colleges in London. Albert's first one-man exhibition was at the Reid Gallery, London, in 1961, and it was only from this time that he began to make a name for himself. His work included genre scenes, landscapes, pictures of clowns (one of his Dutch relatives was a comic actor), religious subjects, and imaginative scenes, typically painted in rich colours and firm brush-strokes. In 1977 the BBC made a documentary film on him entitled *Walk to the Moon*. After his death, his widow was able to devote herself to her own work for the first time, and she was 76 when she had her first one-woman exhibition, which was a critical and financial success, at the Mercury Gallery, London, in 1982. Her paintings were mainly still-lifes and landscapes. There are examples of the work of both Dean and Houthuesen in the Tate Gallery, London.

Howson, Peter. See GLASGOW SCHOOL and OFFICIAL WAR ART.

Hoyland, John (1934–). British abstract painter, born in Sheffield. He studied at Sheffield College of Art, 1951–6, and the

*Royal Academy Schools, 1956–60. Since then he has taught at various art schools in London, and has travelled widely; he was Charles A. Dana professor of fine art at Colgate University, New York, in 1972, and artist-in-residence at the University of Melbourne in 1979. His work is typically on a large scale and is concerned primarily with colour: 'The shapes and colours I paint and the significance I attach to them I cannot explain in any coherent way. The exploration of colour, mass, shape is, I believe, a self-exploration constantly varied and changing in nature: a reality made tangible on the painted surface.' In his early work the paint was soaked into the canvas in a manner akin to that of American *Colour Field painters; in the 1970s his handling became richer and thicker. Hoyland's work has been shown in many international exhibitions and he is regarded as one of the leading British abstract painters of his generation. He also makes screenprints and etchings. See also SITUATION.

Hsü Pei-hung. See XU BEIHONG,

Hubert, Edgar. See OBJECTIVE ABSTRACTIONISTS.

Hudson, Anna Hope ('Nan'). See CAMDEN TOWN GROUP and SANDS.

Hughes, Robert (1938–). Australian art critic, resident in the USA since 1970. He was born in Sydney, where he studied architecture at the University, and he became art critic to the fortnightly magazine *Observer* when he was still an undergraduate. In 1964 he moved to Europe, living first in Italy and then from 1966 in London, where he wrote for the *Sunday Times* and other publications. Since 1970 he has been art critic of *Time* magazine in New York. His books include *The Art of Australia* (1966, revised 1970), *Heaven and Hell in Western Art* (1969), *Lucian *Freud: Paintings* (1988), and *Nothing if not Critical: Selected Essays on Art and Artists* (1990). He writes mainly on 20th-century art and has a richly deserved reputation as a witty and penetrating observer of the contemporary art scene. He has also made films for television, notably two impressive series, *The Shock of the New* (1980) and *American Visions* (1996), both with accompanying books of the same title. In his work for television he has received the kind of praise previously enjoyed by Kenneth *Clark,

but Hughes's approach is very different—forceful rather than suave.

Hughes-Stanton, Blair. See UNDERWOOD.

Hulbert, Thelma. See EUSTON ROAD SCHOOL.

Hulme, T. E. (Thomas Ernest) (1883–1917). British writer (a poet, critic, essayist, and—in his own phrase—'philosophic amateur'). He studied at Cambridge University but was sent down in 1904 for brawling. Thereafter he travelled widely, but he lived mainly in London, where he became friendly with many avant-garde artists. Hulme advocated the creation of a 'new geometrical and monumental art making use of mechanical forms', and he was a supporter of several artists in the *Vorticist circle, notably his friend *Epstein, who described him as 'a large man in bulk, and also large and somewhat abrupt in manner. He had the reputation of being a bully and arrogant . . . [but] only his intolerance of sham made him feared.' Hulme published his art criticism mainly in *The New Age*, a journal that lived up to its name in this period by being a forum for modernist ideas. Ardently militaristic, he enlisted at the beginning of the First World War and was killed in action. He had been writing a book on Epstein, but the manuscript was never found. However, he left numerous notebooks, and the material in these was edited by Herbert *Read into two books: *Speculations: Essays on Humanism and the Philosophy of Art* (1924) and *Notes on Language and Style* (1929).

Hulten, Pontus (1924–). Swedish art historian and administrator, whose international career has been largely concerned with the founding of major collections of modern art. He was born in Stockholm and studied at the universities of Copenhagen and Stockholm. In 1958 Hulten was appointed director of the *Moderna Museet, Stockholm, and in 1973 he became director of the Musée National d'Art Moderne, Paris, in which role he supervised the inauguration of the *Pompidou Centre; in 1981 he was described in the *International Herald Tribune* as 'a big man fond of jokes . . . a playful porpoise among the stuffed whales of the French cultural establishment'. From 1981 to 1982 Hulten was first director of the *Museum of Contemporary Art, Los Angeles, and from 1981 to 1993 he was first director of the Palazzo Grassi, Venice, a centre for tem-

porary exhibitions, largely sponsored by the car firm Fiat. In 1990 he became chief administrative officer of the newly established Kunst- und Ausstellungshalle der Bundesrepublik Deutschland (Art and Exhibition Hall of the German Federal Republic) in Bonn, and he is also director of the Jean *Tinguely museum in Basle. Ponten has organized numerous major exhibitions in his varied roles, including 'Paris-New York' (1977), the first of a series of blockbusters at the Pompidou Centre in which Paris was linked with other great art centres, and 'Futurism and Futurisms' (1986), the inaugural show of the Palazzo Grassi and the largest *Futurist exhibition ever held. In an article entitled 'Europe's Hottest Curators' in the March 1988 issue of *Art News*, Brigid Grauman described Hulten as 'perhaps the most brilliant of the curators who, over the years, have channelled a new enthusiasm for contemporary art'.

Humblot, Robert. See FORCES NOUVELLES.

Hume, Gary. See YOUNG BRITISH ARTISTS.

Humlebaek, Louisiana Museum. See LOUISIANA MUSEUM.

Hundertwasser, Fritz (Friedrich Stowasser) (1928–). Austrian painter, graphic artist, and designer, born in Vienna, where he studied briefly at the Academy in 1948. He adopted the name Hundertwasser in 1949, translating the syllable 'sto' (which means 'hundred' in Czech) by the German 'hundert'. From about 1969 he signed his work 'Friedensreich Hundertwasser', symbolizing by 'Friedensreich' (Kingdom of Peace) his boast that through his painting he would introduce the viewer into a new life of peace and happiness, a 'parallel world', access to which had been lost because the instinct for it had been corrupted by the sickness of civilization. He often adds 'Regenstag' (Rainy Day) to the name—making it in full 'Friedensreich Hundertwasser Regenstag'—on the ground that he feels happy on rainy days because colours then have an extra sparkle. This exaggerated concern with the name is a symptom of the braggadocio and conceit that characterize his life and work. He has a talent for self-advertisement and has built himself up into a picturesque figure given to gnomic utterances about his own significance in the world. Standing outside most contemporary

artistic movements, though borrowing from many, he works mainly on a small scale, often in watercolour. His work has sometimes been compared with that of Paul *Klee, but although it is in the same tradition of figurative fantasy, it lacks Klee's elegance and wit. In his concern with the dehumanizing aspects of 20th-century society, Hundertwasser has been an outspoken critic of modern architecture, and he is now perhaps best known for the design of an idiosyncratic, multi-coloured, fairytale-like housing unit in Vienna—the Hundertwasser House (completed 1986).

Hunter, Leslie (1877–1931). Scottish painter of landscapes, still-life, and occasional portraits, one of the *Scottish Colourists who introduced a knowledge of modern French painting to their country. He was born in Rothesay, Isle of Bute, and in 1892 emigrated with his family to California, where between 1899 and 1906 he studied in San Francisco and then worked there as a painter and illustrator. In 1904 he visited New York and Paris. Much of his early work was destroyed in the San Francisco earthquake of 1906, ruining an exhibition he was planning, and in that year he returned to Scotland, settling in Glasgow. There he was supported by the dealer Alexander Reid (1854–1928), who played an important role in promoting a taste for French painting. His first one-man show was in 1913. Hunter's best-known works are perhaps his views of Loch Lomond, which through his eyes looks so French that it could almost be the River Seine at Argenteuil (*Reflections, Balloch*, NG of Modern Art, Edinburgh, 1929–30).

Huntingdon, Anna Hyatt (1876–1973). American sculptor of animal subjects in a traditional style. She was born in Cambridge, Massachusetts, daughter of the eminent palaeontologist Alpheus Hyatt, who was also an amateur painter. Her love of animals was nurtured by childhood summers spent on a farm in Maryland and she became an expert horsewoman; she said that 'animals have many moods, and to represent them is my joy'. Although she studied briefly at the *Art Students League, New York, under Gutzon *Borglum, she was primarily self-taught. She had her first one-woman exhibition at the Boston Arts Club in 1900. From 1907 to 1911 she travelled in Europe, winning an honourable mention at the 1910 Paris Salon for an equestrian statue of Joan of Arc (an enlarged version in bronze was erected on Riverside Drive, New York, in 1915). In 1923 she married **Archer M. Huntingdon** (1870–1955), a poet, scholar of Spanish literature, and philanthropist (he was the son of a railroad magnate and the cousin (later also step-son) of Henry E. Huntingdon, who created the Henry E. Huntingdon Library and Art Gallery at San Marino, California). In 1908 Archer had founded the Hispanic Society of America in New York; he commissioned *Sorolla y Bastida to paint murals for the interior of the Society and a large equestrian statue of El Cid by Anna stands outside (another cast was erected in Seville in 1927). The Huntingdons collaborated on various philanthropic projects, including schemes for protecting wild animals, and in 1931 they founded Brookgreen Gardens, near Charleston, South Carolina. Originally they envisaged this as a nature retreat and a sculpture garden for Anna's work, but they also collected and commissioned sculpture by other artists for it. By this time, having been weakened by tuberculosis, she was generally concentrating on smaller pieces. She won many awards, including being made a chevalier of the Legion of Honour.

Hurd, Peter. See REGIONALISM.

Hurrell, Harold. See ART & LANGUAGE.

Hussey, Walter. See SUTHERLAND.

Huszár, Vilmos (1884–1960). Hungarian-born painter, designer, and graphic artist, who settled in the Netherlands in 1906. He was one of the founders of De *Stijl in 1917 and he continued his association with the group until 1923. His speciality at this time was designing abstract stained glass and interior decoration. Later he returned to figure painting in a geometrical style.

Hutchison, Sir William Oliphant. See EDINBURGH GROUP.

Hutter, Wolfgang. See FANTASTIC REALISM.

Hyatt Huntingdon, Anne. See HUNTINGDON.

Hyper-Modernism. See PITTURA COLTA.

Hyperrealism. See SUPERREALISM.

Hyppolite (or **Hippolite**), **Hector** (1894–1948). Haitian painter. He is the most famous of his country's remarkable crop of *naive painters, but he did not achieve recognition until the final years of his life, after André *Breton encountered his work on a visit to the island in 1945 and arranged exhibitions of his paintings in Europe. Before this, Hyppolite spent most of his life in poverty and obscurity, and there is little solid information about his early career. He was born in St Marc and followed his father and grandfather in becoming a Voodoo priest. He also worked as a cobbler and house-painter, and his artistic work began with the decoration of doors and walls. It was only towards the end of his life that he began painting easel pictures, and he is said to have regretted that they distracted him from his duties as a Voodoo priest. Many of his paintings were inspired by his religious beliefs, featuring Voodoo scenes and symbols. He used bold, flat forms and vivid colours, and had no interest in technical refinement, his paint sometimes being applied with chicken feathers or his fingers. His success helped to inspire other Haitian naive painters, notably Rigaud Benoit (1911–86), who married Hyppolite's daughter, and Wilson *Bigaud, who was as a boy was a neighbour of Hyppolite in Port-au-Prince.

Ibbotson, Diane. See SUPERREALISM.

ICA. See INSTITUTE OF COMTEMPORARY ARTS.

Idea art. See CONCEPTUAL ART.

Imagist. See ABSTRACT IMAGISTS.

Immaculates. See PRECISIONISM.

Immendorff, Jörg. See NEO-EXPRESSIONISM.

Imperial War Museum, London. See OFFICIAL WAR ART.

Impossible art. See ARTE POVERA.

Impressionism. A movement in painting that originated in France in the 1860s and had an enormous impact on Western art over the following half century. As an organized movement, Impressionism was purely a French phenomenon, but many of its ideas and practices were adopted in other countries, and by the turn of the century it was a dominant influence on avant-garde art in Europe (and also in the USA and Australia). In essence, its effect was to undermine the authority of large, formal, highly finished paintings in favour of works that more immediately expressed the artist's personality and response to the world.

The nucleus of the Impressionist group was formed in the 1860s, and the name was coined facetiously by a reviewer of the first joint exhibition, held in Paris in 1874. Seven more Impressionist exhibitions followed, the last in 1886, by which time the group was beginning to lose its cohesion (it was in any case never formally structured). The central figures (in alphabetical order) were Paul *Cézanne; Edgar *Degas; Édouard Manet (1832–83), although he never exhibited in the group shows; Claude *Monet; Camille *Pis-

sarro; Pierre-Auguste *Renoir; and Alfred Sisley (1839–99). The minor figures included Armand *Guillaumin, who was the last survivor of those who showed in the 1874 exhibition, dying in 1927, the year after Monet. These painters differed from each other in many ways, but they were united in rebelling against academic conventions to try to depict their surroundings with spontaneity and freshness, capturing an 'impression' of what the eye sees at a particular moment, rather than a detailed record of appearances. Their archetypal subject was landscape (and painting out of doors, directly from nature, was one of the key characteristics of the movement), but they treated many other subjects, notably ones involving everyday city life.

The Impressionists were at first generally received with suspicion, bewilderment, or abuse (although the critical response was not as one-sided as is sometimes suggested). To most observers, their vigorous brushwork looked sloppy and unfinished, and their colours seemed garish and unnatural. Among conservative artists and critics, this continued to be the prevailing view for many years. For example, when the painter Gustave Caillebotte (1848–94) left his superb Impressionist collection to the French nation, the academic painter and sculptor Jean-Léon Gérome (1824–1904) wrote that 'For the Government to accept such filth, there would have to be a great moral slackening', and at about the same time in England, Sir Edward *Poynter expressed a similar disdain, although in more temperate language. In more sympathetic circles, however, the Impressionists began achieving substantial success in the 1880s (helped by the dedicated promotion of *Durand-Ruel), and during the 1890s their influence began to be widely felt. Few artists outside France adopted Impressionism wholesale, but many lightened their palettes and loosened their brushwork as they synthesized

its ideas with their local traditions. The support of critics such as Julius *Meier-Graefe in Germany and George *Moore and Frank *Rutter in Britain was important in increasing awareness and understanding of the movement (the first book on Impressionism in English, published in 1903, was a translation of a work by the French critic Camille *Mauclair; the first book on the subject actually written in English appeared a year later—*Impressionist Painting: Its Genesis and Development* by the British landscape painter Wynford Dewhurst (1864–1941), who knew Monet and corresponded with Pissarro).

Outside France, it was perhaps in the USA that Impressionism was most eagerly adopted, both by painters such as Childe *Hassam and the other members of The *Ten and by collectors (Mary *Cassatt helped to develop the taste among her wealthy picture-buying friends). It also made a significant impact in Australia, with Tom *Roberts playing the leading role in its introduction. In Britain, *Sickert and *Steer are generally regarded as the main channels through which Impressionism influenced the country's art, but the differences between their work shows how broadly and imprecisely the term has been used (at the time, D. S. *MacColl commented that it was applied to 'any new painting that surprised or annoyed the critics or public'). For a few years around 1890, Steer painted in a sparklingly fresh Impressionist manner, but his style later became more sober; Sickert adopted the broken brushwork of Impressionism (as did his followers in the *Camden Town Group), but he used much more subdued colour, and he had a taste for quirky, distinctively English subject-matter. In contrast, the painters of the *Newlyn School often painted out of doors in conscious imitation of the French and used comparatively high-keyed colour, but they generally did not adopt Impressionist brushwork. Accordingly, many authorities think that among British artists, only Steer—and he only briefly—can be considered a 'pure' Impressionist.

In addition to prompting imitation and adaptation, Impressionism also inspired various counter-reactions—indeed its influence was so great that much of the history of late 19th-century and early 20th-century painting is the story of its aftermath. The *Neo-Impressionists, for example, tried to give the optical principles of Impressionism a scientific basis, and the *Post-Impressionists began a long series of movements that attempted to free colour and line from purely representational functions. Similarly, the *Symbolists wanted to restore the emotional values that they thought the Impressionists had sacrificed through concentrating so strongly on the fleeting and the casual.

Indépendants, Salon des. See SALON DES INDÉPENDANTS.

Independent Group. A small and informal discussion group that met intermittently between 1952 and 1955 at the *Institute of Contemporary Arts, London. The members, who represented a wide cross-section of the visual arts, included Lawrence *Alloway, Richard *Hamilton, Eduardo *Paolozzi, Reyner Banham (1922–88), an architectural and design historian, and several architects. The issues they discussed included advertising and mass culture, and the first phase of British *Pop art grew out of the Group. After it had ceased to exist, some of the members were involved in mounting the 'This is Tomorrow' exhibition at the *Whitechapel Art Gallery, London.

Index of American Design. See FEDERAL ART PROJECT.

Indiana, Robert (1928–). American painter, sculptor, and graphic artist, born in New Castle, Indiana. His original name was Robert Clark, but he adopted the name of his native state as his own. He studied successively in Indianapolis, Ithaca, Chicago, Edinburgh, and London before settling in New York in 1956. He is regarded as one of the leading American *Pop artists, and although he has done some figurative paintings he is best known for pictures involving geometric shapes emblazoned with lettering and signs. His vivid colours often create effects of visual ambiguity reminiscent of those of *Op art. In 1964 Indiana collaborated with Andy *Warhol in a film *Eat* and in the same year executed a commission for the exterior decoration of the New York State Pavilion at the New York World's Fair consisting of a 6-metre sign reading EAT. He has also done many sculptures of letters forming the word LOVE. In 1978 he settled on the island of Vinalhaven, off the Maine coast.

Informalism. See ART INFORMEL.

Informele Groep. See NUL.

Inkhuk (abbreviation for Institut Khu-dozhestvennoi Kulturi: 'Institute of Artistic Culture'). An organization set up in Moscow in May 1920 for the purpose of working out and implementing a programme of artistic experiment for post-Revolutionary Russia. It was a section of the Department of Fine Arts, which had been formed in 1918 under the Commissariat for People's Enlightenment (IZO *Narkompros). *Kandinsky was Inkhuk's first chief. At the end of 1921 sections were formed in Petrograd under *Tatlin and in Vitebsk under *Malevich. Many of the leading Russian artists of the day were involved in one way or another.

Originally Inkhuk was going to be run according to a programme devised by Kandinsky, but his rarefied ideas were uncongenial to most of the members, who desired an art that would contribute directly to the creation of a Communist utopia. When his programme was voted out, Kandinsky left Inkhuk, and the organization divided into two schools of thought about the form that the new art should take, named 'laboratory art' and 'production art' respectively. The pronouncements of neither side were particularly clear. Laboratory art involved a rationalizing, analytical approach to artistic creation, with a social end in view, but not necessarily the abandoning of traditional materials (such as paint and canvas). In production art the distinction between artist and engineer was to be eliminated and the artist was to become a designer or craftsman for machine production. The production group was the more influential and contributed to the rise of *Constructivism. In the late 1920s Inkhuk also supported *Socialist Realism.

Innes, George. See TONALISM.

Innes, J. D. (James Dickson) (1887–1914). British painter, mainly of landscapes (particularly mountain scenes) but also occasionally of figure subjects. He was born in Llanelli and studied at Carmarthen Art School, 1904–5, and the *Slade School, 1906–8. In 1908 he met Augustus *John and formed a close friendship with him; they often painted together, particularly in their native Wales in 1911 and 1912. Another friend with whom he enjoyed working was Derwent *Lees. Between 1908 and 1913 Innes travelled widely in France,

Spain, North Africa, and the Canary Islands, hoping to recuperate from tuberculosis, but he died of the illness in a nursing home in Kent in 1914. His early work was in an *Impressionist manner influenced by *Steer, but after leaving the Slade he developed a more expressive *Post-Impressionist style, combining a strong sense of pattern with a range of hot colour similar to that used by *Derain and *Matisse. He usually painted on a fairly small scale, often on wooden panels; he also worked a good deal in watercolour.

Inshaw, David. See BROTHERHOOD OF RURAL-ISTS.

installation. A term that can be applied very generally to the disposition of objects in an exhibition (the hanging of paintings, the arrangement of sculptures, and so on), but which also has the more specific meaning of a one-off work (often a large-scale *assemblage) conceived for and usually more or less filling a specific interior (generally that of a gallery). This type of work has various precedents. The tradition of 'site-specific' works has indeed been traced back to prehistoric cave paintings, but there are closer analogies in some of the elaborate *Surrealist exhibitions of the 1930s, with their fun-fair-like atmospheres, in the room-filling *Merz* construction of Kurt *Schwitters, and in Yves *Klein's exhibition of an empty room, *The Void*, in 1958 (this is sometimes considered the earliest example of an installation in the sense in which the term is now understood). However, it was not until the 1970s that the term came into common use and not until the 1980s that certain artists started to specialize in this kind of work, creating a genre of 'Installation art'. In 1990 a Museum of Installation Art was opened in London and in 1994 there was published a book entitled *Installation Art* (by Nicolas de Oliviera, Nicola Oxley, and Michael Petry), the jacket blurb of which claimed that this was 'arguably the most original, vigorous and fertile form of art today'.

In the 1970s installations were often impermanent and could be seen as part of the movement against the collectable art 'object' that was so fashionable at the time (see POST-MINIMALISM). However, many installations are now intended for permanent display, and even some of the most unlikely works have proved collectable. The best-known example is *20:50* (1987) by the British sculptor Richard

Wilson (1953–), which consists of a room filled with used sump oil; this was created for the Matt's Gallery, London, but it was subsequently resited at the Royal Scottish Academy, Edinburgh, and it is now in the Saatchi Collection, London. An example of a more 'traditional' installation is *The Reign of Narcissism* (Museum of Contemporary Art, Los Angeles, 1989) by the American artist Barbara Bloom (1951–). Edward *Lucie-Smith writes of this that 'perhaps in reaction to the self-promotion of certain feminists . . . [it is] . . . a gentle satire on female self-love and self-preoccupation—a bland Neoclassical salon filled with busts and cameos reproducing her own image, plus imitation Louis XVI chairs upholstered in a pattern showing the artist's signature' (*Visual Arts in the 20th Century*, 1996).

Institute of Contemporary Arts (ICA), London. Cultural centre founded by Roland *Penrose and Herbert *Read in 1947 to encourage new developments in the arts and cater for some of the functions fulfilled by the *Museum of Modern Art in New York, organizing exhibitions, lectures, films, concerts, poetry readings, and so on. Its original home was in Dover Street, but it moved to Nash House, the Mall, in 1968. Many leading artists have been members of the ICA and it has played an important role in certain developments; for example, in the 1950s it was the cradle of British *Pop art (see INDEPENDENT GROUP), and in 1969 it was the venue for the first exhibition of *Conceptual art in Britain, 'When Attitudes Become Form'.

intermedia. See MIXED MEDIA.

International Artists' Association. See ARTISTS INTERNATIONAL ASSOCIATION.

International Coalition for the Abolition of Art. See ART WORKERS' COALITION.

International Studio. See *STUDIO*.

International Style (or **International Modern Style**). See MODERN MOVEMENT.

Intimisme. A type of painting featuring intimate domestic scenes, more or less *Impressionist in technique, particularly associated with *Bonnard and *Vuillard, who practised it from the 1890s (this is when the term was first used). Whereas the Impressionists in their landscapes usually aimed at accurately reflecting the colours of the natural world, the Intimistes often exaggerated and distorted colour to express mood, conveying the warmth and comfort of an untroubled domestic life. Vuillard's style remained essentially Intimiste for the rest of his career, but Bonnard's work sometimes has a grandeur and richness to which the term does not seem altogether appropriate.

Ioganson, Boris. See AKHRR

Ipoustéguy, Jean (1920–). French sculptor, born at Dun-sur-Meuse. In 1938 he moved to Paris, where he studied art at evening classes. He initially worked mainly as a painter, and in 1947 he created frescos and stained-glass windows for the church of St Jacques at Montrouge. However, after he settled in the Parisian suburb of Choisy-le-Roi in 1949 he turned exclusively to sculpture. He has worked in various materials, including marble, but his most characteristic works are in bronze. His early sculpture was predominantly abstract, but from the late 1950s he created a distinctive *Expressionist figurative idiom: he 'employs extremely heavy bronze, carefully finished in a black or very dark patina, a smooth mass that is then shattered at many points. It is though the impregnable material has been torn apart by some cosmic explosion' (H. H. *Arnason, *A History of Modern Art*, 1969). He has made numerous public monuments, for example that to the poet Rimbaud in the Place de l'Arsenal, Paris (1984). From the mid-1970s he has also worked as a printmaker.

Irascible Eighteen (or **Irascibles**). A group of American artists who in 1950 protested against the exhibition policy of the Metropolitan Museum, New York, demanding the formation of a department to show modern American art. A photograph (now much reproduced) of fifteen of the Irascibles appeared in *Life* magazine on 15 January 1951. Among them were many of the leading *Abstract Expressionists, including *de Kooning, *Newman, *Pollock, *Rothko, and *Still.

Irish Exhibition of Living Art. See JELLETT.

Irish Museum of Modern Art, Dublin. Museum opened in 1991 in the Royal Hospital, Kilmainham (a district at the west end

of the city). The Hospital, built in 1680–7 to house disabled and veteran soldiers, is the largest and most impressive secular building of its period in Ireland and stands on a commanding site, looking over the River Liffey opposite Phoenix Park. It consists of four ranges around a central courtyard. In 1949 the building was vacated as unsafe (at this time it was serving as the headquarters of the Civic Guard) and it has been many years in restoration and conversion to a museum. When it opened it had no permanent collection, but one has quickly been built up by purchase and gift. It also holds loan exhibitions. The museum is not to be confused with Dublin's other important collection of modern art, the Hugh *Lane Municipal Gallery of Modern Art.

iron and steel. Metals that have been among the main additions to the materials used in sculpture in the 20th century. Steel is a purified form of iron, but the two metals are not always precisely distinguished; up to about the Second World War, the material used in sculpture was generally referred to as iron, but much of it could probably more accurately be described as steel. Iron is one of the most widely distributed of metals and has been used in ornamental work since prehistoric times. Its malleability varies with the impurities present, especially the amount of carbon. The type that has been most used in decorative work is wrought iron, which has a very low carbon content and can be hammered into elaborate shapes. In the 19th century it was superseded for many purposes by cast iron; this contains more carbon and is consequently more brittle, but it had the advantages of being cheaper to produce and less subject to corrosion. Steel combines something of the strength of wrought iron with the malleability of cast iron. 'Cor-Ten' steel is a proprietary name for a type of 'self-weathering' steel popular with some contemporary sculptors. It contains a small amount of copper and acquires a patina that resists corrosion.

The first modern sculptor to use iron was perhaps Pablo *Gargallo, who made hammered masks in the material from about 1907. His work helped to inspire *Picasso to create what has been described as the first steel sculpture, *Guitar* (MOMA, New York, 1912), made of sheet metal and wire. Picasso's sculptural experimentation was an inspira-

tion to *Tatlin, the founder of *Constructivism, in which steel (along with other modern materials) played a large part, its association with engineering making it appropriate to the creation of forms expressing the machine age. Picasso also played an important role in the development of welded sculpture, collaborating from 1928 to 1931 with Julio *González, the main pioneer of the technique. González (who came from a family of metalworkers) taught Picasso welding, in which pieces of metal are joined by melting them together with a blowtorch. This made possible such free-flowing openwork constructions as Picasso's *Woman in a Garden* (Musée Picasso, Paris, 1929–30), which Timothy Hilton describes as 'one of the great sculptures of the twentieth century' and as 'much more "modern" than anything he painted at this time' (*Picasso*, 1975). Among the many sculptors influenced by such 'drawing in space' was David *Smith, who said after seeing reproductions of González's work: 'I learned that art was being made with steel—the material and machines that had previously meant only labor and earning power.' Like González, Smith was highly influential on sculpture after the Second World War, and more than anyone else he established steel as a material with its own expressive qualities, notably by grinding and polishing the surfaces of his work. Smith also helped encourage the use of scrap metal and prefabricated industrial parts in sculpture. Scrap has been much used in *Junk art, for example, and industrial parts in the work of Anthony *Caro, who inspired a generation of British abstract sculptors. *Minimal artists, too, have made much use of steel, valuing its impersonal qualities.

Ironside, Robin (1912–65). British painter, theatrical designer, and writer on art, born in London. He studied art history at the Courtauld Institute and was assistant keeper at the Tate Gallery, London, from 1937 to 1946 (for most of this period he was also assistant secretary of the *Contemporary Art Society). In 1946 he resigned from the Tate to devote himself to painting (in which he was self-taught) and writing about art, supporting himself partly through designing for the stage. His most characteristic paintings were imaginative—often esoteric—figure subjects. Among the theatrical works for which he designed were *Der Rosenkavalier* (Royal Opera House,

Covent Garden, 1948) and *A Midsummer Night's Dream* (Edinburgh Festival, 1954). His best-known book is *Pre-Raphaelite Painters* (1948), the first serious modern work on this group. His other writings include *Painting Since 1939* (1947) in the British Council 'The Arts in Britain' series and introductions to monographs on *Steer (1943) and David *Jones (1949). In his writing and his art he was an independent figure, unconcerned with prevailing fashions.

His brother **Christopher Ironside** (1913–92) was a designer (especially of coins) and painter. He sometimes collaborated with Robin on theatrical work. Christopher's first wife, **Janey Ironside** (née Acheson) (1919–79), was a fashion designer; she was professor of fashion at the *Royal College of Art from 1956 to 1968.

Isakson, Karl (1878–1922). Swedish painter, active mainly in Denmark. He worked in Paris 1905–7 and 1911–14 and was one of the first Scandinavians to show the influence of *Cézanne and the *Cubists. His work had considerable influence on other Scandinavian artists, although it was virtually unknown in Sweden until 1922, when an exhibition was held in Stockholm soon after his death. He painted still-lifes, nudes, and landscapes, and towards the end of his life visionary religious subjects, which he treated with the same regard for structure.

Isham, Samuel. See TONALISM.

Iskusstvo kommuny. See NARKOMPROS.

Island, The. See UNDERWOOD.

Israëls, Jozef. See BIENNALE.

Istrati, Alexandre. See DUMITRESCO.

Itten, Johannes (1888–1967). Swiss painter, designer, writer on art, and teacher, born at Südern-Linden. He trained as a primary school teacher but decided to become a painter and studied under *Hölzel in Stuttgart, 1913–16. In 1916 he opened his own school of art in Vienna, then from 1919 to 1923 he taught at the *Bauhaus, where he was in charge of the 'preliminary course', obligatory for all students. In 1923 he left the Bauhaus and opened another school of his own in Berlin, then from 1932 to 1938 he taught at the Krefeld School of Textile Design. In 1938 he settled in Zurich, where he held four posts concurrently—as director of the School of Arts and Crafts, the Museum of Arts and Crafts, the Rietberg Museum, and the School of Textile Design. He retired in 1961.

Itten's work as a painter consisted mainly of geometrical abstractions, exemplifying his researches into colour. However, he is best remembered as a teacher, especially for his preliminary course at the Bauhaus, which had a great influence on instruction in other art schools. He emphasized the importance of knowledge of materials, but also encouraged his pupils to develop their imaginations through, for example, automatic writing (see AUTOMATISM). His mystical ideas were opposed to the technological outlook of *Gropius (their quarrels caused Itten's departure from the Bauhaus) and he had a reputation as a crank (he followed an obscure faith called Mazdazhan, shaved his head, and wore a long robe), but he influenced many of his students. Frank *Whitford (*Bauhaus*, 1984) describes him as 'a man of strange beliefs, a teacher of unconventional brilliance and a perplexing mixture of saint and charlatan'. Itten wrote several books on the theory of art, the best known of which is probably *Kunst der Farbe*, published in 1961 and in the same year translated into English as *The Art of Color: The Subjective Experience and Objective Rationale of Color*.

IZO Narkompros. See NARKOMPROS.

Izquierdo, María. See TAMAYO.

Jack of Diamonds. See KNAVE OF DIAMONDS.

Jackson, A. Y. (Alexander Young) (1882–1974). Canadian landscape painter, born in Montreal and active mainly in Toronto, where he settled in 1913 after extensive travels in Europe (1905, 1907–9, and 1911–13). Jackson was one of the leading artists of the *Group of Seven and in the latter part of his long career he became a venerated senior figure in Canadian painting. He visited almost every region of Canada, including the Arctic, and responded particularly to the hilly region of rural Quebec along the St Lawrence River. From 1921 he visited the area almost every spring, and the canvases he produced from sketches made there are regarded as his finest works. Their easy, rolling rhythms and rich colouring influenced many other Canadian landscape painters. Jackson moved to Ottawa in 1955 and in 1958 published his memoirs, *A Painter's Country*. He died at Kleinburg, Ontario.

Jacob, Max (1876–1944). French writer, painter, and draughtsman, a colourful figure in the Parisian art world in the early years of the 20th century. He was born in Quimper, the son of a tailor, and moved to Paris in 1894 to study law. After dropping out of his course, he took up journalism (including art criticism), then studied at the *Académie Julian. He was initially unsuccessful at both writing and painting, and he took various lowly jobs to stave off his dire poverty. In 1901 he became friends with *Picasso after seeing his first exhibition in Paris and leaving an admiring note at the gallery (*Vollard's). John *Richardson writes that 'The pale, thin gnome with strange, piercing eyes almost immediately assumed the role of mentor in Picasso's life . . . even if at first they had no language in common except mime and were in so many respects unalike. Jacob was Jewish and homo-

sexual ("*sodomite sans joie . . . mais avec ardour*") and deeply insecure . . . However, he was infinitely perceptive about art as well as literature and an encyclopedia of erudition . . . He was also very, very funny' (*A Life of Picasso*, vol. 1, 1991). During his third visit to Paris, in the winter of 1902–3, Picasso was going through a rare period of abject poverty himself and Jacob helped him out by letting him share his room, Picasso having the bed by day and Jacob by night; a few years later, after Picasso settled in Paris, he and Jacob were neighbours in the *Bateau-Lavoir. Jacob's other close friends in the art world included *Apollinaire and *Gris. His writings, which include poetry, novels, and children's stories, are marked by fantasy and verbal clowning, but also by sharp and ironic observation and intense self-examination. In 1909 he became a convert to Catholicism, although he continued to delve into the occult, and in 1921 he went into semi-monastic retreat at St Benoît-sur-Loire, where he supported himself by painting, his work including pious religious scenes. However, he made visits to Paris, where his old dissolute ways overcame his new piety. In 1943, because he was Jewish, he was arrested by the Germans and sent to a concentration camp at Drancy. Picasso did nothing to save his old friend (their relationship had cooled in the 1930s). Instead, *Cocteau pulled strings to get him freed, but he died of pneumonia the day before he was to be released.

Jacobsen, Georg. See ROLFSEN.

Jacquet, Alain. See MEC ART.

Jagger, Charles Sargeant (1885–1934). British sculptor, best known for his war memorials—he is described by Alan Borg as 'the only major artist to have made his reputation in this way' (*War Memorials: From Antiquity to the Present*, 1991). Jagger was born at

Kilnhurst, Yorkshire, the son of a colliery manager, and at the age of 14 he was apprenticed as a metal engraver with the Sheffield firm of Mappin & Webb. In 1907 he won a scholarship to the *Royal College of Art, where he studied from 1908 to 1911. His early work, such as *Torfrida* (Clifton Park Museum, Rotherham, *c.* 1911) shows the impact of the *New Sculpture in its medievalism and concentration on surface qualities. At the end of his student period he won a travelling scholarship that enabled him to spend several months in Rome and Venice. In 1913 he was placed second to Gilbert *Ledward in competition for the Rome Scholarship and the following year he won the award. However, the First World War intervened before he could take it up. He enlisted in the army, fought at Gallipoli and in France, was wounded three times, and won the Military Cross. His experience of trench warfare is reflected in his huge bronze relief *No Man's Land* (Tate Gallery, London, 1919–20). He began making sketches for this in 1918 when he was recovering from a severe wound, and the finished work was commissioned by the British School of Rome in lieu of the scholarship he had relinquished. It is one of the grimmest images inspired by the war, showing a solitary look-out taking cover behind corpses strewn across barbed wire.

Some of this realism survived in his memorials, the first of which was the Hoylake and West Kirby Memorial, Lancashire (1919–20); it contrasts a powerfully characterized infantryman—dishevelled but resolute—with an allegorical figure of *Humanity*. Jagger's most famous work is the Royal Artillery Memorial (Hyde Park Corner, London, 1921–5), the most prominent feature of which is a huge stone howitzer (fulfilling the wishes of the regiment that the monument should be clearly identifiable as its own). Below this, life-size bronze statues of an officer, a driver, a shell-carrier, and—a bold decision—a dead soldier are combined with stone reliefs depicting war as painful labour in a style reflecting Jagger's admiration for Assyrian art. This was a vision far removed from the symbolic or idealized approach of most contemporary war memorials (for example, Derwent *Wood's nearby Machine Gun Corps memorial) and the work caused considerable controversy, partly because the howitzer was in stone rather than the more natural-seeming bronze (Jagger said that he did not want a dark object against the skyline). In *The Buildings of England*, Sir Niko-laus Pevsner refers to the 'ill-advised portrait in stone of a big gun', but to Arthur Byron (*London Statues*, 1981), the Royal Artillery Memorial is 'a superb work', and to Alan Borg (*War Memorials*, 1991) it is 'one of the outstanding examples of 20th century British art'.

Jagger remained a leading sculptor after the demand for war memorials was over, his major commissions including stone figures at Imperial Chemical House, London (1928). He came to be regarded as a conservative figure, although some of his late work clearly shows the influence of *Art Deco. In 1933, a year before his sudden death from a heart attack, he published an instructional book *Modelling and Sculpture in the Making*; this was still in print in the 1950s and remains a valuable account of studio practice in the early part of the 20th century. A major exhibition of his work was held at the Imperial War Museum, London, in 1985. Jagger's brother David and his sister Edith were painters.

'Jamaican Art Movement'. See MANLEY.

Janco, Marcel (1895–1984). Romanian-Israeli painter, born in Bucharest. In 1915–16 he studied architecture in Zurich, where he became one of the most energetic members of the original *Dada group. At this time he was producing constructions and coloured reliefs as well as oils and collages. He was something of an idealist, seeking a synthesis between abstract painting and architecture, and he was a member of a group of mainly Swiss artists called Das Neue Leben (The New Life), which aimed to remove barriers between 'fine' and 'applied' art and redefine the role of the artist in society. The group ran from 1918 to 1920 and organized exhibitions in Basle, Berne, and Zurich. In 1921 Janco visited Paris and in 1922 returned to Romania, where he was a member of the group Contimporanul, which published a journal of the same name. He left Romania in 1941 and became a Jewish refugee in Israel, settling in Tel Aviv. In the 1940s he abandoned abstraction for an *Expressionist style in which he depicted his new surroundings. He was a member of *New Horizons and in 1953 established an artists' colony at Ein Hod; at about this time he returned to abstraction in a more lyrical vein than that of his early work.

Janis, Sidney (1896–1989). American art dealer and writer on art. Between the depar-

ture of Peggy *Guggenheim from the USA in 1947 and the rise of Leo *Castelli in the 1960s he was the most important figure in promoting the work of avant-garde American artists. He opened a gallery on 57th Street, New York, in 1948. 'By 1949 he had begun to exhibit art that made the gallery a focus of *Abstract Expressionism. With the exhibition "American Vanguard Art" of 1952–3, Janis became associated with figures such as *Baziotes, *de Kooning, *Pollock, *Gottlieb, *Kline, *Rothko and *Motherwell. The gallery never had more than nine American artists at one time, since Janis . . . needed to sell classic European art in order to survive' (catalogue of the exhibition 'American Art in the 20th Century', Royal Academy, London, 1993). Janis was also interested in *naive art and 'discovered' Morris *Hirshfield in 1939. He wrote *They Taught Themselves: American Primitive Painters of the 20th Century* (1942), *Abstract and Surrealist Art in America* (1944), and (with his wife Harriet) *Picasso: The Recent Years, 1939–1946* (1946).

Janson, H. W. See AVANT-GARDE.

Janthur, Richard. See PATHETIKER.

Jaray, Tess (1937–). British painter, graphic artist, and designer. She studied at *St Martin's School of Art, 1954–7, and the *Slade School, 1957–60. From 1964 to 1968 she taught at Hornsey College of Art, London, and subsequently at the Slade School. Her work is abstract, using geometrical shapes subtly arranged and typically painted in soft colours. Sometimes they form a kind of irregular grid evoking the decorative patterns of Islamic architecture (*Minaret*, Graves Art Gallery, Sheffield, 1967). Her own decorative work includes commissions on an architectural scale, notably a floor for Victoria Station, London. She says that what she is trying to suggest in her work is 'the sense of all experience of life being part of a whole, perceptible only in flashes and fragments'.

Jaudon, Valerie. See PATTERN AND DECORATION MOVEMENT.

'Jauran'. See PLASTICIENS.

Jawlensky, Alexei von (1864–1941). Russian *Expressionist painter and printmaker, active mainly in Germany. He came from an aristocratic family and was originally destined for a

military career. In 1889 he began studying painting at the St Petersburg Academy under *Repin and in 1896 he resigned his commission in the Imperial Guard and moved to Munich with his fellow student Marianne von *Werefkin to devote himself completely to art. (Jawlensky and Werefkin were companions for 30 years, but in 1902 he had a child by another woman—Helene Nesnakomoff (who left Russia with them)—and he married her in 1922 after finally parting from Werefkin.)

Munich was to be Jawlensky's home until the outbreak of the First World War, but he travelled a good deal in this period, making several visits to France, for example (he was the first of his Munich associates to have direct contact with advanced French art). In 1905 he met *Matisse in Paris and was influenced by the strong colours and bold outlines of the *Fauves. He combined them with influences from the Russian traditions of icon painting and peasant art to form a highly personal style that expressed his passionate temperament and mystical conception of art. A mood of melancholy introspection—far removed from the ebullience of Fauvism—is characteristic of much of his work and it has been said that he 'saw Matisse through Russian eyes'. In 1909 he was one of the founders of the *Neue Künstlervereinigung, and apart from *Kandinsky he was the outstanding artist of the group. Although he did not become a formal member of its offshoot the *Blaue Reiter, founded in 1911, he was sympathetic to its spiritual outlook. His most characteristic works of this period are a series of powerful portrait heads, begun in 1910 (*Portrait of Alexander Sacharoff*, Städtisches Museum, Wiesbaden, 1913).

On the outbreak of war in 1914 Jawlensky took refuge in Switzerland, where he remained until 1921. His work there included a series of 'variations' on the view from a window—small, semi-abstract landscapes with a meditative, religious aura. Like Kandinsky and others, Jawlensky believed in a correspondence between colours and musical sounds and he named these pictures *Songs without Words*. In 1918 he began a series of nearly abstract heads, in which he reduced the features to a few curves and lines. Unlike Kandinsky, however, he always based his forms on nature. From 1921 he lived in Wiesbaden, and in 1924 he joined with Kandinsky, *Klee, and *Feininger to form the *Blaue Vier. From 1929 he suffered from arthritis and by

1938 this had forced him to abandon painting completely.

Jeanne-Claude. See CHRISTO.

Jeanneret, Charles-Édouard. See LE COR-BUSIER.

Jellett, Mainie (1897–1944). Irish painter, stage designer, writer, lecturer, and administrator, one of the most important pioneers of modern art in her country. She was born in Dublin, where she studied at the Metropolitan School of Art before spending two years (1917–19) at the Westminster School of Art in London, where *Sickert was among her teachers. In 1920 she went to Paris, where she studied with *Lhote and then with *Gleizes (along with her friend Evie *Hone) and she returned to visit Gleizes regularly until 1932. By 1923 she was painting in a completely abstract, *Cubist-inspired style (*Decoration*, NG, Dublin, 1923). Her work in this vein prompted derision when exhibited at the Dublin Painters' Society, and she devoted much of her energy—throughs essays and lectures—to trying to overcome conservative attitudes in Ireland, which was then culturally isolated. In the 1930s figurative elements reappeared in her painting, and her later work included landscapes and religious subjects. She also made designs for the theatre and ballet.

Jellett died young of cancer, but the year before her death, her campaigning on behalf of modern art bore fruit in the founding of the Irish Exhibition of Living Art, of which she was first chairman. This was an exhibiting society that became the main venue for avant-garde art in Ireland for many years. Jellett was succeeded as chairman by Norah McGuinness (1903–80), who was likewise outspoken and energetic in promoting contemporary art. Her own paintings consisted mainly of landscapes and still-lifes.

Jencks, Charles. See POSTMODERNISM.

Jenney, Neil. See NEW IMAGE PAINTING.

Jensen, Knud W. See LOUISIANA MUSEUM.

Jérome, Jean. See PLASTICIENS.

Jeune Peinture Belge. An avant-garde artists' association founded in Brussels in 1945 with the aim of holding exhibitions of contempor-ary Belgian art throughout Europe. The members of the group (who included *Alechinsky and *Bury) were strongly individualistic and had no common programme, but they were basically abstract in their outlook and were influenced particularly by the expressive abstraction of the post-war *École de Paris. Jeune Peinture Belge dissolved in 1948, but it inspired a successor called Art Abstrait (1952–4), which in turn was followed by another group, Formes (1956–7).

Jeunes Peintres de Tradition Française. See PEINTRES DE TRADITION FRANÇAISE.

John, Augustus (1878–1961). British painter and draughtsman, born in Tenby, Wales, the son of a solicitor. He studied at the *Slade School, London, 1894–8. In his early days there 'he appeared a neat, timid, unremark-able personality' (*DNB*), but after injuring his head diving into the sea while on holiday in Pembrokeshire in 1897 he became a dramati-cally changed figure, described by Wyndham *Lewis as 'a great man of action into whose hands the fairies had placed a paintbrush instead of a sword'. He grew a beard and became the very image of the unpredictable bohemian artist. John himself later com-mented that the idea that the accident 'had released hidden and unsuspected springs' was 'all nonsense', but his work changed as well as his appearance; previously it had been described by *Tonks as 'methodical', but it became vigorous and spontaneous, especially in his brilliant drawings—his draughtsman-ship was already legendary by the time he left the Slade.

In the first quarter of the 20th century John was identified with all that was most independent and rebellious in British art and he became one of the most talked-about fig-ures of the day. He was extremely energetic, travelling a good deal, teaching at Liverpool University (1900–2) and at *Chelsea Art School, which he ran with his friend *Orpen (1903–7), and pursuing a complex domestic life. In 1901 he had married Ida Nettleship, a fellow student at the Slade, but even before her death in 1907 he had fathered a child by another woman, Dorothy ('Dorelia') McNeill, who became his favourite model and his wife in everything but name. He had a great repu-tation as a ladykiller, although Dora *Carring-ton wrote in 1917: 'John made many serious attempts to wrest my virginity from me. But

he was too mangy to tempt me even for a second.' In 1911–14 he led a nomadic life, sometimes living in a caravan and camping with gypsies. As well as romanticized pictures of gypsy life he painted deliciously colourful small-scale landscapes, sometimes working alongside his friends J. D. *Innes and Derwent *Lees. During the same period he also painted ambitious figure compositions, with stylized forms that bring him close to French *Symbolism (*The Way Down to the Sea*, Lamont Art Gallery, Exeter, New Hampshire, 1909–11). In the First World War he was an *Official War Artist. It is as a portraitist, however, that John is best remembered. He was taken up by society and painted a host of aristocratic beauties as well as many of the leading literary figures of the day, including Thomas Hardy (Fitzwilliam Museum, Cambridge, 1923), T. E. Lawrence (several paintings and drawings, including a painting in Arab dress, Tate Gallery, London, 1919), and W. B. Yeats (several portraits, the best-known one being in Glasgow Art Gallery, 1930). Increasingly, however, the painterly brilliance of his early work degenerated into flashiness and bombast, and the second half of his long career added little to his achievement, although he remained a colourful, newsworthy figure until the end of his life. He was one of the few British artists who have become familiar to the general public, and his image changed from that of rebel to Grand Old Man (he was awarded the Order of Merit in 1942). He wrote two volumes of autobiography, *Chiaroscuro*, 1952, and *Finishing Touches*, posthumously published in 1964. A new edition entitled *The Autobiography of Augustus John* appeared in 1975.

In the catalogue of an exhibition of John's work held at the National Portrait Gallery, London, in 1975, the gallery's director John Hayes summed up his career: 'In the decade before the Great War John was at the height of his powers and in the van of British painting. Between the wars he became the leading society portraitist, heir to the mantle of *Sargent, and the acknowledged head of his profession. By the time of the great retrospective exhibition at the [Royal] Academy in 1954 his achievement was irrelevant to younger generations of painters, and the decline of his reputation generally was underlined by the low prices fetched by his pictures and drawings at the studio sales of 1962 and 1963.' (In fact the 1962 sale brought good prices, but there was a sharp decline the following year, 'an example

of how the immediate interest after an artist's death quickly wears off': John Herbert, *Inside Christie's*, 1990.) Since then there has been a great revival of interest in John, especially in his earlier work, but the reputation of his sister Gwen *John now stands higher. Augustus's son **Edwin John** (1905–78) and his daughter **Vivien John** (1915–94) were also painters.

John, Gwen (1876–1939). British painter, born in Haverfordwest, Wales. She was the sister of Augustus *John, but his complete opposite artistically, as she was in personality, living a reclusive life and favouring introspective subjects. After studying at the *Slade School, 1895–8, she took lessons in Paris from *Whistler, and adopted from him the delicate greyish tonality that characterizes her work (once when Augustus John mentioned to Whistler that Gwen had a fine sense of character, he replied: 'Character? What's that? It's the tone that matters. Your sister has a fine sense of tone'). In 1899 she returned to London, but in 1904 she settled permanently in France; she had started out to walk to Rome with her friend Dorelia McNeill (later Augustus John's common-law wife), but they got no further than Toulouse. At first she lived in Paris (earning her living modelling for other artists—including *Rodin, who became her lover), then from 1911 in Meudon, on the outskirts of the city. In 1913 she became a Catholic, and she said 'My religion and my art, these are my life'. Most of her paintings depict single figures (typically girls or nuns) in interiors, painted with great sensitivity and an unobtrusive originality. Good examples are her self-portraits in the Tate Gallery and National Portrait Gallery, London. She had only one exhibition devoted to her work during her lifetime (at the New Chenil Galleries, London, in 1936) and at the time of her death was little known. However, her brother's prophecy that one day she would be considered a better artist than him has been fulfilled, for as his star has fallen hers has risen, and since the 1960s she has been the subject of numerous books and exhibitions. 'Few on meeting this retiring person in black', said Augustus, 'with her tiny hands and feet, soft, almost inaudible voice, and delicate Pembrokeshire accent would have guessed that here was the greatest woman artist of her age, or, as I think, of any other . . . Fifty years from now [he was speaking in 1946] I shall be known as the brother of Gwen John.'

John, Sir William Goscombe (1860–1952). British sculptor, medallist, and lithographer, born in Cardiff, the son of a wood-carver, Thomas John; he assumed the name Goscombe from a village in Gloucestershire near his mother's old home. After studying at Cardiff School of Art and assisting his father in restoration work at Cardiff Castle, he moved to London in 1882 and continued his training at various schools, notably the *Royal Academy. Between 1888 and 1891 he spent a good deal of his time abroad (with the aid of a Royal Academy travelling scholarship); he visited Italy, Spain, Greece, and the Near East, and spent a year in Paris, where he met *Rodin. On his return he settled permanently in London, but he kept up close connections with Wales throughout his life (for example he designed the regalia used at the investiture of the Prince of Wales at Caernarvon in 1911). Goscombe John spent his formative years in London at a time when the *New Sculpture was coming to the fore, and his work was strongly influenced by its ideas, as for example in the strain of fantasy evident in *The Elf* (plaster model, 1898, Royal Academy, London; marble version, Glasgow Art Gallery, 1899; bronze versions National Museum of Wales, Cardiff, and elsewhere). He made his reputation with statues of eminent Victorians and Edwardians, including an equestrian figure of Edward VII (casts in Liverpool and Cape Town), but he is now best known for memorials commemorating the Boer War and especially the First World War. Two are particularly highly regarded for their lively sense of dramatic action: the memorial at Port Sunlight (1921), a spectacular ensemble in which soldiers defend women and children around a village cross; and *The Response 1914* (Newcastle upon Tyne, 1923), showing a procession of patriotic volunteers, led by drummer boys with a winged figure of Victory above. Alan Borg (*War Memorials: From Antiquity to the Present*, 1991) writes that 'On the basis of these two works alone', Goscombe John 'deserves to be recognized as one of the major British sculptors of this century'. The figures in these two works are in bronze, but he also worked in stone, as for example in the granite *Memorial to the Engine Room Heroes* (Liverpool, 1916). The figures here show a mild degree of stylization, but generally he was a realist and completely out of sympathy with what he described as the 'Easter Island' style of modern sculpture. His later works included

the Jubilee medal of George V (1935) and the Great Seal of Edward VIII (1936). He left a large collection of his work to the National Museum of Wales, Cardiff, where an exhibition was devoted to him in 1979.

John Moores Liverpool Exhibition. A biennial exhibition, first held in 1957, named after its sponsor, John (later Sir John) Moores (1896–1993), founder of the Littlewoods Organisation (known originally for football pools and subsequently also for mail-order business and department stores). It is held in the Walker Art Gallery, Liverpool. Foreign works have sometimes been included, but it is primarily an exhibition of British painting, aimed at encouraging young British artists and at bringing good contemporary work to Merseyside. Several prizes are awarded at each exhibition and they carry great prestige as well as a substantial cash award (currently the winner is awarded £20,000, the same as the winner of the *Turner Prize, and there are ten prizes of £1000 each for the runners-up). Artists to whom the exhibition has brought recognition early in their careers include John *Bratby, Lucian *Freud, David *Hockney, R. B. *Kitaj, and Euan *Uglow.

Johns, Jasper (1930–). American painter, sculptor, and printmaker. His career has been closely associated with that of Robert *Rauschenberg, and they are considered to have been largely responsible for the move away from *Abstract Expressionism to *Pop art and *Minimal art that characterized American art in the late 1950s. Johns was born in Augusta, Georgia, and studied at the University of Southern Carolina before dropping out and moving to New York in 1949. After two terms at a commercial art college, he worked at various jobs and did military service before meeting Rauschenberg in 1954. They were close friends until 1962, when they broke up with some bitterness (for a time they were lovers, sharing a triangular relationship with a woman). Soon after meeting they formed a partnership to design window displays for upmarket stores, the money they earned allowing them to pursue their artistic experiments. In 1955, inspired by a dream, Johns painted a picture of an American flag—a faithful flat copy of the real thing, except that the brushwork was heavily textured: 'One night I dreamt I painted a large American flag, and the next morning I went out and bought the

materials to begin it.' It was the first of many, and much of his subsequent work has been done in the form of series of paintings representing such commonplace two-dimensional objects—for example *Targets* and *Numbers*. His sculptures have most characteristically been of equally banal subjects such as beer-cans or brushes in a coffee tin. Such works—at one and the same time laboriously realistic and patently artificial—are seen by his admirers as brilliant explorations of the relationship between art and reality; to others, they are as uninteresting as the objects depicted. Johns has said that he is not concerned with their symbolism, but simply wants to look at familiar objects with fresh vision.

In 1958 Johns had his first one-man show—at Leo *Castelli's gallery in New York—and it was a huge success; the *Museum of Modern Art bought four works and only two remained unsold. After this he rapidly became one of the most famous (and most wealthy) of living artists. As early as 1961 he bought a house on Edisto Island, off the coast of South Carolina, to escape some of the pressures of celebrity (it was destroyed by fire in 1968). In the 1970s many of his paintings were characterized by a cross-hatching motif, and in the 1980s he often introduced autobiographical elements, as for example in *Racing Thoughts* (Whitney Museum, New York, 1983), a collage that depicts various elements from his bathroom and other personal references. Much of his later work has been in the form of his prints (he took up lithography in 1960 with Universal Limited Art Editions—see PRINT RENAISSANCE). His other work has included designs for the Merce Cunningham Dance Company, of which he was appointed artistic adviser in 1967.

Johnson, Malvin Gray. See HARLEM RENAISSANCE.

Johnson, Philip. See MUSEUM OF MODERN ART, NEW YORK.

Johnston, Edward. See ROYAL COLLEGE OF ART.

Johnston, Frank. See GROUP OF SEVEN.

Johnstone, Dorothy. See EDINBURGH GROUP.

Jonchery, Charles. See DIRECT CARVING.

Jones, Adrian (1845–1938). British sculptor. From 1867 to 1890 he was an army veterinary surgeon, painting and sculpting in his spare time. When he retired from military service (with the rank of captain) he became a full-time sculptor, specializing in subjects involving horses, of whose anatomy he had an intimate knowledge. His major work is the huge Quadriga (four-horsed chariot) surmounting Constitution Arch at Hyde Park Corner in London; a winged figure of Peace descends on the war chariot, causing the horses to rear to a standstill. The group, which was erected in 1912, was paid for by the financier Lord Michelman; he presented it to the nation in memory of his friend Edward VII, who had encouraged the project. Among Jones's other works is the Cavalry Memorial in Hyde Park (erected 1924). His autobiography, *Memoirs of a Soldier Artist*, was published in 1933. Jones was thoroughly traditional in outlook; he put a premium on fine craftsmanship and said 'I cannot bring myself to believe that ugliness and incongruity without any beauty can ever be called art.'

Jones, Allen (1937–). British painter, printmaker, sculptor, and designer, born in Southampton. He studied at Hornsey College of Art, 1955–9 and 1960–1; in between these two periods he spent a year at the *Royal College of Art, from which he was expelled. In 1961 he was one of the artists who stood out at the *Young Contemporaries exhibition at which *Pop art first made a major impact in Britain and he has remained one of the most committed exponents of Pop. Although he has worked primarily as a painter, printmaker, and designer, he is best known to the public for a distinctive type of sculpture in which figures of women—more or less life-size, dressed in fetishistic clothing, and with what Jones calls 'high definition female parts'—double as pieces of furniture; for example, a woman on all fours supporting a sheet of glass on her back becomes a coffee table, and a standing figure with outstretched hands becomes a hatstand. He began making such sculptures in the late 1960s and was still producing them in the 1990s, although in a manner that he calls 'less aggressive' and 'easier to take' (they have come in for a good deal of criticism for allegedly demeaning women as sex objects; an article in the feminist journal *Spare Rib* in 1973 suggested that they expressed a

castration complex). Jones says that 'eroticism is an absolutely universal subject which relates you to every other human being', and his other work uses similar imagery—legs, stockings, high-heeled shoes, etc., often suggested by women's fashion magazines. His work as a designer has included sets and costumes for the erotic review *Oh! Calcutta!* (1969).

Jones, David (1895–1974). British painter, engraver, and writer, born at Brockley, Kent; his father, a printer, was Welsh, and his mother was English. He studied in London at Camberwell School of Art, 1909–15, and then after serving in France with the Royal Welch Fusiliers, at Westminster School of Art, 1919–22, under Walter *Bayes and Bernard *Meninsky. His studies left him 'completely muddle-headed as to the function of art in general', but after converting to Roman Catholicism in 1921 he met Eric *Gill and under his influence achieved a sense of purpose. Gill not only introduced him to wood engraving but also guided him to reject the current concern with formal properties in favour of an art that aspired to reveal universal and symbolic truths behind the appearance of things. He collaborated with Gill for several years and was engaged to one of his daughters from 1924 to 1927. Jones worked mainly in pencil and watercolour, his subjects including landscape, portraits, still-life, animals, and imaginative themes (Arthurian legend was one of his main inspirations). His book illustrations included woodcuts for several books published by Robert *Gibbings's Golden Cockerell Press. As a writer he is best known for *In Parenthesis* (1937), a long work of mixed poetry and prose about the First World War. T. S. Eliot described it as a work of genius and it won the Hawthornden Prize. After the Second World War Jones retired to Harrow and devoted himself mainly to calligraphic inscriptions in the Welsh language. His work is well represented in the Tate Gallery, London.

Jónsson, Ásgrímur. See THORLÁKSSON.

Jorn, Asger (originally Asger Jørgensen) (1914–73). Danish painter, sculptor, printmaker, ceramicist, designer, collector, and writer, active in Paris for much of his career. He was born at Vejrum, Jutland, and grew up in Silkeborg. Initially he trained to be a teacher, but in 1936 he went to Paris to study

art. He attended *Léger's academy for ten months and then worked for *Le Corbusier on a mural for the 1937 International Exhibition. Throughout the Second World War he lived in Denmark and during the German occupation (1940–5) he printed a banned periodical. After the war he returned to Paris, where in 1948 he was one of the founders of the *Cobra group. The group's central doctrine was freedom of expression, and Jorn's most characteristic works are highly coloured abstracts painted with violent brushwork. In 1951 he became ill with tuberculosis and returned to Silkeborg, where he spent ten months in a sanatorium. After his recovery he travelled widely, but he divided his time mainly between Paris and Albisola Marina in northern Italy. In 1957–61 he participated in the International *Situationist movement, and late in life he took up sculpture. His other works include numerous book illustrations and he also wrote several books himself, beginning with *Held og hasard* (Luck and Chance) in 1952. The others include *Magi og skønne kunster* (Magic and the Fine Arts), published in 1971. Although he lived mainly elsewhere, he retained a great affection for his homeland, and he carried out several major works for sites there, notably a ceramic wall (installed 1959) and a tapestry (1960) for Århus State High School. He presented many works by himself and by his contemporaries to the Silkeborg Museum.

Josephson, Ernst (1851–1906). Swedish painter and draughtsman. He travelled widely in Europe early in his career and in 1882–8 he lived in Paris, where he was the leader of a group of anti-academic Swedish artists. At this time he moved from a naturalistic style to a much more fantastic idiom, often inspired by Nordic myth, and his work is particularly distinguished for its intensity and vitality of colouring. In 1887 he began suffering from mental instability and never fully recovered. None the less, he continued to work intensively, and the bizarre paintings he produced—although little known in his lifetime—were influential on *Expressionism in Sweden. Josephson's work is particularly well represented in the Konstmuseum at Göteborg and in the Nationalmuseum in Stockholm.

Jourdain, Frantz. See SALON D'AUTOMNE.

Jowett, Percy (1882–1955). British painter, teacher, and administrator. He studied at

Leeds School of Art, then from 1904 to 1907 at the *Royal College of Art, London. In 1912 he married Enid Ledward, sister of the sculptor Gilbert *Ledward, and in 1919 he was one of the founders of the *Seven & Five Society. Jowett's work included landscapes, interiors, and flower pieces in oils and watercolour. Christopher Frayling writes that 'contemporary critics treated him as one of the most distinguished English *Post-Impressionists of his generation' (*The Royal College of Art*, 1987), but he is now remembered mainly as a teacher and administrator. He was successively head of Chelsea School of Art, 1927–9, the Central School of Art, 1929–35, and the Royal College of Art, 1935–47, and in 1939 he was appointed one of the officials of the *'Recording Britain' scheme and a member of the War Artists' Advisory Committee (see OFFICIAL WAR ART).

Judd, Donald (1928–94). American sculptor, designer, and writer on art, one of the leading exponents and theorists of *Minimal art. He was born in Excelsior Springs, Missouri, and after serving with the US Army in Korea, 1946–7, he studied in New York at both the *Art Students League and Columbia University. In 1953 he graduated in philosophy at Columbia and he gained an MA in art history there in 1962 (Meyer *Schapiro was one of his teachers). From 1959 to 1965 he earned his living as an art critic, working mainly for *Arts Magazine*. He began his career as a practising artist as a painter, producing what he later called 'half-baked abstractions', but in the early 1960s he took up sculpture with heavily-textured monochrome reliefs. In 1963 he began making the type of work for which he is best known—arrangements of identical rectangular box-like shapes cantilevered ladder-like from a wall. He called these sculptures 'specific objects' and in an article of this title (first published in *Arts Yearbook*, 1965) he championed such work on the grounds that 'actual space is intrinsically more powerful and specific than paint on a flat surface'. Initially he worked mainly in wood, but after a successful exhibition at the Green Gallery, New York, in 1963–4 he began having them industrially manufactured in various metals (or sometimes coloured perspex). In 1970 he began making works for the specific space in which they were to be exhibited, and in 1972 he began producing outdoor works. In spite of great financial success, Judd (who was notoriously touchy) disliked the New York 'art crowd' and in 1973 moved to Marfa, Texas, where he converted the buildings of an old army base into studios and installation spaces. In the 1980s he began designing furniture in a similar style to his sculptures. *Donald Judd: Complete Writings 1959–75* was published in 1976. See also ARTFORUM.

Jugendstil. See ART NOUVEAU.

Julian, Rodolphe. See ACADÉMIE.

Junk art. Art constructed from the waste products of urban life. In so far as Junk art represented a revolt against traditional materials and a desire to show that works of art can be constructed from the humblest and most worthless things, it may be plausibly traced back to *Cubist collages, *Duchamp's *readymades, and the work of Kurt *Schwitters. However, it is not until the 1950s that it is possible to speak of a Junk movement, particularly with the work of Robert *Rauschenberg, who used rags and tatters of cloth, torn reproductions, and other waste materials in his *combine paintings. Lawrence *Alloway, in 1961, was the first to apply the name 'Junk art' to such works, and the term was then extended to sculpture made from scrap metal, broken machine parts, used timber, and so on. Californian *Funk art sometimes made use of similar materials. The Junk art of the USA had analogies in the work of *Tàpies and others in Spain, *Burri and *Arte Povera in Italy, and similar movements in most European countries and in Japan, where the refuse left over from the Second World War was sometimes converted to artistic use.

Juneau, Denis. See NOUVEAUX PLASTICIENS.

Kaesbach, Walter. See HECKEL.

Kahler, Eugen. See BLAUE REITER.

Kahlo, Frida (1907–54). Mexican painter, the daughter of a German-born photographer and a Mexican mother. In 1925, at a time when she was preparing to enter medical school, she suffered appalling injuries in a traffic accident, leaving her a permanent semi-invalid, often in severe pain. During her convalescence she began painting portraits of herself and others. She remained her own favourite model and her art was usually directly autobiographical: 'I paint myself because I am so often alone.' In 1928 she married Mexico's most famous artist, Diego *Rivera, who was twice her age and twice her size. Their relationship was often strained, but it lasted to her death, through various separations, divorce and remarriage (1939–41), and infidelities on both sides (one of her lovers was Leon Trotsky, who was assassinated while living in her house in Coyoacán, Mexico City, in 1940). Kahlo was mainly self-taught as a painter. She was influenced by Rivera, but more by Mexican folk art, and her work has a colourful, almost *naive vigour, tinged with *Surrealist fantasy (André *Breton arranged an exhibition of her work in Paris in 1939, but she did not regard herself as a Surrealist—'I never painted my dreams, I painted my own reality'—and she was scathing about the Surrealists she met apart from Marcel *Duchamp, 'the only one who has his feet on the earth').

Kahlo's paintings of her own physical and psychic pain are narcissistic and nightmarish, but also—like her personality—fiery and flamboyant (*Self-Portrait with Thorn Necklace and Hummingbird*, Harry Ransom Humanities Research Center, University of Texas, Austin, 1940). Rivera described her work as 'acid and tender, hard as steel, and delicate and fine as a butterfly's wing, loveable as a beautiful smile, and profound and cruel as the bitterness of life'. Her paintings were widely shown in Mexico and in the year of her Paris exhibition (1939) she also had a successful show in New York, but during her lifetime she was overshadowed by her husband. Since her death, however, her fame has grown and she has become something of a feminist heroine, admired for her refusal to let great physical suffering crush her spirit or interfere with her art and her left-wing political activities. Her house in Coyoacán was opened as a museum dedicated to her in 1958.

Kahnweiler, Daniel-Henri (1884–1979). German-born art dealer, publisher, and writer, who became a French citizen in 1937. He was a banker by training but not by temperament, and he persuaded rich banker uncles to support him in opening a gallery in Paris—in the rue Vignon—in 1907. Initially he knew nothing about the art trade and simply bought what he liked, his first purchases being paintings by three of the *Fauves—*Braque, *Derain, and *Vlaminck. He was soon buying *Cubist works by Braque and *Picasso, and in 1912 both these artists signed contracts giving Kahnweiler an exclusive right to purchase their entire outputs. He was also a friend and supporter of *Gris, of whom he wrote a standard biography (1946). As well as marketing paintings, Kahnweiler acted as a publisher, bringing out numerous books illustrated by the artists in whose work he dealt (see LIVRE D'ARTISTE). During the First World War he lived in neutral Switzerland, returning to Paris in 1920. Because he was German, his stock had been confiscated during the war and it was sold in 1921–3. Another blow was that several of his artists, including Picasso, had gone over to Paul *Rosenberg. Nevertheless he set up another gallery, and in the inter-war years the artists in whom he dealt

included *Klee and *Masson. He went into hiding during the Second World War, but resumed his activities afterwards. In 1961 he published an autobiography, *Mes Galeries et mes peintres*; in the introduction to the English translation, *My Galleries and Painters* (1971), John *Russell wrote: 'Where the old-style dealers did their artists a favour by inviting them to luncheon, Kahnweiler lived with Picasso, Braque, Gris, Derain, and Vlaminck on a day-to-day, hour-to-hour basis. The important thing was not so much that they should sell as that they should be free to get on with their work; and Kahnweiler, by making this possible, helped to bring into being what now seems to us that last great flowering of French art.'

Kandinsky, Wassily (1866–1944). Russian-born painter, printmaker, designer, teacher, and art theorist, who became a German citizen in 1927 and a French citizen in 1939, one of the most important figures in the development of *abstract art. He was born in Moscow, the son of a prosperous tea merchant, and grew up in Odessa. From 1886 to 1892 he studied law and economics at Moscow University and immediately after graduation began lecturing in law there. In 1895 he worked briefly as art director for a printing firm in Moscow and in 1896 he turned down the offer of a professorship in law at the University of Tartu (also called Dorpat) in Estonia because he had decided to become a painter. He had been interested in art for some time, and was greatly stimulated by an exhibition of French *Impressionist paintings he saw in Moscow in 1895, particularly one of *Monet's *Haystack* paintings, which he thought communicated something about colour and light rather than about haystacks: 'I had the feeling that here the subject of the picture was in a sense the painting itself', he later recalled, 'and I wondered if one couldn't go much further along the same route.' In 1896 he moved to Munich, one of the major artistic centres of Europe; this was to be the centre of his activities until 1914, but he travelled widely in this period and spent a year in Paris, 1906–7. Initially he studied at the art school run by Anton Azbe (1861–1905), meeting *Jawlensky and *Werefkin there, then at the Munich Academy under Franz von *Stuck in 1900. He was older and better educated than his contemporaries and tended to assume a position of leadership among them. One of his fellow students at the

Academy was Paul *Klee, who later became a close friend. Klee said that Kandinsky's 'exceptionally handsome, open face inspired a certain deep confidence' in those around him, and recalled that the student Kandinsky 'used to mix his colours on the palette with the greatest diligence and a kind of scholarliness'. He was indeed so methodical and fastidious in his working methods (contrary to the standard image of artists) that he joked he could paint in evening dress. His father provided him with a generous allowance, and he lived well with his wife (who was also his cousin) in Schwabing, the bohemian quarter of Munich. In 1901 he was one of the founders of the exhibiting society *Phalanx, which also ran an art school, at which he taught; one of his students was Gabriele *Münter, who—following the breakdown of his marriage—became his lover until the First World War separated them (from 1908 they divided their time mainly between Munich and Murnau, a picturesque market town nearby, where they bought a house that became a meeting-place for avant-garde artists).

Kandinsky's work at the turn of the century was much influenced by *Art Nouveau (Munich was one of its major centres) and had strong reminiscences of Russian folk art (his subjects included fanciful fairytale scenes). In the first decade of the century he exhibited in Berlin (at the *Sezession), Dresden (with Die *Brücke), Moscow, Paris (at the *Salon d'Automne), Vienna, Warsaw, and elsewhere. Landscape was his chief subject at this time, and he constantly reworked and simplified his favourite motifs. His colouring became very intense, under the influence of *Fauvism, and his forms became flatter and more attenuated until they began to lose their representational identity. In 1909 (the year in which he was one of the founders of the *Neue Künstlervereinigung) he began a series of *Improvisations*, in 1910 of *Compositions*, and in 1911 of *Impressions*; in these he eliminated all representational content to arrive—in about 1910—at pure abstraction. The choice of names, deriving from musical terminology, was significant, for like the *Symbolists he was interested in analogies between colours and sounds (a great lover of music, he could play the cello and piano and was a friend of Arnold Schoenberg, whose revolutionary atonality he equated with his own experiments). Kandinsky himself described how he came to recognize that colour and line in

themselves could be sufficient vehicles for the expression of emotions; he returned to his studio one evening and failed to recognize one of his own paintings that was lying on its side, seeing in it a picture 'of extraordinary beauty glowing with an inner radiance . . . Now I knew for certain that the subject-matter was detrimental for my paintings'. He discussed the issue of abstraction in his book *Über das Geistige in der Kunst*, which was published late in 1911 (it bears the date 1912) and is the best known of his writings (it has been translated into English as *The Art of Spiritual Harmony* (1914), *On the Spiritual in Art* (1946), and *Concerning the Spiritual in Art and Painting in Particular* (1947); it is now usually referred to as *Concerning the Spiritual in Art*). His views about the nature of art were influenced by mysticism and Theosophy; he did not completely repudiate representation, but he held that the 'pure' artist seeks to express only 'inner and essential' feelings and ignores the superficial and fortuitous.

Even some of Kandinsky's closest associates were puzzled and dismayed by his development of abstract art, and when one of his paintings was rejected by the Neue Künstlervereinigung in 1911 he resigned and founded a rival organization, the *Blaue Reiter. The brief lifetime of this group (broken up by the First World War) marked a period of intense achievement and growing fame for Kandinsky, during which his work was shown at the *Knave of Diamonds exhibition in Moscow (1912), the *Sonderbund exhibition in Cologne (1912), the *Armory Show in New York (1913), the 'Erster Deutscher Herbstsalon' at the *Sturm Gallery in Berlin (1913), and the third exhibition of the *Moderne Kunstkring in Amsterdam (1913). The major work he showed at the 'Herbstsalon' was *Composition VI* (Hermitage, St Petersburg, 1913), a huge, gloriously coloured apocalyptic vision. Other important paintings of the time include *Light Picture* and *Black Lines* (both Guggenheim Museum, New York, 1913), which he later singled out as *Non-Objective works—totally abstract in concept rather than abstracted from nature.

As a Russian citizen, Kandinsky had to leave Munich at the outbreak of war in August 1914 and by the end of the year he was back in Moscow (via Switzerland, Italy, and the Balkans). He had obtained a divorce in 1910 (following a legal separation in 1904) and in 1917 he made a very happy second marriage

to a much younger Russian woman. This encouraged him to re-integrate into Russian life, and after the October Revolution in 1917 he became highly active as a teacher and administrator in various cultural organizations instituted by the new Soviet regime (see INKHUK, NARKOMPROS, and VKHUTEMAS). However, he was out of sympathy with the growing tide of ideas that subordinated fine art to industrial design in the service of the proletariat (even though he made designs for cups and saucers himself), and in 1922 he accepted an offer to take up a teaching post at the *Bauhaus, where he remained until it was closed by the Nazis in 1933. He directed the mural painting workshop and also taught elements of form and colour on the preliminary course followed by all students. His own painting of this period became more geometrical, but in addition to circles and triangles he used arrow-like forms and wavy lines in a manner that ran counter to the typical Bauhaus concern with geometrical purity (*Swinging*, Tate Gallery, London, 1925). The Bauhaus printing workshop produced his portfolio entitled *Kleine Welten* (Small Worlds, 1922–3), containing drypoints, lithographs and woodcuts and marking perhaps the height of his achievement as a graphic artist, and he also branched out into various types of design work (including stage sets and costumes and ceramic tiles). In 1926, to mark his 60th birthday, an exhibition of his work toured Germany, and by this time he was an internationally renowned figure (his reputation was spread in the USA by the *Blaue Vier).

In 1934 Kandinsky moved to Paris and spent the remaining decade of his life in the suburb of Neuilly-sur-Seine, a much admired and respected figure. He continued to paint and write up to his death, although he had difficulty obtaining materials during the Second World War and often used board rather than canvas. The paintings of this last period represent something of a synthesis between the organic style of his Munich period and the more geometrical manner of his Bauhaus period, but there was also a new element of fantasy in the use of amoeba-like forms that show the influence of *Surrealism (*Sky Blue*, Pompidou Centre, Paris, 1940). His influence was immense, through both his paintings and his writings. Examples of his paintings are in many of the world's leading collections, with particularly rich representations in, for example, the Lenbachhaus, Munich (see

LENBACH), the Guggenheim Museum, New York, and the Pompidou Centre, Paris (many presented by the artist's widow). The best collection of his writings is *Kandinsky: Complete Writings on Art*, edited and translated by Kenneth Lindsay and Peter Vergo (2 vols., 1982).

Kane, John (1860–1934). American *naive painter, born in Scotland, the son of a miner. He emigrated to the USA in 1879 and moved around a good deal working at various labouring jobs. However, he considered Pittsburgh his home: 'I have worked in all parts of it, building the blast furnaces...the mills...The filtration plant, the bridges that span the river, all these are my own...I see it both the way God made it and as man changed it.' In 1891 he lost a leg when he was struck by a train, but he became so agile with his artificial limb that few realized he was disabled. After his marriage in 1897 he worked as a painter of railway coaches, as a tinter of photographs, and as a housepainter. He took to drink after his son died soon after birth in 1904 and his wife consequently left him, taking their two daughters with her. Kane then led a wandering life, scraping a living by housepainting and carpentry. His first oil paintings were done c. 1910; he did portraits—an intense *Self-Portrait* (MOMA, New York, 1929) is his best-known work—landscapes, interiors, and cityscapes of industrial Pittsburgh, combining meticulous observation with naive stylization and imaginative reconstruction. He achieved sudden fame at the age of 67 when one of his paintings was accepted for the *Carnegie International Exhibition in Pittsburgh in 1927 (at the insistence of Andrew *Dasburg, who was on the jury). Kane was the first American naive painter to achieve such recognition; some people thought his picture was a hoax, but in the remaining seven years of his life he achieved considerable acclaim and became something of a celebrity (in consequence of which he was re-united with his wife). His autobiography *Sky Hooks* (named after the supports of a housepainter's scaffold) was posthumously published in 1938.

Kanoldt, Alexander. See NEUE KÜNSTLER-VEREINIGUNG MÜNCHEN and NEUE SACHLICH-KEIT.

Kanovitz, Howard. See SUPERREALISM.

Kantor, Morris (1896–1974). American painter, born in Minsk, Russia. He emigrated to New York in 1911 and studied briefly at the Independent School of Art with the aim of being a cartoonist. However, he turned to painting and from 1919 to 1924 he experimented with abstraction, juggling a variety of 'isms'—*Cubism, *Futurism, *Orphism, *Synchromism—in what are generally considered his best works. In 1924 he adopted a naturalistic style and from 1928 concentrated on the human scene in New York, observed through the windows of his apartment on Union Square. Sometimes these works have a note of fantasy or eeriness.

Kantor, Tadeusz (1915–90). Polish painter and experimental artist. He was born at Wielopole near Cracow and trained at the Cracow Academy. His work was highly varied and he was regarded as one of the main pioneers and exponents of avant-garde art in Poland after the Second World War. Following a *Surrealist period that lasted until the mid-1950s he passed through a *Tachiste phase and during the 1960s painted in a more personal idiom, depicting vaguely-suggested objects against a monochromatic background. At this time, too, he experimented with *Pop art. Kantor also worked as a theatre director (during the Second World War he ran an underground experimental theatre, which was revived in the 1950s). Both in his theatrical productions and in his paintings he introduced the factor of chance and he organized Poland's first *Happenings. In the 1970s he experimented with *Conceptual art.

Kapoor, Anish (1954–). British abstract sculptor, born in India, the son of a Hindu father and Jewish mother. In 1973 he settled in London, where he studied at Hornsey School of Art and Chelsea School of Art. Although his sculpture is not obviously indebted to his Asian background, he feels an affinity with the spirituality of Indian art: 'I don't want to make sculpture about form...I wish to make sculpture about belief, or about passion, about experience that is outside of material concern.' His early work was predominantly in fairly lightweight materials, including wood and mixed media, and was often brightly coloured, but in the late 1980s he changed direction. Having acquired a large ground-floor studio where he could handle heavy materials, he turned to working in

stone. Typically his sculptures from this time have consisted of large, rough-hewn blocks. However, he has also made smooth, organic pieces in cast metal (*Turning the World Inside Out*, Rijksmuseum Kröller-Müller, Otterlo, 1995). Kapoor was Britain's representative at the Venice *Biennale in 1990 and in 1991 he was awarded the *Turner Prize.

Kaprow, Allan (1927–). American artist and art theorist, best known as the main creator of *Happenings. He was born in Atlantic City, New Jersey, and graduated from New York University in 1949. He then studied painting at Hans *Hofmann's school, 1947–8, art history under Meyer *Schapiro at Columbia University, 1950–2 (his MA thesis was on *Mondrian), and with the musician John *Cage at the New School for Social Research, New York, 1956–8. From Cage (who is sometimes credited with creating the first Happening at *Black Mountain College in 1952) Kaprow took over the idea of chance and indeterminacy in aesthetic organization. In the mid-1950s he gave up painting for *assemblages and then *environments, and in 1958 published an article in *Art News* in which he argued for the abandonment of craftsmanship and permanence in the fine arts and advocated the incorporation of perishable materials. His first Happenings took place at the Reuben Gallery, New York, in 1959. Kaprow has been an evangelic promoter of his ideas through his teaching at various universities and his voluminous output of writings, as well as through his own performances. His books include *Assemblage, Environments & Happenings* (1966). Claes *Oldenburg and Lucas *Samaras are among the artists who cite him as an important influence on their work.

Karlowska, Stanislawa de. See BEVAN and CAMDEN TOWN GROUP.

Kasatkin, Nikolai. See AKHRR.

Kasmin, John. See HOCKNEY.

Kassák, Lajos. See ACTIVISTS.

Kassel Documenta. See DOCUMENTA.

Kauffer, E. McKnight (1890–1954). American designer and painter, active mainly in England. After studying in San Francisco, Chicago, and Paris, he settled in London in 1914. He was a member of *Group X and of the *Cumberland Market Group, but he virtually abandoned easel painting in 1921 and is best known for brilliant and witty poster designs, notably for the London Transport Board and the Great Western Railway; he created posters for London Underground from 1915 to 1940, under the patronage of its commercial manager Frank Pick (1878–1941), who was the mastermind behind the modern image that the company created in the interwar years through employing some of the best artistic talent of the day. Writing in the *Evening Standard* in 1928, Arnold Bennett said that Kauffer had 'changed the face of London streets' and that his success 'proves that popular taste is on the up-grade'. Kauffer was also a successful textile designer and book illustrator, and in 1935 Paul *Nash wrote that he considered him 'responsible, above anyone else, for the change in attitude towards commercial design in this country . . . his influence as an applied draughtsman has been immensely important'. In 1940 Kauffer returned to the USA and settled in New York. His work in America included posters (for government agencies during the Second World War and afterwards for American Airlines) and also book jackets and illustrations.

Kawara, On (1933–). Japanese painter and *Conceptual artist, born at Kariya. He was self-taught as an artist. In the early 1950s he came to prominence with violently satirical paintings and drawings of disjointed human figures and corpses in which he portrayed the predicament of Japan after the Second World War. Later he devised a method by which he duplicated an original painting in a number of variations that he called 'Original Printed Paintings'. In 1959 he left Japan and after extensive travels settled in New York in 1965. From this time he has devoted himself to Conceptual art, notably with a series of *I am Still Alive* postcards and telegrams sent to friends and other correspondents.

Keane, John. See OFFICIAL WAR ART.

Keating, Sean (1889–1977). Irish painter, born in Limerick. He studied at Limerick Technical College and in 1911 won a scholarship to the Metropolitan School of Art in Dublin, where he was taught by *Orpen, whom he idolized. Later he taught at the School himself and he was president of the Royal Hibern-

ian Academy from 1948 to 1962. Keating is best known for his vigorous, picturesque portrayals of Irish peasants, above all for *Men of the West* (Hugh Lane Municipal Gallery of Modern Art, Dublin, 1915): 'It is Keating who sums up the "discovery" of the West of Ireland as a source for patriotic, heroic, almost propagandist subject matter which seems to have been adopted by the independence movement to straightjacket Irish art into nationalist terms. His own painting is the more successful the less message it contains, and it is at its best when descriptively realist' (Anne Crookshank and the Knight of Glin, *The Painters of Ireland*, 1978).

Kelly, Anthony-Noel. See AVANT-GARDE.

Kelly, Ellsworth (1923–). American painter, sculptor, and printmaker, born in Newburgh, New York. He studied at the Pratt Institute, Brooklyn, 1941–2, and then after service in the US Army at the Boston Museum School, 1946–8. From 1948 to 1954 he lived in Paris, then settled in New York. In 1949 he switched from figurative to abstract art and in the mid-1950s he became recognized as one of the leading exponents of the *Hard-Edge style that was one of the successors to *Abstract Expressionism. His paintings are characteristically very clear and simple in construction, sometimes consisting of a number of individual panels placed together, identical in size but each painted a different uniform colour (he started using this formula in 1952). He was also one of the first artists to develop the idea of the *shaped canvas. His work has been widely exhibited and he has had numerous public commissions, including a mural for Unesco in Paris (1969). Kelly has also made prints in various techniques and has worked as a sculptor (using painted cut-out metal forms—often industrially manufactured—related to those in his paintings).

Kelly, Felix (1914–94). British painter, designer, and illustrator, born in Auckland, New Zealand, the son of a wealthy businessman. He settled in London in 1938 and served in the RAF during the Second World War. Initially he worked as a graphic designer and then branched out into painting. He had no formal artistic training. Kelly's most characteristic pictures are views of country houses that often have an enigmatic, slightly *Surrealistic air. His obituary in *The Times* comments

that 'His good looks, charm and easy manner made him a welcome dinner table guest as well as a recorder of the architectural nuances of the houses to which he was invited'. In 1982 he painted murals at Castle Howard, Yorkshire, funded by the success of the television series *Brideshead Revisited*, largely filmed there. Apart from paintings his work included stage design and book illustrations, notably for Herbert *Read's only novel *The Green Child* (1945; the book was originally published in 1935). Read returned the compliment by writing the introduction to *Paintings by Felix Kelly* (1946).

Kelly, Sir Gerald (1879–1972). British painter, mainly of portraits, born in London of Irish descent; his grandfather was the creator of Kelly's Directories. He was educated at Eton and Cambridge (where he read English), and in 1901 went to Paris, where he studied painting without formal tuition. His first important patron was Sir Hugh *Lane, and by 1914 he was well established as a society portraitist in London, a position he richly consolidated for the rest of his long career. He was very well connected, his diverse circle of friends including Clive *Bell, the occultist Aleister Crowley (who was married to Kelly's sister for a few years), and the writer Somerset Maugham. He painted Maugham several times, most notably in a picture called *The Jester* (Tate Gallery, London, 1911), and he wittily attacked Graham *Sutherland's famous portrait of the writer. Maugham, in turn, based several of the characters in his novels on Kelly. In 1945 he completed state portraits of King George VI and Queen Elizabeth (Windsor Castle) and his career culminated when he was president of the *Royal Academy, 1949–54. Although he was 70 when elected, he still had great drive, and he was a resounding success as president, revitalizing the Academy's image after the damage done by his predecessor, the arch-conservative *Munnings. Kelly became something of a television personality in programmes relating to the Academy's exhibitions and his popularity helped to boost attendances. Apart from portraits, Kelly painted landscapes and also pictures of Asian dancing girls (he visited Burma in 1909) that were once much reproduced in the form of *popular prints. His favourite model, however, was his wife Lilian, known as Jane. He was modest about his abilities, considering himself a craftsman rather than an

artist (he was extremely fastidious about his materials). However, Kenneth *Clark wrote of him: 'He had a great gift for summing up the character of his sitters and painted with scrupulous honesty . . . he was the most reliable portrait painter of his time.'

Kelly, Mary. See FEMINIST ART.

Kelly, Oisín (1915–81). Irish sculptor and designer. He was born in Dublin, where he studied modern languages at Trinity College, 1933–7. In 1937 a scholarship took him to Frankfurt, where he became interested in German *Expressionism, particularly the sculpture of *Barlach. After returning to Ireland he studied at evening classes at the National College of Art, Dublin, and Waterford School of Art, and also worked briefly with Henry *Moore in England. From 1946 to 1964 he taught at St Columba's, Rathfarnham, near Dublin. Kelly was probably the best-known and most prolific Irish sculptor of his time. He worked in a variety of materials, including bronze, copper, and wood, and he produced a wide range of work, including portrait busts, statues, and figures of animals and birds. Above all, he was a leading exponent of church art; good examples of his work in this field are the façade carving of *The Last Supper* (completed 1966) and the font at St Theresa's Church, Sion Mills, County Tyrone. His style, combining traditional Irish elements with mild Expressionist distortion, was influential on several younger Irish artists, notably the painter and stained-glass designer Patrick Pye (1929–), who studied under Kelly at Rathfarnham, and the sculptor John Behan (1932–).

Kemeny, Zoltan (1907–65). Hungarian-born sculptor and designer who became a Swiss citizen in 1957. He studied in Budapest, 1924–30 (at the School of Decorative Arts until 1927, then at the School of Fine Arts), lived in Paris 1930–40, and then in Marseilles until 1942, when he settled in Zurich. Early in his career he worked mainly as a fashion designer, but in 1946 he began making reliefs on the borderline between painting and sculpture, incorporating many different materials and creating swirling surface rhythms. In 1951 he began making translucent reliefs intended to be set up in front of electric lights, and from the mid-1950s he produced the 'Images en Relief' for which he became chiefly known.

These were metal reliefs into which he incorporated curious agglomerations of industrial metal products and mass-produced articles. He devoted himself entirely to sculpture from 1960 (giving up his fashion jobs) and in his last years received several large commissions. In 1964 he won the main sculpture prize at the Venice *Biennale.

Kemp-Welch, Lucy. See OFFICIAL WAR ART.

Kennedy, William. See GLASGOW BOYS.

Kennet, Lady. See SCOTT, KATHLEEN.

Kennington, Eric (1888–1960). British painter, sculptor, and draughtsman, born in London, son of the painter **Thomas Benjamin Kennington** (1856–1916). He studied at various art schools in London and exhibited at the *Royal Academy from 1908, first attracting attention with scenes of Cockney life, notably *Costermongers* (1914), which was bought by William *Nicholson and presented to the Musée de Luxembourg, Paris. In 1914–15 Kennington served in France with the 13th London Regiment, the Kensingtons, and after being invalided out he painted *The Kensingtons at Laventie* (Imperial War Museum, London, 1915), which was a great success when shown at his first one-man exhibition, at the Goupil Gallery, London, in 1916; one reviewer described it as 'decidedly the finest picture inspired by this war as yet by an English artist'. It shows a group of exhausted men from his regiment, and in his paintings and drawings as an *Official War Artist (1916–19) Kennington similarly concentrated on depicting the everyday life of the ordinary soldier. It is for this work that he remains best known. Between the wars he was mainly a portraitist, but he also did book illustrations, including those for T. E. Lawrence's *Seven Pillars of Wisdom* (1926), and he turned seriously to sculpture, in which he was an advocate of *direct carving. His sculptures include the Monument to the 24th Division in Battersea Park, London (1926) (the writer Robert Graves was the model for one of the three soldiers); figures (in carved brick) for the Shakespeare Memorial Theatre in Stratford-upon-Avon (1930); and the recumbent effigy of T. E. Lawrence on his tomb in St Martin's Church, Wareham, Dorset (1940). During the Second World War Kennington was again an Official War Artist; three collections of his work

(mainly pastel portraits) were issued in book form: *Drawing the RAF* (1942), *Tanks and Tank-Folk* (1943), and *Britain's Home Guard* (1945). After the war he worked mainly as a sculptor, and 'He had the constant wish to see sculpture incorporated into architecture as decoration and ornament, even in modern materials' (*DNB*).

Kent, Rockwell (1882–1971). American painter, graphic artist, and writer, born at Tarrytown Heights, New York. He began to train as an architect at Columbia University but dropped out of the course to study painting, his teachers including *Chase and *Henri. His preference was for scenes of the great outdoors, painted in a vivid, dramatic style with strong contrasts of light and shade. They reflected his own lifestyle, for he loved exploring remote areas (including Alaska, Greenland, and Tierra del Fuego) and early in his career he supported himself by working at such jobs as lobsterman and ship's carpenter. His pictures appealed to the American pioneer spirit and by the 1920s he was one of the country's most popular artists. However, he had outspoken left-wing political sympathies and at the time of the anti-Communist witch-hunts in the 1940s and 1950s he was dogged by various investigating committees. He was chairman of the National Council for American-Soviet Friendship and in 1967 was presented with the International Lenin Peace Prize by the Soviet government; he gave the award money to the people of North Vietnam. Kent illustrated numerous books, including his own accounts of his travels, such as *Wilderness* (1920). His other writings include an autobiography, *It's Me, O Lord* (1955).

Kernstok, Károly. See EIGHT (3).

Kertész, André. See BRASSAÏ.

Kettle's Yard, Cambridge. See EDE.

Keynes, John Maynard (1883–1946). British economist, patron, collector, administrator, and philanthropist, a member of the *Bloomsbury Group. In a career divided between the Civil Service (mainly the Treasury) and King's College, Cambridge, he became the most famous economist of his time. His skill at investment and speculation greatly strengthened his college's finances and also made him a personal fortune that allowed him to indulge his love of the arts. His interests in this field were wide-ranging. He was, for example, married to the Russian ballerina Lydia Lopokova (a member of *Diaghilev's Ballets Russes) and he founded the Arts Theatre in Cambridge at his own expense in 1935. Among the Bloomsbury artists, he was particularly associated with Duncan *Grant, who was one of his closest friends and from whom he commissioned work. He also gave financial support to other artists, notably through the founding of the *London Artists' Association in 1925. During the Second World War Keynes was chairman of the Council for the Encouragement of Music and the Arts, and he was first chairman of its successor, the *Arts Council. He was created Baron Keynes of Tilton in 1942. 'The qualities in Keynes which most impressed themselves on his contemporaries were his immense vitality and activity, and his unfailing optimism and conviction that problems were solvable' (*DNB*). There are several portraits of Keynes at King's College, Cambridge, including two bronzes by the German-born sculptor Benno Elkan (1877–1960).

K Foundation. See WHITEREAD.

Kiefer, Anselm (1945–). German painter, born in Donaueschingen. He originally studied law and his intermittent training as a painter included periods of study with Horst *Antes (1968) and Joseph *Beuys (1970–2). Early in his career he was a *Conceptual artist (his work included a series of photographs of himself giving the Nazi salute), but he turned to painting and has come to be regarded as a leading exponent of *Neo-Expressionism. His characteristic works are large, heavily worked canvases, often incorporating material such as straw (he has also sometimes mixed blood with his paint). His subjects frequently refer to German history or Nordic mythology and show an attempt to come to terms with his country's recent past. In his revision of H. H. *Arnason's *A History of Modern Art* (1986) Daniel Wheeeler writes: 'In the great black, apocalyptic paintings of Anselm Kiefer, a poet in paint born in the ashes of the Third Reich, the bardic spirit of the new German art has soared, phoenixlike, to heights of splendor that are as redemptive for painting itself as for the culture the artist both mourns and glorifies.' Many other critics have shared this high opinion of Kiefer (in 1987 Robert

*Hughes described him as 'the best painter of his generation on either side of the Atlantic . . . one of the very few visual artists in the last decade to have shown an unmistakable grandeur of symbolic vision'), but Peter *Fuller referred to the 'nihilistic voids' of his works, which 'consist of nothing but inert matter'.

Kienholz, Edward (1927–94). American sculptor, specializing in life-size three-dimensional tableaux. He was born in Fairfield, Washington, to a farming family and was trained in carpentry and plumbing; as an artist he was self-taught. In 1953 he moved to Los Angeles, where he ran one of the city's first avant-garde galleries, the Now Gallery. This was short-lived (1956–7), but after its closure he opened the Ferus Gallery, which he ran with the critic Walter Hopps. Meanwhile, in his own work he had begun to make painted wooden abstract reliefs in 1954. They grew increasingly three-dimensional and figurative until by 1961 he was producing complete *environments involving life-size figures and various found objects, imcluding furniture. Typically he used the shoddy detritus of contemporary life to create situations of a bizarre and shockingly gruesome character in which death and decay are common themes (his work is sometimes categorized as *Funk art). A much reproduced example is *The State Hospital* (Moderna Museet, Stockholm, 1964–6), showing a mentally ill patient strapped to his bed with his own self-image (in a thought bubble) strapped to the bed above. Both figures are modelled with revolting realism but have glass bowls for heads. H. H. *Arnason (*A History of Modern Art*, 1969) describes the work as 'one of the most horrifying concepts created by any modern artist'. From 1972 Kienholz's work was done in collaboration with his wife, Nancy Reddin Kienholz (1943–), and from 1973 they divided their time between Berlin and Hope, Indiana. Some of his later work commented on Nazism. In 1977, for example, he staged exhibitions consisting of imitation radio-receiving apparatus in decrepit state, which when activated played raucous music by Wagner.

Kiki of Montparnasse (Marie Prin) (1901–53). The most famous artists' model of the 20th century, a celebrated figure in Paris in the period between the two world wars. She came from a farming family in Burgundy and settled in Paris at the end of the First World War; her intention was to get a job in a shoe factory, but she was almost immediately discovered by *Kisling. Among the other artists for whom she posed were *Foujita, Per *Krohg, and most notably *Man Ray, with whom she lived for six years. His most famous picture of her is the photograph entitled *Le Violin d'Ingres* (1924), in which he has painted a violin's f-holes on her naked back. She also appeared in his experimental film *L'Étoile de mer* (1928). From 1926 she exhibited her own paintings (she had a one-woman show in 1930) and she made a name for herself as a night-club singer. In 1929 she published her memoirs. However, her career declined as she lost her looks and she ended her days in drunken poverty.

Kikkert, Conrad. See MODERNE KUNSTKRING.

Kikoïne, Michel. See SOUTINE.

Kinetic art. Term describing art incorporating real or apparent movement (from the Greek *kinesis*, 'movement'). In its broadest sense the term can encompass a great deal of phenomena, including cinematic motion pictures, *Happenings, and the animated clockwork figures found on clocktowers in many cities of Europe. More usually, however, it is applied to sculptures such as *Calder's *mobiles that are moved either by air currents or by some artificial means—usually electronic or magnetic. As well as works employing actual movement, there is another type of Kinetic art that produces illusory movement when the spectator moves relative to it (and *Op art paintings are sometimes included within the field of Kinetic art because they appear to flicker).

The idea of moving sculpture had been proposed by the *Futurists as early as 1909, and the term 'kinetic' was first used in connection with the visual arts by *Gabo and *Pevsner in their *Realistic Manifesto* in 1920. Gabo completed an electrically-driven oscillating wire construction in this year (*Kinetic Sculpture (Standing Wave)*, Tate Gallery, London, 1919–20), and at the same time Marcel *Duchamp was experimenting with *Rotative Plaques* that incorporated movement. Various other works over the next three decades made experiments in the same vein, for example *Moholy-Nagy's *Light-Space-Modulator* (Busch-Reisinger Museum, Harvard University, 1922–30), one

of a series of constructions he made using reflecting metals, transparent plastics, and sometimes mechanical devices to produce real movement. However, for many years Calder was the only leading figure who was associated specifically with moving sculpture (and many people regarded him as eccentric), and it was not until the 1950s that the phrase 'Kinetic art' became a recognized part of critical vocabulary; the exhibition 'Le Mouvement' at the Denise *René Gallery, Paris, in 1955 was a key event in establishing it as a distinct genre. The artists represented in the exhibition included *Agam, *Bury, Calder, Duchamp, *Soto, *Tinguely, and *Vasarely. Kinetic art continued to flourish in the 1960s and 1970s, when it was often combined with other means of expression such as *Light art. It became somewhat less fashionable in the 1980s.

King, Phillip (1934–). British sculptor, born in Tunisia. After reading modern languages at Cambridge University, 1954–7, he studied at *St Martin's School of Art, 1957–8, and began teaching there in 1959; in 1958–60 he was assistant to Henry *Moore. King is probably the most renowned of the generation of avant-garde British sculptors (mainly, like himself, pupils of *Caro) who came to prominence at the *New Generation exhibition in 1965. His work at this time was characteristically in smooth man-made materials such as plastic or fibreglass, often brightly coloured, with the cone shape being a favourite motif (*And the Birds Began to Sing*, Tate Gallery, London, 1964). At the end of the decade he began using more rugged materials, including steel and wood. With Bridget *Riley he represented Britain at the Venice *Biennale of 1968 and his work has been included in many other international exhibitions. A major retrospective show of his work was held at the Hayward Gallery, London, in 1981. King has taught at various art schools in Britain and elsewhere and he was professor of sculpture at the *Royal College of Art from 1980 to 1990.

King, William Dickey. See MARISOL.

Kirchner, Ernst Ludwig (1880–1938). German *Expressionist painter, printmaker, and sculptor, the dominant figure in the *Brücke group. He was born in Aschaffenburg, the son of a distinguished chemist in the paper industry, and moved around a good deal in his childhood because of his father's career before settling at Chemnitz in 1890. From childhood he was nervous and highly imaginative, often disturbed by nightmares. His father opposed his wish to be a painter, so from 1901 to 1905 he studied architecture in Dresden (though with an interlude in Munich in the winter of 1903–4 when he combined his architectural studies with classes in painting—the only tuition he received in the subject). A few weeks before he graduated in July 1905 he founded Die Brücke with a number of other students in Dresden. Like the other members of the group, he was influenced by *Post-Impressionism, particularly *Gauguin and van Gogh, by *Fauvism, and by *Munch. He also claimed that he was the first of the group to appreciate Polynesian and other *primitive art (which he saw in the Zwinger Museum in Dresden), but this had little obvious effect on his work. His paintings consisted mainly of figure compositions, including portraits and nudes (he often spent the summer months in seclusion in the country or on the coast, where he could draw and paint nude models in natural movement). There is often an explicit erotic quality in his work and sometimes a feeling of malevolence. His forms are typically harsh and jagged, and his colours dissonant. From 1910 he began to spend much of his time in Berlin and he settled there in 1911. During the next few years his work developed more independently of the other members of Die Brücke, and his criticisms of his associates were an important factor in the the break-up of the group in 1913. His most celebrated paintings of this period are a series of street scenes of Berlin that are regarded as marking one of the highpoints of Expressionism. In a style that had become more spiky and aggressive he depicted the pace, the glare, and the tension of big city life (*Street, Berlin*, MOMA, New York, 1913).

Kirchner was drafted into the German army in 1915, but he was soon discharged after a mental and physical collapse. He was treated at a sanatorium in Konigstein, near Frankfurt, and painted several murals for the hospital. In 1916 he was hit by a car in Berlin and during his long period of recuperation he settled in Frauenkirch, near Davos, in Switzerland, which became his home for the rest of his life. By 1921 he had recovered from heavy dependence on drugs, but he never fully regained mental equilibrium. When he

started painting again he concentrated on mountain landscapes and peasant scenes, his work gaining in serenity what it lost in vigour. He planned to found a progressive artists' community in Switzerland, and although his idea came to nothing, many young artists sought him out for guidance, for his work had become very well known and he was regarded with awe by some admirers (Kirchner himself—for all his problems—remained unshaken in his belief that he was the greatest German artist of his age). From the late 1920s his style began to move towards abstraction, as he painted less directly from nature. Many exhibitions of his work were held in the 1930s, in Germany and elsewhere, but in the middle of the decade he was overcome again by mental anxiety and physical deterioration. The inclusion of his work in the Nazi exhibition of *Degenerate Art in 1937 caused him acute distress and the following year he shot himself.

Throughout Kirchner's career, printmaking was as important to him as painting and he ranks as one of the 20th century's greatest masters in this field. He produced a huge body of work in woodcut, etching, and lithography, but each print usually exists in only a few impressions, as he liked to print his work himself. His early prints reflect the mannered linearism of Jugendstil, the German version of *Art Nouveau, but this was soon displaced by a harsh contrast of planes and abrupt angularity influenced by his admiration for medieval German woodcuts. In addition to paintings and prints, he also made wooden sculpture, rough-hewn and harshly coloured (*Dancing Woman*, Stedelijk Museum, Amsterdam, 1911).

Kirstein, Lincoln. See LACHAISE.

Kisling, Moïse (1891–1953). Polish-born painter who became a French citizen in 1915. After studying at the Academy in his native Cracow, he moved to Paris in 1910 and became friendly with numerous members of the avant-garde, particularly his fellow expatriates *Chagall, *Modigliani, and *Soutine (his work has a similar melancholy character to theirs); he also knew *Derain, *Gris, and *Picasso, and *Cubism was one of the influences on his eclectic early work. After the outbreak of the First World War, Kisling volunteered for the Foreign Legion, was wounded, and invalided out in 1915. Between 1917 and 1920 he lived in the South of France,

then returned to Paris, where he had a successful exhibition at the Galerie Druet in 1919. By this time he was consolidating the various influences on his work into a personal style marked by elegant draughtsmanship and delicately modulated colours. He had considerable success as a portraitist and also painted nudes and landscapes. From 1941 to 1946 he lived in the USA, mainly in New York, although he also spent a year in Hollywood (1942–3) at the invitation of his friend Artur Rubinstein, the celebrated Polish-born pianist. After returning to France he settled at Sanary-sur-Mer, near Toulon.

Kitaj, Ron B. (1932–). American painter and graphic artist, active mainly in England, where he has been one of the most prominent figures of the *Pop art movement. He was born in Cleveland, Ohio, and studied at the Cooper Union, New York, 1950–1, and the Academy in Vienna, 1951–2. After working as a merchant seaman and serving in the US Army in Germany he came to England on a GI scholarship, studying at the Ruskin School, Oxford, 1958–9, and the *Royal College of Art, 1959–61. His wide cultural horizons gave him an influential position among his contemporaries at the RCA (they included David *Hockney and Allen *Jones), particularly in holding up his own preference for figuration in opposition to the prevailing abstraction. (He has continued to be seen as a champion of figurative art, stressing the importance of drawing and painting from the life, and in 1976 he organized an *Arts Council exhibition of figurative art entitled 'The Human Clay'.) Unlike the majority of Pop artists, Kitaj has had relatively little interest in the culture of the mass media and has evolved a multi-evocative pictorial language, deriving from a wide variety of pictorial and literary sources—indeed he has declared that he is not a Pop artist. Typically his work uses broad areas of flat colour within a strong linear framework, creating an effect somewhat akin to comic strips.

After a visit to Paris in 1975 Kitaj was inspired by the example of *Degas to take up pastel, which he has used for much of his subsequent work. Late 19th-century French art has been a major source of inspiration, as has a preoccupation with his Jewish identity, and he has said: 'I took it into my cosmopolitan head that I should attempt to do *Cézanne and Degas and Kafka over again, after

Auschwitz.' In 1994 a retrospective exhibition of his work at the Tate Gallery, London, received strongly negative reviews; his wife, the American artist Sandra Fisher (1947–94), died of a brain haemorrhage only months later, and Kitaj caused much controversy by blaming this on his critics: 'They tried to kill me and they got her instead.'

Kitchen Sink School. A group of British *Social Realist painters active in the 1950s who specialized in drab working-class subjects, notably interior scenes and still-lifes of domestic clutter and debris; the term was coined by the critic David *Sylvester in an article in the December 1954 issue of the journal *Encounter*. The main artists covered by the term were John *Bratby, Derrick *Greaves, Edward *Middleditch, and Jack *Smith, who were supported by Helen *Lessore's Beaux Arts Gallery in London and by the critic John *Berger; in 1956 they exhibited together at the Venice *Biennale. By their choice of dour and sordid themes and their harsh aggressive style they expressed the same kind of dissatisfaction with the values of post-war British society as the 'Angry Young Men' in literature (writers such as John Osborne, whose *Look Back in Anger* was first produced in 1956, were sometimes referred to as 'kitchen sink dramatists'). The mood did not last and from the late 1950s the painters of the Kitchen Sink School developed in different ways, Bratby, for example emphasizing his *Expressionist handling and Smith eventually turning to abstraction. Berger denounced his former protégés.

kitsch. A term applied to art or artefacts characterized by vulgarity, sentimentality, and pretentious bad taste. In German the word means 'vulgar trash' (from the verb 'verkitschen'—to cheapen or sentimentalize) and was 'originally applied to ephemeral and trashy works, especially sentimental novels and novelettes, and their graphic equivalents, and to poetry of like character' (*Oxford Companion to German Literature*, 1976). Its meaning was extended to cover other forms of expression, and in 1925 the art historian Fritz Karpfen published a book entitled *Der Kitsch: Eine Studie über die Entartung der Kunst* ('Kitsch: A Study of the Degeneration of Art'). The first recorded occurrence of the word in the *Oxford English Dictionary* is of 1926 (quoting a remark about 'listening to "Kitsch" on the wireless') and the first serious critical discussion of the

word in English was Clement *Greenberg's essay 'Avant-Garde and Kitsch' published in *Partisan Review* in 1939. Greenberg thought that kitsch was the outcome of a world in which money and desire had become much more widely spread than taste and knowledge—'a product of the industrial revolution which urbanized the masses of Western Europe and America and established what is called universal literacy'. He argued that before literacy became widespread, formal culture was the preserve of educated people with money and leisure; however, the 'peasants who settled in the cities as proletariat and petty bourgeois' lost the taste for their traditional folk culture and 'set up a pressure on society to provide them with a kind of culture fit for their own consumption. To fill the demand of the new market, a new commodity was devised: ersatz culture, kitsch, destined for those who, insensible to the values of genuine culture, are hungry nevertheless for the diversion that only culture of some sort can provide. Kitsch, using for raw material the debased and academicized simulacra of genuine culture, welcomes and cultivates this insensibility. It is the source of its profits . . . The precondition for kitsch . . . is the availability close at hand of a fully matured cultural tradition, whose discoveries, acquisitions and perfected self-consciousness kitsch can take advantage of for its own ends.'

Greenberg's analysis of how kitsch operates can still be considered broadly valid, but he took an extremely expansive view of what constituted kitsch, including jazz and Hollywood movies—forms that are now treated just as seriously as museum art. Among the artists he mentioned as exemplifying kitsch were Maxfield *Parrish and Norman *Rockwell, who likewise are now treated with respect (at least by some critics). The reappraisal of artists such as these, formerly dismissed as shamelessly vulgar, came in the wake of *Pop art, which blurred the distinctions between 'high' and 'low' art and therefore complicated attitudes towards kitsch. *Postmodernism has further complicated the issue, for now kitsch imagery is used in an 'ironic' way by 'serious' artists such as Jeff *Koons (although Koons himself says he does not perceive any ironic quality in his work: 'What it does have for me is a sense of the tragic'). Artists whose work is still sometimes labelled kitsch in a straightforward, uncomplimentary, unironic sense include Salvador *Dalí (in his late

religious paintings) and Vladimir *Tretchi-koff—the 'King of Kitsch'.

In the USA the term 'Schlock art' is sometimes used as an alternative to 'kitsch'; 'schlock', derived from Yiddish, means 'cheap, shoddy, or defective goods' (it is also used in the combination form 'schlockmeister' or 'schlockmaster'—'a purveyor of cheap merchandise').

Kitson, Linda. See OFFICIAL WAR ART.

Kjarval, Jóhannes. See THORLÁKSSON.

Klapheck, Konrad (1935–). German painter, born in Düsseldorf, where he studied at the Academy, 1954–8. He made his reputation with blandly treated representations of utility objects such as typewriters, telephones, and so on. In the catalogue of the exhibition 'German Art in the 20th Century' (Royal Academy, London, 1985), it is said that 'Far from simply reproducing his motifs he introduces idiosyncratic and technically absurd modifications whose interpretative significance is often clinched by the title he gives his pictures'; an example is *The Logic of Women* (Louisiana Museum, Humlebaek, 1965), which depicts a mysterious-looking sewing machine. Klapheck's work has been seen as both a late flowering of *Surrealism (André *Breton agreed with this) and as a forerunner of *Superrealism. In 1979 he became a professor at the Düsseldorf Academy.

Klee, Paul (1879–1940). German-Swiss painter, graphic artist, writer, and teacher, one of the most individual and best-loved figures in 20th-century art. He was born at Münchenbuchsee, near Berne, to a German father and a Swiss mother (he is often referred to as Swiss, but he was a German citizen throughout his life, and although he eventually sought Swiss citizenship this was not granted until the day after his death). From 1898 to 1901 he studied in Munich, principally at the Academy under Franz von *Stuck. After travelling in Italy, 1901–2, he lived in Berne for the next four years, then in 1906 moved to Munich after marrying the German pianist Lily Stumpf (both Klee's parents were musicians and he was himself a violinist of professional standard—as a boy he had played in the Berne Symphony Orchestra). Lily was the main breadwinner with teaching work until Klee's career took off after the First

World War. In 1911 he became friendly with *Jawlensky, *Kandinsky (whom he had first met as a student ten years earlier), *Macke, and *Marc, and in the following year he took part in the second *Blaue Reiter exhibition. Also in 1912 he visited Paris for the second time (he had earlier been there with Louis *Moilliet in 1905); he met *Delanuay on this occasion and saw *Cubist pictures. At this point he was principally an etcher, his most notable prints including a series of eleven *Inventions* (1903–5)—bizarre and satirical works with freakishly distorted figures. However, in 1914 he visited Tunisia with Macke and Moilliet and was dramatically awakened to the beauty of colour. Two weeks after arriving he wrote: 'Colour possesses me. I no longer need to pursue it: it possesses me forever, I know. Colour and I are one—I am a painter.'

In 1916 he was drafted into the German army, but unlike his friends Macke and Marc (both of whom died in action) he was not involved in combat; his work included painting aeroplanes. After the war he returned to Munich, and in 1919 he applied to succeed Adolf *Hölzel at the Stuttgart Academy. He was rejected on the grounds that his work (in *Schlemmer's words) was 'playful in character and lacking firm commitment to structure and composition'. The following year, however, he had a huge success when the Munich dealer Hans Goltz staged a large retrospective exhibition of his work. This secured his reputation and led *Gropius to invite him to teach at the *Bauhaus; he moved to Weimar to take up the post in January 1921 and remained with the school for the next ten years. He proved an inspired, undogmatic teacher, both in his specialist work in the stained glass, bookbinding, and weaving workshops and in the more general classes of the preliminary course devoted to the understanding of basic principles of design. (His popularity with his students was so great that to mark his 50th birthday in 1929, one of them, Anni *Albers, hired an aeroplane to drop bouquets of flowers on his house.)

In 1925 the Bauhaus published Klee's *Pedagogisches Skizzenbuch*, the best-known of his writings (it was translated into English as *Pedagogical Sketchbook* in 1953). There is no complete and reliable edition of his theoretical texts (few of which were published during his lifetime), and it difficult to summarize his views on art, especially as his statements tend to couched in poetically compressed

language. Frank *Whitford writes (*TLS*, 8 April 1994): 'Apparently objective but in reality highly personal, Klee's theories deploy vivid metaphor and terminology borrowed from natural science in an attempt to identify and comprehend the well-spring of all creation, natural and artistic, and to examine the work of art as a microcosm of the universe.' During his Bauhaus days Klee was particularly close to another theoretician of poetic cast of mind—his colleague Kandinsky (they even lived in adjoining parts of the same building). He kept aloof from the internal disputes of the school (his detachment earned him the nicknames 'Bauhaus Buddha' and 'the heavenly father'), but the quarrels became increasingly tiresome to him and he resigned in 1931 and took up a post at the Academy in Düsseldorf. Two years later he was dismissed by the Nazis and returned to Switzerland, settling permanently in Berne. His work was included in the notorious exhibition of *Degenerate Art in 1937.

Although Klee was not politically inclined, his mood during his last years was one of profound disappointment; he was cut off from the German public that had greatly admired his work, and although he received visits from distinguished admirers (including *Picasso in 1937), the Swiss artistic milieu was generally less sympathetic. In 1935 he suffered the first symptoms of the illness that killed him—a rare debilitating disease called scleroderma—and although he remained highly productive to the end, his earlier playfulness gave way to a preoccupation with malign and malevolent forces. His exquisitely sensitive line grew deliberately rough and crude and his sense of humour became macabre; his imagery was haunted by premonitions of death, as in *Death and Fire* (Paul Klee Foundation, Kunstmuseum, Berne, 1940), one of his starkest and most powerful works. It depicts a ghastly, ashen face, the features of which are made up of letters forming the word 'Tod'—German for 'death'. In the catalogue of the exhibition 'Paul Klee: The Last Years (Hayward Gallery, London, 1974), Douglas Hall writes: 'The late work of Paul Klee, besides its enormous psychic interest, was of high importance for the future development of modern art. His disjunctive method of composition, his abnegation of the necessity to focus on a point or an episode of a painting, represent one of the very few new inventions in painting since cubism.'

Klee was one of the most inventive and prolific of modern masters, his complete output being estimated at some 9,000 works. He usually worked on a small scale; initially he painted only in watercolour, but he took up oils in 1919 and sometimes used both media in one painting. It is impossible to categorize his work stylistically, for he moved freely between figuration and abstraction, absorbing countless influences and transforming them through his unrivalled imaginative gifts as he explored human fantasies and fears. In spite of this variety, his work—in whatever style or medium—is almost instantly recognizable as his, revealing a joyous spirit that is hard to parallel in 20th-century art. The finest collection of his work is in the Paul Klee Foundation in the Kunstmuseum, Berne.

Klein, César. See NOVEMBERGRUPPE.

Klein, Yves (1928–62). French painter and experimental artist, born in Nice, one of the most influential figures in European avant-garde art in the post-war period. Both his parents were painters, but he had no formal artistic training and for much of his short life he earned his living as a judo instructor; in 1952–3 he lived in Japan, where he obtained the high rank of black belt, fourth dan, and in 1954 he published a textbook on the subject. In his early 20s he also travelled a good deal elsewhere (including England and Spain to learn the languages), but in 1955 he settled permanently in Paris. He had started to paint in the mid-1940s and he began to feel a serious vocation as an artist in about 1950. In the mid-1950s he began exhibiting 'monochromes'—pictures in which a canvas was uniformly painted a single colour, usually a distinctive blue that he called 'International Klein Blue'. He used this blue also for other works, including sculptured figures and reliefs of sponges on canvas. In a lecture given at the Sorbonne in 1959, Klein explained his theory of monochrome painting as an attempt to depersonalize colour by ridding it of subjective emotion and so give it a metaphysical quality. Klein also made pictures by a variety of unorthodox methods, including the action of rain on prepared paper (these he called *Cosmogonies*), the use of a flame-thrower (*Peintures de Feu*), or imprints of the human body (*Anthropométries*). In 1958 he created a sensation (and almost a riot) at the Galerie Iris Clert in Paris by an

'exhibition of emptiness'—an empty gallery painted white. It was called *Le Vide* (the Void). In 1960 he gave his first public demonstration of his *Anthropométries*: naked women smeared with blue pigment dragged each other over canvas laid on the floor to the accompaniment of his *Symphonie monotone*—a single note sustained for ten minutes alternating with ten minutes' silence. Critical reception was very mixed: he became a celebrity in Europe, but an exhibition at the Leo *Castelli gallery in New York in 1961 was a dismal failure.

Klein died young of a heart attack, but he produced a large body of work and had wide influence, particularly on the development of *Minimal art. A great showman, he represents the tendency in 20th-century art for the personality of the artist to assume greater importance than the things he makes—a tendency continued most notably by Joseph *Beuys.

Klimt, Gustav (1862–1918). Austrian painter, draughtsman and designer, one of the leading figures in one of the most exciting epochs of Vienna's cultural history. He was born in Vienna, the son of an engraver, and rarely left the city (except to visit a spa in the Austrian lake district every summer—he was something of a hypochondriac). From 1876 to 1883 he studied at the School of Applied Arts, Vienna, then quickly achieved success as a painter of sumptuous decorative schemes in the tradition of Hans Mackart, whose staircase decoration in the Kunsthistorisches Museum in Vienna Klimt completed after Mackart's death in 1884. In this and other schemes he worked in collaboration with his brother Ernst Klimt (1864–92) and Franz Matsch (1861–1942). In spite of his acclaim in official circles, Klimt was drawn to avant-garde art, and his work was influenced by *Impressionism, *Symbolism, and *Art Nouveau. Discontent with the conservative attitudes of the Viennese Artists' Association led him and a group of friends to resign in 1897 and set up their own organization, the *Sezession, of which he was elected first president. In a short time Klimt thus went from being a pillar of the establishment to a hero of the avant-garde, and this new role was confirmed when his enormous allegorical mural paintings for Vienna University aroused great hostility, being called nonsensical and pornographic. (Klimt was given the commission in 1894 and abandoned it in 1905; the paint-

ings—on the themes of *Jurisprudence, Medicine,* and *Philosophy*—were destroyed by fire in 1945.)

Although official commissions dried up after this, Klimt continued to be much in demand with private patrons, as a portraitist as well as a painter of mythological and allegorical themes. He was highly responsive to female beauty (he was a great womanizer) and in both his portraits and his subject pictures he stresses the mystery and allure of womanhood. Notable examples are the magnificent full-length portrait of Emilie Flöge (his sister-in-law and perhaps his lover) in the Historisches Museum der Stadt, Vienna (1902) and *Judith I* (Österreichische Galerie, Vienna, 1901), one of the archetypal images of the *femme fatale*. Characteristically, the figures in Klimt's paintings are treated more or less naturalistically but embellished—in the background or their clothing—with richly decorative patterns recalling butterfly or peacock wings, creating a highly distinct style of extraordinarily lush sensuality. The erotic aspect of his work is even more pronounced in his drawings, most of which were done as independent works rather than as preparatory studies for paintings; characteristically they show naked or semi-naked women in a state of sexual arousal.

In addition to paintings and drawings, Klimt made designs for the *Wiener Werkstätte (he was a member of the board of management). Most of his designs were fairly modest, but the great exception was the major commission of his later years—the mosaics for the dining room of the Palais Stoclet in Brussels, a luxury home built at huge expense for the young Belgian industrialist Adolphe Stoclet, who had just inherited the family fortune. The architect was the Austrian Josef Hoffmann (1870–1956) and some of the finest talents of the Werkstätte collaborated with him in the interior decoration. It was begun in 1905 and Klimt's mosaics were executed in 1909–11; the two long walls of the room are decorated with curling branches of the Tree of Life, with a figure of a young woman symbolizing Expectation on one wall and an embracing couple opposite representing Fulfilment.

Klimt was regarded by many of his contemporaries as the outstanding Austrian artist of his period, and his work superbly evokes an age of luxury and optimism before the First World War. Although he is so closely associ-

ated with Vienna, his reputation spread outside his own country, and in 1910 he was given an exhibition at the Venice *Biennale. It was very popular with the public, although some critics attacked Klimt's work as decadent and the *Futurists regarded it as self-indulgent and irrelevant to modern life. He was influential on some of his Viennese contemporaries, notably *Kokoschka and *Schiele, but as Frank *Whitford writes, 'No school followed him. There was no one quite like him before and no one at all like him afterwards. His effect on the course of painting in the twentieth century was negligible. Yet the transition from the old to the modern can be seen more clearly in his work and the purposes for which it was intended than in that of any other major artist' (*Klimt*, 1990).

Kline, Franz (1910–62). American painter, generally considered one of the most individual of the *Abstract Expressionists. He was born in Wilkes-Barre, Pennsylvania of immigrant parents—a German father and an English mother. After studying art at Boston University, 1931–5, he set off for Paris in 1937 but got no further than London, where he continued his studies at Heatherley's School of Art, 1937–8. On his return to the USA he settled permanently in New York in 1939. His early work was representational, including urban landscapes and commisioned portraits, but he turned to abstraction at the end of the 1940s. This change of direction reflected the influence of Willem *de Kooning (whom he met in 1943), but the most important factor in his 'conversion' was seeing some of his own quick sketches enlarged by a projector, an experience that made him realize their potential as abstract compositions. Elaine de Kooning commented that Kline was amazed at what he saw: 'A four by five inch brush drawing of the rocking chair ... loomed in gigantic black strokes which eradicated any image, the strokes expanding as entities in themselves, unrelated to any reality but that of their own existence ... From that day, Franz Kline's style of painting changed completely.'

Once he had embarked on his new path, Kline very quickly developed a highly personal style of expressive abstraction, converting the brushstrokes of his drawings into large-scale abstract paintings, using bold black patterns on a white ground in a manner reminiscent of oriental calligraphy but with a distinctive rough vigour (he used commercial paints and house-painters' brushes, sometimes up to eight inches wide). He had his first one-man show at the Charles Egan Gallery, New York, in 1950 and made a strong impression, particularly with *Chief* (MOMA, New York, 1950). After this his reputation grew rapidly. Kline referred to his works as 'painting experiences. I don't decide in advance that I'm going to paint a definite experience, but in the act of painting, it becomes a genuine experience for me . . . I'm not painting bridge constructions, sky scrapers or laundry tickets.' However, some of his paintings do allude to memories of the industrial part of Pennsylvania where he grew up; the titles of several of them (including *Chief*) are taken from the names of railway engines, and his dense blacks evoke a feeling of coal country. Towards the end of his life he sometimes used vivid colours, but for the most part he remained loyal to his characteristic black-and-white style. He died of heart disease.

Klingender, Francis. See ARTISTS INTERNATIONAL ASSOCIATION.

Klinger, Max (1857–1920). German painter, sculptor, and graphic artist, born in Leipzig. He studied at the Academies of Karlsruhe and Berlin, then after brief periods in Brussels, Berlin, and Munich he spent the years 1883–6 in Paris, 1886–8 in Berlin, and 1888–93 in Rome. After his return to Germany in 1893 he settled in Leipzig, where his home was one of the centres of the city's cultural life. His work reveals a powerful imagination and an often morbid interest in themes of love and death. As a painter he is best known for the enormous *Judgement of Paris* (Kunsthistorisches Museum, Vienna, 1885–7), in which the frame is part of the decorative scheme. As a sculptor he experimented with polychromy, culminating in his statue of Beethoven (Museum der Bildenden Künste, Leipzig, 1899–1902), in white and coloured marbles, bronze, alabaster, and ivory. It is a graphic artist, however, that Klinger is now best known and that he most clearly showed his originality, especially in his series *Adventures of a Glove*, a grotesque exploration of fetishism that antedated the publication of Freud's theories. His drawings for this were exhibited in Berlin in 1887 when he was only 21 and made a great impact; the etchings that he made from them (three series, beginning in 1881) were widely

influential. The series concerns a hapless young man and his involvement with an elusive lost glove that has clearly sexual connotations. This and other works of Klinger have been seen as forerunners of *Surrealism, and his influence is clearly seen in the work of de *Chirico (one of his greatest admirers), *Dalí, and *Ernst, amongst others.

Klippel, Robert. See DIRECTION 1.

Knave of Diamonds or **Jack of Diamonds** (Bubnovyi Valet). An artists' association, formed in Moscow in 1910, that was for a time the most important of the avant-garde associations in Russia. There are various explanations of how the name came about, one being that it refers to the diamond markings on the uniforms of civil prisoners; the artists involved thus wanted to indicate that they were revolutionaries. The group's first exhibition, in December 1910, featured work by *Goncharova, *Larionov, and *Malevich, the expatriate Russians *Jawlensky and *Kandinsky, and the French *Cubists *Gleizes and *Le Fauconnier. In 1911 Goncharova, Larionov, and Malevich broke away from the group, accusing it of being too dominated by the 'cheap orientalism of the Paris School' and the 'Munich decadence', and founded their own association, the *Donkey's Tail, to promote an art based on native inspiration. The Knave of Diamonds held regular exhibitions up to 1917, then broke up; it reappeared after the Revolution and continued for some time under various different names.

Knight, Dame Laura (née Johnson) (1877–1970). British painter, born at Long Eaton, Derbyshire; her mother was an art teacher. From 1889 to 1894 she studied at Nottingham School of Art, where she met **Harold Knight** (1874–1961), who married her in 1903 and who became a successful portraitist. They lived in Yorkshire, the Netherlands (at an artists' colony at Laren), and Newlyn (1908–18) before settling in London. In the interwar years Laura Knight was one of the most highly regarded of British artists and in 1936 she became the first woman to be elected a *Royal Academician since the original women members Angelica Kauffmann and Mary Moser in 1768 (Annie Swynnerton (1844–1933), a painter of allegorical and mythological subjects, had been elected the first woman ARA in 1922—at the age of 78—but she never made

it to RA). At the height of Knight's considerable fame (she was regarded as a 'character'—the nearest equivalent to a female Augustus *John) she won great popularity for her colourful scenes of gypsies, the ballet, and circus life (Alfred *Munnings introduced her to the circus owner Bertram Mills). She was so strongly identified with such subjects that she called her autobiography *Oil Paint and Grease Paint* (1936) and began it with the words: 'I was not, as most people assume, born in a circus, suckled by an elephant.' The pictures that made her famous now often seem rather corny, but on the other hand her early *Newlyn School landscapes, which at their best have a sparkling sense of *joie de vivre*, have recently come back into favour. Some of the work she did as an *Official War Artist during the Second World War is also now highly regarded; it depicted, for example, women working in armaments factories (*Ruby Loftus Screwing a Breech Ring in the Bofors Gun*, Imperial War Museum, London, 1942). In 1946 she went to Nuremberg to make a pictorial record of the War Criminals' Trial; she made scores of sketches and produced a large painting (Imperial War Museum). In 1965 she published a second volume of autobiography, *The Magic of Line*.

Knights, Winifred. See MONNINGTON.

Koberling, Bernd. See NEO-EXPRESSIONISM.

Kobro, Katarzyna. See STRZEMIŃSKI.

Koehler, Bernhard. See MACKE.

Kokoschka, Oskar (1886–1980). Austrian-born *Expressionist painter, graphic artist, and writer who became a Czech citizen in 1937 and a British citizen in 1947. He was born in Pöchlarn of Austrian and Czech parents and grew up mainly in Vienna, where he studied at the School of Arts and Crafts from 1905 to 1909 (in this period he also worked for the *Wiener Werkstätte, painting fans and designing postcards among other things). In 1909–10 he began to make an impact as a painter with his 'psychological portraits', in which the soul of the sitter was thought to be laid bare. Ernst Gombrich has written of these works: 'Much was made at the time by Kokoschka's champions and detractors of the claim that in his portraits he represented his sitter's soul ... what makes these portraits the

most poignant gallery of individuals painted in this century . . . is the intensity of the artist's personal involvement which made him sweep aside the protective covering of conventional "decorum" to reveal his compassion with a lonely and tormented human being. No wonder, perhaps, that the sitters and the public felt at first uneasy and even shocked by this exposure' (catalogue of the Arts Council exhibition 'Kokoschka', Tate Gallery, London, 1962). A good example of this type of portrait is that of the architect Adolf Loos (Staatliche Museen, Berlin, 1909), showing the sensitive, quivering line through which Kokoschka captured what he called the 'closed personalities, so full of tension' of his sitters. Later his brushwork became much broader and more broken, with high-keyed flickering colours.

Kokoschka had his first one-man exhibition in 1910, at Paul *Cassirer's gallery in Berlin, and in the same year he began to contribute illustrations to the avant-garde Berlin periodical Der *Sturm (he did a good deal of graphic work at this time). In 1915 he was badly wounded whilst serving in the Austrian army, and in 1917—still recuperating—he settled in Dresden, where he taught at the Academy from 1919 to 1924. After this he embarked on a period of wide travel that lasted for seven years, and during this time his attention turned more from portraits to landscapes, including a distinctive type of townscape seen from a high viewpoint (*Jerusalem*, Detroit Institute of Arts, 1929–30). In 1931 he returned to Vienna, but he was outspokenly opposed to the Nazis (who later declared his work *degenerate) and he moved to Prague in 1934 and then to London in 1938. By this time he had an international reputation, but his work was as yet little known in England and he was poor throughout the war years. After the war his fortunes soon improved and he came to be generally regarded as one of the giants of modern art. From 1953 he lived mainly at Villeneuve in Switzerland, and from 1953 to 1963 he ran a summer school at Salzburg, the Schule des Sehens (School of Seeing).

In his later years Kokoschka continued to paint landscapes and portraits, but his most important works of this time are allegorical and mythological pictures, including the *Prometheus* ceiling (1950) for the house of Count Seilern (an Anglo-Austrian art historian and collector) at Princes Gate in London,

and the *Thermopylae* triptych (1954) for Hamburg University. Kokoschka remained steadfastly unaffected by modern movements and throughout his long life he pursued his highly personal and imaginative version of pre-1914 Expressionism. Unlike many other Expressionists, however, he was essentially optimistic in outlook. His writings include an autobiography, *Mein Leben* (1971, English translation, *My Life*, 1974), and several plays, the most important of which is *Mörder Hoffnung der Frauen* ('Murder Hope of Women'), an early example of Expressionist theatre that caused outrage when it was first perfomed in 1908 because of its violence.

Kolbe, Georg (1877–1947). German sculptor, born at Waldheim, Saxony. He trained as a painter in Dresden, Munich, and Paris (at the *Académie Julian, 1898), then took up sculpture during a stay in Rome, 1898–1901. From 1903 he lived in Berlin, but in 1909 he revisited Paris, where he met *Rodin, who together with *Maillol influenced him in turning exclusively to sculpture and in his choice of favourite subject—the nude. Kolbe's early work had vigour and freshness and his lithe figures were often expressive of the dance. In 1929 one such female figure was displayed in the German Pavilion, designed by the great Ludwig Mies van der Rohe, at the Barcelona World Exhibition and it looked completely at home in this exquisite modern setting (by common consent one of the loveliest buildings of the 20th century). However, after the rise of the Nazis (see NATIONAL SOCIALIST ART) Kolbe's work lost its individuality as he turned to evoking the popular image of the 'master race'. George Heard *Hamilton writes: 'The National Socialists approved of his technique quite as much as of his subjects, and after 1933 Kolbe extolled the virtues of health and joy through increasingly monumental and proportionately stereotyped nudes, scarcely to be distinguished from innumerable others, no more but no less competent, which are so conspicuous a feature of German academic sculpture. None the less such work should not be allowed to conceal the rhythmic invention and technical perfection of his earlier figures.'

Kollwitz, Käthe (née Schmidt) (1867–1945). German graphic artist and sculptor. She was born in Königsberg in East Prussia (now Kaliningrad in Russia) and had her main

artistic training in Berlin and Munich. Originally she intended becoming a painter, but she soon realized that her strength lay in drawing and printmaking. She came from a family of strong moral and social convictions, and after marrying a doctor of similar outlook, Karl Kollwitz, in 1891, she moved to one of the poorer quarters of Berlin, where she gained first-hand knowledge of the wretched conditions in which the urban poor lived. The two series of etchings that established her reputation were inspired by a spirit of protest against working conditions of the day, although their subjects are set in the past—*Weavers' Revolt* (1893–7) and *Peasants' War* (1902–8). After about 1910 lithography replaced etching as her preferred medium (she also made woodcuts), and after the First World War she turned from illustrating particular subjects to depicting abstract concepts and great timeless themes such as the Mother and Child. Her work is uncompromisingly serious and often deeply pessimistic in spirit, and many of her later drawings and prints are pacifist in intention (her son was killed in the First World War and her grandson in the Second World War). Appropriately, her best-known sculpture is a war memorial—that at Dixmuiden, Flanders, completed in 1932.

In line with her left-wing views Kollwitz visited the Soviet Union in 1927, but she subsequently became disillusioned with Soviet Communism. In 1919 she had been made the first-ever woman member of the Berlin Academy, but when Hitler came to power in 1933 she was forced to resign. She suffered harassment, but she was never declared a *degenerate artist (in fact the Nazis sometimes used her images—without her name or authorization—in their propaganda), and she continued to produce outstanding work. Her masterpiece is arguably the series of eight lithographs on *Death* (1934–5), memorably showing the powerful breadth of her style, in which all accidentals and inessentials are eliminated. In 1943 her studio in Berlin was destroyed by bombing and she spent the last year of her life as a guest of Prince Ernst Heinrich of Saxony in the castle of Moritzburg near Dresden. She died only a few days before the end of the Second World War. In its poignant concern for suffering humanity, her work represents one of the highpoints of German *Expressionism and of 20th-century graphic art. Only rarely does she lapse into sentimentality. 'I should like', she wrote in 1922, 'to exert influences in these times when human beings are so perplexed and in need of help.'

Komar and Melamid. See SOTS ART.

Konijnenburg, Willem van (1868–1943). Dutch painter, designer, and writer on art. He was born in The Hague, where he studied at the Academy. His work, which includes portraits, murals of religious subjects, and stained-glass windows, continued the tradition of *Symbolism in the Netherlands that had been exemplified most notably by *Thorn Prikker and *Toorop. He believed there was a connection between mathematical proportion, rhythm, and stylization on the one hand and the struggle between good and evil on the other. These views were expounded in various publications, notably his books *Het Wezen der Schoonheid* ('The Nature of Beauty'), published in 1908, and *De aesthetische Idee* ('The Aesthetic Idea'), published in 1916.

Konkrete Kunst. See CONCRETE ART.

Kooning, Willem de. See DE KOONING.

Koons, Jeff (1955–). American sculptor and avant-garde artist. He was born in York, Pennsylvania, and studied at the Maryland Institute of Art, Baltimore, and the Art Institute of Chicago. Before achieving recognition as an artist, he had a prosperous career as a Wall Street commodities broker. He has conducted an extremely successful self-publicity campaign and since the mid-1980s has been one of the most touted artists in the world. His fame (or notoriety) has been enhanced by his relationship with the Italian porn star and politician Ilona Staller (La Cicciolina). She figures in much of his work, which includes glass sculptures of the couple in sexually explicit poses. They married in 1991 but soon separated. Among Koons's other works are vacuum cleaners displayed in perspex cases and Disney-like sculptures of animals. The catalogue of the exhibition 'American Art in the 20th Century' (Royal Academy, London, 1993) comments: 'Despite the artist's fame and fortune, critical opinion is divided. On the one hand, Koons is deemed "slick, facile, cynical", someone who carries "the love of *kitsch to a new level of atrocious taste". On the other, he has been called the most important artist of the 1980s.' See also NEO-GEO.

Košice, Gyula (1924–). Argentine sculptor and experimental artist. He was born in Czechoslovakia and moved to Argentina with his parents when he was four. He studied at the Academia Bellas Artes in Buenos Aires but considers himself largely self-taught. In 1946 he was one of the founders of Madí (the origin of the name is uncertain), an avant-garde group that has been seen as the forerunner of groups such as *Fluxus in Europe. He is regarded as one of the founders of *Constructivism in Argentina and his work often uses modern industrial materials; he was one of the first artists anywhere to incorporate neon tubing (see LIGHT ART) in a work (*MADI Neon No. 3*, Musée de Grenoble, 1946). His best-known works are his *Hydrosculptures*, which use jets or sheets of water. Košice has written a good deal and travelled widely promoting his views. In 1988 he was commissioned to make a sculpture for the Seoul Olympic Games.

Kossoff, Leon (1926–). British painter, born of Russian-Jewish immigrant parents in the East End of London, an area that has provided the chief subject-matter of his paintings. He studied at *St Martin's School of Art, 1949–53, and the *Royal College of Art, 1953–6, and also attended David *Bomberg's evening classes at Borough Polytechnic, 1950–2. His work has close affinities with that of another Bomberg student, Frank *Auerbach—in choice of subject, emotional treatment of it, and use of extremely heavy impasto, 'the paint dripped, dragged, flicked or coagulated, leaving the impression that the surface of the canvas is still moving, heaving and re-forming like boiling tar' (Frances Spalding, *British Art Since 1900*, 1986). Kossoff generally retains a firmer sense of structure than Auerbach, however, often using thick black outlines, and unlike him does not approach abstraction. He says that 'I simply use the paint to get closer to what I'm experiencing visually—the accumulation of memories and the unique quality of the subject on one particular, unrepeatable day'. His reputation was slow to grow, but there was a major retrospective exhibition of his work at the Tate Gallery, London, in 1996.

Kosuth, Joseph (1945–). One of the leading American exponents of *Conceptual art. He was born in Toledo, Ohio, and studied at the Toledo Museum School of Design, 1955–62, and the Cleveland Art Institute, 1963–4, before settling in New York, where he studied at the School of Visual Arts, 1965–7, and at the New School for Social Research (his subjects were anthropology and philosophy), 1971–2. In 1969 he became American editor of the journal *Art-Language* (see ART & LANGUAGE). Kosuth has been much concerned with linguistic analysis of concepts of art, his best-known work being *One and Three Chairs* (MOMA, New York, 1965), which consists of an actual chair alongside a full-scale photograph of a chair and an enlarged photograph of a dictionary definition of a chair. 'Actual works of art', he says, 'are little more than historical curiosities.'

Kounellis, Jannis (1936–). Greek experimental artist, born in Piraeus. In 1956 he settled in Rome, where he studied at the Academy, and he has rarely returned to Greece. His early work included canvases embellished with stencilled letters, numbers, and signs, but in the mid-1960s he abandoned painting and in 1967 became associated with the *Arte Povera movement. His most characteristic works have been *installations, involving various materials and sometimes live animals. In the catalogue of the exhibition 'Italian Art in the 20th Century' (Royal Academy, London, 1989), Kounellis is described as 'one of the most complex and poetically talented artists of the non-figurative neo-avant-garde—an artist in continual growth and one who contributed some of the most significant works of the sixties and the following decade . . . Kounellis has continually rebelled against what he calls "the inertia of style" by challenging the traditional notion of the art object or even the art exhibition. For his first retrospective in the United States in 1986, he extended his installations beyond the walls of the Museum of Contemporary Art in Chicago into four abandoned industrial buildings in different areas of the city.'

Kozloff, Joyce (née Blumberg) (1942–). American painter, one of the leading figures of the *Pattern and Decoration movement. She was born in Somerville, New Jersey, and studied at Carnegie Mellon University, Pittsburgh, and Columbia University, New York, where she took an MFA degree in 1967. In the same year she married the critic **Max Kozloff** (1933–), whose publications include *Renderings: Critical Essays on a Century of Modern Art* (1970); also in 1967 she visited Spain, where

she became fascinated with the elaborate patterns of Islamic art. This was one of the sources that led her to a work in a style that she calls 'deliberately and even ostentatiously decorative. It comes out of a love of objects which are visually rich and sensuous. I found that in the art of other cultures there is that careful and pleasurable attention to detail which have become taboo in recent American art, and so I went to these other sources for inspiration. The paintings have a bold, geometrical structure, but they simultaneously have an intricate texture of lines and strokes on the surface, which draw the viewer up close to the work. I hope, with these paintings, to begin breaking down the hierarchies between the *high* and the *decorative* arts—and between *primitive* and *sophisticated* cultures.' Kozloff's work has included not only paintings, but also a number of large tile decorations, made between 1979 and 1984, for subway and train stations in Buffalo, Cambridge (Massachusetts), Philadelphia, and Wilmington, and for the international terminal of San Francisco airport.

Kramář, Vincenc. See GROUP OF PLASTIC ARTISTS.

Kramer, Hilton (1928–). American critic, born in Gloucester, Massachusetts. After taking his BA at Syracuse University, he did postgraduate work at Columbia University, the New School of Social Research, New York, Harvard University, and Indiana University. In 1954 he became associate editor and feature editor of *Arts Digest* and subsequently has worked for numerous journals, notably the *New York Times*, of which he bacame chief art critic in 1974. Like his colleague on the *Times*, John *Canaday, he sometimes caused controversy because of his forceful views. In addition to journalism, he has written several books, notably *The Age of the Avant-Garde: An Art Chronicle of 1956–1972* (1973), *The Revenge of the Philistines: Art and Culture, 1972–1984* (1985), and monographs on Gaston *Lachaise (1967) and Richard *Lindner (1975).

Krasner, Lee (1908–84). American painter, born in Brooklyn, New York. Between 1926 and 1932 she studied at the Cooper Union School and the National Academy of Design, and in 1937 she was a pupil of Hans *Hofmann. Her early work was naturalistic, but by 1940 she had turned to abstraction and was exhibiting with *American Abstract Artists. In 1941 she met Jackson *Pollock, and she married him in 1945 (they separated shortly before Pollock's death because of his affair with another woman). They sometimes exhibited together in group shows, and Krasner was an important source of encouragement and support to Pollock, whose attitude to his work fluctuated from supreme confidence to dismal uncertainty. She was herself an *Abstract Expressionist painter of some distinction, but it was only after her husband's death in 1956 that she began to receive serious critical recognition. David Anfam (*Abstract Expressionism*, 1990) writes that 'Prejudice alone kept Lee Krasner outside standard histories . . . her fellow artists held the same assumptions about gender that most Americans had then. At one of their hangouts, the Cedar Tavern, Krasner recalled women being "treated like cattle".'

Krebs, Rockne. See LIGHT ART.

Krémègne, Pinchus. See SOUTINE.

Kreutz, Heinz. See QUADRIGA.

Kristian, Roald. See HAMNETT.

Krohg, Christian (1852–1925). Norwegian painter. After taking a degree in law in 1873, he trained as a painter in Germany, then in 1881–2 worked in Paris. Thereafter he lived mainly in Christiania (now Oslo), although he had a lengthy stay in Paris from 1902 to 1909, when he taught at the Académie Colarossi. In 1909 he was appointed director of the newly founded Academy of Fine Arts in Christiania and he held this post until his death. Krohg took his subjects mainly from ordinary life—often from its sombre or unsavoury aspects. In particular, he is well known for his paintings of prostitutes, and he wrote a controversial novel on the same subject (*Albertine*, 1886). His work was often attacked by conservative critics, but his vigorous and forthright tackling of modern issues made him a hero to many Norwegian artists of a younger generation, most notably Edvard *Munch.

His son **Per Krohg** (1889–1965) was also a painter. He trained in Paris, first under his father at the Académie Colarossi, 1903–7, then with *Matisse. In his early work he specialized in scenes of city life, using bright *Fauvist colours and exaggerated gestures

that sometimes border on caricature (*Kiki of Montparnasse*, NG, Oslo, 1928). After settling permanently in Norway in 1930, however, his style became more naturalistic and he worked mainly as a muralist, decorating many public buildings, particularly in Oslo. He taught at the Academy in Oslo from 1946 to 1958 and followed in his father's footsteps by becoming director in 1955.

Kröller-Müller, Hélène (1869–1939). Dutch collector and patron. She was born Hélène Müller, the daughter of a shipper, and married the businessman Anton Kröller in 1888. Originally she collected delftware, but after meeting the critic H. P. Bremmer (1871–1956) in 1906, she turned her attention to modern art from about 1870 onwards. Bremmer remained her adviser for the rest of her life. Both of them were 'reticent and aloof personalities . . . Mrs Kröller lived a fairly secluded life, fully devoted to her cultural activities, which she saw as her lifework. She was in no way a society celebrity. Bremmer, himself a painter of some merit and a friend of many of the Dutch artists of his generation . . . always kept his distance' (catalogue of the Arts Council exhibition 'Drawings from the Kröller-Müller National Museum, Otterlo', London and Newcastle, 1974). The heart of her collection is a superb representation of paintings and drawings by van Gogh. 'Around it she arranged a survey of modern art as she saw it in reference to her own time and opinions . . . The very personal character of the collection is marked by her preference for the harmonious, the classical, and the spiritual in art . . . [but] she did not want to surround herself with rare and beautiful objects for purely personal reasons . . . [She] saw it as a privilege to be able to do this, a privilege she wished to share with others . . . her choices . . . always showed a strong educational motivation.'

The Dutch government built a museum at Otterlo to house the collection in return for its bequest to the nation; designed by Henry van de *Velde, the museum—officially known as the Rijksmuseum Kröller-Müller—opened to the public in 1938, although it was not finished until 1954. It is regarded as one of the finest pieces of museum architecture of the 20th century and is attractively set in wooded country. Mrs Kröller acted as director until her death. Apart from van Gogh, the Dutch artists in whose work it is strong include Bart van der *Leck (who received regular financial support from the founder), *Mondrian (up to about 1920—Mrs Kröller did not care for pure abstract art), and the *Symbolists *Thorn Prikker and Jan *Toorop. Otherwise, French art is best represented, especially *Cubism. There are also examples of non-Western art. Acquisitions have been made since the founder's death; in particular, a sculpture garden was created in the 1960s, featuring work by *Hepworth, *Maillol, *Moore, *Rodin, and other eminent artists.

Kropivnitsky, Lev. See RABIN.

Kruchenykh, Alexei. See ROZANOVA.

Kruger, Barbara (1945–). American *Conceptual artist and designer. She had a successful career as a magazine and book designer in New York before turning to art in the mid-1970s, initially with fibre hangings influenced by Magdalena *Abakanowicz and then with paintings. In 1977 she began using the form for which she is best known—black-and-white photographs or *photomontages carrying texts challenging social stereotyping, particularly of women. Penny Dunford writes that 'Many of the slogans are addressed to an unidentified but often malevolent audience referred to as "You". Although Kruger is a feminist, these slogans are not specifically addressed to men or women . . . By using mass-media images she aims to communicate ideas about social and political power to people who are not familiar with art, and for this reason a number have been reproduced and pasted on advertisement hoardings in cities in Europe and America' (*A Biographical Dictionary of Women Artists in Europe and America Since 1850*, 1990).

Krylov, Porfiry. See KUKRYNIKSY.

Kubin, Alfred (1877–1959). Austrian graphic artist, painter, and writer, born at Leitmeritz (Litoměřice) in Bohemia. After working as a photographer's assistant, he went to Munich to study art in 1898. From 1906 he lived mainly at Zwickledt in Upper Austria, although he travelled a good deal. He was a friend of *Kandinsky and showed his work in the second *Blaue Reiter exhibition in 1912, but his preoccupations were very different to those usually associated with the group. His work shows a taste for the morbid and fantastic, which he combined with pessimistic

social satire and allegory. Often he depicted weird creatures in the kind of murky nightmare world associated with Odilon *Redon, whom he met in 1905. Kubin's imagery reflects his disturbed and traumatic life (he had an unhappy childhood, attempted suicide on his mother's grave in 1896, and in 1903 underwent a mental breakdown after the death of his fiancée). He was obsessed with the theme of death (he is said to have liked to watch corpses being recovered from the river) and with the idea of female sexuality as a symbol of death. In 1909 he published a fantastical novel, *Die andere Seite* (The Other Side), which he illustrated himself. He also illustrated many other books, often ones whose subject-matter matched his own macabre interests, such as the stories of Edgar Allan Poe. From the 1920s his reputation was widespread and he was influential on the *Surrealists. His spidery style changed little throughout his career. A translation of a collection of autobiographical essays was published in 1983 as *Alfred Kubin's Autobiography*.

Kubišta, Bohumil (1884–1918). Czech painter and graphic artist. He was born at Vlčkovice in Bohemia and studied in Prague and Florence. In 1907 he was one of the founders of the avant-garde Prague group The *Eight (2), and in 1909 he visited Paris; this turned his art decisely towards *Cubism, of which he became one of the leading Czech exponents. In 1911 *Kirchner and *Müller met Kubišta when they visited Prague and invited him to become a 'corresponding member' of Die *Brücke. Poverty forced him to join the army in 1913, and just as he was beginning to achieve some material security and had decided to go back to art full-time, he died in the influenza epidemic of 1918.

Kuhn, Walt (1880–1949). American painter, cartoonist, designer, and art adviser, born in New York. His first name was originally William, but he adopted 'Walt' in about 1900. In his late teens he earned his living partly as a racing cyclist, then in 1899 began working as a cartoonist in San Francisco. From 1901 to 1903 he studied in Europe, before settling in New York, where he worked as a cartoonist and illustrator for various journals over the next decade. His painting of this time was influenced by *Fauvism, but Kuhn was more important as a promoter of modern art than for his own work. His most significant role

was in helping to organize the *Armory Show in 1913; he and Arthur B. *Davies were its chief architects. Kuhn was also an adviser to several pioneer collectors of modern art in the USA, notably Lillie P. *Bliss and John *Quinn.

In the wake of the Armory Show, Kuhn experimented with *Cubism, but he reverted to a much more naturalistic style, and in the 1920s he began producing the pictures of circus performers that are his best-known works. Typically they depict a single figure, seated or half-length, boldly and frontally presented against a stark background (*The Blue Clown*, Whitney Museum, New York, 1931). The colours are often strong, even garish, but otherwise these paintings are fairly conservative. Kuhn also painted still-lifes and landscapes and he worked as a designer for musical reviews and of industrial products. He died in a mental hospital after suffering a nervous breakdown.

Kukryniksy. A collective pseudonym of three Soviet artists who always worked together: Mikhail *Kupriyanov* (1903–91), Porfiry *Krylov* (1902–90), and *Nikolai* Sokolov (1903–). All three of them studied at *Vkhutemas in Moscow. The collective produced oil paintings but was famous primarily for its political and social caricatures in newspapers and periodicals, particularly *Pravda*. They started their work as a group in 1925, began making joint contributions to exhibitions in 1929, and joined the permanent staff of *Pravda* in 1933. In the late 1930s and during the Second World War they did many biting caricatures of Hitler and Mussolini. After the war they continued as political caricaturists and also excelled as book illustrators for classics of Russian literature. In 1965 they were awarded the Lenin Prize.

Kuniyoshi, Yasuo (1893–1953). Japanese-American painter, born at Okayama. He emigrated to the USA in 1906 and studied first in Los Angeles and then, after moving to New York in 1910, at several art schools, notably the *Art Students League, 1916–20. His work shows evidence of his Oriental origins only in a very vague way. In the 1920s and early 1930s he painted in a slightly whimsical manner, often with pastoral imagery, but in the 1930s (at which time he began to achieve serious recognition) his style became more sensuous; his pictures of moody women are indebted to

those of his friend *Pascin. His later work showed a deepening social and political conscience, expressed in harsher colouring and sometimes disquieting imagery. During the Second World War he designed posters against Japan, but since the 1960s there has been a growing interest in his work there. From 1933 until his death Kuniyoshi taught at the Art Students League.

Kunst für Alle. See HÖLZEL.

Kunst- und Ausstellungshalle der Bundesrepublik Deutschland, Bonn. See HULTEN.

Kupka, František (Frank, François) (1871–1957). Czech painter and graphic artist, active mainly in France, a pioneer of abstract art. He was born in Opočno in eastern Bohemia and studied at the Academies of Prague (1889–92) and Vienna (1892–3). At this time he was painting historical scenes in a traditional style. In 1895 or 1896 he moved to Paris, which was to be his home for the rest of his life (from 1906 he lived in the suburb of Puteaux). In his early days in Paris he worked mainly as a book illustrator and satirical draughtsman; his paintings were influenced by *Symbolism and then *Fauvism. From an early age he had been interested in the supernatural (later in Theosophy), and from this grew a concern with the spiritual symbolism of colour. It became his ambition to create paintings whose colours and rhythms would produce effects similar to those of music, and in his letters he sometimes signed himself 'colour symphonist'. From 1909 (inspired by high-speed photography) he experimented—in a manner similar to that of the *Futurists—with ways of showing motion, and by 1912 this had led him to complete abstraction in *Amorpha: Fugue in Two Colours* (NG, Prague). This created something of a sensation when it was exhibited at the *Salon d'Automne that year. As with *Delaunay and the *Orphists, to whom his work was closely related, Kupka excelled at this stage in his career in the creation of lyrical colour effects.

At the outbreak of the First World War Kupka volunteered for military service and fought on the Somme; he also did a good deal of propaganda work such as designing posters and was discharged with the rank of captain in 1919. In 1922 he lectured at the Prague Academy, which appointed him a professor in Paris with the brief of introducing Czech students there to French culture. Before the war Kupka had written a theoretical text in French, *La Création dans les arts plastiques*, and in 1923 this was published in Prague as *Tvoření v Umění výtvarém* (Creativity in the Visual Arts). In 1931 he was one of the founder members of the *Abstraction-Création group, but he resigned in 1934. His later work was in a more geometrical abstract style. Although Kupka gradually established a considerable reputation, his pioneering role in abstract art was not generally realized in his lifetime. The re-evaluation of his career began with an exhibition of his work at the Musée National d'Art Moderne, Paris, in 1958, a year after his death.

Kupriyanov, Mikhail. See KUKRYNIKSY.

Kuroda Seiki. See FOUJITA.

Kushner, Robert. See NEO-EXPRESSIONISM and PATTERN AND DECORATION MOVEMENT.

Kuznetsov, Pavel. See BLUE ROSE.

L

LAA. See LONDON ARTISTS' ASSOCIATION.

Laboratory art. See INKHUK.

Labyrinthe. See SKIRA.

Lacey, Bruce (1927–). British sculptor and experimental artist, born at Catford, London. After leaving school aged 13, he worked at a variety of jobs. He took up painting while in hospital suffering from tuberculosis, 1947–8, then studied at Hornsey College of Art, 1948–51, and the *Royal College of Art, 1951–4. 'Within a year of leaving it had all gone . . . All I could do was sit in my little attic studio and play with the sunlight'; he stopped painting, and turned to the world of entertainment, working as a knife-thrower among other things. Then in 1962 he began making *environments and the works for which he is best known—witty animated robots, ingeniously constructed of all manner of debris (*Boy Oh Boy, Am I Living*, Tate Gallery, London, 1964). 'But Lacey's explosive creativity was short-lived. After his hilarious show at the Marlborough Gallery in 1965, he gradually moved away from sculpture, becoming a performer of rituals at Avebury and elsewhere' (catalogue of the exhibition 'British Sculpture in the Twentieth Century', Whitechapel Art Gallery, London, 1981–2). As a Performance artist he works in partnership with his second wife Jill Bruce, whom he married in 1967.

Lachaise, Gaston (1882–1935). French-born sculptor who became an American citizen in 1916. He was born in Paris and his training included a period at the École des *Beaux-Arts. In 1906 he emigrated to the USA, where he became one of the pioneers of modern sculpture. He settled first in Boston, then in 1912 moved to New York, where he became assistant to Paul *Manship. In 1913 he exhibited in the *Armory Show, and he had his first one-man exhibition in 1918, at the Bourgeois Galleries. This established his reputation, and in the 1920s he became 'the darling of the poets and intellectuals associated with *The Dial*, the leading literary review of the period' (Hilton *Kramer). His most important patron was Lincoln Kirstein (1907–96), a writer and founder of the New York City Ballet.

Lachaise was a consummate craftsman in stone, metal, and wood (his father was a cabinet-maker); he helped to reintroduce the method of *direct carving in America, but his most characteristic works are in bronze. His work includes numerous portrait busts, remarkable for their psychological insight (his sitters included the poet E. E. Cummings, the art critic Henry *McBride, who championed his work, and the composer Edgard Varèse), and he earned a good deal of his living with decorative animal sculptures, but he is best known for his female nudes—monumental and anatomically simplified figures, with voluptuous forms and a sense of fluid rhythmical movement (*Standing Woman*, Whitney Museum, New York, 1912–27). Their smooth modelling links them with the work of *Nadelman, who was also at this time helping to lead American sculpture away from the 19th-century academic tradition, but Lachaise's figures are bulkier than those of Nadelman and have an overt sexuality that has caused them to be compared with the the the nudes of *Renoir. (The inspiration for the figures—Lachaise's embodiment of female beauty—was Isabel Dutaud Nagle, a married American woman with whom he fell in love when he was aged about 20; she was the reason for his move to America and he was eventually able to marry her in 1917 after she had obtained a divorce from her first husband. He described her as 'the primary inspiration which awakened my vision and the leading influence that has directed my forces'.) In 1935 Lachaise was given a

retrospective exhibition at the Museum of Modern Art, New York—the first American sculptor to be so honoured. Later that year he died of leukemia.

Lacković, Ivan. See NAIVE ART.

Laethem-Saint-Martin. A Belgian village, near Ghent, that became popular with artists in the late 19th century and which in the early 20th century was the centre of two distinct groups, known as the First and Second Laetham Schools. The artists who made up the First School settled there *c*. 1900 under the aegis of the poet Karel van de Woestijne to enjoy the simple life in communion with nature. The principal figures were the sculptor Georg *Minne and the painters Valerius de Saedeleer (1867–1941), Albert *Servaes, and Gustave van de Woestijne (1881–1947), brother of the poet. Their work consisted mainly of simple peasant scenes and landscapes in a meditative and somewhat melancholy *Symbolist vein. A few years later the members of the Second School came together; they included Frits van den *Berghe and the brothers Gustave and Léon de *Smet. In 1909 they were joined by *Permeke. This Second Laetham School was broken up by the First World War, but it was the chief cradle of Belgian *Expressionism.

La Fresnaye, Roger de (1885–1925). French painter. He was born in Le Mans, the son of an aristocratic army officer, and between 1903 and 1909 studied in Paris successively at the *Académie Julian, the École des *Beaux-Arts, and the Académie Ranson. In 1912–14 he was a member of the *Section d'Or group, and his work shows an individual response to *Cubism; his paintings were more naturalistic than those of *Braque and *Picasso, but he adopted something of their method of analysing forms into planes. The effect in La Fresnaye's work, however, is more decorative than structural, and his prismatic colours reflect the influence of *Delaunay, as in his most famous and personal work, *The Conquest of the Air* (MOMA, New York, 1913), in which he portrays himself and his brother in an exhilaratingly airy setting with a balloon ascending in the background. La Fresnaye's health was ruined during his service in the army in the First World War (he was discharged with tuberculosis) and he never again had the physical energy for sustained

work. In his later paintings he abandoned Cubist spatial analysis for a more linear style. His final works include a number of self-portraits.

Laing, Gerald. See POP ART.

Lam, Wifredo (1902–82). Cuban painter, born in Sagua la Grande. His father was Chinese, his mother of mixed African, Indian, and European origin, and Lam's career was appropriately cosmopolitan. After studying at the Academy in Havana, 1930–3, he settled in Madrid in 1924. In 1938 he moved to Paris, where he became a friend of *Picasso. He also met *Breton (whose book *Fata Morgana* he illustrated in 1940) and in 1939 he joined the *Surrealists. In the same year he had his first one-man exhibition, at the Galerie Pierre Loeb. In 1941 he sailed from Marseilles to Martinique on the same ship as Breton, *Masson, and many other intellectuals who were fleeing the Germans. He made his way back to Cuba in 1942 and over the next few years his work was influenced both by jungle scenery and by savage local rituals. Following visits to Haiti in 1945 and 1946 he also began incorporating images of Voodoo gods and rituals in his work. From 1947 to 1952 he travelled extensively, spending time in Cuba, New York, and Paris. In 1952 he settled in Paris again, but from 1960 he also spent much of his time in Albisola Mare, near Genoa. In the 1970s he began making bronze sculpture.

Lam's work reconciled the European avant-garde with the artistic traditions of Latin America and the powerful mystique of African and Oceanic art, fusing human, animal, and vegetable elements in menacing semi-abstract images (*Rumblings of the Earth*, Guggenheim Museum, New York, 1950). He won several prestigious prizes and his work is included in numerous leading collections of modern art, among them the Tate Gallery, London, and the Museum of Modern Art, New York.

Lamb, Henry (1883–1960). British painter, mainly of portraits. He was born in Adelaide, Australia, where his father, Sir Horace Lamb, was professor of mathematics at the university, and was brought up in Manchester, where his father became professor in 1885. Under parental pressure he studied medicine, but he abandoned it in 1904 to become an artist, training first at *Chelsea Art School

and then in 1907–8 in Paris under J.-E. *Blanche. (On the outbreak of the First World War, however, Lamb returned to his medical studies, qualifying at Guy's Hospital, London, in 1916 and then serving as a medical officer in France, Macedonia, and Palestine; he was gassed and won the Military Cross. He also worked as an *Official War Artist, as he did again in the Second World War.) Lamb was associated with the *Bloomsbury Group and is best known for his sensitive portraits of fellow members, done in the restrained *Post-Impressionist style that characterized his work throughout his career. Above all he is remembered for his portrait of the writer Lytton Strachey (Tate Gallery, London, 1914), in which he 'has relished emphasizing Strachey's gaunt, ungainly figure, and the air of resigned intellectual superiority with which he surveys the world from that incredible slab-like head' (DNB); Sir John *Rothenstein describes it as 'one of the best portraits painted in England in this century'. Apart from portraits, Lamb also painted landscapes and (especially in later life when his health was failing) still-lifes.

Lambert, George Washington (1873–1930). Australian painter. He was born in St Petersburg, the son of an American engineer who had been working on railway construction in Russia (he died three month's before his child's birth). After spending his early years in Russia and Germany, he was educated in England and in 1887 moved to Australia to work on a farm owned by his mother's uncle. He studied in Sydney under Julian Ashton (1851–1942), one of the leading Australian art teachers of the day, and in 1900 won a scholarship to Paris. From 1902 to 1921 he lived in England. His early work in Australia had included scenes of bush life and illustrations for books and magazines, but in England he turned mainly to portraiture in a painterly style similar to that of Augustus *John or *Orpen. During the First World War he went to Egypt and Gallipoli to make paintings for Australian War Records. In 1921 he returned to Australia and settled in Sydney, where he became 'the arbiter of "progressive" taste . . . he was, at the age of forty-seven, at the height of his career, a man of unusual energy and great personal charm . . . Although a skilled exponent of academic methods he saw himself as a champion of youth and was not intolerant of modernist experiments providing

they were not "excessive"' (Bernard Smith, *Australian Painting 1788–1990*, 1991). In 1926 he founded the *Contemporary Group in Sydney. He continued to work mainly as a portrait and figure painter, but in his final years he also took up sculpture. He was the father of the composer Constant Lambert and the sculptor Maurice *Lambert.

Lambert, Maurice (1901–64). British sculptor, born in Paris, son of the painter George W. *Lambert and brother of the composer Constant Lambert. He trained as a sculptor by serving as apprentice to Derwent *Wood, 1918–23. Lambert was a versatile artist, equally adept at carving and modelling; he used a wide variety of materials, including various stones, metals, and woods, and he experimented with glass and concrete. His work included portraits, statues, fountains, and architectural sculpture. Stylistically he was eclectic, achieving a compromise between traditionalism and modernism: 'If he had one eye on the example set by *Brancusi, his other rested on the potential buyer: his *Birds in Flight* [City Art Gallery, Manchester, 1926], for example, has an ingratiating elegance, a vitiating desire to do no more than please' (Frances Spalding, *British Art Since 1900*, 1986). From 1950 to 1958 he taught at the *Royal Academy.

Lamourdedieu, Raoul. See DIRECT CARVING.

Lancaster, Sir Osbert (1908–86). British cartoonist, theatrical designer, writer, book illustrator, and painter, born in London, the son of a publisher. He read law at Oxford University, 1926–30, but while he was there also took lessons at the Ruskin School of Drawing in Oxford and the Byam *Shaw School in London. In 1930–1 he studied at the *Slade School. From 1934 to 1939 he worked for the *Architectural Review*, and he made his reputation with witty books on architecture and design, illustrated with his own lively pen-and-ink drawings. The best-known are *Pillar to Post* (1938) and *Homes Sweet Homes* (1939), in which he satirized pretensions of style, creating categories such as 'Stockbrokers' Tudor' that have become part of the language. In 1939 he became cartoonist to the *Daily Express*, for which he created the 'pocket cartoon'—a small, single-panel image. Over a period of more than 40 years, he 'made these small spaces the vehicle for a brilliantly sustained

comedy of manners ... Lancaster's most familiar characters are Lord and Lady Littlehampton, whose comments on the issues of the day reflect the traditional values and prejudices of the English upper classes' (Edward *Lucie-Smith, *The Art of Caricature*, 1981). Lancaster published various books of these cartoons, and an exhibition entitled 'The Littlehampton Bequest' was held at the National Portrait Gallery, London, in 1973. He was sometimes seen as the last of the Edwardians, a successor to his mentor Max *Beerbohm, but some of his views—particularly his distaste for much modern architecture—came to be shared by many others in his later years. In addition to his cartoons, Lancaster also did a good deal of stage design for opera and ballet. Among his paintings is a series representing Beerbohm's novel *Zuleika Dobson* in the Randolph Hotel, Oxford. His writings include two volumes of autobiography. He was knighted in 1975.

Lanceley, Colin (1938–). Australian painter and sculptor. He was born in Dunedin, New Zealand, and moved to Australia as a child in 1940. After studying at East Sydney Technical College and the National Art School, Sydney (his teachers included *Olsen and *Passmore), he went to Italy on a travelling scholarship in 1965, then settled in London until 1981, when he returned to Sydney. In the early 1960s he became the leading Australian exponent of *Pop art; later his style became more abstract. His work has often included three-dimensional elements, including found objects: 'I work in an area between painting and sculpture, combining both painted and sculpted images, in order to create an ambiguous space in front of the picture surface.'

Land art (or **Earth art** or **Earthworks**). A type of art that uses as its raw materials earth, rocks, soil, and so on. The three terms above are not usually clearly differentiated, although 'Earthworks' generally refers to very large works. This type of art emerged as a movement in the late 1960s and has links with several other movements that flourished at that time: *Minimal art in that the shapes created are often extremely simple; *Arte Povera in the use of 'worthless' materials; *Happenings and *Performance art because the work created was often impermanent; and *Conceptual art because the more ambitious earthwork schemes frequently exist only as projects. There are affini-

ties also with the passion at this time for the study of prehistoric mounds and ley lines—part of the hippie back-to-nature ethos that expressed a disenchantment with the sophisticated technology of urban culture. The desire to get away from the traditional elitist and money-orientated gallery world was also very much typical of the time, although large earthworks have in fact necessitated very hefty expenditure, and far from being populist and accessible, such works are often in remote areas. Some (in common with the ancient ground drawings of Peru that have been held up as historical precedents) are intelligible only from the air and therefore can rarely be appreciated other than by people rich enough to own or hire aeroplanes. Moreover, in spite of the desire to sidestep the gallery system, dealers have proved capable of exploiting this kind of art, just like any other, and some Land artists at least have made handsome livings from it.

The concept of Land art was established by an exhibition at the Dwan Gallery, New York, in 1968 and an exhibition 'Earth Art' at Cornell University in 1969. The Dwan exhibition included the photographic records of Sol *Lewitt's *Box in a Hole* (the burial of a steel cube) and Walter *De Maria's *Mile Long Drawing* (two parallel white lines traced in the Nevada desert). These belong equally (if not more) to the category of Conceptual art, but De Maria has also filled rooms with earth, and other artists have brought materials such as rocks and twigs into the gallery.

The artist associated more than any other with large-scale earthworks *in situ* was Robert *Smithson, whose *Spiral Jetty* (1970) in the Great Salt Lake, Utah, is easily the most reproduced work of this kind. Most of the other leading exponents are—like Smithson—Americans. They include Alice Aycock (1946–), whose work has included underground mazes, Mary Miss (1944–), and Michael Heizer (1944–), whose best-known work is *Double Negative* (1969–70) in the Nevada desert—two cuts 30 feet wide and 50 feet deep, with a total length of 1,500 feet, in an area where he said he found 'that kind of unraped, peaceful religious space artists have always tried to put in their work'. Some critics, however, consider that earthworks can themselves constitute a type of rape or violation. Matthew Baigell writes that Heizer's cuts 'relate to the environment of the area. As often as not, however, there is little sympathetic interaction with

the particular terrain, but rather a brute imposition of alien elements in disregard of local conditions or sociological factors' (*A Concise History of American Painting and Sculpture*, 1984).

*Christo is sometimes grouped with Land artists, although his work really defies classification. Outside the USA, the most noted exponent of Land art is probably the British sculptor Richard *Long.

Lane, Sir Hugh (1875–1915). Irish dealer, patron, collector, and administrator, born at Ballybrack House, County Cork, the son of a clergyman. He spent much of his boyhood travelling on the Continent and in 1893 began working for Colnaghi's, the famous London firm of picture-dealers. In 1898 he set up in business on his own, and his sure eye, energy, and flair soon earned him a fortune. He had no particular interest in Ireland until about 1900, when through the influence of Sarah *Purser and the playwright Lady Gregory (his aunt) he became caught up in the rising tide of nationalism in the arts. In the remaining years of his short life he became 'the most important patron of the arts Ireland has ever had' (Anne Crookshank and the Knight of Glin, *The Painters of Ireland*, 1978). He commissioned John Butler *Yeats to paint a series of eminent contemporary Irishman (it was completed by *Orpen, a distant cousin and close friend of Lane's) and he helped to found Dublin's Municipal Gallery of Modern Art, opened in temporary premises in 1906. In addition to giving and lending numerous works to the gallery (and persuading others to do the same) he offered to bequeath his finest late 19th- and early 20th-century French paintings to Dublin, on condition that a suitable gallery were built to house them. This caused arguments with the Dublin city authorities, however, and he moved the pictures to the National Gallery in London. In 1914 Lane was appointed director of the National Gallery of Ireland, and the following year he was killed when the *Lusitania* (on which he was returning from business in the USA) was torpedoed by a German submarine. A codicil to his will expressed his intention of returning the French pictures to Dublin, but it was unwitnessed, creating a long-term legal dispute about their ownership. In 1959 an agreement was eventually reached whereby the paintings were divided into groups to be shown alternately in Dublin and London. This agreement was renewed in 1980. The Municipal Gallery of Modern Art was given a permanent home in Dublin in 1933, and in 1979 it was renamed the Hugh Lane Municipal Gallery of Modern Art.

Lansere family. See SEREBRYAKOVA.

Lantéri, Edward. See ROYAL COLLEGE OF ART.

Lanyon, Peter (1918–64). British painter, born at St Ives, Cornwall. He studied at Penzance School of Art in 1937, at the *Euston Road Art School in 1938, and then under Ben *Nicholson and Naum *Gabo at St Ives. From 1940 to 1946 he served in the RAF and from 1950 to 1957 taught at the *Bath Academy of Art, Corsham. He also travelled and taught in the USA, but St Ives remained his home and his principal inspiration. Early in his career he made *assemblages influenced by Gabo; they were built up from found objects such as driftwood, pieces of glass, rope, etc, sometimes free-standing and sometimes boxed, and often brightly painted. His paintings developed from a lyrical naturalism to complete abstraction, but they remained based on his observation of the Cornish landscape that he loved. In the 1950s his handling became free and *gestural, and in 1959 he took up gliding, which led him to paint pictures evoking the invisible forces of the air rather than specific places (*Thermal*, Tate Gallery, London, 1960). He wrote that 'The air is a very definite world of activity, as complex and demanding as the sea'. Lanyon died in a gliding accident. Among the notable abstract painters of the *St Ives School, he was the only one who was a native of the town. As well as paintings, he made prints in various techniques.

Lapicque, Charles (1898–1988). French painter, printmaker, and sculptor, born at Taizé, Rhône. He obtained a degree in civil engineering at Lisieux in 1924 and in 1938 became a Doctor of Science with a dissertation on 'Optics and the Perception of Contours'. He took up painting as a hobby in 1925 and during the 1930s exhibited in the main Paris Salons. In 1937 he painted decorations for the Palais de la Découverte at the Paris Exposition Universelle, and in 1941 he began exhibiting with the *Peintres de Tradition Française. After the Second World War his work took on some of the characteristics of the abstraction typical of the *École de Paris

at this time, but it remained based on natural appearances. From the scene before him, he evolved a network of heavy criss-cross lines, the intervals between which were filled with colour as if seen behind a lattice. His colourful style was influenced by *Dufy, with whom he shared a liking for cheerful subjects such as horse races and regattas. In addition to paintings, Lapicque made prints in various techniques and occasionally worked as a sculptor, producing carved stone heads. His obituary in the *Guardian* said that 'Charles Lapicque was for over 50 years an archetypal member of the School of Paris, yet in the 1950s, when various forms of abstraction were dominant, he militated for a figurative painting which can now be seen as prophetic'.

Lapoujade, Robert. See SARTRE.

Larionov, Mikhail (1881–1964). Russian-French painter and designer, one of the leading figures in the development of modernism in Russia in the period before the First World War. He was born at Tiraspol, near Odessa, the son of a doctor, and studied at the Moscow School of Painting, Sculpture, and Architecture, 1898–1908; he was suspended three times during his course because of disagreements with the staff. His fellow student Natalia *Goncharova became his lifelong companion and artistic associate (they eventually married in 1955). Larionov's early work was influenced by *Impressionism, but from 1908, together with Goncharova, he developed a style known as *Neo-primitivism, in which he blended *Fauvist colour with elements drawn from Russian folk art. Together they were involved in a series of avant-garde groups and exhibitions, notably the *Knave of Diamonds group, founded in 1910, the *Donkey's Tail exhibition in 1912, and the *Target exhibition in 1913, at which Larionov launched *Rayonism, a near-abstract movement that was a counterpart to Italian *Futurism.

In May 1914 Larionov and Goncharova accompanied *Diaghilev's Ballets Russes to Paris. They returned to Russia in July on the outbreak of the First World War, and Larionov served in the army and was wounded. After being invalided out, he and Goncharova left Russia permanently in 1915, moving first to Switzerland and then settling in Paris in 1919 (they became French citizens in 1938). In Paris he practically abandoned easel painting and concentrated on theatrical designing for the Ballets Russes. The ballets he worked on included *Les Contes russes* (1922), a sequence of episodes from Russian fairy-tales and folklore, with choreography by Léonide Massine and music by Liadov. After Diaghilev's death in 1929 Larionov took up painting again, but he gradually sank into obscurity and his final years were marred by illness and poverty. His reputation was revived shortly before his death with retrospective exhibitions (jointly with Goncharova) in London (Arts Council, 1961) and Paris (Musée d'Art Moderne de la Ville de Paris, 1963).

Larsson, Carl (1853–1919). Swedish painter, illustrator, printmaker, and writer. He was born in Stockholm, where he studied at the Academy. His work included numerous portraits and book illustrations, as well as several large-scale murals (the best known are those on Sweden's artistic history in the Nationalmuseum, Stockholm, 1896), but he is now remembered mainly for the house he created in the village of Sundborn in Dalarna (Dalecarlia) and for his watercolours of the idyllic life he enjoyed there. Larsson and his wife **Karin** (1859–1928), a textile designer, were given the property by her father in 1889; at this time it was a simple log cabin, used as a holiday home, but they greatly extended and embellished it over the next decade and settled there permanently in 1901. They created a totally new approach to interior decoration, replacing the sombre and cluttered look typical of the late 19th century with simple furniture, bright colours, and a sense of light and air. Larsson delighted so much in the house—called Lilla Hyttnäs—that he recorded every nook and cranny in his watercolours. He said that 'They are a genuine expression of my personality and of my deepest feelings, and of all my limitless love for my wife and children'. From 1895 he published several collections of these watercolours in book form accompanied by his own texts. The books were enormously popular and made Larsson into a national institution. Lilla Hyttnäs soon became a tourist attraction and it was opened as a museum in 1942. To Swedes it epitomizes a healthy, happy society, and it has exercised a lasting influence on Scandinavian interior design. Fittingly, the Swedish furniture firm Ikea was the sponsor of a major exhibition on the Larssons at the Victoria and Albert Museum, London, in 1997: 'Carl and Karin Larsson: Creators of the Swedish Style'.

Lasers. See LIGHT ART.

Laserstein, Lotte (1898–1993). German painter. In the 1920s she made a name as a figure painter in Berlin (her favourite model was the tennis player Traute Rose, whom she sometimes depicted nude), but she left Germany in 1935 because of the Nazis (she was quarter-Jewish) and settled in Sweden, where she was active mainly as a portraitist. She continued working into her 90s and was described in her obituary in *The Times* as 'the last great survivor from the heyday of German realist painting . . . When she last visited London in 1990, she was still inexhaustible, bright as a bird, and slightly intimidating. When asked what she thought of Lucian *Freud (the comparison has frequently come up) she said briskly: "The technique is extraordinary, but his nudes are . . . too nude."'

Lassaw, Ibram (1913–). American sculptor, born in Egypt of Russian parents. His family emigrated to the USA in 1921 and he became an American citizen in 1928. He studied at various art colleges in New York. By 1933 he was experimenting with abstract sculpture (one of the first Americans to do so) and in 1936 he was a founder of *American Abstract Artists (he was president 1946–9). Most of his early work was in plaster, but during his army service in the Second World War he learnt the welding techniques that led to the creation of his distinctive mature style in about 1950. From this time he began making three-dimensional latticework constructions in welded bronze and steel, looking rather like some kind of bizarre scaffolding. In the 1960s his work became more expressive and sometimes took on a suggestion of natural forms. He was a serious student of Zen and his later work has sometimes been held to be expressive of the serenity and sense of cosmic oneness associated with that philosophy. It includes several large indoor and outdoor commissions for religious buildings and private residences.

László, Philip de (1869–1937). Hungarian-born portrait painter (and occasional sculptor) who settled in London in 1907 and became a British citizen in 1914 (although he was interned during the First World War). He trained in Budapest, Munich, and Paris (at the *Académie Julian) and already had an international reputation as a society portraitist when he moved to England. There his career continued in its successful course, his sitters including Edward VII and numerous members of the aristocracy (examples are in the NPG, London). According to the *Dictionary of National Biography*, he had 'a pleasing, courteous, and exuberant manner, and was very popular in society'. He was a fast and fluent worker and his style was elegant but superficial. His working methods and views on art are documented in a book entitled *Painting a Portrait, by De László, Recorded by A. L. Baldry* (1934). A series of photographs, with a running commentary, shows him at work on a half-length portrait of the actress Gwen Ffrangcon-Davies, which he painted in only $8\frac{1}{2}$ hours.

Latham, John (1921–). British experimental artist, born in Northern Rhodesia. After serving in the Royal Navy in the Second Wold War, he studied at Chelsea School of Art, 1946–50. Latham is best known for work in which he uses books as raw material. In 1958 he began making 'skoob' ('books' spelt backwards) reliefs, and in the 1960s he was involved in *Happenings that he called Skoob Tower Ceremonies, in which sculptures made of piles of books were ritually burned—'to put the proposition into mind that perhaps the cultural base has been burned out'. His most famous gesture came in 1966, when—as a part-time lecturer at *St Martin's School of Art—he took a copy of Clement *Greenberg's *Art and Culture* from the library and with the sculptor Barry *Flanagan 'invited artists, students and critics to Latham's house in order to take a page from this book, chew it and, if necessary, spit out the remains into a flask. The chewed pages were then immersed in acid until the solution was converted into a kind of sugar . . . Almost a year later Latham, in response to an urgent request for the book's return, sent back the solution together with a distilling apparatus. A few days later his teaching at St Martin's was abruptly terminated' (Frances Spalding, *British Art since 1900*, 1986). The 'sculpture' created by the chewed pages—entitled *Art and Culture*—was bought by the Museum of Modern Art, New York, in 1970.

La Thangue, H. H. (Henry Herbert) (1859–1929). British painter. He had his main training at the *Royal Academy in London and the École des *Beaux-Arts in Paris. In 1887 he described the Academy as 'the diseased root

from which other evils grow', and he was one of the leading figures in founding the *New English Art Club in opposition to it and in introducing the ideals of French *plein-air* painting to Britain. He lived in the countryside (first in Norfolk, then in Sussex), and *Clausen wrote of him: 'Sunlight was the thing that attracted him: this and some simple motive of rural occupation, enhanced by a picturesque surround.' From about 1898 he turned to peasant scenes set in Provence or Italy, places where he often stayed. As the countryside changed, his work became increasingly nostalgic, as he hankered after what *Munnings called a 'quiet old world village where he could live and find real country models'.

Laurencin, Marie (1885–1956). French painter, illustrator, and stage designer, born in Paris. Apart from evening classes in drawing, she was self-taught as an artist. In 1907 she was introduced by the picture dealer Clovis Sagot to *Apollinaire, *Picasso and their circle (she painted a group portrait of several of her famous friends in 1908; *The Guests*, Baltimore Museum of Art). For several years she lived with Apollinaire, and she exhibited with the *Cubists. Her work, however, was entirely peripheral to the Cubist movement. She specialized in portraits of oval-faced, almond-eyed young girls painted in pastel colours, and although she borrowed a few tricks of stylization from her Cubist friends, her style remained essentially unaffected by them. Her work was lyrically charming and rather repetitive. From 1914 to 1920 she lived in Spain and Germany, then returned to Paris. Apart from paintings, her work included book illustrations and set and costume designs for the ballet and theatre.

Laurens, Henri (1885–1954). French sculptor, printmaker, designer, and illustrator, born in Paris, where he trained as an ornamental stonemason. His early work shows the influence of *Rodin, but in 1911 he became a friend of *Braque (he later met *Gris, *Léger, and *Picasso) and he became one of the first artists to adapt the *Cubist style to sculpture. He made collages, reliefs, and constructions of wood and metal, mainly still-lifes using the familiar Cubist repertory of bottles, glasses, and fruit. Much of his work was coloured, but he retained a genuine sculptor's feeling for mass, and his distrust of intellectual speculation preserved his independence from Cubist theorizing. In the mid-1920s he moved away from his geometrical style to one that featured curved lines and voluptuous forms, notably in female nudes. Many of his fellow artists regarded him as one of the greatest sculptors of his time, but financial success and official recognition were slow in coming. When he failed to win the first prize for sculpture at the 1950 Venice *Biennale, *Matisse was so disgusted that he shared the money from his own painting prize with him. In 1953, however, Laurens won the Grand Prix at the São Paulo Bienal. Apart from sculpture, his work included stage design for *Diaghilev and numerous book illustrations.

Lavery, Sir John (1856–1941). British painter, mainly of portraits. He was born in Belfast and studied in Glasgow, in London, and then in the early 1880s in Paris (at the *Académie Julian and elsewhere). Between 1885 and 1896 he lived mainly in Glasgow (see GLASGOW BOYS), then settled in London, although he travelled a good deal and often wintered in Morocco, where he bought a house in about 1903. Lavery enjoyed immense success as a fashionable portraitist (particularly of women), painting in a dashing and fluid, if rather facile, style. His wife Hazel was an American society beauty, and he said that her social accomplishments helped his career to flourish. He also painted interiors, landscapes, and outdoor scenes such as tennis and bathing parties, and he was an *Official War Artist, 1917–18. In 1940 he published his autobiography, *The Life of a Painter*. His reputation did not long survive his death, but there has recently been a revival of interest in his work, highlighted by a major exhibition in 1985 organized by the Ulster Museum, Belfast, and the Fine Art Society, London (it was shown also in Dublin and Edinburgh).

Law, Bob (1934–). British painter, sculptor, and experimental artist. He had no formal artistic training. His work has been varied, but he is best known for his 'Black Paintings', examples of *Minimal art that at first sight appear to be uniformly black but on close examination reveal subtle variations of colour.

Lawrence, Jacob (1917–) American painter, one of the first black Americans to win recognition in the white art world. He was born in

Atlantic City and studied at the Harlem Art Workshop and other schools in New York in the 1930s. His work is concerned with black culture, both historical and contemporary. In 1936, for example, he began a series on the life of Toussaint L'Ouverture, the former slave who founded the republic of Haiti, and in 1940–1 he did a series of 60 paintings on 'The Migration of the Negro' (examples are in MOMA, New York); contemporary subjects include life in Harlem and desegregation in the South during the 1960s. His later work tends to be more decorative and less concerned with social comment, but all his work is characterized by the stylization of his figures into strong, angular, flattened forms, reminiscent of those of Ben *Shahn. Lawrence has taught at various colleges, including the University of Washington in Seattle, where he settled in 1972.

Lawson, Ernest (1873–1939). American painter, the least distinguished and most orthodox member of The *Eight. He was born in Halifax, Nova Scotia, studied at the *Art Students League in New York and the *Académie Julian in Paris, and settled in New York in 1898. In Paris he was a friend of Somerset Maugham, who later used Lawson as the model for the character Frederick Lawson in his novel *Of Human Bondage* (1915). Unlike the other members of The Eight he was primarily a landscapist (although he did also paint urban scenes) and his style was essentially *Impressionist. Lawson exhibited at the *Armory Show in 1913. During the 1920s he taught in Kansas City and Colorado Springs, and he spent his last three years in Florida.

Leach, Bernard. See ST IVES SCHOOL.

Lebrun, Rico (1900–64). American painter, sculptor, and graphic artist, born in Naples. He moved to the USA in 1924 when the stained-glass studio for which he was working as a designer opened a factory in Springfield, Illinois. In the following year he moved to New York and in 1938 settled in California. His initial success came as an advertising artist and he also taught animation at the Walt Disney film studios (he was involved in the production of *Bambi*, 1943). From the late 1930s, however, he turned to painting deeply serious subjects concerned with man's inhumanity to man. They include a series on The Crucifixion and one on Buchenwald Con-

centration Camp (1954–8), which Matthew Baigell calls 'one of the few major sustained artistic attempts to respond to the mass murders of World War II . . . His large forms and theatrically abrupt lighting schemes as well as his high sense of spiritual drama give his art a Baroque gloss rarely seen in modern times' (*Dictionary of American Art*, 1979). Two years before his death Lebrun took up sculpture.

Lechmere, Kate. See REBEL ART CENTRE.

Leck, Bart van der (1876–1958). Dutch painter and designer, born in Utrecht. After working for eight years in stained-glass studios, he studied painting in Amsterdam, 1900–4. His early work was influenced by *Art Nouveau and *Impressionism, but from about 1910 he developed a more personal style characterized by simplified and stylized forms: his work remained representational, but he eliminated perspective and reduced his figures (which included labourers, soldiers, and women going to market) to sharply delineated geometrical forms in primary colours. In 1916 he met *Mondrian and in 1917 was one of the founders of De *Stijl. At this time his work was purely abstract, featuring geometrically disposed bars and rectangles in a style close to Mondrian and van *Doesburg. However, he found the dogmatism of the movement uncongenial and left it in 1918, reverting to geometrically simplified figural subjects. In the 1920s he became interested in textile design and during the 1930s and 1940s he extended his range to ceramics and interior decoration, experimenting with the effects of colour on the sense of space. His work can best be seen at the Rijksmuseum *Kröller-Müller, Otterlo.

Le Corbusier (Charles-Édouard Jeanneret) (1887–1965). Swiss-born architect, painter, designer, and writer who settled in Paris in 1917 and became a French citizen in 1930. Although chiefly celebrated as one of the greatest and most influential architects of the 20th century, Le Corbusier also has a small niche in the history of modern painting as co-founder (with *Ozenfant) of *Purism in 1918. Up to 1929 he painted only still-life, but from that time he occasionally introduced the human figure into his compositions. He retained the Purist dislike of ornament for its own sake, but his work became more

dynamic, imaginative, and lyrical, though still restrained by his horror of any form of excess. He adopted the pseudonym Le Corbusier in 1920, but continued to sign his paintings 'Jeanneret'; the pseudonym derives from the name of one of his grandparents and is also a pun on his facial resemblance to a raven (French: *corbeau*). Apart from architecture and paintings, his enormous output included drawings, book illustrations, lithographs, tapestry designs, furniture, and numerous books, pamphlets, and articles.

Leduc, Fernand. See AUTOMATISTES and PLASTICIENS.

Leduc, Ozias (1864–1955). Canadian painter, active mainly in his native St Hilaire, Quebec. His career was devoted principally to church decoration, but he also painted portraits, genre scenes, and still-life—mostly for his own pleasure or for friends. In 1897 he visited Paris, and his later work was affected by *Symbolist ideas. He lived modestly and unambitiously, away from the main centres of art, but he was an inspiration to many of those who knew him, notably Paul *Borduas, who said Leduc showed him 'the way from the spiritual and pictorial atmosphere of the Renaissance to the power of illusion which leads into the future. Leduc's whole life shines with this magic illusion.'

Ledward, Gilbert (1888–1960). British sculptor, son of the sculptor Richard Arthur Ledward (1857–90). He studied at various art schools in London, including the *Royal Academy and the *Royal College of Art. In 1913 he was the winner of the first Rome scholarship offered to a sculptor (*Jagger was runner-up), but his studies in Italy were interrupted by the First World War, during which he served in the army. After the war (and again after the Second World War) he had several commissions for memorials, including the five bronze figures on the Guards Memorial in St James's Park, London (unveiled 1926). From 1926 to 1929 he was professor of sculpture at the Royal College of Art. At about this time he became interested in *direct carving, and in 1934 he founded the organization Sculptured Memorials and Headstones to improve the design and carving of memorials in English churchyards and encourage the use of local stone. Among his later works the best known is the Venus Fountain (unveiled 1953) in Sloane Square, London. In the article on Ledward in the *Dictionary of National Biography*, Sir Charles *Wheeler describes him as 'outspoken in his defence of academic traditions although he was always alert to praise the best in modern experimental work . . . He always maintained that of all the arts sculpture was the most permanent and the surest guide to the health of a nation—a barometer of civilization—and he never spared himself in his efforts to produce the best of which he was capable: a truly dedicated artist.'

Lees, Derwent (1885–1931). Australian painter, active mainly in Britain. As a boy he lost a foot in a riding accident. He studied at Melbourne University and in Paris before settling in London, where he trained at the *Slade School, 1905–8. From 1908 to 1918 he taught drawing at the Slade. He was a close friend of J. D. *Innes and Augustus *John and often travelled and worked with them. His main subject was landscape and he shared with them a lyrical response to the countryside; usually he worked on a small scale, with fluid brushwork in oil on panel or watercolour. He travelled widely, visiting Belgium, France, Germany, Italy, and Russia. In his biography of Augustus John (1976), Michael Holroyd describes Lees as 'a copycat of genius . . . He could paint *McEvoys, Inneses or Johns at will and with a fluency that sometimes makes them almost indistinguishable from their originals—though his figures with their great dense areas of cheek and chin do have originality.' In about 1918 Lees began to suffer from mental illness and spent the rest of his life confined in an institution.

LEF (Left Front of the Arts). See MAYAKOVSKY.

Le Fauconnier, Henri (1881–1946). French painter, mainly of figure subjects, including nudes and allegories. He was born at Hesdin, Pas-de-Calais, the son of a doctor, and in 1900 he began studying law at the University of Paris. However, he soon gave this up for art and had his main training at the *Académie Julian. From about 1910 he was influenced by *Cubism and he took part in the first organized group show of Cubist artists, at the *Salon des Indépendants in 1911. In about 1914 his style began to become more *Expressionist, but he still retained structural features derived from Cubism. He spent the First World War in the Netherlands, where he laid

the basis of a European reputation and exercised considerable influence on the development of Expressionism in the country (his work is better represented in Dutch collections than it is in French). After returning to Paris in 1920 he gradually abandoned Expressionism for a more restrained style. He never again enjoyed his former level of fame and in his final years he became a recluse. He is not now generally highly regarded as a painter, but he played an important role in spreading the mannerisms of Cubism. An example of the wide exposure his work had is that his painting *Abundance* (Gemeentemuseum, The Hague, 1911) was reproduced in the *Blaue Reiter *Almanac* in 1912 and in the same year was shown in the *Knave of Diamonds exhibition in Moscow (in 1911 it had been shown at the Salon des Indépendants in Paris).

Lefranc, Jules. See NAIVE ART.

Léger, Fernand (1881–1955). French painter and designer, born at Argentan in Normandy of peasant farming stock. In 1897–9 he was apprenticed to an architect in Caen, then in 1900 settled in Paris, where he supported himself as an architectural draughtsman (and for a while as a photographic retoucher) whilst studying art at the *Académie Julian and elsewhere. His early paintings were *Impressionist in style, but in 1907 he was overwhelmed by the exhibition of *Cézanne's work at the *Salon d'Automne, and in the following year he came into contact with several leading avant-garde artists when he rented a studio in La *Ruche. Robert *Delaunay was among his friends and he met and admired Henri *Rousseau. He was briefly influenced by *Fauvism, but in 1909 he turned to *Cubism. Although he is regarded as one of the major figures of the movement, he always stood somewhat apart from its central course; he disjointed forms but did not fragment them in the manner of *Braque and *Picasso, preferring bold tubular shapes (he was for a time known as a 'tubist'), as in his first major work, *Nudes in a Forest* (Rijksmuseum Kröller-Müller, Otterlo, 1909–10). He also used much brighter colour than Braque and Picasso. In 1912 he had his first one-man exhibition, at *Kahnweiler's gallery, and he was beginning to prosper when the First World War interrupted his career. By this time his work had come close to complete abstraction.

Léger enlisted in the army and served as a sapper in the front line, then as a stretcher-bearer. The war was 'a complete revelation to me as a man and a painter'. It enlarged his outlook by bringing him into contact with people from different social classes and walks of life and also by underlining his feeling for the beauty of machinery: 'During those four war years I was abruptly thrust into a reality which was both blinding and new. When I left Paris my style was thoroughly abstract ... Suddenly, and without any break, I found myself on a level with the whole of the French people; my new companions in the Engineer Corps were miners, navvies, workers in wood. Among them I discovered the French people. At the same time I was dazzled by the breech of a 74-millimetre gun which was standing uncovered in the sunshine: the magic of light on white metal. This was enough to make me forget the abstract art of 1912–13 . . . Once I had got my teeth into that sort of reality I never let go of objects again.' After being gassed, he spent more than a year in hospital and was discharged in 1917. In that year he painted *Soldiers Playing at Cards* (Rijksmuseum Kröller-Müller), which he regarded as 'the first picture in which I deliberately took my subject from our own epoch'.

During the next few years, Léger's work showed a fascination with machine-like forms, and even his human figures were depicted as almost robot-like beings (*The City*, Philadelphia Museum of Art, 1919). In 1920 he met *Le Corbusier and *Ozenfant, who shared his interest in a machine aesthetic, and in the mid-1920s his work became flatter and more stylized, in line with their *Purist style. He used bold, poster-like contrasts of form and colour, with strong black outlines and extensive areas of flat, uniform colour. In the inter-war years he expanded his range beyond easel painting with murals (sometimes completely abstract) and designs for the theatre and cinema (in 1923–4 he conceived, produced, and directed the film *Le Ballet mécanique*, with photography by *Man Ray; it has no plot and shows everyday objects in rhythmic motion). He was also busy teaching at his own school founded with Ozenfant in 1924 as the Académie de l'Art Moderne (Ozenfant left in 1929 but it continued as the Académie de l'Art Contemporain until 1939). He also travelled extensively, making three visits to the USA in the 1930s. The contacts that he made during these visits stood him in good stead when he lived in America during the Second World

War, teaching at Yale University and at Mills College, California.

Léger's work of the war years included pictures of acrobats, cyclists, and musicians, and after his return to France in 1945 he concentrated on the human figure rather than the machine. He joined the French Communist Party soon after his return (he had been sympathetic to it long before this) and favoured proletarian subjects that he hoped would be accessible to the working class. Some of these pictures were very big (notably *The Great Parade*, Guggenheim Museum, New York, 1954), and in his later career he also worked a good deal on large decorative commissions, notably stained-glass windows and tapestries for the church at Audincourt (1951) and a glass mosaic for the University of Caracas (1954). In 1949 he began making ceramic sculptures. Many honours came to him late in life, including the Grand Prix at the 1955 São Paulo *Bienal*. Shortly before his death he bought a large house at Biot, a village between Cannes and Nice, and his widow built a museum of his work here, opened in 1957.

In the catalogue of the exhibition 'Léger and Purist Paris' (Tate Gallery, London, 1970), John *Golding wrote of Léger: 'No other major twentieth-century artist was to react to, and to reflect, such a wide range of artistic currents and movements. Fauvism, Cubism, *Futurism, Purism, *Neo-Plasticism, *Surrealism, *Neo-Classicism, *Social Realism, his art experienced them all. And yet he was to remain supremely independent as an artistic personality. Never at any time in his career could he be described as a follower; the very vigour and strength of his character would in themselves have rendered such a position inconceivable. But his originality lay basically in his ability to adapt the ideas and to a certain extent the visual discoveries of others to his own ends.' However, despite Léger's centrality in modern art, Edward *Lucie-Smith thinks that he 'still ranks as an underappreciated artist, one who is on the whole more respected than loved. His work has a deliberate harshness which repels many spectators' (*Lives of the Great Twentieth Century Artists*, 1986). Certainly he never achieved the popularity with ordinary working-class people that he aimed for.

Legros, Alphonse (1837–1911). French-born etcher, painter, sculptor, and teacher who settled in England in 1863 (encouraged by

*Whistler) and became a British citizen in 1881, although he never acquired fluency in English. His chief importance was as an influential teacher (particularly of etching) at the *Slade School, where he was professor 1876–92 in succession to *Poynter. He encouraged a respect for the tradition of the Old Masters.

Legueult, Raymond. See NÉO-RÉALISME.

Le Havre Group. A name sometimes applied to *Braque, *Dufy, and *Friesz, who all attended the École Municipale des Beaux-Arts in Le Havre in the 1880s and later became members of the *Fauves. Dufy and Friesz were born in Le Havre; Braque moved there from Argenteuil in 1890, when he was 8.

Lehmbruck, Wilhelm (1881–1919). German sculptor. He was born at Duisburg, the son of a miner, and studied in nearby Düsseldorf, first at the School of Arts and Crafts, 1895–9, then at the Academy, 1901–7. His early work was in a fairly conservative academic manner, but when he was living in Paris from 1910 to 1914 he developed a more modern style, influenced by the formal simplifications of *Archipenko, *Brancusi, and *Modigliani, although still essentially in the tradition of *Rodin and *Maillol. One of his most impressive works in this vein is *Kneeling Woman* (MOMA, New York, 1911), notable for its attenuated forms, angular pose, and melancholic expression; it was greatly praised when it was exhibited at the Cologne *Sonderbund exhibition in 1912. His reputation grew substantially after this, and the first book on him was published in Berlin in 1913. In 1914 he had a one-man exhibition at the Galerie Levesque, Paris, but soon afterwards the outbreak of the First World War forced him to return to Germany. He managed to avoid conscription into the army and instead worked in a hospital, the suffering he witnessed being reflected in the poignancy of the sculpture from his final years. In 1916 he moved to Switzerland, where he planned major works, including war memorials, but made only smaller pieces and fragments. The war had brought him to a state of acute depression and he committed suicide in 1919.

Lehmbruck often worked in marble, but he was by temperament a modeller rather than a carver; he liked to work in clay over a spindly armature, and several of his figures were cast in artificial stone to preserve the texture of

the clay. With *Barlach he ranks as the outstanding German *Expressionist sculptor. He also made etchings and lithographs, painted, and wrote poetry. There is a museum devoted to him in his native Duisburg.

Lehmden, Anton. See FANTASTIC REALISM.

Leicester Galleries (Ernest Brown & Phillips), London. Commercial gallery founded in premises off Leicester Square in 1902 by the brothers Wilfred and Cecil Phillips. They were joined in 1903 by Ernest Brown, a dealer of long experience, but the dominant figure in the firm was his son Oliver Brown (1885–1966), who became a partner in 1914 and dedicated his life to the gallery. In the first half of the century it was one of the country's leading venues for promoting avantgarde art. Dennis Farr writes that it was 'directed with great perception by Oliver Brown in unpretentious surroundings . . . Cézanne, Van Gogh, Gauguin, Pissarro, Picasso, and Matisse were all given their first one-man shows [in Britain] at the Leicester Galleries, and, for British artists especially, a series of exhibitions, "Artists of Fame and of Promise", were devised in which, as the title suggests, the established were mixed with the new hopefuls on equal terms' (*English Art 1870–1940*, 1978). Kenneth *Clark wrote that 'The presiding spirit, Oliver Brown, was as small and unpretentious as his gallery, and loved to help young artists and collectors. I made all my early purchases there, usually for sums under five pounds.' Brown's experience was valuable to the *Arts Council in its early days (he served on its arts panel from 1949 to 1954) and his expertise was valued by Christie's auction house (he was a close friend of its chairman Sir Alec Martin). Brian *Sewell recalls that 'Oliver was the prime source of French *Impressionists and *Post-Impressionists in this country from the very moment the market began to exist. When I went to work at Christie's [in 1958], who was the expert who was called in when any French Impressionist pictures were to be catalogued? It was Oliver, and whatever he said went because we were instructed by Alec to accept his opinion' (quoted in John Herbert, *Inside Christie's*, 1990). *Exhibition: The Memoirs of Oliver Brown* was posthumously published in 1968.

Le Moal, Jean (1909–). French painter and designer, born at Authon-de-Perche of Breton stock. He studied at the École des Beaux-Arts, Lyons, and then from 1935 to 1938 at the *Académie Ranson, where—like many other students—he was influenced by Roger *Bissière. Le Moal was an exponent of *Lyrical Abstraction, the type of painting that dominated the *École de Paris in the late 1940s and 1950s. Like his contemporaries *Bazaine, *Estève, *Manessier, and *Singier, he evolved his abstractions from impressions made by natural appearances. His style was characterized by linear arabesques interspersed with spots and flecks of colour. Le Moal also designed stage decor and stained glass.

Lempicka, Tamara de (1898–1980). Polish-born painter, active in Paris and the USA. She was born Tamara Gorska in Warsaw to wealthy parents and in 1916 she married Tadeusz de Lempicki, a Russian lawyer and socialite. In 1918 they fled the Russian Revolution to Paris, where she studied with Maurice *Denis and André *Lhote. She quickly established a reputation as a painter of portraits, mainly of people in the smart social circles in which she moved—writers, entertainers, the dispossessed nobility of Eastern Europe (an example is her portrait of her husband, 1928, in the Pompidou Centre, Paris). Her style owes something to the 'tubism' of *Léger, but is very distinctive in its hard, streamlined elegance and sense of chic decadence—better than anyone else she represents the *Art Deco style in painting. Apart from portraits, her main subjects were hefty erotic nudes and still-lifes of calla lilies. She received considerable critical acclaim and also became a social celebrity, famed for her aloof Garbo-esque beauty, her parties, and her love affairs (with women as well as men). In 1939 she moved to the USA with her second husband Baron Raoul Huffner, repeating her artistic and social success in Hollywood and New York. By the 1950s, however, her work was going out of fashion. She tried working in a different, much looser style and even painted abstracts, but her paintings in this new vein were coolly received and after 1962 she did not exhibit her work. In 1963–78 she lived in Houston, Texas, then spent the last two years of her life in Cuernavaca, Mexico. She continued to paint into her old age, often in Paris, to which she regularly returned. Interest in her began to revive in the 1970s (notably with the exhibition 'Tamara de Lempicka de 1925 à 1935' at the Palais Luxembourg, Paris, in 1972)

and by the 1990s she had again become something of a stylish icon, with her work fetching enormous prices in the saleroom and featuring in television advertisements as a symbol of the high life.

Lenbach, Franz von (1836–1904). German painter. Lenbach was the most successful German portraitist of his day and a dominant figure in the artistic life of Munich in the late 19th century. His splendid house there, which he designed himself, is now a museum—the Lenbachhaus. It displays many examples of his work as well as works that he collected, but its chief attraction is a superb representation of paintings by *Jawlensky, *Kandinsky, *Klee, *Macke, *Marc, and Gabriele *Münter (who presented the collection in 1957).

Lentulov, Aristarkh (1882–1943). Russian painter (of landscapes, portraits, still-life, and genre scenes) and stage designer. He was born in Penza Province and studied in Penza, Kiev, and St Petersburg before settling in Moscow. From 1908 he took part in avant-garde exhibitions and in 1910 he was one of the founders of the *Knave of Diamonds group (his wife was the daughter of a wealthy merchant and Lentulov was able to give the group financial support). In 1911 he travelled to Italy and France, where he was influenced by *Gleizes, *Le Fauconnier, and *Metzinger, and in 1912 he exhibited *Cubist-inspired works. Around 1916 he painted a few abstract pictures, but in the 1920s he changed from experimental work to a more naturalistic and conventional manner, joining *AKhRR in 1926. He taught stage design at *Vkhutemas, 1919–26, and painting at the Moscow Art Institute, 1919–43.

Leonard, Michael. See SUPERREALISM.

Leoncillo, Leonardo. See FRONTE NUOVO DELLE ARTI.

Le Parc, Julio (1928–). Argentinian painter, sculptor, and experimental artist, regarded as one of the leading exponents of *Kinetic art. He was born at Mendoza and studied at the School of Fine Arts in Buenos Aires. In 1958 he settled in Paris and in 1959 became a founder member of the *Groupe de Recherche d'Art Visuel (GRAV). Le Parc professes to adopt a rational and objective attitude to his work,

working according to scientific principles. He often uses the idea of spectator participation, but tries to eliminate subjective response on the part of the spectator, looking for an objective and predictable perceptual response to a planned stimulus. Much of his work consists of devices for disorientating the spectator (distorting glasses and so on), but he has also made some outstanding *mobiles, using perspex or metallic elements to scatter or reflect the light (*Continual Mobile, Continual Light*, Tate Gallery, London, 1963). In H. H. *Arnason's *A History of Modern Art* (3rd edn., 1986), he is described as 'a major bridge between various overlapping but normally separate tendencies in the art of the 1960s, not only light and movement, but also forms of optical, illusionistic painting and programmed art'.

Leslie, Alfred (1927–). American painter. He was born in New York and studied at New York University. In the 1950s he was an *Abstract Expressionist, working with an explosive *Action Painting technique, but in the 1960s he changed course completely and became a *Superrealist. Like Jack *Beal, he paints ambitious figure subjects, often in compositions derived from the Old Masters. He is perhaps best known for *The Killing Cycle*, a series of paintings, on which he worked for over a decade, commemorating the death of the poet and art critic Frank O'Hara (1926–66), who was run over by a taxi.

Lessore, Helen (née Brook) (1907–94). British painter (of portraits, figure subjects, and interiors) and art dealer. She was born in London and studied at the *Slade School, 1924–8. In 1934 she married the portrait sculptor Major **Frederick Lessore** (1879–1951), brother of **Thérèse Lessore** (1884–1945), *Sickert's third wife and herself a painter of figure subjects and urban scenes (see CAMDEN TOWN GROUP). Frederick Lessore had opened the Beaux Arts Gallery in London in 1923, and after his death Helen Lessore ran it until it closed in 1965. The gallery was prominent in supporting avant-garde art: Christopher *Wood had his first one-man exhibition there in 1927, for example, and Barbara *Hepworth had one of her first shows there (with her husband John *Skeaping) in 1928. In the 1950s the gallery helped to launch the careers of Frank *Auerbach and Leon *Kossoff amongst others (their first one-man shows were held there in 1956

and 1957 respectively), and it became particularly associated with the *Kitchen Sink School; its four leading members—John *Bratby, Derrick *Greaves, Edward *Middleditch, and Jack *Smith—were known as the 'Beaux Arts Quartet'.

John Lessore (1939–), son of Helen and Frederick, is a painter of portraits, landscapes, figure subjects, and interiors. He studied at the Slade School, 1957–61, and had his first exhibition at the Beaux Arts Gallery in 1965. In 1978 he began teaching at Norwich School of Art.

Lethaby, W. R. (William Richard) (1857–1931). British architect, designer, writer, and teacher. He was an architect by training, but he designed few buildings, and after the turn of the century he was active mainly as a teacher and writer. From 1894 to 1918 he was art adviser to the London County Council. In this role he helped to found the Central School of Arts and Crafts (see ST MARTIN'S SCHOOL OF ART) in 1896, and he was its principal from 1902 to 1911, introducing 'a programme of workshop training with all the latest equipment to make it one of the most progressive European art schools of its day' (Dennis Farr, *English Art 1870–1940*, 1978). From 1901 to 1918 he was also professor of design at the *Royal College of Art. Lethaby was an outstanding teacher, possessing a clear mind and an enthusiastic manner. He argued that art and architecture should be socially responsible and governed by reason. His books include *Medieval Art* (1904), *Form in Civilisation: Collected Papers on Art and Labour* (1922), which Farr describes as containing 'much practical common sense expressed in an enviably crisp, rigorous manner', and two books on the architecture of Westminster Abbey (1906 and 1925) that are still considered standard works. He was surveyor to the Abbey from 1906 to 1927 and instituted a sensitive programme of conservation of the medieval fabric, halting the tide of 19th-century 'restoration'.

Lett-Haines, Arthur. See MORRIS, SIR CEDRIC.

Levine, Jack (1915–). American painter and draughtsman, born in Boston. As a child he had lessons at the Museum of Fine Arts School in Boston and from 1929 to 1933 he attended painting classes at Harvard University. From 1935 to 1940 he worked intermittently for the *Federal Art Project. Levine is an independent figure, standing apart from groups and movements, and his work is highly distinctive. His style is based upon *Expressionists of the *École de Paris such as *Rouault and *Soutine, but the theme of his art is social satire, through which he mercilessly attacks avarice, corruption, and hypocrisy. His best-known work is *Gangster Funeral* (Whitney Museum, New York, 1953), which shows policemen and political leaders gathered in mourning around a mobster's coffin. For all the savagery of his imagery, there is much subtlety of handling in his work, and he is deeply aware of the work of the Old Masters as well as of contemporary painting; he thinks it is the artist's function to bring 'the great tradition and whatever is great about it up to date'. Levine has also done gentler satires, poking fun at middle-class pretensions, as well as straightforward portraits, and in the 1980s he turned to serious depictions of biblical subjects.

Levine, Sherrie. See PHOTO-WORK.

Lewis, Wyndham (1882–1957). British painter, novelist, and critic, born of a British mother and a wealthy American father on their yacht off Nova Scotia. He came to England as a child, studied at the *Slade School, 1898–1901, then lived on the Continent for seven years, mostly in Paris (although he travelled widely). During this period he became one of the first British artists to become familiar with *Cubism and *Expressionism, but little of his work of this time survives. In 1908 he returned to England and in the years leading up to the First World War emerged as one of the leading figures in British avant-garde art. From 1911 he developed an angular, machine-like, semi-abstract style that had affinities with *Futurism as well as Cubism. He worked for a short time at Roger *Fry's *Omega Workshops, but after quarrelling with Fry in 1913 he formed the *Rebel Art Centre, from which grew *Vorticism, a movement of which he was the chief figure and whose journal *Blast* he edited. He served with the Royal Artillery, 1915–17, and as an *Official War Artist, 1917–18, carrying his Vorticist style into paintings such as *A Battery Shelled* (Imperial War Museum, London, 1918), which is regarded as one of his finest works. In 1919 he founded *Group X as an attempt to revive Vorticism, but this failed, and from the late

1920s he devoted himself mainly to writing, in which he often made savage attacks on his contemporaries (particularly the *Bloomsbury Group).

Lewis's association with the British Fascist Party and his praise of Hitler alienated him from the literary world, and his biographer Jeffrey Meyers (*The Enemy*, 1980) describes him as 'one of the loneliest figures in the intellectual world of the thirties'; earlier W. H. Auden had called him 'that lonely old volcano of the right'. The best-known paintings of his later years are his incisive portraits, more naturalistic than his earlier works but still with a bold, hard simplification of form; the rejection of that of T. S. Eliot (Durban Art Gallery) by the hanging committee of the *Royal Academy summer exhibition in 1938 caused Augustus *John (a longstanding friend of Lewis) to resign from the Academy in disgust. During the Second World War Lewis lived in the USA and Canada. After his return to London he was art critic of the *Listener* from 1946 until 1951 (the artists he supported included *Bacon and *Colquhoun). By the time he stopped working for the *Listener* he was almost blind, but he wrote the introduction for the catalogue of the exhibition 'Wyndham Lewis and the Vorticists' held at the Tate Gallery, London, in 1956. When the director of the Tate, John *Rothenstein, went to discuss the planning of the exhibition with him, he found it 'a sad experience to see the powerful, militant personage I so clearly remembered . . . so utterly reduced . . . his energy ebbed away'.

Lewis was the most original and idiosyncratic of the major British artists working in the first decades of the 20th century, and he was among the first artists in Europe to produce completely abstract paintings and drawings. He built his style on features taken from Cubism and Futurism but did not accept either. He accused Cubism of failure to 'synthesize the quality of LIFE with the significance or spiritual weight that is the mark of all the greatest art' and of being mere visual acrobatics. The Futurists, he wrote, had the vivacity that the Cubists lacked, but they themselves lacked the grandness and the 'great plastic qualities' that Cubism achieved. His own work, he declared, was 'electric with a mastered and vivid vitality' His writings include novels, poetry, collections of essays and criticism, and the autobiographical *Blasting and Bombardiering* (1937) and *Rude Assign-*

ment (1950). *Wyndham Lewis the Artist* (1939) contains a survey by Lewis of his career as a painter.

LeWitt, Sol (1928–). American sculptor, graphic artist, writer, and *Conceptual artist. He was born in Hartford, Connecticut, and studied at Syracuse University, New York, where he graduated in fine art in 1949. After serving in the US Army in Japan and Korea, 1951–2, he settled in New York, where he worked as a graphic designer and also painted. His career did not take off until the early 1960s, when he turned to sculpture and became one of the leading exponents of *Minimal art. His 'structures', as he prefers to call them, characteristically involve permutations of simple basic elements, sometimes arranged in box- or table-like constructions. He is also an exponent of Conceptual art; in 1968, for example, he fabricated a metal cube and buried it in the ground at Visser House at Bergeyk in the Netherlands, documenting photographically the object's disappearance (this has also been considered an example of *Land art). LeWitt has also written numerous articles on Conceptual art. His other work includes prints in various techniques.

Lhote, André (1885–1962). French painter, sculptor, teacher, and writer on art. He was born in Bordeaux, where he was apprenticed to an ornamental sculptor in 1897. He also studied sculpture at the city's École des Beaux-Arts, 1898–1904, and painted in his spare time. In 1905 he gave up sculpture to devote himself to painting and in 1906 he settled in Paris. His early paintings were *Fauvist in spirit, but from 1911 he adopted *Cubist mannerisms in his varied range of subjects, including landscapes, still-lifes, interiors, mythological scenes, and portraits. These pictures were deliberately composed, with complicated systems of interacting planes and semi-geometrical forms precisely articulated and defined by clear, unmodulated colours. His later work included some large decorative works, notably a set of three panels, *Gloire de Bordeaux* (1955), for the Faculty of Medicine at Bordeaux. Lhote, however, was more important as a teacher and critic of modern art than as a practising artist. In 1922 he opened his own school, the Académie Montparnasse, and through this had an extensive influence on younger artists, French and foreign; he founded a South American branch on a visit

to Rio de Janeiro in 1952. His writings included treatises on landscape painting (1939) and figure painting (1950); the two were issued together in a revised edition in 1958 as *Traités du paysage et de la figure*.

Liberman, Alexander. See SCHAPIRO, MEYER.

Libre Esthétique, La. An association of artists formed in Brussels in 1894 to carry on the work of the Groupe des Vingt (XX), which had dissolved in 1893. Les Vingt (so called because there had originally been 20 members) was made up mainly of *Symbolist painters, including *Ensor and *Toorop; the group showed work not only by its own members, but also by non-Belgian artists such as *Cézanne and *Gauguin, and it was influential in spreading the ideas of *Neo-Impressionism and *Post-Impressionism. La Libre Esthétique maintained these ideals, continuing until 1914, with most of the leading avant-garde Belgian artists of the period as members. It was administered by the lawyer and critic Octave Maus (1856–1919), who also founded and ran the weekly periodical *L'Art moderne* (1881–1914), the leading Belgian avant-garde journal of the period. (*L'Art moderne* was also the title of a short-lived periodical published in Paris, 1875–6.)

Lichtenstein, Roy (1923–97). American painter, sculptor, and printmaker, born in New York. He studied at the *Art Students League, 1939, and then at Ohio State University, Columbus, 1940–3 and (after service in the US Army) 1946–9. For the next two years he taught there, then lived in Cleveland, Ohio, 1951–7, working at various odd jobs to support his painting. For the next few years he returned to teaching—at New York State University, Oswego, 1957–60, and Rutgers University, New Brunswick, 1960–3. In the late 1950s his style was *Abstract Expressionist, but in the early 1960s he changed to *Pop art and his first one-man exhibition in this style, at the Leo *Castelli gallery, New York, in 1962 was a sensational success, enabling him to give up teaching the following year and devote himself entirely to painting. In common with other Pop artists, Lichtenstein adopted the images of commercial art, but he did so in a highly distinctive manner. He took his inspiration from comic strips but blew up the images to a large scale, reproducing the primary colours and dots of the cheap print-

ing processes (*Whaam!*, Tate Gallery, London, 1963). The initial stimulus is said to have come from one of his young children, who pointed to a comic book and challenged 'I bet you can't paint as good as that'. Despite their use of such *kitsch material, his paintings show an impressive feeling for composition and colour and Lichtenstein has enjoyed continued critical success as well as popular appeal. In the mid-1960s he began making Pop versions of paintings by modern masters such as *Cézanne and *Mondrian, and also started making screenprints. In the 1970s he expanded his range to include sculpture, mostly in polished brass and imitating the *Art Deco forms of the 1930s. His later work included several large commissions for public places, for example the sculpture *Mermaid* (1979) for the Theatre of the Performing Arts, Miami, and *Mural with Blue Brushstrokes* (1986) for the Equitable Building, New York.

Licini, Osvaldo (1894–1958). Italian painter, born at Monte Vidon Corrado in the Marches, the son of a commercial artist. In 1908–13 he studied at the Academy in Bologna, where he was friendly with *Morandi, and he spent most of the period 1917–26 in Paris. Up to 1931 he painted in a naturalistic style (portraits, landscapes, still-lifes), but then abandoned it for abstraction. His paintings of the 1930s, which put him in the forefront of modernism in Italy, are usually called *Constructivist, but although they use geometric forms, they also have an individual poetic quality that sometimes brings them close to *Klee or *Miró in spirit: 'Painting is the art of colours and signs', Licini said; 'signs express force, will and the idea, while colour expresses magic.' After the Second World War Licini became the first Communist mayor of his home town and worked there in semi-seclusion. He turned from abstraction to a *Surrealist-influenced style in which he expressed a personal mythology. A few months before his death he won the International Grand Prize for Painting at the 1958 Venice *Biennale.

Liebermann, Max (1847–1935). German painter (of portraits, figure subjects, and landscapes), etcher, and lithographer, born in Berlin. From 1873 to 1878 he lived mainly in Paris, and together with *Corinth and *Slevogt he came to be considered one of the leading German representatives of *Impressionism. In 1878 he moved to Munich and in

1884 to Berlin, where he became first president of the *Sezession in 1899. However, he did not keep abreast of developments and a decade later he was regarded as a pillar of the traditionalism against which the German *Expressionists were in revolt. He was one of the dominant figures in the German art world and in the later part of his career he accumulated many honours. When the Nazis came to power, however, he was required—as a Jew—to resign as president of the Prussian Academy and from his other prestigious positions. His widow committed suicide in 1943 rather than suffer at the hands of the Gestapo. There are some good examples of Liebermann's work in the Tate Gallery, London, including his last self-portrait (1934).

Ligare, David. See PITTURA COLTA.

Light art. A general term for works that use artificial light (generally electric) as an artistic medium of its own or as an important constituent of a piece. The major pioneer of light art was the Danish-American artist Thomas *Wilfred, who made his first small works in this vein in 1905, but the idea can be traced back to the 18th century, when the French scientist Louis-Bertrand Castel became interested in the relationship between sound and colour (both of which, he argued, were products of vibration) and constructed various 'ocular harpsichords', some of which incorporated coloured glass. His theories do not seem to have been followed up until the early 20th century, when the Russian composer Alexander Scriabin envisaged a similar type of 'colour organ' to perform in his orchestral work *Prometheus*; it was premiered in 1911, but the light-show accompaniment proved impracticable. Twelve years later, in 1923, Vladimir *Baranoff-Rossiné constructed a piano that produced light as well as sound effects, and various other experiments with light art were made in the interwar years—by *Moholy-Nagy, for example. Hitler's architect Albert Speer (see NATIONAL SOCIALIST ART) used dramatic arrays of searchlights at Nazi rallies in a way that anticipated the son et lumière spectacles now popular as tourist entertainments, and soon after the Second World War Gyula *Košice, in 1946, is credited with being the first artist to make a sculpture consisting essentially of neon tubing (a decade earlier the Czech sculptor Zdeněk Pešánek (1896–1965) had used neon, but not

as the main constituent of a work). In the 1950s Nicolas *Schöffer made some highly ambitious sculptures incorporating light effects, but it was not until the 1960s that it is possible to think of Light art constituting a movement. During this decade there were several large exhibitions of Light art in Europe and the USA (for example 'Light, Motion, Space' at the Walker Art Center, Minneapolis in 1968) and Light art often overlapped with other genres, particularly *Kinetic art, but also for example *Minimal art (notably in the work of Dan *Flavin, who typically used fluorescent tubes rather than neon) and *Pop art (notably in the work of *Chryssa). In the 1960s, also, lasers and holography (which was made possible by lasers) became available to the artist. Lasers have been used most characteristically to create spectacular nocturnal displays, the pioneer in this field being the American artist Rockne Krebs (1938–), who created his first such show in Buffalo, New York, in 1971. Many artists, including Salvador *Dalí, have experimented with holograms, and they have been sold by leading dealers such as Leo *Castelli, but in the art world holography is generally regarded as a curiosity rather than a serious means of expression.

Thomas Wilfred used the word 'Lumia' to refer to his works, and the term *Luminism is now sometimes used as an alternative to 'Light art'. However, this usage is potentially confusing, as the term 'Luminism' already has other meanings in art-historical writing

Lightfoot, Maxwell Gordon. See CAMDEN TOWN GROUP.

Lim, Kim. See TURNBULL.

Lindner, Richard (1901–78). German-born painter who became an American citizen in 1948. He was born in Hamburg, into a bourgeois Jewish family, and grew up in Nuremberg, where he studied piano at the Conservatory. He then moved to Munich, where he studied at the Academy and became art director of a publishing firm. In 1933 he fled Germany because of the rise of Nazism (he left the day after Hitler became Chancellor) and settled in Paris, then moved to New York in 1941. At first he worked very successfully as an illustrator for magazines such as *Harper's Bazaar* and *Vogue* and he did not begin to paint seriously until the the early 1950s. He

had his first one-man exhibition at the Betty *Parsons gallery in 1954. His most characteristic works take their imagery from New York life, often with overtly erotic symbolism, and are painted with harsh colours and hard outlines: 'Lindner's cast of characters—mainly women, precocious children, and men who are "strangers", voyeurs, or fantasizing bourgeois—are often posed while engaged in such daily activities as receiving a visitor. But the intensity of hard-edged color areas, exaggerated body parts with fierce sexual implications, and ambiguous space all transform normal situations into personal, obsessive inner visions' (Matthew Baigell, *Dictionary of American Art*, 1979). The effects he created owed something to *Expressionist exaggeration, *Surrealist fantasy, and *Cubist manipulations of form, but his style is vivid and distinctive and anticipates aspects of *Pop art. Some of his later work does in fact use the kind of garish poster-like imagery favoured by many Pop artists (*Rock-Rock*, Dallas Museum of Fine Arts, 1966–7).

Lindsay. Family of Australian artists. The members included five of the children of Dr R. C. Lindsay of Creswick, Victoria: **Percy Lindsay** (1870–1952), painter and graphic artist; **Sir Lionel Lindsay** (1874–1961), art critic, watercolour painter, and graphic artist in pen, etching, and woodcut, who did much to arouse an interest in the collection of original prints in Australia; **Norman Lindsay** (1879–1969), painter, graphic artist, critic, and novelist; **Ruby Lindsay** (1887–1919), graphic artist; and **Sir Daryl Lindsay** (1889–1976), painter and director of the National Gallery of Victoria, 1942–56. Norman's son **Raymond** (1904–60) and Daryl's wife **Joan** (1896–1984) were also painters. For over half a century this family, through one or other of its members, played a leading role in Australian art.

The most interesting character among them was Norman Lindsay, who according to Robert *Hughes (*The Art of Australia*, 1970) 'has some claim to be the most forceful personality the arts in Australia have ever seen'. He believed that the main impulse of art and life was sex, and his work was often denounced as pornographic. However, when he saw some of Lindsay's works at an exhibition of Australian art in London in 1923, Sir William *Orpen commented that they were 'certainly vulgar, but not in the least indecent. They are

extremely badly drawn, and show no sense of design and a total lack of imagination.'

Linien. See MORTENSEN.

linocut. A term applied to the technique of making a print from a thick piece of linoleum and to the print so made. Linoleum was invented in the 1860s, but it was not used for printing (in the manufacture of wallpaper) until the 1890s. The technique is essentially a development of the woodcut, the earliest of printmaking methods, but linocuts are much simpler to make because the material is soft and grainless and therefore easier to work. For this reason linocuts have been much used in the art education of children, the pioneer in this field being the Austrian painter and teacher Franz *Cižek, who toured Europe and North America with examples of his pupils' work and had a great influence on art teaching. Because of the close association with children's art, the medium has been somewhat lightly regarded, but it has also been used by eminent artists. The members of Die *Brücke were among the earliest to adopt it (*Heckel, who was making linocuts by 1903, before the group was founded, was probably the first major figure to take up the technique). *Kandinsky was making colour linocuts by about 1907.

In Britain, Horace *Brodzky was one of the first to take an interest in linocut, but the most important popularizer of the medium there was Claude Flight (1881–1955). He was probably the first artist to specialize in the technique and he wrote two books on the subject: *Lino-Cuts: A Handbook of Linoleum-Cut Colour Printing* (1927, revised edition 1948) and *The Art and Craft of Lino Cutting and Printing* (1934). Flight taught at the Grosvenor School of Modern Art in London (see MACNAB), where his pupils included the Australian painter and printmaker Dorrit Black (1891–1951). After returning to Australia in 1929 she tried to promote the linocut as a form of original art that was cheap enough to be bought by the ordinary person.

The two most famous artists to use linocut are *Matisse and *Picasso. Matisse took up the medium in 1938 and made about 70 linocuts between then and 1952. Picasso made his first black-and-white linocut in 1939 and began making linocut posters in the early 1950s. In 1958–9 he made a series of 45 colour linocuts and in 1962–3 a series of 55 more. The

medium is particularly suitable for colour prints, since a number of large blocks may be used without undue expense (Picasso, however, devised a method of printing in several colours from one block). Because the surface can be cut rapidly and spontaneously, linocut is also highly suitable for big prints boldly conceived.

Lipchitz, Jacques (1891–1973). Lithuanian-born sculptor who became a French citizen in 1925 and an American citizen in 1958. His father, a Jewish building contractor, did not wish him to become an artist, but he was supported by his mother. After studying engineering in Lithuania he moved to Paris in 1909 and studied at the École des *Beaux-Arts and the *Académie Julian. He also frequented museums and became deeply interested in ancient and non-Western art (in particular, he collected African art). By about 1912 he was part of a circle of avant-garde artists including *Matisse, *Modigliani, and *Picasso, and from 1914 he became one of the first sculptors to apply the principles of *Cubism in three dimensions (*Man with Guitar*, MOMA, New York, 1916). During the 1920s his style changed, as he became preoccupied with open forms and the interpenetration of solids and voids, and from about 1930 he began to use allegorical subject matter drawn from the Bible or classical mythology. After the German invasion of France he fled to Toulouse in 1940 and the following year he moved to the USA, settling at Hastings-on-Hudson, New York, in 1947. His work was already well known in his adopted country: Albert C. *Barnes had commissioned work from him in the 1920s and he had had a large one-man exhibition at the Brummer Gallery, New York, in 1935. In America he returned to greater solidity of form, but with a desire for greater spirituality. At times the tortured, bloated forms of his late work look rather like inflated shrubbery, as in *Prometheus Strangling the Vulture* (Walker Art Center, Minneapolis, 1944–53). Towards the end of his career he carried out several large public commissions, for example *Peace on Earth* (Los Angeles Music Centre, 1967–9). This, like most of his work, is in bronze, but he also made stone carvings. In 1972 he published an autobiography, *My Life in Sculpture*, coinciding with a major exhibition of his work at the Metropolitan Museum, New York, entitled 'Jacques Lipchitz: His Life in Sculpture'. He died on holi-

day in Capri (he usually spent several months each year in Italy) and was buried in Jerusalem (he first visited Israel in 1963 and regarded it as his spiritual home).

Lippard, Lucy (1937–). American art critic, a woman of radical views who is particular known for her writings on *Conceptual art and *Feminist art. She was born in New York and studied at Smith College and the New York Institute of Fine Arts. In 1969 she was one of the founders of the *Art Workers' Coalition, which combined demands for artists' rights with protests against the Vietnam War. She was closely involved with the early history of Conceptual art, and in 1973 published the first attempt in book form to document its growth—*Six Years: The Dematerialization of the Art Object*. This used a collage of chronologically ordered references and quotations and deliberately suspended aesthetic judgement. Part of the reason Lippard was interested in this kind of art was that its theoretical abandoning of a physical 'product' appeared to undermine the commercial values of the art market, although she admitted in her 'postface' to the book that by 1972 Conceptual artists were selling works for substantial sums and that 'art and artists in a capitalist society remain luxuries'. Lippard's other books include *Pop Art* (1969), *Changing: Essays in Art Criticism* (1971), *From the Center: Feminist Essays on Women's Art* (1976), *A Different War: Vietnam in Art* (1990), *Mixed Blessings: New Art in a Multicultural America* (1992), and monographs on Eva *Hesse (1976) and Ad *Reinhardt (1981). From 1987 to 1994 she was adjunct professor at the University of Colorado, Boulder.

Lippold, Richard (1915–). American abstract sculptor, born in Milwaukee. The son of an engineer, he graduated in industrial design from the school of the Art Institute of Chicago in 1937. For several years after this he worked in industry and taught design. In 1942 he made his first sculptures—constructions of wire and scrap metal. From these he developed the 'space cages' for which he has become famous—elegant hanging constructions that give the effect of a gossamer-like network of wires suspended in space. He sometimes increases the impression of weightlessness by exhibiting them in semi-darkness against a black background. Lippold settled in New York in 1944 and had his first

one-man exhibition at the Willard Gallery there in 1947. Since then he has won much acclaim and has had many public commissions, often on a large scale. Indeed, his *Orpheus and Apollo* (1962) in the Philharmonic Hall in the Lincoln Center for the Performing Arts, New York, was said at the time of its installation to be the largest piece of sculpture created in the 20th century.

Lipton, Seymour (1903–86). American sculptor, born in New York. He studied dental sugery at Columbia University, 1923–7, and was entirely self-taught as a sculptor; by 1932 he was seriously committed to art, but for many years after that he pursued a dual career (like *Ferber, another dentist-sculptor). Until the mid-1940s he carved in wood and stone, using violent distortions to reflect the social struggle and anguish of the years of the Depression and the Second World War. In about 1942, however, he took up metal casting and abandoned the human figure as a subject, instead using 'skeletal forms, horns, pelvis . . . to convey the basic struggles in nature on a broader biological level'. By 1945 his work was completely abstract and he became part of a group (Ferber, *Lassaw, *Roszak) whose work paralleled that of the *Abstract Expressionist painters. His first one-man exhibition of metal sculpture was at the Betty *Parsons gallery in 1948. In the 1950s, as he searched for 'a controlled organic dynamism', his violently expressive abstractions began to give way to more lyrical forms fashioned from curving shells of Monel (a nickel-copper alloy) welded together at the edges and covered with nickel-silver or bronze. Towards the end of the 1950s he once again introduced forms suggestive of the human figure, as in *Sentinel* (Yale University Art Gallery, 1959). He had many major public commissions, including *Archangel* (1964) for Philharmonic Hall, Lincoln Center, New York.

Lismer, Arthur. See GROUP OF SEVEN.

Lissitzky, El (Lazar Lissitzky) (1890–1941). Russian painter, designer, graphic artist, and architect. He was born at Pochinok near Smolensk and from 1909 to 1914 studied engineering at Darmstadt, returning to Russia on the outbreak of the First World War. Exempt from military service because of poor health, he worked in an architect's office in Moscow and collaborated with *Chagall on the illus-

tration of Jewish books (he was an expert lithographer). In 1918 Chagall became head of the art school at Vitebsk and in the following year he appointed Lissitzky professor of architecture and graphic art. One of his colleagues at Vitebsk was *Malevich, whose advocacy of the use of pure geometric form influenced Lissitzky, notably in the series of abstract paintings to which he gave the collective name '*Proun' and which he referred to as 'the interchange station between painting and architecture'. They do indeed look like plans for three-dimensional constructions, and at the same time Lissitzky made ambitious architectonic designs that were never realized. In 1921, after a brief period as professor at *Vkhutemas in Moscow, he was sent to Berlin, where he arranged and designed the major exhibition of abstract art at the Van Diemen Gallery that first comprehensively presented the modern movement in Russia to the West (it was later shown in Amsterdam). While in Berlin he worked on *Constructivist magazines; he also made contact with van *Doesburg and members of De *Stijl and with *Moholy-Nagy, who spread Lissitzky's ideas through his teaching at the *Bauhaus. In 1923 he went with *Gabo to a Bauhaus exhibition at Weimar and there met *Gropius. From 1923 to 1925 he lived in Switzerland, then (after a short visit to Russia) from 1925 to 1928 in Hanover. He returned to Russia permanently in 1928 and settled in Moscow. By this time he had abandoned painting and devoted himself mainly to typography and industrial design. His work included several propaganda and trade exhibitions, notably the Soviet Pavilion of the 1939 World's Fair in New York, and his dynamic techniques of *photomontage, printing, and lighting had wide influence.

For many years Lissitzky was the best known of the Russian abstract artists in the West. In his mature work he achieved a fusion of the *Suprematism of Malevich, the Constructivism of *Tatlin and *Rodchenko, and features of the *Neo-Plasticism of *Mondrian.

Lisson Gallery, London. See NEW BRITISH SCULPTURE.

literalists. See *ARTFORUM*.

Liverpool, John Moores Exhibition. See JOHN MOORES LIVERPOOL EXHIBITION.

Liverpool, Tate Gallery. See TATE GALLERY.

livre d'artiste (artist's book). A type of luxury illustrated book in which each illustration is printed directly from the surface on which the artist has worked (etching plate, lithographic stone, etc.). The genre was originated by the dealer Ambroise *Vollard, a great promoter of printmaking, and the first example is regarded as *Parallelement* (1900), a book of poetry by Paul Verlaine illustrated with lithographs by Pierre *Bonnard. Vollard commissioned about 50 such books, the artists involved including *Braque, *Maillol, *Picasso, *Rodin, and *Rouault, and he was soon followed by other publishers, among them *Kahnweiler, who in 1909 issued *Apollinaire's *L'Enchanteur pourrissant* with wood engravings by *Derain. The livre d'artiste has continued to flourish particularly in France, but notable examples have also been produced elsewhere, for example *Six Fairy Tales of the Brothers Grimm* (1969), with etchings by David *Hockney.

Usually livres d'artiste are published in unsewn sheets, rather than bound (this means that they can be specially bound to the owner's requirement or dismantled for individual display of particular illustrations). The number of copies in an edition typically ranges from about 20 to 300. Printing is done by specialist establishments, using carefully selected paper, inks, and typefaces, and the artists and publishers often go to great lengths to secure the exact results they require (for an example, see SKIRA).

Llewellyn, Sir William (1858–1941). British painter, mainly of portraits. In 1928 he succeeded *Dicksee as president of the *Royal Academy, beating *Orpen in the final ballot. He was of little distinction as an artist, but compensated for this with other virtues, 'being tall and handsome in person, with a pleasant, lively manner, and the valuable gifts of quick observation, social tact, frank speech, and sense of humour' (*DNB*).; these qualities helped him to to be a great success in supervising the arrangements for a series of outstanding exhibitions in the 1930s, beginning with one on 'Italian Art 1200–1900' (1930) that was—as Sidney Hutchinson puts it in his *History of the Royal Academy* (1968)— 'absolutely staggering in its content of world-famous masterpieces'. In 1938 Llewellyn stood down from the presidency, having reached—so it was believed—the statutory retirement age of 75; in fact he was five years older, his date of birth having long been given inaccurately.

Lloyd, Frank. See MARLBOROUGH FINE ART.

Locke, Alain. See HARLEM RENAISSANCE.

Locke, Donald. See BOYCE.

Lohse, Richard (1902–88). Swiss painter and graphic artist, born in Zurich, where he studied at the School of Arts and Crafts. In his early works he experimented with various subjects and styles, but in the 1940s he became one of the leading representatives of *Concrete art. His paintings are mathematically-based, often featuring chequer-board or grid-like patterns, but they are not cold or analytical in effect; indeed his work is particularly noted for its beauty and refinement of colour, and has a certain resemblance to *Op art of the kind associated with Bridget *Riley. Lohse began to gain an international reputation from about 1950 and in 1958 he was awarded the Guggenheim International Prize.

London, Courtauld Institute of Art. See COURTAULD.

London, Hayward Gallery. See ARTS COUNCIL.

London, Imperial War Museum. See OFFICIAL WAR ART.

London, Institute of Contemporary Arts. See INSTITUTE OF CONTEMPORARY ARTS.

London, Royal Academy. See ROYAL ACADEMY.

London, Royal College of Art. See ROYAL COLLEGE OF ART.

London, Saatchi Collection. See SAATCHI.

London, St Martin's School of Art. See ST MARTIN'S SCHOOL OF ART.

London, School of. See SCHOOL OF LONDON.

London, Serpentine Gallery. See ARTS COUNCIL.

London, Slade School. See SLADE SCHOOL OF FINE ART.

London, Tate Gallery. See TATE GALLERY.

London, Whitechapel Art Gallery. See WHITECHAPEL ART GALLERY.

London Artists' Association (LAA). Organization founded in 1925 under the patronage of John Maynard *Keynes to provide exhibition space for promising young artists and give them a small but regular income (£3–£5 a week) if they should fail to sell their work. It lasted until 1934. Keynes wrote: 'The idea was that an organization could be formed, which, acting as agent to a group of artists, would allow them to work in greater freedom from continually pressing financial considerations by providing them with a small guaranteed income and taking upon itself the entire management of the business side of their affairs.' Samuel *Courtauld was among the backers. Any works sold were subject to a commission fee, but this was purely to meet running expenses. The Association's first exhibition was at the *Leicester Galleries, London, in 1926, and its headquarters later moved to the Cooling Galleries. Among the artists who had their first one-man shows through the auspices of the LAA were William *Coldstream, Victor *Pasmore, and Claude *Rogers. Other distinguished members included Ivon *Hitchens, Henry *Moore, Paul *Nash, and Ben *Nicholson. Dennis Farr (*English Art 1870-1940*, 1978) writes of the LAA that 'Although short-lived, it performed a valuable service for the younger artists whose reputations had still to be made.'

London Bulletin. See MESENS.

London College of Fashion. See ST MARTIN'S SCHOOL OF ART.

London College of Printing and Distributive Trades. See ST MARTIN'S SCHOOL OF ART.

London Gallery. See MESENS.

London Group. An exhibiting society of British artists formed in 1913 by an amalgamation of the *Camden Town Group with several smaller groups and various individuals. The first president was Harold *Gilman; apart from other ex-Camden Town Group artists, the strongest representation among the early members consisted of *Futurists and those who would soon become known as *Vorticists, among them *Bomberg, *Epstein (who suggested the name), *Nevinson, and *Wadsworth. The first exhibition of the Group was held at the Goupil Gallery, London, in March 1914, with the Vorticists seeming to the press and public to swamp the show. Bomberg's enormous and dazzling *In the Hold* (Tate Gallery, London, 1913–14) was the most spectacular work on view; Lucien *Pissarro said that the 'drunkards' had triumphed over the 'teetotallers'. Membership at this time numbered 32 and after this exhibition an increasing number of non-members were encouraged to submit works to the annual shows. Once the initial Vorticist domination was over, the Group became less aggressively avant-garde, although it still represented advanced taste. Several artists associated with the *Bloomsbury Group joined during the next few years: Mark *Gertler in 1915, Roger *Fry in 1918, Vanessa *Bell and Duncan *Grant in 1919. Fry summed up the progressive aims of the London Group when he wrote that it had 'done for *Post-Impressionism in England what the *New English Art Club did in a previous generation for *Impressionism'. These aims were deprecated by *Tonks, who said: 'The leaders of the London Group have nearly all come from me. What an unholy brood I have raised.' The Group survived such conservative opposition, was revived after the Second World War, and came to be looked on as something of an institution. But with the dignity of an institution it lost its early sense of mission and by 1950 it would have been difficult to distinguish the artistic principles for which it stood. An exhibition marking the Group's silver jubilee was held at the Tate Gallery, London, in 1964. By this time the membership stood at about 90, embracing painters and sculptors of every persuasion. The Group still exists.

London Institute. See ST MARTIN'S SCHOOL OF ART.

London Studio. See *STUDIO*.

Long, Richard (1945–). British avant-garde artist whose work brings together sculpture, *Conceptual art, and *Land art. Born in Bristol, he studied there at the West of England College of Art, 1962–5, and then at *St Martin's School of Art, London, 1966–8. Since 1967 his artistic activity has been based on long solitary walks that he makes through

landscapes, initially in Britain, and from 1969 also abroad, often in remote or inhospitable terrain. Sometimes he collects objects such as stones and twigs on these walks and brings them into a gallery, where he arranges them into designs, usually circles or other fairly simple geometrical shapes (*Circle of Sticks*, 1973; *Slate Circle*, 1979, both Tate Gallery, London). He also creates such works in their original settings, and documents his walks with photographs, texts (which refer to the things he passes and more recently to his state of mind), and maps.

Long is the leading British exponent of Land art; he has an international reputation (as early as 1976 he represented Britain at the Venice *Biennale) and has attracted a great deal of critical commentary, much of it laudatory. Richard Cork, for example, wrote that 'Long achieves the remarkable feat of drawing inspiration from the most ancient sculptural forms and at the same time contributing to adventurous notions about sculpture in his own period' (catalogue of the exhibition 'British Art in the 20th Century', Royal Academy, London, 1987). On the other hand, Peter *Fuller describes his work as 'the barren arrangement of gathered stones' (Boris Ford, ed., *The Cambridge Guide to the Arts in Britain*, vol. 9, 1988). In 1989 Long was awarded the *Turner Prize and in 1991 a major *Arts Council exhibition of his work entitled 'Walking in Circles' was held at the Hayward Gallery, London.

López, Francisco. See SPANISH REALISTS.

López Garcia, Antonio. See SPANISH REALISTS.

López Torres, Antonio. See SPANISH REALISTS.

Lorimer, Hew (1907–93). Scottish sculptor, born in Edinburgh, son of the distinguished architect (and occasional painter) **Sir Robert Lorimer** (1864–1929) and nephew of the painter **John Henry Lorimer** (1856–1936), who was a successful portraitist. Robert Lorimer's most famous work is the Scottish National War Memorial (Edinburgh Castle, 1924–7), a hall-like structure whose rich decoration involved the collaboration of dozens of artists and craftsmen, including the sculptor Alexander Carrick (1882–1966) and the stained-glass designer Douglas Strachan

(1875–1950). Hew Lorimer intended to follow his father into architecture and began studying the subject at Edinburgh College of Art, but he switched to sculpture, and was taught by Carrick, head of the department there from 1928 to 1942, who encouraged his students to practise *direct carving. Between 1933 and 1935 scholarships enabled Lorimer to travel in France and Italy and to spend a period working with Eric *Gill, who passed on his belief that the artist is a humble collaborator in God's creative acts. This idea remained central to Lorimer's work throughout the rest of his career, as did his love of stonecarving. He carried out numerous religious commissions, but his best-known works are probably the seven allegorical figures of the *Liberal Arts* (1952–5) on the façade of the National Library of Scotland, Edinburgh. Duncan Macmillan writes that Lorimer 'helped to keep alive for a younger generation the special combination of spirituality and humanity that marked the best of the Arts and Crafts tradition' (*Scottish Art in the 20th Century*, 1994).

Los Angeles, Museum of Contemporary Art. See MUSEUM OF CONTEMPORARY ART, LOS ANGELES.

'lost generation'. See MURPHY.

'lost sculptures'. See ANDRE.

Lorjou, Bernard. See HOMME-TÉMOIN.

Louis, Morris (Morris Louis Bernstein) (1912–62). American painter, considered the main pioneer of the movement from *Abstract Expressionism to Colour Stain Painting (see COLOUR FIELD PAINTING). The son of Russian-Jewish immigrants, he was born in Baltimore, where he studied at the Maryland Institute of Fine and Applied Arts, 1929–33. In 1934–40 he lived in New York working on the *Federal Art Project (it was during this period that he dropped his last name), but otherwise his whole career was spent first in Baltimore and then from 1947 in nearby Washington (initially he lived in the suburb of Silver Spring, and then from 1952 in the city itself). He isolated himself from the New York art world, concentrating on his own experiments and supporting himself by teaching. However, it was a visit to New York in 1953 with Kenneth *Noland that led to the breakthrough in his

art. He and Noland went to Helen *Franken-thaler's studio, where they were immensely impressed by her painting *Mountains and Sea*, and Louis immediately began experimenting with her technique of applying liquid paint onto unprimed canvas, allowing it to flow over and soak into the canvas so that it acted as a stain and not as an overlaid surface of pigment. He was secretive about his technical methods and it is uncertain how he achieved his control over the flow of colour, but towards the end of his life he suffered from severe back problems caused by his constant bending and stooping over the canvas. Whatever his technique, the effect was to create suave and radiant flushes of colour, with no sense of brush gesture or hint of figuration. His method was exacting, allowing no possibility of alteration or modification. For this reason, perhaps, Louis destroyed much of his work of this period.

Louis painted various series of pictures in his new technique, the first of which was *Veils* (1954; he did another series in 1957–60). The other major series were *Florals* (1969–60), *Unfurleds* (1960–61), and *Stripes* (1961–2). The *Veils* consist of subtly billowing and overlapping shapes filling almost the entire canvas, but his development after that was towards rivulets of colour arranged in rainbow-like bands, often on a predominantly bare canvas.

It was not until 1959 that Louis's reputation began to take off (he had his first foreign exhibition in 1960 at the Institute of Contemporary Arts in London), and he had little time to enjoy his success before dying of lung cancer. However, his reputation now stands very high and he has had enormous influence on the development of Colour Stain Painting. In the introduction to the catalogue of the 1974 Arts Council exhibition of his work, John Elderfield wrote: 'Morris Louis is one of the very few artists whose work has really changed the course of painting ... With Louis, fully autonomous abstract painting came into its own for really the first time, and did so in paintings of a quality that matches the level of their innovation.' See also WASHINGTON COLOR PAINTERS.

Louisiana Museum, Humlebaek, near Copenhagen. Collection of modern art founded by the Danish merchant Knud W. Jensen (1921–) in 1958. It is housed in a series of buildings erected in stages between 1958 and 1982 and linked to a 19th-century house called Louisiana (this had belonged to a nobleman—an ancestor of Jensen's—who married three times, each wife being called Louise). The museum buildings are modern in style, but they make extensive use of rustic materials and are sympathetically related to the beautiful setting, near the sea and a lake (many of the walls are predominantly glass, allowing views of the surrounding landscape, and much of the sculpture in the collection is shown in the open air). The museum is particularly rich in Danish works, but it also has the best collection of international modern art in the country.

Low, Sir David (1891–1963). New Zealand cartoonist, active in Britain for most of his career. He was born in Dunedin and brought up in Christchurch. Although he attended drawing classes there he was essentially self-taught. He first had a drawing published in the Christchurch *Spectator* when he was only eleven, and he became the paper's political cartoonist in 1908, when he was 17. In 1911 he moved to Australia, where he worked for the *Sydney Bulletin*, and in 1919 he settled in London. There he initially worked for the *Star*, an evening paper with a strictly Liberal policy. In 1926 Lord Beaverbrook invited him to work for his *Evening Standard*. Low's Socialist views conflicted with the Conservative policy of this paper, but Beaverbrook thought so highly of him that he offered him 'complete freedom in the selection and treatment of subject matter'. Low worked for the *Standard* from 1927 to 1950 and this period marked the height of his prestige and influence. In 1932 Winston Churchill described him as 'the greatest of our modern cartoonists—the greatest because of the vividness of his political conceptions, and because he possesses what few cartoonists have—a grand technique of draughtsmanship', and in 1933 his depictions of Hitler as a militant pigmy caused the *Evening Standard* to be banned in Germany. As well as satirizing well-known figures, Low invented imaginary characters to symbolize policies and attitudes of mind, the most famous of whom was 'Colonel Blimp', whose name has passed into the language to describe a type of muddle-headed complacent reactionary. In 1950 Low left the *Standard* (Beaverbrook described the day he received his resignation as 'Black Friday'), then worked for the *Daily Herald* until 1953 and for the *Manchester Guardian* from 1953 until his death. He was knighted in 1962.

Many collections of his cartoons appeared in book form, and he wrote *Ye Madde Designer* (1935), about the technique of cartooning, and *British Cartoonists, Caricaturists and Comic Artists* (1942) in the 'Britain in Pictures' series. His autobiography appeared in 1956. John Geipel (*The Cartoon*, 1972) describes Low as 'undoubtedly the most outstanding British political cartoonist, an artist whose long and unchallenged reign straddled four decades ... Low's conception was dramatically bold, simple and assertive, and his facile brushwork has been aptly likened to the techniques of oriental painting.'

Lowe, Peter. See CONSTRUCTIVISM.

Lowry, L. S. (Laurence Stephen) (1887–1976). British painter. He lived all his life in or near Manchester and worked as a rent collector and clerk for a property company until he retired (as chief cashier) in 1952. His painting was done mainly at night after his day's work, but he was not a *naive painter, having studied intermittently at art schools from 1905 to 1925. The most important of his teachers—at Manchester School of Art—was Adolphe Valette (1876–1942), a French painter who settled in Manchester in 1905 and whose work includes some memorably atmospheric views of the city. Lowry, too, concentrated on urban subjects, but his style was very different to Valette's and much more in the tradition of certain painters of the *Camden Town Group. His most characteristic pictures feature firmly drawn backgrounds of industrial buildings, often bathed in a white haze, against which groups or crowds of figures, painted in his distinctive stick-like manner, move about their affairs. There is sometimes an element of humour in Lowry's work, but the prevailing feeling is generally what Sir John *Rothenstein calls 'a kind of gloomy lyricism' (Lowry was a solitary character and said 'Had I not been lonely I should not have seen what I did'). Many of his paintings record his immediate surroundings, but others are semi-imaginary views, such as *The Pond* (Tate Gallery, London, 1950), one of his largest and most ambitious works. Mervyn Levy, the leading scholar of Lowry's work, writes of this picture: 'This is perhaps the Elysium of the artist's dream; the pure poetry of the industrial landscape—miraculous and shining. People and animals, buildings and smoking stacks, the boats bobbing on the pond, and

high up, the most haunting of all the artist's grass-root images—the Stockport Viaduct—combine in a glorious harmony.'

Lowry's first one-man exhibition, at the Reid & Lefevre Gallery, London, in 1939, established his name outside his home area for the first time, and his reputation steadily increased (particularly after a television documentary on him in 1957), leading to a large retrospective exhibition arranged by the *Arts Council in 1966 (it was shown at the Tate Gallery, London, and elsewhere). By this time he was turning from industrial subjects to landscapes and seascapes. He also occasionally painted portraits (there is a self-portrait, 1938, in Salford Museum and Art Gallery). In spite of his growing fame, he continued to lead a spartan life and he turned down a knighthood and other honours (although he did accept some awards, including honorary doctorates from three universities).

In 1976, a few months after Lowry's death, a comprehensive retrospective exhibition of his work at the Royal Academy brought considerable divergence of opinion among critics. Some thought of him as a great artist with an important original vision. Others represented him as a very minor talent, although interesting as a social commentator. What is certain is that his work has struck a chord with the general public; the 1976 exhibition broke attendance records, and two years later Lowry had the very dubious distinction of becoming the only 20th-century painter to be the subject of a number-one hit record, the execrable 'Matchstalk Men and Matchstalk Cats and Dogs' by the one-hit wonders Brian and Michael. The biggest collection of Lowry's work is in Salford Museum and Art Gallery, and he is represented in many other public collections, including the City Art Gallery, Manchester.

Lubarda, Petar (1907–74). Yugoslav painter, born at Ljubotinje. He studied briefly in Belgrade and Paris (at the École des *Beaux-Arts), but he was mainly self-taught as an artist. He lived in Paris from 1926 to 1932, exhibiting at the *Salon des Indépendants. On returning to Yugoslavia he founded his own art school at Cetinje. Lubarda's painting was inspired mainly by the landscape of his native Montenegro, a harsh country of mountains and rocks against the deep blue of sea and sky, his work evolving from *Expressionism towards abstraction. He also painted scenes from his

country's history and legends. His work influenced many younger Yugoslav painters.

lubok (plural: lubki). A brightly coloured Russian popular print, usually depicting folk tales or similar scenes; they were produced from the mid-17th century until at least the First World War. Alla Sytova writes that 'In 19th-century Russia the term "lubok" implied a derogatory assessment of the common man's art by educated society . . . [and] was a synonym for anything coarse, cheap, slipshod and devoid of taste' (*The Lubok: Russian Folk Pictures*, 1984). In the early 20th century, however, the rough vigour of lubki appealed to many avant-garde artists; they were one of the sources of *Neo-primitivism and examples were reproduced in the *Blaue Reiter *Almanac*.

Lucas, Colin. See UNIT ONE.

Lucas, Sarah. See YOUNG BRITISH ARTISTS.

Luce, Maximilien (1858–1941). French painter and graphic artist. He was a friend of *Signac and like him an exponent of *Neo-Impressionism, although he was less rigid in his interpretation of its doctrines. His main subjects were landscape and townscape (especially of industrial areas). He was a fairly minor painter, but he is noteworthy for helping to popularize Neo-Impressionism outside France, particularly in Belgium (he exhibited with Les Vingt and La *Libre Esthétique). There is a museum of his work at Mantes-la-Jolie.

Luchism. See RAYONISM.

Lucie-Smith, Edward (1933–). British poet and writer on art. He was born in Kingston, Jamaica, settled in England in 1946, and read history at Merton College, Oxford. He has worked mainly as a freelance journalist, radio broadcaster, and author, and has written or edited about 50 books, mainly poetry anthologies or popular works on 20th-century art. They include *Movements in Art Since 1945* (1969), *Symbolist Art* (1972), *Art Today* (1977), *Cultural Calendar of the 20th Century* (1979), *Super Realism* (1979), *Art in the Seventies* (1980), *Art in the Thirties* (1985), *American Art Now* (1985), *Lives of the Great Twentieth Century Artists* (1986), *Sculpture Since 1945* (1987), *Art in the Eighties* (1990), *Art Deco Painting* (1990), *Latin American Art of the Twentieth Century* (1993), *Art*

Today (1995; this is a different book from his 1977 work of the same title, although it has the same publisher), and *Visual Arts in the Twentieth Century* (1996). He has also written introductions to collections of homoerotic photographs and articles for numerous journals and newspapers.

Ludwig, Peter (1925–96). German businessman and art collector, born in Koblenz. He studied art history at Mainz University (writing a doctoral thesis on *Picasso in 1950), then went into business and ran various firms, including his wife's family's chocolate factory, which he took over in 1952. His collecting interests were initially very broad, but he came to concentrate on contemporary art, in which he built up one of the world's largest collections, particularly rich in American *Pop art (which he bought en bloc at *Documenta IV in 1968). He made many donations to public collections, and several cultural bodies in Germany and Austria now bear his name, notably the Ludwig Museum in Cologne (founded 1986), which is one of the world's leading galleries of modern art. According to his obituary in *The Times*, Ludwig 'displayed a quasi-scientific approach to collecting and a monastic aversion to the limelight'; his 'aloofness, and a certain irritability with interviewers, saw to it that his name was not well known outside Germany'. See also BREKER.

Lu Haisu. See XU BEIHONG.

Lukács, Georg. See EIGHT (3).

Luks, George (1867–1933). American painter and graphic artist. He was born in Williamsport, Pennsylvania, and began his studies at the Pennsylvania Academy of the Fine Arts, Philadelphia, in 1884. Over the next decade he travelled in Europe, studying at various academies en route. In 1894 he became an illustrator on the *Philadelphia Press* and became friendly with other newspaper artists—*Glackens, *Shinn, and *Sloan—who introduced him to Robert *Henri. In 1896 Luks moved to New York, where he turned more to painting and became a member of The *Eight and the *Ashcan School. A flamboyant character who identified himself with the poorer classes and made a pose of bohemianism, he was much given to tall tales and sometimes posed as 'Lusty Luks', an ex-boxer. His work

was uneven and unpredictable. It had vigour and spontaneity but often lapsed into superficial vitality. One of his best-known works is *The Wrestlers* (Museum of Fine Arts, Boston, 1905), which shows his preference for earthy themes and admiration for the bravura painterly technique of artists such as Manet. Luks taught for several years at the *Art Students League and also ran his own school. His death was slightly mysterious, his body being found in a doorway; newspapers reported that he had died sketching in the street, but some of his friends assumed he had picked one fight too many.

Luminism. A term used in several different ways in art-historical writing, some fairly distinct, others more vague. The three most distinct ones are: to describe an aspect of mid-19th-century American landscape painting in which the rendering of light and atmosphere was paramount; as an alternative term for *Light art; and as a name for *Neo-Impressionism in Belgium. In this last sense, the name derives from the group Vie et Lumière founded in 1904. Its members, several of whom had exhibited with La *Libre Esthétique, included Anna Boch (1848–1936), Emile Claus (1849–1924), the French-born William Degouve de Nuncques (1867–1935), Adrien Heymans (1839–1921), and George Morren (1868–1941). By loose extension, the term 'Luminism' was also used from about 1910 to refer to the late phase of *Impressionism in the Netherlands. In his book *Modern Masterpieces* (1940), Frank *Rutter used the term more vaguely, to characterize the 'attempt to express in paint the colour of light' that he thought typical of Impressionism.

Lunacharsky, Anatoly. See NARKOMPROS.

Lüpertz, Markus. See NEO-EXPRESSIONISM.

Lurçat, Jean (1892–1966). French painter and designer, born at Bruyères, Vosges. He studied in Nancy before moving to Paris in 1912. For a time he was influenced by *Cubism, but more important and lasting influences on his painting came from his extensive travels during the 1920s in the Mediterranean countries, North Africa, and the Middle East. His pictures were dominated by impressions of desert landscapes, reminiscences of Spanish and Greek architecture, and a love of fantasy that led him to join the *Surrealist movement for a short period in the 1930s. Lurçat is chiefly remembered, however, for his work in the revival of the art of tapestry in both design and technique. His designs combined exalted themes from human history with fantastic representations of the vegetable and insect worlds, and he succeeded in reconciling the stylizations of medieval religious tapestry with modern modes of abstraction. In 1939 he was appointed designer to the tapestry factory at Aubusson and together with Marcel *Gromaire he brought about a renaissance in its work. He made more than a thousand designs, the most famous probably being the huge *Apocalypse* (1948) for the parish church of Assy (Haute-Savoie). From 1930 onwards he did a number of coloured lithographs, stage designs, and book illustrations, and in the 1960s he renewed his painting activities. He also wrote poetry and books on tapestry.

Lutyens, Sir Edwin. See ROYAL ACADEMY.

Lyon, Robert. See ASHINGTON GROUP.

Lyrical Abstraction. A rather vague term, used differently by different writers, applied to a type of expressive but non-violent abstract painting flourishing particularly in the 1950s and 1960s, chiefly in France; the term seems to have been coined by the French painter Georges *Mathieu, who spoke of 'abstraction lyrique' in 1947. European critics often use it more or less as a synonym for *Art Informel or *Tachisme; Americans sometimes see it as an emasculated version of *Abstract Expressionism. To some writers the term implies particularly a lush and sumptuous use of colour.

MA. See ACTIVISTS.

McAllister, Isabel. See GILBERT, SIR ALFRED.

McAlpine, Alistair. See NEW GENERATION.

McBride, Henry (1867–1962). American art critic, born at West Chester, Pennsylvania. He worked as a writer and illustrator of seed catalogues before he saved enough money to move to New York in 1889. After studying at the *Art Students League and elsewhere, he taught at various schools and gained a wide experience of art through travels in Europe. In 1913 he began working for the New York *Sun* and—at the age of 46—at last found his vocation in 'art criticism of a dry, subhumorous, and subtle sort' (*Dictionary of American Biography*). Some of his first articles (unsigned) were on the *Armory Show (1913) and they were among the most moderate and informative devoted to the exhibition. McBride continued writing for the *Sun* until 1950 and also contributed criticism to *The Dial*, which during the 1920s (it ceased publication in 1929) was 'the most distinguished literary monthly in the US to champion modern artistic movements' (*Oxford Companion to American Literature*). From 1930 to 1932 he was editor of *Creative Art*, which was initially published as a supplement to the American edition of the London-based *Studio*. When the *Sun* merged with the *World Telegram* in 1950, it dispensed with the services of McBride (now in his 80s), but he was taken on by *Art News*, for which he wrote a regular column, 1950–5. He 'endured old age philosophically' and 'died the undisputed dean of American art critics' (*Dictionary of American Biography*).

McBride was a much liked man who had many friends in the art world; he even got on tolerably well with the quarrelsome Dr *Barnes. His sympathies were wide (at the end of his career he was writing perceptively about such rising stars as *Pollock and *Rothko) and his literary style was relaxed and unpretentious. A collection of his articles was published in 1975 as *The Flow of Art: Essays and Criticisms of Henry McBride*.

MacBryde, Robert (1913–66). British painter and theatre designer, born at Maybole, Ayrshire. After working for five years as an engineer in a factory he studied at *Glasgow School of Art, 1932–7. He formed an inseparable relationship with his fellow student Robert *Colquhoun and they lived and worked together until the latter's death in 1962. MacBryde himself consistently maintained that Colquhoun was the dominant figure artistically, and his work (mainly still-lifes and figure subjects) has been overshadowed by that of his partner. Colquhoun was certainly the more imaginative, but some critics maintain that MacBryde had a better sense of colour.

McCahon, Colin (1919–87). New Zealand painter. With Rita *Angus and Toss *Woollaston, McCahon formed 'the trinity of native-born painters who pioneered the modern movement in New Zealand art' (Gil Docking, *Two Hundred Years of New Zealand Painting*, 1971) and he is generally considered his country's foremost 20th-century artist. He was born in Timaru, studied at Dunedin School of Fine Arts, and 'roamed the length of New Zealand' (Docking). His paintings—intense and visionary in style—are mainly landscapes and religious subjects, and he often combined the two, as in his *Stations of the Cross* series, in which Christ's Passion is placed in the North Otago hills. In 1953 McCahon was appointed keeper of the Auckland City Art Gallery and in 1964 he became lecturer in painting at the University of Auckland.

Macció, Rómulo. See OTRA FIGURACIÓN.

MacColl, D. S. (Dugald Sutherland) (1859–1948). British painter, critic, lecturer, and administrator. He was born in Glasgow and studied at University College London and Lincoln College, Oxford, where he graduated in classics in 1884. In the next few years he travelled extensively on the Continent and also studied at Westminster School of Art under Frederick *Brown and at the *Slade School under *Legros. From 1890 to 1895 he was art critic of the *Spectator* and from 1896 to 1906 of the *Saturday Review* (and again from 1921 until 1930, when he moved to the newly founded *Week-end Review*). In these positions he helped to influence public taste in favour of *Impressionism, and his book *Nineteenth Century Art* (1902) contains one of the earliest balanced assessments of the movement. He did not care for the *Post-Impressionists, however, and thought that *Cézanne must have suffered from an eye defect. MacColl was keeper of the *Tate Gallery, 1906–11, and of the Wallace Collection, 1911–24, one of the founders of the *Contemporary Art Society in 1910, and a vigorous controversialist (he was one of Roger *Fry's most earnest critics); in the *Dictionary of National Biography* he is described as 'highly versatile, volcanically energetic, utterly honest and self-confident'. As a painter he concentrated on landscape watercolours, although he also did portraits in oils, including one of Augustus *John (Manchester City Art Gallery, 1907). He exhibited regularly at the *New English Art Club from 1892 and became a member in 1896. His books include *Confessions of a Keeper* (1931) and a monograph on *Steer (1945).

McCubbin, Frederick (1855–1917). Australian painter, born in Melbourne, where he spent most of his life. In the 1890s he was a member of the *Heidelberg School, and he is best known for the scenes of pioneer life he painted at this time (*Bush Burial*, Geelong Art Gallery, 1890). After a visit to Europe late in life in 1906, his work was more directly influenced by *Impressionism. He was a teacher of drawing at the Melbourne National Gallery School from 1886 until his death. His son **Louis** (1890–1952) was also a painter. His major work is a huge mural of battle scenes for the Australian National War Museum in Canberra (1920–9). From 1936 to 1950 he was director of the National Gallery of South Australia.

Macdonald, Frances. See GLASGOW FOUR.

MacDonald, J. E. H. (James Edward Hervey) (1873–1932). Canadian landscape painter. He was born in Durham, England, the son of a Canadian father, and moved to Hamilton, Ontario, when he was 14. In 1889 the family moved to Toronto, where he studied at the Central Ontario School of Art and Design. After spending several years in England working as a commercial artist, he returned to Toronto in 1907. In 1911 he met Lawren *Harris, who persuaded him to devote all his time to painting; they began working together and their shared dream of creating a uniquely Canadian type of landscape painting culminated in 1920 in the formation of the *Group of Seven. MacDonald's best-known works include *The Solemn Land* and *Autumn in Algoma* (NG, Ottawa, 1921 and 1922 respectively)—large, spectacular canvases that are regarded as being among the very finest produced by the group. He was important in its affairs not only as a painter, but also as a spokesman against reactionary criticism. From 1921 he taught at the Ontario College of Art, where he became principal in 1929. His last works included some sketches of beach and surf in Barbados, where he had gone to recuperate following a stroke in 1931.

Macdonald, Jock (1897–1960). Canadian painter, born in Thurso, Scotland, the son of an architect. Initially he worked as an architectural draughtsman, and after serving in the First World War he studied commercial design at Edinburgh College of Art, 1919–22. For the next few years he worked as a designer for a textile firm and taught at Lincoln School of Art, before emigrating to Canada in 1926 to take up a post as head of design at the newly-founded Vancouver School of Decorative and Applied Arts. It was only at this point that he began painting, encouraged by Fred Varley, who was head of drawing, painting, and composition at the school. Macdonald's early paintings were in the tradition of the *Group of Seven (of which Varley was a member), but in 1934 he produced his first abstract work, *Formative Colour Activity* (NG, Ottawa). In the late 1930s he became a friend of Emily *Carr, whom he considered 'undoubtedly the first artist in the country and a genius without question', and in 1940 of Lawren *Harris, who encouraged him in his abstract experiments. These included *automatic paintings in a *Surrealist vein in the late 1940s and early 1950s. In 1947 Macdonald settled in Toronto

and in 1953 he was one of the founders there of the abstract group *Painters Eleven. From this time his output was prodigious, as he threw himself into experimenting with various media and techniques. His latest works are radiant in colour and suggestive of organic growth (*Nature Evolving*, Art Gallery of Ontario, Toronto, 1960). Macdonald taught at various art colleges in the course of his career (from necessity—he constantly had financial problems) and he played a leading role in advancing the cause of modern art in Canada.

Macdonald, Margaret. See GLASGOW FOUR and MACKINTOSH.

Macdonald-Wright, Stanton (1890–1973). American painter, designer, experimental artist, teacher, administrator, and writer, remembered chiefly as a pioneer of abstract art. He was born in Charlottesville, Virginia, moved to California as a child, and entered the Art Students League of Los Angeles in 1905. In 1907 he moved to Paris, where he studied briefly at the Académie Colarossi, the *Académie Julian, and the École des *Beaux-Arts. He met Morgan *Russell in 1911 and together they evolved *Synchromism—a style of painting based on the abstract use of colour. They first exhibited their works in this style in 1913 and claimed that they, rather than *Delaunay and *Kupka (whose work of the time was very similar), were the originators of a new type of abstract art. In 1914–16 Macdonald-Wright lived in London, where he helped his brother, the critic Willard Huntingdon *Wright, with his book *Modern Painting: Its Tendency and Meaning* (1916). He returned to the USA in 1916, living first in New York, and then from 1919 in California. By this time he had abandoned Synchromism for a more traditional representational style. From 1922 to 1930 he was director of the Art Students League of Los Angeles, and from 1935 to 1942 he worked for the *Federal Art Project, in which capacity he invented a material called Petrachrome for the decoration of walls. He was also involved in other types of experimental work, including colour processes for motion pictures (he was interested in the theatre as well as cinema, writing satires and designing sets for the Santa Monica Theater Guild). In 1937 he visited Japan, and from 1942 to 1952 he taught Oriental and modern art at the University of California at Los Angeles. After a second visit to Japan in 1952–3 he gave up teaching and devoted himself full-time to painting, working in a suave, colourful, abstract style that was at times close to his early Synchromism. Some of his best work was done in this late stage of his career. From 1958 he spent part of every year in a Zen monastery in Japan.

McEvoy, Ambrose (1878–1927). British painter, born at Crudwell, Wiltshire, the son of an Irish-American soldier of fortune and naval inventor who had fought in the Confederate Army in the American Civil War, alongside a brother of *Whistler. Encouraged by Whistler, McEvoy studied from 1893 to 1896 at the *Slade School, where he was a contemporary of Augustus *John. He began as a painter of poetic landscapes and restful interiors, but from about 1915 he gained success mainly as a portraitist. His most characteristic pictures are of beautiful society women, often painted in watercolour in a rapid, sketchy style. They can be merely flashy or cloyingly sweet (during the First World War one critic joked that at a time of sugar shortage McEvoy was 'a positive asset to the nation'), but the finest have something of the air of romantic refinement of Gainsborough, an artist McEvoy greatly admired. In 1918 he was an *Official War Artist in France. His wife **Mary McEvoy** (1870–1941), whom he married in 1902, was a painter of interiors with figures, flowers, and portraits.

McGill, Donald (1875–1962). British cartoonist whose name is synonymous with a distinctive type of jolly seaside postcard in which the humour depends on sexual innuendo of an unsubtle but mild sort. He was born in London, the son of a prosperous former army officer, and began his career as an engineering draughtsman. It was not until 1905, when he was 30, that he took up cartooning, after making a humorous sketch to cheer up a nephew in hospital. By 1908 he was a full-time postcard designer and this was his exclusive profession for the rest of his life (apart from a brief period in the Second World War when he worked as a clerk in the Ministry of Labour). The start of his career coincided with a boom in the postcard market, following certain changes in postal regulations (including a reduction of the postal cost to half the letter rate); by 1914 more than 800 million postcards were sent annually in Britain. McGill

worked for various publishers and by the 1930s had become the dominant figure in the market. His humour was closely related to that of music-hall comedy acts (which he enjoyed seeing) and he said that the jokes for his postcards always came before the drawings. A typical example features a shop assistant and a large-bosomed customer: 'Brassiere? Yes Madam. What bust?' 'Ee luv, nothing bust, it just wore out.' His gallery of types included the domineering battleaxe, the hen-pecked husband, and the pretty, flirtatious girl. Some of his figures, especially the grotesquely curvaceous fat ladies, are descendants of the 18th-century caricatures of Thomas Rowlandson. George Orwell wrote an essay on McGill (published in the magazine *Horizon* in 1941) and described his work as genuine folk art. McGill's postcards are still reproduced and imitated. In personality he was somewhat different to what their ribald humour might suggest: Elfreda Buckland (*The World of Donald McGill*, 1984) writes that he was 'described as modest and courteous with a soft, cultured voice'.

Macgillivray, James Pittendrigh. See GLASGOW BOYS.

Macgregor, William York. See GLASGOW BOYS.

McGuinness, Norah. See JELLETT.

Mach, David. See NEW BRITISH SCULPTURE.

Maciunas, George. See FLUXUS.

MacIver, Loren (1909–). American painter, born in New York, where she has lived for most of her life. Apart from lessons in a children's class at the *Art Students League in 1919–20 she was self-taught as an artist. During the 1930s she worked for the *Federal Art Project and in 1936 her work was included in the Museum of Modern Art's 'Fantastic Art, Dada and Surrealism' exhibition. Her paintings do indeed have something of a *Surrealist sense of fantasy, but they are highly individual and distinctive. They hover between figuration and abstraction and concentrate on capturing fleeting impressions of beautiful or magical images seen in the commonplace—a bunch of flowers on a garbage tip, the rainbow colours in an oil slick, the patterns left by children's chalk marks on a pavement (*Hopscotch*, MOMA, New York, 1940): 'Quite simple things can lead to discovery. This is what I would like to do with painting: starting with simple things, to lead the eye by various manipulations of colors, objects and tensions toward a transformation and a reward ... My wish is to make something permanent out of the transitory.' The word 'poetic' is often applied to her subtle, mysterious work, and she feels an artistic kinship with poets (she was married to one, Lloyd Frankenberg, who died in 1975).

From the 1940s MacIver had a growing reputation as one of America's foremost women painters, and her popularity led to an expansion in her artistic activity; she designed book illustrations, magazine covers, and posters, and did murals for ships of the Moore-McCormack and American Export Lines. In the 1950s and 1960s she travelled extensively in Europe and added imagery from the streets of Paris and Venice to her repertoire. Her only human subjects have been portraits of poets and clowns.

Mack, Heinz (1931–). German sculptor and experimental artist, born at Lollar, Hesse. After an injury to his hand forced him to abandon plans to become a pianist, he studied at the Academy in Düsseldorf from 1950 to 1953, then took a degree in philosophy at Cologne University (1956). Early in his career he worked as a painter, but in 1957 he founded the *Kinetic group *Zero with Otto *Piene and since 1958 he has concentrated on working with light. Typically his works use polished aluminium and glass or plastic; irregular movement is imparted to them by an electric motor so as to cause constantly changing light reflections. Mack has used many other kinds of material, however, and his work has included water sculptures and wind sculptures. He is interested in environmental work and has made several visits to the Sahara in connection with his project for a 'vibrating column of light in the desert'. Since 1968 he has also done stage design. Mack is regarded as one of the leading exponents of Kinetic art and has had numerous commissions for public sculptures.

Macke, August (1887–1914). German painter and designer, one of the founders of the *Blaue Reiter. He was born at Meschede, Westphalia, and grew up in Bonn and Cologne. His main training was at the Düsseldorf Acad-

emy, 1904–6, and he also studied with Lovis *Corinth in Berlin, 1907–8. Between 1907 and 1912 he visited Paris several times and he came closer in spirit to French art than any other German painter of his time, evolving a personal synthesis of *Impressionism, *Fauvism, and *Orphism (he met Robert *Delaunay in 1912). His subjects were generally light-hearted, without any of the angst associated with other *Expressionists, and although his colour was bright it was never strident; often he showed people enjoying themselves (*Zoological Garden, I*, Lenbachhaus, Munich, 1912). In 1910 he joined the *Neue Künstlervereinigung in Munich and in 1911 was part of the breakaway group that formed the Blaue Reiter. Apart from a few experiments, his work moved less towards abstraction than that of the other members of the group. In 1914 he visited Tunisia with Paul *Klee and Louis *Moilliet, and the vivid watercolours he did on this trip are often considered to be his finest achievements. Apart from painting, Macke made pottery, woodcarvings, and a few prints, and he also did a good deal of design work, notably for carpets, embroideries, tapestries, and wall-hangings, many of which were executed by his wife Elizabeth; she was the niece of Bernhard Koehler (1849–1927), a Berlin industrialist and art collector who was an important patron for the Blaue Reiter group as a whole.

Macke volunteered for the army soon after the outbreak of the First World War, seeing the conflict as a chance to cleanse and renew Western society. He changed his mind very quickly when he saw action, writing to his wife: 'It is all so ghastly that I don't want to tell you about it. Our only thought is for peace.' A few weeks after enlisting, he was killed in action, aged 27. Franz *Marc, who was to suffer the same fate himself two years later, wrote of his friend: 'Those of us who worked with him . . . knew what secret future this man of genius bore within him. With his death one of the most beautiful and most daring trends in the history of modern German art is abruptly broken off; none of us is in a position to continue where he left off . . . the loss of his harmonies means that colour in German art must pale by several tones and assume a duller, dryer ring. More than any of us he gave colour the clearest and purest sound—as clear and lucid as his whole being.' Another artist who admired Macke greatly (even though he was very different stylisti-

cally) was Max *Ernst, who described him as 'a subtle poet, the very image of just and intelligent enthusiasm, generosity, judgement and exuberance'.

McKenna, Stephen. See POSTMODERNISM.

Mackennal, Sir Bertram. See NEW SCULPTURE.

Mackintosh, Charles Rennie (1868–1928). Scottish architect, designer (chiefly of furniture), and watercolourist, born and principally active in Glasgow. He was one of the most original and influential artists of his time and a major figure of *Art Nouveau. His most famous building is *Glasgow School of Art (1897–9), to which he later added a library block and other extensions (1907–9). They are strikingly original in style—clear, bold, and rational, yet with an element of fantasy. In his interior decoration and furniture design, often done in association with his wife, Margaret Macdonald (1864–1933), he worked in a sophisticated calligraphic style but avoided the exaggerated floral ornament often associated with Art Nouveau. His finest achievements in this field were four tea-rooms in Glasgow, designed with all their furniture and equipment for his patron Catherine Cranston (1897–c. 1911, now mainly destroyed). Mackintosh had an enormous reputation among the avant-garde on the Continent, especially in Germany and Austria, where the advanced style of the early 20th century was sometimes known as 'Mackintoshismus'; his work was widely exhibited and he was particularly esteemed among members of the Vienna *Sezession, who urged him to come and live in the city. However, admiration was more restrained in his own country, where he antagonized fellow architects by criticizing traditional values: 'How absurd it is to see modern churches, theatres, banks etc. . . . made in imitation of Greek temples' he said in 1896. The First World War brought a decline in his career, for there was little call for work as sophisticated as his. In 1914 he moved to London and thereafter virtually gave up architecture. He did, however, do some fine work as a designer, particularly of fabrics. From 1923 to 1927 he lived at Port Vendres in the south of France, where he devoted himself to watercolour painting, mainly landscapes. He died in London of cancer. After the death of his wife five years later, the contents

of their studios were officially appraised as 'practically of no value', but Mackintosh's reputation now stands very high in all the fields of his activity. See also GLASGOW FOUR.

McLaughlin, John. See HARD-EDGE PAINTING.

McLean, Bruce. See BODY ART.

McLean, John (1939–). British abstract painter, born in Liverpool to Scottish parents. His father, **Talbert McLean** (1906–92), was a painter, whose later work was influenced by *Abstract Expressionism; after the Second World War, during which he served in the armed forces, he returned to Scotland and taught at Arbroath High School until 1972. John studied at St Andrews University, 1957–62, then did postgraduate work in art history at the Courtauld Institute of Art, London, 1963–6. He was mainly self-taught as a painter. For most of his career he has lived in London, where he has taught at various art colleges, but he was artist-in-residence at Edinburgh University, 1984–5, and he lived in New York, 1987–9. His paintings typically feature broadly brushed shapes and rich colours (*Strathspey*, Gallery of Modern Art, Glasgow, 1993). He writes that 'My works have no hidden meanings. To understand, all you have to do is look. Everything only works in relation to everything else in the painting . . . Looking triggers imagination and association . . . I only work with the feelings I can elicit with drawing, colour and surface . . . Instinct and spontaneity are crucial. Thought goes into it too, in the same way it does in singing and dancing.' He has had numerous one-man exhibitions in Britain and abroad and is regarded as one of the outstanding British abstract painters of his generation.

MacMonnies, Frederick (1863–1937), American sculptor, active for much of his career in Paris. Born in Brooklyn, New York, he became *Saint-Gaudens's studio assistant in 1880 and in 1884 went to Paris to study at the École des *Beaux-Arts. For most of the period up to the outbreak of the First World War he remained based in Paris, but he sent work back to the USA and became one of the leading American sculptors of public monuments in his generation. His most notable works include a statue of Shakespeare (1895) and a set of bronze doors representing the Art of Printing (*c.* 1898)

for the Library of Congress in Washington, and the fountain figures *Truth* and *Inspiration* (1913) for the New York Public Library. He worked in a traditional style but sometimes caused controversy because of the alleged indecency of his nudes. In 1915 MacMonnies returned to the USA, where he took up portrait painting. This increasingly occupied his time, but as a painter he is regarded as 'competent but unoriginal' (Mathew Baigell, *Dictionary of American Art*, 1979). His most important later work is the monument commemorating the Battle of the Marne, erected near Meaux in France in 1926. He was made a chevalier of the Legion of Honour by his second country in 1896 and a commander of the order in 1933. By this time the 'bright young sculptor of the 1890s' had become 'the quintessential academic, and the modern movements of the early 20th century took place without his notice' (Baigell).

Macnab, Iain (1890–1967). British graphic artist (wood engraver, etcher, draughtsman), painter, and teacher. He was born in the Philippines, the son of an official of the Hong Kong and Shanghai Bank, and grew up in Scotland. From 1911 to 1914 he studied accountancy (which later stood him in good stead in his administrative posts), then served in the army during the First World War until 1916, when he was wounded and invalided out. In 1917 he began studying at *Glasgow School of Art, then moved to Heatherley's School in London; after a brief period in Paris, he returned to Heatherley's as joint principal, 1919–25. He left to found his own school in London, the Grosvenor School of Modern Art, which he ran from 1925 until its closure in 1940. The teachers included Claude Flight (see LINOCUT), Frank *Rutter, Graham *Sutherland, and R. H. *Wilenski. During the Second World War Macnab served in the RAF. After the war he returned to Heatherley's as director of art studies, 1946–53. His best-known works are his wood engravings, which are mainly figure compositions and landscapes in a bold, clear style. He made them both as book illustrations and as independent works. In 1938 he published *The Student's Book of Wood Engraving*.

MacNair, Herbert. See GLASGOW FOUR.

McShine, Kynaston. See PRIMARY STRUCTURES.

MacTaggart, Sir William (1903–81). Scottish painter, grandson of **William McTaggart** (1835–1910), who had been the leading Scottish landscape painter of his period. He studied at Edinburgh College of Art, 1918–21, and in the 1920s regularly visited the south of France for the sake of his health. His work—mainly landscapes and still-lifes—was much influenced by his grandfather's free and fervent brushwork and also by French painters, particularly *Rouault, an exhibition of whose work MacTaggart saw in Paris in 1952. From Rouault he took in particular the use of soft black outlines around richly glowing colours. MacTaggart taught at the Edinburgh College of Art, 1933–58, and was president of the Royal Scottish Academy, 1959–64. He was knighted in 1962 and made a chevalier of the Legion of Honour in 1968.

McWilliam, F. E. (Frederick Edward) (1909–92). British sculptor, born at Banbridge, County Down. He studied drawing at the *Slade School, 1928–31, and in 1931–2 lived in Paris, where a visit to *Brancusi's studio fired his imagination and led to his taking up sculpture in 1933. His early work was influenced by the playful *biomorphic forms of *Arp and in 1938 he joined the English *Surrealist Group. After the Second World War (during which he served in the RAF) McWilliam's work moved away from Surrealism to a more rugged style, sometimes in the 'Existentialist' vein associated with Kenneth *Armitage and Lynn *Chadwick (see GEOMETRY OF FEAR), although he also did fairly straightforwardly naturalistic figures, as in his statue of the sculptor Elisabeth *Frink (Harlow New Town, 1956), one of the many public commissions he received. He always retained links with his native Ireland, although he seldom returned; his early life there gave him 'a lasting awareness and hatred of intolerance and religious bigotry', and in 1972–3 he made a series of bronze figures entitled *Women of Belfast* inspired by the city's political troubles: 'The sculptures are concerned with violence, with one particular aspect—bomb blast—the woman as victim of man's stupidity. I did not choose the subject consciously; it happened, I suppose, because the situation in Ulster is inescapable, even at this safe remove, something that is always nagging at the back of one's mind.' As well as bronze, McWilliam worked in stone, concrete, and terracotta. From 1947 to 1968 he

taught at the Slade School. There are examples of his work in the Tate Gallery, London, and in numerous other public collections in Britain.

Maddox, Conroy (1912–). British painter, born at Ledbury, Hertfordshire. He has been the most committed, energetic, and enduring British exponent of *Surrealism, remaining true to its ideals throughout a very long career. In 1937 he worked with the Paris Surrealists and the following year he joined the short-lived English Surrealist Group; he thought that 'the collapse of the English Surrealist movement can be attributed to its failure to establish a coherent political position' (Charles Harrison, *English Art and Modernism: 1900–1939*, 1981). One of Maddox's paintings from this period, *Passage de l'Opera* (Tate Gallery, London, 1940), shows a clear debt to *Magritte in its enigmatic bowler-hatted figures, but he has also worked in different veins and has made collages and objects as well as paintings. Much of his work has been inspired by his intense antagonism to religion ('It is not that I am just against religion: I want to destroy it', he said in 1994) and he has made something of a speciality of deriding nuns. In 1974 he published a book on *Dalí.

Madí. See KOŠICE.

Maeght, Aimé (1906–) and **Marguerite** (1905–77). French dealers, collectors, patrons, and publishers, husband and wife. They married in 1928 and in 1937 opened the Galerie Arte in Cannes. At the end of the Second World War they moved to Paris, where they opened the Galerie Maeght in 1945 with an exhibition of *Matisse's work. The gallery promoted the work of a wide range of artists, including *Braque, *Giacometti, *Kandinsky, *Léger, and *Miró; it moved with the times, showing Francis *Bacon in 1966, for example. Branches of the gallery opened in Zurich in 1970 and Barcelona in 1974. From the time they settled in Paris, the Maeghts also became active as publishers, producing illustrated books by the artists they represented (Aimé Maeght had trained as a lithographer) and monographs devoted to them. The death of their son Bernard in 1953 prompted them to create a lasting memorial, and they did this by turning their home at St-Paul-de-Vence, near Nice, into the Fondation Maeght—in addition to exhibition halls and a sculpture

park, it includes ceramic and print studios, a cinema, a concert hall, a bookshop and a reference library. The buildings (1962–3) were designed by the Spanish-born American architect José Luis Sert (1902–83), who worked in close collaboration with artists, particularly his friend Miró, who executed ceramics and mosaics. Other artists involved in this way included Braque, who designed a fountain and stained glass, and Chagall, who designed mosaics. The Fondation Maeght has major works by most of the leading artists for whom the Maeghts acted as dealers, and with its beautiful setting is regarded as one of the world's most attractive museums of modern art.

Mafai, Mario (1902–65). Italian painter, born in Rome. Early in his career he painted abstracts, but in 1928 he became, with *Scipione, the founder of the *Roman School, which cultivated poetic expressiveness in opposition to the stereotyped classicism of the *Novecento. Though less imaginative, less visionary than those of Scipione, Mafai's pictures, especially his still-lifes and town scenes, were touched with poetic sensibility. During the Second World War he painted a series of *Fantasies* depicting horrors of the Fascist regime, and after the war his style moved to a delicate lyricism expressed particularly in landscapes and street scenes. Late in his career he also returned to abstract painting.

Magic(al) Realism. Term coined by the German critic Franz Roh in 1925 to describe the aspect of *Neue Sachlichkeit characterized by sharp-focus detail. In the book in which he originated the term—*Nach-Expressionismus, Magischer Realismus, Probleme der neuesten europäischen Malerie* (1925)—Roh also included a rather mixed bag of non-German painters as 'Magic Realists', among them *Miró, *Picasso, and *Severini. Subsequently critics have used the term to cover various types of painting in which objects are depicted with photographic naturalism but which because of paradoxical elements or strange juxtapositions convey a feeling of unreality, infusing the ordinary with a sense of mystery. The paintings of *Magritte are a prime example.

In the English-speaking world the term gained currency with an exhibition entitled 'American Realists and Magic Realists' at the Museum of Modern Art, New York, in 1943.

The organizer of the exhibition, Alfred H. *Barr, wrote that the term was 'sometimes applied to the work of painters who by means of an exact realistic technique try to make plausible and convincing their improbable, dreamlike or fantastic visions'.

The term has been adopted in literary criticism to describe 'a kind of modern fiction in which fabulous and fantastical events are included in a narrative that otherwise maintains the "reliable" tone of objective realistic report' (*Concise Oxford Dictionary of Literary Terms*, 1990).

Magnelli, Alberto (1888–1971). Italian painter, active mainly in France. He was born in Florence into a wealthy family and was self-taught as an artist. In his early work he moved from a naturalistic style to one influenced by *Futurism and then *Cubism (he visited Paris in 1914 and met *Picasso). After the First World War his style became more representational under the influence of *Metaphysical Painting. Until 1931 he lived in Florence, then moved to Paris; he lived in or near the city for the rest of his life (apart from the years of the Second World War when he lived in Provence and became friendly with *Arp, *Taueber-Arp, and Sonia *Delaunay). In the late 1930s he turned to pure abstraction, his work characteristically making use of a dynamic interplay of hard-edged shapes. An exhibition at the Galerie René Drouin, Paris, in 1947 established his reputation and from the 1950s he was much honoured and recognized as one of Italy's leading abstract artists.

Magritte, René (1898–1967). Belgian painter, sculptor, printmaker, and film-maker, one of the outstanding figures of *Surrealism. He was born in Lessines, the son of a prosperous manufacturer (there is some doubt about his exact profession), and studied at the École des Beaux-Arts, Brussels, 1916–18, following an adolescence clouded by the suicide of his mother in 1912. After initially working in a *Cubist-Futurist style, he turned to Surrealism in 1925 under the influence of de *Chirico and by the following year had already emerged as a highly individual artist with *The Menaced Assassin* (MOMA, New York), a picture that displays the startling and disturbing juxtapositions of the ordinary, the strange, and the erotic that were to characterize his work for the rest of his life.

In 1927–30 Magritte lived in Paris, partici-

pating in Surrealist affairs, but like many others in the movement he fell out with André *Breton, and he spent almost all of the rest of his life working in Brussels, where he lived a life of bourgeois regularity (the bowler-hatted figure who often features in his work is to some extent a self-portrait). Apart from a period in the 1940s when he experimented first with pseudo-*Impressionist brushwork and then with a *Fauve technique, he worked in a precise, scrupulously banal manner (a reminder of his early days of his career when he made his living designing wallpaper and drawing fashion advertisements) and he always remained true to Surrealism. Iconographically he had a repertory of obsessive images that appeared again and again in ordinary but incongruous surroundings. Enormous rocks that float in the air and fishes with human legs are typical leitmotifs. He loved visual puns and paradoxes and repeatedly exploited ambiguities concerning real objects and images of them (many of his works feature paintings within paintings), inside and out-of-doors, day and night. In a number of paintings, for example, he depicted a night scene, or a city street lit only by artificial light, below a clear sunlit sky. He also made Surrealist analogues of famous paintings—for example David's Madame Récamier and Manet's The Balcony—in which he replaced the figures with coffins. Late in life he also made wax sculptures based on such paintings, and some of them were cast in bronze after his death (Madame Récamier, Pompidou Centre, Paris). He also made prints and a few short comic films, using his friends as actors.

Magritte's work was included in many Surrealist exhibitions, but it was not until he was in his 50s that he began to achieve international success and honours; in the 1950s and 1960s he painted several large mural commissions (notably for the Casino at Knocke-le-Zoute, 1951–3) and he was given major retrospective exhibitions in Brussels (1954), New York (1965), and Rotterdam (1967). By the time of his death his work had had a powerful influence on *Pop art, and it has subsequently been widely imitated in advertising. In the fertility of his imagery, the unforced spontaneity of his effects, and not least his rare gift of humour, he was one of the very few natural and inspired Surrealist painters. J. T. *Soby summed this up felicitously in his book on the artist (1965) when he wrote: 'In viewing Magritte's paintings . . . everything seems proper. And then abruptly the rape of commonsense occurs, usually in broad daylight.'

Maillol, Aristide (1861–1944). French sculptor, painter, graphic artist, and tapestry designer. He was born in Banyuls-sur-Mer, in the south-east of France, near the Spanish border, and moved to Paris in 1881 to study painting (he entered the École des *Beaux-Arts in 1885). His early career, however, was spent mainly as a tapestry designer, and he opened a tapestry studio in Banyuls in 1893. He first made sculpture in 1895, but it was only in 1900 that he decided to devote himself to it after serious eyestrain made him give up tapestry. In 1902 he had his first one-man exhibition (at the Galerie *Vollard in Paris), which drew praise from *Rodin; in 1905 came his first conspicuous success as the *Salon d'Automne; and after about 1910 he was internationally famous and received a constant stream of commissions. With only a few exceptions, he restricted himself to the female nude, expressing his whole philosophy of form through this medium. Commissioned in 1905 to make a monument to the 19th-century revolutionary Louis-August Blanqui, he was asked by the committee what form he proposed to give it and replied 'Eh! une femme nue.' More than any other artist before him he brought to conscious realization the concept of sculpture in the round as an independent art form stripped of literary associations and architectural context, and in this sense he forms a transition between Rodin and the following generation of modernist sculptors. This was acknowledged in his lifetime. In 1929 Christian Zervos wrote in Cahiers d'art: 'With other premises and a very different effect, Maillol was a precursor of today's *Constructivism. All his figures create an impression of massive structure, of a search for beautiful volume.' Maillol himself said 'My point of departure is always a geometrical figure', and that although 'there is something to be learned from Rodin . . . I feel I must return to more stable and self-contained forms. Stripped of all psychological details, forms yield themselves up more readily to the sculptor's intentions.' He rejected Rodin's emotionalism and animated surfaces; instead, Maillol's weighty figures, often shown in repose, are solemn and broadly modelled, with simple poses and gestures.

Although it was forward looking in many ways, Maillol's work also consciously continued the classical tradition of Greece and Rome (he visited Greece in 1908); at the same time it has a quality of healthy sensuousness (his peasant wife sometimes modelled for him).

Maillol settled at Marly-le-Roi on the outskirts of Paris in 1903 but usually spent his winters in the South. In 1939 he returned to his birthplace. He took up painting again at this time, but apart from his sculpture the most important works of his maturity are his book illustrations, which helped to revive the art of the book in the 1920s and 1930s. His finest achievements in this field are the woodcut illustrations (which he cut himself) for an edition of Virgil's *Eclogues* (begun 1912 but not published until 1926), which show superb economy of line. He also made lithographic illustrations. There are Maillol museums in Banyuls (his former studio) and Paris (opened in 1995), and examples of his work in many important collections of modern art.

Maistre, Roy de (1894–1968). Australian painter, active mainly in England. He was born at Bowral, New South Wales, and studied at the Royal Art Society of New South Wales and Sydney Art School. De Maistre also studied music at the Sydney Conservatorium and throughout his career he was interested in the analogy between colour combinations and musical harmony. This led him to early experiments with abstraction with Roland *Wakelin; they produced the earliest abstracts painted in Australia, but only one survives—de Maistre's *Rhythmic Composition in Yellow Green Minor* (Art Gallery of New South Wales, Sydney, 1919). Between 1923 and 1928 he lived in Europe, mainly France, and returned to Europe permanently in 1930, settling in London after a brief period of residence in France. He became a friend of Francis *Bacon and in the 1930s he ran an art school in London with Martin Bloch (1883–1954). After the Second World War (in which he worked for the Red Cross) he exhibited widely. He painted portraits, interiors, still-life, and religious subjects (he became a convert to Roman Catholicism in 1949) in a style that Sir John *Rothenstein characterized as 'reticent but extremely complex'. *Cubism was one of the major influences on his eclectic style. There are several examples of his work in the Tate Gallery, London.

Makovets. A society of artists and writers founded in Moscow in 1921. The name derived from the hill on which the famous monastery at Zagorsk (one of Russia's holiest places) was built in the 14th century—a gesture indicating the emphasis its members placed on spiritual and religious values in art (the society was originally known as the 'Art is Life' Union of Artists and Poets). The painters involved in the organization included Vasily Chekrygin (1897–1922), whose highly promising career was cut short by his death in a railway accident, Sergei Gerasimov (1885–1964), and Alexander *Shevchenko. Their works included landscapes and portraits in a lyrical, sometimes *Expressionist style. Alan Bird (*A History of Russian Painting*, 1987) writes that the society had no 'chance of public success in the artistic world of revolutionary Russia controlled by the followers of *Tatlin and *Malevich'; to such people 'easel painting was ostensibly anathema, and all figurative art, even when, as in some pictures and drawings by Chekrygin, it was used to show in graphic terms the hunger that stalked the country, was considered an affront to the new spirit of the nation'. The society organized one exhibition (Moscow, 1922) and published a journal, also called *Makovets* (two issues, Moscow, 1922; a third issue was censored), before breaking up in 1926. After this Gerasimov changed course completely, abandoning his exquisite watercolours for vast *Socialist Realist propaganda canvases. In spite of this he fell foul of authority in 1948 when he was removed from his teaching post in Moscow after being accused of encouraging *Impressionism. The following year he repainted one of his best-known pictures, *The Mother of a Partisan* (Russian Museum, St Petersburg, 1943), to make the title figure conform more closely to the Soviet heroic ideal of womanhood.

Malevich, Kasimir (1878–1935). Russian painter, designer, and writer, with *Mondrian the most important pioneer of geometric *abstract art. He was born in Kiev, where he studied at the School of Art, 1895–6. For a few years he worked for a railway company to raise money, then moved to Moscow, where he continued his studies at the School of Painting, Sculpture, and Architecture (1904–5) and elsewhere. At this time he also became involved in underground politics (he was once arrested for distributing banned literature), showing the left-wing sympathies that were to run

throughout his life. His early paintings were in an unexceptional *Post-Impressionist manner, but he began to absorb the influence of contemporary French art (partly through the superb collections of *Morozov and *Shchukin) and of Russian avant-garde artists, particularly *Goncharova and *Larionov (with whom he was a member of the *Knave of Diamonds group). By the time of the *Donkey's Tail exhibition in 1912 he was painting peasant subjects in a massive 'tubular' style similar to that of *Léger and had also produced some exhilarating *Cubo-Futurist pictures, combining the fragmentation of form of *Cubism with the multiplication of the image of *Futurism (The Knife Grinder, Yale University Art Gallery, 1912). Malevich, however, was dissatisfied with representational art or—as he put it—fired with the desire 'to free art from the burden of the object'. He was a devout Christian, with mystical leanings, and he thought that by abandoning the need to depict the external world he could break through to a deeper level of meaning and 'swim in the white free abyss' (he often used the analogy of flight and space when discussing his paintings). His first abstract work was a backdrop for the Futurist opera Victory over the Sun, produced in the Luna Park Theatre, St Petersburg, in December 1913; his original drawing (now in the Theatrical Museum, St Petersburg) shows a rectangle divided almost diagonally into a black upper segment and a white lower one. From this he developed *Suprematism, which brought abstract painting to a geometric simplicity more radical than anything previously seen. He claimed that he made a picture 'consisting of nothing more than a black square on a white field' as early as 1913, but Suprematist paintings were first publicly exhibited in Petrograd (now St Petersburg) in 1915 (there is often difficulty in dating his work, and also in knowing which way up his paintings should be hung, photographs of early exhibitions sometimes providing conflicting evidence).

Over the next few years Malevich moved away from absolute austerity, tilting rectangles from the vertical, adding more colours, and introducing a suggestion of the third dimension by overlapping forms (Suprematist Composition, Stedelijk Museum, Amsterdam, c. 1915); there is sometimes even a degree of painterly handling (Yellow Parallelogram on White, Stedelijk Museum, Amsterdam, c. 1917). However, around 1918 he returned to his purest ideals with a series of White on White paintings, in which a tilted white square is placed on a background of the same colour, the difference between them being visible only through variations in the brushwork (Suprematist Composition: White on White, MOMA, New York, c. 1918). After this he seems to have realized he could go no further along this road and virtually gave up abstract painting, turning more to teaching, writing, and making three-dimensional models that were influential in the growth of *Constructivism. In 1919, at the invitation of *Chagall, he started teaching at the art school in Vitebsk, where he exerted a profound influence on *Lissitzky, and in 1922 he moved to Petrograd, where he taught at the Institute for Artistic Culture from 1922 to 1927 and lived for the rest of his life. He went to Warsaw and Berlin in 1927, accompanying an exhibition of his work, and during this trip he visited the *Bauhaus. In the late 1920s he returned to figurative painting, but the stylized work he produced was out of favour with a political system that now demanded *Socialist Realism from its artists and he ran into trouble with the authorities. However, he remained a revered figure among artists and after his death he lay in state at the Leningrad Artists' Union in a coffin—designed by himself—bearing Suprematist designs.

Malevich wrote various theoretical tracts (several collections of his writings have been published) and his influence was spread through these as well as his paintings. In Cubism and Abstract Art (1936) Alfred H. *Barr gave the following assessment of his importance in 20th-century art: 'In the history of abstract art Malevich is a figure of fundamental importance. As a pioneer, a theorist and an artist he influenced not only a large following in Russia but also, through Lissitzky and *Moholy-Nagy, the course of abstract art in Central Europe. He stands at the heart of the movement which swept westward from Russia after the war and, mingling with the Dutch De *Stijl group, transformed the architecture, furniture, typography and commercial art of Germany and much of the rest of Europe.'

Malfatti, Annita (1889–1964). Brazilian painter, one of the leading pioneers of modern art in her country. (Her Christian name is often given as Anita, but she seemed to prefer the form with two 'n's, signing her work this

way.) She was born in São Paulo, where she studied at Mackenzie College, 1904–6. In 1910 she travelled to Germany (her mother was of German descent) to continue her artistic education, going first to Dresden and then to Berlin, where she studied at the Academy under Lovis *Corinth. His work made a great impact on her, and she was also influenced by *Post-Impressionism, *Expressionism, and *Cubism. She returned to Brazil on the outbreak of the First World War and in 1915 went to New York, where she studied at the *Art Students League and met Marcel *Duchamp, 'who painted on enormous plates of glass'. In 1916 she returned to Brazil and a year later shocked the Brazilian public when she exhibited 53 of her works in São Paulo. In the newspaper *O Estado de São Paulo* the critic Monteiro Lobato called her a paranoiac and mystifier, and she became an emblem of revolt against conservative art. She was one of the painters who participated in the *Semana de Arte Moderna (Modern Art Week) in São Paulo in 1922, regarded as a major event in the development of avant-garde art in Brazil. From 1922 to 1928 she travelled in Europe. After her return she participated in many exhibitions, but her work had now lost much of its early vigour in favour of a cheerful folklorish quality.

Malraux, André (1901–76). French writer and statesman, born in Paris into a well-to-do family. He worked in the book trade before becoming a political activist (and archaeologist) in China in the 1920s and fighting in the Spanish Civil War in the 1930s. Out of his experiences he wrote a number of novels on revolutionary themes. In the Second World War he served in the tank corps, was taken prisoner by the Germans, escaped, and worked for the Resistance. He was a friend of Charles de Gaulle and after the war he became increasingly involved in politics, serving as France's Minister of Culture from 1959 until his retirement in 1969 (in this role he initiated a programme of cleaning the great buildings and monuments of Paris and commissioned ceiling decorations for the Paris Opera from Marc *Chagall, 1963–4). His postwar writings were devoted mainly to art, in a philosophical—at times metaphysical—vein. The major work is *La Psychologie de l'art*, originally published in three volumes as follows: *Le Musée imaginaire*, 1946, translated as *Museum without Walls*, 1949; *La Création artistique*, 1948, translated as *The Creative Act*, 1949; *La Monnaie*

de l'absolu, 1949, translated as *The Twilight of the Absolute*, 1951. A revised version of the work was published in four volumes in 1951 entitled *Les Voix de silence*, translated as *The Voices of Silence*, 1953 (the individual volumes are entitled *Museum without Walls*, *The Metamorphoses of Apollo*, *The Creative Process*, and *The Aftermath of the Absolute*; a one-volume edition appeared in 1954). His other major work on art was *La Métamorphose des dieux*, 1957, translated as *The Metamorphosis of the Gods*, 1960. Malraux's writings reflect the broadening of aesthetic outlooks in the 20th century, when for the first time it has been possible to have some familiarity with the art of the whole world throughout the entire course of human history. He thought that art should be appraised entirely by aesthetic standards, expressing this notion in his now famous concept of the 'museum without walls', in which all works of art—whatever their origin—are available to be appreciated for their formal qualities, independently of whatever they originally signified.

Mamontov, Savva. See VRUBEL.

Mancini, Antonio. See BOLDINI.

Mané-Katz (originally Mané Katz) (1894–1962). Russian-born painter (and occasional sculptor) who became a French citizen in 1927. Born at Kremenchug in the Ukraine, he studied in Vilna and Kiev, then went to Paris in 1913 and entered the École des *Beaux-Arts. He returned to Russia in 1914 on the outbreak of war, but settled in Paris in 1921. Between 1928 and 1937 he travelled widely in Egypt, Palestine, and Syria. In 1939 he volunteered for the French army and was taken prisoner; on his release he went to the USA in 1940, returning to Paris in 1945. Mané-Katz painted still-lifes and landscapes, but he was chiefly known for his ghetto scenes and pictures of Jewish life and folklore. They are somewhat reminiscent of *Chagall's treatments of similar themes, but more brilliantly coloured. Mané-Katz visited Israel annually from 1948 and died in Tel Aviv. He bequeathed the works in his studio to the city of Haifa.

Manessier, Alfred (1911–93). French painter, lithographer, and designer of tapestries and stained glass, born at Saint-Ouen, the son of a merchant. In 1929 he moved to Paris to study architecture at the École des *Beaux-Arts but

turned to painting, studying informally at several academies. He was encouraged particularly by Roger *Bissière, whom he met at the *Académie Ranson in 1935. During the 1930s he was influenced by *Cubism and *Surrealism, but after staying at a Trappist monastery in 1943 he became deeply committed to religion and turned to expressing spiritual meaning through abstract art. Characteristically his paintings feature rich colours within a loose linear grid, creating an effect reminiscent of stained glass (a medium in which he was very prolific, designing some 200 windows, and in which he did some of his best work). After the Second World War he came to regarded as one of the leading exponents of expressive abstraction (see ART INFORMEL) in the *École de Paris, and he won numerous awards, including the main painting prize at the 1962 Venice *Biennale. In later life he lived in seclusion near Chartres and his reputation underwent something of an eclipse, but a major retrospective was devoted to him at the Grand Palais, Paris, in 1992. The following year he died from injuries received in a car crash.

Mánes Union of Artists. An association of artists in Prague, analagous to the *Salon d'Automne in Paris, largely responsible for introducing progressive trends to Czech art in the early years of the 20th century. It was founded in 1887 in opposition to the conservative Prague Academy of Arts and named after Josef Mánes (1820–71), who is regarded as the founder of Czech national painting. Among the exhibitions staged by the Union were: 1905, works by *Munch; 1907, French *Impressionist and *Post-Impressionist paintings; 1910, French artists from the *Salon des Indépendants, including examples of the *Fauves; 1914, *Cubist works, but without *Picasso, *Braque, or *Gris. The Mánes Union continued until 1949.

Manet, Édouard. See IMPRESSIONISM, MODERN ART, and MODERNIST PAINTING.

Manguin, Henri-Charles (1874–1949). French painter, born in Paris. In 1894 he became a student at the École des *Beaux-Arts, where he made friends with *Camoin, *Marquet, and *Matisse. Like them, he became one of the *Fauves, exhibiting at the famous 1905 *Salon d'Automne show that gave them their name. In the same year he visited St-Tropez and

loved the light and the landscape so much that he was based there for the rest of his life. Throughout his career he retained the Fauvist love of bright colour, but he toned down Fauvist aggressiveness to create a stylish and exuberant art that to many people represented the acceptable face of modernism. He generally worked on a fairly small scale and was very popular with private collectors. His subjects included Riviera scenes, nudes, and still-lifes.

Maniera Nuova. See PITTURA COLTA.

Manley, Edna (1900–87). Jamaican sculptor, born Edna Swithenbank in Bournemouth, the daughter of an English clergyman and a Jamaican mother. She studied sculpture in London, at the *Royal Academy and elsewhere. In 1921 she married her cousin Norman Manley and settled with him in Jamaica, where he had a distinguished career as a barrister and later as a politician, doing more than anyone else to lead the island to self-government. Edna Manley's sculpture to some extent formed an artistic counterpart to her husband's political activities, for she is regarded as the fountainhead of the nationalistic 'Jamaican Art Movement'; several of her works have become icons of a period when black Jamaicans were seeking self-determination, notably *Negro Aroused* (NG, Kingston, 1935), a powerfully stylized piece in carved mahogany. In the 1940s Manley's work became more intimate, but from the 1950s she did numerous large-scale public commissions, including *He Cometh Forth* (1962), an allegory of Jamaican independence in the Sheraton Hotel, Kingston. After the death of her husband in 1969, her work tended to grow more introspective, expressing her grief (*Angel*, Kingston parish church, 1970). In the last two years of her life she gave up sculpture for painting.

Mann, Harrington. See GLASGOW BOYS.

Manolo (Manuel Hugué) (1872–1945). Spanish sculptor, born in Barcelona into an impoverished family. He attended evening classes in drawing but had no formal training in sculpture. From 1901 to 1910 he lived in Paris, where he was a member of *Picasso's circle and was noted for his high spirits. In 1910 (with a contract from *Kahnweiler) he moved to the Pyrenean village of Céret, near the

border with Spain, then in 1927, following a severe attack of multiple arthritis, he settled in Caldas de Mombuy in Catalonia, a village renowned for its thermal waters. After the arthritis attack he had to give up stone-carving, and his work consisted mainly of small bronzes, including nudes in a style similar to that of *Maillol and reliefs on traditional Spanish themes—bullfighting, flamenco dancing, and so on. He had a considerable reputation in the 1920s and 1930s, now somewhat faded.

Man Ray (1890–1977). American painter, photographer, draughtsman, sculptor, and film-maker, born in Philadelphia, the son of a Russian-Jewish immigrant tailor. He was originally called Emmanuel Radinski, but he was known only as Man Ray from the age of about 15 because other youngsters jeered at his foreign-sounding name. In 1897 his family moved to New York, where he worked as a designer whilst attending evening classes in art. After seeing the *Armory Show in 1913 he began painting in a *Cubist style. In 1915 he began a lifelong friendship with Marcel *Duchamp, and these two together with *Picabia were the mainstays of the New York *Dada movement. Man Ray also collaborated with Duchamp and Katherine *Dreier in forming the *Société Anonyme in 1920. His activities at this time were very varied, including painting aerographs (see AIRBRUSH) and making the first packaged objects—a field that *Christo later made his own. In 1921 he settled in Paris, where he continued his Dada activities and then became a member of the Surrealist movement. For several years he earned his living mainly as a fashion and portrait photographer (he had a high reputation in these fields), while he pursued his more creative work on the side, but he painted regularly again from the mid-1930s. In 1940 he moved back to America to escape the German occupation of Paris and settled in Hollywood, then in 1951 returned to Paris, where he died. His autobiography, *Self Portrait*, was published in 1963.

From the 1940s photography took a secondary place in Man Ray's activities, but it is as a photographer that his reputation is now most secure. In the 1920s and 1930s he was one of the most inventive artists in this field, particularly for his development of the technique of 'solarization' (the complete or partial reversal of the tones of a photographic image) and

for his exploitation of 'Rayographs'—photographs produced without a camera by placing objects directly on sensitized paper and exposing them to light (Christian *Schad had earlier used the same method). The models who appear in his photographs include Meret *Oppenheim, his mistress *Kiki of Montparnasse, his assistant Lee Miller (1907–77), who herself became a distinguished photographer and later married Roland *Penrose, and his wife Juliet Browner (Juliet Man Ray), a dancer, whom he married in 1946. In addition to his celebrity as a photographer, Man Ray gained an international reputation as one of the most prominent figures of Dada and Surrealism; several of his *objects have become icons of the movements, but critics have often been dismissive about his paintings. His most famous object is probably *Gift* (1921), consisting of a flatiron with a row of nails sticking out of its smooth face (the original is no longer extant; a reconstruction is in MOMA, New York). His best-known painting is probably *Observatory Time* (private collection, 1934), showing an enormous pair of floating lips. He made several experimental (including abstract) films and collaborated with Duchamp on one entitled *Anemic Cinema* (1926); 'anemic' is an anagram of 'cinema'.

Manship, Paul (1885–1966). American sculptor. He was born in St Paul, Minnesota, and had his initial training there at the Institute of Art. In 1903 he began working for an engraving company and independently as an illustrator and designer, then in 1905 moved to New York. There he studied at the *Art Students League and worked as assistant to Solon *Borglum. In 1906 he studied at the Pennsylvania Academy of the Fine Arts, but he returned to New York the following year. In 1909 he won a scholarship to the American Academy in Rome, where he worked from 1909 to 1912. After his return to the USA he lived mainly in New York, although from 1922 to 1926 he was based in Paris. Manship worked in an elegant, streamlined style, his beautifully crafted figures (in bronze and stone) characterized by clarity of outline and suave generalized forms. A dedicated student of the history of art, he was influenced by archaic Greek and Indian sculpture, but his work also has a kinship with fashionable *Art Deco. He achieved great success as a sculptor of public monuments, one of the best known being the gilded bronze *Prometheus* (1933) in

Rockefeller Center Plaza, New York, and he was also an accomplished portraitist. Because of the sleek stylization of his work, he for a time had a reputation as a pioneer of modern sculpture in America, but his modernism was fairly superficial and by about 1940 he was being labelled an academic artist.

Manson, J. B. (James Bolivar) (1879–1945). British painter and art administrator, born in London. His father—a writer and editor—did not want him to follow the risky career of an artist and compelled him to work in a bank, which he hated. He took lessons part-time at Heatherley's School and eventually saved enough money to leave the bank and study at the *Académie Julian in Paris, 1903–4. After his return to London he achieved modest success with portraits, landscapes, and still-lifes painted in an unexceptional *Impressionist manner. He met Lucien *Pissarro in 1910 and through him was drawn into *Sickert's circle, becoming secretary of the *Camden Town Group and of its successor the *London Group. In 1912 he became a curator at the Tate Gallery, and although he continued to paint and exhibit, he was mainly occupied with administration, especially after he was appointed director of the gallery in 1930. His directorship was notable mainly in a negative sense, for he was hostile to avant-garde art and tried to prevent works by artists of the calibre of *Matisse and *Rouault entering the collection. The modern painters in whom he was interested included *Degas and *Sargent, on both of whom he wrote books (he published several other, generally fairly slight books, including *Hours in the Tate Gallery*, 1926). A genial character, Manson was fond of the bottle and in 1938 he was compelled to resign from the Tate on the grounds of 'ill-health' after uttering 'remarkably life-like and penetrating cock-a-doodle-dos' at an official banquet in Paris (the episode is recounted with gusto by Kenneth *Clark in his autobiography, *Another Part of the Wood*; he says it was 'the only public banquet that I have ever really enjoyed').

A memorial exhibition of Manson's work was held at the dealer Wildenstein's in 1946, but after that his paintings were neglected for many years. However, two exhibitions were devoted to him in London in the 1970s: at the Maltzahn Gallery in 1973, and at the New Grafton Gallery in 1979 (the centenary of his birth). See also EDE.

Manzoni, Piero (1933–63). Italian experimental artist. He was born into an aristocratic family at Soncino and studied briefly at the Brera Academy in nearby Milan, the city in which he spent most of his short career. Until 1956 he painted in a traditional style (mainly landscapes), but he then turned to avant-garde work, making pictures featuring impressions left by objects such as keys and scissors that had been dipped in paint or tar. In 1957 he began to produce *Achromes*, textured white paintings influenced by *Burri and by *Klein (whom he met at an exhibition of the Frenchman's work in Milan in 1957). Manzoni's first one-man exhibition was held in the foyer of the Teatro delle Maschere, Milan, in the same year. From 1959 he devised a series of provocative works and gestures that included signing people's bodies and designating them works of art, a block on which is inscribed upside down 'The base of the world' (Herning Park, Denmark, 1961), and cans of his own excrement. His early death was caused by cirrhosis. He is regarded as one of the forerunners of *Arte Povera and *Conceptual art. There are examples of his work in the Tate Gallery, London, MOMA, New York, and other major collections.

Manzù, Giacomo (1908–91). Italian sculptor, painter, graphic artist, and designer, born in Bergamo. He came from a poor family (his father was a cobbler) and from the age of eleven he worked successively for a wood-carver, a gilder, and a stucco-worker. In this way he learnt the elements of several crafts, but he was mainly self-taught as an artist. He left Bergamo for the first time in 1927 to do his military service in Verona, where he occasionally attended classes at the Accademia Cignaroli and was impressed by the Romanesque bronze doors of the church of San Zeno Maggiore. When he finished his military service, Manzù went to Paris in 1928 with the aim of studying sculpture (he hoped to meet *Maillol, whose work he knew through illustrations in books), but he had no means of support and after collapsing from hunger he was deported as an undesirable alien. On his return to Italy he settled in Milan, where a commission for decorative work at the Catholic University in 1929 enabled him to devote himself seriously to sculpture. Milan was the main centre of his activities until 1964, when he moved to Ardea, near Rome.

Manzù's early work was influenced by Egyptian and Etruscan art, but he soon turned to a more Impressionistic style owing much to the example of *Rodin and *Rosso. In the 1940s he simplified his style, so that although the surface of the work is often animated, the feeling it produces is one of classic calm. His sculpture included nudes, portraits, and scenes from everyday life, but he was best known for religious subjects. In 1938 he produced his first figure of a cardinal, a type of work that became particularly associated with him. His *Cardinals* have been variously interpreted as expressions of an anti-clerical attitude or as glorifications of ecclesiastical dignity, but Manzù himself always said that he regarded them as still-lifes with no deeper significance than a plate of apples, representing 'not the majesty of the church but the majesty of form'. Only one is a portrait, the over-life-size statue of Cardinal Giacomo Lercaro in San Petronio, Bologna, commissioned in 1953.

In 1947 Manzù entered a competition for a set of bronze doors for St Peter's, Rome; he was awarded the commission in 1952, but the work was not completed until 1967. The competition theme had been 'The Triumph of the Saints and Martyrs', but Manzù received papal permission to create instead a 'Door of Death', featuring a series of visual meditations suggesting death as the threshold of another world. Meanwhile he had carried out another bronze door for Salzburg Cathedral (1957–8) on the theme of Love, and a third followed for the church of St Laurenz in Rotterdam (1965–8) on the theme of War and Peace. These works have been much praised and show the possibility of producing sculpture that fits within a traditional religious context and yet is in a modern and personal idiom.

Apart from sculpture, Manzù also produced paintings and prints (including a series of 20 etchings illustrating an edition of Virgil's *Georgics*, 1947) and worked as a stage designer (for example for Wagner's *Tristan und Isolde* at the Teatro della Fenice, Venice, in 1971). He taught at the Turin Academy, 1940–3, the Brera Academy in Milan, 1943–54, and *Kokoschka's summer school in Salzburg, 1954–60. The awards he received included the City of Venice prize for an Italian sculptor at the 1948 Venice *Biennale and the Lenin Prize in 1966. There is an outstanding collection of his work in the Raccolta Amici di Manzù in Ardea (a branch of the Galleria Nazionale d'Arte Moderna).

Mapplethorpe, Robert. See CELANT.

Mara, Pol (1920–). Belgian painter, born and trained in Antwerp. He went through phases of abstraction and *Surrealism before turning to *Pop art in the 1960s and becoming perhaps his country's best known representative of the movement. He uses images from the mass media, predominantly of women, often with a strongly erotic, voyeuristic flavour.

Marc, Franz (1880–1916). German painter (and occasional printmaker and sculptor), born in Munich, where he spent most of his life. He was the son of a landscape painter and after studying philosophy and theology at Munich University he switched to painting and trained at the Academy, 1900–2. His early work was in an academic style, but visits to Paris in 1903 and 1907 introduced him to *Impressionism and *Post-Impressionism. He was particularly impressed by the work of van Gogh, under whose influence his style moved towards *Expressionism. In 1910 he met August *Macke, who became his closest friend, and in the same year he was greatly impressed with an exhibition of *Matisse's work in Munich. At the beginning of 1911 he joined the *Neue Künstlervereinigung and at the end of the year he joined *Kandinsky and others in founding a splinter group, the *Blaue Reiter. On the outbreak of the First World War in August 1914 he volunteered almost immediately for the army, but his initial mood of elation changed after Macke was killed in action the following month. Marc himself died in combat at Verdun in March 1916. He was unable to paint while he was in the army, but his drawings and letters show how appalled he was by the carnage he saw.

Marc had a deeply religious disposition (he visited Mount Athos in Greece, with its famous monasteries, in 1906), and the death of his father in 1907 brought on him a sense of profound spiritual malaise. Through painting he sought to uncover mystical inner forces that animate nature. His ideas were expressed most forcibly in paintings of animals (eventually they became his exclusive subject), for he believed they were both more beautiful and more spiritual than man: 'The ungodly human beings who surrounded me did not arouse my true emotions, whereas the inherent feel for life in animals made all that was good in me come out.' He visited the zoo in

Berlin several times and from 1907 to 1910 earned a good part of his living by teaching animal anatomy to artists. There was a vogue for animal painting in Munich at this time, but Marc's approach was radically different to that of any of his contemporaries. Using non-naturalistic, symbolic colour and simplified rhythmic shapes, he said he tried to paint animals not as we see them, but as they feel their own existence. In a letter to Macke in December 1910 he explained the emotional value he assigned to colours: 'Blue is the main principle, astringent and spiritual. Yellow is the female principle, gentle, gay and spiritual. Red is matter, brutal and heavy and always the colour to be opposed and overcome by the other two.'

In 1912 Marc saw an exhibition of *Futurist paintings in Berlin and also met *Delaunay in Paris. These events helped to move his work towards abstraction, as in *Animal Destinies* (Kunstmuseum, Basle, 1913), one of his most celebrated paintings, which uses panic-stricken animals to symbolize a world on the edge of destruction. On the back of the picture he wrote: 'Und alles Sein ist flammend Leid' (And all being is flaming suffering), and later, whilst serving at the front, he remarked of this work: 'It is like a premonition of this war, terrible and gripping, I can hardly believe I painted it.' His final paintings became still more abstract, losing almost entirely any representational content, as in *Fighting Forms* (Neue Pinakothek, Munich, 1914), an image of convulsive fury in which there are the merest suggestions of beak- and claw-like forms. These late works are considered among the most powerful representatives of German Expressionism.

Marca-Relli, Conrad (1913–). American painter, born in Boston of Italian parents. In 1926 he settled in New York; he studied there briefly at various art schools, but was mainly self-taught as an artist. After serving in the US Army, 1941–5, and then travelling in Europe and Mexico, he came to prominence in the 1950s as one of the second wave of *Abstract Expressionists, and was particularly acclaimed for his large (sometimes mural scale) *collages, which he developed from 1953. In these he attached cut-out shapes of painted canvas to a canvas ground, using a black glue that served to outline the forms. During the 1960s he experimented with relief paintings and constructions and briefly with

free-standing sculpture before returning to collage paintings.

Marchand, André (1907–). French painter, born at Aix-en-Provence. He took up painting, self-taught, in 1923 and in 1929 moved to Paris, where he began exhibiting at the *Salon d'Automne in 1932 and the *Salon des Indépendants in 1933. In the late 1930s he became a friend of *Gruber and developed a rather mannered figure style influenced by him and by *Picasso. However, in the 1940s his vision changed and he developed a style in which pattern, line, and colour were stressed. By the end of the 1940s his work was verging on abstraction, but he believed that painting should not be devoid of social comment and never entirely abandoned figuration. His subjects included landscapes, sometimes populated with mythological nudes, and still-life. He also made designs for tapestry and ballet decor and did a good deal of graphic work.

Marchand, Jean (1882–1941). French painter (of landscapes, figure compositions, still-life, and occasional decorative schemes), engraver, illustrator, and designer. He was born in Paris and studied there at the École des *Beaux-Arts, 1902–9, whilst supporting himself by designing jewellery, textiles, and other types of applied art. His earliest paintings included landscapes and scenes of tramps sleeping out of doors. In about 1912 he also experimented with *Cubism and occasionally with *Futurist multiple images, but soon after this he settled into a style of vigorous naturalism akin to that of *Derain. When some of his work was shown at a mixed exhibition at the Carfax Gallery, London, in 1915, Clive *Bell wrote: 'No living painter is more purely concerned with the creation of form and the emotional significance of shapes and colours that Marchand.' His first one-man show was at the Carfax Gallery in 1919 and after this he exhibited frequently in Paris and internationally. In the late 1920s he made a lengthy visit to the Middle East, in the course of which he painted a mural for the Residence at Beirut. Apart from paintings he produced a good deal of graphic work, including numerous book illustrations in lithograph and woodcut.

Marcks, Gerhard (1889–1981). German sculptor and printmaker, born in Berlin. He had a varied but patchy artistic training, beginning

as a painter. In 1919 he was one of the first teachers to be appointed at the *Bauhaus, and was put in charge of the ceramic workshop. Encouraged by his fellow teacher *Feininger, he also took up woodcut and this led to an increasing use of wood as a material in his sculpture. He became disillusioned with the increasingly technological outlook of the Bauhaus, so he left when it moved to Dessau in 1925 and took up a teaching position at the Kunstgewerbeschule at Burg Giebichenstein near Halle, becoming director in 1928. In 1933 his work was declared *degenerate by the Nazis and he retired to the Baltic coast. After the Second World War he was professor at the State School of Art in Hamburg, 1946–50, then moved to Cologne, where he spent the rest of his life. His major work was the completion of a series of statues on the façade of the church of St Catherine in Lübeck (1947) that had been left unfinished by *Barlach, but his refined and somewhat sentimental style is generally closer to that of *Lehmbruck.

Marcoussis, Louis (1878–1941). Polish-French painter and etcher. Originally he was called Louis Markus; his adopted name, suggested by *Apollinaire, came from the village of Marcoussis near Paris. He was born in Warsaw into a cultured Jewish family that had converted to Catholicism, studied at the Academy in Cracow from 1901 to 1903, then moved to Paris. During the First World War he served with distinction in the French army and he was granted French nationality on the basis of this. His early paintings were *Impressionist in style and in 1907–10 he earned his living as a cartoonist, but in 1910 he met Apollinaire, *Braque, and *Picasso and joined the *Cubist group. He remained faithful to Cubism for the rest of his career and is regarded as one of the most appealing minor masters of the movement, combining clarity and simplicity of structure with delicacy of handling. Douglas *Cooper writes of him: 'Marcoussis was a sensitive and gifted artist who was intelligent enough to understand and interpret in his own way the painting of Braque and Picasso. He was not a prolific artist, but in the small group of Cubist works—especially the prints—which he produced before joining the French army in 1914 he proved himself an accomplished Cubist disciple ... [he] was most successful in small still-life compositions ... After 1920 Marcoussis created a suave, but essentially decorative, personal idiom based on modified cubistic procedures.' He illustrated a number of books including two by the Romanian-French poet Tristan Tzara, one of the founders of *Dada. Marcoussis's wife, whom he married in 1913, was the Czech painter Alicia Halicka (1895–1975).

Mariani, Carlo Maria. See PITTURA COLTA.

Marin, John (1870–1953). American painter and printmaker, born in Rutherford, New Jersey. He began painting when he was 18, but worked for several years as an architectural draughtsman before he took up art seriously. From 1899 to 1901 he studied in Philadelphia at the Pennsylvania Academy of the Fine Arts (where *Anshutz was one of his teachers), then from 1901 to 1903 in New York at the *Art Students League. In 1905 he went to Europe and remained there (apart from a brief return visit in 1909) until 1910, living mainly in Paris. He was influenced by *Whistler's watercolours and etchings, but he did not come into contact with avant-garde movements until after his return to America, when he became a member of *Stieglitz's circle in New York. The *Armory Show in 1913 also made an impact on him. Responding especially to German *Expressionism and the planimetric structure of the late work of *Cézanne, he developed a distinctive semi-abstract style that he used most characteristically in powerful watercolours of city life and the Maine coast (where he often painted in the summer). His oil paintings (which became more important in his work from the 1930s) are often similar in effect to watercolours, leaving part of the canvas bare. Marin also made etchings, mainly early in his career. From the 1920s he enjoyed a high reputation. He was an individualist, belonging to no school, and he is considered one of the outstanding watercolourists of the 20th century.

Marinetti, Filippo Tommaso (1876–1944). Italian writer and artistic entrepreneur, the founder of *Futurism and the movement's chief theorist and promoter. He was born in Alexandria, the son of a wealthy lawyer, and family money later allowed him the freedom to pursue his artistic interests. In 1893 he moved to Paris, then studied law in Genoa, graduating in 1899. At this point he settled in Milan, but he kept close links with Paris (his early poetry—up to 1912—was written in

French) and it was in Paris that he launched Futurism in 1909 with his famous manifesto published on the front page of *Le Figaro*. Over the next few years, up to the beginning of the First World War, he was extremely vigorous in promoting Futurist ideas, travelling widely around Europe, organizing exhibitions, giving lectures, holding press conferences, and so on. Wherever he went, he attracted attention because of his outspoken and provocative behaviour. In London in 1911, for example, he challenged a journalist to a duel for making slighting remarks about the Italian army, and in Italy 'Marinetti gained enormous publicity from the three trials for obscenity that followed the publication in 1910 of his novel *Mafarka futurista*, the offending item being Mafarka's eleven-metre-long penis which he wrapped round himself when he slept. Marinetti was acquitted at the first trial, given a two-and-a-half-month suspended sentence at the second, and had the same suspended sentence confirmed at the third' (Caroline Tisdall and Angelo Bozzola, *Futurism*, 1977).

Marinetti agitated for Italy to enter the First World War, and when the country did so in 1915, he volunteered for the army; during his service he was wounded and decorated for bravery. The war had a disastrous effect on the Futurist movement, but Marinetti continued promoting it afterwards. In 1918 he founded the Futurist Political Party, which supported Mussolini (a friend of Marinetti's) in his rise to power. He moved to Rome in 1925, and in 1929 launched *Aeropittura as an offshoot of Futurism. In 1935—ever-aggressive in his nationalism—he served as a volunteer in the army when Italy invaded Abyssinia, and in 1942 (in spite of his advanced age) he once again enrolled in the army and fought in Russia. He was soon repatriated because of illness, and he spent the last months of his life at Bellagio di Como, where he was archivist of the Accademia d'Italia (of which he had been made a member in 1929).

Throughout his life Marinetti kept up a stream of writing, often in an experimental vein; in his poetry, for example, he sometimes used typography that had expressive qualities of its own, anticipating *Concrete poetry. He also occasionally tried his hand in the visual arts, making collages, for example, and also producing a *Self-Portrait (Dynamic Collection of Objects)* (private collection, 1914), made up of odds and ends including matchboxes,

brushes, and a handerchief—an anticipation of the *Surrealist *object. Although he is not regarded as a major writer or artist himself, he had an enormous influence as a provocateur—so much so that he is described by Robert *Hughes as 'one of the key figures of twentieth-century culture. He was the prototype of avant-garde promoters. For how do you create interest in something as utterly marginal to the public as new art? By turning it into fresh copy. The Futurists . . . realized that the newspapers wanted to run sensational stories about weirdos, not virtuously tolerant reviews of the avant-garde. Marinetti brilliantly used this appetite by trumpeting an art movement as a broad "revolution" in living that aims to change life itself, embracing everything from architecture to athletics, politics and sex.'

Marini, Marino (1901–80). One of the leading Italian sculptors of the 20th century, also a painter, etcher, and lithographer. He was born in Pistoia, studied at the Academy in Florence, and worked mainly as a graphic artist until he was invited by Arturo *Martini to succeed him as professor of sculpture at the Villa Reale School of Art at Monza, near Milan, in 1929. During the 1930s he made frequent visits to Paris and travelled widely in Europe. He had his first one-man exhibition at the Galleria Milano in 1932. In 1940 he became professor of sculpture at the Brera Academy in Milan, which was his home for most of the rest of his life (although he lived in Switzerland, 1943–6). His travels (particularly his visits to Paris) brought him into contact with many distinguished modern artists (*Braque, *Giacometti, *Gonzáles, *Maillol, *Picasso—to name but a few), but he did not ally himself with any avant-garde movements, remaining essentially isolated in his artistic aims. Although he experimented with various materials, he worked mainly in bronze and concentrated on a few favourite themes, most notably the Horse and Rider, a subject in which he seemed to express an obscure but poignant tragic symbolism (*Horseman*, Tate Gallery, London, 1947). His other subjects include female nudes and he also made numerous portrait busts, remarkable for their psychological penetration and sensuous exploitation of the surface qualities of the material (a cast of his bust of Henry *Moore (1962) is in the National Portrait Gallery, London). Often he polychromed his bronzes,

sometimes working with corrosive dyes. In 1948 he took up painting seriously, producing colourful near-abstracts. During the 1950s his reputation became international (he had a highly successful exhibition at Curt *Valentin's gallery in New York in 1950 and won the main sculpture prize at the Venice *Biennale in 1952). There are Marini museums in Florence, Milan, and Pistoia and his work is represented in many major collections of modern art.

Marisol (Marisol Escobar) (1930–). American sculptor, born in Paris of Venezuelan parents. She spent much of her childhood in Los Angeles but in 1949 studied at the École des *Beaux-Arts and the *Académie Julian, Paris. In 1950 she moved to New York, where she studied at the *Art Students League under *Kuniyoshi, the *Hofmann School, and the New School for Social Research. In about 1953, after seeing an exhibition of Pre-Columbian art, she turned her attention primarily to sculpture, at first making small, playfully erotic terracottas. From about 1955, perhaps influenced by the gently satirical sculptures of William Dickey King (1925–), she began to carve life-size figures from wood. Her subjects included family groups and parodies of middle-class social life, such as *Women and Dog* (Whitney Museum, New York, 1964). Her figures combined block-like wooden torsos with plaster faces, hands, and legs, often cast from her own face or limbs. She embellishes her figures with a variety of accessories such as necklaces, umbrellas, television sets, mirrors, pots of flowers, and so on, so that they sometimes verge on being *assemblages. Her works have been widely exhibited and by the mid-1960s she had an international reputation. This was the heyday of *Pop art and her work has some affinities with it, but in her combination of caricature, humour, and social satire she has remained uniquely herself. In her lifesize portrait figures—which include President Lyndon B. Johnson, Queen Elizabeth II, and the comedian Bob Hope—she demonstrates a gift for conveying the commonplace character of famous people.

Marlborough Fine Art, London. Firm of art dealers, founded in London in 1946 by two Austrian-born dealers who had emigrated to England because of the rise of Nazism: Frank Lloyd (1911–) and Harry Fischer (1903–77)

(who had no connection with the Fischer Galerie that organized the auction of confiscated *degenerate art in Lucerne, Switzerland, in 1939). They served together in the British army during the Second World War and decided to open a gallery when peace returned. It specialized in contemporary art and quickly became the most prestigious British dealer in this field, representing artists of the calibre of Francis *Bacon, Barbara *Hepworth, Oscar *Kokoschka, Henry *Moore, Victor *Pasmore, and Graham *Sutherland. In 1967 G. S. Whittet, formerly the editor of *Studio International*, wrote that it was 'held in awe as the post-war phenomenon in London dealing companies' (*Art Centres of the World: London*). Originally it was located in Old Bond Street and is now in Albemarle Street, where it continues to hold regular exhibitions of the work of leading contemporary artists. There is a branch of the firm in New York.

Marquet, Albert (1875–1947). French painter and draughtsman, born in Bordeaux. In 1890 he settled in Paris, where he studied at the École des Arts Décoratifs (he became a lifelong friend of his fellow student *Matisse) and later at the École des *Beaux-Arts. With Matisse he became one of the *Fauves and for a time his boldness of colour almost matched that of his friend. However, he soon abandoned Fauvism and developed a comparatively naturalistic style. He painted some fine portraits and did a series of powerful female nudes (1910–14), but he was primarily a landscapist. His favourite—eventually almost exclusive—themes were ports and the bridges and quays of Paris, subjects he depicted with unaffected simplicity and great sensitivity of tone. He was also an outstanding draughtsman; his rapid brush drawings have an economy and vigour recalling the work of Oriental masters (Matisse called him 'our Hokusai'). From 1925 he painted mainly in watercolour. Marquet travelled extensively and built up an international reputation, but he refused all awards, including the Legion of Honour, and lived very quietly (he was timid in personality, perhaps partly because he was short-sighted and had a limp). His work is particularly well represented in the Musée des Beaux-Arts in Bordeaux.

Marsh, Sir Edward (1872–1953). British civil servant, scholar, collector, and patron. He was

born in London, great-grandson of Spencer Perceval, the Prime Minister who was assassinated in the House of Commons in 1812, and studied classics at Cambridge University. From 1896 until his retirement in 1937 he worked with disinction in the Colonial Office. He began his collecting career with 18th- and 19th-century watercolours, but in December 1911 he bought Duncan *Grant's *Tulips* (City Art Gallery, Southampton) from the second exhibition of the *Camden Town Group at the Carfax Gallery and was converted to modern British painting: 'How much more exciting to back what might roughly be called one's own judgement . . . to go to the studios and the little galleries, and to purchase, wet from the brush, the possible masterpieces of the possible Masters of the future! Besides, to buy an old picture did nobody any good except the dealer; whereas to buy a new one gave pleasure, encouragement, and help to a man of talent, perhaps of genius.' Marsh was never very rich (in 1938 he wrote that 'I have spent on an average a little over £200 a year on modern pictures'), but he became one of the most important supporters of contemporary British art and built up a superb and varied collection (in 1938 he said it consisted of 'about 150 pictures' by '86 different hands'; he added comparatively few works after this). The artists represented included *Gertler, John and Paul *Nash, *Sickert, Matthew *Smith, and Stanley Spencer: 'Clearly, Marsh preferred the *belle peinture* tradition and had no sympathy for abstract or violently expressive art' (Dennis Farr, *English Art 1870–1940*, 1978). He was particularly generous in his support of Gertler, who in 1915 wrote 'I really cannot express my thanks to you for your extraordinary goodness'. Marsh was a trustee of the Tate Gallery and from 1936 to 1952 was chairman of the *Contemporary Art Society. During his lifetime he presented more than a hundred works to the Society and he bequeathed his collection to it, through which it was distributed to numerous galleries in Britain and the Commonwealth. Marsh was a significant figure in the world of literature as well as the visual arts; he edited several volumes of poetry, translated works from French and Latin, was Rupert Brooks's executor, and corrected the proofs of numerous books by Winston Churchill (he was his private secretary for most of the period from 1905 to 1928) and Somerset Maugham. In 1939 he published *A Number of People: A Book of Reminiscences*. An exhibition entitled 'An Honest Patron: A Tribute to Sir Edward Marsh' was held at the Bluecoat Gallery, Liverpool, in 1976.

Marsh, Reginald (1898–1954). American painter and illustrator. He was born in Paris to wealthy American parents, both of whom were painters (Fred Dana Marsh and Alice Marsh), and he was brought to the USA when he was two. After graduating from Yale University in 1920 he studied at the *Art Students League, New York, in the early 1920s. Until 1930 he worked mainly as a newspaper illustrator, but he took up painting seriously after a study trip to Paris in 1925–6, and in the 1930s he became well known for his paintings depicting shabby and tawdry aspects of life in New York. His favourite subjects included Coney Island, the amusement arcades of Times Square, and the cheap and grubby street life of the Bowery district (*Tattoo and Haircut*, Art Institute of Chicago, 1932). He was also capable of bitter satire against the smug complacency of the wealthy, but in general his work shows a love of depicting teeming life through ugly yet colourful subjects rather than a desire for social protest. His aim was to depict contemporary life in the manner of the Old Masters and he worked mainly in tempera (he also experimented with reviving other venerable techniques). To some extent his work expressed a rejection of the affluent and genteel circumstances in which he grew up. He said he would 'rather paint an old suit of clothes than a new one because an old one has character; reality is exposed not disguised. People of wealth spend money to disguise themselves.' Marsh's first wife, Betty Burroughs, was a sculptor.

Martin, Agnes (1912–). Canadian-born painter, printmaker, and writer on art who settled in the USA in 1932 and became an American citizen in 1950. She has lived mainly in New Mexico, but part of her intermittent studies in art were at Columbia University, New York (1941–2 and 1951–2), and she again lived in New York from 1957 to 1967. During this time she was a neighbour of several other painters (among them Robert *Indiana, Ellsworth *Kelly, and James *Rosenquist) in a block of artists' lofts, but essentially she has lived a fairly solitary life, a fact that is perhaps reflected in the cool detachment of her paintings. Up to the mid-1950s

her paintings were representational, but she then turned to abstraction, and by 1964 had arrived at her characteristic type of work—a square monochromatic canvas covered with a fine grid of horizontal and vertical lines: 'My forms are square, but the grids are never absolutely square . . . when I cover the square grid surface with rectangles, it lightens the weight of the square, destroys its power.' From 1967 to 1974 she concentrated on writing, but after her return to painting she achieved a high reputation, winning several honours. According to the catalogue of the exhibition 'American Art in the 20th Century' (Royal Academy, London, 1993), 'There is a timeless quality about her images that, going beyond their superficially *Minimalist character, reflects an interest in nature and poetry as well as in the Chinese philosopher Chuang Tzu.' On the other hand, Peter *Fuller referred to the 'numbing vacuity' of her work.

Martin, Kenneth (1905–84). British painter, sculptor, and printmaker. He was born in Sheffield and studied part-time at Sheffield School of Art, 1927–9, whilst working as a designer, and then at the *Royal College of Art, 1929–32. In 1930 he married his fellow student Mary Balmford, whose artistic development as Mary *Martin had close affinities with his own. At this time he painted in a naturalistic style, but during the 1940s his work became less representational until in 1948–9 he produced his first abstract pictures. His wife soon followed suit and in the early 1950s they began making abstract constructions. With Victor *Pasmore and others they became recognized as leaders of the *Constructivist movement that burgeoned in England in the 1950s. Kenneth Martin's contribution came not only through his work, but also by writing and organizing exhibitions. He also explored other forms of abstract art, including *mobiles, and in the 1960s he became interested in the role of chance in art, making drawings in which the random selection of numbers determined the placement of lines on a grid. Of his conversion to abstraction he said: 'The moment I became a purely abstract artist I began to realize what I'd been missing . . . That I'd really missed the whole of the modern movement.' From 1946 to 1967 Martin was a visiting teacher at Goldsmiths' College of Art, London. He won various awards and had several public commissions, including a stainless steel fountain

for Brixton Day College (1961). His work is well represented in the Tate Gallery, London.

Martin, Sir Leslie. See CIRCLE.

Martin, Mary (née Balmford) (1907–69). British painter and maker of constructions, the wife of Kenneth *Martin. She was born in Folkestone, Kent, and studied in London at Goldsmiths' College, 1925–9, and the *Royal College of Art, 1929–32. Early in her career she painted landscapes and still-lifes in a style influenced by *Post-Impressionism, but during the 1940s her work, like that of her husband, moved towards abstraction. She made her first purely abstract painting in 1950, her first geometric abstract relief in 1951, and her first free-standing construction in 1956. With her husband she was regarded as one of the leaders of *Constructivism in England and she had numerous major commissions: among them were a screen for Musgrave Park Hospital, Belfast (1957), reliefs for the liner SS *Oriana* (1960), and a wall construction for the University of Stirling (1969). In 1969 she was joint winner of the first prize at the *John Moores Liverpool Exhibition. An *Arts Council exhibition was devoted to her and her husband in 1970–1.

Martini, Arturo (1889–1947). Italian sculptor and painter, born at Treviso, where he served apprenticeships as a goldsmith and in a ceramics factory before turning to sculpture in 1906. He moved to Venice in 1908 and in 1909 went to Munich to study under *Hildebrand. In 1912 and 1914 he visited Paris and after the First World War (during which he worked in an armaments factory and gained a knowledge of casting) he worked mainly in Rome, Venice, and Milan (he taught at the Villa Reale Art School at Monza, near Milan, in the 1920s). Some of his early work was extremely adventurous, notably the bizarrely *Expressionist *Prostitute* (Ca' Pesaro, Venice, 1909–13) in coloured terracotta, but in 1921 he became associated with the journal *Valori plastici* and, in line with its views calling for a return to the Renaissance tradition, his work took on a classical simplicity. It is also possible to detect the influence of Hildebrand in his generalized forms. However, his work was far from being mere revivalism or pastiche. There is often an air of *Surrealist strangeness in his sculptures, especially his rather ghostly terracotta figures, and he reflected the troubles

through which he lived: 'Condemned to work in an increasingly provincial, dictatorially brutal cultural environment, Martini gave expression to the hopes and anguish of his times in a series of powerful yet infinitely fragile figures' (Fred Licht, *Sculpture: 19th and 20th Centuries*, 1967). Martini began to paint in the late 1930s, and in 1945, suffering an artistic crisis, he published a pamphlet announcing the death of sculpture, *La Scultura: lingua morta*. Pietro *Consagra replied to this in his book *Necessità della scultura* (1952).

Martyn, Edward. See AN TÚR GLOINE.

Masereel, Frans (1889–1972). Belgian graphic artist and painter, active mainly in France. He was born in Blankenberge and studied at the Academy in Ghent, 1907–8. Before the First World War he travelled extensively and during the war he settled in Switzerland. He moved to Paris in 1920 and in 1940 fled the German invasion and settled in the South of France, thereafter living mainly in Avignon and Nice. Masereel was a prolific illustrator of books and periodicals. Much of his work was motivated by social concern, one of his chief themes being the suffering caused by war. He often used the formula of *romans in beelden* (novels in pictures), which are series of woodcuts telling a story without a text. His style was mildly *Expressionist.

Mass Observation. See ASHINGTON GROUP.

Masson, André (1896–1987). French painter, printmaker, sculptor, stage designer, and writer, one of the major figures of *Surrealism. He was born at Balagne and at the age of eight moved with his family to Brussels, where he studied art part-time whilst working as a pattern-drawer in an embroidery studio. In 1912 he moved to Paris, where he studied at the École des *Beaux-Arts until the outbreak of the First World War, when he joined the army. During the war he was seriously wounded and deeply scarred emotionally. His pessimism was accompanied by a profound and troubled curiosity about the nature and destiny of man and an obscure belief in the mysterious unity of the universe; he devoted the whole of his artistic activity to penetrating and expressing this belief.

After the war Masson lived in the South of France until 1922, when he returned to Paris. Initially he was influenced by *Cubism, but in 1924 he joined the Surrealist movement and remained a member until 1929, when he left in protest against *Breton's authoritarian leadership. His work belonged to the spontaneous, expressive, semi-abstract variety of Surrealism, and included experiments with *automatism, chance effects, and unusual materials (he sometimes incorporated sand in his paintings). Themes of metamorphosis, violence, psychic pain, and eroticism dominated his work. In 1936 he lived in Spain until the Civil War drove him back to France and in 1941–5 he took refuge from the Second World War in the USA. There his work formed a link between Surrealism and *Abstract Expressionism. It included a series of large canvases reflecting the carnage he had lived through, among them *There is No Finished World* (Baltimore Museum of Art, 1942), which features disintegrating monsters symbolizing (in his own words) 'the preciousness of human life and the fate of its enterprises, always threatened, destroyed, and recommenced'. In 1945 Masson returned to France and two years later settled at Aix-en-Provence, where he concentrated on landscape painting, achieving something of the spiritual rapport with nature associated with Chinese painting. Apart from paintings his work included designs for the theatre, book illustrations, and several sculptures. He also wrote a good deal on art, including the two-volume book *Métamorphose de l'artiste* (1956).

MAT. See SPOERRI.

Mataré, Ewald (1887–1965). German sculptor, printmaker, painter, designer, and teacher. He was born in Aachen and had his main training at the Academy in Berlin (he also spent a few months there with *Corinth). During the First World War he served briefly in the army, and in 1918 he joined the *Novembergruppe in Berlin. In 1920 he began making woodcuts (mainly portraits and animal studies in a style influenced by *Expressionism) and in 1922 he took up sculpture, which soon became his main concern. His first sculptures were woodcarvings; originally he used driftwood, but he moved on to fine pieces of timber and made great play of exploiting beautiful grain. Characteristically he used broadly contoured forms and polished his surfaces to immaculate smoothness, unbroken by projections or incisions. He worked in a similar vein when using other

materials, but in his metal sculpture he sometimes enhanced the surface by inserting gems. His favourite theme was the human figure (*Standing Figure*, Lehmbruck Museum, Duisburg, 1926–7) and his other subjects included animals and portraits. In 1932 he became professor of sculpture at the Academy in Düsseldorf, but he was dismissed by the Nazis the following year and his work was declared *degenerate. After the Second World War he was re-instated at Düsseldorf, and his post-war work included a number of public commissions, especially for churches. Among these were doors for Cologne Cathedral (1947–54), the Alte Kirche in Krefeld (1942), and the Church of World Peace in Hiroshima (1953–4). He also designed the complete interior decoration of the St Rochuskirche in Düsseldorf. In addition to such large-scale ecclesiastical works, Mataré designed liturgical objects such as chalices. In these, and in his later sculpture, his style was more decorative than in his austere pre-war work.

Mather, Frank Jewett. See WRIGHT.

Mathieu, Georges (1921–). French painter, born in Boulogne. After studying philosophy and law, he began to paint in 1942. In 1947 he settled in Paris and in the 1950s gained an international reputation as one of the leading exponents of expressive abstraction. His fame has depended partly on a flair for publicity that has led to him being described as 'the Salvador *Dalí of *Art Informel'. He works rapidly, often on a large scale, with sweeping impulsive gestures, sometimes squeezing paint straight from the tube onto the canvas. 'To him, speed of execution is essential for intuitive spontaneity . . . Typically Matthieu turned to elaborate titles taken from battles or other events of French history, reflecting his insistence that he is a traditional history painter working in an abstract means. In love with spectacle and performance, he has at times painted, dressed in armor, before an audience, attacking the canvas as though it were the Saracen and he Roland. His critics have frequently raised the question as to who won the battle' (H. H. *Arnason, *A History of Modern Art*, 3rd edn., 1988). Matthieu has written several books expounding the theories behind his work.

Matisse, Henri (1869–1954). French painter, sculptor, draughtsman, printmaker, and designer, one of the most illustrious artists of the 20th century. From the 1920s he enjoyed an international reputation alongside *Picasso as the foremost painter of his time. Unlike Picasso, he was a late starter in art, and he was not quite so prolific or versatile, but for sensitivity of line and beauty of colouring he stands unrivalled among his contemporaries.

Matisse was born in Le Cateau, Picardy, the son of a shopkeeper (originally a draper, he became a grain merchant). To alleviate the boredom of life as a solicitor's clerk, Matisse attended drawing classes and he took up painting in 1890 when he was convalescing from an appendicitis operation. He later recalled that 'When I started to paint I felt transported into a kind of paradise', and in 1891 he abandoned his legal career to study art in Paris. He attended various schools, including the *Académie Julian, the École des Arts Décoratifs, the École des *Beaux-Arts, and (briefly in 1899), the *Académie Carrière. His early pictures—mainly still-lifes and landscapes—were sober in colour, but in the summer of 1896, painting in Brittany, he began to adopt the lighter palette of the *Impressionists. In 1899 he began to experiment with the *Neo-Impressionist technique, which he still used five years later in one of his first major works—the celebrated *Luxe, calme et volupté* (Musée d'Orsay, Paris, 1904–5), exhibited at the *Salon des Indépendants in 1905 and bought by *Signac. During the same years he had been painting with *Marquet, had met *Derain and through him *Vlaminck, and in 1905, together with these and other friends from student days, he took part in the sensational exhibition at the *Salon d'Automne that give birth to the name '*Fauves'. In the same year (Matisse's *annus mirabilis*) he acquired his first important patrons—the expatriate Americans Gertrude, Leo, and Michael *Stein—and they were soon followed by the great Russian collectors Ivan *Morozov and Sergei *Shchukin. Previously he had struggled to earn a living, but their patronage freed him from financial worries and meant he could afford to travel (before the First World War he visited Germany, where his work was becoming influential among the *Expressionists, Morocco, Russia, and Spain). His growing reputation also attracted many pupils to the art school he ran in Paris from 1907 to 1911. At the outbreak of the First World War he volunteered for military

service, but he was rejected as too old at 44. For the next two years he often found it difficult to paint because of the anxieties of the war, but he was able to work at etching. He also took comfort in music (he was a good amateur violinist).

Matisse had met Picasso as early as 1906, and like him was excited by African sculpture at this time. During the second decade of the century he was influenced by *Cubism (or rather responded to its challenge) and painted some of his most austere and formal pictures (*Bathers by a River*, Art Institute of Chicago, 1916–17). In the 1920s, however, he returned to the luminous serenity that characterized his work for the rest of his long career. From 1916 he spent most of his winters on the Riviera, mainly at Nice. The luxuriously sensual works he painted there—odalisques, still-lifes of tropical fruits and flowers, and glowing interiors—are irradiated with the strong sun and rich colours of the south. His extraordinary ability to orchestrate rich colour has been well described by John *Berger: 'It is comparatively easy to achieve a certain unity in a picture by allowing one colour to dominate, or by muting all the colours. Matisse did neither. He clashed his colours together like cymbals and the effect was like a lullaby.'

During the 1930s Matisse began to travel widely again. In 1930, for example, he visited Pittsburgh to serve on the jury of the *Carnegie International Competition, and while he was in the USA he met Dr Albert C. *Barnes, who commissioned murals from him for the Barnes Foundation. By this time he was an international celebrity, with a stream of articles, books, and exhibitions devoted to him; in 1930–1, for example large exhibitions of his work were held in Basle, Berlin, New York, and Paris. In 1940 he settled permanently in the South of France to escape the German occupation of Paris. He lived mainly in the Hôtel Régina in Nice. Following two major operations for duodenal cancer in 1941, he was confined to bed or a wheelchair, but he worked until the end of his life and one of his greatest and most original works was created in 1948–51, when he was in his 80s. This is the Chapel of the Rosary at Vence, a gift of thanksgiving for a woman who had nursed him after his operations and then become a nun at the Dominican convent in Vence (Matisse lived there from 1943 to 1949). He designed every detail of the chapel and its fur-

nishings, including the priests' vestments. The stained-glass windows show his familiar love of colour, but the walls feature murals of pure white ceramic tiles decorated with black line drawings of inspired simplicity. Matisse was not a believer, but he created here one of the most moving religious buildings of the 20th century and expressed what he called 'the nearly religious feeling I have for life'.

In his bedridden final years Matisse also embarked on another kind of highly original work, using brightly-coloured cut-out paper shapes (*gouaches découpées*) arranged into purely abstract patterns (*L'Escargot*, Tate Gallery, London, 1953). 'The paper cut-out', he said, 'allows me to draw in the colour. It is a simplification for me. Instead of drawing the outline and putting the colour inside it—the one modifying the other—I draw straight into the colour.' The colours he used in his cut-outs were often so strong that his doctor advised him to wear dark glasses. They must rank among the most joyous works ever created by an artist in old age. Unlike many of his great contemporaries, Matisse did not attempt to express in his work the troubled times through which he lived. His concerns were aesthetic, not moral—'to study separately each element of construction; drawing, colour, values, composition; to explore how these elements could be combined into a synthesis without diminishing the eloquence of any one of them by the presence of the others'. He summed up his guiding principle when he wrote: 'What I dream of is an art of balance, of purity and serenity devoid of troubling or disturbing subject-matter . . . like a comforting influence, a mental balm—something like a good armchair in which one rests from physical fatigue.'

Matisse made sculptures at intervals throughout his career, the best known probably being the four bronzes called *The Back I–IV* (casts in the Tate and elsewhere, 1909–c. 1929), in which he progressively removed all detail, paring the figure down to massively simple forms. He also designed sets and costumes for *Diaghilev and was a brilliant book illustrator. His work is represented in most important collections of modern art, the finest holdings being at the Barnes Foundation in Merion, Pennsylvania, the Hermitage, St Petersburg, and the Pushkin Museum, Moscow. There are also Matisse museums in his birthplace, Le Cateau, and in Nice. His scattered thoughts on art (often expressed in

the form of interviews) have been collected in *Matisse on Art* by Jack D. Flam (1973).

His son **Pierre Matisse** (1900–89) was an art dealer. He settled in the USA in 1925 and became an American citizen in 1942. The art historian William Rubin described him as 'the great American dealer of the European *Surrealist generation that came of age in the late 1920s and 1930s' and wrote that 'Considering his importance he was remarkably unconcerned with his own image.' Among the many exhibitions he held in the Pierre Matisse Gallery, New York (opened 1932), the best known is probably 'Artists in Exile' (1942), which featured the work of many Surrealists who had moved from Europe to America to take refuge from the Second World War. He was particularly associated with *Miró (he held 37 exhibitions of his work), and the other artists whose work he sold included *Tanguy, a friend since schooldays. Matisse did not deal only in the work of the Surrealists, however; the artists he represented in his lengthy career included figures as varied as *Balthus, *Chagall, *Giacometti, and *Riopelle. He also sold his father's work, although he never actually devoted an exhibition to it. He was married three times; his first wife, Alexina Sattler, later married Marcel *Duchamp.

Matta (Roberto Matta Echaurren) (1911–). Chilean painter and sculptor who has worked mainly in Paris, but also in Italy and the USA. He trained as an architect in his native Santiago and in Paris under *Le Corbusier in 1934–5, but he turned to painting in 1937 and in the same year joined the *Surrealist movement. In 1939 he fled from Europe to New York, where with other emigrés including *Breton, *Ernst, *Masson, and *Tanguy he formed a strong and influential Surrealist presence. Matta played a particularly significant role in encouraging *Gorky, *Pollock, and others to experiment with *automatism; he, 'more than any other of the Surrealists, made himself available to young New Yorkers. A keen intellectual and scintillating conversationalist, he was able to focus attention on issues, to crystallize and dramatize them verbally' (Irving Sandler, *Abstract Expressionism*, 1970). From about 1944 Matta began to create his most characteristic works—large canvases bordering on abstraction that evoke fantastic subjective landscapes and take as their theme the precariousness of human existence in a world dominated by machines and hidden forces. In 1948 he broke with the Surrealists and returned to Europe, but his work continued in a similar vein. He lived in Rome in the early 1950s, then mainly in Paris, although he travelled widely. In 1957 he began making sculpture.

Matterism (or **Matter Painting**). A type of painting, predominantly abstract, that uses a heavy impasto, with materials such as shells, sand, slate, iron filings, etc. embedded in it. It became popular in the 1950s, particularly in Belgium and the Netherlands. Exponents included René Guiette (1893–1976) and Marc Mendelson (1915–) in Belgium, and Bram Bogart (1921–) and Jaap Wagemaker (1906–72) in the Netherlands. Among the other artists who are sometimes embraced by the term are *Dubuffet, *Fautrier, and *Tàpies.

Matulka, Jan. See SMITH, DAVID.

Matveyev, Alexander (1878–1960). Russian sculptor. He was born in Saratov and had his main training at the Moscow School of Painting, Sculpture, and Architecture, 1899–1902. One of his teachers there was *Trubetskoy, whose impressionistic handling influenced his early work. Matveyev was also influenced by *Art Nouveau (he was a member of the *World of Art group) and by *Symbolism (he took part in the *Blue Rose exhibitions). He was a friend of the Symbolist painter *Borisov-Musatov (a fellow native of Saratov) and one of his most famous works is Borisov-Musatov's funerary memorial (1910–12) at Tarusa, near Moscow. Beautifully carved in granite, it captures the delicate, melancholy spirit of the painter's work, showing 'the figure of a boy . . . sunk in a dream . . . The theme of luminous calm is in accord with the substance and meaning of the monument and also with the general character of Borisov-Musatov's work' (Dmitri Sarabianov, *Russian Art*, 1990). After the Russian Revolution in 1917, Matveyev's style became more heroic, in line with the ideals of *Socialist Realism, but he always retained independence of spirit, resisting the empty rhetoric that characterized so much Soviet art in Stalin's time; in 1949 he was officially censured for the deadly sin of *formalism. An exhibition commemorating the 100th anniversary of his birth was held in the Russian Museum, Leningrad, in 1978.

Mauclair, Camille (pseudonym of Séverin Faust) (1872–1945). French writer. His large and varied output included fiction, poetry, and literary and musical criticism, but he is best known for his writings on art, in which he supported *Symbolism but was a fervent opponent of various forms of avant-garde art, seeing himself as an upholder of French tradition. John Rewald (*The History of Impressionism*, 1946, 4th edn., 1973) writes of him: 'As art critic of the *Mercure de France* [from 1892] he had published many articles of a pretentious character, launching insolent attacks on all the great contemporary painters. He saw in *neo-impressionism a *trifling technique*, referred to *Gauguin's art as *colonial*, spoke of the *gangsterism* of Lautrec, poured out his scorn for *Cézanne, and treated *Pissarro with contempt... But when the painters were finally rewarded with recognition, and when most of those he slandered had died, Mauclair did not scruple to add his voice to the general expressions of admiration. It must be admitted, however, that he remained at least faithful to his opinions concerning Cézanne and never ceased to consider him a poor provincial artist stricken with incompetence and ambition . . . Under the Vichy government, Mauclair, once more a turncoat, wrote a book on the Jews in art, denouncing Pissarro among others. After the liberation of France, he was condemned to "national unworthiness."'

Mauclair's *The French Impressionists* (1903) was the first book on the movement to appear in English (this translation preceded the French edition—*L'Impressionnisme, son histoire, son esthétique, ses maîtres*, 1904). In spite of its shortcomings, Bernard Denvir comments that it 'contributed much to the appreciation of the movement, especially in England and the USA' (*The Thames and Hudson Encyclopaedia of Impressionism*, 1990). Mauclair's other books include *La Farce de l'art vivant* (2 vols., 1929–30) and monographs on *Besnard (1914), *Monet (1924, English translation 1925), and *Rodin (1918, preceded by an English translation in 1905). See also FAUVISM.

Maurer, Alfred H. (1868–1932). American painter, a pioneer of modernism in his country. He was born in New York, son of **Louis Maurer** (1832–1932), a lithographer who worked for the famous Currier & Ives firm of popular printmakers. After studying at the National Academy of Design and working as a lithographer, he went to Paris in 1897 and briefly attended the *Académie Julian; apart from a short visit to America in 1901, he remained in Paris until 1914. His early style was influenced by *Whistler, and he won first prize at the *Carnegie International Exhibition in 1901 with a picture that was virtually an act of homage to him—*An Arrangement* (Whitney Museum, New York, 1901), showing a woman in front of a Japanese screen. In about 1907 Gertrude *Stein introduced Maurer to the work of the *Fauves, and he rapidly became a convert to a modernist idiom. His paintings in the Fauvist style were introduced to America by *Stieglitz in a joint exhibition with John *Marin at the 291 Gallery in 1909, and when Arthur B. *Davies and Walt *Kuhn visited Paris in 1912 to prepare for the *Armory Show they were helped by Maurer with introductions to the dealer Ambroise *Vollard. Maurer himself exhibited in the Armory Show (1913), in the *Forum Exhibition that followed it in 1916, and in the first exhibition of the *Society of Independent Artists in 1917.

Maurer was a rather introverted character and throughout his life there was tension between him and his father, a much more forceful character who was not in sympathy with modernist styles. The tension intensified in 1914, when the outbreak of the First World War compelled Maurer to leave France and financial considerations obliged him to live with his family. During the 1920s he reverted to a more naturalistic style, and an air of melancholy in his work has been interpreted as sadness for promise unfulfilled. His self-portraits of this period present him as a sad, even tortured figure (*Self-Portrait with Hat*, Walker Art Center, Minneapolis, 1922). In the early 1930s he painted some pictures featuring *Cubist mannerisms (*Still-life with Doily*, Brandeis University Art Collection, 1930–1), but by this time he no longer took part in avant-garde activities. The final loss of confidence in his work seems to have been caused by the acclaim that his father started to receive in his extreme old age; with the flowering of *Regionalism, his scenes of the American West suddenly took on a new lease of life. A month after his father died, at the age of 100, Maurer hanged himself.

Maus, Octave. See LIBRE ESTHÉTHIQUE.

Maximalism. See POST-MINIMALISM.

May, Phil. See BATEMAN.

Mayakovsky, Vladimir (1893–1930). Russian poet, playwright, critic, editor, designer, and painter, a leading figure in avant-garde art in the years of tumultuous activity before and after the 1917 Revolution. He was born in Bagdadi, Georgia, and moved to Moscow with his family in 1906, following the death of his father. In 1908 he joined the Bolshevik Party, and he was arrested several times for his involvement in left-wing political activities; he began writing poetry while he was in prison. From 1911 to 1914 he was a student at the Moscow School of Painting, Sculpture, and Architecture, where one of his fellow pupils was David *Burliuk. He and Mayakovsky became leading figures of the Russian *Futurist movement, in spite of their youth; their activities included poetry readings and public clowning that anticipated *Performance art. In 1914 Burliuk and Mayakovsky were expelled from art school. Over the next couple of years Mayakovsky painted some *Cubo-Futurist pictures, but his main work in the visual arts was as a poster designer. In 1915 he met the critic Osip Brik (1888–1945), who was later head of *Inkhuk in Moscow. Brik helped to promote Futurism, and Mayakovsky fell in love with his wife, Lili Brik, to whom he dedicated numerous literary works.

Like other Futurists, Mayakovsky supported the 1917 Revolution, and in its aftermath he was involved in various kinds of *agitprop art, including performing in propaganda films and designing posters for the Russian Telegraph Agency—bold, cartoon-like images intended to be understood by the barely literate. He had the support of *Narkompros, but the leaders of the Communist Party generally regarded Futurism as elitist, Lenin describing one of Mayakovsky's works as 'incomprehensible rubbish' (entitled *150,000,000*, it is a description of a boxing match between the entire population of Russia and the American President, Woodrow Wilson). In 1923 Mayakovsky was one of the founders of the group LEF (Left Front of the Arts), which published a journal of the same name. This was a response to the conservative trends in art and literature that had re-emerged following the country's civil war (1918–21): 'Mayakovsky's aim was to regroup the Left and re-establish its claims to be the true art of the Revolution' (Charles

Harrison and Paul Wood, *Art in Theory 1900–1990*, 1992). The journal became the principal mouthpiece for 'Production art' (see INKHUK), in which art was essentially a form of industrial design, but it folded in 1925. Mayakovsky refounded the journal in 1927 as *Novy Lef* (New Lef), which placed an emphasis on documentary photography. Like its predecessor, *Novy Lef* had a short life, closing in 1928. By this time, *Socialist Realism was emerging as the official style of Soviet art and Mayakovsky was accused of being 'unintelligible to the masses'. In 1930 he organized a retrospective exhibition of his work, shown in Moscow and Leningrad, with the intention of demonstrating his relevance to the present day. Its poor reception, coupled with an unhappy love life, led him to shoot himself that year.

The huge crowds that attended Mayakovsky's funeral in Moscow showed that he did indeed command popular support, but over the next few years his reputation dwindled. In 1935, however, Lili Brik wrote to Stalin commending Mayakovsky's 'enormous revolutionary heritage', and Stalin responded by declaring him 'the best and most talented poet of our Soviet epoch'. From this point he became regarded as an official laureate, with the details of his life and beliefs rewritten to suit Stalinist propaganda. As the writer Boris Pasternak put it, he was 'propagated cumpulsorily like potatoes in the reign of Catherine the Great. This was his second death. He had no hand in it.'

Mayor, Fred. See UNIT ONE.

Mazzacurati, Marino. See ROMAN SCHOOL.

Meadows, Bernard (1915–). British sculptor, mainly in bronze, born in Norwich. After studying at Norwich School of Art, 1934–6, he was studio assistant to Henry *Moore in London, 1936–9. He had two periods of study at the *Royal College of Art, 1938–40 and 1946–8, interrupted by war service in the RAF, 1941–6. During his period in the RAF he spent some time on the Cocos Islands in the Indian Ocean, from which he derived the crab motif that he used in many of his works (*Black Crab*, Tate Gallery, London, 1952). Characteristically his sculpture is abstract but suggests animal and plant forms—during the 1960s he sometimes used real fruits in his casting. Meadows taught at Chelsea School of Art,

1940–60, and was professor of sculpture at the Royal College of Art, 1960–80.

Mécano. A review founded by van *Doesburg in Leiden in 1922 and edited by him under the pseudonym I. K. Bonset; it ran to four numbers, 1922–3. Van Doesburg was at this time interested in *Dada, and the contributors included leaders of the movement such as *Arp, *Hausmann, *Picabia, and *Schwitters, who made fun of the *Bauhaus for its solemn sense of dedication. In this review van Doesburg also attempted to extend the principles of *Constructivism to poetry.

Mec art. A term (abbreviation for 'mechanical art') applied to works produced by transferring photographic images to canvas treated with photosensitive emulsion. Andy *Warhol used photographic transfers unadapted in many of his screenprints, but the European artists associated with Mec art have usually modified or restructured the original image to create a new, synthetic one. The term was perhaps first used by the French experimental artist Alain Jacquet (1939–) in 1964 (with a pun on the word 'mec', French slang meaning 'bloke'), and it was adapted soon afterwards by several other artists, among them the Belgian Pol *Bury, the Greek Nikos (Nikos Kessanlis, 1930–), and the Italians Gianni Bertini (1922–) and Mimmo *Rotella.

Medley, Robert (1905–94). British painter and theatre designer, born in London. He studied at the Byam *Shaw School , 1921–3, the *Royal Academy Schools briefly in 1924, the *Slade School, 1924–6, and in Paris under Jean *Marchand, 1926–7. In the 1930s he worked with the left-wing Group Theatre, designing sets and costumes for plays by W. H. Auden (who was Medley's lover for a time), T. S. Eliot, Christopher Isherwood, and Louis MacNeice. During this period he became interested in *Surrealism and his work was included in the London International Surrealist Exhibition in 1936. In the Second World War he worked mainly on camouflage in the Middle East. Before and after the war he taught at Chelsea School of Art, then in 1951–8 taught stage design at the Slade School. From 1958 to 1965 he was head of the Department of Fine Art at Camberwell School of Arts and Crafts. His main subjects as a painter were landscape, still-life, and figure compositions, and his approach was highly varied. In 1979 he summed up his stylistic development as follows: 'Early influences until 1939 were the *Bloomsbury Group and the *École de Paris, though from 1932 Surrealist and political pressures also exerted their influence. After the war my work was concerned with the movement of human figures in space . . . and with industrial landscape . . . By the 1960s the freedom of line and direct brushwork disintegrated the "representational", but the pictures remained metaphors for actual visual experiences. This was followed by an entirely non-figurative and geometric period . . . I now work in both conventions—non-figurative and figurative—as I feel inclined.' In 1976 he played the role of Diocletian in Derek Jarman's film *Sebastiane* and in 1983 he published an autobiography, *Drawn from Life*. He continued working and exhibiting until the end of his long life and in the year of his death he won a prize for the most distinguished work in the Royal Academy summer exhibition.

Medunetsky, K. See OBMOKHU.

Mehring, Howard. See WASHINGTON COLOR PAINTERS.

Meidner, Ludwig (1884–1966). German painter, graphic artist, and writer, born at Bernstadt, Silesia. In 1903–5 he studied at the Breslau Academy, in 1905–6 he eked out a living as a fashion artist in Berlin, and in 1906–7 he studied at the *Académie Julian in Paris. He was unaffected by avant-garde developments there, although he became a friend of *Modigliani, who did several portraits of him (throughout his life Meidner remained an independent figure who stood apart from the main groups). In 1908 he returned to Berlin, and in about 1912 he began to paint visionary and apocalyptic scenes that gave him a reputation as 'the most *Expressionist of the Expressionists' (*Apocalyptic Landscape*, Los Angeles County Museum of Art, 1913). At the same time he began a period of prolific and equally ecstatic literary work. Whilst serving in the German Army, 1916–18, he wrote two books, *Septemberschrei* (September Cry) and *Im Nacken das Sternenmeer* (Behind My Head the Sea of Stars). However, his intense Expressionist period ended abruptly and in 1923 he wrote: 'It is only with the deepest blushes that I can read my youthful work.' In painting and drawing he now turned mainly to Jewish

themes, but for a while he gave up art and became a successful writer of humorous stories for a Berlin newspaper. Growing persecution of Jews led him to leave Berlin in 1935 and settle in Cologne, where he became drawing master at the Jewish Hochschule. In 1939 he fled to England, where he was interned in 1940-1. He returned to Germany in 1953, settled in Frankfurt, and in 1963 moved to Darmstadt. By this time he was almost forgotten, but in 1964 there were celebrations in Germany to mark his 80th birthday. Werner *Haftmann (*Painting in the Twentieth Century*, 1965) describes Meidner as 'a visionary and prophet of high stature endowed with keen feeling for the soul of his time, yet utterly unable to draw'. George Heard *Hamilton (*Painting and Sculpture in Europe: 1880–1940*, 1967) writes that 'His contribution to Expressionism was small, but once seen it is not easily forgotten'. See also PATHETIKER.

Meier-Graefe, Julius (1867–1935). German art historian. He spent most of his career in Berlin, where he was co-founder of the literary and artistic journal *Pan* (1895–1900), 'a luxuriously produced publication, large in format, printed to perfection on exquisite paper . . . Its policy was one of open-mindedness and generosity, and it welcomed contributors from all over Europe' (Robert Schmutzler, *Art Nouveau*, 1977). Its prestige helped to make Berlin the most important German art centre apart from Munich. From 1895 to 1904 Meier-Graefe lived in Paris, where he ran a gallery called La Maison Moderne, which championed *Art Nouveau (the great Art Nouveau architect Henri van de *Velde designed furniture for his apartment). In this period he also founded the periodical *Dekorative Kunst* (published in Munich, 1897–1929) and a companion title in French, *L'Art décoratif* (1898–1914). Meier-Graefe's own publications were devoted mainly to French painting, and John Rewald comments that his 'numerous and enthusiastic writings on *impressionism did much to spread its fame in Germany and abroad' (*The History of Impressionism*, 1946, 4th edn., 1973). His most important work was *Die Entwicklungsgeschichte der modernen Kunst* (3 vols., 1904; translated as *Modern Art*, 1908), which Rewald describes as 'the first broadly conceived general history of modern art, assigning dominant places to van Gogh, *Cézanne, *Vuillard, *Bonnard, Lautrec, Seurat, *Signac, *neo-impressionism

in general, *Rodin, Puvis de Chavannes, Monticelli, Carrière, *Redon, *Denis, *Gauguin, etc' (*Post-Impressionism*, 1956, 3rd edn., 1978). In 1930 Meier-Graefe moved to France and he died in Switzerland. By this time he was reviled by the Nazis for his support of *degenerate art (quotations from his writings were displayed on the walls of the 'Degenerate Art' exhibition in Munich in 1937 along with those of other like-minded critics, who were pilloried along with the pictures).

Melamid, Alexander. See SOTS ART.

Meldrum, Max (1875–1955). Australian painter. He was born in Edinburgh, emigrated to Melbourne in 1889, and studied there at the National Gallery of Victoria Art School. In 1899 he won the School's travelling scholarship and went to France, where he lived for the next 12 years. He returned to Melbourne in 1911 and in 1917 established a school there at which he disseminated his highly opinionated ideas on art. These theories were also expressed in a book published in 1917—*Max Meldrum: His Art and Views*, edited by Colin Colahan. Meldrum's ideas were based on study of the Old Masters, particularly Velázquez, whom he revered above all other painters. He regarded painting as a wholly objective exercise in defining and translating optical impressions by analysing tone in a rationally ordered way: 'The careful study of undisputed art strongly leads me to the conviction that the art of painting is a pure science.' He thought that modern art, with its emphasis on colour and individual expression, spelt social decadence. Meldrum's paintings faithfully reflect his doctrines, being competently handled but singularly lacking in inspiration. In spite of his obvious limitations as an artist, his views gained many adherents in Melbourne and Sydney in the inter-war period. He was a powerful personality (Norman *Lindsay called him 'the mad Mullah') and 'inspired in his students the devotion appropriate to a Messiah. He mercilessly drilled every shred of personal vision out of them, and they loved him for it' (Robert *Hughes, *The Art of Australia*, 1970). None of his pupils gained any great distinction. Meldrum's outspokenness and dedication to his convictions often brought him into public conflict, particularly in his role as a trustee of the National Gallery of Victoria (1937–45).

Melly, George (1926–). British jazz singer, writer, broadcaster, and collector. A flamboyant personality, he has been described by Bamber Gascoigne (*Encyclopedia of Britain*, 1993) as 'something of a living art object in a wide repertoire of large and violently coloured suits'. However, he has also done serious work in art history, his writings including a monograph on Scottie *Wilson (1986). He is a noted collector of modern paintings and he helped to organize an exhibition of cartoons about modern art at the Tate Gallery, London, in 1973, entitled 'A Child of Six Could Do It'. His television appearances include chairing the Channel 4 art quiz show *Gallery* which ran for several series in the 1980s; the opposing teams were lead by Maggi *Hambling and Frank *Whitford.

Melville, Arthur. See GLASGOW BOYS.

Mendelson, Marc. See MATTERISM.

Méndez, Leopoldo. See TALLER DE GRÁFICA POPULAR.

Meninsky, Bernard (1891–1950). British painter, draughtsman, theatrical designer, and illustrator, best known as a teacher. Born in the Ukraine, he was brought to England as a baby and spent his childhood in Liverpool. From 1906 to 1910 he studied at Liverpool College of Art, where he won several awards, and in 1910–11 he spent a few months at the *Académie Julian in Paris. After a year at the *Slade School, 1912–13, he joined Gordon *Craig's theatre school in Florence as a teacher of drawing and stage design. In 1914 he returned to London and began teaching at the Central School of Arts and Crafts. During the First World War he was a clerk with the Royal Fusiliers and also worked as an *Official War Artist. In 1920 he succeeded *Sickert as teacher of life-drawing at Westminster School of Art, whilst continuing to teach part-time at the Central School. He held both these posts until 1939. During the Second World War he taught at the City of Oxford Art School, then in 1945 returned to the Central School. In the war years he had produced a series of lyrical gouaches depicting figures in landscape and these formed the basis for the oil paintings of his last years. He committed suicide. His renown as a teacher has perhaps caused his stature as an artist to be underestimated in his lifetime and since.

Menpes, Mortimer (1860–1938). British painter and graphic artist, born in Australia. He moved to England in 1879, met *Whistler the following year, and became his hero-worshipping studio assistant: 'I was almost a slave in his service, ready and only too anxious to help, and no matter in how small a way.' Like Whistler, Menpes was influenced by the art of Japan and visited the country twice; he also travelled extensively elsewhere, including South Africa, where he made illustrations of the Boer War in 1900. Menpes mainly painted landscapes and portraits. His early work was very much in Whistler's manner, but later his style became more linear and detailed. He wrote *Whistler as I Knew Him* (1904) and illustrated numerous books, including his own *War Impressions* (1901) and several travel books by his daughter Dorothy Menpes.

Mérida, Carlos (1891–1985). Guatemalan painter, active mainly in Mexico. In 1910–14 he studied in Paris under van *Dongen, meeting *Modigliani, *Picasso, and other members of the avant-garde. He returned to Guatemala in 1914 and in 1919 moved to Mexico, where he worked as *Rivera's chief assistant for several years. In 1927–9 he was again in Europe, where he became friends with *Klee and *Miró, then returned to Mexico. His early work was in a politically-conscious figurative style, but in the 1930s he was influenced by *Surrealism (he took part in the International Surrealist Exhibition in Mexico City in 1940, organized by *Breton and *Paalen), and he eventually developed a completely abstract manner. From the 1950s much of his work was done for architectural settings, and he often worked in mosaic (for example at the Municipal Palace, Guatemala City, 1956) as well as in fresco.

Merkurov, Sergei (1881–1952). Russian sculptor. He was born in Armenia, studied in Zurich and Munich, and lived in Paris for several years before settling in Moscow in 1909. His best-known works are his enormous statues of Lenin and Stalin in Moscow and elsewhere, many of them now destroyed. Most typically he worked in granite, but his largest statue of Stalin in Yerevan (1950, destroyed) was in copper. The statue itself was about 16 metres high, and Matthew Cullerne Bown (*Art*

Under Stalin, 1991) writes that 'It stood on an ornate pedestal as big as a house.' The pedestal, like those of some of the Soviet war memorials of the time, contained a museum, and Bown comments that 'It seems likely that the model which Soviet artists and architects had in mind when devising schemes of this kind was New York's Statue of Liberty (of which they were acutely aware)'. The Russian art historian Mikhail Sokolov writes that 'In spite of the pompously apologetic intention behind these official commissions, Merkurov managed to convey in them the cruel, despotic character of Stalin's rule'. From 1945 to 1950 Merkurov was director of the Pushkin Museum of Fine Arts in Moscow. See also SOCIALIST REALISM.

Merz. See SCHWITTERS.

Merz, Mario. See ARTE POVERA.

Mesens, E. L. T. (Edouard Léon Théodore) (1903–71). Belgian musician, poet, collagist, exhibition organizer, and dealer, born in Brussels. He was a talented composer in his youth, but he gave this up in 1923 to concentrate on poetry. His interest in the visual arts developed under the influence of *Duchamp and *Picabia, whom he met in Paris in 1921, and he was influenced towards *Surrealism by the paintings of de *Chirico. He became a friend and champion of *Magritte and a highly active figure in the Surrealist movement, although more as an organizer than an artist. In 1936 he was the Belgian representative on the committee of the International Surrealist Exhibition in London, and in 1938 he settled in London. He became director of the London Gallery in Cork Street, the headquarters of Surrealism in England, organizing exhibitions of the work of many European artists there (including *Ernst, *Schwitters, and *Tanguy); he also edited the gallery's publication, the *London Bulletin*, an important documentary source for the period (it ran for 20 issues, 1938–40; the first issue was called *London Gallery Bulletin*). The gallery closed during the Second World War (when Mesens worked on French broadcasts for the BBC), but it reopened in 1946 and survived into the early 1950s. Mesens then returned to Belgium. In his own work as an artist, he was best known for his collages, which he created from an assortment of materials—tickets, ribbons, pieces of paper and print, etc. He made exten-sive use of printed words to create disconcerting or amusing ambiguitities and suggested meanings, some of which might almost be regarded as anticipations of *Conceptual art.

Messagier, Jean (1920–). French painter, born in Paris, where he studied at the École des Arts Décoratifs. He is usually categorized as an exponent of *Lyrical Abstraction. His work is often inspired by his love of nature, conveying suggestions of the countryside. In keeping with a near-mystical outlook that he shares with *Tal-Coat, his paintings are intended to induce an attitude of contemplation in the viewer. He has also worked as a printmaker and sculptor.

Messel, Oliver (1904–78). British theatre, film, and interior designer, painter, and socialite, born in London, grandson of the caricaturist Edwin Linley Sambourne (1844–1910), chief cartoonist to *Punch*, 1900–10. He was educated at Eton, from which he went to the *Slade School, where he made a reputation for the head masks he designed for student parties. An exhibition of these was held in the Claridge Galleries, London, in 1925, leading to his first professional commission later that year—producing masks for *Diaghilev for a Ballets Russes production of *Zéphyr et Flore* at the London Coliseum (the sets were by Georges *Braque). After this auspicious start, his advance was rapid, and by 1932 'Messel was established as one of the foremost stage designers in Britain, and his name attached to a production had become as great a draw as that of any "star" actor or actress' (*DNB*). In 1934 he published *Stage Designs and Costumes*, his only book. Messel designed sets and costumes for works of various kinds, although generally at the lighter end of the scale, and he also worked for films, beginning with *The Scarlet Pimpernel* in 1935. His style was sophisticated and fanciful, typically with much use of white. During the Second World War he served in the army, and after the war he branched out into interior design, notably with a number of rooms and suites at the Dorchester Hotel, London, in the early 1950s. His social connections also made him sought after as a designer for lavish parties and weddings. In 1966 he retired to Barbados, intending to turn more seriously to painting, but in fact he was soon greatly in demand as a designer of gardens and houses, both on Barbados and the neighbouring island of

Mustique, a resort popular with the rich and privileged. In 1982 a large collection of Messel's work, covering virtually every production he worked on, was placed on long-term loan at the Theatre Museum, London, by his nephew Lord Snowdon (Antony Armstrong-Jones, 1930–), a photographer, designer, and documentary film-maker.

Meštrović, Ivan (1883–1962). Yugoslavian (Croatian)-born sculptor and architect who became an American citizen in 1954. He was born at Vrpolje, into a peasant family, and studied at the Academy in Vienna, 1900–4. In 1908–9 he lived in Paris, where he met *Rodin. After returning to Yugoslavia he worked in a style that was basically classical but furbished with a superficial air of modernity. He passed the First World War in Rome, Geneva, Paris, and London, where a large exhibition of his work was held at the Victoria and Albert Museum, contributing to the growth of his international reputation (he became easily his country's best-known artist). In 1919 he returned to Yugoslavia, where he was appointed a professor at the Zagreb Academy and received many public commissions, including an enormous mausoleum outside Belgrade in commemoration of the Unknown Soldier (1934), one of the many works in which he expressed his ardent patriotism. During the Second World War he had several commissions from the Vatican, and after living in Switzerland from 1943 to 1946 he settled in the USA. He was professor of sculpture at Syracuse University, New York, 1947–55, and at the University of Notre Dame, Indiana, from 1955 until his death. His work in the USA included a number of monuments. The great reputation he enjoyed in his lifetime has declined since his death, the rhetoric of his large-scale works now seeming rather ponderous; his smaller, more lyrical pieces have dated less. There are Meštrović museums at Split (his former house, which he designed himself) and Zagreb; and the church of the Holy Redeemer at Otavice is in effect another specialized collection of his work—he designed the building and created the sculptural decoration. He was highly prolific and there are other examples of his work in many major collections of modern art, including the Tate Gallery, London.

Metaphysical Painting. A style of painting invented by de *Chirico in about 1913 and practised by him, *Carrà (from 1917), *Morandi (from 1918), and a few other Italian artists (notably de *Pisis, *Sironi, and *Soffici) until about 1920. The term was coined by de Chirico and Carrà in 1917, when both were patients at a military hospital in Ferrara. Metaphysical Painting started with no inaugural programme, although attempts were later made to define a 'metaphysical aesthetic' in the periodical *Valori plastici*, which ran from 1918 to 1921, and in Carrà's book *Pittura metafisica* (1919). The meaning attached to the term 'metaphysical', which occurs in the titles of several pictures by de Chirico particularly, was never precisely formulated, but the style is characterized by images conveying a sense of mystery and hullucination. This was achieved partly by unreal perspectives and lighting, partly by the adoption of a strange iconography involving, for example, the use of tailor's dummies and statues in place of human figures, and partly by an incongruous juxtaposition of realistically depicted objects in a manner later taken over by some of the *Surrealists. But the dreamlike quality conveyed by Metaphysical painters differed from that of the Surrealists because of their concern with pictorial structure and a strongly architectural sense of repose deriving from Italian Renaissance art.

Metcalf, Willard L. See TEN.

Metelli, Orneore (1872–1939). Italy's most famous *naive painter, born at Terni in Umbria, where he was a master-shoemaker (he designed as well as made shoes and won several awards at national and international competitions). Metelli took up painting when he was 50 and often worked far into the night after a day at the shoemaker's craft (he sometimes painted a small boot or pair of boots after his signature on his canvases). His main subjects were portraits and scenes in his home town; occasionally he did copies of Old Masters.

Meteyard, Sidney Harold. See PRE-RAPHAELITISM.

Methuen, Lord (Paul Ayshford). See BATH ACADEMY OF ART.

Metzger, Gustav (1926–). German-born artist who settled in England in 1939 as a refugee from Nazism (his parents were Polish

Jews) and now calls himself stateless. From 1941 to 1944 he worked at joinery and farming, then studied art in Cambridge, Oxford, Antwerp, and London (under *Bomberg at Borough Polytechnic, 1950–3). Until 1957 he was a painter, but he had told Bomberg that he was looking for something 'extremely fast and intense' and in 1960 he began 'painting' with acid on nylon. In doing so he became one of the pioneers of *Auto-destructive art and he has devoted much of his career to demonstrating and promulgating it. He has written and lectured a good deal on the subject and in 1966 organized a Destruction in Art Symposium (DIAS) in London. Metzger was one of the 'Seven German Artists' represented at the 'Art into Society/Society into Art' exhibition staged at the Institute of Contemporary Arts, London, in 1974. In the accompanying catalogue he advocated a three-year strike by artists, claiming that if they ceased all artistic activities from 1977 to 1980, this would cripple the mechanisms for the production, distribution, and consumption of art. From 1980 he has lived mainly in Germany, Switzerland, and the Netherlands.

Metzinger, Jean (1883–1956). French painter (mainly of still-life, landscapes, and figure compositions) and writer on art. He was born in Nantes, where he studied at the Académie des Beaux-Arts, and moved to Paris after three of his paintings sold well at the *Salon des Indépendants in 1903. After passing through *Neo-Impressionist and *Fauvist phases, he became one of the earliest devotees of *Cubism and a central figure of the *Section d'Or group. He was undistinguished as a painter and is remembered mainly as the co-author with *Gleizes of the book *Du Cubisme* (1912), the first book to be published on the movement. In the year in which the book appeared, Metzinger painted a portrait of Gleizes (Museum of Art, Rhode Island School of Design, Providence). In the 1920s he turned from Cubism to a more naturalistic style, but from about 1940 he made a partial return to his earlier manner.

Meunier, Constantin (1831–1905). Belgian sculptor and painter, well known for his sincere but rather heavy-handed glorification of the nobility of labour in his treatment of such subjects as miners, factory workers, and stevedores. 'Meunier did in sculpture for the urban proletariat what Zola had done for it in litera-

ture. He may not have encompassed all the inherent possibilities of his theme, but at least he gave to proletarian society an archetype which was to be as commonly recognized as Van Dyck's characterization of the English gentleman was in the seventeenth century' (Fred Licht, *Sculpture: 19th and 20th Centuries*, 1967). In the early 20th century he had considerable influence on younger sculptors interested in *Social Realist subjects. There is a museum of his work in Brussels and his most ambitious work, the Monument to Labour (erected after his death), is in the Place de Trooz there.

Meyer, Hannes. See BAUHAUS.

Meyer, Ursula. See CONCEPTUAL ART.

Michaux, Henri (1899–1980). Belgian-born poet and painter who became a French citizen in 1955. Before settling in France in 1940 he led an adventurous life of travel. He began to write in 1922, did his first paintings in 1926, and took up art seriously in the late 1930s. Michaux was an independent figure and his work is richly imaginative and often mystical in feeling (he was deeply religious and the death of his wife in an accident in 1948 intensified his visionary bent). Like the *Surrealists, he experimented with *automatism and in the mid-1950s he began to make drawings whilst under the influence of the hallucinogenic drug mescalin to explore 'the landscapes of the mind'.

Micro-emotive art. See ARTE POVERA.

Middleditch, Edward (1923–87). British painter, born in Chelmsford. After war service (during which he was awarded the MC) he studied in London at the Regent Street Polytechnic, 1948, and the *Royal College of Art, 1948–52. His contemporaries at the RCA included Derrick *Greaves and Jack *Smith, and with these two and John *Bratby he became one of the leading representatives of the *Kitchen Sink School in the 1950s. However, Middleditch was more interested in nature than in *Social Realism (landscapes and flowers are his favourite subjects) and in the 1960s his work became increasingly abstract without completely abandoning subject-matter. He taught at various art schools, notably Norwich School of Art, where he was

head of fine art, 1964–84. From 1984 to 1986 he was keeper of the *Royal Academy Schools.

Mies van der Rohe, Ludwig. See BAUHAUS.

Miki, Tomio. See NEO-DADA ORGANIZERS.

Milioti, Nikolai and **Vasily.** See BLUE ROSE.

Millares, Manolo (or **Manuel**) (1926–72). Spanish painter, born at Las Palmas in the Canary Islands. He was self-taught as an artist. After beginning as a landscape painter he turned to *Surrealism (influenced by *Klee and *Miró) and by 1949 he was experimenting with abstraction. He first visited Spain in 1953 for the International Congress of Abstract Art at Santandar, and in 1955 he settled in Madrid. In 1957 he was a founder-member of the avant-garde group *El Paso. His paintings are highly emotional and often incorporate unusual materials—such as torn sackcloth—in the manner of *Burri or *Tàpies (*Painting 150*, Tate Gallery, London, 1961).

Miller, Godfrey (1893–1964). New Zealand-born painter who became a pioneer of abstract art in Australia. He was born in Wellington, where he trained as an architect. After serving in Egypt and Gallipoli in the First World War, he travelled widely. His intermittent training as a painter included periods of study at the *Slade School, London, between 1929 and 1938. In 1938 he returned to New Zealand, then settled in Sydney, Australia, soon afterwards. He lived a reclusive life and did not exhibit until 1952, when he was nearly 60 (he inherited a shipping fortune, and so had no need to make money from his work). His first one-man exhibition was at the Macquarie Galleries, Sydney, in 1957, and his eccentric, diffident personality helped to promote him quickly to the status of a cult figure. He painted in a semi-abstract style, with a fine grid of lines dissolving the subject into a kind of *Cubist mosaic (*Still-Life with Musical Instrument*, NG of Victoria, Melbourne, 1962).

Miller, Kenneth Hayes (1876–1952). American painter and teacher. He was born in Oneida, New York, and studied at the *Art Students League and then at the New York School of Art, where he joined the teaching staff in 1899 after returning from a trip to Europe. In 1911 he moved to the Art Students League,

teaching there intermittently until 1951. During this career of more than half a century he became one of the most renowned teachers of the day; his pupils included George *Bellows, Isabel *Bishop, Edward *Hopper, Reginald *Marsh, and George *Tooker. Miller's early paintings had been in a romantic vein, influenced by his friendship with Albert Pinkham *Ryder, but from about 1920 his work became more solid and intellectual, influenced by Renaissance figure compositions. His subjects, however, were contemporary, notably scenes of women shopping (*The Fitting Room*, Metropolitan Museum, New York, 1931), and his preference for depicting everyday New York life influenced several of his pupils. In 1923 Miller began working in a studio in 14th Street, in the heart of the city's shopping district, and some of the painters influenced by him in the interwar period are known as 'The Fourteenth Street School'. During his lifetime he was highly regarded as an artist as well as a teacher, but he was virtually forgotten after his death. Interest in him greatly revived in the 1970s.

Miller, Lee. See MAN RAY and PENROSE.

Milles, Carl (1875–1955). Sweden's most famous sculptor. He was born at Lagga, near Uppsala, and from 1892 to 1897 was apprenticed to a cabinet-maker in Stockholm, whilst also attending classes in carving and modelling. From 1897 to 1904 he lived in Paris, where he worked for a time as assistant to *Rodin, then moved to Munich (1904–6), where he was influenced by *Hildebrand. In the following two years he lived in Rome, Stockholm, and Austria, then settled at Lidingö, near Stockholm, in 1908. His travels had given him a wide knowledge of ancient, medieval, and Renaissance art, as well as of recent developments, and he forged from these varied influences an eclectic but vigorous style. He is best known for his numerous large-scale fountains, distinguished by rhythmic vitality and inventive figure types (he would fuse classical and Nordic types such as tritons and goblins), and sometimes by a grotesque humour. In 1930 he was appointed professor of modelling at the Stockholm Academy, and his growing international reputation was marked by a one-man exhibition at the Tate Gallery, London, in 1927. From 1931 to 1945 he was professor of sculpture at the Cranbrook Academy at Bloomfield Hills,

Michigan; his work in the USA includes fountains in Chicago, Kansas City, New York, and St Louis. He became an American citizen in 1945 but returned to Sweden in 1951 and died at Lidingö, where his home is now an open-air museum of his work, known as Millesgården.

Milne, David Brown (1882–1953). Canadian painter, mainly of landscape, born near Paisley, Ontario. In 1904 he gave up his job as a schoolteacher to study at the *Art Students League, New York, remaining there until 1907 whilst he supported himself with commercial work such as lettering. He continued living in the USA until 1928, first in New York (where he exhibited at the *Armory Show in 1913) and then from 1915 at Boston Corners in the Berkshire Hills in New York State. In 1918–19 he served with the Canadian army and became an *Official War Artist in Britain, France, and Belgium. After returning to Canada in 1928 he lived in seclusion in various parts of Ontario, although he was a regular visitor to Toronto. His love of solitude limited the impact he made in his lifetime, but he is now regarded as one of the finest and most individual Canadian painters of his time. He particularly admired the work of Tom *Thomson and lamented his early death by drowning: 'I rather think it would have been wiser to have taken your ten most prominent Canadians and sunk them in Canoe Lake—and saved Tom Thomson.' However, he was not interested in the aggressive nationalism of Thomson's followers in the *Group of Seven (another reason for his comparative lack of public acclaim). Rather, he was concerned with 'pure' painting. His style was vigorous and spontaneous, with a calligraphic quality in the handling. From 1937 he worked mainly in watercolour, a medium he used in an oriental-like way as a sensitive means of expressing his emotional response to nature (*Rites of Autumn*, NG, Ottawa, 1943). Late in life he also painted fantasy subjects, some of a whimsically religious nature.

Minaux, André. See HOMME-TÉMOIN.

Minimal art. A type of abstract art, particularly sculpture, characterized by extreme simplicity of form and a deliberate lack of expressive content; it emerged as a trend in the late 1950s and flourished particularly in the 1960s and 1970s. (The term was evidently first used in print by the British philosopher Richard Wollheim in an article entitled 'Minimal Art' in *Arts Magazine* in January 1965, although the American writer Barbara Rose is sometimes credited with coining it; the term 'Minimalism' had been used by David *Burliuk as early as 1929, but with a vaguer meaning, referring to 'the minimum of operating means' in John *Graham's paintings.) There are numerous precedents for the stark simplicity of Minimal art. In 1777, for example, the poet Goethe designed an Altar of Good Fortune for his garden in Weimar consisting of two utterly pure geometrical stone shapes—a sphere surmounting a cube; and in 1883 the journalist Alphonse Allais (1855–1905) created a burlesque version of minimalism when he exhibited in Paris a plain sheet of white paper with the title *First Communion of Anaemic Young Girls in the Snow* (he also produced all-black and all-red pictures with similar comic titles: *Negroes Fighting in a Cave at Night* and *Apoplectic Cardinals Harvesting Tomatoes by the Red Sea*). Such byways aside, the roots of Minimal art can be traced to the stark geometric abstractions of *Malevich and the *ready-mades of *Duchamp in the second decade of the century, and after this the idea of extreme reductivism occurred in various aspects of avant-garde art—certain sculptures of *Brancusi, for example, the *Spatialism of Lucio *Fontana, and the monochromatic canvases of Yves *Klein. As a movement, however, Minimal art developed mainly in the USA rather than Europe and its impersonality is seen as a reaction against the emotionalism of *Abstract Expressionism. Leading sculptors of the movement include Carl *Andre, Don *Judd, and Tony *Smith; leading painters (for whom the immediate precedents were *Albers and *Reinhardt) include Frank *Stella (in his early work), and *Hard-Edge abstractionists such as Ellsworth *Kelly and Kenneth *Noland.

According to *The Tate Gallery: An Illustrated Companion* (1979), 'The theory of minimalism is that without the diverting presence of "composition", and by the use of plain, often industrial materials arranged in geometrical or highly simplified configurations we may experience all the more strongly the pure qualities of colour, form, space and materials'. Minimal art has close links with *Conceptual art (Minimalist sculpture often has a strong element of theoretical demonstration about it, with the artist leaving the fabrication of the design to industrial specialists),

and there are sometimes affinities with other contemporaneous movements such as *Land art. There is even a kinship with *Pop art in a shared preference for slick, impersonal surfaces (some Minimal artists, however, have used 'natural' products such as logs rather than machine-finished products). Like Pop art, Minimal art proved a commercial success for many of its leading practitioners, and it generated a huge amount of critical commentary; sometimes it seemed that the less there was to see in a work, the more verbiage it attracted. See also PRIMARY STRUCTURES.

Minne, Georg (1866–1941). Belgian sculptor, painter, and graphic artist, born at Ghent, the son of an architect. He initially studied architecture at the Ghent Academy, then transferred to painting and sculpture. In 1886 he met the *Symbolist poet Maurice Maeterlinck and began to illustrate Symbolist books, including Maeterlink's *Serres chaudes* (1889), in a pseudo-medieval manner. Then, turning his attention increasingly to sculpture, he became one of the most successful artists in expressing Symbolist ideas in bronze and marble. His favourite theme was the kneeling adolescent. Robert *Goldwater (*Symbolism*, 1979) writes: 'Characteristically, Minne's figures are oblivious of anything but their own emotion; clasping to themselves their regretful emaciated bodies, they contemplate a world within. If Minne so often uses a kneeling posture, it is because he thus inhibits movement and implies humility in a pose at once natural and symbolic . . . the figure remains in dolorous isolation, its body an encumbrance to thought. Minne's obsession with the enervated world of the adolescent, with its overtones of mysticism and anxious sexuality, is very much of its time (*Munch especially comes to mind, and, somewhat later, *Schiele).' As the names Munch and Schiele suggest, Minne's work has links with *Expressionism, and it was influential on Expressionist sculptors such as *Lehmbruck, who admired Minne's Fountain of the Kneeling Youths (1898–1906), commissioned for the Hagen Museum and now in the Folkwang Museum, Essen. From 1898 Minne lived at *Laethem-Saint-Martin, with the exception of the years of the First World War, when he took refuge in Wales. In about 1908 he began to turn away from his Symbolist outlook, which no longer seemed viable. Thinking that he had lost touch with nature, he studied anatomy and turned to a more realistic and socially-oriented style in the manner of his countryman Constantin *Meunier. From the 1920s, by which time he was internationally famous, he did little more than re-work earlier motifs, carving in a monumental, block-like manner. However, in some of his representations of the mother and child from the late 1920s there is a note of sensuality in an *oeuvre* that was otherwise deliberately ascetic.

Minotaure. A journal of art and literature published in Paris between February 1933 and May 1939 (13 numbers appearing irregularly); it was devoted mainly to *Surrealism and constituted the movement's most important journal in this period (which may be considered its zenith), following La *Révolution surréaliste* and *Le Surréalisme au service de la révolution* and preceding *VVV. Albert *Skira was the administrative director and *Tériade was the artistic director; when Tériade left after the ninth issue (October 1936), Skira established an editorial committee that included *Breton, *Duchamp, and *Éluard. The title was suggested by André *Masson and the writer Georges Bataille (1897–1962), who at this time were, in Masson's words, 'concerned with the most mysterious of the Greek and Iranian mythologies'. For the cover of the first issue *Picasso created a collage that had at its centre a drawing of a minotaur holding a sword (MOMA, New York, 1933); among the other artists who designed covers for the journal were *Derain, *Ernst, *Magritte, and *Matisse. In keeping with such elevated company, *Minotaure* was luxuriously produced, the illustrations including original prints. Because of these high standards 'It was possible for the first time outside exhibitions and exhibition catalogues to show lavishly a full range of surrealist painting and sculpture. There was work by Ernst, *Tanguy, *Dalí, *Miró and Masson, *Arp, *Giacometti, and a number of new artists who joined the movement in the thirties: *Brauner, *Bellmer, *Paalen, *Dominguez, *Seligmann, *Cornell, *Matta . . . At the time of the International Surrealist Exhibition in London in 1936, Tériade reproduced works by the English surrealists . . . *Hayter, *Burra, *Agar, *Penrose, *Nash, *Moore. At the same time, *Minotaure* is rich in photography. *Man Ray's photographs had . . . appeared in La *Révolution surréaliste*, but they were small and ghostly, while in

Minotaure they are full, dramatic images' (catalogue of the exhibition 'Dada and Surrealism Reviewed', Hayward Gallery, London, 1978). Another eminent photographer, *Brassaï, also made a major contribution to the journal.

Minton, John (1917–57). British painter, graphic artist, and designer, born at Great Shelford, Cambridgeshire. After studying in London at St John's Wood School of Art, 1936–8, he spent a year in Paris, where he shared a studio with Michael *Ayrton (with whom he later collaborated on designs for John Gielgud's production of *Macbeth* at the Piccadilly Theatre, London, in 1942). Among the artists whose work he saw in Paris, he was particularly influenced by the brooding sadness of *Berman and *Tchelitchew. In 1941–3 he served in the Pioneer Corps, and after being releaed on medical grounds he had a studio in London at 77 Bedford Gardens (the house in which *Colquhoun, *MacBryde, and Jankel *Adler lived), 1943–6. From 1946 to 1952 he lived with Keith *Vaughan. Minton was a leading exponent of *Neo-Romanticism and an influential figure through his teaching at Camberwell School of Art (1943–7), the Central School of Arts and Crafts (1947–8), and the *Royal College of Art (1948–56): the *Phaidon Companion to Twentieth-Century Art* (1973) comments that 'His graphic and topographical mannerisms were rife in postwar British art schools, until the vogue succumbed to *Pasmore's neo-*Bauhaus and other intellectually more viable formulations'. He was extremely energetic, travelling widely and producing a large body of work as a painter (of portraits, landscapes, and figure compositions), book illustrator, and designer. After about 1950, however, his work went increasingly out of fashion. He made an effort to keep up with the times with subjects such as *The Death of James Dean* (Tate Gallery, London, 1957), but stylistically he changed little. Minton was renowned for his charm and generosity, but he was also melancholic and troubled by self-doubt. He committed suicide with an overdose of drugs.

Mir Iskusstva. See WORLD OF ART.

Mirko (Mirko Basaldella) (1910–69). Italian sculptor, born at Udine, brother of the painter *Afro and of the sculptor Dino *Basaldella. He trained at Venice, Florence, and Monza, where he was a pupil of Arturo *Martini. In the late 1940s he began to experiment with abstraction and he worked with many different materials in his search for fresh and expressive forms. He had numerous public commissions, his best-known works being bronze gates and balustrades for the Mausoleo delle Fosse Ardeatine, Rome (1949–51), a memorial to the 320 Italians executed by the Germans in 1944 in reprisal for the killing of 32 German soldiers. Their spiny, tormented forms convey 'the horror of modern extermination, perpetuating the moment of anguish rather than dealing in the facile coinage of patriotic condolence' (Fred Licht, *Sculpture: 19th and 20th Centuries*, 1967). Mirko also worked as a painter and in 1951 he did murals and mosaics for the Food and Agriculture Organization Building, Rome. In 1953 he won a second prize in the international competition for the Monument to the Unknown Political Prisoner (see BUTLER, REG) and in 1955 he was awarded the grand prize for sculpture at the São Paulo *Bienal. He moved to the USA in 1958 to teach at Harvard University.

Miró, Joan (1893–1983). Spanish painter, sculptor, graphic artist, and designer. The son of a prosperous goldsmith, he was born in Barcelona and studied there at La Lonja Academy of Fine Arts, 1907–10, and after two years working as a clerk, at an art school run in a liberal spirit by the painter Francisco Galí (1880–1965). In 1917 he met *Picabia and in 1918 he had his first one-man show (a failure) at the gallery of the Barcelona dealer José Dalmau. He first visited Paris in 1919 and from then until 1936 (when the Spanish Civil War began) his regular pattern was to spend the winter in Paris and the summer at his family's farm at Montroig, about 70 miles from Barcelona.

Miró's early paintings show the influence of various modern movements—*Fauvism, *Cubism (he was a friend of *Picasso), and *Dadaism—but he is particularly associated with the *Surrealists, whose first manifesto he signed in 1924. Throughout his life, whether his work was purely abstract or whether it retained figurative suggestions, Miró remained true to the basic Surrealist principle of releasing the creative forces of the unconscious mind from the control of logic and reason. However, even though André *Breton wrote that he was 'probably the most Surrealistic of us all', Miró stood

apart from the other members of the movement in the variety, geniality, and lack of attitudinizing in his work. Mixing abstraction, *primitivism, and elements of a personal mythology, it lies outside all classification and shows none of the superficial devices beloved of other Surrealists. One of the works in which he first displayed an unmistakable personal vision is *Harlequin's Carnival* (Albright-Knox Art Gallery, Buffalo, 1924–5), featuring a bizarre assembly of insect-like creatures dancing and making music—a scene inspired by 'my hallucinations brought on by hunger'. Much of his work has the delightful quality of playfulness seen in this picture, but he was inspired to much more sombre and even savage imagery by the Spanish Civil War, during which he designed propaganda posters for the Republicans fighting against Franco.

Miró settled in Paris in 1936 because of the Civil War, but in 1940 he returned to Spain to escape the German occupation of France and thereafter lived mainly on the island of Majorca. It was from about this time that he began to achieve international recognition, a milestone in this respect being a large retrospective exhibition devoted to him at the Museum of Modern Art, New York, in 1941. For the rest of his long life he worked with great energy in a wide variety of fields and with an unquenchable thirst for experiment. In 1944 he began making ceramics in collaboration with the potter Josep Llorens Artigas (1892–1980), and slightly later he took up sculpture, initially small-scale terracottas, but eventually large-scale pieces for casting in bronze. He visited the USA for the first time in 1947 and did a large mural for the Terrace Hilton Hotel in Cincinnati. This fulfilled his desire to communicate with a large public, and several of his major works of the 1950s were in a similar vein: a mural for Harvard University in 1950 (now replaced by a ceramic copy; the original is in MOMA, New York) and two vast ceramic wall decorations, *Wall of the Sun* and *Wall of the Moon* (installed 1958), for the Unesco Building in Paris: 'I'd like to get beyond easel painting, which in my opinion pursues a petty aim, and find ways of getting closer, in terms of painting, to the broad mass of human beings who have always been in my thoughts.' Another aspect of his desire to make his art widely accessible is his productivity as a printmaker (etchings and lithographs). He continued to explore new techniques into his old age, taking up stained-glass design when he was in his eighties.

In spite of the world-wide fame he acquired, he was a modest, retiring character, utterly devoted to his work, and in one of his rare public statements he criticized Picasso for what seemed to him like a mania for publicity. The Foundation Joan Miró was opened in 1975 on the heights of Montjuic overlooking Barcelona. It is designed both as a memorial museum housing a collection of Miró's works and as a centre of artistic activity. Other examples of his large output are in many major collections of modern art.

Miss, Mary. See LAND ART.

Mitchell, Joan (1926–92). American painter, born in Chicago, where she had her main training at the Art Institute of Chicago School, 1944–7. In 1950, after a year in Europe on a scholarship, she moved to New York. She began her career as a figurative painter, but in the early 1950s she met several leading *Abstract Expressionists and became a representative of the second generation of the movement, painting in a free, vigorous, roughly-textured style that owes much to *de Kooning in particular. Mitchell said that 'Music, poems, landscapes and dogs make me want to paint' and her work often conveys a feeling of landscape (which was her main subject in her figurative days). From 1955 she lived mainly in France and she died in Paris.

mixed media. A term used to describe works of art composed of a variety of different materials. Such works have been made since ancient times, but the term is applied particularly to modern pieces in which a range of unconventional materials is used, thereby making a succinct statement of medium (such as 'oil on canvas') impossible. Mixed media in this sense was popularized by the *Dadaists and *Surrealists, to whom the use of unconventional materials was an aspect of artistic anarchy and freedom. The terms 'composite media', 'intermedia', and 'multimedia' have sometimes been used more or less synonymously with 'mixed media', but they are more usually applied to works in which different forms of art (rather than different materials) are combined, for example *installations with *Performance art or *Video art. 'Multimedia' is now, however, used primarily in another sense, referring to the publishing

of various types of information—text, pictures, sound—on CD-ROM.

mobile. Term coined by Marcel *Duchamp in 1932 to describe the motor- or hand-powered *Kinetic sculptures of Alexander *Calder and soon extended to those he produced where the movement is caused by a combination of air currents and their own structural tension. Typically they consisted of flat metal parts suspended on wires. Jean-Paul *Sartre wrote of Calder's invention: 'A mobile does not suggest anything: it captures genuine living movements and shapes them. Mobiles have no meaning, make you think of nothing but themselves. They are, that is all; they are absolutes. There is more of the unpredictable about them than in any other human creation . . . In short, although mobiles do not seek to imitate anything . . . they are nevertheless at once lyrical inventions, technical combinations of an almost mathematical quality and sensitive symbols of Nature.' Many other sculptors (notably Lynn *Chadwick) have experimented with the genre, and mobiles have been adopted as articles of interior decoration and (on a miniature scale) as playthings for babies.

Moderna Museet (Modern Art Museum), Stockholm. The Swedish national collection of modern art. It is situated on Skeppsholmen (Ship Island), a former naval base in the centre of the city. In 1954 a large building on the island (an old drill hall, originally 18th century but much altered) was given to the Nationalmuseum to house its modern works, and this opened as the Moderna Museet in 1958. The first director was the painter Otte Sköld (1894–1958), who was also head of the Nationalmuseum. He died soon after the opening and was succeeded by Pontus *Hulten, who was director until 1974. Hulten quickly established the Moderna Museet as one of the world's leading institutions in its field, with an outstanding permanent collection and a vigorous exhibition programme. In 1966, for example, the museum was the site for Niki de *Saint Phalle's creation of her huge sculpture *Hon*, considered a pioneering work of *Environment art and *Installation art, and in 1968 a reconstruction of *Tatlin's model for the Monument to the Third International was made for an exhibition deovted to him (*Hon* no longer exists, but the Tatlin model remains in the museum's collection).

In line with the politics of Sweden at this time, the Moderna Museet expressed social democratic ideals and aimed to appeal to a broad audience, including children, for whom education programmes and workshops were devised.

The museum has a particularly strong tradition in contemporary art, but its collections and exhibitions cover the whole field of modernism (it also covers photography; the Fotografiska Museet was amalgamated into the Moderna Museet in 1974). In 1994 it moved to temporary accommodation in an old tram depot on the Birger Jarlsgatan in the north of the city whilst a new museum (designed by the Spanish architect Rafael Moneo) was built adjacent to the original (now converted into an architecture museum). The new Moderna Museet building opened in 1998. It is more than four times the size of the original building, giving it space to sustain varied programmes for temporary exhibitions, film, and video, as well as show substantial parts of the permanent collection. The director at this time was the first non-Swede to run the Moderna Museet, David Elliott (formerly director of the *Museum of Modern Art, Oxford), who took over in 1996.

modern art. An imprecise term that can be used purely chronologically to designate any art produced in present and recent times, but which is usually applied more specifically to art that is consciously in tune with the progressive attitudes and beliefs of those times—the 'spirit of the age'. In the second sense, modern art is characterized by the questioning or abandoning of traditional techniques, subjects, or ideas, and in common parlance today the phrase often suggests the kind of painting and sculpture that reactionaries (or normal people, depending on the point of view) find unintelligible or lacking in skill (an exhibition of cartoons about modern art held at the Tate Gallery, London, in 1973 was entitled 'A Child of Six Could Do It', in reference to the sort of slighting remark that is often made about such work).

There is no general agreement on when modern art can be regarded as starting. As with *contemporary art, the question is complicated by the fact that the point from which we view the issue is constantly moving forward in time, so that the term 'modern' has to be considered relatively rather than absolutely (the first citation of the phrase

'modern art' in the *Oxford English Dictionary* is from the *Art Journal* in 1849). From today's standpoint, however, the beginnings of modern art are usually placed within the period from the mid-19th century to the First World War, although some critics like to trace its antecedents and analogues further and further back (the Institute of Contemporary Arts in London opened in 1947 with an exhibition called '40 Years of Modern Art' and followed it with one entitled '40,000 Years of Modern Art'; for the earliest of all such antecedents see OBJET TROUVÉ). Three key events in French art in the mid-19th century are often taken as notional starting-points: the first occurred in 1855, when Gustave Courbet (1819–77) expressed his unconventionality and hatred of authority by organizing a pavilion of his own paintings at the Paris Universal Exhibition; the second was the Salon des Refusés in 1863, when artists whose work had been rejected by the official state Salon arranged their own show; and the third was the first *Impressionist exhibition in 1874.

Art historians who have preferred to go further back in time for their starting point include Sheldon Cheney in his book *The Story of Modern Art* (1941, revised edn., 1958) and John *Canaday in his *Mainstreams of Modern Art* (1959, 2nd edn., 1981). Cheney writes in his foreword that 'I have accepted here the broadest traditional usage of the term "modern art" as covering the course of creative invention since about 1800'. Canaday begins his first chapter with the words 'Where does modern art begin? . . . Modern art begins nowhere because it begins everywhere. It is fed by a thousand roots, from cave-paintings twenty-five thousand years old to the spectacular novelties of last week's exhibitions.' However, he chooses to begin his own account at virtually the same point as Cheney—with the generation of the French Revolution, specifically the paintings of Jacques-Louis David (1748–1825). In a more recent book with the same title as Cheney's, Norbert Lynton's *The Story of Modern Art* (1980, revised edn., 1989), the author begins his account in earnest in the 1890s, but in his opening paragraph he remarks that 'The essential change of direction had already happened in the eighteenth century'. He sums up the main elements of this change as follows: 'loss of faith in the classical tradition as the guide to excellence, abetted by the passion for historical studies which proved that tradition to be itself a complex of contradictory models; growing self-consciousness about style, compounded by the new idea that art is a matter of self-expression, the artist now being expected to find his own motivation and reveal it in the subject-matter and in the manner of his art'.

In his *Modern European Art* (1972), Alan *Bowness presents a well-argued case for regarding 1863 as 'the most convenient date from which to begin any history of modern painting', considering the question as much in terms of the growing independence of artists as in terms of style. He sees the Salon des Refusés as an event of far-reaching importance, partly because of the way in which 'it undermined the prestige of the Salon, in the eyes both of the public and of the artists. It is hard now to appreciate the dominant role played in the mid-19th century by the Paris Salon, or the Royal Academy in England, or similar bodies elsewhere. Their large mixed annual exhibitions provided the normal channel for the public exposure of artists' works. There were no alternatives, and for an artist to say he was not going to exhibit at the Salon was rather like an artist today saying he does not believe in selling his work, or would have nothing to do with museums. But after the Salon des Refusés the situation was never the same. Artists began to arrange their own exhibitions, as the Impressionists, for example, did in 1874; and, more significantly, the activities of the art dealers increased rapidly in importance. Very quickly there emerged the pattern familiar in advanced capitalist countries today, where the dealer acts as the artist's agent, administering his business affairs, and organizing the public exhibition of his work.' Bowness also considers that Edouard Manet (1832–83), the most discussed artist at the Salon des Refusés, was 'thinking in a new way about art—a way, moreover, which is recognizably modern'. This modernity lies in the self-awareness of his pictures, which often seem to be more concerned with the act of painting than with the ostensible subject. It is their freedom from the traditional literary, anecdotal, or moralistic associations of painting that has caused him to be regarded as one of the pioneers of modern art.

Roger *Fry recognized the great importance of Manet when he gave the title 'Manet and the *Post-Impressionists' to the landmark exhibition he organized in London in 1910. To many critics, the Post-Impressionists provide

as good a starting-point as any for indicating the beginnings of modern art, for it was they and other artists of their generation who first seriously undermined the traditional assumption that painting and sculpture were concerned with recognizably representing natural appearances (the *Museum of Modern Art, New York, implicitly supports this view, for its collections go back to about 1880, as do the beginnings of Post-Impressionism). However, it was not until the early 20th century that the idea of art as the imitation of nature was completely overthrown, so critics who regard this factor as an essential component of modern art prefer to place its origins in the extraordinarily fertile period from about 1905 up to the outbreak of the First World War in 1914. This decade saw the birth of a number of radical 'isms', notably *Cubism, *Expressionism, and *Fauvism, in which natural appearances were distorted beyond anything that had been seen in the 19th century, and also the development of *abstract art, in which representation was abandoned altogether. Soon afterwards, in 1915, there was born another radical movement, *Dada, that went beyond stylistic innovation and began questioning the nature and validity of art. This type of questioning has become one of the keynotes of avant-garde art in the 20th century, and many critics therefore see the ten-year span from 1905 (the debut of Fauvism) to 1915 (the first stirrings of Dada) as the period in which the foundations of modern art—as the term is now understood—were laid. Kurt Rowland, for example, writes: 'The first quarter of the twentieth century witnessed an artistic revolution without equal in the history of art. In an unbelievably short time many new ideas and styles were originated and followed to their conclusion so that the succeeding generation found it difficult to make any significant additions to them. The years leading up to the First World War may be described as the most explosive: even a perfunctory look at the works of this period confirms that the principles of modern art, architecture and design—and therefore the manner in which today we experience and approach our environment—were laid down before 1914' (*A History of the Modern Movement: Art, Architecture, Design*, 1973).

Modern Art Association. See CONTEMPORARY ART SOCIETY.

Moderne Kunstkring (Dutch: 'Modern Art Circle'). A society of Dutch artists founded in 1910 by the painter and critic Conrad Kikkert (1882–1965) with the aim of bringing modern developments from Paris (where Kikkert had recently settled) to the Netherlands. It held its first exhibition in 1911 at the *Stedelijk Museum in Amsterdam, the artists represented including *Braque, *Cézanne (with no fewer than 28 works), and *Picasso. *Mondrian, who also exhibited, was so impressed by what he saw (including the first *Cubist pictures publicly exhibited in the Netherlands) that he moved to Paris soon afterwards. The other Dutch artists who took part in the exhibition included Kees van *Dongen (who had lived in Paris since 1899), Leo *Gestel, and Jan *Sluyters. The society held comparably impressive exhibitions in 1912 and 1913 (the latter including more than a dozen works each by *Kandinsky and *Marc), but its activities were ended by the First World War. Theo van *Doesburg acknowledged the important role the Moderne Kunstkring played in introducing abstract art to the Netherlands, and De *Stijl was in a sense its successor.

modernism. An imprecise term, defined in the *Oxford English Dictionary* as 'the methods, style, or attitude of modern artists, specifically a style of painting in which the artist deliberately breaks away from classical and traditional methods of expression; hence, a similar style or movement in architecture, literature, music etc.' John A. Walker (*Glossary of Art, Architecture and Design Since 1945*, 1973, 3rd edn., 1992) regards modernism as 'the ideological basis of *modern art', but Charles Harrison and Paul Wood (*Art in Theory 1900–1990*, 1992) write that 'modern art cannot simply be equated with Modernism. Rather, Modernism stands on the one hand for a cluster of notionally independent values associated with the practice of modern art and on the other for a particular form of critical *representation* of the modern in art—a representation in which the pursuit of art's moral independence is taken to be decisive.'

The 'cluster of values' to which Harrison and Wood refer are largely concerned with ideas of change and progress, and historians and critics have devoted a good deal of time to discussing where to locate the changes of attitude, style, and technique that brought about an outlook that can be called modernist. Arnold Hauser (1892–1978), a Hungarian-

born British-naturalized art historian, placed the origins of the 'modern temper in art' as early as the 16th century. In his book *Mannerism: The Crisis of the Renaissance and the Origin of Modern Art* (2 vols., 1965), Hauser defined 'modern' art in terms of self-consciousness, and in accordance with his Marxist views he related this to a crisis resulting from the beginnings of modern capitalism. It is more usual, however, to locate the origins of modernism in the Paris of the mid-19th century, and the idea that art must change because the experience of life itself changes is often specifically traced to the poet and critic Charles Baudelaire (1821–67). Baudelaire believed that 'absolute and eternal beauty does not exist' and promoted the idea of an art that portrays modern life; he was a friend of Edouard Manet, whose pictures are often regarded as central works in the tradition of modernism because they marked the beginning of a trend for avant-garde painting to become increasingly preoccupied with the visual and material facts of the medium for their own sake. Mid-19th-century Paris also witnessed a decisive breaking of the monopoly of state-sponsored exhibitions, and such affirmation of the artist's liberty and individuality has been seen as an important strand in modernism. This 'freedom', however, is dependent on a shift from the patronage of state institutions to that of a private art market based on the promotion of a relatively small number of 'stars', so the much-prized individuality is as rooted in economic factors as the art of the past.

The 'particular form of critical *representation*' mentioned by Harrison and Wood is associated above all with Clement *Greenberg; indeed they say his name is 'virtually synonymous with Modernist criticism'. Greenberg saw modernism as a continuous, self-critical tradition concerned with 'purely optical experience' (see MODERNIST PAINTING), beginning with Manet and virtually ignoring any art produced outside Paris and New York. He wrote that 'Modernism has never meant anything like a break with the past ... Modernist art develops out of the past without gap or break.' The modern work that did not fit into his critical scheme—for example *Kinetic art and *Pop art—he dismissed as 'novelty art'. Greenberg's contemporary and rival Harold *Rosenberg was very different in outlook; for him modernism was more a set of disruptions than a continuous process, his

notion of persistent experimentalism being reflected in the title of his book *The Tradition of the New* (1959). Rosenberg's views have been shared by other critics and historians who admire modern art at its most politically subversive, for example in *Dada.

For those who accept Greenberg's formulation, it is possible to regard modernism as having come to an end in the extreme reductivism of *Minimal art. The reactions against such austerity are one aspect of *Postmodernism.

Modernismus. A term adopted into English from German by the architect and writer Sir Reginald Blomfield (1856–1942) as a synonym for *modernism or more specifically to characterize what he regarded as the unacceptable face of modernism—'a revolt against the past ... in blind ignorance of the accumulated experience of man'. Blomfield used the term as the title of a book, *Modernismus* (1934), in which he wrote that 'Since the war, Modernism, or "Modernismus", as it should be called on the German precedent, has invaded this country like an epidemic'. In 1935 he had a radio discussion of the subject with Eric *Newton, which was published in the *Listener* and reprinted as a chapter in the Penguin book *Art in England* (1938), edited by R. S. Lambert. In this discussion Blomfield said: 'I discriminate between what I have attacked as Modernismus and the true and right Modernism ... The people I am up against are the deliberate extremists, who pose as the creators of methods of presentation which were never dreamt of in the past ... of these men I say that they are either incompetent or are endeavouring to bluff the public ... I attribute Modernismus ... to the lack of intellectual discipline in the generation that has grown up since the War. It is impatient of restraint, and nurses the vain idea that the world can start all over again and that the Modernismist can start it ... It is not Modernism that is wrong, but its misuse and perversion.' Blomfield's biographer Richard A. Fellowes writes that his 'merciless and indiscriminate attack on the Modern Movement ... alienated virtually the whole of the succeeding generation', but the term he introduced was occasionally used by later writers, sometimes facetiously; in 1948 Wyndham *Lewis referred to T. S. Eliot's *The Waste Land* as a 'bit of modernismus'.

Modernist Painting. A term used by Clement *Greenberg to describe what he regarded as

the mainstream of painting since Manet—painting that openly acknowledges its physical nature as a flat surface. Greenberg discussed the term in his essay 'Modernist Painting', first published in 1960 and frequently reprinted. He writes: 'Realistic, illusionist art had dissembled the medium, using art to conceal art. Modernism used art to call attention to it. The limitations that constitute the medium of painting—the flat surface, the shape of the support, the properties of pigment—were treated by the Old Masters as negative factors that could be acknowledged only implicitly or indirectly. Modernist painting has come to regard these same limitations as positive factors that are to be acknowledged openly. Manet's paintings became the first Modernist ones by virtue of the frankness with which they declared the surfaces on which they were painted . . . Whereas one tends to see what is *in* an Old Master before seeing it as a picture, one sees a Modernist painting as a picture first. This is, of course, the best way of seeing any kind of picture, Old Master or Modernist, but Modernism imposes it as the only and necessary way, and Modernism's success in doing so is a success of self-criticism.' In *Art in Theory 1900–1990* (1992), Charles Harrison and Paul Wood write that 'More than any other single text in English, this essay has come to typify the *Modernist critical position on the visual arts . . . At the time of its publication Greenberg was closely engaged with the painters Morris *Louis and Kenneth *Noland, whose form of abstract painting he was soon to label "*Post-Painterly Abstraction". The essay can be read as a form of response to this work . . . and as preparing a position for it as the most advanced outcome of an unquestionable historical development.'

Modern Movement. A term that in the 20th century has sometimes been used more or less as a synonym for *modern art or for *modernism, but which is generally used to refer primarily to architecture and design rather than to painting and sculpture. R. H *Wilenski's book *The Modern Movement in Art* (1927) is about painting and sculpture; Nikolaus Pevsner's *Pioneers of the Modern Movement* (1936) is mainly about architecture and design (although it has a chapter on painting) and was retitled *Pioneers of Modern Design* for its third edition in 1960; Kurt Rowland's *A History of the Modern Movement* (1973) is, as the subtitle

states, about 'Art, Architecture, Design'. In architecture the term is particularly equated with the style known as 'International Modern' (or 'International Style'). Characterized by rationality and clarity of design, clean lines, generally cubic shapes, and a conscious renunciation of all historical references, this style was dominant among progressive architects in the period between the two world wars. Leading exponents included *Gropius, *Le Corbusier, and Mies van der Rohe (see BAUHAUS), and the style also influenced certain aspects of the work of Frank Lloyd Wright (1867–1959), the most illustrious American architect of his time. These four are generally regarded as the greatest architects of the 20th century, which is an indication of the central importance of the International Modern Style. It continued to flourish after the Second World War, but its dominance was challenged in the 1950s by a rougher and more expressive style called Brutalism and in the 1960s and 1970s by the eclecticism of *Postmodernism and the 'structural exhibitionism' of High Tech (see POMPIDOU CENTRE).

Modern Painters. A quarterly art journal founded in London by the critic Peter *Fuller in 1988; the title is a reference to a work by the Victorian writer John Ruskin, and the journal aimed to stir appreciation of British artists who maintained traditional skills in drawing and painting—Lucian *Freud and Graham *Sutherland for example. At the same time, it launched an assault on various institutions and organizations (including 'most of the existing art magazines') for promoting 'a tacky preference for the novel and the fashionable'—*Gilbert & George and Julian *Schnabel were among the stars of the avant-garde who were attacked in the first issue. After Fuller's death in 1990 the journal became less doctrinaire. Among its well-known contributors are Brian *Sewell; Sister Wendy Beckett (1930–), a nun who presents television programmes on art and tends to be loved by the public and derided by the critics; and the rock singer David Bowie (1947–), who is also an actor (he appeared as Andy *Warhol in Julian Schnabel's film *Basquiat*), painter, sculptor, collector of 20th-century art, and publisher of art books through his company 21 ('It's called 21 for the 21st century', he says). His first contribution to *Modern Painters* was a long interview with *Balthus, published in 1994; the first book published by his company

was Matthew Collings's *Blimey! From Bohemia to Britpop: The London Artworld from Francis Bacon to Damien Hirst* (1997).

Modersohn-Becker, Paula (1876–1907). German painter, born Paula Becker into a cultured middle-class family in Dresden. From an early age it was her ambition to be an artist, but her family persuaded her to qualify as a teacher before they supported her artistic career. Her training in art included lessons in London (where she stayed with relatives in 1892), Bremen (where she did her teacher training, 1893–5), and Berlin (at the School of Art for Women, 1896–8). In 1898 she joined the artists' colony at *Worpswede, and in 1901 she married Otto Modersohn (1865–1943), another member of the group. Her early work—mainly landscapes and scenes of peasant life—was in the lyrical, rather sentimental manner associated with Worpswede at this time, but in a career that lasted less than a decade she developed a massively powerful style through which she expressed a highly personal vision of the world. This development was influenced by four visits she made to Paris between 1900 and her early death in 1907. The work of *Gauguin and van Gogh in particular helped her to find the 'great simplicity of form' for which she had been searching, and in her mature work she concentrated on single figures, including self-portraits and portraits of peasants. She also did some impressive still-lifes. In her self-portraits she typically shows herself with wide, staring eyes and often in the nude. Although she had a weak physical constitution, she worked with great discipline and perseverance, producing about 650 paintings in in her short career, as well as many drawings and a few etchings. She died of a heart attack three weeks after giving birth to her first child. She was little known at the time of her death, but is now regarded as one of the outstanding German artists of her time. Her symbolic use of colour and pattern, her subjective outlook (she wrote that 'the principal thing is my personal feeling') and the almost primitive force of some of her work give her a place among the most important precursors of *Expressionism.

Modigliani, Amedeo (1884–1920). Italian painter, sculptor, and draughtsman, active in France from 1906, one of the legendary figures of modern art. He was born in Leghorn (Livorno) into a Jewish merchant family. Serious childhood illness (pleurisy and typhus) prevented him from following a normal education, but in 1898 he began studying with a local landscape painter; after a brief stay in Florence in 1902, he moved to Venice, where he continued his studies at the Institute of Fine Arts. He stayed in Venice until 1906, when he settled in Paris; apart from visits to his family in Italy and a year spent in Nice and Cagnes, 1918–19, this was his home for the rest of his life, and he became a familiar figure in the café and night life of Montmartre.

Although virtually his whole career was spent in France (little survives of his early work), Modigliani laid the foundations of his style in Italy with his studies of the Renaissance masters. In particular, he is often seen as a spiritual heir of Botticelli because of the linear grace of his work. His early paintings in Paris show numerous other influences, including *Gauguin, the *Fauves, and then *Cézanne (like many other artists, Modigliani was enormously impressed by his memorial exhibition at the Salon d'Automne in 1907). In 1909, however, he met *Brancusi and under his influence devoted himself mainly to stone carving until 1915, when the war made it impossible for him to get materials (his delicate health in any case made sculpture increasingly difficult, especially as the stone dust aggravated his illness). He therefore returned to painting, and his finest and most characteristic works were produced in the last five years of his short life. Both as a sculptor and as a painter his range was limited. With few exceptions, his sculptures are heads or crouching caryatid figures and his paintings are portraits or female nudes. His portraits include many of his artist friends, such as *Juan Gris* (Metropolitan Museum, New York, 1915) and *Jacques Lipchitz* (Art Institute, Chicago, 1916). Common to virtually all his work are extremely elongated, simplified forms and a superb sense of rhythmic vitality, but there is a great difference in mood between, for example, his sculpted heads (*Head*, Tate Gallery, London, c. 1911–12), which have the primitive power of the African masks that inspired them, and his gloriously sensual nudes (*Reclining Nude*, MOMA, New York, c. 1919), which were censured for their open eroticism (an exhibition of them at the Galerie Berthe Weill, Paris, in 1917 was closed by the police).

Modigliani's early death from tuberculosis was hastened by his notoriously dissolute

lifestyle, and his mistress Jeanne Hébuterne, pregnant with their second child, committed suicide the day after he died. He had exhibited little during his lifetime, although from 1916 the Polish-born dealer Léopold Zborowski (1889–1932) supported him with regular payments. His posthumous fame was established by an exhibition at the Galerie *Bernheim-Jeune, Paris, in 1922 and a biography by André *Salmon in 1926—*Modigliani, sa vie et son oeuvre*. His position as one of the outstandingly original artists of his time is now secure, but his fame rests even more on his reputation as a bohemian artist *par excellence*: in the popular imagination he is the archetypal romantic genius, starving in a garret, addicted to drugs and alcohol, an inveterate womanizer, but painting and carving obsessively.

Moffat, Sandy. See GLASGOW SCHOOL.

Moholy-Nagy, László (1895–1946). Hungarian-born painter, sculptor, designer, photographer, experimental artist, and writer who became an American citizen in 1944. He was born in Bácsborsod and studied law at Budapest University before serving in the Austro-Hungarian army in the First World War. He took up art in 1917 whilst recovering from a wound and was completely self-taught in his wide range of skills. By temperament he was an engineer and his approach to art was methodical and rational; he even gave his works pseudo-scientific titles consisting of combinations of letters and numbers, such as *K VII* (Tate Gallery, London, 1922), the 'K' standing for 'Konstruction'. In 1919 he moved to Vienna and then in 1921 to Berlin, where he painted abstract pictures influenced by *Lissitzky (himself recently arrived from Russia). He also experimented with *collage, photograms (see SCHAD), and *photomontage, and in 1922 had his first one-man exhibition at the *Sturm Gallery. From 1923 to 1928 he taught at the *Bauhaus, taking over from *Itten the running of the preliminary course. Frank Whitford (*Bauhaus*, 1984) emphasizes the difference in approach between these two highly distinctive characters: 'Even Moholy's appearance proclaimed his artistic sympathies. Itten had worn something like a monk's habit and had kept his head immaculately shaved with the intention of creating an aura of spirituality and communion with the transcendental. Moholy sported the kind of overall worn by workers in modern industry. His nickel-rimmed spectacles contributed further to an image of sobriety and calculation belonging to a man mistrustful of the emotions, more at ease among machines than human beings.'

As well as directing the preliminary course, Moholy was also co-editor, with *Gropius, of the Bauhaus publications. The substance of his teaching was summed up in his book *Von Material zu Architektur* (1929), translated as *The New Vision, from Material to Architecture* (New York, 1932). Although he was regarded as a brilliant teacher, his assertiveness and rejection of a spiritual dimension in art made him unpopular with some of his colleagues. He resigned when Hannes Meyer replaced Gropius as director in 1928, then worked for some years in Berlin, chiefly on stage design and experimental film. In 1934 he left Germany because of the Nazis, moving to Amsterdam and then in 1935 to London, where he worked on designs for the science fiction film *Things to Come* (1936), produced by his fellow-Hungarian Alexander Korda, and contributed to the *Constructivist review *Circle* (1937). In 1937 he emigrated to Chicago, where he became director of the short-lived New Bauhaus (1937–8), then founded his own School of Design (1939; it changed its name to the Institute of Design in 1944), directing it until his death.

Moholy was one of the most inventive and versatile of Constructivist artists, pioneering especially in his use of light, movement (see KINETIC ART), photography, and plastic materials, and he was one of the most influential teachers of the 20th century. He was an emphatic advocate of the Constructivist doctrine that so-called fine art must be integrated with society as a whole. His views were most fully expressed in his posthumously published book *Vision in Motion* (1947), but even at the outset of his career his utilitarian outlook had been clear: 'My conscience asks unceasingly: is it right to become a painter at a time of social upheaval?', he wrote in his diary in 1919. 'During the last hundred years art and life have had nothing in common. The personal indulgence of creating art has contributed nothing to the happiness of the masses.'

His wife, the Czech-born **Lucia Moholy**, née Schulz (1894–1989), was a photographer and writer on photography. The couple married in 1921 and divorced in 1934. In that year

Lucia settled in England and she became a British citizen in 1947. She is perhaps best-known for her book *A Hundred Years of Photography: 1839–1939* (1939), commissioned by the recently founded Penguin Books. This was the first general history of photography to be published in English and was an enormous success, selling 40,000 copies in two years.

Moilliet, Louis (1880–1962). Swiss painter and designer of stained glass. He was born in Berne, where he was a schoolfriend of Paul *Klee, and studied in *Worpswede, Weimar, and Stuttgart. In 1911 he introduced Klee to the *Blaue Reiter circle, and in 1914 he visited Tunisia with Klee and *Macke. He spent the First World War in Switzerland, after which he travelled extensively, especially in the Mediterranean. As a painter he worked mainly in watercolour in a style influenced by *Orphism. The same feeling for colour comes out in the stained-glass windows he designed for Swiss churches, notably the Lucaskirche at Lucerne (1934–6) and the Zwinglikirche at Winterthur (1943–4). His work is well represented in Swiss museums.

Moira, Gerald. See ROYAL COLLEGE OF ART.

Molinari, Guido (1933–). Canadian painter, sculptor, and writer, one of his country's leading abstract artists. He was born in Montreal, where he studied at the École des Beaux-Arts, 1948–51, and the Musée des Beaux-Arts, 1951. From the beginning of his career Molinari was devoted to abstract art with rigorous seriousness and from 1955 to 1957, while still in his early 20s, he ran Galerie l'Actuelle, a small avant-garde showplace in Montreal for non-figurative art. In his very early work he experimented with *automatism, but by 1956 (when he held a one-man show at his own gallery) his paintings consisted of simple arrangements of black straight-edged forms on white (*Black Angle*, NG of Canada, Ottawa, 1956). Such works were influenced by the formal purity of Les *Plasticiens, but Dennis Reid (*A Concise History of Canadian Painting*, 1973) writes that they are 'much more economical and finally more emotionally satisfying than anything the Plasticiens were ever able to achieve'. In the early 1960s Molinari began using vertical bands of colour and from 1963 he made the bands of equal width. This 'stripe' format brought his work within the orbit of *Op art and he was represented at the

exhibition that more than any other established the movement—'The Responsive Eye' at the Museum of Modern Art, New York, in 1965. After this Molinari began to experiment with geometric divisions of the canvas, for example into chequer-board patterns. He has also made sculpture and has written a good deal on art, including articles in the magazine *Situations*, which he helped to found in 1959. A collection of his writings, *Écrits sur l'art (1954–1975)*, was published in Ottawa in 1976. In the same year the National Gallery of Canada organized a major retrospective that was shown in Ottawa, Montreal, Toronto, and Vancouver. Some of his later paintings are virtually monochromatic.

Moll, Oskar (1875–1947). German painter. He was born in Brieg (now Brzeg, Poland) and trained in Berlin under Lovis *Corinth. His early works were *Impressionist in style, but from 1907 up to the outbreak of the First World War he made several visits to Paris and came under the influence of the *Fauvist work of *Matisse, of which he made a fine collection. In response to Fauvism, he painted landscapes, interiors, and still-lifes in a cultured, decorative style—less intense in colour and feeling than his French models. In 1918 he was a founding member of the Berlin *Novembergruppe and in the same year he joined the staff of the Breslau Academy of Art, of which he was made director in 1926. Several distinguished artists, including Otto *Müller and Oskar *Schlemmer, came to teach there at his invitation. In 1934 Moll was dismissed from his post by the Nazis as a *degenerate artist and settled in Berlin. Much of his work was destroyed during the Second World War. His wife **Margarete** ('Greta') **Moll** (1884–1977) was a sculptor and painter. A portrait of her by Matisse (1908) is in the National Gallery, London.

Molvig, Jon (1923–70). Australian painter. He was born in Newcastle, New South Wales, the son of a Norwegian immigrant steel worker, and after army service in the Second World War he studied at East Sydney Technical College. From 1949 to 1953 he lived in Europe, then settled in Brisbane. In the 1950s his style was predominantly *Expressionist, marked by brilliant but often subtle colouring (he is widely regarded as one of the finest colourists in Australian art). His subjects included portraits, figure compositions, and landscapes.

In 1961 his style changed abruptly, as he turned to semi-abstraction with totemic imagery; he abandoned oils for synthetic resins, burning them with a blowtorch to produce a heavy, pitted surface. In *The Art of Australia* (1970) Robert *Hughes describes Molvig as 'a wildly eclectic painter . . . his work has been criticized for its lack of consistency: but it is the restlessness of a strong vision . . . the energy of his imagination proved to be a rallying-point for younger artists in Brisbane in the early sixties, such as Andrew Sibley [1933–].'

Mondrian, Piet (originally Pieter Mondriaan) (1872–1944). Dutch painter, one of the most important figures in the development of *abstract art. He was born in Amersfoort, near Utrecht; his father (a strict Calvinist schoolteacher, described by a friend of Mondrian as 'sententious, forbidding, and frankly disagreeable') was an amateur artist and his uncle was a professional painter. Between 1892 and 1897 he studied intermittently at the Amsterdam Academy and his initial progress was slow (he was unsure of his vocation and for a time considered becoming a minister of religion). His early paintings were naturalistic and direct, often delicate in colour, though greys and dark greens predominated (*Mill by the Water*, MOMA, New York, c. 1905). Between 1907 and 1910 his work took on a *Symbolist character, partly under the influence of Jan *Toorop and perhaps partly because of his conversion to Theosophy (he joined the Dutch Theosophical Society in 1909), and he also experimented with a kind of loose *Neo-Impressionist technique, using large blobs (rather than small dots) of pure colour (CHURCH AT ZOUTELANDE, Tate Gallery, London, 1910). At the beginning of 1912 he moved to Paris, where he initially lived in the studio of his countryman Conrad Kikkert (see MODERNE KUNSTKRING). He divided his time between Paris and the Netherlands until the outbreak of the First World War in 1914 made it impossible to continue working in France. In this period he was strongly influenced by *Cubism, painting a series of pictures on the theme of a tree in which the image became progressively more fragmented and abstract (*Flowering Apple Tree*, Gemeente Museum, The Hague, 1912). By 1914 he had virtually eliminated curved lines from his work, using a structure that was predominantly horizontal and vertical, with the merest suggestion of natural forms underlying the patterning.

During the First World War Mondrian worked mainly at Laren, near Amsterdam. This was a place much favoured by intellectuals and provided a sympathetic climate in which to develop his ideas about abstract art. In 1915 he met Theo van *Doesburg, and two years later he joined him in founding the association De *Stijl; it promoted a new kind of rigorously geometrical abstract painting of which Mondrian became the main exponent. In this style, which he named *Neo-Plasticism, he limited himself to straight lines and basic colours to create an art of great clarity and discipline that he thought reflected the laws of the universe, revealing immutable realities behind the ever-changing appearances of the world. Typically he used a bold grid of black lines (all completely straight and either strictly horizontal or strictly vertical) to form an asymmetrical network of rectangles of various sizes that were painted with a narrow range of colours (the three primaries—blue, red, and yellow—plus black, white, and initially grey, although this was later dropped). At first his work was very similar to van Doesburg's, but by about 1920 the two men had begun to develop separately (see ELEMENTARISM). Mondrian gradually refined his methods until by about 1925 he used his simple repertoire to achieve a sense of taut balance and poise that none of his imitators could match. A good example is *Composition in Yellow and Blue* (Boymans Museum, Rotterdam, 1929), of which George Heard *Hamilton writes: 'Five lines of slightly varying thickness intersect to create six rectangles, all of different sizes, four white, one yellow, and one blue. The means could scarcely be "purer", nor the result more "complete". There is no conventional balance or symmetry, but the elements of line, shape, and colour are disposed on the flat surface so that each is held in subtle but inescapable relation to every other . . . His compositions . . . have no centre, no focus, and their tensions are so distributed across the entire surface that each square inch is essential to the whole.'

From 1919 to 1938 Mondrian lived in Paris, where in 1931 he joined the *Abstraction-Création group. For many years he had struggled to earn a living (sometimes producing watercolours of flowers to make ends meet), but in the 1920s he gradually became known to an international circle of admirers, his patrons including the American Katherine *Dreier (from 1926). A retrospective

exhibition of his work was organized at the Stedelijk Museum, Amsterdam, in 1922 to mark his 50th birthday, an indication of the esteem he enjoyed among the avant-garde in his own country. In 1938 he left Paris because of the threat of war and for the next two years lived in London, near Naum *Gabo and Ben *Nicholson (who had encouraged him to move). After the house next door to his studio was hit by a bomb, he moved to New York in 1940 and spent his remaining years there, adapting well to his new home even though he was now almost 70. In America he developed a more colourful style (he dispensed with the black grid), with syncopated rhythms that reflect his interest in jazz and dancing (*Broadway Boogie-Woogie*, MOMA, New York, 1942-3); he was noted for his immaculate tidiness and rather ascetic, priestly air (Ben Nicholson compared his studio to a hermit's cave), but he had a passion for social dancing and took lessons in fashionable steps. John Milner (*Mondrian*, 1992) writes: 'Even in middle age, when he was already enjoying some celebrity, his studio was stark and denuded of all but the most necessary comforts. His only indulgence was a gramophone. Some of his furniture was constructed from wooden boxes ... He had no wife, no children, to enrich and complicate the simplicity of his daily life, to impose upon him or to upset the stillness of the studio where he lived and found the real measure of his world . . . He rarely smiled for photographs, appearing reserved, austere, preoccupied and a little awkward in company ... [but] he was welcoming and helpful to visitors.'

Mondrian's enormous influence was not limited to artists whose styles and aesthetic outlooks were similar to his own. He also had a powerful impact on much industrial, decorative, and advertisement art from the 1930s onwards; indeed Ian Dunlop writes that 'it is no exaggeration to say that his effect on the look and style of contemporary life has been greater than that of any modern artist, even of such supreme masters as *Matisse and *Picasso' (*Piet Mondrian*, 1967). His influence was spread by his writings as well as his paintings. Apart from numerous articles in the periodical *De Stijl*, he wrote the book *Néo-plasticisme* (Paris, 1920), which was published by the *Bauhaus in German translation as *Neue Gestaltung* (1924), and the essay 'Plastic Art and Pure Plastic Art', published in *Circle* (1937). *Piet Mondrian: Plastic Art and Pure Plastic*

Art, 1937, and Other Essays, 1941-43, was published in New York in 1945; *The New Art—The New Life: The Collected Writings of Piet Mondrian* in London in 1987.

Monet, Claude (1840-1926). French *Impressionist painter. He is regarded as the archetypal Impressionist in that his devotion to the ideals of the movement was unwavering throughout his long career, and it is fitting that one of his pictures—*Impression: Sunrise* (Musée Marmottan, Paris, 1872)—gave the movement its name. Early in his career he often endured great poverty, but he began to prosper in the 1880s and by 1890 was successful enough to buy the house at Giverny (about 40 miles from Paris) where he had lived since 1883. From 1890 he concentrated on series of pictures in which he painted the same subject at different times of the day and in different lights—*Haystacks* or *Grainstacks* (1890-1) and *Rouen Cathedral* (1891-5) are the best known, but he also did many pictures of the Thames, for example, during three visits to London between 1899 and 1904 (he stayed at the Savoy Hotel, from which he had a good view of the river). In 1904 he exhibited 37 views of the Thames at *Durand-Ruel's gallery in Paris, including 18 of Waterloo Bridge. In addition to his trips to London, Monet visited Venice several times during his later years and also went to Norway (as a guest of Queen Christiana). However, his attention was focused increasingly on the celebrated water-garden that he created at Giverny, which served as the theme for his series of paintings on *Waterlilies* (*Nymphéas*) that began in 1899 and grew to dominate his work completely (in 1914-16 he had a special studio built in the grounds of his house so he could work on the huge canvases). In his final years he was troubled by failing eyesight (he had a cataract operation in 1923), but he painted until the end, completing a great decorative scheme of waterlily paintings that he donated to the nation in 1926, the year of his death. They were installed in the Orangerie, Paris, in 1927.

Apart from the relatively minor figure of Armand *Guillaumin (who died the year after him), Monet was the last survivor of the group who had exhibited in the first Impressionist exhibition in 1874, and in his later years he was the Grand Old Man of French painting, the friend of the Prime Minister Georges Clemenceau and other notables. As a central figure of Impressionism, he exerted a huge

influence on late 19th-century art, and it is sometimes claimed that the almost abstract forms of his final waterlily paintings influenced later art. Certainly there is a resemblance between Monet's late works and some forms of abstraction, which has long been noted; *Kandinsky seems to have been aware of the abstract suggestions of Monet's work as early as 1895, and in 1937 Meyer *Schapiro referred to 'the Water Lilies, with their remarkable spatial forms, related in some way to contemporary abstract art', but he was not specific about which contemporary art he had in mind. Often a kinship is pointed out between Monet's shimmering visions and *all-over treatment of certain *Abstract Expressionist paintings, particularly those of Jackson *Pollock. However, Irving Sandler considers the resemblance fortuitous: 'The influence of Impressionism on Pollock is problematic. It is true that the "drip" pictures resemble Monet's *Nymphéas*, yet Pollock did not see any of Monet's late canvases, except perhaps in reproduction, and Impressionism was not seriously or sympathetically considered by advanced artists during the 1940s' (*Abstract Expressionism*, 1970). See also ABSTRACT IMPRESSIONISM.

Monnington, Sir Thomas (1902–76). British painter. He was born in London, the son of a barrister, and studied at the *Slade School, 1918–23. Winner of the Rome Scholarship in 1923, he spent most of the next three years in Italy, and there painted the work with which he established his reputation, a large enigmatic figure painting entitled *Allegory*, which was bought by the *Contemporary Art Society and presented to the Tate Gallery. Back in England, he made a name for himself as a decorative painter with commissions for St Stephen's Hall in the Palace of Westminster (1927) and the Bank of England (1928–37), whilst also working as a portraitist and teaching part-time at the *Royal Academy Schools and the *Royal College of Art. During the Second World War he designed camouflage and was an *Official War Artist. He taught at Camberwell School of Art, 1946–9, and at the Slade School, 1949–67. In the 1950s he began producing geometric abstract paintings, including a huge ceiling for the Conference Hall of Bristol Council House (1956), symbolizing progress in nuclear physics, electronics, aeronautics, and biochemistry. From 1966 until his death he was a popular and successful

president of the Royal Academy; he was chiefly responsible for opening the Academy's private rooms and their treasures to the public, and his major achievement, in the words of his obituary in *The Times*, was 'to bring the Academy into a closer relationship with the contemporary scene'. A memorial exhibition of Monnington's work was held at the Royal Academy in 1977; in the catalogue his successor as president, Sir Hugh Casson, wrote that he was 'remembered and loved by everybody in the world of art'.

Monnington's first wife, Winifred Knights (1899–1947), was also a painter, mainly of figure subjects. She studied at the Slade School, won the Rome Scholarship in 1920, and married Monnington in Rome in 1924. Her most characteristic works were large decorative compositions, including *The Marriage at Cana* for the British School in Rome (now in the NG of New Zealand, Wellington).

Monosiet, Pierre. See NAIVE ART.

montage (French: 'mounting'). A pictorial technique in which a number of cut-out illustrations, or fragments of them, are arranged together and mounted on a suitable background; the term also refers to the picture so created. Ready-made images alone are used and they are generally chosen for their subject and message; in both these respects montage can be distinguished from *collage, in which materials of varied kinds can be used, often primarily with an interest in their decorative qualities. Montage is now associated particularly with advertising, but it has also been used by artists. *Photomontage is montage using photographic images only. In cinematic usage, the term 'montage' refers to the assembling of separate pieces of film into a sequence or superimposed image.

Moon, Jeremy (1934–73). British painter and sculptor, born in Altrincham, Cheshire. He read law at Christ's College, Cambridge, 1954–7, then briefly studied at the Central School of Art and Design, London, but he was mainly self-taught as an artist. Originally he worked as a sculptor (he was a friend of Phillip *King, a fellow student at Cambridge) and he won a prize for sculpture at the 1962 *Young Contemporaries exhibition. From 1963, however, he concentrated on painting and taught the subject part-time at Chelsea School of Art. In his short career he gained a reputation as

one of the leading British exponents of *Hard-Edge abstraction; often he worked on *shaped canvases. He was killed in a motorcycle accident. His obituary in *The Times* described him as 'a most thoughtful, highly intelligent and sensitive painter . . . one of the outstanding British painters of his generation'.

Moore, George (1852–1933). Anglo-Irish writer and painter, born in County Mayo. In 1873 he went to Paris intending to become a painter (he studied at the *Académie Julian), but he realized that his talent lay in writing and eventually won fame as a novelist, notably with *Esther Waters* (1894). He remained in Paris for most of the 1870s and often returned afterwards. From 1880 to 1901 he divided his time mainly between London and Ireland, from 1901 to 1911 he lived in Dublin (where he was a leading figure of the Irish cultural renaissance), and then settled in London for the rest of his life. In Paris he was friendly with many of the leading French painters of the day (in 1911 he wrote 'I am the only one in Dublin who knew Manet, *Monet, Sisley, *Renoir and *Pissarro), and he was one of the first writers to introduce *Impressionism to the English-speaking world (for example, his essay '*Degas—The Painter of Modern Life', published in the *Magazine of Art* in September 1890, was the first article in English on this artist). He was art critic to the *Speaker* from 1891 to 1895 and also wrote for other journals; many of his articles were collected in his books *Impressions and Opinions* (1891) and *Modern Painting* (1893). His other books include *Reminiscences of the Impressionist Painters* (1906) and several volumes of autobiography. Such works are a lively commentary on a great age of French painting, but they are often inaccurate, and Julian Campbell writes that 'Much of Moore's writing about art is superficial and repetitive' (*The Irish Impressionists*, 1984). In his later years he turned increasingly against modern art. Moore owned a good collection of pictures and his portrait was painted by many of his artist friends, including *Blanche, Manet, *Orpen, *Sickert, *Tonks, and Jack *Yeats.

Moore, Henry (1898–1986). British sculptor, draughtsman, and printmaker. He is regarded as one of the greatest sculptors of the 20th century and from the late 1940s until his death he was unchallenged as the most celebrated British artist of his time. He

was born in Castleford, Yorkshire, the son of a miner, and despite an early desire to become a sculptor, he began a career as an elementary school teacher at the insistence of his father. In 1917–19 he served in the army (he was gassed at the Battle of Cambrai), then after a brief return to teaching went to Leeds College of Art (1919–21) on an ex-serviceman's grant; Barbara *Hepworth, who became a close friend, was one of his fellow students. In 1921 he won a scholarship to the *Royal College of Art, and after completing his training in 1924 he taught there until 1931. His first one-man exhibition was at the Warren Gallery, London, in 1928, and his first public commission was a stone relief of the *West Wind* (1928–9) for the exterior of the new headquarters of the London Underground Railway. Jacob *Epstein was among other sculptors who worked on the building, and there was a predictably hostile public response to the grandly simplified figures—'grotesque caricatures' according to one letter to *The Times*. In 1932 Moore became the first head of sculpture in a new department at Chelsea School of Art and he continued there until the school was evacuated to Northampton on the outbreak of war in 1939. During the 1930s he lived in Hampstead in the same area as Hepworth, Ben *Nicholson, the critic Herbert *Read, and other leading members of the avant-garde. In 1940, after the bombing of his studio, he moved to Much Hadham in Hertfordshire, where he lived for the rest of his life.

Most of Moore's early work was carved, rejecting the academic tradition of modelling in favour of the doctrine of *truth to materials, according to which the nature of the stone or wood—its shape, texture, and so on—was part of the conception of the work (see also DIRECT CARVING). He also rejected classical conceptions of beauty in favour of an ideal of vital force and formal vigour that he found exemplified in much ancient sculpture (Mexican, Sumerian, etc.), which he studied in the British Museum (see PRIMITIVISM), and also in the frescos of Giotto and Masaccio, which he saw in Italy in 1925 in the course of a travelling scholarship. In 1934 (in *Unit One*) he wrote: 'For me a work must first have a vitality of its own. I do not mean a reflection of the vitality of life, of movement, physical action, frisking, dancing figures, and so on, but that a work can have in it a pent-up energy, an intense life of its own, independent of the object it may represent. When a

work has this powerful vitality we do not connect the word Beauty with it. Beauty, in the later Greek or Renaissance sense, is not the aim in my sculpture.'

During the 1930s Moore's work was influenced by European avant-garde art as well as ancient sculpture, particularly the *Surrealism of *Arp. Although he produced some purely abstract pieces, his sculpture was almost always based on forms in the natural world—often the human figure, but also, for example, bones, pebbles, and shells. The reclining female figure and the mother and child were among his perennial themes. By the late 1930s he was well-known in informed circles as the leading avant-garde sculptor in Britain (Kenneth *Clark and Eric *Gregory were among his early supporters), and his wider fame was established by the poignant drawings he did as an *Official War Artist (1940–2) of Londoners sheltering from air-raids in underground stations. After the war his reputation grew rapidly (particularly after he won the International Sculpture Prize at the 1948 Venice *Biennale), and from the 1950s he carried out numerous public commissions in Britain and elsewhere. Many of these commissioned works stand in prominent places in the great cities of the world, for example outside the Lincoln Center in New York and the National Gallery in Washington.

In the postwar period there were major changes in Moore's way of working. Bronze took over from stone as his preferred material and he often worked on a very large scale, requiring the use of assistants (over the years they included Anthony *Caro, Phillip *King, and Bernard *Meadows). There was a tendency, also, for his works to be composed of several elements grouped together rather than of a single object. Some critics discerned a falling away of powers in his later work, marked by a tendency towards inflated rhetoric, but to others he remained a commanding figure to the end. A man of great integrity and unaffected charm, Moore was held in almost universally high esteem. The tributes paid after his death made it clear that he was widely regarded not only as one of the greatest artists of the century, but also as one of the greatest Englishmen in any field. He held broad socialist principles, was pleased to find that his work could be appreciated by a wide audience and not just an elite, and gave his time generously to serve on public bodies. 'In personal appearance . . . it was often said

that he looked more like a successful farmer than an artist. He had an attractive modesty that hid great self-confidence and ambition. He kept a light Yorkshire accent all his life, and expressed himself in simple straightforward terms, avoiding any philosophizing. Interpretations of his work he left to others; he was the maker, driven by some creative force that he could not and perhaps did not wish to understand' (*DNB*).

Moore's output was immense. The complete catalogue of his sculptures lists almost a thousand works, and the bronzes usually exist in about three to ten versions each, bringing the total number of pieces up to something in the region of 6,000. It has therefore been reasonably claimed that 'By the time Henry Moore died in 1986, his work had been distributed more widely throughout the Western world than that of any other sculptor, living or dead' (Peter *Fuller in the catalogue of the exhibition 'Henry Moore', Royal Academy, London, 1988). From the late 1960s he also worked a good deal as a printmaker, producing several series of etchings such as *Elephant Skull* (1969) and the *Sheep Portfolios* (1972 and 1974). He did little formal writing, but often made perceptive comments on his own and other artists' work, a collection of which has been made as *Henry Moore on Sculpture* (1966). In 1977 he set up the Henry Moore Foundation, a charitable foundation to advance public appreciation of art, especially his own work. As well as arranging exhibitions of his work worldwide, it funds fellowships and publications. Most major collections of modern art have examples of his work; those with particularly fine holdings include the Moore Sculpture Gallery (opened in 1982) at Leeds City Art Gallery, the Tate Gallery, London, the Art Gallery of Ontario, Toronto, and the Hirshhorn Museum and Sculpture Garden, Washington.

Moore, Thomas Sturge. See SHANNON, CHARLES.

Moores, John. See JOHN MOORES LIVERPOOL EXHIBITION.

Moorman, Charlotte. See SKY ART and VIDEO ART.

Morandi, Giorgio (1890–1964). Italian painter and etcher. He lived all his life in his native Bologna, where he studied at the

Academy, 1907–13. Apart from brief associations with *Futurism and *Metaphysical Painting, he stood aloof from the intellectual turmoil and aesthetic experiments of the 20th century. Early in his career (and again in the 1940s) he painted landscapes, but he came to specialize almost exclusively in still-life, eschewing literary and symbolic content, and using subtle combinations of colour within a narrow range of tones. His style has something in common with *Purism, but is more mellow and intimate, breathing an air of serenity and cultivated sensibility; the greatest influence on his work was *Cézanne, whom he revered. After the Second World War Morandi acquired an international reputation, winning the City of Venice Prize for an Italian Painter at the 1948 Venice *Biennale and the Grand Prix for Prints (1953) and then for Painting (1957) at the São Paulo Bienal. His work was much admired among younger Italian artists for its pure devotion to aesthetic values and its poetic qualities. Edward *Lucie-Smith describes him as 'arguably the greatest artist Italy has produced in the twentieth century' (*Lives of the Great Twentieth Century Artists*, 1986), although *Modigliani too would have many supporters for this title.

Moreau, Gustave. See ROUAULT.

Moreau, Luc-Albert. See NÉO-RÉALISME.

Moreni, Mattia. See GRUPPO DEGLI OTTO PITTORI ITALIANI.

Moreno, Maria. See SPANISH REALISTS.

Morgner, Wilhelm (1891–1917). German painter, printmaker, and draughtsman, born in Soest, where he spent most of his short career. He was an *Expressionist artist of outstanding promise, but he died in the First World War when he was only 26. From 1908 to 1910 he trained in *Worpswede with the painter Georg Tappert (1880–1957), who moved to Berlin in 1910 and encouraged Morgner to exhibit there. His work was shown not only in Berlin, but also at the second *Blaue Reiter exhibition in Munich in 1912 and in the *Sonderbund exhibition in Cologne in 1913. By this time Morgner had moved from vigorous scenes of country life, with fiery, spiralling brushwork recalling van Gogh, to pure abstracts such as *Astral Composi-*

tion (Westfälisches Landesmuseum, Münster, 1913). He was beginning to make a name for himself among his fellow artists when he was called up for military service in 1913, the year before the war started. From this point he produced only drawings and watercolours. He fought at the front from the beginning of the war and was reported missing at the Battle of Langemarck in France. In the catalogue of the exhibition 'The Fallen' (MOMA, Oxford, 1988), Jill Lloyd writes that 'At his best, Morgner was able to achieve a degree of freshness and imaginative potency in terms of subject and style which mark him out clearly from the ranks of contemporary Expressionists. In many ways he was both an "outsider" in the movement and one of its strongest and most original representatives. His work exemplifies all of Expressionism's major concerns.' Morgner himself said that 'Every picture should be a life symphony. I don't mean by this an allegorical symphony to life or something similar; but that the lust for life should ring through in the colours and lines.'

Morison, Stanley. See GILL, ERIC.

Morley, Malcolm (1931–). British painter, born in London. He became interested in painting whilst he was in prison (he served a three-year sentence for house-breaking) and then studied at Camberwell School of Art, 1952–3, and the *Royal College of Art, 1954–7. At this period he was deeply interested in American *Abstract Expressionism, and in 1958 he settled in New York. Whilst working as a waiter he met his hero Barnett *Newman, who gave him advice and encouragement. In the 1960s he turned from abstract to figurative work and became one of the pioneers of *Superrealism (a term he coined). From about 1970, however, his paintings became increasingly loose in handling, often depicting animals in lush landscapes (Peter *Fuller described these works as 'incoherent and overblown canvases based on his masturbatory fantasies'). In 1984 he was the first winner of the *Turner Prize, awarded for 'the greatest contribution to art in Britain in the previous twelve months'. The decision caused much controversy because Morley had for so long been resident in the USA.

Morlotti, Ennio. See FRONTE NUOVO DELLE ARTI and GRUPPO DEGLI OTTO PITTORI ITALIANI.

Morozov, Ivan (1871–1921). Russian art collector. He was a wealthy Moscow businessman, owner of a complex of textile mills, and—like his brother Mikhail (1870–1903)—a passionate lover of French *Impressionist and *Post-Impressionist painting, on which he spent huge sums. Many of the pictures in his collection were bought from *Durand-Ruel, but Morozov also employed a representative in Paris to buy from other sources. He also regularly visited Paris himself, and Félix *Fénéon wrote that 'No sooner had he got off the train than he found himself in an art shop'. In 1907 he acquired a group of pictures from Ambroise *Vollard and later bought from this dealer a *Cubist portrait by *Picasso (of Vollard himself, Pushkin Museum, Moscow, 1910), even though—unlike the other great Russian collector of the time, Sergei *Shchukin—he was not particularly sympathetic to Cubism. Morozov corresponded regularly not only with dealers, but also with many French artists, including *Bonnard, *Denis, *Matisse, and *Vuillard, from whom he also commissioned works (Denis visited Moscow in 1909 to install a series of five large paintings on *The Story of Psyche*, and Morozov ordered six additional pictures from him). The chief glory of the collection was a group of seventeen *Cézannes; at this time it was probably the finest representation of his paintings in the world, featuring superb examples of every genre in which he worked. Morozov's collection was less accessible than Shchukin's, but it was visited by many artists and connoisseurs. In 1918, following the Russian Revolution, it was nationalized and opened to the public. During the 1920s it was amalgamated with that of Shchukin, and they were later divided between the Hermitage in Leningrad (now St Petersburg) and the Pushkin Museum in Moscow, each of which consequently boasts one of the greatest collections of early 20th-century French painting in the world.

Morrell, Lady Ottoline. See CONTEMPORARY ART SOCIETY.

Morrice, James Wilson (1865–1924). Canadian landscape and figure painter, active mainly in Paris. He was born in Montreal, the son of a merchant who collected art and encouraged his son's interest in painting. After studying art in Toronto, he moved to Paris in 1890 and enrolled at the *Académie Julian. Paris remained his home for the rest of his life, but he spent a great deal of time travelling, visiting North Africa, Venice, and the West Indies among other places, as well as making frequent trips to Canada, where he worked in Quebec, Montreal, and along the St Lawrence River (*The Ferry, Quebec*, NG, Ottawa, c. 1909). Morrice was friendly with many leading artists in Paris. His early inspiration came from *Whistler and *Conder; later his style became gently *Fauvist under the influence of *Matisse and *Marquet. His work was important in introducing modern trends to Canada (although he did not exhibit in his own country after 1916); Dennis Reid (*A Concise History of Canadian Painting,* 1973) writes that 'countless young Canadians sought out his work. Along with Horatio *Walker, he was the Canadian who then had the strongest reputation abroad.' See also CANADIAN ART CLUB.

Morris, Sir Cedric (1889–1982). British painter and teacher, born at Sketty, Glamorgan, the son of Sir George Lockwood Morris, to whose baronetcy he succeeded in 1947. In his early years he was a farmer in Canada and also studied singing at the Royal College of Music before taking up art seriously shortly before the First World War; he attended various academies in Paris but was essentially self-taught. During the war, his delicate health prevented him from enlisting in the army, but he was a good horseman and helped *Munnings in training horses that were to be sent to the Front. Soon after the end of the war Morris met the painter Arthur Lett-Haines (1894–1978), and although each had other liaisons, they lived together until Lett's death sixty years later. Theirs was 'a partnership of complementaries. Morris was quiet, humorous, impractical, country-loving, and determined to concentrate on his art. Lett-Haines was complex and sophisticated, a natural organizer and dedicated to expanding recognition of Morris's art' (*DNB*). After a short period in Newlyn (see NEWLYN SCHOOL), 1919–20, they lived in Paris from 1921 to 1926, then London from 1926 to 1929, before settling in East Anglia. In 1937 they founded the East Anglian School of Painting and Drawing, originally at Dedham, Essex, then from 1940 at Hadleigh, Suffolk, where they lived permanently from this date. The School was anti-academic in approach: 'what the pupil felt about appearances mattered more than what he or she saw: drawing, dictated by feeling,

could employ emotive distortion' (Frances Spalding, *British Art Since 1900*, 1986). Well-known students of the School include Lucian *Freud and Maggi *Hambling, both of whom felt they profited greatly from the teaching. Morris's work included portraits, landscapes, and still-lifes, but he is best known for his paintings of flowers, done in startlingly vivid colours (he was devoted to gardening and often brought exotic botanic specimens back from his travels around the world). Lett-Haines was a very different kind of artist—more experimental and concerned with symbolism. Morris became fairly well known and successful between the wars (he exhibited with the *Seven & Five Society from 1926 to 1932). After about 1940, however, he sank from fashionable consciousness, although he remained an admired figure in East Anglia. He gave up painting in 1975 because of failing eyesight, but he lived long enough to see the beginnings of a revival of interest in his work. In 1984, two years after his death, an exhibition was devoted to him at the Tate Gallery, London.

Morris, Desmond. See OBJET TROUVÉ.

Morris, Edmund. See CANADIAN ART CLUB.

Morris, George L. K. (1905–75). American art critic, painter, and occasional sculptor, born in New York. After taking a BA degree at Yale University in 1928, he studied at the *Art Students League, New York, in 1929, and at the Académie Moderne, Paris, under *Léger and *Ozenfant, 1930. In Paris he was converted to abstract art and he became one of its most vigorous advocates in print. He was co-editor with *Taeuber-Arp of the abstract art magazine *Plastique* (published in Paris and New York, 1937–9), and from 1937 to 1943 he worked on the New York journal *Partisan Review*, which was dedicated to intellectual freedom. In 1936 he was a founder member of *American Abstract Artists and he was president of this association from 1948 to 1950. He exhibited frequently during the 1930s and 1940s and had a retrospective at the Institute of Contemporary Art, Washington, in 1958. His paintings were eclectic and decorative, characterized by bright, generally unmodulated colours and hard-edged (but not necessarily geometrical) shapes; in the 1950s he went through a slightly more 'painterly' phase, perhaps influenced by *Abstract

Expressionism, but in the 1960s he reverted to his earlier style.

Morris, Robert (1931–). American sculptor, painter, experimental artist, and writer. He was born in Kansas City and studied engineering at the university there whilst also attending classes at the city's Art Institute. After service in the US Army, 1951–2, he began his artistic career in San Francisco, painting *Abstract Expressionist pictures and also being involved with other activities including improvisatory theatre. In 1961 he moved to New York, where he took an MA in art history at Hunter College in 1963 (his thesis was on *Brancusi). Meanwhile he had turned from painting to sculpture and he emerged as one of the most prominent exponents and theorists of *Minimal art. He also experimented with *Performance art, *environments, and earthworks (see LAND ART), and through such activities he was prominent in breaking down traditional ideas linking the work of the artist with the studio, promoting instead the idea executing works *in situ*. Morris's most characteristic sculptures consist of large-scale, hard-edged geometric forms, but he has also made *anti-form pieces in soft, hanging materials. In 1983 he changed tack completely, returning to painting in an emotive figurative style, often with explicit political messages.

Morris, William. See BRANGWYN, CRANE, and WIENER WERKSTÄTTE.

Mortensen, Richard (1910–93). Danish painter and designer, born in Copenhagen, where he studied at the Royal Academy, 1931–2. While still a student he discovered the work of *Kandinsky and during the 1930s he played an important role in introducing abstraction to Denmark, being one of the founders in 1934 of the group Linien (The Line), a small circle of abstract artists; it published a periodical of the same name. In 1947 Mortensen settled in Paris, but he returned to Copenhagen to become a professor at the Academy in 1964, holding this post until 1980. During the Second World War Mortensen painted some harsh, tormented canvases, but his most characteristic pictures are sophisticated in composition and refined in colour; they feature smooth, taut sheets of colour interlocking with sharp lines, creating a subtle interplay between surface tension and spatial allusion and combining clear

articulation with a lively feeling of spontaneity. He also produced tapestry cartoons and made designs for theatrical sets and costumes.

Mortimer, Raymond. See NEO-ROMANTICISM.

Morton, Thomas Corsan. See GLASGOW BOYS.

Moscow, Pushkin Museum. See MOROZOV and SHCHUKIN.

Moses, Grandma (born Anna Mary Robertson) (1860–1961). The most famous of American *naive painters. She was born on a farm at Greenwich in Washington County, New York State, of Irish and Scottish ancestry. In 1887 she married a farmer, Thomas Moses; they lived in Virginia for 20 years, then returned to New York State, where Anna spent the rest of her life within a few miles of her birthplace. She regularly won prizes with embroidery at county fairs, and when arthritis made it impossible for her to continue with this in her 70s, she took up painting, initially copying postcards and popular prints. At first her work was crude, but she soon developed a lively, fresh, and colourful style, abounding in lovingly observed detail. Her first exhibition was held in a drugstore in Hoosick Falls, New York State, and her work was 'discovered' there by Louis J. Caldor, an engineer and art collector who happened to be passing through the town. In 1940, at the age of 80, she had a one-woman show at the Galerie St Etienne in New York, and thereafter she rapidly became famous and something of a national institution, her work being widely reproduced, notably on Christmas cards (her winter scenes were ideal for this; she sometimes dusted 'glitter' over the snow to make it look more realistic to her eye). In 1949 she was received at the White House by President Harry Truman, and in 1960 Governor Nelson Rockefeller proclaimed 7 September—her 100th birthday—'Grandma Moses Day' in New York State. She produced more than 1,000 pictures (working on a sort of production line system, three or four at a time, painting first the skies and last the figures), her favourite subjects being scenes of what she called the 'old-timey' farm life she had known in her younger days. She described this life in her autobiography, *My Life's History* (1952); in the preface Otto Kallir writes that 'Her kind and good-natured approach to everything that

surrounds her can be felt in her personal presence as well as in her work'. Her paintings are represented in many American collections, notably the Bennington Museum, Vermont.

Moskowitz, Robert. See NEW IMAGE PAINTING.

Motherwell, Robert (1915–91). American painter, collagist, printmaker, writer, editor, and teacher, one of the pioneers and principal exponents of *Abstract Expressionism. He was born in Aberdeen, Washington, and began to study painting at the Otis Art Institute, Los Angeles, in 1926, when he was only 11. However, it was not until he settled in New York in 1940 that he took up painting seriously. Before then he had taken a degree in philosophy at Stanford University (1936), followed by postgraduate work at other universities interspersed with two trips to Europe. His scholarly background coloured his writings on art, and their erudite approach helped to set the serious intellectual tone of the Abstract Expressionist movement. He had moved to New York to study art history under Meyer *Schapiro at Columbia University, but after becoming friendly with *Matta and other expatriate *Surrealists he turned increasingly to painting and he decided to become a professional artist in 1941. His first one-man exhibition was at Peggy *Guggenheim's Art of this Century gallery in 1944. Motherwell was unusual among the Abstract Expressionists in that his work was essentially abstract from the beginning of his career, but there is often a suggestion of figuration in his paintings. Moreover, his intellectual sensibilities are reflected in the fact that there is frequently an underlying inspiration from literature, history, or his personal life in his work. He painted, for example a long series of works (more than 100 pictures) entitled *Elegy to the Spanish Republic*; it was inspired by the Spanish Civil War ('the most moving political event of the time'), but not begun until a decade later in 1949. Motherwell wrote of the series: 'The *Spanish Elegies* are not "political" but my private insistence that a terrible death happened that should not be forgot . . . The pictures are also general metaphors of the contrast between life and death, and their interrelation.'

During the 1940s Motherwell established friendships with the other leading exponents

of Abstract Expressionism and in 1948 he joined several of them in founding the *Subjects of the Artist School. His earliest paintings had been amorphous and improvisatory, influenced by Surrealist ideas of *automatism (he admired *Miró above all the other Surrealists). By the late 1940s, however, he was using very bold slabs of paint, often ovals or upright rectangles, in a manner similar to that of Franz *Kline; his palette was subdued and like Klein he made highly dramatic use of black on white (*Elegy to the Spanish Republic XXXIV*, Albright-Knox Art Gallery, Buffalo, 1953–4). His style did not change greatly until 1967, when he began a series of *Colour Field paintings called *Open* featuring large areas of dense, sensuous colour broken only by a few spare lines (*Open No. 122 (in Scarlet and Blue)*, Tate Gallery, London, 1969). He chose the name 'Open' for its suggestions of expansiveness and simplicity. At about the same time he took an increased interest in printmaking, using etching and coloured aquatint to achieve similar effects to those in the paintings. Eventually he set up his own printing facilities at Greenwich, Connecticut, where he moved from New York in 1971 (in this year he was divorced from Helen *Frankenthaler, whom he had married in 1958).

Motherwell was highly prolific as an artist and also energetic as a teacher, writer, and editor. He taught at *Black Mountain College in 1950, Hunter College, New York, 1951–5, and Columbia University, 1964–5, and he lectured widely elsewhere. He wrote articles for numerous avant-garde periodicals, including *VVV* and *Dyn* (see PAALEN), and he edited a major series of books, *Documents of Modern Art* (1944–61), and launched another one, *Documents of 20th-Century Art*, in 1971. An anthology of his own writings, *The Writings of Robert Motherwell*, was published in the latter series in 1978.

Mousseau, Jean-Paul. See AUTOMATISTES.

Moynihan, Rodrigo (1910–90). British painter, born on the island of Tenerife to an Irish father (a fruit-broker) and a Spanish mother. He moved to England at the age of eight and travelled widely before studying at the *Slade School, 1928–31. His work was varied and fluctuated between figuration and abstraction. In the early 1930s he was one of the most radical of British abstract painters (see OBJECTIVE ABSTRACTIONISTS), but he then turned to figurative art and taught at the *Euston Road School, founded in 1937, the fountainhead of a long-lived soberly realistic strain in British painting. However, unlike his fellow-teacher *Coldstream, who advocated a socially relevant art, Moynihan approached his subjects in a more impersonal way. After being invalided out of the army, he became an *Official War Artist in 1943, concentrating on the everyday life of the troops. From 1948 to 1957 he was professor of painting at the *Royal College of Art, and one of his best-known works is the large *Portrait Group* (Tate Gallery, 1951), showing the nine members of the teaching staff of the painting school there (himself included). In 1956 he reverted to abstract art, in a style influenced by *Abstract Expressionism, but in the 1970s he took up figurative art again (mainly portraits and still-lifes), characteristically painting in pale, muted colours. From 1957 he lived mainly in France. Moynihan's first wife was the painter Elinor Bellingham Smith (1906–88), his second wife the painter Anne Dunn (1929–).

Mraz, Franjo (1910–81). Yugoslav (Croatian) *naive painter. He was born at Hlebine and with *Generalic and *Virius was one of the best-known figures in the school of naive painters associated with this village. After the Second World War, however, he settled in Belgrade, where he worked full-time as an artist. Before the war he painted mainly scenes of peasant life; after the war he often took his subjects from his experiences in the Liberation movement.

Mucha, Alphonse (1860–1939). Czech painter and designer. He was born at Ivančice in Moravia and worked as a theatrical scene painter before studying in Munich and then in Paris, where he settled in 1888; it was his main home until about 1905, when he began to spend an increasing amount of time in his homeland. Mucha had a highly varied career, but he is best known for his luxuriantly flowing poster designs, which rank among the most distinctive products of the *Art Nouveau style. They often feature beautiful women, but they have nothing of the morbid sexuality typical of the period. Some of the best known were made in the 1890s for the celebrated actress Sarah Bernhardt, for whom Mucha also designed sets, costumes, and jewellery. He was successful in the USA as well as Europe, making four journeys there between

1903 and 1922. A Chicago industrialist and Slavophile, Charles Richard Crane, sponsored his series of twenty huge paintings entitled *Slav Epic* (Moravský Krumlov Castle, 1909–28). Although he is so strongly associated with Paris, Mucha was an ardent patriot, and in 1922 he settled in Prague. Czechoslavakia had won its independence only in 1918 and Mucha did a good deal of work for the new nation (giving his services free), including designing its first banknotes and stamps. When the Germans occupied Prague in 1939 (a few months before his death) he was one of the first to be arrested and questioned by the Gestapo. After the war his work was long out of fashion, but a revival of interest began in the 1960s. Since then numerous books and exhibitions have been devoted to him (notably a major exhibition of his paintings, posters, drawings, furniture, and jewellery shown at the Grand Palais, Paris, in 1980, and afterwards in Darmstadt and Prague) and in the popular imagination he has become one of the symbols of the turn-of-the-century era.

Muche, Georg (1895–1987). German painter, designer, and architect, born at Querfurt. He trained in Berlin and Munich, 1912–15, and taught at the *Sturm Art School in Berlin, 1916–20. In 1920 he became the youngest teacher at the *Bauhaus, assisting *Itten in the preliminary course and running the weaving workshop. Like Itten, Muche had mystical leanings, but he also became interested in a technological appproach to art and designed two experimental houses intended as prototypes for cheap, mass-produced buildings using modern materials. He left the Bauhaus in 1927 and joined Itten in the school he had opened in Berlin. From 1931 to 1933 he taught at the Breslau Academy and from 1939 to 1958 at the Krefeld School of Textile Engineering. Although he devoted much of his career to textiles, Muche was primarily a painter. He was somewhat unusual in that he began as an abstractionist (in a manner reminiscent of *Kandinsky), then turned to a more figurative style in the 1920s, with a penchant for portraying decorative plant forms.

Muehl, Otto. See VIENNA ACTIONISTS.

Mueller, Otto. See MÜLLER.

Mukhina, Vera (1889–1953). Russian sculptor and designer. She was born in Riga, Latvia,

into an old merchant family, grew up in Kiev and Kursk, where she took lessons in drawing and painting, and in 1910 moved to Moscow, where she studied at various private art academies. From 1912 to 1914 she lived in Paris, where she studied under *Bourdelle at the Académie de la Grande Chaumière, met other leading sculptors including *Lipchitz and *Zadkine, and was a close friend of *Popova (together they travelled in Italy in 1914). She returned to Moscow after the outbreak of the First World War, and for the next few years she worked mainly on theatrical designs, sometimes in collaboration with *Exter (they worked together on the science fiction film *Aelita*, 1923). In the 1920s Mukhina emerged as one of the leading sculptors in Lenin's Plan for Monumental Propaganda, in which Communist ideals were to be expressed in public art. She became recognized as one of the outstanding sculptural exponents of *Socialist Realism, and her career was crowned with the gigantic *Worker and Collective Farm Girl*, made to surmount the Soviet pavilion at the International Exhibition in Paris in 1937. The group (now at the entrance to the Park of the People's Economic Achievements, Moscow) stands almost 25 metres high and weighs about 35 tonnes. Showing a pair of heroic figures striding forward, with a hammer and sickle held proudly aloft, it became one of the greatest symbols of Stalin's USSR (it was, for example, adopted as a logo by one of the state film studios, appearing at the beginning and end of its films). Matthew Cullern Bown (*Art under Stalin*, 1991) writes that 'This work established Mukhina as the most celebrated Soviet sculptor of her age, both at home and abroad ... Fashioned from the novel material of stainless steel, it was conceived as an image of Soviet industrial progress. In fact, it was completely handmade, laboriously fashioned in individual sections, each shaped on a carved wooden template ... For me, the work's appeal consists in its combination of great formal brio—huge size, dynamic design, stainless steel skin—on the one hand, and unashamed corniness on the other.' In 1941, in recognition of her masterpiece, Mukhina was awarded one of the newly instituted Stalin Prizes for art. She subsequently won four other Stalin Prizes and many other honours. Her later work included the design of glass figurines and vases, some of which were mass-produced.

Müller, Otto (1874–1930). German *Expressionist painter and graphic artist, born at Liebau in Silesia (now Libawka, Poland). After four years' apprenticeship in lithography at Breslau he studied painting in Dresden, 1896–8, and remained based there until 1908. He was a prolific worker but later destroyed most of his paintings from these years. Those that survive show he was strongly influenced by the curvilinear forms of *Art Nouveau. In 1908 he moved to Berlin and after being rejected by the Berlin *Sezession in 1910 he joined forces with other rejected artists to form the Neue Sezession; among them were members of Die *Brücke, which he also joined. Apart from *Kubišta—who became a member in theory rather than practice—he was the group's last significant recruit. Under the influence of other members, particularly *Kirchner, his style became more harsh and angular, with emphatic outlines. However, he remained distinct from them in certain ways. He painted in distemper, which produced a matt finish, and his gentle colour harmonies are very different from the brilliant or harsh hues often associated with German Expressionist painting. His whole outlook, in fact, was tranquil rather than violent, and his most typical paintings depict a kind of primitive arcadia in which nude figures disport themselves in forests or on lake shores. After about 1920 he also did many gypsy subjects (his grandfather is said to have been a gypsy and he had great sympathy for their way of life, studying their culture at first hand in Bulgaria, Hungary, and Romania). From 1919 until his death he taught at the Academy in Breslau.

multimedia. See MIXED MEDIA.

multiples. A term designating works of art other than prints or cast sculpture that are designed to be produced in a large—potentially limitless—number of copies. Whereas prints and casts of sculptures are copies of an original work hand-made by the artist, multiples are different, for the artist often produces only a blueprint or set of specifications for an industrial process of manufacture in materials such as plastic. Similarly, they differ from the 'multiple original' paintings produced from 1950 by Jean *Fautrier, in which he hand finished a basic design printed on a large number of canvases. The idea of multiples in the sense defined above was devised by *Agam and *Tinguely; in 1955 they proposed the production of such works to the art dealer Denise *René, who later tried unsuccessfully to patent the word 'multiple'. The first examples were produced in 1962 and many artists took up the idea, among them *Le Parc and *Oldenburg. Usually they are similar in style to the artist's 'normal' work. In theory, multiples represented a democratization of art—works were no longer to be regarded as rare items for collectors and connoisseurs but as consumer goods for the masses like any other industrial product. In practice, however, they are too expensive for a mass market and have been sold through galleries rather than high street shops or supermarkets (although Richard *Hamilton designed a plastic relief showing the exterior of the Guggenheim Museum, New York, that was sold in the museum shop). In 1971 substantial exhibitions of multiples were held at the Philadelphia Museum of Art ('Multiples: The First Decade') and the Whitechapel Art Gallery, London ('New Multiple Art'); by the end of the decade the idea seemed to be dying out, but it revived in the 1990s.

Munari, Bruno. See AEROPITTURA.

Munch, Edvard (1863–1944). Norwegian painter and printmaker of figure compositions, portraits, and landscapes, his country's greatest artist. He was born in Løten, the son of a doctor, but his family moved to Christiania (now Oslo) when he was a baby. After leaving school he began training as an engineer, but he abandoned this for art, studying at the Royal School of Design, 1881–3. However, he learnt more from informal tuition from Christian *Krohg, who was a hero to many young artists because of his championing of new ideas. Through Krohg, Munch became part of Christiania's bohemian world of artists and writers, who outraged bourgeois society with their advocacy of sexual as well as artistic freedom. In 1885 he visited Paris for the first time, and soon after returning to Norway painted the first picture in which he showed a distinctly personal vision, *The Sick Child* (NG, Oslo, 1885–6). Munch himself described this hauntingly sad scene (of which he painted five later versions) as 'the breakthrough in my art. Most of what I have done since had its birth in this picture.' The choice of subject was highly significant, for it reflected his own tragic childhood. His

mother and favourite sister had died of tuberculosis in 1868 and 1877 respectively, and his father—driven close to insanity with grief—became almost dementedly pious. Munch wrote that 'Illness, madness, and death were the black angels that kept watch over my cradle', and in his paintings he gave expression to the neuroses that haunted him. Certain themes—jealousy, sickness, the awakening of sexual desire—occur again and again, and he painted extreme psychological states with an unprecedented conviction and an intensity that sometimes bordered on the frenzied. Already in *The Sick Child* he showed some of the bold simplification of form, the expressive use of non-naturalistic colour, and the pungency of feeling that were to characterize his mature work.

In 1892 Munch was invited to exhibit at the Verein Berliner Künstler (Association of Berlin Artists), and the anguished intensity of his work caused such an uproar that the exhibition was closed. The scandal made him famous overnight in Germany, so he decided to base himself there and from 1892 to 1908 he lived mainly in Berlin (although he moved around restlessly, staying in boarding houses, and made frequent visits to Norway as well as journeys to France and Italy). During this period—the heart of his creative life—he devoted much of his time to an ambitious series of pictures that he called collectively *The Frieze of Life*—'a poem of life, love, and death'. The idea was to display the pictures together, as he thought that the force of his vision could be fully appreciated only when his work was seen en masse. The *Frieze* never had a definitive form, but it included some of Munch's finest work, including his most famous picture, *The Shriek* (NG, Oslo, 1893), a vision of panic that has become one of the great icons of the modern world. Many of the other pictures in the series deal with a different kind of dread—the fear engendered by female sexual power. Munch characteristically depicted this in three stages—awakening womanhood, voracious sexuality, and an image of death—and he sometimes combined two or even all three of these aspects in one picture. Although he was tall, strikingly handsome, and very attractive to women, Munch was wary of the opposite sex and reluctant to contemplate marriage for fear that any children he might have would inherit the family disposition to mental and physical illness.

Munch translated the images from many of his paintings into prints. He had begun etching in 1894 to earn extra money, but he soon came to love printmaking and also mastered lithography and woodcutting. His woodcuts (often in colour) are particularly impressive, exploiting the grain of the wood to contribute to their effect of rough vigour. Together with the woodcuts of *Gauguin (who likewise took up the medium in the 1890s) they were the major stimulus for the great revival of the technique in the 20th century, especially among the German *Expressionists. By a process of artistic feedback, Munch's prints also influenced his own paintings, for after refining his ideas as he turned a composition from painting to print, he often translated the image back into a painting in a simpler and more powerful form.

In 1908 Munch suffered what he called 'a complete mental breakdown', the legacy of heavy drinking, overwork, a wretched love affair, and the general debilitating effects of his nomadic lifestyle. After recuperating in a clinic in Copenhagen for eight months he returned to settle in Norway in 1909, determined to change his life. He realized that his mental instability was part of his genius ('I would not cast off my illness, for there is much in my art that I owe to it'), but he made a conscious decision to devote himself to recovery and abandoned his familiar anguished imagery, looking to the world around him for subjects rather than inwards to the mind or soul. Almost immediately he began work on a project that emphasized his change of direction—a series of large canvases to decorate the Assembly Hall of Oslo University (1910–16). The subjects, which deal with universal forces, include *History* and *The Sun*. Munch depicted them with bright and vigorous colours and an energetic technique.

In 1916 Munch bought a large house called Ekely, at Skøyen on the outskirts of Oslo, and he spent most of the rest of his life there, leading an increasingly isolated existence. By now he was a much honoured figure in Norway; ironically, he had begun to receive official recognition (he was made a Knight of St Olav in 1908) at the very time when the most creative part of his career was ending. He remained extremely productive for the rest of his life, his favourite subjects in his later years including landscapes and scenes of workmen. Occasionally he rekindled some of the passion and profundity of his earlier days, as in the last of his numerous self-portraits, *Between the Clock*

and the Bed (Munch Museum, Oslo, 1940–2), in which he shows himself old and frail, hovering on the edge of eternity. His final years were marred by trouble with his eyesight and by the German invasion of Norway in 1940 (earlier his art had been declared *degenerate by the Nazis). At his death he left the huge body of his own work still in his possession to the City of Oslo: about 1,000 oils, 4,500 watercolours, 15,000 prints, and 6 sculptures. A journalist who saw Munch's house soon after his death described the remarkable scene: 'The interior had a wondrous appearance and in no way resembled a house inhabited by an ordinary mortal. Munch lived in a few sparsely furnished rooms, as if he had not really moved in and was just a passing visitor . . . On the top floor of the main building, in rooms that had obviously not been lived in for many years, were massive piles of prints: thousands upon thousands of etchings, lithographs and woodcuts . . . covered in dust and neglected.' This astonishing legacy is now housed in the Munch Museum, Oslo, which opened in 1963.

Munch ranks as one of the most powerful and influential of modern artists. His impact was particularly strong in Scandinavia and Germany, where he and van Gogh are regarded as the two main sources of Expressionism. The intensity with which he communicated mental anguish opened up new paths for art. 'Just as Leonardo da Vinci studied anatomy and dissected corpses,' he said, 'so I try to dissect souls.'

Munich, Lenbachhaus. See LENBACH.

Munich New Artists' Association. See NEUE KÜNSTLERVEREINIGUNG.

Munnings, Sir Alfred (1878–1959). English painter, a specialist in scenes involving horses, which he loved passionately. He was born at Mendham, Suffolk, the son of a miller and a farmer's daughter, and trained as a lithographer, 1893–8, whilst studying in the evenings at Norwich School of Art. In 1903–4 he studied at the *Académie Julian, Paris. Because he had lost the sight of an eye in an accident, he was refused for combat service in the First World War, but he helped to train horses for the army and in 1917 he became an *Official War Artist for the Canadian Government. In this capacity he painted the work that made his reputation—a portrait of Gen-

eral J. E. B. Seeley (later Lord Mottistone) mounted on his horse Warrior (NG, Ottawa). He was at the height of his popularity in the interwar years, when he cut a figure in fashionable society and was often invited to the grandest country houses to paint the owners with their horses (he was also besieged with commissions when he visited the USA in 1924). From 1944 to 1949 he was president of the *Royal Academy (he beat Augustus *John in the election by 24 votes to 11). He had no interest in administration or the Academy's finances and his presidency was remarkable mainly for the speech he made at the RA annual dinner in 1949, a typically rabid attack on 'this so-called modern art', which he characterized splenetically as 'affected juggling . . . damned nonsense . . . violent blows of nothing . . . foolish drolleries' (his successor as PRA, Sir Gerald *Kelly, comments in the article he wrote on Munnings for the *Dictionary of National Biography* that 'from the age of 30 he suffered from painful attacks of gout, to which was sometimes attributed his explosive and lurid language'). Munnings's speech was broadcast live on radio and was a national talking-point the next day. Amazingly, one of the few works he attacked specifically was Henry *Moore's serenely beautiful and fairly traditional *Madonna and Child* (1944) in St Matthew's Church, Northampton.

Munnings was an artist of considerable natural ability, but he became rather slick and repetitive and his continued popularity is more with lovers of horses and the countryside than with lovers of painting. His work can best be seen at Castle House, Dedham, Suffolk, his home from 1919, which his widow converted into a Munnings Museum. He wrote a three-volume autobiography, *An Artist's Life* (1950), *The Second Burst* (1951), and *The Finish* (1952); a one-volume abridgement appeared in 1955.

Münter, Gabriele (1877–1962). German painter, born in Berlin. She was a talented pianist before she took up painting. In 1902 she became a pupil of *Kandinsky at the *Phalanx School in Munich and she was his lover until the First World War parted them in 1914 (he returned to Russia; she went to Switzerland). With Kandinsky and *Jawlensky she helped to found the *Neue Künstlervereinigung, Munich, in 1909 and she contributed to many of the most significant avant-garde exhibitions in Germany up to the First World

War, including both *Blaue Reiter exhibitions. After the war she travelled a good deal before settling in Murnau (where she had previously lived with Kandinsky) in 1931. Their relationship had often been a difficult one (Kandinsky felt guilty because he was married and could not obtain a divorce), but she revered him as a man and artist: 'He was a holy man . . . He loved, understood, treasured, and encouraged my talent.' Stylistically, however, her work is closer to Jawlensky. Landscape was her chief subject. She lived a secluded life after her return to Murnau, but in 1957, to mark her 80th birthday, she presented 120 paintings by Kandinsky (as well as 60 of her own and many by other leading contemporaries) to the city of Munich. This superb collection is now in the Lenbachhaus (See LENBACH).

Murphy, Gerald (1888–1964). American painter. His career as an artist was short, his surviving output is tiny, and he was virtually forgotten for many years, but since his rediscovery a few years before his death he has won a reputation as an intriguing figure of the 'lost generation'—Gertrude *Stein's term for American intellectuals and artists who settled in Paris after the First World War, rebelling against traditional values and seeking freedom of expression. Murphy was born in Boston, the son of a successful leather and luggage merchant, and after graduating from Yale University in 1912 he worked in the family business for several years. In 1921 he moved to Paris, discovered modern art when he saw an exhibition at the Paul *Rosenberg gallery, and decided to become a painter. He took lessons with Natalia *Goncharova, through whom he met *Diaghilev, who commissioned him to repaint scenery for his Ballets Russes that had been damaged in a fire. Among the other leading figures whom he knew in the art world were *Braque, *Léger (who became a close friend), and *Picasso. His American friends in France included the writers Scott Fitzgerald and Ernest Hemingway and the composer Cole Porter, all of whom visited Murphy's summer retreat in Antibes—the 'Villa America'. Murphy shared with Léger an enthusiasm for machine-made objects and strong, flat forms, and between 1924 and 1929 he painted a number of bold, schematized images of objects such as pens, matchboxes, and safety razors that have something in common with *Purism but seem closer in

spirit to *Pop art, which they anticipate by a generation (*Razor*, Dallas Museum of Art, 1924). These works so impressed Léger that he described Murphy as 'the only American painter in Paris'. In 1929, however, Murphy stopped painting because of problems with his children's health, and in 1932 he returned to the USA to help the family firm through the difficulties of the Depression. Some of his paintings remained in storage in Europe until after the Second World War and his work was more or less unknown until an exhibition of it was held at the Dallas Museum of Fine Arts in 1960. Since then several books have been published on him, including one by Calvin *Tomkins.

Murray, Elizabeth (1940–). American painter and printmaker, born in Chicago. She studied at the Art Institute of Chicago, 1958–62, and Mills College, Oakland, California, where she took an MFA degree in 1964. After working as a teacher in Buffalo (where she also set up a print workshop), she settled in New York in 1967. In the early 1970s her work became abstract, and from 1976 she began to use *shaped canvases, a format that she has made her own. She has not only used unusual irregular shapes, but also has taken the idea further into pictures made up of multiple canvases, sometimes in overlapping, interlocking layers and sometimes arranged in patterns like jigsaws in which the pieces do not quite fit; *Painter's Progress* (MOMA, New York, 1981) is made up of 19 parts. She says of such works 'I want the panels to look as if they had been thrown against the wall, and that's how they stuck there', but in spite of the energy and seeming spontaneity of her work, she plans it very carefully, making full-scale preparatory drawings. Typically her paintings are large and exuberant, often brilliantly coloured. At first glance they usually look purely abstract, but they often contain figurative elements. Murray has also produced coloured lithographs. Her work has been widely exhibited and she is regarded as one of the most inventive and distinctive American abstract artists of her generation; she says she aims to be '*expressive* in paint' and that she puts 'heart and soul' into her work.

Musée d'Art Moderne de la Ville de Paris. Paris's municipal collection of 20th-century art, opened in 1961 in a wing of the Palais de Tokyo on the right bank of the Seine. This

building was erected for the 1937 World Exhibition and one of the highlights of the museum is *Dufy's decorative scheme *The Spirit of Electricity*, painted for the Pavilion of Light at this exhibition. The permanent collection is rich and varied, reflecting artistic developments in Paris from *Fauvism onwards. There are also frequent exhibitions of contemporary art. The museum is not to be confused with the Musée National d'Art Moderne, which was originally housed in another wing of the Palais de Tokyo and is now part of the *Pompidou Centre.

Musée National d'Art Moderne, Paris. See POMPIDOU CENTRE.

Museum of Contemporary Art, Chicago. Museum founded in 1967 by a group of art lovers in Chicago who thought that the city's major gallery, the Art Institute, gave insufficient representation to modern art. It opened that year in a turn-of-the century building in East Ontario Street that was originally a bakery and had later been the home of Playboy Enterprises. The building was modernized and the exterior was embellished with a large copper frieze by Zoltan *Kemeny. In 1977 the museum expanded into an adjacent building, and in 1996 it moved to a large new building designed by the German architect Josef Paul Kleinhues in a park-like setting near Lake Michigan. The museum was established to cover 'the untried, the unproved, the problematical, and the controversial' in art, and from the first has mounted a broad-ranging exhibition programme covering diverse fields. It has also built up a large permanent collection.

Museum of Contemporary Art (MOCA), Los Angeles. Museum devoted to art since 1940, opened in 1979. Pontus *Hulten was the first director. The founders and benefactors have included several prominent local collectors of modern art, among them Robert A. Rowen (1910–), Taft Schreiber (1908–76) and his wife Rita Bloch Schreiber (1909–89), and Marcia Weisman (née Simon) (1918–), sister of Norton Simon, the famous collector of Old Masters, and wife at this time (they divorced in 1981) of fellow-collector Frederick R. Weisman (1912–) (the Weismans are the subject of a double portrait by David *Hockney, 1968). In 1983 the museum moved into temporary accomodation in a large warehouse con-

verted by the American architect Frank O. Gehry, and in 1986 into its present home–a striking *Postmodernist building by the Japanese architect Arata Isozaki. It has a large permanent collection, particularly rich in American art, and also holds temporary exhibitions. Other exhibitions are held in the warehouse building, which is now an adjunct of the main museum and known as Temporary Contemporary (in 1996 it was renamed Geffen Contemporary in honour of the recording executive David Geffen, who gave $5 million to the museum). Its size and uncluttered spaces make it particularly suitable for displaying large works.

Museum of Living Art, New York. See GALLATIN.

Museum of Modern Art (MOMA), New York. The world's pre-eminent collection of visual arts from the late 19th century to the present day. It was founded in 1929 by a group of seven well-connected art lovers, among whom were Lillie P. *Bliss and Abby Aldrich *Rockefeller. In May 1929 they formed a committee, and in summer of the same year they appointed a director (Alfred H. *Barr—an inspired choice), rented premises in the loft of an office building on Fifth Avenue, and issued a brochure entitled *A New Art Museum*, which set out some of their aims. Their immediate purpose was to hold 'some twenty exhibitions during the next two years', but the ultimate objective was 'to acquire, from time to time, either by gift or purchase, the best modern works of art . . . It is not unreasonable to suppose that within ten years New York, with its vast wealth, its already magnificent private collections and its enthusiastic but not yet organized interest in modern art, could achieve perhaps the greatest museum of modern art in the world.' Barr was even more ambitious in his plans (and amazingly clear-sighted in the way he envisioned the future broad scope of the collection); he proposed that 'In time the Museum would probably expand beyond the narrow limits of painting and sculpture in order to include departments devoted to drawings, prints, and photography, typography, the arts of design in commerce and industry, architecture (a collection of *projets* and *maquettes*), stage designing, furniture and the decorative arts. Not the least important collection might be the *filmotek*, a library of films.'

In October 1929 the seven founders held their first formal meeting as trustees; the industrialist A. Conger Goodyear (1877–1964) was elected president, Miss Bliss was vice-president, and Mrs Rockefeller was treasurer. Later in the same month, seven more trustees were elected, including Duncan *Phillips. The museum's first exhibition, '*Cézanne, *Gauguin, Seurat, Van Gogh', opened on 8 November, accompanied by a catalogue illustrating almost all of the 101 works on show. The exhibition was a great success, attended by 47,000 people in its four-week run, with 5,400 packing the galleries on the last day (the landlord of the building threatened to cancel the lease because the crowds were clogging the elevators). By the end of the year the Museum had also bought its first acquisitions—eight prints and a drawing—and Goodyear had presented the first sculpture to enter the collection, a nude torso by *Maillol. The first painting acquired by the museum was *Hopper's *House by the Railroad* (1925), given by Stephen C. Clark, one of the trustees, early in 1930. A trickle of other gifts followed, but the core of the permanent collection was established by Lillie Bliss's bequest at her death in 1931. (The phrase 'permanent collection' was abandoned in 1941 in favour of 'Museum Collection', as it was the policy to sell works that were regarded as surplus in order to raise funds.)

In 1932 the museum moved to larger premises at 11 West 53rd Street. The collection was at this time growing slowly during the Depression years, but in 1935 it was given its first purchase fund by Abby Aldrich Rockefeller, one of her many benefactions to the museum. In 1937 it moved temporarily to the Rockefeller Center to allow the construction of a new building at the site in West 53rd Street (this remains the museum's home, but it has since expanded enormously in size in various stages). In 1939 the new premises opened and the museum celebrated its 10th anniversary with an exhibition entitled 'Art in Our Time', in which all its departments were represented: Painting and Sculpture, Drawings and Prints, Architecture, Industrial Design, Posters, Film, and Photography. Among the exhibits was *Picasso's recently acquired *Les Demoiselles d'Avignon*, now the most famous work in the collection. The catalogue of the exhibition recorded that in its first decade the museum had held 112 exhibitions attended by about one-and-a-half mil-

lion people. By this time the balance of its collections and activities had moved strongly from 19th-century to 20th-century art: in the words of the 'Art in our Time' catalogue, 'our aim has been to present to the public the living art of our own time and its sources'.

In 1943 the museum announced that Barr had resigned as director 'to devote his full time to writing the works on modern art which he has had in preparation and which heavy directorial duties have made it impossible for him to undertake'; however, he continued to work at the museum until his retirement in 1967, first as director of research and then from 1947 as director of the museum collections (the varied titles are somewhat confusing; there was no overall director again until 1949, the Museum being run in the intervening period by a committee, and Barr remained MOMA's dominant presence). Another distinguished scholar of modern art, James Thrall *Soby, was briefly director of the department of painting and sculpture, 1943–5. In 1944 he wrote an article for *Museum News* explaining MOMA's acquisitions policy: 'In recent years the Museum has sometimes been berated for not buying more painting and sculpture by American abstract and Expressionist artists [members of *American Abstract Artists had in fact picketed the museum in 1940] . . . But it should be remembered that the Museum does not exist for the direct benefit and patronage of artists. We do not consider it our job to force contemporary art in one direction or another through propaganda or patronage, much as enthusiasts for a particular dogma would like to have us do so. For in the final analysis it is not our job to lead artists, but to follow them—at a close yet respectful distance.' In spite of such robust words of defence, as MOMA grew in size and prestige, its power to make reputations was generally acknowledged. Alexander *Calder, for example, wrote in 1966 that 'I have long felt that whatever my success has been' was 'greatly as a result of the show I had at MOMA in 1943'.

In 1947 MOMA came to an arrangement with the Metropolitan Museum, New York, whereby it was to sell to the Metropolitan 'paintings and sculptures which the two museums agree have passed from the category of modern to that of "classic"', with the proceeds being used to buy new works for MOMA. In 1953, however, the board of trustees announced a change of policy,

described by Barr as follows: 'A permanent nucleus of "masterworks" was to be selected under the supervision of the Board. In accordance with this new policy, the 1947 agreement with the Metropolitan Museum was terminated; the Museum of Modern Art would no longer sell . . . its "classical" paintings in order to purchase more "modern" works. Instead it would permanently place on view masterpieces of the modern movement beginning with the latter half of the nineteenth century.'

In 1953 MOMA added the Abby Aldrich Rockefeller Sculpture Garden, designed by the celebrated architect Philip Johnson (1906–), who had two periods in charge of the museum's Department of Architecture and has also been a generous benefactor of works of art from his own collection. Johnson remodelled the sculpture garden in 1964 when he added a new east wing to the museum. In 1966 MOMA was again greatly enlarged when it took over the adjacent premises formerly occupied by the *Whitney Museum. When Alfred Barr retired the following year, MOMA had become such a huge institution that it employed more than 500 people. In 1976 it announced plans for a new west wing. To help finance this it sold the air rights over the museum to a property developer, who built an apartment block—Museum Tower—over the new wing, which was opened in 1984. In 1996 MOMA bought adjacent land for further expansion.

Museum of Modern Art, Oxford. Institution founded in Oxford in 1966 by a group of art lovers under the chairmanship of Trevor Green, an architect. Initially they hoped to create a museum with a permanent collection of post-1945 art, but this proved financially unfeasible, so they decided instead to establish a home for a programme of changing exhibitions. The original premises were in King Edward Street, and in 1970 the museum moved to its present home—part of a 19th-century storehouse in Pembroke Street that was formerly used as a brewery. A large extension was completed in 1981. The museum mounts a wide range of exhibitions (which often tour in Britain and abroad) and also hosts lectures and seminars. Many of the exhibitions have dealt with art that is generally little known in Britain, particularly from Eastern European countries, and their catalogues have made significant contributions to scholarship. The

museum has built up a research library and archive based on its activities, and has a particularly important *Rodchenko collection, assembled for an exhibition of his work in 1979 (much of the material was donated by the artist's family in Moscow). The impressive contributions to Russian studies reflect the fact that the director of the museum for most of its history, David Elliott (1949–), is a noted scholar of Russian art. He succeeded Nicholas Serota (see TATE GALLERY) as director in 1976 and left to become director of the Moderna Museet, Stockholm, in 1996.

Museum of Modern Art, San Francisco. See SAN FRANCISCO MUSEUM OF MODERN ART.

Museum of Modern Art, Stockholm. See MODERNA MUSEET.

Museum of Modern Art and Design of Australia, Melbourne. See ANGRY PENGUINS.

Museum of Modern Art at Heide, Bulleen, Victoria. See ANGRY PENGUINS.

Museum of Modern Western Art, Moscow. See SHCHUKIN.

Museum of Non-Objective Art, New York. See GUGGENHEIM.

'Museum without Walls'. See MALRAUX.

Myers, Jerome (1867–1940). American painter and etcher, born in Petersburg, Virginia, into a poor family. He spent his youth in Philadelphia and Baltimore, working at various odd jobs, then in 1886 settled in New York, where he worked as a theatrical scene painter for the next three years whilst studying at evening at the Cooper Union and the *Art Students League. During the 1890s he worked for an engraving company and in the art department of the *New York Tribune*, and he visited France in 1896. He began to paint in 1900, encouraged by the art dealer William Macbeth, at whose gallery he had his first one-man show in 1908. Myers's most characteristic works depict city slums, and he was one of the first American artists to paint such scenes. His own deprived background had given him sympathy for slum dwellers (his friend and fellow painter Harry Wickey (1892–1968) wrote that he 'enjoyed nothing so much as being in their midst'), but he

portrayed them in a picturesque, romanticized way rather than in a spirit of *Social Realism. He was one of the founder members of the Association of American Painters and Sculptors, which organized the *Armory Show in 1913, but he was uninfluenced by the modern art that was shown there, continuing to work in the same style throughout his life. By the end of his life his work looked distinctly nostalgic, and in 1940, shortly before his death, he commented 'Something is gone. Something is missing. I say to myself, "It is the warmth of human contact; that's what it is. It is gone. Men and women and children hide behind the walls of their homes." New Yorkers no longer live in the open.' His autobiography, *Artist in Manhattan*, was published in 1940.

Myslbek, Josef (1848–1922). The leading Czech sculptor of the late 19th and early 20th centuries. He created numerous statues of national heroes in Prague, most notably the famous St Wenceslas Monument in Wenceslas Square, which was begun in 1900, and unveiled in 1913 but not completed until 1923, the year after Myslbek's death. His work is in the Renaissance tradition but has a suitably Romantic Slavonic ardour. In addition to statues he made many portraits.

Nabis. A group of painters, mainly French, active in Paris in the 1890s; their outlook was essentially *Symbolist and they were particularly influenced by *Gauguin's expressive use of colour and rhythmic pattern. The name Nabis (Hebrew for 'prophets') was suggested by the poet Henri Cazalis in reference to the missionary zeal with which they promoted Gauguin's teachings. *Sérusier, who met Gauguin at Pont-Aven in 1888, was the driving force behind the group and with *Denis was its main theorist. Other members included *Bonnard, *Maillol (before he turned to sculpture), Ranson (see ACADÉMIE), *Roussel, *Vuillard, the Hungarian Josef Rippl-Rónai (1861–1927), the Swiss *Vallotton, and the Dutchman Jan Verkade (1868–1946). They were active in design (of posters, stained glass, and theatrical decor) and book illustration as well as painting. Group exhibitions were held between 1892 and 1899, after which the members gradually drifted apart. Several of them, however, continued Nabis ideas into the 20th century, notably Denis and Sérusier, whose work remained esoteric in spirit and bound up with their religious beliefs. (Verkade was even more devout, entering a Benedictine monastery in Germany in 1894 and being ordained in 1902, after which he was known as Dom Willibrod Verkade; he continued to paint fairly regularly up to the First World War.) Bonnard and Vuillard departed radically from Nabis ideas in the quiet *Intimiste scenes for which they became chiefly famous, but their later decorative work sometimes retained a feeling for flat pattern that recalls their Nabis days.

Nadelman, Elie (1882–1946). Polish-born sculptor and draughtsman who became an American citizen in 1927. After brief studies in his native Warsaw and in Munich he settled in Paris in 1903 or 1904 and lived there until 1914. Initially he was influenced by *Rodin, but he soon became interested in more avant-garde trends and he later claimed that in some of his work (particularly drawings) of around 1906–7 he had anticipated *Picasso in the diffraction of forms typical of *Cubism. He knew many leading members of the Parisian avant-garde (including *Apollinaire, *Brancusi, Picasso, and the *Steins), and his early patrons included Helena Rubinstein (1870–1965), the Polish-born cosmetics manufacturer and art collector. His first one-man exhibition was at the Galerie Druet, Paris, in 1909. With the outbreak of the First World War he moved to London and then New York, helped by Madame Rubinstein, who commissioned him to make sleek marble heads for her beauty salons.

Nadelman already had a considerable reputation when he arrived in America and his first one-man show there (at *Stieglitz's gallery in 1915) was a great success. Within a short time he was well established in the New York art world, his friends including Paul *Manship and Gertrude Vanderbilt *Whitney. He married a wealthy widow in 1919 and they lived in some style, with a town house in Manhattan and an estate at Riverdale, New York State. They also spent lavishly collecting American folk art. Nadelman's work has a witty sophistication appropriate to the high society world in which he moved, as with *Man in the Open Air* (MOMA, New York, 1915), a delightful bowler-hatted bronze in a pose mimicking ancient Greek sculpture. With his humour went a bold simplification and distortion of forms (akin to those of *Lachaise) that place him among the pioneers of modern sculpture in America. The Depression had a disastrous effect on his market (he had to sell the house in Manhattan) and his career virtually ended when a good deal of his work was accidentally destroyed in 1935. He was already leading a reclusive life by this time, but during the Second World War he taught

ceramics and modelling at the Bronx Veterans' Hospital. Two years after his death there was a major exhibition of his work at the Museum of Modern Art, New York.

Nagare, Masayuki (1923–). Japanese abstract sculptor, active in the USA as well as in his own country. He was born in Nagasaki, the son of a distinguished statesman, and had a samurai upbringing; his interest in martial arts led him to study with a swordsmith, laying the foundations of the understanding of materials and superb craftsmanship that he later displayed in his sculpture. After briefly attending Ritsumeikan University (founded by his father), he served as a fighter pilot, 1943–5, and in the aftermath of the Second World War he led a wandering life for about a decade, associating with artists, including writers and potters. During this time he produced pottery himself and developed a passion for stone by visiting war-scarred graveyards and re-erecting fallen tombstones. In 1955 he had his first one-man exhibition at the Mimatsu Gallery, Tokyo, dedicating it to the memory of American and Japanese pilots killed in the war. The sculptures he showed here were in metal and wood, but he took up stone carving the following year. From 1958 his work began to attract American collectors visiting Japan (see ROCKEFELLER), and he had his first great success with a 600–ton stone wall entitled *Stone Crazy* for the Japanese Pavilion at the 1964 New York World's Fair. Its popularity with critics and public alike encouraged him to spend most of the next decade in the USA, where his work included the well-known *Cloud Fortress* (1969–75) in the plaza outside the World Trade Center, New York, consisting of two gigantic triangular clusters in black granite.

Disillusioned with American involvement in Vietnam, Nagare has reaffirmed his identity as an Asian and from 1975 he has worked mainly in Japan, where he has carried out numerous major commissions and is recognized as one of the country's outstanding artists. His studio is on the island of Shikoku, remote from Tokyo, and he has devoted much effort to the cultural revitalization of rural Japan, notably with Nagare Park on Okushiri Island (begun 1980, partly destroyed by earthquake 1993, but subsequently reconstructed). His sculpture is abstract but often evokes the human figure or other forms, such as the sharp edges and subtle curves of samurai sword blades. Most characteristically he works in granite, polished to mirror smoothness; often he contrasts sleek shapes with raw, rough surfaces, and he has also used other materials, including bronze and steel, with a similar feeling for their own special qualities.

Nagel, Peter. See ZEBRA.

naive art. Term applied to painting (and to a much lesser degree sculpture) produced in more or less sophisticated Western or Westernized societies but lacking conventional expertise in representational skills. Colours are characteristically bright and non-naturalistic, perspective non-scientific, and the vision childlike or literal-minded. The term '*primitive' is sometimes used synonymously with naive, but this can be confusing, as 'primitive' is also applied loosely to paintings of the pre-Renaissance era as well as to art of 'uncivilized' societies. Other terms that are sometimes used in a similar way are 'folk', 'popular', or 'Sunday painters', but these too have their pitfalls, not least 'Sunday painter', for many amateurs do not paint in a naive style, and naive artists (at least the successful ones) often paint as a full-time job. Sophisticated artists may also deliberately effect a naive style, but this 'false naivety' (*faux naïf*) is no more to be confused with the spontaneous quality of the true naive than the deliberately childlike work of say *Klee or *Picasso is to be confused with genuine children's drawing. Naive art has a quality of its own that is easy to recognize but hard to define. Scottie *Wilson summed it up when he said 'It's a feeling you cannot explain. You're born with it and it just comes out.'

Naive art, as the term is now generally understood, developed in the 19th century (before then, pictures that have a naive quality might more reasonably be classified as folk art or simply as amateurish works) and the first notable exponent was perhaps the American Edward Hicks (1780–1849), famous for his religious scenes (he was a Quaker preacher). It was not until the early years of the 20th century, however, that there has been a vogue for naive art. Henri *Rousseau was the first naive painter to win serious critical recognition and he remains the only one who is regarded as a great master, but many others have won an honourable place in modern art. The first significant collector of naive art was the French humorous writer Georges

Courteline (1858–1929), whose collection in his Paris home was illustrated in the satirical magazine *Cocorico* in August 1900. However, it was the critic Wilhelm *Uhde—in the years after the First World War—who was mainly responsible for putting naive painters on the map. At first their freshness and directness of vision appealed mainly to fellow artists, but a number of major group exhibitions in the 1920s and 1930s helped to develop public taste for them: they included the exhibition of Courteline's collection at the Galerie *Bernheim-Jeune, Paris, in 1927; 'Maîtres Populaires de la Réalité', shown at the Salle Royal, Paris, in 1937 and then at the Kunsthaus, Zurich; and 'Masters of Popular Painting: Modern Primitives of Europe and America' at the Museum of Modern Art, New York, in 1938.

Most of the early naive painters to make reputations were French (mainly because Uhde was active in discovering and promoting them in France); they included *Bauchant, *Bombois, Jean Eve (1900–68), Jules Lefranc (1887–1972), Dominique Peyronnet (1872–1943), René Rimbert (1896–), *Séraphine, and *Vivin. By the middle of the century, however, most countries had their share of such painters. They included the Belgian Léon Greffe (1881–1949), the German *Paps, the Greek *Theophilos, the Italian Orneore *Metelli, the Pole *Nikifor, the Spaniard Miguel *Vivancos, and the Swiss Adolf *Dietrich. In Britain the best-known figures include Beryl *Cook and Alfred *Wallis (two painters who show the huge difference of approach and style that can exist betwen artists given the same label). L. S. *Lowry is also often claimed as a naive painter, but some critics regard him as outside this classification because of his many years of study at art school. In the USA the leading figures include Morris *Hirschfield, John *Kane, Grandma *Moses, and Horace *Pippin. Haiti is noteworthy in that naive painting has been the country's central tradition in 20th-century art, the leading figures including Wilson *Bigaud, Hector *Hyppolite, and Pierre Monosiet (1922–83), who was first director of the Musée d'Art Haitien in Port-au-Prince from 1972 until his death. The richest crop of naive painters, however, has been in the former Yugoslavia (mainly Croatia). Ivan *Generalić is the most famous figure; others include Franjo Filipović (1930–), Ivan Lacković (1932–), Franjo *Mraz, Ivan *Rabuzin, and Mirko *Virius. A Gallery of Primitive Art was founded in Zagreb, the capital of Croatia, in 1952, and there are other museums in the country specializing in naive art.

The Yugoslavian painters are unusual in that they have concentrated around four main centres: Hlebine (see HLEBINE SCHOOL), Kovačica, Oparić, and Uzdin. In many other countries, naive painters have worked in isolation from each other and from the orthodox art production around them. They are extremely diverse in both their habits and their work. Some have shown an interest in painting since childhood, others have taken it up in middle age or late in life. From necessity or choice many of them have been spare-time artists, painting for their own pleasure while earning a living by other means. Many have been interested primarily in depicting scenes and incidents from the daily life around them. These have often given great attention to realistic detail, rendering each feature with painstaking precision, whether or not it could in actuality be so seen within the image as a whole. Others have given free rein to imagination and fantasy, sometimes with an almost *Surrealistic effect. The traditional principles of perspective usually go by the board, though many naive artists are capable of rendering distance and depth by their own means. So-called 'psychological' perspective is a prominent feature of much naive painting, the relative size of figures and objects being determined by psychological interest without regard to natural proportions. As in the case of Rousseau, naive painters have often been admired for qualities in their work of which they themselves were unaware. If it is possible to point to any quality which the best naive work has in common with that of sophisticated artists, it is a power of pictorial construction (lacking almost always in the work of children and psychotics) and a power to invest the depiction of the commonplace and familiar with poetic freshness. The cult of naive painting, however, has perhaps led to the overrating of much work, for the truly outstanding naive painter is probably as rare as the truly outstanding artist in any other field. When their work acquires financial value, there is the danger—as happened to some extent in Yugoslavia during the late 1960s—that naive painters begin to repeat themselves, with a consequent loss of spontaneity in their work.

Nakanishi, Natsuyuki. See HI-RED CENTER.

Nakian, Reuben (1897–1986). American sculptor, born at College Point, New York, the son of Armenian immigrant parents. He studied at several art colleges before being apprenticed to Paul *Manship, 1917–20. In Manship's workshop he became friendly with Gaston *Lachaise and they shared a studio in the early 1920s. At this time Nakian worked in a polished traditional style and in the 1930s he was particularly known as a portraitist. During the Second World War he confined himself mainly to drawing, and when he returned to sculpture in earnest in about 1947 it was with a radically changed style. Influenced by his friend Arshile *Gorky, he became one of the sculptors (others were *Lassaw, *Lipton, and *Roszak) who created a kind of three-dimensional version of *Abstract Expressionism. Typically he used cloth stretched on chicken wire and dipped in plaster or glue, creating rough, sensuous textures. Later he had his works cast in bronze and sometimes added elements in welded steel. Often he based his work on mythological themes, but retained only vague suggestions of figurative elements (*Goddess of the Golden Thighs*, Detroit Institute of Arts, 1964–5). Much of his work is on a large scale, intended for outdoor display.

Namuth, Hans. See ACTION PAINTING.

Narkompros (NKP). A cultural organization founded in Soviet Russia in 1917 shortly after the October Revolution; the word is an abbreviation of *Narodny Komissariat Prosveshcheniya* (People's Commissariat for Enlightenment). Narkompros was directed by the writer and politician Anatoly Lunacharsky (1875–1933) and was in charge of general cultural and educational policy. It contained several sections, including a Visual Arts Section called IZO Narkompros; this was headed by the painter David Shterenberg (1881–1948), who was based in Petrograd (St Petersburg), assisted by *Tatlin in Moscow. IZO organized a series of state exhibitions (21 between 1918 and 1921), administered the new art schools (*Svomas/*Vkhutemas) and research institutes (*Inkhuk), and was involved in public commissions. Many avant-garde artists and critics were involved with IZO Narkompros in one way or another. In 1918–19 it published its own journal, *Iskusstvo kommuny* (Art of the Commune), the contributors including *Altman, *Malevich, *Pougny, and *Punin. Narkompros also contained sections devoted

the cinema (FOTO-KINO), literature (LITO), music (MUSO) and the theatre (TEO). In the early years, partly because of Lunacharsky's tolerance and liberalism, Narkompros maintained a fairly independent stance, but by the late 1920s (especially after Lunacharsky's departure in 1929) it had become part of the Communist apparatus.

Nash, Paul (1889–1946). English painter, book illustrator, writer, photographer, and designer, born in London, the son of a barrister. Nash was one of the most individual British artists of his period, taking a distinguished place in the English tradition of deep attachment to the countryside (he saw himself as a successor to Blake and Turner) whilst at the same time responding imaginatively to European modernism. The most important part of his training was at the *Slade School, 1910–11, after which he worked briefly for Roger *Fry's *Omega Workshops. At the outbreak of the First World War he enlisted with the Artists' Rifles and in 1917 was posted to the front at Ypres. He was invalided out after a few months, but he returned to France the same year as an *Official War Artist (a result of the success of his exhibition 'Ypres Salient' at the Goupil Gallery, London, 1917). The paintings he produced include some powerful views of the pitted and shattered landscape of No Man's Land that rank among the most famous images of the conflict (*We Are Making a New World*, Imperial War Museum, London, 1918). He held a second successful exhibition, 'The Void of War', at the *Leicester Galleries, London, in 1918, and although his later career was varied and distinguished, many critics think that his First World War paintings mark the summit of his achievement.

During the 1920s and particularly the 1930s Nash was influenced by *Surrealism (above all by de *Chirico, an exhibition of whose work he saw in London in 1928), and he often concentrated on mysterious aspects of landscape. For much of this time he lived in rural areas (Kent, 1921–5; Sussex, 1925–33; Dorset, 1934–5), basing his work on scenes he knew well but formalizing and imaginatively transforming them, sometimes almost to the point of abstraction (*Landscape from a Dream*, Tate Gallery, London, 1937–8). He continued to be involved in the London art world, however; as well as teaching at the *Royal College of Art, 1924–5 and 1938–40, he was the prime mover behind the formation of the avant-

garde group *Unit One in 1933 and he helped to organize and exhibited in the International Surrealist Exhibition in 1936. During the Second World War he was again an Official War Artist, even though at the outbreak of war he was already very ill with the asthmatic condition that killed him. His Second World War paintings are not generally as highly regarded as those of the First, but they include one acknowledged masterpiece, *Totes Meer (Dead Sea)* (Tate Gallery, London, 1940–1), which shows shot-down aircraft with their wings looking like undulating waves. Nash based it on a dump of wrecked planes he saw near Oxford, where he was living at this time, and he wrote that 'a pervasive force, baffled yet malign, hung in the heavy air'. His final paintings, produced when he was very weak, were of flowers.

Nash also designed scenery, fabrics, and posters, and he was considered to be one of the finest book illustrators of his day, working in pen and ink, lithography, and wood engraving, sometimes in colour. He regarded his illustrations to an edition of Sir Thomas Browne's *Urn Burial* (1932) as his most successful work in this field. In 1936 he published a guidebook to Dorset in the Shell Guide series, and two collections of his writings appeared posthumously: *Outline* (a fragment of autobiography with some letters and essays) in 1949, and *Poet and Painter* (his correspondence with the poet Gordon Bottomley) in 1955. A collection of his photographs taken for use in his paintings was published as *Fertile Image* in 1951.

His brother **John Nash** (1893–1977) was also a landscape painter and an illustrator, excelling in meticulous flower drawings for botanical publications. Like Paul he was an Official War Artist in both world wars. His work is well represented in the Tate Gallery.

National Art Collections Fund. See CONTEMPORARY ART SOCIETY.

National Socialist art. The art endorsed and encouraged by the Nazis from 1933 to 1945—that is from the time when Hitler became Chancellor of Germany as head of the National Socialist Workers' Party of Germany (Nationalsozialistische Deutsche Arbeiterpartei) until the end of the Second World War. Hitler, who had been an unsuccessful painter in his youth, realized that art could have immense propaganda value and used it to promote the cult of his own personality as well as the Nazi ideas of Nordic racial superiority and 'Strength through Joy' (Kraft durch Freude). Hand-in-hand with this policy went the repression, ridicule, and eventually destruction of art that conflicted with Nazi ideology (see DEGENERATE ART).

On 15 October 1933 Hitler laid the foundation stone of a new museum, the House of German Art, in Munich, and the city celebrated with a Day of German Art. The architect of the museum was Paul Ludwig Troost (1878–1934), who was Hitler's most trusted adviser on art; after his death, Albert Speer (1905–81) became Hitler's chief architect, adapting Troost's stark, bludgeoning classicism to works on a megalomaniac scale. In April 1935 Joseph Goebbels, Hitler's propaganda minister, issued a decree bringing all artists under the jurisdiction of the Reich Chamber of Culture (Reichskulturkammer), founded in 1933, and artists were ordered to produce a 'racially conscious' popular art. Two years later Goebbels declared: 'The freedom of artistic creation must keep within the limits prescribed, not by any artistic idea, but by the political idea.'

In 1937 the House of German Art opened with an exhibition of such approved art—the Great German Art Exhibition, the first of an annual series that went on until 1944. These eight exhibitions were huge: all but one of them showed over a thousand works (the average number was about 1,200) and well over 500 artists were represented at each one. Hitler intervened personally at the preview of the first exhibition, rejecting 80 pictures with the remark 'I won't tolerate unfinished paintings' and accepting works by certain artists who had previously been rejected. He entrusted the organization of the seven exhibitions that followed to his personal photographer, Heinrich Hoffmann. Within the next few years some 20,000 officially approved paintings were disseminated to museums throughout the country, where they took the place of the degenerate works that had been purged. They were removed from public view at the end of the war and have only recently started to emerge again.

The fact that these works have so long been kept in storage indicates the strong feelings that they still arouse. In *The Arts of the Third Reich* (1992) Peter Adam goes so far as to say that Nationalist Socialist art 'whether it be in the form of fine arts, architecture, film, literature,

or music, cannot be considered in the same way as the art of other periods. It must be seen as the artistic expression of a barbaric ideology. One can only look at the art of the Third Reich through the lens of Auschwitz.' Many of the militaristic pictures are certainly hard to stomach, but among the other genres there is much that could be closely paralleled in the academic art of any other Western country (not least the discreetly salacious nudes that were seen in abundance at the Great German Art Exhibitions). Reviewing Adam's book, David Watkin attacked the 'astonishing crudity' of the author's view and wrote: 'what surely strikes the unbiased observer is the mild and traditional character of most of the images reproduced in his book. This is the kind of art and architecture which would have been produced in Germany in the 1930s whoever was in power.'

In *Art in the Third Reich* (1980), Berthold Hinz had earlier expressed a similar view to Watkin: 'thousands of artists sent thousands of works to the official art exhibits held in the Third Reich. Art works in such vast numbers could not simply be willed into being . . . It is inconceivable that several thousand painters, graphic artists, and sculptors would suddenly have renounced their artistic heritage and submitted to any official decrees on art . . . These artists were not necessarily politically committed—many artists successful under National Socialism would later cite this point to exonerate themselves—but subscribed to pictorial and formal traditions that the art policy of the regime found useful, or at least not objectionable.'

Among Third Reich painters a representative figure is Adolf Ziegler (1892–1959), who was appointed president of the Reich Chamber of Visual Arts (Reichskammer der Bildenden Künste) in 1936 and as such was responsible for choosing the works shown in the infamous 'Degenerate Art' exhibition in 1937. He specialized in paintings of nudes and was nicknamed 'the master of German pubic hair'. Among sculptors, the best-known figures were Arno *Breker, Georg *Kolbe, and Josef Thorak (1889–1952), who was 'popularly nicknamed "Professor Thorax" because of his preoccupation with Herculean masculinity . . . his gigantomania inspired the story of a visitor who had asked the studio assistant about the sculptor's whereabouts, only to be told "The Herr Professor is up in the left ear of the horse."' (Richard Grunberger, *A Social His-*

tory of the Third Reich, 1971). See also TOTALITARIAN ART.

Nauman, Bruce (1941–). American experimental artist, born at Fort Wayne, Indiana. He studied mathematics, physics, and art at the University of Wisconsin, then did two years' postgraduate study at the University of California, Davis, 1964–6. In 1965 he gave up painting and has subsequently worked in fields that have been variously described as *Body art, *Conceptual art, or *Performance art. His early work included wax casts of parts of his own body and holographic self-images. In the 1970s he became interested in viewer participation, setting up sculptural 'situations' with which they could interact, but in the 1980s he returned to objects. His work has been represented in many major exhibitions and in 1991 he won the city of Frankfurt's Max Beckmann Prize. Since 1979 he has lived in New Mexico.

Nay, Ernst Wilhelm (1902–68). German painter, born in Berlin, where he trained at the Academy under *Hofer, 1925–8. He visited Paris in 1928 and Rome in 1930, but more significant for his work was a trip to Norway (as a guest of *Munch) in 1937, during which he visited the Lofoten Islands, within the Arctic Circle. They inspired a series of powerful *Expressionist landscapes, with heavy brushstrokes and vivid colours, in which he first developed a personal style. His work was declared *degenerate by the Nazis and he was called up for military service in 1940, but he managed to continue to paint whilst serving in France. After the war Nay lived in Hofheim until 1951, when he settled in Cologne. By this time he was working in a completely abstract style, characteristically featuring large, freely arranged spots of sumptuous colour (he was a member of the Cologne group *Zen, which practised a German version of *Art Informel). By the mid-1950s Nay was regarded as one of his country's leading painters; he was prominently represented in the first three *Documenta exhibitions in 1955, 1959, and 1964, and he was West Germany's representative at the Venice *Biennale in 1964.

Nederlandse Informele Groep. See NUL.

Neel, Alice (1900–84). American painter, born at Merion Square, Pennsylvania. She studied at Philadelphia School of Design for Women

(now Moore College of Art), 1921–5, and after living briefly in Cuba, settled in New York in 1927. In the 1930s she worked for the *Federal Art Project and painted scenes or urban poverty, but she was principally a portraitist. She was an independent figure, unconcerned with passing fashions, and fame came to her late in life, when her stark, frontal, penetrating images suddenly attracted widespread attention. The most famous example is probably *Andy Warhol* (Whitney Museum, New York, 1970), in which Warhol is seen as a frail rather than a glamorous figure, stripped to the waist exposing the scars left by the assassination attempt on him in 1968. Neel also painted occasional nudes, and Margaret Walters (*The Nude Male: A New Perspective*, 1978) describes her as 'probably the finest of all contemporary painters of the nude . . . One of the qualities that makes Neel's works so powerful and difficult is the combination of a deep physical empathy with her sitters . . . and a vision so unsentimental that it verges on brutality.'

Negret, Edgar (1920–). Colombian sculptor. He was born in Popayán and studied at the School of Fine Arts, Cali, 1938–43. His career has been spent mainly in Bogotá, but he has had two periods in New York, 1948–50 and 1953–63, and in between them travelled in Europe, 1951–3. Early in his career he produced semi-abstract stonecarvings in the tradition of *Arp, but in the 1950s he turned to *Constructivism, using industrial metal parts bolted together, usually painted a uniform colour (*Coupling*, Public Gardens, Bogotá, 1966). He is regarded as one of South America's leading abstract sculptors and has won munerous awards in international exhibitions.

Neiman, LeRoi. See WARHOL.

Neizvestny, Ernst (1926–). Russian sculptor and graphic artist. During the years of Soviet oppression in the arts, when *Socialist Realism was the officially sanctioned style, Neizvestny was one of the leading figures in *Unofficial art. In the Second World War he joined the army at the age of 16 and was badly wounded, an event that helped to shape his predilection for themes of life and death, as seen through the sufferings of the Russian people. Writhing forms and clenched fists are typical of his work. Following Stalin's death in 1953 there was a slight thaw in the political climate and in 1962 Neizvestny had a public confrontation with his successor Khruschev, who had denounced modern art (after Khruschev's fall from power, however, he began a friendly correspondence with Neizvestny, who designed a memorial for the former premier's grave). In 1969 Neizvestny was the subject of a book by John *Berger—*Art and Revolution: Ernst Neizvestny and the Role of the Artist in the USSR*. In 1976 he was was given permission to leave Russia; he moved to Switzerland and later settled in the USA.

Nemon, Oscar (1906–85). Yugoslavian-born sculptor who settled in Britain in 1939. He is best known for public statues, including several in prominent positions in London. Among them are two of the leading military figures of the Second World War: Lord Portal (unveiled 1975) in Victoria Embankment Gardens, and Lord Montgomery (unveiled 1980) in Whitehall. They are essentially in a fairly stodgy traditional style, but given a superficially modernist surface animation that makes them look as if they are covered in bronze bird droppings. More successful is Nemon's seated statue of Sigmund Freud, which was modelled in plaster in Vienna to mark Freud's 75th birthday in 1931 but was not cast for almost another 40 years, after a world-wide appeal for funds among the psychiatric profession. It was unveiled in 1970 outside Swiss Cottage Library, near Freud's last home in Maresfield Gardens, Hampstead, which is now the Freud Museum. A cast of the head of Nemon's statue is in the museum.

Neoclassicism. A term that usually refers to a major revival of the ideals and forms of ancient Greek and Roman art in the late 18th and early 19th centuries, but which in the context of modern art is applied to a more limited revival of the spirit of classicism among avant-garde artists in the second and third decades of the 20th century, marking a return to restraint after a period of unprecedented experimentation. Other terms for this phenomenon include 'the New Classicism', 'the classical revival', 'the return to order', and 'the call to order' (this last being the title of a book by Jean *Cocteau, published in 1926—*Le Rappel à l'ordre*). The first stirrings of Neoclassicism are evident in *Picasso's work in 1914 (*The Painter and his Model*, Musée Picasso, Paris), and 'The First World War has,

rightly, been seen as a catalyst in the post-war "return to order", inducing a craving for the stability and proven value of tradition following disruption, carnage and vandalism on a scale unparalleled in living memory' (catalogue of the exhibition 'On Classic Ground: Picasso, *Léger, de *Chirico and the New Classicism, 1910–1930', Tate Gallery, London, 1990). Among the most impressive expressions of the movement are a number of paintings by Picasso of the early 1920s in which he depicted massively grand figures, nude or in 'timeless' draperies, consciously recalling the world of antiquity (*The Pipes of Pan*, Musée Picasso, Paris, 1923). Such works have been seen partly as a response to his trip to Italy in 1917 (in the course of which he visited the Archaeological Museum in Naples), and during his 'classical period' he spent a good deal of time on the Mediterranean coast, where he felt more open to antique influence: 'It is strange, in Paris I never draw fauns, centaurs, or mythical heroes . . . they always seem to live in these parts.'

Most of the other artists who were prominent in the classical revival also came from Mediterranean countries (chiefly France, Italy, and Spain), and—like Picasso—many of them spent part of their working lives on the Riviera or in other areas fairly remote from the modern industrial world, where the surroundings helped evoke the idea of an arcadian existence free from strife. However, the 'return to order' also found expression in ways that were very different to arcadian reverie. The *Purists, for example, attempted to combine the classical ideals of clarity and order with a functionalist outlook appropriate to the machine age, and in Italy the Fascist Party used classical imagery to foster nationalist sentiment (see NOVECENTO ITALIANO).

Neo-Conceptual art. See CONCEPTUAL ART.

Neo-Concrete art. See CLARK, LYGIA.

Neo-Dada. A term that has been applied to various styles, trends, or works that are perceived as reviving the methods or spirit of *Dada. It has been used as a synonym for *Nouveau Réalisme and *Pop art, for example, and has been applied to the work of Jasper *Johns.

Neo-Dada Organizers. A group of Japanese artists based in Tokyo, active from 1960 to 1963. Those associated with it included Genpei Akasegawa (1937–), Shusaku Arakawa (1936–), and Tomio Miki (1937–78). They were essentially *anti-art in spirit, their work including violent demonstrations.

Neo-Expressionism (also known as Energism; New Fauvism; Vehement, Violent, or Wild Painting; in France as Figuration Libre, in Italy as the *Transavantgarde). Movement in painting (and to a lesser extent sculpture) emerging in the late 1970s, characterized by intense subjectivity of feeling and aggressively raw handling of materials. Neo-Expressionist paintings are typically large and rapidly executed, sometimes with materials such as straw (see KIEFER) or brocken crockery (see SCHNABEL) embedded in their surfaces. They are usually figurative, often with violent or doom-laden subjects, but the image is sometimes almost lost in the welter of surface activity. Neo-Expressionism was put firmly on the map by a number of large exhibitions at the beginning of the 1980s, including 'A New Spirit in Painting' at the Royal Academy, London, in 1981. To some extent the movement marked a return from the 'anything goes' experimentation of the 1970s to more traditional forms. This development was welcomed by art dealers and collectors, but critical reaction has been very mixed. Several exponents, above all Schnabel, have become rich and famous, but to many critics their work seems deliberately bad, ignoring all conventional ideas of skill; indeed the term 'Bad Painting' (from the title of an exhibition at the New Museum, New York, in 1978) has been applied to certain works in the vein (Punk Art and Stupid Painting are alternative terms). Distinguishing between good 'Bad Painting' (i.e. that which deliberately cultivates crudeness for its emotional value) and bad 'Bad Painting' (something that is just a mess) is an unenviable critical task.

Neo-Expressionism has flourished mainly in Germany (where its exponents are sometimes called Neue Wilden—'New Wild Ones'), Italy, and the USA. Leading exponents include: in Germany, Georg *Baselitz, Rainer Fetting (1949–), Jörg Immendorf (1945–), Anselm Kiefer, Bernd Koberling (1938–), Markus Lüpertz (1941–), and A. R. Penck (born Ralf Winkler) (1939–); in Italy, Sandro *Chia, Francesco Clemente (1952–), Enzo Cucci (1949–), and Mimmo Paladino (1948–); in the USA, Robert Kushner (1949–),

David Salle (1952–), and Julian Schnabel. See also NEW IMAGE PAINTING.

The term 'Neo-Expressionists' had earlier been adopted (in 1952) by a group of German abstract painters called *Quadriga.

Neo-Geo. Term (short for Neo-Geometric Conceptualism) applied to the work of a group of American artists active in New York in the mid-1980s who employed a variety of styles and media but were linked by the fact that their paintings, sculpture, or other products were predominantly cool and impersonal, in reaction from the emotionalism of *Neo-Expressionism. Jeff *Koons, who exhibited consumer products such as vacuum cleaners in a reworking of *Dada *ready-mades, is the best-known figure of the group. Others include Haim Steinbach (1944–), who creates kitsch-like still-lifes, and Philip Taaffe (1955–), who paints geometrically-patterned pictures parodying earlier styles such as *Op art. Another abstract painter, Peter Halley (1953–), has been described as 'the chief theorist of Neo-Geo' (Daniel Wheeler, *Art Since Mid-Century*, 1991). Many critics have seen the work of these artists as cynical and empty ('dead on arrival' is one memorable description), but Neo-Geo has been a hit with certain collectors, notably Charles *Saatchi, who has bought it in bulk.

The term 'Neo-Geo' has also been applied to the work of certain artists outside the USA, including the Swiss John Armleder (1948–). He is perhaps best known as a *Performance artist (he was a member of *Fluxus in the 1970s), but he has also made paintings referring ironically to earlier abstract styles.

Neo-Impressionism. A movement in French painting—both a development from *Impressionism and a reaction against it—in which the Impressionist approach to depicting light and colour was made more rational and scientific. The term was coined in 1886 by the critic Félix *Fénéon. Georges Seurat (1859–91) was the founder of the movement and far and away its outstanding artist. His friend Paul *Signac was its main theoretician. The theoretical basis of Neo-Impressionism was *divisionism, with its associated technique of 'pointillism'—the use of dots of pure colour applied in such a way that when seen from an appropriate distance they achieve a maximum of luminosity. In each painting the dots were of a uniform size, chosen to harmonize with the scale of the work. In Seurat's paintings, this approach combined solidity and clarity of form with a vibrating intensity of light; in the hands of lesser artists, it often produced works that look rigid and contrived. As an organized movement Neo-Impressionism was short-lived, but it had a significant influence on several major artists of the late 19th and early 20th centuries, notably *Matisse, who worked with Signac and another Neo-Impressionist, Henri-Edmond *Cross, at St Tropez in 1906.

Neo-Mannerism. See PITTURA COLTA.

Neo-Plasticism. Term coined by Piet *Mondrian for his style of austerely geometrical abstract painting and more broadly for the philosophical ideas about art that his work embodied. He claimed that art should be 'denaturized', by which he meant that it must be purely abstract, with no representational relation to the natural world. To this end he limited the elements of pictorial design to the straight line and the rectangle (the right angles in a strictly horizontal-vertical relation to the frame) and to the primary colours—blue, red, and yellow—together with black, white, and grey. In this way he thought that one might escape the particular and achieve expression of an ideal of universal harmony. These ideas were greatly influenced by the writings of Dr Matthieu Schoenmaekers, a Dutch author of popular books on philosophy and religion, whom Mondrian admired for a time but later considered to be a charlatan. In his book *Het Nieuwe Wereldbeeld* (The New Image of the World), published in 1915, Schoenmaekers wrote of the pre-eminence of horizontals and verticals as follows: 'the two fundamental complete contraries which shape our earth are: the horizontal line of power, that is the course of the earth around the sun, and the vertical, profoundly spatial movement of rays that originate in the centre of the sun'; and he similarly stressed the importance of the primary colours: 'The three principal colours are essentially yellow, blue and red . . . Yellow is the colour of the ray . . . Blue is the contrasting colour to yellow . . . it is the firmament, it is line horizontality. Red is the mating of yellow and blue . . . Yellow radiates, blue "recedes", and red floats.'

Mondrian took from Schoenmaekers the term 'nieuwe beelding', which he used in his first published work, the long essay 'De

Nieuwe Beelding in de Schilderkunst' (Neo-Plasticism in Pictorial Art), which appeared in twelve instalments of the periodical *De *Stijl* in 1917–18. Paul Overy (*De Stijl*, 1991) writes that 'The terms *beeldend* and *nieuwe beelding* have caused more problems of interpretation than any others in the writing of Mondrian and other De Stijl contributors who adopted them. These Dutch terms are really untranslatable, containing more nuances than can be satisfactorily conveyed by a single English word. *Beeldend* means something like "image forming" or "image creating", *nieuwe beelding* "new image creation", or perhaps "new structure". In German, *nieuwe beelding* is translated as *neue Gestaltung*, which is close in its complexity of meanings to the Dutch. In French, it was rendered as "néo-plasticisme", later translated literally into English as "Neo-Plasticism", which is virtually meaningless.' The first usage of the French word was by Mondrian himself in his book *Le Néo-Plasticisme* (1919); the first occurrences of the words 'neo-plastician', 'Neoplastic', and 'Neo-plasticism' cited in the *Oxford English Dictionary* are of 1933, 1934, and 1935 respectively. Later, some English writers adopted the phrase 'the New Plastic', which Overy describes as an 'absurd term'.

Neo-primitivism. A movement or trend in Russian painting in the early 20th century in which influences from the Western avant-garde were combined in a deliberately crude way with features derived from peasant art, *lubki (brightly coloured popular prints), and other aspects of Russia's artistic heritage. The main exponents of Neo-primitivism were *Goncharova and *Larionov, and it was given its name by Alexander *Shevchenko in a book published in 1913—*Neo-Primitivism: Its Theory, its Possibilities, its Achievements*. D. V. Sarabianov (*Russian Art*, 1990) writes that 'Chronologically, Russian Neoprimitivism coincided with German *Expressionism: born in 1906–07, it was at its height between 1910 and 1913 . . . In the *Donkey's Tail and the *Target manifestos . . . the Neoprimitivists proclaimed their determination to follow in the national artistic traditions . . . It was this bias towards the national which led to Larionov's and Goncharova's break with the *Knave of Diamonds. It had become too slavishly devoted, in their opinion, to French painting . . . Perhaps the most important distinguishing feature of Russian Neoprimitivism was the fact that it constituted an independent movement, whereas in other countries the style [*primitivism] was just a part of Expressionism, *Cubism or *Fauvism.' Among the other painters influenced by Neo-primitivism were David *Burliuk, *Chagall, and *Filonov. It also affected Russian poets, for example *Mayakovsky, in their choice of peasant themes or use of deliberate archaisms, incorrect spellings, and other deviations from standard usage. Anthony Parton, author of *Mikhail Larionov and the Russian Avant-Garde* (1993), writes that 'Neo-primitivism was not only a vibrant and instinctive style of painting. In its attempt to re-evaluate in painterly terms the visual traditions of the Russian nation and to revitalize art by adopting a more spontaneous and expressive approach, it left its stamp on an entire generation of Russian artists.'

Neo-Realism. An aesthetic philosophy developed by Harold *Gilman and Charles *Ginner in 1913. They exhibited together under the name 'Neo-Realists' on two occasions: at the *Allied Artists' Association in 1913, and in a joint exhibition at the Goupil Gallery, London, in 1914. The catalogue of the Goupil exhibition was prefaced by an article by Ginner entitled 'Neo-Realism'; it had originally been published in the periodical *The New Age* on 1 January that year. In this article he put forward the idea that good art is the result of constantly renewed contact with nature: 'the aim of Neo-Realism is the plastic interpretation of life through the intimate research into Nature.' He thought that the *Impressionists and the three foremost *Post-Impressionists—*Cézanne, *Gauguin, and van Gogh—had exemplified this contact with nature, but that the *Neo-Impressionists had neglected it in favour of scientific interests and that the *Cubists and *Matisse had debased art because they had lost direct contact with reality. Ginner thought that the lack of such contact led to Academicism, which he defined as 'the adoption by weaker commercial painters of the creative artist's personal methods of interpreting nature and the consequent creation of a formula'. In the catalogue of the 1981–2 *Arts Council Harold Gilman exhibition, Andrew Causey writes that 'Neo-Realism drew an aggressive riposte from *Sickert [in *The New Age*, 30 April 1914], not because he deeply disagreed with it, as he admitted, but probably because he resented the pontifical

tone of what was certainly a statement of modest substance.'

The term 'Neo-Realism' has also been used in other ways, notably as a synonym for *New Realism or *Nouveau Réalisme. In Werner *Haftmann's *Painting in the Twentieth Century* (1961) it is used more or less as a synonym for *Neue Sachlichkeit. Haftmann uses the term 'Neo-Verism' in a similar way.

Néo-Réalisme. A term applied to the work of a number of French painters of the 1930s (not a group or a movement) who stood aloof from avant-garde developments and practised a style of 'poetic naturalism' deriving mainly from the late *Impressionism of *Bonnard. The painters embraced by the term include Jean Aujame (1905–65), Maurice Brianchon (1899–1979), Charles *Dufresne, André *Dunoyer de Segonzac, Raymond Legueult (1898–1978), and Luc-Albert Moreau (1882–1948).

Neo-Romanticism. A movement in British painting and other arts, *c*.1935–*c*.1955, in which artists looked back to certain aspects of 19th-century Romanticism, particularly the 'visionary' landscape tradition of William Blake and Samuel Palmer, and reinterpreted them in a more modern idiom. The term was coined by the critic Raymond Mortimer (1895–1980) in 1942. Painters and graphic artists whose work is embraced by it include Michael *Ayrton, John *Craxton, John *Minton, John *Piper, Graham *Sutherland, and Keith *Vaughan, who all worked in a landscape tradition that was regarded as distinctly national and projected a Romantic image of the countryside at a time when it was under threat from Nazi Germany. Other artists whose work has been dubbed Neo-Romantic include the poet Dylan Thomas, the film director Michael Powell, and photographers such as Bill Brandt (1904–83) and Edwin Smith (1912–71). All aspects of the movement were covered in the exhibition 'A Paradise Lost: The Neo-Romantic Imagination in Britain, 1935–55' held at the Barbican Art Gallery, London, in 1987.

The term Neo-Romanticism has also been applied to certain painters working in France in the 1930s, notably *Bérard, *Berman and *Tchelitchew, who typically painted dreamlike imaginary landscapes with rather mournful figures. Their work influenced the British Neo-Romantics.

In the 1980s the term was one of the many that was used as a synonym for *Neo-Expressionism, but it did not catch on in this sense.

Neo-Verism. See NEO-REALISM.

Nesterov, Mikhail (1862–1942). Russian painter, active mainly in Moscow. For most of his career he concentrated on subjects from Russian Orthodox teaching, often involving figures in landscapes. His mystical, poetic style was influenced by Renaissance and *Symbolist art he saw on his extensive travels in Europe. After the 1917 Revolution he successfully came to terms with the new order, becoming one of the best portraitists of his day and also painting scenes from contemporary life. Alan Bird (*A History of Russian Painting*, 1987) writes that 'his journals reveal that he was never detached from political and social events and they are now important records of artistic development in Russia in the sixty years up to his death in 1942.'

Neue Künstlervereinigung München (NKV) ('New Artists' Association of Munich'). An association of artists founded in Munich in 1909 as a more liberal alternative to existing exhibiting venues, particularly the *Sezession. *Kandinsky was elected president, Alexander Kanoldt (1881–1939) was secretary, and Adolf Erbslöh (1881–1947) was chairman of the exhibition committee. Other members included *Jawlensky, *Kubin, *Münter, and *Werefkin. They were strongly influenced by *Fauvism and the three exhibitions that they held (1909, 1910, and 1911) were far too advanced for the critics and public and were met with torrents of abuse (the first two exhibitions were held in the gallery of the Munich dealer Heinrich Thannhauser, who said he had to clean spit off the paintings each evening). The second exhibition was European in character, including works by the Russians David and Vladimir *Burliuk, by *Le Fauconnier, *Picasso, and *Rouault, and by members of the Fauves (*Braque, *Derain, van *Dongen, *Vlaminck), some of whom had already moved on to *Cubism. Franz *Marc came to the NKV's defence after this exhibition and it was in this way that he met *Kandinsky. When Erbslöh rejected an abstract painting submitted by Kandinsky for the third exhibition, Kandinsky resigned and with Marc founded the *Blaue Reiter. They moved so quickly that the Blaue Reiter's first

exhibition opened on the same day as the NKV's last and stole its thunder.

Neue Leben. See JANCO.

Neue Sachlichkeit (New Objectivity). Movement in German painting in the 1920s and early 1930s reflecting the resignation and cynicism of the post-war period. The name was coined in 1923 by Gustav Hartlaub, director of the Kunsthalle, Mannheim, and used as the title of an exhibition he staged there in 1925, featuring 'artists who have retained or regained their fidelity to positive tangible reality'. The movement was not characterized by a unified style or by any kind of group affiliation, but its major trend involved the use of meticulous detail and violent satire to portray the face of evil. This marked a continuation of the interest in social criticism that had characterized much of *Expressionism, but Neue Sachlichkeit rejected the abstract tendencies of the *Blaue Reiter, in which Expressionism had reached its high point just before the First World War. *Dix and *Grosz were the greatest figures of the movement, which was dissipated in the 1930s with the rise of the Nazis (see NATIONAL SOCIALIST ART). Other artists associated with Neue Sachlichkeit include Conrad *Felixmüller, Christian *Schad, and Rudolf *Schlichter, and among lesser figures Heinrich Davringhausen (1894–1970), who turned to abstraction after he settled in France in 1936, Alexander Kanoldt (1881–1939), Anton Räderscheidt (1892–1970), who also turned to abstract painting after the Second World War, and Georg Scholz (1890–1945). Georg *Schrimpf is also sometimes embraced by the term, although his connection was one of technique rather than subject. See also MAGIC REALISM.

Nevelson, Louise (1899–1988). Russian-born American sculptor, painter, and printmaker. She was born Louise Berliawsky in Kiev and in 1905 emigrated to the USA with her family, who settled in Rockland, Maine. Her father became prosperous working in lumber and property and both parents encouraged her to develop her artistic gifts. In 1920 she married a businessman, Charles Nevelson, and settled in New York. She had a son in 1922 and did not take up art seriously until she was 30, studying at the *Art Students League, 1929–30, then under Hans *Hofmann (first for six months in Munich, then in New York). She had left her son behind to go to Munich and after her return to the USA she separated from her husband; during the 1930s she often endured great poverty as she tried to support herself and her child. In 1932 she worked with Ben *Shahn as assistant to Diego *Rivera on his murals at the Rockefeller Center in New York. She started to make sculpture in 1932 and had her first one-woman show in 1941, at the Nierendorf Gallery, New York. In 1944 she started experimenting with abstract wood assemblages and in 1958 began the 'sculptured walls' for which she became internationally famous. These are wall-like reliefs made up of many boxes and compartments into which abstract shapes are placed together with commonplace objects such as chair legs, sections of balustrade, and other 'found objects' (*An American Tribute to the British People*, Tate Gallery, London, 1960–4). These constructions, which she painted a uniform black or (from 1959) white or gold, won her a reputation as a leader in both *assemblage and *environments. They have great formal elegance but also a strange ritualistic power. In the late 1960s she began to work in a greater variety of materials, including aluminium and transparent perspex, and she sometimes produced small constructions for reproduction as *multiples. From the same time, with her belated fame, she began to receive commissions for large open-air sculptures, which she executed in aluminium or steel. Her work was shown in numerous individual and group exhibitions throughout the world and in old age she received a stream of honours.

Nevinson, C. R. W. (Christopher Richard Wynne) (1889–1946). British painter and printmaker, born in London, son of the writer and philanthropist Henry Woodd Nevinson. He studied at St John's Wood School of Art, 1907–8, the *Slade School, 1908–12, and in Paris at the *Académie Julian, 1912–13. At the Slade he greatly disliked his teacher *Tonks (who advised him to give up art), later referring to him as 'that old woman Tonks' and 'Henrietta Tonks' (Nevinson was very touchy and had something of a persecution complex). In Paris he shared a studio with *Modigliani and met *Marinetti and other *Futurists. With Marinetti, Nevinson wrote the Futurist manifesto *Vital English Art*, published in the *Observer* on 7 June 1914, and he

became the outstanding British exponent of Futurism in painting, finding his ideal subjects during the First World War. He served in France with the Red Cross and the Royal Army Medical Corps, 1914–16, before being invalided out, and his harsh, steely images of life and death in the trenches met with great acclaim when he held a one-man exhibition at the *Leicester Galleries, London, in 1916. Stylistically they drew on certain *Cubist as well as Futurist ideas, but they are closer to the work of the *Vorticists (with whom he had exhibited in 1915). *Returning to the Trenches* (NG, Ottawa, 1914–14), depicting a column of weary marching men, is one of his best-known works of this time, its jagged forms creating a feeling of relentless mechanism.

In 1917 Nevinson returned to France as an *Official War Artist, and he was the first to make drawings from the air (he also produced lithographs). Some of his work was considered too unpleasant and was censored (he had probably experienced more horror at first hand than any other Official War Artist), but a second one-man exhibition at the Leicester Galleries in 1918 was another triumph. At the end of the war Nevinson renounced Futurism and the more conventional paintings he produced thereafter are generally regarded as an anticlimax. In later years he mainly painted landscapes and flower pieces, but he continued to produce figure subjects; examples are *Any Winter Afternoon in England* (City Art Gallery, Manchester, 1930), depicting a football match, and *Twentieth Century* (Laing Art Gallery, Newcastle upon Tyne, 1932–5), an ambitious but rather turgid attempt to portray a world on the brink of catastrophe. In the *Dictionary of National Biography*, R. H. *Wilenski writes of Nevinson: 'Although at bottom a sensitive neurotic, he addressed himself boldly to the general public and wrote truculently in the newsppers, in the catalogues of his exhibitions, and in his autobiography *Paint and Prejudice* (1937).'

New Abstraction. See POST-PAINTERLY ABSTRACTION.

New Age. See HULME.

New American Painting. A term used more or less synonymously with *Abstract Expressionism. It was the title of an exhibition at the Museum of Modern Art, New York, in 1959.

new art. A term sometimes (but now rarely) used as a translation of *Art Nouveau (in *Brighton Rock*, 1938, Graham Greene writes 'He touched a little buzzer, the New Art doors opened') and sometimes used very vaguely to describe the latest trends in art. John A. Walker (*Glossary of Art, Architecture and Design Since 1945*, 1973, 3rd edn., 1992) writes that this 'feeble expression' is 'generally employed when critics and exhibition organisers are at a total loss for a name'. He cites as examples of its use an anthology of essays entitled *The New Art* (1966), edited by Gregory Battcock, and an exhibition of the same title at the Hayward Gallery, London, in 1972.

New Art Club. See FERGUSSON.

New Artists' Association of Munich. See NEUE KÜNSTLERVEREINIGUNG MÜNCHEN.

Newbery, Francis ('Fra') (1855–1946). British painter, teacher, and administrator. He was born in Membury, Dorset, and studied at Bridport Art School and then at the *Royal College of Art, London, where he subsequently taught. In 1885 he was appointed director of *Glasgow School of Art, a post he held until 1918, when he retired to Dorset because of ill-health. His period in Glasgow marked the high point of the School of Art's prestige, and he personally played a major role in its success, showing admirable skill as an administrator and a flair for recognizing and encouraging talent. His own paintings, including landscapes, portraits, and genre scenes, are accomplished but unexceptional. An example is his full-length portrait of Charles Rennie *Mackintosh (c. 1914) in the National Portrait Gallery, Edinburgh.

His wife **Jessie Newbery** (née Rowat) (1864–1948) taught embroidery at Glasgow School of Art. Their daughter **Mary Newbery** (1892–1985), also known by her married name, Mary Sturrock, was a painter, a member of the *Edinburgh Group.

New British Sculpture. A term sometimes applied to the work of a loosely connected group of British sculptors who emerged in a series of exhibitions at the beginning of the 1980s, notably 'Objects and Sculpture' shown at the Institute of Contemporary Arts, London, and the Arnolfini Gallery, Bristol, in 1981. There is no single common factor linking these sculptors, but predominantly their

work is abstract (although sometimes with human associations), using industrial or junk material, and several of them are represented by the same dealer—the Lisson Gallery, London. Among the leading figures are: Tony *Cragg, Grenville Davey (1961–), Richard *Deacon, Anish *Kapoor (each of these four has won the *Turner Prize), David Mach (1956–), Julian Opie (1958–), Richard Wentworth (1947–), Alison Wilding (1948–), and Bill Woodrow (1948–). Most of these are well represented in the *Saatchi Collection.

New Classicism. See NEOCLASSICISM.

New Contemporaries. See YOUNG CONTEMPORARIES.

New Decorativeness. See PATTERN AND DECORATION MOVEMENT.

New English Art Club (NEAC). An artists' society founded in London in 1886 in reaction against the conservative and complacent attitudes of the *Royal Academy. The founders—largely artists who had worked in France and had been influenced by *plein-air* painting—included Frederick *Brown (who drafted the constitution), *Clausen, Stanhope *Forbes, Arthur Hacker (1858–1919), *La Thangue, *Sargent, *Steer, Edward Stott (1859–1918), and *Tuke. There were about 50 members when the inaugural exhibition was held in April 1886 at the Marlborough Gallery in London. Several of them were members of the *Newlyn School and various *Glasgow Boys joined the following year. In 1889, however, the Club came under the control of a minority group led by *Sickert, and in that year he and his associates held an independent exhibition under the name 'The London *Impressionists'. Sickert resigned in 1897 (he returned in 1906) and from then up to about the First World War the NEAC was effectively controlled by Brown, Steer, and *Tonks (all of whom taught at the *Slade School). In this period its members included most of the best painters in England. From about 1908, however, it began to lose initiative to progressive groups such as the *Allied Artists' Association and the *Camden Town Group. After the War the Club occupied a position midway between the Academy and the avant-garde groups. With the gradual liberalization of the Academy exhibitions, its importance diminished, but the Club still exists.

New English Style. See CONTEMPORARY STYLE.

New Fauvism. See NEO-EXPRESSIONISM.

New Figuration. A very broad term for a general revival of figurative painting in the 1960s following a period when abstraction (particularly *Abstract Expressionism) had been the dominant mode of avant-garde art in Europe and the USA. The term is said to have been first used by the French critic Michel Ragon, who in 1961 called the trend 'Nouvelle Figuration'.

New Generation. The title of four exhibitions, sponsored by the Peter Stuyvesant [tobacco company] Foundation, held at the *Whitechapel Art Gallery, London, in 1964, 1965, 1966, and 1968, with the aim of introducing young British painters and sculptors to the public. *Op and *Pop art were well represented, but the series is best remembered for the 1965 exhibition, which featured a group of sculptors who were seen as creating a new school of British abstract sculpture, largely under the influence of Anthony *Caro (they had all been his pupils at *St Martin's School of Art). Subsequently their work has been referred to as 'New Generation Sculpture'. The leading figures were Phillip *King, Tim *Scott, and William *Tucker; others were David Annesley (1936–), Michael Bolus (1934–), and Isaac Witkin (1936–). William *Turnbull is usually grouped with them, even though he was appreciably older and did not train at St Martin's or show at the New Generation exhibition. Their work had in common a liking for simple shapes and strong colours—sometimes close to *Minimal art, sometimes with a Pop flavour. Alistair McAlpine (1942–), later Lord McAlpine of West Green, made a collection of the work of these seven sculptors and presented it to the Tate Gallery, London, in 1970.

New Horizons. A group of Israeli artists formed in 1948 under the leadership of Yossef Zaritsky (1891–1985), a Russian-born painter who had emigrated to Israel in 1923. The group held annual exhibitions until 1963. It brought together older and younger generations of artists and represented the first deliberately modernist movement in Israel. Michael *Janco was among the members.

New Image Painting (or New Image Art). A vague term applied since the late 1970s to the work of certain avant-garde artists who work in a strident figurative style, often with cartoon-like imagery and abrasive handling owing something to *Neo-Expressionism. It was given currency by an exhibition entitled 'New Image Painting' at the Whitney Museum, New York, in 1978. Subsequently the term 'New Image' has been used in the title of other exhibitions and in a book by Tony Godfrey, *The New Image: Painting in the 1980s* (1986). In the catalogue of the Whitney exhibition we are told that the New Image painters 'felt free to manipulate the image on canvas so that it can be experienced as a physical object, an abstract configuration, a psychological asso-ciative, a receptacle for applied paint, an ana-lytically systemized exercise, an ambiguous quasi-narrative, a specifically non-specific experience, a vehicle for formalist explor-ations or combinations of any'. Slightly more helpfully, Daniel Wheeler in his revision (1986) of H. H. *Arnason's *A History of Moderrn Art* writes that the work of the artists in the Whitney Show 'had little in common other than their recognizable but distinctly idio-syncratic imagery presented, for the most part, in untraditional, nonillusionistic con-texts . . . The great progenitor of the New Imagists was Philip *Guston, who in 1970 let it be known that he had abandoned his famous *Abstract Expressionist style . . . for a rather raucous form of figuration that seemed to ape not only the primitive, heavy-handed manner of 1930s strip cartoons but also their narrative order and broad, goofy, humor.'

The American artists who have been labelled New Image painters include Jennifer Bartlett (1941–), Jonathan Borofsky (1942–), Neil Jenney (1945–), Robert Moskowitz (1935–), Susan Rothenberg (1945–), Pat Steir (1940–), Donald Sultan (1951–), and Joe Zucker (1941–). Some of these have also been claimed as representatives of Neo-Expression-ism. In Britain the term 'New Image' has been applied particularly to painters of the 1980s *Glasgow School.

New Lef. See MAYAKOWSKY.

Newlyn School. A name applied to the painters who worked in the Cornish fishing village of Newlyn from the 1880s, particularly those directly linked with Stanhope *Forbes, who was the founder and leader of the school.

One of the attractions of Newlyn was the mild climate, which made it particularly suitable for outdoor work, and Forbes and his asso-ciates were among the pioneers of *plein-air* painting in Britain. The village also made a strong appeal to artists because of its pic-turesque charm, which was strongly remin-iscent of Brittany—at that time a favourite haunt of painters. Many of them shared Forbes's first impression of Newlyn: 'Here every corner was a picture, and, more impor-tant from the point of view of the figure-painter, the people seemed to fall naturally into their places, and to harmonize with their surroundings.'

Apart from Forbes and his wife Elizabeth, the artists most closely associated with New-lyn in its heyday include: Frank Bramley (1857–1915); Norman Garstin (1847–1926); Thomas Cooper Gotch (1854–1931), better known for his later work, particularly his alle-gorical pictures of children; Fred Hall (1860–1948); and Henry Scott *Tuke. Many of the Newlyn artists were associated with the *New English Art Club, but they also showed their work at the *Royal Academy. The golden period of Newlyn was over by the turn of the century; thereafter it was vulgarized by an influx of inferior talent, and *St Ives came to have a greater attraction for 20th-century artists. However, distinguished painters con-tinued to be associated with Newlyn: Harold and Laura *Knight lived there, 1908–18, for example, and Dod and Ernest *Procter studied with Forbes and settled in the village after their marriage in 1912. The landscape and seascape painter Lamorna Birch (1869–1955), a friend of Forbes and the Knights, lived a few miles from Newlyn at Lamorna (he was origin-ally called Samuel John Birch but adopted the name of his home as a personal name).

Newman, Barnett (1905–70). American painter, one of the leading figures of *Abstract Expressionism and one of the the initiators of *Colour Field Painting. He was born in New York, the son of Polish immi-grant parents and studied at the *Art Stu-dents League, 1922, and the City College of New York, 1923–7, before working for his father's clothing company, 1927–37 (he again attended the Art Students League in 1929–30). During the 1930s he had a hard time finan-cially; the Depression almost ruined his father's business, and unlike most American painters of the time Newman did not work for

the *Federal Art Project, being unwilling to accept State handouts. Part of his living came from teaching art in high schools. He destroyed most of his early work and stopped painting in the early 1940s, but he began again in 1944, and in the second half of the 1940s evolved a distinctive style of mystical abstraction—he considered 'the sublime' to be his ultimate subject-matter (see ABSTRACT SUBLIME). The work with which he announced this style was *Onement I* (MOMA, New York, 1948), a monochromatic canvas of dark red with a single stripe of lighter red running down the middle. Such stripes (or 'zips' as Newman preferred to call them) became a characteristic feature of his work. By the time he painted *Onement I* Newman already had a reputation as a controversialist and a spokesman for avant-garde art (in catalogue essays and in articles in journals such as *Tiger's Eye*, of which he was associate editor), and in 1948 he collaborated with *Baziotes, *Hare, *Motherwell, and *Rothko in founding the *Subjects of the Artist School.

In 1949 Newman painted his first wall-size pictures (he was one of the pioneers of the very large format) and in 1950 he had his first one-man exhibition, at the Betty *Parsons gallery. This was coolly received by critics and fellow artists, and by the mid-1950s his very spare style had separated him from the predominantly '*gestural' idiom of his colleagues. For a time he became a somewhat marginalized figure and he stopped painting in 1956. He had a heart attack in 1957, but the following year a resurgence began with a series of paintings in black-and-white, and in the last decade of his life his reputation soared and his output was prolific. In the 1960s he began producing large steel sculptures featuring slender shafts recalling the vertical strips of his paintings (*Broken Obelisk*, MOMA, New York, 1963–9) and in his late years he also experimented with *shaped canvases, painting several triangular pictures. His work had great influence on the development of Colour Field Painting. His reputation stands high, but he is not without his detractors. John *Canaday, for example wrote that: 'there is nothing inherently mystical or even expressive about a Newman painting . . . the response is entirely in the mind of the observer . . . and is stimulated not by what the painting is, but by what Newman said it was. Newman's fans among critics are either people who knew him well, worked with him

and discussed theories with him, or other people who have had the experience at second hand through what these critics have written. In either case, the experience is simply not there in the paintings . . . if ever there was literary painting, it is Barnett Newman's, an extreme case of dependence on verbal exercises.'

New Metaphysical Art. See TURNER PRIZE.

New Metaphysical Painting. See PITTURA COLTA.

New Museum of Contemporary Art, New York. Museum devoted to contemporary art (meaning in this instance work done within the last ten years), founded in 1977 by Marcia Tucker (1940–), formerly a curator at the *Whitney Museum of American Art. It was originally called the New Museum and was located in the New School of Social Research on Fifth Avenue. In 1983 it moved to its present premises at 583 Broadway, a handsome late 19th-century building. The museum is devoted mainly to temporary exhibitions, but it also has a small 'semi-permanent' collection, works being periodically sold to buy others (as in the early days of the *Museum of Modern Art, New York).

New Realism. A vague term, of dubious value, that has been used in at least three distinct senses in connection with art of the 1960s and later. First, it has been used in a way similar to the term *New Figuration to describe a revival of figurative art after a dominant period of abstraction; whereas 'New Figuration' has been used very broadly, however, 'New Realism' has often been applied more specifically to works that are objective in spirit, particularly *Superrealist pictures or those of Philip *Pearlstein. In a second sense, 'New Realism' has been used as a straight translation of *Nouveau Réalisme and applied to works incorporating three-dimensional objects, usually mass-produced consumer goods, in *assemblages or attached to the surface of a painting. Thirdly—and perplexingly—it has been used as a synonym for *Pop art; an exhibition of English Pop that circulated to The Hague, Vienna, and Berlin in 1964–5 was entitled 'Nieuwe Realisten'.

New Scottish Group. See FERGUSSON.

New Sculpture. A trend in British sculpture between about 1880 and 1910 characterized chiefly by an emphasis on naturalistic surface detail and a taste for the spiritual or *Symbolist in subject-matter in reaction against the blandness of much Neoclassical sculpture. The name was coined by the critic Edmund *Gosse in a series of four articles, 'The New Sculpture, 1879–1894', published in the *Art Journal* in 1894. Leading representatives of the trend include Gilbert *Bayes, Alfred *Drury, Edward Onslow Ford (1852–1901), Sir George *Frampton, Sir Alfred *Gilbert, the Australian-born Sir Bertram Mackennal (1863–1931), Frederick William Pomeroy (1857–1924), Sir William Reynolds-Stephens (1862–1943), Sir Hamo *Thornycroft, Albert Toft (1862–1949), and Derwent *Wood. Their archetypal product was 'the "ideal" sculpture . . . the free-standing figure untrammelled by the requirements of the public monument and dependent not on prior commission but on the hope that a collector would finance the transition from fragile plaster to the lasting but expensive marble or bronze' (John Glaves-Smith in 'Reverie, Myth, Sensuality: Sculpture in Britain 1880–1910', catalogue of an exhibition at the City Museum and Art Gallery, Stoke-on-Trent, 1992). Most typically these ideal figures were in bronze, although polychromy—using such materials as ivory and coloured stones—was also a feature of the New Sculpture. Mythology and poetry were the main sources of imagery. Although the New Sculpture did not survive the First World War as a major force, some of the practitioners went on working in the idiom long after this.

New Tendency. See NOUVELLE TENDANCE.

Newton, Algernon (1880–1968). British painter, born in London, grandson of one of the founders of Winsor & Newton, the firm of artists' colourmen. He left Clare College, Cambridge, after two years without taking a degree and then studied at various art colleges in London, including the School of Animal Painting in Kensington run by Frank Calderon (1865–1943). Newton specialized in urban views painted in a sombre, naturalistic style; his penchant for scenes involving waterways earned him the nickname 'the Canaletto of the canals' (*The Surrey Canal, Camberwell*, Tate Gallery, London, 1935). He also painted landscapes in Cornwall and York-shire and was in demand for 'portraits' of country houses. Generally he worked from sketches done on the spot and occasional photographs. In his obituary in *The Times* he is described as 'a painter of quiet distinction . . . He could take the most forbidding canal or group of factory buildings, and, without romanticizing or shrinking any detail, create a poetic and restful composition out of it.'

Newton, Eric (1893–1965). British writer on art and designer of mosaics. He was born at Marple Bridge, in Cheshire, and studied at Manchester University. From 1913 to 1933 (interrupted by army service in the First World War) he worked as a mosaic designer and craftsman with the firm of L. Oppenheimer, Manchester. An example of his work is the apse of the chapel of the Royal Hospital School, Holbrook, Suffolk (begun 1925), in which the mosaics represent the Holy Family in Glory. Newton was art critic of the *Manchester Guardian*, 1930–47, and the *Sunday Times*, 1937–51; he rejoined the *Guardian* in 1956 and remained with the paper for the rest of his life. His many books include *European Painting and Sculpture* (1941, several times revised and reprinted), *War Through Artists' Eyes: Paintings and Drawings by British War Artists* (1945), *British Sculpture 1944–1946* (1947), *In My View* (a collection of essays) (1950), *The Meaning of Beauty* (1950), *The Romantic Rebellion* (1962), and monographs on Christopher *Wood (1938), Stanley *Spencer (1947), and Wyndham *Lewis (1951, joint author with Charles Handley Read). He was a clear and polished writer and also an articulate lecturer and radio broadcaster. In 1959–60 he was Slade professor of fine art at Oxford University, and from 1963 until his death he lectured in art history at the Central School of Arts and Crafts, London. His second wife, Stella Mary Newton (née Pearce), a leading authority on the history of dress, played a central role in establishing her subject as a serious academic discipline, partly through founding a specialist postgraduate course at the *Courtauld Institute.

New York, Art Students League. See ART STUDENTS LEAGUE.

New York, Museum of Modern Art. See MUSEUM OF MODERN ART, NEW YORK.

New York, New Museum of Contemporary Art. See NEW MUSEUM OF CONTEMPORARY ART.

New York, Solomon R. Guggenheim Museum. See GUGGENHEIM.

New York, Whitney Museum of American Art. See WHITNEY.

New York Realists. An informal name applied in the early years of the 20th century to Robert *Henri and his disciples, whose work included scenes of unidealized contemporary urban life.

New York School. Term applied to the innovatory painters, especially the *Abstract Expressionists, who worked in New York in the 1940s and 1950s and whose critical and financial success helped the city to replace Paris as the world's leading centre of avant-garde art. An exhibition staged by the Los Angeles County Museum in 1965 entitled 'New York School: The First Generation, Paintings of the 1940s and 1950s' included the following fifteen artists, giving a good idea of the concentration of talent in the city at this time: William *Baziotes, Willem *de Kooning, Arshile *Gorky, Adolph *Gottlieb, Philip *Guston, Hans *Hofmann, Franz *Kline, Robert *Motherwell, Barnett *Newman, Jackson *Pollock, Richard *Pousette-Dart, Ad *Reinhardt, Mark *Rothko, Clyfford *Still, and Bradley Walker *Tomlin. In the foreword to the catalogue Maurice Tuchman wrote: 'The title of our exhibition and the criteria behind the choice of artists were based on historical considerations: the first generation of New York School painters were those whose activity centred in New York City after 1940 and who had achieved by 1950 a mature and distinctly individual style. The term "New York School" as a geographical indicator is more valid in application to the first generation than in relation to its followers, for the proliferation and dispersal of the achievement and ideas of the earlier group of artists make it impossible to impose such localized restraints on the younger generation.' Putting this more pithily, one might say that whereas all the early leaders of Abstract Expressionism worked in New York, some of the main figures of the second generation worked elsewhere.

Nicholson, Ben (1894–1982). British painter and maker of painted reliefs, one of the most distinguished pioneers of abstract art in Britain. He was born at Denham, Buckinghamshire, son of Sir William *Nicholson and Mabel Nicholson, who was the sister of James *Pryde and herself a painter. After studying briefly at the *Slade School, 1910–11, he spent most of the next few years abroad for the sake of his health (he suffered from asthma) and did not devote himself seriously to art until 1920, when he married the painter Winifred Dacre, the first of his three wives. Nicholson's early work consisted mainly of simple and fastidious still-lifes, very much in the tradition of his father, and of landscapes (although he destroyed many experimental paintings). He first saw *Cubist paintings on a visit to Paris in 1921 and in the following years his still-lifes showed a personal response to the standard Cubist repertoire of jugs and glasses, which he arranged as flat shapes on the picture plane. His most sophisticated work in this vein is *Au Chat Botté* (City Art Gallery, Manchester, 1932), a picture of a shop window that incorporates reflections in the glass of objects behind the artist. Nicholson was also influenced by the *naive painter Alfred *Wallis, whose work he discovered in 1928 and whose roughly textured surfaces he emulated.

From the early 1930s Nicholson turned to abstraction, partly because of the influence of Barbara *Hepworth (they shared a studio from 1932 and married in 1938) and partly because of the impact of several visits he made to Paris at this time. He joined the *Abstraction-Création association in 1933 and became friendly with several leading avant-garde artists there, *Mondrian's work in particular coming as a revelation to him. Nicholson visited his studio in 1933, and later commented: 'The paintings were entirely new to me and I did not understand them on this first visit (and indeed only partially understood them on my second visit a year later). They were merely, for me, part of the very lovely feeling generated by his thought in the room. I remember after this first visit sitting at a café table on the edge of a pavement almost touching all the traffic going in and out of the Gare Montparnasse, and sitting there for a very long time with an astonishing feeling of quiet and repose!' In 1933 Nicholson made his first abstract relief and in 1934 his first strictly geometrical 'white relief' in painted wood, using only straight lines and circles. Such works were the most uncompromising examples of abstract art made by a British artist up to that date (*White Relief*, Tate Gallery, London, 1935). He also did paintings in a similar intellectual vein but marked by a

poetic refinement of colour that offsets their severity of composition (*Painting*, Tate Gallery, 1937). By this time Nicholson was recognized as being at the forefront of the modern movement in England. He was a member of *Unit One (1933), and one of the editors of *Circle* (1937), and under his chairmanship the *Seven & Five Society organized the first all-abstract exhibition to be held in England (1935). Simon Wilson describes him as 'the only English painter to develop a pure abstract art of international quality between the two world wars' (*The Tate Gallery: An Illustrated Companion*, 1989).

In 1939 Nicholson and Hepworth moved to Cornwall, where they became the nucleus of the *St Ives School. Nicholson remained in St Ives until 1958, when he settled in Switzerland with his third wife, the Swiss photographer Felicitas Vogler. After the Second World War he won an international reputation, accompanied by many awards, among them first prize at the *Carnegie International Exhibition in 1952 and the first Guggenheim International Painting Prize in 1957. In 1968 he was awarded the Order of Merit. He returned to England in 1971 and died in London. His late work moved freely between abstraction and figuration and included large, freestanding reliefs, notably one in marble in the garden of Sutton Place, Surrey (1982). 'Nicholson devoted his life to his art, which he took with intense seriousness', but he was 'something of a practical joker and a master of puns . . . He was a determined avoider of formality and convention in his life and in his art' (*DNB*).

Nicholson's first wife, **Winifred Nicholson** (1893–1981), also known by her maiden name of Roberts and her mother's surname Dacre, was a painter of distinction. She is best known for her flower paintings, but she also did other subjects and abstracts, all her work showing a joy in light and colour. Even after they separated in 1931 (they divorced in 1938) she and Ben Nicholson took a keen interest in each other's work; he said 'I learnt a great deal about colour from Winifred Nicholson and a great deal about form from Barbara Hepworth'. **Kate Nicholson** (1929–), the daughter of Ben and Winifred Nicholson, and **Rachel Nicholson** (1934–), the daughter of Nicholson and Hepworth, are also painters. Another daughter of Nicholson and Hepworth married the art historian Alan *Bowness.

Nicholson, Sir William (1872–1949). British painter and graphic artist, the father of Ben *Nicholson. He was born in Newark-on-Trent and studied at Sir Hubert *Herkomer's school of art in Bushey, Hertfordshire, 1888–9, and the *Académie Julian, Paris, 1889–90. In 1893 he married James *Pryde's sister Mabel, and he is perhaps best remembered for the brilliant poster designs he did in collaboration with Pryde under the name J. & W. *Beggarstaff. As a painter he was successful mainly as a portraitist; his early work was strongly influenced by *Whistler (his friend and fellow-dandy), but his colouring became brighter in the 1920s. He also painted landscapes, still-lifes, and other subjects, made woodcuts, and designed for the stage, including the sets for the first production of *Peter Pan* in 1904. His still-lifes are now his most admired paintings—typically small, unpretentious, and sensitively handled. There are examples of his work in the National Portrait Gallery and the Tate Gallery, London.

Niestlé, Jean Bloé. See BLAUE REITER.

Nikifor (*c.* 1895–1968). Polish *naive painter, born at Krynica. His mother was a deaf and dumb beggar (he did not know his father) and Nikifor himself had a speech impediment. He lived the life of a tramp, wandering through the villages of Galicia, and made paintings on any scraps of paper available, including the backs of cigarette packets, selling them for a trifle. His main subjects were architectural scenes and cityscapes, in which he mixed reality with fantasy, and he was also fond of representing himself in various imagined situations (he was deeply and naively religious and often depicted himself as a bishop-judge condemning those who had done him some injustice). He was very prolific and some thousands of his small paintings are in existence. Usually they are inscribed with meaningless combinations of letters (he was illiterate). Nikifor was 'discovered' in 1930, and late in life he achieved material comforts, but by then he was too old and ill to enjoy them. He has a high reputation in Poland and has been the subject of several books and documentary films.

Nikos. See MEC ART.

Nitsch, Hermann. See VIENNA ACTIONISTS.

NKV. See NEUE KÜNSTLERVEREINIGUNG.

Noé, Luis Felipe. See OTRA FIGURACIÓN.

Noguchi, Isamu (1904–88). American sculptor and designer, born in Los Angeles, the son of a Japanese father and an American mother, both of whom were writers. He was brought up in Japan, 1906–18, and after returning to the USA he was briefly apprenticed in 1922 to Gutzon *Borglum, who told him he would never make a sculptor. For the next two years he studied medicine at Columbia University and also took sculpture classes at the Leonardo da Vinci School in New York, until in 1924 he decided definitively to be an artist. In 1927 he won a Guggenheim Fellowship that enabled him to spend two years in Paris, where he worked as *Brancusi's assistant and under his influence turned from figuration to abstraction. He returned to New York in 1929 and in the same year had his first one-man show there at the Eugene Schoen Gallery. Although he used various materials, including wood, bronze, and iron, Noguchi was essentially a stone-carver, and his work has a kinship with Brancusi's in its craftsmanship and respect for materials as well as its expressive use of organic shapes (see DIRECT CARVING). For several years he supported himself mainly by making academic portrait busts, but in 1938 he scored his first major success, winning a competition to make a huge stainless steel piece for the façade of the Associated Press Building in Rockefeller Center, New York. Before this he had already begun what was to be a highly distinguished career as a stage designer, working most notably for the choreographer Martha Graham (1894–1991). His first design for her was for *Frontier* (1935, the first time she had used a set) and he continued collaborating with her until 1966. Noguchi drew on the Japanese tradition of No drama in his stage designs, creating spare, elegant abstract environments. Apart from Martha Graham, he worked for other famous choreographers, including George Balanchine and Merce Cunningham, and also for the Royal Shakespeare Company, designing Sir John Gielgud's production of *Macbeth* in 1955.

After the Second World War Noguchi became recognized internationally as one of the leading sculptors of the day and from the 1960s he had many major commissions for public spaces that allowed him to fulfil his long-held ambition to combine Western modernism with Eastern traditions of contemplative art (he had begun designing sculptural gardens—as well as children's playgrounds—in the 1930s, but he had not had the opportunity to put them into practice). Examples of this type of work are the Water Garden at Chase Manhattan Bank Plaza, New York (1963), and Hart Plaza, Detroit (1975), with its huge Dodge Memorial Fountain in stainless steel and granite. Throughout his career Noguchi frequently returned to Japan and his work is regarded as a successful marriage of East and West. He published an autobiography, *A Sculptor's World*, in 1968.

Nolan, Sir Sidney (1917–92). The most internationally famous of Australian painters. He was born in Melbourne, and after leaving school at the age of 15 he had various short-term jobs, including work in commercial art. In 1934 he began taking evening classes at the Art School of the National Gallery of Victoria, Melbourne, he became a full-time artist in 1938, and he held his first one-man show (at his Melbourne studio) in 1940. The works shown were abstract and too advanced for local taste; few of them sold and an outraged visitor threw a can of paint at one of them. His style changed radically whilst he was serving in the Australian army, 1942–5; stationed in the Wimmera District of Victoria, he painted a series of landscapes that gave the first unmistakable signs of his originality of vision, vividly capturing the heat and emptiness of the bush. In 1946 he began a series of paintings on the notorious 19th-century bushranger Ned Kelly, who had become a legendary figure in Australian folk history, and it was with these works that he made his name. He returned to the Kelly theme throughout his career, and he also drew on other people and events in Australian history, for example the explorers Burke and Wills, who died in 1861 on the first expedition to cross the country from south to north, and the Eureka Stockade, a goldminers' uprising against colonial rule in 1854. In works on such themes he created a distinctive idiom to express this novel Australian iconography and memorably portrayed the hard, dry beauty of the desert landscape. Technically his work is remarkable for the lush fluidity of his brushwork, and he sometimes painted on glass or other smooth materials.

In 1950 Nolan won the Dunlop Prize, which

enabled him to visit Europe for the first time. He soon made a name for himself in Britain (he had his first London exhibition at the Redfern Gallery in 1951) and from 1955 lived mainly in England. (One of his staunchest British supporters was Kenneth *Clark, who first saw Nolan's work in 1949 during a visit to Australia and was 'confident that I had stumbled on a genius . . . an entirely original artist'.) Nolan also worked in Paris (where he studied printmaking with *Hayter in 1957) and in the USA, and he travelled extremely widely (the Australian airline Qantas commissioned him to fly around the world gathering material for a series of paintings to decorate their offices). Among the places he visited, Antarctica and New Guinea in particular inspired him, and he also painted pictures on literary themes such as the legend of Leda and the Swan. Apart from paintings and prints, Nolan occasionally made set and costume designs, for example for a production of Stravinsky's *The Rite of Spring* at the Royal Opera House, London, in 1962. He was knighted in 1981 and received many other awards. His prolific output is represented in many Australian galleries, and there are several works in the Tate Gallery, London. See also *ANGRY PENGUINS*.

Noland, Kenneth (1924–). American abstract painter and sculptor, born in Asheville, North Carolina. After serving in the US Air Force during the Second World War he studied at *Black Mountain College, 1946–8, and then under *Zadkine in Paris, 1948–9. In 1949 he moved to Washington, DC, where he became a close friend of Morris *Louis. On a visit to New York in 1953 they were greatly impressed by Helen *Frankenthaler's *Mountains and Sea* and they began experimenting with the kind of pouring and staining techniques she pioneered. They became the leading figures of the group of *Colour Field Painters known as the *Washington Color Painters, but from the late 1950s Noland began to use centralized circular images. At first these were fuzzy, but they became much more precisely articulated until by 1960 he was producing crisp, target-like images featuring concentric circles of strongly contrasting colours on a square canvas. During the 1960s he developed other sharply delineated formats that won him a reputation as one of the leading exponents of *Hard-Edge Painting. The 'targets' lasted until 1962 (*Gift*, Tate

Gallery, London, 1961–2), and were followed by a chevron motif (1962–4), which developed into diamond-shaped pictures (1964–7), sometimes of very large format. From 1967 he used horizontal stripes running across a long rectangular canvas. At about the same time he began making sculpture, influenced by his friend Anthony *Caro. Noland lived in New York from 1961 to 1963, then in South Shaftesbury, Vermont, until 1979, when he settled in South Salem, New York.

Nolde, Emil (1867–1956). German painter and printmaker, one of the most powerful representatives of *Expressionism. He was born Emil Hansen, the son of a farmer, at Nolde in Schleswig-Holstein and adopted the name of his village as his surname when he married in 1902. Originally he trained as a cabinetmaker and woodcarver, and he came late to artistic maturity. In the 1890s he spent several years teaching drawing at St Gall in Switzerland, and the financial success of some comic postcards he designed showing mountains with human faces enabled him to study painting seriously—in Munich, in Dachau (in *Hölzel's school), and finally at the *Académie Julian in Paris, 1899–1900. The following years were very difficult for him (his wife became a semi-invalid), and he was almost 40 when he first made an impact as a painter at the 1906 exhibition of the Berlin *Sezession. In the same year he became a member of Die *Brücke, but he was essentially an isolated figure, standing apart from his great German contemporaries. This was a reflection of his suspicious and touchy character (he resigned from Die Brücke after 18 months and was expelled from the Sezession in 1910 after making a vicious personal attack on Max *Liebermann).

In the early part of his career Nolde lived mainly in Berlin, but he moved around a good deal in Germany and travelled extensively elsewhere (in 1913–14 he visited Russia, the Far East, and the South Sea islands as part of an ethnographic expedition); however, at times he lived almost like a hermit, painting on the lonely moorlands and seashore of north Germany. His travel broadened his knowledge of the kind of *primitive art that was then beginning to excite avant-garde artists, but Nolde had already established the essential features of his style before his contact with such art, and when the term 'primitive' is applied to his work, it refers to its brutal force, not to any exotic trappings. He

was a deeply religious man and is most famous for his paintings of Old and New Testament subjects, in which he expressed intense emotion through violent colour, radically simplified drawing, and grotesque distortion (*Pentecost*, Staatliche Museen, Berlin, 1909). The majority of his pictures, however, were landscapes, and he was also one of the outstanding 20th-century exponents of flower painting, working with gloriously vivid colour, often in watercolour; Frank *Whitford calls him 'perhaps the greatest modern watercolourist'. Nolde also made many prints (etchings, lithographs, and woodcuts), mainly early in his career (there are few after 1926). Although he was a supporter of the Nazi Party, he was declared a *degenerate artist and in 1941 was forbidden to paint. However, he executed small watercolours in secret (these are called the *Ungemalte Bilder*, 'Unpainted Pictures') and from these made larger oils after the war. From 1926 he lived at Seebüll, where there is now a Nolde Foundation that has an outstanding collection of his work. An anthology of his letters was published in 1927 and his autobiography has been published in four volumes, two of them posthumous (1931, 1934, 1965, 1967); a one volume edition, *Mein Leben*, appeared in 1976.

Non-Conformist art. See UNOFFICIAL ART.

Non-Figurative Artists' Association, Montreal. See PLASTICIENS.

Non-Objective art. A general term for *abstract art that is intended to be completely non-representational, rather than derived (however remotely or obliquely) from appearances in the world around us; most commonly it is applied to severely geometrical works. The term was coined by *Rodchenko, who used it in the title of some of his paintings (*Non-Objective Painting: Black on Black*, MOMA, New York, 1918). It is also particularly associated with *Malevich, who in 1919 wrote: 'In referring to non-objectivity, I merely wished to make it plain that *Suprematism is not concerned with things, objects, etc.' In 1927 the *Bauhaus published a book by Malevich entitled *Die gegenstandslose Welt*, which appeared in English translation in 1959 as *The Non-Objective World*. The *Guggenheim Museum in New York was originally called the Museum of Non-Objective Art.

Nordrhein-Westfalen Collection (Kunstsammlung Nordrhein-Westfalen), Düsseldorf. Collection of 20th-century paintings founded in 1961 in Düsseldorf, capital of the Land (state) of Nordrhein-Westfalen (North Rhine-Westphalia) and opened to the public in 1965. It is unusual among collections in that it was founded by parliamentary decree and built up from scratch rather than developing by a process of organic growth. The decision to found it was taken after the regional government of Nordrhein-Westfalen bought 88 works by Paul *Klee from an American private collection. 'The acquisition of the Klee collection established the pattern of future purchasing in two respects. First, from the historical point of view, in that it was decided not to include any artists earlier than Klee's generation. The *Impressionists and Fin-de-Siècle artists were excluded and, following what was in any case a clear art-historical break at this time, the collection started with the *Fauves, the *Cubists, and the *Expressionists. The precedent of the Klee pictures also established quality as the central concern of the collection. Indeed, quality is the sole criterion. All other factors—historical, national, regional, local—have been disregarded' (Werner Schmalenbach in the catalogue of the exhibition 'Picasso to Lichtenstein: Masterpieces of Twentieth-Century Art from the Nordrhein-Westfalen collection in Düsseldorf', Tate Gallery, London, 1974).

Norwich, Sainsbury Centre for the Visual Arts. See SAINSBURY CENTRE FOR THE VISUAL ARTS.

Nouveau Réalisme. A term coined by the French critic Pierre *Restany in 1960 (in a manifesto of this name) to characterize the work of a group of artists who incorporated real objects (often junk items) in their work to make ironic comments on modern life. The Nouveau Réalisme movement was part of the vogue for *assemblage and had affinities with *Junk art and *Pop art. Restany also recognized a debt to *Dada—hence the title of an exhibition he held at his Galerie J in Paris in 1961, '40° au-dessus de Dada' ('40 Degrees above Dada'). In the following year another representative exhibition, entitled 'New Realists', took place at the Sidney *Janis gallery in New York. Yves *Klein was closely associated with Restany in the foundation of Nouveau Réalisme, and among the other leading

artists involved were *Arman, *César, and *Tinguely (all three exhibited at both the Paris and New York shows mentioned above).

Nouveaux Plasticiens. A group of four Canadian abstract painters formed in Montreal in 1959: they succeeded Les *Plasticiens as leaders of the avant-garde and were the dominant force on the city's art scene during the 1960s. The members were Jean Goguen (1928–), Denis Juneau (1925–), Guido *Molinari, and Claude *Tousignant. They painted large, completely abstract canvases, sometimes *Hard-Edge and verging on *Op art.

Nouvelle Tendance (or New Tendency). A term applied to an international trend in the early 1960s uniting elements of *Constructivism and *Kinetic art and linking artists and movements in Europe, Japan, and South America. These individuals and organizations were very varied, but they often shared certain characteristics: the appropriation of new materials and techniques from science and industry; a cult of group activity; the incorporation of light and sound effects; and an iconoclastic attitude towards traditional aesthetic standards. These shared attitudes and loose asociations between groups formed the Nouvelle Tendance. The name derives from an exhibition entitled 'Nove Tendencje' held at the Galerija Suvremene Umjetnosti, Zagreb, in 1961. Several further 'Nove Tendencje' exhibitions were held in Zagreb, and in 1963 the *Groupe de Recherche d'Art Visuel (GRAV) helped to organize a large exhibition in Frankfurt entitled 'European Avant-Garde: Arte Programmata, Neue Tendenzen, Anti-Peinture, Zero'. The term was introduced to the USA by George *Rickey in 1964. In Germany and the Netherlands New Tendency ideas were promoted by the *Zero and *Nul groups respectively, and in Italy they found expression in *Arte Programmata.

Novecento Italiano (Italian 20th Century). Association of Italian artists, founded in 1922 and officially launched in 1923 at an assembly at the Pesaro Gallery in Milan; it aimed to reject European avant-garde movements and revive a naturalistic type of art based on classical Italian tradition. The Novecento thus represented a tendency that had already found expression in *Carrà and de *Chirico's interest in Renaissance art. However, the association had no clear artistic programme (although it wished to revive large-scale figurative compositions) and numbered within its ranks artists of very different styles and temperaments, among them *Campigli, Carrà, and *Marini. Increasingly the Novecento came to be associated with Fascist propaganda (Mussolini had been one of the speakers at the launch) and during the 1930s it was the main bastion of reactionary attitudes. It disbanded in 1943. See also NEOCLASSICISM and TOTALITARIAN ART.

Novelli, Gastone. See CONTINUITÀ.

'novelty art'. See MODERNISM.

November Group. An association of Finnish *Expressionist artists founded in Helsinki in November 1917. This was only a month before Finland's declaration of independence from Russia, and the members of the group were sometimes aggressively nationalistic in their approach. Tyko *Sallinen was the leading figure; among the others were Ilmari Aalto (1891–1934), Alvar Cawén (1886–1935), Marcus Collin (1882–1966), and Ragnar Ekelund (1892–1960). The group held annual exhibitions until 1924.

Novembergruppe. A group of radical left-wing artists formed in Berlin in December 1918; it was named after the revolution that had broken out in Germany the previous month, at the end of the First World War, and the professed aim of the Novembergruppe was to help national renewal by means of a closer relation between progressive artists and the public. The prime movers in the creation of the group were César Klein (1876–1954), a painter and theatrical designer, and Max *Pechstein. Others who quickly joined included Rudolf *Belling, Heinrich *Campendonk, Otto *Müller, and Hans *Purrmann. In 1919 the group created the Arbeitsrat für Kunst (Workers' Council for Art) in an attempt to bring about a dialogue between art and the masses, but this collapsed in 1921 and interest and support came mainly from the middle classes. Artistically the group covered a wide spectrum, from *Cubism and *Expressionism to geometrical abstraction and *Social Realism. Through its numerous exhibitions in the 1920s the it did much to foster an artistic revival, and many of its aims were more fully realized at the *Bauhaus. The group disbanded in 1929.

Novy Lef. See MAYAKOVSKY.

Nul. Dutch group of *Kinetic and experimental artists, founded in 1960. Its members included Armando (H. D. van Dodeweerd) (1929–), Henk Peeters (1925–), and Jan Schoonhoven (1914–). It was a continuation of the Nederlandse Informele Groep (founded 1957), to which they had all belonged. 'Nul' is Dutch for 'nought' or 'zero' and the group was inspired by the German group *Zero; the two organizations often exhibited together. There was a group periodical *Nul=0*, of which three numbers appeared between 1961 and 1963.

Nyolcak. See EIGHT (3).

0.10 ('Zero–Ten'). See POUGNY.

object. A term applied to a type of three-dimensional work (generally fairly small) made up of any materials that take the artist's fancy and usually put together with some symbolic or ironic meaning. Works in this vein were produced by the *Dadaists, and the idea was anticipated to some extent by *Marinetti, who made a *Self-portrait (Dynamic Collection of Objects)* in 1914, but it was the *Surrealists who really cultivated the object. It is impossible to define the term with any great precision, and the Surrealists listed (or invented) various categories, many of which seem intended to mystify rather than clarify. They include the *objet trouvé and the *ready-made, both of which have a fairly clearly understood meaning, and also, for example, the 'poem-object' (invented by *Breton) and the 'symbolically functioning object' (invented by *Dalí). Sarane Alexandrian (*Surrealist Art*, 1970) describes the poem-object as 'a kind of relief which incorporates objects in the words of a poetic declaration so as to form a homogeneous whole', whilst the symbolically functioning object 'expresses a repressed desire or allows a compensatory satisfaction of the libido. Dalí made one consisting of a woman's shoe inside which was placed a glass of milk.' The most famous of all Surrealist objects is probably Meret *Oppenheim's *Cup, Saucer and Spoon in Fur* (MOMA, New York, 1936), also known simply as *Object*, which Alexandrian classifies as a 'dreamt object': 'According to Breton, this corresponds to "the need, inherent in the dream, to magnify and dramatize". It is a humble, familiar object, which by some caprice of desire is given a sumptuous appearance.'

Breton, inspired by a dream in which he had seen a curious book with wool pages, had first suggested creating such dream-objects in 1924. In December 1928 an advertisement in issue 8 of *La *Révolution surréaliste* announced a forthcoming exhibition of objects, but this never took place, and their heyday was the 1930s. The idea that they should form a distinctive category of art was promoted by Dalí in an article entitled 'Objects surréalistes' in the third issue of *Le Surréalisme au service de la révolution* (December 1931). He regarded the object as 'absolutely useless from the practical and rational point of view, created wholly for the purpose of materializing in a fetishistic way, with the maximum of tangible reality, ideas and fantasies having a delirious character'. The first group exhibition of Surrealist objects was held in 1936 at the Galerie Charles Ratton, Paris, followed in 1937 by 'Surrealist Objects and Poems' at the London Gallery (see MESENS). Discussing the London exhibition, Anna Gruetzner writes: 'The idea behind the surrealist object was essentially poetic. The surrealists regarded such objects as concrete manifestations of their dreams, secret fantasies and fears. They believed that an object was created through its discovery and that each object had a special animistic quality which made it a "modern" token or fetish and an expression of a primitive shared state of mind which the surrealists thought they had acquired once they had freed themselves from the conventions and inhibitions of their own society' (catalogue of the exhibition 'British Sculpture in the Twentieth Century', Whitechapel Art Gallery, London, 1981). The British artists particularly associated with making objects include Eileen *Agar, Paul *Nash, and Roland *Penrose. An example by Penrose is *Captain Cook's Last Voyage* (Tate Gallery, London, 1936), featuring a nude female torso in painted plaster encased in a wire globe and set on a base incorporating part of a saw. Anna Gruetzner writes that 'Its message was that Captain Cook's last voyage would be an exploration of sexual love. The globe is a symbol of man's universal bond,

which was one of the surrealist goals, but it is also a cage which imprisons this female dummy and there is a further hint of violence in the saw handle which protrudes from the severed figure.'

In reference to more recent art, the term 'object' has been used so broadly as to become virtually meaningless. It was employed for example in the subtitle of an exhibition at the Hayward Gallery, London, in 1997–'Material Culture: The Object in British Art of the 1980s and 1990s'—in which the works on show varied greatly in size and approach.

object book. See BOOK ART.

'objecthood'. See *ARTFORUM*.

Objective Abstractionists. A group of British painters associated with an exhibition entitled 'Objective Abstractions' held at the Zwemmer Gallery, London, in 1934. Seven artists participated: Graham *Bell, Thomas Carr (1909–), Ivon *Hitchens, Rodrigo *Moynihan, Victor *Pasmore, Ceri *Richards, and Geoffrey Tibble (1909–52). Another painter, Edgar Hubert (1906–), was associated with the group but did not exhibit. Only four of these artists were out-and-out abstract painters at this time: Bell, Hubert, Moynihan, and Tibble. All eight, however, were united by the aim of taking nature as an initial 'objective' point of reference; thereafter the painting might develop according to its own logic. The abstracts they produced were freely painted, and Sir John *Rothenstein writes that 'several of the exhibits proclaimed the autonomy of paint and brush in a way that anticipated the *abstract expressionism of twenty years later'.

objet trouvé (French: found object). An object found by an artist and displayed with no, or minimal, alteration as (or as an element in) a work of art. It may be a natural object, such as a pebble, a shell, or a curiously contorted branch, or a man-made object such as a piece of pottery or old piece of ironwork or machinery. The essence of the matter is that the finder-artist recognizes such a chance find as an 'aesthetic object' and displays it for appreciation by others as he would a work of art. The practice began with the *Dadaists (especially Marcel *Duchamp) and was particularly cultivated by the *Surrealists. George Heard *Hamilton writes that the

devotees of the objet trouvé believed that such pieces 'by their unexpected isolation from their customary purpose and environment could open magic casements on interior psychic seas . . . But the technique was easily abused, especially by interior decorators, until no bit of driftwood or broken bone was free from Surrealist implications.' Subsequently, found material has been much used in *assemblage.

Although the objet trouvé is considered a 20th-century phenomenon, the zoologist (and Surrealist painter) Desmond Morris (1928–) thinks that the earliest known art object in the world comes into this class. It is the three-million-year-old Makapansgat Pebble (University of Witwatersrand, Johannesburg), discovered in the Transvaal in 1925. 'Investigations revealed that it could not have come from the cave where it was found and must have been carried from a location about three miles away. What made it special was that it had the shape of a human skull, on one side of which were small cavities that looked like a pair of sunken eye-sockets above a simple mouth. There is no suggestion that this "face" had been artificially manufactured but its accidental resemblance is so striking that it seems certain the object was collected and brought back to a favoured dwelling place as a "treasured possession" . . . the cave where it was discovered was not occupied by prehistoric man but by the early man-apes known as Australopithecines' (*The Human Animal*, 1994).

Obmokhu (Society of Young Artists). A group of Russian artists, most of them pupils of *Rodchenko and *Tatlin in the Moscow *Vkhutemas, who experimented with spatial constructions and the properties of industrial materials. In 1920 Obmokhu held an exhibition of work by thirteen students of Vkhutemas. These were not socially useful designs, but open spatial constructions making dynamic use of the spiral form. A year later, however, most of these artists aligned themselves with the *Constructivists, signed a manifesto condemning non-useful (i.e. 'fine') art as a 'speculative activity', and thereafter devoted themselves to theatrical or industrial design. Prominent among them were the *Stenberg brothers and Konstantin (or Kasimir) Medunetsky (1899–c. 1935), one of whose constructions, from 1919, was illustrated in *Circle* in 1937.

Obregón, Alejandro (1920–92). Columbian painter, born in Barcelona, Spain. He was widely travelled in his early years (his schooling was in England and his training included brief periods in Barcelona and Boston). In 1948–51 he was director of the School of Fine Arts in Bogotá, then lived in France for several years. He absorbed (or partially absorbed) influences from numerous artists and styles, and by the mid-1950s he had developed a richly-coloured semi-abstract style related to European *Art Informel and American *Abstract Expressionism. His subjects, however, were often drawn directly from his Columbian surroundings; they ranged from mountain landscapes to the political troubles of his country. In 1956 he settled in the coastal town of Barranquilla (although he made frequent trips to Bogotá and France); the sea and the tropical coastal vegetation were among his favourite subjects. Obregón's work was widely exhibited in Latin America and elsewhere and in 1956 he won first prize at the Guggenheim International Exhibition in New York. Edward *Lucie-Smith described him as 'an outsize personality . . . [he] built himself a brilliant early reputation, though it has now been somewhat compromised by two factors—his own propensity for pictorial rhetoric, and the international success of his compatriot *Botero' (*Latin American Art of the 20th Century*, 1993).

Obrist, Hermann. See SCHMITHALS.

O'Connor, Victor. See *ANGRY PENGUINS*.

O'Conor, Roderic (1860–1940). Irish painter and etcher, active for most of his life in France (mainly Paris), where he settled in 1883 after studying in London and Antwerp. He was strongly influenced by *Gauguin and van Gogh, and by the early 1890s was painting in a full-blooded *Post-Impressionist style with bold colour often used non-naturalistically and thick brushwork. Gauguin (whom he met at Pont-Aven) asked him to return to the South Seas with him, but O'Conor declined. After the death of his father in 1893 he was financially secure and had no need to promote his work (he often sold direct to collectors, including Somerset Maugham, who used aspects of O'Conor's character in his novel *The Moon and Sixpence*, 1919, about a Gauguinesque artist). He lived a fairly reclusive life (although he was friendly with many British visitors to France, including Clive *Bell and Roger *Fry) and he was virtually unknown in the British and Irish art worlds. It was only after his death that he was recognized as the outstanding pioneer of Post-Impressionism among English-speaking artists. He did, however, notably influence Matthew *Smith, whom he met in 1919 (they were the subject of a joint exhibition at Roland, Browse & Delbanco, London, in 1956: 'Two Masters of Colour, Matthew Smith and Roderic O'Conor'). O'Conor was mainly a landscapist, but he also painted still-lifes, portraits, interiors, and figure subjects. After about 1910 his colouring became less intense and some of his late work comes within the orbit of *Intimisme. There are good examples of his work in the Ulster Museum, Belfast, the National Gallery, Dublin, and the Tate Gallery, London.

Oelze, Richard (1900–80). German painter, born at Magdeburg. He was a taciturn, maverick figure who for his first 40 years led a wandering existence, often in poverty, then lived almost like a hermit for the rest of his days. Recognition did not come until he was almost 60, but he is now regarded as Germany's leading exponent of *Surrealism apart from Max *Ernst.

Oelze studied at the *Bauhaus in Weimar, 1921–5, then for the next few years lived mainly in Dresden and Berlin. From 1933 to 1936 he lived in Paris, where he was associated with the Surrealists (in 1936 his work was shown in the International Surrealist Exhibition in London and in the exhibition 'Fantastic Art, Dada, Surrealism' at the Museum of Modern Art, New York). After spending two years mainly in Italy and Switzerland he returned to Germany in 1938 and served in the army in the Second World War, during which he was taken prisoner. After his release he settled at *Worpswede until 1962, when he moved finally to Posteholz near Hamelin. His reputation began to grow after his work was shown in the 1959 *Documenta exhibition and in the last years of his life he received various distinctions (including the Max Beckmann Prize of the City of Frankfurt in 1978), although he continued to live a life of solitude, fiercely defending his privacy. He had trained in the precise style of *Neue Sachlichkeit and his early work is sometimes classified as *Magic Realism. The best-known example is

Expectation (MOMA, New York, 1935), showing a crowd of apprehensive figures—viewed from the back—looking at or for some unseen presence in the sky. It has an eerie science-fiction feel that is also seen in some of Oelze's later works, notably his weird semi-abstract landscapes made up of vegetable-like as well as geological forms.

Official War Art. Art sponsored by the British Government during the First and Second World Wars to make a visual record of all aspects of the war effort for information and propaganda purposes. By extension the term is also applied to art produced under official auspices for other Allied countries. Australia commissioned work for the Australian War Memorial in Canberra (originally intended to commemorate the First World War, but extended to encompass all wars in which the country was involved); Canada had a Canadian War Records Office that commissioned paintings and drawings; and the USA had a War Portraits Commission.

In the First World War, official art was directed by the Ministry of Information, which was advised by a committee drawn from distinguished figures in the art world and public life, among them Campbell Dodgson, keeper of prints and drawings at the British Museum, and Eric Maclagan, later director of the Victoria and Albert Museum. In 1916 the Ministry launched the Official War Artists scheme, under which artists were recruited, with appropriate military ranks, to serve as chroniclers (the Germans already had a similar scheme in operation). The first artist to be commissioned was Honorary 2nd Lieutenant Muirhead *Bone, who left for France on 16 August 1916 and toured the front in a chauffeur-driven car. Many others soon followed, among them some of the most illustrious British artists of the time. They included men who had already been serving in the armed forces, such as Paul *Nash, C. R. W. *Nevinson, and Stanley *Spencer, and others who were too old for active duty. The works produced varied enormously in style and quality (the committee was admirably broad in its choice of artists) and included imaginative evocations of the war as well as sober factual records. There were many portraits of participants, but two of the most notable portraitists who worked as Official War Artists— *Orpen and *Sargent—showed a different and unexpected side to their talents, powerfully

depicting the horrors they saw. Charles Harrison (*English Art and Modernism*, 1981) writes that 'the War was the occasion of the first major exercise in this country of state patronage of modern art. Virtually every professional artist of any demonstrable competence who was prepared to put on uniform was offered employment as an official war artist sooner or later.'

In autumn 1939, soon after the outbreak of the Second World War, the Ministry of Information appointed Kenneth *Clark chairman of a small group that became known as the War Artists' Advisory Committee (Muirhead Bone was one of the members). It met weekly at the National Gallery, of which Clark was director, and its functions were principally 'to draw up a list of artists qualified to record the War at home and abroad . . . [and] to advise on the selection of artists from this list for war purposes and on the arrangement for their employment'. Clark regarded his work on the committee as 'my only worthwhile activity' during the war: 'We employed every artist whom we thought had any merit, not because we supposed that we would get records of the war more truthful or striking than those supplied by photography, but because it seemed a good way of preventing artists being killed' (*Ravilious was one of the rare fatalities). Several painters who had been Official War Artists in the First World War were employed in the same capacity in the Second, among them Nash and Spencer, but the Committee mainly employed men of a younger generation. The terms in which they were employed varied; some were given salaried posts for a specific period, while others were given one-off commissions. The Committee also encouraged artists, whether serving or civilian, to submit pictures for consideration. Generally the commissions in the Second World War were on a smaller scale than those in the First, with many works being executed in watercolour (Spencer's huge canvases of shipbuilding on the Clyde are a conspicuous exception). Henry *Moore's drawings of Londoners sheltering from air raids in Underground stations are perhaps the best-known of all the works produced under the auspices of Clark's Committee.

In both wars women were employed as Official War Artists on the home front, notably the animal painter Lucy Kemp-Welch (1869–1958) in the First and Laura *Knight in the Second. A huge number of works was

produced. The largest collection (about 10,000 items) is in the Imperial War Museum, London, which was opened in 1920 and moved to its present home (the former Royal Bethlehem Hospital) in 1936. There is another major collection in the Tate Gallery, London, and many provincial museums have good examples.

The tradition of Official War Art has been continued by the Artistic Records Committee of the Imperial War Museum, established in 1972. Artists who have worked under its auspices include Linda Kitson (1945–), who went on its behalf to the Falkland Islands during the war there against Argentina in 1982; John Keane (1954–), who went to the Gulf War in 1991; and Peter Howson (1958–) (see also GLASGOW SCHOOL), who went to Bosnia in 1993. Howson's exhibition 'War in Bosnia' at the Imperial War Museum in 1994 attracted considerable attention because of its unsparing depiction of atrocities: 'Now that I've actually seen dead bodies, and guts and brains, and starving children, it has made the work authentic.'

Ofili, Chris. See SAATCHI.

Ogilvie, Zina Lilias. See DRUMMOND.

O'Gorman, Juan (1905–82). Mexican architect and painter, born in Coyoacán, the son of Irish parents. He graduated from the school of architecture of the National University of Mexico in 1927, and between then and the mid-1930s he designed a series of houses in Mexico City (notably ones for himself and Diego *Rivera) that were among the first in the Americas to show the functional ideas of *Le Corbusier. As head of the Department of Construction in the Ministry of Public Instruction he was in charge of the building of thirty new schools (1932–5) that confirmed his leadership in progressive architecture. In the 1930s, however, he abandoned architecture for painting, and he is described by Edward *Lucie-Smith as 'the most interesting of the less acclaimed artists in the Mexican Muralist movement' (*Latin American Art of the 20th Century*, 1993). His work was strongly nationalistic and his anti-fascist, anti-church frescos at Mexico City airport (1937–8) were destroyed in 1939 during a political swing to the right. In the 1950s he returned to architecture, now advocating a more 'organic' approach inspired in part by the great Ameri-can architect Frank Lloyd Wright. His most celebrated work is the Library of the National University in Mexico City (1951–3), in which a modern structural design is completely covered externally in mosaics of his own design symbolically representing the history of Mexican culture. 'The flat, almost windowless surfaces of the library tower are covered in intricate designs made of native stones, producing an effect that is more like woven cloth than like painting. The designs are of Pre-Columbian inspiration . . . The building and its decoration rightly became a symbol of the ability of Mexican artists to revive certain aspects of the Indian past without seeming sentimental or nostalgic' (Lucie-Smith). In 1953–6 O'Gorman built a second house for himself outside Mexico City. This too was lavishly decorated in mosaics externally and internally and it was designed to harmonize with the lava formation of the landscape. It was demolished in 1969. O'Gorman committed suicide.

O'Gorman, Pablo. See TALLER DE GRÁFICA POPULAR.

O'Hara, Frank. See LESLIE.

Oinonen, Mikko. See SEPTEM.

O'Keeffe, Georgia (1887–1986). American painter. One of the pioneers of modernism in the USA, she was a member of the circle of *Stieglitz, whom she met in 1916 and married in 1924. She was born near Sun Prairie, Wisconsin, and trained at the Art Institute of Chicago, 1905–6, and the *Art Students League, New York, 1907–8. For the next two years she worked as a commercial artist, then taught at schools in South Carolina, Texas, and Virginia. In 1915–16 she did a series of abstract drawings and watercolours that evoked the natural world in simple forms and vivid colours. They impressed Stieglitz (who when he first saw her work is said to have exclaimed 'Finally, a woman on paper!') and he gave O'Keeffe her first one-woman show in 1917. She settled in New York the following year with the promise of his financial support. In the 1920s her work became more representational, but she remained interested in the underlying abstract forms of objects rather than in depicting them naturalistically. Particularly characteristic and admired are her near-abstract paintings based on

flower and plant forms, works of great elegance and rhythmic vitality, whose sensuous forms are often sexually suggestive (*Black Iris*, Metropolitan Museum, New York, 1926). In the 1920s she also painted townscapes of New York in a manner close to that of the *Precisionists and landscapes done in broad, simple forms. From the 1930s she spent each winter in New Mexico and she settled there after Stieglitz's death in 1946, the desert landscape appearing frequently in her paintings (bleached animal bones were a favourite subject). She began to travel widely in the 1950s and many of her later paintings were inspired by views of the earth, sky, and clouds seen from an aeroplane. Her growing reputation was marked by a major retrospective exhibition at the *Whitney Museum, New York, in 1970. She became partially blind in the following year and did little work thereafter. A museum of her work opened in Santa Fe in 1997.

Oldenburg, Claes (1929–). Swedish-born sculptor and graphic artist who became an American citizen in 1953, a leading figure of *Pop art. He was born in Stockholm, the son of a consular official. His father's diplomatic duties took the family to New York in 1929–33 and Oslo in 1933–6 before they settled in Chicago in 1936. Oldenburg studied art and literature at Yale University, 1946–50, then returned to Chicago, where he took courses at the Art Institute whilst earning his living with part-time jobs as a reporter and illustrator. In 1956 he settled in New York, where he came into contact with a group of young artists including Jim *Dine, Allan *Kaprow, and George *Segal, who were in revolt against *Abstract Expressionism, and from *c*. 1958 he was involved in numerous *Happenings. Creating the props and costumes for these helped to turn his interest from painting to three-dimensional work—*environments as well as sculpture. His inspiration was drawn largely from New York's street life—shop windows, advertisements, graffiti, and so on—and in 1961 he opened 'The Store', at which he sold painted plaster replicas of domestic objects. This led to the work with which his name is most closely associated—giant sculptures of foodstuffs, typically made of canvas stuffed with foam rubber (*Dual Hamburger*, MOMA, New York, 1962), and 'soft sculptures' of normally hard objects such as typewriters and washbasins, typically made of shiny vinyl.

With these he was hailed as one of the leaders of American Pop art. Subsequently Oldenburg has also become well known for projects for colossal monuments—for example, *Lipsticks in Piccadilly Circus* (Tate Gallery, London, 1966), consisting of a magazine cutting of an array of lipsticks pasted onto a picture postcard. The first of these projects to be realized was a giant lipstick erected at Yale University in 1969. Since 1976, in collaboration with his second wife, the Dutch writer Coosje van Bruggen, Oldenburg has concentrated almost exclusively on such large-scale projects, for example the 20-metre-high *Match Cover* erected in Barcelona in 1992.

Olitski, Jules (1922–). Russian-born American painter and sculptor, one of the leading figures of *Post-Painterly Abstraction, specifically of *Colour Field Painting. He was born in Snovsk in the Ukraine shortly after his father was executed for political offences and was brought to the USA by his mother and grandmother in 1923. His main training was at the *Art Students League, New York, 1939–42. In 1949–51 he travelled in Europe and studied sculpture under *Zadkine in Paris. His early paintings were influenced by *Fauvism and he then went on to heavily-textured abstracts, but in 1960 the direction of his work changed radically when he began experimenting with stain techniques in the manner of *Frankenthaler and *Louis. In 1964 he began using a spray gun and in the second half of the 1960s he developed the type of painting for which he is best known—vast canvases covered with luscious mists of atmospheric colour; he said that ideally he would like 'nothing but some colours sprayed into the air and staying there'. Sometimes there are some heavier touches at the edges of the canvas in a sort of ironic reference to *Abstract Expressionism, and in the 1970s Olitski returned to a more textural handling of paint, often reducing his colours to delicate modulations of greys and browns. He took up sculpture seriously in 1968 and has worked mainly with painted steel.

Oliviera, Nathan. See BAY AREA FIGURATION.

Ollila, Yrjö. See SEPTEM.

Olsen, John (1928–). One of Australia's leading abstract painters, born in Newcastle, New South Wales. He grew up and studied in Syd-

ney, where he had his first one-man exhibition at the Macquarie Galleries in 1955. A year later he was one of the artists who took part in the *Direction 1 exhibition—a milestone in the development of abstract art in Australia. In 1957–60 Olsen travelled in Europe, and on his return to Australia helped to form the group *Sydney 9, aimed at increasing appreciation of abstraction in his country. In Europe Olsen's work had been strongly influenced by the *Expressionism of the *Cobra group and the totemic imagery of Alan *Davie, whom he met in London. Back in Australia, he applied the lessons he had learned to an imaginative exploration of the bush landscape, notably in his series *Journey into You Beaut Country* (1961), in which lively calligraphic brushwork evokes a feeling of vegetation and insect life. In 1972 Olsen painted a mural for the newly completed Sydney Opera House, and in 1978 he made an extensive painting tour of Africa.

Omega Workshops. Decorative arts company founded by Roger *Fry in London in 1913 with the twin aims of improving the standard of design in Britain and providing work for the young avant-garde artists in his circle. The headquarters were at 33 Fitzroy Square in Bloomsbury, a handsome Robert Adam house that is now part of the London Foot Hospital; there were two showrooms on the ground floor and two large workshops on the first floor. In a prospectus, Fry wrote that the Workshops would undertake 'almost all kinds of decorative design, more particularly those in which the artist can engage without specialized training in craftsmanship'. A press view was held on 8 July 1913, and the works on show 'included tables and chairs, fabrics, bedspreads, clothes, large decorative curtains, screens, designs for murals, and a miscellany of pots, parasols and pencil boxes' (Richard Shone, *Bloomsbury Portraits*, 1976). A critic in *The Times* wrote 'what pleases us most about all the work of these artists is its gaiety . . . we wish them all the success they deserve', and this positive review help stimulate sales in the early months of the Workshops. Several commissions came from aristocratic patrons, including Lady Ottoline Morrell (see CONTEMPORARY ART SOCIETY). Fry disliked the smooth finish of machine products, and Omega works characteristically have the irregularities of hand craftsmanship, although the furniture it sold was originally bought ready-made and then painted on

the premises, and its linens were expertly printed in France. The favourite Omega motifs included flowers, nudes, and abstract patterns, and colour was often very bright; *Cubism and *Fauvism were strong influences.

Apart from Fry himself, the designers most closely associated with Omega were Vanessa *Bell and Duncan *Grant, and several other distinguished artists worked for the enterprise, including Paul *Nash and William *Roberts. However, all the work was sold anonymously. Artists were paid a regular wage (the financing came from Fry himself and from subscribers including George Bernard Shaw), and this steady income could be of great importance. For example, Nina *Hamnett wrote: 'Feeling brave one morning I went to Fitzroy Square and asked to see Mr Fry. He was a charming man, with grey hair, and said I could come round the next day and start work. I went round and was shown how to do Batiks. I was paid by the hour. I made two or three pounds a week and felt like a millionaire.' Not all the employees were so charmed by Fry, however, and in October 1913 Wyndham *Lewis left in unpleasant circumstances, together with Frederick *Etchells, Cuthbert Hamilton (see GROUP X), and Edward *Wadsworth. Lewis claimed publicly that Fry had played 'a shabby trick' on him and Spencer *Gore (not a member of Omega) by cheating them of a commission from the *Daily Mail* to decorate a room for the forthcoming Ideal Home Exhibition. It is extremely unlikely that Fry would have played 'a shabby trick' on anyone (Edith *Sitwell described him as 'warm-hearted, generous-minded and kindly'), and the affair seems to have originated in a simple misplaced message. However, it caused considerable bad publicity and gave Lewis a lasting hatred of the *Bloomsbury Group. In the second issue of *Blast* he attacked 'Fry's curtain and pincushion factory' as 'abject, anaemic, and amateurish'. Fry, with his Quaker-like calm, refused to be drawn into a public quarrel, but in a letter to Simon *Bussy (28 December 1913) he wrote that 'Lewis's vanity touches on insanity'.

The First World War had a disastrous effect on Omega's sales (Fry in any case had little business aptitude) and in June 1919 the Workshops' remaining stock was sold off; the company was officially liquidated in 1920. The best idea of Omega furnishings in a contemporary setting can be gained at Charleston,

the country home of Bell and Grant at Firle in Sussex. There are also good examples in London at the Courtauld Gallery and the Victoria and Albert Museum.

Ono, Yoko. See FLUXUS.

Onslow Ford, Edward. See NEW SCULPTURE.

Onslow Ford, Gordon. See PAALEN.

Op art (abbreviation of Optical art, on the analogy of Pop art). A type of abstract art that exploits certain optical phenomena to cause a work to seem to vibrate, pulsate, or flicker. Op art flourished mainly in the 1960s; the term was first used in print in the American magazine *Time* in October 1964 and had become a household phrase by the following year, partly through the attention given to the exhibition 'The Responsive Eye' held at the Museum of Modern Art, New York, in 1965. This was the first international exhibition with a predominance of Op paintings. The development of Op art as a recognizable movement had begun a few years earlier than this, in about 1960, the works and theories of Josef *Albers being among the main sources. The devices employed by Op artists (after-images, effects of dazzle and vibration, and so on) are often elaborations on the well-known visual illusions to be found in standard textbooks of perceptual psychology, and maximum precision is sought in the control of surfaces and edges in order to evoke an exactly prescribed retinal response. Many Op paintings employ repeated small-scale patterns arranged so as to suggest underlying secondary shapes or warping or swelling surfaces. This kind of work can retain much of its effect in reproduction, but Op art also embraces constructions that depend for their effects on light and/or movement, so Op and *Kinetic art sometimes overlap.

The two most famous exponents of Op art are Bridget *Riley and Victor *Vasarely. Their work illustrates the considerable impact that Op made on fashion and design in the 1960s—its instant popular success (accompanied by a fairly cool critical reception) is hard to parallel in modern art. Op art became something of a craze in women's fashion and in 1965 Riley unsuccessfully tried to sue an American clothing company that used one of her paintings as a fabric design. One of Vasarely's designs was used on the plastic carrier bags of

France's chain of COOP stores. Other leading artists whose work falls mainly or partly within the category of Op include *Agam, *Anuszkiewicz, *Cruz-Diez, *Sedgeley, and *Soto. See also PERCEPTUAL ABSTRACTION.

Opie, Julian. See NEW BRITISH SCULPTURE.

Oppenheim, Meret (1913–85). German-Swiss painter, sculptor, designer, and maker of *objects. She was born in Berlin and studied at the Kunstgewerbeschule in Basle. In 1932 she moved to Paris, where she was introduced to the *Surrealist group by *Giacometti and became for a while the model and disciple of *Man Ray. He described her as 'one of the most uninhibited women I have ever known' and she became celebrated among the Surrealists as the 'fairy woman whom all men desire'. She had a long career, but she is remembered mainly for one early work: *Object* (MOMA, New York, 1936), a fur-lined tea cup and saucer. This became famous after being shown at two major exhibitions in 1936—the International Surrealist Exhibition in London, and 'Fantastic Art, Dada, Surrealism' at the Museum of Modern Art, New York. George Heard *Hamilton writes that 'it was immediately recognized as a unique and "marvellous" metaphor, soon to be used, like *Duchamp's *Mona Lisa*, as a symbol of artistic anarchy by those who feared and distrusted the modern movement'. In 1937 she returned to Switzerland, where her career was sporadic. Among her later works the best known is probably *Cannibal Feast*, made for a Surrealist exhibition in Paris in 1959; it involved a nude woman lying on a table and covered with food. In her final years Oppenheim received commissions for public sculptures, notably a fountain in the Waisenhausplatz in Berne (1983).

Organ, Bryan (1935–). British painter, born in Leicester. He studied at Loughborough College of Art, 1952–5, and the *Royal Academy Schools, 1955–9. From 1959 to 1965 he taught at Loughborough College of Art, and since then has been a full-time artist. He has painted numerous subjects, but is best known for his portraits. Since 1966, when he painted Malcolm Muggeridge and Sir Michael Tippett, he has had numerous celebrity sitters, most famously Lady Diana Spencer (NPG, London, 1981), whom he painted shortly before she married the Prince of Wales.

Orlan. See BODY ART.

'Orovida' (Orovida Pissarro). See PISSARRO.

Orozco, José Clemente (1883–1949). Mexican painter, with his contemporaries *Rivera and *Siqueiros one of the trio of politically and socially committed fresco painters who were the dominant force in modern Mexican art. He was born in Ciudad Guzmán and grew up in Guadalajara and Mexico City. Originally he trained to be an architect, but he abandoned this idea after losing his left hand in an accident in 1900 and turned instead to painting, studying under Dr *Atl at the Academy of San Carlos in Mexico City, 1906–14. Following the first outburst of revolutionary activity in Mexico in 1910 (which was to last on and off until 1920), Orozco began working as a political cartoonist. In 1912 he began a series of watercolours called 'House of Tears' dealing with prostitutes (a favourite symbol of human degradation for Orozco). The angry reaction of critics and moralists to these works was one of his reasons for leaving for the USA, where he spent three unhappy and unproductive years, 1917–20.

His career as a muralist began after he returned to Mexico in 1920. The country was now relatively stable under the government of Alvaro Obregón, who encouraged paintings on nationalistic subjects as a way of creating a positive identity for the country after years of turmoil. Orozco's first murals were in the Escuela Nacional Preparatoria (National Training School), 1923–4. They were controversial because of their caricatural style, and all except *Maternity* and *The Rich Banquet while the Workers Quarrel* were subsequently destroyed or altered. His style matured towards a greater monumentality in frescos in the Casa de los Azulejos (House of Tiles), Mexico City (1926), and in a second series at the National Training School (1926–7). The work brought him little recognition, however, so from 1927 to 1934 (broken by a brief trip to Europe in 1932) he again worked in the USA. This time he was much more successful than during his first stay, carrying out a number of important mural commissions, most notably a cycle for Dartmouth College, New Hampshire, on *The Coming* and *The Return of Quetzalcoatl* (1932–4). This huge scheme showed his outlook crystallizing into a contrast between a pagan paradise and a capitalist hell. Unlike Rivera and Siqueiros,

Orozco did not align himself with a particular political viewpoint (the Mexican Communist Party called him a 'bourgeois sceptic'), but his work had an intense humanitarian mission.

Orozco returned to Mexico in 1934 with a big reputation after his success in the USA, and he spent most of the rest of his life engaged on mural projects in Mexico City and Guadalajara, the country's second city. His last work, *Hidalgo and the Liberation of Mexico*, for the Senate Chamber of the Palace of Government in Guadalajara, was finished shortly before his death in 1949. In his last years his work became ever more violent in expression, moved by a passionate concern for the suffering and miseries of mankind. Four years before his death, Orozco's autobiography was published; it was translated into English in 1962. His studio in Guadalajara is now a museum dedicated to him; a commemorative statue of Orozco stands in the park opposite.

Orpen, Sir William (1878–1931). British painter, chiefly famous as one of the leading fashionable portraitists of his day. He was born at Blackrock, near Dublin, into a cultured family: his father (a solicitor) and his brother (an architect) were good amateur watercolourists. A child prodigy, Orpen began studying at the Metropolitan School of Art, Dublin, in 1890, when he was only 11. In 1897 he settled in London and spent two years at the *Slade School, winning the composition prize in 1899. His contemporaries at the Slade included Augustus *John, with whom he ran the short-lived *Chelsea Art School, 1903–7, which failed because they were too busy to give it the necessary attention (Orpen was not only successfully pursuing his career as a portraitist in the same period, but also teaching part-time at the Metropolitan School in Dublin, 1902–14). The circles in which he moved can be gauged from his *Homage to Manet* (City Art Gallery, Manchester, 1909), which shows a group of some of the leading figures in the art world informally arranged around a tea-table beneath Manet's portrait of his pupil Eva Gonzales; the six figures represented are the patron and collector Sir Hugh *Lane, D. S *MacColl, who at this time was keeper of the Tate Gallery, the novelist and critic George *Moore, and the painters *Sickert, *Steer, and *Tonks.

Orpen's style in portraiture had much in common with that of his friend John, being vigorous and painterly but sometimes rather

flashy. He was at his best when he was away from his standard boardroom and drawing-room fare, and his numerous self-portraits are often particularly engaging, as he pokes fun at himself in character roles. Up to the First World War he had a steady rise in worldly success and after the war he earned an average of about £35,000 a year, rising to over £50,000 a year in 1929—a colossal sum then. In 1920 a story appeared in London newspapers that he had refused an offer of £1,000,000 to work for a dealer in the USA, and he was one of the few British artists of his time capable of attracting public attention in such a way.

Apart from portraits, Orpen also painted genre subjects, landscapes, interiors, nudes, and allegories, and he did memorable work as an *Official War Artist in France (he also attended the 1919 Peace Conference in Paris and painted *The Signing of the Peace in the Hall of Mirrors, Versailles, 28 June, 1919* (Imperial War Museum, London)). He wrote two books, *An Onlooker in France 1917–1919* (1921) and *Stories of Old Ireland and Myself* (1924) and edited *The Outline of Art* (1923), which was written largely uncredited by Frank *Rutter. Orpen's reputation faded badly after his death, but it underwent a great revival in the 1970s.

Orphism (or **Orphic Cubism**). Terms coined by *Apollinaire to describe a type of painting—a development from *Cubism—practised by Robert *Delaunay and some of his associates between 1911 and the outbreak of the First World War in 1914. The reference to Orpheus, the singer and poet of Greek mythology, reflected the desire of the artists involved to bring a new element of lyricism and colour into the austere intellectual Cubism of *Picasso, *Braque, and *Gris. Apollinaire first used the terms in print in his book *Les Peintres cubistes* (1913), but he is said to have used them earlier in a lecture at the exhibition of the *Section d'Or in October 1912. (Previously the word 'Orphic' had been used by the *Symbolists.) Apart from Delaunay, the artists whom Apollinaire mentioned as practitioners of Orphism were Marcel *Duchamp, Fernand *Léger, and Francis *Picabia (all members of the Section d'Or), but Franz *Kupka, another member of their circle, was in fact closer in style to Delaunay than these three. Apollinaire described Orphism as 'the art of painting new structures with elements that have not been borrowed from the visual sphere, but have been created entirely by the

artist himself, and been endowed by him with fullness of reality. The works of the Orphic artist must simultaneously give a pure aesthetic pleasure, a structure which is self-evident, and a sublime meaning, that is, a subject. This is pure art.' Although this is not very clear, it indicates a move towards abstraction, and by 1912 both Delaunay and Kupka were painting completely non-representational pictures characterized by intensely vibrant fragmented colours. Despite its short life, Orphism was highly influential, notably on the *Synchromists, who also worked in Paris, and on several major German painters, particularly *Klee (who visited Delaunay in 1912), *Macke, and *Marc. On 19 October 1913 the *New York Times* published an article entitled '"Orpheism" Latest of Painting Cults', emphasizing Kupka's role in the development of abstract art.

Oshogbo Workshop. See SEVEN-SEVEN.

Osma. See EIGHT (2).

Osthaus, Karl Ernst. See SONDERBUND.

Otero, Alejandro (1921–90). Venezuelan painter, sculptor, administrator, and writer, regarded as one of his country's leading artists. He was born at El Manteco, Bolivar State, and studied painting, sculpture, and stained glass at the School of Fine and Applied Arts, Caracas, 1939–45. On graduation he was awarded a government grant that enabled him to visit Paris. His early work had been influenced by *Cézanne and *Cubism, and in Paris he moved to complete abstraction; the transition can be seen in his *Cafetera* (Coffee-pot) series. Otero had a longer stay in Paris in 1949–52, and after his return to Venezuela he was one of the artists who worked on the design of University City Caracas. This was masterminded by Carlos Raúl Villanueva (1900–75), who was an art patron as well as an architect, and commissioned work from artists of the stature of *Arp, *Calder, and *Léger for his buildings; Otero contributed to the exterior design of the School of Architecture. In 1955 he began a long series of *Coloritmos* (Colour-rhythms), probably his best-known works, which feature patterns of vertical or horizontal stripes in a manner anticipating *Op art. From 1960 to 1964 he again lived in Paris, and after his return to Venezuela he was vice-president of the

National Institute of Culture and Fine Arts, 1964–6. He had a solo exhibition at the Venice *Biennale in 1966, and the following year he began producing large outdoor *Constructivist sculptures, a good example of which is *Delta Solar* (1977) outside the Air and Space Museum in Washington, DC. Otero also wrote and lectured a good deal on art.

Otra Figuración (Another Figuration). A group of four Argentinian painters who worked closely together from 1961 to 1966: Ernesto Deira (1928–86), Rómulo Macció (1931–), Luis Felipe Noé (1933–), and Jorge de la Vega (1930–71). They worked in a colourful *Expressionist style, their paintings often featuring monstrous creatures reminiscent of those seen in the work of the members of *Cobra.

Otterlo, Kröller-Müller Museum. See KRÖLLER-MÜLLER.

Oulton, Therese (1953–). British painter and printmaker, born in Shrewsbury. She originally studied anthropology, but she was so impressed by a chance visit to an exhibition of Morris *Louis's *Veil* paintings that she took up art, first studying at evening classes and then full-time at *St Martin's School of Art, London, 1975–9, and the *Royal College of Art, 1980–3. In 1984 she had her first one-woman show, at Gimpel Fils Gallery, London, and she very quickly established a considerable reputation with her sombre, richly worked abstract or semi-abstract paintings. They are often seen as evoking landscape or architectural forms and Oulton has even been discussed in terms of the great British tradition of landscape painting; David Cohen, for example, wrote in 1988: 'When she was nominated for the *Turner Prize last year she was perhaps the first candidate in the award's ignoble history to demonstrate the sort of artistic accomplishment Turner himself might have wanted to associate with his memory' (*Modern Painters*, Spring 1988). Oulton has also produced lithographs and monotypes.

Outsider art. See ART BRUT.

Ovenden, Annie and **Graham**. See BROTHERHOOD OF RURALISTS.

Oxford, Museum of Modern Art. See MUSEUM OF MODERN ART, OXFORD.

Ozenfant, Amedée (1886–1966). French painter, writer, and teacher. He was born in St Quentin, where he studied at the municipal drawing school before moving to Paris in 1905 to study architecture and painting. In 1918 he met *Le Corbusier, with whom he founded *Purism. Until 1926 he painted in the cool style characteristic of Purism, depicting such objects as bottles and glasses in profile. After this his style became somewhat freer and included figure compositions. However, he is much better known as a teacher and writer than for his own artistic work. In 1924 he founded an art school in Paris with *Léger, the Académie de l'Art Moderne. From 1935 to 1939 he lived in London, then from 1939 to 1955 in New York, founding schools in both cities (he became an American citizen in 1944 but later reverted to French nationality). His liberal sentiments brought him official disfavour in America in the McCarthy era and he returned to France in 1955, settling in Cannes, where he directed a studio for foreign art students. His most important book was *Art* (1927), subtitled *Bilan des arts modernes: Structure d'un nouvel esprit* ('The Balance Sheet of Modern Arts: The Structure of a New Spirit'). The book was translated into English as *Foundations of Modern Art* (1931, enlarged edn., 1952). It is a study of the interrelationship of all forms of human creativity, including science and religion, and is one of the most widely read books by any modern artist. His other books were *Journey Through Life: Experiences, Doubts, Certainties, Conclusions* (1939) and *Mémoires, 1886–1962*, published posthumously in 1968. He also edited two periodicals, *L'*Élan* (1915–16) and *L'*Esprit nouveau* (1920–5). The great reputation he enjoyed in the interwar period declined sharply afterwards. Indeed in 1973 John *Golding wrote that 'Perhaps no other artistic reputation of comparable stature within the contemporary field has undergone, during the past decades, such an almost total eclipse.'

Paalen, Wolfgang (1905/7–59). Austrian-born painter who became a Mexican citizen in 1945. He was born in Vienna, and after studying in France, Germany, and Italy, he lived in Paris from the late 1920s until 1939, when he emigrated to Mexico at the invitation of Frida *Kahlo. Paalen had a varied career in avant-garde circles (in the early 1930s, for example he painted cool abstractions and was a member of *Abstraction-Création), but he is best remembered for his involvement with *Surrealism, which lasted from 1936 to 1941. His most characteristic pictures depict phantasmogoric clawed creatures that he called 'Saturnine Princes'. He also experimented with *automatism and is credited with inventing the technique of *fumage. In 1940 he helped to organize an international Surrealist exhibition in Mexico City. However, the following year he abandoned Surrealism and concentrated on his 'Dynaton' movement, aimed at uniting aspects of pre-Columbian art (which he studied and collected) and modern science. He put forward his ideas in the review *Dyn* (6 issues, 1942–4), his writings for which (in English) were collected in his book *Form and Sense*, published in New York in 1945. His collaborator in the Dynaton movement was another former Surrealist, the British-born (later American) painter Gordon Onslow Ford (1912–). Together they arranged a Dynaton exhibition at the San Francisco Museum of Art in 1951. Later in the 1950s Paalen developed a violent abstract style. He committed suicide.

Pacheco, Maria Luisa (1919–82). Bolivian-born American painter. She studied painting at the Academy of Fine Arts of the University of San Andres in her native La Paz and later returned there to teach. From 1946 to 1951 she worked as an illustrator on the La Paz daily newspasper *La Razón*, then in 1951–2, with a fellowship from the Spanish government, she studied in Madrid. Before her period in Madrid she had worked in the vein of *Social Realism then dominant in Bolivia, her subjects including Indians and tin miners, but the influence of Spanish painters such as *Canogar and *Tàpies turned her to abstraction and she became Bolivia's 'major Modernist artist of the period just after the Second World War' (Edward *Lucie-Smith, *Latin American Art of the 20th Century*, 1993).

In 1956 Pacheco moved to the USA, settling in New York and subsequently becoming an American citizen. In her first years in the USA she absorbed *Abstract Expressionism and especially admired the work of *de Kooning. Later she developed an individual form of abstraction in collages of corrugated board, plywood, canvas, and sand that reflect the shapes and luminosity of the Andean landscape. In the 1960s she painted a series entitled *Tiahuanacu*, named after Bolivia's most important site of pre-Columbian culture.

Paik, Nam June. See VIDEO ART.

Painters Eleven. A group of Canadian abstract painters based in Toronto and active from 1953 to 1960. The most important member was William *Ronald. Apart from being abstract rather than figurative artists, the painters had little in common stylistically and for this reason the non-committal name of the group was deliberately chosen. They were united mainly by the desire to promote their work in an environment unfavourable to abstract art and in this achieved considerable success, especially after they were guest exhibitors with *American Abstract Artists in New York in 1956: 'The Canadians were generously received by the American critics and . . . back home the exhibition drew more attention than any of their previous activities. It really marked the acceptance among the

informed public of the existence in Toronto of contemporary "modern" artists' (Dennis Reid, *A Concise History of Canadian Painting*, 1973). A group of their works is in the Robert McLaughlin Gallery, Oshawa, Ontario.

Paladino, Mimmo. See NEO-EXPRESSIONISM.

Palazzo Grassi, Venice. See HULTEN.

P&D. See PATTERN AND DECORATION MOVEMENT.

Pane, Gina. See BODY ART.

Paolozzi, Sir Eduardo (1924–). British sculptor, printmaker, and designer, born in Edinburgh of Italian parentage. He studied at Edinburgh College of Art, 1943, and the *Slade School, 1944–7. While still a student he had his first one-man exhibition as a sculptor, at the Mayor Gallery, London, in 1947, and in the same year he began making witty collages using cuttings from American magazines, advertising prospectuses, technological journals, etc. (*I Was a Rich Man's Plaything* (Tate Gallery, London, 1947). Paolozzi regarded these collages as 'ready-made metaphors' representing the popular dreams of the masses, and they have been seen as forerunners of *Pop art (he eventually amassed a large collection of 20th-century pulp literature, art, and artefacts, which he presented to the University of St Andrews). In 1947–50 he lived in Paris, where he was influenced by the legacy of *Dada and *Surrealism, and in the early 1950s he was a member of the *Independent Group, the nursery of British Pop art.

From the 1950s Paolozzi has worked primarily as an abstract or semi-abstract sculptor, often on a large scale. His work of the 1950s was characteristically heavy and bulky, often incorporating industrial components, showing his interest in technology as well as popular culture. In the 1960s his work became more colourful, including large totem-like figures made up from casts of pieces of machinery and often brightly painted. In the 1970s he made solemn machine-like forms and also box-like low reliefs, both large and small, in wood or bronze, sometimes made to hang on the wall, compartmented and filled with small items. The compartmented reliefs were sharply and precisely cut and had some resemblance to the work of Louise *Nevelson. His more recent

work has included several large public commissions, for example mosaic decorations for Tottenham Court Road undeground station in London (commissioned 1979, installed 1983–5) and *The Wealth of Nations* (installed 1993), a huge bronze sculpture 'commissioned by the Royal Bank of Scotland for a new building at South Gyle on the edge of Edinburgh. It must be the largest and most ambitious piece of public sculpture made in Britain for many years. It represents a great, fallen giant, struggling as the classical Laocoon struggled with the serpents who overpowered him, but Paolozzi's figure is struggling not with living serpents, but with the modern, abstract, mechanized shapes of the modern world of technology' (Duncan Macmillan, *Scottish Art in the 20th Century*, 1994). Paolozzi has taught at various art schools and universities in Britain, Europe, and the USA. He was knighted in 1989 and has been awarded many other honours.

papier collé (French: 'pasted paper'). A type of *collage in which pieces of decorative or printed paper are incorporated into a picture or—when stuck on a ground such as canvas—themselves constitute the picture. The technique was invented by *Braque in September 1912 in his *Fruit-Dish and Glass* (private collection); he incorporated three pieces of paper printed with a wood grain pattern into the picture, representing wall panelling and a table. John *Golding writes that in such works the paper fragments 'can be said to exist on three levels. They are flat, coloured, pictorial shapes. They represent or suggest certain objects in the picture by analogies of colour and texture or by the addition of keys and clues. Thirdly, and this is the aspect of *papier collé* that most relates it to other forms of *Cubist *collage*, the pieces of paper exist as themselves, that is to say one is always conscious of them as solid, tactile pieces of extraneous matter incorporated into the picture and emphasizing its material existence.' The technique was almost immediately adopted by *Picasso. Like Braque, he often used newsprint, and in *Guitar, Sheet-Music and Glass* (McNay Art Institute, San Antonio, Texas, 1912) he has used a fragment of printed music as well as a cutting from the newspaper *Le Journal*. *Gris too made extensive use of papier collé, and *Matisse's use of cut-out paper shapes in his late work is a development of the technique.

Paps (Dr Waldemar Rusche) (1882–1965). Germany's most famous *naive painter, born at Naumburg. An internationally distinguished ophthalmologist, he was head of the eye clinic in the hospital of St Josef Stift in Bremen and began to paint after retiring at the age of 70. His subjects included scenes remembered from his travels as a young ship's doctor (he was particularly fond of harbour scenes), flower pieces, and the life around his North German home. His style was colourful and lively. The nickname by which he is known is German for 'Dad'.

Paris, École des Beaux-Arts. See BEAUX-ARTS.

Paris, Musée d'Art Moderne de la Ville de Paris. See MUSÉE D'ART MODERNE DE LA VILLE DE PARIS.

Paris, Musée Nationale d'Art Moderne. See POMPIDOU CENTRE.

Paris, School of. See ÉCOLE DE PARIS.

Paris Biennale. See BIENNALE.

Park, David. See BAY AREA FIGURATION.

Park, Stuart. See GLASGOW BOYS.

Parkes, Kineton. See DIRECT CARVING.

Parrish, Maxfield (1870–1966). American painter and illustrator, born in Philadelphia, son of the landscape painter **Stephen Parrish** (1846–1938). He studied at the Pennsylvania Academy of the Fine Arts and also attended classes given by the author-illustrator Howard Pyle (1853–1911), celebrated for his children's books. In 1895 Parrish designed a cover for *Harper's Weekly* and thereafter rapidly made a name for himself with illustrations, posters (he won a national poster competition in 1897), and advertisements. He also branched out into mural painting, notably with a series on Old King Cole (1906) for the Knickerbocker Hotel (now the St Regis-Sheraton Hotel) in New York. His greatest fame and popularity, however, came with colour prints designed for the mass market. Sentimental scenes such as *The Garden of Allah* (copyrighted 1919) and *Dawn* (1920) sold by the million and were found in homes all over the country. They are in a lush and romantic style, set in an escapist world combining elements of the Arabian Nights, Hollywood, and classical antiquity, with languorous maidens and idyllic landscape backgrounds. His draughtsmanship and detailing are immaculate and his colouring distinctively high-keyed and luminous. Many of his advertisements were in a similar vein. In the 1930s his style went out of fashion and he retired to paint landscapes, working up to his death at the age of 95. Shortly before this there was a revival of interest in his work, which had long been dismissed as *kitsch; in 1964, for example, the Metropolitan Museum, New York, bought his painting *Errant Pan* (c. 1915). See also POPULAR PRINTS.

Parsons, Betty (née Pierson) (1900–82). American art dealer, collector, painter, and sculptor, born in New York into a wealthy family. In 1919 she married Schuyler Parsons, a socialite, but divorced him in 1922. From then until 1933 she lived in Paris. After returning to the USA she lived in California for three years, supporting herself mainly by teaching (she had lost most of her money in the stock marlet crash of 1929), and in 1936 she settled in New York. There she learned the art gallery trade working for various dealers, notably running the Wakefield Gallery (within the Wakefield Bookshop), which specialized in contemporary art, and in 1946 she opened her own gallery. The following year Peggy *Guggenheim closed her New York gallery, and for a brief period after this Parsons was the leading dealer of the *Abstract Expressionists: *Newman, *Pollock, *Rothko, and *Still were among the artists she represented. In the early 1950s, however, 'Many of the Abstract Expressionists left Parsons for Sidney *Janis in an attempt to find a more commercial manager of their increasing fame and fortune. But Parsons . . . continued her love for undiscovered talent, supporting Robert *Rauschenberg and other young artists. By the time the gallery closed in 1977, she had presented most of the major [American] artists of the previous three decades, especially *Colour Field and *Minimal painters' (catalogue of the exhibition 'American Art in the 20th Century', Royal Academy, London, 1993). Parsons always kept up her own work as an artist, and from the 1960s she had numerous one-woman shows. Her painting was predominantly abstract, and her sculpture often made use of found items such as pieces of driftwood, which she used in painted constructions.

Pascali, Pino (1935–68). Italian sculptor and experimental artist, born at Bari and active in Rome, where he studied at the Academy, 1955–9. After passing through a phase of expressive abstraction he made 'play pieces' such as his *Fictitious Sculptures* of 1966 (animals made of white canvas stretched over wooden ribs) and his *Water Pieces* of 1967 (aluminium basins filled with water dyed to imitate sea-water). Some of his work is regarded as representative of *Arte Povera. He died from injuries received in a motorcycle accident. In the catalogue of the exhibition 'Italian Art in the 20th Century' (Royal Academy, London, 1989), we are told that Pascali was 'the personality most representative of the extraordinary artistic vitality of the sixties' and that 'His path of development was like the crashing of an ocean wave; it was violent and acerbic, charged with fantasy, with mythical and profound meanings, with references to the earth.' This will not be obvious to the uninitiated.

Pascin, Jules (Julius Pincas) (1885–1930). Bulgarian-born painter and draughtsman. He led a wandering life, and although he acquired American citizenship in 1920, after moving to New York during the First World War, he is chiefly associated with Paris, where he belonged to the circle of emigré artists who gravitated around *Chagall, *Modigliani, and *Soutine. He was born in Vidin, Bulgaria, the son of a Spanish father and an Italian mother. After travelling widely and studying painting in Berlin, Munich, and Vienna, he settled in Paris in 1905. In the same year he adopted the name Pascin to distance himself from his family, who disapproved of his bohemian life. He lived in the USA from 1914 to 1920, then returned to Paris. His work includes portraits of his friends, café scenes, and flower pieces, as well as a few large paintings with biblical themes, but the bulk of his output consists of erotically charged studies of nude (or very flimsily dressed) teenage girls. They have been compared to the work of *Degas and Toulouse-Lautrec, but Pascin's paintings are less penetrating and more obviously posed. He can be rather repetitive, but his best work has great delicacy of colour and handling and a poignant sense of lost innocence. Pascin achieved financial success, but he led a notoriously dissolute life and was emotionally unstable; on the day on which a major exhibition of his work was due to open at the Galerie Georges Petit in Paris he committed suicide in his studio (slashing his wrists and then hanging himself). As a mark of respect, several galleries in Paris closed on the day of his funeral. There are examples of his work in many major collections, notably the *Barnes Foundation, Merrion, Pennsylvania, which has about 50 Pascins.

Pasmore, Victor (1908–). British painter and maker of constructions who is unusual in having achieved equal eminence as both a figurative and an abstract artist. He was born at Chelsham, Surrey, and from 1927 to 1937 worked as a clerk for the London County Council, while attending evening classes at the Central School of Arts and Crafts. From 1930 he exhibited with the *London Group (he became a member in 1934) and in 1934 he exhibited with the *Objective Abstractionists at the *Zwemmer Gallery. His work at this time was still figurative, in a freely-handled, *Fauve-influenced style, but the work of his fellow exhibitors at the Zwemmer Gallery led him to experiment with abstraction. He soon reverted to naturalistic painting, however, and in 1937 he combined with William *Coldstream and Claude *Rogers in founding the *Euston Road School. Characteristic of his work at this time and in the early 1940s are some splendid female nudes and lyrically sensitive Thames-side landscapes that have been likened to those of *Whistler (*Chiswick Reach*, NG, Ottawa, 1943). In 1948 he underwent a dramatic conversion to pure abstraction, and by the early 1950s he had developed a personal style of geometrical abstraction. As well as paintings, he made abstract reliefs, partly under the influence of Ben *Nicholson and partly under that of Charles *Biederman's book *Art as the Evolution of Visual Knowledge*, lent to him in 1951 by Ceri *Richards. His earlier reliefs had a hand-made quality, but later—through the introduction of transparent perspex—he gave them the impersonal precision and finish of machine products (examples are in the Tate Gallery, London). Through work in this style he came to be regarded as one of the leaders of *Constructivism in Britain. Later his paintings became less austere and more organic.

Pasmore has been an influential teacher and has been much concerned with bringing abstract art to the general public. He taught at Camberwell School of Art, 1943–9, the Central School of Art and Design, 1949–53, and

King's College, Newcastle upon Tyne (now Newcastle University), as head of the painting department, 1954–61. The 'basic design' course that he taught at Newcastle (based on *Bauhaus ideas) spread to many British art schools. From 1955 to 1977 he was consulting director of urban design for the south-west area of Peterlee New Town, County Durham, where he attempted to 'achieve the sort of synthesis between architecture and painting envisaged by *Le Corbusier and van *Doesburg. The result has echoes of De *Stijl' (*Buildings of England*). In 1966 Pasmore bought a house on Malta and since then has divided his time mainly betwen there and London. He has won many honours, and Kenneth *Clark described him as 'one of the two or three most talented English painters of this century'.

Paso, El. See EL PASO.

Passmore, John. See DIRECTION 1.

Pasternak, Leonid (1862–1945). Russian painter and graphic artist, born in Odessa. He was a friend of many literary, musical, and political personalities, notably Leo Tolstoy, whose works he illustrated (*War and Peace*; *Resurrection*), and whom he portrayed on many occasions. In 1921 he left the Soviet Union and settled in Berlin, where he worked mainly as a portraitist (his sitters included Max *Liebermann and Albert Einstein). He left Germany because of the rise of Nazism and settled in England in 1938, spending his last years in Oxford. There are examples of his work in the Tate Gallery, London, including a drawing (1919) of his son Boris, the celebrated writer, and in the Ashmolean Museum, Oxford.

Paterson, James. See GLASGOW BOYS.

Pathetiker, Die ('The Exponents of Pathos'). A group of three German *Expressionist painters—Richard Janthur (1883–1950), Ludwig *Meidner, and Jakob Steinhardt (1887–1968)—that held one exhibition, in 1912 at the *Sturm Gallery in Berlin, and then broke up.

Pattern and Decoration (P&D) movement (also known as 'the New Decorativeness'). A movement in American art, originating in New York in the mid-1970s, in which painters and other artists produced works that consist

essentially of complex and generally brightly coloured patterns (abstract, figurative, or a mixture of both). The movement was one aspect of the reaction against the stark impersonality of *Minimal art (see POST-MINIMALISM) and also represented a defence of the idea that decorative art is a humanizing influence and should not be regarded as inferior to 'fine' art. Many of the artists involved in the movement were women, influenced by the feminist concern with highly decorative crafts such as quiltmaking that have traditionally been the preserve of women. They included Valerie Jaudon (1945–), whose work is influenced by Celtic patterns, Joyce *Kozloff, and Miriam *Schapiro. However, several men also were involved in the movement, notably Robert Kushner (1949–) and the sculptor Ned Smyth (1948–). The New York Pattern and Decoration Group first met in 1975 and organized an exhibition the following year. Many of the members were taken up by the dealer Holly Solomon, who had recently established a gallery in New York, and their work enjoyed considerable success in the later 1970s.

Pau-Brasil. See AMARAL.

Peake, Mervyn (1911–68). British writer and illustrator, born in China, the son of medical missionaries. He is now best known as a novelist, but he studied at the *Royal Academy Schools and spent much of his career teaching drawing, notably at Westminster School of Art, 1935–8, and the Central School of Arts and Crafts, 1950–60. His reputation rests mainly on his trilogy of novels *Titus Groan* (1946), *Gormenghast* (1950), and *Titus Alone* (1959), a work of grotesque Gothic fantasy to which his vividly imaginative drawing style was well matched (originally, however, the books were published without his accompanying illustrations). Peake also illustrated numerous other books, including Coleridge's *The Rime of the Ancient Mariner* (1943), Stevenson's *Treasure Island* (1949), and several by himself (among them an instructional manual, *The Craft of the Lead Pencil*, 1946). In 1946 he was commissioned by the Ministry of Information to make drawings of people liberated from Belsen concentration camp—an experience that left him emotionally scarred. In the last decade of his life he was gradually incapacitated by Parkinson's disease and his final works were completed with the aid of his wife

Maeve Gilmore. Peake is described in the *Dictionary of National Biography* as 'Tall, thin, dark, and haggard . . . gentle, gracious, unworldly, and unpractical. He lived in many ways outside convention, wearing strange clothes and behaving in a gently whimsical fashion which puzzled the ordinary.'

Pearlstein, Philip (1924–). American painter and printmaker, a leading proponent of the return to naturalism and interest in the human figure that was one aspect of the move away from the dominance of *Abstract Expressionism in American art. He was born in Pittsburgh and studied there at the Carnegie Institute, graduating in 1949, before settling in New York. In 1955 he took an MA in art history at New York University. His early works (mainly landscapes) were painted with a vigorous *gestural handling, but in the 1960s he developed a cooler, more even type of brushwork. He specializes in starkly unidealized portrayals of the nude figure (singly or in pairs), usually set in domestic surroundings (*Male and Female Models Leaning on Chair*, Art Institute of Chicago, 1970). Because of the clarity of his compositions and the relentlessness of his scrutiny, he is sometimes described as a *Superrealist, but his work has an individuality that puts him outside this classification. He uses harsh lighting, oblique angles, and cropping of the image (heads are often excluded and the body is seen in voyeuristic close-up) in a way that suggests candid photography, but his pictures do not try to counterfeit the effect of photographs; the handling of paint is smooth—but vigorous rather than finicky. In addition to oils, he has also worked in watercolour and produced etchings and lithographs. Pearlstein calls himself a 'post-abstract realist' and describes the figures in his paintings as 'a constellation of still-life forms'. He feels that he has 'rescued the human figure from its tormented, agonized condition given it by the expressionist artists'.

Pechstein, Max (1881–1955). German painter and printmaker. He was born near Zwickau and began his training as an apprentice to a decorative painter. From 1900 to 1906 he studied in Dresden, where he was a star pupil first at the School of Arts and Crafts and then at the Academy, winning several prizes. In 1906 he joined Die *Brücke, which had been founded by four other Dresden students the previous year. After visiting Italy on a scholarship in 1907, he spent a few months in Paris before settling in Berlin (which was his home for the rest of his life) in 1908. His energy and charm as well as his talent quickly made him a leading figure in Berlin's artistic life and in 1910 he was elected president of the Neue *Sezession. In the same year the other members of the Brücke moved to Berlin. Pechstein had kept up his contact with them in the intervening years, but in 1912 *Kirchner expelled him because he had exhibited his work at the Sezession without the group's consent. In 1913–14, showing an interest in the exotic shared with other *Expressionists, Pechstein visited the Palau Islands in the Pacific, where he painted lively, near-*Fauvist scenes depicting the paradisal life of the island fishermen. His other subjects included nudes, landscapes, portraits, and opulent flower pieces. Among the German Expressionists he was the most French in spirit (he was particularly influenced by *Matisse) and, probably because his work was essentially decorative rather than emotionally intense, he was the first member of the Brücke to achieve popular success and general recognition; the 1920s marked the height of the fashion for his work. Since then his reputation has faded whilst those of his former colleagues has grown.

Pechstein was in Palau when the First World War broke out. He was taken prisoner by the Japanese but escaped and made his way back to Germany via the USA and Holland in 1915. Immediately drafted into the army, he fought on the Somme but was discharged in 1917 following a nervous collapse. At the end of the war he was one of the founders of the *Novembergruppe and in 1923 he began teaching at the Berlin Academy. He was dismissed by the Nazis in 1933 (his work was declared *degenerate) and reinstated in 1945. His later paintings became repetitive, and the high quality of his work in his pre-First World War period is sometimes forgotten. In addition to paintings, he produced a large number of prints—etchings, lithographs, and woodcuts. His posthumously published memoirs (*Max Pechstein: Erinnerungen*, 1960) are an important primary source for the history of the Brücke.

Pedersen, Carl-Henning (1913–). Danish painter, born in Copenhagen and self-taught as an artist. His early paintings were abstract,

but in the 1940s he turned to *Expressionism and in 1948 became a founder member of the *Cobra group. Characteristically he portrays a fantastic world of palaces and princesses, demons and dwarfs. Pedersen became well known internationally when his work was shown at the Venice *Biennale in 1962. There is a museum dedicated to him and his wife, the painter Else Alfelt (1910–74), at Herning in Denmark.

Peeters, Henk. See NUL.

Peintres de Tradition Française (Painters in the French Tradition). A name applied to a group of French painters who during and immediately after the Second World War aimed to work in a style that they regarded as both modern and quintessentially French. The name comes from an exhibition entitled 'Vingt Jeunes Peintres de Tradition Française' held at the Galerie Braun, Paris, in 1941. It was the first exhibition of avant-garde art mounted during the German occupation and it was held without German permission. The main members of the group were *Bazaine, *Estève, *Lapique, *Le Moal, *Manessier, and *Singier. Werner *Haftmann writes that 'All these painters took *Orphism as their starting point and strove to lend a poetic quality to the strict construction of *Cubism by enriching the colour and intensifying the expressive quality of abstract form. With regard to content, they strove to transcend modern man's alienation from visible nature and to attain, through poetic feeling, to a new harmony with the environmental world . . . Their religious bias guided them to the symbolic art of the Middle Ages, in particular to the spirituality of Romanesque and Gothic stained-glass windows, in which they rediscovered the formal characteristics of Orphic Cubism—the flatness, the luminous suggestive colour, the strict hierarchy of forms, the designation of object forms by evocative signs' (*Painting in the Twentieth Century*, 1965).

Pellizza da Volpedo, Giuseppe. See DIVISIONISM.

Penck, A. R. See NEO-EXPRESSIONISM.

Pène du Bois, Guy (1884–1958). American painter and writer on art. He was a pupil of Robert *Henri, and as art critic or reporter on several newspapers he was a leading spokesman for the painters in Henri's circle. His own paintings concentrated on themes set in New York, particularly the social life of the rich, often treated satiricallly, with the figures like mannequins. He wrote several short books on American artists, including *Hopper and *Sloan, and an autobiography, *Artists Say the Silliest Things* (1940).

Pennell, Joseph (1857–1926). American etcher, lithographer, and writer, born in Philadelphia. He is of no particular distinction as an artist and is remembered primarily for *The Life of James McNeill *Whistler* (2 vols., 1908), which he wrote with his wife, Elizabeth Robins Pennell. They lived in London from 1884 to 1917, first met Whistler soon after their arrival, and became regular companions of the artist in the 1890s, especially after his wife's death in 1896. In 1897 the *Century* magazine commissioned them to write an article on Whistler 'in the nature of a record of such of his table talk as may be of public interest, with all sorts of picturesque incidents of him'. In 1900 Whistler gave permission for them to write his biography, and to this end they amassed an enormous amount of material, collecting all the documents they could find and interviewing countless people who knew him. After their return to the USA in 1917, they deposited their materials in the Library of Congress; they include more than a hundred volumes of articles and clippings. Their biography, which is in a vein of unqualified adulation, was highly successful, reaching its 6th edition in 1920. The following year the Pennells published *The Whistler Journal*, a diary covering the years 1900–3, containing material not included in their biography.

Penrose, Sir Roland (1900–84). British writer, collector, exhibition organizer, and artist, born in London, the son of a painter. As an artist he holds a distinguished place among British *Surrealists (he produced collages and *objects as well as paintings), but he is chiefly remembered for the missionary zeal with which he promoted Surrealism and contemporary art in general in England. After taking a degree in architecture at Queens' College, Cambridge, he went to Paris in 1922 to study painting—on the advice of Roger *Fry (who like Penrose came from a Quaker family). He stayed until 1935 and during that time came to know many leading artists, including *Ernst, *Man Ray, *Miró, and above all

*Picasso, who became a lifelong friend. After his return to England he was one of the organizers of the International Surrealist Exhibition in London in 1936. During the Second World War he was a camouflage instructor. In 1947 he was co-founder (with Herbert *Read) and first chairman of the *Institute of Contemporary Arts in London, and he organized several major exhibitions at the Tate Gallery, London: Picasso paintings (1960), Max Ernst (1961), Miró (1964), Picasso sculpture and ceramics (1967). The best known of his writings is *Picasso: His Life and Work* (1958, 3rd edn., 1981), which John *Richardson describes as 'a book of incalculable value. My only reservation stems from Penrose's fear of causing Picasso offence. For better or worse his portrait of the artist is without shadows.' Penrose's other books included studies of Miró (1970), Man Ray (1975), and Tàpies (1978), and he also wrote poetry. His second wife, whom he married in 1947, was the photographer Lee Miller, who had formerly been a pupil and favourite model of Man Ray. An *Arts Council touring exhibition was devoted to Penrose in 1980. There are examples of his work in the Tate Gallery, London. His library and archive were bought by the Scottish National Gallery of Modern Art in 1994, and a year later the gallery bought 25 works from the outstanding collection (mainly of Surrealist art) he had assembled.

Penwith Society. See ST IVES SCHOOL.

Peploe, S. J. (Samuel John) (1871–1935). Scottish painter, the oldest of the *Scottish Colourists. He lived almost all his life in Edinburgh, but he often visited France, studied briefly at the *Académie Julian, and made his home in Paris, 1910–13. During this stay in Paris he moved from an *Impressionist style to one influenced by *Cézanne and the *Fauves, but later his work became less aggressively modern. In the 1920s he frequently visited the island of Iona, which—together with still-life—was his favourite subject. There is a large collection of Peploe's work in the Kirkaldy Museum and Art Gallery. His son **Denis Peploe** (1914–93) was also a painter.

Perceptual Abstraction. A broad term sometimes used to embrace several types of abstract art that developed in the 1950s in reaction against *Abstract Expressionism, such as *Hard-Edge Painting, *Minimal art, and *Op art. The term indicates a change from expressive and painterly qualities to an emphasis on clarity and precision based on objective perception.

Perceval, John (1923–). Australian painter and ceramic artist, born at Bruce Rock, Western Australia. He showed artistic talent from an early age (and an enforced stay in bed because of poliomyelitis when he was 15 enabled him to develop his skills), but he had almost no formal training. In 1944 he married Mary Boyd (1926–), the sister of Arthur *Boyd and herself a painter and potter (in 1978, after divorcing Perceval, she married Sidney *Nolan). Perceval's early works were in a vigorous and spontaneous *Expressionist vein, sometimes exploring the fantasies and fears of childhood. In the late 1940s and early 1950s he worked mainly as a potter, but in 1956 he returned seriously to painting, principally as a landscapist. Robert *Hughes writes: 'His work, owing to its unreflective spontaneity, is uneven; but at its best its voracious appetite for stimuli and its good humour are matched by few of his contemporaries' (*The Art of Australia*, 1970). Three of Perceval's children are painters: **Matthew** (1945–), **Tessa** (1947–), and **Celia** (1949–). See also ANTIPODEANS.

Pereira, Irene Rice (1901–71). American painter, born at Chelsea, a suburb of Boston. After studying at the *Art Students League, New York, 1927–30, she travelled widely in Europe, returning to New York c. 1933. During her travels she had studied with *Ozenfant in Paris in 1931 and she shared his interest in mechanistic imagery and 'unadorned functionalism'. By the late 1930s she had developed a geometrical abstract style (one of the earliest American artists to do so) and continued to explore this mode for the rest of her life. Generally she used rectangular and trapezoid shapes in conjunction with linear grids and loosely brushed textures, and sometimes she added layers of transparent or translucent materials to the canvas, increasing the sense of mysterious spatial effects. She came to see her art in metaphysical terms and wrote several books concerning her interest in light, space, and mysticism, among them *The Nature of Space* (1957) and *The Transcendental Formal Logic of the Infinite* (1966). Pereira taught at several colleges and universities in New York and elsewhere.

Performance art. An art form combining elements of theatre, music, and the visual arts. It is related to the *Happening (the two terms are sometimes used synonymously), but Performance art is usually more carefully programmed and generally does not involve audience participation.

The tradition of Performance art can be traced back to the *Futurists, *Dadaists, and *Surrealists, who often staged humorous or provocative events to promote their work or ideas, then through such activities as Georges *Mathieu painting in front of an audience in the 1950s and Yves *Klein directing nude models smeared with paint in the early 1960s. However, it was only in the later 1960s and particularly in the 1970s that Performance art became recognized as a category of art in itself (the first quotation cited under the term in the *Oxford English Dictionary* dates from 1971). 'At that time [the 1970s]', RoseLee Goldberg writes, 'Conceptual art was in its heyday and performance was often a demonstration, or an execution, of [its] ideas . . . Art spaces devoted to performance sprang up in the major international art centres, museums sponsored festivals, art colleges introduced performance courses, and specialist magazines appeared' (*Performance Art: From Futurism to the Present*, 1988).

The form and tone of Performances have varied enormously. The *Vienna Actionists, for example, cultivated sadomasochism and scatology (the abuse of the performer's body is something that often occurs also in *Body art, with which Performance art sometimes overlaps). The British Performance artist Stuart *Brisley is another whose work has often focused on self-inflicted discomfort and humiliation, but in Britain the field has more often been characterized by whimsicality (in the 1970s there was a fad for Performance groups with quaint names such as John Bull Puncture Repair Kit and for wacky newsworthy stunts; in 1975, for example, the three-man Ddart Performance Group walked around East Anglia in a 150-mile circle with a pole attached to the members' heads).

Performance art has also been used as an adjunct to rock music (Laurie *Anderson is the most noted exponent) and as a vehicle for political dissent, as well as for the exploration of private fantasies. Among the artists in whose work it has played a large role are Joseph *Beuys, *Gilbert & George, and Bruce *Nauman.

The British painter Giles Auty (1934–), a strong critic of the world of contemporary art, writes: 'My own feelings about so-called Performance Art are that it is often too lacking in art, skill, relevance or sense . . . The best performance artists I have yet seen were the Leicester Square buskers of the 'fifties' (*The Art of Self Deception*, 1977).

Peri, László (or **Peter**). See BERGER.

Perilli, Achille (1927–). Italian painter and theatre designer, born in Rome, where he was a founder member of the *Forma group in 1947 and of the *Continuità group in 1961. He was also co-founder of the magazines *Arti visive* (1952), *L'Esperienza moderna* (1957), and *Grammatica* (1964). Early in his career he produced paintings derived from gestures and 'signs', which by 1960 he had developed into 'Picture-Stories' with small figures in series against a monochrommatic background in imitation of comic strips. In more recent years he has done a good deal of work for the theatre.

Permeke, Constant (1886–1952). Belgian painter, draughtsman, and sculptor, with Frits van den *Berghe and Gustave de *Smet one of the leading exponents of *Expressionism in Belgium in the period between the two world wars. He was born in Antwerp, the son of a painter, **Henri-Louis Permecke** (1849–1912), and studied at the Academies of Bruges and Ghent before settling at *Laethem-Saint-Martin in 1909. From 1912 to 1914 he lived in Ostend. He was badly wounded in 1914 whilst serving in the Belgian army and was evacuated to England. In 1919 he returned to Belgium, where he lived in Antwerp and then Ostend before building his own house and studio at Jabbeke, near Bruges, now a Permeke museum (he called his home De Vier Windstreken, 'The Four Corners of the Earth'). His subjects were taken mainly from the life of the coastal towns of Belgium and he is best known for his strong and solemn portrayals of sailors and fishermen with their women (*The Fiancés*, Musées Royaux, Brussels. 1923). In addition to figure paintings, he painted numerous seascapes. From 1935 he also made sculpture, carving in artificial stone. During the Second World War he was unable to obtain materials for painting or sculpture and so concentrated on drawing in various media. After the war he was

appointed to two prestigious posts in Antwerp, as director of the Institut National Supérieur and the Académie Royale des Beaux-Arts, but he soon resigned in order to devote himself to painting.

Pešánek, Zdeněk. See LIGHT ART.

Peters, DeWitt. See BIGAUD.

Pétridès, Paul. See UTRILLO.

Petrov-Vodkin, Kuzma (1878–1939). Russian painter, graphic artist, designer, writer, and teacher. He was born in Khvalynsk, a Volga port in Saratov province, southern Russia, and studied in Samara (1893–5), St Petersburg (1895–7), Moscow (1897–1905), briefly in Munich (1901), and Paris (1905–8). During these years he also visited Italy, Greece, and Africa. After his return to Russia from Paris he settled in St Petersburg, where he taught at various art schools. He was one of the most original and independent Russian painters of his day, creating a highly distinctive style blending *Symbolism with the traditions of medieval Russian and Italian Renaissance art; he specialized in large-scale figure groups in which he displayed something of the stately, solemn grandeur of Quattrocento frescos. With this powerful design went strong—sometimes harsh—colouring and a curious sense of space based on a curved horizontal axis (Petrov-Vodkin himself referred to 'spherical perspective'). He also painted still-lifes, in which he showed the same quality of dignified severity that characterized his figure paintings; he thought that 'a simple apple lying on the table contained all the secrets of the universe'. His other work included stage design and he also wrote several books, mainly autobiographical.

Pettoruti, Emilio (1892–1971). Argentine painter, born at La Plata. From 1913 to 1923 he studied and worked in Europe, taking part in the *Futurist movement in Italy, and experimenting with the *Cubism of Juan *Gris, whom he met in Paris. After his return to Argentina in 1924 he had a great influence on the younger generation of painters there through his advocacy of European modernism. An exhibition of his paintings at the Galeria Witcomb in Buenos Aires in 1924 provoked a scandal, even though the pictures were mild and decorative by European standards, and in 1930 he caused further controversy, when as director of the Museum of Fine Arts in La Plata he exhibited current European art (he had two terms as director of the museum, both short-lived because of official disapproval of his activities). By the late 1940s his own work had become abstract. In 1952 he returned to Europe and settled in Paris, where he died. He published a book of memoirs, *Un Peintre devant son miroir*, in 1962.

Peverelli, Cesare. See SPATIALISM.

Pevsner, Antoine (1886–1962). Russian-born sculptor and painter who became a French citizen in 1930. He was the elder brother of Naum *Gabo and like him one of the pioneers of *Constructivism. Born in Orel, he grew up in Briansk and studied at the School of Fine Arts in Kiev, 1902–9, then briefly at the Academy in St Petersburg. Between 1911 and 1914 he made lengthy visits to Paris, where *Archipenko and *Modigliani were among his friends. After two years in Norway with Gabo he returned to Russia in 1917, and taught at the Moscow School of Painting, Sculpture, and Architecture (and after the Revolution in the institutions descended from it—*Svomas and *Vkhutemas). After experimenting with various avant-garde styles, he had turned to abstraction by about 1918 (or perhaps a few years earlier—there is often difficulty in dating his work). In 1920 he was co-signatory of Gabo's *Realistic Manifesto*, which set forth the ideals of Constructivism, and in 1922 he helped to organize a major exhibition of Soviet art in Berlin. He left Russia in 1923 because the authorities were turning against the 'pure' art in which he was interested in favour of utilitarian work. After a few months in Berlin, he settled in Paris in October 1923 and lived there for the rest of his life.

Up to this time Pevsner had been a painter, but he now turned to sculpture, at first working mainly in plastic, then in welded metal. His early sculptures often retained vestiges of representation, as in his witty *Portrait of Marcel Duchamp* (Yale University Art Gallery, 1926), but increasingly he worked in a pure abstract idiom. His later work was characterized by bold spiralling forms (*Dynamic Projection in the 30th Degree*, Baltimore Museum of Art, 1950–1). Pevsner was a founder member of *Abstraction-Création in 1931 and was influential in transmitting Constructivist ideas to other artists in the group. His style was

similar to that of Gabo, but his outlook was different in important ways, for he had a religious rather than a scientific cast of mind; he thought that 'the power of the constructive work must be like that of painting, which represents the divine song and music; it must have an active life of great power and eternal salvation.' By the end of his career Pevsner was a much honoured figure. In 1956, for example, he had a large retrospective exhibition at the Musée National d'Art Moderne, Paris, in 1958 he represented France at the Venice *Biennale, and in 1961 he was awarded the Legion of Honour. There are examples of his work in many collections of modern art, including the Tate Gallery, London.

Pevsner, Sir Nikolaus. See POSTMODERNISM.

Peyronnet, Dominique. See NAIVE ART.

Phalanx. An association of artists organized in Munich in 1901 in opposition to the conservative views of the Academy and the *Sezession. *Kandinsky was one of the founders of the association and its leading figure, becoming president in 1902. He wrote that the society's 'set task is to further common interests through close association. Primarily, it means to help young artists overcome the difficulties that are frequently encountered when they wish to show their work.' For the first group exhibition in August 1901 Kandinsky designed a magnificent poster in *Art Nouveau style showing Greek warriors advancing across a battlefield in phalanx formation. The militaristic name of the association was chosen to suggest its aggressive, progressive spirit. Eleven more exhibitions followed before Kandinsky dissolved Phalanx in 1904 because of lack of public support. The exhibitions featured not only work by members, but also by 'guest' artists—*Monet for the 7th exhibition in 1903, and French *Post-Impressionists and *Neo-Impressionists at the 10th exhibition in 1904. This was the most important of the exhibitions, confirming Kandinsky's internationalism and having a marked effect on several young artists, notably *Kirchner. In 1902–3 Phalanx ran an art school. One of the first students was Gabriele *Münter, who became Kandinsky's mistress.

Phantastischer Realismus. See FANTASTIC REALISM.

Philipson, Sir Robin (1916–92). British painter and teacher. He was born in Broughton-in-Furness, Lancashire, but moved to Scotland with his family when he was 14 (his father was a stationmaster with the London Midland & Scottish Railway) and considered himself Scottish 'by adoption'. He studied at Edinburgh College of Art, 1936–40, and after serving in the King's Own Scottish Borderers in India and Burma during the Second World War, he returned to the college as a teacher in 1947; from 1960 to 1982 he was head of its School of Drawing and Painting. His paintings were characteristically semi-abstract, strongly-coloured, robustly worked, and often violent in expression—cockfighting was a favourite theme. He was a spirited promoter of art in Scotland and much admired for his personal charm as well as for his varied professional activities (he was president of the Royal Scottish Academy, 1973–83, and a member of the Royal Fine Art Commission for Scotland, 1968–80).

Phillips, Duncan (1886–1966). American collector and writer on art. His family had made a fortune in steel and glass and he devoted much of his substantial inheritance to collecting, following his own judgement and buying mainly the work of late 19th- and 20th-century artists. After his father and brother died in quick succession in 1918, Phillips conceived the idea of making his collection a memorial to them, and in 1921 he opened his Washington home to the public three afternoons a week. The collection was subtitled 'A Museum of Modern Art and its Sources' (it includes a few examples of the work of earlier artists, among them El Greco and Goya) and it represented the first permanent museum of modern art in the USA (the *Société Anonyme was founded a year earlier, but intially concentrated on temporary exhibitions). It proved so popular that Phillips moved with his family to another home in 1930 and made the house over completely as a gallery. Although there have been substantial extensions since then, the Phillips Collection retains its intimate, domestic air, and is widely regarded as one of the world's finest small museums. In his book *A Collection in the Making* (1926), Phillips wrote of his wish to create 'such an intimate, attractive atmosphere as we associate with a beautiful home. To a place like that I believe people would be inclined to return once they have found it and

to linger as long as they can for art's special study and its special sort of pleasure.' Phillips's other writings include a collection of essays entitled *The Enchantment of Art* (1914) and in 1929 he edited and published a few issues of a short-lived periodical called *Art and Understanding*. His wife Marjorie (née Acker), whom he married in 1921, was a painter and took an active role in building and administering the collection. She became director after her husband's death and in 1970 published *Duncan Phillips and his Collection*. On her retirement in 1972, her son Loughlin became director of the Phillips Collection, which continues to acquire new works.

Phillips, Helen. See HAYTER.

Phillips, Peter (1939–). British painter, born in Birmingham. He studied at the Birmingham College of Art, 1955–9, and at the *Royal College of Art, 1959–62, and with a number of fellow RCA students—Derek *Boshier, David *Hockney, Allen *Jones, R.B. *Kitaj—he emerged as one of the leading exponents of British *Pop art at the *Young Contemporaries exhibition of 1961. Typically his imagery is drawn from modern American culture—jukeboxes, pinball machines, automobiles, film star pin-ups and so on—painted in the tight, glossy manner of commercial art. However, the images are usually set into bold heraldic frameworks or fragmented into sections and reorganized, so that illusionism and abstraction are combined. The *Phaidon Dictionary of Twentieth Century Art* (1973) describes the result as 'a slightly pointless marriage of comic book image and Post-Cubist composition'. In 1964–6 Phillips lived in New York, then settled in Zurich.

Phillips, Tom (1937–). British painter, graphic artist, musician, and writer, born in London. He studied English literature at St Catherine's College, Oxford, 1957–60, and painting at Camberwell School of Art, 1961–3, his teachers including *Auerbach and *Uglow. Phillips's work resists classification and has been much concerned with the fusion of words and images. Simon Wilson (*British Art from Holbein to the Present Day*, 1979) writes that his 'primary source material is the modern, photographically based, coloured picture postcard of which he is an obsessional collector . . . Phillips typically develops some specific human or social theme and then

submits the source image to an elaborate painting process so devised that the theme is embodied in a visual scheme of maximum richness and subtlety.' In 1966 he began using texts from a Victorian novel (*A Human Document* by W. H. Mallock, 1892) and has produced various suites of prints and other works based on it under the collective title *A Humument*. A by-product of this work is his opera *Irma* (first produced 1973, recorded 1980). Another ambitious project is his set of illustrations to Dante's *Inferno* (1979–83), consisting of etchings, lithographs, and screenprints accompanying his own translation. His writings include the book *Music in Art* (1997).

Philpot, Glyn (1884–1937). British painter and sculptor, born in London. He studied at Lambeth School of Art, 1900–3, and at the *Académie Julian, Paris, 1905. In 1906 and 1910 he travelled in Spain and his early work was much influenced by Spanish art, particularly the sombre, dignified portraits of Velázquez. It was as a portraitist that Philpot had his main success, which was at its height in the 1920s. However, he also did a mural of *Richard I Leaving England for the Crusades* (1927) for St Stephen's Hall, Westminster, and had ambitions as a painter of allegories and religious subjects (he became a convert to Catholicism in 1905). Unlike his friend Oswald *Birley, Philpot grew tired of routine fashionable portraiture (however lucrative it was) and in 1931 he moved to Paris for a year and started working in a more modern idiom—flatter and more stylized than his earlier manner: 'The change has arisen from the conviction that new modes of expression are continually necessary if the artist is to add to the sum of beauty in the world . . . In my own case the change has been towards a simplification of technique . . . a simplification of form. Add to this a disregard for logical chiaroscuro, when this was found to hamper the sharper detachment of one plane from another, and this is all.' The new style met with a mixed reception and some of Philpot's earlier admirers were dismayed: 'Glyn Philpot "Goes Picasso"' read a headline in the *Scotsman* on 30 April 1932. He died suddenly of heart failure in his London studio. The day after his funeral his friend and disciple Vivian Forbes (1891–1937) committed suicide; his behaviour had been unbalanced for several years. Philpot was out of fashion for many years, but his reputation began to revive in

the 1970s (coinciding with a general renewal of interest in the *Art Deco style, of which he is sometimes said to be a representative) and there was a major exhibition of his work at the National Portrait Gallery, London, in 1984–5. He is now perhaps best known for his portraits of negroes—his West Indian servant Henry Thomas was a favourite model.

photogram. See SCHAD.

Photographic Realism or **Photorealism**. Terms more or less synonymous with *Super-realism, although some critics prefer to restrict them to works painted directly from a photograph or photographs rather than use them for all paintings in a photographically detailed style.

photomontage. Term applied to a technique of making a pictorial composition from parts of different photographs and also to the image so made. The technique has antecedents in the 19th century, particularly in the work of O. G. Rejlander (1813–75), a Swedish photographer and painter active in England. Known as 'the father of art photography', he tried to expand the expressive range of photography by experimenting with double exposures and printing from several negatives onto a single sheet of paper. His best-known work in this vein is the highly elaborate allegorical scene *The Two Ways of Life* (1857), printed from 30 negatives onto two sheets joined together. As the term is now generally understood, however, photomontage involves cutting out, arranging, and pasting pre-existing photographic images rather than the manipulation of negatives taken for a particular purpose. Photomontage in this sense was largely the creation of the *Dadaists (specifically the Berlin Dadaists), who used the technique for political propaganda, social criticism, and generally to assist the shock tactics in which they indulged. Often they incorporated type and graphic symbols in the image, the elements being chosen for the meaning they convey rather than (as is often the case in *collage) for their decorative qualities. Raoul *Hausmann claimed to have invented photomontage in 1918, but no one person can be given the credit. John *Heartfield and Hannah *Höch ranked with Hausmann among the most distinguished pioneers. Photomontage has also been memorably used by, for example, Max *Ernst and

other *Surrealists and by *Pop artists such as Richard *Hamilton, but it is now mainly associated with advertising. See also MONTAGE.

photo-work. A term used since the 1970s to describe various types of works of art based on photographic images that have been manipulated by the artist in some way. It is a difficult term to define with any precision, as artists have routinely made use of photographic imagery since the days of *Pop art. However, it generally carries with it the suggestion that a photograph is physically the essential component of the work, rather than merely a part of a *mixed media work or the starting-point for a work in some other medium. Many *Conceptual artists in particular work with photographs; examples are Victor *Burgin, Jan *Dibbets, and Barbara *Kruger. Some Conceptual artists arrange photographs into new images or place them in a series to record an event or process, but the manipulation may involve only the addition of a text or even less. The extreme example is the work of the American Sherrie Levine (1947–), who in the early 1980s photographed reproductions of paintings and reproductions of photographs and presented them as her own works of art. This is somewhat in the spirit of *Duchamp's *ready-mades, although such procedures—considered to exemplify one aspect of *Postmodernism—are now dignified with the term 'appropriation', meaning 'the direct duplication, copying or incorporation of an image ... by another artist who re-presents it in a different context, thus completely altering its meaning and questioning notions of originality and authenticity' (*The Thames and Hudson Dictionary of Art and Artists*, revised edn., 1994). Other artists put in rather more effort. *Gilbert & George, for example, create spectacular wall-sized panels in which black-and-white photographs arranged into regular grids are overlaid with garish tints; the artists themselves call these images 'photo-pieces', rather than 'photo-works'. They first exhibited such pieces in 1971; earlier they had made 'postcard sculptures'. David *Hockney, also, has created elaborate images using photographs—in his case 'photocollages' made up of as many as six hundred overlapping prints. At the other extreme are the pictures of the American Cindy Sherman (1954–), in which the 'manipulation' occurs before the photograph is taken, rather than after it, and the photographic print itself is

presented perfectly 'straight'. Sherman photographs herself acting out roles from imaginary movies, sometimes dressed in elaborate costume, as a way of examining female stereotyping. It is questionable to what extent such images should be called 'photo-works' rather than simply 'photographs', but they routinely feature in books on art as well as on photography. Some critics prefer to use such terms as 'fabricated photography', 'set-up photography', or 'staged photography' to describe them.

Picabia, Francis (1879–1953). French painter, designer, writer, and editor, born in Paris of a Spanish father and a French mother. His talent as an artist was modest, but his restless and energetic personality gave him a significant role successively in the *Cubist, *Dadaist, and *Surrealist movements, and through his publications he played an important role in disseminating avant-garde ideas. A private income enabled him to carry on his activities without having to worry about earning a living, as well as to indulge his love of fast cars, fast women, and wild living in general.

Picabia studied at the École des Arts Décoratifs in Paris, 1895–7, and for the next ten years was a prolific and successful painter of *Impressionist landscapes. In 1908–9 he experimented with *Neo-Impressionism, and then with *Fauvism and Cubism. In 1911 he met Marcel *Duchamp, who was to be the most important influence on his career, and with him became an exponent of *Orphism. He painted his first purely abstract works in 1912. In 1913 he visited New York as spokesman for the Cubist pictures in the *Armory Show, and he returned in 1915–16, when he, Duchamp, and *Man Ray were involved in the first stirrings of Dada. He contributed to *Stieglitz's review *291*, and after moving to Barcelona (where he lived 1916–17), he launched his own magazine based on it—*391* (1917–24). In 1917 he returned to New York for six months (during which he produced three Americanized issues of *391*), then lived in Zurich (1918–19) before returning to Paris, where he helped to launch the Dada movement in 1919 and began publishing a review called *Cannibale*. However, in 1921 he denounced Dada for being no longer 'new', and became involved with André *Breton and the nascent Surrealist movement. In 1924 he attacked this, too, in the pages of *391*, but some of his later works are in a Surrealist idiom. From 1925 to 1945 he lived mainly on the Côte d'Azur, experimenting with various styles. In 1945 he settled permanently in Paris and in his final years returned to abstract painting.

Apart from his contributions to avant-garde magazines, Picabia published various pamphlets and wrote poetry. He also conceived the fantasy ballet *Relâche* (1924), with music by Erik Satie, together with the film *Entr'acte* (directed by René Clair), which was used to fill the intermission between the ballet's two acts. Among Picabia's paintings, the most highly-regarded today are those in his 'machinist' style, in which mechanistic and *biomorphic forms are combined in dynamic compositions. The most famous is *I See Again in Memory My Dear Udnie* (MOMA, New York, 1914).

Picasso, Pablo (1881–1973). Spanish painter, sculptor, draughtsman, printmaker, ceramicist, and designer, active mainly in France, the most famous, versatile, and prolific artist of the 20th century. He was the dominant personality in the visual arts during much of the first half of the 20th century and he provided the incentive for many of the revolutionary changes during this time. Although it is conventional to divide his work into certain phases, these divisions are to some extent arbitrary, as his energy and imagination were such that he often worked simultaneously on a wealth of themes and in a variety of styles. Picasso himself said: 'The several manners I have used in my art must not be considered as an evolution, or as steps toward an unknown ideal of painting. When I have found something to express, I have done it without thinking of the past or future. I do not believe I have used radically different elements in the different manners I have used in painting. If the subjects I have wanted to express have suggested different ways of expression, I haven't hesitated to adopt them.'

Picasso was born in Málaga, the son of an undistinguished painter and drawing-master, José Ruiz Blasco (1838–1913), and he was remarkably precocious; his first word as a baby is said to have been 'lápiz' (pencil), and although he was not quite the child genius he later liked to suggest, he certainly showed exceptional talent by the time he was in his early teens. In 1895 his family moved to Barcelona, where he studied at the School of Fine Arts, 1896–7, before attending the Academy in Madrid for a few months in 1897. By

this time he had his own studio in Barcelona, and he thrived on the city's intellectual and bohemian life, centring on the café Els Quatre Gats (The Four Cats). In 1900 he made his first visit to Paris and by this time had already absorbed a wide range of influences. Between 1900 and 1904 he alternated between Barcelona and Paris, and this time coincides with his Blue Period, when he took his subjects from the poor and social outcasts, and the predominant mood of his paintings was one of slightly sentimentalized melancholy expressed through cold ethereal blue tones (La Vie, Cleveland Museum of Art, 1903). He also did a number of powerful etchings in a similar vein (The Frugal Repast, 1904)

In 1904 Picasso settled in Paris and quickly became a member of a circle of avant-garde artists and writers. A brief phase in 1904–5 is known as his Rose (or Circus) Period. The predominant blue tones of his earlier work gave way to pinks and greys and the mood became less austere. His favourite subjects were acrobats and dancers, particularly the figure of the harlequin. In 1906 he met *Matisse, but although he seems to have admired the work being done by the *Fauves, he did not share their interest in the decorative and expressive use of colour (indeed his work often shows little concern with colour, and it is significant that—unlike most painters—he preferred to work at night by artificial light). Until 1909 he lived with other artists and non-conformists in the ramshackle *Bateau-Lavoir, but he rarely suffered real poverty (see JACOB) and his work soon began to attract the attention of important collectors, even though he did not exhibit at any of the usual salons. In 1905–6 the Americans Gertrude and Leo *Stein, the German Wilhelm *Uhde, and the Russian Sergei *Shchukin began buying his paintings, and in 1907 he was taken up by the dealer *Kahnweiler.

The period around 1906–7 is sometimes referred to as Picasso's 'Negro period', because of the influence of African sculpture on his work at this time, but rather than marking a coherent phase, this influence was 'the leading feature of a period of indecision which lasted more than a year' (Timothy Hilton, Picasso, 1975). *Cézanne was another major influence on Picasso at this time, as he concentrated on the analysis and simplification of form. This process culminated in Les Demoiselles d'Avignon (MOMA, New York, 1907), which in its distortions of form was as violent

a revolt against tradition as the paintings of the Fauves in the realm of colour. The painting shows five sinister-looking naked women, and its title was jokingly suggested by André *Salmon, who pretended to see a resemblance between them and prostitutes in the Carrer d'Avinyo (Avignon Street) in Barcelona. At the time the picture was incomprehensible even to other avant-garde artists, including Matisse and *Derain, and it was not shown publicly until 1916 or reproduced until 1925. It is now seen not only as a pivotal work in Picasso's personal development but as the most important single landmark in the development of 20th-century painting. It was the herald of *Cubism, which Picasso developed in close association with *Braque and then *Gris from 1907 up to the First World War. Towards the end of this period, Picasso made an almost equally revolutionary contribution to sculpture by creating works from pieces of commonplace material, for example Guitar (Musée Picasso, Paris, 1912), which is made of cardboard, paper, and string. His sculptures of this type (which represent a development of Cubist *collage into three dimensions) were generally fairly small and jokey, but the idea was soon developed in a more ambitious way, and through *Tatlin (who visited Picasso in 1914) it inspired *Constructivism.

During the First World War Picasso continued working in Paris, but in 1917 he went to Rome with his friend Jean *Cocteau to design costumes and scenery for the ballet Parade, which was being produced by *Diaghilev. Picasso fell in love with one of the dancers, Olga Koklova, and they married in 1918, moving into a grand apartment in a fashionable part of Paris, as the bohemian days of his youth were left behind. The visit to Italy was also an important factor in introducing the strain of monumental *Neoclassicism that was one of the most prominent features of Picasso's work in the early 1920s (Mother and Child, Art Institute of Chicago, 1921), but at this time he also became involved with *Surrealism—indeed André *Breton hailed him as one of the initiators of the movement. However his predominant interest in the analysis and synthesis of form was at bottom opposed to the irrational elements of Surrealism, its exaltation of chance, or fascination with material drawn from dreams or the unconscious.

Following his serene Neoclassical paintings, Picasso began to make violently expres-

sive works, fraught with emotional tension, anguish, and despair. This phase begins with *The Three Dancers* (Tate Gallery, London, 1925), painted at a time when his marriage was becoming a source of increasing unhappiness and frustration (Picasso could not obtain a divorce, so he remained officially married to Olga until her death in 1955; he remarried in 1961). The life-size figures in *The Three Dancers* are aggressively distorted in a savage parody of classical ballet; Alfred H. *Barr calls the picture 'a turning point in Picasso's art almost as radical as the proto-cubist *Demoiselles d'Avignon*'. Following this he became concerned with the mythological image of the Minotaur and images of the Dying Horse and the Weeping Woman. The period culminated in his most famous work, *Guernica* (Centro de Arte Reina Sofia, Madrid, 1937), produced for the Spanish pavilion at the Paris Exposition Universelle of 1937 to express horror and revulsion at the bombing of the Basque capital Guernica by General Franco's German allies during the Spanish Civil War. It was followed by a number of other paintings attacking the cruelty and destructiveness of war, including *The Charnel House* (MOMA, New York, 1945). 'Painting is not done to decorate apartments', he said: 'it is an instrument of war against brutality and darkness.'

Picasso remained in Paris during the German occupation, but from 1946 he lived mainly in the South of France, where he added pottery to his other activities (from 1948 to 1955 he lived in Vallauris, a town renowned for its ceramics); he settled at his final home, the Villa Notre-Dame-de-Vie at Mougins, in 1961. In 1944 he had joined the Communist Party, and in the post-war years he attended several International Peace Congresses organized by the Party, including one in Sheffield in 1950. His later output as a painter does not compare in momentousness with his pre-war work, but it remained prodigious in terms of sheer quantity. It included a number of variations on paintings by other artists, including 44 on Velázquez's *Las Meninas* (the theme of the artist and his almost magical powers is one that exercised him greatly throughout his career). Some critics think that Picasso remained a great master to the end of his long life, but others see a sad falling off in his post-war work. Douglas *Cooper, for example, described the paintings of his old age as 'incoherent doodles done by a frenetic dotard in the anteroom of death',

whereas to John *Richardson they constitute 'a phenomenal finale to a phenomenal œuvre'. These pictures are often aggressively sexual in subject and almost frenzied in brushwork (*Reclining Nude with Necklace*, Tate Gallery, London, 1968); they have been seen as sources for *Neo-Expressionism.

Picasso's interest in sculpture was fairly sporadic, much of his three-dimensional work being executed in short bursts of activity, but in this field too he ranks as one of the outstanding figures in 20th-century art. In *Modern Sculpture* (1965) Alan *Bowness writes that 'Picasso's sculpture sparkles with bright ideas—enough to keep many a lesser man occupied for the whole of a working lifetime . . . it is not inconceivable that the time will come when his activities as a sculptor in the second part of his life are regarded as of more consequence than his later paintings'. His best-known sculptures include some slight but amusing works in which he demonstrated his remarkable sharpness of eye in transforming found objects (see OBJET TROUVÉ); the most celebrated example is *Head of A Bull, Metamorphosis* (Musée Picasso, Paris, 1943), made of the saddle and handlebars of a bicycle. However, he also made much more ambitious and considered pieces, the largest being the over-lifesize bronze *Man with a Sheep* (1943), one cast of which stands in the main square in Vallauris.

As a graphic artist (draughtsman, etcher, lithographer, linocutter), Picasso ranks with the greatest of the century, one of his outstanding achievements being the set of etchings known as the *Vollard Suite* (see VOLLARD). He was a prolific book illustrator, and as few other artists had the power to concentrate the impress of his genius in even the smallest and slightest of his works. Picasso's emotional range is as wide as his varied technical mastery. By turns playful and tragic, his work is suffused with a passionate love of life, and no artist has more devastatingly exposed the cruelty and folly of his fellow men or more rapturously celebrated the physical pleasures of love. There are Picasso museums in Paris (consisting mainly of works from the artist's own collection) and in Barcelona, and other examples of his huge output (which has been estimated at over 20,000 works) are in collections throughout the world.

Just as Picasso's work has been more discussed than that of any other modern artist, so his personal life has inspired a flood of

writing, particularly regarding his relationships with women. He once described women as either 'goddesses or doormats' and he has been criticized for allegedly demeaning them in his work (especially his later erotic paintings) as well as mistreating them in person. Several of the women in his life came out of their relationships with him badly. His first wife became almost deranged, screaming abuse at him in public, and his second wife committed suicide some years after his death, as did Marie-Thérèse Walter, who became his mistress in 1927, when she was 17 and he was 45. Picasso tried unsuccessfully to prevent two of his long-term lovers from publishing their memoirs of life with him: Fernande Olivier's *Picasso et ses amis* (1933, translated as *Picasso and His Friends*, 1965), and Françoise Gilot's *Life with Picasso* (1964). (Olivier, an artists' model whom he met in 1904, was his first great love; Gilot, a painter, was the mother of two of his children including **Paloma Picasso** (1949–), a jewellery designer.) John Richardson describes Gilot's book as telling the story of a 'young girl seduced, manipulated and betrayed by a sadistic old Bluebeard' and writes that it outraged Picasso so much (he maintained he was the one who had been betrayed) that it 'cast a shadow over the rest of his life'. David *Sylvester, however, regards it as 'one of the most illuminating and entertaining books ever written about an artist'.

Pick, Frank. See KAUFFER.

Pictorialism. See TONALISM.

Piene, Otto (1928–). German painter, sculptor, and experimental artist, born in Laasphe, Westphalia. At the age of 16 he was called up for war service as an anti-aircraft gunner and was taken prisoner. After the war he trained at the Academies of Munich and Düsseldorf, 1948–53, and then studied philosophy at Cologne University, 1953–7. With Heinz *Mack and Günther *Uecker he founded the *Zero group in 1957 and he is regarded as a leading exponent of *Kinetic art and *Light art. His work has included large out-of-doors light projects such as *Lichtlinie* at the Institute of Technology, Cambridge, Massachusetts, in 1968. In 1969 he coined the term *Sky art to refer to certain works of this type. From 1964 he has taught at various universities in the USA while continuing to work in Düsseldorf.

Pignatari, Décio. See CONCRETE POETRY.

Pignon, Édouard (1905–93). French painter, graphic artist, ceramicist, and designer, born at Bully-les-Mines, Pas-de-Calais. A miner's son, he worked in the mines himself until 1927, when he moved to Paris and kept himself by a variety of occupations while painting in his spare time and attending evening classes in sculpture. In 1936 he opted for painting on the advice of *Picasso, but it was not until 1943 that he was able to devote himself entirely to art. During the 1930s his work included large canvases depicting the life of working people in a style influenced by Picasso and *Léger. In the 1940s his style developed into a more painterly synthesis of the post-*Cubist structure of Picasso and Léger with the decorative colour of *Matisse, and from the 1950s his handling became freer and looser. Apart from the scenes of working life with which he is most closely associated, Pignon treated a wide range of subjects, including landscapes in the South of France (from the 1950s he spent much of his time in Provence), sea scenes, nudes in landscapes, cock fights, and a series of *Battles* in the 1960s. He was inspired by Picasso to take up ceramics and his other work included theatre designs and book illustrations.

Pilgrim Trust. See 'RECORDING BRITAIN'.

Pillet, Edgard. See GROUPE ESPACE.

Pincus-Witten, Robert. See POST-MINIMAL-ISM.

Piper, John (1903–92). British painter, printmaker, draughtsman, designer, and writer, born at Epsom, Surrey, the son of a solicitor. He reluctantly became an articled clerk in his father's legal firm, but after his father's death in 1926 he studied at Richmond School of Art and then the *Royal College of Art, 1926–8. From 1928 to 1933 he wrote art criticism for the *Listener* and the *Nation*, and he was among the first to recognize such contemporaries as William *Coldstream, Ivon *Hitchens, Victor *Pasmore, and Ceri *Richards. He became a member of the *London Group in 1933 and of the *Seven & Five Society in 1934. Also in 1934 he met the writer Myfanwy Evans (1911–97) and soon afterwards began assisting her on the avant-garde quarterly *Axis*, which was

launched in 1935. Evans became Piper's second wife in 1937. At this time he was one of the leading British abstract artists, but by the end of the decade he had become disillusioned with non-representational art and reverted to naturalism. He concentrated on landscape and architectural views in a subjective, emotionally charged style that continued the English Romantic tradition. Some of his most memorable works in this vein were done during the Second World War when he made pictures (watercolours as well as oils) of bomb-damaged buildings for the *'Recording Britain' scheme and for the War Artists' Advisory Committee (it was not until 1944, however, that he was actually appointed an *Official War Artist). A similar stormy atmosphere pervades his famous views of country houses of the same period, which were done either for himself or on private commission; for example, he made a series of paintings of Renishaw Hall, Derbyshire, for Sir Osbert *Sitwell.

Piper's work diversified in the 1950s and he became recognized as one of the most versatile British artists of his generation. He did much work as a designer of stained glass (notably at Coventry Cathedral) and also for the stage. His stage designs included sets for several Benjamin Britten operas, beginning with *The Rape of Lucretia* (1946); Myfanwy Evans wrote the librettos for three of the Britten operas her husband designed—*The Turn of the Screw* (1951), *Owen Wingrave* (1970), and *Death in Venice* (1973). In addition Piper made book illustrations and designed pottery and textiles, including a tapestry in Chichester Cathedral (1966). As a writer he is probably best known for his book *British Romantic Artists* (1942). He also compiled several architectural guidebooks to English counties (Oxfordshire, 1938; Shropshire, 1939; Buckinghamshire, 1948; Berkshire, 1949), usually in collaboration with his friend the poet Sir John Betjeman. Betjeman wrote a book on Piper in the 'Penguin Modern Painters' series (1944). Piper's work is extensively represented in the Tate Gallery, London. His son **Edward Piper** (1938–90) was a painter, photographer, and graphic designer.

Pippin, Horace (1888–1946). Black American *naive painter. He was born at West Chester, Pennsylvania, and brought up in Goshen, New York. After leaving school at the age of 15, he worked at various jobs (bellboy, foundry-

man, junk dealer) then enlisted in the US Army in 1917. Pippin had drawn since childhood and he kept an illustrated diary of his experiences as a soldier in France. A severe wound paralysed his right arm and after returning to the USA he settled in West Chester and supplemented his disability pay by doing light work. Through exercise he strengthened his arm and he began to paint in oils in about 1930. His work included scenes from personal experience (including memories of the war) and from the imagination (he did numerous religious pictures). He was 'discovered' in 1937 and the following year his work was included in a major exhibition at the Museum of Modern Art, New York—'Masters of Popular Painting: Modern Primitives of Europe and America'. In the 1940s he attained a considerable reputation. His work has a dramatic feeling and psychological intensity rare in naive painting, especially in his paintings on John Brown, the anti-slavery campaigner.

Pirie, Sir George. See GLASGOW BOYS.

Pisis, Filippo de (1896–1956). Italian painter and writer, born at Ferrara. He studied literature and philosophy at Bologna University, 1916–19, then moved to Rome, where he took up painting. Some of his early work has a slight kinship with *Metaphysical Painting, and he also flirted briefly with *Dada, but most of his work was broadly within the *Impressionist tradition. Between 1920 and 1940 he lived mostly in Paris. George Heard *Hamilton has written of his work: 'He excelled at the quick sketch of still-life, the sudden glimpse of a landscape or of a brightly furnished interior, apparently unpremeditated but deftly brushed. With the exception of *Modigliani . . . no other Italian artist of modern times came closer to grasping the essentially pictorial qualities of French painting.' In the 1930s de Pisis visited England three times and became friends with Vanessa *Bell and Duncan *Grant. He moved to Milan after the outbreak of the Second World War and in 1944 settled in Venice, where he was much influenced by 18th-century Venetian painting. His work featured prominently at the Venice *Biennale in 1948 and 1954, but the last decade of his life was marred by ill-health caused by a disease of the nervous system. His writings included poetry and art criticism.

Pissarro, Lucien (1863–1944). Anglo-French painter and graphic artist, born in Paris, the eldest son of the celebrated *Impressionist painter **Camille Pissarro** (1830–1903). His four brothers all became painters. Lucien was taught and continuously coached by his father, and the letters they exchanged are valuable documents on late 19th-century art. Lucien visited England in 1870 as a child, worked there briefly in 1883–4, and settled permanently in the country in 1890 (although he often made trips to France), becoming a British citizen in 1916.

Pissarro had a thorough knowledge of printing techniques, and in 1894 he founded the Eragny Press (named after a village in Normandy where his father lived). This was one of the most distinguished of the private presses that flourished at this time, creating books that existed primarily for the sake of their appearance—typography, illustration, binding—rather than their content. The illustrations were mainly from Pissarro's own drawings, engraved on wood by himself and his wife Esther, and they are remarkable for their use of colour. Pissarro mixed his own inks and sometimes worked on tinted paper. Most of the Eragny Press's early books were set in the 'Vale' typeface designed by Pissarro's friend Charles *Ricketts, but after the closure of the Vale Press in 1904, Pissarro's own 'Brook' typeface was used. Many of his books were in French and the firm was heavily dependent on foreign sales; the outbreak of the First World War caused its closure in 1914.

In spite of his intense involvement in printing, Pissarro always regarded painting as his primary concern. From 1905 he was a member of *Sickert's circle. He became a member of the *New English Art Club in 1906 and of the *Camden Town Group in 1911. His first one-man show was at the Carfax Gallery, London, in 1913. From 1934 he exhibited at the *Royal Academy. His main subject was landscape. He was a modest and unassuming character and has been overshadowed by his more famous father, but he was an important as a link between French Impressionism and *Neo-Impressionism and English art.

Lucien's daughter, **Orovida Pissarro** (1893–1968), often known simply as 'Orovida', was a painter and etcher, mainly of animal subjects.

Pistoletto, Michelangelo (1933–). Italian painter, sculptor, and experimental artist,

born in Biella in Piedmont. From 1947 to 1958 he worked with his father, a picture restorer, and also did advertising work. He had his first one-man show at the Galleria Galatea, Turin, in 1960, and in 1962 he began making the 'mirror paintings' for which he is best known. In these he used life-size cut-out photographs of people, usually shown in arrested action, which he pasted onto thin sheets of polished steel. The spectator sees his or her own moving image reflected in the steel alongside the photographic image. Subsequently Pistoletto has worked in a wide variety of media and styles. He was involved in *Arte Povera and *Happenings, for example, and in 1980 he began making over-life-size heads and torsos carved in polyurethane or marble.

Pitchforth, Vivian (1895–1982). British painter, printmaker, and teacher. He was born in Wakefield and studied there, in Leeds, and (after army service in the First World War, which left him deaf) at the *Royal College of Art, 1920–5. In 1926 he began teaching at Camberwell School of Art and he subsequently taught at several other art colleges in London. He was given his first one-man exhibition by the *London Artists' Association in 1928. During the Second World War he was an *Official War Artist, working first in Britain but ending up recording naval operations in South-East Asia. In the course of this work he contracted a severe lung ailment and was placed in a hospital in Durban. He remained in South Africa until 1948, exhibiting in Cape Town, Durban, and Johannesburg, then returned to London. From this time he devoted himself mainly to watercolour. His work consisted primarily of landscapes, in which he showed a deep love of the countryside. He also painted seascapes and architectural subjects and made etchings and woodcuts. He continued working until the end of his life, and in 1979 he wrote: 'Enthusiasm and dedication are everything, on top of years of hard drawing.'

Pite, Beresford. See ROYAL COLLEGE OF ART.

Pittsburgh International. See CARNEGIE INTERNATIONAL.

Pittura Colta ('Cultured Painting'). A movement in painting, flourishing from the 1980s, in which artists imitate certain features of the figure style of the Old Masters in an ironic way

that is considered characteristic of *Postmodernism. The name was coined by the Italian critic Italo Mussa, who published a book entitled *La Pittura colta* in 1983, and the movement is associated mainly with Italy. Probably the best-known of the artists who work in this vein is Carlo Maria Mariani (1931–). Others are Alberto Abate (1946–), Bruno d'Arcevia (1946–), Antonella Cappuccio (1946–), and Vittorio Scialoja (1942–). They all paint mythological or pseudo-mythological scenes in a gaudy, sleek, and stagey reworking of Old Master conventions. Other names that have been applied to the movement include Anacronismo, Hyper-Mannerism, Maniera Nuova, Neo-Mannerism, and New *Metaphysical Painting. Non-Italian artists who have worked in a similar style include the American David Ligare (1945–); in addition to figure compositions he paints classical landscapes, somewhat in the manner of 17th-century artists such as Nicolas Poussin, but with a glossy modern air (*Landscape for Baucis and Philemon*, Wadsworth Atheneum, Hartford, Connecticut, 1984).

Pittura Metafisica. See METAPHYSICAL PAINTING.

Planas-Casa, José. See BATLLE PLANAS.

Plasticiens, Les. A group of four Canadian abstract painters founded in Montreal in 1955: Louis Belzile (1929–); Jean-Paul Jérôme (1928–); Rodolphe de Repentigny (1926–59), who painted under the name 'Jauran' and who was also a mathematician, philosopher, and art critic; and Fernand Toupin (1930–). The group published a manifesto on 10 February 1955 proclaiming: 'The Plasticiens are drawn, above all else in their work, to the "plastic" facts: tone, texture, form, line, the ultimate unity of these in painting, and the relationship between these elements . . . The significance of the work of the Plasticiens lies with the purifying of the plastic elements and of their order; their destiny lies typically in the revelation of perfect forms in a perfect order . . . The Plasticiens are totally indifferent, at least consciously so, to any possible meanings in their paintings.' Their style was austerely geometric, the name of the group being a reference to *Mondrian's *Neo-Plasticism. However, they acknowledged the importance of Les *Automatistes in promoting abstract art in Montreal, even though the

spontaneous style associated with that group was very different to their own. In 1956 Les Plasticiens were partially absorbed in the larger Non-figurative Artists' Association of Montreal, which included abstract artists of various persuasions (Fernand Leduc of Les Automatistes was president, and de Repentigny was secretary). In 1959 the *Nouveau Plasticiens was formed. Jauran died in a climbing accident later that year.

Plastique. See TAEUBER-ARP.

Plastov, Arkady (1893–1972). Russian painter, one of the outstanding representatives of *Socialist Realism. He divided his time between Prislonikha (his native village) and Moscow, where he studied at the Stroganov Institute, 1912–14, and the Moscow Institute of Painting, Sculpture, and Architecture, 1914–17. Until 1931, when he became a full-time artist, he worked also as a farmer, and he was above all a painter of agricultural life. Alan Bird (*A History of Russian Painting*, 1987) describes him as 'the painter who more than any other is associated with scenes of sunlit life on collective farms . . . he devoted his unquestionable abilities to the glorification of the Soviet peasant and farmworker in whose staunchness, spiritual gentleness, diligence and patriotism he saw the true and enduring qualities of Russian life . . . his work has a confidence which carries it beyond vulgarity . . . it displays a liveliness of invention, a sureness of technique, a flamboyant, baroque quality which matches the wedding cake splendours of Russian architecture of that period and which merits more than the jeers it has received in the West or the senseless attacks made on it by latter-day critics in the Soviet Union itself'. Plastov also painted portraits, designed posters (mainly early in his career), and made book illustrations. His work is well represented in the Tretyakov Gallery, Moscow, and the Russian Museum, St Petersburg.

Poiré, Emmanuel (known as Caran d'Ache). See BATEMAN.

Poiret, Paul. See DUFY.

Poliakoff, Serge (1906–69). Russian-born painter, printmaker, and designer who settled in Paris in 1923 and became a French citizen in 1962. He was born in Moscow into a musical family. In 1919, in the wake of the

Revolution, he left Russia with his aunt Nadia Poliakoff, a singer, and travelled to Constantinople, Sofia, Belgrade, Vienna, and Berlin before arriving in Paris, where he earned his living as a guitarist for many years. In 1930 he began to study painting, attending various art schools, including the *Slade School during a two-year stay in London, 1935–7. His early work was figurative, but after his return to Paris in 1937 he met *Kandinsky and Robert and Sonia *Delaunay, and under their influence he turned to abstraction in 1938. He had his first one-man exhibition at the Galerie L'Esquisse, Paris, in 1945, and in 1952 he was able to give up his work as a musician and devote himself full-time to painting. By this time he had developed his characteristic style, featuring bold irregular slabs of mat, roughly textured colour (*Abstract Composition*, Tate Gallery, London, 1954). He adopted an almost religious attitude towards painting, saying 'You've got to have the feeling of God in the picture if you want to get the big music in'. In the 1950s he gained recognition as one of the leading abstract painters in the *École de Paris, but his reputation had declined somewhat by the time of his death. As well as paintings, he made lithographs and stage designs.

Polke, Sigmar (1941–). German painter, born at Oels (now Olesnicka) in Lower Silesia. From 1961 to 1966 he studied at the Düsseldorf Academy, where he was influenced by Joseph *Beuys. His paintings are typically commentaries on other paintings, parodying the conventions of modernity (*Untitled—Referring to Max Ernst*, Stadtisches Kunstmuseum, Bonn, 1981). An exhibition of Polke's work was held at the Tate Gallery, Liverpool, in 1995. Reviewing this show, Frank *Whitford wrote in the *Sunday Times*: 'He sends up the gestural spontaneity of abstract expressionism, the pseudo-philosophical pretensions of conceptualism, and pop art's prostration before the totems of consumerism . . . He clearly feels that humour, both sophisticated and crude, is the best antidote to self-important artistic attitudes . . . Devices such as these may strike you as witty or amusing, arch or pointlessly complex.'

Pollock, Jackson (1912–56). American painter, the commanding figure of the *Abstract Expressionist movement. He was born on a sheep ranch at Cody, Wyoming, and grew up in Arizona and California, moving homes several times in childhood because of his father's lack of success as a farmer. In 1929 he moved to New York and studied at the *Art Students League under the *Regionalist painter Thomas Hart *Benton. He was influenced not only by Benton's vigorous style, but also by his image as a virile, truculent, hard-drinking macho-man (Pollock began treatment for alcoholism in 1937 and in 1939 he started therapy with Jungian psychoanalysts, using his drawings in sessions with them). During the 1930s he painted in the manner of the Regionalists, and was influenced also by the Mexican muralists (he attended *Siqueiros's experimental workshop in New York in 1936) and by certain aspects of *Surrealism, particularly the use of mythical or totemic figures as archetypes of the unconscious. From 1935 to 1942 he worked for the *Federal Art Project, and in 1943 he was given a contract by Peggy *Guggenheim; his first one-man show was held at her Art of This Century gallery in that year. A characteristic work of this time is *The She-Wolf* (MOMA, New York, 1943), a semi-abstract picture with vehemently handled paint and ominous imagery recalling the monstrous creatures of *Picasso's *Guernica* period.

By the mid-1940s Pollock's work had become completely abstract, and the 'drip and splash' style of *Action Painting for which he is best known emerged with some suddenness in 1947. Instead of using the traditional easel, he laid his canvas on the floor (he worked in a large, barn-like studio on Long Island, where he settled in 1945 with his wife Lee *Krasner) and poured and dripped his paint from a can (using commercial enamels and metallic paint because their texture was better suited to the technique); instead of using brushes, he manipulated the paint with 'sticks, trowels or knives' (to use his own words), sometimes obtaining textured effects by the admixture of 'sand, broken glass or other foreign matter'. As he worked, Pollock moved around (and sometimes through) his paintings, creating a novel *all-over style that avoided any points of emphasis and abandoned the traditional idea of composition in terms of relation among parts. The design of the painting had no relation to the size or shape of the canvas—indeed in the finished work the canvas was sometimes docked or trimmed to suit the image. The drip paintings were first publicly shown at Betty *Parsons's gallery in 1948. Initially they shocked most

people, but Irving Sandler (*Abstract Expressionism*, 1970) writes that 'a small number of artists and critics were stunned by the originality and dynamism of his painting . . . he opened the way to a kind of painting that was more direct, improvisational, abstract, and larger in size than that of the Abstract Surrealists of the time or of such earlier pioneers of improvisation as *Kandinsky. Pollock revitalized American abstraction, giving other artists the confidence to risk basing their own painting on the spontaneous gesture, knowing that it could yield a unified picture full of energy, drama, and passion . . . it was Pollock who unleashed the creative energies of the Abstract Expressionists.' Willem *de Kooning summed up the importance of the 1948 exhibition when he commented 'Jackson's broken the ice'.

Pollock's drip period lasted only from 1947 to 1951 (in the 1950s he went back to quasi-figurative work), but it is on the paintings of these four years that his enormous reputation rests. Among the most celebrated are *Autumn Rhythm* (MOMA, New York, 1950) and *Lavender Mist* (NG, Washington, 1950), which Robert *Hughes describes as 'his most ravishingly atmospheric painting . . . In it one sees the delicacy—at a scale that reproduction cannot suggest—with which Pollock used the patterns caused by the separation and marbling of one enamel wet in another, the tiny black striations in the dusty pink, to produce an infinity of tones. It is what his imitators could never do, and why there are no successful Pollock forgeries; they always end up looking like vomit, or onyx, or spaghetti, whereas Pollock—at his best at any rate—had an almost preternatural control over the total effect of those skeins and receding depths of paint . . . So one is obliged to speak of Pollock in terms of perfected visual taste, analogous to natural pitch in music—a far cry, indeed, from the familiar image of him as a violent expressionist.' Irving Sandler, too, stresses the subtlety of Pollock's work, writing that far from being 'a kind of solitary, super-primitive, free of culture', as conceived by the popular imagination, he 'was, in fact, an artist of sophistication and erudition, alive to most every tradition in Western art'.

Pollock's drip paintings were subjected to a good deal of critical abuse (he was nicknamed 'Jack the Dripper'), but he had the support of influential writers, particularly Clement *Greenberg and Harold *Rosenberg, and in 1949 the French painter Georges *Mathieu said that he considered him the 'greatest living American painter'. By this time he was becoming well known to the public and in August 1949 *Life* magazine discussed Mathieu's claim in an article entitled 'Jackson Pollock: Is he the Greatest Living Painter in the United States?' The article pointed out that he was 'virtually unknown in 1944', but that 'Now his paintings hang in five US museums and 40 private collections'. After his death in a car crash at the age of 44, a flood of articles appeared on him, discussing his alcoholism and larger-than-life personality as much as his art. By about 1960 he was generally recognized as the most important figure in the most important movement in the history of American painting, but a movement from which artists were already in reaction (see POST-PAINTERLY ABSTRACTION). His unhappy personal life and his untimely death contributed to his status as one of the legends of modern art; he was the first American painter to become a 'star'. Francis V. O'Connor, author of a standard biography of Pollock (1967), has written of him: 'As a man Pollock was described by his contemporaries as gentle and contemplative when sober, violent when drunk. These extremes found equilibrium in his art. He was highly intelligent, widely read and, when he chose, incisively articulate. He believed that art derived from the unconscious, saw himself as the essential subject of his painting, and judged his work and that of others on its inherent authenticity of personal expression.'

Pomeroy, Frederick William. See NEW SCULPTURE.

Pomodoro, Arnaldo (1926–). Italian sculptor and designer, born at Morciano di Romagna. He studied architecture and stage design and served an apprenticeship in goldsmithery before taking up sculpture. In 1954 he settled in Milan and had his first exhibition there in 1955. His most characteristic works are large-scale bronzes, sometimes incorporating wheels, sprockets, and other machine parts. Some of his works are constructed from parts that can be arranged at will by the spectator. In 1963 he was awarded the Sculpture Prize at the São Paulo Bienal and in 1964 he won the Prize for Italian Sculpture at the Venice *Biennale.

Pomodoro, Giò (1930–). Italian sculptor and designer, born at Orciano di Pesaro. He was self-taught as a sculptor and like his brother Arnaldo worked as a jeweller early in his career. He settled in Milan in 1953 and had his first exhibition in Florence in 1954. In 1959 he won the Sculpture Prize at the Paris *Biennale. His work has been varied, but he is best known for abstract reliefs. In his *Surfaces in Tension* series (begun 1958) he used stretched fabric and tried to integrate the surface of the piece with the surrounding space. He was a member of *Coninuità.

Pompidou Centre (in full, Centre National d'Art et de Culture Georges Pompidou). Cultural centre in Paris named after Georges Pompidou (1911–74), who was President of France from 1967 to 1974. In 1969 he declared: 'I passionately wish that Paris could have a cultural centre that would be both a museum and a centre for creativity—a place where the plastic arts, music, cinema, literature, audio-visual research, etc. would find a common ground.' The site chosen for this centre was the Plateau Beaubourg, a once thriving area near the centre of Paris that had degenerated into a slum and become derelict between the two world wars (it has given the Pompidou Centre its colloquial name 'Beaubourg Centre', or simply 'Beaubourg'). An international competition for the building produced 681 submissions, including bizarre ideas such as a giant egg and an enormous hand extended towards the sky, each finger being intended to house a separate department. The winning design—chosen by an international jury—was submitted by an Italian and a British architect working in partnership: Renzo Piano and Richard Rogers (later Lord Rogers). Their huge building was constructed in 1971–7 (it was inaugurated in 1977 with a large exhibition of the work of Marcel *Duchamp) and it soon became one of the most famous sights of the city and one of the busiest art centres in the world. It is a leading example of High Tech architecture, with the building's service systems fully exposed on the exterior; they are brightly and systematically coloured—yellow for the electrical system, blue for the air-conditioning ducts, and so on. It has been described as looking like a 'crazy oil refinery', and as architecture it has attracted extremes of praise and censure. The large plaza in front of the building is conceived as part of the Centre and is the main

forum for the city's street performers. Also outside the building is the ebullient Beaubourg Fountain (1980) by Jean *Tinguely and Niki de *Saint Phalle.

The Pompidou Centre, of which Pontus *Hulten was the first director, is divided into various departments, including a library, an industrial design centre, and an institute for the development and promotion of avant-garde music. The largest of the departments and the main reason for the Centre's popularity is the national collection of modern art—the Musée National d'Art Moderne—which was formerly housed in the Palais de Tokyo, adjacent to the *Musée d'Art Moderne de la Ville de Paris. It was opened there in 1947, but its origins are much older, for it is the heir to the Musée du Luxembourg, opened in 1818 as a showcase for the work of living artists. The Musée National d'Art Moderne has one of the world's greatest collections of modern art, exceeded in scope and quality probably only by the *Museum of Modern Art in New York. All the major movements are represented. Among the highlights is the studio of Constantin *Brancusi, which he left to the state and which has been reconstructed at the Centre.

Pompon, François (1855–1933). French sculptor, born at Saulieu, near Dijon, the son of a carpenter. He studied briefly at the École des Beaux-Arts in Dijon, but his main training was as a stonemason, and after settling in Paris in 1894 he worked as an assistant for various sculptors (including *Rodin) for the next 20 years. Although he later had several commissions for public monuments, it was not until the last decade of his career that he achieved genuine recognition. This came with his *Polar Bear* (Pompidou Centre, Paris), which scored a great success at the 1922 *Salon d'Automne and at the Exposition Internationale des Arts Décoratifs et Industriels Modernes (see ART DECO) in 1925. It was so popular that it was reproduced in a variety of forms (small pottery versions sold in large numbers), and Pompon was belatedly hailed as the greatest animal sculptor since Antoine Barye (1796–1875). He was acclaimed not only for the excellence of his craftsmanship, but also for his skill in rendering the essential form of animals with great economy of means. After Pompon's death his studio was reconstructed in the Jardin des Plantes, Paris, and after the Second World War its contents

were distributed to various museums, including the Musée Regional de Saulieu and the Musée des Beaux-Arts in Dijon. In 1994 the latter museum held a major exhibition of Pompon's work, which was also shown at the Musée d'Orsay, Paris. Reviewing this exhibition in the *Burlington Magazine* (November 1994), Patrick Elliott wrote: 'Pompon was probably the most influential animal sculptor of the 20th century and was among the first modern sculptors to draw direct inspiration from Egyptian, Gallo-Roman and Oriental art, types which profoundly affected the genesis of early avant-garde sculpture ... However, to hail him as a missing link in the formation of modern sculpture would be to misunderstand his art and even do him a disservice. He was a 19th-century sculptor who came to terms with the modern world rather than a 20th-century sculptor who opened new doors.'

Ponç, Joan (1927–84). Spanish painter and graphic artist, born in Barcelona, where he was a founding member of the *Dau al Set group in 1948. At this time his work was *Surrealist in flavour, featuring a world of fantastic landscapes inhabited by monsters. In the 1960s his style became more abstract, although still retaining vague Surrealist overtones. Apart from paintings, he produced a large body of graphic work, including etchings and lithographs. From 1955 to 1962 he lived in Brazil.

Poons, Larry (1937–). American abstract painter, born in Japan. Originally he studied music, but in 1958 he turned to painting and spent about six months at the Boston Museum School. In 1963, he had his first one-man exhibition, at the Green Gallery, New York, and thereafter he exhibited frequently, both in solo shows and major collective exhibitions. One of these was 'The Responsive Eye' at the Museum of Modern Art, New York, in 1965, the exhibition that gave currency to the term '*Op art', and Poons's early work are usually classified under this heading. They were an attempt to transpose musical structures into abstract geometrical compositions. Typically they featured a background of pure, bright, flat colour, against which ovoid spots of strongly contrasting colour (green against an orange background, for example) were arranged in patterns that can seem random but are in fact controlled by underlying grids.

The dots often seem to flicker or jump across the canvas. The lack of any points of emphasis in the compositions was reminiscent of the *all-over style initiated by Jackson *Pollock, and Poons shared with the *Abstract Expressionists a preference for very large canvases. By the end of the 1960s his work had become more painterly, the colour more austere and the dots extended to streaks. At the same time the paintings gained in depth and atmosphere, but Poons's interest remained primarily in the manipulation of colour. In the 1970s he broke completely with his earlier style, producing thickly-textured, amorphous compositions with cracked and blistered surfaces (in some works he incorporated pieces of foam rubber soaked in paint).

Pop art. A movement based on the imagery of consumerism and popular culture, flourishing from the late 1950s to the early 1970s, chiefly in the USA and Britain. The term was coined *c*. 1955 by the British critic Lawrence *Alloway ('I don't know precisely when it was first used', he later recalled, but 'sometime between the winter of 1954–5 and 1957 the phrase gained currency in conversation'; the first appearance in print recorded in the *Oxford English Dictionary* is of September 1957). Initially Alloway used the term (and also the expression 'Pop culture') to refer to 'the products of the mass media', rather than to 'works of art that draw upon popular culture', but by the early 1960s the phrase was being used as a label for such art. Comic books, advertisements, packaging, and images from television and the cinema were all part of the iconography of the movement, and it was a feature of Pop art in both the USA and Britain that it rejected any distinction between good and bad taste: 'there was some tension between two aims: that of breaking down the distinction between high art and popular culture and that of using elements of popular culture in order to comment critically on modern society' (Jonathan Law, ed., *European Culture: A Contemporary Companion*, 1993).

In the USA Pop art was initially regarded as a reaction from *Abstract Expressionism because its exponents brought back figural imagery and made use of impersonal handling. It was seen as a descendant of *Dada (in fact Pop art is sometimes called *Neo-Dada) because it debunked the seriousness of the art world and embraced the use or reproduction of commonplace subjects

(comic strips, soup tins, highway signs) in a manner that had affinities with *Duchamp's *ready-mades. The most immediate inspiration, however, was the work of Jasper *Johns and Robert *Rauschenberg, both of whom began to make an impact on the New York art scene in the mid-1950s. They opened a wide new range of subject-matter with Johns's paintings of flags, targets, and numbers and his sculptures of objects such as beer cans and Rauschenberg's *collages and *combine paintings with Coca-Cola bottles, stuffed birds, and photographs from magazines and newspapers. While often using similar subject-matter, Pop artists generally favoured commercial techniques in preference to the painterly manner of Johns and Rauschenberg. Examples are Andy *Warhol's silkscreens of soup-tins, heads of Marilyn Monroe, and so on, Roy *Lichtenstein's paintings in the manner of comic strips, Mel *Ramos's brash pin-ups, and James *Rosenquist's billboard-type pictures. Claes *Oldenburg, whose subjects include ice-cream cones and hamburgers, has been the major Pop art sculptor.

John Wilmerding (*American Art*, 1976) writes that Pop art 'cannot be separated from the culmination of affluence and prosperity during the post-World-War-II era. America had become a ravenously consuming society, packaging art as well as other products, indulging in commercial manipulation, and celebrating exhibitionism, self-promotion, and instant success . . . Pop's mass-media orientation may further be related to the acceleration of uniformity in most aspects of national life, whether restaurants or regional dialects. Shared by all Americans were the principal preoccupations of Pop art—sex, the automobile, and food. These became almost interchangeable, as Americans increasingly blurred distinctions between bathroom, highway, supermarket, and kitchen.'

In Britain, too, Pop art revelled in a new glossy prosperity following years of post-war austerity. British Pop was nurtured by the *Independent Group and the work that is often cited as the first fully-fledged Pop art image (though some of *Paolozzi's collages might also claim this title) was produced under its auspices—Richard *Hamilton's collage *Just What Is It that Makes Today's Homes So Different, So Appealing?* (Kunsthalle, Tübingen, 1956). However, British art first made a major impact at the *Young Contemporaries exhibition in 1961 (at about the same time that

American art became a force). The artists in this exhibition included Derek *Boshier, David *Hockney, Allen *Jones, R. B. *Kitaj, and Peter *Phillips, who had all been students at the *Royal College of Art. In the same year the BBC screened Ken Russell's film 'Pop Goes the Easel', in which Peter *Blake was one of the featured artists. Other British exponents of Pop include the sculptor Clive Barker (1940–), whose works are sometimes chromium-plated, the painter Gerald Laing (1936–), best known for pictures of cars, and the painter, printmaker, and sculptor Colin Self (1941–). Although there are exceptions (notably the erotic sculptures of Allen Jones), British Pop was generally less brash than American, expressing a more romantic view of the subject-matter in a way that can now strike a note of nostalgia. However, much of the imagery in British Pop came directly from the USA, expressing what Edward *Lucie-Smith describes as 'an uninhibited romantic hymn to a civilization half-real and half-imagined, a wonderland of pin-ups and pin-ball machines'.

Richard Hamilton defined Pop art as 'popular, transient, expendable, low-cost, mass-produced, young, witty, sexy, gimmicky, glamorous, and Big Business', and it was certainly a success on a material level, getting through to the public in a way that few modern movements do and attracting 'big-money collectors. However, it was scorned by many critics. Harold *Rosenberg, for example, described Pop as being 'Like a joke without humour, told over and over again until it begins to sound like a threat . . . Advertising art which advertises itself as art that hates advertising.'

Although mainly associated with Britain and the USA, Pop art has also had adherents elsewhere, including Valerio *Adami in Italy and *Erró, an Icelandic artist working in Paris. There are links with other movements, too, such as *Nouveau Réalisme in France. Some Pop artists have continued working with Pop imagery long after the movement's heyday was over, Allen Jones in Britain being a leading example.

Popova, Lyubov (1889–1924). Russian painter and designer, born near Moscow. She was one of the leading figures of Russian avant-garde art in its most exciting period, but she died tragically young of scarlet fever. After studying painting in Moscow, 1907–8,

she travelled extensively (she came from a wealthy bourgeois family) and in 1912–13 worked in Paris, frequenting the studios of two *Cubist artists—*Le Fauconnier and *Metzinger. When the First World War broke out she returned from Italy to Moscow, where she worked with *Tatlin and contributed to major avant-garde exhibitions. From Cubism she developed to complete abstraction in a series of pictures she called *Painterly Architectonics* (1916–20). They owe something to both Tatlin and *Malevich, but have a distinctive voice, especially in her rich colouring. Camilla Gray (*The Great Experiment: Russian Art 1863–1922*, 1962) writes that 'after Tatlin and Malevich, Popova was the outstanding painter of the post-1914 abstract schools in Russia . . . [Her paintings] are often executed on a rough board, and the angular forms—in strong blues, greens and reds—are brushed in on this crude, raw surface, leaving the impression of lightning-swift movement, a darting, breathless meeting of forces, a kiss-imprint, as it were, of the driving energy around us.'

Popova also worked as a designer of costumes and sets for the stage and of textiles ('everyday clothes for women in which subtle geometric patterns were placed against a plain background', Anna Moszynska, *Abstract Art*, 1990). Her best-known stage designs are her *Constructivist sets for Vsevolod Meyerhold's production of Fernand Crommelynck's *The Magnanimous Cuckold* (1922) at the Actors' Theatre in Moscow.

popular prints. A term used in the context of 20th-century culture to describe mass-produced and mass-marketed coloured reproductions that are generally bought as items of furnishing by people who otherwise demonstrate no interest in art. This kind of print was pioneered by the American firm of Currier & Ives, which operated in New York from 1857 to 1907, and in the 20th century many specialist firms have catered for the market: Frost & Reed and the Medici Society in Britain, for example, the New York Graphic Society in the USA, and Hanfstaengl in Germany. The subject has been given little serious attention, but Christine Lindey devotes an illuminating chapter to it in her book *Art in the Cold War: From Vladivostok to Kalamazoo, 1945–1962* (1990). She writes: 'Popular prints provided an ideal world: one in which fruits are unblemished, flowers never fade, and snow is never slushy . . . Landscapes are peaceful and unscarred,

animals roam free, children never grow up and work is virtually non-existent . . . Popular prints often echoed the outlooks as well as the looks of the mass-media imagery which conditioned daily life. As in the films and magazines, women were eternally glamorous and unharassed, foreigners quaint and Highland lakes ever misty. Christ, his saints, presidents and monarchs were invariably Caucasian and mostly Aryan. Nudes were coy and sex was never directly mentioned, though frequently alluded to in pounding waves on lonely rocks or in the abandoned dance of a billowing ballerina . . . The ubiquity of popular prints stemmed partly from the manner in which they were marketed and used. They were often sold by mail-order catalogue or in department stores. They were sold alongside household goods . . . [and] Populist advice on the choosing and hanging of pictures often suggested the suitability of particular subjects for specific rooms . . . taken overall, popular taste remained conservative. In the mid-fifties, the prints buyer from Sears, Roebuck, the biggest retailer in the world, regretted that: "Rembrandt, Renoir and Van Gogh don't sell . . . Our best seller is called *Fiery Peaks*. It's a picture of the Cascade Mountains either at sunset or sunrise, you can't tell which" . . . Although some Old and Modern Masters did reach a wide audience, the contemporary vanguard never reached wide popularity, and the majority of prints which were truly popular, in that they sold vast quantities, were traditional in style and content . . . the artists who fulfilled this demand mostly worked in a manner considered anachronistic or devoid of aesthetic merit by contemporary arbiters of taste.'

Few of these artists are well known by name, although Maxfield *Parrish was famous in the USA for many years and Sir Gerald *Kelly was once prominent in the field, his picture of a Burmese girl entitled *Saw Ohn Nyun* achieving enormous sales: Lindey writes that 'In 1961, when the leading British print publishers jointly prepared a poll of best-selling prints, Sir Gerald's was the winner', but she points out that another industry source claims the bestseller for the period 1959–61 was Rodrigues Clemente's *Red Skirt* (the picture that hangs on the living-room wall of Jack and Vera Duckworth in the television soap opera *Coronation Street*). The other artists who have achieved large sales of popular prints include the British marine

painter Montague *Dawson and the Russian-born, South African-domiciled Vladimir *Tretchikoff, probably the most financially successful specialist in the market; *The Chinese Girl* (1952), the most famous of his exotic beauties, is said to have sold more than half a million copies in large format. Among 'serious' artists whose work has achieved success in popular print form are Salvador *Dalí (particularly with religious works such as *Christ of St John of the Cross*) and Andrew *Wyeth (particularly with *Christina's World*).

P-Orridge, Genesis (1950–). British *Performance artist, rock musician, and editor, born Neil Andrew Megson in Manchester (he adopted his pseudonym in 1971). He gave his first performance in 1967 and in 1969 founded the group COUM Transmissions, which typically used sexual and violent imagery as a protest against industrial society. In 1976, as a means of reaching a wider audience, he founded the rock group Throbbing Gristle, which included his companion Cosey Fanni Tutti. 'It was as COUM that they caused a scandal in London in 1976; their exhibition 'Prostitution' at the *Institute of Contemporary Arts, consisting of documentation from Cosey's activities as a model for a pornographic magazine, sparked off a row in the press and in Parliament. Despite the warning on the invitation card that no one under the age of eighteen would be admitted, the press was outraged, accusing the *Arts Council (who partially sponsor the ICA) of wasting public money. Subsequently COUM were unofficially banned from exhibiting in galleries in England' (RoseLee Goldberg, *Performance Art*, 1988). Showing a different side to his talents, P-Orridge was co-editor of *Contemporary Artists* (1977), a vast compendium of information 'on 1350 artists of international reputation [P-Orridge included], selected by an international advisory board'.

Porter, Fairfield (1907–75). American painter, printmaker, writer, and editor, born in Winnetka, Illinois, son of an architect, **James Porter** (d. 1939), and brother of the distinguished photographer **Eliot Porter** (1901–90). He studied at Harvard University, 1924–8, and the *Art Students League, New York, 1928–30. His favourite subjects were interiors and landscapes, treated in a quiet, intimate way. His basic approach varied little over the years, but from the late 1940s his handling became broader, influenced by *Abstract Expressionism; in this sense there is a kinship with the work of his friend Larry *Rivers, although Porter's paintings are more solid and traditional (*Katie and Anne*, Hirshhorn Museum, Washington, 1955). Matthew Baigell (*Dictionary of American Art*, 1979) writes that 'His was a broad, placid stroke and a blonde palette, that of a modernized American *Impressionist or a follower of Pierre *Bonnard' (he was in fact influenced by an exhibition of the work of Bonnard and *Vuillard he saw at the Art Institute of Chicago in 1938). From 1935 Porter wrote art criticism and in 1951 he became associate editor of *Art News*. A collection of his criticism was published in 1979—*Art in its Own Terms: Selected Criticism, 1935–1976*; he also wrote a monograph on *Eakins (1959).

Portinari, Cândido (1903–62). Brazilian painter of Italian descent. He was born at Brodowski and studied at the National School of Fine Arts, Rio de Janeiro, 1918–21. In 1928 he was awarded a scholarship that took him to Europe for three years, 1928–31. Portinari is best known for his portrayals of Brazilian workers and peasants, but he dissociated himself from the revolutionary fervour of his Mexican contemporaries, and painted in a style that shows affinities with *Picasso's '*Neoclassical' works of the 1920s (which he saw in Paris during his scholarship years). In the 1940s he work acquired greater pathos and he also turned to biblical subjects, notably with a ceramic tile design on the life of St Francis of Assisi (1944) for the façade of the church of San Francisco at Pampulha, a suburb of Belo Horizonte. He gained an international reputation and his major commissions included murals for the Hispanic section of the Library of Congress in Washington (1942) and for the United Nations Building in New York (two panels representing *War* and *Peace*, 1953–5).

Posada, José Guadalupe (1851–1913). Mexican graphic artist. His enormous output was largely devoted to political and social issues, attacking, for example, President Porfirio Díaz, and revealing the dreadful conditions in which the poor lived. From 1890 he made his studio in Mexico City an open shop fronting the street, and turned out sensational broadsheerts and cheap cartoons that spread among the illiterate throughout the

country. His work had the vigour and spontaneity of genuinely popular art, with the inborn Mexican taste for the more gruesome aspects of death—one of his recurring motifs is the *calavera* or animated skeleton. He made a lasting impression on both *Orozco and *Rivera during their student days.

Post-Conceptual art. See CONCEPTUAL ART.

Post-Impressionism. Term applied to various trends in painting, particularly in France, that developed from *Impressionism or in reaction against it in the period c. 1880–c. 1905. Roger *Fry coined the term as the title of an exhibition, 'Manet and the Post-Impressionists', which he organized at the Grafton Galleries, London, in 1910–11. The exhibition was dominated by the work of *Cézanne, *Gauguin, and van Gogh, who are considered the central figures of Post-Impressionism. These three artists varied greatly in their response to Impressionism: Cézanne, who wished 'to make of Impressionism something solid and enduring, like the art of the museums', was preoccupied with pictorial structure; Gauguin renounced 'the abominable error of naturalism' to explore the symbolic use of colour and line; and van Gogh's uninhibited emotional intensity was the fountainhead of *Expressionism. Georges Seurat, a figure of almost equal importance, concentrated on a more scientific analysis of colour (see NEO-IMPRESSIONISM). The general drift of Post-Impressionism was away from the naturalism of Impressionism towards the series of avant-garde movements (such as *Fauvism and *Cubism) that revolutionized European art in the decade leading up to the First World War. (Some writers extend the notion of Post-Impressionism to cover these developments, making the term embrace the period c. 1880–c. 1914, but this makes an already broad concept less rather than more useful.)

Fry organized his first Post-Impressionist exhibition at short notice (to fill a gap in the gallery's programme) and in an almost casual atmosphere, but he brought together a highly impressive (if far from balanced) collection of pictures, mainly loaned by leading French dealers, including *Bernheim-Jeune and *Durand-Ruel. He was assisted by Clive *Bell and by the literary critic Desmond MacCarthy, who acted as secretary. There were more than 200 exhibits, Cézanne, Gauguin,

and van Gogh being represented by more than 20 pictures each. It was the first time they had been seen in such strength in Britain and the exhibition created what the *Daily Mail* called 'an altogether unprecedented artistic sensation' or what *Sickert more succinctly described as a 'rumpus'. Ian Dunlop (*The Shock of the New*, 1972) writes that 'There is a strong case for saying that it marks the high-water mark of public concern for art in Britain'. The extensive press coverage included some vicious attacks: Robert Ross, critic of the *Morning Post*, wrote that 'If the movement is spreading, it should be treated like the rat plague in Suffolk'. Some visitors were angry (Duncan *Grant recalled people shaking their umbrellas at the pictures) and others mocked (Desmond MacCarthy wrote of 'a stout elderly man . . . who went into such convulsions of laughter on catching sight of Cézanne's portrait of his wife . . . that his companion had to take him out and walk him up and down in the fresh air'). The conservative opinion was that the pictures on show were childish, crude, and the product of moral degeneracy or mental derangement. However, there was also a positive response. Duncan Grant said that he and Vanessa *Bell were 'wildly enthusiastic' about the exhibition, and it powerfully affected the work of several of the painters in Sickert's circle (see CAMDEN TOWN GROUP), in general encouraging the use of strong, flat colours. Sickert himself was on the whole rather blasé about it (he admired Gauguin and admitted—or pretended—to embarrassment that he had once advised him to stick to stockbroking, but he thought Cézanne overrated, lacking 'a sense of aplomb', and he disliked van Gogh's way of applying paint, although he said this was 'a mere personal prefer-ence').

Recalling the event forty years later, Clive Bell described the exhibition as 'a prodigious success. It set all England talking about contemporary painting, and sent the more alert not only to Paris but to museums and collections where they could have a look at primitive, oriental and savage art. The attendance was a record for the gallery; the sales were more than satisfactory; the Yorkshire Penny Bank, which held the Grafton Galleries in mortgage, made a pretty penny.' Douglas *Cooper, however (writing at about the same time as Bell), gave a very different assessment: 'one cannot help feeling that it was an unfortunate exhibition, for it presented a distorted

view of Post-Impressionist developments and, by virtue of its own inconsistencies, had the effect of frightening the English public away from rather than encouraging it to take an active interest in modern French art.'

In 1912 Fry organized a second Post-Impressionist exhibition at the Grafton Galleries. This was more wide-ranging, coherent, and up-to-date than the first (it included several *Cubist works), with a British section chosen by Clive Bell and a Russian section organized by Boris *Anrep. It too caused a great deal of controversy, but did not have quite the same impact as the first.

Post-Minimalism. A term coined in 1971 by the American critic Robert Pincus-Witten (1935–) to refer to developments in American art that succeeded *Minimal art (which had been the dominant avant-garde trend of the 1960s); Pincus-Witten first used it in print in an article entitled 'Eva *Hesse: Post-Minimalism into Sublime' in the November 1971 issue of *Artforum. It generally implies a reaction against the values of Minimalism, but sometimes it is used more neutrally, with the term 'Anti-Minimalism' being used to suggest a more deliberate antipathy. The broadness with which the terms are used can be gauged from the third edition (1986) of H. H. *Arnason's History of Modern Art, in which chapter 24 is entitled 'The Post-Minimal Seventies' and embraces such phenomena as *Conceptual art, *Land art, *Performance art, *Process art, and *Video art. The more or less common factor linking these was a desire to get away from 'the emphatic object qualities of Minimalist art . . . along with the commercialism that had overtaken the art scene . . . To avoid the stigma of commercialism and to recover something of the moral distance traditionally maintained by the avant-garde in its relations with society at large, certain anti-Minimalists ceased to make objects altogether, except as containers of information, metaphors, symbols, and meaningful images.'

Pincus-Witten also coined the word 'Maximalism' as a 'shock value journalistic term' to characterize various forms of art that were fashionable in the early 1980s, notably *Neo-Expressionism. It has also been used loosely as a synonym for *Postmodernism. Pincus-Witten published Post-Minimalism: Essays 1966–76 in 1977 and Post-Minimalism into Maximalism: American Art 1966–86 in 1987.

Postmodernism. A term that has been used in a broad and diffuse way, with reference to a wide range of cultural phenomena, to characterize a move away—beginning in about 1960—from the highbrow seriousness of *modernism in favour of a more eclectic and populist approach to creativity; according to one of the leading writers on the subject, 'Post-Modernism is fundamentally the eclectic mixture of any tradition with that of its immediate past: it is both the continuation of Modernism and its transcendence' (Charles Jencks, What is Post-Modernism?, 1986). The word came into common use in the 1970s and has featured prominently in discussions of contemporary art, on both an academic and a journalistic level, since about 1980. It has been employed both as a stylistic term (one can speak of Postmodern paintings or films) and as a period designation (the Postmodern age), but there has been much disagreement about how it should be used and even about whether it is worth using at all (as modernism is in itself a difficult concept, is it hard to be clear about the ways in which Postmodernism can be regarded as a development from it, and some writers even choose to refer to Postmodernisms). The diversity that is inherent to the concept of Postmodernism makes it particularly resistant to definition or summary, but Chris Baldick makes a brilliant attempt in the Concise Oxford Dictionary of Literary Terms (1990): 'it is applied to a cultural condition prevailing in the advanced capitalist societies since the 1960s, characterized by a superabundance of disconnected images and styles—most noticeably in television, advertising, commercial design, and pop video. In this sense . . . postmodernity is said to be a culture of fragmentary sensations, eclectic nostalgia, disposable simulacra, and promiscuous superficiality, in which the traditionally valued qualities of depth, coherence, meaning, originality, and authenticity are evacuated or dissolved amid the random swirl of empty signals . . . in very crude terms, where a modernist artist or writer would try to wrest a meaning from the world through myth, symbol, or formal complexity, the postmodernist greets the absurd or meaningless confusion of contemporary existence with a certain numbed or flippant indifference, favouring self-consciously "depthless" works . . . those who most often use it [the term] tend to welcome "the postmodern" as a liberation from the hierarchy of "high" and "low" cultures; while sceptics

(sometimes dismissively referring to the post-modern enthusiasts as "posties") regard the term as a symptom of irresponsible academic euphoria about the glitter of consumerist capitalism and its moral vacuity.'

The term was evidently first used by the Spanish literary critic Federico de Onís in his *Antología de la poesía española e hispano-americana, 1882–1932* (1934) and soon after-wards by the British historian Arnold Toynbee in his multi-volume work *A Study of History* (the part in which it appears was written in 1938 but not published until 1947). Toynbee used the word in a largely negative sense. He thought the Postmodern age began in about 1875 and was characterized by the decline in Christianity, capitalism, individualism, and the influence of the West. After Toynbee, the word appeared sporadically for the next two decades, mainly in literary contexts, and it was introduced to serious discussion of the visual arts by Nikolaus Pevsner (1902–83) during the 1960s. Pevsner used it in connection with architecture, and the writer chiefly responsible for popularizing it in English is the Anglo-American architectural historian Charles Jencks (1939–), author of *The Language of Post-Modern Architecture* (1975) and other books on the subject. Jencks used the term to describe a reaction against the austere, rational, clean-cut International Modern Style (see MODERN MOVEMENT) in favour of brash eclecticism, and it is in this sense that Postmodernism as a style has its clearest meaning. Postmodern architects returned to regional and traditional sources, introducing colour and ornament, often in a 'jokey' manner. One of the best known among them, the American Robert Venturi (1925–), wrote that he liked 'elements which are hybrid rather than pure' and preferred 'messy vitality' to 'obvious unity'.

Outside architecture it is usually less easy to categorize works as Postmodernist, but the word is often applied to paintings and sculpture that similarly blend disparate styles and make knowing cultural references, often in an ironic way. *Pop art, for example, has been retrospectively labelled Postmodernist, and there is indeed a kinship in the way it emphasized style and surface and blurred the distinction between high art and popular culture. More recently, the paintings that have been described as Postmodernist include the pseudo-classical works of the British artist Stephen McKenna (1939–) and of the Italian

Carlo Maria Mariani (see PITTURA COLTA), as well as Peter *Blake's *The Meeting or Have a Nice Day Mr Hockney* (Tate Gallery, London, 1981–3), a playful reworking of a picture by the 19th-century French painter Gustave Courbet, showing Blake, David *Hockney, and Howard *Hodgkin as the main protagonists. Other works that have been labelled Postmodernist range from pop songs by Madonna to novels by Salman Rushdie to films such as Jean-Jacques Beineix's *Diva* (1981), which uses elements of plot, setting, and character from several different cinematic genres. More broadly, some critics believe that Postmodernism pervades the whole of contemporary Western society; they argue that in a world dominated by technology and the mass media, culture inevitably becomes superficial and self-referential.

Post-Object art. See CONCEPTUAL ART.

Post-Painterly Abstraction. A term coined by the critic Clement *Greenberg to characterize a broad trend in American painting, beginning in the 1950s, in which abstract painters reacted in various ways against the *gestural 'painterly' qualities of *Abstract Expressionism. Greenberg used the term as the title of an exhibition he organized at the Los Angeles County Museum of Art in 1964. He took the word 'painterly' (in German 'malerisch') from the great Swiss art historian Heinrich Wölfflin (1864–1945), who had discussed it in his book *Kunstgeschichtliche Grundbegriffe* (1915), translated as *Principles of Art History* (1932). By it he understood 'the blurred, broken, loose definition of colour and contour'; Post-Painterly Abstractionists, in contrast, moved towards 'physical openness of design, or toward linear clarity, or toward both'. The characterization was never a very exact one, but essentially it described a rejection of expressive brushwork in favour of broad areas of unmodulated colour. The term thus embraces more precisely defined types of abstract art including *Colour Field Painting and *Hard-Edge Painting. Among the leading figures of the trend are Helen *Frankenthaler, Al *Held, Ellsworth *Kelly, Morris *Louis, Kenneth *Noland, Jules *Olitski, and Frank *Stella.

An alternative term that was used for a while but did not catch on in the same way is New Abstraction. It comes from the title of an exhibition at the Jewish Museum, New York,

Potter, Beatrix (1866–1943). British writer and illustrator of children's books, born in London to wealthy but neglectful parents. She was educated by governesses in her 'unloved birthplace' and sought solace from her loneliness in painting and drawing, particularly animals. Her love of nature was stimulated by holidays in Scotland and the Lake District (in old age she wrote 'It sometimes happens that the town child is more alive to the fresh beauty of of the country than a child who is country born'). In the late 1880s, to amuse young relatives, she began making drawings of animals dressed in clothes and engaged in human activities, and in 1893 she began writing picture letters to the child of one of her former governesses. These grew into her first book, *The Tale of Peter Rabbit*, which she published privately in 1901. The following year it was published commercially by the firm of Frederick Warne & Co., launching her highly successful career. (In 1905 she became engaged to Norman Warne, manager of her publishers, but he died of leukemia the following month; eventually, in 1913, she married her solicitor. Her parents disapproved of both matches, as they regarded her suitors as socially inferior.) She published more than 20 other books, including *The Tale of Benjamin Bunny* (1904) and *The Tale of Jemima Puddle-Duck* (1908), works that made her a part of nursery folklore. 'Her books were the first English classics for very young children, though their readership has always included many adults who return to them again and again to delight in their wit . . . In old age she came to resemble her own Mrs Tiggywinkle, round and twinkling-eyed' (*Oxford Companion to Children's Literature*, 1984). The earnings from her books allowed her to buy land and property in the Lake District, where she became a successful sheep breeder and was a generous supporter of the National Trust. Examples of her work are in the Beatrix Potter Gallery, Hawkshead, and the Tate Gallery and Victoria and Albert Museum in London. An exhibition was devoted to her at the Tate in 1987.

Pougny, Jean (Ivan Puni) (1892–1956). Russian-French painter of Italian descent (his grandfather was the composer Cesare Pugni). He was born in Kuokalla (later renamed Repino after Ilya *Repin), near St Petersburg, and studied in Paris (at the *Académie Julian and elsewhere), 1910–12. After returning to St Petersburg he became a member of avant-garde circles that included *Larionov, *Malevich, and *Tatlin. Pougny came from a well-off family, and his wife, the painter Kseniya Boguslavskaya (1892–1972), was an heiress; their wealth enabled them to finance avant-garde activities, including two major *Futurist exhibitions in St Petersburg (at this time known as Petrograd): 'Tramway V: The First Futurist Exhibition of Paintings' (1915) and '0.10. The Last Futurist Exhibition of Paintings' (1915–16). The second exhibition was originally intended to be called '0-10' (Zero-to-Ten) rather than 0.10 (Zero-point-Ten), but the latter form came about through a printing error in the catalogues and posters. Bruce Altshuler writes that the exhibition marked a 'radical break in Russian art, with the juxtaposition of Malevich's *Suprematist paintings and Tatlin's counter-reliefs. Moving to complete abstraction, they both departed from the *Cubist imagery of their colleagues and established the ground for the development of Russian art after the Revolution. The name of the exhibition referred to this new beginning . . . as Malevich wrote . . . in May 1915, "we intend to reduce everything to zero . . . [and] will then go beyond zero." It was to be the last Futurist exhibition, the end of Western European domination of the Russian avant-garde, and the beginning of a new age' (*The Avant-Garde in Exhibition*, 1994). At the time of these exhibitions Pougny himself was producing work in both Cubist and Suprematist vein. After the Revolution, he was given a teaching position at the reorganized Academy of the Fine Arts in Petrograd, but in 1919 he left Russia. He went first to Finland and then Berlin, where he exhibited at the *Sturm Gallery and with the *Novembergruppe. In 1923 he settled in Paris, where he abandoned his abstract and Cubist styles and painted mainly still-lifes and interiors in a late *Impressionist style, not unlike that of *Vuillard. He became a French citizen in 1946 and the following year was made a Chevalier of the Legion of Honour. Alan Bird (*A History of Russian Painting*, 1987) describes Pougny and his wife as 'artists of talent but of limited individuality'.

Pound, Ezra (1885–1972). American writer, active in Europe for most of his career. He is

principally famous as a poet, but he also wrote criticism and was an aggressive and controversial promoter of modern ideas in the visual arts as well as in literature. Pound was born in Hailey, Idaho, and studied Romance languages at the University of Pennsylvania and Hamilton College, Ithaca, New York. After teaching briefly at Wabash Presbyterian College, he settled in Europe in 1908, living mainly in London until 1920. His British friends included Wyndham *Lewis, and it was Pound who coined the name *Vorticism for the movement that Lewis launched in 1914. Pound contributed to the Vorticist magazine *Blast*, and wrote elsewhere about the work of several of the artists connected with the movement (for example, he contributed the 'Prefatory Note' to *Gaudier-Brzeska's memorial exhibition at the *Leicester Galleries in 1918). He also persuaded the American collector John *Quinn to buy Vorticist works. From 1920 to 1924 Pound lived in Paris, where he was involved in the *Dada movement, than settled at Rapallo in Italy until 1945. He became a supporter of Fascism and he developed bizarre economic theories that led him into anti-Semitic ideas about an international conspiracy of Jewish bankers. During the Second World War he made many broadcasts on Rome Radio attacking the US Government and the American war effort. He was arrested in 1945 and returned to America to face charges for treason, but he was pronounced 'insane and mentally unfit for trial' and was committed to a hospital for the criminally insane in Washington. There he regularly received visitors and kept up a voluminous output of writing. In 1958 he was released and allowed to return to Italy, where he spent the rest of his life. The events of his later years clouded his reputation, but he is regarded as holding a central position in modern literature; T. S. Eliot said that he was 'more responsible for the 20th century revolution in poetry than any other individual' and in the introduction to the *Oxford Companion to Twentieth-Century Poetry in English* (1994) Ian Hamilton comments that within its pages 'Ezra Pound is most often mentioned as an influence on other poets'. An exhibition entitled 'Pound's Artists: Ezra Pound and the Visual Arts in London, Paris and Italy' was held at the Tate Gallery, London, in 1985.

Pousette-Dart, Richard (1916–92). American abstract painter, born at St Paul, Minnesota.

He was mainly self-taught as an artist, although he learned much from his father, **Nathaniel Pousette-Dart** (1886–1965), a painter and writer. In 1936 he settled in New York. Initially he worked as a secretary and bookkeeper by day and painted by night, but by 1940 he had become a full-time artist. His work at this time was vaguely *Surrealist, with forms resembling primitive hieroglyphs painted in a heavy impasto. Over the next decade his rough textures gradually dissolved any suggestion of identifiable forms into an *all-over style of rich, jewel-like colours and he became recognized as part of the *Abstract Expressionist movement. However, his work retained a lyrical character of his own and David Anfam (*Abstract Expressionism*, 1990) describes him as 'a rather neglected figure, perhaps because of a religious mysticism which separated him from the mainstream'. Apart from painting, Pousette-Dart also experimented with various other media, including collage, photography, and sculpture (in metal and wire).

Poynter, Sir Edward (1836–1919). British painter and administrator, son of the architect Ambrose Poynter. He made his reputation with the huge *Israel in Egypt* (Guildhall, London, 1867) and he became one of the most popular painters of the day with similar elaborate historical tableaux in which he displayed his great prowess as a draughtsman. In the latter part of his career, however, he confined himself to smaller works, devoting his time mainly to administration. He was first *Slade professor of fine art at University College London, 1871–5; director for art at the South Kensington Museum (now Victoria and Albert Museum) and principal of the National Art Training School (now the *Royal College of Art), 1875–81; director of the National Gallery, 1894–1904; and president of the *Royal Academy, 1896–1918: 'A man of distinguished bearing, a good linguist, an artist with practical knowledge of every process of painting, possessing intimate experience of art education and long familiarity with the business of the Academy, he was well suited to this position' (*DNB*). At the Slade he established an emphasis on draughtsmanship that was to become characteristic of the school and at South Kensington he revived a stagnant curriculum (by virtue of this office he was also supervisor of the chief provincial art schools, and in these too he raised standards).

However, he was hostile towards recent developments in art, castigating the 'clique of self-styled "Impressionists" and their apologists in the Press' for 'their incompetency in drawing and slovenliness in execution' (preface to the 4th edition of his *Lectures on Art*, 1897). In his role as director of the National Gallery, Poynter was responsible for the arrangement and opening of the *Tate Gallery in 1897.

Praesens. See BLOK.

Prampolini, Enrico (1894–1956). Italian painter, sculptor, and designer, born in Modena. He joined the *Futurist movement in 1912 and in 1914 began making *mixed media, 'polymaterial' compositions (*arte polimaterica*) built up from a variety of materials—cork, sponges, tin foil, and so on. During the First World War he went through a *Dadaist phase, but then returned to Futurism (in 1929 he was one of the signatories of *Marinetti's manifesto of the offshoot movement *Aeropittura). From 1925 to 1927 he lived in Paris. With *Magnelli he was one of the leading pioneers of abstract art in Italy and he participated regularly in international exhibitions of abstract art. Apart from painting and sculpture, his work included a good deal of theatrical design.

Prassinos, Mario (1916–85). Greek-French painter, designer, and graphic artist, born in Constantinople. He moved to Paris in 1922, studied languages at the Sorbonne, 1932–6, and acquired French nationality in 1940. In 1937 he began exhibiting *Surrealist paintings, but after the Second World War he turned to expressive abstraction in the *Tachiste manner. Much of his work was concerned with the image of his grandfather Pretextat; Prassinos explained the obsession in his book *Les Pretextats* (1973). His work also included illustrations for several books and designs for the theatre and ballet.

praticiens. See DIRECT CARVING.

Precisionism. A movement in American painting, originating *c*. 1915 and flourishing in the interwar period, particularly the 1920s, in which urban and especially industrial subjects were depicted with a very smooth and precise technique, creating clear, sharply-defined, sometimes quasi-*Cubist forms. The terms 'Cubist-Realists', 'Immaculates', and 'Sterilists' have also been applied to Precisionist painters. There was no formal group, but some of the artists involved in the movement exhibited together. *Demuth, *O'Keeffe, and *Sheeler were the best-known figures; others included George *Ault, Ralston Crawford (1906–78), Preston *Dickinson, and Niles Spencer (1893–1952). In Precisionist painting the light is often brilliantly clear (although Ault is best known for his night scenes), and frequently forms are chosen for their geometric interest. There is no social comment—indeed there are usually no human figures in the paintings. Rather, the American industrial and technological scene is endowed with an air of epic grandeur. The degree of Cubist influence varied greatly. Some of Sheeler's paintings are in an almost photographically realistic style, whereas Dickinson's works are sometimes semi-abstract. Precisionism was influential in both imagery and technique on American *Magic Realism and later on *Pop art.

Preece, Patricia (1900–71). British painter of figure subjects and portraits, the second wife of Stanley *Spencer, with whom she had a bizarre relationship. She trained at the *Slade School, London, where she met another painter, Dorothy Hepworth, who became her lifelong companion. From 1921 to 1925 they lived in Paris, where Preece studied under *Lhote and Hepworth attended the Académie Colarossi; after returning to England they settled in Spencer's home village, Cookham, in 1927. Preece met Spencer in 1929 and became friendly with him and his first wife Hilda *Carline. Hilda later wrote that Patricia was interested in Spencer for his money (he did indeed spend recklessly on her) and 'set about to procure him, trying to keep the road clear to get rid of him when she wanted to … She vamped him to a degree unbelievable … If he went to her house, she always received him half or quarter dressed.' Spencer wanted to share his life with both women, but in 1937 he was divorced from Hilda and married Patricia five days later. However, Patricia then barred him from her home virtually immediately and the marriage was never consummated. She continued living with Dorothy Hepworth, and Penny Dunford writes that 'Hepworth devoted herself and her art to Preece, for the majority of works exhibited under Preece's name were executed by Hepworth, while Preece, who was the more out-

going of the two, negotiated with dealers and attended private views' (*A Biographical Dictionary of Women Artists in Europe and America Since 1850*, 1990). Preece's first solo exhibition was at the Reid & Lefevre Gallery, London, in 1936; Duncan *Grant wrote the preface to the catalogue.

Prem, Heimrad. See SPUR.

Prendergast, Maurice (1859–1924). Canadian-born American painter and printmaker. He was a member of The *Eight, but stood somewhat apart from the rest of the group. Boston was his home for most of his life and he spent much of his career travelling and painting abroad (he studied at the *Académie Julian, Paris, in the early 1890s); it was only in 1914 that he moved to New York, the centre of The Eight's activities. The main thing he had in common with other members was a desire to revive American art from academic stagnation, and his work is remarkable for its brilliant decorative colour. His paintings were often of people enjoying themselves in innocent pleasures (*Central Park in 1903*, Metropolitan Museum, New York, 1903). He was one of the first American artists to be influenced by *Post-Impressionism, notably in the way in which he emphasized flat pattern rather than illusionistic space. His love of colour and decorative effects was instinctive, however, rather than based on theoretical considerations. In 1913 he showed seven works in the *Armory Show and at this time he stood out as one of the most stylistically advanced American artists. Collectors of his work included Albert C. *Barnes, Lillie P. *Bliss, and John *Quinn. Most of his paintings were in watercolour, but in later years he turned increasingly to oils. He also made about 200 monotypes (mainly between 1891 and 1902), an unusually large œuvre in this medium. There is an outstanding collection of them in the Terra Museum of American Art, Chicago.

Pre-Raphaelitism. A term originally applied to the work of a group of young, idealistic British artists founded in 1848, and subsequently used to describe a dreamy, romantic, pseudo-medieval style of painting that was highly popular in Britain in the late 19th century and lingered well into the 20th. The link between the two types of Pre-Raphaelitism was the painter-poet Dante Gabriel Rossetti (1828–82); he was a member of the original

group, which favoured morally uplifting themes treated in a devoutly detailed style, but he subsequently changed his approach and specialized in pictures of langourous *femmes fatales*. His smouldering temptresses, together with the more pallid and ethereal beauties of Sir Edward Burne-Jones (1833–98), were immensely influential at the turn of the century, when they were part of the taste for *Symbolism. The painters who continued the Pre-Raphaelite tradition in the 20th century include Maxwell *Armfield, Robert Anning *Bell, Frank Cadogan *Cowper, Evelyn *De Morgan, Sidney Harold Meteyard (1868–1947), John Byam *Shaw, and John Melhuish Strudwick (1849–1937). After the First World War, work in this style was increasingly considered old-fashioned, and the reputations of the original Pre-Raphaelites slumped. Robin *Ironside's book *Pre-Raphaelite Painters*, published in 1948 to mark the centenary of the founding of the Brotherhood, was the first scholarly modern book on the subject, but it was not until the 1960s that there was a major revival of interest in Pre-Raphaelitism.

Preston, Margaret (1875–1963). Australian painter, printmaker, writer, and lecturer, born in Adelaide and active mainly in Sydney. She had a thorough training, beginning at the Adelaide School of Design and progressing via Melbourne to Munich and Paris. After briefly returning to Australia, she had a second, longer stay in Europe, from 1910 to 1920, during which she lived in Paris and London and moved from an academic style to a more modern idiom influenced by *Fauvism. She was 'a woman of great independence of mind, volatile in temperament, ardently patriotic and consumed by a passion for experimentation in painting media and all kinds of graphic techniques' (Bernard Smith, *Australian Painting 1788–1990*, 1991). In the 1920s her work was characterized by 'strong, simple and blocky shapes, first only in oils, later in woodcut, lino-cut, masonite-cut, silk-screen, and monotype—and indeed almost anything else that could be cut and printed' (Smith). A good example is *Implement Blue* (Art Gallery of New South Wales, Sydney, 1927), a powerful still-life showing a collection of crockery and other tableware casting dense blue shadows. By the time she painted this picture she was recognized as one of the leading artists in the country; the journal *Art in Australia* devoted a special issue to her in 1927. Her characteristic

subjects included bush landscapes and flower paintings of native flora, and she was passionately devoted to the idea of creating a distinctive national art, promoting this through writing and lecturing as well as painting. She was one of the first to appreciate Aboriginal art, her article 'The Indigenous Art of Australia', published in *Art in Australia* in March 1925, being a pioneering work in the field. Much of her own work from the 1940s onwards shows the influence of such art, particularly in her adoption of earthy colours.

Primary Structures. Name given to a type of sculpture that came to prominence in the mid-1960s, characterized by a preference for extremely simple geometrical shapes and frequently a use of industrially fabricated elements. The term was popularized by an exhibition entitled 'Primary Structures' at the Jewish Museum, New York, in 1966, organized by the museum's curator of painting and sculpture, Kynaston McShine (1935–). Among the artists who worked in this vein were Carl *Andre, Dan *Flavin, Donald *Judd, Sol *LeWitt, Robert *Morris, and Tony *Smith. Primary Structures comes within the scope of *Minimal art and the two terms have sometimes been used synonymously.

primitivism. A term employed in the context of 20th-century art to refer to the use by Western artists of forms or imagery derived from the art of so-called primitive peoples, or more broadly to describe an approach in which the artist seeks to express or celebrate elemental forces by using unconventional procedures or techniques that bypass the methods normally associated with the trained painter or sculptor. In the broader sense, the term 'primitivism' has been used to embrace such diverse phenomena as child art, *naive art (which is sometimes known as primitive art), the art of the mentally ill (see ART BRUT), and *Graffiti art. These varied forms of art are linked to each other and to the art of 'primitive' peoples by a belief that such 'innocent' expression can have a freshness and emotional honesty often lacking in mainstream Western art.

The word 'primitive' suggests a lack of sophistication relative to some particular standard. It was once widely used, for example, of pre-Renaissance European painting, especially of the Italian and Netherlandish schools (as in the expression 'the Flemish

primitives'); the Renaissance had established the idea of painting as the imitation of nature that dominated Western art for centuries, so paintings from earlier periods were long found wanting in the representational skills that had become accepted as the norm. This usage of the word 'primitive' is now much less common and no longer has derogatory implications. The term 'primitive art' is now mainly used to cover the art of societies outside the great Western, Near Eastern, and Asian civilizations, particularly Pre-Columbian art, North American Indian art, African art south of the Sahara, and Oceanic art. Again, the term was once derogatory or patronising, as such art generally seemed uncouth or savage to Western eyes, but it is now used as a label of convenience; as Robert *Goldwater wrote in 1955, 'We all know by now that primitive art is not primitive in any esthetic sense, since we rank its finest achievements with those of the highest of high cultures; nor in any technical sense, since it includes powerful stone carvings and bronze and gold work of great delicacy; and it is often not primitive in any cultural sense, since the societies from which it emerges vary from the simple structures of the interior of New Guinea or the south-western Congo to the complicated feudal organizations of Benin and the civilizations of Central America'.

For centuries, such art was known in the West mainly as colonial booty, and it attracted interest either for its curiosity value or (if made of precious materials) for its monetary worth (in 1520 Albrecht Dürer enthused about Aztec treasures sent to the Emperor Charles V from 'the new land of gold'). Although the idea of the 'noble savage' untainted by European civilization had a vogue in the 18th century, it was not until the 1890s that primitivism made a significant impact on Western art—in the work of *Gauguin, who tried to escape 'the disease of civilization' among the natives of Tahiti. From about 1905 many other avant-garde artists followed his example in cultivating primitive art as a source of inspiration, finding in it a vitality and sincerity that they thought had been polished out of Western art. Usually they followed Gauguin in spirit rather than body, although *Nolde and *Pechstein, for example, visited Oceania. Many artists in Paris collected African masks (which could be bought very cheaply in curio shops), among them *Derain,

*Matisse, *Picasso, and *Vlaminck, and their influence is particularly clear in Picasso's *Les Demoiselles d'Avignon* (MOMA, New York, 1907), the painting that stands as the fountainhead of *Cubism. More generally, the simplification and exaggeration of forms seen in much primitive art were influential on the anti-naturalistic trend of avant-garde art in the period of unprecedented experimentation in the decade before the First World War.

Australian aboriginal art has tended to be excluded from broad discussions of primitivism because it was not until after this key period that it became the subject of serious interest: 'Despite being one of the longest continuous traditions of art in the world, dating back at least fifty millennia, it remained relatively unknown until the second half of the twentieth century' (Wally Caruana, *Aboriginal Art*, 1993). Margaret *Preston, in the 1920s, was one of the first to consider Aboriginal art as *art*, rather than ethnographic material, and she was one of the first non-Aboriginals to be influenced by it in her own work.

European artists saw examples of primitive art not only in their own and other artists' studios, but also in various public collections. Picasso, for example, visited the Musée d'Ethnographie in Paris, the members of Die *Brücke frequented the Museum für Völkerkunde in Dresden, and Henry *Moore was impressed by the powerful block-like forms of Maya sculpture he saw in the British Museum in London. Moore later said 'I began to find my own direction, and one thing that helped, I think, was the fact that Mexican sculpture had more excitement for me than negro sculpture. As most of the other sculptors had been moved by negro sculpture, this gave me a feeling that I was striking out on my own.' In spite of their enthusiasm for such art, few Western artists in the first half of the 20th century had much knowledge of the cultural background of the primitive objects they admired; in line with *formalist aesthetics, they believed that visual devices could be transposed from one culture to another without loss of power or meaning. Patrick *Heron expressed such an outlook in 1955 when he wrote: 'The palpable forms, the actual rhythms, the precise manipulations of space—these are the prime realities, the determining factors, the definite features which cause an art to be great or trivial. Even the horror of a stone bowl made for containing

twitching human remains, fresh-torn from sacrificial victims, is in a curious way neutralized if the thing is "beautiful": that is, if it transmits a vital rhythm.' (Heron was referring to a Maya 'Chacmool' figure, holding an offering bowl, that had inspired Henry Moore.)

Such visual 'appropriation' of the culture of 'primitive' peoples has sometimes been interpreted as a kind of exploitation, akin to the exploitation or native labour or resources by colonial powers. However, there is evidence that certain modern artists approached primitive art in a spirit that was far from cynical or opportunist. For example, the American art historian Patricia Leighten has argued that there was a close link between Picasso's use of African masks as source material and contemporary anarchist protests against imperialism ('The White Peril and *l'art nègre*: Picasso, Primitivism, and Anticolonialism', *Art Bulletin*, vol. lxxii (1990), pp. 609–30). Similarly, in 1931, the Paris *Surrealists used tribal art in their exhibition 'The Truth about the Colonies', which was a protest against a recently opened official exhibition celebrating the French colonies. See also NEO-PRIMITIVISM.

Prini, Giovanni. See GALLERIA NAZIONALE D'ARTE MODERNA, ROME.

Print Renaissance or Print Revival. Terms sometimes used to describe an upsurge of interest in printmaking among American artists from the late 1950s. It was characterized by the opening of several workshops specializing in the creation of high quality artists' prints, the first of which (producing lithographs) was Universal Limited Art Editions (ULAE) at West Islip on Long Island, New York, set up in 1957 by the Russian-born Mrs Tatyana Grosman (1904–82). Her friends Fritz *Glarner and Larry *Rivers were among the first to work there; they were followed by Jasper *Johns (1960), Robert *Rauschenberg (1962), and other well-known artists. In 1960 the most famous establishment of the Print Renaissance—the Tamarind Lithography Workshop—was established in Los Angeles (it is named after a street there) by June Wayne (1918–), a painter, printmaker, designer, and writer. She had 'received a grant from the Ford Foundation to set up a workshop where experienced lithography printers would work with students, already trained in an art

school or university, in a master-and-apprentice system. The students would progress as they mastered successively more complex techniques until they became master lithographers, at which time they either succeeded the shop master, set up their own shops, or became teachers of lithography' (Riva Castleman, *Prints of the 20th Century*, revised edn., 1988). In addition, practising artists were given two-month fellowships to work there. The Workshop flourished in Los Angeles until 1970 and then was transferred to the University of New Mexico in Albuquerque as the Tamarind Institute. During its decade in Los Angeles, 104 artists held fellowships, including Sam *Francis and Louise *Nevelson. Among the successful Tamarind graduates was Kenneth Tyler (1931–), who in 1966 was one of the founders of Gemini GEL (Graphics Editions Ltd.) in Los Angeles. In 1967 it produced Rauschenberg's six-feet-high *Booster*, the largest lithograph ever printed up to that date. It was not only lithography that figured in the Print Renaissance; *screenprinting became popular in the early 1960s, and the Crown Point Press in Oakland, California, established by Kathan Brown in 1962, specialized in intaglio processes such as etching.

Process art. A term applied to a trend in avant-garde art in the late 1960s and early 1970s in which emphasis is put not on the formal aspects of a work but on the processes involved in creating it and on the processes of change and decay it is subject to thereafter. This stress on impermanence is seen as an aspect of *Post-Minimalism—the reaction against the impersonality, *formalism, and commercialism of *Minimal art. In his revision (1986) of H. H. *Arnason's *History of Modern Art*, Daniel Wheeler writes that Process artists 'took perishability as an all-important criterion in their choice of materials and allowed the deteriorating effect of time to become their principal means. The Process artist's action concludes once he has selected the substance—ice, grass, soil, felt, snow, sawdust, even cornflakes—of his piece and has "sited" it, usually in some random, structureless way, such as scattering, piling, draping, or smearing. The rest is left to natural forces, time in tandem with gravity, temperature, atmosphere, etc.' Examples of Process art include Richard *Serra's *Splashing* (1968), in which he splashed molten lead against the bottom of a wall in the Leo *Castelli gallery,

New York, and Robert *Morris's *Untitled* (1967–73), consisting of clouds of steam. Some Process art has a more enduring life, however, including sculptures made of soft material (see SOFT ART), in which there is a degree of permanency but no fixed form.

Procházka, Antonin. See GROUP OF PLASTIC ARTISTS.

Procktor, Patrick (1936–). British painter, printmaker, illustrator, and theatrical designer, born in Dublin. After serving in the Royal Navy, he studied at the *Slade School, 1958–62. His work is varied in subject—including landscapes, townscapes, figure compositions, portraits, and interiors—and is frequently based on his extensive travels. He often works in watercolour and his style is distinguished by limpid colouring. As a printmaker he favours aquatint. The books he has illustrated include Coleridge's *Rime of the Ancient Mariner* (1976), and his own publications include *A Chinese Journey* (1980), illustrated with aquatint landscapes. He has taught at various art schools in London and elsewhere, including the *Royal College of Art.

Procter, Dod (1892–1972). British painter of portraits, figure subjects, landscapes, and flowers, born Doris Shaw in London. Her father was a ship's doctor and her mother (as Eunice Richards) had trained as a painter at the *Slade School. Dod studied under Stanhope *Forbes in Newlyn (see NEWLYN SCHOOL), 1907–10, and then at the Académie Colarossi in Paris. In 1912 she married the painter **Ernest Procter** (1886–1935), who had been a fellow student in Newlyn and Paris. They lived mainly in Newlyn, but they spent a year in Rangoon, Burma, carrying out decorations at the Kokine Palace (1920) for a Chinese millionaire, and Dod travelled widely after Ernest's death. She was one of the best painters working in Newlyn in the period after its heyday, and she was very popular among her fellow artists; in 1907 Laura *Knight described her as 'a charming young thing, with a brilliant complexion, enormous dark eyes and long slender legs—swift and active as a gazelle'. However, she is now remembered mainly for one work—*Morning* (Tate Gallery, London, 1926). She wrote that 'When I had finished it, I knew it was the best thing I had done up to then', and many of her

contemporaries were likewise quick to recognize it as an exceptional work. The *Daily Mail* bought it for the nation when it was on show at Newlyn Art Gallery, and in 1927 it was voted 'picture of the year' at the *Royal Academy summer exhibition. Dod returned in triumph to Newlyn, where she was greeted by flags and a brass band, and the painting went on a tour of provincial galleries. It shows Cissie Barnes, the 16-year-old daughter of a local fish merchant, lying sleeping on her bed in the dawn light. The simplified, strongly-modelled forms of the body recall the contemporary work of *Picasso. Simon Wilson remarks that 'Its power as a painting certainly partly stems from its strong atmosphere of burgeoning adolescent sexuality, although this does not seem to have been acknowledged at the time' (*Tate Gallery: An Illustrated Companion*, 1990). In the 1930s Dod's style became much softer and more painterly. She continued working into old age, and when she died in Newlyn in 1972 she was the last link with the village's great artistic flowering at the turn of the century.

Ernest Procter's range of subjects was similar to that of his wife, but his figure paintings leaned more towards allegorical and religious themes (he was a devout Christian) and he did a good deal of decorative work, including a remarkable composition for the altar wall of St Mary's Church, Penzance. Nikolaus Pevsner describes it as 'a spectacular affair of 1934, with a whole prospect including the heavenly host, a corrugated silvery backcloth, jagged rays; all smacking a little of the Wurlitzer' (*The Buildings of England: Cornwall*, 1970). Ernest also worked as a designer—of carpets, furniture, and glassware, for example—and he invented a novel technique that he called 'Diaphaenicons', 'in which layers of plate glass were mounted one behind the other and lit in such a way that the images on them, usually flowers, appeared to float in three-dimensional space' (catalogue of the exhibition 'Dod Procter RA . . . Ernest Procter ARA', Laing Art Gallery, Newcastle upon Tyne, 1990). In 1934 he was appointed director of studies in design and craft at *Glasgow School of Art, but he died the following year.

Proctor, Thea. See CONTEMPORARY GROUP.

Production art. See INKHUK.

Proun. A term coined by *Lissitzky for a series of abstract pictures he made between 1919

and *c.* 1924; it is said to be an acronym of Russian words meaning 'Project for the affirmation of the new'. The Prouns were influenced by *Suprematism, 'but by converting *Malevich's squares and planes into images of three-dimensional forms, now tipped and tilted to secure effects of multiple perspectives, Lissitzky created strongly architectural paintings' (George Heard *Hamilton); Lissitzky, indeed, described Prouns as 'the interchange station between painting and architecture', and in 1923 he designed a Proun Room for the 'Great Berlin Art Exhibition', 'where he combined, for the first time, *Constructivist detailing and furniture with Suprematist wall reliefs and other Suprematist features. Thereafter, this peculiar synthesis constituted the basis of a whole series of exhibitions throughout the 1920s' (*Macmillan Encyclopedia of Architects*, 1982). These represent one of the first steps towards the concept of *Environment art.

Pryde, James (1866–1941). British painter and designer. He was born in Edinburgh and studied there at the Royal Scottish Academy, 1886–7, and then for three months at the *Académie Julian, Paris. In the 1890s he designed posters with his brother-in-law William Nicholson under the name J. & W. *Beggarstaff. Pryde sometimes supplemented his income at this time by taking small parts on the stage. As a painter he is best known for dramatic and sinister architectural views, with figures dwarfed by their gloomy surroundings. They have something of the spirit of the prison etchings by the 18th-century Italian artist Giovanni Battista Piranesi, but they are broadly brushed, and in the entry on Pryde in the *Dictionary of National Biography*, Derek Hudson says that they were probably influenced by his 'early Edinburgh memories—the high-ceilinged, dimly-lit interior of the house [in which he lived] in Fettes Row, the four-poster in Mary Queen of Scots' bedroom at Holyrood, the strings of washing outside the upper windows of the tall tenement buildings off the High Street'. Pryde—'tall and handsome', but 'dilatory, extravagant, and unproductive for long periods'—did little after 1925. However, in 1930 he designed the sets for Paul Robeson's memorable *Othello* at the Savoy Theatre, London.

public art. A term that can in its broadest sense be applied to any painting or sculpture

designed to be displayed in public open spaces but which since about 1970 has also been used in a more restricted sense to refer to art that is envisaged as part of the life of the community in which it is sited. The most common form of such public art has been the mural. Michael Archer (*Art Since 1960*, 1997) writes that 'No longer was it acceptable for artists commissioned to make works for public spaces simply to impose their solutions upon a passive public. Lengthy periods of consultation, public meetings and discussion were entered into to establish the wishes and requirements of the local population before any work was undertaken . . . Russian revolutionary art and the murals of the Mexicans Diego *Rivera . . . and David Alfaro *Siqueiros . . . were looked to as influential precursors by the public artists of the 1970s. The task of the mural was twofold: to depict events that celebrated the political power of the working class (in whose areas they overwhelmingly appeared) and to provide some visual excitement in what was otherwise usually a depressed and run-down area. Many of these community-based projects were completed across the US and Europe.' Initially such projects were generally informally funded (sometimes relying on donations of material) and often involved collaboration between professional artists and local people. In the 1980s, however, funding from local government and other official sources became more common. In 1983 the Public Art Development Trust was established in Britain.

Puni, Ivan. See POUGNY.

Punin, Nikolai (1888–1953). Russian art critic. From 1918 to 1921 he was active in the organization of *Narkompros and in 1921 he was one of the founders of the Petrograd (St Petersburg) section of *Inkhuk. During the 1920s he was one of the most widely read of Russian writers on art. He believed that modern art criticism should be scientific and even tried to reduce the creative process to a mathematical formula: $S(Pi + Pii + Piii . . .)Y = T$, where S is the sum of the principles (P), Y is intuition, and T is artistic creation. It is therefore not surprising that Punin preferred the 'engineer' *Tatlin to the artist *Malevich, concluding that Malevich was too subjective to examine material in a scientific and impartial manner. Even so, Punin was a keen supporter of many different members of the Russian avant-garde. He also did valuable research on earlier Russian art. His *formalist views were opposed to the ideals of *Socialist Realism demanded by Stalin, and after the Second World War he was one of a number of critics who were persecuted for their 'cosmopolitan' views (the campaign against them was led by Alexander *Gerasimov). In 1949 Punin was arrested and sent to a prison camp in Siberia, where he died.

Punk art. See NEO-EXPRESSIONISM.

Purism. A movement in French painting advocating an art of clarity and objectivity in tune with the machine age; its founders and sole exponents were Amédée *Ozenfant and *Le Corbusier, who met in Paris in 1918, and it flourished from then until 1925. Feeling that *Cubism—'the troubled art of a troubled time'—was degenerating into an art of decoration, they regarded their association as a call for order, or as they put it, 'a campaign for the reconstitution of a healthy art', their object being to 'inoculate artists with the spirit of the age'. They set great store by 'the lessons inherent in the precision of machinery' and held that emotion and expressiveness should be strictly excluded from art, apart from the beauty of functional efficiency—the 'mathematical lyricism' that is the proper response to a well-composed picture. Their characteristic paintings are still-lifes—cool, clear, almost diagrammatically flat, and impersonally finished.

Despite the anti-emotionalism of this functionalist outlook, Ozenfant and Le Corbusier advocated Purism with missionary fervour and dogmatic certainty. Ozenfant had begun the attack on Cubism with an article in his periodical *L'*Élan* in 1916, but as a movement Purism was launched with a short book he wrote with Le Corbusier, *Après le Cubisme* (1918). They also expounded their ideas in another joint book, *La Peinture moderne* (1925), and in the journal *L'*Esprit nouveau*, which they ran from 1920 to 1925. The journal attracted contributions from eminent artists and writers of various persuasions, but Purism was more important in theory than in practice and did not succeed in establishing a school of painting. Both protagonists seemed to realize that it represented something of a dead end pictorially and moved on to much looser styles. Its main sequel is to be found in

the architectural theories and achievements of Le Corbusier and more generally in the field of design, where there is some kinship with the contemporary ideals of the *Bauhaus. As George Heard *Hamilton writes, 'Purism did encourage a serious look at the products and the methods of producing objects in modern times . . . Whenever we admire the simple contour or refined shape of an article of daily use, we share in the Purist aesthetic.' See also NEOCLASSICISM.

Purrmann, Hans (1880–1966). German painter. He was born in Speyer, son of the painter **Georg Heinrich Purrmann** (1844–1900), and trained with his father and then in Karlsruhe and Munich. From 1906 to 1914 he lived in Paris, where he became a friend of *Matisse and helped to run his art school. He was one of Matisse's most talented followers and he wrote of the master: 'In my personal contact with Matisse, I noticed how strictly he examined and judged the effect as a whole. He always seemed to ask himself how he should fill his canvases to create something expressive, clear and penetrating, without any superfluous ballast.' Until 1935 Purrmann worked mainly in Berlin, then moved to Italy, his work having been declared *degenerate by the Nazis. From 1944 he lived mainly in Switzerland. In his later work he moved from the bright *Fauvist colour inspired by Matisse to a mellower style akin to that of late *Renoir.

Purser, Sarah (1848–1943). Irish painter, designer, patron, collector, and administrator. Her father was a wealthy industrialist, but his business collapsed in 1873 and she endured considerable poverty for several years. She studied at the Metropolitan School of Art, Dublin, c. 1874–6, and at the *Académie Julian, Paris, 1878–9. On her return to Ireland she became a successful society portraitist and in her own words 'went through the British aristocracy like the measles'. Although her paintings are highly accomplished (and made her a good deal of money), they are generally fairly run-of-the-mill and she is more important for her other roles in Irish art. She knew everyone who mattered (from 1911 she held regular social gatherings for Dublin's intelligentsia at her home, Mespil House) and in 1924 she founded the Friends of the National Collections of Ireland. One of its aims was to campaign for the return of Sir Hugh *Lane's pictures from London to Dublin and she helped to secure Charlemont House as the home for what became the Hugh Lane Municipal Gallery of Modern Art. Perhaps most importantly, she was the founder of the stained-glass workshop *An Túr Gloine; the work produced there, which can be seen in so many Irish churches, is her finest memorial.

Puryear, Martin (1941–). American sculptor, born in Chicago into a middle-class black family. He studied painting at the Catholic University, Washington, graduating in 1963, then worked as a Peace Corps volunteer in Sierra Leone, studied printmaking and sculpture at the Academy in Stockholm, and travelled in Japan. After returning to the USA he took a Master of Fine Arts degree at Yale University in 1971 and settled in New York in 1973. His work is abstract, typically in wood and usually elegantly austere and softly curving in form (*Lever #3*, NG, Washington, 1989). He is one of the few African-American artists to have personal experience of Africa, and Edward *Lucie-Smith writes: 'Attempts to align his work with African artefacts have been made by enthusiastic critics, but seem fruitless in the face of Puryear's own statement that, when in Africa, he felt like an outsider—not part of the customs of the people among whom he lived' (*Art Today*, 1995). Puryear has a high reputation; Daniel Wheeler (*Art Since Mid-Century*, 1991) writes that his may be 'the most impressive new sculpture to come from an American in the 1980s'.

Pushkin Museum, Moscow. See MOROZOV and SHCHUKIN.

Puteaux Group. A group of artists, affiliated with the *Cubists, who met informally between 1911 and 1913 in the studios of Jacques *Villon and Raymond *Duchamp-Villon in the Parisian suburb of Puteaux. Their brother Marcel *Duchamp was also a member of the group, and others included *Archipenko, *Gleizes, *Gris, *Kupka, *Léger, and *Metzinger. The group (under the direction of Duchamp-Villon) produced a rather uninspired 'Cubist House' at the *Salon d'Automne of 1912 and in the same year organized the *Section d'Or exhibition. They criticized Analytical Cubism on the ground that it lacked human interest and introduced an interest in colour that led to *Orphism.

Puvis de Chavannes, Pierre. See BIENNALE

Puy, Jean (1876–1960). French painter and printmaker, born at Roanne. He trained at the École des Beaux-Arts, Lyons (1895–8) and in Paris at the *Académie Julian (1898) and the *Académie Carrière (1899), where he became a friend of *Matisse. His early work was *Impressionist, but he became one of the more moderate members of the *Fauves, exhibiting with them at the famous *Salon d'Automne show of 1905. He painted traditional subjects such as landscapes, nudes, interiors, and flowers in a bright, clear, spontaneous style. After the heyday of Fauvism (1905–7) his work became more straightforwardly naturalistic. Apart from paintings he produced etchings, lithographs, and woodcuts as book illustrations. His brother **Michel Puy** (1878–?) was an art critic; he was one of the first writers to champion the Fauves and was also sympathetic to *Cubism.

Pye, Patrick. See KELLY, OISÍN.

Pyle, Howard. See PARRISH.

Quadriga. A group of four German abstract painters founded in Frankfurt in 1952: Karl Otto Götz (1914–), Otto Greis (1913–), Heinz Kreutz (1923–), and Bernard Schultze (1915–). They were later joined by Emil Schumacher (1912–). Their work was a German version of *Art Informel. The group first exhibited at the Galerie Franck in Frankfurt in December 1952 with the title 'Neo-Expressionists', but at the opening of the exhibition the writer René Hinds gave a speech in which he coined the name 'Quadriga' for the four artists. It referred to a Roman four-horsed chariot and was meant to suggest the energy of their work. Schultze and Schumacher went on to join the *Zen 49 group of abstract painters.

Quietism. See TONALISM.

Quinn, John (1870–1924). American lawyer, collector, and patron. Quinn was of Irish ancestry and came to collecting through purchasing manuscripts of Irish literary works. He did not start collecting paintings and sculpture until after the turn of the century, but he then rapidly became a major figure in the field of avant-garde art; indeed, he was described by Alfred H. *Barr as 'the greatest American collector of the art of his time'. He was legal representative to the *Armory Show (1913), and was a major lender to and purchaser at the exhibition. It introduced him to *Brancusi's work, and from then until his death eleven years later, Quinn was Brancusi's most important patron, buying most of his output. The other artists he patronized included Augustus *John, whom he met in London in 1909. John's biographer Michael Holroyd paints a very unattractive picture of Quinn: 'while being financially generous, he was a triumphantly mean man. His letters to Augustus and other artists and writers are always business letters, and almost always interchangeable . . . To lack of humour he prudently added lack of charm, and . . . perfected the art of boredom . . . He ensnared his victims in the web of his money and inflicted on them his terrible jokes, appalling lectures, his deathly political harangues' (*Augustus John*, 1976). The other artists whose work Quinn collected included *Epstein, *Gaudier-Brzeska (his interest in these two came through his friend Ezra *Pound), *Matisse, *Picasso, and *Rousseau, as well as various Americans. Quinn also played an important role in creating a buoyant art market in New York by successfully campaigning for works of art less than 20 years old to be exempt from import duty. His collection was known only to his friends during his lifetime, but in 1926 part of it was shown in a memorial exhibition at the New York Art Center. The collection was sold at auction in Paris and New York in 1926–7. Its dispersal encouraged A. E. *Gallatin to open his own collection to the public as the Museum of Living Art in New York.

Quinn, Marc. See YOUNG BRITISH ARTISTS.

Quintanilla, Isabel. See SPANISH REALISTS.

RA. See ROYAL ACADEMY.

Rabin, Oskar (1928–). Russian painter, one of the leading figures of *Unofficial art in the Soviet Union. He was born in Moscow and trained at the Riga Academy, 1944–7. For many years he worked as a railway porter and engine driver in Moscow, painting in his spare time, but from 1967 he was a full-time artist. His subjects were often taken from the railway and also included fantastic cityscapes juxtaposed with incongruous objects such as a samovar, a torn vodka label, or even a Titian nude. Characteristically he painted in thick impasto, mainly with a palette knife and generally in subdued ochre and umber tones. Although his work did not conform to the ideals of the officially approved *Socialist Realism, he was allowed to exhibit abroad, and he was the only Unofficial artist included in the exhibition of contemporary Soviet art held at the Grosvenor Gallery, London, in 1964. In a review of this exhibition, the art critic of *Time* magazine wrote: 'The only Russian painter who might be at home in any Western city's art museum is Oskar Rabin, an outcast.' In the following year he had a one-man exhibition at the same gallery and the *Daily Telegraph*'s art critic, Terence Mullaly, described him as a 'major talent'. However, Alan Bird (*A History of Russian Painting*, 1987) writes that although 'Rabin's paintings have a modest gentleness and sentimental charm ... his work does not differ noticeably from the run of pictures to be seen in exhibitions sponsored by the [Soviet] Union of Artists'. Rabin left Russia in 1978 and settled in Paris. His wife **Valentina** (1924–) is a painter, as was her brother, Lev Kropivnitsky (1922–79), who spent nine years in labour camps.

Rabuzin, Ivan (1921–). Yugoslav *naive painter, born in the village of Ključ, near Novi Marof, in the Zagorje region of Croatia. He trained as a cabinet-maker in Zagreb, where he also attended evening classes in drawing. In 1950 he became foreman of a furniture factory in Novi Marof and in 1956 he held his first one-man exhibition in this village. He won first prize at the Federal Exhibition of Yugoslav Amateur Painters at Zagreb in 1958, and had his second one-man exhibition,' at the Gallery of Naive Art in Zagreb, in 1960. In the same year a film about his work appeared on Yugoslavian television. His growing success enabled him to give up his job at the furniture factory in 1963 and devote himself full-time to painting. In 1969 he was awarded the Henri Rousseau prize in Bratislava, and his work has been seen in many exhibitions in his own country and abroad. Rabuzin's most typical subjects are landscapes, painted in a bright and optimistic manner. Usually there are no figures, but there are often signs of human activity—neatly ploughed fields and so on. Everything is in perfect order, in a radiant vision: 'In my picture I beautify nature. In other words, in nature I create an order that suits me, I create a world that pleases me and appears the way I want it to.'

Rackham, Arthur (1867–1939). British illustrator, celebrated for his work in children's books. He was born in London, into a comfortable middle-class family. From 1885 to 1892 he worked as a clerk in an insurance office whilst attending evening classes at Lambeth School of Art, where his fellow students included Charles *Ricketts and Charles *Shannon. In 1892 he started working as a pictorial journalist for the *Westminster Budget* and he began illustrating books the following year. The book that established his reputation was *Fairy Tales of the Brothers Grimm*, published in 1900, and from then until the First World War he had his golden period, when Edmund *Dulac was his only serious rival as an illustrator of children's books. They were very different in

style. Dulac was much more painterly, using strong expressive colour, whereas Rackham relied on wiry line and subtle, muted colour. He said he believed in 'the greatest stimulating and educative power of imaginative, fantastic and playful pictures and writings for children in their most impressionable years', and he worked in a striking vein of Nordic fantasy, creating a bizarre world populated by goblins, fairies, and weird creatures (he looked rather like a gnome himself). After the First World War the market for expensive children's books declined, but he continued to prosper from gallery sales of his work. He had a high reputation abroad as well as in Britain, notably in the USA, which he visited in 1927. He also visited Denmark (1931) in preparation for illustrations to an edition of Han's Christian Andersen's *Fairy Tales* (1932). From the 1920s he occasionally painted in oils, and in 1933 he made a solitary venture into stage design for a production of Humperdinck's opera *Hansel and Gretel*. His last work, finished shortly before his death, was a set of illustrations for an edition of Kenneth Grahame's *The Wind in the Willows* (1940). Rackham's wife, Edyth Starkie (1867–1941), was a portrait painter.

Räderscheidt, Anton. See NEUE SACHLICHKEIT.

Raedecker, John (1885–1956). Dutch sculptor, painter, and draughtsman, born in Amsterdam, the son of a decorative sculptor. He originally trained in his father's profession, then studied drawing at the Amsterdam Academy and took up painting. From the 1920s, supported by the critic H. P. Bremmer (see KRÖLLER-MÜLLER), he became the leading Dutch sculptor working in a traditional vein. His most famous work, designed in collaboration with the architect J. J. P. Oud, is the National Monument (1947–56) in Amsterdam, a memorial to the Second World War.

Rainer, Arnulf (1929–). Austrian painter, printmaker, photographer, and collector, born in the spa town of Baden, near Vienna. He had virtually no formal instruction in art (he stayed for a total of less than a week at the two art schools he attended in Vienna in 1949–50), and his technical procedures are often unconventional. His early works, mainly drawings and prints, were inspired by the fantastic vein of *Surrealism, and after a

visit to Paris in 1951 he was influenced by *Abstract Expressionist and *Art Informel paintings that he saw there. Although he met André *Breton in Paris, he soon moved away from Surrealism, and in the mid-1950s he began producing *Overpaintings*, in which he took as a basis a painting, drawing, or photograph (either his own work or someone else's) and partially obliterated the image with monochromatic colour. A similar concern with reworking surfaces occurs in many of his prints, in which he sometimes uses the same plates again and again. Riva Castleman writes that 'His earliest prints taken from these plates date from 1964, but the same plates, progressively covered with more scratches, capturing the ink ever more thickly, were still being printed in 1986 and the artist had no intention of abandoning them' (*Prints of the 20th Century*, revised edn., 1988). Overpaintings dominated Rainer's work for about a decade, until the mid-1960s, but he also produced a series of cruciform pictures during this period (*Black Cross*, Lenbachhaus, Munich, 1956). In 1963 he began collecting *Art Brut and the following year he began experimenting with hallucinogenic drugs—indications of his interest in extreme emotional states. From 1973 he sometimes painted with his fingers. Rainer has collaborated with other artists, notably Dieter *Roth.

Ramírez Villamizar, Eduardo (1923–). Colombian sculptor, born in Pamplona. He originally studied architecture, then turned to painting in 1943; in the 1950s he moved on to reliefs and by 1963 was making fully three-dimensional works. Since then he has come to be regarded alongside *Negret as his country's leading abstract sculptor. He lived in New York from 1963 to 1973 and has had numerous public commissions in the USA as well as in his own country. Edward *Lucie-Smith writes: 'Ramírez Villamizar's sculptures are in general less complex than Negret's, and more regular and rational in their approach to form. They are often characterized by powerful, repeated diagonal rhythms. Their simplicity and use of repeated units bring them close to American *Minimal Art but they avoid all trace of minimalist passivity' (*Latin American Art of the 20th Century*, 1993).

Ramos, Mel (1935–). American painter. He was born in Sacramento, California, and stud-

ied at San José State College and Sacramento State College, 1954–8. His first exhibition was at the Bianchini Gallery, New York, in 1964, but he has lived and worked mainly in California, where he has taught at the California State University, Hayward, since 1967. Ramos is usually described as a *Pop artist, but his smooth, impersonal handling (in oils and watercolour) brings him also within the orbit of *Superrealism. He specializes in paintings of nude women of the calendar pin-up or 'playmate' type. Sometimes they are posed with oversized products such as pieces of cheese and sometimes they allude to the work of leading painters of the past (more rarely the present). 'One of the central issues of my work has been the notion that art grows from art. I've been fascinated by the myths, iconography, and clichés that have perpetuated themselves throughout the history of art in various forms and idioms.' The jokey quality of his work is reflected in his titles; two typical series are 'You Get More Spaghetti with Giacometti' and 'You Get More Salami with Modigliani'.

Ramsden, Mel. See ART & LANGUAGE.

Ranson, Paul. See ACADÉMIE.

Ratcliffe, William. See CAMDEN TOWN GROUP.

Rauschenberg, Robert (1925–). American painter, printmaker, designer, and experimental artist; with his friend Jasper *Johns, whom he met in 1954, he is regarded as one of the most influential figures in the move away from the *Abstract Expressionism that had dominated American art in the late 1940s and early 1950s. Rauschenberg was born in Port Arthur, Texas, and became interested in art after a chance visit to a gallery while serving in the US Navy as a neuro-psychiatric technician, 1942–5. He said of his work in the navy: 'This is where I learned how little difference there is between sanity and insanity and realized that a combination is essential.' After leaving the navy he studied at Kansas City Art Institute, 1946–8, the *Académie Julian, Paris, 1948, *Black Mountain College, 1948–9, and the *Art Students League of New York, 1949–52. Black Mountain College made the greatest impact on him and he returned several times in the early 1950s. The people he met there included the composer John *Cage and the dancer Merce Cunningham (1919–),

both of whom influenced him greatly (he was designer for Cunningham's dance company from 1955 to 1965).

Rauschenberg had his first one-man show (coolly received) at the Betty *Parsons gallery, New York, in 1951. At this period his work included minimalist monochromatic paintings. In the mid-1950s he began to incorporate three-dimensional objects into what he called '*combine paintings'. The best-known example is probably *Monogram* (Moderna Museet, Stockholm, 1955–9), which features a stuffed goat with a rubber tyre around its middle, splashed with paint in a manner recalling *Action Painting. Other objects he used included Coca-Cola bottles, fragments of clothing, electric fans, and radios, and because of his preoccupation with such consumer products he has been hailed as one of the pioneers of *Pop art. In 1958 he was given a one-man show by Leo *Castelli and from this time his career began to take off. By the early 1960s he was building up an international reputation, and in 1964 he was awarded the Grand Prize at the Venice *Biennale. This caused great controversy, the Vatican newspaper *L'Osservatore Romano* describing the award as 'the total and general defeat of culture'.

In the 1960s Rauschenberg returned to working on a flat surface and was particularly active in the medium of *screenprinting. He has been interested in combining art with new technological developments and in 1966 he helped to form EAT (Experiments in Art and Technology), an organization to help artists and engineers work together. 'I am, I think, constantly involved in evoking other people's sensibilities. My work is about wanting to change your mind. Not for the art's sake, not for the sake of that individual piece, but for the sake of the mutual coexistence of the entire environment.' In line with these beliefs, in 1985 he launched Rauschenberg Overseas Cultural Exchange (ROCI), an exhibition dedicated to world peace that toured the world and included works created specifically for each place visited. Since 1971 Rauschenberg has lived mainly on Captiva Island off the coast of Florida.

Raverat, Gwen (1885–1957). British graphic artist, theatre designer, painter, and writer, born in Cambridge, the daughter of Sir George Darwin, professor of astronomy, and granddaughter of Charles Darwin. She studied at the *Slade School, 1908–11, but was

mainly self-taught in wood engraving, which was her primary activity. In 1911 she married Jacques Raverat, a French mathematics student at Cambridge who had taken up painting and studied with her at the Slade. They spent much of their time in France until his death in 1925; thereafter she lived in London and Cambridge. She was a founder of the Society of Wood Engravers in 1920 and was best known for her book illustrations, notably of collections of poems by her cousin Frances Cornford and for the *Cambridge Book of Poetry for Children*, selected by Kenneth Grahame (1932). Her style was bold and vigorous and she was uninterested in technical virtuosity. Although she was art critic for *Time and Tide* from 1928 to 1939, she did not consider herself a writer and was surprised at the success of *Period Piece* (1952), an account of her childhood with her own illustrations, which became a bestseller on both sides of the Atlantic.

Ravilious, Eric (1903–42). British watercolour painter, printmaker, and designer, born in London. He had his main training at the *Royal College of Art (1922–5), where he was influenced by his teacher Paul *Nash and became a lifelong friend of his fellow student Edward *Bawden. In addition to paintings, his highly varied output included book illustrations and book-jackets and designs for furniture, glass, textiles, and the Wedgwood pottery factory (including a commemorative mug for Edward VIII's coronation; this was withdrawn following Edward's abdication, but the design was used in revised form for the coronations of George VI and Elizabeth II). Ravilious was one of the outstanding wood engravers of his time, his book illustrations in this medium making striking use of bold tonal contrasts and complex patterning (some of his work was done for Robert *Gibbings's Golden Cockerel Press). He also experimented with colour lithography. In 1940 he was appointed an *Official War Artist, and he produced some memorable watercolours of naval scenes off Norway (*Norway, 1940*, Laing Art Gallery, Newcastle upon Tyne). While on a flying patrol near Iceland in September 1942 his plane disappeared, and he was officially presumed dead the following year.

His wife **Tirzah Ravilious**, née Garwood (1908–51), whom he married in 1930, was a painter and illustrator. She gave up her career for motherhood (they had three children), but she started work again after Eric's death, even though she was already suffering from the cancer that caused her own early death.

Raw Materialist art. See ARTE POVERA.

Ray, Man. See MAN RAY.

Raynal, Maurice. See ROSENBERG, LÉONCE.

Rayonism (Rayonnism, Rayism; in Russian, Luchism). A type of abstract or semi-abstract painting practised by the Russian artists *Goncharova and *Larionov and a few followers from about 1912 to 1914 and representing their own adaptation of *Futurism. Rayonism was launched at the *Target exhibition in Moscow in 1913. In the same year Larionov published a manifesto on the subject, although it bore the date June 1912 (he claimed to have been painting in a Rayonist manner as early as 1909, but Russian artists of this time were not averse to backdating their works in an effort to stake their claims as pioneers of modernism). The manifesto stated: 'Rayonism is a synthesis of *Cubism, Futurism and *Orphism', and Rayonist pictures do indeed combine something of the fragmentation or splintering of form of Cubism, the dynamic movement of Cubism, and the colour of Orphism. The style was bound up with a very unclear theory of invisible rays, in some ways analogous to the 'lines of force' that were postulated by the Futurists. These lines or rays were thought to be emitted by objects and intercepted by other objects in the vicinity, and it was the artist's task to manipulate them for his own aesthetic purposes: 'The rays which emanate from the objects and cross over one another give rise to rayonist forms. The artist transfigures these forms by bending them and submitting them to his desire for aesthetic expression.' In early Rayonist paintings an underlying subject is broken up into bundles of slanting lines, but in later ones the lines take over the picture completely so that there is no discernible naturalistic starting-point and the work becomes completely abstract, as in Larionov's *Rayonist Composition: Domination of Red* (MOMA, New York, dated on painting 1911, but thought to have been executed *c*. 1913–14). Rayonism was short-lived as both Goncharova and Larionov virtually abandoned easel painting after they left Russia in 1915 and they had no significant followers.

Raysse, Martial (1936–). French painter and experimental artist. He was born at Golfe-Juan, near Nice, and has worked mainly in Paris. He has experimented with various media (including neon lighting), but is best known for his *assemblages of commonplace objects in the spirit of *Pop art. Often these works have a neat, display-rack character: 'I wanted my works to possess the serene self-evidence of mass-produced refrigerators.' Raysse has also made a name as a theatrical designer.

RCA. See ROYAL COLLEGE OF ART.

Rea, Betty. See ARTISTS INTERNATIONAL ASSOCIATION.

Read, Sir Herbert (1893–1968). British poet and critic, who throughout the middle third of the 20th century was virtually unchallenged as his country's foremost advocate and interpreter of modern art. He was born at Kirbymoorside, Yorkshire, of farming stock, and studied at Leeds University before serving in France in the First World War; his distinguished record as a soldier lent an added authority to his later pacifism. After the war he worked at the Treasury, then in the ceramics department of the Victoria and Albert Museum, 1922–31, before becoming Watson Gordon professor of fine arts at Edinburgh University, 1931–3. By this time he had published several collections of his verse as well as various art-historical studies (including *English Stained Glass*, 1926, still a standard work), critical works on English literature, and the first of his philosophical works on art, *The Meaning of Art* (1931). In 1933 he returned to London as editor of the *Burlington Magazine* (1933–9) and his attention turned increasingly to contemporary art; in 1933 he published *Art Now*, the first comprehensive defence in English of modern European art, in 1934 he edited the modernist manifesto *Unit One*, and in 1936 he was one of the organizers of the International *Surrealist Exhibition in London. At this time he lived near Henry *Moore, Barbara *Hepworth, and Ben *Nicholson, and he acted as the public mouthpiece of the group of artists of which they were the centre; Moore later wrote that 'In the 1930s he was available to all in the way that he could see both sides of any situation and act as a link between the different things that were going on.' In the late 1930s Read planned

a Museum of Modern Art in London, of which he would have been the first director. The Second World War ruined the plans, but some of the ideas bore fruit in the *Institute of Contemporary Arts, which he founded with Roland *Penrose in 1947 as 'an adult play-centre . . . a source of vitality and daring experiment'.

In 1950 Read returned to Yorkshire, but he spent a good deal of his time abroad as a speaker at international conferences. He also kept up a steady stream of books. His most influential work was probably *Education Through Art* (1943), which used the insights of psychoanalysis to promote the idea of teaching art as an aid to the development of the personality. His other books include *A Concise History of Modern Painting* (1959) and *A Concise History of Modern Sculpture* (1964), both of which have been frequently reprinted. By the time he wrote these surveys he was becoming disenchanted with contemporary artistic developments, and in 1967 he described 'the anti-art manifestations of *Tinguely, *Rauschenberg, Jasper *Johns, *Warhol and *Oldenburg' as a 'confused but comprehensible form of Nihilism . . . behind them is a deep despair, a denial of the meaningfulness of life'. In his later years he was regarded as 'something of a sage. It was not a role to which he ever pretended, for he was a man of conspicuous modesty' (*DNB*). His reputation has remained undimmed since his death: in the winter 1993 issue of *Modern Painters*, David Cohen wrote: 'Herbert Read was indubitably a giant in the history of modernism. Alfred H. *Barr is his only serious rival as the most influential English-speaking advocate of contemporary art between the early 1930s, when Read first turned his professional attention to the subject, and his death in 1968.' However, not everyone was impressed by Read and his work. John *Skeaping wrote: 'I distrusted him—his style of writing struck me as a specious use of pseudo-intellectual jargon', and he quoted Edith *Sitwell describing him as 'That crashing bore'.

ready-made. A name given by Marcel *Duchamp to a type of work he invented consisting of a mass-produced article selected at random, isolated from its functional context, and displayed as a work of art. His first ready-made (1913) was a bicycle wheel, which he mounted on a kitchen stool. Strictly speaking, this was a 'ready-made assisted', but other

'pure' ready-mades soon followed, notably *Bottle Rack* (1914), *In Advance of the Broken Arm* (a snow shovel, 1915), and the celebrated *Fountain* (1917), consisting of a urinal which he signed 'R. Mutt' (the name of a firm of manufacturers of sanitary ware); most of the originals have disappeared, but several replicas exist. The ready-made can be considered a type of *objet trouvé (found object), although Duchamp himself made a clear distinction between them, pointing out that whereas the objet trouvé is discovered and chosen because of its interesting aesthetic qualities, its beauty and uniqueness, the ready-made is one—any one—of a large number of indistinguishable mass-produced objects. Therefore the objet trouvé implies the exercise of taste in its selection, but the ready-made does not. When *Fountain* was rejected by the hanging committee of the *Society of Independent Artists, Duchamp defended his creation by writing: 'Whether Mr Mutt with his own hands made the fountain or not has no importance. He CHOSE it. He took an ordinary article of life, placed it so that its useful significance disappeared under a new title and point of view . . . [he] created a new thought for that object.' He thus demonstrated his belief in the absurdity of life and the values of art, his 'contention that it is futile to define a work of art except as an intellectual or philosophical decision, as a mental fact, as a victory of consciousness over matter and of will over taste' (George Heard *Hamilton). The ready-made was one of *Dada's most enduring legacies to modern art. It was much used in *Nouveau Réalisme and *Pop art, for example, and Robert *Rauschenberg calls *Bicycle Wheel* 'one of the most beautiful pieces of sculpture I've ever seen'.

realism. A term used with various meanings in the history and criticism of the arts, and—particularly in the study of 20th-century art—in a confusing variety of combination forms. In its broadest sense, the word is used as vaguely as 'naturalism', implying a desire to depict things accurately and objectively. Often, however, the term carries with it the suggestion of the rejection of conventionally beautiful subjects or of idealization in favour of a down-to-earth approach, with a stress on low life or the activities of the common people. In a more specific sense, the term (usually spelled with a capital R) is applied to a movement in 19th-century (particularly French) art characterized by a rebellion against the traditional historical, mythological, and religious subjects in favour of unidealized scenes of modern life.

The term *Social Realism has been applied to 19th- and 20th-century works that are realistic in this second sense and make overt social or political comment. It is to be distinguished from *Socialist Realism, the name given to the officially approved style in the Soviet Union and some other Communist countries; far from implying a critical approach to social questions, it involved toeing the Partly line in a traditional style.

Since the 1950s the term 'realism' has also been used in a completely different way, describing art that eschews conventional illusionism. This usage is found mainly in the terms *New Realism and *Nouveau Réalisme, which have been applied to works made of materials or objects that are presented for exactly what they are and are known to be.

*Magic Realism and *Superrealism are names given to two styles characterized by extreme realism—in the sense of acute attention to detail. *Neo-Realism and *Néo-Réalisme refer to specific minor aspects of British and French art respectively, but both terms have also been used in vaguer senses.

Reality. See HOPPER.

Rebay von Ehrenweisen, Baroness Hilla. See GUGGENHEIM.

Rebel Art Centre (also called Cubist Centre). Organization founded by Wyndham *Lewis in April 1914 at 38 Great Ormond Street, London, after he had quarrelled with Roger *Fry and broken with the *Omega Workshops. The Centre was intended to be a place in which artists and craftsmen could meet, work, and hold discussions, lectures, and classes. Lewis issued a prospectus in which he said the Centre would be based on 'principles underlying the movements in painting known as *Cubist, *Futurist and *Expressionist'. Financial backing came from the painter Kate Lechmere (1887–1976). Other members included *Dismoor, *Etchells, *Nevinson, Helen Saunders (1885–1963), and *Wadsworth. A group exhibition of Rebel Art Centre work was held at the *Allied Artists' Association in June 1914; the Centre closed the following month, but *Vorticism grew out of it.

Rebeyrolle, Paul (1926–). French painter, born at Eymoutiers, Haute-Vienne. Rebeyrolle had painted from childhood and took it up seriously when he moved to Paris in 1944, studying at the Académie de la Grande Chaumière. He had grown up in the countryside with a love of hunting and fishing and often painted rural themes; the Vaugirard slaughterhouses, near where he lived, also provided some of his subjects, which he treated in earthy colours in a robust style, with a caricature-like approach to faces and bodies. With a number of like-minded painted he founded the *Social Realist group *Homme-Témoin in 1948. He won the Prix de la Jeune Peinture in 1950 and the Prix Fénéon in 1951 and became regarded as a leader in the realist tendency—in opposition to the prevailing abstraction—in post-war French painting. His work also had a notable influence on young British realists of the time. In 1956 Rebeyrolle started to develop a looser style and in the 1960s his subjects were sometimes barely legible among his splashed and swirling paint.

'Recording Britain' (in full 'Recording the Changing Face of Britain'). A project for making a pictorial record of Britain begun in 1939 at a time when widespread destruction was expected to occur during the Second World War. It was sponsored by the Pilgrim Trust, a foundation established in 1930 by the American philanthropist Edward Harkness (1874–1940) 'to help preserve the national heritage of the United Kingdom of Great Britain and Northern Ireland, and to promote the future well-being of the country and its people'. The scheme was administered by three leading figures in the art world (who later were all members of the War Artists' Advisory Committee—see OFFICIAL WAR ART): Kenneth *Clark (director of the National Gallery), William Russell *Flint (representing the *Royal Academy), and Percy *Jowett (principal of the *Royal College of Art); they agreed the subjects, chose the artists, and organized exhibitions of the work produced (including several at the National Gallery). Almost a hundred artists took part, including Walter *Bayes, Graham *Bell, John *Piper, Michael *Rothenstein, Kenneth *Rowntree, and Ruskin *Spear, and more than 1,500 pictures were produced, covering most of the English counties and several in Wales. In 1943 the Victoria and Albert Museum, London, took responsibility for the paintings, loaning some

of them to provincial galleries. After the war the Oxford University Press published four volumes of reproductions of the pictures for the Pilgrim Trust (*Recording Britain*, edited by Arnold Palmer, 1946–9), and the Edinburgh firm of Oliver & Boyd later published a companion volume on Scotland (*Recording Scotland*, edited by James B. Salmond, 1952).

Redon, Odilon (1840–1916). French painter and graphic artist, one of the outstanding figures of *Symbolism. He led a retiring life, first in his native Bordeaux, then from 1870 in Paris, and until he was in his fifties he worked almost exclusively in black-and-white—in lithographs and charcoal drawings. In these he developed a highly distinctive repertoire of weird subjects—strange amoeboid creatures, insects, and plants with human heads—influenced by the writings of Edgar Allan Poe. He remained virtually unknown to the public until the publication of J. K. Huysmans's celebrated novel *A Rebours* in 1884; the book's hero, a disenchanted aristocrat who lives in a private world of perverse delights, collects Redon's drawings, and with his mention in this classic expression of decadence, Redon too became a figurehead of the movement. During the 1890s he turned to painting and revealed remarkable powers as a colourist that had long lain dormant. Much of his early life had been unhappy, but after undergoing a religious crisis in the early 1890s and a serious illness in 1894–5, he was transformed into a much more buoyant and cheerful personality, expressing himself in radiant colours in visionary subjects, flower paintings, and mythological scenes (*The Chariot of Apollo* was one of his favourite themes). He showed equal facility in oils and pastels, and after 1900 also carried out a number of decorative schemes, the largest of which (1910–11) was for the library at the former abbey of Fontfroide, Narbonne, the home of one of his patrons, Gustave Fayet. The two main panels in this scheme represent *Night* and *Day*. Redon's flower pieces, in particular, were much admired by *Matisse, and the *Surrealists regarded him as one of their preecursors. By the end of his life he was a distinguished figure (he was awarded the Legion of Honour in 1903), although still a very private person. A collection of his writings was published posthumously in 1922 under the title *A Soi-même*; it contains personal material such as diaries as well as art criticism.

Redpath, Anne (1895–1965). Scottish painter. She was born in Galashiels, the daughter of a tweed designer (she later described how she used flecks of colour in a manner similar to tweed makers: 'I do with a spot of red or yellow in a harmony of grey, what my father did in his tweed'), and studied at Edinburgh College of Art, 1913–19. In 1920 she married James Beattie Michie, an architect with the War Graves Commission in France, where they lived for the next fourteen years. During this time she did little painting, devoting herself to her family (she had three sons). In 1934 she returned to Scotland, living first in Hawick and then from 1949 in Edinburgh (she became gradually estranged from her husband, who worked in London). From the 1950s she attained a distinguished position in the Scottish art world and was awarded various honours. Her main subjects were landscapes and still-lifes, richly coloured and broadly handled in the tradition of the *Scottish Colourists (in her later work there is sometimes a hint of *Expressionism). She travelled a good deal, painting landscapes in, for example, Spain and Portugal. 'Like her painting, Anne Redpath's character had a style which delighted those who knew her. She had great and very feminine charm, and an integrity which allowed her to enjoy the material success of her last years without being in any way altered by it' (*DNB*).

Reed, John and **Sunday**. See ANGRY PENGUINS.

Reed, Paul. See WASHINGTON COLOR PAINTERS.

Refus Global. See AUTOMATISTES.

Regionalism. A movement in American painting, flourishing chiefly in the 1930s, concerned with the depiction of scenes and types from the American Midwest. The term is often used more or less interchangeably with *American Scene Painting, but Regionalism can be more precisely thought of as the Midwestern branch of this broader category. Like all American Scene painters, the Regionalists were motivated by a patriotic desire to establish a genuinely American art by using local themes and repudiating avant-garde styles from Europe. Specifically they were moved by a nostalgic desire to glorify, or at least to record, rural and small-town America, and it was on this that their widespread popularity depended. The period when they flourished coincided with the Great Depression, and at this time of profound national doubt, they reasserted America's faith in itself, giving the public pictures with which they could readily identify. Robert *Hughes has pointed out the irony 'that Regionalism, supposed to be the expression of American democracy, was in its pictorial essence the kissing cousin of the official art of 1930s Russia. If *socialist realism meant sanitized images of collective rural production, green acres, new tractors, bonny children and muscular workers, so did the capitalist realism [of Regionalism] . . . Both were arts of idealization and propaganda.'

The three major Regionalists were Thomas Hart *Benton, John Steuart *Curry, and Grant *Wood, who were all Midwesterners but differed greatly in temperament and style. They scarcely knew one another personally, but the idea of a group identity was skilfully promoted by Maynard Walker, a Kansas art dealer. Walker got a Benton self-portrait onto the cover of the Christmas 1934 issue of *Time* magazine and this largely created the image of Regionalism in the public eye; thus, as Robert Hughes writes, 'it became the only art movement ever launched by a mass-circulation magazine', or as Benton put it: 'A play was written and a stage erected for us. Grant Wood became the typical Iowa small towner, John Curry the typical Kansas farmer, and I just an Ozark hillbilly. We accepted our roles.' Benton was the most vociferous of the group and in his autobiography *An Artist in America* (1937) he summed up the attitudes he shared with the other Regionalists: 'We objected to the new Parisian aesthetics which was more and more turning away from the living world of active men and women into an academic world of empty pattern. We wanted an American art which was not empty and we believed that only by turning the formative processes of art back again to meaningful subject matter, in our cases specifically American subject matter, could we expect to get one.' The fanatically patriotic critic Thomas Craven (1889–?) was an even more strident spokesman for the Regionalists: 'He attacked not only the contemporary French painters but American expatriates, and tossed in New Yorkers for good measure: they were all iniquitous and effete, compared with the artistic renaissance taking place west of the Mississippi. Craven

undoubtedly overpraised these painters. Wood and Curry, at least, died unhappy, haunted by the contrast between Craven's claims of greatness for them and their own knowledge of themselves' (E. P. Richardson, *A Short History of Painting in America*, 1963).

On the fringes of the Regionalist movement were Charles *Burchfield and Ben *Shahn. Burchfield's work has a streak of fantasy absent from that of the others, and Shahn was driven by a spirit of social protest. Among the other artists who are sometimes considered part of the movement are painters of the rural scene in other parts of the USA during this period, for example Peter Hurd (1904–84), brother-in-law of Andrew *Wyeth, in New Mexico and Paul Sample (1896–1974) in Vermont. Specifically local styles did not develop anywhere and Regionalism died out in the 1940s in the more international spirit that prevailed during and after the Second World War, although individual artists, notably Benton, continued working in the style long after this (Curry and Wood were both dead by 1946).

Rego, Paula (1935–). Portuguese-born British painter of figure, animal, and fantasy subjects. Her parents were Anglophiles and sent her to London, where she studied at the *Slade School, 1952–6. It was at the Slade that she met her husband, the painter Victor Willing (1928–88). They lived in Portugal from 1957 to 1963, divided their time between the two countries from 1963 to 1975, then settled in London. Some of Rego's early work was semi-abstract, but in the 1980s she became well known for enigmatic figurative paintings that suggest a narrative element without making a story explicit; Edward *Lucie-Smith writes that they 'offer sly commentaries on male-female relationships, portrayed from a recognizably female point of view' (*Visual Arts in the Twentieth Century*, 1996). There is some similarity with the work of *Balthus, but Rego's paintings are more brightly coloured and cartoon-like. She has also made prints (sometimes combining etching with aquatint) in a similar vein. In 1990 she was appointed the first Associate Artist of the National Gallery, London. She painted murals in the restaurant of the gallery's new Sainsbury Wing in 1991, and in 1992 she became the first living artist to be given an exhibition in the gallery.

Rego Monteiro, Vicente do. See SEMANA DE ARTE MODERNA.

Reid, Alexander. See HUNTER.

Reid, Sir Norman (1915–). British painter (mainly of still-life) and administrator. He was born in London of Scottish extraction and studied at Edinburgh College of Art. During the Second World War he served with the Argyll and Sutherland Highlanders. In 1946 he joined the staff of the *Tate Gallery, London; he became deputy director in 1954 and he was director from 1964 until 1979. During his time at the Tate he had little opportunity for his own painting, but after his retirement he returned to it full-time, and he had his first one-man exhibition in 1991.

Reid, Robert. See TEN.

Reid Dick, Sir William. See DICK.

Reinhardt, Ad (1913–67). American painter and writer on art, born in Buffalo, New York, the son of German and Russian immigrants. He studied art history under Meyer *Schapiro at Columbia University, New York, 1931–5, and in 1936–7 had lessons with the abstract painter Carl Holty (1900–73) and at the National Academy of Design. From the beginning of his career Reinhardt's work was abstract, but it changed radically in style over the years. During the 1930s he worked in a crisp, boldly contoured geometrical style that owed something to both *Cubism and the *Neo-Plasticism of *Mondrian. In the 1940s he passed through a phase of *all-over painting which has been likened to that of Mark *Tobey, and in the late 1940s he was close to certain of the *Abstract Expressionists, including *Motherwell, with whom he jointly edited *Modern Artists in America* (1950), a book based on conversations with contemporary artists. During the 1950s he turned to geometric and then monochromatic paintings, influenced by Josef *Albers, with whom he taught at Yale University, 1952–3. At first his monochromatic paintings were usually blue or red, but from the late 1950s he devoted himself to all-black paintings with geometrical designs of squares or oblongs barely perceptibly differentiated in value from the background colour (*Abstract Painting No. 5*, Tate Gallery, London, 1962). This reduction of his work to 'pure aesthetic essences' reflects

his belief in the complete separation between art and life—'Art is art. Everything else is everything else.' His later work was influential 'on the development of *Minimal art. Irving Sandler writes (*Abstract Expressionism*, 1970): 'In some respects, Reinhardt's intentions resembled those of *Newman *Still, and *Rothko. Like them, he wanted to create an absolute, timeless, suprapersonal art, and his stance was as moralistic as theirs. Unlike them, however, he renounced extra-aesthetic associations in favor of a purist approach.' His views, indeed, were extremely uncompromising and he was an outspoken critic of trends in modern art of which he did not approve, as a polemical writer, as a lecturer, and as a satirical cartoonist (from 1942 to 1947 he worked as an artist-reporter on the avant-garde newspaper *PM*). *Art-as-Art: The Selected Writings of Ad Reinhardt*, edited by Barbara Rose, appeared in 1991.

Reiss, Winold. See DOUGLAS.

Rejlander, O. G. (Oscar Gustav). See PHOTOMONTAGE.

René, Denise (1919–). French dealer. She established her first gallery in the Rue La Boétie, Paris, in November 1944, soon after the city was liberated from the Germans, and in the years immediately after the war it was a rallying-point for geometrical abstraction at a time when the type of spontaneous abstraction known as *Art Informel was becoming dominant in France. This was typical of René's independence of spirit, for she followed her own interests rather than prevailing fashion (she disparagingly likened Art Informel to 'flaking walls, decomposing flowers, and patches of earth'). In 1955 she mounted probably the most famous exhibition of her career—'Le Mouvement', the show that launched *Kinetic art as a movement. A few years later her gallery became the centre of activities for the *Groupe de Recherche d'Art Visuel, founded in 1960, one of the best-known associations of Kinetic artists. René also took the lead in promoting *Op art in France (indeed *Vasarely, the father of Op art, had been the subject of her first exhibition in 1944). During the 1960s her reputation became international and she organized several shows abroad. In 1966 she opened a second gallery in Paris, in the Boulevard Saint-Germain, specializing in graphic art

and *multiples. This was called the Galerie Denise René Rive Gauche, while the original became known as the Galerie Denise René Rive Droite. In 1967 and 1971 she opened galleries in Krefeld and New York respectively, but she later closed these, retaining only the Paris galleries.

Renoir, Pierre-Auguste (1841–1919). French painter and (late in his career) sculptor. He was one of the original *Impressionists and is now perhaps the best loved of them, for his characteristic subjects—pretty children, flowers, beautiful scenes, above all lovely women—have instant appeal, and he communicated the joy he took in them with great directness. Like several of the other Impressionists he endured great hardship early in his career, but from about 1880 he prospered and by the turn of the century he was internationally famous. In the 1890s he began to suffer badly from arthritic rheumatism (worsened when he broke an arm falling from his bicycle in 1897) and from 1903 he lived mainly on the French Riviera for the sake of the warm climate; in 1907 he bought an estate called Les Collettes at Cagnes, near Nice. From 1912 he was confined to a wheelchair, but he continued to paint, his brush pushed between his crippled fingers by his nurse. In the 1880s he had turned from contemporary themes to 'timeless' subjects—particularly nudes, but also young girls in unspecific settings. He also took up mythological subjects (*The Judgement of Paris*, Hiroshima Museum of Art, c. 1913–14). His late paintings are typically much hotter in colouring than those of his classic Impressionist days, with very full, rounded forms and supple handling.

In 1907 Renoir made his first sculpture and in 1913 he took up the art seriously. By this time he was incapable of manipulating the necessary materials himself, so he directed assistants to act as his hands. The first and most important of the assistants (who was found for Renoir by Ambroise *Vollard) was the Spanish-born Richard Guino, a pupil of *Maillol. (Renoir and Guino parted company not entirely amicably in 1918, and half a century later—in 1968—Guino successfully sued Renoir's heirs to have his 'co-authorship' of the sculptures he had worked on recognized). Renoir made about two dozen sculptures in this way, the best known being the bronze *Venus Victorious* (c. 1914), a very ample life-size nude in the tradition of Maillol (he and

Renoir greatly admired each other's work). Casts of the *Venus* are in the Tate Gallery, London, at Renoir's home at Cagnes (now the Musée Renoir), and elsewhere.

One of Renoir's sons was the celebrated film director Jean Renoir, who wrote a lively and touching biography published in 1962 in both French and English (*Renoir, My Father*).

Renqvist, Torsten (1924–). Swedish painter, sculptor, printmaker, and writer on art. He was born at Ludvika, Kopparberg, and studied in Copenhagen and Stockholm. In the 1950s he became recognized as one of his country's leading exponents of *Expressionism on account of his vigorous paintings, with their harshly contrasting colours, and his writings in Swedish art journals, in which he opposed geometrical abstraction. Landscapes expressing the desolate grandeur of the Lafoten Islands were among his characteristic works of this time. In the mid-1960s he began to make sculpture, working with metal and wood in a deliberately crude style that sometimes verged on abstraction. He has also done a good deal of printmaking, in which he has often shown his social commitment, as in his series of etchings *Insurrection*, inspired by the Hungarian uprising of 1956. In 1964 he represented Sweden at the Venice *Biennale and he had a major retrospective at the Moderna Museet, Stockholm, in 1974. He has carried out several large public commissions in Sweden, for example the sculpture *Scarecrow* (City Library, Gothenburg, 1971).

Repentigny, Rodolphe de. See PLASTICIENS.

Repin, Ilya (1844–1930). The most celebrated Russian painter of his day, equally renowned for his portraits (his sitters included many of his most famous contemporaries) and for his dramatic scenes from Russian history, painted in a colourful, full-blooded style. He became professor of history painting at the St Petersburg Academy in 1894 and was an influential teacher, his pupils including *Grabar and *Serov. *Jawlensky and *Werefkin were among the students who reacted against what they considered his academic style. After the 1917 Revolution Repin retired to his country home at Kuokkala, near St Petersburg (now renamed Repino after him), but he continued to be a figure of massive authority in Russian art. With the imposition of *Socialist Realism in the 1930s he was established

as the model and inspiration for the Soviet painter.

Restany, Pierre (1930–). French critic, chiefly known as the ideologist of the *Nouveau Réalisme movement, which he launched with a manifesto in 1960. The following year he organized an exhibition of work by the Nouveaux Réalistes at the Galerie J in Paris, run by his wife Jeanine Restany. It was entitled '40° au-dessus de *Dada' (40 Degrees above Dada), and this offended one of the leading members of the group, Yves *Klein, who disliked having his work—which he regarded as highly spiritual—linked to the anarchy of Dada. Restany had intended to convey the idea that it was necessary to go beyond the nihilism of Dada, that impassioned revolt was no longer appropriate. Instead, artists should 'create a language based on the industrial world of today', which should be regarded not as oppressive, but as a source of poetry. Restany's output includes monographs on *César (1976) and Klein (1984), as well as an autobiography, *Une Vie dans l'art* (1983).

Reth, Alfred (1884–1966). Hungarian-born painter who settled in Paris in 1905 and became a French citizen. In 1910 he began exhibiting with the *Cubists, and an exhibition of his work at the *Sturm Gallery in Berlin in 1913 helped to make him 'influential in the rapid diffusion of Cubist ideas in Central Europe before the First World War. He may also have produced between 1909 and 1912 some of the earliest purely abstract drawings' (George Heard *Hamilton). In the 1920s his work was influenced by *Surrealism and in the 1930s he made abstract constructions in wood and metal, calling them *Formes dans l'espace* (he became a member of *Abstraction-Création in 1932). Reth's work is often notable for his experimentation with materials: he incorporated sand, cement, eggshells, plaster, and pebbles in his paint.

'return to order'. See NEOCLASSICISM.

Reverdy, Pierre. See ROSENBERG, LÉONCE.

Reverón, Armando (1889–1954). Venezuelan painter, born in Caracas. Reverón was a strange character but also 'the best Venezuelan painter of the first half of the century' (Edward *Lucie-Smith, *Latin American Art of the 20th Century*, 1993). He was raised in a foster

home in Spain after his parents' marriage broke up. Following a childhood attack of typhoid fever he became melancholic and irascible, and retreated into a private fantasy world for which he found an outlet in his art. In 1908–11 he studied painting at the Academy in Caracas, then went to Spain, where he studied first at the School of Fine Arts, Barcelona, then at the Academy in Madrid. After a trip to Paris in 1915, he returned to Caracas. In 1921 Reverón moved to the coastal town of Macuto with his wife and model Juanita and a monkey; he built a home and studio of wood, palm leaves, and thatch, where he lived and worked in primitive seclusion. His most characteristic paintings are of two main types—local landscapes and nude or semi-nude female figures, singly or in groups. His style was soft-edged and *Impressionistic, somewhat in the manner of *Bonnard, but with colours bleached by the fierce tropical light. Besides Juanita and local types, Reverón used as models life-sized rag dolls, which he made himself and posed as if they were real people. In spite of his isolation, his work was widely exhibited (in France and the USA as well as Venezuela) and he won several awards, including a medal at the Paris Exposition Universelle in 1937. His mental instability became increasingly severe and in 1953 he entered a sanatorium, where he died the following year.

Revold, Axel (1887–1962). Norwegian painter, born at Ålesund. He studied in Paris under *Matisse, 1908–10, and in 1919–20 he returned to Paris to learn the technique of fresco, having won a competition for the mural decoration of the Exchange in Bergen. This he carried out in 1921–3, and it was the first of a number of commissions in which he led a revival of fresco painting in Norway; others included the library of Oslo University (1933) and the New Town Hall in Oslo, a very large scheme (begun 1938) on which he collaborated with Alf *Rolfsen and other artists. In both his frescos and his easel paintings, Revold's style was influenced by the strong colours of Matisse and to a lesser extent by *Cubism. His favourite subjects were Norway's countryside and everyday life. Revold was a professor at the Academy in Oslo, 1925–46, and its director, 1935–46.

Révolution surréaliste, La. The first major periodical of the *Surrealist movement, pub-

lished in Paris between December 1924 and December 1929; there were twelve issues, appearing at irregular intervals (nos. 9 and 10 were published together in October 1927). André *Breton was the driving force behind its creation, but the first three issues were edited by two of his writer friends, Pierre Naville and Benjamin Péret (who later married the Spanish Surrealist painter Remedios *Varo). In contrast to many *Dada magazines, with their dynamic typography and air of anarchy, La Révolution surréaliste was consciously serious in tone and sober in appearance, its layout based on the scientific journal La Nature. The lead article of the first issue was on dreams; the front cover photographs were by *Man Ray and the back cover was an advertisement for Breton's first Surrealist manifesto, published a couple of months earlier. Artists whose work was illustrated included *Ernst, *Masson, and *Picasso, and there was also a still from a Buster Keaton film. Issues two and three became more anarchic and pessimistic in tone, under the influence of Antonin Artaud (1896–1948), a writer, draughtsman, stage designer, actor and director, who has been described by John *Golding as 'one of the most unpredictable and most extreme personalities to be associated with the movement'. Unhappy at Artaud's dominance, Breton took over the editorship himself for the rest of the magazine's life and transformed its outlook. Hitherto the illustrations had been fairly meagre, but 'The pages of issue number four and of all the subsequent issues . . . were to be enriched by an astonishing diversity of visual material, including reproductions of many of the works now acknowledged to be the movement's masterpieces' (John Golding, 'The Blind Mirror: André Breton and Painting' in Visions of the Modern, 1994). By its final issue it was selling over 1,000 copies, a substantial number for an avant-garde journal.

It was succeeded as the main mouthpiece of Surrealism by another magazine edited by Breton, Le Surréalisme au service de la révolution, which appeared very irregularly in six issues between July 1930 and May 1933 (the last two issues were published together). It sold less well than its predecessor, but Breton later reflected that 'of all the Surrealist publications, Le Surréalisme au service de la révolution . . . is by far the richest . . . the best balanced, the best constructed, and also the most alive (with a dangerous and exalted life). It is there

that Surrealism is shown at full flame.' The final issue carried an advertisement for another review, *Minotaure*, the first number of which had appeared in February 1933 and which became the main Surrealist journal for the next six years.

Rewald, John. See BARNES.

Reynolds-Stephens, Sir William. See NEW SCULPTURE.

Rhythm Group. A group of British and American painters working in Paris in the circle of J. D. *Fergusson in the years immediately before the First World War and influenced by the bright colours of *Fauvism. The name comes from the magazine *Rhythm* (1911–13), of which Fergusson was art editor. Among the members of the group was the American-born painter Anne Estelle Rice (1877–1959), who lived in Paris from 1906 to 1911, then settled in England. Fergusson painted several portraits of her, including *Blue Beads* (Tate Gallery, London, 1910). The group exhibited together at the Stafford Gallery, London, in 1912.

The Rhythm Group was also the name of an association of Polish artists, active formally from 1922 to 1932 and informally for several years after its disbandment. The group had no clear artistic policy but was associated particularly with the *Art Deco style (the members produced a good deal of commercial design as well as paintings).

Riabushinsky, Nikolai. See GOLDEN FLEECE.

Rice, Anne Estelle. See RHYTHM GROUP.

Rice, John Andrew. See BLACK MOUNTAIN COLLEGE.

Richards, Ceri (1903–71). British painter, printmaker, designer, and maker of reliefs, born at Dunvant, near Swansea, into a Welsh-speaking family (he did not learn English until he was about 5 or 6). From his father, a tin-plate worker, he inherited a love of music and poetry, which often inspired his work. His output was many-sided, and Sir John*Rothenstein writes that 'Richards's work is widely admired but there is little consensus of opinion about its essential character . . . As the spectator surveys in his mind's eye the long succession of Richards's works in many

media, he sees images close to nature, others so remote as to border on the abstract, images that are massive and still, others in a state of violent animation; some of them of a rare originality and others directly borrowed from other artists (Richards was at times an avid borrower but far too honest a man to disguise what he borrowed in the least degree).'

Richards was apprenticed as an electrician before studying at Swansea School of Art, 1921–4, and the *Royal College of Art, London, 1924–7. He lived in London for the rest of his life except during the Second World War, when he was head of painting at Cardiff School of Art (earlier he had taught at Chelsea School of Art and later he taught successively at Chelsea, the *Slade School, and the RCA until 1960). In 1934 he exhibited with the *Objective Abstractionists and in 1936 at the International Surrealist Exhibition in London. He said that *Surrealism 'helped me to be aware of the mystery, even the "unreality", of ordinary things', and at this time he was also strongly influenced by *Picasso, notably in a series of semi-abstract relief constructions begun in 1933. After the Second World War his painting drew inspiration from the large exhibition of Picasso and *Matisse at the Victoria and Albert Museum in 1945. His best-known works include the *Cathédrale engloutie* series, based on a Debussy prelude (which Richards used to play on the piano) and *'Do not go gentle into that good night'* (Tate Gallery, London, 1956), based on a poem by Dylan Thomas (whom he once met). Richards's work also included book illustrations, theatre designs, mural decorations for ships of the Orient line, and designs for stained glass and furnishings for the Blessed Sacrament Chapel in Liverpool Roman Catholic Cathedral (1965). He received numerous awards and distinctions, including a gold medal at the Royal National Eisteddfod of Wales in 1961.

His wife **Frances Richards**, née Clayton (1903–85), a fellow student at the RCA whom he married in 1929, was a painter, printmaker, illustrator, and pottery designer (she came from Stoke-on-Trent, heart of the British pottery industry). She taught at Camberwell School of Art, 1928–39, and Chelsea School of Art, 1947–59.

Richardson, Sir Albert. See ROYAL ACADEMY.

Richardson, John (1924–). British writer, editor, art dealer, and lecturer. Originally he

trained to be a painter, studying at the *Slade School. In 1949 he moved to France, where he lived with Douglas *Cooper in the Château de Castille, near Avignon, which they turned into a private museum of *Cubist art. Richardson became a friend of several leading artists, above all *Picasso, whom he saw regularly during the 1950s: 'I had already envisaged writing a book about him, and so, whenever possible, I noted down his answers to my questions, as well as scraps of his conversation.' After quarrelling with Cooper (as many people did), Richardson settled in New York, where he worked for Christie's, 1964–72, and subsequently for other leading firms in the art trade. From 1981 to 1991 he was editor-at-large to *House and Garden*, and from 1990 to 1994 he was contributing editor to *Vanity Fair*. In 1995–6 he was Slade professor of fine art at Oxford University. Richardson's literary output has included brief but highly regarded monographs on Manet (1958, revised edn., 1982) and *Braque (1959, in the 'Penguin Modern Painters' series), as well as various articles, but all his previous writings have been overshadowed by his magisterial *Life of Picasso*, the first volume of which (covering the period up to 1906) appeared in 1991. This was immediately acclaimed not only as the essential source on Picasso's early life, but also as one of the most impressively thorough biographies ever devoted to a major artist: Robert *Hughes described it as 'the most illuminating biography yet written on a twentieth-century visual artist . . . the cant-free crispness of its writing—let alone Richardson's irrepressible eye for the offbeat or scandalous detail—makes it a continuous pleasure to read.' The second volume (1907–17) was published in 1996.

Richier, Germaine (1904–59). French sculptor, born at Grans, near Arles, the daughter of a vineyard owner. She had a traditional training as a carver, studying first at the École des Beaux-Arts, Montpellier, 1922–5, and then privately under *Bourdelle in Paris, 1925–9. However, from about 1940 she began to create a distinctive type of bronze sculpture. Her figures became long and thin, combining human with animal or insect (and sometimes vegetal) forms. The surfaces of these powerful and disquieting works have a tattered and lacerated effect, creating a macabre feeling of decomposition, and she was one of the pioneers of an open form of sculpture in which

enclosed space becomes as important and alive as the solid material. Such figures were extremely difficult to cast and she showed great technical resourcefulness in bringing them to completion. The public sometimes found her work shocking, especially her *Crucified Christ* (church of Notre-Dame-de-Toute-Grâce, Assy, 1950), which caused a storm of controversy. Nevertheless, her international prestige grew steadily in the postwar years and in 1951 she won the Sculpture Prize at the São Paulo *Bienal. In 1947 she began to make engravings, from 1951 she made a few sculptures with coloured backgrounds painted by Hans *Hartung or other artists, and in the last two years of her life she took up painting herself. She died of cancer. Her first husband, whom she married in 1929, was the Swiss sculptor Otto Bänninger (1897–1973) and during the Second World War she lived in Switzerland; her second husband, whom she married in 1955, was the French writer René de Soulier, whose books include *L'Art fantastique* (1961).

Richmond, Sir William Blake. See FRY.

Richter, Gerhard (1932–). German painter, born in Dresden. After working as an advertisement and stage painter he studied at the Academy in Dresden, 1952–6. In 1961 he moved to West Germany and studied at the Academy in Düsseldorf, 1961–3. He has worked in a variety of styles but is best known for his personal variety of *Superrealism, in which by a blurring of detail he gave the impression of an out-of-focus snapshot. He has taught in Hamburg and Düsseldorf.

Richter, Hans (1888–1976). German-born painter, sculptor, film-maker, and writer who settled in the USA in 1941 and became an American citizen. He was born in Berlin and studied at the Academy there and at the Academy in Weimar. In his early work he was involved with various avant-garde movements and after being wounded and discharged from the German army in 1916 he moved to Switzerland, where he became a member of the Zurich *Dada group. In 1918 he began collaborating with *Eggeling on abstract 'scroll' drawings, which presented sequential variations of a design on long rolls of paper. After quarrelling in 1921, each of them extended their experiments independently into film, and Richter's *Rhythmus 21*

(1921) is generally regarded as the first abstract movie. In 1920 Richter moved back to Germany, where he founded the *Constructivist periodical *G in Berlin in 1923. From 1932 to 1941 he lived in Switzerland and France, then moved to the USA. In 1942 he became head of the Institute of Film Techniques at the City College of New York, retiring in 1956. His later films included *Dreams that Money Can Buy* (1944), which is *Surrealist in style, made up of sequences by himself, Alexander *Calder, Marcel *Duchamp, Max *Ernst, Fernand *Léger, and *Man Ray. He also made a film about Calder's work (1963). Richter continued to paint, his later works featuring rhythmic effects of movement over large canvases. He wrote several books on film and art, notably *Dada: Kunst und Anti-Kunst* (1964), translated as *Dada: Art and Anti-Art* (1965).

He is not to be confused with **Hans Theo Richter** (1902–69), a draughtsman and printmaker active mainly in Dresden, where he taught at the Hochschule der Bildenden Künste from 1947 until his death.

Ricketts, Charles (1866–1931). British painter, designer, sculptor, collector, and writer on art. He was born in Geneva to an English father and a French mother and brought up mainly in France and Italy. In 1882 he began studying wood engraving at Lambeth School of Art and there met fellow student Charles *Shannon, who became his lifelong companion. They lived first in Kensington and Chelsea (at this time a cheap area of London) and moved to Richmond (1898), Holland Park (1902), and finally St John's Wood (1923) as their fortunes improved. Ricketts initially made his mark in book production, first as an illustrator, then as the driving force behind the Vale Press (1896–1904), one of the finest private presses of the day, for which he designed founts, initials, borders, and illustrations. After the closure of the press (following a disastrous fire), Ricketts turned to painting and occasional sculpture, and in 1906 he began to make designs for the theatre. His paintings—typically rather melodramatic, heavy-handed figure subjects—have not worn well, but his colourful stage designs are still much admired, and the *Oxford Companion to the Theatre* comments that 'Even before the appearance of *Diaghilev, Ricketts was already a pioneer in the protest against an unimaginative realism'. He had a great reputation as an art connoisseur and in 1915 turned down the offer of the directorship of the National Gallery. Later he regretted this decision, but he served on various committees and put much energy into trying to combat modernism in art. Most of the highly varied collection he made with Shannon was bequeathed to the Fitzwilliam Museum in Cambridge, although the gem of the collection—Piero di Cosimo's *Fight Between Lapiths and Centaurs*—went to the National Gallery. By the standards of other noteworthy collectors, they were never very rich (Ricketts calculated that their combined income rarely exceeded £1,000 a year), but they bought with flair and discrimination, the Old Master drawings they acquired being particularly outstanding. Ricketts's main books were *The Prado and its Masterpieces* (1903), *Titian* (1910), and *Pages on Art* (1913); *Self-Portrait* (taken from his letters and journals) was posthumously published in 1939.

Rickey, George (1907–). American painter, sculptor, and writer on art, born at South Bend, Indiana, the son of an engineer. In 1913 he moved with his parents to Scotland and he took a degree in history at Balliol College, Oxford, in 1929. Before returning to the USA in 1930 he also studied art at the Ruskin School, Oxford, and under *Lhote in Paris. In the USA he taught at various universities, while continuing to keep in touch with Europe through visits. Until he was in his early 40s he devoted most of his time to painting, his work including murals for Olivet College, Michigan, and the Post Office at Selinsgrove, Pennsylvania. In 1949, however, he began to make *mobiles, and thereafter he devoted most of his energies to this type of *Kinetic sculpture. He worked first in glass and then from 1950 in metal, usually stainless steel. Originally he used simple rod-like forms, then in 1965 he began experimenting with planes based on regular forms such as the rectangle or cube—with 'emphasis on surfaces rather than lines'. His sculptures are often designed to be situated out-of-doors and usually rely on air currents to set them in motion. He has had numerous public commissions in the USA and elsewhere. His writings include the book *Constructivism: Origins and Evolution* (1967), regarded as a standard work on the subject.

Rietveld, Gerrit. See STIJL.

Riley, Bridget (1931–). British painter and designer, rivalled only by *Vasarely as the most celebrated exponent of *Op art. She was born in London and studied there at Goldsmiths' College, 1949–52, and the *Royal College of Art, 1952–5. Her interests in optical effects came partly through her study of the *Neo-Impressionist technique of pointillism, but when she took up Op art in the early 1960s she worked initially in black-and-white. She turned to colour in 1966. By this time she had attracted widespread attention (one of her paintings was used for the cover to the catalogue of the exhibition 'The Responsive Eye' at the Museum of Modern Art, New York, in 1965, the exhibition that put Op art on the map), and the seal was set on her reputation when she won the International Painting Prize at the Venice *Biennale in 1968.

Riley's work shows a complete mastery of the effects characteristic of Op art, particularly subtle variations in size, shape, or placement of serialized units in an overall pattern. It is often on a large scale and she frequently makes use of assistants for the actual execution. Although her paintings often create effects of vibration and dazzle, she has also designed a decorative scheme for the interior of the Royal Liverpool Hospital (1983) that uses soothing bands of blue, pink, white, and yellow and is reported to have caused a drop in vandalism and graffiti. She has also worked in theatre design, making sets for a ballet called *Colour Moves* (first performed at the Edinburgh Festival in 1983); unusually, the sets preceded the composition of the music and choreography. Riley has travelled widely (a visit to Egypt in 1981 was particularly influential on her work, as she was inspired by the colours of ancient Egyptian art) and she has studios in London, Cornwall, and Provence. She writes of her work: 'My paintings are not concerned with the Romantic legacy of Expressionism, nor with Fantasies, Concepts or Symbols. I draw from Nature, although in completely new terms. For me Nature is not landscape, but the dynamism of visual forces—an event rather than an appearance— these forces can only be tackled by treating colour and form as ultimate identities, freeing them from all descriptive or functional roles.'

Rilke, Rainer Maria. See BALTHUS and WORPSWEDE.

Rimbert, René. See NAÏVE ART.

Ringgold, Faith (née Jones) (1930–). American painter, sculptor, *Performance artist, *Fibre artist, lecturer, and writer whose work has been much concerned with black and feminist issues. She was born in New York, where she studied at City College under *Gwathmey and *Kuniyoshi, completing her studies in 1959 after having two children. During the 1960s her paintings often depicted the oppression of blacks, using bold, strongly coloured, stencil-like shapes, as in *Die* (Bernice Steinbaum Gallery, New York, 1967), a huge scene of a street riot. She sometimes used the American flag as a background and was prosecuted for desecrating it. Since 1970 she has been primarily concerned with feminist issues, campaigning vigorously and successfully for greater representation of woman artists in exhibitions at venues such as the Whitney Museum of American Art. In the early 1970s she painted a large mural, depicting successful women, in the women's prison on Riker's Island, New York, but she then changed her way of working and from 1973 began to produce fabric figures, through which she hoped to reach a wider audience than through painting (they were made easily portable, so they could be used in her lectures and Performances). She used traditional African craft techniques and said 'I emulate the nameless women who worked with paint and dyes, yarn and cloth and other soft and impermanent materials'. In the late 1970s she began making 'story-quilts', collaborating with her mother Willy Posey, a dress designer.

Riopelle, Jean-Paul (1923–). Canadian painter, sculptor, and graphic artist. Riopelle is considered the leading Canadian abstract painter of his generation, although he has spent most of his career in Paris. He was born in Montreal, where he had lessons with a local painter, Henri Bisson, from the age of 6. His early works were landscapes, but he turned to abstraction under the influence of *Borduas and became a member of his group Les *Automatistes in 1946 before settling in Paris in 1947. *Breton, *Mathieu, and *Miró gave him encouragement in his early days there. He had his first one-man show in 1949, at the Galerie Nina Dausset, Paris, and many others followed in the 1950s as he built up an international reputation—he was the first Canadian artist to achieve such widespread recognition since James Wilson *Morrice and Homer *Watson at the beginning of the

century (his New York debut exhibition was at the Pierre Matisse Gallery in 1954 and his London debut exhibition at the Gimpel Gallery in 1956). His paintings of the late 1940s were in a lyrical manner, but in the 1950s his work became tauter, denser, and more powerful, the paint often applied with a palette knife, creating a rich mosaic-like effect (*Pavane*, NG, Ottawa, 1954). Later his handling became more calligraphic. Riopelle is a prolific artist and at home in various media; he has worked in watercolour, ink, crayon, and chalk, as well as oil, and also produced prints (etchings and lithographs), sculpture, and huge collage murals. In spite of his long residence in France, he has kept up a close association with his native country; in 1962 he represented Canada at the Venice *Biennale, where he was awarded the Unesco prize, and since 1970 he has spent a good deal of time in Montreal.

Rippl-Rónai, Josef. See NABIS.

Rissanen, Juho (1873–1950). Finnish painter and graphic artist. His training included periods of study as a private pupil of *Schjerfbeck and under *Repin at the St Petersburg Academy. He had his first one-man exhibition in 1897 and thereafter his work was widely exhibited in Finland, where he was a member of the *Septem and *November groups, and elsewhere (his work won a bronze medal at the Paris World Fair of 1900). Until 1908, when he first visited Paris, Rissanen concentrated on Finnish peasant subjects, based on his childhood environment. These are considered his finest works, depicting life's fateful procession with power and dignity. Subsequently, under a variety of international influences, his work gained in urbanity what it lost in force and originality. Among his public commissions were murals for Helsinki's City Library (1909) and National Theatre (1910) and for the Museum at his birthplace Kuopio (1928). Between the two world wars Rissanen lived mainly in Paris, and in 1939 he emigrated to the USA, settling in Florida, where he died.

Rivera, Diego (1886–1957). Mexican painter, the most celebrated figure in the revival of monumental fresco painting that is Mexico's most distinctive contribution to modern art. He was born in Guanajuato, to educated parents of liberal views. In 1892 the family moved to Mexico City, and in 1896 Rivera enrolled in

evening classes at the Academy of San Carlos whilst still at school. He became a full-time student there two years later; one of his teachers was Dr *Atl. In 1907 he went to Madrid on a four-year scholarship. He visited Paris in 1909 and after a brief return to Mexico he settled there from 1911 to 1920. During this time he became one of the lions of café society and was friendly with many leading artists. He became familiar with modern movements, but although he made some early experiments with *Cubism, for example, his mature art was firmly rooted in Mexican tradition. At about the time of the Russian Revolution he had become interested in politics and in the role art could play in society. In 1920–1 he visited Italy to study Renaissance frescos (already thinking in terms of a monumental public art), then returned to his homeland, eager to be of service to the Mexican Revolution.

In 1920 Alvaro Obregón, an art lover as well as a reformist, had been elected president of Mexico, and Rivera, who was an extremely forceful personality, swiftly emerged as the leading artist in the programme of murals he initiated glorifying the history and people of the country in a spirit of revolutionary fervour. Many examples of his work are in public buildings in Mexico City, and they are often on a huge scale, a tribute to his enormous energy. His first mural, the allegorical *Creation*, was painted for the National Training School in 1922. His most ambitious scheme, in the National Palace, covering the history of Mexico, was begun in 1929; it was still unfinished at his death, but it contains some of his most magnificent work. Rivera's murals were frankly didactic, intended to inspire a sense of nationalist and socialist identity in a still largely illiterate population; their glorification of creative labour or their excoriation of capitalism can be crude, but his best work has immense vigour and shows formidable skill in choreographing the incident- and figure-packed compositions, in combining traditional and modern subject-matter, and in blending stylized and realistic images.

In 1927 Rivera visited the Soviet Union and in 1930–4 he worked in the USA, painting several frescos that were influential on the muralists of the *Federal Art Project. His main commission in America was a series on *Detroit Industry* (1932–3) in the Detroit Institute of Arts; another major mural, *Man at the Crossroads* (1933), in the Rockefeller Center, New York, was destroyed before completion because he

included a portrait of Lenin. It was replaced with a mural by *Brangwyn. Throughout his career Rivera also painted a wide range of easel pictures, in some of which he experimented with the encaustic (wax) technique. There is a museum of his work at Guanajuato.

Rivera was an enormous man (standing over six feet and weighing over 20 stones), and although he was notoriously ugly he was irresistibly attractive to women. He had numerous love affairs and was married three times, his second wife (and his third, for they divorced and remarried) being the painter Frida *Kahlo. Her parents said 'it was like a marriage between an elephant and a dove', and a biographer wrote: 'Part of his appeal was his monstrous appearance—his ugliness made a perfect foil for the type of woman who likes to play beauty to a beast—but the greater attraction was his personality. He was a frog prince, an extraordinary man, full of brilliant humour, vitality, and charm.'

Rivera, José de (1904–85). American abstract sculptor, born at West Baton Rouge, Louisiana. Before taking up art he worked in industry as a machinist, blacksmith, and tool and die maker, and he brought to his sculpture consummate skills in metalworking. He studied at night classes at the Studio School, Chicago, 1929–30, and began making sculpture in 1930. In 1930 he travelled in Europe (where he was impressed by the work of *Brancusi) and Egypt. He worked for the *Federal Art Project, 1937–8, his work under its auspices including a sculpture entitled *Flight* (1938) for Newark Airport, New York. In 1938 he began making completely abstract sculpture using curved metal sheets, which he sometimes painted. His first one-man show was at the Mortimer Levitt Gallery, New York, in 1946. From the mid-1950s his most characteristic works featured very elegant flowing linear forms in highly polished metal. Some of them were designed to be exhibited on slowly rotating turntables, for example *Construction No. 67* (Tate Gallery, London, 1959). In 1961 he said: 'What I make represents nothing but itself. My work is really an attempt to describe the maximum space with the minimum of material.'

Rivera, Manuel. See EL PASO.

Rivers, Larry (1923–). American painter, sculptor, graphic artist, and designer, born in New York. He is regarded as one of the leading figures in the revival of figurative art that was one aspect of the reaction against the dominance of *Abstract Expressionism. After serving in the US Army Air Corps, 1942–3, he earned his living for several years as a jazz saxophonist. He began painting in 1945, studying at the Hans *Hofmann School, 1947–8, and at New York University under *Baziotes, 1948. His work of the early and mid-1950s continued the vigorous painterly handling associated with Abstract Expressionism, but was very different in character. Some of his paintings were fairly straightforwardly naturalistic, such as the powerful and frank nude study of his mother-in-law, *Double Portrait of Berdie* (Whitney Museum, New York, 1955), but others looked forward to *Pop art in their quotations from well-known advertising or artistic sources, their use of lettering, and their deadpan humour. An example is *Washington Crossing the Delaware* (MOMA, New York, 1953), based on the famous painting by the 19th-century German-American painter Emanuel Gottlieb Leutze, one of the icons of American history. In the late 1950s and 1960s his work came more clearly within the orbit of Pop, sometimes incorporating cut-out cardboard or wooden forms, electric lights, and so on, but his sensuous handling of paint set him apart from other American Pop artists. Rivers has also made sculpture, collages, and prints, designed for the stage, acted, and written poetry.

Roberts, Tom (1856–1931). British-born Australian painter. He was the most important figure in introducing *Impressionism to Australia and he is regarded as the father of the country's indigenous tradition of landscape painting. In 1869 he emigrated from England with his widowed mother; they settled in Melbourne, where he studied at the National Gallery of Victoria's School of Art, 1874–81, whilst working as a photographer's assistant. In 1881 he returned to England to study at the *Royal Academy, and during a walking tour of Spain in 1883 he first acquired some knowledge of Impressionism through meeting artists who had studied in Paris. Roberts returned to Melbourne in 1885 and was soon the leading figure of the *Heidelberg School, whose work was based on open-air painting. His fellow member Arthur *Streeton said that from Roberts's 'quick perception and expression of the principles of Impressionism ...

sprang the first national school of painting in Australia'. As well as landscapes (and portraits—with which he earned a major part of his living), Roberts painted scenes of rural genre and history (including outlaw life), in which his 'imagination runs parallel to the prevalent tone of Australian writing in the nineties . . . [celebrating] . . . virtues of mateship, courage, adaptability, hard work and resourcefulness . . . Their use indicates a growing sense of cultural identity. These virtues were thought distinctively—even uniquely—Australian' (Robert *Hughes, *The Art of Australia*, 1970).

In 1903 Roberts returned to London, where he completed his most prestigious commission, the enormous (and to many people enormously dull) *Opening of the First Commonwealth Parliament* (British Royal Collection, on loan to High Court of Australia, Canberra, 1901–3). Bernard Smith writes that '"The Big Picture" has sometimes been looked upon as a most unfortunate aberration in the middle of his career, from which his art never fully recovered' (*Australian Painting 1788–1990*, 1991), and Roberts himself felt that after it he went through a 'black period' of depression and artistic uncertainty. However, he continued to enjoy reasonable success in Europe, exhibiting his work at the *Royal Academy, the Paris Salon, and elsewhere. He did not return permanently to Australia until 1923, when he settled at Kallista, near Melbourne. By the time of his death, Robert Hughes writes that 'he had been overshadowed by the more prolific, and by then shallower, talents of his old friend, Arthur Streeton'.

Roberts, William (1895–1980). British painter, chiefly of figure compositions and portraits. He was born in London and had his main training at the *Slade School, 1910–13. After travelling in France and Italy, he worked briefly for the *Omega Workshops, then in 1914 joined the *Vorticist movement, signing the manifesto in the first number of *Blast*. His style at this time showed his precocious response to French modernism and was close to that of *Bomberg in the way he depicted stiff, stylized figures through geometrically simplified forms. After the First World War (in which he served in the Royal Artillery and as an *Official War Artist) his forms became rounder and fuller in a manner reminiscent of the 'tubism' of *Léger. Often his paintings showed groups of figures in everyday settings,

his most famous work being *The Vorticists at the Restaurant de la Tour Eiffel: Spring 1915* (Tate Gallery, London, 1961–2), an imaginative reconstruction of his former colleagues celebrating at a favourite rendezvous to mark the publication of the first issue of *Blast*. In response to the exhibition 'Wyndham *Lewis and the Vorticists' at the Tate Gallery in 1956, Roberts wrote a series of pamphlets (1956–8) disputing Lewis's claim (in the catalogue introduction) that 'Vorticism, in fact, was what I, personally, did, and said, at a certain period.' However, on the occasion of the exhibition 'Vorticism and its Allies' at the Hayward Gallery in 1974, Roberts issued another pamphlet, *In Defence of English Cubists*, in which he strangely contradicted his earlier statements, declaring that the term Vorticism 'should only be used in reference to his [Lewis's] own work; and that the term Cubist should be employed to describe the abstract painting of his contemporaries of the 1914 period'. Roberts remained active as a painter as well as a controversialist, working until the day of his death.

Roberts, Winifred. See NICHOLSON, BEN.

Robertson, Eric. See EDINBURGH GROUP.

Robinson, William Heath (1872–1944). British cartoonist, illustrator, and writer, born in London, son of an illustrator and wood engraver, Thomas Robinson. He studied at Islington School of Art and briefly at the *Royal Academy (1890). Initially he tried to make a career as a landscape painter, but failing to make much progress in this, he went into book illustration, following his father and his two elder brothers, **Charles Robinson** (1870–1937) and **Thomas Heath Robinson** (c. 1869–1950). He illustrated a great variety of material, including John Bunyan and Shakespeare, and in his early work had a strong line in grotesque horror, notably in a two-volume edition of the complete works of Rabelais (1904). However, he became best known for his humorous work, in particular for his drawings of absurdly ingenious machinery designed to perform inappropriately trivial tasks such as shuffling cards or serving peas. This kind of illustration first appeared in the earliest of the books he wrote himself, *The Adventures of Uncle Lubin* (1902), a children's story in which the eponymous hero constructs a ramshackle airship, sailing-boat,

and submarine whilst searching for his missing baby nephew, who has been carried off by a bird. The phrase 'Heath Robinson', used to describe eccentric machinery, had entered the language by the First World War (the earliest citation in the *Oxford English Dictionary* is of 1917). His other books include an autobiography, *My Line of Life* (1938), *Let's Laugh: A Book of Humorous Inventions* (1939), and *Heath Robinson at War* (1942). The humorous books by other authors that he illustrated included Norman Hunter's *The Incredible Adventures of Professor Branestawm* (1933), in which the character of the absent-minded inventor was probably suggested by Heath Robinson's drawings, which by this time were very well known (in 1934 he designed a house full of his gadgets for the Ideal Home exhibition). Heath Robinson also made stage designs, and even though he was 'quiet, shy, and modest' (*DNB*), he appeared on radio and television. See also HORN.

Roca Rey, Joaquín (1923–). Peruvian sculptor, born in Lima, where he studied at the National School of Fine Arts. Between 1948 and 1952 he lived in Europe, exhibiting in Florence, Madrid, Paris, and Rome. On his return to Peru, he became his country's leading artist in introducing modern trends in sculpture, his figures being influenced by the simplified rounded forms of *Arp and Henry *Moore. He has worked in a variety of materials, including metal, stone, and wood, and has had numerous public commissions.

Roche, Alexander. See GLASGOW BOYS.

ROCI. See RAUSCHENBERG.

Rockefeller, Abby Aldrich (1874–1948). American collector and patron, born Abby Aldrich in Providence, Rhode Island. In 1901 she married **John D. Rockefeller Jr** (1874–1960), son of the immensely wealthy founder of Standard Oil. She had broad artistic interests, but in the 1920s she began to specialize in modern painting, collecting work by *Cézanne, *Matisse, *Picasso, and numerous American artists, among them *Demuth, *Hopper, and *O'Keeffe. In 1928 she staged an exhibition in her New York home of the work of George Overbury 'Pop' Hart (1869–1933), a colourful bohemian figure who made impromptu pictures of scenes observed on his travels, and the show belatedly established

his reputation. The following year she was one of the founders of the *Museum of Modern Art, New York. She was its first Treasurer and gave generous financial support; MOMA acknowledged her great contribution to its early development by naming its Print Room (1949) and Sculpture Garden (1953) after her. She supported various other cultural institutions, and during the Depression she helped several artists, including *Shahn and *Sheeler, by giving them commissions. Her husband was also greatly interested in art, although mainly in earlier periods (he provided the funds for the Metropolitan Museum, New York, to buy the medieval collection of George Grey *Barnard). His most notable contribution to 20th-century art was commissioning Rockefeller Center, New York, a huge office complex (begun 1929) featuring some superb *Art Deco interiors and Paul *Manship's famous figure of *Prometheus* which overlooks the skating rink. **Blanchette Hooker Rockefeller** (Mrs John D. Rockefeller III) (1909–92), the daughter-in-law of Abby and John, was also a collector, mainly of contemporary work, and patron. On a visit to Japan in 1959 she bought sculptures by Masayuki *Nagare, and his first visit to the USA in 1962 was made at her invitation. From 1959 to 1965 she was president of the Museum of Modern Art.

Rockwell, Norman (1894–1978). American illustrator and painter, born in New York. He left school at 16 to study at the *Art Students League and by the time he was 18 was a full-time professional illustrator. In 1916 he had a cover accepted by the *Saturday Evening Post*, the biggest-selling weekly publication in the USA (its circulation was then about 3 million), and hundreds of others followed for this magazine until it ceased publication in 1969. He also worked for many other publications. Rockwell's subjects were drawn from everyday American life and his style was anecdotal, sentimental, and lovingly detailed; he described his pictorial territory as 'this best-possible-world, Santa-down-the-chimney, lovely-kids-adoring-their-kindly-grandpa sort of thing'. Such work brought him immense popularity, making him a household name in the USA, indeed something of a national institution; in 1943 an exhibition of his work raised more than $100 million for war bonds, and his books, such as *Norman Rockwell, Illustrator* (1946) and *Norman Rockwell, Artist and*

Illustrator (1970), were bestsellers (the latter is said to have sold over 50,000 copies in six weeks at $60 a copy). For most of his career critics dismissed his work as corny, but late in life he began to receive serious attention as a painter. In his later years, too, he sometimes turned to more weighty subjects, producing a series on racism for *Look* magazine, for example. From 1953 until his death he lived at Stockbridge, Massachusetts, where a large museum of his work opened in 1993. Part of the funding for it came from Steven Spielberg, America's most commercially successful film-maker, who feels an affinity with the American painter who has appealed most to a mass audience.

Rodchenko, Alexander (1891–1956). Russian painter, sculptor, industrial designer, and photographer, one of the leading *Constructivists. He was born in St Petersburg and studied at the art school at Kazan, 1910–14, then at the Stroganov Art School in Moscow. After the 1917 Revolution he was one of the leading spirits in *Narkompros and *Inkhuk. His output was prolific and his artistic evolution was rapid, as he moved from *Impressionist pictures in 1913 to pure abstracts, made with a ruler and compass, in 1916. He was influenced by *Malevich's *Suprematism, but was without Malevich's mystical leanings, and he coined the term '*Non-Objective' to describe his own more scientific outlook; his *Non-Objective Painting: Black on Black* (MOMA, New York, 1918) is a response to Malevich's *White on White* paintings, using curvilinear rather than rectilinear forms. In 1917 he began making three-dimensional constructions under the influence of his friend *Tatlin, and some of these developed into graceful hanging sculptures. Like Tatlin and other Constructivists, however, Rodchenko came to reject pure art as a parasitical activity ('The art of the future will not be the cosy decoration of family homes'), and after 1922 he devoted his energies to industrial design, typography, film and stage design, propaganda posters, and photography. His only journey outside Russia came in 1925, when he went to Paris to supervise part of the Soviet contribution to the 'Exposition Internationale des Arts Décoratifs et Industriels Modernes' (the exhibition that gave *Art Deco its name). In the mid-1930s, after *Socialist Realism had become the official art style of the Soviet Union, he returned to easel painting. Initially he produced circus scenes, but in 1943 he began to paint abstract 'drip' pictures that—amazingly—prefigure those of Jackson *Pollock.

Rodchenko's photography is probably the most original and enduring part of his output. It was geared towards reportage and creating a pictorial record of the new Russia, but much of it is remarkable for its 'abstract' qualities, partly created by his novel exploitation of unusual angles and viewpoints (he was accused of the deadly sin of *formalism by some Soviet critics). Often he pointed his camera sharply upwards or downwards to create a powerful play of diagonals—'Rodchenko perspective' and 'Rodchenko foreshortening' became current terms in the 1920s—and his dramatic use of light and shadow influenced, for example, the great Soviet film director Sergei Eisenstein.

Rodchenko's wife, Varvara Stepanova (1894–1958), was a painter and designer. Of all the leading members of the avant-garde who switched to industrial design in the early 1920s, she was the only one who had received professional training in the applied arts. She is perhaps best known for her sports clothes, in which she used loud contrasts of colour (for purposes of identification) while rejecting as superfluous all ornamental or 'aesthetic' elements. She also wrote poetry and collaborated with her husband on various journalistic projects.

Rodhe, Lennart (1916–). Swedish painter, designer, and graphic artist, born in Stockholm. His early work was *Cubist, but in the late 1940s he turned to geometrical abstraction. In the 1960s his style became freer. Rodhe has had numerous commissions for the decoration of public buildings in Sweden, and he has also produced designs for tapestry and the stage and a large body of graphic works. From 1958 to 1968 he was director of the Academy in Stockholm and his teaching there was influential in the promotion of geometrical abstraction in Sweden.

Rodin, Auguste (1840–1917). French sculptor and graphic artist, one of the greatest and most influential European artists of his period. He was the first sculptor since the heyday of Neoclassicism to occupy a central position in public attention and he opened up new possibilities for his art in a manner comparable to that of his great contemporaries in painting—*Cézanne, *Gauguin, and van

Gogh. He struggled early in his career (he was rejected by the École des *Beaux-Arts three times) and his work was often the subject of controversy, but after a large exhibition of his works at the Paris World Fair in 1900 he was widely regarded as the greatest living sculptor. His most characteristic works were figures or groups of a historical, literary, allegorical, or symbolic nature. At the centre of his career was a commission he received from the French state in 1880 to make a set of bronze doors for a proposed Musée des Art Décoratifs. Rodin never definitively finished the huge work—*The Gates of Hell* (he worked on it intermittently until 1900 and the museum never came into being in the proposed form)—but he poured some of his finest creative energy into it, and many of the nearly 200 figures that are part of it were the basis of famous independent sculptures, most notably *The Thinker* and *The Kiss* (the marble version of *The Kiss* in the Tate Gallery, London, was carved by an assistant in 1901–4; see DIRECT CARVING). The several casts that exist of the complete structure of the *Gates* were made after Rodin's death. The overall design is a kind of Romantic reworking of Ghiberti's 15th-century *Gates of Paradise* at the Baptistery of Florence Cathedral, the twisted and anguished figures, irregularly arranged, recalling Michelangelo's *Last Judgement* and Gustav Doré's illustrations for Dante's *Inferno* (1861). The modelling is often rough and 'unfinished' (unlike the smooth finish of the marble *Kiss*) and anatomical forms are exaggerated or simplified in the cause of intensity of expression.

These traits were taken further in some of Rodin's monuments, most radically in his statue of Balzac. This was commissioned by the Société des Gens de Lettres in 1891, but Rodin's design was so unconventional—an expression of the elemental power of genius rather than a portrait of an individual—that it was rejected, and the monument was not finally cast and set up until 1939—at the intersection of the Boulevards Raspail and Montparnasse in Paris. It ranks as the most original piece of public statuary created in the 19th century, and *Brancusi wrote that it was 'indisputably the starting point of modern sculpture'. Rodin himself described it as 'the sum of my whole life'. After 1900 he created no more major monuments, his sculpture consisting mainly of portrait busts, including many of eminent personalities. In this period

he was also a prolific draughtsman, mainly of the female nude, some of the drawings being highly erotic. (He was famed for his sexual appetite, but this was excused as an aspect of his Olympian stature; his lovers included Gwen *John.) He also made etchings and published two books; *L'Art* (1911), a series of his conversations (translated as *On Art and Artists*, 1957); and *Les Cathédrales de France* (1914), which shows his love of the art of the Middle Ages (translated as *The Cathedrals of France*, 1965). Rodin left his own collection of his works to the state to found the Musée Rodin in Paris, opened in 1919. It has casts of virtually all his sculptural work. His villa at Meudon (now a suburb of Paris) is an annexe to the Musée Rodin; the sculptor is buried in the garden, with a cast of *The Thinker* overlooking his grave. There is also a Rodin Museum in Philadelphia.

Although the literary and symbolic significance attached to Rodin's work has been out of keeping with the conception of 'pure' sculpture that has predominated in the 20th century, his influence on modern art has been immense. Single-handedly he revived sculpture from a period of stagnation when it had lagged behind the momentous achievements of contemporary painters and made it once again a vehicle for intense personal expression. His sense of movement and energy and his use of the partial figure (particularly the torso) as a legitimate subject were among his most potent legacies, inspiring *Bourdelle (his long-time assistant), for example. Just as important as his direct influence was the fervent reaction against his dominance among the avant-garde. As George Heard *Hamilton writes, 'Perhaps the proof of his greatness is to be seen in the work of such men as *Maillol, Brancusi, *Lipchitz, and others, who had to reject his method and his programme in order to assert their independence. Through the loyal opposition, so to speak, Rodin's inexhaustible energies reach to the present.'

Roerich, Nikolai (1874–1947). Russian painter, designer, archaeologist, anthropologist, and mystical philosopher, born in St Petersburg, where he first studied law before training at the Academy, 1893–7. He was a prolific painter of landscapes and of imaginary historical scenes that evoke a coourful pagan image of Russia's past. They reveal the same feeling for exotic splendour and bold, sump-

tuous colour that he displayed in his set and costume designs for *Diaghilev's Ballets Russes, notably for Stravinsky's *Rite of Spring* (1913), for which Roerich created the scenario with the composer. A man of immense energy, Roerich combined his career as an artist with one as an archaeologist and anthropologist. In 1925–8 he made a 16,000-mile expedition in Central Asia accompanied by his wife and his elder son, who spoke Chinese, Mongolian, Tibetan, and several Indian languages; his 'investigation of the cultures of the region [is] still the bedrock of anthropological studies of Central Asia' (*The Times Atlas of World Exploration*, 1991). From 1928 until his death he directed a Himalayan research station at Kulu in India, and many of his later paintings feature mountain landscapes.

Roerich had a deep interest in esoteric religions and the mysteries of nature, and he developed a philosophy in which art should unite humanity. In 1933 he designed a flag for the protection of cultural property in the event of war and drew up a peace pact that was signed by President F. D. Roosevelt and representatives of several other countries. He was nominated for the Nobel Peace Prize for his work in this field. There are Roerich museums in Moscow and New York (he lived in the USA, 1920–3), but the best collection of his work is in the Russian Museum, St Petersburg. His younger son, **Svetoslav** (1904–93), was also a painter, and was married to the great-neice of Rabindranath *Tagore.

Rogers, Claude (1907–79). British painter of portraits, landscapes, and genre scenes. He was born in London and studied at the *Slade School, 1925–9. With William *Coldstream and Victor *Pasmore he founded the *Euston Road School in 1937 and he became one of the leading upholders of its sober figurative tradition, although in his later work the underlying abstract quality of the composition became of more importance. During the Second World War he served in the Royal Engineers until he was invalided out in 1943. He then taught part-time at Hammersmith and *St Martin's Schools of Art, and after the war he continued his teaching career at Camberwell School of Art, 1945–9, the Slade School, 1949–63, and Reading University, where he was professor of fine art, 1963–72. In the *Dictionary of National Biography* he is described as 'a stocky, bespectacled, bearded, warmly ebullient but gentle man, with a delightful sense

of humour, lively mind, and sensitive nature'. He was married to the painter Elsie Few (1909–80).

Rohlfs, Christian (1849–1938). German painter and printmaker, born at Niendorf, Holstein. He turned to painting after a boyhood accident led to the amputation of one of his legs, forcing him to abandon plans to take over his father's farm. From 1901 he lived mainly in Hagen. Until he was well over 50 he painted in a fairly traditional naturalistic manner, but he then discovered the work of the *Post-Impressionists, particularly van Gogh, whose brilliant colour and intense personal feeling were a revelation to him. He became one of the pioneers of *Expressionism in Germany, and in 1905–6 he painted with Emil *Nolde. His favourite subjects were visionary views of old German towns, colourful landscapes, and flower pieces. Rohlfs's work in his new style won him considerable acclaim; in 1924 numerous celebrations were held to mark his 75th birthday, and in 1925 a museum of his work was founded in Hagen. A year before his death, however, he was declared a *degenerate artist by the Nazis and forbidden to exhibit.

Rohner, Georges. See FORCES NOUVELLES.

Roland, Browse & Delbanco. See BROWSE.

Rolfsen, Alf (1895–1979). Norwegian painter, printmaker, draughtsman, and writer on art, best known as one of his country's leading muralists. He was born in Christiania (now Oslo) and had his main training at the Copenhagen Academy, 1913–16. In 1919–20 he studied in Paris, where he met Diego *Rivera, with whom he discussed the relationship between painting and architecture. Rolfsen made several other visits to Paris and he was influenced by modern French painting, particularly *Cubism and the work of *Derain. His first fresco commission, for the Telegraph Building in Oslo, was carried out in 1922. Many others followed, notably work at Oslo Town Hall (1938–50), where he was one of a team of painters including Axel *Revold. His last fresco was for the Hansa Brewery in Bergen (1967). Rolfsen also produced easel paintings (including landscapes, portraits, and figure compositions), as well as lithographs and book illustrations, and he wrote and lectured on art. His writings include

material about mural painting and a book on the Danish painter Georg Jacobsen (1887–1976), published in 1956.

Roman School (Scuola Romana). A trend in Italian painting centred on the work of *Mafai and *Scipione, who were opposed to the empty rhetoric prevailing in much Italian art of the 1920s and 1930s (see NOVECENTO ITALIANO). Mafai and Scipione exhibited together in 1928 (this is regarded as the date of the launch of the Roman School) and the term 'Scuola di via Cavour' (after the site of Mafai's studio in Rome) was applied to them and the sculptor Marino Mazzacurati (1907–69) by the critic Roberto Longhi in 1929. Although different in temperament and methods, the two painters were close friends and united in the desire to replace the ponderous classicism of the Novecento with a new Romantic *Expressionism inspired by artists such as *Soutine. The ideals of the Roman School lived on into the second half of the century in the work of such painters as Toti Scialoja (1914–), Giovanni Stradone (1911–), and Renzo Vespignani (1924–).

Rome, Galleria Nazionale d'Arte Moderna. See GALLERIA NAZIONALE D'ARTE MODERNA.

Ronald, William (William Ronald Smith) (1926–). Canadian-American painter and radio and television presenter, a leading figure in the development and acceptance of abstract art in Canada. He was born in Stratford, Ontario, and studied under Jock *Macdonald at Ontario College of Art, Toronto, 1947–51. In 1953 he was the driving force behind the formation of the Toronto group of abstract artists *Painters Eleven, but in 1955 he moved to New York, where he enjoyed considerable success among the second generation of *Abstract Expressionists; in a work such as *Central Black* (Robert McLaughlin Gallery, Oshawa, Ontario, 1955–6), the slashing brushstrokes recall the work of Franz *Kline. Ronald lived in the USA until 1965, becoming an American citizen in 1963, but he retained a large following in Toronto and exerted a strong influence on painters there. With the decline in Abstract Expressionism his popularity waned, but after his return to Canada he achieved success as a radio and television celebrity, presenting chatshows and programmes on art and current affairs. He also developed a kind of road-show

performance in which, dressed in immaculate white, he painted on stage before an audience to the accompaniment of rock music. In the 1970s he returned to serious painting and in 1983 he completed a series of pictures inspired by Canada's prime ministers.

Rooke, Noel. See GIBBINGS.

Rosai, Ottone (1895–1957). Italian painter, born in Florence, where he studied briefly at the Institute of Decorative Arts and the Academy of Fine Arts. He was precocious and had his first exhibition of graphic works in Pistoia in 1911 and an exhibition of paintings in Florence in 1912. In 1913 he met *Soffici and under his influence was associated with the *Futurists. After the First World War (during which he served in the Italian army) Rosai was briefly influenced by *Metaphysical Painting, but by 1920 he had developed a distinctive personal style in which he depicted scenes of urban life in a quasi-*naive manner. Werner *Haftmann (*Painting in the Twentieth Century*, 1965) has written of these works: 'The subject-matter is working-class Florence; ancient, poverty-stricken streets, hillsides covered with grey olive trees, the poor people eking out their existence in the nooks and crannies of the grey city. These simple pictures have the profound, painstaking charm of non-professional art and convey a forlorn note, rendered more poignant by the refusal of poetic effects.' From about 1930 Rosai painted large landscapes and townscapes in which forms were influenced by mild *Cubist stylization. His work was widely exhibited in Italy and he was one of the most popular Italian artists of his day.

Rosati, James (1912–). American sculptor, born at Washington, Pennsylvania. Originally he was a violinist (he played with the Pittsburgh Symphony Orchestra, 1928–30) and he was self-taught as a sculptor. He settled in New York in 1944 and had his first one-man show there—at the Peridot Gallery—in 1954. Rosati has worked in various media as both a carver and a modeller and has been described by the American art historian Dore Ashton as 'one of the most versatile sculptors of his generation'. Typically his work is abstract and block-like, sometimes with minimal allusions to the human figure. He has won numerous awards and public commissions.

Rose, Barbara. See AVANT-GARDE and COOL ART.

Rose, William. See DIRECTION 1.

Rosenberg, Harold (1906–78). American writer, lecturer, and administrator, one of the most influential critics in the field of contemporary art from the 1950s until his death. He was born in Brooklyn, New York, and studied at City College, New York, 1923–4, then at St Lawrence University, graduating with a law degree in 1927. From 1938 to 1942 he was art editor of the *American Guide* series published for the Works Progress Administration (see FEDERAL ART PROJECT) and he later held various other government posts. Early in his career he wrote poetry and essays on literary and general cultural issues (his first book was a collection of poems entitled *Trance Above the Streets*, 1943), and it was not until 1952 that he published his first important work devoted to the visual arts—an essay in *Art News* in which he coined the term *Action Painting. This label became particularly associated with Jackson *Pollock, but the artist Rosenberg most favoured among the *Abstract Expressionists was Willem *de Kooning. This was one of the many ways in which he differed from the other great spokesman for Abstract Expressionism, his rival Clement *Greenberg. Whereas Greenberg came to be concerned only with formal values, Rosenberg had an ethical and political conception of art, believing that the critic should less 'judge it' than 'locate it', subordinating visual analysis to intellectual understanding. He thought that authentic modern art should be perpetually disruptive (see AVANT-GARDE) and he attacked the manipulative fashions created by both the market-place and the museum—*Pop art, for example, he treated with disdain.

Rosenberg was art critic of the *New Yorker* magazine from 1968 until his death, and he also wrote for a wide range of other journals, from *Encounter* to *Vogue*. He was a visiting lecturer or professor at several universities and won various academic awards. His numerous books include collections of essays, notably *The Tradition of the New* (1959), critical works, among them *The De-Definition of Art: Action Art to Pop to Earthworks* (1972), and monographs on de Kooning (1974), Arshile *Gorky (1962), Barnett *Newman (1978), and Saul *Steinberg (1978).

Rosenberg, Isaac (1890–1918). British painter and poet. He was born in Bristol of Jewish immigrant parents from Lithuania and was brought up in the East End of London. In 1904 he began an apprenticeship as an engraver and started attending evening classes in art. He also frequented the *Whitechapel Art Gallery, where he became friendly with *Bomberg and *Gertler. In 1911 the patronage of three wealthy Jewish women enabled Rosenberg to go to the *Slade School, where he studied until 1914. He then went to South Africa for a year to visit his sister and try to improve his delicate health (he had weak lungs); whilst there he lectured on modern art and published a few articles. In 1915 he enlisted in the 12th Suffolks—a bantam regiment for men under regulation height—and he was killed in action on the Somme. The anti-Semitism that he encountered in the army made him conscious of his Jewishness, which had previously not been particularly important to him, and it affected his writing (he wrote a play called *Moses*, for example). Many of his finest poems were written in the trenches, where it was difficult for him even to get writing materials.

Rosenberg made little impact in his lifetime; he had three modest collections of his writing published at his own expense, but otherwise only two of his poems appeared in print, and his paintings were shown in public only three times—at the *New English Art Club in 1912 and 1914 and in the exhibition 'Twentieth Century Art—A Review of Modern Movements', organized by Bomberg at the Whitechapel in 1914. In 1922 a collection of his poetry was published, but although his work was admired by many other poets, his reputation grew only slowly. It was many years before he was generally mentioned in the same breath as other notable war poets such as Rupert Brooke and Wilfred Owen (who were inherently more conspicuous because they were officers). In the 1970s, however, there was a strong growth of interest in Rosenberg, who was the subject of several books and exhibitions. As a painter he did some landscapes and allegorical scenes, but the bulk of his work consists of portraits (before the war he had hoped to earn his living from them). There are several self-portraits (the National Portrait Gallery and the Tate Gallery, London, each has an example) and these convey particularly well the nervous sensitivity of his style and seriousness of

attitude: 'Art is not a plaything,' he wrote, 'it is blood and tears.'

Rosenberg, Léonce (1877–1947) and **Paul** (1881–1959). French art dealers, brothers. In 1906 they took over the Paris gallery of their father, Alexandre Rosenberg, who had set up in business in 1872, specializing first in Old Masters and later in *Impressionist and *Post-Impressionist pictures. However, in 1910 they split the business, and for the next few years Léonce was primarily a collector rather than a dealer. He returned to dealing during the First World War, when *Kahnweiler's forced absence in neutral Switzerland allowed him to become the main advocate of *Cubism by giving contracts to *Braque, *Gris, and *Léger. In 1918 he opened the Galerie de l'Effort Moderne, which for a few years was a powerful force in promoting avant-garde art. Between 1924 and 1927 it issued the *Bulletin de l'Effort Moderne* (40 issues), which provided a forum not only for his own views, but also, for example, for those of Giorgio de *Chirico, Theo van *Doesburg, and the critics Maurice Raynal (1884–1954) and Pierre Reverdy (1889–1960). Soon after the war, however, several of the leading artists Rosenberg represented (including *Picasso) went over to his brother Paul, and Léonce made himself unpopular in the early 1920s when he acted as an expert for the French government's liquidation of Kahnweiler's confiscated pre-war stock; this outraged many people in the art world, as it gave Rosenberg 'a chance to liquidate the stock of his commercial rival at knock-down prices and take advantage of his privileged position to expand his own' (catalogue of the exhibition 'The Essential Cubism', Tate Gallery, London, 1983). During the 1930s his business was badly hit by the Depression.

Paul Rosenberg's gallery was very upmarket and he concentrated on promoting established artists rather than fostering new talent. Picasso (1918), Braque (1922), and Léger (1927) all moved from Léonce to Paul, and in 1936 he also became *Matisse's dealer. In the period between the world wars he maintained a branch of his gallery in London, and in 1940 he moved his business to New York, where his son Alexandre acted as manager.

Rosenberg, Lev. See BAKST.

Rosenblum, Robert. See ABSTRACT SUBLIME.

Rosenquist, James (1933–). American painter, born in Grand Falls, North Dakota, one of his country's leading *Pop artists. After studying at the Minneapolis School of Art and the University of Minnesota, he won a scholarship to the *Art Students League, New York (1955–6), where he met Robert *Indiana, Jasper *Johns, and Robert *Rauschenberg. During the 1950s he supported himself for several years as a commercial artist and billboard painter, and he later recalled his excitement on entering an advertising factory for the first time in 1954 and seeing 'sixty-foot long paintings of beer glasses and macaroni salads sixty-feet wide. I decided I wanted to work there.' He was the only major Pop artist who knew this part of the advertising world as an insider. In 1962 he had his first one-man exhibition (at the Green Gallery, New York), in which he adapted the imagery of his advertising work. Mathew Baigell writes that 'A typical painting by Rosenquist consists of enlarged, overscaled, and juxtaposed fragments of unrelated objects; the effect is that of random layers of paintings on a billboard or images interrupted by turning the dial of a television set' (*Dictionary of American Art*, 1979). Rosenquist has sometimes incorporated objects such as mirrors and neon lights in his paintings, and in the 1970s he began experimenting with printmaking, but he has continued to produce his characteristic billboard-style works.

Rossetti, Dante Gabriel. See PRE-RAPHAELITISM.

Rosso, Medardo (1858–1928). Italian sculptor, born in Turin. He was virtually self-taught, for he was dismissed from the Brera Academy in Milan in 1883 after only a few months' training when he appealed for drawing to be taught from the nude model rather than casts of statues. In 1884 he first visited Paris, and he lived there from 1889 to 1897, the period of his most intense creative activity. It is indeed with French rather than Italian art that his work has affinity, for he created a sculptural equivalent of *Impressionism, depicting everyday subjects and capturing a feeling of movement, atmosphere and transitory effects of light. (He liked to have his sculptures displayed among paintings; he thought that they benefited from coloured light reflected from the surfaces of the pictures.) His favourite medium was wax,

which he used with great subtlety to express his view that matter was malleable by atmosphere: 'We are mere consequences of the objects that surround us.' His subjects included portraits, single figures, and groups in contemporary settings (*The Bookmaker*, MOMA, New York, 1894; *Conversation in a Garden*, Galleria Nazionale d'Arte Moderna, Rome, 1893).

In his early days in Paris Rosso struggled to earn a living (he made funerary monuments for his basic income), but his career blossomed in the 1890s, partly because of the patronage of Henri Rouart (a friend of *Degas), who helped Rosso find clients as well as purchasing works himself. *Rodin, too, tried to help him, but Rosso was suspicious of him and thought he was trying to steal his ideas (it has been suggested that the 'Impressionistic' handling of Rodin's celebrated Balzac monument is indebted to Rosso). In 1897 Rosso returned to Italy and thereafter made almost no new sculpture, devoting his time instead to organizing exhibitions of his work throughout Europe. Through these, and the championship of critics such as Ardengo *Soffici, his work became extremely well known, and after Rodin's death in 1917, *Apollinaire spoke for many when he described him as 'beyond doubt the greatest living sculptor'. His reputation remains high and he is considered one of the most original artists of his time (not even Rodin challenged so decisively the traditional preoccupations of sculpture). He was particularly influential on the *Futurists, who took over and developed many of his ideas; in the *Manifesto of Futurist Sculpture* (1912) *Boccioni called him 'the only great modern sculptor who has attempted to open up a larger field to sculpture, rendering plastically the influences of an ambiance and the atmospheric ties which bind it to the subject'. Rosso's output was fairly small; replicas of several of his works and a collection of his drawings are in the Museo Medardo Rosso at Barzio in Italy.

Roszak, Theodore (1907–81). American painter and sculptor, born at Poznań, Poland. He emigrated to the USA with his family in 1909 and studied at the Art Institute of Chicago, 1922–4, and the National Academy of Design, New York, 1925–6. In 1927 he returned to Chicago, where he was a part-time instructor at the Art Institute until 1929. He then went to Europe and worked in

Prague, where he was influenced by de *Chirico and the *Surrealists. In 1931 he returned to the USA and settled in New York. From this point in his career sculpture gradually gained prominence in his work. In 1938–40 he taught at the Design Laboratory, New York, which was inspired by the *Bauhaus, and developed an interest in geometrical abstraction that lasted until the mid-1940s. From this time he continued to work in welded steel and bronze, but his style changed to one of expressive abstraction involving quasi-organic forms; this brought him within the group of sculptors, including *Ferber and *Lassaw, whose work paralleled that of the *Abstract Expressionist painters. Examples of his work in this mode are *Whaler of Nantucket* (Art Institute of Chicago, 1952) and *Sea Sentinel* (Whitney Museum, New York, 1956).

Rot, Diter. See ROTH.

Rotella, Mimmo (1918–). Italian painter and experimental artist, born at Catanzaro, Calabria. He studied at the Academy in Naples, then in 1951–2 at the University of Kansas on a Fulbright Scholarship. Since his return to Europe he has divided his time mainly between Rome and Paris. In 1954 he began exhibiting collages made up of fragments of posters torn from walls, calling them *Manifesti lacerati*, and he wrote: 'Tearing posters down from the walls is the only recourse, the only protest against a society that has lost its taste for change and shocking transformations.' The French *affichistes worked in a similar manner, but Rotella seems to have arrived at the technique independently. In 1960 he became associated with *Nouveau Réalisme in Paris and he was a pioneer of this kind of work in Italy.

Roth, Dieter (Diter Rot) (1930–). German painter, printmaker, designer, and experimental artist, born in Hanover of a Swiss father and a German mother. He moved to Switzerland in 1943 and was apprenticed as a graphic designer in Berne, 1947–51. In 1955–7 he lived in Copenhagen, and since 1957 has been based mainly in Reykjavik, Iceland, although he has continued to travel a good deal and in 1964–7 lived in the USA, where he taught at Yale University and elsewhere. His work has been extremely varied and has included objects incorporating edible

materials such as chocolate. However, he is best known for his prints: 'Roth's random accretions of compositional ideas have produced a large body of graphic and multiple work, often in unorthodox media and in collaboration with other artists' (Riva Castleman, *Prints of the 20th Century*, 2nd edn., 1988). The artists with whom he has collaborated include Richard *Hamilton.

Rothenberg, Susan. See NEW IMAGE PAINTING.

Rothenstein, Sir William (1872–1945). British painter, graphic artist, writer, and teacher, born in Bradford. In 1888–9 he studied at the *Slade School in London and in 1889–93 at the *Académie Julian in Paris. There he became a close friend of *Whistler and was encouraged by *Degas. His best works are generally considered to be his early Whistlerian paintings such as *The Doll's House* (Tate Gallery, London, 1899), which shows Augustus *John and Rothenstein's wife as characters in a tense scene evoking Ibsen's play *A Doll's House*. From about 1898, however, he specialized in portraits of the famous and those who later became famous. In the latter part of his career he was much more renowned as a teacher than as a painter. His outlook was conservative (he regarded pure abstraction as 'a cardinal heresy') and as principal of the *Royal College of Art, 1920–35, he exercised an influence second only to that of Henry *Tonks at the Slade School. Rothenstein's publications include various collections of his portrait drawings and lithographs and three volumes of memoirs—*Men and Memories* (2 vols., 1931–2) and *Since Fifty* (1939). His brother **Albert Rothenstein** (1881–1953) was a painter (see CAMDEN TOWN GROUP), designer, and prolific book illustrator. In 1914 he changed his surname to Rutherston because anti-German feeling made 'Rothenstein' a handicap.

William's son, **Sir John Rothenstein** (1901–92), was a distinguished art historian. He was director of the *Tate Gallery, 1938–64, and the author of numerous books on art, mainly on 20th-century British painting. His best-known publication is the three-volume series *Modern English Painters* (1952, 1956, 1973; new edition of the whole work, 1984). This contains stimulating essays on some sixty leading British painters from *Sickert to *Hockney, almost all of whom Rothenstein

knew personally. His other books include *British Art Since 1900: An Anthology* (1962) and monographs on Edward *Burra (1973), Augustus *John (1962), John *Nash (1984), Paul *Nash (1961), and Matthew *Smith (1962).

Another son, **Michael Rothenstein** (1908–93), was a painter, graphic artist, and writer, best known as a printmaker. He worked in a variety of techniques, in both abstract and figurative styles, and liked to experiment with materials. His books include *Frontiers of Printmaking* (1966). John Rothenstein wrote of his brother that 'Recognition of his highly varied achievements have been far more marked abroad than at home . . . The many awards Michael has won include the Gold Medal at the 1970 Buenos Aires Print Biennale and the Grand Prix at the Norwegian Print Biennale, 1976.'

Rothko, Mark (1903–70). Russian-born American painter, one of the outstanding figures of *Abstract Expressionism and one of the creators of *Colour Field Painting. He was born Marcus Rothkowitz in Dvinsk and emigrated to the USA in 1913; he changed his name at about the same time that he acquired American citizenship in 1938. After dropping out of Yale University in 1923 he moved to New York and studied at the *Art Students League under Max *Weber, but he regarded himself as essentially self-taught as a painter. In the 1930s and 1940s he went through phases influenced by *Expressionism and *Surrealism, but from about 1947 he began to develop his mature and distinctive style. Typically his paintings feature large rectangular expanses of colour arranged parallel to each other, usually in a vertical format. The edges of these shapes are softly uneven, giving them a hazy, pulsating quality as if they were suspended and floating on the canvas. His paintings are often very large and the effect they produce is one of calmness and contemplation, but in spite of their tranquillity, they cost him enormous emotional effort: 'I'm not an abstract artist . . . I'm not interested in the relationship of colour or form or anything else. I'm interested only in expressing basic human emotions—tragedy, ecstasy, doom and so on. And the fact that a lot of people break down and cry when confronted with my pictures shows that I can communicate these basic human emotions . . . The people who weep before my pictures are having the same religious experience as I had when I painted them.'

Rothko was poor for much of his career (from 1929 to 1959 he earned at least part of his living by teaching art), but his reputation grew in the 1950s and in 1961 he was given a major retrospective exhibition at the Museum of Modern Art, New York. The catalogue introduction, by Peter Selz, is written in a fulsome style that immediately attracted parody and set the tone for much subsequent writing on Rothko, who probably inspired more over-the-top prose than any other artist of his time. A sample from Selz is: 'Unlike the doors of the dead which were meant to shut out the living from the place of absolute night, even of patrician death, these paintings—open sarcophogi—moodily dare, and thus invite the spectator to enter their orifices.' In spite of his soaring reputation (and the money it brought), Rothko was plagued by depression. He had a prickly temperament, drank heavily, took barbiturates to excess, was fearful and suspicious of younger artists, had two unhappy marriages, and felt he was misunderstood (he disliked having his work discussed in *formalist terms). Robert *Hughes writes: 'In the studio, Rothko was a man of resolution: one of the last artists in America to believe, with his entire being, that painting could carry the load of major meanings and possess the same comprehensive seriousness as the art of fresco in the sixteenth century or the novel in nineteenth-century Russia. Outside its door, he dithered. The least eddy on the surface of the day, a misplaced phone call or a mislaid bank statement, could drop him into the Black Hole.' His early works had often been bright and vivid in colour, but from the 1950s they became increasingly sombre, typically employing blacks, browns, and maroon. He regarded his fourteen paintings for a non-demoninational chapel in Houston, Texas (now known as the Rothko Chapel), 1967–9, as his masterpieces. His last paintings include a series of stark black on grey canvases that suggest his painful state of mind leading up to his suicide (he slashed his veins in his studio).

Rothko's reputation stands high, but he has not been without detractors. After visiting an exhibition of his work in 1972, Keith *Vaughan wrote: 'Feeble stuff. Large decor. Boring to paint and look at. Not surprising he killed himself if that was all there was to do.'

Rouault, Georges (1871–1958). French painter, draughtsman, printmaker, and designer who created a personal style of *Expressionism that gives him a highly distinctive place in modern art. He was born in Paris, the son of a cabinet-maker, and from 1885 to 1890 was apprenticed to a stained-glass maker, his work including the restoration of medieval glass; the vivid colours and strong outlines characteristic of the medium left a powerful imprint on his work. In 1891 he entered the École des *Beaux-Arts, where with *Matisse and *Marquet he was a pupil of Gustave Moreau (1826–98), a brilliant and sympathetic teacher. He was Moreau's favourite pupil and became the first curator of the Musée Moreau in Paris, opened in 1903. At about the same time he underwent a psychological crisis, and although he continued to associate with the group of artists around Matisse who were later known as *Fauves, he did not adopt their brilliant colours or their typical subjects; instead he painted characters such as clowns, prostitutes, and outcasts in sombre but glowing colours. These subjects expressed his hatred of cruelty, hypocrisy, and vice, depicting the ugliness and degradation of humanity with passionate conviction. His familiar cast of characters also included judges (*The Three Judges*, Tate Gallery, London, c. 1936), on the subject of which he said: 'If I have made them such lamentable figures, it is doubtless because I betrayed the anguish which I feel at the sight of a human being who has to pass judgement on other men.'

Rouault's work initially disturbed the public, but he achieved financial security after *Vollard became his agent in 1917 and during the 1930s he gained an international reputation; in 1937, for example, he had a one-man show at the Pierre Matisse gallery in New York, and in 1938 there was an exhibition of his prints at the Museum of Modern Art, New York. He worked in various printmaking techniques, often for book illustrations commissioned by Vollard. Vollard also funded the publication of *Miserere* (1927), a suite of 58 prints forming a meditation on death. Rouault, who had conceived the idea for the project in 1912, himself created the captions for the prints, using phrases from the Bible. From about 1940 he devoted himself almost exclusively to religious art. In addition to his prolific output of paintings, drawings, and prints, his work also included ceramics and designs for tapestry, for stained glass, and for *Diaghilev's ballet *The Prodigal Son* (1929), for which the music was written by Prokofiev. By

the time of his death Rouault was a much honoured figure and he was given a state funeral.

Rousseau, Henri (known as Le Douanier Rousseau) (1844–1910). French painter, the most celebrated of *naive artists. His nickname refers to the job he held with the Paris municipal toll-collecting service (1871–93), although he never actually rose to the rank of 'Douanier' (Customs Officer). Before this he had served in the army—he later claimed to have seen service in Mexico, but this seems to be a product of his imagination. He began to paint as a hobby, self-taught, when he was about 40, and from 1886 he exhibited regularly at the *Salon des Indépendants. In 1893 he took early retirement so he could devote himself to art. His character was extraordinarily ingenuous and he suffered much ridicule (although he sometimes interpreted sarcastic remarks literally and took them as praise) as well as enduring great poverty. However, his faith in his own abilities never wavered. He tried to paint in a traditional academic style, but it was the innocence and charm of his work that won him the admiration of the avant-garde. He was 'discovered' by *Vollard and members of his circle in about 1906–7 and in 1908 *Picasso gave a banquet, half-serious, half-burlesque, in his honour. His first one-man show was arranged by Wilhelm *Uhde in a furniture shop in the rue Notre-Dame-des-Champs, Paris, in 1909, and in 1910 Max *Weber (who had become friendly with Rousseau a few years earlier) organized an exhibition of his work at *Stieglitz's 291 gallery in New York.

Rousseau is now best known for his jungle scenes, the first of which was *Tiger in a Tropical Storm (Surprised!)* (NG, London, 1891) and the last *The Dream* (MOMA, New York, 1910). These two paintings are works of great imaginative power, in which he showed his extraordinary ability to retain the utter freshness of his vision even when working on a large scale and with loving attention to detail. He claimed such scenes were inspired by his alleged experiences in Mexico, but in fact his sources were illustrated books and visits to the zoo and botanical gardens in Paris. His other work ranges from the jaunty humour of *The Football Players* (Philadelphia Museum of Art, 1908) to the eerie, mesmeric beauty of *The Sleeping Gypsy* (MOMA, New York, 1897). Rousseau was buried in a pauper's grave, but his greatness began to be widely acknowledged soon after his death; a retrospective exhibition of his work was organized at the Salon des Indépendants in 1911.

Roussel, Ker-Xavier (1867–1944). French painter, born at Lorry-les-Metz. From schooldays he was a friend of *Denis and *Vuillard (whose sister he married in 1893) and he met *Bonnard at the *Académie Julian in Paris, where he enrolled in 1888. With these and several other friends he formed a group of *Symbolist painters called the *Nabis. The group drifted apart after its last exhibition in 1899 and from this time Roussel concentrated on bucolic subjects from pagan antiquity, painted in a late *Impressionist manner, with nervous brushwork and sparkling colours. He also did several large decorative commissions, including a curtain for the Théâtre des Champs-Elysées, Paris (1913), and murals for the Palais des Nations at Geneva (*Pax Nutrix*, 1936) and the Palais de Chaillot in Paris (*La Danse*, 1937).

Roussel, Theodore (1847–1926). French painter and etcher who settled in England in the 1870s. He was a friend of *Whistler and was influenced by him in his paintings and his prints. Whereas Whistler experimented only mildly with colour printmaking, however, Roussel became fascinated by it and developed new techniques and production processes; he was president of the Society of Graver-Printers in Colour. His paintings included portraits, landscapes, and genre subjects, but he is now remembered primarily for a beautiful nude, *The Reading Girl* (Tate Gallery, London, 1886–7). Frank *Rutter wrote that 'At the time when it was added to our national collection [1927], Sir William *Orpen publicly stated his opinion that this was the finest nude painted in his time' (*Modern Masterpieces*, 1940).

Rowat, Jessie (Jessie Newbery). See GLASGOW SCHOOL and NEWBERY.

Rowen, Robert A. See MUSEUM OF CONTEMPORARY ART, LOS ANGELES.

Rowntree, Kenneth (1915–97). British painter, born in Scarborough. He studied at the Ruskin School of Drawing, Oxford, 1930–4, and the *Slade School, 1934–5. A Quaker, he was exempt from military service

in the Second World War, but he worked for the *'Recording Britain' scheme and also on the decoration of buildings. His first one-man exhibition was at the *Leicester Galleries, London, in 1946. In the later 1940s and the 1950s he did a good deal of work as a muralist, for example at the Barclay School, Stevenage (1946), and for the ships RMS *Orsova* and *Iberia* (1955). He taught at the *Royal College of Art, 1949–58, and was professor of fine art at the University of Newcastle upon Tyne, 1959–80. In his later work he experimented with materials, creating collages and reliefs: in the catalogue of an exhibition of his work held at the Laing Art Gallery, Newcastle upon Tyne, in 1976–7, John Milner wrote that 'He is as likely to work with a fret-saw and drill, or with stencil and pieces of tea-chest, as he is to squeeze out paint from a tube of oil colour'. He also experimented with abstraction, but landscape (including gardens) and buildings remained his favourite subjects.

Roy, Jamini (1887–1972). Indian painter. He was born at Baliatore in rural Bengal and studied at the Government School of Art in Calcutta, 1906–14. At the beginning of his career he painted portraits in an academic style, and he was later influenced by *Post-Impressionism, but in the late 1920s he turned to the local folk art tradition as a source of inspiration, seeing in it a way to recapture an archaic innocence that had been pushed aside by Western influence. His work became very popular in India and was discovered by Allied troops and other Westerners who found themselves in Calcutta during the Second World War. In this way he became one of the few modern Indian artists whose work was known outside his own country. To Westerners it had some of the same attraction as European *naive painting. His style was imitated (and generally coarsened) by many followers, including his sons.

Roy, Pierre (1880–1950). French painter, illustrator, and designer, born at Nantes. His family had connections with that of the writer Jules Verne, whose stories made a great impression on Roy as a boy and may have had some influence on the direction that his art took in later life. After working in an architect's office, where he learned precise draughtsmanship, he moved to Paris in 1904 and studied at the École des *Beaux-Arts, the *Académie Julian, and the École des Arts Décoratifs. His early work was *Neo-Impressionist and in 1908 he came into the circle of the *Fauves, but in about 1920 he discovered the work of de *Chirico and began moving towards the *Surrealist style with which he is most closely associated. He took part in the first Surrealist group exhibition—at the Galerie Pierre in Paris in 1925—and in several of their other group shows. His work is in a similar vein to that of *Dalí and *Magritte, creating a sense of the bizarre or mysterious through strange juxtapositions of objects painted with an almost photographic realism. Perhaps his best-known painting is *The Dangers of the Stairway* (MOMA, New York, 1927–8), showing a large snake winding its way down a staircase in an otherwise scrupulously boring middle-class interior. His other work included designs for theatre and ballet sets and book illustrations in lithograph and woodcut. Roy's 'oldest and most faithful friend' (in his son's words) was Boris *Anrep, whom he met in Paris in 1908. Anrep bequeathed one of Roy's pictures to the Tate Gallery, London.

Royal Academy of Arts, London. The national art academy of England, founded in 1768. It was first based in Pall Mall, and after moving to Somerset House (1780) and then to the National Gallery's premises in Trafalgar Square (1837), it transferred to its present home in Burlington House, Piccadilly, in 1869. The artists who founded the RA aimed to raise the status of their profession by establishing a sound system of training and expert judgement in the arts and to arrange for the exhibition of works attaining an appropriate standard of excellence. The Academy's annual summer exhibition, to which anyone can submit works, has been held every year since 1769, and the RA Schools have also existed from the beginning. They were unchallenged as Britain's main training ground for artists until the opening of the *Slade School in 1871, but by this time the teaching at the RA had become slipshod and out-of-date, based on drawing from plaster casts of antique statues rather than from the live model. A correspondent to *The Times* in 1886, signing himself an 'RA Gold Medallist', considered the teaching to be 'lamentably inefficient...I never met an Academy student who does not say that he stops in the Academy Schools because he cannot leave for Paris. I have never met an Academy student who,

having left the Academy Schools for the French, did not strenuously advise others to do the same.' It was not only the reputation of the Schools but of the Academy as a whole that sank very low at about this time, and it became regarded as the bulwark of orthodox mediocrity in opposition to creative and progressive art.

In the late 19th and early 20th centuries other organizations, such as the *New English Art Club (1886) and the *London Group (1913), were formed to give progressive artists alternative venues at which to show their work. Adventurous work was rarely shown at the Academy's exhibitions (where traditionalism ruled to such an extent that top hats and tail coats were required dress on private view days until 1940), and in the 1930s there were several notable instances of leading artists resigning from the Academy because of outmoded views and taste. In 1935 *Sickert (elected a full Academician only the previous year) resigned because the president, Sir William *Llewellyn, refused to sign a letter to *The Times* protesting against the threatened destruction of *Epstein's sculptures on the British Medical Association building, and in the same year Stanley *Spencer resigned his associateship when two of his paintings were rejected by the hanging committee of the summer exhibition (he did not return until 1950); in 1938 Augustus *John similarly left in protest after Wyndham *Lewis's portrait of T. S. Eliot was rejected (John rejoined two years later).

After the presidency (1944–9) of *Munnings, who was notorious for his opposition to modern art, the Academy's policy became more liberal, and the gap between official and progressive art narrowed. The Schools, too, have won back some of their former distinction. But something of the reputation for stuffiness continued up to the 1970s, and the Academy's aim at its inception to provide exhibitions of the best contemporary work from year to year has been challenged by commercial galleries and by bodies such as the *Arts Council. The RA's annual summer exhibition still remains a popular event, however, and the Academy regularly organizes major loan exhibitions (the first was in 1870). They have included several recent large survey shows of 20th-century art: 'German Art in the 20th Century' (1985), 'British Art in the 20th Century' (1987), 'Italian Art in the 20th Century' (1989), and

'American Art in the 20th Century' (1993). In 1997 it staged a highly controversial show called 'Sensation' (see AVANT-GARDE).

The presidents of the RA in the 20th century have been: Sir Edward *Poynter, 1896–1918; the architect Sir Aston Webb (1849–1930), 1919–24; Sir Frank *Dicksee, 1924–8; Sir William *Llewellyn, 1928–38; the architect Sir Edwin Lutyens (1869–1944), 1938–44, Sir Alfred Munnings, 1944–9; Sir Gerald *Kelly, 1949–54; the architect Sir Albert Richardson (1880–1964), 1954–6; Sir Charles *Wheeler, 1956–66; Sir Thomas *Monnington, 1966–76; the architect Sir Hugh Casson (1910–), who is also a watercolourist and illustrator, 1976–84; Sir Roger *de Grey, 1984–93; and the architect Sir Philip Dowson (1924–), 1993– .

Royal College of Art (RCA), London. Britain's pre-eminent training school for artists and designers. Since 1967 it has been a postgraduate university institution, but it has had many changes of status, name, and location since it was founded in 1837 at Somerset House as the School of Design. Originally it was a school of industrial design, the fine arts being the province of the *Royal Academy. In 1852 it moved to Marlborough House and was renamed the Central School of Practical Art. It became part of the Government Department of Science and Art in 1853 and in 1857, renamed the National Art Training School, it moved to join the Museum of Ornamental Art (later the Victoria and Albert Museum) in South Kensington. In 1863 it moved to new buildings in Exhibition Road, and in 1896 it was renamed the Royal College of Art by Queen Victoria and allowed to grant diplomas. At this time the principal (or headmaster as the post was sometimes known) was John Sparkes (d. 1907); he was succeeded by Walter *Crane, 1897–8, and then by Augustus Spencer (1860–1924), who held the position until 1920.

By the turn of the century the college had turned much more to fine art, away from industrial design, and in 1900 it was divided into four schools: Mural and Decorative Painting; Sculpture and Modelling; Architecture; and Design. The original heads of these schools (who were called 'instructors', then from 1901 'professors') were respectively Gerald Moira (1867–1959), whose work included murals at the Central Criminal Court (Old Bailey) and other public buildings

in London; the French-born Edward Lantéri (1848–1917), who was influential in training exponents of the *New Sculpture; Beresford Pite (1861–1934), a founder member (1884) of the Art Workers' Guild, which aimed to increase understanding and collaboration between different branches of the visual arts; and W. R. *Lethaby, one of the outstanding art educators of his day. Lethaby brought with him several specialist teachers, most notably Edward Johnston (1872–1944), the celebrated calligrapher, who taught writing and illumination at the RCA for almost 40 years. Among the other distinguished and long-serving teachers was Frank *Short, who was in charge of etching from 1891 to 1924.

Spencer was followed as principal by William *Rothenstein, 1920–35, whose conservative values were highly influential, and he was succeeded by Percy *Jowett, 1935–47. During the Second World War the RCA was relocated to Ambleside in the Lake District, 1940–5. This interlude was well managed on the whole, but by the time of its return to London the college had become somewhat stagnant. It was given new life by Robin *Darwin, who was head from 1948 to 1971 (in 1967 his title changed from principal to rector). Darwin introduced many new departments, including fashion design and photography, aligned the college more closely with industry (he aimed to 'provide courses of a thoroughly practical nature in all primary industrial fields'), and revitalized the teaching staff (he said that when he joined 'two of the five professors were alleged not to have exhanged a word for fifteen years'). His overall concern was to make the RCA a 'magnet for talent'. It was during Darwin's long period in charge that the college moved to its present home, a new eight-storey building in Kensington Gore (1961), and that it was given a Royal Charter and empowered to award degrees (1967).

Although the RCA had some highly illustrious students early in the 20th century, most notably Barbara *Hepworth and Henry *Moore, its golden age is usually reckoned to fall within Darwin's period in charge. In 1987 Christopher Frayling (1946–), professor of cultural history at the college (he became rector in 1996), published *The Royal College of Art: One Hundred & Fifty Years of Art & Design*, in which he named the period 'roughly 1948–1968' as 'the days . . . when the RCA couldn't do anything wrong if it tried'. Its absolute peak of esteem perhaps came in the late 1950s and early 1960s with the generation of students who were largely responsible for launching British *Pop art—Derek *Boshier, David *Hockney, Allen *Jones, R. B. *Kitaj, Peter *Phillips (see YOUNG CONTEMPORARIES).

Rozanova, Olga (1886–1918). Russian painter, designer, writer, and administrator, born at Malenki in Vladimir province. She was an energetic figure in the avant-garde in the most momentous period of 20th-century Russian art, but her career was cut short when she died suddenly of diphtheria at the age of 32. After studying at the Bolshakov Art College and the Stroganov Art School in Moscow, 1904–10, she became a member of the *Union of Youth in 1911. In an essay published in the Union's journal in 1913 she was among the first Russians to advocate abstract art. Her painting at this time was *Futurist in style and she illustrated many Futurist books, often in collaboration with her husband Alexei Kruchenykh (1886–1968), a poet and critic who was one the leading theorists of the movement. By the time she illustrated his book *Universal War* (1916) her style had become purely abstract in a manner close to *Suprematism (she also experimented with other abstract styles). Kruchenykh subscribed to a theory of poetry called 'transrationalism', which 'proclaimed the liberation of words from their conventional meanings and resulted in a kind of abstract sound-poetry . . . Rozanova's success in transposing the abstract qualities of Kruchenykh's poems into the medium of collage depended in large measure upon her acceptance of his theories. In breaking down syntax and in his use of part-words and letters Kruchenykh destroyed literal meaning in his poems and found himself free to experiment with a wide range of associations aroused by both the sound of his poem and its image on the paper' (M. N. Yablonskaya, *Women Artists of Russia's New Age*, 1990).

After the 1917 Revolution, Rozanova (who was an ardent public speaker) devoted much of her energy to the reorganization of industrial art, travelling widely throughout the country, which was in a state of chaos. She was mainly responsible for creating a special sub-section of *Narkompros dealing with industrial art and she drew up a plan for Moscow's museums in this field that was put into practice after her death. Her idea of

reconciling art and industry was realized in the *Constructivist movement.

Rubbo, Anthony Dattilo (1870–1955). Italian-born painter who settled in Australia in 1897 and ran an art school in Sydney from 1898 to 1941. He also taught for many years at the Royal Art Society School, Sydney. Rubbo admired the work of the *Post-Impressionists and his teaching helped to promote an advanced style based on their work. His pupils included three of the pioneers of modernism in Australia—Roy de *Maistre, Grace Cossington *Smith, and Roland *Wakelin. Wakelin wrote of him: 'Rubbo, with his virile personality and tremendous enthusiasm, was an inspiration to us all.'

Rubinstein, Helena. See NADELMAN.

Ruche, La ('The Hive'). A twelve-sided, three-storey building in the rue Dantzig in Paris, near the Vaugirard abattoirs, opened in 1902 with the idea of forming the centre of an artistic community. It was the brainchild of Alfred Boucher (1850–1934), an undistinguished painter and sculptor who bought some land in 1895 and built a few studio huts on it; he was encouraged to erect something more ambitious when he acquired various pieces of pavilions that had been dismantled after the 'Exposition Universelle' in Paris in 1900. The main building originally had 24 cramped wedge-shaped studios, but 140 others were eventually erected on the site. They were badly built and without conveniences such as water and gas, but they were extremely cheap. Many foreign artists found a home there on first coming to Paris, among them *Archipenko, *Chagall, *Lipchitz, *Modigliani, and *Soutine. Some French artists also had studios there for a time (*Delaunay, *Laurens, *Léger) and some poets and writers lived there (Guillaume *Apollinaire, Blaise Cendrars, Max *Jacob). Political refugees also found shelter at La Ruche. The building was scheduled for demolition in 1966, but it was saved because of its important historical associations, and after restoration was reopened as studios in 1978.

Ruralists, Brotherhood of. See BROTHERHOOD OF RURALISTS.

Ruscha, Ed (1937–). American painter, printmaker, designer, and photographer. He was born in Omaha, Nebraska, and studied at the Chouinard Art Institute, Los Angeles, 1956–60. His work has been varied and experimental, often using unconventional materials (such as blood and foodstuffs), but he is best known for his books of deadpan photographs of banal features of American life, which are early examples of *Book art. The first was *Twentysix Gasoline Stations* (1962). To many people, these books are exceedingly boring, but Ruscha's admirers see great depths in them: 'Mimicking the way in which Americans use their cameras, these collections of snapshot-like pictures question the medium's artistic potential and raise broader issues about our society's strange affair with photography. Ruscha's books are so simple they become profound' (George Walsh, Colin Naylor, and Michael Held, eds., *Contemporary Photographers*, 1982). Some of his more conventional paintings and prints are representative of *Pop art, depicting advertising signs in a bold, brash manner (*Large Trademark with Eight Spotlights*, Whitney Museum, New York, 1962).

Ruskin, John. See DIRECT CARVING and TRUTH TO MATERIAL(S).

Russell, John (1919–). British art critic and exhibition organizer. He was born in London and studied at Magdalen College, Oxford. After war service at the Ministry of Information and the Admiralty, he became a journalist and was the regular art critic of the *Sunday Times* from 1949 to 1974. He then moved to New York as art critic of the *New York Times*. His numerous books (mainly but not exclusively on art) include *Paris* (1960), *Max *Ernst* (1967), *Henry *Moore* (1968), *The World of *Matisse* (1970), *Francis *Bacon* (1971), *Edouard *Vuillard* (1971), and *The Meanings of Modern Art* (1981). They combine accessibility and an admirably fluent style with sensitivity and sound scholarship. In 1984 he won the prestigious Mitchell Prize for art history. As a member of the art panel of the *Arts Council from 1958 until 1968 he organized three exhibitions at the Tate Gallery, London: *Modigliani (1964), *Rouault (1966), and *Balthus (1968); he was also co-organizer of the exhibition '*Pop Art' at the Hayward Gallery in 1969.

Russell, Morgan (1886–1953). American painter, active mainly in Paris; with Stanton *Macdonald-Wright he was the founder of

*Synchromism, one of the earliest abstract art movements. Russell was born in New York, the son of an architect. Originally he intended following his father's profession, but on a visit to Paris in 1906 he was overwhelmed by the Michelangelo sculptures he saw in the Louvre and decided to become a sculptor. After returning to New York he studied sculpture at the *Art Students League and painting under Robert *Henri. In 1908 he settled in Paris, where he met Gertrude and Leo *Stein and through them *Matisse, at whose art school he briefly studied. By 1910 Morgan was turning away from sculpture and devoting himself increasingly to painting, and in 1911 he met Macdonald-Wright, with whom he developed theories about the analogies between colours and musical patterns. In 1913 they launched Synchromism, and Russell's *Synchromy in Orange: To Form* (Albright-Knox Art Gallery, Buffalo, 1913–14) won him considerable renown in Paris. His later work, in which he reintroduced figurative elements, was much less memorable than were his pioneering abstract paintings. From about 1930 much of his work consisted of large religious pictures. He lived in Paris until 1946, then returned to the USA.

Russell, Sir Walter Westley. See CAMDEN TOWN GROUP.

Russolo, Luigi (1885–1947). Italian painter and musician, born at Portogruaro in the Veneto, son of the local cathedral organist. His only formal training as a painter was as an assistant to a restorer who was working on Leonardo da Vinci's mural of *The Last Supper* in Milan. Russolo was one of the signatories of the two *Futurist painters' manifestos in 1910, but he has become best known as 'the most spectacular innovator among the Futurist musicians' (*New Grove Dictionary of Music and Musicians*, 1980). In 1913 he published a manifesto *L'Arte dei rumori* ('The Art of Noises', expanded in book form in 1916) and later in the same year he demonstrated in Modena the first of a series of *intonarumori* ('noise-makers'), which produced a startling range of sounds. In 1913–14 he gave 'noise concerts' in Milan (causing a riot), Genoa, and London, and others followed after the First World War, notably in Paris in 1921. They were highly controversial, but *Mondrian praised the Paris performances in the journal *De *Stijl* and several leading composers, notably Ravel and

Stravinsky, seemed to think that they opened up interesting new possibilities. Russolo indeed has been regarded as a pioneer of today's electronic music. Unfortunately his handful of noise compositions have been lost and the machines were all destroyed during the Second World War while they were in storage in Paris; one recording survives, but of very poor quality. In 1927–32 Russolo lived in Paris as a refugee from Fascism. After a brief period in Spain, he returned to Italy in 1933 and settled at Cerro di Laveno on Lake Maggiore. His early paintings had made rather crude use of the Futurist device of 'lines of force'; after the First World War his style became more naturalistic.

Rustin, Jean (1928–). French painter, born in Montigny-lès-Metz. After the Second World War he settled in Paris, where he studied at the École des *Beaux-Arts, 1947–53, and built up a successful career as an abstract painter, culminating in a retrospective at the Musée d'Art Moderne de la Ville de Paris in 1971. However, he then changed direction dramatically and began producing bleak and disturbing figurative works, typically showing aged, decrepit nudes—men and women—in bare, cell-like rooms. They are sometimes compared with Francis *Bacon's paintings, but Rustin's vision—though just as despairing—is much quieter. Edward *Lucie-Smith writes that 'Rustin's work is sometimes linked by critics to the cataclysmic politics of the twentieth century, in particular to the Holocaust. The artist denies that there is any connection to this or to any other specific event, just as he denies that the paintings are meant to be portraits of the mentally ill. For him, they reflect not only his own inner tensions, but the general collapse of value systems' (*Visual Arts in the 20th Century*, 1996).

Rutherston, Albert. See ROTHENSTEIN.

Rutter, Frank (1876–1937). British art critic, born in London, the son of a solicitor (John Ruskin was among his clients). After taking a degree in Semitic languages at Cambridge University in 1899 he became a professional art critic in 1901, writing for *The Times, Financial Times*, and *Sunday Times*, as well as for journals such as the *Studio*. He was one of the staunchest British supporters of *Impressionism and of modern French painting in general, and he denigrated the *Royal Academy,

which he thought outmoded. In 1908 he was one of the founders of the *Allied Art Association and in 1909 he launched and edited its journal, *Art News*. Roger *Fry's first *Post-Impressionist exhibition in 1910 inspired Rutter to write a short book entitled *Revolution in Art: An Introduction to the Study of *Cézanne, *Gauguin, Van Gogh, and Other Modern Painters* (1910), in which he rather strangely equates artistic radicals with political ones. He writes that Cézanne (whom he incorrectly says was a Communist) and Gauguin 'are to their younger comrades what Marx and Kropotkin are to the young social reformers of the day'. From 1912 to 1917 he was curator of the City Art Gallery in Leeds, where he was an early mentor of Herbert *Read, who assisted Rutter on his illustrated quarterly periodical *Art and Letters*, which ran from 1917 to 1920. In 1917 he returned to London and worked for the Admiralty until the end of the First World War. Rutter's numerous books include *Guide to Cambridge* (1922, and much revised and reprinted), *The Poetry of Architecture* (1923), *Since I Was Twenty-Five* (1927), *Evolution in Modern Art: A Study of Modern Painting, 1870–1925* (1932), *Art in My Time* (1933), and *Modern Masterpieces: An Outline of Modern Art*, posthumously published in 1940. He also wrote much of the text of *Orpen's *The Outline of Art* (1923); in the original edition he is credited only with the final chapter, but in a revised edition published in 1950 the book is described as a work of 'collaboration of one of the greatest painters living at that date, Sir William Orpen, and one of the finest writers upon art, Frank Rutter'.

Ryback, Issachar (1897–1934). Russian painter, printmaker, and designer, born at Elisavetgrad in the Ukraine into a Jewish family. He studied in Kiev and Moscow, then in 1921 moved to Berlin, where he exhibited with the *Sezession and was a member of the *Novembergruppe. After spending a year back in Russia, he settled in Paris in 1926. Like his countryman *Chagall, Ryback based much of his work on memories of the Jewish environment in which he grew up. In addition to Jewish subjects he also painted flower pieces, animals, and portraits. In 1933 he visited England and held an exhibition of his work sponsored by the Cambridge University Arts Society. By this time he was already suffering from the spinal disease that carried him off prematurely two years later. In 1964 a

Ryback Museum was opened in Tel Aviv to house works donated by his widow.

Ryder, Albert Pinkham (1847–1917). American painter of imaginative subjects. He lived most of his life as a solitary and dreamer in New York, and his methods and approach as an artist were largely self-taught. His pictures reflect a rich inner life, with a haunting love of the sea (he was born at the fishing port of New Bedford, Massachusetts), and a constant search to express the ineffable: 'Have you ever seen an inch worm crawl up a leaf or twig, and then clinging to the very end, revolve in the air, feeling for something to reach something? That's like me. I am trying to find something out there beyond the place on which I have a footing.' This imaginative quality and eloquent expression of the mysteriousness of life is expressed typically through boldly simplified forms and eerie lighting (*The Race Track* or *Death on a Pale Horse*, Cleveland Museum of Art). In spite of his self-imposed isolation, Ryder's works became well known in his lifetime and he has been much imitated and faked. His own paintings have often deteriorated because of unorthodox technical procedures.

Ten of Ryder's pictures were included in the *Armory Show of 1913 and he has been seen as a precursor of *Expressionism and abstract art. He was greatly admired by Jackson *Pollock, who in 1944 said 'Ryder is the only American painter who interests me', and the critical and popular favour Ryder enjoyed in the 1950s and 1960s was linked to the success of *Abstract Expressionism.

Rylov, Arkady (1870–1939). Russian painter and graphic artist, active mainly in St Petersburg/Leningrad, where he studied (1894–7) and later taught (1918–29) at the Academy. He was primarily a landscape painter and is remembered mainly for *In Blue Space* (Tretyakov Gallery, Moscow, 1918), showing swans flying over the sea; it 'has been hailed as the first expression of the new sense of freedom and the joyous outlook brought about by the Revolution' (Mary Chamot, *Russian Painting and Sculpture*, 1963). In the 1920s some of Rylov's paintings had a luscious breadth (*Forest River*, Russian Museum, St Petersburg, 1929), but in the 1930s his work became less interesting as it fell into line with the propagandist ideals of *Socialist Realism (*Tractor: Timber Cutting*, Tretyakov Gallery, 1934). His

Reminiscences was posthumously published in 1954.

Rysselberghe, Théo van (1862–1926). Belgian painter, graphic artist, designer, and sculptor, born in Ghent. He studied at the Academies of Ghent and Brussels and during the 1880s and 1890s he travelled a great deal, visiting Africa and the Far East as well as various parts of Europe. In 1886 he was impressed with the work by Georges Seurat he saw at the final *Impressionist exhibition in Paris; by the following year he had adopted Seurat's pointillist technique and he became the leading Belgian exponent of *Neo-Impressionism. In 1898 he moved to Paris, where he was friendly with the *Symbolist circle of artists and writers; his painting *A Reading* (Museum of Fine Arts, Ghent, 1903) shows several leading literary figures including André Gide, Maurice Maeterlinck, and Émile Verhaeren. During his time in Paris he kept up close contacts with his native country, forming an important artistic link between Belgium and France (he was responsible for having works by several of the *Fauves exhibited at La *Libre Esthétique in Brussels in 1906). In 1910 he settled at St Clair in Provence, where he abandoned Neo-Impressionism for a broader style of painting. His work is well represented in the Rijksmuseum *Kröller-Müller at Otterlo. Apart from paintings, his output included a variety of design work, including furniture, jewellery, and stained glass, much of it for Siegfried Bing's Paris gallery L'Art Nouveau, the establishment that gave the *Art Nouveau style its name. Late in his career he also took up portrait sculpture. His brother **Octave van Rysselberghe** (1855–1929) was one of Belgium's leading Art Nouveau architects.

Saatchi, Charles (1943–). Iraqi-born British businessman and art collector. In 1970 he was co-founder with his brother Maurice of Saatchi & Saatchi, which became the world's largest advertising agency. He has devoted much of his enormous wealth to buying contemporary art on a huge (almost industrial) scale, and in 1985 the Saatchi Collection was opened to the public in a new gallery (converted from a warehouse) in St John's Wood, north London. While his patronage has been welcomed by many (not least the artists who have benefited from it), others have been critical of the way in which his bulk buying has given him such power in the art market. He helped to create the boom in *Neo-Expressionism and *Neo-Geo. In 1997 a selection of work from the Saatchi Collection was loaned to the *Royal Academy as an exhibition entitled 'Sensation' (see AVANT-GARDE). One of the artists represented in the exhibition, Chris Ofili (1968–), was quoted in the *Sunday Times* as saying: 'The problem with the whole Saatchi phenomenon is that there are a lot of young artists who are trying to get success so quickly. They don't conceive ideas that will last a long time. They just want to get the attention of this buyer overnight and make a bit of money. Some of those with works already in his collection produce half-hearted crap knowing he'll take it off their hands.' The article in which the quotation appeared commented that Ofili's work *The Holy Virgin* had 'generated much of the exhibition's controversy because of its [use of] female genitalia and his trademark, elephant dung'.

Sabogal, José (1888–1956). Peruvian painter, born in Cajabamba. After extensive travels in Europe, North Africa, and South America, he settled in Lima in 1919 and the following year became a professor at the city's Escuela de Bellas Artes. From 1933 to 1943 he was director of the School and in this position exerted a strong influence on other artists. He was indeed the dominant figure in Peruvian art in his lifetime and he was responsible for awakening an interest in the native arts and crafts of his country. However, Edward *Lucie-Smith writes: 'Despite Sabogal's keen consciousness of his messianic role in Peruvian art and his success in instilling this consciousness into those who surrounded him, his connection with Indian culture remained superficial. His pictures offer representations of Indian life without in any way participating in it' (*Latin American Art of the 20th Century*, 1993).

Sage, Kay (1898–1963). American *Surrealist painter, born in Albany, New York, to wealthy parents. She was mainly self-taught as an artist. In 1900–14 and 1919–37 she lived in Italy (she was married to an Italian prince, 1925–35), and Giorgio de *Chirico was an early influence on her work. In 1937 she moved to Paris, where she met *Tanguy in 1939. He followed her to the USA in 1940 and they married later that year. From the time of her return to America architectural motifs became prominent in her work—strange steel structures depicted in sharp detail against vistas of unreal space—and her pictures also included draperies from which faces and figures sometimes mistily emerged (*Tomorrow is Never*, Metropolitan Museum, New York, 1955). Sage also made mixed-media constructions. Tanguy's sudden death in 1955 cast a shadow over her last years and she committed suicide. Between 1957 and 1962 she published four collections of her poems, one of which, *Mordicus* (1962), was illustrated by *Dubuffet.

Sainsbury Centre for the Visual Arts, Norwich. Gallery and study centre presented to the University of East Anglia (together with an endowment to maintain it) by Sir Robert

Sainsbury (1906–), president of the family supermarket chain, his wife Lisa, and their son David (who paid for the building). It was opened in 1978. The collection it houses, begun by Sir Robert in the 1920s, is very diverse but is particularly strong in contemporary art (especially sculpture) and in primitive art (including African, Oceanic, and Pre-Columbian). Among the artists whose work Sir Robert has most avidly collected are Francis *Bacon (he patronized him when he was virtually unknown), John *Davies, Alberto *Giacometti, and Henry *Moore. The building, designed by Sir Norman Foster, is a leading example of High Tech architecture and has often been compared in appearance to an aircraft hangar. It has aroused controversy because of 'certain practical difficulties that have been of particular concern to the university's art, history and music departments, which the building also houses: the administrative staff sit in wide open spaces suffering from agoraphobia, while the lecturers are forced to give seminars in cramped windowless cubicles that become so hot that their doors have to be left permanently open. Nonetheless, as an art gallery the Sainsbury Centre is magnificent, indeed one of the most tastefully and imaginatively displayed in Britain' (Michael Jacobs and Paul Stirton, *The Mitchell Beazley Traveller's Guides to Art: Great Britain*, 1984). An extension, the arc-shaped 'Crescent Wing', also designed by Foster, was opened in 1991.

Members of the Sainsbury family have made many other benefactions to the arts. Most famously, Sir Robert's nephews, Sir John, Simon, and Timothy Sainsbury, financed a major extension to the National Gallery, London—the Sainsbury Wing—opened in 1991.

Saint-Gaudens, Augustus (1848–1907). The leading American sculptor of his generation. He was born in Dublin of a French father and an Irish mother, who settled in America when he was an infant. His training included a period of six years studying in Paris and then Rome, after which he settled in New York in 1874. His first important commission was the Admiral Farragut Monument (1878–81) in Madison Square Park, New York, and following its successful reception he quickly achieved a leading reputation among American sculptors and retained this throughout his life. He was an energetic man and he pro-

duced a large body of work in spite of the high standards of craftsmanship he set himself. His preferred medium was bronze and he was primarily a maker of public monuments, although he also did a good deal of work on a smaller scale, including busts, medallions, and the design of the US $20 gold piece (1907). His style was vigorously naturalistic. Most of his work is in the USA, but there are good examples elsewhere, notably a statue of Charles Stewart Parnell in Dublin and a life-size bronze relief of Robert Louis Stevenson (1904) in St Giles Cathedral, Edinburgh (an earlier, smaller version is in the Tate Gallery, London). A replica of his statue of Abraham Lincoln is in Parliament Square, London (the original, unveiled 1887, is in Lincoln Park, Chicago); the replica, presented by the American Government, was unveiled in 1920, following a dispute in which it was proposed instead to erect a replica of George Grey *Barnard's controversial statue of the President. Saint-Gaudens was a highly important figure in the development of American sculpture; he turned the tide against Neoclassicism and made Paris, rather than Rome, the artistic mecca of his countrymen. From 1885 he spent his summers at Cornish, New Hampshire, and settled there in 1900; his studio was declared a national historic site in 1964. Casts of most of his works can be seen there.

St Ives School. A loosely structured group of artists, flourishing particularly from the late 1940s to the early 1960s, who concentrated their activities in the Cornish fishing port of St Ives. Like *Newlyn, St Ives had been popular with artists long before this: in the winter of 1883–4 *Whistler had spent several weeks painting there with two of his disciples, *Menpes and *Sickert; Helene *Schjerfbeck and Anders *Zorn spent the winter there in 1887–8; the St Ives Arts Club had been founded in 1888, the St Ives Society of Artists in 1927 (it had its own sales gallery to cater for the tourist trade), and the St Ives School of Painting in 1938. In 1920 Bernard Leach (1887–1979), probably the most famous British ceramicist of the 20th century, established a pottery there. However, St Ives did not become of more than local importance in painting and sculpture until Barbara *Hepworth and Ben *Nicholson moved there in 1939, two weeks before the outbreak of the Second World War. They were anxious that their children should be safely outside

London, and their friend Adrian *Stokes, who lived at Carbis Bay (virtually a suburb of St Ives), invited the family to stay with him. Hepworth lived in St Ives for the rest of her life (her studio is now a museum of her work) and Nicholson (who had discovered Alfred *Wallis on a day-trip to St Ives in 1928) lived there until 1958. They formed the nucleus of a group of avant-garde artists who made the town an internationally recognized centre of abstract art, and it is to these artists that the term 'St Ives School' is usually applied, even though many of them had little in common stylistically, apart from an interest in portraying the local landscape in abstract terms. The one with the greatest international prestige was Naum *Gabo, who lived in St Ives from 1939 to 1946.

After the war a number of abstract painters settled in or near the town or made regular visits. The residents included Bryan *Wynter, who moved there in 1945 and settled at Zennor, about five miles away, Terry *Frost, who lived there intermittently (at first in a caravan) from 1946 to 1963, and Patrick *Heron, who rented a cottage in St Ives every summer from 1947 to 1955 and then bought a house at Zennor; the visitors included Roger *Hilton (who eventually settled in St Ives in 1965), Adrian *Heath, and Victor *Pasmore. Peter *Lanyon was the only notable abstract artist to be born in St Ives.

Many of the avant-garde artists became members of the St Ives Society of Artists, and there was some antagonism between them and the traditionalists. In 1946 the modernists showed their work separately in the crypt of the Mariners' Chapel in St Ives and were consequently known as the Crypt Group. The group held two more exhibitions, in 1947 and 1948, but in 1949 the Penwith Society was formed in an attempt to reconcile traditionalists and abstractionists (the name comes from the district of Cornwall in which St Ives is situated). It was intended as a tribute to Borlase Smart (1881–1947), a leading light of the St Ives Society of Artists, who was a traditionalist himself but sympathetic to modern ideas. It became more associated with the modernists, however (Herbert *Read was the first President), and organized Britain's first post-war exhibitions of abstract art. It was largely thanks to its activities that St Ives attracted so much attention in the 1950s and early 1960s from artists, critics, and dealers (American visitors included the abstract painters Larry *Rivers, Mark *Rothko, and Mark *Tobey, and the critic Clement *Greenberg).

The heyday of the St Ives School was over by the mid-1960s, but the town continued to be an artistic centre. In 1993 the Tate Gallery opened a branch museum there (the Tate Gallery, St Ives), housing changing displays of the work of 20th-century artists associated with the town. The building includes a stained-glass window commissioned from Patrick Heron.

St Martin's School of Art, London. Art college founded in 1854 in Shelton Street, London, near the church of St Martin-in-the-Fields, which initially provided sponsorship. It became independent of the church in 1859. In 1913 it moved to Charing Cross Road, which is still the site of one of its its principal buildings (it also occupies premises nearby in Southampton Row, Long Acre, and elsewhere). St Martin's developed into one of the largest art schools in the country, and in the 1960s it became famous for its sculpture department, where Anthony *Caro was a highly influential teacher, encouraging a generation of artists to work with welded metal. In 1989 St Martin's amalgamated with the Central School of Art and Design (founded in 1896 as the Central School of Arts and Crafts) to form the Central St Martin's College of Art and Design. This is one of five colleges that make up the London Institute, the others being Camberwell College of Arts (formerly Camberwell School of Art and Crafts), Chelsea College of Art and Design (formerly Chelsea School of Art), the London College of Fashion, and the London College of Printing and Distributive Trades (formerly London College of Printing and Graphic Art). According to a 1997 prospectus, 'Together, the five colleges offer the largest provision for art and design education and related studies in Europe, with around 22,000 students in total.'

St-Paul-de-Vence, Fondation Maeght. See MAEGHT.

St Petersburg, Hermitage. See MOROZOV and SHCHUKIN.

Saint Phalle, Niki de (1930–). French sculptor, graphic artist, and film-maker, one of the great entertainers of modern art. She was born at Neuilly-sur-Seine, Paris, the daughter of a banker, and was brought up in New York,

where her family settled in 1933. After being expelled from various convent schools and working briefly as a model, she eloped with an aspiring poet when she was 18. In 1951 she and her husband moved to France, settling in Paris, and in 1952 she started painting without formal artistic training. She began making reliefs and assemblages in 1956 and first came to public prominence in 1960 with 'rifle-shot' paintings that incorporated containers of paint intended to be burst and spattered when shot with a pistol. After she separated from her husband in 1960, she lived with Jean *Tinguely, with whom she collaborated on numerous projects, notably the enormous sculpture *Hon* (Swedish for 'She') erected at the Moderna Museet, Stockholm, in 1966; the Swedish artist Per Olof Ultvedt (1927–) also worked on *Hon*. It was in the form of a reclining woman (more than 25 metres long) whose interior was a giant *environment reminiscent of a fun-fair; visitors entered through the vagina. The attractions inside included a milk bar in one of the breasts and a cinema showing Greta Garbo movies. Externally the figure was gaudily painted in a manner similar to that of Saint Phalle's series of *Nanas*—grotesque fat ladies. Her other work has included *Happenings and films, and since 1979 she has been creating a huge sculpture garden—the Tarot Garden—at Garavicchio in Italy. Her recent projects include a touching book on AIDS addressed to her son (*AIDS: You Can't Catch it Holding Hands*, 1987) and a huge figure of the Loch Ness Monster made for an exhibition of her work in Glasgow in 1992.

Saint-Point, Valentine de. See FUTURISM.

Saito, Yoshishige (1904–). Japanese painter and maker of constructions, born in Tokyo. He was self-taught as an artist. Much of his work of the 1930s was *Surrealist in style. He came to prominence in 1956 with his series of *Oni* paintings featuring Japanese demons, and he had his first one-man show at the Tokyo Gallery in 1958. From then he was recognized as one of the leading exponents of abstract art in Japan. From *Lyrical Abstraction he turned to a more novel mode, working with an electric drill on plywood covered with a uniform colour. Such works made him an international reputation and won him numerous awards. From 1964 to 1973 he was professor of art at Tama College of Art, Tokyo.

Salisbury, Frank O. (1874–1962). British painter and stained-glass designer. He was born in Harpenden, the son of a plumber and glazier, and was apprenticed to his brother in a stained-glass workshop in St Albans before winning a scholarship to the *Royal Academy, London, where he studied 1892–7, winning several medals and awards. These included a scholarship to visit Italy in 1896, and his admiration for Renaissance frescos helped establish his taste for large scenes of pageantry. He painted numerous murals in buildings in London and elsewhere and also produced easel pictures of historical events and religious and allegorical scenes. In addition he had a successful career as a portraitist, painting five British prime ministers, five US presidents, and many other notables (including Mussolini on a visit to Italy in 1934). There are examples of his work in the National Portrait Gallery, London. His style was solid and traditional, in keeping with his personal appearance, which was 'consciously Victorian' (*DNB*). Salisbury published his memoirs, *Portrait and Pageant*, in 1944; a revised edition appeared in 1953 as *Sarum Chase* (the name of his house in Hampstead). Kenneth *Clark writes that Salisbury 'dressed like a Harley Street gout specialist . . . He lived in Hampstead in a sham Jacobean house which he had built for himself, and everything in the house was sham, including things that might just as easily have been genuine. It had a marvellous consistency.'

Salle, David. See NEO-EXPRESSIONISM.

Sallinen, Tyko (1879–1955). The outstanding Finnish *Expressionist painter. He was born at Nurmes, the son of a tailor who belonged to a strict fundamentalist religious sect (the Hihhulit), and his unhappy and repressive early years later formed the background for some of his paintings. After running away from home at the age of 14, he spent several years as an itinerant jobbing tailor in Sweden, then studied art in Helsinki, 1902–4. In 1909 and 1914 he visited Paris, where he became acquainted with avant-garde French painting, particularly *Fauvism. Its influence can be seen in what is probably his most famous picture, *Washerwomen* (Ateneum, Helsinki, 1911), a work that caused an outcry because of its bold colours and very rough handling. Sallinen's favourite subjects were scenes of Finnish peasant life such as this and also

views of the harsh Karelian landscape. He was the leading member of the *November Group, founded in 1917, and came to be regarded as the nationalist Finnish painter par excellence. His fame spread outside Finland and his work was widely exhibited. From the 1930s he also painted several murals.

Salmon, André (1881–1969). French writer—a poet, novelist, art critic, biographer, and memoirist. He was born in Paris, the son of an engraver, and grew up in St Petersburg, where his father had found work. After returning to France to do military service he settled on a literary career in Paris, seeing himself mainly as a poet, but writing art criticism to earn a living. In 1904 he met *Picasso, and along with two other noted writers—*Apollinaire and Max *Jacob—became one of his intimate circle of friends. John Richardson writes that 'When he met Picasso, Salmon was the epitome of a romantic young poet: tall, lantern-jawed, saturnine . . . By all accounts he was a charming man, loved and admired by Picasso . . . Apollinaire thought very highly of Salmon and collaborated with him on three plays, none of which ever came to anything. Too much of his brilliance evaporated in talk' (*A Life of Picasso*, vol. 1, 1991). Salmon was a progressive and prolific but not particularly distinguished critic. In addition to Picasso and the *Cubists, he wrote about *Modigliani, helping to establish his reputation and legend, and *Rousseau. In 1920 he published *La Négresse du Sacré Coeur*—a *roman à clef* about the artists and writers he had known in the *Bateau-Lavoir, with Picasso thinly disguised as a painter called Sorgue. He also describes this world in the first volume of his memoirs, *Souvenirs sans fin: Première époque (1903–1908)* (1955; two more volumes followed, 1956 and 1961), a book that is evocative but not always trustworthy. John Richardson describes it as 'garrulous, self-promoting, diffuse. For all that he was in at the birth of the Rose period, that he came up with the title of *Les Demoiselles d'Avignon*, that he was one of the closest observers of cubism, he lets us down time and again by telling us everything except what we need to know. There is a reason for these omissions. During the Spanish Civil War Salmon sided with Franco; and during World War II he worked for a collaborationist newspaper. His memoirs—written between 1945 and 1955—have to be read in the light of his former friend's resentment and disapproval.'

Salmond, Gwen. See CHELSEA ART SCHOOL.

'Salon Cubism'. See CUBISM.

Salon d'Automne. Annual exhibition founded in Paris in 1903 as a more progressive alternative to the official Salon and other current exhibiting venues, including the *Salon des Indépendants; it was held in the autumn (October or November), so as not to clash with these other shows, which took place mainly in spring and summer. The founders were a group of painters and poets, among them Carrière (see ACADÉMIE), *Renoir, *Rouault, and *Vuillard, led by the architect Frantz Jourdain (1847–1935), now best remembered for his Samaritaine department store in Paris, a masterpiece of *Art Nouveau. The early Salons d'Automne played an important role in establishing the reputations of *Cézanne and *Gauguin. There was a small Gauguin exhibition in 1903 (the inaugural show) and a major retrospective in 1906; Cézanne was strongly represented in 1905 and was given a memorial exhibition in 1907 that made a powerful impact on many members of the avant-garde. However, the Salon d'Automne is famous above all for the sensational launch of *Fauvism at the 1905 exhibition.

In 1913, Herwarth Walden, Berlin's leading promoter of avant-garde art, gave the name 'First German Salon d'Automne' (Erster Deutscher Herbstsalon) to the greatest of the exhibitions he organized at his *Sturm Gallery.

Salon de Mai. A gallery founded in Paris in 1945 with the purpose of encouraging and exhibiting younger abstract artists. It did much to promote interest in abstract art during the 1950s.

Salon des Indépendants. Annual exhibition held in Paris by the Société des Artistes Indépendants, an association formed in 1884 by Georges Seurat (see NEO-IMPRESSIONISM) and other artists in opposition to the official Salon. There was no selection committee and any artist could exhibit on payment of a fee. This meant that many interesting avant-garde works were shown, but also that they ran the risk of being swamped by a sea of mediocrity. It became the main showcase for the *Post-Impressionists (Henri *Rousseau was also a regular exhibitor) and was a major art event in Paris up to the First World War. By then,

however, it had been challenged by the smaller but more discriminating *Salon d'Automne.

Salon des Réalités Nouvelles. A commercial gallery opened by the art dealer Fredo Sidès in Paris in 1946; it became the leading exhibition centre in the city for geometrical abstraction. In 1939 Sidès had used 'Réalités Nouvelles' as the title of a *Constructivist exhibition organized in collaboration with van *Doesburg's widow at the Galerie Charpentier, Paris.

Salt, John (1937–). British painter and graphic artist. He studied at the College of Art in his native Birmingham and at the *Slade School, London. After teaching at various art colleges, he moved to New York in 1967 and lived there until 1978. In the USA his style changed abruptly from a mechanical style of abstraction to *Superrealism and by the mid-1970s he had become one of the best-known artists working in this vein. His main theme is the automobile, particularly cars that have been wrecked or abandoned and left to rust.

Samaras, Lucas (1936–). Greek-born sculptor and experimental artist who settled in the USA in 1948 and became an American citizen in 1955. He studied at Rutgers University under Allan *Kaprow, then in 1959–62 did postgraduate work in art history (specializing in Byzantine art) at Columbia University, New York. His work has been highly varied in scale, medium, and approach. In 1959 he took part in Kaprow's first *Happening at the Reuben Gallery, New York, and his own work of this time included figures made from rags dipped in plaster and pastels combining *Surrealist fantasy with *Pop art imagery. During the 1960s he worked a good deal with *assemblages, creating bizarre and sometimes sinister objects studded with with nails and pins. He also experimented with light and reflection, notably in his *Mirrored Room* (1966), an *environment with mirrors in which the spectator was reflected endlessly. Perhaps his best-known works are his 'Autopolaroids'—intimate photographs of his own body that he began making in 1970 and which brought him considerable notoriety.

Sambourne, Edwin Linley. See MESSEL.

Sample, Paul. See REGIONALISM.

Sandle, Michael (1936–). British sculptor and printmaker, active mainly in Germany. He was born in Weymouth and studied at Douglas School of Art and Technology, Isle of Man, 1951–4. After doing his National Service in the Royal Artillery, he studied printmaking at the *Slade School, London, 1956–9, then briefly worked as a lithographer in Paris. During the 1960s he taught at various art colleges in Britain and Canada, then in 1973 settled in Germany to teach at Pforzheim. In 1980 he became professor of sculpture at the Karlsruhe Academy. Sandle has concentrated on producing large, elaborate, carefully crafted works (typically in bronze) that echo the tradition of 19th-century public monuments but in a modern idiom and an anti-authoritarian vein; instead of glorifying events, they attack the abuse of power. An example is *A Mighty Blow for Freedom* (Gallery of Modern Art, Glasgow, 1988), showing a powerful figure smashing a television set. In 1997 he resigned from the *Royal Academy in protest against its showing a controversial exhibition of contemporary art (see AVANT-GARDE).

Sandler, Irving. See AVANT-GARDE.

Sands, Ethel (1873–1962). American-born painter, patron, and hostess who became a British citizen in 1916. She was born at Newport, Rhode Island, and settled in England with her wealthy socialite parents in 1879. In 1894 she went to Paris, where she studied for several years under Carrière (see ACADÉMIE) and met her lifelong companion, the painter Anna Hope ('Nan') Hudson (1869–1957), who was also American-born. 'They were basically two independent, individual women, whose mutual love and understanding rescued them from the loneliness of spinsterhood' (Wendy Baron, *Ethel Sands and Her Circle*, 1977). Sands's father died in 1888 and her mother in 1896, leaving her a substantial fortune that enabled her to spend lavishly on entertaining. From 1898 to 1920 her main home was the Manor House at Newington in Oxfordshire, but she also spent much time in London and France. In 1905 she met *Sickert and like many members of his circle became a founder member of the *London Group in 1913 (as did Hudson). Her paintings are mainly interiors and still-lifes, very much in the manner of Sickert, who often gave her advice. She is more important, however, as one of the leading artistic hostesses of her time. From 1913 to

1937 her London home was at 15 The Vale, Chelsea. Boris *Anrep created a mosaic floor for the entrance hall; Sickert was commissioned to carry out decorations but never did the work. In both world wars Sands served as a nurse in France.

San Francisco Museum of Modern Art. The largest collection of 20th-century art in the USA apart from the *Museum of Modern Art, New York. The museum was founded in 1916 by the San Francisco Art Association and was originally called the San Francisco Museum of Art (the change to its present name—recognizing the fact that its collections were devoted almost entirely to the 20th century—was made in 1976). It has had various changes of home, and in 1995 it moved to a spectacular new building designed by the Swiss architect Mario Botta. The museum is particularly strong in American art, but it also has good representations of other schools.

Sant, Tom Van. See SKY ART.

Santayana, George (1863–1952). Spanish-American philosopher and man of letters. Santayana was born in Madrid to Spanish parents and always kept his Spanish nationality, but he was educated in the USA, wrote in English, and is generally considered American by adoption. He graduated from Harvard University in 1886 and taught philosophy there from 1889 until 1912. In that year his mother died, leaving him an inheritance sufficient to retire on, and he spent the rest of his life in Europe, first in England, then Paris, and finally Rome, where he settled in 1925. He was regarded as one of the most eminent philosophers of his day and he had distinguished friends, but he preferred to lead a secluded existence, spending his final years in a convent. Santayana's varied literary output included a novel, an autobiography, poetry, and literary criticism, as well as philosophical works. In these he avoided technical terms and he was admired for his unpedantic style. His ideas on art were part of an overall theory of values embracing morals and rational living, although as he became more withdrawn from the world, his views became more morally detached. His best-known book is *The Theory of Beauty* (1896), in which he defined beauty as 'pleasure objectified' and argued that the justification of art is that it adds to human happiness. Some of the analogies

between the visual arts and music that he expressed here looked forward to *abstract art. He developed his aesthetic ideas further in *Reason in Art* (1905), the fourth volume of a five-volume treatise entitled *The Life of Reason* (1905–6).

Santomaso, Giuseppe. See GRUPPO DEGLI OTTO PITTORI ITALIANI.

São Paulo Bienal. See BIENNALE.

Sargent, John Singer (1856–1925). American painter, chiefly famous as the outstanding society portraitist of his age—*Rodin called him 'the Van Dyck of our times'. He was born in Florence, the son of wealthy parents, and he had an international upbringing and career—indeed he has been described as 'an American born in Italy, educated in France, who looks like a German, speaks like an Englishman, and paints like a Spaniard' (William Starkweather, 'The Art of John S. Sargent', *Mentor*, October 1924). His 'Spanishness' refers to his deep admiration for Velázquez, for although he was encouraged to paint directly by Charles Carolus-Duran (1838–1917), with whom he studied in Paris, 1874–6, the virtuoso handling of paint that characterized his style derived more particularly from Old Masters such as Velázquez and Frans Hals (he visited Madrid and Haarlem to study their work in 1879–80). From 1885 he was based in London, but he continued to travel extensively and often visited America. The lavish elegance of his work brought him unrivalled success, and his portraits of the wealthy and privileged convey with brilliant bravura the glamour and opulence of high-society life. Even in his lifetime he was deprecated for superficiality of characterization by some critics and fellow artists (who no doubt found it easy to be jealous of his success), but although psychological penetration was certainly not his strength, he was admirably varied in his response to each sitter's individuality, and for sheer beauty of brushwork his portraits are unsurpassed in 20th-century art.

As with many successful portraitists, Sargent's heart lay elsewhere; indeed he came to hate portrait painting, referring to it as 'a pimp's profession', and after about 1907 he took few commissions. Despite his sophistication and charm and the entrée to high society that his success gave him, he was a very

private person, who never married and led a quiet life. He loved painting landscape watercolours, showing a technique as dashing in this medium as in his oil paintings, and from 1890 he devoted much of his energies to ambitious allegorical mural schemes in the Public Library and the Museum of Fine Arts in Boston: 'Landscape I like, but, most of all, decoration, where the really aesthetic side of art counts for so much more.' For the Library his subject was *The History of Religion* (his friend E. A. *Abbey painted a series on *The History of the Holy Grail* for the same building at the same period). Sargent began work in 1890 and the paintings (in oil on canvas) were installed in stages between 1895 and 1916. They led to the commission from the Museum, for which he painted subjects from classical mythology between 1916 and 1925, completing the work shortly before his death. (As models for the *Danaides* he used dancing girls from the chorus-line of the Ziegfeld Follies.) His murals are in a high-flown, sometimes rather dreary *Symbolist manner and have evoked mixed reactions. A very different side to his talents is revealed in the enormous *Gassed* (Imperial War Museum, London, 1918), which he painted as an *Official War Artist. It has remarkable tragic power and is one of the greatest pictures inspired by the First World War. Sargent's reputation plummetted after his death (in 1929 Roger *Fry called him 'undistinguished as an illustratror and non-existent as an artist'), but it has soared again since the 1970s.

Sartre, Jean-Paul (1905–80). French philosopher, novelist, playwright, critic, and political activist, a highly influential figure in his country's intellectual life from the 1940s. Before the Second World War he held various teaching posts; during the war he served in the army, was captured by the Germans, and after being released, worked for the Resistance; after the war he was a full-time writer. His energetic involvement in many of the important issues of the time and his unceasing concern with moral problems won a worldwide audience for his ideas. He was a leading spokesman for existentialism, a system of ethical thought that stresses the importance of personal experience and individual responsibility in the face of a meaningless universe. His writings on the visual arts form a small part of his output and are mainly concerned with a few painters or sculptors

who particularly interested him, notably Alexander *Calder, Alberto *Giacometti, and the painter Robert Lapoujade (1921–), who in 1961 had an exhibition of abstract works inspired by the French-Algerian conflict (Galérie Pierre Domec, Paris) for which Sartre wrote a lengthy catalogue introduction. The artist most closely associated with Sartre is Giacometti; his isolated, emaciated figures are often seen as embodiments of the existentialist spirit, and Sartre wrote the introduction to the catalogue of the exhibition that established Giacometti's reputation in the USA (Pierre Matisse Gallery, New York, 1948). Some of Sartre's other writings on art were published in English in *Art News*, and his *Essays in Aesthetics*, selected and translated by Wade Baskin, was published in 1963; Baskin writes that 'Sartre approaches art with an open mind but seeks always to fit his findings into his philosophical scheme'. Apart from Calder and Giacometti, the famous artists among Sartre's friends included André *Masson, who designed the sets for his play *Morts dans sépulture* in 1946.

Saryan, Martiros. See BLUE ROSE.

Sash, Cecily (1925–). South African painter and teacher, born in Delmas, a small town in the Transvaal. She trained as an art teacher at the Witwatersrand Technical College Art School in Johannesburg, 1943–6, had a year of study in London and on the Continent, 1948–9, and later took a degree in fine art at the University of Witwatersrand, Johannesburg, 1952–4. After teaching for some years at a girls' school she returned to the University of Witwatersrand as senior lecturer in charge of design. In 1965 she received an Oppenheimer grant and spent a year studying attitudes to art education in Britain and the USA, and became recognized as an expert on the subject in South Africa. Her work as a painter has been varied. In spite of periods of abstraction, it has often reflected her environmental preoccupations, especially with plants and wildlife. She has also designed mosaics and tapestries. In 1974 she moved to Britain.

Saunders, Helen. See REBEL ART CENTRE.

Saura, Antonio (1930–). Spanish painter and graphic artist, born in Huesca and active mainly in Madrid. He began to paint during a long illness in 1947 and was self-taught. His

early work was *Surrealist and while he was living in Paris from 1953 to 1955 he met the founder of the movement, André *Breton. Back in Spain, however, he quickly abandoned Surrealism for a violently expressive semi-abstract style that has been seen as one of the most forceful protests against the Franco regime (the sudden change was partly inspired by the brutal suppression of student demonstrations soon after his return to Madrid). The stormy atmosphere and thickly textured figures in his work create a feeling of tortured humanity (*Great Crucifixion*, Boymans Museum, Rotterdam, 1963). In 1957 he was one of the founders of the *El Paso group. Apart from paintings his work has included drawings in ink and gouache, collages, and prints of various kinds (etchings, lithographs, screenprints), and he has also written numerous articles on artistic and social issues.

Saville, Jenny. See YOUNG BRITISH ARTISTS.

Savinio, Alberto (originally Andrea de Chirico) (1891–1952). Italian musician, writer, painter, and designer, born in Athens, brother of Giorgio de *Chirico. He studied music at the Athens Conservatory (graduating when he was only 12) and in Munich under Max Reger. As a composer he concentrated on theatrical works, writing his first opera, *Carmela*, when he was 15. From 1910 to 1915 he lived in Paris with his brother, to whom he was devoted; he adopted his pseudonym in 1912 to distinguish himself from Giorgio. When Italy entered the First World War in 1915, Savinio was posted to Ferrara and then Salonika, where he worked as in interpreter. After the war he began to write articles for the periodical *Valori plastici* in which he helped to define the character of *Metaphysical Painting; other writings by Savinio helped to inspire the imagery of the faceless mannequins that appear in so many of his brother's paintings. In 1926 Savinio moved back to Paris and began to paint seriously (earlier he had made drawings for the stage and some collages). Jean *Cocteau organized the first exhibition of his work, at the Galerie Jacques Bernheim, Paris, in 1927. His work was in a rather heavy-handed *Surrealist idiom, often using mythological imagery. In 1933 he returned to Italy, where he continued to paint and work on a wide variety of artistic activities, including writing semi-autobiographical novels such as *Capitano Ulise* (1934).

After the Second World War he worked mainly for the theatre as writer, composer, designer, and producer.

Saytour, Patrick. See SUPPORTS-SURFACES.

Scarfe, Gerald (1936–). British caricaturist, designer, sculptor, printmaker, painter, filmmaker, and writer, born in London. He suffered from severe asthma throughout most of his childhood and took up drawing during long periods of confinement in bed. After a brief period working for an advertising agency he became a freelance caricaturist, working for *Punch* from 1960, *Private Eye* from 1961, the *Daily Mail* from 1966, and the *Sunday Times* and *Time* magazine from 1967. The first of many collections of his drawings, *Gerald Scarfe's People*, was published in 1966. His work is varied in subject, style, and technique, but he is best known for line drawings in which he grotesquely distorts his subjects' features: 'I like to see how far I can stretch a face and still make it recognizable.' He has also worked in other media in a similar vein and has been widely exhibited (a large, highly entertaining exhibition of his sculpture was held in the Festival Hall, London, in 1983, for example). He has done a good deal of stage and film design (he won an Olivier award for best stage costumes in 1994) and he has also worked on animated films, including the Disney movie *Hercules* (1997). His autobiography, *Scarfe by Scarfe*, was published in 1986.

Scarlet Rose. See BLUE ROSE.

Schad, Christian (1894–1982). German painter, born at Miesbach, son of an affluent lawyer who encouraged his interest in art. He studied briefly at the Academy in Munich but learned more by frequenting Schwabing, the artists' quarter of the city. After avoiding military service by inventing a heart complaint, Schad lived in Switzerland (first Zurich, then Geneva) from 1915 to 1920 and was involved in the *Dada movement there. His work of this period included photograms—photographic images made without a camera or lens by placing two- or three-dimensional objects on sensitized paper and exposing the arrangement to light. The technique was not new (indeed it predates photography proper), but Schad was evidently the first to make abstract images in this way. The poet Tristan

Tzara, his fellow Dadaist, coined the punning term 'Schadograph' for these images, which Schad first made in 1918. In the 1920s the technique was taken up by *Man Ray (who called his versions 'Rayographs') and by *Moholy-Nagy. In 1920 Schad returned briefly to Germany, then lived in Rome and Naples until 1927. He then spent two years in Vienna before settling in Berlin in 1927. In the next few years he gained a reputation as one of the leading exponents of *Neue Sachlichkeit, specializing in chillingly decadent portraits and nudes from the sophisticated world in which he moved. In 1935, however, Schad more or less abandoned painting for business, and although he took up art seriously again after the Second World War, he never made the impact that he had done with his earlier work.

Schamberg, Morton L. (1881–1918). American painter and photographer, born in Philadelphia. He was a pioneer of modernism in America, but his promising career was cut short when he died aged 36 in the terrible influenza epidemic of 1918. After studying architecture at the University of Pennsylvania (1899–1903), he went to the Pennsylvania Academy of the Fine Arts (1903–6), where he was taught by *Chase and became a friend of *Sheeler. Between 1906 and 1912 he made several trips to Europe, during which he was influenced by various modern movements, particularly *Cubism. In the next few years he moved towards abstraction; his machine-like imagery derived partly from *Picabia and looked forward to *Precisionism. He met Picabia through Sheeler, who also introduced him to Marcel *Duchamp and *Man Ray. Apart from Man Ray, Schamberg was the first American to create work directly related to *Dada. The best-known example is *God* (Philadelphia Museum of Art, *c.* 1918), an assemblage of plumbing pipes—his only known sculpture. From 1913 Schamberg earned his living mainly as a photographer, concentrating on portraiture.

Schapire, Rosa. See SCHMIDT-ROTTLUFF.

Schapiro, Meyer (1904–96). American art historian. He was born in Lithuania into a scholarly Jewish family, emigrated to the USA with his family when he was 3, and became an American citizen in 1914. For the whole of his lengthy career he was associated with Colum-

bia University, New York, where he studied (BA, 1924; MA, 1926; PhD, 1929) and then taught, rising from lecturer in 1928 through various grades of professor; after his retirement in 1973 he was emeritus professor. He also taught as visiting lecturer or professor at various other universities in the USA and elsewhere; in 1968, for example, he was Slade professor of fine art at Oxford University.

Schapiro was a distinguished medievalist, making important contributions to the study of Early Christian and Romanesque art, but he also wrote and lectured on modern painting and sculpture and was friendly with numerous artists, who found him an intellectually stimulating companion because of his wide-ranging socio-cultural knowledge and his openness to varied traditions and methodologies. He was interested in Freudian analysis and Gestalt psychology, for example, and 'was one of the few art historians writing in the English language in the 1930s who applied the resources of the Marxist intellectual tradition to the problems of the analysis of modern art and its development' (Charles Harrison and Paul Wood, eds., *Art in Theory 1900–1990*, 1992). He enjoyed 'almost legendary renown as a lecturer, and, by virtue of his generosity and receptiveness to new ideas, is, for many, the exemplar of the modern scholar-teacher' (Charles Mauner in *Thinkers of the Twentieth Century*, 2nd edn., ed. Roland Turner, 1987). In 1974 his 70th birthday was marked by a gesture that showed the enormous respect in which he was held in the art world: twelve artists produced a series of prints, and the proceeds from their sale was used to endow a professorship in his name at Columbia University. The artists involved were S.W *Hayter, Jasper *Johns, Ellsworth *Kelly, Alexander Liberman (1912–), Roy *Lichtenstein, André *Masson, Robert *Motherwell, Claes *Oldenburg, Robert *Rauschenberg, Saul *Steinberg, Frank *Stella, and Andy *Warhol. Schapiro himself painted fairly seriously in his spare time, and this no doubt played a part in establishing his rapport with artists.

Schapiro's celebrity was all the more remarkable in that he was reluctant to write books or to republish articles in which he saw 'imperfections, inconsistencies, and unclear formulations'. Indeed, he was known at one time as 'the most famous art historian who never wrote a book' (his monographs on van Gogh (1950) and Cézanne (1952) are

essentially introductions to collections of plates rather than full-scale studies). However, between 1977 and 1994 his *Selected Papers* appeared in four volumes. Volume 2, *Modern Art: 19th and 20th Centuries* (1978), includes essays on abstract art, the *Armory Show, Cézanne, *Gorky, *Mondrian, and *Picasso, among other topics. This book won the Mitchell prize for outstanding writing on art history in the English language, and Sir John Pope-Hennessy, chairman of the prize jury, commented: 'If a census were taken of the living critics who have exercised a formative influence on our attitude to the art of the immediate past, it would generally be conceded that the most original and most influential was Professor Meyer Schapiro.'

Schapiro, Miriam (1923–). American painter and maker of collages. She was born in Toronto, Canada, and had her main training in art at the State University of Iowa, 1943–9. Subsequently she taught at several colleges and universities. Her early work was *Abstract Expressionist, but she then turned to a *Hard-Edged geometrical style (*Big Ox No. 2*, La Jolla Museum of Contemporary Art, 1968). In the late 1960s she became active in the feminist movement and in 1971, with Judy *Chicago, she founded the Feminist Art Program at the California Institute of the Arts, Valencia. Her most characteristic later works are large, dynamic collages that she calls 'femmages', made up of buttons, sequins, pieces of embroidery, and other materials from the history of women's 'covert' art (*Black Bolero*, Art Gallery of New South Wales, Sydney, 1980).

Scheyer, Galka. See BLAUE VIER.

Schiele, Egon (1890–1918). Austrian painter and draughtsman, born in Tulln. He studied at the Vienna Academy, 1906–9, and in 1907 met *Klimt, who was a strong influence on his early *Art Nouveau style. By 1909, however, he had begun to develop his own highly distinctive style, which is characterized by an aggressive linear energy expressing acute nervous intensity. He painted portraits, landscapes, and allegorical works, but he is best known for his drawings of nudes (including several self-portrait drawings), which have an explicit and disturbing erotic power—in 1912 he was briefly imprisoned on indecency charges and several of his drawings were burnt. The figures he portrays are typically lonely or anguished, their bodies emaciated and twisted, expressing an aching intensity of feeling. During the First World War he served in the Austrian army, but he was able to continue painting and drawing during his military service. His work was much exhibited, and he was beginning to receive considerable acclaim when he died in the appalling influenza epidemic of 1918 (three days after his wife).

His posthumous reputation was long confined mainly to Austria, but he became well known in Britain and the USA during the 1960s (an exhibition at the Boston Museum of Contemporary Art in 1960 was the first major showing of his work in the English-speaking world). He has since come to be generally regarded as one of the greatest masters of *Expressionism, and only Klimt and *Kokoschka are better known among modern Austrian artists. His work is admired for its powerful mastery of line as well as for the intensity with which he treats his obsessions with sex, death, and decay. Frank *Whitford writes of him (*Egon Schiele*, 1981): 'Schiele sees the individual as primarily a sexual being and views sex as a destructive force . . . [His] men and women are victims of their own sexuality who know that whatever pleasure they may experience will immediately be followed by pain . . . His figures, even in the bloom of youth, have the look of death in their eyes and their skin bears the marks of sickness and disease. Even when sexual activity is suggested or described it is not life-affirming but is presented as a metaphor of death. The figure drawings, symbolic compositions and landscapes . . . speak of physical decline and of mental collapse into madness; but these states are described in a way which suggests Schiele found them irresistible. No other modern artist has defined and described this aspect of the human condition in so powerful a fashion.'

Schjerfbeck, Helene (1862–1946). Finnish painter, born in Helsinki, where she began her training at the Finnish Fine Art Association's Drawing School as a precious 11-year-old. In the 1880s she travelled widely, working mainly in France but also in St Ives (see ST IVES SCHOOL) and St Petersburg, making a name with open-air scenes notable for their fresh colouring. From about 1900 her health (always delicate) began to fail badly (although she lived into her 80s) and she adopted a

solitary life at Hyvinkää, developing a much more simplified style in which the subtle colour harmonies recall those of *Whistler. For several years she was more or less forgotten in Helsinki, but in 1917 she had a one-woman show there, organized by Gösta Stenman, an art dealer and journalist, and after this she was recognized as one of the pioneers of modernism in Finland. John Boulton-Smith (*Modern Finnish Painting and Graphic Art*, 1970) describes her as 'a genuine, small, highly civilized master' and writes that 'no painter in Scandinavia made a more intelligent and original contribution to the early modern movement, save only *Munch'. Her work included landscapes, still-lifes, figure compositions, and portraits, notably a long series of self-portraits that are regarded being among her finest achievements.

Schlemmer, Oskar (1888–1943). German painter, sculptor, stage designer, and writer on art. He was born in Stuttgart, where he trained in marquetry and then studied at the Academy under Adolf *Hölzel, 1906–11. During the First World War he served in the infantry and—after being wounded—as a cartographic draughtsman. From 1920 to 1929 he taught at the *Bauhaus, in the metalwork, sculpture, and stage-design workshops. Later he taught at the Breslau Academy, 1929–32, and at the State School for Fine and Applied Arts in Berlin, 1932–3. In 1933, however, he was dismissed by the Nazis, who declared his work *degenerate. He lived in Switzerland from 1933 to 1937 and from 1940 spent most of his time in Wuppertal, where a manufacturer of lacquer had invited him to establish a laboratory for experiments in lacquer technique. He died of a heart attack.

Schlemmer had a mystical temperament and his ideas on art were complex. Some of his early work was influenced by *Cubism and he showed a deep concern for pictorial structure; characteristically his paintings represent rather mechanistic human figures, seen in strictly frontal, rear, or profile attitudes set in a mysterious space (*Group of Fourteen Figures in Imaginary Architecture*, Wallraf-Richartz-Museum, Cologne, 1930). He rejected what he considered the soullessness of pure abstraction, but he wished to submit his intuition to rational control: 'Particularly in works of art that spring from the imaginative faculty and the mysticism of our souls, without the help of external subject-matter or content, strict regularity is absolutely indispensable.' His cool, streamlined forms are seen also in his sculpture. Schlemmer did much work for the theatre, notably designs for the *Constructivist *Triadic Ballet*, to music by Paul Hindemith, which was performed at the Bauhaus in 1923.

In the catalogue of the exhibition 'German Art in the 20th Century' (Royal Academy, London, 1985), Schlemmer is described as 'one of the most versatile artists of the 20th century, not only successful in the conventional genres—painting, wall design, sculpture, drawings and graphics—but responsive to the challenges of advertising and utilitarian art, and inventive in the devising of lively teaching models for the educational activities of the Bauhaus'. His ideas on teaching are expressed in his book *Man: Teaching Notes from the Bauhaus* (1971). Also available in English translation is *The Letters and Diaries of Oskar Schlemmer* (1972).

Schlichter, Rudolph (1890–1955). German painter, illustrator, and writer. he was born at Calw and studied in Stuttgart and Karlsruhe. During the First World War he was called up for armed service, but he was dismissed after going on hunger strike. After the war he settled in Berlin, where he lived until 1932. He took part in *Dada activities and earned his living mainly as a book illustrator, but he is remembered chiefly for his paintings in a *Neue Sachlichkeit vein. His subjects—taken mainly from the city's streetlife and bohemian subculture—included portraits and scenes of sexual violence and deviation (particularly shoe fetishism). His brushwork was loose and vigorous rather than in the detailed manner usually associated with Neue Sachlichkeit. In 1932 he moved to Rottenburg. He was critical of the Nazis and in 1937 some of his paintings were included in the infamous exhibition of *degenerate art. In 1938 he was imprisoned for three months. He settled in Munich in 1939 and after the Second World War his work was influenced by *Surrealism. 'Characteristic of his sharp writing style are his books, *Das widerspenstige Fleisch* (*The Recalcitrant Flesh*, 1932), and *Das Abenteuer der Kunst* (*An Adventure in Art*, 1949). The first includes astonishingly frank sex confessions, the second polemicized all abstract art . . . in which he saw cultural ruination, or at best a merely ornamental value' (Franz Roh, *German Art in the Twentieth Century*, 1968).

Schlock art. See KITSCH.

Schmidt-Rottluff, Karl (né Schmidt) (1884–1976). German *Expressionist painter, printmaker, and sculptor, born at Rottluff near Chemnitz (he added 'Rottluff' to his name in 1906). In 1905 he began to study architecture at the Technische Hochschule, Dresden, but soon turned to the figurative arts and in the same year was one of the founders of Die *Brücke. He was the most independent member of the group, participating to only a limited extent in its activities, and his style was harsher than that of the other members. It was particularly forceful in his woodcuts, which are amongst the finest representatives of Expressionist graphic art. Their bold, abrupt manner was reflected in his paintings, with their flat ungraduated planes of contrasting colours. In 1906 Schmidt-Rottluff stayed with *Nolde on the island of Alsten, Norway, and in 1907 he painted with *Heckel at Dangast on the coast north-west of Bremen (he visited Dangast again each summer until 1912). Apart from landscapes, such as the ones he painted in these places, his subjects included portraits, figure compositions, and still-life. In 1911, like the other members of Die Brücke, he moved to Berlin, where he lived for most of the rest of his life (although he spent the years 1915–18 serving in the army on the Eastern front). In the 1910s and 1920s his work was influenced by the stylized forms of African sculpture. Later, perhaps under the influence of *Kirchner or as a result of a trip to Paris in 1924 and a longer stay in Italy in 1930, his style became somewhat more naturalistic.

Schmidt-Rottluff's work was declared *degenerate by the Nazis and in 1941 he was forbidden to paint (he was placed under the supervision of the SS). In 1943 he retired to Chemnitz, but after the war he returned to Berlin and he became a professor at the Hochschule für Bildende Künste in 1947. In 1967 he presented a large collection of his own works to found the Brücke Museum in Berlin. A good collection of his graphic works was presented to the Victoria and Albert Museum, London, by his friend the art historian Dr Rosa Schapire (1874–1954); she left his painted portrait of her (1919) to the Tate Gallery, London. Another fine collection of his prints (he made etchings and lithographs as well as woodcuts) is in the Leicestershire Museum and Art Gallery, Leicester.

Schmithals, Hans (1878–1964). German painter and designer, born in Bad Kreuznach. From 1902 he studied and then taught at a private applied arts school in Munich run by Hermann Obrist (1863–1927), a Swiss designer and craftsman who created some of the finest *Art Nouveau ornament, and Wilhelm von Debschitz (1871–1948), a German designer, painter, and writer on art. The school (the Lehr- und Versuch-Atelier für angewandte und freie Kunst, informally known as the Debschitz-Schule) was remarkably progressive in its teaching methods, and is regarded as a significant precursor of the *Bauhaus (Obrist was shortlisted for the directorship in 1919). Obrist left the school in 1904, but Debschitz continued it until 1914. Schmithals taught stuccowork and the hand-painting of wallpaper, and in the same period he painted pictures in which natural forms are so schematized into Art Nouveau patterns that they come close to anticipating *abstract art. In his designs for objects such as carpets and textiles he sometimes did use purely abstract patterns. In 1909–11 Schmithals lived in Paris, and then returned to Munich. He was virtually forgotten in the period between the two world wars, but there was a revival of interest in his work during the 1950s, when the Art Nouveau style in general was being rediscovered.

Schnabel, Julian (1951–). American painter (and latterly sculptor and film director). He was born in Brooklyn, New York, studied at the University of Houston, graduating in 1972, and had his first one-man show at the Contemporary Arts Museum, Houston, in 1976. In 1979 two exhibitions at the Mary Boone Gallery, New York, brought him his first notable success, and in the 1980s he enjoyed a meteoric rise as the most touted figure in the international art world. As early as 1982 he had a retrospective exhibition at the Stedelijk Museum in Amsterdam, one of the world's leading museums of modern art, and it became common for the press to treat him more like a pop star than a painter. His paintings are large and in a *Neo-Expressionist vein; often they are on unusual materials such as carpet or velvet, and some of them are encrusted with broken crockery (*Humanity Asleep*, Tate Gallery, London, 1982) or incorporate other three-dimensional objects (sometimes the supports themselves are three-dimensional, with central projections like a

chimney breast). Schnabel writes of his work: 'My painting is more about what I think the world is like than what I think I'm like. I'm aiming at an emotional state, a state that people can literally walk into and let themselves be engulfed by.' He says that he regards his 'peers' as 'Duccio, Giotto and van Gogh' and although some people in the art world evidently share his colossally high opinion of himself, many critics find his pictures ugly, pretentious, and boring. Robert *Hughes, for example, writes that 'Schnabel's work is to painting what Sylvester Stallone's is to acting—a lurching display of oily pectorals—except that Schnabel makes bigger public claims for himself.' A widespread feeling is that the huge prices his works have fetched depend more on media hype and the investment value of contemporary art than on any intrinsic merit. When one of his paintings failed to attract even a single bid at an auction in 1990, the audience broke into spontaneous applause. In 1983 Schnabel began making sculpture, and he has also directed the film *Basquiat* (1996), about the *Graffiti artist Jean-Michel Basquiat.

Schoenberg, Arnold. See BLAUE REITER.

Schöffer, Nicolas (1912–92). Hungarian-born sculptor and experimental artist who settled in Paris in 1937 and took French nationality. Early in his career he made sculpture in the *Constructivist tradition and in 1948 he began making 'spatiodynamic' constructions—open towers constructed of plexiglass or thin metal plates from which light was reflected. To these he added movement (in 1950) and sound (in 1954). Financed by the electrical firm Phillips and helped by their technicians, he created his first 'cybernetic' sculpture in 1956. This was a robot, *CYSP 1*, which responded to colours and sounds. In 1957 he gave a 'luminodynamic' spectacle at Grand Central Station, New York, and in 1961 at Liège he built a luminous, sound-emitting tower 52 metres high. His most ambitious schemes remained on paper: cities of leisure raised on pylons above the ground and other grandiose projects involving the conditioning of living-space by the most sophisticated technological means. However, Schöffer also made much smaller pieces, intended to be mass-produced and offered for sale at moderate prices. He was awarded the Grand Prix at the Venice *Biennale of 1968.

Scholz, Georg. See NEUE SACHLICHKEIT.

School of Altamira. See GOERITZ.

School of London. An expression coined by R. B. *Kitaj in 1976 and given wide currency when it was used as the title of a British Council exhibition that toured Europe in 1987—'A School of London: Six Figurative Painters' (the six were Michael *Andrews, Frank *Auerbach, Francis *Bacon, Lucian *Freud, Kitaj himself, and Leon *Kossoff). In 1989 the term was used as the title of a book by Alistair Hicks—*The School of London: The Resurgence of Contemporary Painting*. The book covers other artists apart from the original six, including Gillian *Ayres and Howard *Hodgkin. It is not clear what the label is meant to mean and several critics have denied that any such thing as a School of London exists. Frank *Whitford, for example, writes that 'The term . . . has more to do with public relations than art history or criticism, since the members of the supposed school are linked by little more than a shared (and once unfashionable) interest in figuration and intermittent friendships. Some of them have painted portraits of one or more of the others, but their styles are quite different.'

School of Paris. See ÉCOLE DE PARIS.

Schoonhoven, Jan. See NUL.

Schreib, Werner. See CACHETAGE.

Schreiber, Taft and **Rita Bloch**. See MUSEUM OF CONTEMPORARY ART, LOS ANGELES.

Schrimpf, Georg (1889–1938). German painter, born in Munich. He was self-taught as an artist; in his early years he worked as a baker's apprentice and a labourer and for a time he led a wandering life in Italy. His early paintings were *Expressionist, but after revisiting Italy in 1922 his style became much more classical. He painted in the precise, detailed manner associated with the *Magic Realist vein of *Neue Sachlichkeit, but his subjects were mainly calm and gentle (women, children, animals, landscapes) and his forms were smoothly rounded. 'Some of his pictures exude simplicity and a quiet grandeur; others are much too insipid, for something of the amateur painter remained in this sincere man. His naive insights often hit the nail on the head, and at the time he was particularly

popular with the complicated intellectual' (Franz Roh, *German Art in the Twentieth Century*, 1968). From 1926 to 1933 Schrimpf taught at the School of Applied Art, Munich, and later at the Schöneberg Academy, Berlin.

Schultze, Bernard. See QUADRIGA and ZEN 49.

Schumacher, Emil. See QUADRIGA and ZEN 49.

Schwabe, Randolph (1885–1948). British draughtsman, etcher, lithographer, and teacher, born in Manchester of German descent. He studied at the *Royal College of Art, 1899, the *Slade School, 1900–6, and the *Académie Julian, Paris, 1906. In the First World War he was an *Official War Artist. After the war he taught at Camberwell and Westminster Schools of Art, then from 1930 until his death was professor at the Slade School. In 1939 he was appointed one of the administrators of the '*Recording Britain' scheme and one of the members of the War Artists' Advisory Committee. He specialized in architectural and figure subjects, and his work also included designs for the theatre and book illustrations, notably for Francis M. Kelly's *Historic Costume* (1925) and *A Short History of Costume and Armour* (1931). 'He took the task of teaching very seriously and was much respected by all his students, though his gentle, kindly manner never inspired the terror commanded by his predecessor Henry *Tonks. His drawings and prints are not remarkable for imagination but are beautifully precise and reasonable statements of fact' (Stephen *Bone in *DNB*).

Schwarzkogler, Rudolf (1940–69). Austrian *Body or *Performance artist. Like the *Vienna Actionists, with whom he occasionally worked, Schwarzkogler was often concerned with violence and pain (he sometimes used medical instruments, recalling his father, a doctor who committed suicide in 1943 after losing both legs in the Second World War). He achieved a place in the pantheon of great artistic oddballs by reputedly cutting off his own penis as part of a performance; however, the story depended on a misreading of the photographic documentation of the work (the object that is shown in close-up being cut with a razor blade is in fact a dead fish). The photographs first became widely known when they were exhibited at *Documenta V in 1972, and one of the critics who launched the legend (with an article in *Artforum*) had the appropriately cutting name of Lizzie Borden. Among the other critics who discussed the issue was Robert *Hughes, who described Schwarzkogler as 'the Vincent van Gogh of Body Art', who 'proceeded, inch by inch, to amputate his own penis, while a photographer recorded the act as an art event'. The true version of events is documented in the catalogue of an exhibition of Schwarzkogler's work shown at the Pompidou Centre, Paris, and elsewhere in 1992–4. Schwarzkogler, though, did undoubtedly abuse his body, and he committed suicide by falling from a window.

Schwitters, Kurt (1887–1948). German painter, sculptor, maker of constructions, writer, and typographer, a leading figure of the *Dada movement who is best known for his invention of 'Merz'. The word was first applied to collages made from refuse, but Schwitters came to use it of all his activities, including poetry. He used the word as a verb as well as a noun: the painter Georg *Muche was nonplussed when Schwitters asked him to *merz* with him, and he wrote an article entitled 'Ich habe mit Schwitters gemerzt'.

Schwitters was born in Hanover and studied there at the School of Arts and Crafts, 1908–9, and then at the Dresden Academy, 1909–14. In his early work he was influenced by *Expressionism and *Cubism, but after the First World War (in which he served for a time as a draughtsman) he became the chief (indeed, virtually only) representative of Dada in Hanover. In 1918 he began making collages from refuse such as bus tickets, cigarette wrappers, and string, and in 1919 he invented Merz. The name was reached by chance: when fitting the word 'Commerzbank' (from a business letterhead) into a collage, Schwitters cut off some letters and used what was left. He called the collages Merzbilden (Merz pictures) and in about 1923 began to make a sculptural or architectural variant—the Merzbau (Merz building)—in his house in Hanover (it was destroyed by bombing in in 1943 but has been reconstructed in the Sprengel Museum, Hanover). From 1923 to 1932 he published a magazine called *Merz* and in this period he was much occupied with typography. In 1937 his work was declared *degenerate by the Nazis and in the same year he fled to Norway, where at Lysaker he began a second Merzbau

(destroyed by fire in 1951). When the Germans invaded Norway in 1940, he moved to England, where he lived for the rest of his life—in London (after release from an internment camp) from 1941 to 1945, and then at Ambleside in the Lake District. Here, in an old barn in Langdale, he began work on his third and final Merzbau, with financial aid from the Museum of Modern Art, New York. It was unfinished at his death and is now in the Hatton Gallery, Newcastle upon Tyne. The day before he died, Schwitters became a British citizen.

Scialoja, Toti. See ROMAN SCHOOL.

Scipione (Gino Bonichi) (1904–33). Italian painter, born at Macerata near San Marino. He was the son of a soldier and adopted his pseudonym (in 1927) in homage to Scipio Africanus, the great Roman general who defeated Hannibal. In 1909 his family moved to Rome and he studied briefly (1924–5) at the Academy there before being expelled with his friend Mario *Mafai. With Mafai he was the founder of the *Roman School, which introduced a romantic *Expressionist vein into Italian painting in opposition to the prevailing pomposity of much art that was favoured under Mussolini's Fascist government. His subjects were mainly scenes of modern Rome, painted with violent brushwork and a feeling of visionary intensity. His career was very short, virtually ending in 1931, when he made the first of several visits to a sanatorium to treat the tuberculosis that caused his early death. Nevertheless his influence was profound: 'After his retrospectives at the Venice *Biennale of 1948 and the Galleria Nazionale d'Arte Moderna of Rome in 1954, Scipione's post-war reputation reached legendary proportions. Despite his relatively small production, he became a symbol of heroic individuality in the context of the Fascist period' (catalogue of the exhibition 'Italian Art in the 20th Century', Royal Academy, London, 1989).

Scott, Kathleen (1878–1947). British portrait sculptor, born Kathleen Bruce at Carlton-in-Lindrick, Nottinghamshire, the daughter of a clergyman. After spending a few months at the *Slade School, she studied in Paris at the Académie Colarossi and under *Rodin, 1901–6. In 1908 she married Captain Robert Falcon Scott (Scott of the Antarctic), who died on his return from the South Pole in 1912. Her most famous work is the statue commemorating him (unveiled 1915) in Waterloo Place, London. She did portrait busts of many other distinguished contemporaries. After her husband's death she was granted the rank of a widow of a Knight Commander of the Order of the Bath and was known as Lady Scott. In 1922 she married Lieutenant-Commander Edward Hilton-Young, who in 1935 became Baron Kennet; some reference books, including Tate Gallery catalogues and the *Dictionary of National Biography*, list her as Lady Kennet. Her autobiography, *Self-Portrait of an Artist*, was posthumously published in 1949.

Her son, **Sir Peter Scott** (1909–90), was one of the world's most distinguished ornithologists and also a noted painter and illustrator of wildfowl. He trained as a painter at the Munich Academy and at the *Royal Academy, where he exhibited from 1933. In addition to bird subjects he painted portraits, and his books include *Portrait Drawings* (1949). The books he illustrated include Paul Gallico's *The Snow Goose* (1946).

Scott, Tim (1937–). British abstract sculptor, born at Richmond, Surrey. He studied at the Architectural Association, London, and at *St Martin's School of Art under Anthony *Caro, then lived in Paris from 1959 to 1961. After his return to London he began teaching at St Martin's and became head of the sculpture department there in 1980. Scott was one of the artists who made a great impact at the *New Generation exhibition at the Whitechapel Art Gallery in 1965. His work at this time consisted mainly of constructions of blocks and slabs of varied materials including wood and plastic. At the end of the decade he turned to forged steel as his favourite material, and in the 1970s he made compositions of rusted or painted steel bars and girders; they were bolted or riveted into forms that were less chunky and more flowing than the ones he had previously used. In the 1980s his style became rougher and more aggressive.

Scott, William (1913–89). British painter of still-life (usually involving kitchen objects) and abstracts. He was born at Greenock, Scotland, of Irish and Scottish parents and was brought up in Ulster. He studied at Belfast College of Art, 1928–31, and the *Royal Academy, 1931–5. In 1937–9 he lived in France (mainly Pont-Aven and St-Tropez) and he said: 'I picked

up from the tradition of painting in France that I felt most kinship with—the still-life tradition of Chardin and *Braque, leading to a certain kind of abstraction which comes directly from that tradition.' His work continued to be based on still-life, but for a time in the 1950s he painted pure abstracts. They featured forms such as circles and squares, but they were not geometrically exact and were bounded by sensitive painterly lines. In the late 1960s and 1970s his style became more austere. Although his work was restricted in range and undemonstrative in character, Scott came to be regarded as one of the leading British artists of his generation. He won several awards, including first prize at the 1959 *John Moores Liverpool Exhibition. His work is represented in the Tate Gallery, London, and many other collections in Britain and elsewhere, and there is a large mural by him in Altnagelvin Hospital, Londonderry (1958–61). He lived mainly in London and Somerset.

Scottish Colourists. A term applied to four Scottish painters who in the period c. 1900–14 each spent some time in France, where they were strongly influenced by the rich colours and bold handling of recent French painting, notably *Fauvism. They are F. C. B. *Cadell, J. D. *Fergusson, Leslie *Hunter, and S. J. *Peploe. The term was popularized by a book by T. J. Honeyman dealing with Cadell, Hunter, and Peploe (*Three Scottish Colourists*, 1950), but it is usual to add Fergusson to their number, even though he stands apart from the rest in that he returned to live in France after the First World War, whereas the other three remained in Scotland. All four painters knew each other, and they exhibited together as 'Les Peintres de L'Écosse Moderne' at the Galerie Barbazanges, Paris, in 1924, but they did not function as a group. They can be regarded as the successors of the *Glasgow Boys and they have been described as the first 'modern' Scottish artists; certainly they were the main channel through which *Post-Impressionism reached their country. None of them was represented in Roger *Fry's Post-Impressionist exhibitions of 1910 and 1912, but this reflects insular English attitudes towards Scottish art rather than the quality of their work.

Scottish National Gallery of Modern Art, Edinburgh. Collection of 20th-century art founded in 1960 as an extension of the National Gallery of Scotland. Because the *Tate Gallery includes historic British art as well as modern art, the Scottish National Gallery of Modern Art is the United Kingdom's only national museum devoted solely to 20th-century art. Unlike the Tate, however, it remains under the control of its parent body—the Trustees of the National Galleries of Scotland. The original nucleus of the collection consisted of 20th-century paintings and sculptures that happened to be owned by the National Gallery of Scotland. They were nearly all by Scottish artists, but the gallery has since built up a wide-ranging international collection in which most of the major movements and many of the greatest figures are represented. It is particularly strong in *Dada and *Surrealism, and in 1994 its importance as a centre for the study of these movements was greatly enhanced by the purchase of Sir Roland Penrose's library and archive. The following year it bought 25 works of art from Penrose's collection. The original home of the gallery was Inverleith House, a modestly-sized Georgian mansion in the Royal Botanical Gardens. This was always intended as a temporary measure, but it was not until 1984 that the gallery re-opened in its present much larger premises, an impressive Greek Revival building dating from 1825 that was formerly John Watson's School. See also CURSITER.

screenprinting. A printing technique based on stencilling, originally used for commercial work but popular with artists for creative printmaking since the 1960s. The essence of the technique is that a fine mesh screen, stretched tightly over a wooden frame, is placed above a sheet of paper and colour is forced through the mesh with a rubber blade called a squeegee. Usually the screen is made of silk—hence the term silkscreen printing, which is often used in the USA; however, as the screen can also be made of cotton, nylon, or metal, the more inclusive term is useful. Some exponents prefer instead to use the term serigraphy (from *sericum*, Latin for silk) to distinguish artistic printmaking from purely commercial applications. There are various ways of applying the design to the screen. The earliest and most basic was to attach a cut-out stencil to it; this is an improvement on the simple stencil where, for example, a letter O required connecting

pieces to prevent the centre falling out—a problem that does not arise when the stencil is supported by the mesh. A refinement of this method is to paint the design directly on the screen with a glue- or varnish-like substance that blocks the holes in the mesh. The blocked-out areas form the negative part of the design, the colour being squeezed through the untouched parts of the screen. However, more sophisticated methods enable the artist to create a positive design directly on the screen with a waxy or waterproof medium that is eventually dissolved to allow the ink through only in the parts that have been so treated. Photographic images can be used in the design by shining a light through a transparency onto a chemically treated mesh. Screenprints are almost invariably coloured, a different screen generally being used successively for each colour.

The origins of screenprinting are murky, but the technique seems to have come to Europe from Japan in the late 19th century. It was soon adopted for advertising purposes, and photographic images were first used in the medium in about 1916. Rowland *Hilder is said to have produced a screenprint in Britain as early as 1924, but the technique was evidently first seriously used for original printmaking by American artists in the 1930s, when its cheapness was probably an important factor during the Depression years. Ben *Shahn was an exponent at this time, and Jackson *Pollock made a few screenprints in the early 1950s, but it was not until the early 1960s that the medium made an important impact in the art world. It was especially favoured by *Pop artists, whose bold images were well served by its capacity for strong, flat colour and its relative crudeness of detail (subtle handling is discouraged because of the texture of the mesh). Moreover, for artists who took their imagery from the world of popular culture, it was particularly appropriate to use a medium with such strong commercial associations and one that could incorporate ready-made cultural references in the form of photographs. The artist who more than any other put screenprinting on the map was Andy *Warhol, whose background in advertising gave him an affinity with the technique. Other leading American artists of the time who took up screenprinting include Roy *Lichtenstein and Robert *Rauschenberg. Both Warhol and Rauschenberg extended the technique by screenprint-

ing a design onto a canvas to serve as the basis of a painting.

In Britain screenprinting took off as a creative medium at very much the same time as in the USA. The *Institute of Contemporary Arts launched a project to commission screenprints from leading artists in 1962 and it proved a great success, Richard *Hamilton and Eduardo *Paolozzi being among those whose imaginations were fired by the medium. Subsequently artists of many different styles and outlooks have used screenprinting. Among the most remarkable prints—and certainly the most technically complex—are those of the American *Superrealist Richard *Estes, who has sometimes used as many as 80 screens in one work. He writes: 'It seemed to me that silkscreen was very clean—sharp lines and opaque inks. I could work in layers which is more or less the way I paint . . . You can get it perfect—you don't ever have to worry about a color or tone until you print it. Just mix the color you want and put it on. It's limiting in the sense that the line is cut out so it's pretty hard and sharp. That seems to fit pretty well with most of what I'm doing with the paintings—the sharpness of the line.'

Scully, Sean (1945–). British-born abstract painter who became an American citizen in 1983. He was born in Dublin and after an apprenticeship as a commercial engraver he studied at Croydon College of Art and then (1968–71) at the University of Newcastle upon Tyne, where he subsequently taught (1971–3). In 1973 he moved to New York. His work is uncompromisingly abstract, typically featuring dense, richly-coloured latticeworks of stripes. He considers abstraction 'a non-denominational religious art. I think it's the spiritual art of our time.'

Scuola Romana. See ROMAN SCHOOL.

Seago, Edward (1910–74). British painter, writer, and illustrator, born in Norwich. He was confined to bed for much of his childhood (he suffered from a mysterious heart complaint), had little formal education, and was mainly self-taught as an artist. From 1928 to 1933 he travelled with circuses in Britain and abroad, and he wrote three illustrated books on the circus in the 1930s. However, he became best known for landscapes and portraits. During the Second World War he

served as a camouflage officer and after being invalided from the army in 1944 he was invited by Field-Marshal Alexander (a devoted amateur artist) to paint scenes of the Italian campaign (reproductions of his paintings were published in book form as *With the Allied Armies in Italy* in 1945). In 1953 he was appointed an official Coronation artist and in 1956–7 he accompanied the Duke of Edinburgh on a world tour. An exhibition of the pictures he painted on this tour was held at St James's Palace in 1957. The books Seago illustrated included three by his friend John Masefield, among them *Tribute to Ballet* (1938). His style as a painter and illustrator was fluid but rather facile.

Searle, Ronald (1920–). British graphic artist, born in Cambridge, where he studied at the Cambridge School of Art, 1936–9. After the Second World War (most of which he spent in Japanese prisoner-of-war camps) he settled in London and established his reputation with *Fifty Drawings* (1946), a record of his captivity. However, it is as a caricaturist and humorous illustrator that he has become famous; in particular, his creation of the fiendish schoolgirls of St Trinian's (who first appeared in *Hurrah for St Trinian's!*, 1948) has made him a household name in Britain. The St Trinian's characters typically blend mock horror and grotesque distortion with effervescent humour and Edward *Lucie-Smith writes that their 'combination of infantalism and sadism . . . seems particularly English' (*The Art of Caricature*, 1981). In 1960 Searle settled in France and in 1973 a major exhibition of his work was held in the Bibliothèque Nationale in Paris; he was the first living foreign artist to be so honoured. Searle is also a painter, etcher, and lithographer, and has worked on the design of several films, notably *Those Magnificent Men in Their Flying Machines* (1965).

Section d'Or. Group of French painters who worked in loose association between 1912 and 1914, when the First World War brought an end to their activity. The members included *Delaunay, *Duchamp, *Duchamp-Villon, *Gleizes, *Gris, *Léger, *Metzinger, *Picabia, and *Villon. Their common stylistic feature was a debt to *Cubism. The name of the group, which was also the title of a short-lived magazine it published, was suggested by Villon. It refers to a mathematical proportion known as the Golden Section in which a straight line or rectangle is divided into two parts in such a way that the ratio of the smaller to the greater part is the same as the greater to the whole (roughly 8:13). The proportion has been studied since antiquity and has been said to possess inherent aesthetic value because of an alleged correspondence with the laws of nature or the universe. The choice of this name reflected the interest of the artists involved in questions of proportion and pictorial discipline. They held one exhibition, the 'Salon de la Section d'Or' at the Galerie la Boétie, Paris, in October 1912; *Apollinaire gave a lecture here at which he is said to have introduced the term *Orphism to describe the work of several of the members of the group. Although *Kupka's name is not included in the catalogue, there is some evidence that he showed work at the exhibition and he is generally included among the Orphists.

Sedgley, Peter (1930–). British *Op and *Kinetic artist, born in London. He had no formal artistic training and until 1959 he worked as an assistant in various architectural practices. He then joined the RAF and was discharged with ignominy in 1960. He began to paint in 1963, influenced by Bridget *Riley, with whom in 1968 he set up S.P.A.C.E. (Space Provision, Artistic, Cultural and Educational), a scheme for providing studio space for young artists. In 1967 Sedgley began to incorporate lights in his work, for example in his 'video-rotors'—painted rotating discs on which varied electronically-programmed light patterns were played. From about 1970 he has experimented with combining sound with colour; often he works on a large scale, creating environments in which spectator movement triggers photoelectric cells, causing colours to change. Since the early 1970s Sedgley has lived mainly in Germany and he has an international reputation as one of the most inventive artists in his field.

Segal, George (1924–). American sculptor, born in New York. His career was slow to mature. He studied at various art colleges and took a degree in art education at New York University in 1950, but until 1958 he worked mainly as a chicken farmer, painting *Expressionist nudes in his spare time. In 1958 he made his first sculpture and in 1960 he began producing the kind of work for which he has become famous—life-size unpainted plaster

figures, usually combined with real objects to create strange ghostly tableaux. Examples are *The Gas Station* (NG, Ottawa, 1963), *Cinema* (Albright-Knox Art Gallery, Buffalo, 1963), and *The Restaurant Window* (Wallraf-Richartz-Museum, Cologne, 1967). The figures are made from casts taken from the human body; he uses his family and friends as models. In the 1970s he began to incorporate sound and lighting effects in his work. Segal has been classified with *Pop art and *Environment art, but his work is highly distinctive and original, his figures and groups dwelling in a lonely limbo in a way that captures a disquieting sense of spiritual isolation. From the late 1970s he has also made public monuments, notably *The Holocaust* (Lincoln Park, San Francisco, 1982), in which the figures are cast in bronze.

Segall, Lasar (1891–1957). Lithuanian-born painter and graphic artist who settled in Brazil in 1923 (following a visit in 1912) and became a Brazilian citizen. Before and after the first journey to Brazil he lived in Germany (mainly Berlin and Dresden), where he developed an *Expressionist style. He was the first to exhibit Expressionist pictures in Brazil and had a great influence on younger painters there. His work often expresses his compassion for the persecuted and downtrodden, particularly the Jews who suffered under Nazism. After his death his home and studio in São Paulo were converted into a museum of his work, opened in 1970.

Segonzac, André Dunoyer de. See DUNOYER DE SEGONZAC.

Seiki, Kuroda. See FOUJITA.

Sélection. An art shop and exhibition gallery in Brussels, opened by the writers André de Ridder and Paul-Gustave van Hecke in 1920 and operative until 1931. Their bulletin, also named *Sélection*, grew to become the most important avant-garde art periodical in Belgium; the last 12 numbers, issued between 1928 and 1931, took the form of monographs. Most of the leading Belgian *Expressionists showed their work at Sélection, and from 1927 to 1931 several of them—including van den *Berghe, de *Smet, and *Tytgat—were under contract to submit half their output to the gallery.

Self, Colin. See POP ART.

Seligmann, Kurt (1900–62). Swiss-born painter, graphic artist, designer, and writer who became an American citizen. He was born in Basle and studied at the École des Beaux-Arts in Geneva and the Academy in Florence. From 1929 to 1938 he lived in Paris, where he became involved with the *Surrealist movement. His paintings of this time had a magical and apocalyptic character, with hazy shapes and swirling draperies fading into the landscape. He also made various Surrealist *objects. In 1939 he emigrated to the USA and settled in New York, where he taught at Brooklyn College and the New School of Social Research. His work in his new country included sets for ballet and modern dance and a series of pictures called 'Cyclonic Forms' in which he purported to express his reactions to the American landscape. He made a serious study of the occult and wrote a book called *The Mirror of Magic* (New York, 1948); a British edition appeared in 1971 entitled *Magic, Supernaturalism and Religion*. Seligmann died in an accident when he slipped in icy conditions and discharged a gun he was carrying.

Semana de Arte Moderna (Modern Art Week). A series of events held in the Teatro Municipal, São Paulo, Brazil, from 13 to 17 February 1922, representing the country's first major public expression in the field of modern art. Edward *Lucie-Smith (*Latin American Art of the 20th Century*, 1993) writes that 'The Semana was a mixture of events incorporating music, literature and poetry as well as art. An important element in it was the desire first for a real confrontation with the bourgeois public of the city (a boom town whose inhabitants were less interested in the arts than they were in making money) and, secondly, to assert a new cultural nationalism, for the event coincided with the centenary of Brazilian independence.' Among the events of the Semana were concerts featuring music written and conducted by Heitor Villa-Lobos, the most famous of Brazilian composers. The centrepiece, however, was an exhibition, in which the participants included the painters Emiliano di *Cavalcanti (one of the organizers of the Semana), Annita *Malfatti, and Vicente do Rego Monteiro (1899–1970) and the sculptor Victor Brecheret (1894–1955). Their work provoked a hostile reception from the press

and was indiscriminately labelled 'futurist', as *Futurism was the only modern movement whose name was at least vaguely familiar in Brazil at this time (the organizers of the Semana imitated the kind of polemical slogans typical of Futurism). The artists themselves 'sometimes used titles suggesting an affinity with *Cubism—though this was not always borne out by the paintings themselves' (Lucie-Smith). Much of the work on show was tentative, but the desire to create an art that was both authentically modern and authentically Brazilian was realized later in the decade in the work of Tarsila do *Amaral (who married one of the Semana's organizers, the poet Osvald de Andrade).

'Sensation'. See AVANT-GARDE.

Septem. An association of seven Finnish painters formed in 1910. The members aimed to introduce colouristic freedom, based on *Impressionism and *Post-Impressionism, to Finnish art. They were partly inspired by an exhibition held in Helsinki in 1904, at which works by the great Impressionists and several of the leading *Neo-Impressionists were first shown in Finland, but the immediate stimulus for the formation of the group was the poor reception given to an exhibition of Finnish art in Paris in 1908; the critic of the *Echo de Paris* wrote that 'The painting of the Finns is solemn and joyless, thinly composed, cold in colour'. Willy *Finch and Knut Magnus Enckell (1870–1925) were the prime movers of the association; the other members were Mikko Oinonen (1883–1956), Yrjö Ollila (1887–1932), Juho *Rissanen, briefly Ellen Thesleff (1869–1954), and Verner Thomé (1878–1953). They first exhibited together in 1912 and the association was active until the end of the 1920s. It offered encouragement to the younger generation of Finnish painters who later founded the *November Group.

Séraphine (or **Séraphine de Senlis**) (Séraphine Louis) (1864–1942). French *naive painter. After being orphaned very young, she passed her youth as a farm-hand and later entered domestic service in Senlis. She began painting when she was about 40 and was 'discovered' by Wilhelm *Uhde in 1912. Her pictures are mainly fantastic, minutely detailed compositions of fruit, leaves, and flowers. She was intensely devout and painted in a trance-like state of religious ecstasy, regarding her works as offerings to the Virgin Mary. In the late 1920s her reason began to fail and she became obsessed with visions of the end of the world. She died in a home for the aged at Clermont.

Serebryakova, Zinaida (1884–1967). Russian painter, born into an artistic family; her father, Yevgeny Lansere (1848–86), was a sculptor; her brothers Yevgeny (1875–1946) and Nikolai Lansere (1879–1942) were a painter and architect respectively; and Alexandre *Benois was her uncle. Like Benois, she was a member of the *World of Art group, but her work was little influenced by *Art Nouveau or *Symbolism. She specialized in peasant scenes and portraits and painted one of the loveliest self-portraits in 20th-century art, *In Front of the Mirror* (Tretyakov Art Gallery, Moscow, 1909). Another beautiful self-portrait (1922) is in the Russian Museum, St Petersburg. In 1924 she settled in France, and her later career was undistinguished.

Serial art. A term that from the 1960s, especially in the USA, has been applied to two types of avant-garde art (although the two types may overlap and have in common the fact that they are usually produced by mathematically-minded artists). First, it has been used to describe a kind of *Minimal art in which simple, uniform, interchangeable elements (often commercially available objects such as bricks) are assembled in a regular, easily apprehended arrangement. Carl *Andre is a noted exponent of this kind of work. Secondly, more broadly, the term has been applied to works of art that are conceived in series or as part of a larger group; often the individual work is regarded as incomplete in itself, needing to be seen within the context of the whole. 'Whether an artist produces the same work in an edition or in different materials [Tony *Smith, for example], or a continuous image over a long period of time [Paul *Feeley], or where the overall structure takes precedence over each individual work, the thrust of serial art is the same: away from the uniquely conceived work of art—the "original", the "masterpiece" . . . The works in a series interact and reinforce each other, so that the whole is greater than any part and is the sum of the parts' (Eugene C. Goossen in *Britannica Encyclopedia of American Art*, 1973). The term was popularized by two exhibitions in the USA: 'Art in Series' at Finch College

Museum (1967) and 'Serial Imagery' at Pasadena Art Museum (1968).

Serota, Nicholas. See TATE GALLERY.

Serov, Valentin (1865–1911). Russian painter and graphic artist, born in St Petersburg, son of the composer Alexander Serov. He studied privately under *Repin and then in 1880–5 at the Academy in St Petersburg, where he became a friend of *Vrubel. His work includes landscapes, genre pictures, and historical scenes, as well as book illustrations, but he is best known as a portraitist. In this field he was the greatest Russian painter of his time and a match for any artist in the world. Like *Sargent, he was a cosmopolitan figure, used to moving in high society, and he brought to his work something of the same quality of aristocratic authority and poise associated with the American's portraits. Like Sargent, too, he painted with superb technical freedom and finesse, and it was only after his death that an exhibition of his work, including a large number of studies, showed the amount of labour he put into what seemed like the effortless expression of a natural gift. He was just as good with informal portraits as with grand showpieces. His two most famous paintings (both in the Tretyakov Gallery, Moscow) are intimate early works, the breathtakingly beautiful *Girl with Peaches* (1887) and the almost equally lovely *Girl in the Sunshine* (1888); later, as his fame grew, he painted many of the leading Russian celebrities of his time, particularly artists, musicians, and writers. Serov was a member of the *World of Art group and some of his later work shows a tendency towards flat *Art Nouveau stylization. The most remarkable example is a nude, almost monochromatic portrait of the dancer Ida Rubinstein (Russian Museum, St Petersburg), painted in Paris in 1910 (at about the same time as Romaine *Brooks's equally striking nude portrayal of this exotic beauty). Serov had a difficult personality (he could be gloomy and rude), but he was greatly admired for the integrity and sincerity of his work; he never let his skill lapse into mere virtuosity. From 1897 to 1909 he taught at the Moscow Institute of Painting, Sculpture, and Architecture, where his pupils included *Petrov-Vodkin.

Serpentine Gallery, London. See ARTS COUNCIL.

Serra, Richard (1939–). American sculptor, born in San Francisco. He studied at the University of California at Berkeley and Santa Barbara, graduating in 1961, and then at Yale University, where he was taught by Josef *Albers. In 1965–6 he lived in Paris and Florence with his first wife Nancy *Graves, then settled in New York. His early work was varied; the materials he used included wooden logs, molten lead splashed along the base of a wall, and vulcanized rubber sheets (arranged so that the weight of the material was allowed to determine the shape of the piece). Much of this work has been described as *Process art. In about 1970 the direction of his art changed as he began to use industrial materials, often on a gigantic scale in works intended for specific sites. His sculptures have often aroused controversy, most notably *Tilted Arc* (1981), a huge slab of curved, tilted steel—120 ft (36 metres) long and 12 ft (3.6 metres) high—commissioned by the General Services Administration for Federal Plaza, New York. It was hated by many people who worked in the area not only on aesthetic grounds (it was described as a 'hideous hulk of rusty scrap metal') but also because it interfered with the social activities of the plaza. After highly-publicized legal proceedings it was removed in 1989. Serra refused to consider a proposed relocation to one side of the plaza, as it had been conceived for one particular position: 'Every site has an ideology . . . what I try to do is expose that ideology.' He claims that 'it's not the business of art to deal with human needs'.

Serrano, Andres. See AVANT-GARDE.

Sert, José Luis. See MAEGHT.

Sérusier, Paul (1864–1927). French painter and art theorist, born in Paris. In 1888, while he was a student at the *Académie Julian, he met Émile *Bernard and *Gauguin at Pont-Aven. He was converted to their *Symbolist views and with *Bonnard, *Denis, *Vuillard, and others he founded the *Nabis, a group inspired by Gauguin's expressive use of colour and rhythmic pattern. With Denis, Sérusier became the principal theorist of the group, and after visiting the school of religious painting at the Benedictine monastery at Beuron in Germany in 1897 and 1903 his ideas were permeated with concepts of religious symbolism. His early paintings had

generally featured Breton peasants, but from about 1900 he concentrated on religious subjects. However, his paintings are generally considered of less interest than his ideas on art, which he set out in his book *ABC de la peinture* (1921), dealing with colour relationships and systems of proportion. From 1908 he taught at the *Académie Ranson.

Servaes, Albert (1883–1966). Belgian painter, born in Ghent. He attended evening classes at the Ghent Academy, but he was essentially self-taught as a painter. In 1905 he joined the artists' community at the nearby village of *Laethem-Saint-Martin. Servaes found the mystical fervour of the community congenial and he changed from brash *Impressionist pictures to scenes from the Bible and rustic life, featuring heavy figures painted in sombre earth colours—works that have won him a reputation as one of the founders of Belgian *Expressionism. The tragic bitterness of his religious paintings aroused the hostility of the Roman Catholic authorities, which regarded him as an extremist, and several of his works were removed from churches. In 1945 he settled in Switzerland; his work after this time seldom reached the intensity of his earlier paintings.

Servranckx, Victor (1897–1965). Belgian painter, sculptor, designer, and writer on art, born at Diegem, near Brussels. From 1912 to 1917 he studied at the Académie des Beaux-Arts in Brussels, where his fellow students included *Magritte and Pierre-Louis Flouquet (1900–67). Servranckx was a brilliantly successful student (he won the Académie's Grand Prix) and while still very young he was one of the pioneers of abstract art in his country; his first one-man show—at the Giroux Gallery, Brussels in 1917—was the first exhibition in Belgium to include abstract art. His early works often carried a suggestion of machine imagery (like those of his fellow pioneer Flouquet). In about 1927 his style changed under the influence of visionary experiences, and he tried to celebrate what he regarded as the essential cosmic unity of life in sinuous, whirling forms. After the Second World War he returned to a more sober style, but freer and more flexible than his early work. Servranckx also made abstract sculpture and worked as a designer of carpets and furniture. From 1932 he taught at the École des Arts Industriels et Décoratifs d'Ixelles in Brussels.

set-up photography. See PHOTO-WORK.

Seuphor, Michel (1901–). Belgian-born painter, graphic artist, writer, and editor who became a French citizen in 1954. He was born in Antwerp and in 1925 moved to Paris, where he was one of the founders of the *Cercle et Carré association of abstract artists in 1929 and editor of its journal. His own paintings were in a geometrical abstract style (he also made prints in a variety of techniques), but he is better known for his writings. They include a standard book on abstract art, *L'Art abstrait: ses origines, ses premiers maîtres* (1949), and dictionaries of abstract painting (1957) and modern sculpture (1959), all of which have been translated into English. Seuphor also wrote poetry.

Seurat, Georges. See NEO-IMPRESSIONISM.

Seven & Five Society. An association of progressive British artists, originally consisting of seven painters and five sculptors, formed in 1919 and disbanded in 1935. Ivon *Hitchens was the only significant artist among the founder members (he was also the only original member to survive to the society's demise), and the association was originally 'an expedient alliance of young ex-Servicemen reluctant to resume their education or to re-enter their professions' (Charles Harrison, *English Art and Modernism: 1900–1939*, 1981). The first exhibition of the society was held at Walker's Galleries, London, in April 1920, by which time the membership had grown to eighteen. The members regarded themselves as being in rebellion against academic art, but in retrospect their work seems timid-and provincial. However, the membership changed radically and in the late 1920s and early 1930s the society was Britain's most important association of avant-garde artists. After Ben Nicholson joined in 1924 (he became chairman in 1926) the society turned increasingly towards abstraction. In 1934, at Nicholson's suggestion, the name was changed to 'Seven & Five Abstract Group', and the final exhibition (the 14th) held at the *Zwemmer Gallery in October 1935, was the first all-abstract exhibition to be held in England. Apart from Nicholson and Hitchens, the artists represented included Barbara *Hepworth and Henry *Moore (both of whom had exhibited with the group since 1932).

Seven-Seven, Twins (c. 1944–). Nigerian painter, born in Ibadan, the son of a dyer and cloth-merchant. He is the best-known artist to emerge from the Oshogbo Workshop, a Nigerian 'art school' in which untrained persons were simply given paints and materials. Several students, and in particular Twins, produced impressive work characterized by subjective fantasy and rich decorativeness. His paintings have been exhibited in Europe and the USA as well as Africa, and the income from sales has helped to finance his other wide-ranging artistic activities in music (he is a singer and songwriter) and the theatre.

Severini, Gino (1883–1966). Italian painter, designer, and writer on art, active for much of his career in Paris. He was born in Cortona, moved to Rome in 1899, and decided to become a painter after meeting *Boccioni in 1901. Another important early influence on Severini was *Balla, who introduced him to *Divisionism. In 1906 he settled in Paris, where he became a friend of his fellow Italian *Modigliani, and he played an key role in transmitting the ideas of the French avant-garde to the *Futurists. He signed both the Futurist manifestos of painting in 1910 and he remained active in the movement until the First World War. Like other Futurists, he was much concerned with showing movement, but he was distinctive in his subject-matter, favouring scenes of colourful Parisian night life in which—influenced by *Cubism—he broke up forms into a multitude of contrasting and interacting shapes suggesting the rhythm of music and dance (*Dynamic Hieroglyphic of the Bal Tabarin*, MOMA, New York, 1912). His most spectacular work in this vein was *The Pan-Pan at the Monico* (1911–12, destroyed in the Second World War; second version, 1960, Pompidou Centre, Paris), which *Apollinaire described as 'the most important work painted by a Futurist brush'.

During the First World War Severini was excused military service because of poor health, but he painted some of the most dynamic Futurist pictures inspired by the conflict. In contrast, his other wartime work included still-lifes in the manner of Synthetic Cubism, reflecting his friendship with *Gris and *Picasso (*Still Life*, Metropolitan Museum, New York, 1917). In some of his work he came close to pure abstraction, but he was also influenced by the 'return to order' (see NEO-CLASSICISM) that the war helped to inspire in

many avant-garde artists. He became interested in mathematical proportions and compositional rules, publishing a book on the subject in 1921, *Du Cubisme au classicisme* (a scholarly Italian edition appeared in 1972). In the 1920s his style became more traditional and he carried out several decorative commissions, including murals for churches in Switzerland. He also worked as a theatrical designer. Severini returned to Italy in 1935, but in 1946 he settled permanently in Paris. In the late 1940s his style once again became semi-abstract. His later work included more large-scale decorative work, notably murals in the Palazzo dei Congressi, Rome (1953). His writings include the autobiographical *Tutta la vita di un pittore* (1946).

Sewell, Brian (1931–). British art critic. His father committed suicide before he was born, and his mother, a painter and musician, brought him up with stifling possessiveness. After studying history of art at the *Courtauld Institute, he worked at Christie's auction house, 1958–66, then briefly set up as a dealer on his own. He became famous overnight in 1979 when he acted as spokesman for his friend and former teacher Anthony *Blunt, who had been sensationally exposed as a former Soviet spy. With his extraordinarily plummy voice, Sewell fitted to perfection the public image of an upper-class aesthete, and after the Blunt scandal died down he continued to be a familiar media figure. In 1984 he became art critic of the London *Evening Standard*, and soon made a controversial reputation with uncompromising attacks on work that he regarded as worthless or pretentious (which included the products of several highly-regarded avant-garde artists; see VIDEO ART, for example). To his numerous admirers, he is a voice of sanity in a predominantly mad art world, but to many people in the contemporary art establishment, he is a venomous reactionary. On 5 January 1994 the *Standard* published a letter signed by 35 of his opponents, accusing him of a 'dire mix of sexual and class hypocrisy, intellectual posturing and artistic prejudice'. The signatories included John *Golding, Eduardo *Paolozzi, and Rachel *Whiteread. Later in the year, however, Sewell showed that he had strong support when he achieved the rare distinction of becoming 'critic of the year' in the British Press Awards for the second time (the first was in 1989). A collection of his writings, *The*

Reviews that Caused the Rumpus, was published in 1994 (revised edn., entitled *An Alphabet of Villains*, 1995). Among the other journals Sewell writes for is *Modern Painters*, and to some extent he has inherited the mantle of its founder, Peter *Fuller, as the critic supporters of the avant-garde love to hate. Edward *Lucie-Smith, one of the fellow-critics with whom he has crossed swords, describes him as 'a mixture of Lady Bracknell and the mannerisms of an offended llama'. See also CANADAY.

Sezession. A name adopted by several groups of artists in Germany and Austria who in the 1890s broke away ('seceded') from the established academies, which they regarded as too conservative, and organized their own, more avant-garde exhibitions. The first of these groups was formed in Munich in 1892, its leading members being Franz von *Stuck and Wilhelm Trübner (1851–1917). There were Sezessionen also in Vienna (1897), with Gustav *Klimt as first President, and Berlin (1899), led by Max *Liebermann. When in 1910 a number of young painters were rejected by the Berlin Sezession—among them members of Die *Brücke—they started the Neue Sezession under the leadership of Max *Pechstein.

Shahn, Ben (1898–1969). American painter, illustrator, photographer, designer, teacher, and writer, born at Kovno, Lithuania, at that time part of Russia. His family emigrated to the USA in 1906 and settled in New York. In 1913–17 he was apprenticed to a commercial lithographer and he worked in this profession until 1930. However, he also took evening classes at various colleges in New York, studying biology, 1919–21, then painting, 1921–2. In 1924–5 and 1927–9 he travelled in Europe and North Africa. Shahn's background (his father had been sent to Siberia for revolutionary activities and he grew up in a Brooklyn slum) gave him a hatred of cruelty and social injustice, which he expressed powerfully in his work. He first made a name with a series of pictures (1931–2) on the Sacco and Vanzetti case (these two Italian immigrants had been executed for murder in 1927 on very dubious evidence, and many liberals believed that they had really been condemned for their anarchist political views). The Sacco and Vanzetti paintings are in a deliberately awkward, caricature-like style that vividly expresses Shahn's anger and compassion. He did a similar series in 1932–3 on the trial of

the labour leader Tom Mooney, which had taken place in 1916.

In 1933 Shahn was assistant to Diego *Rivera on the latter's murals for the *Rockefeller Center, New York, and he subsequently painted a number of murals himself, notably for the Bronx Post Office, New York (1938–9), and the Social Security Building, Washington (1940–1). From 1935 to 1938 he worked as an artist and photographer for the Farm Security Administration, a government agency that documented rural poverty. During the Second World War his work included designing posters for the Office of War Information. After the war he returned to easel painting and was also active as a book and magazine illustrator and as a designer of mosaics and stained glass. His later work tended to be more fanciful and reflective and less concerned with social issues. From the 1950s he gave more time to teaching and lecturing and in 1956–7 he was Charles Eliot Norton professor of poetry at Harvard University. His Norton lectures were published as *The Shape of Content* (1957) in which he summarized his humanistic, anti-abstract artistic philosophy. His other writings include various essays and the book *Paragraphs on Art* (1952).

Shannon, Charles (1863–1937). British painter, illustrator, and collector, born at Quarrington, Lincolnshire, the son of a country parson. In 1881–5 he studied wood engraving at Lambeth School of Art, where in 1882 he met Charles *Ricketts, who became his lifelong companion. They lived together for almost 50 years until Ricketts's death in 1931. Ricketts had the more dominant personality and Kenneth *Clark writes that he 'did most of the talking. Shannon was quiet and recessive, but his rare interpolations showed good sense and considerable learning. One could see that Ricketts turned to him as to a reasonable wife.' Another friend of the couple, the poet, critic, and wood engraver Thomas Sturge Moore (1870–1944), wrote that 'between Ricketts and Shannon existed the most marvellous human relationship that has ever come within my observation, and in their prime each was the other's complement, but neither easily indulged the other; their union was more bracing than comfortable'. Shannon's output as a painter consisted mainly of portraits and imaginative subjects treated in a lush style based on 16th-century Venetian art. They were highly regarded in

their day but have dated badly. He made lithographs in a similar vein. In 1929 he fell from a ladder while hanging a picture and injured his brain; although he lived for eight more years, he never fully recovered and often did not recognize Ricketts.

Shannon, Sir James (1862–1923). British painter, born in the USA of Irish parents. He moved to London in 1878 and studied at the National Art Training School (later renamed the *Royal College of Art). In 1881, when he was only 19, he had a hit at the *Royal Academy with a portrait of one of Queen Victoria's ladies-in-waiting and thereafter he was one of the most successful society portraitists of his day. His style, which harked back to great 18th-century portraitists such as Gainsborough and Reynolds, was fluid and rather flashy and he was often accused of flattering his sitters; in 1910 the *Art Journal* commented that 'through Mr Shannon our duchesses realise all their aspirations, present and posthumous'. He spent his last years in a wheelchair because of a horse-riding accident, but he continued to paint. He was knighted in 1922.

shaped canvas. A term that began to be used in the 1960s for paintings on supports that departed from the traditional rectangular format. Non-rectangular pictures were of course not new at this time: Gothic and Renaissance altarpieces often had pointed tops, the oval was particularly popular in the Baroque and Rococo periods, and so on. In the context of modern art, however, the term 'shaped canvas' usually alludes specifically to a type of abstract painting that emphasizes the 'objecthood' of the picture, proclaiming it as something that exists entirely in its own right and not as a reference to or reproduction of something else. Various artists have been claimed as the 'inventor' of the shaped canvas in this sense, but its most prominent early exponent was undoubtedly Frank *Stella, who has used such shapes as Vs, lozenges, and fragments of circles. Subsequently Elizabeth *Murray has been perhaps the most original and committed devotee. The leading exponent in Britain has been Richard *Smith. He was one of the artists represented in an exhibition entitled 'The Shaped Canvas' at the *Guggenheim Museum, New York, in 1974, organized by Lawrence *Alloway. Shaped canvases have

also occasionally been used by modern figurative painters, most notably Anthony *Green.

Shaw, John Byam (1872–1919). British painter and illustrator, born in Madras, the son of a high court official. He came to England in 1878 and studied at St John's Wood School of Art and the *Royal Academy Schools. His style was heavily influenced by the Pre-Raphaelites and he was at his best with medieval subjects, although at one time his most famous picture was probably *The Boer War* (City Art Gallery, Birmingham, 1901). In 1910 he founded the Byam Shaw and Vicat Cole School of Art in Kensington with the painter Rex Vicat Cole (1870–1940), a close friend who later wrote *The Art and Life of Byam Shaw* (1932). Among the teachers was another close friend, Eleanor Fortescue-Brickdale (1872–1945), another upholder of the Pre-Raphaelite tradition. The school still continues today as the Byam Shaw School of Art, although it is now located in north London. Shaw's son, James Byam Shaw (1903–92), was an art historian, one of the world's most distinguished authorities on Old Master drawings. (The double-barrelled form 'Byam Shaw' is now the family name, but the painter used 'Byam' as a Christian name.)

Shchukin, Sergei (1854–1936). Russian collector and patron, born in Moscow. He was a member of a large merchant family with diverse business interests, and he had four brothers who also were enthusiastic art collectors. His serious collecting career began in 1897 when he bought a *Monet (*Lilacs at Argenteuil*, Pushkin Museum, Moscow, 1873) at *Durand-Ruel's gallery during a business trip to Paris. After this he became devoted to modern French painting and filled his magnificent house in Moscow with choice examples. Like the other great Russian collector of such works, Ivan *Morozov, he commissioned new works as well as buying from dealers. Among the *Impressionists and *Post-Impressionists Shchukin had particularly fine representations of the work of *Cézanne, *Gauguin, Monet, and *Renoir, but the artists who figured most prominently in his collection were *Matisse (37 paintings) and *Picasso (51 paintings, mainly *Cubist works). In 1909 Shchukin commissioned large decorative panels of *The Dance* and *Music* from Matisse, and the artist visited Moscow in 1911 to supervise the

installation of his work. Shchukin referred to the pink drawing-room, which was devoted to Matisse's work, as 'my fragrant garden', and at this time he undoubtedly had the finest representation of his paintings in the world; in 1914 the Russian art historian and critic Yakov Tugendkhold (1882–1928) wrote: 'In spite of the exhibitions I had seen in Paris and the number of his works in his own studio, it was not until after my visit to Shchukin's house that I could say that I really knew Matisse.' His collection was more accessible than Morozov's, being open to the general public at certain times. After the Russian Revolution both collections were nationalized and amalgamated administratively under the title Museum of Modern Western Art, although they remained in their original homes for several years. In 1928 they were brought together under one roof in Morozov's former home, but in 1948 the Museum of Modern Western Art was dissolved and the paintings were divided between the Hermitage, Leningrad (now St Petersburg), and the Pushkin Museum, Moscow.

Sheeler, Charles (1883–1965). American painter and photographer, the best-known exponent of *Precisionism. He was born in Philadelphia, where he studied at the Philadelphia School of Industrial Art (1900–03) and at the Pennsylvania Academy of the Fine Arts (1903–6) under William Merritt *Chase. Between 1904 and 1909 he made several trips to Europe (the final one in company with his friend Morton *Schamberg), and he gradually abandoned the bravura handling of Chase for a manner influenced by European modernism—the paintings he exhibited at the *Armory Show in 1913, for example, were much indebted to *Cézanne. In 1912 Sheeler took up commercial photography for a living while continuing to paint, and in 1918 he moved to New York. He worked for a while in fashion photography, but his shy and undemonstrative personality was not suited to this world, and he concentrated more on very mundane subjects such as plumbing fixtures. The clarity needed in such work helped to transform his style of painting to a meticulous smooth-surfaced manner that was the antithesis of his early approach. He began to paint urban subjects in about 1920 and over the next decade shifted from simplified compositions influenced by *Cubism (on 'the borderline of abstraction' in his own words) to

highly-detailed photograph-like images. In 1927 he was commissioned to take a series of photographs of the Ford Motor Company's plant at River Rouge, Michigan (he also made paintings of the plant). His powerful photographs, presenting a pristine view of American industry, were widely reproduced and brought him international acclaim (he was invited to photograph factories in Russia, but declined the offer). Increasingly, also, he was recognized as the finest painter in the Precisionist style, his work standing out as much for its formal strength as for its technical polish (*American Landscape*, MOMA, New York, 1930).

Sheeler's paintings continued in this realistic vein in the 1930s, but in the mid-1940s his style changed dramatically; he began using multiple viewpoints and bold unnaturalistic colours, although his brushwork remained immaculately smooth (*Architectural Cadences*, Whitney Museum, New York, 1954). In 1959 he suffered a stroke and had to abandon painting and photography. His work in represented in many major American collections.

Shepherd, David (1931–). British painter and wildlife conservationist, born in London. He started his career with aviation subjects, but in 1960 he began painting African wildlife and it is in this area that he has become internationally famous—not only with his paintings (and *popular prints reproduced from them), but also through his fundraising activities to preserve endangered species. He has published several books on his work and also an autobiography entitled *The Man Who Loves Giants* (1975, second edition 1989); this was also the title of a BBC television documentary on his life. Apart from wildlife, his great passion is steam locomotives—likewise a favourite subject in his paintings (the 'Giants' in the title of his autobiography refers to both elephants and engines). Shepherd has also painted portraits and occasional religious works.

Sher-Gil, Amrita (1913–41). Indian painter, born in Budapest, the daughter of an aristocratic and scholarly Sikh father and a mother who came from a cultured Hungarian professional family. From 1921 to 1929 Sher-Gil lived in Simla. She showed a talent for drawing from childhood, and from 1929 to 1934 she studied painting in Paris, first at the

Académie de la Grande Chaumière and then at the École des *Beaux-Arts. Although she immersed herself in the bohemian life of the city, she did not identify with any of the avant-garde movements of the day, developing instead a romantic love of India, where she returned at the end of 1934. Apart from a year in Hungary, 1938–9, when she married her cousin, Dr Victor Egan, the rest of her short life was spent in India. Sher-Gil declared that it was her artistic mission 'to interpret the life of Indians, and particularly the poor Indians, pictorially'. However, her interest in the poverty and pathos of her country was aesthetic rather than motivated by any sense of *Social Realism. She produced sentimentalized images of the suffering masses in a flat, stylized manner that revived something of the spirit of Rajput miniatures.

Sherlock, Marjorie. See CAMDEN TOWN GROUP.

Sherman, Cindy. See PHOTO-WORK.

Shevchenko, Alexander (1882–1948). Russian painter, born at Kharkov. He studied in Paris, 1905–6, then in Moscow at the Stroganov Art School and the Moscow School of Painting, Sculpture, and Architecture, 1906–9, and he evolved a style combining influences from both Russian peasant art and French *Cubism (see NEO-PRIMITIVISM). In line with these two interests he wrote two theoretical tracts, both published in Moscow in 1913: *Neo-Primitivism: Its Theory, its Possibilities, its Achievements* and *The Principles of Cubism and Other Modern Trends in Painting of All Times and Peoples*. At around this time he contributed to several avant-garde exhibitions, including *Donkey's Tail and *Target. From 1918 to 1930 he was a professor at *Vkhutemas, and in 1921 he became a member of *Makovets.

Shinn, Everett (1876–1953). American painter, illustrator, and designer, born in Woodstown, New Jersey. He studied at the Pennsylvania Academy of the Fine Arts, 1893–6, while at the same time working as a reporter-illustrator on the *Philadelphia Press*. His colleagues on the newspaper included *Glackens, *Luks, and *Sloan, who like Shinn became members of The *Eight and the *Ashcan School in New York (he moved there in 1896). Shinn differed from his associates in his choice of subject, preferring scenes from the theatre and music-hall to low-life imagery. However, in 1911 he did murals on local industrial subjects for Trenton City Hall, New Jersey, and these have been described as the earliest instance of *Social Realist themes in public mural decoration. He also did decorations in a more lighthearted manner for the interior of the Stuyvesant (later Belasco) Theatre, New York (1907) and for private homes. In addition Shinn painted fashionable portraits and illustrated numerous books. His interest in the theatre led him to write plays, and he worked for a time as an art director for motion pictures. However, he never achieved much success in these fields and in his later career he worked mainly as a commercial artist.

Shirlaw, Walter. See ART STUDENTS LEAGUE OF NEW YORK.

Shkolnik, Iosif. See UNION OF YOUTH.

'Shock art'. See AVANT-GARDE.

Shore, Arnold. See BELL, GEORGE.

Short, Sir Frank (1857–1945). British engraver in various techniques, born at Wollaston, Worcestershire. He was the son of an engineer and trained to follow his father's profession; his scientific background gave him a deep understanding of materials, and he made his own tools and invented new ones. His main artistic training was at the *Royal College of Art. Short revived aquatint and mezzotint as both creative and reproductive media, and his etchings were praised by *Whistler, who often visited Short's studio for advice on technical matters. From 1891 to 1924 he taught at the Royal College of Art: 'Many artists who were to gain high reputation owed much to his training, his high standards, and his constant advocacy of earnest and serious accomplishment in craft ... In a lecture he once said: "An artist must be a workman; and an artist afterwards, if it please God"' (*DNB*).

Shterenberg, David. See NARKOMPROS.

Sibley, Andrew. See MOLVIG.

Sickert, Walter Richard (1860–1942). British painter, printmaker, teacher, and critic, one of the most important figures of his time in

British art. He was born in Munich of a Danish-German father and an Anglo-Irish mother and he remained cosmopolitan. The family settled in London in 1868. Both his father and his grandfather were painters, but Sickert—after a good classical education—initially trained for a career on the stage, 1877–81. He toured with Sir Henry Irving's company but never progressed beyond small parts and in 1881 he abandoned acting and became a student at the *Slade School. In the following year he became a pupil of *Whistler (who taught him etching as well as painting), and in 1883 he worked in Paris with *Degas. Between 1885 and 1905 Sickert spent much of his time in Dieppe, living there 1899–1905, and also visited Venice several times. From 1905, when he returned to England, he became the main channel for influence from avant-garde French painting in British art—inspiring a host of younger artists with the force of his personality as well as the quality of his work. The *Allied Artists' Association (1908), the *Camden Town Group (1911), and the *London Group (1913) were all formed largely by artists in his circle. In 1918–22 Sickert again lived in Dieppe, then settled permanently in England, living in London and Brighton before moving to Broadstairs, Kent (1934), and finally to Bathampton, near Bath (1938).

Sickert took the elements of his style from various sources but moulded them into a highly distinctive manner. From Whistler he derived his subtle modulations of tone, although his harmonies were more sombre and his touch rougher, using thick crusty paint. To Degas he was indebted particularly for his method of painting from photographs and for the informality of composition this encouraged. His favourite subjects were urban scenes and figure compositions, particularly pictures of the theatre and music-hall, nudes, and drab domestic interiors (Sir William *Rothenstein wrote that he was 'fastidious in his person, in his manners, in his choice of clothes', but his 'genius for discovering the dreariest house and the most forbidding rooms in which to work was a source of wonder and amazement to me'). Sickert himself wrote in 1910 that 'The more our art is serious, the more will it tend to avoid the drawing-room and stick to the kitchen'. This attitude permeates his most famous painting, *Ennui*, a compelling image of a stagnant marriage, of which he painted at least four versions, that in the Tate Gallery, London (*c.* 1914), being the largest and most highly finished.

From the 1920s Sickert received many honours. His later works—often based on press photographs or Victorian illustrations—are very broadly handled, painted in a rough, vigorous technique, with the canvas often showing through the paint in places. The colour is generally much higher-keyed than in his earlier work and sometimes almost *Expressionist in its boldness. The prevailing critical opinion for many years was that these late works marked a significant decline, but major claims have recently been made for them, particularly following the 1981 *Arts Council exhibition 'Late Sickert: Painting 1927 to 1942'.

Sickert was highly prolific as a painter, and his work is represented in many public collections. In addition he was an outstanding and resourceful printmaker (he experimented with various techniques and with coloured papers, trying to capture the rich tonal effects of his paintings) and a brilliant although somewhat dilettante teacher (he opened seven private art schools, each of brief duration, and also taught part-time at Westminster School of Art, 1908–12 and 1915–18). He was celebrated for his wit and charm and was a stimulating talker and an articulate writer on art; Osbert *Sitwell edited a posthumous collection of his writings entitled *A Free House!* (1947). Sickert was married three times; his third wife (from 1926) was the painter Thérèse *Lessore. His brother **Bernard Sickert** (1862/3–1932) was a landscape painter and etcher.

One of the more eccentric theories about the Jack the Ripper murders of 1888 has it that Sickert (against his will) was part of a team that carried out the killings to cover up a scandal about an illegitimate child born to the Duke of Clarence (Queen Victoria's grandson); see Stephen Knight, *Jack the Ripper: The Final Solution* (1976, revised edn., 1984) and Jean Overton Fuller, *Sickert & the Ripper Crimes* (1990).

Signac, Paul (1863–1935). French painter and writer on art. After the death of Georges Seurat in 1891 he became the acknowledged leader of the *Neo-Impressionist movement, and in 1899 he published *D'Eugène Delacroix au néo-impressionisme*, which was long regarded as the authoritative work on the subject. The

book, however, was more in the nature of a manifesto in defence of the movement than an objective history. It reflected Signac's use of more brilliant colour from about 1890, as he moved away from the scientific precision advocated by Seurat to a freer and more spontaneous manner. His work had a great influence on *Matisse, who visited him at St-Tropez in 1904 (a keen yachtsman, Signac spent a good deal of time on the Mediterranean and French Atlantic coasts; harbour scenes were his favourite subjects).

silkscreen. See SCREENPRINTING.

Sillince, Wiliam. See TRUTH TO MATERIAL(S).

Simberg, Hugo (1873–1917). Finnish painter and graphic artist, born at Hamina. After training at the Finnish Fine Arts Association and in Helsinki, he studied privately with *Gallen-Kallela, on whose advice he made a tour abroad in 1896, visiting London, where he admired the work of the *Pre-Raphaelites, and Paris. In 1897–8 he travelled in Italy, and in 1899 he visited the Caucasus. Although he painted fairly straightforward landscapes and portraits, most of Simberg's work is in a highly distinctive *Symbolist vein. Drawing on his country's rich folk traditions, he depicted a vividly imaginative world in which devils and angels and personifications of Death and Frost mingle with humans. In such work his style was colourful and bizarre, sometimes with an almost *naive quality of freshness. Gallen-Kallela wrote that Simberg had a 'quite wonderful gift, completely in the character of the Old Masters of the thirteen or fourteen hundreds. And it is a genuine, not affected, naivety. His works seem like sermons that everyone must listen to, and they stick in the memory.' Simberg usually worked on a small scale (his output includes many watercolours, drawings, and etchings), but in 1904–7 he did impressive monumental work, including frescos and stained glass, for the newly-built church (now catherdal) at Tampere, Finland's second largest city. His later career was marred by illness.

Sime, Sidney (1864/7–1941). British illustrator, painter, and designer. He was born in Manchester into a poor family and worked in coal-mines as a boy and then at various other jobs before studying at Liverpool School of Art in the mid-1880s. During the 1890s his work was published in several leading weekly and monthly magazines, including the *Idler*, *Pall Mall*, and the *Strand*, and he became a well-known figure in the London art world, his friends including Max *Beerbohm and Augustus *John. However in 1903 he settled in the village of Worplesdon (near Guildford) in Surrey, and lived for the rest of his life in semi-seclusion (although he was something of a celebrity among the locals). Sime specialized in scenes of the weird and macabre and was good at evoking a sense of brooding menace. He found a kindred spirit in the writer Lord Dunsany and illustrated several of his books, beginning with *The Gods of Pegana* (1905). Sime was also a fine caricaturist and he occasionally made stage designs, notably for a production of Ibsen's *The Pretenders* at the Theatre Royal, Haymarket, London, in 1913.

Simmons, Edward. See TEN.

Singier, Gustave (1909–84). Belgian-born painter, designer, and printmaker who settled in Paris in 1919 and became a French citizen. He had a family background of craft, for his father was a joiner and his mother a weaver. Early in his career he worked as a commercial designer-decorator (mainly for shops and apartments), painting in his spare time and taking evening classes at various art academies. However, in 1936 he met the painter Charles Walch (1898–1948), who encouraged him to take up art professionally, and from that year he began exhibiting regularly at commercial galleries and avant-garde salons. In 1941 he was one of the founders of the group *Peintres de Tradition Française and in 1945 one of the founders of the *Salon de Mai. He had his first one-man exhibition in 1949, at the Galerie Billiet Caputo, Paris, and from 1951 to 1954 he taught at the *Académie Ranson. Singier's early work combined elements from *Cubism, *Expressionism, and *Fauvism. After the Second World War his painting became completely abstract, featuring flat, patchwork-like patterns in bright colours (*Provence I*, Tate Gallery, London, 1957). He often worked in watercolour as well as oils. Apart from paintings, his work included prints (etchings and lithographs) and designs for stained glass, tapestry, and the theatre.

Siqueiros, David Alfaro (1896–1974). Mexican painter, one of the trio of muralists (with *Orozco and *Rivera) who have dominated

20th-century Mexican art. He was born in Chihuahua, the son of a lawyer, and was a political activist from his youth. In 1914 he abandoned his studies at the Academy of San Carlos in Mexico City to join the revolutionary army fighting against President Huerta. His services were appreciated by the victorious General Carranza, who in 1919 sponsored him to continue his studies in Europe, where he was friendly with Rivera (later they became rivals). On returning to Mexico in 1922 he took a leading part in the artistic revival fostered by President Alvaro Obregón. Siqueiros was active in organizing the Syndicate of Technical Workers, Painters, and Sculptors and was partly responsible for drafting its manifesto, which set forth the idealistic aims of the revolutionary artists: 'our own aesthetic aim is to socialize artistic expression, to destroy bourgeois individualism . . . We proclaim that this being the moment of social transition from a decrepit to a new order, the makers of beauty must invest their greatest efforts in the aim of materializing an art valuable to the people, and our supreme object in art, which today is an expression for individual pleasure, is to create beauty for all, beauty that enlightens and stirs to struggle.'

Siqueiros's political activities led to his imprisonment or self-imposed exile several times; from 1925 to 1930 he completely abandoned painting for political activity and he later fought in the Spanish Civil War. It was not until 1939 that he eventually completed a mural in Mexico—*Portrait of the Bourgeoisie* for the headquarters of the Union of Electricians in Mexico City (his slow start had prompted Rivera to retort in answer to criticism from him: 'Siqueiros talks: Rivera paints!'). Thereafter, however, Siqueiros's output was prodigious. He painted many easel pictures as well as murals, and though he insisted they were subordinate to his wall paintings, they were important in helping to establish his international reputation. His murals are generally more spectacular even than those of Orozco and Rivera—bold in composition, striking in colour, freely mixing realism with fantasy, and expressing a raw emotional power. In contrast with the sense of disillusionment and foreboding sometimes seen in Orozco's work, Siqueiros always expressed the dynamic urge to struggle; his work can be vulgar and bombastic, but its sheer energy is astonishing. He often experimented technically, working with industrial materials and equipment,

including spray-guns, cement-guns, and blow-torches (his use of unconventional methods influenced Jackson *Pollock, who attended the experimental workshop Siqueiros ran in New York in 1936). In his late years he was showered with honours from his own country and elsewhere; he received the Lenin Peace Prize in 1967, for example, and in the following year became the first president of the newly-founded Mexican Academy of Arts. His final major work, the Polyforum Siqueiros (completed 1971) in Mexico City, is a huge auditorium integrating architecture, sculpture, and painting.

Sironi, Mario (1885–1961). Italian painter, sculptor, designer, caricaturist, and writer, born in Sassari, Sardinia. The year after his birth his family moved to Rome. In 1902 he began studying engineering (his father's profession), but he abandoned it for painting in 1903. At life classes at the Academy in Rome he became friendly with *Balla, *Boccioni (with whom he shared a flat in Paris in 1908), and *Severini, and in 1914 he moved to Milan and joined the *Futurists. However, his association with the movement was for ideological rather than stylistic reasons; his paintings of the period were often concerned with modern urban life, but they are solid rather than dynamic in feeling. After the First World War, in which he served at the front, Sironi returned to Milan and was briefly influenced by *Metaphysical Painting. In 1922, the year in which Mussolini gained power, he joined the Fascist Party and was a founder of *Novecento. Until the fall of Mussolini in 1943 he was the leading caricaturist for the Fascist press, to which he also contributed much writing, including art criticism. He came to regard easel painting as a bourgeois anachronism and in the 1930s devoted much of his energies to propaganda work and didactic murals, including *Italy between the Arts and Sciences* (1935) for the University of Rome and *Law between Justice and Strength* (1936) for the Palace of Justice, Milan. His style in these murals was anti-naturalistic, based on such sources as Roman and Byzantine mosaics and Romanesque sculpture. It was denounced in some quarters as degenerate and prompted a heated debate in the press on the appropriate style for Fascist art. After the fall of Mussolini, Sironi returned to easel painting. His work also included sculpture and design for opera. A retrospective exhibition of his work was

staged at the Venice *Biennale the year after his death.

Sisley, Alfred. See IMPRESSIONISM.

Situation (in full, 'Situation: An Exhibition of British Abstract Painting'). An exhibition staged in September 1960 at the Galleries of the Royal Society of British Artists, London, by a group of predominantly young British painters who were united by their admiration for American *Abstract Expressionism. The catalogue listed 20 artists, but only 18 in fact showed their work. Paintings included had to be totally abstract and at least 30 square feet (c. 3 square metres) in size; the name of the exhibition came from the participants' idea that an abstract painting that occupied the whole field of vision would involve the spectator in an 'event' or 'situation'. Robyn *Denny was the organizing secretary and other artists represented included Gillian *Ayres, Bernard and Harold *Cohen, John *Hoyland, Bob *Law, Richard *Smith, and William *Turnbull. These artists felt frustrated by the lack of exposure given to large-scale abstract works by commercial galleries, and in organizing the exhibition themselves they aimed to bypass the dealer system. The following year, however, the London dealers *Marlborough Fine Art staged an exhibition featuring 16 of the 18 who had participated in the original show, with the addition of the sculptor Anthony *Caro; this was entitled 'New London Situation: An Exhibition of Abstract Art'. In 1962–3 the *Arts Council organized a touring exhibition of the work of the group entitled 'Situation: An Exhibition of Recent British Abstract Art'. The three exhibitions marked a move towards a more international context for British painting.

Sometimes the artists who took part in the exhibitions are called 'Situationists' (for example in Daniel Wheeler's *Art Since Mid-Century*, 1991), but this usage is regrettable, as it runs the risk of confusion with *Situationism.

Situationism. A radical political and cultural movement, centred in France but international in scope, that flourished from 1957 to 1972. It is sometimes considered a kind of post-war version of *Surrealism, but the Situationists were more concerned with politics and more theoretical in outlook than the Sur-realists, and they had a comparatively negligible impact on art. What the two movements shared was a desire to disrupt conventional bourgeois life, and Situationism had its moment of glory in 1968 when its ideas were for a short time put into practice, playing a part in the student revolts in Paris and France's general strike.

The Situationist International (Internationale Situationniste) was formed in 1957 by the amalgamation of two cultural groups: the Movement for an Imaginist Bauhaus (descended from *Cobra) and the Lettrist International (Lettrism, which has some kinship with *Concrete poetry, is defined in the *New Shorter Oxford English Dictionary* as 'a movement in French art and literature characterized by a repudiation of meaning and the use of letters (sometimes invented) as isolated units'). The chief spokesman of the Situationists was Guy Debord (1931–), editor of the journal *Internationale situationniste* (12 issues, 1958–69). The other main Situationist periodical was *Spur* (7 issues, 1960–1), produced by a group of the same name in Munich. In addition to journals such as these, the Situationists created posters and films, and Debord promoted street events that he hoped would jolt passers-by out of their normal ways of looking and thinking. Among the visual artists associated with the movement, the best known was Asger *Jorn, who exhibited pictures that were painted over partially obliterated reproductions of works of art, intending thereby to call into question the value of originality. In the *Fontana Dictionary of Modern Thought* (ed. Alan Bullock and Oliver Stallybrass, 2nd edn., 1988), Krishan Kumar writes of the Situationists: 'Instead of the take-over of the state and economy that was the aim of most revolutionaries, they demanded a "revolution of everyday life" that would transform personal relationships and cultural outlooks. Through changes in attitude to sex, family life, work, and the urban environment, there would take place a thoroughgoing cultural politicization that would substitute itself for the conventional institutions of politics. The Situationists were the inspiration of many of the best-known graffiti that covered the walls of Paris in May '68: "demand the impossible"; "do not adjust your mind, there is a fault with reality"; "Je suis Marxiste, style Groucho."'

The Situationists disbanded in 1972. A large exhibition on the movement was held at the Pompidou Centre in Paris in 1989.

Sitwell. Family of British writers, patrons, and collectors. **Sir George Sitwell** (1860–1943) was an antiquarian and genealogist. He had three children, who formed probably the most famous literary family of the 20th century: **Dame Edith Sitwell** (1887–1964), **Sir Osbert Sitwell** (1892–1969), and **Sir Sacheverell Sitwell** (1897–1988). They grew up at the family seat, Renishaw Hall, Derbyshire, and are seen as children in *Sargent's group portrait *The Sitwell Family* (1900), which is still at Renishaw. All three of them published numerous prose and verse works. Edith is best known as a poet, Osbert as an autobiographer, and Sacheverell for his writings on art and architecture, including several pioneering books on Baroque art, which was little appreciated in Britain when he started his career; *Southern Baroque Art* (1924) was the first of these books. The Sitwells were outspoken critics of culture they regarded as outmoded and they became vigorous champions of modernism in art, literature, and music, particularly in the 1920s and 1930s (after the Second World War their reputations and influence generally declined). Their most famous protégé was the composer William Walton, who collaborated with Edith on *Façade* (1922), a suite of 'abstract poems' or 'patterns in sound'; it was greeted with abuse when first performed in public in 1923 but subsequently became popular in the concert hall and recordings. The Sitwells also helped to promote *Diaghilev's Ballets Russes and in 1919 they sponsored an exhibition of 'French Art 1914–17' at the Mansard Gallery, London, which included work by *Derain, *Dufy, *Matisse, and *Modigliani. They patronized numerous artists, including several who made illustrations for their books. Osbert, who inherited Renishaw Hall when his father died, commissioned John *Piper to make a series of paintings of the house and estate, many of which were reproduced in his autobiography (5 vols., 1944–50, with a 6th volume appearing in 1962).

There are many portraits of the Sitwells, particularly Edith, whose extremely flamboyant appearance made her an inviting subject. Among the painters who depicted her were Roger *Fry (City Art Gallery, Sheffield, 1918), the Chilean-born Alvaro Guevara (1894–1951) (Tate Gallery, London, c. 1919), Wyndham *Lewis (Tate Gallery, c.1923–35), and Pavel *Tchelitchew (several pictures—she had an unrequited passion for him). The photographer and stage designer Sir Cecil Beaton (1904–80) took many pictures of her, and she also appears in Boris *Anrep's mosaic floor in the National Gallery, London (as 'Sixth Sense' in *The Modern Virtues*). Osbert Sitwell, too, appears in Anrep's floor (as 'Apollo' in *The Awakening of the Muses*), but the best-known portrait of him is the brass head by Frank *Dobson (Tate Gallery, 1923).

Sjoo, Monica. See FEMINIST ART.

Skeaping, John (1901–80). British sculptor and draughtsman, born at South Woodford, Essex, the son of a painter. At the age of 13 he went to Blackheath School of Art, London, and subsequently studied at Goldsmiths' College, the Central School of Art and Design, and in 1919–20 the *Royal Academy Schools. He won several awards and scholarships, including the Prix de Rome in 1924; Barbara *Hepworth was runner-up. The couple married in Rome in 1925 and were divorced in 1933, by which time Hepworth was living with Ben *Nicholson. During their marriage Skeaping was influenced by Hepworth's advocacy of *direct carving, making works in which he tried to exploit the natural qualities of stone and wood: 'Perhaps I was jealous of her admiration for *Moore and felt that she didn't really think much of my work.' In the 1930s, however, he reverted to a more traditional style and worked mainly as an animal (particularly horse) sculptor in bronze. He made numerous figures of famous racehorses, including several for Paul Mellon, well-known as an art collector as well as a horse breeder. In the Second World War Skeaping was an *Official War Artist and also served in the SAS. In 1948 he began teaching at the *Royal College of Art and was professor of sculpture there, 1953–9. He published several books, including *Animal Drawing* (1936), *How to Draw Horses* (1941), *How to Draw Dogs* (1961), and *Drawn From Life: An Autobiography* (1977).

Skira, Albert (1904–73). Swiss publisher, born in Geneva. After working in a bank and as an entertainments organizer in luxury hotels, he set up business as a bookseller and in 1931 began his publishing career with Ovid's *Les Métamorphoses*, illustrated by *Picasso. This was quickly followed by more luxury editions of poetry illustrated by *Dalí, *Matisse, and other distinguished artists. He also began

publishing art books with high-quality colour illustrations. From 1933 to 1941 he lived in Paris, where he published the avant-garde periodical *Minotaure* (1933–9; 13 numbers appearing irregularly); it covered contemporary artistic and literary trends, particularly *Surrealism, as well as primitive art and anthropology. The journal was beautifully produced, the illustrations including original prints. In 1941 Skira returned to Geneva, where he published *Labyrinthe* (1944–6; 23 issues); it covered the same type of subjects as *Minotaure*, but was much less lavish in presentation—in fact it was printed as a newspaper. It showed Skira's desire to reach a wide readership, but he also continued with his luxury products, in which he demonstrated an almost fanatical devotion to achieving the highest possible standards. In this he was matched by Matisse, and they spent seven years on *Florilège des Amours de Ronsard* (Anthology of the *Amours* of Ronsard), from the initial agreement in 1941 to publication in 1948, overcoming what Alfred H. *Barr describes as a series of 'extraordinary trials and misadventures' to achieve the exact results they wanted in design and typography. The book features 126 lithographs in brown crayon on grey-tinted paper, illustrating the love poems of Ronsard. By this time Skira was publishing books on a wide range of artistic subjects, and from the 1950s he produced various series of beautifully illustrated books on the history of art in which he brought his high standards to a mass audience; they include 'The Great Centuries of Painting' and 'The Taste of our Time'. See also LIVRE D'ARTISTE.

Sköld, Otte. See MODERNA MUSEET.

Sky art. A term coined in 1969 by the German artist Otto *Piene to describe works, generally large in scale, that are viewed in or from the sky. It has been used to embrace traditional activities such as kite-flying and firework displays and also works using highly advanced technology. Examples by Piene include *Olympic Rainbow* (1972), consisting of five helium-filled polythene tubes each 600 metres long, produced for the Munich Olympic Games, and *Sky Kiss* (1981–6), in which Charlotte Moorman (see VIDEO ART) played her cello whilst suspended from helium-filled tubes. Among the artists who uses high technology is Tom Van Sant

(1926–), whose work includes *Desert Sun* (1986), in which a series of mirrors reflected sunlight to the sensors of a satellite orbiting the earth. See also AIR ART.

Slade School of Fine Art, London. A training school for artists founded in 1871 as part of University College London. It is named after the art collector Felix Slade (1790–1868), who in his will endowed chairs of fine art at the universities of London, Oxford, and Cambridge. At Oxford and Cambridge the Slade professorships involve only the giving of lectures for a general audience (many distinguished art historians have held the posts), but in London (where Slade also endowed six scholarships) the college authorities added to his gift by voting money to fund a teaching institution giving practical instruction in painting and graphic art (and from 1893 sculpture). The first Slade professor was Sir Edward *Poynter, 1871–5. His successors have been: Alphonse *Legros, 1876–92; Frederick *Brown, 1892–1917; Henry *Tonks, 1918–30; Randolph *Schwabe, 1930–48; Sir William *Coldstream, 1949–75; Sir Lawrence *Gowing, 1975–85; Patrick *George, 1985–7; and Bernard *Cohen, 1988– .

In his inaugural address at the opening of the Slade on 2 October 1871, Poynter praised the French system of training in which from an early stage in their career students drew and painted from the living model (rather than casts of antique sculpture) and gained practical experience by working in the studio of an established artist. He introduced this system and founded the tradition of outstanding draughtsmanship from the nude model that came to characterize the Slade. It rapidly took over from the *Royal Academy (where the teaching was considered arid and academic) as the country's leading art school and had its finest period during the long professorship of Brown, the heyday lasting from about 1895 until the outbreak of the First World War. The students during these two decades included some of the most illustrious names in 20th-century British art—among them David *Bomberg, Mark *Gertler, Spencer *Gore, Duncan *Grant, Augustus and Gwen *John, Wyndham *Lewis, Matthew *Smith, Paul *Nash, Ben *Nicholson, William *Orpen, Stanley *Spencer, and Edward *Wadsworth. After the war the *Royal College of Art began to rival the Slade in importance and it went through a fairly quiet period in

the 1930s and 1940s under Schwabe, followed by a resurgence under Coldstream. Apart from the professors themselves, many other distinguished artists have taught at the Slade, including Philip Wilson *Steer, who was on the staff from 1893 to 1930, and Reg *Butler, who taught sculpture from 1951 to 1980. Lectures in art history were first given in 1890, and Roger *Fry is among the leading critics and scholars who have delivered them. In 1960 a course in the study of film was introduced and a professorship in the subject was established in 1967. A centre for electronic media was established in 1994. The school is still in its original location, part of the main building of the college, built in 1827–9, but an extension was completed in 1995. By this time the Slade had an average of about 250 students, equally balanced between undergraduates and postgraduates. According to a 1997/98 prospectus, there were 18 full-time and 25 part-time members of staff.

Sleigh, Sylvia. See ALLOWAY.

Slevogt, Max (1868–1932). German painter, printmaker, and illustrator, with *Corinth and *Liebermann one of his country's leading exponents of *Impressionism. He was born at Landshut, Bavaria, into a well-connected family (his father, who died when Slevogt was 2, was a friend of Prince Luitpold, the future regent of Bavaria). From 1885 to 1889 he studied at the Munich Academy, and then spent a few months at the *Académie Julian, Paris, 1889–90. In 1901 he moved from Munich to Berlin, where he taught at the Academy from 1917. Slevogt's early work was sombre, but from about 1900 his style became lighter, looser, and more colourful. His subjects included landscapes, portraits, and scenes from contemporary life; he loved the theatre and his best-known works include a number of portrayals of the Portuguese baritone Francesco d'Andrade in his most celebrated role as Mozart's Don Giovanni (an example, 1902, is in the Staatsgalerie, Stuttgart). Slevogt's vigorous brushwork, bold effects of light, and energetic sense of movement give his work great dash, but he never adopted the fragmentation of colours typical of the Impressionists and always retained something of the Bavarian Baroque tradition. He also differed from the Impressionists in that he devoted a good deal of his time to large decorative schemes; these included a fresco of

Golgotha in the Friedenskirche at Ludwigshafen (1932; destroyed in the Second World War) that was often considered his masterpiece. He was a prolific illustrator, both for journals such as *Jugend* and *Simplicissimus* and for books, and also made many independent prints (etchings and lithographs).

Sloan, John (1871–1951). American painter and graphic artist. He was born in Lock Haven, Pennsylvania, and grew up in Philadelphia, where from 1891 he worked as an illustrator on various newspapers and periodicals, particularly the *Philadelphia Press*. In the early 1890s he also attended classes at the Pennsylvania Academy of the Fine Arts, and in 1896 he began to paint seriously, influenced by Robert *Henri. In 1904 he settled permanently in New York, where he and Henri were among the members of The *Eight. Sloan was the most political member of the group and as well as taking his most characteristic subjects from everyday lower-class New York life, he did illustrations for socialist periodicals, including *The Masses*, of which he was art editor from 1912 to 1916. However, he was not interested in using his art for what he called 'socialist propaganda', and he resigned from the magazine after a dispute over policy. Sloan's paintings of the pre-First World War period are generally solid, broadly brushed, and low-keyed in colour, typically featuring street scenes or domestic interiors; however, he could also be sharply satirical and occasionally he expressed himself in a totally different vein, as in *Wake of the Ferry* (Phillips Collection, Washington, 1907), a hauntingly melancholic marine picture. After the *Armory Show (1913) he broadened the scope of his work beyond urban subjects to include landscapes and nudes and his style became harder and brighter. He also made etchings throughout his career, and *Bellows called him 'the greatest living etcher'.

Sloan's 'impact on the art scene came not only through his art but also through his quick tongue, dedication to causes, leadership of organizations, and popularity as a teacher' (David W. Scott in *Britannica Encyclopedia of American Art*, 1973). For most of the period from 1914 to 1937 he taught at the *Art Students League, his students including Alexander *Calder, Barnett *Newman, and David *Smith. He was director in 1931–2 but resigned because of the organization's

unwillingness to hire foreign teachers. Sloan also taught at the art schools run by *Archipenko and *Luks, and from 1918 until his death he was president of the *Society of Independent Artists. In 1939 he published an autobiographical-critical book, *The Gist of Art*. The best collection of his work is in the John Sloan Trust, Wilmington, Delaware.

Sluyters, Jan (1881–1957). Dutch painter, born in 's Hertogenbosch and active mainly in Amsterdam, where he trained at the Academy. He was one of the best-known artists in the Netherlands in the inter-war period and the one in whom French modernism is most variously reflected. His early works show the influence of his countrymen van Gogh and George Hendrik Breitner (1857–1923), the leading Dutch *Impressionist, and also of *Fauvism. He also experimented with *Cubism before finally developing a lively personal style of colourful *Expressionism that is best seen in his nudes—he had a predilection for painting nude children. His other work included portraits (*Self-Portrait*, Stedelijk Museum, Amsterdam, 1924) and still-lifes. Many Dutch museums have examples of his work.

Smart, Borlase. See ST IVES SCHOOL.

Smet, Gustave de (1877–1943). One of the leading Belgian *Expressionist painters. He was born in Ghent, where he studied at the Academy, 1888–95. In the first decade of the 20th century he spent much of his time at the artists' colony of *Laetham-Saint-Martin. His early work was *Impressionist in style, but he was influenced towards Expressionism by Jan *Sluyters and Henri *Le Fauconnier, whom he met in Holland when he took refuge there during the First World War. He returned to Belgium in 1922 and lived successively in Kalmthout, Ostend, Bachte-Maria-Leerne, Afsnee, and Deurle, where he died. Typically de Smet painted scenes of rural and village life in which forms are treated in a schematic way owing something to *Cubism, and there is often an air of unreality reminiscent of that in *Chagall's work (*Village Fair*, Musée des Beaux-Arts, Ghent, c. 1930). In the catalogue of the exhibition 'Nine Flemish Painters 1880–1950' (Royal Academy, London, 1971) he is described as 'the most classical of the Flemish expressionists, and the most humane'. With Frits van den *Berghe and Constant *Per-mecke he had great influence on Belgian painting in the inter-war period. His brother **Léon de Smet** (1881–1966) was also a painter.

Smith, Bernard. See ANTIPODEANS.

Smith, David (1906–65). American sculptor, painter, and draughtsman. He was one of the most original and influential American artists of his generation and is widely considered the outstanding American sculptor of the 20th century. Born in Decatur, Indiana, he began studying art at Ohio University in 1924 but soon dropped out of the course, and in the summer of 1925 worked at the Studebaker motor plant at South Bend, Indiana, where he acquired the skills in metalwork that stood him in good stead later in his career. From 1926 to 1931 he studied painting intermittently at the *Art Students League, New York, while supporting himself by a variety of jobs. His main teacher was the Czech-born abstract painter Jan Matulka (1890–1972), whom he described as 'a guy I'd rather give more credit than anyone else'. Among his friends at this time were Arshile *Gorky and Willem *de Kooning. In the early 1930s he began to attach objects to his paintings, and from this he moved on to sculpture, making his first welded iron pieces (probably the first by any American artist) in 1933. These were inspired by the work of Julio *González, which first made him realize the potential of iron as an artistic material (John *Graham showed Smith illustrations of González's work in *Cahiers d'art*). From 1935 Smith concentrated on three-dimensional work, but he always maintained that there was no essential difference between painting and sculpture and that although he owed his 'technical liberation' to González, his aesthetic outlook was more influenced by *Kandinsky, *Mondrian, and *Cubism. He continued to paint throughout his life and was a prolific draughtsman.

In 1935–6 Smith made an extensive tour of Europe. On his return to the USA he worked for the *Federal Art Project and also began making a series of relief plaques called *Medals for Dishonor*, which stigmatized violence and greed. In 1938 he had his first one-man exhibition, at the East River Gallery, New York. By this time he was producing sculpture of considerable originality, constructing compositions from steel and 'found' scrap, parts of agricultural machinery, etc. He had a love of technology and wrote: 'The equipment I use,

my supply of material, comes from factory study, and duplicates as nearly as possible the production equipment used in making a locomotive . . . What associations the metal possesses are those of this century: power, structure, movement, progress, suspension, destruction, brutality.' In 1940 he settled at Bolton Landing in upstate New York, where he built a studio he called 'Terminal Iron Works'. This was his home for the rest of his life, and he alternated sustained periods of lonely creativity with brief binges in New York City.

Smith was employed as a welder on defence work, 1942–4, then returned to sculpture. From this time he began to build up an international reputation, his work being shown in numerous one-man and group exhibitions (including a retrospective at the Museum of Modern Art, New York, in 1957 and a representation at the Venice *Biennale in 1958). However, he also found time to teach at various colleges. During the 1940s and 1950s his sculpture was predominantly open and linear, like three-dimensional metal calligraphy. Perhaps the best-known work in this style is *Hudson River Landscape* (Whitney Museum, New York, 1951). From the end of the 1950s, however, his style became more monumental and geometrical, with boxes and cylinders of polished metal joined at odd angles. Although the forms are often massive, the effect they create is not one of heaviness, but of unstable dynamism, the exhilarating sense of freedom being enhanced by the reflection of sunlight from the bright surfaces (they are generally intended for outdoor settings). Smith often created these works in series, such as *Agricola*, *Cubi*, *Tank Totem*, *Voltri*, *Zig*. They initiated a new era in American sculpture, ushering in the sort of objectivity that characterized *Post-Painterly Abstraction, and gave Smith a place as the peer of the great *Abstract Expressionist painters who were his contemporaries. Like the most famous of the Abstract Expressionists, Jackson *Pollock, Smith died in an automobile accident: 'During the preceding thirty-odd years he had absorbed the inventions of Cubist and *Constructivist sculpture, tinctured by *Surrealism, and literally forged directly in metal a style that was wholly original, wholly American and still unfolding at his death' (Whitney Museum of American Art, *200 Years of American Sculpture*, 1976).

Smith, Edwin. See NEO-ROMANTICISM.

Smith, Eric. See DIRECTION 1.

Smith, Grace Cossington (1892–1984). Australian painter, born in Sydney. In 1910 she began taking lessons at Dattilo *Rubbo's art school, and in 1912–14 she visited England (where she briefly attended the Winchester Art School) and Germany. After her return to Sydney in 1914 she became one of students interested in *Post-Impressionism enrolled in Rubbo's painting classes at the Royal Art Society of New South Wales School. Her painting *The Sock Knitter* (Art Gallery of New South Wales, Sydney, 1915), exhibited at the Royal Art Society show in 1915, is—in its flattened space and *Fauve-like colours—arguably the first 'modern' picture painted and exhibited in Australia. In the early 1920s Smith was briefly influenced by Max *Meldrum's all-pervasive tonal theory of painting, but she reverted to richer colour and to the application of paint in crisp, juxtaposed strokes. In the 1930s she turned increasingly to light-filled interiors of her own home. Although her work was influenced by artists such as *Matisse and later *Cézanne, Smith never regarded herself as a particularly radical or innovatory artist. Her interest in modernism was inspired not by its intellectual prescriptions, but because for her it constituted a more lively approach to painting.

Smith, Jack (1928–). British painter (and occasional sculptor), born in Sheffield. He studied at Sheffield College of Art, 1944–6, and then (after doing National Service) in London at *St Martin's School of Art, 1948–50, and the *Royal College of Art, 1950–3. In the mid-1950s he was a leading figure of the *Kitchen Sink School. A typical work of this period is *Mother Bathing Child* (Tate Gallery, London, 1953), which does in fact prominently feature a kitchen sink. It is set in a crowded house that Smith and his family at this time shared with another Kitchen Sink painter, Derrick *Greaves, and the sculptor George Fullard (1923–73). Apart from interiors with figures such as this, he also painted still-lifes and seascapes. Even at this time he attached as much importance to formal qualities as to the nature of the subject-matter and in the 1960s his work became completely abstract. 'The closer the painting is to a diagram or graph, the nearer it is to my intentions. I like every work to establish a fact in the most precise, economical way', he wrote

in 1963. Typically his abstracts feature sharply-defined shapes arranged against a plain ground in a way that suggests musical analogies—he writes of 'The sound of the subject, its noise or its silence, its intervals and its activities'. Smith won first prize at the first *John Moores Liverpool Exhibition in 1957 and his work has been widely exhibited in Britain and abroad.

Smith, John Guthrie Spence. See EDINBURGH GROUP.

Smith, Joshua. See DOBELL.

Smith, Kiki. See SMITH, TONY.

Smith, Sir Matthew (1879–1959). British painter, born in Halifax, Yorkshire, the son of Frederick Smith, a successful wire manufacturer. Frederick was a cultivated man who wrote poetry and collected violins, but he was apprehensive about Matthew's passion for art, especially because he showed only very modest talent in his early years. He worked for four years in his father's factory before studying design at Manchester School of Art, 1900–4, and painting at the *Slade School, 1905–7. From 1908 to 1914 he spent much of time in France, studying briefly (1911) under *Matisse, and he came to identify strongly with French art. In 1912 he married the painter Gwen Salmond (see CHELSEA ART SCHOOL). During the First World War he served in the army (despite being initially rejected as unfit) and was wounded, but he was still able to paint. Indeed it was during the war that he first began to show maturity and confidence in his work (*Fitzroy Street Nude, No. 1*, Tate Gallery, London, 1916), and it was at this time that he met *Sickert, who encouraged him and whom Smith considered 'full of uncommon sense'. After the war Smith lived intermittently in France until 1940, mainly in Paris and Aix-en-Provence. He was delicate in health and of a nervous disposition, but this is hardly apparent from his work, which uses colour in a bold, unnaturalistic manner echoing the *Fauves. His lush brushwork, too, has great vigour, and he was one of the few English artists to excel in painting the nude, his dark saturated colours and opulent fluency of line creating images of great sensuousness; his favourite model for his nudes was the painter Vera Cuningham (1897–1955), with whom he had an affair. He also painted landscapes (most notably a series done in Cornwall in 1920) and still-lifes.

Smith had his first one-man exhibition in 1926, at the Mayor Gallery, London, and after this his reputation steadily grew; in 1928 Augustus *John described him as 'one of the most brilliant and individual figures in modern English painting'. Frank *Auerbach and Francis *Bacon are among the many other artists who have admired Smith's painterliness; Bacon said he was 'one of the very few English painters since Constable and Turner to be concerned with painting—that is, with attempting to make idea and technique inseparable'. His work is in many public galleries, the best collection being in the Guildhall Art Gallery, London.

Smith, Richard (1931–). British painter, born at Letchworth, Hertfordshire. He studied at the Luton School of Art, 1948–50, and after doing National Service in Hong Kong, at St Alban's School of Art, 1952–4, and at the *Royal College of Art, 1954–7. Since 1957 he has spent a good deal of his time in the USA and his early work was influenced by both the vigorous handling of *Abstract Expressionism and the brash imagery of American advertising. It was essentially abstract but contained allusions to packaging, creating an individual type of *Pop art (he was a member of the *Independant Group, the cradle of British Pop). His work was often very large in scale and 'in the early Sixties he formed a link between the new figuration of Pop and the pure abstraction of the *Situation painters' (Simon Wilson, *British Art from Holbein to the Present Day*, 1979). From about 1963 he experimented with *shaped canvases, which he sometimes made project from the wall, turning the picture into a three-dimensional object. This led to further experimentation with the support, and some of his most characteristic paintings use a kite-like format in which the canvas is stretched on rods that are part of the visual structure of the work (*Mandarino*, Tate Gallery, London, 1973). In these the colouring is usually much more subdued and soft than in his Pop phase, sometimes with a watercolour-like thinness of texture and vague allusions to nature. Smith has probably taken the concept of the shaped, projecting, and suspended canvas further than anyone else. In the catalogue to an exhibition of his work at the Tate Gallery, London, in 1975 he is described as 'one of the most

important and widely exhibited British painters of the generation which came to prominence at the end of the fifties' and as 'one of the most verbally fluent and intellectually capable artists of his generation'.

Smith, Tony (1912–80). American sculptor, painter, and architect, born at South Orange, New Jersey. After studying at the *Art Students League, New York, 1933–6, and the New Bauhaus, Chicago, 1937–8, he served an apprenticeship in architecture as clerk of works to Frank Lloyd Wright and practised as an architect from 1940 to 1960, during which time he also painted. He began to take an interest in sculpture around 1940, but although he taught at various colleges in the 1940s and 1950s (in addition to his architectural career) and was closely associated with leading avant-garde figures such as Barnett *Newman, Jackson *Pollock, Mark *Rothko, and Clyfford *Still, he did not exhibit sculpture publicly until 1964. From that time he quickly emerged as one of the leading exponents of *Minimal art. His work was sometimes very large in scale, composed of bold geometrical shapes (often repeated modular units) that he had industrially manufactured in steel. Many of his works were placed outdoors, helping to bring to American sculpture a new interest in the environment. A well-known example is *Gracehoper* (Detroit Institute of Arts, 1972), which one can walk through.

His daughter **Kiki Smith** (1954–) is a sculptor and *Body artist.

Smithson, Robert (1938–73). American sculptor and experimental artist. He was born at Passaic, New Jersey, and studied at the *Art Students League, New York, 1955–6, and then briefly at the Brooklyn Museum School. In the 1960s his work belonged mainly to the category of *Minimal art; he was interested in mathematical impersonality and as well as making block-like steel sculptures he experimented with reflections and mirror-images. From the late 1960s he turned to *Conceptual art; he expressed his ideas mainly through *Land art and became the best-known artist working in this field. In 1968 he began a series of 'Sites' and 'Non-Sites'. The latter consisted of photographs and plans of locations he had visited (particularly derelict urban or industrial sites) displayed with specimens of rock or geological refuse he had gathered there,

arranged into random heaps or in metal or wood bins: 'Instead of putting a work of art on some land, some land is put into the work of art.' Smithson then moved on to large-scale earthworks, the best-known of which is the enormous *Spiral Jetty* (1970), a spiral road running out into Great Salt Lake, Utah (it has periodically become submerged and then reappeared with changing water levels). He was killed in a plane crash when he was surveying a work in progress, *Amarillo Ramp* in Texas. It was completed according to his plans by his wife Nancy Holt (1938–), also a sculptor and Land artist, and his friends Richard *Serra and Tony Shafrazi. Smithson wrote many articles expounding his views on art: *The Writings of Robert Smithson*, edited by Nancy Holt, was published in 1979.

Smyth, Ned. See PATTERN AND DECORATION MOVEMENT.

snare picture. See TRAP PICTURE.

Snow, Michael (1929–). Canadian filmmaker, painter, sculptor, and musician, born in Toronto. He studied design at the Ontario College of Art, Toronto, then in 1953 travelled in Europe, working as a jazz musician. Back in Toronto he had his first one-man exhibition as a painter at the Isaacs Gallery in 1957, but he earned his living as an animator with a small film company, Graphic Associates. Here he met his future wife Joyce Wieland (1931–), a painter, film-maker, experimental artist, and maker of stuffed wall-hangings and quilts. They married in Paris in 1960 and spent most of the following decade in New York. Each began making films in 1963 and Snow became regarded as a leading figure in the American Underground. At the same time he continued to exhibit as a painter and sculptor in Toronto and became well known for his 'Walking Wonan' series (1962–7), executed in various media, featuring a generalized silhouette of a young woman caught in mid-stride (shiny life-size metal versions were shown at Expo 67 in Montreal). Dennis Reid (*A Concise History of Canadian Painting*, 1973) accords Snow an extraordinarily high status; he describes him as 'the giant figure of painting in Toronto' and writes that 'a number of informed observers look upon Snow as one of the greatest innovative geniuses film has ever attracted'. He has continued to be a leading figure in Canadian art, and in 1994 his work

was conspicuously displayed in various parts of Toronto as 'The Michael Snow Project'; this included, for example, enormous sculptures on the exterior of the Skydome sports stadium.

Snowdon, Lord (Antony Armstrong-Jones). See MESSEL.

Soby, James Thrall (1906–79). American art historian, administrator, and collector, born in Hartford, Connecticut. In 1926, having abandoned his studies at Williams College, Williamstown, he visited Paris, where he made his first purchases of contemporary art. From 1928 to 1938 he worked at the Wadsworth Atheneum in Hartford, and during this period built up a collection that included works by such illustrious figures as *Ernst, *Matisse, *Miró, and *Picasso. In 1943 he began a long association with the *Museum of Modern Art, New York. He was briefly director of painting and sculpture, 1943–4, and was a Trustee until his death, organizing a number of exhibitions on major artists (including *Rouault in 1947, *Modigliani in 1951, *Balthus in 1956) as well as group shows (notably 'Twentieth-Century Italian Art', 1949, on which he collaborated with Alfred H. *Barr). He also wrote a number of monographs unconnected with exhibitions, including two on Ben *Shahn (1957 and 1963), and contributed a monthly column on art to the *Saturday Review of Literature* in the 1940s and 1950s. His art collection, together with most of his archive material, was bequeathed to the Museum of Modern Art.

Socialist Realism. The name of the officially approved type of art in Soviet Russia and other Communist countries, involving in theory a faithful and objective reflection of real life to educate and inspire the masses, and in practice the compulsory and uncritical glorification of the State. Socialist Realism was an aspect of the dictatorship of Stalin, who was leader of the Soviet Union from the death of Lenin in 1924 until his own death in 1953. Alan Bird (*A History of Russian Painting*, 1987) writes that 'He saw all aspects of avant-garde culture, including painting, as subversive infiltrations of the purity of Soviet life' and that his minister Andrey Zhdanov (1896–1948) 'made himself responsible for imposing an iron control on artistic expression'. The principles of Socialist Realism

began to take shape in the late 1920s and were proclaimed in the 1932 decree 'On the Reconstruction of Literary and Art Organizations' (before this, the term 'Heroic Realism' had often been used, but 'Socialist Realism' now became the official label). Socialist Realism was never defined specifically in terms of style, but increasingly it became associated with stereotyped images painted in a conventional academic manner.

In the 1930s there were four main types of Socialist Realist paintings: domestic scenes, portraits (see GERASIMOV), industrial and urban landscapes, and scenes on collective farms (see PLASTOV). During the Second World War, patriotic scenes from Russian history were added to the list, following the success of Sergei Eisenstein's famous film *Alexander Nevsky* (released 1938, withdrawn at the time of the German-Soviet pact in 1939, and shown again after the German invasion of Russia in 1941). In sculpture, the most typical products of Socialist Realism were heroic statues, the leading artists in this field including Sergei *Merkurov and Vera *Mukhina. After the death of Stalin there was some relaxation of strictures, but the system still remained stifling to creativity, and any form of experiment remained extremely difficult (see UNOFFICIAL ART). In the West, Socialist Realism remained synonymous with repression, and its products were generally regarded as morally tragic and aesthetically comic (although the merits of many of the artists are now being recognized). The titles alone of some pictures are crushingly dispiriting, for example *Comrade Stalin together with the Leading Workers of the Party and Government Inspect the Work of a Soviet Tractor of the New Type*.

Socialist Realism spread to the remotest parts of the Soviet Union, one of the most praised painters of the Stalin era being Semyon Chuikov (1902–80), who worked in Kirgizia in the extreme south of the country, near the Chinese border. His most famous work is *A Daughter of Soviet Kirgizia* (Tretyakov Gallery, Moscow, 1948, and other versions), showing a schoolgirl, book in hand, walking proudly through a vast landscape: 'She embodies in her resolute progress across the expanse of her native land, the future hopes of a small, once backward nation, now offered—under Soviet power—the benefits of a modern educational programme' (Mathew Cullerne Bown, *Art Under Stalin*, 1991).

Socialist Realism had an equally powerful

grip on Russian literature and even music. In 1934 the constitution of the Union of Writers stated that Socialist Realism 'demands from the artist a true and historically concrete depiction of reality in its revolutionary development . . . combined with the task of educating workers in the spirit of Communism', and in 1948 several leading Soviet composers (including the two greatest, Prokoviev and Shostakovich) were censured for *formalism and had to make a grovelling public apology. They wrote a joint letter to 'Dear Comrade Stalin' in which they said: 'We are tremendously grateful . . . for the severe but profoundly just criticism of the present state of Soviet music . . . We shall bend every effort to apply our knowledge and our artistic mastery to produce vivid realistic music reflecting the life and struggles of the Soviet people.' See also TOTALITARIAN ART.

Social Realism. A very broad term for painting (or literature or other art) that comments on contemporary social, political, or economic conditions, usually from a left-wing viewpoint, in a realistic manner. Often the term carries with it the suggestion of protest or propaganda in the interest of social reform. However, it does not imply any particular style; Ben *Shahn's caricature-like scenes on social hypocrisy and injustice in the USA, the dour working-class interiors of the *Kitchen Sink School in Britain, and the declamatory political statements of *Guttuso in Italy are all embraced by the term. See also REALISM.

Société Anonyme, Inc. (or a Museum of Modern Art). An association founded in 1920 by Katherine *Dreier together with Marcel *Duchamp and *Man Ray for the promotion of contemporary art in America by lectures, publications, travelling exhibitions, and the formation of a permanent collection. In French the term 'société anonyme' means 'limited company', so the name—suggested by Man Ray—was intended as a tautological *Dada jest; as Miss Dreier loved to explain, it meant 'incorporated corporation'. However, the work of the society was serious and trailblazing. Its museum, which opened at 19 East 47th Street, New York, on 30 April 1920, was the first in the USA, and one of the earliest anywhere, to be devoted entirely to modern art (although as it existed mainly for temporary exhibitions, the Phillips Collection (see PHILLIPS, DUNCAN) has the distinction of

being the first *permanent* museum of modern art in the USA). Between 1920 and 1940 the Société organized 84 exhibitions, the largest—at the Brooklyn Museum in 1926—being the most important in the field since the *Armory Show in 1913. The emphasis of the exhibitions was on avant-garde and abstract art and it was through them that such artists as *Klee, *Malevich, *Miró, and *Schwitters were first exhibited in America. To some extent, therefore, the Société carried on the tradition that had been started by the 291 Gallery of *Stieglitz in the years before the Armory Show, and to some extent also it prepared the way for the *Museum of Modern Art, which was founded in 1929. The Museum of Modern art soon eclipsed the Société Anonyme and Miss Dreier's finances were in any case badly hit by the Depression, but she continued officially as President (as Duchamp did as secretary) until the Société officially closed in 1950. Nine years earlier, in 1941, they had presented the superb permanent collection that the Société had built up (over 600 works) to Yale University art Gallery.

Society of Independent Artists. As association formed in New York in December 1916 as a successor to the Association of American Painters and Sculptors, which had been dissolved—its task accomplished—after mounting the *Armory Show in 1913. The aim of the Society of Independent Artists was to give progressive artists an opportunity to show their work by holding annual exhibitions in rivalry with the National Academy of Design, which was regarded as a bastion of conservatism. These exhibitions were organized on the model of the French *Salon des Indépendants, without jury or prizes, giving anyone the right to show their work on payment of a modest fee. The first exhibition, held at the Grand Central Palace in New York in April 1917, was the largest, featuring about 2,500 works by about 1,200 artists (mainly Americans, but including leading Europeans such as *Brancusi and *Picasso). It was known as 'The Big Show' and was probably the largest art exhibition held in the USA up to that time. The exhibits were arranged alphabetically to preclude the kind of judgements associated with a hanging committee. However, the exhibition is remembered mainly because of a work that was not shown, for Marcel *Duchamp (one of the Society's officials) resigned after his *ready-made in the form of

a urinal was rejected. Although much recondite aesthetic theory has been read into this gesture, it is likely that the main purpose was to demonstrate the incongruity of a society with the professed purpose of allowing anyone to exhibit anything. The first President of the Society was William *Glackens; he was followed by John *Sloan, who held the post from 1918 until his death in 1951. Annual exhibitions continued to be held until 1944, but they soon declined in terms of quantity and quality; the 1919 exhibition had only about a third of the number of works of the inaugural show.

Society of Sculptors and Associates. An association formed in Sydney in 1950 for the furtherance of innovative trends in Australian sculpture. Lyndon Dadswell (1908–86) was the first president. He taught at the National Art School, Sydney from 1937 to 1967 (interrupted by service in the Second World War), and was noted for his broadmindedness, trying to show his students that there are many valid approaches to creating sculpture.

Soffici, Ardengo (1879–1964). Italian critic and painter, born at Rignano in Tuscany. He studied at the Academy in Florence, then from 1900 to 1907 spent his formative years in Paris, where he wrote for avant-garde periodicals and knew such figures as *Apollinaire, *Braque, *Modigliani, and *Picasso. In 1907 he settled in Florence and in the period before the First World War he was prominent in introducing the discussion of modern art— particularly *Cubism—to Italy; in 1913 he published three of his articles in book form as *Cubismo e oltre*. He championed the work of *Rosso, but initially he was hostile to *Futurism; however, under the influence of *Boccioni and *Carrà, he became converted to the movement in 1913. After the war his views became increasingly conservative and he joined Carrà and de *Chirico in the attacks they made on Cubism and Futurism in their journal *Valori plastici*. Soffici's own work as a painter reflects his changing critical outlook, but it is not considered to have much independent merit.

Soft art. Term applied to sculpture using non-rigid materials, a vogue of the 1960s and 1970s. The materials employed have been very varied: rope, cloth, rubber, leather, paper, canvas, vinyl—anything in fact that offers a certain persistence of form but lacks permanent shape or rigidity. The earliest example of Soft art was perhaps the typewriter cover that Marcel *Duchamp mounted on a stand and exhibited in 1916. However, this belongs rather to the category of *ready-mades, and Soft art as a movement is generally traced to Claes *Oldenburg's giant replicas of foodstuffs (ice-cream sundaes, hamburgers, slices of cake, etc.) made from stuffed vinyl and canvas. Other artists who have experimented with soft materials have been many and diverse, representing a variety of movements including *Pop art and *Arte Povera. An exhibition on the theme, in which some sixty artists were represented, was staged in Munich and Zurich in 1979–80. The movement—if such it can be called—has certain affinities with *New Realism, since in general, although the work may be representative of something else, the materials are not concealed and make no pretence to be other than what they are.

Sokolov, Nikolai. See KUKRYNIKSY.

Solomon, Holly. See PATTERN AND DECORATION MOVEMENT.

Somerville, J. W. See EDINBURGH GROUP.

Sonderbund. An organization founded in Düsseldorf in 1909 to mount exhibitions of contemporary art; the full name was Sonderbund Westdeutscher Kunstfreunder und Künstler (Special League—or Federation—of Art-lovers and Artists in Western Germany). The 'art-lovers' included collectors, dealers, museum officials, and writers, the first president of the Sonderbund being Karl Ernst Osthaus (1874–1921), a banker, collector, and critic. He was one of the first Germans to support the *Post-Impressionists (he had personally travelled to Aix-en-Provence to buy directly from *Cézanne) and he founded the Folkwang Museum in Hagen (opened 1902 in a building remodelled by Henry van de *Velde), one of the earliest public museums of contemporary art in Germany. (After Osthaus's death, the contents of the museum were transferred to Essen, and the building in Hagen, much altered, is now the Karl Ernst Osthaus Museum.) Four Sonderbund exhibitions were held—the first three in Düsseldorf (1909, 1910, 1911) and the final one in Cologne

(1912). The Cologne exhibition—held at the Kunsthalle from May to December—was by far the most important. Its aim was to provide 'a conspectus of the movement that has been termed *Expressionism'. Van Gogh was the central figure of the exhibition, and Cézanne, *Gauguin, and *Munch were also very well represented. In an anteroom were paintings by El Greco, a great forerunner of Expressionism. German painters (especially those of Der *Blaue Reiter and Die *Brücke) were naturally to the fore, but the exhibition was international in scope, with artists from eight other countries on show. It was influential on the planning of the *Armory Show, which took place the following year. Originally an all-American exhibition had been envisaged, but when Arthur B. *Davies saw the catalogue he wrote to Walt *Kuhn: 'I wish we could have a show like this.' Kuhn immediately set out for Europe, just managed to catch the exhibition as it was being dismantled, and picked up valuable advice from artists and dealers. However, Kuhn was much more interested in French than in German painting, and German art was poorly represented in the Armory Show.

Sørensen, Henrik (1882–1962). Norwegian painter and graphic artist, born at Fryksände in Sweden. His training included a period studying with *Matisse in Paris, 1909–10, and his lively and colourful work combined certain *Expressionist features with traditional Norwegian themes. His subjects included portraits, landscapes, and religious compositions, and he did numerous murals for public buildings. The largest commission was for the new Town Hall in Oslo (1938–50); others were for Linköping Cathedral in Sweden (1934) and the League of Nations in Geneva (1939). Sørensen was also a noted book illustrator. There are museums devoted to him at Holmsbu, near Oslo, where he had his summer house, and at Telemark.

Sorolla y Bastida, Joaquín (1863–1923). Spanish painter and graphic artist, active mainly in his native Valencia and in Madrid. He was a prolific and popular artist, working on a wide range of subjects—genre, portraits, landscapes, historical scenes—and producing many book illustrations. His pleasant and undemanding style was marked by brilliant high-keyed colouring and vigorous brushwork, representing a kind of conservative version of *Impressionism. He was well known outside Spain, and in 1910–20 he painted a series of fourteen large mural panels for the Hispanic Society of America in New York (see HUNTINGDON), representing scenes typical of the various provinces of Spain. The great reputation that he enjoyed in his lifetime faded quickly after his death and his work has only recently come into fashion again. His former home in Madrid is now a delightful museum dedicated to his work.

Sorrell, Alan (1904–74). British painter, illustrator, and designer. He was born in London, the son of a watchmaker, and studied at Southend School of Art and then (after an interval as a commercial designer) at the *Royal College of Art, 1924–7. From 1928 to 1931 he was in Italy as winner of the Rome Scholarship, and from 1931 to 1948 he taught at the Royal College. During the Second World War he served in the RAF and as an *Official War Artist. His work included several murals (for example at Southend Central Library, 1934), but after the war he became best known for his drawings of archaeological and historical subjects, and particularly for his dramatic reconstructions of ancient monuments as he imagined them in their prime, complete with contemporary figures. Some of these were commissioned by the Ministry of Works for use in site displays or in guidebooks. Sorrell's wife **Elizabeth**, née Tanner (1916–91), was also a painter, mainly of landscapes and flowers and chiefly in watercolour. She studied at Eastbourne School of Art, 1934–8, and the Royal College of Art, 1938–42, and married Sorrell in 1947. A joint exhibition of their work was held at Chelmsford Art Gallery in 1975. Both of them are represented in the Tate Gallery, London.

Soto, Jesús Rafael (1923–). Venezuelan *Kinetic artist, active mainly in Paris. He was born in Ciudad Bolivar and in 1942–7 he studied at the School of Fine and Applied Arts in Caracas; his fellow students included *Cruz-Diez and *Otero, who like Soto were among the pioneers of abstract art in Venezuela. In 1947–50 he was director of the School of Fine Arts in Maracaibo, then settled in Paris, where he initially earned his living as a guitarist. His early works included geometrically patterned paintings and in 1952 he began making constructions using perspex sheets marked with lines or designs over a patterned surface; the

movement of the spectator produced apparent movement in the work. He incorporated real movement for the first time in 1958 in his *Vibration Structures*, in which flexible rods or wires (which could be made to vibrate by the spectator) were hung in front of bands of closely-meshed lines (*Horizontal Movement*, Tate Gallery, London, 1963). In the 1960s he gained an international reputation and he has had numerous public commissions, including two murals for the Unesco building in Paris (1970) and several works in Caracas, the capital of Venezuela, notably the ceiling of the Teresa Carreno Theatre (1983). In 1973 he founded a museum of modern art in his home town.

Sots art (or **Sotz art**). A type of *Unofficial art practised in the Soviet Union in the 1970s and 1980s in which the officially sanctioned style of *Socialist Realism was undermined by treating its conventions in an ironic or mocking way (the term derives from the Russian for Socialist Realism—Sotsialisticheskiy Realism). Among the best-known exponents of this kind of work were Erik Bulatov (1933–) and the team of Komar and Melamid: Vitaly Komar (1943–) and Alexander Melamid (1945–). Bulatov often combined conventional, naturalistic images with vivid, poster-like inscriptions, relating his work to both *Pop art and *Conceptual art, while Komar and Melamid have typically used a mock-heroic style in their paintings: 'they combine pity, tenderness and disgust, a complex assortment of attitudes which are then re-addressed to what they identify as a mad, brutal, terrifying but also dear motherland, the Soviet state. They painted Stalin among antique columns and draperies, accompanied by a semi-naked muse . . . they designed an "advertisement" for Coca-Cola quoting (apparently) Vladimir Lenin, in the manner of official Soviet posters' (Aleksandr Yakimovich in Matthew Cullerne Bown and Brandon Taylor, eds., *Art of the Soviets*, 1993). Such works led to Komar and Melamid being expelled from the Moscow Union of Artists for 'distortion of Soviet reality and deviation from the principles of Socialist Realism'. They left the Soviet Union in 1977 and settled in the USA, becoming American citizens in 1988. Edward *Lucie-Smith writes that 'What made Komar and Melamid famous was the skill with which the parodied the Soviet style at its most kitsch . . . In the western world the paintings

appealed because they allowed the audience to have its cake and eat it—to enjoy the traditional skills of the artists while at the same time relishing the ironic comedy of the imagery' (*Art Today*, 1995).

Soulages, Pierre (1919–). French abstract painter, printmaker, sculptor, and designer, born at Rodez. He was mainly self-taught and did not take up painting in earnest until 1946, when he settled in Paris (during the Second World War he had served in the army, then worked as a farmer). His first one-man show was at the Galerie Lydia Conti, Paris, in 1949, and from that time he quickly gained a reputation as one of the leading exponents of *Tachisme. His paintings characteristically feature broad, powerful, sombre strokes; originally he worked entirely in black-and-white, to which he subsequently added subdued blues, browns, and greys. His preference for such a solemn palette exemplifies his view that 'the more limited the means, the stronger the expression'. The primitive force of his work reflects his love of the prehistoric and Romanesque art of the Massif Central region in which he was born, but the forms of his paintings sometimes also resemble blown-up hieroglyphs or Chinese characters (in 1957 he won the grand prize at the Tokyo *Biennial and in 1958 he visited the Far East, where he admired Oriental calligraphy). In the 1980s he began making completely black paintings, sometimes consisting of several panels. Apart from paintings, his work has included bronze sculptures, etchings, lithographs, and designs for the stage. He has won numerous awards and his work is included in many major collections of modern art.

South Bank Exhibition. See FESTIVAL OF BRITAIN.

South Bank Style. See CONTEMPORARY STYLE.

Soutine, Chaïm (1893–1943). Lithuanian-born painter who settled in France in 1913 and became one of the leading *Expressionists of the *École de Paris. He was born in the village of Smilovichi, near Minsk, the son of a poor Jewish clothes-mender, and he had to contend with the Orthodox Jewish prohibition on image-making (the money to go to art school came from damages after he was beaten up by the son of a rabbi). In 1910–13 he studied at the School of Fine Arts in Vilnius,

his fellow students including Michel Kikoïne (1892–1968) and Pinchus Krémègne (1890–1981), with whom he kept up a friendship in Paris. His other friends in the circle of expatriate artists there included *Chagall and also *Modigliani, who painted a memorable portrait of him (NG, Washington, 1917). Soutine suffered from depression and lack of confidence in his own work (he was reluctant to exhibit and sometimes destroyed his own pictures), and he endured years of desperate poverty until the American collector Dr Albert C. *Barnes bought a number of his paintings in 1923. Thereafter he had a prosperous career.

Soutine's work included landscapes, portraits, and figure studies of characters such as choirboys and page-boys. His style is characterized by thick, convulsive brushwork, through which he could express tenderness as well as turbulent psychological states. There is something of an affinity with van Gogh, although Soutine professed to dislike his work and felt more kinship with the Old Masters whose work he studied in the Louvre; his pictures of animal carcasses, for example, are inspired by Rembrandt's *Flayed Ox*. However, the gruesome intensity of works such as *Side of Beef* (Albright-Knox Art Gallery, Buffalo, 1925) was not gained simply through study of similar pictures, for Soutine visited abattoirs and even brought a carcass into the studio. His neighbours complained of the smell of the rotting meat and called the police, whom Soutine harangued on the subject of how much more important art was than sanitation. The filthy state in which he lived was notorious: André *Salmon recalled that Soutine consulted a specialist about earache and that 'In the canal of the painter's ear the doctor discovered, not an abscess, but a nest of bed bugs'. In 1941–3, during the German occupation, Soutine lived at Champigny-sur-Veude in Touraine, but he died in Paris after going there for an emergency operation on a stomach ulcer.

Soutter, Louis. See ART BRUT.

Sovart. See UNOFFICIAL ART.

Soyer, Moses (1899–1974) and **Raphael** (1899–1987). Russian-born painters, twins, who became American citizens in 1925. They were born in Borisoglebsk, emigrated to America with their family in 1913, and stud-

ied at various art schools in New York. They are best known for their *Social Realist subjects, particularly those of the Depression years of the 1930s, in which they depicted the lives of working people with sympathy and at times a touching air of melancholy, as in Raphael's well-known *Office Girls* (Whitney Museum, New York, 1936). From 1936 they were employed by the *Federal Art Project, their work including collaborating on murals for the Post Office at Kingsessing, Pennsylvania (1939). Both brothers also did many self-portraits and wrote on art. In the 1930s Moses wrote articles defending Social Realism and attacking *Regionalism. Raphael published several autobiographical volumes and a book on Thomas *Eakins (1966). He taught at the *Art Students League, 1933–42, and at other schools in New York. Another brother, **Isaac** (1907–81), who came to America in 1914, was also a painter.

S.P.A.C.E. See SEDGLEY.

Spanish Realists. Name given in the 1970s to a group of five Spanish artists, active mainly in Madrid and linked by ties of family or friendship, who worked in a detailed naturalistic style, sometimes akin to *Superrealism: Francisco López (1932–); Antonio López García (1936–); Antonio López Torres (1902–), uncle of López García; Maria Moreno (1933–), wife of López García; and Isabel Quintanilla (1938–), wife of Francisco López. All of them are painters, except for Francisco López, who is a sculptor and draughtsman. Their work has been shown in various group exhibitions in Spain and elsewhere.

Spare, Austin (1886–1956). British painter, printmaker, draughtsman, designer, writer, and editor, born in Smithfield, London, the son of a policeman. He left school at 13 and worked in a stained-glass factory whilst studying in the evening at Lambeth School of Art. From there he won a scholarship to the *Royal College of Art, where he remained until 1905. By this time he had already had work exhibited at the *Royal Academy and had been spoken of as a great talent in the making, but from an early age he was deeply involved in the occult (stimulated by a friendship with an old lady who claimed to be a witch) and this took precedence over pursuing conventional career success. From 1916 to 1917 he was co-editor of *Form: A Quarterly of the Arts*, reviving it

(after service in the army in the First World War) in 1921–2 (nominally as a monthly). He was then co-editor of another short-lived periodical, *The Golden Hind: A Magazine of Art and Literature* (1922–4). From 1927 he lived as a semi-recluse. During the Second World War he was badly injured by a bomb, losing the use of both arms for a time. He took up painting again after the war and exhibited his work, but he died in poverty and obscurity. Spare's output included straightforward pictures (particularly portraits), but his most characteristic works are weird images of a world of spirits and elementals. He believed that he could conjure up these images from deep levels of the mind (he called the process atavistic resurgence) and on one occasion is said to have caused such an image to materialize for two inquisitive visitors; it was 'so appalling that one of the witnesses committed suicide shortly afterwards and the other went mad' (Kenneth Grant in Richard Cavendish, ed., *Encyclopedia of the Unexplained*, 1974). Spare discussed his occult beliefs in his books *The Book of Pleasure (Self-Love): The Psychology of Ecstasy* (1913) and *The Focus of Life: The Muttering of Aäos* (1920), both of which are illustrated with his drawings. He sometimes experimented with *automatism and a collection of his work in this vein, *A Book of Automatic Drawings*, was published in 1972.

Sparkes, John. See ROYAL COLLEGE OF ART.

Spatialism (or **Spazialismo**). A movement launched by Lucio *Fontana in Milan in 1947, in which he grandiosely intended to synthesize colour, sound, space, movement, and time into a new type of art. The main ideas of the movement were anticipated in his *Manifesto Blanco* (White Manifesto) published in Buenos Aires in 1946. In it he spoke of a new 'spatial' art in keeping with the spirit of the post-war age. On the negative side it repudiated the illusory or 'virtual' space of traditional easel painting; on the positive side it was to unite art and science to project colour and form into real space by the use of up-to-date techniques such as neon lighting and television. The new art of Spatialism would 'transcend the area of the canvas, or the volume of the statue, to assume further dimensions and become . . . an integral part of architecture, transmitted into the surrounding space and using new discoveries in science and technology'. Five more mani-

festos followed; they were more specific in their negative than their positive aspects, and carried the concept of Spatialism little further than the statement that its essence consisted in 'plastic emotions and emotions of colour projected upon space'. In 1947 Fontana created a 'Black Spatial Environment', a room painted black, and in 1949 a 'Spatial Environment' (*Ambiente Spaziale*), an arrangement of neon light; these are considered to have foreshadowed *Environment art. His holed canvases (beginning in 1949) and slashed canvases (from 1959) are also considered to exemplify Spatialism.

Several Italian artists joined Spazialismo, among them Roberto *Crippa, Enrico Donati (1909–), Gianni Dova (1925–), and Cesare Peverelli (1922–), but as a movement it was short-lived (the last of the manifestos was in 1952). Fontana, however, continued to give his works titles such as 'Concetto Spaziale', as in *Spatial Concept 'Waiting'* (Tate Gallery, London, 1960), and although his ideas were vague, his outlook was influential, for he was one of the first to promote the idea of art as gesture or performance, rather than the creation of an enduring physical work.

Spazzapan, Luigi (1890–1958). Italian painter, born at Gradisca, Friuli. He studied in Vienna and Paris and in 1928 settled in Turin, where he became a leading figure in avant-garde circles. His early work was *Fauvist, and from this he developed to a kind of visionary *Expressionism. He painted landscapes (generally regarded as his best works), still-lifes, and figure compositions, and was a prolific draughtsman.

Spear, Ruskin (1911–90). British painter, born in Hammersmith, London, the son of a coach-painter. He studied at Hammersmith School of Art, 1926–30, and the *Royal College of Art, 1931–4, and subsequently taught at various art schools, notably the RCA, where he was a tutor from 1948 to 1977. During the Second World War (when he was exempt from military service because of the after-effects of childhood polio) he took part in the *'Recording Britain' scheme (at this time he also played in various bands—he was an accomplished jazz pianist). Spear was best known for his portraits (including many of celebrities) and landscapes, especially views of Hammersmith: in the introduction to the catalogue of Spear's retrospective exhibition

at the Royal Academy in 1980, his friend the painter Robert Buhler (1916–89) remarked that 'one could say that Ruskin Spear has done for Hammersmith what *Sickert did for Camden Town'. Characteristically his pictures are broadly brushed, with a spontaneous, improvisatory look. Less typical works include an altarpiece (the *Annunciation*) for the church of St Clement Danes, London (1958), replacing one destroyed in the Second World War, and murals for the liner *Canberra* (1959).

'specific objects'. See JUDD.

Speed, Harold (1872–1957). British painter, draughtsman, and writer on art, born in London, the son of an architect. He began to study architecture at the *Royal College of Art in 1887 but turned to painting and transferred to the *Royal Academy Schools, 1891–6, winning a gold medal and a travelling scholarship that took him to Belgium, France, Italy, and Spain, 1894–5. His work includes a fresco, *Autumn* (1895–6), in a lunette of the Royal Academy's restaurant, and he also painted landscapes, interiors, and historical scenes, but he is best known as a portraitist. He worked in a traditional style and often made highly finished portrait drawings; several examples are in the National Portrait Gallery, London. Speed wrote three books: *The Science and Practice of Drawing* (1913), *The Science and Practice of Oil Painting* (1924), and *What is the Good of Art?* (1936).

Speer, Albert. See NATIONAL SOCIALIST ART.

Spencelayh, Charles (1865–1958). British painter. He was born in Rochester, Kent, and studied at the *Royal College of Art and in Paris. Early in his career he lived in or near London, later in Manchester, and finally (from 1941) at Bozeat, Northamptonshire. Completely resistant to any modern developments in art, Spencelayh continued the tradition of Victorian genre painting into the second half of the 20th century. He specialized in anecdotal domestic scenes, most typically showing old codgers pottering around in junk shops or other cluttered interiors. From 1892 until the year of his death he exhibited fairly regularly at the *Royal Academy, a record for longevity that has rarely been exceeded. Critics generally regarded his work as trivial and outmoded, but the public liked

it, voting his *Why War?* (Harris Museum and Art Gallery, Preston) 'picture of the year' at the RA exhibition in 1939 (in wartime he often pandered to national sentiment by depicting patriotic themes or including patriotic details). He knew his market well and appreciated the value of a good title; part of his income came from reproduction of his works on calendars, greetings cards, and so on, and he once altered the title of a picture (showing a man reading a bank statement) from *Overdrawn at the Bank* to *A Good Balance*, changing it from a non-seller to one that he said 'went like hot cakes'. Spencelayh also painted portraits (including miniatures) and made etchings. His son **Vernon** (1891–?) painted in a similar style.

Spencer, Augustus. See ROYAL COLLEGE OF ART.

Spencer, Gilbert. See SPENCER, SIR STANLEY.

Spencer, Niles. See PRECISIONISM.

Spencer, Sir Stanley (1891–1959). English painter, one of the most original figures in 20th-century British art. He was born in Cookham in Berkshire and lived for most of his life in this village, which played a large part in the imagery of his paintings. His education was fairly elementary, but he grew up in a family in which literature, music, and religion were dominant concerns (his father was an organist and music teacher), and his imaginative life was extremely rich. He said he wanted to 'take the inmost of one's wishes, the most varied religious feelings . . . and to make it an ordinary fact of the street', and he is best known for pictures in which he set biblical events in his own village. For him the Christian religion was a living and present reality, and his visionary attitude has been compared to that of William Blake.

Spencer studied at the *Slade School, 1908–12, winning a composition prize in his final year. From 1915 to 1918 he served in the army, first at the Beaufort War Hospital in Bristol, then in Macedonia. He was appointed an *Official War Artist in 1918, but his experiences during the war found their most memorable expression a decade later when he painted a series of murals for the Sandham Memorial Chapel at Burghclere in Hampshire (1927–32), built to commemorate a soldier who had died from an illness contracted in

Macedonia. The arrangement of the murals consciously recalls Giotto's Arena Chapel in Padua (c.1305), but Spencer painted in oil, not fresco, and he concentrated not on great events, but on the life of the common soldier, which he depicted with great human feeling. There is no violence, and Spencer said that the idea for one of the paintings—*The Dug-Out*—occurred to him 'in thinking how marvellous it would be if one morning, when we all came out of our dug-outs, we found that somehow everything was peace and the war was no more'.

By this time Spencer was a celebrated figure, his greatest public success having been *The Resurrection: Cookham* (Tate Gallery, London, 1924–6), which when first exhibited in 1927 was hailed by the critic of *The Times* as 'the most important picture painted by any English artist in the present century ... What makes it so astonishing is the combination in it of careful detail with modern freedom of form. It is as if a *Pre-Raphaelite had shaken hands with a *Cubist.'

Spencer was again an Official War Artist during the Second World War, when he painted a series of large canvases showing shipbuilding on the Clyde (Imperial War Museum, London), memorably capturing the heroic teamwork that went into the war effort. His career culminated in a knighthood in the year of his death, but his life was not a smooth success story, and in the 1930s he somewhat alienated his public with the expressive distortions and erotic content of his work. In 1935 he resigned as an Associate of the *Royal Academy when two of his pictures, considered caricature-like and poorly drawn, were rejected for the annual summer exhibition, but he rejoined the Academy in 1950. He had problems with his personal as well as his professional life. In 1937 he divorced his first wife, Hilda *Carline, and married Patricia *Preece, but the second marriage was a disaster and Hilda continued to play a large part in his life; he painted pictures in memory of her and even wrote letters to her after her death in 1950. Some of his nude paintings of Patricia vividly express not only the sexual tensions of his life, but also his belief in the sanctity of human love; the best known is the double nude portrait of himself and Patricia entitled *The Leg of Mutton Nude* (Tate Gallery, 1937). In his later years Spencer acquired a reputation as a landscapist as well as a figure painter. He also occasionally did

portraits. There is a gallery devoted to him at Cookham, containing not only paintings, but also memorabilia such as the pram that he used for pushing his painting equipment around the village (he cut an eccentric figure).

His younger brother **Gilbert Spencer** (1892–1979) was also a painter of imaginative subjects and landscapes, working in a style close to that of Stanley. Examples of his work are in the Tate Gallery, London, and Holywell Manor, Balliol College, Oxford, where he painted murals.

Spero, Nancy. See GOLUB.

Spielmann, M. H. (Marion Harry). See AMSHEWITZ.

Spilliaert, Léon (1881–1946). Belgian painter and draughtsman, born at Ostend, the son of a perfume dealer. He was self-taught as a painter, and although he belonged to several artists' associations he was an independent figure (it is notable that he was completely uninfluenced by the work of *Ensor, Ostend's most famous artist). His work combines elements of *Art Nouveau, *Expressionism, and *Symbolism in a distinctive personal vision. He depicts a world of dreamlike solitude, often showing a single figure in a state of anguish or helplessness; a woman seen against a bleak expanse of sea or sky was a favourite subject. He worked mainly in watercolour, ink, and coloured chalk, rather than oils, with sparse and economical draughtsmanship characterized by billowing wavy lines and broad, flat surfaces. One of his most reproduced works is *Dizziness* (Museum of Fine Arts, Ostend, 1908), a scene of nightmarish intensity showing a silhouetted woman beginning to descend a mysterious and terrifyingly steep structure. 'There is in his work a striking hallucinatory quiet, the result of a strong psychic concentration. Man and nature are absorbed in a rarefied timelessness' (catalogue of the exhibition 'Ensor to *Permeke: Nine Flemish Painters, 1880–1950', Royal Academy, London, 1971). The *Surrealists were impressed by his work.

Spilliaert lived in Ostend until his marriage in 1916, when he moved to Berchem-Sainte-Agathe near Brussels. In 1931 he returned to Ostend, then in 1935 he settled permanently in Brussels. From 1904 he made visits to Paris, where he sometimes exhibited, for example at the *Salon des Indépendants.

Spoerri, Daniel (originally Daniel Feinstein) (1930–). Swiss sculptor, *Performance artist, designer, writer, publisher, dancer, and choreographer. He was Romanian by birth, but he fled with his family in 1942, after the death of his father, and was adopted by his Swiss uncle, Théophile Spoerri. Between 1950 and 1954 he studied ballet in Zurich and Paris, and from 1955 to 1957 he was principal dancer with the Berne Opera. He also worked in other theatrical roles, notably as a stage designer and chorographer, and from 1957 to 1959 he was assistant director of the Landestheater in Darmstadt. In 1959 he moved to Paris, where he set up a firm called Editions MAT (Multiplication d'Art Transformable) that produced *multiples by artists including Alexander *Calder, Marcel *Duchamp, and Jean *Tinguely. Through Tinguely (whom he had known in Switzerland), Spoerri met Yves *Klein, and these three were among the founder members of the *Nouveau Réalisme group in 1960. In the same year, Spoerri made his first *trap picture, consisting of everyday items fixed to a support and hung on a wall. He often collaborated with other artists, and was briefly associated with the *Fluxus group. In 1966–7 he lived on the island of Simi, near Rhodes, then moved to Düsseldorf, where he opened the Restaurant Spoerri in 1968. Two years later he founded the Eat Art Gallery in premises above the restaurant and held exhibitions of works made of food by artists including *Arman, Joseph *Beuys, *César, and Niki de *Saint Phalle. Such enterprises have won him a reputation as one of the leading showmen in contemporary art.

Spur. A group of German artists active in Munich from 1958 to 1966. The founders of the group were the painters Heimrad Prem (1934–79), Helmut Sturm (1932–), and Hans-Peter Zimmer (1936–), and the sculptor Lothar Fischer (1933–). The name 'Spur' (German for 'track') was adopted in 1958 when they happened to be thinking about footprints they had made in the snow. Their work was semi-abstract, but they advocated art that was socially motivated and were influenced by the vivid portrayal of suffering that is often seen in late medieval German art. Another important influence was Asger *Jorn, who encouraged them and helped them to exhibit their work. From 1959 to 1962 they were part of the *Situationist movement, and their journal *Spur* (7 issues, 1960–1) was one of the leading Situationist publications. In 1962, however, they were expelled by the movement. In 1965 Spur began collaborating with another German group, Wir (We); in 1966 they joined forces to become the Geflecht (Network) group, but this dissolved the following year because of differences of opinion.

Staeger, Ferdinand. See NATIONAL SOCIALIST ART.

Staël, Nicolas de (1914–55). Russian-born painter and printmaker who became a French citizen in 1948. He was born in St Petersburg, son of Baron Vladimir Ivanovich de Staël-Holstein. In 1919 his family was forced to leave Russia because of the Revolution (he would later become incensed if anyone suggested they had 'fled') and moved to Poland. Both parents had died by 1922 and Nicolas and his two sisters were adopted by a family of rich Russian expatriates in Brussels, where he studied at the École des Beaux-Arts, 1932–6. In the next two years he travelled widely (France, Italy, Spain, North Africa), then in 1938 settled in Paris, where he studied briefly with *Léger. On the outbreak of war in 1939 he joined the Foreign Legion and was sent to Tunisia. He was demobilized in 1941 and moved to Nice, where he turned from figurative to abstract art, although the forms he used were usually suggested by real objects. In 1943 he returned to Paris, where he had his first one-man exhibition the following year at the Galerie L'Esquisse. After the war he quickly gained a reputation as one of the leading abstract painters of the *École de Paris, his work showing a sensuous delight in handling paint that was unrivalled at the time. Typically his works feature luscious blocks or patches of thick paint (often applied with a knife), subtly varied in colour and texture. In 1951 he began to reintroduce figurative elements into his work, his subjects including suggestions of landscapes and still-life (*Landscape Study*, Tate Gallery, London, 1952). From 1952 he spent much of his time working in the bright light of the South of France, and his late works are often very intense in colour. In spite of critical and financial success, de Staël felt that he had failed to reach a satisfactory compromise between abstraction and figuration, and he committed suicide.

staged photography. See PHOTO-WORK.

Stain Painting. See COLOUR FIELD PAINTING.

Stamos, Theodorus (1922–97). American painter, born in New York to Greek immigrant parents, one of the minor figures of the first generation of *Abstract Expressionists. He was considerably younger than most of the other members of the group, a reflection of the precocity that won him a scholarship to study sculpture at the American Artists School, New York, in 1936, when he was only 14. Soon after this he took up painting, self-taught, and he had his first one-man exhibition in 1943, at the Wakefield Gallery, New York (run by Betty *Parsons). In the same year he met *Gottlieb and *Newman (he already knew *Gorky). At this time Stamos's painting was influenced by *Surrealism, often suggesting mysterious underwater forms (a characteristic he shared with *Baziotes). In 1948 he travelled in Europe, and after he returned to New York his work became more abstract, although he continued to find inspiration in natural forms and ancient mythological symbols. Many of his subsequent paintings belonged to extensive series, such as the *Sun-Box* series, which ran through most of the 1960s and featured his most austere and geometrical works. After 1970, most of his paintings were part of his *Infinity Field* series, which incorporated several sub-groups, such as the *Lefkada* series, named after a Greek island that he often visited. Apart from paintings, Stamos made book illustrations and tapestry designs, and he taught at various art schools, including *Black Mountain College (where Kenneth *Noland was among his students) and the *Art Students League, New York.

Starkie, Edith. See RACKHAM.

Stażewski, Henryk. See BLOK.

Steadman, Ralph (1936–). British caricaturist, illustrator, printmaker, designer, and writer, born in Wallasey, Cheshire. He studied through a postal course and part-time at the London College of Printing. From 1956 to 1959 he worked as a cartoonist for Kemsley (Thomson) Newspapers, then turned freelance. He has been highly prolific, working for a numerous magazines and newspapers, including *Private Eye*, *Punch*, and the *Daily Telegraph*, and illustrating many books. The books include several that he wrote himself, among them *Sigmund Freud* (1979, reissued as *The Pen-*

guin *Sigmund Freud*, 1982) and *I, Leonardo* (1983). These show his anarchic humour, but he is also capable of savagery and moral indignation, as in a cover illustration for *Weekend Magazine* in 1978 protesting against seal-hunting; it shows a woman in a sealskin coat symbolically spattered with the blood of the slaughtered animals. With Gerald *Scarfe (his exact contemporary), Steadman is regarded as one of the outstanding satirical draughtsmen in British art. However, whereas Scarfe is essentially a portraitist, Steadman is more of a social commentator, who 'transforms appearances in a quasi-surrealistic way, using the new shapes as metaphors for character' (Edward *Lucie-Smith, *The Art of Caricature*, 1981). Typically he works in pen-and-ink in a swift, fluid style. His work has been widely exhibited and he has won numerous awards.

Stedelijk Museum (Municipal Museum), Amsterdam. One of the world's outstanding collections of international modern art. It had its origins in the bequest of Sophia de Bruyn-Suasso to the city in 1890. A handsome building was erected to house the bequest and also modern pictures for which there was no room in the city's foremost museum, the Rijksmuseum, and it was opened as the Stedelijk Museum in 1895. A new wing was added in 1954 and there have been further extensions. The collection of painting and sculpture ranges from about 1850 to the present day. It is rich in Dutch works and has other areas of great strength, notably the world's finest representation of *Malevich's paintings.

Steer, Philip Wilson (1860–1942). British painter (of landscapes and occasional portraits and figure compositions), born in Birkenhead, son of an undistinguished portrait painter, Philip Steer (1810–71). With *Sickert (his friend and exact contemporary), Steer was the leader in his generation among the progressive British artists who looked to France for inspiration. He turned to painting after giving up a job in the Department of Coins and Medals in the British Museum in 1878 and had his main training in Paris, 1882–4, first at the *Académie Julian and then the École des *Beaux-Arts. He revisited France on several occasions, but unlike Sickert he never mastered the language (indeed he left the École des Beaux-Arts when—to reduce numbers—new regulations were introduced

forcing all foreign students to take stiff examinations in French). With other admirers of French painting, he was one of the founders of the *New English Art Club in 1886 and he regularly exhibited there. In 1892 George *Moore wrote 'it is admitted that Mr Steer takes a foremost place in what is known as the modern movement', and around this time Steer was indeed at his peak, producing the beach scenes and seascapes that are regarded not only as his finest works but also as the best *Impressionist pictures painted by an Englishman. They are remarkable for their great freshness and their subtle handling of light, and unlike Sickert's paintings they are devoid of any social or literary content. Among them are several depicting the seaside resort of Walberswick in Suffolk, where he had friends and often stayed at this period.

After about 1895 Steer's work became more conventional and more closely linked to the English tradition of Gainsborough (especially in portraits), Turner, and Constable. In the 1920s he turned increasingly to watercolour. He taught at the *Slade School from 1893 to 1930 and in 1931 was awarded the Order of Merit. His sight began to fail in 1935 and he had stopped painting by 1940. His work is well represented in the Tate Gallery, London. In character Steer was benign, modest, dryly amusing, and held in affectionate regard by almost everyone who knew him. He was a confirmed bachelor and a hypochondriac who carried his worries about his health to comic lengths: in his own home 'he donned a hat to go upstairs, because of the changes in temperature between one room and another' (Bruce Laughton, *Philip Wilson Steer*, 1971).

Stefánsson, Jón. See THORLÁKSSON.

Steichen, Edward. See STIEGLITZ.

Stein, Gertrude (1874–1946). American writer, collector, hostess, eccentric, and self-styled genius, born at Allegheny, Pennsylvania, into a wealthy family. After abandoning medical studies she settled in Paris in 1903, returning only once to the USA, for a lecture tour in 1934. Her home at 27 rue de Fleurus became famous as a literary and artistic salon; many distinguished American visitors to Paris found it their introduction to modern French painting. With her brother, the art critic **Leo Stein** (1872–1947), who lived with her from 1903 to 1912, she was one of the first

collectors of the work of *Braque, *Matisse, and *Picasso (who painted a well-known portrait of Gertrude, 1906, Metropolitan Museum, New York); another brother, **Michael** (1865–1938), and his wife **Sarah** (1870–1953), were also collectors. Gertrude's writings, which she claimed to be a literary counterpart to *Cubism, are often opaque in style, concerned with the rhythm and sound of words rather than their meaning. The best-known and most approachable of her many books is *The Autobiography of Alice B. Toklas* (1933), which in fact is her own autobiography, composed as though by Miss Toklas (1877–1967), her secretary and companion from 1907. Alfred H. *Barr writes that Leo Stein was 'the critic who first felt that Matisse *and* Picasso were the two important artists of his time', but Leo later turned his back on their work, describing Cubism as 'god-almighty rubbish'. Clive *Bell maintained that 'Neither Gertrude or Leo had a genuine feeling for visual art . . . Pictures were pegs on which to hang hypotheses.' On her death, Gertrude's art collection passed to Miss Toklas, and when she in turn died in 1967 it was sold. Several of the paintings eventually went to leading public collections, including the Museum of Modern Art, New York.

Steinbach, Haim. See NEO-GEO.

Steinberg, Leo (1920–). American art historian. He was born in Moscow, grew up in Berlin, settled in England in 1933, and emigrated to the USA in 1945. After several years as a freelance writer and teacher of drawing, he turned to art history and gained a PhD from the Institute of Fine Arts, New York University, in 1960. He was then a professor of art history at Hunter College, City University of New York, and moved to the University of Pennsylvania in 1975. His learned, stimulating, and sometimes provocative writings have ranged from the Renaissance to contemporary art. A collection of his pieces on modern art, including three essays on *Picasso, was published in 1972 as *Other Criteria: Confrontations with Twentieth-Century Art*. In 1983 he became the first art historian to receive the Award in Literature from the American Academy and Institute of Arts and Letters.

Steinberg, Saul (1914–). American draughtsman and painter, born at Rămnicul-Sârat in Romania. He studied architecture in

Milan, taking a doctorate at the Reggio Politecnico there in 1940, and emigrated to New York in 1942. Steinberg had begun publishing cartoons in 1936 (in the Milanese magazine *Bertoldo*) and in the USA he became one of the most celebrated cartoonists of his day, famous particularly for his work for the *New Yorker* magazine. He has worked in a variety of styles, often parodying modes of both traditional and modern painting. Matthew Baigell (*Dictionary of American Art*, 1979) describes him as 'a serious observer of modern life, aware of the masks and roles people must assume to cope with contemporary conditions. His point of view is not that of a cartoonist illustrating one-liner jokes, but of a perceptive individual profoundly and humorously engaged in illuminating the corners of the modern mind.' Several collections of his drawings have been published, including *All in Line* (1945), *The Art of Living* (1949), *The Labyrinth* (1959), and *The New World* (1965). His other work has included *collages, *assemblages, and paintings of various kinds, notably a mural for the United States Pavilion at the 1958 Brussels World's Fair.

Steinhardt, Jakob. See PATHETIKER.

Steir, Pat. See NEW IMAGE PAINTING.

Stella, Frank (1936–). American painter, printmaker, and writer on art, a leading figure of *Post-Painterly Abstraction. He was born in Malden, Massachusetts, a suburb of Boston, and began to paint abstract pictures while he was at school at Phillips Academy, Andover. In 1954–8 he studied history at Princeton University and also attended painting classes. At this time he was influenced by *Abstract Expressionism, but after settling in New York in 1958 he was impressed by the flag and target paintings of Jasper *Johns and the direction of his art changed completely. He began to emphasize the idea that a painting is a physical object rather than a metaphor for something else, saying that he wanted to 'eliminate illusionistic space' and that a picture was 'a flat surface with paint on it—nothing more'. These aims were first given expression in a series of black 'pinstripe' paintings in which regular black stripes were separated by very thin lines. They made a big impact when four of them were shown at the Museum of Modern Art's '16 Americans' exhibition in 1959, inspiring a mixture of

praise and revulsion. Soon after this he began using flat bands of bright colour (*Hyena Stomp*, Tate Gallery, London, 1962), then to identify the patterning more completely with the shape of the picture as a whole he started working with notched and *shaped canvases. In the 1970s he began to experiment with paintings that included cut-out shapes in relief and he abandoned his impersonal handling for a spontaneous, almost graffiti-like manner (*Guadalupe Island, Caracara*, Tate Gallery, London, 1979).

Stella has been an influential figure not only in painting but also on the development of *Minimal sculpture (his friends have included *Andre and *Judd). In 1983–4 he delivered the Charles Eliot Norton lectures at Harvard University, which were published in 1986 as *Working Space*. John *Golding writes of this book: 'The *Working Space* of the title is Stella's plea for the reintroduction of greater spatial expansiveness, expressiveness and experiment into contemporary art: "What painting wants more than anything else is working space—space to grow into and expand into." He feels—knows, indeed—that abstraction is the real, the great art of our time, but he is appalled by the dullness and flatness which he sees as characterizing so much abstract painting of recent years and which he finds shallow in every sense of the word: too "close-valued", too conservative, too introverted, too much conditioned by technique' ('Frank Stella's *Working Space*' in *Visions of the Modern*, 1994).

Stella, Joseph (1877–1946). American painter, born at Muro Lucano, near Naples, Italy. He emigrated to the USA in 1896, and after abandoning medicine as a career he studied from 1897 to 1901 at the *Art Students League and the New York School of Art. He was an excellent draughtsman and for several years earned his living as an illustrator. From 1909 to 1912 he lived in Italy and France, where he had his first significant contacts with modern art. He was particularly influenced by *Futurism and he became the leading American exponent of the style. His first and most famous Futurist painting was *Battle of Lights, Coney Island, Mardi Gras* (Yale University Art Gallery, 1913–14), a densely fragmented portrayal of a crowded amusement park at night. In such paintings Stella gave a romanticized image of the industrialized townscape of New York. In particular he was

obsessed with Brooklyn Bridge, which he described as 'a shrine containing all the efforts of the new civilization of America' (*Brooklyn Bridge*, Yale University Art Gallery, 1917–18).

Stella soon abandoned the Futurist idiom, but industrial and urban themes continued to inspire him. He was active in the administration of two leading avant-garde associations—the *Society of Independent Artists and the *Société Anonyme—and in the early 1920s he experimented with various styles, including *Precisionism. In the 1920s and 1930s he spent much of his time in Italy and France (he lived in Paris 1930–4). From the mid-1920s his work grew more conservative and included mystical and sacred subjects. By the time declining health forced him to give up his studio in 1942 his reputation had faded greatly. David W. Scott (in *Britannica Encyclopedia of American Art*, 1973) writes of Stella: 'A man of vivid and mercurial temperament, he worked in the widest variety of styles, but created in the process several pictures that stand as landmarks of modernism in America.'

Stenberg, Vladimir (1899–1982) and **Georgy** (1900–33). Russian painters and designers, brothers, who worked together until Georgy died in an accident. They were born in Moscow, where they studied at the Stroganov Art School, which was reformed in 1918 as the Free State Art Studios (*Svomas). After the October Revolution in 1917 they were vigorous participants in avant-garde activities. In 1918, for example, they worked on agit-decorations (see AGITPROP ART) for May Day and for the first anniversary of the Revolution. They were members of *Obmokhu and *Inkhuk and allied themselves with the *Constructivists; they made *Structures* of materials such as iron and glass, and their 'cinema and theatrical advertisements and posters were pioneer examples of Constructivist typography and design' (Camilla Gray, *The Great Experiment: Russian Art 1863–1922*, 1962). In the 1920s they worked much as set and costume designers for the stage. From 1929 to 1932 they taught at the Architecture-Construction Institute, Moscow. After Georgy's death Vladimir worked mainly as a poster designer, sometimes in collaboration with his sister **Lydia Stenberg** (1903–62) and later his son **Sten Stenberg**.

Stepanova, Varvara. See CONSTRUCTIVISM and RODCHENKO.

Sterilists. See PRECISIONISM.

Stern, Irma (1894–1966). South African painter. From 1913 to 1920 she studied in Germany, mainly in Berlin, where she was a member of the *Novembergruppe. She was influenced particularly by *Pechstein's *Expressionist style and she was the most important artist in introducing European modernism to South African, where her work initially caused outrage. Her prolific output consisted mainly of figure subjects, including scenes of African villages, but she also painted still-lifes of fruit and flowers. Her home in Cape Town is now a museum dedicated to her. It houses not only examples of her own work, but also African, European, and South American art she collected.

Stevenson, Robert Macaulay. See GLASGOW BOYS.

Stieglitz, Alfred (1864–1946). American photographer, editor, writer, publisher, and art dealer who during the first two decades of the 20th century did more than anyone else to bring European avant-garde art before the American public. He was born in Hoboken, New Jersey, the son of a successful German immigrant businessman, and in 1881 was sent to Berlin to study mechanical engineering. While he was there he developed an interest in photography and by the time he returned to the USA in 1890 he already had an international reputation. In 1905, with another eminent photographer, Edward Steichen (1879–1973), he opened the Little Galleries of the Photo-Secession, which later became known as 291 Gallery (from its address at 291 Fifth Avenue, New York). It soon branched out from photography, and Stieglitz devoted much of his energy to promoting modernist painting and sculpture; the gallery presented the first American exhibitions of *Matisse (1908), Toulouse-Lautrec (1909), *Rousseau (1910), *Picabia (1913), *Severini (1917), and the first one-man exhibition of *Brancusi anywhere (1914). It also gave the first exhibition of children's art and the first major exhibition of African art in America. Stieglitz also championed American artists, among them Georgia *O'Keeffe, whom he married in 1924.

From 1903 to 1917 Stieglitz edited the journal *Camera Work*, which he published from the 291 Gallery. At first devoted exclusively to

photography, it was later extended to cover all the visual arts and opened its pages to avant-garde American writers. The 291 Gallery was closed in 1917 when the building was pulled down, but Stieglitz continued his work with the Intimate Gallery (1925–9) and An American Place (1929–46).

In spite of all his other activities, Stieglitz found time for his own photography and he is regarded as one of the most important figures of the history of the medium, playing a large part in establishing it as an independent art form: 'From 1902 until the time of his death, Stieglitz was the very centre of photographical activity in the United States. He taught, he lectured, he wrote; his influence was incalculable' (Cecil Beaton and Gail Buckland, *The Magic Image*, 1975). His subjects included landscapes, views of New York, and studies of Georgia O'Keeffe, whom he lovingly depicted hundreds of times, often concentrating on details such as her hands or her torso. He rejected retouching and other forms of manipulation, believing that vision was more important than technique, although he insisted on using the highest quality materials. His collection of art and photographs has been distributed to various collections, including the Art Institute of Chicago and the Metropolitan Museum, New York.

Stijl, De (Dutch: 'The Style'). The name of an organization of mainly Dutch artists founded in 1917 and of the journal they published to promote their ideas. It was a very loose association (the 'members' did not exhibit together and some of them scarcely knew each other) and it was held together mainly by Theo van *Doesburg, who was a tireless propagandist for its ideas. The other 'collaborators' (in Dutch *medewerkers*) were, like van Doesburg, principally painters (notably *Huszár, van der *Leck, and *Mondrian), but they also included the sculptor *Vantongerloo and several architects, among them Gerrit Rietveld (1888–1964), who is now perhaps best known for his furniture designs. Their common aim was to find laws of equilibrium and harmony that would be applicable to life and society as well as art, and the style associated with De Stijl was one of austere abstract clarity (see NEO-PLASTICISM). As George Heard *Hamilton writes, 'They wanted to create a style appropriate for every aspect of contemporary life, one so coherent, so intelligible, and so complete that the distinctions between art and life would eventually be erased when everything produced by human agencies, from teacups to town plans, would participate in a universal visual and intellectual harmony'.

The journal was founded by van Doesburg and Mondrian in Leiden in 1917 and van Doesburg continued to edit it until 1928 (it appeared roughly monthly, but irregularly; the place of publication—befitting van Doesburg's peripatetic career—also varied, the editorial offices at one time being in Weimar). It rarely sold more than about 300 copies, but its circulation was widespread. A final issue (no. 90) was published by Mme van Doesburg in memory of her husband, after whose death in 1931 the association disbanded. At first the journal was devoted to the principles of Neo-Plasticism, but in 1921 van Doesburg welcomed *Dadaists such as *Arp and *Schwitters as contributors and later edited a Dadaist supplement called *Mécano* (4 issues, 1922–3). Mondrian did not contribute to the De Stijl after 1924, and soon afterwards dissociated himself from the group because of van Doesburg's launching of a splinter movement that he called *Elementarism.

By this time van Doesburg had also quarrelled with most of his original collaborators, but despite the lack of cohesion, De Stijl was probably the most influential of the many avant-garde publications in Europe between the two world wars. It was influential on artistic practice as well as theory, but it was in architecture and the applied arts (including furniture design and typography), rather than in painting and sculpture, that it had its greatest impact. This is seen particularly in the work of the *Bauhaus and in the clean-lined architectural style known as 'International Modern' (see MODERN MOVEMENT), of which Rietveld's Schroder House in Utrecht (1924) is an early and famous example. George Heard Hamilton writes that 'Of all the movements of the twentieth century De Stijl has seemed the most doctrinaire and at first glance the least accessible, yet ultimately and paradoxically it may have been the most influential. Modern architecture has been in large measure shaped by the basic principles and examples of De Stijl; in painting and sculpture its geometrical tradition has never been negligible, however often it may momentarily have been eclipsed by contrary tendencies.'

Still, Clyfford (1904–80). American painter, one of the major figures of *Abstract Expressionism but the one least associated with the New York art scene. He was born in Grandin, North Dakota, and studied at Spokane University (graduating in 1933) and Washington State College, Pullmann, where he taught until 1941. After working in war industries in California, 1941–3, he taught for two years at the Richmond Professional Institute, Richmond, Virginia. He then lived briefly in New York (1945–6), where he had a one-man exhibition at Peggy *Guggenheim's Art of This Century gallery in 1946. Although he stood somewhat apart from the other Abstract Expressionists, he was friendly with Mark *Rothko (they had met in 1943), the two men sharing a sense of almost mystical fervour about their work. In 1946–50 he taught at the California School of Fine Arts in San Francisco (see BAY AREA FIGURATION), then lived in New York, 1950–61. By the time he returned to New York Still had created his mature style and had a rapidly growing reputation He was one of the pioneers of the very large, virtually monochromatic painting. But unlike *Newman and Rothko, who used fairly flat, unmodulated pigment, Still used heavily loaded, expressively modulated impasto in jagged forms. His work can have a raw aggressive power, but in the 1960s it became more lyrical.

In 1961 Still moved to Maryland to work in tranquillity away from the art world. Scorning galleries, dealers, and critics, and rarely exhibiting, he considered himself something of a visionary who needed solitude to give expression to his high spiritual purpose, and he gained a reputation for cantankerousness and pretentiousness. His comment on his painting *1953* (Tate Gallery, London, 1953) is typical of his high-flown prose: 'there was a conscious intention to emphasize the quiescent depths of the blue by the broken red at its lower edge while expanding its inherent dynamic beyond the geometries of the constricting frame . . . In addition, the yellow wedge at the top is a re-assertion of the human context—a gesture of rejection of any authoritarian rationale or system of politico-dialectical dogma.' Still presented large groups of his paintings to the Albright-Knox Art Gallery, Buffalo, the Metropolitan Museum, New York, and the San Francisco Museum of Art, and his work is represented in many other major collections.

Stockholm, Moderna Museet. See MODERNA MUSEET.

Stokes, Adrian (1902–72). British writer and painter. He was born in London and studied politics, philosophy, and economics at Magdalen College, Oxford, 1920–3. In the winter of 1920–1 he first visited Italy and he returned there many times over the next decade, leading to his first important book *The Quattro Cento* (1932), in which he articulated his 'love of stone'. This preoccupation led him to friendship with a number of artists—particularly Barbara *Hepworth and Henry *Moore—to whom *direct carving was important. In 1936 Stokes took up painting and in 1937 he studied at the *Euston Road School. From 1939 to 1946 he lived at Carbis Bay, Cornwall, and by encouraging Hepworth and Ben *Nicholson to settle near him at the outbreak of the Second World War he he helped to bring about the heyday of the *St Ives School. After the war he lived briefly in Switzerland, then returned to England in 1950, settling permanently in London in 1956. He continued to write and paint up to his death. His books sold badly, but he had a loyal following, and some of his admirers today consider him the most eloquent and poetic British art critic since John Ruskin. Others find his prose hard going. An intensely subjective writer, with an interest in psychoanalysis, Stokes responded passionately, even ecstatically, to art, believing its task was to show the 'utmost drama of the soul as laid-out things'. His books include *The Stones of Rimini* (1934), *Colour and Form* (1937), *Art and Science* (1949), *Three Essays on the Painting of our Time* (1961), *Painting and the Inner World* (1963), and *Reflections on the Nude* (1967). *The Image in Form: Selected Writings of Adrian Stokes*, was published in 1972, edited by his friend Richard Wollheim (1923–), a philosopher who often writes on artistic matters; and *The Critical Writings of Adrian Stokes*, edited by Lawrence *Gowing, appeared in three volumes in 1978. Stokes also wrote poetry. As a painter his work included still-lifes (which Patrick *Heron said had 'a kind of luminosity which seems to derive from the inside of objects') and landscapes. There are examples of his work in the Tate Gallery, London, and an Arts Council exhibition of his work was held at the Serpentine Gallery in London in 1982.

He is not to be confused with another **Adrian Stokes** (1854–1935), a landscape

painter and author of *Landscape Painting* (1925).

Stölzl, Gunta. See BAUHAUS and FIBRE ART.

Stone, Reynolds (1909–79). British engraver, letter-cutter, designer, and painter. He was born and educated at Eton (where his father was a housemaster), then studied history at Magdalene College, Cambridge. After working for the Cambridge University Press and a small commercial printer, he set up on his own as a wood engraver in 1934 and from 1939 also worked (self-taught) as a letter-cutter in stone. His highly varied output included book illustrations (his speciality was quiet rural scenes), memorial tablets (including that to Sir Winston Churchill in Westminster Abbey, 1965), and the design of £5 and £10 notes for the Bank of England (1963–4). Myfanwy *Piper (1951) and Kenneth *Clark (1977) wrote books on him. His daughter Phillida Gili (1944–) is an illustrator, mostly of children's books.

Stoop, Frank. See TATE GALLERY.

Störtenbecker, Nikolaus. See ZEBRA.

Stott, Edward. See NEW ENGLISH ART CLUB.

Strachan, Douglas. See LORIMER.

Stradone, Giovanni. See ROMAN SCHOOL.

Strang, William (1859–1921). British painter, etcher, and draughtsman. He was born in Dumbarton, where he was briefly apprenticed to a shipbuilding firm before moving to London (he lived there for the rest of his life) and studying at the *Slade School, 1876–80. Under the guidance of Alphonse *Legros he took up etching and it was in this field that he originally made a name for himself. By the mid-1890s he had an international reputation, but from this time he turned increasingly to painting, and after the turn of the century he was regarded more as a painter-etcher than an etcher-painter. At first he concentrated on imaginative (often allegorical) scenes in a pseudo-Venetian manner influenced by his friends *Ricketts and *Shannon, but he came to specialize mainly in portraits—one of the most striking examples is *Lady with a Red Hat* (City Art Gallery, Glasgow, 1918), in which the sitter is the writer Vita Sackville-

West. He made highly-finished portrait drawings as well as paintings and etchings. Strang also painted some rather strange modern allegories, combining 'real' and 'dressed-up' figures, but he is now probably best remembered for a much more modest genre scene, *Bank Holiday* (Tate Gallery, London, 1912), a memorable piece of social observation showing a handsome but awkward young couple making an outing to a restaurant. Strang's work was unfashionable for many years after his death, but an exhibition devoted to him in 1981 (shown at the Graves Art Gallery, Sheffield, the City Art Gallery, Glasgow, and the NPG, London) did much to put him back on the map.

His son **Ian Strang** (1886–1952) was an etcher, draughtsman, and painter, mainly of architectural and landscape subjects. He wrote *The Student's Book of Etching* (1938). Another son, **David Strang** (1887–1967), was a painter and etcher.

Streeton, Sir Arthur (1867–1943). Australian painter. He was a prolific landscape painter, working in an *Impressionist style similar to that of his friend Tom *Roberts. Between 1898 and 1924 he spent most of his time abroad (in 1918 he was an *Official War Artist with the Australian forces in France). His work became stereotyped, but he was enormously popular in his own country, regarded as the foremost portrayer of the remote and awesome Australian landscape. By the end of his career he had long enjoyed the status of a national institution. See also HEIDELBERG SCHOOL.

Struck, Hermann. See CASSIRER.

Strudwick, John Melhuish. See PRE-RAPHAELITISM.

Strzemiński, Vladislav (1893–1952). Polish abstract painter and art theorist. He was born at Minsk in Russia and fought in the Russian army in the First World War, losing an arm and a leg in 1915. In hospital he met the sculptor Katarzyna Kobro (1898–1951), also Russian-born, who became his wife. After the war he studied in Moscow, 1918–19, then was assistant to *Malevich at the art school in Vitebsk before settling in Poland in 1922. In 1923 he organized the first exhibition of modern art in Poland, in Vilnius (now in Lithuania), and in 1924 he was one of the founders of the *Constructivist group *Blok, which

published a magazine of the same name. He wrote several theoretical works, of which the most important, published in 1928, was the book *Unizm w malarstwie* (Unism in Painting), in which he expounded a new system of painting called 'Unism'. He claimed that in order to be seen as an optical unity a canvas should not be divided into sections by lines, masses, or rhythms, but instead should consist of an all-over pattern. 'Line divides—the purpose ought not to be the division of the picture, but its unity, presented in a direct way: optically.' Therefore the painter must renounce line, rhythm ('because it exists only in ther relations of independent parts'), oppositions, contrasts, and division ('because it concentrates and intensifies the forms around the contour, and cuts the picture in sections'). He claimed that with Unism he had gone beyond Malevich in abstraction because not only were his pictures '*non-objective' in the sense of having no subject, they had no images either (i.e. he had banished Malevich's squares and similar basic forms). In this way he anticipated *Minimal art.

In 1930 Strzemiński helped to found another avant-garde group, a.r. (revolutionary artists), in Lodz. After the Second World War he painted a series of vividly coloured works in which he depicted 'after-images'—images left in the eye after it has been looking at a bright light source. From 1945 to 1950 he taught art history at the Higher School of Fine Arts in Łódź. His work is well represented in the Sztuki Museum, Łódź.

Stuck, Franz von (1863–1928). German painter, sculptor, and graphic artist, born at Tettenweis, Bavaria. He studied in Munich and in 1892 was a founding member of the *Sezession there. In 1895 he became a professor at the Munich Academy, where *Kandinsky and *Klee were among his pupils. His favourite subjects were mythological and allegorical scenes, often treated in a morbidly erotic *Symbolist style: he did at least eighteen pictures of a naked woman entwined with an enormous snake under such titles as *Sensuality*, *Sin*, and *Vice*. He had an extraordinarily high reputation in his day (now badly faded) and enjoyed a princely lifestyle. The house in which he lived in Munich is now a museum dedicated to him. He designed and decorated the house himself, attempting to create the ideal of the Gesamtkunstwerk ('total work of art').

Studio, The. Monthly journal of contemporary art published in London from 1893 to 1987. It soon became the leading English-language journal in its field, with an international circulation. The cover of the first issue was designed by Aubrey Beardsley (1872–98), one of the outstanding exponents of *Art Nouveau, and in its early days the journal was particularly associated with this style—so much so that in Germany the term 'Studio-Stil' gained currency for a while as a synonym for it. From 1897 to 1921 and from 1927 to 1939 an American edition was published concurrently under the following titles: *The International Studio* (1897–1921), *Creative Art, incorporating The Studio of London* (1927–31), *Atelier* (1931–2), and *The London Studio* (1932–9). Thereafter only the British edition was published. In 1964 the title was changed to *Studio International: Journal of Contemporary Art*, and in its later years it concentrated on American and European rather than British art.

Studio 35. See SUBJECTS OF THE ARTIST SCHOOL.

Sturm, Der (German: The Assault). The name of a magazine and an art gallery in Berlin, both of which were founded and owned by Herwarth Walden (1878–1941?), a writer and composer whose aim was to promote avant-garde art in Germany. The magazine ran from 1910 to 1932 and the gallery from 1912 to 1932. They became the focus of modern art in Berlin, publicizing the *Expressionism of the *Blaue Reiter group, for example. Other activities associated with Sturm included an art school, 1916–32. The gallery held more than a hundred exhibitions, the most important being the 'First [and only] German *Salon d'Automne' (Erster Deutscher Herbstsalon), held in the autumn of 1913. It covered almost the entire range of avant-garde painting and sculpture at that time, including some 360 works by more than 80 artists from 12 countries. George Heard *Hamilton writes that it 'ranks with Roger *Fry's [*Post-Impressionist] exhibitions of 1910 and 1912 as one of the few occasions when one individual comprehended the fundamental directions of the modern movement and was able to demonstrate them with paintings and sculpture, many of which are still of primary artistic and historical importance'. Walden's activities extended also to publishing art books and portfolios of prints, organizing lectures and

discussions, and experiments with Expressionist theatre. In 1932 he left Germany because of the economic depression and the rise of Nazism and moved to the Soviet Union, where he is said to have died as a political prisoner in 1941.

Sturm, Helmut. See SPUR.

Sturrock, A. R. See EDINBURGH SCHOOL.

Subjects of the Artist School. A short-lived (1948–9) school at 35 East 8th Street, New York, aimed at promoting avant-garde art, especially *Abstract Expressionism (the name was intended to convey the idea that there was meaning in abstract art). The founders were William *Baziotes, David *Hare, Robert *Motherwell, Barnett *Newman, and Mark *Rothko. They organized lectures that were open to the public, the speakers including *Arp, John *Cage, *de Kooning, *Glarner, *Gottlieb, and *Reinhardt. The lectures were well attended, but the school failed financially and closed in spring 1949. Later that year the venue was taken over by three professors from New York University's School of Education, who under the name Studio 35 used it as studio and exhibition space for their students. Studio 35 also continued the tradition of lectures, but it too was short-lived, closing in spring 1950. The most important consequence of the Subjects of the Artist School was that it was the cradle of 'The Club', a loose-knit discussion group for artists and writers that was founded in 1949 and met weekly during the 1950s.

Süli, András (1897–1969). Hungarian *naive painter, born in Algyö. A basket-weaver by trade, he began to paint in 1933, but in 1938, disappointed at lack of recognition, he burned most of his pictures and abandoned art. It was not until the 1960s that he was 'discovered'; in 1969, the year of his death, several of his pictures were shown at the First Triennial Exhibition of Naive Art in Bratislava. Since then his work has been included in a number of international exhibitions of naive art and he has won a reputation as Hungary's leading naive painter. Only about 30 of his pictures are known to exist. They are based on the world around him (domestic scenes, farm life, and so on), brightly coloured with the flat decorative quality of a child's sampler.

Sullivan, E. J. (Edmund Joseph). See HILDER.

Sultan, Donald. See NEW IMAGE PAINTING.

Superrealism. Style of painting (and to a lesser extent sculpture), popular particularly in the USA and Britain from the late 1960s, in which subjects are depicted with a minute and impersonal exactitude of detail. Hyperrealism and Photographic Realism (or Photorealism) are alternative names, and some artists who practice the style do indeed work from photographs (sometimes using colour slides projected on the canvas); sharpness of detail is evenly distributed over the whole picture (except where out-of-focus effects in the photograph are faithfully recorded), but the scale is often greatly enlarged, as when portrait heads are blown up to giant size. (Some critics prefer to use the terms 'Photographic Realism' or 'Photorealism' only when a picture has been painted direct from a photograph, but most are not so restrictive.)

The immediate progenitor of Superrealism was *Pop art; banal subject-matter from the consumer society was common to both, and certain artists, such as Malcolm *Morley (who coined the word Superrealism) and Mel *Ramos, overlap both fields. The kind of humour found in Pop is very rare in Superrealism, however, which tends to be cool and impersonal, with subjects often chosen because they are technically challenging (involving multiple reflections, for example). Like Pop, Superrealism was a commercial hit; Edward *Lucie-Smith writes that 'in purely wordly terms, [it] is the only innovative art style to have achieved a marked success in the late sixties and early seventies. From its first appearance on the New York art-scene it scored a triumph with collectors. With critics and institutions it was somewhat slower to make an impact' (*Super Realism*, 1979). Some critics, indeed, regard it as involving a great deal of painstaking work but very little else; others think that its exponents can achieve a strange kind of intensity, the effect of the indiscriminate attention to detail bring—somewhat paradoxically—to create a strong feeling of unreality.

The leading American Superrealist painters include: Chuck *Close; Robert Cottingham (1935–), whose most characteristic works are close-ups of advertising signs and who says he aims for 'a detached

Supports-Surfaces

unsentimental observation of a piece of our world'; Don *Eddy; Richard *Estes; Audrey Flack (1931–), who is unusual in that she aims for emotional effect in her still-lifes of religious symbols and images of vanity and death; and Howard Kanovitz (1929–), whose work sometimes has a *Surrealist element or uses figures that appear to have been cut out and pasted on a background. Painters who are often labelled Superrealist but who stand somewhat apart because of the imaginative element in their work are Jack *Beal, Alfred *Leslie, and Philip *Pearlstein.

British Superrealist painters include Graham Dean (1951–), Michael English (1943–), David Hepher (1935–), Diane Ibbotson (1946–), Michael Leonard (1933–), whose work includes highly detailed portrait drawings in a style mimicking the Old Masters, and John *Salt.

Although it is particularly associated with the USA and Britain, Superrealism has spread to other countries. Claude Yvel (1930–), who specializes in paintings of motorcycles, is a noted French exponent, for example; in Germany the style has affinities with *Ugly Realism and some of the work of Gerhard *Richter; and the *Spanish Realists are sometimes described as Superrealists.

The leading Superrealist sculptors have been the Americans John *De Andrea and Duane *Hanson, whose work often uses real clothes or props and shows attention to minutiae such as body hair. The British sculptor John *Davies is sometimes called a Superrealist, but his work is too personal for this label.

In the 1930s the term 'Superrealism' was fairly commonly used as an alternative to *Surrealism, but this usage has died out.

Supports-Surfaces. A group of French painters, active from 1967 to 1972, who in reaction from *Conceptual art and other avant-garde forms of expression, placed emphasis on the practice and materials of painting. They held several exhibitions (the first to use the group name was at the Musée d'Art Moderne de la Ville de Paris in 1970), and in 1971 they founded a journal, *Peinture, cahiers théoriques*, as their mouthpiece. While their theorizing was highly elaborate, involving notions of class struggle as well as technical matters, their paintings tend towards bland abstraction. The leading figures in the group included Daniel Dezeuze (1942–),

Patrick Saytour (1935–), and Claude Viallat (1936–).

Suprematism. A Russian abstract art movement, created by and chiefly associated with *Malevich. He claimed that he began Suprematism in 1913, but he coined the name in 1915 in a pamphlet manifesto accompanying the exhibition in Petrograd (St Petersburg) at which the movement was officially launched, '0.10: The Last Futurist Exhibition' (see POUGNY). The pamphlet was originally called *From Cubism to Suprematism in Art, to New Realism in Painting, to Absolute Creation*, but it was republished in expanded form the following year as *From Cubism and Futurism to Suprematism: The New Realism in Painting*. As these titles suggest, Malevich acknowledged a debt to *Cubism and *Futurism, but he aimed to go beyond them in abandoning all reference to the visible world and expressing the supremacy of pure form: 'Suprematism is the rediscovery of pure art which, in the course of time, had become obscured by the accumulation of "things".' His Suprematist paintings were indeed the most radically pure abstract works created up to that date, for he limited himself to basic geometric shapes—the square, rectangle, circle, cross, and triangle—and a narrow range of colours. Although he somewhat softened his approach for a time, allowing pastel colours and introducing elliptical shapes, Malevich then returned to complete austerity and reached the ultimate distillation of his ideas in a series of paintings of a white square on a white ground (c. 1918), after which he announced the end of Suprematism.

The spiritual ideas that Malevich attempted to embody in Suprematism are difficult to summarize, for his writing is often vague and mystical. In his original manifesto he wrote that 'Forms must be made which have nothing in common with nature', but also that he sought through Suprematism 'a world in which man experiences totality with nature'. He stated that 'The Suprematists have deliberately given up the objective representation of their surroundings in order to reach the summit of the "unmasked" art and from this vantage point to view life through the prism of pure artistic feeling'. In spite of his wish to create an abstract art that was pure and independent, some artists applied Suprematist designs to functional objects, such as textiles and pottery, and Malevich's

work was influential for a time even on scientifically-minded artists such as *Rodchenko. Suprematism, indeed, made a powerful impact on the avant-garde in Russia until the Soviet regime demanded work that was socially useful (see CONSTRUCTIVISM) and later had great influence on the development of art and design in the West.

Surrealism. Movement in art and literature flourishing in the 1920s and 1930s, characterized by a fascination with the bizarre, the incongruous, and the irrational. It was closely related to *Dada, its principal source; several artists figured successively in both movements, each of which was conceived as a revolutionary mode of thought and action—a way of life rather than a set of stylistic attitudes. Both were strongly anti-rationalist and much concerned with creating effects that were disturbing or shocking, but whereas Dada was essentially nihilist, Surrealism was positive in spirit.

Surrealism originated in France. Its founder and chief spokesman was the writer André *Breton, who officially launched the movement with his first *Manifeste du surréalisme*, published in 1924. In this long and difficult document he defined Surrealism as: 'purely psychic automatism through which we undertake to express, in words, writing, or any other activity, the actual functioning of thought, thoughts dictated apart from any control by reason and any moral or aesthetic consideration. Surrealism rests upon belief in the higher reality of specific forms of associations, previously neglected, in the omnipotence of dreams, and in the disinterested play of thinking.' He said its purpose was 'to resolve the previously contradictory conditions of dream and reality into an absolute reality, a super-reality'. Within this general aim it embraced a large number of different and not altogether coherent doctrines and techniques, characteristically aimed at breaching the dominance of reason and conscious control by methods designed to release primitive urges and imagery. Breton and other members of the movement drew liberally on Freud's theories concerning the unconscious and its relation to dreams.

Breton's first manifesto dealt primarily with Surrealism in literature, but he soon extended his theoretical concerns to the visual arts. The way in which Surrealist artists set about exploration of submerged impulses and imagery varied greatly (in spite of Breton's demands there was little doctrinal unity, and defections, expulsions, and personal attacks are a feature of the history of the movement). Broadly speaking, however, there were three contrasting approaches. Some artists, for example *Ernst and *Masson, cultivated various types of *automatism in an effort to eliminate conscious control. At the other extreme, *Dalí, *Magritte, and others painted in a scrupulously detailed manner to give an hallucinatory sense of reality to scenes that make no rational sense. Finally, in Surrealist *objects, as well as in some paintings, the startling juxtaposition of unrelated items was used to create a sense not so much of unreality as of a fantastic but compelling reality outside the everyday world. The text quoted to justify this search for the unexpected combination of incompatibles was a sentence from the 19th-century poet Lautréamont, whom the Surrealists regarded as one of their precursors: 'Beautiful as the chance encounter of a sewing machine and an umbrella on a dissecting table.'

Paris remained the centre of Surrealism until the Second World War, when the emigration of many European artists to the USA made New York the new hub of its activity. However, it became the most widely disseminated and controversial aesthetic movement of the 1920s and 1930s, spread partly by a number of prestigious journals (beginning with *La *Révolution surréaliste* in 1924) and partly by a series of major international exhibitions. The first of these was held at the Wadsworth Atheneum, Hartford, Connecticut, in 1931, and two of the most famous were held in 1936: the 'International Surrealist Exhibition' at the New Burlington Galleries, London, and 'Fantastic Art, Dada, Surrealism' at the Museum of Modern Art, New York. The movement did not take root in Germany (Ernst, the major German Surrealist, lived mostly in France and the USA), but it flourished vigorously in Belgium—in the work particularly of Magritte, the most inspired of all Surrealist painters, and *Delvaux, the most long-lived upholder of the tradition. Many artists who were not in sympathy with the political aims of Surrealism (for a time it was associated with the French Communist Party), and who were never formal members of the movement, nevertheless found its liberating effects on the imagination bracing and were influenced by its imagery. In

Britain, Henry *Moore and Paul *Nash were among the major artists who went through a Surrealist phase, and Herbert *Read was the most distinguished critic who gave the movement his support. The English Surrealist Group was founded in 1936, but it was social rather than revolutionary in its aims.

By the end of the Second World War, Surrealism had more or less broken up as a coherent movement (an exhibition at the Galerie Maeght, Paris, in 1947, organized by Breton and Marcel *Duchamp, was the last major show staged by original members). However, although it had spent its main force, the spirit of Surrealism lived on. With its stress on the marvellous and the poetic, Surrealism offered an alternative approach to the formalism of *Cubism and various types of abstract art, and its methods and techniques continued to influence artists in many countries. It was, for example, a fundamental source for *Abstract Expressionism. A good many individual Surrealists, too, remained devoted to its ideals long after its heyday was past and new groups emerged, for example in Chicago and Prague. Among the artists who have most unwaveringly kept the spirit of Surrealism alive is Conroy *Maddox, who in 1978 said 'No other movement has had more to say about the human condition, or has so determinedly put liberty, both poetic and political, above all else'.

Surréalisme au service de la révolution. See *RÉVOLUTION SURRÉALISTE*.

Survage, Léopold (1879–1968). Russian-French painter. Born in Moscow of a Finnish mother and a Danish father, he began a course in architecture there, but in 1908 settled in Paris to study painting under *Matisse. However, he was more attracted by the *Cubists and exhibited with them at the *Salon des Indépendants in 1911. Survage became a minor but individual figure in the movement. He preferred townscapes to the more usual Cubist still-lifes and he had a curious spatial sense that gave his work a suggestion of mystery foreign to the more orthodox Cubist work. In the 1920s he abandoned Cubism and adopted a mild form of *Surrealism. He had a gift for large-scale decoration and in 1937 he painted three panels 20 metres long for the Railway Pavilion at the Paris Exposition Universelle, for which he was awarded a gold medal. After the Second World War he began painting abstracts. He was made a member of the Legion of Honour in 1963.

suspended paintings. See GILLIAM.

Sutherland, D. M. (David Macbeth). See EDINBURGH GROUP.

Sutherland, Graham (1903–80). British painter, printmaker, and designer, born in London, the son of a high-ranking civil servant. He abandoned an apprenticeship as a railway engineer to study engraving and etching at Goldsmiths' College, London, 1921–6, and up to 1930 he worked exclusively as a printmaker, specializing in landscape etchings in the visionary Romantic tradition of the 19th-century artist Samuel Palmer. From 1926 to 1935 he taught engraving at Chelsea School of Art, and from 1935 to 1940 he taught composition and book illustration there. In the early 1930s, following a decline in the market for prints, Sutherland began experimenting with oils, and by 1935 he had turned mainly to painting. Again he initially concentrated on landscape, his paintings showing a highly subjective response to nature, inspired mainly by visits to Pembrokeshire, where he went every summer from 1934 until the outbreak of the Second World War. His landscapes are not topographical, but semi-abstract compositions of haunting and monstrous shapes rendered in distinctive acidic colouring, evoking what he called the 'exultant strangeness' of the place (*Entrance to a Lane*, Tate Gallery, London, 1939). During the 1930s Sutherland also designed posters, and it was at an exhibition of posters in 1935 that his work first attracted the attention of Kenneth *Clark, who became an important patron and a close friend.

From 1940 to 1945 Sutherland worked as an *Official War Artist, mainly recording the effects of bombing; his poignant pictures of shattered buildings rank among the most famous images of the home front. Soon after the war he took up religious painting and portraiture, and it was in these two fields that he chiefly made his mark in his later career, showing his characteristic love of a fresh challenge: 'I have never disliked working outside my normal scope and it interests me to try and solve new problems.' His first religious work (or his first since student days) was a large and powerful *Crucifixion* (1946) for St

Mathew's, Northampton (the commission was given to Sutherland when he was present at the unveiling of Henry *Moore's *Madonna and Child* in this church in 1944). Both the Moore sculpture and the Sutherland painting were commissioned by Canon Walter Hussey (1909–85), later Dean of Chichester, 'one of the most remarkable contemporary ecclesiastical patrons of music and art, a man never content with anything but the best' (John Hayes, *The Art of Graham Sutherland*, 1980). He described Sutherland's *Crucifixion* as 'profoundly disturbing and purging'. Sutherland's first portrait was that of Somerset Maugham (Tate Gallery, 1949), commissioned by the sitter. It has an almost caricature quality (Maugham's friend Sir Gerald *Kelly said it made him look 'like an old Chinese madam in a brothel in Shanghai'), and another famous portrait, that of Winston Churchill (1954), was so hated by the sitter (who thought it made him look 'half-witted') that Lady Churchill had it secretly destroyed. Sutherland's most celebrated work, however, has become widely popular—it is the immense tapestry of *Christ in Glory* (completed 1962) in Coventry Cathedral. In addition to such figure subjects Sutherland continued to paint landscapes—many of them inspired by the French Riviera, where he lived for part of every year from 1947—and late in his career returned to printmaking, producing coloured lithographs. He was prodigiously hardworking, his output also including ceramics and designs for stage sets and costumes.

Sutherland was one of the most celebrated British artists of the 20th century and he received many honours, notably the Order of Merit in 1960. Douglas *Cooper described him as 'the most distinguished and the most original English artist of the mid-20th century . . . no other English painter can compare with Sutherland in the subtlety of his vision, in the forcefulness of his imagery and in the sureness of his touch. And there is none whose sensibility and inspiration are so unmistakably and naturally English, yet whose handling and technical approach are so authoritative, modern and European' (*The Work of Graham Sutherland*, 1961). He had a high reputation outside Britain; in 1952, for example, he had retrospectives at the Venice *Biennale and the Musée National d'Art Moderne, Paris, and Kenneth Clark wrote that 'perhaps no other English painter since Con-

stable has been received with so much respect in the critical atmosphere of Paris'. Indeed in his later career Sutherland was generally more admired by foreign than by British critics, who tended to find his work old-fashioned. Examples are in numerous major collections, and the Graham Sutherland Gallery at Picton Castle in Dyfed (formerly Pembrokeshire) opened to the public in 1976.

Suvero, Mark di. See DI SUVERO, MARK.

Svomas (*Svobodniye gosudarstvenniye khudozhestvenniye masterskiye*: Free State Art Studios). The name of art schools founded in several Russian cities, including Moscow and Petrograd (St Petersburg), after the 1917 Revolution. Their very liberal regimes soon resulted in chaos. The Moscow Svomas was founded in 1918 from an amalgamation of the Moscow School of Painting, Sculpture, and Architecture with the Stroganov Art School. In 1920 it was renamed *Vkhutemas. The Petrograd Svomas was created in 1919 from the Petrograd Free Art Educational Studios (Pegoskhuma), which had been formed a year earlier when the St Petersburg Academy was abolished. In 1921 the name reverted to Academy.

Swynnerton, Annie. See KNIGHT.

Sydney Group. A group of Australian artists founded in Sydney in 1945 to offer an alternative exhibiting venue to the New South Wales Society of Artists, which was considered to be in decline. Wallace Thornton (1915–91) was the first president, and the artists who joined included Arthur *Boyd and Sidney *Nolan. Bernard Smith writes that 'realistic comment, expressionism and abstract paintings came to figure in annual exhibitions predominantly neo-romantic in flavour' (*Australian Painting 1788–1990*, 1991).

Sydney 9. A group of nine Australian artists founded in Sydney in 1960 with the object of introducing a better understanding of abstract art to the country. The group held only one exhibition (shown in Melbourne as well as Sydney) before disbanding. John *Olsen was the best-known member.

Sylvester, David (1924–). British writer, broadcaster, lecturer, and exhibition organizer. He was born in London, where he attended University College School. Although

he won a place at Trinity College, Cambridge, he turned this down in favour of journalism, beginning his career with articles published in the left-wing journal *Tribune* in 1942. Subsequently he has written for many other journals, including *Encounter* (it was in its pages that he coined the phrase *Kitchen Sink School in 1954), the *Listener*, the *New Statesman*, the *Observer*, and *The Times*. Almost all his work on art has been devoted to 20th-century topics ('I wish I had had the nerve to write more about old masters'), but he has ranged widely within his chosen field. He has also written on the cinema and sport—'two areas which had obsessed me from the time I was about eight'. From 1951 he has organized many major exhibitions, beginning with a retrospective of Henry *Moore's work at the Tate Gallery, London (he had previously spent a few months as Moore's part-time secretary but said 'this had to stop because we spent too much time arguing about art'). He was a visiting lecturer at the *Slade School, 1953–7, and at the *Royal College of Art, 1960–70, and he has made several films and many radio broadcasts. His films include *Giacometti* (1967), of which he was writer and producer, and his work for radio has included conversations with many distinguished artists: 'Beginning in 1960 I have recorded long interviews for the BBC with most leading American artists.' Some of these interviews have been printed as articles or in exhibition catalogues, and those with Francis *Bacon (one of the artists Sylvester most admires) were made into a book, *Interviews with Francis Bacon* (1975, enlarged edn., 1980). His other books include two monographs on *Magritte (1969 and 1992), and he was editor and co-author of a five-volume catalogue raisonné of Magritte's work (1992–6). He is admired for his lively and unpretentious style, which is well illustrated in *About Modern Art: Critical Essays 1948–1996* (1996).

Symbolism. A loosely organized movement in literature and the visual arts, flourishing c. 1885–c. 1910, characterized by a rejection of direct, literal representation in favour of evocation and suggestion. It was part of a broad anti-materialist and anti-rationalist trend in ideas and art towards the end of the 19th century and specifically marked a reaction against the naturalistic aims of *Impressionism. Symbolist painters tried to give visual expression to emotional experiences, or as

the poet Jean Moréas put it in a Symbolist Manifesto published in *Le Figaro* on 18 September 1886, 'to clothe the idea in sensuous form'. Just as Symbolist poets thought there was a close correspondence between the sound and rhythm of the words they used and their meaning, so Symbolist painters thought that colour and line in themselves could express ideas. Symbolist critics were much given to drawing parallels between the arts, and *Redon's paintings, for example, were compared with the poetry of Baudelaire and Edgar Allan Poe and with the music of Claude Debussy. Many painters were inspired by the same kind of imagery as Symbolist writers (the *femme fatale* is a common theme), but *Gauguin and his followers (see SYNTHESISM) chose much less flamboyant subjects, often peasant scenes. Religious feeling of an intense, mystical kind was a feature of the movement, but so was an interest in the erotic and the perverse—death, disease, and sin were favourite subjects. Stylistically, Symbolist artists varied greatly, from a love of exotic detail to an almost primitive simplicity in the conception of the subject, and from firm outlines to misty softness in the delineation of form. A broad tendency, however was towards flattened forms and broad areas of colour—in tune with *Post-Impressionism in general.

Although chiefly associated with France, Symbolism had international currency, and such diverse artists as *Hodler and *Munch are regarded as part of the movement in its broadest sense. Symbolist sculptors include the Belgian Georg *Minne and the Norwegian Gustav *Vigeland. George Heard *Hamilton comments that 'the Symbolists, by freeing painting from what Gauguin called "the shackles of probability", created the philosophical as well as practical premises for much twentieth-century art'.

Synchromism. An abstract or semi-abstract movement in painting, closely related to *Orphism, founded in 1912 by Stanton *Macdonald-Wright and Morgan *Russell, two young American artists living in Paris. The term, meaning literally 'colours together', was coined by Russell on the analogy of 'symphony'. As it suggests, he and his colleague were primarily interested in the abstract use of colour (they met in 1911 when studying colour theory with the Canadian painter Percyval Tudor-Hart (1873–1954)). In 1912 Russell said that he wished to do 'a piece

of expression solely by means of colour and the way it is put down in showers and broad patches, distinctly separated from each other, or blended . . . but with force and clearness and large geometric patterns'. Similarly, Macdonald-Wright said 'I strive to divest my art of all anecdote and illustration and to purify it so that the emotions of the spectator can become entirely "aesthetic", as in listening to music'. The Synchromists were influenced by scientific writings on optics and by the paintings of the *Neo-Impressionists and *Fauves; they were working in a similar direction to the Orphists but fairly independently. Compared with most other pioneer abstractionists, they were scientifically minded in their choice of colours, relying more on predetermined scales of colour than on intuition. Matthew Baigell (*A History of American Painting*, 1971) writes: 'Although natural objects were largely eliminated, Russell found in the movement of light and color a metaphor for the universal movement of life, and Macdonald-Wright saw in them a metaphor for the rhythms of human anatomy . . . Russell's style differed considerably from Macdonald-Wright's . . . Russell applied color of equal intensity all over his canvas, thus activating the entire surface . . . Macdonald-Wright, on the other hand, varied the intensity of colors, allowing some to become strong while leaving others quite pale . . . Russell was closer to the most advanced European sensibility . . . In fact, one may go so far as to say that in the years between 1913 and 1915, no painter got his canvases as "flat" as Russell did.'

Russell's *Synchromy in Green* (destroyed), exhibited at the *Salon des Indépendants in 1913, was the first painting to bear the Synchromist name. Later that year Russell and Macdonald-Wright exhibited together at the Neue Kunstsalon, Munich (June), and then at the Galerie *Bernheim-Jeune, Paris (October). At both exhibitions they issued a brash manifesto in which they claimed that 'it is the quality itself of form that we try to explain and reveal by colour, and for the first time colour appears in that role'. They argued that, in contrast, Orphist paintings were purely decorative and did not express volume. However, most critics of the time could see little difference between Orphism and Synchromism, and the Americans were appalled to find that they were generally dismissed as followers of their European counterparts: 'In retrospect it can be argued that *Delaunay's

use of colour is in fact more fluid, transparent and painterly, Russell's forms more solid, jagged and angular. Macdonald-Wright, too, achieves a distinctive sculptural or volumetric definition of form. It is in those canvases where the two Americans build their compositions around discs that they most resemble Delaunay' (Milton W. Brown, 'The Modern Spirit: American Painting 1908–1935', Arts Council exhibition, Edinburgh and London, 1977).

The First World War separated the founders of Synchromism (Macdonald-Wright moved to London and Russell stayed in Paris), but they exhibited together at the Carroll Galleries, New York, in 1914, and their work influenced a number of American painters over the next few years. Among them were Thomas Hart *Benton (who sometimes used the word 'Synchromy' in the title of his paintings) and Andrew *Dasburg. These two, together with Macdonald-Wright and Russell, exhibited work in a Synchromist vein at the *Forum Exhibition in New York in 1916. Patrick Henry *Bruce, an American living in Paris, was also close in style to Synchromism for a while. Macdonald-Wright and Russell continued styling their paintings 'Synchromist' into the 1920s, but by then they had moved on to different styles.

Synthesism. Term applied to a manner of painting associated with *Bernard, *Gauguin, and their associates at Pont-Aven in Brittany. It involved the simplification of forms into large-scale patterns and the expressive purification of colours. Bernard believed that form and colour must be simplified for the sake of more forceful expression. 'Anything that overloads a spectacle . . . occupies our eye to the detriment of our minds. We must simplify in order to disclose its [i.e. Nature's] meaning . . . reducing its lines to eloquent contrasts, its shades to the seven fundamental colours of the prism.' Gauguin too spoke much of 'synthesis', by which he meant a blending of abstract ideas of rhythm and colour with visual impressions of nature, and he advised his disciples to 'paint by heart' because in memory coloured by emotion forms became more integrated and meaningful. Bernard and Gauguin each claimed credit for developing Synthesism and they probably acted as mutual catalysts, Bernard providing a theoretical rationale for Gauguin's intuitions and Gauguin's genius as a painter giving the

theory brilliant visual expression. Synthesism was at its most vital between about 1888 and 1894, but some artists working at Pont-Aven continued the style well into the 20th century.

Synthetic Cubism. See CUBISM.

Systemic art. Term coined by the critic Lawrence *Alloway in 1966 to refer to a type of abstract art characterized by the use of very simple standardized forms, usually geometrical in character, used either in a single image or repeated in a pattern arranged according to a clear principle of organization. Alloway originated the term when he organized an exhibition called 'Systemic Painting' at the *Guggenheim Museum, New York, in 1966; the artists represented—all American—included Al *Held, Ellsworth *Kelly, Kenneth *Noland, Larry *Poons, and Frank *Stella. Systemic art has been described as a branch of *Minimal art, but Alloway extended the term to cover *Colour Field Painting.

Systems Group. See CONSTRUCTIVISM.

Szènes, Arpad. See VIEIRA DA SILVA.

Taaffe, Philip. See NEO-GEO.

tableaux-objects. A term applied by *Braque and *Picasso to certain of their *Cubist pictures to emphasize that they were constructed objects with their own independent existence rather than primarily a reflection of something in the outside world.

Tachisme (or **Tachism**). A style of abstract painting popular in the late 1940s and the 1950s characterized by the use of irregular dabs or splotches of colour (*tache* is French for spot or blotch). The term was first used in this sense in about 1951 (the French critics Charles Estienne and Pierre Guéguen have each been credited with coining it) and it was given wide currency by Michel Tapié in his book *Un Art autre* (1952). In its intuitive, spontaneous approach, Tachisme has affinities with *Abstract Expressionism (although initially it developed independently of it), and the term is often used as a generic label for any European painting of the time that parallels the American movement. However, Tachisme was primarily a French phenomenon (associated particularly with the *École de Paris) and Tachiste paintings are characteristically more suave, sensual, and concerned with beautiful handling (*belle facture*) than the work of the Abstract Expressionists, which can be aggressively raw in comparison. Leading exponents of Tachisme include Jean *Fautrier, Georges *Mathieu, and Pierre *Soulages, together with Hans *Hartung and *Wols, who were German-born but French-based.

The terms 'abstraction lyrique' (*Lyrical Abstraction), '*Art Autre (other art), and '*Art Informel' (art without form) are often used more or less synonymously with Tachisme, although certain critics use them to convey different nuances, sometimes corresponding with niceties of theory rather than observ-

able differences in practice. It seems reasonable, however, to regard Tachisme as one aspect of the broader notion of Art Informel. (To add to the confusion of terminology, the word 'tachiste' was used differently in the 19th century, being applied pejoratively to the *Impressionists.)

Taeuber-Arp, Sophie (née Taeuber) (1889–1943). Swiss designer, textile artist, painter, sculptor, and editor, the wife and frequent collaborator of Jean *Arp. She was born at Davos and studied textile design at the School of Art in St Gallen, 1908–10. After continuing her studies in Munich (where she also trained as a dancer) and in Hamburg, she taught weaving and textile design at the School of Arts and Crafts in Zurich from 1916 to 1928. She met Arp in 1915 and they evidently fell in love at first sight, although they did not marry until 1922. From 1915 until Arp's departure for Cologne in 1919 they collaborated on works of various kinds—mainly abstract collages—and were leading lights of the *Dada movement in Zurich. Arp wrote that 'In 1915 Sophie Taeuber and I carried out our first works in the simplest forms, using painting, embroidery and pasted paper', and he often paid tribute to the inspiration she gave him: 'It was Sophie Taeuber who, through the example of her clear work and her clear life, showed me the right way, the way of beauty.' Herbert *Read also stresses her love of clarity, which contrasted with Arp's taste for the accidental: 'For all its feminine charm and playful fantasy, Sophie's work was always marked by a certain craft-like quality: she was delicate but precise, and if one reviews her work as a whole, one is struck by its geometrical regularity. Her ideal was always clarity. But Arp, early in his Dada days, discovered "the law of chance", the part that could be played in art by the unconscious' (*Arp*, 1968). Sophie played an important part

in Arp's career not only because of artistic stimulation, but also because in the 1920s her income from teaching and design (including clothes and jewellery) was their chief means of support.

In 1927–8 the Arps collaborated with van *Doesburg on the decoration of the Aubette restaurant in Strasbourg, then settled at Meudon, near Paris, where they lived from 1928 to 1940. They were members of the abstract groups *Cercle et Carré and *Abstraction-Création, and Sophie founded and edited a periodical of abstract art, *Plastique*, of which five numbers appeared between 1937 and 1939, in French, German, and English. The first number was devoted to *Malevich and the third to American art. The Arps left Meudon following the German invasion, and from 1941 to 1942 they lived at Grasse in southern France. In 1942 they fled to Switzerland, where Sophie died in an accident with a leaking stove the following year. She was little known as a painter in her lifetime, but over 600 oils by her came to light after her death.

Taft, Lorado (1860–1936). American sculptor, writer, and teacher, born in Elmwood, Illinois. He studied at the École des *Beaux-Arts in Paris, 1880–6, and taught sculpture at the Art Institute of Chicago, 1886–1929. In his day Taft was well known for portraits and allegorical public sculpture, particularly fountains such as the Fountain of Time (Washington Park, Chicago, 1922), but he is now remembered mainly for his books, *The History of American Sculpture* (1903), the first comprehensive work on the subject, and *Modern Tendencies in Sculpture* (1921), in which he defended the academic tradition and attacked abstraction. In addition to writing and teaching, he spread his ideas as a public lecturer, touring clubs and schools in Illinois. Taft's studio in Chicago has been preserved as a national monument.

Tagore, Rabindranath (1861–1941). Indian writer, philosopher, composer, critic, painter, and social reformer, born in Calcutta. The most famous member of a renowned patrician family that produced several distinguished intellectuals, he was influential in introducing Indian culture to the West and vice versa (he was devoted to India but also international in spirit, travelling and lecturing widely in Europe and the USA). He was

regarded with awe by his followers, but others found him cold and arrogant (for example *Epstein, who made a portrait bust of him). Tagore's main reputation was as a writer; in 1913 he became the first Asian to win the Nobel Prize for literature, awarded for his poems *Gitangali: Song Offerings*, written in Bengali and translated by himself into English. He was also a prolific composer of songs and was deeply interested in the visual arts. In this field he helped to introduce modern Western influence to India, notably through bringing an exhibition of German *Expressionist art to Calcutta in 1922. He dabbled in painting himself throughout his life, but it was not until 1924, when he was 63, that he took it up in earnest. It then became a passion, and he produced more than 2,000 pictures in the remaining 17 years of his life. They owe something to Expressionism and *Surrealism, something to various Eastern influences. Although they were well received when shown in Europe and the USA in 1930, they are now regarded as being of marginal interest; Brian *Sewell describes them as 'abysmal' and refers to him as 'Rabindranath the Bore'. An exhibition entitled 'Rabindranath Tagore: A Celebration of his Life and Works' was held at the Museum of Modern Art, Oxford, in 1986. Two of his nephews were painters and writers: **Gaganendranath Tagore** (1867–1938) and his brother **Abanindranath Tagore** (1871–1951). His great-niece was married to Svetoslav *Roerich.

taille direct. See DIRECT CARVING.

Takamatsu, Jiro. See HI-RED CENTER.

Takis (Panayotis Vassilakis) (1925–). Greek experimental artist, best known for his novel work in *Kinetic sculpture. He was born in Athens and was self-taught as an artist, making his first sculptures in 1946. Since 1954 he has lived mainly in Paris, although he has also spent a good deal of time in Athens. His creations often employ magnetic fields in which various metal objects produce changing patterns—the magnet's 'live force and vibration gives life to what has semed to be a dead material'. Sometimes he combines light effects and music with movement. In 1972 a major retrospective exhibition at the Centre National d'Art Contemporain in Paris showed the variety of his work over the previous 20 years.

Tal-Coat, Pierre (1905–85). French painter, born at Clohars-Carnoët, Brittany, of a family of fishermen. He was originally called Pierre Jacob, but he adopted the name Tal-Coat in 1926. After working as a blacksmith's apprentice and a lawyer's clerk, he was briefly employed moulding and painting ceramics in a pottery factory, but he was self-taught as an artist. From 1924 to 1926 he did military service in Paris and then moved to Doëlan, near Pouldu. He returned to Paris in 1931 and became a member of the *Forces Nouvelles group. In 1936–9 he did a series of powerfully expressive *Massacres*, based on incidents in the Spanish Civil War. They have something in common with *Picasso's *Guernica*, and Tal-Coat was strongly influenced by him at this time. In the early 1940s, however, his work changed direction radically, as he developed the type of picture for which he is best known: starting from the impression of a natural scene he took this to the point of of abstraction, suggesting the interplay of light and movement without specific representation. In 1947 André *Masson introduced him to Chinese landscape painting, which subsequently influenced his work. From the early 1950s his painting took on a mystical character. By this time he was established as a leading figure in the school of *Lyrical Abstraction that dominated the *École de Paris in the late 1940s and 1950s.

Taller de Gráfica Popular (TGP). A printmaking establishment founded in Mexico City in 1937 as 'a collective work centre' by three left-wing artists: Luis Arenal (1908–?), Leopoldo Méndez (1902–69), and the American Pablo O'Higgins (1904–83); the name means 'People's Graphics Workshop'. A short Declaration of Principles issued by the founders explained some of their aims and beliefs. They wanted to help 'the Mexican people defend and enrich their national culture' and believed that 'in order to serve the people, art must reflect the social reality of the times'. They aimed to 'co-operate professionally with other cultural workshops and institutions, workers' organizations, and progressive movements and institutions in general' and to 'defend freedom of expression and artists' professional interests'. The work of the TGP was part of a tradition of socially-committed printmaking of which *Posada was the most famous representative and it parallelled the concerns of the contemporary Mexican muralists, *Orozco, *Rivera, and *Siqueiros. In the 1940s and 1950s there were usually about 12 to 15 artists working at the TGP at any one time, teaching printmaking as well as producing their own work. They issued their prints as single images, in portfolios, or as posters. Various techniques were used, including lithography, but woodcut and linocut tended to be favoured because of their cheapness. The subject-matter included attacks on Fascism and the exploitation of the poor, and after the Second World War the TGP became involved in the government's literacy campaign.

Tamarind Lithography Workshop. See PRINT RENAISSANCE.

Tamayo, Rufino (1899–1991). Mexican painter, printmaker, sculptor, and collector, born at Oaxaca into a Zapotec Indian family. Apart from the trio of great muralists—*Orozco, *Rivera, and *Siqueiros—he was probably the most celebrated Mexican artist of the 20th century, but his work was very different from theirs, for he was concerned with pictorial values rather than with the political messages they held so dear. Although he acknowledged the muralists' 'distinguished qualities', he thought that their desire 'to produce, above all, art that was Mexican, led them to fall into the picturesque, and be careless of the really plastic problems'.

Tamayo was orphaned when he was 11 and moved to Mexico City to live with an aunt and uncle. He attended drawing classes at the Academy of San Carlos, but he was essentially self-taught. In 1921 he was appointed chief of the Department of Ethnographic Drawing at the National Archaeological Museum, where his duties included drawing works of Pre-Columbian art in the collection. From 1926 to 1928 he lived in New York, where he had his first one-man exhibition at the Weyhe Gallery in 1926. After his return to Mexico City, he taught under Rivera at the National School of Fine Arts and the Academy of San Carlos, 1928–30. At this time he was living with María Izquierdo (1902–55), whose paintings—mainly still-lifes in a richly coloured, almost *naive style—influenced his work. This was only one of many influences that Tamayo absorbed—from modern European movements, particularly *Surrealism, as well as from native traditions—for he 'has often been described as an artist who is essentially a

synthesist, who brings together ideas from a variety of sources—*Gauguin, *Cézanne, *Picasso, *Matisse, Stuart *Davis, *Miró . . . Despite his evident eclecticism, he is also powerfully individual, and much of this individuality comes from his treatment of colour. It is always very subtle, even when the paintings are almost in monochrome, and frequently rich, saturated and full of sonorous harmonies . . . Linked to Tamayo's colour is his feeling for texture. His picture surfaces are tactile and richly worked, making the picture visibly a work of craft as well as well as a work of art' (Edward *Lucie-Smith, *Latin American Art of the 20th Century*, 1993).

From 1936 to 1950 Tamayo lived in New York, although he returned regularly to Mexico, and from 1957 to 1964 he lived in Paris, then settled permanently in Mexico. By this time he was internationally famous, with a list of major exhibitions and distinctions to his credit, including the Grand Prize for Painting at the 1953 São Paulo *Bienal. His work was varied in subject, including still-lifes, portraits (notably many of his pianist wife, Olga), nudes, animals, and scenes of the culture and myths of the Mexican Indians. He did several murals in Mexico, but usually worked on canvas affixed to the wall rather than in fresco. His work also included a large number of prints in various techniques and sculpture in bronze and iron. Some of his late sculptures were very large (*Conquest of Space*, San Francisco International Airport, 1983). Throughout his life Tamayo was an ardent collector. He donated his collections to his native city of Oaxaca to form museums of Pre-Columbian art (1974) and contemporary art (1981).

Tanguy, Yves (1900–55). French-born painter who became an American citizen in 1948. He was born in Paris, the son of a naval officer, and was a schoolfriend of *Matisse's son Pierre, who later became his dealer in New York. In 1918 he joined the merchant navy, then did military service before returning to Paris in 1922. Whilst working at various odd jobs he began sketching cafe scenes that were praised by *Vlaminck, and in 1923 he decided to take up art seriously after being greatly impressed by the work of de *Chirico (he is said to have jumped from the platform of a moving bus, at the risk of serious accident, when he saw one of his pictures in a dealer's window). He had no formal artistic training. In 1925 he met André *Breton and joined the

*Surrealist group. His work developed quickly and by the time of his first one-man exhibition, at the Galerie Surréaliste in 1927, he had already created a distinctive style. Characteristically he painted in a scrupulous technique reminiscent of that of *Dalí, but his imagery is highly distinctive, featuring marine- or lunar-like landscapes whose ghostly plains are scattered with structures that suggest giant weathered bones arranged into fantastic pylons (he was fascinated by the kind of strange rock formations he saw in Africa during his merchant navy days). In 1939 Tanguy met the American Surrealist painter Kay *Sage in Paris; he followed her to the USA and they married in 1940. The couple lived first in New York and from 1942 at Woodbury, Connecticut. In that year his work was included in the 'Artists in Exile' exhibition at Pierre Matisse's gallery—a show that helped to introduce the expatriate Surrealists to an American audience. After the Second World War he built up an international reputation; in 1953 he had one-man exhibitions in Paris, Milan, and Rome. In America his work continued in the style he had established before the war, but his pictures tended to become bigger and more boldly coloured.

Tanning, Dorothea (1910–). American painter, sculptor, designer, and writer, born at Galesburg, Illinois. Except for two weeks of classes at the Art Institute of Chicago in 1930 she was self-taught as an artist. In 1935 she settled in New York, where she worked at odd jobs (including being a model and film extra) to support herself whilst she learned about art by visiting galleries and reading voraciously. She was deeply impressed by the exhibition 'Fantastic Art, Dada, Surrealism' at the Museum of Modern Art in 1936 and this set her on the road as a painter. Her early work was in the hyper-realistic vein of *Surrealism; most characteristically she depicted the erotic fancies of young girls in the creepy atmosphere of the Gothic novel (*Eine Kleine Nachtmusik*, Tate Gallery, London, 1943). In 1942 she met Max *Ernst at the Julien Levy Gallery (where she had her first one-woman exhibition two years later) and in 1946 she married him. Initially they divided their time between New York and Arizona, then from 1949 lived mainly in France, settling there in 1955. The work of her famous husband had virtually no influence on Tanning. She continued in her highly detailed style until the

mid-1950s, when her work became semi-abstract, with mysterious imagery of an erotic or violent nature seen through a kind of subtly-coloured mist. In the 1960s she began to make Surrealist sculpture from textile materials. She was still vigorously active in the 1990s. Mathew Baigell (*Dictionary of American Art*, 1979) writes of Tanning that 'She has produced what may be considered one of the most individual œuvres in Surrealism by any artist who was not one of its European founders.'

Taos Colony. A loose group of American painters who worked in and around Taos, New Mexico, from about 1910. Taos, a community consisting of three villages (the biggest of which is San Fernando de Taos, generally known simply as Taos), was an early Spanish settlement and it has a picturesque atmosphere attractive to painters and writers. The painter most closely associated with the community was Ernest Blumenschein (1874–1960), who first visited it in 1897, later often spent the summer there, and settled permanently in 1919. Marsden *Hartley and John *Sloan were among the visitors in the 1920s, and Andrew *Dasburg settled there in 1930. The Taos artists often depicted Indian life and their work also included landscapes and still-lifes, but no particular style was associated with the colony.

Tapié, Michel. See ART AUTRE and ART INFORMEL.

Tàpies, Antoni (1923–). The best-known Spanish painter to emerge in the period since the Second World War. He was born in Barcelona and grew up in a cultured environment (his father was a lawyer and his mother came from a family of booksellers). From 1943 to 1946 he studied law at Barcelona University and he was largely self-taught as an artist. In 1948 he became a member of the avant-garde group *Dau al Set, and in 1950 he had his first one-man exhibition, at the Galeries Laietanes, Barcelona. He lived in Paris 1950–1 on a French goverment scholarship and has often returned there, but Barcelona has remained the centre of his activities. His early works were in a *Surrealist vein, influenced by *Klee and *Miró, but in about 1953, after turning to abstraction, he began working in *mixed media, in which he has made his most original contribution to art. He incorporated clay and marble dust in his paint and used discarded materials such as paper, string, and rags (*Grey and Green Painting*, Tate Gallery, London, 1957). By the end of the 1950s he had an international reputation; in 1958, for example, he won first prize for painting at the *Carnegie International in Pittsburgh and the Unesco and David E. Bright prizes at the Venice *Biennale. From about 1970 (influenced by *Pop art) he began incorporating more substantial objects into his paintings, such as parts of furniture. He explained his belief in the validity of commonplace materials in his essay *Nothing is Mean* (1979). Tàpies has travelled extensively and his ideas have had worldwide influence. Apart from paintings, he has also made sculpture, etchings, and lithographs. There are examples of his work in many major collections.

Tappert, Georg. See MORGNER.

Tarbell, Edmund C. See TEN.

Target Exhibition. Exhibition organized in Moscow by *Goncharova, *Larionov, and *Malevich in March 1913 at which *Rayonism was launched. Malevich also showed paintings in his *Cubo-Futurist style.

Tarsila do Amaral. See AMARAL.

Tate Gallery, London. The national collection of British art from the mid-16th century onwards and of modern art from the late 19th century to the present day. It is named after Sir Henry Tate (1819–99), the sugar tycoon, who in 1889 offered the nation his collection, consisting mainly of the work of Victorian contemporaries, on condition that the government found a suitable site for the gallery. Following great controversy over where it should be located, the Tate Gallery opened at Millbank, overlooking the Thames, in 1897, on a site previously occupied by part of Millbank Prison. The building is an undistinguished classical structure designed by Sidney R. J. Smith, an architect who is otherwise virtually unknown. It originally had eight galleries and housed Tate's gift of 67 paintings and three bronze sculptures, together with about 100 other works, including 18 of his own paintings presented by George Frederic Watts (1817–1904), the Grand Old Man of British art.

At the time of its opening, the Tate was not

the independent gallery that had been envisaged by its founder. It was subordinate to the National Gallery and was intended only for recent British art (its official title was the National Gallery of British Art, although it was referred to as the Tate Gallery from the beginning and this name was formalized in 1932). Complete independence from the National Gallery did not come until 1954, but the Tate was given its own board of trustees in 1917, by which time it had begun to take on its dual character of historical British collection and general modern collection. Two key developments in this respect were, first, the opening of a wing in 1910 to accommodate most of the paintings left by J. M. W. Turner in his studio at his death (1851), which had previously been housed (but in the main unexhibited) at the National Gallery; and secondly, the deliberations of the Curzon Committee (chaired by Lord Curzon), set up in 1911 to enquire into various matters concerned with the nation's art collections. The Committee published its report in 1915, and two of its recommendations were that the Tate should extend its coverage to become 'a National Gallery of British Art in all its branches' and that a gallery of modern foreign art should be added on vacant land behind the Tate. Caution was expressed, however, over what kind of modern art should be displayed there: 'We have not in our mind any idea of experimentalising by rash purchase in the occasionally ill-disciplined productions of some contemporaneous continental schools, whose work might exercise a disturbing and even deleterious influence upon our younger painters.'

The Curzon Committee's report happily coincided with Sir Hugh *Lane's bequest of 39 modern paintings, mainly French, including outstanding *Impressionist works. Lane's collection went on show at the Tate in 1917 and made a powerful impact on Samuel *Courtauld, who in 1923 gave the Tate £50,000 for the purchase of Impressionist and *Post-Impressionist pictures. Thanks to Lane and Courtauld, the Tate had an excellent representation in this field by the time the new galleries for the display of modern foreign art opened in 1926 (they were paid for by the picture dealer Sir Joseph Duveen (1869–1939), later Lord Duveen of Millbank). The first significant influx of 20th-century art came in 1933, with the bequest of the Dutch-born collector Frank Stoop, which included works by *Braque, *Cézanne, *Matisse, *Modigliani,

*Picasso, and *Rousseau. However, Stoop's taste was generally confined to the period before the First World War, and when an abstract by *Kandinsky (*Cossacks*, 1910–11) was presented to the Tate in 1938 (by Hazel McKinley, Peggy *Guggenheim's sister), Kandinsky remarked that it was 'the first truly modern painting in the famous museum in London'. (It was also the first German *Expressionist painting to enter a public collection in Britain.)

During the Second World War the Tate concentrated on building up the British collections (an understandable policy at a time of patriotic fervour and when the country was isolated from the Continent), and it was not until 1949 that a really positive attitude towards acquiring modern foreign works began to emerge. In that year the gallery bought two *Cubist Picassos, a *Léger, a *Matisse, a *Rouault, and two paintings and a sculpture by *Giacometti (a sculpture gallery had been added in 1937, paid for by Lord Duveen). During the 1950s the Tate started venturing into post-war art—first mainly *École de Paris, later American—and at the same time many of the finest 19th-century paintings were moved in stages to the National Gallery. In 1958 the Friends of the Tate Gallery was founded to raise funds to help with the purchase of works, and from about this time there began a sustained attempt to build up a modern collection that was representative of the range and variety of modern art, containing as far as possible works from all the major movements and leading artists (during the 1960s, 20th-century British works were absorbed into the modern collection, taking their place in an international context).

Considering its limited funds in a time of rocketing prices for art, the Tate has succeeded well in its aim of broad coverage, although many other museums have richer collections in specific areas. Nevertheless, the gallery has often been attacked for purchasing works that are outside (or ahead of) public taste. The most famous example is the outcry in 1976 over Carl *Andre's 'Tate bricks', but this was preceded by anger and abuse directed at works that have now taken their places in the pantheon of 20th-century art, notably Matisse's *L'Escargot* (bought in 1962) and Picasso's *The Three Dancers* (bought in 1965). In addition to purchases, the Tate's holdings have been enhanced by several outstanding bequests from collectors and artists:

in 1968–9, for example, Mark *Rothko presented nine of his paintings, and in 1977 Naum *Gabo gave a large collection of his work in various media.

In 1974 the Tate established a Print Department (before this, the British Museum and the Victoria and Albert Museum had more or less divided the national responsibility for collecting prints). The core of the collection was presented by the Institute of Contemporary Prints, a charitable trust set up in 1972 under the chairmanship of Alistair McAlpine, who had already been a generous benefactor to the Tate (see NEW GENERATION). Among the other departments of the Tate are the Archive and the Library—major resources for scholarship in 20th-century art. The enormous postwar growth in the size of the gallery's collections and the scope of its activities has posed severe problems of space, in spite of several extensions to the building. In 1988 a branch of the Tate was opened in Liverpool and in 1993 another one in *St Ives, but most of the gallery's holdings still remained in storage. In 1994 the Trustees therefore announced a bold decision to create a new museum—the Tate Gallery of Modern Art—in the decommissioned Bankside Power Station, a huge, starkly magnificent building occupying a prime site on the Thames opposite St Paul's Cathedral. It was designed by Sir Giles Gilbert Scott and built in 1947–63; the remodelling into a gallery has been entrusted by the Swiss architects Jacques Herzog and Pierre de Meuron. The building is scheduled to open to the public in the year 2000, with the original gallery at Millbank then becoming the Tate Gallery of British Art.

The first keeper of the Tate Gallery, 1897–1906, was Sir Charles Holroyd (1861–1917), a painter, etcher (he was a favourite pupil of *Legros), and writer on art. He left to become director of the National Gallery and was succeeded at the Tate by D. S. *MacColl, keeper from 1906 until 1911, when he moved to the Wallace Collection. The next keeper (who during his tenure, 1911–30, assumed the title of director) was Charles *Aitken, previously in charge of the *Whitechapel Art Gallery. He was succeeded as director by J.B. *Manson, 1930–8; Sir John *Rothenstein, 1938–64; Sir Norman *Reid, 1964–79; Sir Alan *Bowness, 1980–8; and Nicholas Serota (1946–), appointed in 1988; previously Serota had been director successively of the *Museum of Modern Art, Oxford, and the Whitechapel Art Gallery.

Tatlin, Vladimir (1885–1953). Russian painter, designer, and maker of abstract constructions, the founder of *Constructivism. He was born in Kharkov in the Ukraine, the son of a railway engineer. His mother, a poet, died when he was 2 and he had an unhappy childhood, disliking his father—a stern disciplinarian—as well as his stepmother. These circumstances left him with a distrustful nature and he was later constantly suspicious of rivals such as *Malevich. Tatlin's training was somewhat sporadic, and for some years he combined art with occasional voyages as a merchant seaman to earn his living; many of his early pictures are of maritime subjects, notably *The Sailor* (Russian Museum, St Petersburg, 1911–12), which is a self-portrait. His main period of study was at the art school in Penza, 1904–10, after which he enrolled at the Moscow School of Painting, Sculpture, and Architecture. From this time he exhibited in several avant-garde exhibitions, experimenting with a number of styles, and he was closely associated with *Goncharova and *Larionov.

In 1914 (not 1913 as long believed) Tatlin visited Berlin and Paris. He haunted *Picasso's studio and on his return to Russia began making a series of abstract *Painted Reliefs*, *Relief Constructions*, and *Corner Reliefs* inspired by Picasso's sculptural experiments. Very few of these revolutionary works survive, most being known only from photographs. He used a variety of materials—tin, glass, wood, plaster, etc., and Camilla Grey writes: 'For the first time in Tatlin's constructions we find real space introduced as a pictorial factor; for the first time inter-relationships of a number of different materials were examined and co-ordinated' (*The Great Experiment: Russian Art 1863–1922*, 1962). After the October Revolution of 1917, Tatlin's constructions made from 'real materials in real space' were felt to be in accordance with the new 'culture of materials' and he threw himself wholeheartedly into the demand for socially oriented art, declaring: 'The events of 1917 in the social field were already brought about in our art in 1914, when material, volume and construction were laid as its basis.' He became one of the most prominent figures in the art world and in 1918 he was made director of the Moscow section of IZO *Narkompros. In 1919 he was commissioned to design the Monument to the Third International (the organization set up by the Bolsheviks to co-ordinate

the activities of Communist movements throughout the world). The huge monument—in the form of a leaning, openwork, spiral tower—was intended for a position in the centre of Moscow; it was to be in glass and iron, and parts of it were to revolve. It was intended to be both functional and symbolic, housing various offices of the revolutionary government and including such features as an immense projector for throwing propaganda images onto clouds. Tatlin described it as 'A union of purely plastic forms (painting, sculpture and architecture) for a utilitarian purpose'. A model was exhibited in December 1920 at the exhibition of the VIIIth Congress of the Soviets. *Gabo condemned the design as impracticable and it was never executed (it was intended to be much bigger than the Eiffel Tower), but it is recognized as the outstanding symbol of Soviet Constructivism. (The original model has been destroyed, but there is a reconstruction in the Moderna Museet, Stockholm.)

The Monument to the Third International was the culmination of Tatlin's career, and the rest of it is something of an anticlimax. He continued to be active in teaching and administration, and his own work was mainly in the field of applied art, designing furniture, workers' clothes, etc. In the late 1920s and early 1930s he devoted his energies to designing a human-powered flying machine that was a combination of bicycle and glider; he called it Letatlin (a compound of his name and the Russian verb 'to fly'). In the early 1930s he took up painting again, working in a fairly conventional style, but his main activity from this time was theatre design. His later years were spent in lonely obscurity, and there has even been some suspicion that he lived for several years after his official death date.

Tchelitchew, Pavel (1898–1957). Russian-born painter and stage designer who became an American citizen in 1952. He was born at Kaluga into an aristocratic family. In 1918, following the Revolution, the family fled to Kiev, where he studied at the Academy and was encouraged by *Exter. His work at this time was abstract, in a *Constructivist vein. In 1921–3 he lived in Berlin, working mainly as a theatrical designer, then settled in Paris from 1923 to 1934. He soon abandoned abstraction, but throughout his life he was a ceaseless experimenter and his style changed restlessly.

During his Paris years he continued to build his reputation as a stage designer (he worked for *Diaghilev and the Russian-born choreographer George Balanchine among others), and he also became one of the leading exponents of *Neo-Romanticism in painting. His subjects included landscapes, portraits, and figure compositions (among them circus scenes recalling *Picasso's work in his Blue period). Some of his paintings were fairly naturalistic, but others used multiple images and violent distortions of perspective. His friends in Paris included Gertrude *Stein and through her he met the English writer Geoffrey Gorer, who helped to arrange Tchelitchew's first one-man exhibition, at the Claridge Gallery, London, in 1928. He painted a portrait of Gorer's mother (*Mrs R. A. Gorer*, Tate Gallery, London, 1930) and the poet Edith *Sitwell was among his other sitters. Sitwell fell in love with Tchelitchew, but her passion was thwarted because he was homosexual; however, they became great friends and she helped to promote his career. In 1934 Tchelitchew settled in New York, but he continued to spend the summers in Europe until the outbreak of the Second World War. In America he was again in demand as a stage designer, but he grew tired of this kind of work and gave it up in 1942 to concentrate on painting, in which he continued to try out new styles and approaches. The best-known picture of his American period is probably *Hide and Seek* (MOMA, New York, 1942), a *Surrealist-like work in which strangely coloured children's heads weirdly metamorphose into vegetable forms (such subjects reflect something of his belief in the occult—he thought he possessed magical powers). From 1949 he lived mainly in Italy and he died at Grottaferrata, near Rome. By this time he was an international celebrity.

Ten, The (more formally, Ten American Painters). A group of well-established American painters from Boston and New York who exhibited together from 1898 to 1919 after resigning from the Society of American Artists, whose exhibitions they considered too conservative and too large. Most of the members of the group had studied in Paris in the 1880s and the common factor in their work was an interest in *Impressionism. They were Frank W. Benson (1862–1951); Joseph R. De Camp (1858–1923); Thomas W. Dewing (1851–1938); Childe *Hassam; Willard L.

Metcalf (1858–1925); Robert Reid (1862–1929); Edward E. Simmons (1852–1931). Edmund C. Tarbell (1862–1938); John H. Twachtman (1853–1902); and Julian Alden Weir (1852–1919). After the death of Twachtman his place was taken by W. M. *Chase. Between 1898 and 1917 the group held twenty annual exhibitions in New York (at various galleries) and these were sometimes shown in other cities; a final exhibition was shown in Washington in 1919. The early exhibitions were generally well received, but by the time the group broke up the prevailing feeling in the press was that the painters had gone somewhat stale. The death of Chase in 1916 was probably also a factor in deciding to discontinue the exhibitions, as was the advancing age of the members. Although their art was not particularly radical, they were important in the context of modern art in helping to establish a tradition of setting up exhibiting organizations independent of official bodies, foreshadowing such ventures as The *Eight and the *Armory Show.

The Ten was also the name of a group of American *Expressionist painters who exhibited together from 1935 to 1939. *Gottlieb and *Rothko were the best-known members. Most were figurative painters, but a few were members of *American Abstract Artists.

Tenison, Nell. See CUNEO.

Tériade (pseudonym of Efstratios Eleftheriades) (1897–1983). Greek critic, editor, and publisher, active in France. In 1915 he moved to Paris to study law, but he turned to art, working for *Cahiers d'art, founded by his countryman Christian Zervos, and then from 1933 to 1936 serving as artistic director on Albert *Skira's *Minotaure, a journal that became famous for its superb production values. He worked on other publishing projects for Skira, and in 1937 founded the bilingual (French and English) review Verve, which continued until 1960 (38 numbers appearing irregularly, with publication suspended in 1940–3). This covered a wide range of artistic and literary subjects, with a good deal of material on contemporary French art, and it was opulently produced, becoming famous for its high-quality colour illustrations. Its success enabled Tériade to set up a publishing company called Éditions Verve, whose output included 26 *livres d'artistes (among them three by *Chagall that had been commis-

sioned by *Vollard but left unfinished at his death in 1939). Éditions Verve's other publications included albums of photographs by Henri Cartier-Bresson (1908–), revered as one of the greatest of all photographers (he is also a painter and draughtsman). Tériade wrote a book on *Léger (1928) as well as art criticism that was published in various journals. An exhibition devoted to him was held at the Grand Palais, Paris, in 1973.

TGP. See TALLER DE GRÁFICA POPULAR.

Tharrats, Joan Josep (1918–). Spanish painter and art critic, born at Gerona. In 1948 he was a founder member of the association *Dau al Set in Barcelona and he was responsible for the designing and printing of its magazine of the same name. He also worked as an art critic for the Barcelona newspaper Revista. Tharrats took up painting in about 1950 with imaginary landscapes that had affinities with *Metaphysical Painting. In about 1956, however, he turned to expressive abstraction and developed a richly colourful manner of *Art Informel, describing his paintings as maculaturas ('smudges').

Thayer, Abbott Handerson (1849–1921). American painter and naturalist. He was born in Boston and trained in New York and Paris. In 1879 he returned to New York, where he became one of the most successful figure painters of the day. Matthew Baigell (Dictionary of American Art, 1979) writes that 'He was the arch-idealist of his time, creating from about 1890 on a series of images of angels and Madonnas—generalized religious imagery featuring young women in flowing robes, often virginal white. Thayer strove for the generalized and timeless, but somehow his young women remain very much of their period and nationality. Theirs is a distinctly American female beauty, yet strangely sexless.' In similar vein, James Flexner (The Pocket History of American Painting, 1950) writes that Thayer 'specialized in glorifying The American Girl. With little wings, she was a fairy; with big wings, an angel; nude, she was The Spirit of the Water Lily; dressed, Virginity.' Baigell considers that Thayer's paintings are 'among the most dated of his period', but there is much to admire in his graceful drawing and fluid brushwork (somewhat in the manner of *Sargent) and his work has recently undergone something of a revival,

being reproduced on greetings cards and similar merchandise. In 1901 Thayer settled in Dublin, New Hampshire, where he became a semi-recluse, painting landscapes and immersing himself in the study of natural history, particularly animal camouflage. He had published an article on this subject in 1897 ('The Law which Underlies Protective Coloration' in the *Annual Report* of the Smithsonian Institution), and with his son Gerald Handerson Thayer he wrote the book *Concealing Coloration in the Animal Kingdom* (1909, new edn., 1918). His ideas were soon adapted to military use, and Thayer spent part of the First World War in England giving advice on their implementation. (It was at this time that the word 'camouflage' came into use; the earliest citation of the word in the *Oxford English Dictionary* is from 1917.)

Thek, Paul. See FUNK ART.

Theophilos (Theophilos Hadjimichalis) (*c.* 1870–1934). Greek *naive painter, the most famous produced by his country. He was born at Varia, near Mytilene, on the island of Lesbos, and earned his living as an itinerant craftsman, travelling from village to village decorating shops and houses. His subjects were mainly from ancient Greek history, the War of Independence against Turkey, and idealized representations of Greek soldiers, peasant women, etc. He was 'discovered' in 1929 in consequence of the vogue for naive painting, which was then at its height, and thereafter he worked on panel paintings rather than popular murals (most of which have been destroyed). In the 1930s he was exalted as a model of authentic Greekness and the first monograph was published on him in 1939. His countryman *Tériade promoted him in Paris as a Greek equivalent of Henri *Rousseau. Several substantial exhibitions have been dedicated to Theophilos (Athens, 1947; Berne, 1960; Paris, 1961) and a museum of his work opened at his birthplace in 1965.

Theosophy. See ABSTRACT ART.

Thesleff, Ellen. See SEPTEM.

Thiebaud, Wayne (1920–). American painter, born at Mesa, Arizona. From 1938 to 1949 he worked as a cartoonist and advertisement designer in New York and Hollywood, with an interval for service in the US Army Air Force, 1942–6. He then studied at Sacramento State College, graduating in 1951, before teaching in the Art Department of Sacramento City College (1951–9) and subsequently as professor of art in the University of California at Davis. In 1961 he began painting the kind of picture for which he is best known: still-lifes of cafeteria foodstuffs—cakes, pies, pastries, ice-cream cones, etc.—depicted against an empty background, emphasizing by monotonous repetition their synthetic, assembly-line character. They have the bright colours, strong outlines, and well-defined shadows of advertisement and poster art, bringing them within the orbit of *Pop art, but Thiebaud uses thick, juicy paint that distinguishes him from most other Pop artists. In 1963 he began painting figures in a similar vein of mass-produced anonymity.

Thoma, Hans (1839–1924). German painter and administrator. Early in his career he specialized in landscapes—mainly scenes from his native Black Forest—and these are now considered his best works. Later he turned to figurative subjects, including Wagnerian themes; these won him an immense reputation in his day, but are now considered rather ponderous. From 1876 to 1899 he lived in Frankfurt, but he was a member of the Munich *Sezession. In 1899 he moved to Karlsruhe to become director of the Kunsthalle, which has the largest collection of his work. By this time he was one of the most famous of German artists, and in his later years he was showered with honours. He published two autobiographical books (1909 and 1919).

Thomas, Grosvenor. See GLASGOW BOYS.

Thomé, Verner. See SEPTEM.

Thomson, Tom (1877–1917). Canadian landscape painter, one of the main creators of an indigenous Canadian school of painting. He was born in Claremont, Ontario, and in 1904 settled in Toronto, where he spent most of his career as a commercial artist. Encouraged by J. E. H. *MacDonald and others, he began to paint seriously in about 1907, but it was only in 1914 that he was able to devote himself to art full time. He did much of his painting out of doors, notably a series of fluently spontaneous oil sketches he produced in Algonquin Provincial Park, a huge wilderness park

(covering almost 3,000 square miles) north-east of Toronto (during the summer months he combined his painting with working there as a fireranger and guide). Among his more formal paintings, the most famous is the bold and brilliantly coloured *Jack Pine* (NG, Ottawa, 1917), which has become virtually a national symbol of Canada. Thomson's career ended tragically when he was mysteriously drowned in Algonquin Park, but his ideals were contin-ued by the artists who formed the *Group of Seven, to whom he was an inspiration (he knew most of them well). His death was prob-ably an accident, but the uncertainty sur-rounding it helped to establish him as a legendary figure in Canadian art.

Thorak, Josef. See NATIONAL SOCIALIST ART.

Thorláksson, Thórarinn B. (1867–1924). Ice-landic painter, a pioneering figure in his country's art. He had been interested in draw-ing since childhood and in 1885 he gave up his career as a bookbinder to devote himself to art. There being nowhere to train in Iceland, he went to Copenhagen and studied first at the Academy and then at a private school. On his return to Iceland in 1900 he had a one-man show in Reykjavik—the first exhibition by an Icelandic artist ever to be held in Ice-land. For the rest of his life he was the leading spirit in Icelandic art, notably in helping to found the Listvinafélag (Friends of Art Society), which was established in Reykjavik in 1916 and built the country's first exhib-ition hall, the Listvinahús. His work included portraits, interiors, and moody, almost mys-tical views of the Icelandic landscape, imbued with national feeling (Iceland was at this time struggling for independence from Denmark). He exerted a great influence on the next generation of Icelandic painters, including Ásgrímur Jónsson (1876–1958), Jóhannes Kjarval (1885–1972), and Jón Stefánsson (1881–1963). His work is well represented in the National Gallery of Iceland, Reykjavik.

Thorn Prikker, Johan (1868–1932). Dutch painter and designer, born in The Hague, where he studied at the Academy of Fine Arts, 1883–7. Early in his career he passed through phases of *Impressionism and *Neo-Impres-sionism, then changed to an elaborate linear style with which he became a leading expon-ent of *Symbolism and *Art Nouveau, as in his most famous painting—the mystical, exotic

The Bride (Kröller-Müller Museum, Otterlo, 1893). From 1895 he concentrated on the design of mosaics, murals, and stained glass, mainly for churches, continuing in this vein after he settled in Germany in 1904. He taught at several art schools in Germany and was a major force in the development of modern religious art. His masterpiece is perhaps the cycle of windows in the Romanesque church of St George in Cologne, completed in 1930. The American stained-glass artist Robert Sow-ers comments that here 'lead lines are used with a graphic eloquence and deep smoulder-ing colours with a monumental gravity that have no parallel even in the greatest medieval windows'.

Thornton, Wallace. See SYDNEY GROUP.

Thornycroft, Sir Hamo (1850–1925). British sculptor, one of the leading exponents of the *New Sculpture. Early in his career he concen-trated on idealized figures in which he expressed a 'poetic mood' praised by the critic Edmund *Gosse; the best-known example is probably *The Mower* (Walker Art Gallery, Liver-pool, 1884; there are also several small-scale versions). From the 1890s, however, he was increasingly preoccupied with portrait sculp-ture and above all public monuments, becom-ing perhaps the most distinguished British practitioner in this field in the early 20th cen-tury. His statues, dignified and thoughtful in tone, include those of Oliver Cromwell out-side the Houses of Parliament, London (unveiled 1899), Alfred the Great in Winches-ter (1901), Gladstone in the Strand, London (1905), Lord Armstrong in Newcastle upon Tyne (1906), Lord Curzon in Calcutta (1912), and Edward VII in Karachi (1915). These are all in bronze, but he also worked in stone. Thornycroft taught at the *Royal Academy Schools from 1882 to 1914. He was knighted in 1917 and in 1923 he was awarded the gold medal of the Royal Society of British Sculptors for his services to art.

 Both his father, Thomas Thornycroft (1815–85), and his mother, Mary Thornycroft (1814–95), were sculptors. They were primar-ily portraitists, but Thomas is now chiefly remembered for his dramatic Boadicea mon-ument at Westminster Bridge, London, show-ing the fearsome warrior queen in her chariot. He began work on the group in 1856 and was encouraged by Prince Albert, who lent him horses as models. The plaster model

was complete at Thornycroft's death, but it was not cast in bronze until 1897, after his son had presented it to the nation, and it was finally erected in 1902.

391. A *Dada periodical founded by *Picabia in Barcelona in 1917; subsequent issues were published in New York, Lausanne, Zurich, and Paris until 1924. The name was meant to recall *Stieglitz's short-lived periodical 291, to which Picabia had contributed. Although 391 was mainly literary in content, it also featured visual material. Issue no. 12 (March 1920) contained one of Picabia's best-known iconoclastic statements—a large inkblot labelled 'La Sainte Vierge'.

Throbbing Gristle. See P-ORRIDGE.

Tibble, Geoffrey. See OBJECTIVE ABSTRACTIONISTS.

Tiffany, Louis Comfort (1848–1933). American designer, interior decorator, and architect, his country's most famous exponent of the *Art Nouveau style. He was born in New York, the son of a prosperous jeweller, and spent virtually all his career there. His initial training was as a painter, but in the 1870s he turned more to the decorative arts and founded an interior decorating business in 1879. Tiffany became famous above all for his highly distinctive glass vases and lamps, but until about 1900 his firm was better known for stained glass and mosaic work (it did interiors for many socially prominent New Yorkers as well as for clubs). Most of his architectural work, including his own mansion on Long Island, has been destroyed, but the loggia of the main entrance of his masterpiece, Laurelton Hall (1903–5), has been installed in the Metropolitan Museum, New York. Tiffany was also an art patron and established a foundation that provided study and travel grants for students.

Tihanyi, Lajos. See ACTIVISTS.

Tilson, Joe (1928–). British painter, sculptor, and printmaker, born in London. After working as a carpenter and cabinet-maker, 1944–6, and serving with the RAF, 1946–9, he studied at *St Martin's School of Art, 1949–52, and at the *Royal College of Art, 1952–5. He won the Rome Prize in 1955 and spent three years in Italy and Spain, then taught at St Martin's,

1968–63 (he has also been guest lecturer at various universities in Britain and abroad). In the 1960s Tilson was associated with *Pop art, his most chartacteristic works being brightly coloured wooden reliefs that included words or lettering among the pictorial symbols (9 Elements, NG of Modern Art, Edinburgh, 1963). Later Tilson's work became broader in range and more subjective in treatment. An inventive graphic artist, he has worked in various printmaking techniques, including etching, screenprinting, and woodcut.

Tinguely, Jean (1925–91). Swiss sculptor and experimental artist. He was born in Fribourg and studied at the Basle School of Fine Arts, 1941–5. In 1952 he settled in Paris, then after a year in Düsseldorf moved to New York in 1960. Tinguely's work was concerned mainly with movement and the machine, satirizing technological civilization. His boisterous humour was most fully demonstrated in his *Auto-destructive works, which turned *Kinetic art into *Performance art. The most famous was Homage to New York, presented at the Museum of Modern Art, New York, on 17 March 1960. The object on which the work was based was constructed of an old piano and other junk; it failed to destroy itself as programmed and caused a fire. Tinguely was an innovator not only in his combination of Kineticism with *Junk sculpture, but also in the impetus he gave to the idea of spectator participation, as in his Cyclograveur, in which the spectator mounts a saddle and pedals a bicycle, causing a steel nail to strike against a vertically mounted flat surface, and the Rotozazas, in which the spectator plays ball with a machine. Such works have been interpreted as ironic ridicule of the practical functions of machines. Tinguely's most famous work is somewhat more traditional—the exuberant Beaubourg Fountain (1980) outside the *Pompidou Centre, Paris, done in collaboration with Niki de *Saint Phalle; it features fantastic mechanical birds and beasts that spout water in all directions.

Tobey, Mark (1890–1976). American painter and draughtsman, born in Centerville, Wisconsin. Apart from a few lessons at the Art Institute of Chicago, he had no formal training in art. From 1911 he divided his time for several years between New York and Chicago, working as a fashion illustrator, interior decorator, and portrait draughtsman. In 1918

he became a convert to the Baha'i faith and much of his subsequent work was inspired by an interest in Oriental art and thought. From 1922 to 1930 he lived mainly in Seattle (apart from a period in Europe, 1925–6) and from 1931 to 1938 he was artist-in-residence at Dartington Hall, a progressive school in Devon, England. During this period he also travelled extensively, notably to China, where he spent a month in a Zen monastery in 1934. From 1938 to 1960 he lived in Seattle again, then settled in Basle, Switzerland, where he died.

Following his visit to the Far East in 1934–5, Tobey developed a distinctive style of painting that he called 'white writing', characterized by calligraphic white patterns overlying dimly discerned suggestions of colour beneath. Although he painted representational pictures in the style, he turned increasingly to abstractions (*Northwest Drift*, Tate Gallery, London, 1958). Their '*all-over*' manner anticipated and perhaps influenced Jackson *Pollock, but unlike *Action painters, Tobey believed that 'painting should come through the avenues of meditation rather than the canals of action'. After the Second World War he built up an international reputation. Unusually for an American painter, he was more highly esteemed abroad than in his own country, and he was influential on French *Tachisme in the 1950s. He won the City of Venice painting prize at the 1958 Venice *Biennale and the first prize for painting at the 1961 *Carnegie International.

Toft, Albert. See NEW SCULPTURE.

Toklas, Alice B. See STEIN.

Tomkins, Calvin (1925–). American writer and editor who has had a distinguished career in art journalism. He was born in Orange, New Jersey, and studied at Princeton University, graduating in 1948. From 1955 to 1959 he worked at *Newsweek* magazine, and in 1960 became staff writer at the *New Yorker*. His first book was *The Bride and the Bachelors* (1965), a collection of profiles that features *Cage, *Duchamp, *Rauschenberg, and *Tinguely. He became friendly with Duchamp whilst interviewing him and in 1966 published *The World of Marcel Duchamp*, in the Time-Life Library of Art series, the best popular account of the artist. His other books include *Merchants and Masterpieces: The Story of the Metropol-*

itan Museum of Art (1970), *Living Well is the Best Revenge* (1971) (about Gerald *Murphy), *Off the Wall: The Art World of Our Time* (1980), *Post- to Neo-* (1988), and *Duchamp* (1997).

Tomlin, Bradley Walker (1899–1953). American painter. He was born in Syracuse, New York, and studied at Syracuse University, 1917–21. In 1922 he moved to New York City and for the next ten years earned his living mainly as a commercial artist. During this time he made three journeys to Europe: 1923–4, 1926–7, and 1928. The Depression affected his commercial work, so he turned to teaching (at various schools) from 1932 to 1941. In his early work he experimented with a variety of styles, but he destroyed many paintings in the 1930s when he began to question himself as an artist. In the late 1930s he began to find a more individual path with semi-abstract still-lifes that blend elements of *Cubism and *Surrealism (*Still-Life*, Whitney Museum, New York, 1939). By 1947 his work had become completely abstract and in the last years of his life he developed into one of the minor masters of *Abstract Expressionism. His paintings of this time characteristically feature a rich but coolly coloured *all-over pattern of cryptic dashes, dots, and crosses (*Number 9: In Praise of Gertrude Stein*, MOMA, New York, 1951).

Tonalism. A trend in American painting, *c*. 1880–*c*. 1910, in which subjects (particularly landscapes) were treated in a muted, romantic, idealized manner akin to the type of soft-focus, impressionistic style of photography known as Pictorialism (or Pictorial photography) that was popular at the same time. The term 'tonalism' (or 'tonalist') was evidently first used in print by the painter Samuel Isham (1855–1914) in his book *The History of American Painting* (1905), but it did not really catch on until it was used by the art historian Wanda Corn in the title of an exhibition at the M. H. de Young Memorial Museum, San Francisco, in 1972: 'The Color of Mood: American Tonalism, 1880–1910' (earlier the term 'Quietism' had sometimes been used to describe the trend). Corn described Tonalism as 'a style of intimacy and expressiveness, interpreting very specific themes in limited color scales and employing delicate effects of light to create vague, suggestive moods'. In its use of soft brushwork and blurred outlines, Tonalism was related to *Impressionism,

which developed at more or less the same time in the USA, but the Tonalists can be distinguished from the Impressionists because of their preference for subdued colouring and for creating a mood of mystery or poetic reverie (scenes were often depicted at dusk or in mist, rather than in the clear daylight chiefly associated with the Impressionists). The painters who are considered to typify Tonalism include Thomas Dewing (see TEN), who specialized in interiors rather than in landscapes, George Innes (1825–94), probably the most famous American landscapist of his generation, and Dwight Tryon (1849–1925). *Whistler, too, is sometimes embraced by the term, although he spent most of his career in Europe

Tonks, Henry (1862–1937). British painter, draughtsman, and teacher, born in Solihull, Warwickshire. Tonks trained as a doctor and rose to the position of senior resident medical officer at the Royal Free Hospital in London. He had been interested in art since childhood, however, and in 1888 (the year in which he became a Fellow of the Royal College of Surgeons) he began attending evening classes at Westminster School of Art under Fred *Brown. When Brown was appointed professor at the *Slade School in 1892 he invited Tonks to become his assistant, and in 1893 he abandoned his successful medical career for the more precarious life of an artist and art teacher. (However, he worked as a plastic surgeon during the First World War.) Tonks remained at the Slade until 1930, succeeding Brown as professor in 1918, and became the most renowned and formidable teacher of his generation—'in appearance tall, gaunt, and severe' (*DNB*). Under him the Slade maintained its position as the dominant art school in Britain (although it was now challenged by the *Royal College of Art), and he was a major influence as an upholder of traditional values and an opponent of modern ideas: 'I don't believe I really like any modern development.' He set high standards for his pupils, particularly in draughtsmanship (his own forte) and he got on well with them, in spite of being notorious for his sarcasm and abruptness. The duality in his nature came out in other ways, too: he was secretive, touchy, suspicious, and resentful of criticism, but capable of close friendships, as, for example, with his fellow-teacher *Steer. Sir John *Rothenstein writes that 'To students whom he considered

to be of promise . . . his kindness was proverbial, although his ability to distinguish great talent from promise was far from unerring. He recognized the genius of Augustus *John with reluctance, while the modest geese whom he acclaimed as swans were many.' Because of his refusal to move with the times he was increasingly looked on as a back number by more progressive artists and students, but he remained a dominant presence in the art world and is mentioned in virtually all artists' memoirs of the period.

Tonks's own paintings are mainly figure subjects, often consciously (or self-consciously) poetic in spirit: 'A painter who is not a poet ought to be put in the stocks.' Rothenstein refers to 'the sheer prettiness of much of his art', but his pictures often look rather laborious, partly because of his technique of 'Tonking', which involved using an absorbent material to soak excess oil from the canvas after each day's work and so produce a dry surface for the next session. His best-known work is probably the conversation piece *Saturday Night in The Vale* (Tate Gallery, London, 1928–9), which shows George *Moore reading aloud to a gathering at Tonks's studio in The Vale, Chelsea. Moore complained that he had been made to look like a 'flabby old cook', whereas Tonks had depicted himself as a young and elegant 'demi-god'.

Tooker, George (1920–). American painter, born in Brooklyn, New York. After graduating in literature from Harvard University in 1942, he served in the US Marines, then studied at the *Art Students League, 1943–4. His teachers there included Reginald *Marsh, and it was from him and Paul *Cadmus (with whom he studied privately) that he acquired his preference for painting in egg tempera. His technique is scrupulously detailed in the manner of the Old Masters, but his subjects express the spiritual desolation and debilitating uniformity of modern life. The figures in his paintings all look more or less like one another and go through life as if on a conveyer belt, tense and drained of energy. They are physically close to one another, but emotionally distant. *Subway* (Whitney Museum, New York, 1950) is perhaps his most famous work—a terrifying vision of Kafkaesque isolation.

Toorop, Jan (1858–1928). Dutch painter, graphic artist, and designer. He was born in

as well as Germany, Italy, and the Soviet Union; Socialist Realism spread to China in the 1950s (see XU BEIHONG). Golomstock writes that 'The ceremonial portrait of the leader (in painting and in monumental sculpture) occupied the most important position in the hierarchy of genres of totalitarian art. The majority of the most important State prizes were awarded to works in this genre, and it was their creators who filled the key positions in artistic life and constituted the artistic establishment of their countries . . . The second most important genre of totalitarian art—the "historico-revolutionary theme" or "historical painting"—was also devoted primarily to portrayals of the leaders, this time as "creators of history" leading the revolutionary masses . . . the religious nature of these paintings is made apparent not so much by their titles as by their use of the compositional schemes characteristic of Christian iconography. The numerous paintings of meetings between the leaders and various sections of the population, for example, remind one of paintings of "The Appearance of Christ to the People" . . . the tendency to deify the leader . . . is an important characteristic of all totalitarian art . . . Although totalitarian art included many representations of the happy life of the people and their devoted labour, this genre occupied a considerably less important place in the artistic hierarchy. Labour . . . was always portrayed either as a fierce struggle or a joyful festival . . . The most neglected genres in totalitarian art were landscape and still-life. Even a landscape, however, was always treated in one of two ways: either as an image of the Fatherland, intended to inspire people with love for their country, or as an arena for social transformations—the so-called "industrial landscape".'

Toulouse-Lautrec, Henri de. See ANQUETIN and CONDER.

Toupin, Fernand. See PLASTICIENS.

Tousignant, Claude (1932–). Canadian abstract painter, born in Montreal. From 1948 to 1951 he studied at the Montreal Museum of Fine Arts School, where he was introduced to geometrical abstraction. In 1952 he went to Paris, but he was not impressed by current French painting and returned to Canada the following year. Tousignant's work is rigorously abstract and concerned primarily with colour: 'What I wish to do is to make painting objective, to bring it back to its source—where only painting remains, emptied of all extraneous matter—to the point at which painting is pure sensation.' His most characteristic works of the 1950s employed clear, intense colours laid on in long, closely-packed, asparagus-like forms. In 1959, with three other Montreal painters, he founded the group *Nouveau Plasticiens, whose work tended towards *Hard-Edge abstraction. On a visit to New York in 1962 he was impressed by the work of Barnett *Newman and in pursuit of his aim 'to say as much as possible with as few elements as possible' he adopted large, austere rectangular shapes. This in turn led to concentric 'target' images and to the use of circular canvases in 1965. Tousignant has also made sculpture.

Tower of Glass. See AN TÚR GLOINE.

Town, Harold (1924–90). Canadian abstract painter, printmaker, and sculptor, born in Toronto, where he spent most of his life. He studied there at Ontario College of Art, 1942–5, and in 1952–9 was a member of *Painters Eleven. This was a channel for the influence of *Abstract Expressionism in Canada, but he subsequently worked in a variety of abstract styles, often developing themes in long series over a number of years His work included murals for several public buildings, for example Toronto International Airport (1962). In 1956 and 1964 he represented Canada at the Venice *Biennale.

'Tramway V'. See POUGNY.

Transavantgarde (or **Trans-avant-garde**). A term, translated from the Italian *transavanguardia* (beyond the avant-garde), used sometimes as a synonym for *Neo-Expressionism and sometimes to refer more broadly to any work that is regarded as representing advanced fashion in art. Thus in an essay (translated from the Italian and largely unintelligible) in the catalogue of the exhibition 'American Art in the 20th Century' (Royal Academy, London, 1993), Achille Bonito Oliva (who coined the term) refers to the 'hot trans-avant-garde' of artists such as Julian *Schnabel (i.e. Neo-Expressionism) and the 'cold trans-avant-garde' of artists such as Jeff *Koons (i.e. *Neo-Geo).

Transcendental Group of Painters. See HARRIS.

trap picture (tableau piège; Fallenbild). A type of work in which chance remains of an actual event, for example a meal, are glued to a board and then hung as a picture. The 'trap picture' or 'snare picture' is claimed to be a 'frozen document' or continued remembrance of the actual occurrence. It was first practised by Daniel *Spoerri and later taken up by other members of the *Nouveau Réalisme group, to which he belonged.

Treasury Relief Art Project (**TRAP**). See FEDERAL ART PROJECT.

Tretchikoff, Vladimir (1913–). Russian-born painter who settled in South Africa in 1946 and became a citizen of the country, one of the most financially successful but also one of the most critically reviled artists of the 20th century. He was born in Petropavlosk, Kazakhstan, the son of a wealthy landowner. After the 1917 Revolution the family fled to Harbin in north China, a city that was predominantly Russian-built and which became a major haven for Russian refugees. Tretchikoff was self-taught as an artist. He began his career working on scenery at Harbin's opera house, then after earning money as a portraitist he set out for Paris at the age of 16. However, he initially got no further than Shanghai, where he worked as a cartoonist for the American *Evening Post*. He then moved on to Singapore, where he became a cartoonist for the *Straits Times* before joining the British Ministry of Information as a propaganda artist after the outbreak of the Second World War. In 1942 he was evacuated shortly before Singapore fell to the Japanese; his ship was torpedoed and he spent three weeks in an open lifeboat before landing in Java. There he was imprisoned by the Japanese, but he was soon paroled and allowed to paint. His wife and child had meanwhile been safely evacuated to South Africa, and after the war Tretchikoff joined them there, settling in Cape Town, where he held a one-man exhibition (the first of many in his new country) in 1948. A review of this show in the *Cape Times* praised Tretchikoff's work as marking 'a return to sound craftsmanship and the end of crazy obscurantism', and his paintings are meant to appeal to the man or woman in the street rather than the art enthusiast. Typically they feature romantic or sugary themes, melodramatic lighting, and slick brushwork—adding up to what a less complimentary reviewer described as 'cheap sensation and lachrymose sentimentality'. His most famous work is *The Chinese Girl* (1952), depicting an Oriental beauty whom he described as 'refined and demure, and with all the charm and infinite promise of the East'. He did many other works in a similar vein, with titles such as *Balinese Girl* and *Miss Wong*, and his other favourite subjects include African tribesmen and tribeswomen portrayed as the noble savage (*Zulu Maiden*), and flower pieces, generally consisting of a single bloom, accompanied by tear-like drops of water and with titles such as *The Bleeding Lily*, *The Lost Orchid*, and *The Weeping Rose*.

Tretchikoff's enormous popular success depended not only on his choice and treatment of subject, but also on his skilful marketing. As well as showing extensively in South Africa, he organized several tours of his work in Britain, Canada, and the USA between 1953 and 1973 (the peak period of his fame), exhibiting in major department stores rather than galleries. The paintings themselves were generally not for sale, but reproductions of them (see POPULAR PRINTS) sold in vast quantities. Attendance figures at the exhibitions were phenomenal: according to Tretchikoff's autobiography, *Pigeon's Luck* (1973), 205,000 people visited his show at Harrods in London during its four-week run in 1962, and in Winnipeg in 1965 a third of the city's population saw his show 'in spite of snow storms'; according to *Who's Who of Southern Africa* the total attendance at all his exhibitions is three million. Tretchikoff has been the subject of several books and documentary films, including one for the BBC. To most critics, however, his work is excruciatingly vulgar, and he has been dubbed the 'King of *Kitsch'. Tretchikoff himself says 'I'm nothing to do with kitsch', and in 1991 he refused to allow his work to appear on the cover of a book on the subject.

Trier, Hann. See ZEN 49.

Troost, Paul Ludwig. See NATIONAL SOCIALIST ART.

Trubetskoy, Prince Pavel or **Paolo** (1866–1938). Russian sculptor. Trubetskoy was born and grew up in Italy, then lived in Russia from 1898 to 1905 and afterwards in Paris, the USA

(his mother was American), and Italy. He was self-taught and formed his style under the influence of *Rodin. His most important commission was the equestrian statue of Alexander III in St Petersburg (1899–1909). This is over life size in bronze on a granite base, but he usually worked on a much smaller scale and was known principally for statuettes of animals and impressionistic portraits. Such works won him a great reputation, notably at the Paris International Exhibition of 1900, and after a period of total neglect they are once again becoming fashionable. Examples of his work are in the Tretyakov Gallery, Moscow, and the Russian Museum, St Petersburg.

Trübner, Wilhelm. See SEZESSION.

truth to material(s). A belief, particularly associated with Henry *Moore, that the form of a work of art should be inseparably related to the material in which it is made. The origins of the concept, although not the phrase, are found in the writings of the British critic John Ruskin (1819–1900), especially in his book *The Seven Lamps of Architecture* (1856). His interpretation of the idea is more sophisticated than Moore's, for he relates this 'truth' to the knowledge and expectations of the spectator, as opposed to some inner quality of the material itself. In 1934, in *Unit One*, Moore wrote that 'Each material has its own individual qualities ... Stone, for example, is hard and concentrated and should not be falsified to look like soft flesh ... It should keep its hard tense stoniness.' Although in theory the idea could be applied to any material, in effect it was used by Moore as an argument for *direct carving, as practised by himself and contemporaries such as Barbara *Hepworth and John *Skeaping. Some other sculptors of the period, such as *Brancusi and *Epstein, even when not dogmatically committed to carving, made a clear distinction in handling in their respective treatments of bronze and stone.

Moore later admitted that the idea of truth to materials had become a fetish and in 1951 he conceded that it should not be made into a criterion of value, 'otherwise a snowman made by a child would have to be praised at the expense of a *Rodin or a Bernini'. (A virtuoso in marble cutting, Bernini was renowned for his skill in creating lifelike effects and therefore exemplified the kind of 'falsification' Moore had criticized in *Unit One*; commenting on the elaborate curls of the wig in his bust of Louis XIV, Bernini—according to a contemporary report—said that it was 'no easy thing to attain that lightness in the hair to which he aspired, for he had to struggle against the contrary nature of the material'.) The extreme 'anti-Bernini' position that Moore had the good sense to warn against was satirized in a *Punch* cartoon of 1954—by William Sillince (1906–74)—in which two artistic types looking at a snowman admire the child's 'instinctive understanding of the right use of a medium', unaware that they are about to be pelted with snowballs from behind. Although the phrase itself is closely associated with the aesthetic debates of the 1930s, the concept of truth to materials survived in the emphasis on form as the expression of process and material found in the work of *Minimalists and *Post-Minimalists such as Robert *Morris and Richard *Serra.

Tryon, Dwight. See TONALISM.

Tucker, Albert (1914–). Australian painter and printmaker, born in Melbourne. Because he could not afford full-time training, he was mainly self-taught as an artist. In the 1930s and 1940s he took a vigorous part in controversies about modern art in Australia, contributing several articles to *Angry Penguins*. He served in the army in the Second World War, and in 1947 he visited Japan, where he worked briefly as an official artist to the Allied Occupation Forces. Later that year he moved to Europe, where he lived in London (1947–8), France (1948–50), Germany (1951), Italy (1952–6), and London again (1956–8). He then spent two years in New York before returning to Melbourne in 1960. Tucker's early work, influenced by *Expressionism and *Surrealism, is marked by a highly personal interpretation of social, political, and psychological concerns, as in his *Images of Evil* series (1943). In 1952, whilst living in Italy,he painted a series of religious pictures, and in 1955 (partly because of contact with *Nolan in Rome) he turned for the first time to themes of the Australian frontier: bushranging, exploration, and the desert. These tough-minded works reveal the impact of *Art Brut and the textural pictures of *Burri and *Tàpies. During the 1960s and 1970s Australian imagery became dominant in his work, as in the *Bush* series, but in the 1980s he turned more to portraiture.

Tucker, Marcia. See NEW MUSEUM OF CONTEM-
PORARY ART.

Tucker, William (1935–). British-born
abstract sculptor, writer on art, and teacher
who settled in the USA in 1976 and later
became an American citizen. After reading
history at Oxford University, 1955–8, he stud-
ied in London at the Central School of Art and
Design and *St Martin's School of Art,
1959–60. In 1965 he was among the artists
included in the *New Generation exhibition
at the Whitechapel Art Gallery, which
marked the emergence of a new British sculp-
tural avant-garde inspired by Anthony *Caro.
In 1974 Tucker published *The Language of Sculp-
ture*, and in 1975 he organized a major *Arts
Council exhibition at the Hayward Gallery,
London, entitled 'The Condition of Sculpture:
A Selection of Recent Sculpture by Younger
British and Foreign Artists'. In 1976 he began
teaching at the University of Western
Ontario, Canada, and in 1978 moved to
Columbia University, New York.

Tudor-Hart, Percyval. See SYNCHROMISM.

Tugendkhold, Yakov. See SHCHUKIN.

Tuke, Henry Scott (1858–1929). British
painter, born at York into a distinguished
Quaker family. He studied at the *Slade
School, 1875–80, then in Italy and Paris,
where he was strongly influenced by contem-
porary French *plein-air* painting. Tuke had
known and loved Cornwall since childhood
and after he returned to England in 1883 he
settled there, living first at Newlyn (see NEW-
LYN SCHOOL) and then from 1885 in a cottage
near Falmouth. His favourite subject—which
he made his own—was nude boys in a sunlit
atmosphere against a background of sea or
shore. At first the freshness of these works—so
different from the frigid studio nudes to
which the public was accustomed—caused
prudish objections (Tuke was a founder mem-
ber of the *New English Art Club in 1886 and
the sight of one of his paintings caused the
dealer Martin Colhaghi to withdraw his
financial backing for the group's first exhib-
ition). However, they soon became favourites
with the public and are now placed among
the finest and most individual works of Eng-
lish *Impressionism. Tuke also painted por-
traits throughout his life.

Tunnard, John (1900–71). British painter and
designer, born at Sandy, Bedfordshire, son of
the painter J. C. Tunnard. After studying
design at the *Royal College of Art, 1919–23,
he worked as a textile designer until 1929,
when he started painting. A year later he
moved to Cornwall. In 1933 he had first one-
man exhibition at the Redfern Gallery, Lon-
don, and from then on his work was seen in
many individual and group shows. From the
mid-1930s he was influenced by *Surrealism,
particularly by *Miró. His paintings often
combined forms from both technology and
the natural world (he was an amateur natu-
ralist) in semi-abstract compositions. In the
Second World War he served as a coastguard
in Cornwall. After the war he taught at Pen-
zance School of Art, 1948–64, his pupils
including Terry *Frost. In 1977 the Arts Coun-
cil arranged an exhibition of his work, shown
at the Royal Academy and elsewhere in
Britain.

Tunnicliffe, Charles Frederick (1901–79).
British engraver, illustrator, and painter, born
in Langley, near Macclesfield, Cheshire. After
growing up on a farm he studied at Maccles-
field School of Art, 1915–21, and the *Royal
College of Art, London, 1921–5 (Frank *Short
was among his teachers). From 1925 to 1929
he taught part-time at Woolwich Polytechnic
and during the the Second World War he was
assistant art master at Manchester Grammar
School, but apart from these two periods he
was a freelance artist. After the war he settled
at Malltreath in Anglesey. Tunnicliffe special-
ized in natural history subjects, particularly
birds, and was best known as a book illustra-
tor. He made his name with his wood engrav-
ings for Henry Williamson's *Tarka the Otter*
(1932), and he illustrated almost a hundred
other books. He worked in etching and scraper-
board as well as wood engraving and also
made detailed bird studies in watercolour. In
1978 he was awarded the gold medal of the
Royal Society for the Protection of Birds. He
showed his work at the *Royal Academy every
year from 1934 to 1978, and the Academy
devoted an exhibition to him in 1974.

Turcato, Giulio (1912–95). Italian abstract
painter. He was born in Mantua and studied
in Venice. In 1943 he settled in Rome, where
he joined *Forma in 1947 and edited its jour-
nal. Through this and other publications he
became a leading spokesman for the cause of

abstract art. Turcato's paintings were highly varied. In his early work he was influenced by *Cubism, *Expressionism, and *Fauvism, and in the 1950s he turned to the looser, more *gestural style of *Art Informel. Subsequently he experimented with unusual supports, including 'rough pockmarked sheets of foam rubber that gave to me the sense of the surface of the moon'. The paint he used on them included fluorescent and phosphorescent pigment: 'I was searching to make painting visible in the dark because, for me, it is absurd that one cannot see a painting or a wall in the dark.'

Turnbull, John. See GROUP X.

Turnbull, William (1922–). British sculptor and painter, born in Dundee. He left school at 15 and worked as an illustrator on detective and love stories for the local publishing house of D. C. Thompson whilst studying art at evening classes. After serving as an RAF pilot in the Second World War he studied at the *Slade School, 1946–8, then in 1948–50 lived in Paris, where he saw a good deal of his fellow Scot and Slade student *Paolozzi and met such illustrious figures as *Brancusi and *Giacometti. In 1950 he had his first exhibition (a joint show with Paolozzi) at the Hanover Gallery, London. Since then he has had numerous one-man exhibitions (including a retrospective at the Tate Gallery in 1973) and has been included in many important group shows. As a sculptor Turnbull moved from *Surrealistic and primitivist works to painted steel geometrical constructions in the manner of *Caro. As a painter he was one of the first British artists to work in the manner of the American *Colour Field Painters (he helped to organize the *Situation exhibition in 1960). In 1960 he married the Singapore-born sculptor Kim Lim (1936–).

Turner, John Doman. See CAMDEN TOWN GROUP.

Turner Prize. An annual prize (originally £10,000, now £20,000) for British achievement in the visual arts, named after the great English painter J. M. W. Turner. It was established in 1984 by the Patrons of New Art, a body founded two years earlier (as part of the Friends of the Tate Gallery) to encourage the collection of contemporary art. The regulations have changed somewhat since the prize

was inaugurated. Originally it was awarded for 'the greatest contribution to art in Britain in the previous twelve months' and was open to critics and administrators (who were shortlisted but never won) as well as artists; since 1991 those eligible are British artists under the age of 50 who have had 'an outstanding exhibition or other presentation of their work' in the previous twelve months. The work of shortlisted artists (originally six, now four) is exhibited at the Tate Gallery before the winner is announced. For the first three years the prize was supported by an 'anonymous patron' (the collector Oliver Prenn), and from 1987 it was backed by the American financiers Drexel Burnham Lambert. This firm suffered a financial collapse in 1990 and the prize was suspended that year; since then it has been sponsored by Channel 4 Television, which broadcasts the award ceremony live from the Tate. The director of the gallery is on the jury that makes the award.

Like the Booker Prize in literature, the Turner Prize attracts a great deal of publicity, but much of this attention has been expressed as damning criticism, as it is regarded by many as showcasing all that is most pretentious and self-regarding in contemporary art. After the first award (to Malcolm *Morley) in 1984, Giles Auty (see PERFORMANCE ART) wrote in the *Spectator*: 'In my quarter of the hall, groans of disbelief were followed by the audible speculation that Morley's "greatest contribution to art in Britain in the previous 12 months" may have been his fill-time residence in America.' At the exhibition of the shortlisted candidates in 1997 there were protests from a group called New Metaphysical Art, which earlier in the year published a manifesto decrying the 'progressive trivialisation of art, the uncritical and endless use of parody and pastiche'. The group described the Turner Prize as a 'monster which, year after year, with few exceptions, tramples on art and progressively muddies artistic judgement . . . the four fabricators shortlisted for the prize this year represent, as in previous years, little more than predictable gimmickry and gross banality'.

The winners of the Turner Prize have been: 1984, Malcolm Morley; 1985, Howard *Hodgkin; 1986, *Gilbert & George; 1987, Richard *Deacon; 1988, Tony *Cragg; 1989, Richard *Long; 1990, prize suspended; 1991, Anish *Kapoor; 1992, Grenville Davey (1961–); 1993, Rachel *Whiteread; 1994, Antony Gormley (1950–);

1995, Damien *Hirst; 1996, Douglas Gordon (1967–); 1997, Gillian Wearing (1963–).

Twachtman, John H. See TEN.

Twombly, Cy (1929–). American abstract painter and draughtsman, born in Lexington, Virginia. He studied at the school of the Museum of Fine Arts, Boston, 1948–9, the *Art Students League, New York, 1950–1, and *Black Mountain College, 1951–2. In 1957 he settled in Rome. His work is characterized by apparently random scrawls on white or black grounds. In his rejection of traditional ideas of composition, he shows an affinity with the *all-over style initiated by Jackson *Pollock, but Twombly's work is looser and more disorganized than Pollock's. He has an international reputation and his paintings fetch huge prices in the saleroom. In the catalogue of the exhibition 'American Art of the 20th Century' (Royal Academy, London, 1993), we are informed that 'While most American artists of his generation sought their inspiration in contemporary popular culture, Twombly turned to the traditional sources of Western art: Greek and Roman antiquity and the Renaissance. Characters from Classical mythology and Antique figures and sites . . . became the focus of his abstractions. They were evoked by cryptic scraps of words, pictorial metaphors ans allusive signs . . . A careful reading of Twombly's images permits the viewer to penetrate an apparent chaos to arrive at their inner silence and the opening of a window on the classical past.' However, the critic Bernard Levin spoke for many when he dismissed Twombly's pictures as 'silly scribblings'.

291 Gallery. See STIEGLITZ.

Tworkov, Jack (1900–82). Polish-born American painter. He emigrated to the USA in 1913, took a degree in creative writing at Columbia University in 1923, and studied at the National Academy of Design, New York, 1923–5. His early work was influenced by *Cézanne, but in the 1930s he worked for the *Federal Art Project and reluctantly had 'to salve my social conscience at the expense of my aesthetic instincts'. During the Second World War he worked as a tool designer, and when he returned to painting he began to reject European modernism for a more personal manner. An important factor in this was his friendship with Willem *de Kooning. They had met in 1934 and in 1948–53 they worked in adjacent studios in New York. Under de Kooning's influence Tworkov abandoned his figurative style and turned to *Abstract Expressionism, but around 1960 his style changed again and he moved to more geometrical designs. His paintings of the 1970s, with their closely-hatched brushstrokes within a geometrical framework, represent his most individual statements. In 1974 he wrote that he aimed at 'a painting style in which planning does not exclude intuitive and sometimes random play'. Tworkov taught at several institutions, notably Yale University, where he became chairman of the department of art in 1963.

Tyler, Kenneth. See PRINT RENAISSANCE.

Tytgat, Edgard (1879–1957). Belgian painter, printmaker, and writer, born in Brussels, the son of a lithographer, who gave him his initial training in art. He began his career painting portraits, landscapes, and interiors in an *Impressionist style, and during the First World War he worked as a book illustrator in London, where he printed a memorial volume to his friend Rik *Wouters. After the war he returned to Belgium and turned to painting subjects such as circus and carnival themes in a mildly *Expressionistic, consciously *naive way. His work often drew on popular prints and folk art and it has a quality of humour that sets it apart from that of the other Belgian Expressionists. In 1923 he settled at Woluwe-St-Lambert. He wrote a good deal, including reminiscences of his childhood, but only part of his output has been published.

Tzara, Tristan. See DADA.

Ubac, Raoul (1910–85). Belgian painter, sculptor, graphic artist, photographer, and designer, active mainly in France. Between 1928 and 1934 he travelled extensively in Europe and his artistic training was irregular and varied. From about 1934 to 1942 he concentrated on photography, joining the *Surrealist group in Paris and contributing Surrealist photographs to the journal *Minotaure*. In 1942 he abandoned both Surrealism and photography, returning to painting, and in 1946 he began to make double-sided reliefs in slate. His early work had been abstract, but after the Second World War it became more figurative. Apart from paintings and sculpture, he did a large amount of graphic work, including woodcuts and book illustrations, and also made designs for tapestry (notably a series for the Nouveau Palais de Justice, Lille, 1969) and for stained glass (including work done in collaboration with Georges *Braque for a church at Varengeville). In 1957 he settled in L'Oise. See also HARE.

Uecker, Günther (1930–). German painter, sculptor, designer, and experimental artist, born at Wendorf, Mecklenberg. He studied at the Academies of Berlin-Weisensee, 1949–53, and Düsseldorf, 1955–8. In 1957 he began using nails in his work and most of his subsequent work has included them. At first they were driven into panels—usually painted white—and then into various spatial constructions or existing objects such as chairs or a television set. 'The interplay of light and shade is an integral part of these constructions and is realized either through the movement of the viewer or the proper movement of the objects' (catalogue of the exhibition 'German Art in the 20th Century', Royal Academy, London, 1985). In 1961 he joined the *Zero Group and in the 1960s he experimented much with *Kinetic art and light sculptures. His other work has included set and costume designs for opera. In 1974 he became a professor at the Düsseldorf Academy.

Uglow, Euan (1932–). British painter. He was born in London of English and Welsh parents and studied at Camberwell School of Art, 1948–51, and the *Slade School, 1951–4 (in 1952–3 he spent much of his time travelling on scholarships, mainly in Italy and Spain). Since 1961 he has taught part-time at Camberwell and the Slade. Uglow has painted landscapes, portraits, and still-lifes, but he is best known for his carefully composed nudes, in which the naturalistic tradition stemming from the *Euston Road School (*Coldstream was one of his teachers at Camberwell) is combined with geometrical precision of composition. Sir John *Rothenstein writes that 'He is probably the slowest of professional painters; it sometimes takes him three-quarters of an hour even to pose the model in the precise position he requires ... His output is therefore exceptionally small, sometimes amounting to no more than three or four canvases a year.' In spite of this and his aversion to publicity, he has built up a strong reputation among contemporary figurative painters, especially among his fellow artists. In 1972 he won first prize at the *John Moores Liverpool Exhibition. He has his detractors, however; Peter *Fuller dismissed his work as 'mannerist and without merit'.

Ugly Realism. A term applied to the work of a group of German painters, active in Berlin in the 1970s, whose pictures typically convey feelings of revulsion at the alienation, brutality, and shallowness of modern industrial society. Their work represents a revival of the spirit of *Neue Sachlichkeit; some members used sharp detail in the manner of *Superrealism, whilst others were more *Expressionist. Johannes Grützke (1937–) was perhaps the best-known figure in the group.

An exhibition entitled 'Berlin: A Critical View—Ugly Realism' was held at the Institute of Contemporary Arts, London, in 1978–9.

Uhde, Wilhelm (1874–1947). German collector, dealer, entrepreneur, and writer on art, active mainly in France. He was born in Friedeberg in der Neumark and studied in Munich and Florence, abandoning law for the history of art (a decision that caused his prosperous but puritanical family to disown him). In 1904 he settled in Paris and the following year he was buying pictures by *Braque and *Picasso at a time when these artists were practically unknown. John *Richardson writes that 'He liked to see himself as a missionary preaching the gospel of modern German literature and modern French painting, despite the stigma of having to earn his living as a *marchand amateur* (a private dealer) . . . Picasso took a strong liking to this free spirit, who had such a sharp clear eye and a sharp clear mind. Uhde responded with total devotion' (*A Life of Picasso*, vol. 1, 1991). Later, however, their friendship ended, as Picasso objected to Uhde's turgid book, *Picasso et la tradition française* (1928), 'which puts forward a view of the artist as the embodiment of the German and Gothic soul. This was too big a price to pay for Uhde's adulation. Picasso stopped seeing him' (Richardson). Uhde knew many other distinguished avant-garde figures and was a link between French and German artists; when *Klee visited Paris in 1912, Uhde introduced him to leading *Cubist painters, including *Delaunay, whose work made a great impact on Klee. (Uhde was homosexual, but in 1908 he had made a brief, unconsummated marriage of convenience to Sonia *Delaunay-Terk, so she could escape from her Russian family.)

After the outbreak of the First World War in 1914 Uhde's collection was seized (and later sold) by the French as he was considered an enemy alien, and he was forced to leave France. (Ironically, he was later considered an enemy by his own country; in 1938 he published a book entitled *Von Bismarck bis Picasso* and the following year Hitler—incensed at the linking of these names—stripped him of his German nationality.) After the war Uhde returned to Paris and took up dealing again, becoming well known for discovering and encouraging *naive artists (earlier he had been one of the first to appreciate Henri *Rousseau, publishing the first monograph on him in 1911 and organizing the first retrospective of his work in 1912). In 1947 he published his best-known book, *Fünf primitive Meister*, dealing with *Bauchant, *Bombois, Rousseau, *Séraphine, and *Vivin (French and English editions appeared in 1949). After his death he was honoured by the French when a room at the Musée d'Art Moderne in Paris was devoted to works of the '20th-century primitives' and named after him.

Uhlmann, Hans (1900–75). German sculptor, born in Berlin. He studied at the Institute of Technology, Berlin, 1919–24, and in 1926, after working in industry, he began teaching electrical engineering there. He began making sculpture in 1925 and had his first one-man show at the Galerie Gurlitt, Berlin, in 1930. In 1933 he exhibited with the *Novembergruppe. From 1933 to 1935 he was a political prisoner and after his release was forbidden by the Nazis to exhibit. He went back to work in industry, but continued to produce sculpture and became the first German to make abstract constructions, using metal sheets, rods, and wires (he had visited the Soviet Union in the early 1930s and was influenced by Russian *Constructivism). Characteristically these sculptures are austere but elegant, sometimes painted. They were first exhibited at the Galerie Gerd Rosen, Berlin, where Uhlmann had a one-man show in 1947; subsequently he exhibited frequently in Germany and abroad, and Daniel Wheeler (*Art Since Mid-Century*, 1991) writes that he was 'an all-important bridge figure between the original pre-Nazi phase of German abstraction and the triumph of nonfigurative forms in postwar Germany'. In 1950 he was awarded the Kunstpreis der Stadt Berlin and was appointed a professor at the Berlin Academy, where he took over the metal sculpture class in 1953.

Ullrich, Dietmar. See ZEBRA.

Ultra-Conceptualism. See CONCEPTUAL ART.

Ultvedt, Per Olof. See SAINT PHALLE.

Umělecký měsíčník (Art Monthly). See GROUP OF PLASTIC ARTISTS.

Underground art. See UNOFFICIAL ART.

Underwood, Leon (1890–1975). British sculptor, painter, printmaker, teacher, and writer,

born in London, the son of an impoverished dealer in antiquities and coins. He studied at the Regent Street Polytechnic, 1907–10, the *Royal College of Art, 1910–13, and (after war service as a camouflage officer in the Royal Engineers) at the *Slade School, 1919–20. A versatile and original figure, Underwood was out of sympathy with the main trends of modernism, describing abstraction as 'artfully making emptiness less conspicuous'. Nevertheless, from the early 1960s critics began to speak of him as 'the father of modern sculpture in Britain', in view of the streamlined stylized forms of his carvings and bronzes in the 1920s and 1930s and the influence of his teaching. He taught part-time at the Royal College of Art (where Henry *Moore was one of his pupils) from 1920 to 1923, resigning after an argument with the principal, William *Rothenstein, and at his own Brook Green School in Girdlers Road, Hammersmith, which he opened in 1921 and ran intermittently until 1938. Underwood travelled widely and wrote several books, including three on African art. In *Art For Heaven's Sake* (1934) he expressed his ideas about the superiority of intuition and imagination over technology, often in pithy, epigrammatic form: 'Type your circulars and keep a pen for your love letters.' He illustrated his own books (and a few by other authors) with etchings and woodcuts. His painting, which was sometimes influenced by *primitive art, was generally less interesting than his sculpture.

In 1931 Underwood edited a literary and artistic periodical called *The Island* (four issues, June to December, issues 2 and 3 being combined in September). The contributors included Eileen *Agar (who provided financial backing), Henry Moore, and the painter-engravers Gertrude Hermes (1901–83) and Blair Hughes-Stanton (1902–81), who were both former pupils of Underwood and who married in 1926. Christopher Neve (*Leon Underwood*, 1974) writes that 'in the course of regular fortnightly meetings in Underwood's studio, starting in March 1931, they began to realize that they shared a belief . . . that poetic imagination was more important than style or method. Moving round this theme, they conceived the idea of setting themselves up as a group, *The Islanders*, not so much with the intention of disseminating their ideas—that part of *The Island*'s function, since it was never run as a commercial proposition, was purely incidental—as to provide opportunities for

members to discuss the problem among themselves . . . The result was a good deal of talk about the priestly function of the artist . . . The issue of December 1931 includes a statement written specially for *The Island* by Mahatma Gandhi in which he wishes the project well and says that religion is "the proper and eternal ally of art".'

Union of Youth (Soyuz Molodyozhi). An association of Russian avant-garde artists founded in St Petersburg in late 1909; it was established formally in February 1910 and broke up in 1914. The Union, which was sponsored by the businessman and collector Lerky Zheverzheyev (1881–1942), existed primarily as an exhibition society and to promote public discussions and spectacles relating to modern trends in the visual arts. Most of the leading members of Russia's avant-garde were associated with it in one way or another. It held six exhibitions between 1910 and 1914, the first put on in St Petersburg and Riga, the others either in St Petersburg or Moscow. Various styles were represented at these exhibitions, but the Union became principally a centre of the Russian *Futurist movement. On consecutive evenings in December 1913 at the Luna Park Theatre in St Petersburg it staged two works that were remarkable for their Futurist decor: Vladimir *Mayakovsky's first play *Vladimir Mayakovsky: A Tragedy*, with a backcloth by *Filonov and Iosif Shkolnik (1883–1926) assisted by *Rozanova, and the Futurist opera *Victory over the Sun*, for which *Malevich designed the sets and costumes. It was to these designs that Malevich traced the beginning of *Suprematism. Alan Bird (*A History of Russian Painting*, 1987) writes that 'The Union of Youth was the last important movement in Russian painting before the advent of the 1914–18 war. It paved the way for the Futurists to seize control of the cultural life of the nation after the revolution of 1917, and thus set the styles of post-revolutionary art, music and poetry.'

Unism. See STRZEMIŃSKI.

Unit One. A group of eleven avant-garde British artists formed in 1933. Its birth was announced in a letter to *The Times* by Paul *Nash, published on 12 June of that year. The members were the painters John Armstrong (1893–1973), John Bigge (1892–1973), *Burra, *Hillier (who replaced Frances *Hodgkins,

named in Nash's letter), Nash, *Nicholson, and *Wadsworth; the sculptors *Hepworth and *Moore; and the architects Colin Lucas (1906–84) and Wells Coates (1895–1958), who was also one of the outstanding industrial designers of the day. Douglas *Cooper was secretary. In April 1934 the group published a book, *Unit One: The Modern Movement in English Architecture, Painting and Sculpture*, edited by Herbert *Read, which was originally intended as the first of a series. In his introduction Read explained that the name was chosen because 'though as persons, each artist is a *unit*, in the social structure they must, to the extent of their common interests be *one*'. He said that the group 'arose almost spontaneously among a few artists well-known to each other, out of a consciousness of their mutual sympathies and common necessities'. Coinciding with the publication of the book, they held their only group exhibition, at the Mayor Gallery, London (founded in 1933 by Fred Mayor (1903–73), one of the most progressive British art dealers of this period). Between May 1934 and April 1935 a reduced version of the exhibition toured to six provincial venues (Liverpool, Manchester, Hanley, Derby, Swansea, and Belfast). It attracted a good deal of publicity (much of it negative) and helped to stimulate interest in avant-garde art (according to the *Irish News*, the show was 'the first collection of modern art ever exhibited in Belfast'). Despite their 'mutual sympathies', the artists of Unit One had no common doctrine or programme and the group was breaking up by the time the exhibition tour ended. However, although it was short-lived, Unit One made a considerable impact on British art of the 1930s, and the two main trends it represented (abstraction and *Surrealism) were shown in two major exhibitions in London in 1936: 'Abstract and Concrete' at the Lefevre Gallery, and the International Surrealist Exhibition at the New Burlington Galleries.

Universal Limited Art Editions. See PRINT RENAISSANCE.

Unofficial art. A term for art produced in the Soviet Union that did not conform to the ideals of *Socialist Realism, which became the officially sanctioned style of the state in 1932. Any form of artistic independence was virtually impossible under the tyrannical rule of Stalin (1924–53), but there was a slight

thaw under his successor Nikita Khrushchev, who in 1956 denounced Stalin's abuse of power. Unofficial art began to appear in public a few years after this, in about 1960, and in 1962 one of its leading figures, the sculptor Ernst *Neizvestny, had a public confrontation with Khrushchev about the validity of modern art. The authorities could still be highly repressive, however, and in 1974 an open-air exhibition of Unofficial art in a field near Moscow was broken up with water-cannon and bulldozers, causing it to be dubbed the 'Bulldozer Show'. Unofficial art was stylistically varied and individualistic, often reflecting avant-garde Western movements, but from about 1970 a distinctive strand emerged within it—*Sots art, in which the conventions of Socialist Realism were mocked. During the 1970s such art began to be seen in the West (for example at an exhibition at the *Institute of Contemporary Arts, London, in 1977); several Unofficial artists were allowed to leave the Soviet Union and a few achieved success in Europe and the USA, notably Neizvestny and the team of Komar and Melamid (see SOTS ART). During the late 1980s the much more liberal policies of Mikhail Gorbachev (Soviet leader 1985–91) brought great changes: 'museum officials began to treat their collections with a measure of *glasnost* or openness, and no longer feared the consequences of exhibiting works by the avant-garde. The George *Costakis collection of avant-garde art was rehabilitated and put on display in the Tretyakov Gallery [in Moscow] and Costakis himself was invited back to Russia as an honoured guest. Western scholars were admitted to much hitherto unseen material' (Matthew Cullerne Bown and Brandon Taylor, eds., *Art of the Soviets*, 1993). The Soviet authorities came to see the benefits—financial as well as cultural—of exporting art to the West, and by the time the Soviet Union broke up in 1991 there was even a company called Sovart that placed Soviet artists with Western galleries. 'Sovart' is also one of several names that have been used as alternatives to 'Unofficial art'; others are 'Non-Conformist art' and 'Underground art'.

Utrillo, Maurice (1883–1955). French painter, born in Paris, the illegitimate son of Suzanne *Valadon. He took his surname from the Spanish painter Miguel Utrillo (1862–1934), who legally recognized him as his son in order to help him (his real father—according to some

sources—was the Symbolist painter Pierre Puvis de Chavannes, who was 40 years older than Valadon). Utrillo began to paint in 1902 under pressure from his mother, who hoped it would remedy the alcoholism to which he had been a victim since boyhood (in 1934 the Tate Gallery wrongly stated in a catalogue that he had died of drink in that year, resulting in a libel suit, settled out of court). Valadon gave him his first lessons, but he was largely self-taught. He first exhibited his work publicly at the *Salon d'Automne in 1909 and had his first one-man show in 1913, at the Galerie Blot in Paris. This received little attention, but in 1923 a joint exhibition with his mother at the Galerie *Bernheim-Jeune in Paris was a success, and thereafter he became prosperous and critically acclaimed. In 1937 he settled at Le Vésinet on the outskirts of Paris and in his final years gave as much time to religious devotions as to painting.

Utrillo was highly prolific, painting mainly street scenes in Montmartre, although he also did numerous views of churches and cathedrals (*Church at St Hilaire*, Tate Gallery, London, *c.* 1911). The period from about 1910 to 1916 is known as his 'white period' because of the predominance of milky or chalky tones in his pictures (he sometimes mixed plaster with his paint), and it is generally agreed that he did his best paintings during this time. They subtly convey solitude and emotional emptiness and have a delicate feeling for tone and atmosphere, even though he often worked from postcards rather than directly from the motif. His later work is livelier and more freely painted, but less touching. Utrillo's work is in many museums and (no doubt because of the deceptive simplicity of his paintings) he is among the most forged of modern artists. In 1976 the Greek-Cypriot dealer Paul Pétridès (1901–93), who had looked after Utrillo in his later years, was convicted of handling stolen paintings, and this cast doubt on his probity in authenticating works by the master.

Utter, André. See VALADON.

Valadon, Suzanne (1865–1938). French painter, born at Bessines-sur-Gartempe, near Limoges. She was the illegitimate daughter of a maid and was brought up in Paris in bleak and unaffectionate circumstances. As a girl she worked as a circus acrobat, but she had to abandon this after a fall and then became an artists' model and the reigning beauty of Montmartre. The artists she posed for included *Renoir, Toulouse-Lautrec, and the *Symbolist painter Pierre Puvis de Chavannes (each of whom numbered among her lovers). She had drawn from childhood, and Toulouse-Lautrec brought her work to the attention of *Degas, who encouraged her to develop her artistic talent. In 1896 she married, and the financial support of her husband allowed her to work full-time as an artist. Her first one-woman show was in 1915 and after the First World War she achieved critical and financial success. She had no formal training and owed little to the influence of the artists with whom she associated, her painting showing a fresh and personal vision. Her subjects included still-life and portraits (including self-portraits in which she brings out her formidable strength of character), but she was at her best in figure paintings, which often have a splendid earthy vigour and a striking use of bold contour and flat colour (*The Blue Room*, Pompidou Centre, Paris, 1923). A child of the people, she has been compared with the writer Colette for her sharpness of eye and avidity for life. After divorcing her first husband, in 1914 she married the painter André Utter (1886–1948), who was a friend of her son Maurice *Utrillo and some 20 years younger than her. In her final years she was estranged from both Utter and Utrillo and her health was ruined by the excesses of her life.

Valentin, Curt (1902–54). German art dealer who settled in the USA in 1936. In 1937 he opened a gallery in New York (originally called the Buchholz Gallery, after a firm he had worked for in Berlin, but renamed the Curt Valentin Gallery in 1951). Before he moved to the USA he had built up links with many distinguished artists in Europe, and he played an important role in introducing German art to American audiences, helping to overcome the dominance previously enjoyed by French art (he also dealt in British and Italian works). Max *Beckmann was one of his main enthusiasms (he helped organize the major exhibition of his work at the St Louis Art Museum in 1948), and the other artists he promoted included *Arp, *Feininger, *Kirchner, and *Klee. He dealt in sculpture as well as painting, and he was much admired in the art world for his knowledge and fairness. His gallery closed the year after his death.

Vale Press. See RICKETTS.

Valette, Adolphe. See LOWRY.

Vallgren, Ville (1855–1940). The leading Finnish sculptor at the turn of the century. He spent most of his career in Paris (1877–1913), but he sent work back to Finland, notably his 'Havis Amanda' fountain, Helsinki, featuring a central bronze figure of a nymph in his characteristically graceful *Art Nouveau style and four playful sea-lions around the rim of the granite bowl. Parts of it were exhibited to great acclaim at the Paris Salon of 1908. There is a museum dedicated to Vallgren near Helsinki.

Vallotton, Félix (1865–1925). Swiss-born painter, printmaker, illustrator, sculptor, and writer who became a French citizen in 1900. He was born in Lausanne and after attending evening classes in art locally he moved to Paris in 1882 to study at the *Académie Julian. Paris remained his home until his death, but he often visited Switzerland and made numer-

ous other journeys abroad. In his early days in France he copied and repaired paintings and did illustrations for popular journals to earn a living, and in the 1890s he worked a good deal in woodcut; apart from *Gauguin, he was the most important French pioneer of the revival of this medium. His woodcut style was less forceful and more polished than Gauguin's, although still very striking. Typically he used very strong contrasts of black and white to create a vigorous sense of pattern. He was a friend of *Bonnard and *Vuillard and in the 1890s he sometimes exhibited with their *Symbolist group the *Nabis. In 1899 he married into the *Bernheim-Jeune family of picture dealers, and the financial security this brought him enabled him to concentrate on his painting. In his canvases he took over something of the simplifications of form and sharp contrasts between blocks of light and shadow that characterize his woodcuts. His subjects included landscapes, portraits, nudes, and interiors. Vallotton often worked at Honfleur, and from 1920 in the South of France, especially at Gagnes (*Road at St Paul*, Tate Gallery, London, 1922). He wrote three novels, including the posthumously published *La Vie meurtrière* (1930), which is autobiographical and illustrated by himself.

Valori plastici. An art periodical published in Rome from 1918 to 1921 in both Italian and French editions (it was originally a monthly but became bi-monthly). The editor and publisher was Mario Broglio (1891–1948), a critic and painter, who was conservative in outlook. The first number contained articles by *Carrà, de *Chirico, and *Savinio setting forth the ideals of *Metaphysical Painting. Under the Fascist regime *Valori plastici* was one of the few channels that informed the Italian public about current trends elsewhere in Europe (it carried articles on *Cubism and De *Stijl, for example). However, the main tenor of the journal—supported by Carrà and de Chirico—was in favour of a return to the Italian classical tradition of naturalism and fine craftsmanship, and European avant-garde movements were criticized for forsaking the principles of that tradition.

Valtat, Louis (1869–1952). French painter, born in Dieppe. He entered the École des *Beaux-Arts, Paris, in 1877, and subsequently studied at the *Académie Julian. His early work was in a *Neo-Impressionist style, but by the mid-1890s he was painting with pure, strong colours in a manner that anticipated *Fauvism. He later exhibited with the Fauves, notably at the famous *Salon d'Automne exhibition in 1905 at which they acquired their name, but he was never a formal member of the group. While most of the Fauves abandoned the style after a few years, Valtat continued to explore the use of pure colour throughout his life. Until 1914 he spent much of his time in the South of France, then lived in relative seclusion in the valley of the Chevreuse near Paris. He maintained a prolific output of landscapes, still-lifes, figure studies, portraits, and flower pieces, but disappeared from the public gaze. In 1948 he went blind. It was only after his death that he was recognized as a significant precursor of Fauvism.

Vanni, Samuel (1908–92). Finnish painter, born at Viipuri (now Vyburg in Russia). He trained at various art schools in Finland and elsewhere, notably the *Académie Julian, Paris. His early work included landscapes, portraits, and still-lifes, but after the Second World War he became one of the pioneers of abstract art in Finland. Initially he moved to abstraction through simplifying natural forms, but in the 1960s his style became more geometrical and his work sometimes verged on *Op art. Vanni's output included several large murals in public buildings. He was influential not only through such works, but also through his teaching at art schools in Helsinki.

Van Sant, Tom. See SKY ART.

Vantongerloo, Georges (1886–1965). Belgian sculptor, painter, architect, and writer on art, active mainly in France. He was born in Antwerp and studied at the Academy there and at the Brussels Academy. In 1914 he was wounded whilst serving with the Belgian army and from 1914 to 1918 was interned in the Netherlands. There he joined the De *Stijl group in 1917 and turned from the conventionally naturalistic style he had previously practised to abstract sculptures in which he applied the principles of *Neo-Plasticism to three dimensions (*Interrelation of Volumes*, Tate Gallery, London, 1919). From 1919 to 1927 he lived in the French Riviera resort of Menton and then for the rest of his life in Paris, where he was a member of *Cercle et Carré and in 1931 one of the founders of *Abstraction-

Création. From 1928 Vantongerloo began to design ambitious (and unrealized) architectural projects, including a 'Skyscraper City' (1930), whose cubiform structure resembles that of his sculptures. In the 1940s his sculpture became more varied as he began using wire and perspex, exploring effects of reflection and refraction. His paintings were based on horizontal and vertical lines until 1937, when he introduced rhythmic curving lines. He was a close friend of Max *Bill, who organized several exhibitions of his work and became his executor.

Vantongerloo was one of the pioneers of a mathematical approach to abstract art. He rejected his friend *Mondrian's idea that only constructions based on the right angle reflect the harmony of the universe, believing that this was only one way among many of achieving formal relations that would embody spiritual values. Some of his ideas on ideas are expressed in his collection of essays *L'Art et son avenir*, published in 1924. His work is represented in many major collections of modern art.

Vargas, Alberto. See AIRBRUSH.

Varley, Fred. See GROUP OF SEVEN and MAC-DONALD, JOCK.

Varo, Remedios (1908–63). Spanish painter and designer, active for most of her career in Mexico. She was born at Anglés, near Girona, the daughter of a hydraulic engineer, and studied at the Academy in Madrid. From 1930 to 1932 she lived in Paris, then settled in Barcelona. In 1936 she met the French *Surrealist poet Benjamin Péret, who was fighting with the Republicans against the Fascists in the Spanish Civil War. When the Republicans were defeated, the couple moved to Paris, where they married in 1937 (Varo had earlier been briefly married to a fellow student in Madrid). Through her husband, Varo was drawn into the Surrealist movement; she exhibited in the International Surrealist Exhibition in Paris in 1938, for example, and her paintings were reproduced in *Minotaure*, the most luxurious of the periodicals associated with the movement. In 1942 the couple fled German-occupied France and settled in Mexico City, where several exiled Surrealists had already taken up residence, notably Leonora *Carrington (who became a close friend of Varo) and Wolfgang *Paalen. Varo

separated from Péret in 1948. Initially she earned her living in Mexico as a commercial artist and designer, and did not paint full-time until 1953; most of her surviving paintings therefore date from the last decade of her life. Characteristically they depict strange, delicately painted figures set in a weird fantasy world; the atmosphere is often claustrophobic, but sometimes accompanied by a sense of whimsical humour rather than of menace. Edward *Lucie-Smith (*Latin American Art of the 20th Century*, 1993) writes that they 'demonstrate her interest in the occult and in alchemy, and often contain hints of the alienation she felt as a woman trying to make a place for herself in a man's world. Among her sources were the traditional designs on tarot cards, and the work of El Greco and (inevitably) Bosch. Once she actually began to exhibit her work [from 1956] she was rapidly accepted as a leading figure in the Mexican art world, yet . . . Mexico itself seems to have had little impact on what she did.'

Vasarely, Victor (1908–97). Hungarian-born painter, sculptor, and designer who settled in Paris in 1930 and became a French citizen in 1959, the main originator and one of the leading practitioners of *Op art. He studied in Budapest at the Poldini-Volkman Academy of Painting and the Mühely School (known as the *Bauhaus of Budapest) before he moved to Paris in 1930. For the next decade he worked mainly as a commercial artist, particularly on the designing of posters, showing a keen interest in visual tricks and space illusions. From 1943 he turned to painting and he had his first one-man exhibition in 1944, at Denise *René's gallery. About three years later he adopted the method of geometrical abstraction for which he is best known. Typically he created a hallucinatory impression of movement through visual ambiguity, using alternating positive–negative shapes in such a way as to suggest underlying secondary shapes. His fascination with the idea of movement led him to experiment with *Kinetic art and he also collaborated with architects in such works as his relief in aluminium for Caracas University (1954), and the French Pavilion at 'Expo '67' in Montreal, hoping to create a kind of urban folk art. From the mid-1950s he wrote a number of manifestos, which, together with his painting, were a major influence on younger artists working in the same fields.

From 1961 Vasarely lived mainly in the South of France and he founded two museums devoted to his work in Provence—the Fondation Vasarely at Aix-en-Provence, which he designed himself, and the Château and Musée Vasarely at Gordes (both are now closed). He had a great talent for self-publicity and there is also a Vasarely Museum at Pecs, his home town in Hungary. According to his obituary in *The Times*, 'To him the artist was simply an artisan who creates his artefacts at will and in volume, so that they can be accessible to the ordinary person'. His work was shown throughout the world and he won numerous awards and honours, including first prize at the São Paulo *Bienal in 1965 (jointly with *Burri) and being made a member of the Legion of Honour in 1970. Vasarely's son, Jean-Pierre, who works under the name *Yvaral, is also an Op and Kinetic artist.

Vaughan, Keith (1912–1977). British painter, draughtsman, designer, and writer, born in Selsey, Sussex. From 1931 to 1939 he worked in the art department of an advertising agency, painting—self-taught—in his spare time. In the Second World War he served in the St John's Ambulance Brigade and the Pioneer Corps and as a clerk in a prisoner-of-war camp in Yorkshire. After the war he taught part-time at various art schools in London, notably the *Slade School (from 1954), and travelled extensively. In the 1940s, with his friend John *Minton, he was one of the leading exponents of *Neo-Romanticism, characteristic works of this time being coloured drawings of moonlit houses. His post-war work, in which he concentrated on his favourite themes of landscapes and male nudes in a landscape setting, became grander and more simplified, moving towards abstraction (*Leaping Figure*, Tate Gallery, London, 1951). Some of his late pictures are almost pure abstracts, the rich slabs of paint giving only the merest suggestion of natural forms. He had numerous one-man shows of his paintings, and his output also included textile designs and book-jackets. Occasionally he did larger works, including an abstract ceramic mural for a bus-shelter in Corby New Town, Northamptonshire (1954; destroyed). His varied activities brought him critical and financial success, but he felt deep insecurity about his work and his role in life, as is revealed in his book *Journal and Drawings* (1966), extracts from a diary he had begun in

1939. A new edition, *Journals 1939–1977*, edited by Alan Ross, appeared in 1989. As well as containing many perceptive comments about art, it gives a remarkably frank (and often highly amusing) account of Vaughan's homosexual and masturbatory activities (the first edition was much less explicit) and movingly chronicles the struggle with cancer that led to his suicide. He made 'sex trousers' with a constricting silk codpiece and contrived an electronic masturbating device (his beloved 'black box'), and wrote that although he listed his recreations in the *International Who's Who* as 'Eating and drinking with friends, bathing in the Ionian Sea', what he should say was 'Drinking alone, sexual self-pleasuring with autoerotic devices'.

Vautier, Benjamin. See BODY ART.

Vauxcelles, Louis (1870–?). French art critic. In the period between the turn of the century and the First World War, he was probably the most widely read of French critics, his work appearing in many newspapers and periodicals, particularly *Excelsior* and *Gil Blas*, for which he was the regular art correspondent. Alfred H. *Barr describes him as 'an able and witty critic', but outside specialist circles he is now remembered solely because he gave rise to the names of two of the 20th century's most famous art movements—*Fauvism and *Cubism. He said of *Braque, 'Let us not make fun of him since he is honest', but he soon became identified with vociferous opposition to Cubism, and by 1918 he was even spreading false rumours that *Picasso and *Gris were disillusioned with the movement. Because of this he has sometimes been pigeonholed as an arch-conservative, but although he was hostile to certain types of avant-garde art (particularly abstraction) he was broadly anti-academic in his sympathies. He founded two periodicals, *Le Carnet des artistes* in 1916, and the more substantial *L'Amour de l'art*, which he edited from 1920 to 1923. His only book, *Le Fauvisme*, appeared in 1958. His later years are obscure and his date of death is unknown.

Vedova, Emilio (1919–). Italian painter and graphic artist, born in Venice, where he has spent most of his career. He had no formal training as an artist, but he painted from an early age and began to exhibit in 1936. From the beginning a main theme of his work has been social injustice and in 1942 he joined the

anti-Fascist association *Corrente in Milan. The influences on his early work included *Rouault and *Picasso's *Guernica*. After the Second World War (during which he worked with the Resistance in Rome) Vedova turned to abstraction. Initially his style was geometric, but he developed a violent, improvisatory manner with which he gained a reputation as one of the leading Italian exponents of *Art Informel. He continued to express his political convictions in his abstract works (they often have titles such as *Cycle of Protest* and *Concentration Camp*) and critics have seen them as the expression of a passionate impulse for freedom and claustrophobic dread of oppression. Vedova has won numerous awards for painting and graphic art, including the Grand Prize for painting at the 1960 Venice *Biennale. In the early 1960s he enlarged his range by making free-standing painted constructions with movable parts that 'engage in an aggressive dialogue with the surrounding space' (catalogue of the exhibition 'Italian Art in the Twentieth Century', Royal Academy, London, 1989).

Vega, Jorge de la. See OTRA FIGURACIÓN.

Vehement Painting. See NEO-EXPRESSION-ISM.

Velde, Bram van (1895–1981). Dutch painter and printmaker, active mainly in France. He was born at Zoeterwoude, near Leiden. In 1907, at the age of 12, he was apprenticed to an interior decorator, who was so impressed with his talent that in 1922 he sent him to *Worpswede to complete his artistic education. He moved to Paris in 1925, and apart from the years 1932–6, which he spent in Majorca, he lived there until 1965. During the Second World War he was reduced to abject poverty and virtually stopped painting between 1940 and 1945. He had his first one-man exhibition in 1946 (at the Galerie Mai, Paris), but he did not achieve substantial recognition until 1958, when there was a retrospective exhibition of his work at the Kunsthalle, Berne. In 1965 he moved to Switzerland and settled in Geneva.

At Worpswede van Velde was deeply influenced by German *Expressionism and his work remained Expressionist in spirit throughout his career. On his arrival in Paris he adopted a *Fauvist palette, painting landscapes and flower pieces in vivid colours, and

he later incorporated formal simplifications derived from *Cubism. But even before 1930 the subject of his paintings would often recede and virtually disappear behind flecks and lines of colour, and these early works have therefore been regarded as anticipating the abstract manner he adopted in the late 1930s. By 1945 he had developed his mature style, characterized by vaguely defined fluid shapes that trigger off associations of figures, faces, masks, and objects but obstinately refuse identification. His paintings have been said to embody the spirit of Existentialism, and the writer Samuel Beckett—an early champion—characterized his work as 'primarily a painting of the thing in a state of suspense . . . the thing alone . . . the thing immobile in the void.'

H. H. *Arnason (*A History of Modern Art*, 1969) describes van Velde as 'one of the most isolated and powerful of *Art Informel painters' and writes that he was 'the European artist closest perhaps to aspects of American *Action Painting, particularly that of his fellow Hollander *de Kooning. He provides an unconscious link between the Americans and the *Cobra group.' Van Velde's paintings give the feeling of dynamic spontaneity, but in fact he worked slowly and deliberately, often taking months to complete a picture. Consequently his œuvre is fairly small—about 200 paintings. A good collection of them is in the Musée d'Art et d'Histoire in Geneva.

His brother **Geer van Velde** (1898–1977) was also a painter and likewise active mainly in France. He was self-taught as an artist. In 1925 he moved to Paris and lived in or near the city for the rest of his life, apart from the war years, which he spent at Cagnes-sur-Mer. His most characteristic works are abstracts painted in light, translucent colours, often delicate shades of blue. His compositions are more geometrical than those of his brother; behind the lines and abstract shapes there appear to lie vague suggestions of still-lifes or interiors.

Velde, Henry van de (1863–1957). Belgian architect, designer, painter, writer, and teacher, one of the chief creators and exponents of the *Art Nouveau style and a key figure in the development of art teaching in the 20th century. He was born in Antwerp, where he studied painting at the Academy, 1880–3. In 1888 he adopted the *Neo-Impressionist style, but he gave up painting soon

afterwards. This was the result of acute self-questioning that followed a nervous collapse in 1889 brought on by the death of his mother. He decided that 'what is of use to only one person is close to being of use to no one, and in the near future only what is of use to *all* will be considered useful', and thereafter he devoted himself to architecture and applied art. In 1895 he created a house for himself ('Bloemenwerf') in the Brussels suburb of Uccle, designing everything from the architecture to the kitchen utensils, and in 1896 he carried out decorations for Siegfried Bing's Paris shop Maison de l'Art Nouveau, from which the name of the new style derived. Van de Velde's work for Bing featured the sinuous curves typical of Art Nouveau, but he believed in a rational use of form, unencumbered by tradition, and thought that ornament should grow naturally from the structure rather than being mere superficial decoration. In 1897 some of his work was exhibited in Dresden to great acclaim, leading to several commissions in Germany, where he moved in 1900. His German patrons included Karl Ernst Osthaus (see SONDERBUND), for whom he remodelled the Folkwang Museum at Hagen (1900–2) and who wrote a biography of van de Velde (1920). From 1902 to 1917 he lived in Weimar, where he was appointed head of the new Kunstgewerbeschule (School of Arts and Crafts). The teaching here was novel in that pupils—instead of studying the art of the past—were encouraged to think in terms of the needs of the modern world. Van de Velde's successor in Weimar was Walter *Gropius, who developed his ideas at the *Bauhaus.

In 1917 van de Velde moved to Switzerland, then in 1920 the Netherlands, where he began to work for Hélène *Kröller-Müller, for whom he later designed the celebrated museum at Otterlo (1937–54). This shows the much severer style of his later years. In 1926 he returned to Belgium, and the following year he became head of the newly-founded Institut Supérieur des Arts Décoratifs in Brussels. He taught there for the next 20 years and in this period received many state commissions, including the Belgian pavilions at the Paris Exposition Universelle in 1937 and the New York World's Fair in 1939. In 1947 he retired to Switzerland. In addition to his highly varied artistic output, he wrote several books on his ideas and also an autobiography, *Geschichte meines Lebens*, posthumously published in 1962.

Venice, Palazzo Grassi. See HULTEN.

Venice Biennale. See BIENNALE.

Venturi, Lionello. See GRUPPO DEGLI OTTO PITTORI ITALIANI.

Venturi, Robert. See POSTMODERNISM.

Vergeaud, Armand. See CORPORA.

Verism. An extreme form of realism in which the artist tries to reproduce the exact appearance of a subject with rigid truthfulness and scrupulous attention to detail, repudiating idealization and imaginative interpretation. The term has been applied, for example, to the most realistic Roman portrait sculpture. In the context of 20th-century art it has been applied to *Superrealism (sometimes also called Photorealism) and rather less justifiably to *Magic Realism and the 'hand-painted dream photographs' of *Dalí and other *Surrealists working in the same vein. The phrase 'Veristic Surrealism' is sometimes used to characterize this last type.

Verkade, Jan. See NABIS.

Ver Sacrum. Periodical (a miscellany of literature, illustration, and graphic work) published in Vienna from 1898 to 1903 as the journal of the Vienna *Sezession; the name means 'sacred spring'. It is described by Peter Vergo (*Art in Vienna 1898–1918*, 1975) as 'from an artistic and literary standpoint . . . one of the outstanding periodicals of its day. The editors . . . sought to realize new conceptions of layout and design, to create a unity out of the printed page, subordinating the individual processes of ornamentation and typography to a single purpose. An important role was played by the illustrative material; there were reproductions of works by corresponding members of the association from abroad, as well as valuable photographs of the Secession's own exhibitions.' Several leading poets wrote for the journal and 'There were also frequent musical contributions, reinforcing the image of artistic unity *Ver Sacrum* sought to propagate'. For the first two years it was published monthly and then from January 1900 every two weeks. The tighter schedule had an adverse effect on the quality of the later issues.

Verve. A group of Dutch painters active in The Hague from 1952 to 1957. Their work was figurative, sometimes with *Surrealist leanings. The leading figure was Co (short for Jacobus) Westerik (1924–). This group is not to be confused with *Verve*, a journal of art and literature published by *Tériade, 1937–60.

Vesch/Gegenstand/Objet. A trilingual (Russian, German, French) periodical founded in Berlin in 1922 by El *Lissitzky and the Soviet writer Ilya Ehrenburg with the object of publicizing Russian *Constructivism in the rest of Europe. For this broad audience Lissitzky modified the doctrinaire rejection of non-utilitarian art characteristic of Soviet Constructivism. In the initial editorial he wrote: 'We have called our review *Objet* because for us art means the creation of new "objects" … But no one should imagine in consequence that by objects we mean expressly functional objects. Obviously we consider that functional objects turned out in factories—aeroplanes and motor cars—are also products of genuine art. Yet we do not wish to confine artistic creation to these functional objects.' The periodical ran for only three issues before folding in 1923.

Vespignani, Renzo. See ROMAN SCHOOL.

Viallat, Claude. See SUPPORTS-SURFACES.

Viani, Alberto. See FRONTE NUOVO DELLE ARTI.

Video art. A broad term applied to works created by visual artists in which video and television equipment and technology is used in any of various ways. Edward *Lucie-Smith (*Visual Arts in the Twentieth Century*, 1996) writes that Frank Popper, in his *Art of the Electronic Age* (1993), 'distinguishes at least six types of video art: the use of technological means to generate new visual imagery; the use of video to give performances a more permanent form; what he calls "guerrilla video"—that is, the use of video to distribute images and information likely to be suppressed by the ruling establishment; the use of video-cameras and monitors in sculptural installations; live performances which involve the incidental use of video; and finally, advanced technological manifestations, often involving the use of videos with computers.'

Wolf *Vostell incorporated working television sets in assemblages in 1959, but the creator of video art as a genre is usually regarded as Nam June Paik (1932–), a Korean musician, *Performance artist, and sculptor, who settled in New York in 1964 and acquired a portable Sony video recorder in 1965 as soon as this new equipment was available there. He is said to have made his first recording on the day he bought the recorder and to have showed the tape the same evening at an artists' club, the Café-a-Go-Go. Paik had trained as a pianist, and had been inspired by John *Cage's 'prepared piano' to experiment with magnets to interfere with broadcast images on television screens. After he turned to video he often collaborated with the cellist Charlotte Moorman (1940–94), notably in *Bra for Living Sculpture* (1969), in which she played her instrument whilst wearing a bra incorporating two miniature television screens (predictably dubbed 'boob tubes'). (Moorman was arrested for indecent exposure whilst performing in another Paik work.)

Whereas Paik sees himself as an entertainer (he has often appeared on television chat shows), another well-known specialist in video art, the American Bill Viola (1951–), is more serious—his detractors might say portentous—in tone. A representative work is *To Pray Without Ceasing* (1992), which Viola describes as 'a contemporary "book of hours" and image vigil to the infinite day, functioning as an unfolding sequence of prayers for the city. A 12–hour cycle of images plays continuously onto a screen mounted to a window facing the street. The images are projected continuously, 24 hours a day, seven days a week. A voice can be heard quietly reciting a text (excerpts from Walt Whitman's "Song of Myself"), audible from speakers mounted above and on each side of the window, interior and exterior. During the day, sunlight washes out the image and only the voice is present. The video playback is synchronized to the time of day by computer … The 12 sections or 'prayers' in the work vary in length from 15 minutes to two hours and describe a cycle of individual and universal life.'

Such works have won praise from many critics; the catalogue of the exhibition 'American Art in the 20th Century' (Royal Academy, London, 1993), for example, refers to Viola's 'technically virtuoso installations' and his 'magical deployment of electronic impressionism'. However, in the same year Brian *Sewell described Viola's work as 'amateur

and incompetent' and wrote that 'his claims to be an artist are inexcusably pretentious, and the support of his apologists is quite absurd. His wretched video films have nothing to do with the arts of painting and sculpture . . . Viola's work has no place in an art gallery—it simply isn't art; if it has a place at all, then it is in the cinema—but in that context it is no more than the wretched stuff of peripheral experiment and jiggery-pokery.' Twelve years earlier, in more measured terms, Calvin *Tomkins had questioned the basis of such art in his essay 'To Watch or Not to Watch' (1981): 'Museum-going is a tiring business, granted, but nothing brings on a nap quicker than a semi-dark room, a sofa, and a little video art. The notion of using video as a purely visual medium seems like a wrong notion to me, for the simple reason that video takes place in time. Visual artists, who are trained to deal with space, often have a very uncertain grasp of time, and of the importance of time-defined arts such as theatre . . . Video art asks for the kind of concentration that we are expected to give to painting and sculpture, but it also asks us to give up our time to it. Nothing I have seen to date comes anywhere near to justifying those demands.'

Vie et Lumière. See LUMINISM.

Vieira da Silva, Maria Elena (1908–92). Portuguese-born painter, graphic artist, and designer who settled in Paris in 1928 and became a French citizen in 1956. She studied sculpture with *Bourdelle and *Despiau, then painting with *Bissière, *Friesz, and *Léger, and engraving with *Hayter. In 1930 she married the Hungarian painter Arpad Szènes (1900–84), who became her principal artistic mentor. In the mid-1930s she became to attract attention with pictures consisting of flecks of colour against a greyish or neutral background. These works, which evoke a sense of landscape, giving the impression of space without recourse to traditional devices of perspective, have something in common with Bissière's paintings, but Vieira da Silva's spiky linear organization is her own. From 1940 to 1947 she lived with her husband in Brazil, where her reputation grew. After her return to France she rapidly gained recognition as one of the most gifted painters in the style of expressive abstraction that dominated the *École de Paris at this time. From 1948 she exhibited frequently in London and

New York and her work is represented in many of the world's major collections of modern art. She won numerous awards, among them the Grand Prix at the 1961 São Paulo *Bienal. Apart from paintings her work included prints and designs for stained glass and tapestries.

Vienna Actionists or **Viennese Actionism** (Wiener Aktionismus). Names applied to a group of Austrian *Performance artists who worked together in the 1960s and who represent the most unsavoury, sadomasochistic trends in the genre. The three main members of the group were Gunter Brus (1938–), Otto Muehl (1925–), and Hermann Nitsch (1938–), who first collaborated in 1961 and in 1966 began calling themselves the Institut für Direkte Kunst (Institute for Immediate Art). Other people associated with them included Brus's wife Anni Brus, the actor Heinz Cibulka, and Rudolf *Schwarzkogler. The early work of the group had included crude *assemblages and *Action Paintings, from which they progressed to deliberately extreme and provocative performances, typically involving substances such as blood and excrement and often involving nude performers. The titles of some of Muehl's 'actions' give a flavour of their content: 'Penis Action' (1963); 'Christmas Action: A Pig is Slaughtered in Bed' (1969); and 'Action with Goose', performed at the Wet Dream Festival, Amsterdam, in 1971. He often submitted himself to degradation and humiliation, as in 'Libi' (1969), in which a broken egg was dripped into his mouth from the vagina of a menstruating woman. This kind of performance led to the arrest of the participants on several occasions. Nitsch was the chief spokesman of the group. He described such work as 'an aesthetic form of praying' and maintained that it could bring liberation from violence through catharsis: 'All torment and lust, combined in a single state of unburdened intoxication, will pervade me and therefore YOU. The playacting will be a means of gaining access to the most "profound" and "holy" symbols through blasphemy and desecration.'

A retrospective exhibition of the group was scheduled to be held in Edinburgh in 1988, but it was cancelled because it was thought likely to prove too shocking.

Vigeland, Gustav (1869–1943). The most famous of Norwegian sculptors. Born in

Mandal, he studied in Oslo and Copenhagen and then (1892–5) in Paris (spending a few months with *Rodin) and Italy. At this time he worked in a painstakingly naturalistic style, but in 1900 he began studying medieval sculpture in preparation for restoration work on Trondheim Cathedral and this led to his work becoming expressively stylized. In the same year he made his first sketches for the massive project that occupied him for the rest of his life and which he left unfinished at his death—a series of allegorical groups at Frogner Park, Oslo. Originally only a fountain was planned, but with the help of assistants he went on to create numerous other groups, including a 17-metre-high column composed of intertwining bodies. The symbolism of the scheme is not clear, but essentially it represents 'a statement of the doubt, disillusion, and physical decline that beset humanity in its passage through the world' (George Heard *Hamilton). Reactions to the whole megalomaniac conception, which involves scores of bronze and granite figures, have been mixed since the project was completed in 1944, some critics finding it stupendous, others tasteless and monotonous. Hamilton comments: 'Were its quality only better, the fountain in the Frogner Park might, for its size, allegorical intricacy, and for the artist's life-long dedication to his ideal, be described as sculptural Wagnerism.'

Villanueva, Carlos Raúl. See OTERO.

Villeglé, Jacques de la. See AFFICHISTE.

Villers, Gaston de. See BERNHEIM-JEUNE.

Villon, Jacques (1875–1963). French painter, graphic artist, and designer, born at Damville in Normandy, the elder brother of Marcel and Suzanne *Duchamp and of Raymond *Duchamp-Villon. His original name was Gaston Duchamp, but he changed it in 1895 because of his admiration for the 15th-century poet François Villon. In 1894 he moved to Paris to study law (his father's profession), but he soon abandoned it for art, initially earning his living mainly as a newspaper illustrator. He was one of the founders of the *Salon d'Automne in 1903 and in 1905 he shared an exhibition with his brother Duchamp-Villon at the Galerie Legrip, Rouen. From about this time he began devoting more attention to painting, initially working in a

*Neo-Impressionist style, and from 1910 it was his main concern. In 1911 he began experimenting with *Cubism, and the following year he was one of the founders of the *Section d'Or group, whose name he coined (see also PUTEAUX GROUP). He exhibited (and sold) nine paintings at the *Armory Show in New York in 1913. After the First World War (during which he served in the army) he began painting geometrical abstracts (*Colour Perspective*, Guggenheim Museum, New York, 1921), but in the 1920s he earned his living mainly as a printmaker (he was an expert etcher). In 1921 he had a one-man exhibition at the *Société Anonyme. New York, and for most of the inter-war period he was probably better known in the USA than in Europe. During this time he moved back and forth between abstraction and a highly schematized type of figuration (*Portrait of the Artist's Father*, Guggenheim Museum, 1924). After the Second World War Villon enjoyed substantially greater recognition than in the earlier part of his career, winning First Prize at the *Carnegie International in 1956 and the Grand Prize for painting at the Venice *Biennale in 1958, when he was in his 80s. In 1955 he designed stained-glass windows for Metz Cathedral.

Vingt, Les. See LIBRE ESTHÉTIQUE.

Viola, Bill. See VIDEO ART.

Viola, Manuel. See EL PASO.

Violent Painting. See NEO-EXPRESSIONISM.

Virius, Mirko (1889–1943). Yugoslav *naive painter, born in the village of Djelekovac in Croatia, where he worked on the land. He painted from his schooldays but did not start his serious career as an artist until 1936, when he began working with Franjo *Mraz and Ivan *Generalić from the nearby village of Hlebine, the centre of Yugoslav naive painting; together they were known as the 'Hlebine Trio'. Virius became a friend of the peasant writer Pavlek Miskina and belonged to the Leftist Peasant Party. Because of his Communist views he was placed in a concentration camp in Zemun after the outbreak of the Second World War and he died there in 1943. The spirit of social consciousness showed strongly in his paintings, which were mainly on peasant themes. His style is somewhat more

naturalistic than that of many naive painters, with a fairly orthodox sense of scale and perspective, but his colours are strong and simple.

Virius is generally regarded as the second greatest painter of the *Hlebine School and within his own field some critics have ranked him as the equal or even the superior of Generalić. Unlike Generalić he preferred to work in oils and canvas rather than in a glass-painting technique. His work was first shown outside Yugoslavia at the São Paulo *Bienal in 1955, when the impression it made was so great that its sale was forbidden by the Yugoslav state. Since that time it has been exhibited in many countries.

Vivancos, Miguel García (1895–1972). Spain's best-known *naive painter, born in Mazarron, Murcia. He worked in Barcelona at various jobs (chauffeur, docker, glazier), then after fighting in the Spanish Civil War escaped to France in 1938. During the German occupation he was held in a concentration camp. In 1944 he settled in Paris, where he was employed in a clothing firm as a painter on silk and began to paint on his own. He attracted the attention of André *Breton, who wrote about him and introduced his work to dealers. During the 1950s he had one-man shows in several Paris galleries and was included in international exhibitions of naive art. He painted mainly architectural subjects and cityscapes in a manner akin to that of *Vivin.

Vivin, Louis (1861–1936). French *naive painter. He had a passion for painting from childhood but could not devote himself to it regularly until he retired from his job in the Post Office in 1922. In 1925 he was 'discovered' by Wilhelm *Uhde and thereafter he won wide recognition. His work included genre scenes, flower pieces, hunting scenes and views of Paris, notable for their charmingly wobbly perspective effects.

Vkhutemas (Vysshie Khudozhestvenno-Tekhnicheskiye Masterskiye: Higher Technical-Artistic Studios). An art school in Moscow set up after the Revolution by combining the former School of Painting, Sculpture, and Architecture with the Stroganov Art School; when it was founded in 1918 it was called *Svomas, but it was renamed Vkhutemas in 1920. *Gabo describes the workings of the school as follows (quoted by Camilla Gray in

The Great Experiment: Russian Art 1863–1922, 1962): 'it was both a school and a free academy where not only the current teaching of special professions was carried out (there were seven departments: Painting, Sculpture, Architecture, Ceramics, Metalwork and Woodwork, Textiles, and Typography) but general discussions were held and seminars conducted among the students on diverse problems where the public could participate, and artists not officially on the faculty could speak and give lessons. It had an audience of several thousand students, although a shifting one . . . There was a free exhange between workshops and also the private studios such as mine . . . During these seminars, as well as during the general meetings, many ideological questions between opposing artists in our abstract group were thrashed out. These gatherings had a much greater influence on the later development of constructive art than all the teaching.' Among the artists who had studios and taught in the Vkhutemas were *Kandinsky, *Malevich, *Pevsner, and *Tatlin. Gabo was not officially on the staff, but he taught sculpture there. The programme of the Vkhutemas was controlled by the Institute of Artistic Culture (*Inkhuk). In 1925 the name was changed from Vkhutemas to Vkhutein (Higher Technical Institute) and in 1930 the school was reorganized under central Communist Party control.

George Heard *Hamilton writes of Vkhutemas: 'The combination in one institution of theory and practice in both fine arts and the crafts . . . was symptomatic of the Soviets' desire to eliminate class distinctions between artist and artisan, as well as to emphasize the structural, materialistic basis of all artistic production. It may also account for the fact that *Constructivist design had a more lasting effect in the crafts, especially in typography, than in the major arts after further "leftist" experimentation was prohibited.'

Vlaminck, Maurice de (1876–1958). French painter (mainly of landscape and still-life), printmaker, and writer, born in Paris, to a Flemish father and a French mother. He left home in 1892 at the age of 16, and from 1893 to 1896 was a professional racing cyclist (he was a large and athletically built man), enjoying the attention his success at the sport brought him: 'At that time women admired us in the same way as today they admire an

airman.' An attack of typhoid fever ended this career, and after doing his military service, he earned his living for the next few years mainly as a violinist in nightclub orchestras (both his parents were musicians). A colourful and many-sided character, he also did other jobs, including playing billiards semi-professionally, and in 1902 he published his first novel, *D'Un Lit dans l'autre* ('From One Bed to Another'), with illustrations by *Derain (they became friends after they were both involved in a minor railway accident, and they shared a studio in 1901–2). All the while Vlaminck painted in his spare time. Apart from a few lessons from a family friend when he was a boy, he had no formal instruction in art, and he liked to inveigh against all forms of academic training, boasting that he had never set foot in the Louvre: 'I try to paint with my heart and my loins, not bothering with style.' In 1901 he was overwhelmed by an exhibition of van Gogh's work at the Galerie *Bernheim-Jeune in Paris: 'I was so moved that I wanted to cry with joy and despair. On that day I loved van Gogh more than I loved my father.' This turned him decisively towards art as a career, and in 1905 he exhibited with Derain, *Matisse and others at the 1905 *Salon d'Automne that launched *Fauvism. At this time his work showed a love of pure colour typical of the movement; often he used unmixed paint squeezed straight from the tube. From 1908, however, his palette darkened and his work became more solidly constructed, under the influence of *Cézanne. In 1910–14 he was also mildly influenced by *Cubist stylization, although he came to dislike *Picasso and regard him as a charlatan.

During the First World War Vlaminck was briefly mobilized, but he spent most of it working in war industries. Soon after the war he moved out of Paris and in 1925 settled in a farmhouse in Eure-et-Loire. Thereafter his subjects were taken mainly from the surrounding countryside. His work became rather slick and mannered, but his reputation grew steadily in France and abroad during the interwar years. After the German invasion of France in 1940, he—like several other well-known artists—was courted by the Nazis for propaganda purposes, and in 1941 he visited Germany as part of a group that included Derain, *Despiau, van *Dongen, *Dunoyer de Segonzac, and *Friesz. In 1944, immediately after the Liberation, he was arrested and interrogated, and although no action was taken against him, the suspicions of collaboration damaged his career. By the end of his life, however, he had been more or less rehabilitated. In addition to novels, Vlaminck wrote several volumes of memoirs. He was a pioneer collector of African art, although this had no influence on his style. There are examples of his work in many collections of modern art.

Vollard, Ambroise (*c.* 1867–1939). French dealer, connoisseur, publisher, and writer, one of the most important champions of avant-garde art in the early 20th century. He was a lawyer by training and began his career in the art world by buying prints from the quayside stalls along the River Seine. He opened a gallery at 39 rue Lafitte, Paris, in 1893, moved to better premises at 6 rue Lafitte the following year, and in 1895 gave the first major exhibition of *Cézanne's work. From that time up to the outbreak of the First World War the gallery was one of the city's most important centres of innovative art, other landmark events including the first one-man exhibitions of *Picasso (1901) and *Matisse (1904). The clientele included some of the leading collectors of the day, among them *Barnes, *Morozov, and Gertrude and Leo *Stein. In addition to buying and selling paintings, Vollard played an important role as a publisher by encouraging his artists to work as printmakers: he commissioned them to illustrate books (literary classics as well as contemporary works) and also issued independent portfolios of prints: 'My idea was to order engravings from artists who were not professional engravers. What might have been looked upon as a hazardous venture, turned out to be a great artistic success.' These publications (often commercial failures) were a kind of private passion, financed by his successful picture dealing, and he spared neither time nor money to achieve the finest results. The first work to bear his imprint was a portfolio of 12 colour lithographs by *Bonnard entitled *Quelques Aspects de la vie de Paris* (1895), and his most famous publication was Picasso's *Vollard Suite*, consisting of 100 etchings on various themes (notably *The Sculptor's Studio*) made between 1930 and 1937. Vollard's portrait was painted many times, among others by Bonnard, Cézanne, Picasso, *Renoir, and *Rouault. His writings include books on Cézanne, *Degas, and Renoir and the autobiographical

Recollections of a Picture Dealer (1936); a slightly expanded French version, *Souvenirs d'un marchand de tableaux*, appeared in 1937.

Vordemberge-Gildewart, Friedrich (1899–1962). German-born abstract painter who settled in the Netherlands in 1938 and became a Dutch citizen; he was one of the first artists to work in an abstract style throughout his entire career. Born in Osnabrück, he moved to Hanover in 1919 to study architecture and sculpture. He began making abstract reliefs in the same year. In Hanover he met *Arp, *Lissitzky, *Schwitters, and most importantly van *Doesberg, through whom he joined De *Stijl in 1924. Vordemberge-Gildewart was to remain faithful to the ideas of De Stijl for the rest of his life. In 1925–6 he lived in Paris and had several other stays there in the next few years, during which he had his first one-man show (in 1929 at the Galerie Povolozky) and became a member of *Abstraction-Création (in 1932). He moved from Hanover to Berlin in 1936, then in 1937 left Germany because of the Nazis, moving first to Switzerland and then settling in Amsterdam in 1938. As well as painting, his work in the Netherlands included designing window displays for department stores, and he also taught at the Academy in Rotterdam. In 1954 he returned to Germany when Max *Bill appointed him head of the Department of Visual Communication at the Hochschule für Gestaltung in Ulm, and he died in Ulm eight years later.

Vordemberge-Gildewart's work was severely geometrical, influenced by *Suprematism and *Constructivism (he sometimes added relief elements—such as sections of picture framing—to his paintings) and then most deeply by De Stijl. His austerity extended to the naming of his works, which were given numbers rather than titles, as in *Composition No. 15* (Tate Gallery, London, 1925). Harold Osborne (in the *Oxford Companion to Twentieth-Century Art*, 1981) writes of Vordemberge-Gildewart: 'It was his declared aim to bring about a reconciliation between art and technology. His meticulously planned work was tasteful as decoration in a suitably severe environment but was lacking in charm and barren of emotional appeal.' However, H. H. *Arnason (*A History of Modern Art*, 1969) is more generous in his evaluation, writing that he created 'a personal and consistent style in both painting and relief construction, a style of simplicity and clarity that has nevertheless enlarged the vocabulary of abstraction'.

Vorticism. An avant-garde British art movement launched in 1914; it was related to *Cubism and *Futurism and was mainly concerned with the visual arts, but it also embraced literature (its central figure, Wyndham *Lewis, was a writer as well as painter, and its name was suggested by the American poet Ezra *Pound, to whom the vortex represented 'the point of maximum energy', an expression of the dynamism of modern life). Vorticism was highly aggressive in tone, celebrating movement and the machine, and attacking what Lewis considered the complacency and sentimentality of contemporary British culture. It was short-lived, its vigour being dissipated by the First World War, but it had a powerful, revitalizing impact; it was the country's first organized movement to encompass abstract art and it subsequently exercised considerable influence on the development of British modernism.

Although Vorticism was not officially launched until 1914, the movement started to take shape in October the previous year, when Lewis and several of his associates left the *Omega Workshops because of a quarrel with Roger *Fry. In April 1914 Lewis formed the short-lived *Rebel Art Centre, and the names of several of the leading 'rebel' artists were used (without permission) by *Marinetti in his Futurist manifesto *Vital English Art*, published in the *Observer* on 7 June 1914 while he was visiting London. This unauthorized appropriation of his name stung Lewis into producing the first issue of his magazine *Blast: Review of the Great English Vortex* (dated June, but published in July), in which he made a bitter attack on *Vital English Art* in the shape of his own *Vorticist Manifesto*. In addition to Lewis, the signatories included Jessica *Dismoor, Henri *Gaudier-Brzeska, Pound, William *Roberts, and Edward *Wadsworth. The manifesto attacked ('blasted') a wide range of targets in an attempt to jolt Britain out of its insularity and rid it of its lingering Victorian values.

Although Lewis dissociated himself so vehemently from Marinetti, the exuberant typography of *Blast* was clearly influenced by Futurism, which was also one of the main sources for the paintings and sculptures produced by the Vorticists (even the word 'vortex' had been used by the Futurists, notably in the

title of some of *Boccioni's paintings). Lewis criticized Futurism as melodramatic, but it—like Vorticism—was essentially concerned with showing the energy of modern life. However, whilst Futurist paintings often involved blurring of forms to suggest speed, Vorticist paintings were characteristically hard, harsh and angular, evoking what *Blast* called 'the forms of machinery, factories, new and vaster buildings, bridges and works'. Because Vorticism shared some of the loud aggressiveness of Futurism, the word is sometimes associated with ceaseless, swirling energy, but to Lewis the Vortex was a still centre in the maelstrom of life, and however explosive his paintings are, they are always lucidly constructed, with a feeling of intellectual rigour rather than emotional abandon. Lewis attacked Cubism as well as Futurism, but the fragmentation of forms characteristic of Vorticism was undoubtedly indebted to Cubism.

The Vorticists held only one exhibition, at the Doré Gallery, London, in June 1915. Apart from the formal members, the artists taking part included David *Bomberg and Christopher *Nevinson. Jacob *Epstein was not included, but his work was reproduced in *Blast* and he is generally considered an associate of the movement. Several of the artists represented in the exhibition were by now producing pure abstracts; the show was far too advanced for the critics and was 'treated as an incomprehensible joke devoid of all serious merit' ('Vorticism and its Allies', Hayward Gallery, London, 1974). The second (and final) number of *Blast* appeared in July 1915, by which time the war was scattering the Vorticists and breaking up the movement (Gaudier-Brzeska had already been killed in action). Pound did his best to keep its spirit alive. He persuaded the American collector John *Quinn to buy Vorticist works (Quinn even staged a Vorticist exhibition in New York in 1917) and he encouraged the American-born photographer Alvin Langdon Coburn (1882–1966), who had settled in Britain in 1912, to experiment with semi-abstract photographic equivalents of Vorticist paintings—'Vortographs', produced by taking the image through a prismatic arrangement of mirrors. When Lewis returned from war service he made rather half-hearted plans for a third issue of *Blast*, but nothing materialized, and his attempt to revive Vorticism in 1919 as *Group X was a failure.

Lewis was the dominant figure of the movement, both as an artist and as a theorist, and he later claimed that 'Vorticism, in fact, was what I, personally, did, and said, at a certain period' (introduction to the catalogue of the exhibition 'Wyndham Lewis and the Vorticists', Tate Gallery, London, 1956). However, there was clearly a close similarity of style between his paintings and those of several of his associates, one of whom—William Roberts—vigorously disputed his claims. Roberts was only one of the other Vorticists who produced work of memorable quality, so he was fully justified in insisting they should not be dismissed as minor acolytes.

Vostell, Wolf (1932–). German artist, born at Leverkusen, best known as one of Europe's leading organizers of *Happenings. He studied graphic techniques and typography in Cologne (1950–3) and Wuppertal (1954–5), then painting at the École des *Beaux-Arts, Paris (1955–7), and the Düsseldorf Academy (1957–8). In 1954 he devised the term 'décollage' for collages he made from fragments of torn posters (a technique influenced by the *affichistes). Subsequently he applied the word to other works (as in 'Décollages-Happenings') and in 1962–9 he published a magazine called *Dé-coll/age*. He first organized Happenings in Paris in 1958 and thereafter in numerous other cities, including Berlin and New York. In 1962 he joined the *Fluxus movement. Much of his work has been politically motivated, with the accent on violence and destruction, and he described the student riots in Paris in 1968 as 'the greatest Happening of all'.

Vrubel, Mikhail (1856–1910). Russian painter and designer, the outstanding exponent of *Symbolism in his country. He was born in Omsk of Danish and Polish ancestry and had a wide experience of European art and literature (he had a very thorough academic education and visited France and Italy in 1876, 1892, and 1894). After graduating in law (his father's profession) he studied at the St Petersburg Academy, 1880–4. He then moved to Kiev, where he worked on the restoration of paintings in the ancient church of St Cyril—in his subsequent career he showed an affinity with the spirituality of medieval religious art. (Vrubel also made designs for murals for St Vladimir's Cathedral in Kiev, but the paintings were not executed.) In 1889 he moved from Kiev to Moscow and there was taken up

by the wealthy art patron Savva Mamontov (1841–1918); a portrait of him by Vrubel (1897) is in the Tretyakov Gallery, Moscow. In 1890 Vrubel began to do interpretations of Mikhail Lermontov's poem *The Demon* and the theme became central to his work. In treating it he passed from fairly naturalistic depictions to highly idiosyncratic anguish-ridden images rendered in brilliant fragmented brushwork that recalls the effects of medieval mosaics. The obsessive treatment of the theme reflected his own emotional instability; in 1902 the first symptoms of approaching insanity became apparent, in 1906 he went blind, and he died in a lunatic asylum.

Vrubel was little appreciated in his lifetime, but he stands out as the great precursor of much that was best in 20th-century Russian painting. In *Russian Art* (1990), Dimitry Sarabianov writes that 'Vrubel brought Russian art into the twentieth century . . . He ignored the conventional path which led from *Realism to *Impressionism and established the *Modern*—or Russian *Art Nouveau—style before Russian Impressionism had ever had time to develop . . . He modelled himself on the artists of the Renaissance, whom he saw as a free, independent, proud and enlightened breed of men . . . [and] created for himself a kind of myth . . . conducting himself like some kind of hero of history or literature . . . early twentieth-century poets admired him . . . warmly, for they saw in him a forerunner and a founding father of the whole new movement in Russian culture. For the first time in Russia a painter found himself ahead of his literary counterparts, confident of his own gifts and independent of all theories . . . In spite of all this, however, he was a solitary figure for much of his creative life, for fame and followers came too late.' His work is well represented in the State Museum of Russian Art, Kiev, the Tretyakov Gallery, Moscow, and the Russian Museum, St Petersburg.

Vuillard, Édouard (1868–1940). French painter, draughtsman, designer, and lithographer, born in Cuiseaux, Saône-et-Loire. His family moved to Paris when he was 10 and he went to school with Maurice *Denis and Ker-Xavier *Roussel (his future brother-in-law). All three of them studied at the *Académie Julian, and together with other students—including *Bonnard, *Sérusier, and *Vallotton—formed a group of painters called the *Nabis, whose work was predominantly *Sym-

bolist. The group flourished throughout the 1890s, and at this time Vuillard painted intimate interiors and scenes from Montmartre, his sensitive patterning of flattish colours owing something to *Gauguin but creating a distinctive manner of his own. He also designed posters and theatrical sets. From about 1900 he turned to a more naturalistic style and with Bonnard he became the main practitioner of *Intimisme, making use of the camera to capture fleeting, informal groupings of his friends and relatives in the intimate settings of their homes and gardens. He had several close female friends and preferred painting women and children to men. His work also included landscapes and portraits. Although he was financially successful, he lived modestly, sharing an apartment with his widowed mother until her death in 1928; she often features in his paintings. He was reserved and quiet in personality, although affectionate and much liked. After the First World War he seldom showed his paintings, except at the gallery of his dealer *Bernheim-Jeune, and his subsequent work remained little known to the public until a retrospective exhibition at the Musée des Arts Décoratifs in Paris in 1938. Shortly before this he had done decorative paintings for the Palais des Nations at Geneva (1936) and the Palais de Chaillot in Paris (1937), in both cases working with Roussel. He died at La Baule while fleeing the German invasion. For many years he kept a detailed journal (there are 48 volumes of it in the Institut de France, Paris), in which he revealed his thoughtful attitude towards art and life.

VVV. A *Surrealist journal edited by David *Hare and published in New York, 1942–4, during which period it was a rallying point for the European Surrealists who had taken refuge from the Second World War in the USA. Two of these exiles, André *Breton and Max *Ernst, were editorial advisers to the journal, and they were joined from the second issue by Marcel *Duchamp. There were only four issues in all: no. 1 appeared in June 1942, nos. 3 and 4 together in March 1943, and no. 4 in February 1944. The journal's subheading was 'Poetry, Plastic Arts, Anthropology, Sociology, Psychology', and the title was explained by Breton as a reference to the words Victory, View, and Veil in a passage mentioning 'Victory over the forces of regression', the 'View around us' and the 'View

inside us', and 'the myth in process of formation beneath the VEIL of happenings' (he also stresses the word 'vow', but does not capitalize it, so it does not seem to be part of his formulation). *VVV* was carefully produced, but because of wartime conditions it was necessarily less luxurious than *Minotaure*, its pre-decessor as the main Surrealist journal. It continued *Minotaure*'s practice of having specially commissioned covers: no. 1 was designed by Ernst; the double issue 2 and 3 by Duchamp (replacing *Chagall who was originally scheduled to do it); and no. 4 by *Matta.

Wadsworth, Edward (1889–1949). British painter, printmaker, draughtsman, and designer, born at Cleckheaton, Yorkshire, son of a wealthy industralist. He took up painting while he was studying engineering in Munich, 1906–7, and had his main training at the *Slade School, 1908–12, winning prizes for landscape and figure painting. In 1913 he worked for a short time at Roger Fry's *Omega Workshops, but he left with Wyndham *Lewis and joined the *Vorticist group (he was a good linguist and published translations from *Kandinsky's writings in the first number of *Blast*, 1914). At this time his work included completely abstract pictures such as the stridently geometrical *Abstract Composition* (Tate Gallery, London, 1915). This is close in style to Lewis's work of the same date, but there was a great difference in personality between the two men, as Ezra *Pound observed: 'Mr Lewis is restless, turbulent, intelligent, bound to make himself felt. If he had not been a vorticist painter he would have been a vorticist something else . . . If, on the other hand, Mr Wadsworth had not been a vorticist painter he would have been some other kind of painter . . . I cannot recall any painting of Mr Wadsworth's where he seems to be angry. There is a delight in mechanical beauty, a delight in the beauty of ships, or of crocuses, or a delight in pure form. He liked this, that or the other, and so he sat down to paint it' ('Edward Wadsworth, Vorticist', *The Egoist*, 15 August 1914). Many other critics echoed Pound's belief that Wadsworth was a born painter, for throughout his career his highly finished craftsmanship won admiration even from those who were not usually sympathetic to avant-garde art.

In the First World War Wadsworth served with the Royal Naval Volunteer Reserve as an intelligence officer in the Mediterranean, then worked on designing dazzle camouflage for ships, turning his harsh Vorticist style to practical use. This experience provided the subject for one of his best-known paintings, the huge *Dazzle-Ships in Drydock at Liverpool* (NG, Ottawa, 1919). The lucidity and precision seen in this work were enhanced when Wadsworth switched from oil painting to tempera in about 1922. At the same time his style changed, as he abandoned *Cubist leanings for a more naturalistic idiom. He had a passion for the sea and often painted maritime subjects, developing a distinctive type of highly composed marine still-life, typically with a *Surrealistic flavour brought about by oddities of scale and juxtaposition and the hypnotic clarity of the lighting (*Satellitium*, Castle Museum, Nottingham, 1932). In the 1920s and 1930s he was among the most European in spirit of British artists. He travelled widely on the Continent and in 1933 contributed to the Paris journal *Abstraction-Création*. In the same year he was a founder member of *Unit One. Around this time he again painted abstracts (influenced by *Arp), but he reverted to his more naturalistic style in 1934. In the later 1930s he had several commissions for murals, notably two panels for the liner *Queen Mary* in 1938 (these were so large that he painted them in the parish hall at Maresfield, Sussex, the village where he had settled in 1928, as this was the only building in the neighbourhood that could accommodate them).

Wadsworth was an impressive graphic artist as well as a painter. In this field he is best known for his vigorous, angular wood engravings of ships and machinery, which played a part in the revival of the woodcut after the First World War. The drawings that he published in *The Black Country* (1920, introduction by Arnold Bennett) are comparably bold, but his copper engravings for his other collection in book form, *Sailing Ships and Barges of the Western Adriatic and the Mediterranean* (1926), are delicately executed. For an

artist, Wadsworth was 'unusually businesslike, answering letters by return of post and punctiliously fulfilling his commissions' (*DNB*), but he has been aptly described by Sir John *Rothenstein as 'a true poet of the age of machines'.

Wagemaker, Jaap. See MATTERISM.

Wakefield Gallery, New York. See PARSONS.

Wakelin, Roland (1887–1971). Australian painter, born at Greytown, New Zealand. In 1912 he settled in Sydney, where he studied under *Rubbo. Like other pupils of Rubbo, he experimented with *Post-Impressionism and although his work was unexceptional by European standards, it was too advanced for local taste. When the Royal Art Society rejected Wakelin's *Down the Hills to Berry's Bay* (Art Gallery of New South Wales, Sydney, 1916) 'Rubbo was furious; he challenged a committee member to a duel, with pistols, swords or fists; the picture was hastily hung' (Robert *Hughes, *The Art of Australia*, 1970). By 1919 Wakelin was experimenting with abstraction with Roy de *Maistre—the first Australian artists to do so. However, soon after this he came under the powerful influence of Max *Meldrum and reverted to a sober, traditional style. In 1922–5 he visited Europe and this renewed his faith in modern art. *Cézanne was a dominant influence in the work he produced following his return to Australia, but in the 1930s his style became more romantic. From this time he added little to his earlier achievements or significance.

Walch, Charles. See SINGIER.

Walden, Herwarth. See STURM.

Walker, Dame Ethel (1861–1951). British painter and occasional sculptor, born in Edinburgh, the daughter of a prosperous iron-founder. She was interested in art from her schooldays but did not take up painting seriously until she was in her late 20s. Her main training was at the *Slade School under Frederick *Brown, 1892–4. Afterwards she attended evening classes under *Sickert and returned to the Slade on and off until 1921, partly to study sculpture. In 1900 she became the first woman member of the *New English Art Club and it was there that she mainly exhibited, building a reputation as one of the outstanding British women artists of her period. She painted portraits, flowerpieces, interiors, and seascapes in an attractive *Impressionist style, but her most individual works are large decorative compositions inspired by her vision of a Golden Age. They show the influence of French *Symbolist painting as well as of her interest in philosophy and religion, and they are sometimes tinged with a suggestion of orientalism (*The Zone of Hate*, 1914–15, and *The Zone of Love*, c. 1930–2; both Tate Gallery, London). 'Her visionary world was in sharp contrast to her appearance and to the studio where she lived with her canvases around her, clearing a space for meals on a table strewn with papers, brushes, and paint. The small energetic figure dressed in a rough tweed suit was a familiar sight in Chelsea, striding in Battersea Park with her dogs who shared her studio' (*DNB*). A memorial exhibition, shared with Frances *Hodgkins and Gwen *John, was held at the Tate Gallery in 1952. Examples of her work are in many public collections in Britain.

Walker, Horatio (1858–1938). Canadian painter of landscapes and scenes of peasant farming life, active mainly in Quebec City and New York. He worked in a sentimental style influenced by painters of the 19th-century Barbizon School (he visited France in 1881) and at the peak of his career he was immensely successful: Dennis Reid writes that 'By 1907 he was easily the most famous Canadian-born painter, represented in most major collections' (*A Concise History of Canadian Painting*, 1973). By the time of his death, however, his reputation had already faded badly. See also CANADIAN ART CLUB.

Walker, John (1939–). British abstract painter and printmaker, born in Birmingham. He studied at Birmingham College of Art, 1955–60, then at the Académie de la Grande Chaumière, Paris, 1960–1. His work has been much concerned with texture and he has sometimes included substances such as chalk dust and collaged pieces of canvas in his pictures, producing a battered, time-worn effect. Since 1970 he has worked mainly in the USA and he has also spent a good deal of time in Australia. His awards include first prize at the *John Moores Liverpool Exhibition in 1976.

Walker, Maynard. See REGIONALISM.

Walkowitz, Abraham (1878–1965). American painter, born at Tyumen in Siberia. In 1889 his family emigrated to New York, where he studied at the National Academy of Design. He travelled in Europe in 1906–7, studying at the *Académie Julian in Paris, and returned to New York a convinced modernist. Jerome *Myers remembered him as 'John the Baptist' returning from Paris 'to preach the gospel in modern art', and he was one of the most influential among the foreign-born artists who introduced avant-garde movements to America in the years leading up to the *Armory Show. He had his first one-man exhibition in 1908 (at the Julius Haas Gallery), and *Stieglitz gave him several shows at his 291 Gallery between 1912 and 1917. He was also included in the Armory Show and in the *Forum Exhibition (1916). His work of this time (consisting mainly of drawings) was restlessly experimental—often rhythmically abstract and somewhat *Futurist in effect, with an energetic mesh of criss-crossing lines.

In the 1920s Walkowitz began to work mainly in oils and turned to figurative subjects, sometimes with overtones of social concern. In the 1930s eye trouble forced him to give up painting. He remained a well-known figure in the New York art scene (he persuaded 100 artists to paint his portrait and exhibited the works at the Brooklyn Museum in 1944), but his contribution to the development of modernism in the USA was largely forgotten until very late in his life. His ideas on art were set out in his book *A Demonstration of Objective, Abstract, and Non-Objective Art* (1945).

Wallis, Alfred (1855–1942). British *naive painter of sailing ships and landscapes, born in Devonport. He went to sea as a cabin boy and cook at the age of 9, and from 1880 worked as a fisherman in Cornwall. In 1890 he opened a rag-and-bone store in St Ives, and after retiring from this did a few odd jobs, including selling ice-cream. He began to paint in 1925 to ease the loneliness he felt at his wife's death and was discovered by Ben *Nicholson and Christopher *Wood in 1928, the unselfconscious vigour of his work making a powerful impression on them. They introduced his work to friends, including H. S. *Ede (whose collection of Wallis's paintings can be seen at Kettle's Yard, Cambridge) and Herbert *Read. Wallis painted from memory and imagination, usually working with ship's paint on odd scraps of cardboard or

wood. Although he rapidly became the best known of British naive artists, he died in a workhouse. His admirers in the art world arranged for the great potter Bernard Leach to design his gravestone in Barnoon Cemetery, St Ives. The inscription on it reads: 'Alfred Wallis, Artist and Mariner'.

Walton, Cecile. See EDINBURGH GROUP.

Walton, Edward Arthur. See GLASGOW BOYS.

Walton, George. See GLASGOW SCHOOL.

War Art. See OFFICIAL WAR ART.

Warhol, Andy (1928–87). American painter, printmaker, sculptor, draughtsman, filmmaker, writer, and collector, one of the most famous and controversial artists of the 20th century. He was born in Pittsburgh to Czechoslovakian immigrant parents; his surname was originally Warhola. After studying painting and design at the Carnegie Institute of Technology, Pittsburgh, 1945–9, he settled in New York. In the 1950s he was enormously successful as a commercial artist (specializing in shoe advertisements); he twice won the Art Directors' Club Medal (1952 and 1957) and by 1956 he was earning $100,000 a year. At the same time he was exhibiting drawings (to little critical attention) and he published six books of reproductions of them between 1954 and 1959.

In 1960 Warhol began making paintings based on mass-produced images such as newspaper advertisements and comic strips, then in 1962—at the suggestion of a friend—he started using dollar bills and Campbell's soup cans as his subjects. At first he painted these freehand, but he quickly switched to the *screenprint process. The soup can pictures were first exhibited in the summer of 1962 at the Ferus Gallery in Los Angeles, then in autumn of the same year at the Stable Gallery, New York. The second exhibition was a sensational success and Warhol soon became the most famous and controversial figure in American *Pop art. In the same vein as his soup cans he did pictures of Coca-Cola bottles and made equally banal sculptures of Brillo soap pad boxes and similar cartons. He also embarked on a lengthy series of pictures of Marilyn Monroe, Elvis Presley, Elizabeth Taylor, and other celebrities. Similar in method but different in effect were his pictures of

disasters such as car crashes and views of the electric chair. Whatever the subject in his pictures, he often made use of rows of repeated images. The screenprinting process allowed infinite replication, and he was opposed to the idea of a work of art as a piece of craftsmanship, hand-made and expressing the personality of the artist: 'I want everybody to think alike. I think everybody should be a machine.' In keeping with this outlook he used clippings of 'dehumanized' illustrations from the mass media as his sources, turned out his works like a manufacturer, and called his studio 'The Factory'. There he was surrounded by a crowd of helpers and hangers-on, described by Robert *Hughes as 'cultural space-debris, drifting fragments from a variety of sixties subcultures'. Warhol liked to give the impression that he took a paternal interest in his followers, but Eric Shanes (*Warhol*, 1991) writes that 'Just how cynical he could be in his dealings with his entourage is demonstrated by an incident that occurred in October 1964 when one of his hangers-on, Freddie Herko, committed suicide by jumping from a fifth-floor window in Greenwich Village while high on LSD: Warhol was heard to complain repeatedly that Herko should have forewarned him so that he could have filmed his death'.

In 1965 Warhol announced his retirement as an artist to devote himself to films and to managing the rock group The Velvet Underground, but in fact he never gave up painting and in the 1970s and 1980s he made an enormous amount of money churning out commissioned portraits of wealthy patrons; in 1986 the Christmas catalogue for the Neiman-Marcus department stores advertised a portrait session with him for $35,000 ('Become a legend with Andy Warhol'). In the 1980s he sometimes collaborated with other painters, including the *Graffiti artist Jean-Michel Basquiat and LeRoi Neiman (1927–), who is best-known for his illustrations in *Playboy* magazine.

As a film-maker, Warhol became perhaps the only 'underground' director to be well-known to the general public. His first films were silent and virtually completely static: *Sleep* (1963)—a man sleeping for six hours; and *Empire* (1964)—the Empire State Building seen from one viewpoint for eight hours: 'I like boring things.' Later films, such as the two-screen *Chelsea Girls* (1966), gained widespread attention because of their voyeuristic concentra-

tion on sex. In 1968 Warhol was shot and severely wounded by a bit-part player in one of his films, a member of SCUM (The Society for Cutting Up Men), an incident that added to his legendary status. By this time he was perhaps already more famous for his celebrity-courting, partying lifestyle and deliberately bland persona than for his art; indeed, it could be argued that his advertising skills were nowhere more brilliantly deployed than in promoting himself.

In purely financial terms his success in self-promotion was prodigious. At his death (following a routine gall bladder operation) he left a fortune estimated at $100,000,000, most of which went to create an arts charity, the Andy Warhol Foundation. His status as an artist, however, is controversial. Even his most fervent admirers tend to admit that he added little to his achievement as a painter after the mid-1960s, but large claims are sometimes made for his earlier works. Eric Shanes, for example, writes: 'Through pioneering a variety of techniques, but principally the visual isolation of imagery, its repetition and similarity to printed images, and the use of garish colour to denote the visual garishness that is often encountered in mass culture, Andy Warhol threw much direct or indirect light upon modern *anomie* or alienated world-weariness, nihilism, materialism, political manipulation, economic exploitation, conspicuous exploitation, media hero-worship, and the creation of artificially-induced needs and aspirations. Moreover, in his best paintings and prints he was a very fine creator of images, with a superb colour sense and a brilliant feel for the visual rhythm of a picture resulting from his intense awareness of the pictorial potentialities of abstract forms.' Bernard Levin, however, probably speaks for many in describing Warhol as 'that one-man demonstration of the triumph of publicity over art'.

Warhol published a celebrity magazine called *Interview*, and several books appeared under his name, some genuinely written by him, others put together from tapes. They include *'a' A Novel* (1968) and *The Philosophy of Andy Warhol (From A to B and Back Again)* (1975). *The Diaries of Andy Warhol* appeared posthumously in 1989. His extensive collection of art and artefacts (including much jewellery but comparatively few paintings) was auctioned at Sotheby's, New York, in 1988; the catalogue extended to six volumes. In 1994 a

museum dedicated to his work opened in his home town of Pittsburgh, and the Warhol Foundation has helped to build a museum of modern art at Medzilaborce in Slovakia, near to the village of Mikova, where his parents once lived.

Washington, DC, Hirshhorn Museum and Sculpture Garden. See HIRSHHORN.

Washington, DC, Phillips Collection. See PHILLIPS, DUNCAN.

Washington Color Painters. Name given to a group of American painters living in Washington, DC, who in the 1950s and 1960s were leading exponents of *Colour Field Painting. The two most important figures were Morris *Louis and Kenneth *Noland; others were Gene Davis (1920–85), Thomas Downing (1928–), Howard Mehring (1931–), and Paul Reed (1919–). The name comes from an exhibition entitled 'The Washington Color Painters' held at the Washington Gallery of Modern Art in 1965. Sometimes they are known as the Washington Color Field painters.

Watson, Homer (1855–1936). Canadian landscape painter, born and active for most of his life at Doon, near Kitchener, Ontario. He was mainly self-taught. His early works were rather dry and descriptive, but after a visit to England in 1887–90 his style became much freer and more *Impressionist (although it was before this visit, in 1882, that Oscar Wilde, seeing Watson's work in Toronto, dubbed him 'the Canadian Constable'). Around the turn of the century Watson was internationally famous, but after his wife's death in 1918 he devoted much of his time to spiritualism, and by the time of his own death he was bankrupt and forgotten.

Watt, Alison (1965–). Scottish painter of portraits, figures, and still-life, born in Greenock. She studied at *Glasgow School of Art from 1983 to 1988, and like Stephen *Conroy, who was a year ahead of her there, she had achieved substantial success before she completed her postgraduate studies, winning the John Player Portrait Award in 1987. In 1989 she was commissioned by the National Portrait Gallery, London, to paint a portrait of the Queen Mother. Duncan Macmillan (*Scottish Art of the 20th Century*, 1994) writes that 'Watt's

success in England perhaps reflects the extent to which her work can be aligned with the tradition of figure painting represented by *Coldstream and Lucian *Freud . . . in the way she draws she is closer to the English tradition than to James *Cowie, for example, to whom she has been compared . . . She picks up elements of imagery and technique from a variety of sources and recombines them in a way that is self-consciously surreal and enigmatic . . . Although she does not use chiaroscuro as Conroy does but paints with a light tonality, as with his painting the real quality of her work lies in her command of the classic painterly virtues of texture and surface.'

Watts, George Frederic. See TATE GALLERY.

Wayne, June. See PRINT RENAISSANCE.

Wearing, Gillian. See TURNER PRIZE.

Webb, Sir Aston. See ROYAL ACADEMY.

Weber, Max (1881–1961). Russian-born American painter, sculptor, printmaker, and writer, whose work more than that of any other American artist synthesized the latest European developments at the beginning of the 20th century. He was born in Belostok (now Białystok, Poland) and emigrated to New York with his parents when he was 10. After studying at the Pratt Institute, New York, from 1898 to 1900, he taught in schools for several years, then travelled in Europe, 1905–8. In Paris he studied briefly at the *Académie Julian and with *Matisse, fell under the spell of *Cézanne, admired the early *Cubism of *Braque and *Picasso, and became a friend of Henri *Rousseau (in 1910 he arranged the first American exhibition of Rousseau's work at *Stieglitz's 291 Gallery). After his return to New York in 1909, Weber rapidly became a controversial figure—no other American avant-garde artist of the time exhibited his work more widely or was more harshly attacked by the critics. His work was influenced by *Fauvism and primitive art (he was one of the first American artists to show interest in it—specifically in native American art), but most importantly by Cubism (in sculpture as well as painting). After about 1917, however, Weber's work became more naturalistic. During the 1930s his subjects often expressed his social concern, notably in pictures of refugees (in 1937 he was national

chairman of the left-wing *American Artists' Congress), and in the 1940s his work included scenes with rabbis and Jewish scholars—mystical recollections of his Russian childhood. He published several books, including *Cubist Poems* (1914), *Essays on Art* (1916), and the autobiographical *Max Weber* (1945). In the 1920s he taught at the *Art Students League, his most important pupil being Mark *Rothko.

Weight, Carel (1908–97). British painter of portraits, landscapes, townscapes, and imaginative figure compositions, born in London, partly of German and Swedish descent. Originally he trained to be a singer, but he gave this up for painting and studied at Hammersmith School of Art, 1928–30, and at Goldsmiths' College, 1930–3. He exhibited at the *Royal Academy from 1931 and his first one-man exhibition was at the Cooling Gallery, London, in 1933. In the Second World War he served with the Royal Engineers and Army Education Corps and was appointed an *Official War Artist in 1945, working in Austria, Greece, and Italy. He began teaching at the *Royal College of Art in 1947 and was professor of painting there from 1967 until his retirement in 1973. In 1969 a series of short monographs called 'Painters on Painting' was published under his general editorship; it included a study of *Léger by Peter *de Francia.

Weight was something of a maverick figure ('I don't like the art world very much. I don't like the dealers and I don't like the critics') and his work is highly individual. Carol Fitzgerald has written of him: 'His paintings often present an apparently realistic suburban setting in which unexpected human dramas are enacted. Subjects are depicted in strong colour, idiosyncratic perspective and small, open brushmarks, and the integration of figures, setting, light and atmosphere produces a strong emotional content, sometimes humorous, sometimes menacing' (in Alan Windsor, ed., *Handbook of Modern British Painting*, 1992). Weight himself wrote of his work in 1979: 'I aim to create in my painting a world superficially close to the visual one but a world of greater tension and drama. The products of memory, mood and imagination rise upon a foundation of fact. My art is concerned with such things as anger, love, fear, hate and loneliness, emphasized by the ordinary landscape in which the dramatic scene is set.'

Weir, Julian Alden. See TEN.

Weisman, Marcia and **Frederick R.** See MUSEUM OF CONTEMPORARY ART, LOS ANGELES.

Wentworth, Richard. See NEW BRITISH SCULPTURE.

Werefkin, Marianne von (1870–1938). Russian painter, born at Tula, near Moscow. She studied under *Repin in St Petersburg and in 1891 met her fellow-student *Jawlensky, who became her companion for the next 30 years. They shared a dislike of the historical realism practised by Repin and in 1896 moved to Munich in search of a more sympathetic environment. They were founder members of the *Neue Künstlervereinigung in 1909 and in 1914 they settled at Ascona in Switzerland. Werefkin finally parted from Jawlensky in 1921 when he moved to Wiesbaden; she remained at Ascona for the rest of her life.

Werefkin's early painting was influenced by *Symbolism, but in Germany she developed an *Expressionist style characterized by bright, flat colours and often a rather mystical mood. George Heard *Hamilton writes that her 'enthusiasm for French Symbolist poetry and painting, her belief in the necessity for a new art more immediately expressive of individual personality, and her encouragement of her companions were important contributions to the development of the new ideas in Munich, more important than her own paintings and drawings, which she herself considered secondary to the work of her friends'.

Werenskiold, Erik (1855–1938). Norwegian painter and graphic artist. He was one of the leading personalities in Norwegian art, the friend of numerous writers and intellectuals, and a symbol of national culture. His work included landscapes, in which he showed an affectionate yet unsentimental approach to his native land, portraits of many of the leading Norwegians of his day (*Henrik Ibsen*, NG, Oslo, 1895), and book illustrations. After the turn of the century he was influenced by *Cézanne.

Werner, Theodor. See ZEN 49.

Wesselmann, Tom (1931–). American painter, sculptor, and printmaker, born in Cincinnati. He studied psychology at the University of Cincinnati, 1951–2 and 1954–6, and

during the latter period also took classes at the Art Academy of Cincinnati. From 1956 to 1959 he continued his studies in art at the Cooper Union, New York. Originally he had intended becoming a cartoonist, but he turned to painting. In 1961 he had the first of many one-man exhibitions (at the Tanager Gallery, New York) and soon afterwards he emerged as one of the leading figures in American *Pop art. He often incorporates elements of *collage or *assemblage in his work, using household objects such as television sets and sometimes including sound effects. His subjects are characteristically aggressively sexual and he is best known for his continuing series *Great American Nude* (begun 1961), in which the nude becomes a depersonalized sex symbol set in a realistically depicted commonplace environment. He emphasizes the woman's nipples, mouth, and genitals, with the rest of the body depicted in flat, unmodulated colour. In other works he isolates parts of the body still further, as in his *Smoker* series, in which the mouth—often depicted on a huge scale—becomes a provocatively erotic symbol. In the 1980s he began making massive 'drawings' cut from sheets of aluminium or steel. He has also made prints in a variety of techniques.

West Coast Figuration. See BAY AREA FIGURATION.

Westerik, Co. See VERVE.

Westhoff, Clara. See WORPSWEDE.

Wheeler, Sir Charles (1892–1974). British sculptor (and occasional painter). He was born in Codshall, Staffordshire, and studied at Wolverhampton School of Art, 1908–12, and the *Royal College of Art, 1912–17. Wheeler did many portrait busts, but the major part of his output was devoted to public sculpture; his biggest commission was for the Bank of England, for which he did various works between 1930 and 1937, including three bronze doors and a series of giant stone figures on the exterior. His style could be rather ponderous, and Dennis Farr writes that 'Wheeler was at his best when applying his lyrical academicism to smaller-scale work, although his bronze group for the Jellicoe Fountain, Trafalgar Square (begun in the late 1930s, unveiled 1938), with its Scandinavian air, is a delightful monument in a period not

well endowed in this respect' (*English Art 1870–1940*, 1978). From 1956 to 1966 Wheeler was president of the *Royal Academy. The most notable event of his presidency was the controversial sale of the Academy's greatest treasure, Leonardo da Vinci's cartoon of *The Virgin and Child with St Anne and St John the Baptist* (now in the National Gallery); fear that the masterpiece would leave Britain 'provoked extensive press and public obloquy', but the sale 'did secure the [Academy's] finances for almost the next 20 years' (*DNB*). The matter is discussed at length in Wheeler's autobiography, *High Relief*, published in 1968. His wife, Muriel Bourne, was a painter and sculptor.

Whishaw, Anthony. See BROWSE.

Whistler, James Abbott McNeill (1834–1903). American painter and etcher, active mainly in England, where he was one of the key artistic figures of his period. He was celebrated as a wit and a dandy as well as an artist and he loved controversy. His art is in many respects the opposite of his often aggressive personality, being discreet and subtle, but the creed that lay behind it was radical. He believed that painting should exist for its own sake, not to convey literary or moral ideas, and he often gave his pictures musical titles to suggest an analogy with the abstract art of music: 'Art should be independent of all claptrap—should stand alone, and appeal to the artistic sense of eye or ear, without confounding this with emotions entirely foreign to it, as devotion, pity, love, patriotism and the like. All these have no kind of concern with it, and that is why I insist on calling my works "arrangements" and "harmonies".' He was a laborious and self-critical worker, but this is belied by the flawless harmonies of tone and colour he created in his paintings, which are mainly portraits and landscapes (including many views of the Thames). His work is related to *Impressionism (although he was more interested in evoking a mood than in accurately depicting the effects of light) and to *Symbolism, and it was strongly influenced by Japanese art, but his exquisite taste allowed him to combine disparate sources in a novel, almost abstract synthesis.

In his book *Modern Painting* (1893) George *Moore gives a good indication of Whistler's importance in turn-of-the-century British art: 'More than any other painter, Mr Whistler's influence has made itself felt in English art.

More than any other man, Mr Whistler has helped to purge art of the vice of subject and belief that the mission of the artist is to copy nature.' He was a magnetic personality and had a powerful impact on the life and work of many of his contemporaries. Indeed, by the end of his life 'he had a substantial band of followers ready to proclaim him the greatest artist of the nineteenth century' (Allen Staley in Mervyn Levy, ed., *Whistler Lithographs*, 1975). Those who were most immediately influenced by him included his pupils Walter *Greaves, Gwen *John, Mortimer *Menpes, and W. R. *Sickert, together with his laudatory biographer Joseph *Pennell. More generally, Dennis Farr has written that 'In both his oils and graphics, the treatment of certain themes . . . shows a continuing preoccupation with the formal, one might almost say geometrical aspect, that anticipates the two-dimensional abstraction of much twentieth-century art' (*English Art 1870–1940*, 1978).

Whistler, Rex (1905–44). British painter, graphic artist, and stage designer, born at Eltham, Kent. His main training was at the *Slade School, 1922–6, and he also studied in Rome. He is best known for his decorations in a light and fanciful style evocative of the 18th century, notably the series of murals *In Pursuit of Rare Meats* (1926–7) in the restaurant of the Tate Gallery, London. He also did numerous book illustrations and much work for the stage, including ballet and opera. In 1940 he was commissioned in the Welsh Guards and he was killed in action in Normandy. His brother **Laurence Whistler** (1912–), a writer and glass engraver, has published several books on him.

Whitechapel Art Gallery. An art gallery in Whitechapel High Street, in the East End of London, devoted to temporary exhibitions, mainly of modern art (there is no permanent collection). It had its origins in the activities of Canon Samuel Augustus Barnett, rector of St Jude's Whitechapel from 1873 to 1894; he was a noted social reformer who from 1881 organized art exhibitions as one of his means of bringing spiritual uplift to his parish, described by his bishop as 'the worst in the diocese, inhabited mainly by a criminal population'. Private individuals who admired Barnett's work, notably the philanthropist John Passmore Edwards, financed a permanent gallery, which was built in 1897–9. The

architect was Charles Harrison Townsend, and the façade is one of the best examples of his free and vigorous Arts and Crafts style; Sir Nikolaus Pevsner described it as 'a façade without any borrowed motifs of the past, as original as any *Art Nouveau on the Continent'. Walter *Crane designed a mosaic to go over the entrance, but it was never executed because of lack of funds. The interiors are very simple, with top daylighting to the main gallery. The Whitechapel opened in 1900, with Charles *Aitken (later director of the Tate Gallery) as first director. In its early years it was a stimulus to several notable artists living in the East End, notably David *Bomberg, Mark *Gertler, and Isaac *Rosenberg, and in 1914 Bomberg organized an exhibition there entitled 'Twentieth Century Art—a Review of Modern Movements'. During the 1930s the gallery ran shows of local amateur art that contrasted with the elitism of West End exhibitions. Madge Gill (see AUTOMATISM) was one of the artists who took part in these shows. The Whitechapel continues to be one of the country's leading venues for exhibitions of modern art (see, for example, NEW GENERATION). The gallery is an independent charitable trust and receives support from the *Arts Council and other bodies.

Whiteley, Brett (1939–92). Australian painter, born in Sydney, where he studied at the Julian Ashton Art School, 1957–9. In 1960 he travelled to Europe on a scholarship and after a few months in Italy moved to London in 1961. At this time there was something of a vogue for Australian art in Britain and he quickly achieved success; he won the international prize at the Paris *Biennale for Young Artists in 1961 and had his first one-man exhibition in 1962, at the Matthiesen Gallery, London. After spending a year and a half in New York and a year in Fiji, he returned to Sydney in 1970. Whiteley's work was based on the human figure but often came close to abstraction. His imagery was sometimes erotic or violent; in 1964–5, for example, he did a series based on the crimes of the infamous sex murderer Christie, who was executed in London in 1953. His later life was marred by personal problems, including divorce and a battle with addiction to alcohol and drugs: 'He remained an artist of prolific output and his work showed little of the desperate struggle his life had become . . . He was found dead in a motel room, the coroner's verdict being "death by

self-administered substances"—believed to be a tragic accident, his spirits and health having improved markedly in the months before his death' (Alan McCulloch and Susan McCulloch, *Encyclopedia of Australian Art*, 3rd edn., 1994). Christopher Allen (*Art in Australia*, 1997) writes that Whiteley was the artist who most 'truly speaks for middlebrow Australian culture in the seventies and eighties . . . the media loved him and his every sketch met with adulation . . . With his brilliant facility, bright colours, images of sun, sea and sexual passion, he became the acceptable face of modernism and his pictures, though growing steadily worse and more vacuous, continued to fetch higher and higher prices.'

Whiteread, Rachel (1963–). British sculptor, born in London. Her mother, Pat Whiteread, is an artist in various media: 'I'm a Christian socialist feminist artist, and it doesn't matter to me what the medium is, as long as it's the right one.' Rachel studied at Brighton Polytechnic, 1982–5, and the *Slade School, London, 1985–7. In 1988 she began making a novel type of sculpture consisting of casts of domestic features or the spaces around them (such as the space under a bed). These pieces, carrying 'the residue of years and years of use' culminated in *Untitled (House)* (1993), a concrete cast of an entire house in Grove Road in the East End of London, sponsored by Tarmac Structural Repairs. The house itself was demolished once the cast was made, leaving Whiteread's ghostly replica on the site. It won her the *Turner Prize in 1993 and generated so much publicity that it made her probably the most famous artist in Britain apart from Damien *Hirst (although, unlike Hirst, she does not court media attention). The Turner jury praised the work for 'its combination of austere monumentality and immediacy of reference to the everyday world', its 'haunting qualities' and its 'poetic strangeness'. Many people, however, regarded it as an ugly lump of concrete, and on the night Whiteread received her £20,000 prize money, she was also given a spoof rival award of £40,000 for producing the year's worst body of work. The spoof award was given by the K Foundation, otherwise known as the pop music duo KLF, agents provocateurs of the art world, who the previous year had become notorious for burning £1,000,000 in £50 notes, representing almost all the money they had made from their records. The £40,000 they awarded Whiteread

(in cash) was nailed to a picture frame hung on railings outside the Tate and she was given 30 minutes to accept it or see it go up in flames. She accepted it and gave it away. Later that year a controversy ensued about the fate of *House*, which had only temporary planning permission. Some supporters regarded it as a masterpiece that should be preserved at all costs, but other people thought it was an eyesore. In spite of a vigorous campaign to save it, the work was demolished in 1994. Following her success as the first woman to win the Turner Prize, in 1997 Whiteread became the first woman to represent Britain with a solo show at the Venice *Biennale (Barbara *Hepworth in 1950 and Bridget *Riley in 1968 had shared the British Pavilion).

Whitford, Frank (1941–). British writer, teacher, and broadcaster, born in Bishopstoke, Hampshire. He studied at Wadham College, Oxford, the *Courtauld Institute of Art, London, and the Freie Universität, West Berlin. For several years he worked as a cartoonist for the *Sunday Mirror* and the London *Evening Standard*, then from 1970 taught at various institutions, including the *Slade School and the *Royal College of Art. His books (mainly on German and Austrian art) include *Expressionism* (1970), *Japanese Prints and Western Painters* (1977), *Bauhaus* (1984), and monographs on *Kandinsky (1971), *Schiele (1981), and *Klimt (1990). They combine high scholarly standards with an accessible style. Whitford has also helped to organize several exhibitions, has written for various journals and newspapers, particularly the *Sunday Times*, and has appeared in radio and television programmes about art, including the Channel 4 quiz show *Gallery*, in which Maggi *Hambling and *George Melly were other regulars.

Whitney, Gertrude Vanderbilt (1875–1942). American sculptor, patron, and collector, the founder of the Whitney Museum of American Art. She was born in New York, the daughter of Cornelius II Vanderbilt, an immensely wealthy railroad magnate. In 1896 she married Harry Payne Whitney, a financier and world-class polo player. After her marriage she turned seriously to art, her training as a sculptor including periods at the *Art Students League, New York, and in Paris, where she knew *Rodin. She won several major commissions, notably for monuments

commemorating the First World War, including the Washington Heights War Memorial, New York (1921), and the St-Nazaire Monument, Providence, Rhode Island (1924), marking the landing of American troops in France. Her style was traditional, but she was sympathetic towards progressive art and is much more important as a patron than as an artist. In 1907 she opened her New York studio as an exhibition space for young artists who found the commercial galleries closed to them, and in 1908 she bought four of the seven paintings that were sold at The *Eight's exhibition. In 1914 she put her patronage on a more formal basis when she bought the house adjoining her studio, converted it into galleries, and opened it as the Whitney Studio; later she founded a series of organizations in New York with the same aim of helping young artists— the Friends of Young Artists (1915), the Whitney Studio Club (1918), and the Whitney Studio Galleries (1928). In 1929 she offered to donate her own collection of about 500 American paintings, sculptures, and drawings to the Metropolitan Museum, New York, but the gift was turned down. Consequently in 1930 she announced the founding of the Whitney Museum of American Art and it opened the following year at 10 West 8th Street in a group of converted brownstone buildings. Originally the museum aimed to cover the whole span of American art, but in 1949 the Trustees decided that it could not compete with established collections in the historical field and sold all works done before 1900. In 1966 this decision was modified; the museum began again to collect earlier works, but it concentrates on the 20th century. There have been two changes of location to provide more space for the rapidly expanding collection. In 1954 the museum moved to a new building at 22 West 54th Street on land provided by the *Museum of Modern Art, and in 1966 to its present home—a spectacular building designed for it by Marcel Breuer at 945 Madison Avenue. The museum now has the largest and finest collection of 20th-century American art in the world, including, for example, some 2,000 works by Edward *Hopper donated by his widow. Every other year it holds the Whitney Biennial, a major showcase for work by living artists (this began in 1973; previously the exhibition had been annual).

Also named after Mrs Whitney is the Whitney Gallery of Western Art at the Buffalo Bill

Historical Center at Cody, Wyoming. She was instrumental in acquiring the land for the Center and did a large equestrian statue of Buffalo Bill for it (1924). She donated funds to many other good causes, artistic and otherwise (in the First World War she equipped and maintained a hospital in France), but she was 'a woman of modest disposition who carried out her public activities quietly' (*Dictionary of American Biography*). In 1932 she published a novel, *Walking the Dusk*, under the pseudonym E. J. Webb.

Her nephew **John Hay Whitney** (1904–82) was a publisher, diplomat (he was Ambassador to Great Britain, 1956–60), and collector of paintings, including 20th-century works. From 1946 to 1956 he was chairman of the Museum of Modern Art, New York.

Wickey, Harry. See MYERS.

Wieland, Joyce. See SNOW.

Wiener Aktionismus. See VIENNA ACTIONISTS.

Wiener Werkstätte (German: Viennese Workshops). Arts and crafts studio established in Vienna in 1903 by members of the *Sezession. The designers and craftsmen working here, like the British designer William Morris (1834–96), aimed to combine usefulness with aesthetic quality and to reach a wide public. Again like Morris, they were defeated in the last aim because their prices were necessarily high. They made everything from jewellery to complete room decorations (including mosaics) and in the early years of the operation often worked in an *Art Nouveau style. The workshops closed in 1932. See also KLIMT.

Wilding, Alison. See NEW BRITISH SCULPTURE.

Wild Painting. See NEO-EXPRESSIONISM.

Wilenski, R. H. (Reginald Howard) (1887–1975). British writer on art (and occasional painter). He was born in London and studied at Balliol College, Oxford. From 1923 to 1926 he was art critic for the London *Evening Standard*, and he later wrote for the *Observer* and other newspapers. Much of his writing was devoted to modern art, and in the 1920s and early 1930s (until overtaken by Herbert *Read)

he ranked as the leading spokesman for Britain's artistic avant-garde, particularly in sculpture. He was a vigorous champion of *Epstein at a time when he received routine abuse from many critics, and he was an early supporter of *Moore (on whom he published the first substantial article, in *Apollo* in 1930) and of *Hepworth. His books of this period include *The Modern Movement in Art* (1927) and *The Meaning of Modern Sculpture* (1932). In the latter he made a vehement attack on the cult of Greek sculpture, which he regarded as concerned only with 'the desirability of beautiful boys and pretty girls'. This he contrasted with the austere 'creed' of the modern sculptor, who—influenced by Negro art—valued abstract form and personal engagement with the material through *direct carving. Wilenski published many other books in his long career, generally smoothly-written popular works, although *Flemish Painters 1430–1830* (2 vols., 1960) is a massively dense and rather eccentric compilation of information, many years in the making. He was also editor of 'The Faber Gallery' (begun 1945), a series of short monographs with colour plates, and he wrote many of the individual volumes himself. His best-known book is probably *Modern French Painters* (1940, 2nd edn., 1945). Reviewing this in the *New Statesman*, Clive *Bell described it as 'a book which everyone who cares for painting should read, which anyone seriously concerned with modern art must read . . . On every other page Mr Wilenski produces a surprise.' In his celebrated *History of Impressionism*, John Rewald calls it 'an interesting but completely unreliable book'.

Wilfred, Thomas (Richard Edgar Løvstrøm) (1889–1968). Danish-American experimental artist, born at Naestved. After studying music and art in Copenhagen, London, and Paris, he settled in the USA in 1916. Wilfred was one of the leading pioneers of *Light art, probably the first person to conceive of light as an independent art medium, through which he aimed to create a kind of abstract visual music. He began experimenting with light patterns in 1905, starting with 'a cigar box, a small incandescent lamp, and some pieces of glass'. In 1919 he built his first 'Clavilux', in which light passed through an assembly of adjustable mirrors and coloured glass slides—controlled by keyboards—before being projected on a screen, where it could be made to produce subtle and complicated gradings and

mixtures of colour. He first demonstrated his invention at the Neighbourhood Playhouse in New York in 1922, and subsequently made more than 20 works of this kind and many other light structures. In 1930 he founded the Art Institute of Light in New York for scientific research into the artistic uses of light, and this carried on until 1943. Wilfred called his new art form 'Lumia' and in an article he wrote in 1948 he spoke of using it to 'express the human longing for a greater reality, a cosmic consciousness, a balance between the human entity and the great common denominator, the universal rhythmic flow' ('Composing in the Art of Lumia', *Journal of Aesthetics and Art Criticism*, December 1948). He made tours with his light projections in the USA, Canada, and Europe, but until the 1960s he was generally regarded more as a curiosity than a serious artist.

Williams, Frederick (1927–82). Australian painter and printmaker, regarded as the most original portrayer of his country's landscape. He studied at the National Gallery School in his native Melbourne, 1944–9, then in London at Chelsea School of Art (where John *Berger was among his teachers) and the Central School of Arts and Crafts, 1951–6. His earliest etchings, often with music-hall subjects, were produced at about this time. He returned to Australia in 1957, and from the late 1950s began to produce landscapes revealing a distinctly personal vision of the country's landscape, such as *Charcoal Burner* (NG of Victoria, Melbourne, 1959). By increasing reductivism his paintings of the 1970s became powerfully evocative of a sense of primeval mystery and remoteness. Unlike other modern Australian artists who had memorably portrayed aspects of their country's landscape (notably Arthur *Boyd, Russell *Drysdale, and Sidney *Nolan), Williams rarely featured the human figure in his paintings. Bernard Smith writes that he used 'a palette which has long been associated with the Australian landscape: ochres, russets, pale olive greens, pale blues, and dull brick reds. His surfaces are rich and opulent, varying from thin, transparent stains to creamy, impasted accents; the colour finely modulated and grained, seen as though bleached by veils of dust or heat-haze. The horizon is often placed near the top of the picture or is not there at all, so that the landscape is seen as if from the air. Williams does not seek to convey an impression of a

particular place but a region, or something about the character of the bushland more general still' (*Australian Painting 1788–1990*, 1991). In the 1970s he broadened his range to include marine subjects and murals (Adelaide Festival Theatre, 1972). His work is represented in many leading public collections, including all Australian state galleries.

Williamson, Curtis. See CANADIAN ART CLUB.

Willing, Victor. See REGO.

Willumsen, Jens Ferdinand (1863–1958). Danish painter, sculptor, architect, engraver, potter, writer, and collector. He was born in Copenhagen, where he studied at the Academy. In 1888–9 he visited Paris, and he was again in France between 1890 and 1894, abandoning his early naturalistic style under the impact of *Gauguin (whom he met in Brittany) and *Symbolism. His work became highly individual, notable for its obscure and disturbing subject-matter and glaringly bright colours (*After the Tempest*, NG, Oslo, 1905). His sculpture is often polychromatic, using *mixed media, showing the influence of *Klinger. Willumsen was also influenced by El Greco, on whom he wrote a long book (2 vols., 1927). He designed two villas for himself in Denmark, but after the First World War he spent most of his life in the South of France. His later work included numerous portraits. He was one of the leading personalities of his time in Danish art, idolized as a genius by his admirers, but decried by others. There is a museum devoted to Willumsen at Frederikssund in Denmark, containing work he collected as well as produced himself.

Wilmarth, Christopher (1943–87). American abstract sculptor, born in Sonoma, California. He worked as a studio assistant to Tony *Smith before studying at the Cooper Union, New York, where he graduated in fine art in 1965; in 1969 he began teaching there. His early work was in wood (for a time he earned his living as a cabinetmaker), but his favoured materials were glass and steel. Unlike many sculptors who used these materials, however, he aimed for poetic rather than industrial effects (the French poet Stéphane Mallarmé was one of his greatest inspirations). His forms were fairly minimalist, but he made subtle play with the qualities of glass—its reflectiveness, translucency, transparency, or opacity. Wilmarth committed suicide. Although he had a fairly low profile, he had many admirers. Reviewing an exhibition of his work art the Museum of Modern Art, New York, in 1989, Robert *Hughes described him as 'by far the best American sculptor of his generation'.

Wilson, Richard. See INSTALLATION.

Wilson, Scottie (Robert) (1889–1972). British self-taught painter of imaginative subjects, born in Glasgow of working-class parents. A colourful character, he ran away from home at the age of 16, did military service in India and South Africa, and lived in Canada from about 1930 to 1945. He started to draw in the 1930s and had his first one-man exhibition in 1943, in Toronto. At the end of the Second World War he returned to Britain and became something of a character in the London art world, although he became increasingly reclusive as he grew old. He was barely literate and fond of the bottle, and his appearance suggested either a music-hall comedian or a near-vagrant—'mended spectacles, grog-blossom nose, canny expression, cloth cap, muffler, boots, and an habitual Woodbine between his fingers' (George Melly, *It's All Writ Out For You: The Life and Work of Scottie Wilson*, 1986). Although he lived in very modest lodgings, he made a good living selling his pictures to dealers.

Unlike the work of most *naive painters (with whom he is sometimes grouped), his pictures are not 'realistic' renderings of scenes from the daily life with which he was familiar, but decorative fantasies (often in coloured inks) incorporating stylized birds, fishes, butterflies, swans, flowers, self-portraits, and totem heads. The last of these he saw in Canada, and some critics rather fancifully suggested that they represented the powers of evil in contrast to the powers of good symbolized in the images taken from nature. All his work, however, was intended to be decorative rather than symbolic. He is represented in a number of major collections, including the Tate Gallery, London, the Museum of Modern Art, New York, and the Pompidou Centre, Paris.

Wir. See SPUR.

Wise-Ciobotaru, Gillian. See CONSTRUC-TIVISM.

Wiszniewski, Adrian. See GLASGOW SCHOOL.

Witkin, Isaac. See NEW GENERATION.

Woestijne, Gustave van de. See LAETHEM-SAINT-MARTIN.

Wölfflin, Heinrich. See POST-PAINTERLY ABSTRACTION.

Wölfli, Adolf. See ART BRUT.

Wollheim, Richard. See STOKES.

Wols (Alfred Otto Wolfgang Schulze) (1913–51). German-born painter, graphic artist, and photographer, active mainly in France. He was born in Berlin, the son of a distinguished lawyer, and grew up in Dresden, where his father was appointed head of the Saxon State Chancellory in 1919. His interests included music and he considered a career as a violinist. He also showed a talent for drawing from early childhood, but it was not until 1932, when he studied briefly at the *Bauhaus in Berlin, that he was converted to a serious interest in art. On *Moholy-Nagy's advice he moved to Paris in that year. He met leading artists such as *Arp, *Giacometti, and *Léger, but earned his living as a photographer, working under the name Wols. In 1933 he moved to Spain, and his refusal to return to Germany for labour service resulted in lifelong expatriation. After being imprisoned in Barcelona in 1935 for political activities, he returned to France, where he was official photographer to the 1937 International Exhibition. As a German citizen, he was interned at the outbreak of the Second World War but liberated in 1940 and lived in poverty in the South of France. At the end of the war he returned to Paris, where he had his first one-man show (of drawings) at the Galerie René Drouin in 1945. He was befriended by the writers Jean-Paul *Sartre and Simone de Beauvoir, for whose books he did illustrations, and by the late 1940s he was beginning to make a name for himself as a painter (Drouin had persuaded him to take up oils), but his irregular life, poverty, and excessive drinking had undermined his health and he died aged only 38. His posthumous fame far outstripped his reputation during his lifetime and he came to be regarded as the 'primitive' of *Art Informel and one of the most original masters of expressive abstraction. His output included a large number of drawings, many finely executed watercolours, and a comparatively small number of oils.

Wonner, Paul. See BAY AREA FIGURATION.

Wood, Christopher (1901–30). British painter, mainly of landscapes, harbour scenes, and figure compositions. He was born at Knowsley, near Liverpool, and briefly studied architecture at Liverpool University. In 1921 he studied at the *Académie Julian in Paris and subsequently travelled widely on the Continent. He was influenced by modern French art (*Cocteau, *Diaghilev, and *Picasso were among his friends), but his work has an entirely personal lyrical freshness of vision, touched with what Gwen *Raverat felicitously described as 'fashionable clumsiness'. In a remarkably short time he achieved a position of high regard in the art worlds of London and Paris, but he was emotionally unstable and his early death was probably suicide (he was killed by a train). After this he became something of a legend as a youthful genius cut off before his prime—the introduction to the catalogue of the 1978 Arts Council exhibition of his work (by William Mason) is typically rhapsodic in its praise: 'These two qualities—sincerity and naïveté—are those which seem to express most accurately the life and painting of Christopher Wood and indeed those were the words used by his friends in their many eulogies of him . . . His painting was ageless and young, and represented for his generation and for future generations all of the vigour, joy and exuberance of youth coupled with a freshness of vision and sense of colour as strong as if his life had been spent within a rainbow.' Much of his best work was done in Cornwall, where he and his friend Ben *Nicholson discovered the *naive painter Alfred *Wallis in 1928. There are examples of Wood's work in the Tate Gallery, London.

Wood, F. Derwent (1871–1926). British sculptor, born in Keswick. He trained in Karlsruhe, then in London at the *Royal College of Art, the *Slade School, and finally the *Royal Academy, where he won a gold medal in 1895. While still a student he was employed as an assistant by Sir Thomas *Brock. In 1896–7 he worked in Paris, then taught at *Glasgow School of Art, 1897–1901, before settling in London. In the First World War he served in the Royal Army Medical Corps and was in charge of making masks for plastic surgery at

Wandsworth Hospital. From 1918 to 1923 he was professor of sculpture at the Royal College of Art. Wood's sculpture consisted mainly of portraits and memorials. His best-known work is the monument to the Machine Gun Corps (1925) at Hyde Park Corner in London, featuring a svelte, langorous nude bronze figure of David (an inscription explains this choice: 'Saul hath slain his thousands, and David his tens of thousands'). To Susan Beattie (*The New Sculpture*, 1983) it represents 'a weary and corrupted tradition' contrasting with the 'searing realism' of Sargeant *Jagger's nearby Royal Artillery Monument, but to many people—for all its 'sickening irrelevance'—it is a beautiful figure.

Wood, Grant (1892–1942). American painter, one of the leading exponents of *Regionalism. He was born on a farm near Anamosa, Iowa, and spent most of his life in his native state, mainly at Cedar Rapids. His training in art was varied but uneven; as a painter he was largely self-taught, although he studied at the *Académie Julian, Paris, in 1933, during one of his four visits to Europe (the others were in 1920, 1926, and 1928). Early in his career he was something of an artistic jack-of-all-trades, employed as a metalworker, interior decorator, and teacher, as well as a painter (and in his army service during the First World War he did camouflage work). The turning-point in his life came when he obtained a commission to make stained-glass windows for the Cedar Rapids Veteran Memorial Building in 1927 and went to Munich to supervise their manufacture the following year. Influenced by the Early Netherlandish paintings he saw in museums there, he abandoned his earlier *Impressionist style and began to paint in the meticulous, sharply detailed manner that characterized his mature work (he has been called 'the Memling of the Midwest').

Wood's subjects were taken mainly from the ordinary people and everyday life of Iowa: 'At first I felt I had to search for old things to paint—something soft and mellow. But now I have discovered a decorative quality in American newness.' He came to national attention in 1930 with his painting *American Gothic*, depicting a farming couple (his sister and dentist were in fact the models) in front of a farmhouse with a pointed Gothic-style window; he had seen such a building in southern Iowa and said that 'I imagined American Gothic people with their faces stretched out

long to go with this American Gothic house'. The painting won a bronze medal at an exhibition at the Art Institute of Chicago (which now owns the work), but it aroused violent controversy because many people regarded it as an insulting caricature of plain country folk. However, it gradually won great popularity and is now one of the most familiar and best-loved images in American art. Wood never again achieved quite the same bite and freshness of his masterpiece, but his other work included some highly distinctive and original pictures. Among them are *The Midnight Ride of Paul Revere* (Metropolitan Museum, New York, 1931), which has a captivating air of fantasy, and *Daughters of the Revolution* (Cincinnati Art Museum, 1932), which Wood described as 'the only satire I have ever painted'. It was his pictorial revenge on members of the Daughters of the American Revolution, who had opposed the dedication of his stained-glass windows in Cedar Rapids because they had been made in Germany—America's recent enemy. As described by members of the Sons of the American Revolution, the painting showed 'three sour-visaged, squint-eyed and repulsive-looking females, represented as disgustingly smug and smirking because of their ancestral claim to be heroes of the American Revolution'. Wood also painted some vigorous stylized landscapes, and he supervised several Iowa undertakings of the *Federal Art Project. In 1934 he became assistant professor of fine arts at the University of Iowa. He died of cancer.

Woodrow, Bill. See NEW BRITISH SCULPTURE.

Woollaston, Sir Mountford Tosswill ('Toss') (1910–). New Zealand painter, who with Rita *Angus and Colin *McCahon pioneered a move away from conventional figuration in his country's art. He was born at Toko, Taranaki, studied at various art schools, and has lived mainly in the Nelson and Greymouth districts. His work combines influences from *Cézanne and *Expressionism and is mainly devoted to landscapes and portraits of family and friends. He spoke of his painting as 'a very quiet song hummed or murmured to myself', and the poet Charles Brasch called him 'one of the first to see and paint New Zealand as a New Zealander'. Woollaston set out some of his ideas on art in a lecture delivered at the City Art Gallery, Auckland, in 1960; two years later it was published as a

pamphlet entitled *The Far-Away Hills: A Meditation on New Zealand Landscape*. In 1979 he became the first New Zealand painter to be knighted. His autobiography, *Sage Tea*, was published in 1981.

Workers' Council for Art (Arbeitsrat für Kunst). See NOVEMBERGRUPPE.

Works Progress Administration (WPA). See FEDERAL ART PROJECT.

World of Art (Mir Iskusstva). The name of an informal association of Russian artists and of the journal they published from 1899 to 1904; the association was formed in St Petersburg in 1898 and in its original form lasted until 1906 (it was revived in 1910 as an exhibiting society, and this lasted until 1924). Sergei *Diaghilev was the journal's editor, and his contributors and collaborators included Léon *Bakst and Alexandre *Benois. The group encouraged interchange with Western art (many articles in the journal had previously appeared in European magazines) and became the focus for avant-garde developments in Russia. In particular it promoted the *Art Nouveau style. Some of the artists involved in the group (notably Nikolai *Roerich) were also interested in evoking the spirit of ancient Russia, and this synthesis of old and new was best expressed in the decor for Diaghilev's ballet company, which revolutionized European stage design when he brought it to Paris. The revived World of Art—with Benois providing the initial impetus—held 21 exhibitions between 1910 and 1924 in St Petersburg, Moscow, and elsewhere. Among the artists who showed work at them were leading avant-garde figures including *Chagall, *Kandinsky, *Lissitzky, and *Tatlin.

Worpswede. A north German village near Bremen that in the last decade of the 19th century became the centre of a group of artists who settled there, following the example of the Barbizon School in France. The most famous artist of the group was Paula *Modersohn-Becker, and the 'Worpswede School' is sometimes regarded as one of the roots from which German *Expressionism sprang. Another woman artist in the group was the sculptor Clara Westhoff (1878–1954); in 1901 she married the Austrian poet Rainer Maria Rilke (1875–1926), who published a book on Worpswede in 1903.

Worringer, Wilhelm (1881–1965). German art historian and aesthetician, professor at the universities of Bonn (1920–8), Königsberg (1928–46), and Halle (from 1946). His writings, which tend to be somewhat metaphysical in tone, encouraged a more sympathetic response to non-realist styles and *Expressionist distortion in art. His best-known books are *Abstraktion und Einfühlung* (1908) (translated as *Abstraction and Empathy*, 1953) and *Formprobleme der Gotik* (1912), which has been translated in an American edition as *Form Problems of the Gothic* (1919) and in an English edition, with an introduction by Herbert *Read, as *Form in Gothic* (1927). Charles Harrison and Paul Wood write that *Abstraktion und Einfühlung* was 'continuously reprinted for over forty years. It was influential in countering what Worringer called the "European-classical prejudice of our customary historical conception and valuation of art". It also furnished theoretical support for that widespread modern tendency in which enthusiasm for so-called *primitive art was conjoined with interest in modern forms of abstraction' (*Art in Theory 1900–1990*, 1992).

Wotruba, Fritz (1907–75). The leading Austrian sculptor of the 20th century, also a designer and architect. He was born in Vienna and trained there as an engraver, 1921–4, before studying sculpture under Anton Hanak (1875–1934). His masterly craftsmanship soon won him acclaim, as when his work was shown in an exhibition of Austrian art in Paris in 1929; Aristide *Maillol is said to have refused to believe that such work could have been done by a 22-year-old. After the annexation of Austria by Nazi Germany in 1938, Wotruba took refuge in Switzerland. He returned to Vienna in 1945 and was made professor and later rector at the Academy. In his most characteristic works he carved directly in stone (see DIRECT CARVING), preferring a hard stone with a coarse texture. He began his career working in a naturalistic style reminiscent of Maillol, but moved towards abstraction by reducing the figure to bare essentials. It was essentially the method used by *Brancusi, but in contrast to Brancusi's smooth, subtle abstractions, Wotruba's figures are solid, block-like structures. They were left in a rough state, creating a feeling of primitive power (*Feminine Rock*, Middelheim Open-Air Museum of Sculpture, Antwerp, 1947–8). He also worked in bronze (*Standing Man*, Tate

Gallery, London, 1949–50). Wotruba had many public commissions for sculptural works, and from 1959 he also made stage designs, for example costumes for a performance of Wagner's *Ring* in Berlin in 1967. Near the end of his life he branched out into architecture, designing the church of the Holy Trinity on the outskirts of Vienna (constructed 1974–6). His work was admired and imitated by many younger Austrian artists, bringing about a revival of sculpture in his country, and was much acclaimed elsewhere. It is represented in numerous major public collections.

Wouters, Rik (1882–1916). Belgian painter, sculptor, and printmaker, born in Mechelen (Malines), the son of an ornamental sculptor. He is regarded as his country's leading exponent of *Fauvism, but his career was cut tragically short when he died following operations for cancer of the eye. He learned woodcutting in his father's workshop and studied sculpture in Brussels, but he was essentially self-taught in painting, which became his main occupation from 1908. His work is less violent in colour than that of the French Fauvists and often has a quality of serene intimacy, notably in portraits of his wife Nel, who was his favourite model (*The Artist's Wife*, Pompidou Centre, Paris, 1912; *Woman in Blue with Amber Necklace*, Musées Royaux, Brussels, 1912). In 1912 he had a successful one-man exhibition at the Galerie Giroux, Brussels, and this enabled him to visit Paris. He was called up for military service at the beginning of the First World War, but he deserted. After being released from internment in the Netherlands, he settled in Amsterdam, where he died.

WPA. See FEDERAL ART PROJECT.

Wright, Frank Lloyd. See MODERN MOVEMENT.

Wright, Willard Huntingdon (1888–1939). American art and literary critic and novelist, brother of the painter Stanton *Macdonald-Wright. He was born in Charlottesville, Virginia, grew up in California, and studied at Harvard University. In 1912 he moved to New York, where he worked as a journalist, and in 1913 (soon after seeing the *Armory Show) he joined his brother in Paris, where he lived for the next two years. At the time he moved

abroad his main preoccupation was philosophy (his first book was *What Nietzsche Taught*, 1915), but he turned more to art; one of the first articles he sent back from Paris was 'Impressionism to Synchromism' (*The Forum*, December, 1913), in which he discussed the avant-garde movement recently founded by his brother. In 1915 Wright returned to New York, via London, and his book *Modern Painting: Its Tendency and Meaning* was published in both cities that year. The hero of the book is *Cézanne, and John Rewald writes that, as far as American critics of his time were concerned, Wright was 'in first place among those who seriously studied Cézanne's work', discussing it 'with insight, erudition, and a philosophical as well as historical point of view' (*Cézanne and America*, 1989). However, Wright was not so perceptive about van Gogh, 'who did little more than use a borrowed and inharmonious palette to express ideas wholly outside the realm of art'.

In 1916 Wright organized the *Forum Exhibition in New York, one of the most important avant-garde shows of its period, and in the same year he published an article ('The Aesthetic Struggle in America', *The Forum*, February 1916) in which he attacked conservative critics such as Royal Cortissoz (1869–1948), Kenyon Cox (1856–1919), Frank Jewett Mather, Jr. (1868–1953), and the British-born Charles H. Caffin (1854–1918). Wright's last main contribution to art literature was *The Future of Painting* (1923). Soon after it was published he became dangerously ill (his health had never been robust); during a lengthy convalescence he was forbidden serious reading, so he got through hundreds of detective novels. Convinced he could do better, he took up the genre himself and in 1926—under the pseudonym S. S. Van Dine—he published *The Benson Murder Case*, the first of a series of books featuring the super-sleuth Philo Vance, whose scholarship and urbanity were modelled on Wright's own. The books were immensely popular and earned him a fortune.

Wyeth, Andrew (1917–). American painter, son of **Newell Convers Wyeth** (1882–1945), a highly successful illustrator of children's books. Wyeth had lessons from his father and later learned tempera technique from his brother-in-law Peter Hurd, a *Regionalist painter, but he considers himself largely self-taught, saying 'I worked everything out by trial and error.' His paintings consist almost

entirely of depictions of the people and places of the two areas he knows best—the Brandywine Valley around his native Chadds Ford, Pennsylvania, and the Port Clyde area of the Maine coast, where he has his summer home. He usually paints in watercolour or tempera with a precise and detailed technique, and often he conveys a sense of loneliness and nostalgia (trappings of the modern world, such as motor cars, rarely appear in his work). He had his first one-man exhibition at the Macbeth Gallery in New York in 1937, when he was only 19. It was a sell-out success, and he became famous with *Christina's World* (1948), which was bought by the Museum of Modern Art, New York, in 1949 and has become one of the best-known American paintings of the 20th century. It depicts a friend of the artist, Christina Olson, who had been so badly crippled by polio that she moved by dragging herself with her arms. She is shown in a field on her farm in Maine, 'pulling herself slowly back towards the house'. The unusual viewpoint and the heavily-charged atmosphere are typical of Wyeth's work. Because Christina is seen from the back, some viewers assumed that she was an attractive young girl frolicking in the grass, and were shocked when they saw Wyeth's portraits of the gaunt, middle-aged figure. Many other viewers, however, saw in it a deeper significance; as Sir David Piper wrote, it 'seems to express both the tragedy and the joy of life with such vivid poignancy that the painting becomes a universal symbol of the human condition—and is recognized as such; the picture has had a continuing fan mail from people who have identified with it.'

Building on the fame of *Christina's World*, Wyeth has gone on to have an enormously successful career. He has won numerous awards and in 1976 was the first native-born living American artist to be honoured with a retrospective exhibition at the Metropolitan Museum, New York. There is a wide disparity of critical opinion about him, however: J. Carter Brown, director of the National Gallery in Washington, has called him 'a great master', whereas Professor Sam Hunter, one of the leading authorities on 20th-century American art, has written: 'What most appeals to the public, one must conclude, apart from Wyeth's conspicuous virtuosity, is the artist's banality of imagination and lack of pictorial ambition. He comfortably fits the common-sense ethos and non-heroic mood of today's popular culture, despite his occasional lapses into gloomy introspection.' Wyeth himself explained his popularity by saying 'It's because I happen to paint things that reflect the basic truths of life: sky, earth, friends, the intimate things.'

Wynne, David (1926–). British sculptor, born at Lyndhurst, Hampshire. After serving in the Royal Navy, 1944–7, and studying zoology at Trinity College, Cambridge, he became a sculptor in 1949 with no formal art training. His work is fairly traditional in style (he thinks that art should be beautiful and 'remind people of heaven') and he is best known for animal sculpture. His many public commissions—often on a large scale—include the 2-ton black marble *Guy the Gorilla* in Crystal Palace Park, London (1963), the bronze *Tyne God* (3 tons) and *Flying Swans* at the Civic Centre in Newcastle upon Tyne (1968), and the Queen Mother's Gates in Hyde Park, London (1993). He has also made portrait busts of many famous sitters (for example, Sir Thomas Beecham, 1957; casts in the Festival Hall and NPG, London, and elsewhere). His other work includes the design of the Common Market 50 pence piece (1973), showing a ring of clasped hands.

Wynter, Bryan (1915–75). British painter, born in London. He studied at Westminster School of Art, 1937–8, and at the *Slade School, 1938–40. In 1945 he settled at Zennor, Cornwall (see ST IVES SCHOOL), and he taught at the *Bath Academy, 1951–6. During the decade 1946–56 his work consisted mainly of gouache landscapes, but in 1956 he began painting the abstracts that are his best-known works. They remain tenuously based on nature and have an affinity with the work of Roger *Bissière: 'The landscape I live among is bare of houses, trees, people; is dominated by winds, by swift changes of weather, by moods of the sea; sometimes it is devastated and blackened by fire. These elemental forces enter into the paintings and lend their qualities without becoming motifs.' In 1964 Wynter moved to St Buryan in Cornwall, and at about this time his style changed, his work becoming more decoratively patterned and less intense. In the 1960s he also began making *Kinetic constructions that he called IMOOS (Images Moving Out Onto Space).

Xenakis, Iannis (1922–). French composer, architect, and experimental artist, born at Brăila in Romania to Greek parents. His family returned to Greece in 1932 and he began to study engineering at Athens Polytechnic. The war intervened and after the German invasion of Greece in 1941 he fought in the Resistance, losing the sight of an eye when he was badly wounded in 1945. In 1947, after completing his engineering course, he settled in Paris, where he assisted *Le Corbusier in his architectural practice from 1948 to 1960. He became a French citizen in 1965. Xenakis is best known as a composer; his works 'are examples of a new and individual kind of musical thinking, based on models drawn from architecture, physics, and mathematics' (*New Oxford Companion to Music*, 1983). In the visual arts he is notable for being among the most prominent creators of 'total environments' involving both spectacle and sound, in particular for pioneering the use of multiple lasers in light environments. For the French Pavilion at 'Expo '67' in Montreal he created a vast 'Polytope' made up of large concave and convex mirrors suspended on electrified cables producing 'visual melodies' by the action of light sources. In 1972 he created a still more strange and elaborate form of total spectacle at the Roman Baths off the Boulevard St Michel in Paris.

Xu Beihong (Hsü Pei-hung) (1895–1953). Chinese painter, teacher, and administrator, the most important figure in introducing Western ideas about art to his country. After the death of his father (a painter and village teacher) in 1915, Xu moved from his home in Jiangsu province to Shanghai, where he made a living by painting whilst studying French at university. From 1919 to 1927 he lived in Europe (with one brief trip home), travelling widely and studying in Paris (at the École des *Beaux-Arts) and Berlin. After his return to China he held a variety of teaching and administrative posts in Shanghai, Peking, and Nanjing, and when the country became the People's Republic of China in 1949 he was appointed director of the newly-founded Central Academy of Fine Arts and chairman of the National Artists' Association. His career was ended by a stroke in 1951. Xu's most characteristic works were large historical compositions. They were decidedly old-fashioned by European standards or even by the standards of his only rival in importance in introducing Western art to China—Liu Haisu (1896–1994), who was influenced by *Impressionism and *Post-Impressionism and who caused a scandal by introducing drawing from live models in his teaching at the Shanghai Academy. However, Xu's style was novel to most Chinese eyes and it was highly influential, proving completely compatible with the Soviet-inspired *Socialist Realism that became the official style in Communist China in the 1950s.

Xul Solar (Oscar Agustín Alejandro Schulz Solari) (1887–1963). Argentinian painter, born at San Fernando, near Buenos Aires. He was the son of German-Italian immigrants, hence his rather jumbled name, which he compressed to Xul Solar. From 1912 to 1924 he travelled widely in Europe (in Italy he was a friend of his fellow-countryman *Pettoruti), then returned to Buenos Aires. Although he had absorbed features from European movements such as *Cubism and *Dada, he was self-taught as an artist and his work has a highly personal sense of fantasy and humour befitting his visionary and mystic outlook. He worked on a small scale, chiefly in tempera and watercolour, rarely exhibited, and sought no honours. His work has been divided ino three phases. The first runs from 1917 to 1930, when his paintings featured colourful forms of geometric tendency, stylized emblems and

signs, sometimes with numerals, letters, and words spelling out the subject of the picture. Many pictures of this period also feature double or multiple transparent images. The second phase runs from 1930 to 1960, when he often treated architectural and topographical themes, featuring sparse modelling, nearly traditional perspective, and more restrained colour. The third phase runs from 1960 until his death three years later; during this period he returned to the lyrical colour of his early work and focused on the alphabet, his pictures being interwoven with words from two languages he invented—a universal language he called *Panlengua* and a Pan-American language, *Neocriolla*. He also invented a very complicated game based on chess, which he called *Panjuego* (Pangame, i.e. universal game). Xul Solar's friend the writer Jorge Luis Borges referred to his paintings as 'documents for the ultraterrestial world, of the metaphysical world in which the gods take on the imaginative forms of dreams'. The works of his 'alphabetical' phase have sometimes been compared with Paul *Klee's pictographic compositions. Xul Solar was given a major retrospective exhibition at the Museo Nacional de Belles Artes in Buenos Aires in 1964 and has had a powerful influence on younger Argentinian artists.

Yakulov, Georgy. See BLUE ROSE.

YBAs. See YOUNG BRITISH ARTISTS.

Yeats, Jack Butler (1871–1957). The best-known Irish painter of the 20th century, born in London, the son of **John Butler Yeats** (1839–1922), a barrister who became an unremarkable but successful portrait painter, and brother of the celebrated poet William Butler Yeats. He had an idyllic childhood in Sligo, his ancestral home on the north-west coast of Ireland, and studied at various art schools in London, notably Westminster School of Art under Fred *Brown. From 1910 he lived in Dublin. Early in his career he worked mainly as an illustrator; he did his first oil paintings in about 1897 (the year of his first one-man exhibition in London), but he did not work regularly in the medium until about 1905. The subjects he painted included Celtic myth and everyday Irish life (including scenes of fairs and horse races), and through these he contributed to the upsurge of nationalist feeling in the arts that accompanied the movement for Irish independence. His early work as a painter was influenced by the French *Impressionist pictures he saw in the collection of Hugh *Lane, but in the 1920s he developed a more personal *Expressionist style characterized by high-keyed colour and extremely loose brushwork (there is some similarity to the work of *Kokoshka, who became a great friend in the last decade of Yeats's life). Yeats has many admirers, but some critics think that his late paintings often degenerate into a muddy mess. He was immensely prolific, producing more than 1,000 paintings and a great many drawings. His work is represented in numerous galleries in Ireland, notably the National Gallery and the Hugh Lane Gallery of Modern art in Dublin and the Sligo County Museum and Art Gallery, which has material relating also to

his father and brother. There are also numerous examples in the USA, where he has long been popular. Yeats was a writer as well as a painter—the author of several plays, novels, and volumes of poetry, as well as *Life in the West of Ireland* (1912) and *Sligo* (1930).

Yoshihara, Jiro (1905–72). Japanese painter and entrepreneur, born in Osaka. He was a wealthy industrialist and was mainly self-taught as an artist. During the 1930s he was a pioneer of abstract art in Japan, but he is best known as the central figure of the *Gutai Group, which he founded in 1954 and sustained with his wealth for the rest of his life. In 1957 Yoshihara was awarded first prize at the Tokyo *Biennale. His paintings of this time are 'a sophisticated mixture of Eastern and Western modes. They mingle Zen, and Zen versions of traditional oriental calligraphy, with things learned from American *Abstract Expressionism' (Edward *Lucie-Smith, *Visual Arts in the Twentieth Century*, 1996).

Young British Artists (YBAs). An imprecise term applied to a number of highly publicized British avant-garde artists active from the late 1980s, several of whom are well known for their grubbily glamorous lifestyles as well as for what they create; they do not form an organized group and their work is diverse, but there are ties of friendship linking many of them and they have been supported chiefly by Charles *Saatchi. These artists are sometimes also referred to as the 'Freeze' generation, in reference to the exhibition organized by Damien *Hirst in 1988 that first brought them media attention. Subsequently there have been several other exhibitions featuring their work, most notably 'Sensation' (see AVANT-GARDE) at the Royal Academy, London, in 1997. In a supplement on this exhibition published in the magazine

Time Out, Elaine Paterson wrote that 'Young British artists are always being photographed at parties, sipping champagne, and they are the subjects of *postmodern TV documentaries that validate the artists' work while avoiding telling you what it's about and why it's good . . . pop stars like Jarvis Cocker, Neil Tennant and David Bowie [see MODERN PAINTERS] hang about with them.' The two best-known artists who featured in 'Sensation' are Damien Hirst and Rachel *Whiteread. Among the others were the brothers Dinos (1962–) and Jake (1966–) Chapman, whose work includes figures modelled on bland shop-window dummies but with horrible mutilations or freakish mutations; Tracey Emin (1963–), whose work is largely autobiographical and includes *Everyone I Have Ever Slept With 1963–1995* (Saatchi Collection, 1995), an igloo-shaped tent adorned with the names of everyone with whom she has shared a bed since birth (including her own aborted foetuses); Gary Hume (1962–), who paints large figurative pictures characterized by flat, reductive forms (in 1997 he won the £30,000 Jerwood Painting Prize); Sarah Lucas (1962–), whose work often has sexual themes, for example *Two Fried Eggs and A Kebab* (Saatchi Collection, 1992), in which the foods arranged on a table mimic breasts and female genitals; Marc Quinn (1964–), best known for *Self* (Saatchi Collection, 1991), a three-dimensional self-portrait head made of his own frozen blood (it is displayed in a refrigerated cabinet); and Jenny Saville (1970–), who paints huge pictures of mountainously obese nude women.

Young Contemporaries. Exhibition of works by British art students held in London since 1949 on a roughly annual basis (lack of funds or organization—they are generally arranged by the students themselves—has sometimes prevented the shows taking place). The first Young Contemporaries show was held at the Royal Society of British Artists (RBA Galleries). Other venues have included the *Institute of Contemporary Arts, and some of the exhibitions have toured to the provinces. The most famous Young Contemporaries exhibition was that of 1961, when British *Pop art first appeared in force in the work of Derek *Boshier, David *Hockney, Allen *Jones, R. B. *Kitaj, and Peter *Phillips, all of them students or former students at the *Royal College of Art. In 1974 the name was changed to 'New Contemporaries'.

Youngerman, Jack (1926–). American painter, sculptor, graphic artist, and designer, born in Louisville, Kentucky. After studying at the universities of North Carolina, 1944–6, and Missouri, 1947, he attended the École des *Beaux-Arts, Paris, 1947–8, and remained in Europe until 1956, when he settled in New York. 'He then became known for bringing a special *Matisse-like rhythm and grace to the *Constructivist tradition by rendering leaf, flower or butterfly forms with the brilliantly coloured flatness and clarity of *Hard-Edge painting' (H. H. Arnason, *A History of Modern Art*, 3rd edn., revised by Daniel Wheeler, 1986). Apart from paintings his work has included brilliantly coloured lithographs and screenprints, with sharply outlined abstract shapes, and he has also made sculpture.

Yuon, Konstantin. See AKHRR.

Yvaral (Jean-Pierre Vasarely) (1934–). French painter and experimental artist, born in Paris, son of Victor *Vasarely. He studied graphic art and publicity at the École des Arts Appliqués, Paris, 1949–51, and adopted the name Yvaral in 1950. In 1960 he was a founder member of the *Groupe de Recherche d'Art Visuel (GRAV), and like the other members he approaches art in a scientific spirit: 'All my work can be reduced to systems of organization used by contemporary scientific research.' He has been strongly influenced by his father and much of his work can be classified as *Op art. Characteristically he has used devices such as moiré patterns of approaching and receding forms within a shallow depth dimension. His work has also included *Kinetic sculpture, screenprints, and *multiples.

Yvel, Claude. See SUPERREALISM.

Zack, Léon (1892–1980). Russian-born painter, sculptor, illustrator, and designer who became a French citizen in 1938. He was born at Nijni-Novgorod, and studied literature at Moscow University while at the same time attending classes at art schools. In 1920 he left Russia, living for two years in Florence and a year in Berlin before settling in Paris in 1923. His early work was figurative—typically pictures of dreamy youths, gypsies, harlequins, and vagabonds—but in the 1940s he gradually turned towards abstraction. Originally his abstracts were geometric, but by the late 1950s he had arrived at a much freer and more expressive *Tachiste mode, with sensitively worked blotches disposed in the middle of a monochromatic textured surface. In the 1950s he also took up religious art, designing stained-glass windows for St Sulpice, Paris, in 1957 and for the Sacré-Coeur, Mulhouse, in 1959, as well as sculptures (including crucifixes) for other churches. Zack's other work included book illustrations and ballet decor.

Zadkine, Ossip (1890–1967). Russian-born sculptor who worked mainly in Paris and became a French citizen in 1931. He was born in Vitebsk and grew up in Smolensk. His father was a classics teacher and his mother came from a Scottish family of shipbuilders. In 1905 Zadkine was sent to Britain (where he had relatives on his mother's side) to learn 'English and good manners'. Taking advantage of his independence, he pursued his love of sculpture (which had distracted him from academic studies in Russia), attending lessons at Sunderland College of Art, and then in London, where he moved in 1906. In 1909 he settled in Paris and after spending a few months at the École des *Beaux-Arts he worked independently. By 1912 he was friendly with many leading figures in avant-garde art, among them *Apollinaire, *Archipenko, *Brancusi, *Lipchitz, and *Picasso. He deeply admired *Rodin, but *Cubism had a greater influence on his work. His experiments with Cubism, however, had none of the quality of intellectual rigour associated with Picasso and *Braque, for Zadkine's primary concern was with dramatically expressive forms. The individual style he evolved made great use of hollows and concave inflections, his figures often having openings pierced through them.

In 1915 he joined the French army but was invalided out after being gassed. He worked in Paris during the 1920s and 1930s and spent most of the Second World War in New York (where he taught at the *Art Students League), returning to Paris in 1944. Often Zadkine's work can seem merely melodramatic, but for his greatest commission—the huge bronze *To a Destroyed City* (completed 1953) standing at the entry to the port of Rotterdam—he created an extremely powerful figure that is widely regarded as one of the masterpieces of 20th-century sculpture. With its jagged, torn shapes forming an impassioned gesture mixing defence and supplication, it vividly proclaims anger and frustration at the city's destruction and the courage that made possible its rebuilding. This work gave Zadkine an international reputation and many other major commissions followed it, including monuments in Amsterdam and Jerusalem. Zadkine also painted, made lithographs, and designed tapestries. The house in which he lived in Paris is now a museum devoted to his work.

Zahrtmann, Kristian. See GIERSING.

Zaritzky, Yossef. See NEW HORIZONS.

Zborowski, Léopold. See MODIGLIANI.

Zebra. A group of four German painters formed in Hamburg in 1965 for exhibition

and promotional purposes: Dieter Asmus (1939–), Peter Nagel (1942–), Nikolaus Störtenbecker (1940–), and Dietmar Ullrich (1940–). They worked in a figurative style, influenced by photography but non-naturalistic in colouring. Often they used a convention of depicting living things in greys or near-greys and inanimate objects in bright colours, and usually maintained a distance between the figural content and the flat poster-like background. Their work was widely exhibited in Germany and elsewhere (for example at Fischer Fine Art, London, in 1975).

Zeisler, Claire. See FIBRE ART.

Zemlja. An association of progressive Yugoslavian (Croatian) painters founded in Zagreb by Krsto *Hegedušić in 1929. The artists involved were *Social Realists and their work represented a protest against oppression. One of their aims was to make direct contact with peasant life (this was the significance of the name Zemlja—Earth), and their style was strongly influenced by folk art. Hegedušić and others of the group visited the village of Hlebine near the Hungarian frontier, and Hegedušić's encouragement of the young peasant artist Ivan *Generalić helped the village to become the most famous centre of Yugoslav *naive art (see HLEBINE SCHOOL). Zemlja was officially banned in 1935.

Zen 49. A group of German abstract painters founded in Munich in 1949 and active until 1957. It adopted the name Zen 49 in 1950, having originally been called the Gruppe der Ungegenständlichen (Group of Non-representational Artists). The founder members included Willi *Baumeister. Those who joined later included Bernhard Schultze (1915–), Emil Schumacher (1912–), both of whom had previously been members of *Quadriga, Hann Trier (1915–), and Theodor Werner (1886–1969). Their work was thought to express the spirit of Zen Buddhism and was essentially a German version of *Art Informel.

Zero. A group of *Kinetic artists formed in Düsseldorf in 1957 by Heinz *Mack and Otto *Piene, who were joined in 1961 by Günter *Uecker (there were other members from time to time, but these three formed the core). Their views were put forward in a periodical, also called Zero (two numbers

appeared in 1958 and a third in 1961). Although they were interested in technology, they stressed the importance of working with nature, rather than against it, and carried out several environmental projects. They also— unlike many Kinetic artists—valued the intrusion of the irrational in their work. The group disbanded in 1966.

0.10 ('Zero–Ten'). See POUGNY.

Zervos, Christian. See CAHIERS D'ART.

Zhdanov, Andrei. See SOCIALIST REALISM.

Zheverzheyev, Lerky. See UNION OF YOUTH.

Ziegler, Adolf. See NATIONAL SOCIALIST ART.

Zimmer, Hans-Peter. See SPUR.

Zinkeisen, Anna (1901–76). British painter, illustrator, and designer. She was born in Kilcreggan, Dunbartonshire, the daughter of a research chemist of German descent, and trained at the *Royal Academy, London, where she exhibited regularly from 1921. Her output was varied, including landscapes, society portraits, flower pieces, murals (notably four large panels for the liner Queen Mary, 1933–4), book illustrations, and various types of advertising work—all done in a fluent and assured style, often evoking the fashionable world in which she lived. During the Second World War she showed a different side to her talents when she worked as a medical illustrator at St Mary's Hospital, Paddington, London, making detailed records of wounds. Her sister **Doris Zinkeisen** (1898–1991) was also a painter and designer; she, too, trained at the Royal Academy and she shared a studio with Anna for some years. Doris was best known as a stage designer. She worked for some of the leading theatrical personalities of the time (including Noël Coward and Lawrence Olivier) and in 1938 she published Designing for the Stage. During the Second World War she was an *Official War Artist, and after the liberation of Europe she produced paintings of Belsen concentration camp (Imperial War Museum, London).

Zorach, William (1889–1966). Lithuanian-born American sculptor. His family emigrated to the USA when he was 4 and he was brought up in Cleveland, Ohio, where he was appren-

ticed to a commercial lithographer and attended evening classes at Cleveland Institute of Art. In 1907 he moved to New York and studied at the National Academy of Design. After living in Paris for a year, 1910–11, he returned to Cleveland, then settled permanently in New York in 1912 (from the 1950s he also had a summer home in Bath, Maine). Initially Zorach worked as a painter in a *Fauvist style, but he took up sculpture in 1917 and abandoned painting (apart from watercolours) about five years later. His sculpture is figurative and its salient characteristics are firm contours, block-like bulk, and suppression of details: 'I owe most', he said, 'to the great periods of primitive carving in the past—not to the modern or the classical Greeks, but to the Africans, the Persians, the Mesopotamians, the archaic Greeks and of course to the Egyptians.' He was a pioneer in America of *direct carving in stone and wood and in this as well as in his formal austerity he exercised a powerful influence on modern American sculpture. He had numerous major commissions, including relief carvings for the Municipal Court Building, New York (1958). His most most famous work is not a carving, however, but the alumimium *Spirit of the Dance* (1932) for Radio City Music Hall, New York—a heroic female figure that was banished for a time because of its nudity but reinstated through public pressure. Zorach taught at the *Art Students League from 1929 to 1966. He wrote two books, *Zorach Explains Sculpture* (1947) and a posthumously published autobiography, *Art is my Life* (1967), as well as numerous articles on art; two of his articles on his own work were put together in book form as *William Zorach* (1945).

His wife, **Marguerite Thompson Zorach** (1887–1968), was one of America's leading modernist painters in the years immediately before and immediately after the *Armory Show (1913), in which both she and her husband exhibited. At this time she painted in a style influenced by Fauvism and *Expressionism. In her later career, however, much of her time was spent selflessly helping her husband with his sculptural commissions, producing many of the preliminary drawings for his work.

Zorn, Anders (1860–1920). Swedish painter, etcher, and occasional sculptor, born at Mora. He studied at the Stockholm Academy, 1875–81, leaving because of its restrictive and out-dated ideas. For the next 15 years he lived mainly outside his own country, becoming the most cosmopolitan Scandinavian artist of his time and an international success. He was based in London (1882–5), then Paris (1888–96), and visited Spain, Italy, the Balkans, North Africa, and (on several occasions) the USA, where he painted three presidents and many other prominent figures. Originally he worked almost exclusively in watercolour, but in the late 1880s he abandoned the medium for oils (he began to use them seriously in the winter of 1887–8, when he stayed in *St Ives). In 1896 he returned to Sweden and settled at Mora (although he continued to travel), building his own house, which is now a museum dedicated to him. Zorn's paintings were of three main types: portraits, genre scenes (often depicting the life and customs of the rural area in which he lived), and female nudes. It is for his nudes—unashamedly healthy and voluptuous works—that he is now best known. He often placed his figures in landscape settings and he delighted in showing vibrant effects of light on the human body, depicted through lush brushwork that recalls the handling of his friend Max *Liebermann. Zorn also gained a great reputation as an etcher and he occasionally made sculpture, including one large work—the statue of Gustavus Vasa in Mora (1903). His work is well represented in the Zornmuseet at Mora and the Nationalmuseum in Stockholm. Between 1907 and 1914 he wrote some autobiographical notes, which were published in 1982.

Zox, Larry (1936–). American abstract painter, born at Des Moines, Iowa. He studied at the University of Oklahoma, Norman, Drake University, Des Moines, and the Des Moines Art Center (where George *Grosz was a visiting teacher), then settled in New York in 1958. In 1963 he began creating series of paintings in which each work was based on a standardized compositional scheme but differed in colour from the others in the series. These works—often large in scale—have been classified as *Minimal or *Systemic art, and the strong, aggressive colours of his paintings sometimes approached the hallucinatory effects of *Op art. In the 1970s the forms in his paintings became softer and more irregular.

Zucker, Joe. See NEW IMAGE PAINTING.

Zuloaga y Zabaleta, Ignacio (1870–1945). Spanish painter, born at Eibar in the Basque Pyrenees. He came from a long line of craftsmen, his father being a metalworker, and he was mainly self-taught as an artist. In 1890 he visited Paris and subsequently spent much of his career there. He was on friendly terms with *Degas, *Gauguin, and *Rodin, but this did not affect his work, which was strongly national in style and subject-matter. Bullfighters, gypsies, and brigands were among his favourite subjects, and he also painted religious scenes and society portraits (these were one of the main sources of the considerable fortune he earned). His inspiration came from the great Spanish masters of the past, notably Velázquez and Goya, and he is credited with being one of the first to 'rediscover' El Greco. He was extremely popular in his lifetime (unusually for a Spanish artist, his reputation was higher abroad than at home), but his work now often looks rather stagy. Highlights of his career include a resoundingly successful one-man show in New York in 1925 and the award of the main painting prize at the Venice *Biennale in 1938. In Spain Zuloaga worked mainly in Madrid (where he died), Segovia, and Seville, and later in the Basque fishing port of Zumaya; there are museums devoted to him in Segovia and Zamaya.

Zwemmer, Anton (1892–1979). Dutch-born bookseller, publisher, and art dealer, active in England. In 1916 he became the manager of a foreign-language bookshop in Charing Cross Road, London, and in the 1920s he developed it into a specialist art bookshop that played an important role in spreading knowledge and appreciation of modern art in Britain in the inter-war years. Kenneth *Clark later recalled that 'Few people can now remember how difficult it was for anyone to learn about the history of art in the years immediately after the 1914–18 war . . . the few books on art published in England were singularly unappetising and unsuccessful. In this wilderness, Mr Zwemmer's bookshop was the one source of refreshment . . . colour reproductions of Van Gogh did not exist, and when they first appeared in Mr Zwemmer's windows they were deliriously exciting. The same is true of *Picasso and *Matisse, only that with them one could enjoy the added excitement of a movement belonging to one's own time.' In a similar vein Henry *Moore wrote: 'I discovered Zwemmer's bookshop in October 1921, in my first term at the Royal College of Art. I was a provincial student, raw from Yorkshire. That first year in London was the most tremendous exhilaration for me. No doubt the British Museum contributed most of all to my great excitement and education—but the art books I found in Zwemmers had a great share, too.' (Both quotations are from *Anton Zwemmer: Tributes from Some of his Friends on the Occasion of his 70th Birthday*, privately printed in 1962.) From 1929 to 1968 the Zwemmer Gallery operated in Lichfield Street, adjacent to the bookshop. It held many important exhibitions of contemporary art, including *Dalí's first one-man show in Britain (1934) and the final exhibition of the *Seven & Five Society (1935), which was the first all-abstract show to be held in England. Zwemmer also published books, including the first monograph on Henry Moore (1934, by Herbert *Read). There are now several branches of the bookshop, but the company had serious financial difficulties in the early 1990s and was for a time in receivership.

Zwobada, Jacques (1900–67). French sculptor. He was born at Neuilly-sur-Seine and studied briefly at the École des *Beaux-Arts in Paris. His early inspiration was *Rodin, as can be seen in his monument to Simon Bolivar (1933) at Quito in Ecuador. In about 1935 he abandoned sculpture and taught drawing in Paris at the Académie de la Grande Chaumière and the *Académie Julian. He took up sculpture again in about 1950, working in a semi-abstract style characterized by a rhythmical interplay of masses and voids. In 1956 his wife died suddenly and he devoted msot of the rest of his career to creating a funerary monument to her at Mentana, near Rome, where he had bought property shortly before her death. The monument consists of several figures and groups arranged in a semi-circle, with various subsidiary pieces. The last group he added, shortly before his own death, was the symbolically apt *Orpheus and Eurydice*.